8·6-87 $145.00 (2 vols)

ART
MUSEUMS
OF THE
WORLD

ART MUSEUMS OF THE WORLD

Norway–Zaire

VIRGINIA JACKSON
Editor-in-Chief

MARLENE A. PALMER and ERIC M. ZAFRAN
Associate Editors

ANN STEPHENS JACKSON
Assistant Editor

INTRODUCTION by JAMES L. CONNELLY
Advisory Editor

GREENWOOD PRESS
NEW YORK • WESTPORT, CONNECTICUT • LONDON

Library of Congress Cataloging-in-Publication Data
Main entry under title:

Art museums of the world.

 Bibliography: p.
 Includes index.
 Contents: v. 1 Afghanistan–Nigeria———v. 2 Norway–Zaire.
 1. Art museums. I. Jackson, Virginia.
N410.A78 1987 708 85-5578
ISBN 0-313-21322-4 (lib. bdg. : set : alk paper)
ISBN 0-313-25876-7 (lib. bdg. : v. 1 : alk paper)
ISBN 0-313-25877-5 (lib. bdg. : v. 2 : alk paper)

Library of Congress Catalog Card Number: 85-5578
ISBN 0-313-21322-4 (lib. bdg. : set : alk paper)
ISBN 0-313-25876-7 (lib. bdg. : v. 1 : alk paper)
ISBN 0-313-25877-5 (lib. bdg. : v. 2 : alk paper)

First published in 1987

Greenwood Press, Inc.
88 Post Road West
Westport, Connecticut 06881

Printed in the United States of America

∞

The paper used in this book complies with the
Permanent Paper Standard issued by the National
Information Standards Organization (Z39.48-1984).

10 9 8 7 6 5 4 3 2 1

Contents

ART
MUSEUMS
OF THE
WORLD

Norway

———— Oslo ————

NATIONAL GALLERY OF NORWAY (officially NASJONALGALLER-IET), Universitetsgaten 13, Oslo.

The National Gallery of Norway was founded in 1837 but did not open to the public until 1842. In 1882 the collection was moved into a new building that already housed a sculpture collection established by an Oslo bank. The new building, designed by the German architect Heinrich Ernst Schirmer (1814–87), became the central block of the present structure. Subsequently the building and sculpture collection were given to the city of Oslo but in 1903 were taken over by the national government. In 1908 a semiprivate collection of prints and drawings was acquired.

The National Gallery focuses its collecting activities on Norwegian painting, sculpture, prints, and drawings. Other Oslo institutions also collect Norwegian art of various types: The Oslo Museum of Applied Arts (Kunstindustrimuseet i Oslo), which contains decorative arts; the Norwegian Folk Museum (Norsk Folkemuseum), which focuses on folk art and architecture; and the University Collection of Northern Antiquities (Universitets Oldsaksamling), which comprises archaeological materials and pre-Renaissance art, including several magnificent carved stave church portals.

More than half of the National Gallery's approximately fifty exhibition rooms are devoted to the work of Norwegian artists, the most famous of whom is Edvard Munch. Although Munch's work may be seen in greater quantity at the Munch Museum (also in Oslo), the number of outstanding paintings by the artist in the National Gallery's collection makes a visit essential to anyone wishing to see Munch at his best. In paintings from the 1880s, like the *Sick Girl* (1885–86) and *Self-Portrait*, the beginnings of Munch's expressive personal style are

evident. *The Cry*, *Puberty* (1895), and *Girls on a Bridge* are among the out-standing works of the 1890s and the early years of the twentieth century to be seen in the three galleries devoted to Munch's works. His late works often contain figures whom he viewed as representative of the constructive forces in society, as seen in the *Man in the Cabbage Field* (1916).

Although Munch is the only Norwegian artist to have achieved international fame, a number of others represented in the National Gallery's collections have produced works that deserve attention. The earliest of them is Johan Christian Dahl (1788–1857), regarded as the "grand old man of Norwegian painting." Although he studied in Copenhagen and spent most of his working career in Dresden, Dahl was an ardent patriot and played an active role in the movement to preserve traditional Norwegian architecture, particularly the stave churches. He also was instrumental in founding the National Gallery. As seen in his *Sognefjord in Winter* (1827) and *Norwegian Mountain Landscape* (1851), Dahl painted the rugged Norwegian landscape in a romantic style not unlike that in which American painters such as Frederic Edwin Church were depicting their country's mountains, lakes, streams, and forests about the same time.

One of the fascinations of the panorama of Norwegian art to be seen in the National Gallery—at least for visitors familiar with American art—is the number of remarkable parallels between artistic development in the two countries. This may be explained by the fact that both were at some distance from the major European cultural capitals, and artists from both countries gravitated to these centers about the same time: first to Rome, then Düsseldorf and Munich, and finally to Paris.

Other significant mid-nineteenth-century Norwegian artists to be seen in the Gallery's collections are Adolphe Tideman and Hans Gude, both associated with the Düsseldorf school. While Tideman specialized in genre scenes of Norwegian peasantry, Gude created sweeping panoramas, at first romantic and later more sober. *Norwegian Highlands* of 1852 and *Bridge in Northern Wales* of 1863 are particularly noteworthy. *The Bridal Journey* of 1848 is an interesting collabo-ration between Gude and Tideman depicting a bridal party in a small boat making its way down one of the country's spectacular fjords.

In the 1870s a number of Norwegian artists gravitated first to Germany and then to Paris, where they came under the spell of French painting. Among the best of them was Harriet Backer, whose work presented her countrymen with easily identifiable interior settings such as the *Farm Interior* (1886) and *Blue Interior* (1883), and Christian Krogh, a journalist and novelist who concentrated on life as lived and experienced by the individual. His *Albertina* (1886–87) depicting prostitutes awaiting examination by the police doctor is reminiscent of Courbet and early Degas.

In the 1890s an interesting group of artists including Theodore Kittelsen, Gerhard Munthe, and Harold Sohlberg began to depict the Norwegian countryside and subjects drawn from Norwegian folk tales in non-naturalistic styles related to Symbolism and Art Nouveau. Sohlberg's *Flowery Meadow in the North* of

1905 is a striking example of this "neo-Romantic" school. Munthe alternated his style of the cooly realistic landscape idiom with formalistic decorative art and later developed what may be called a "primordial cultural identity" as seen in his watercolor *Steed from the Nether World* (1892).

The sculptor Gustav Vigeland, whose life's work was the creation of the astonishing outdoor sculpture garden in Oslo's Frogner Park, is represented in the National Gallery's collection by several works, including the early bronze relief *Helvete*.

During the first decade of the twentieth century several Norwegian artists studied in Paris with Henri Matisse: Jean Heiberg, who was also influenced by the Danish painter Georg Jacobsen; Axel Revoid; Henrik Sørensen; and Per Krohg. Their work exhibited together in one gallery reveals their receptivity to Matisse's relatively conservative modernist ideas. Particularly noteworthy are Heiberg's *Brother and Sister*, 1930, and Sørensen's typical *Landscape from Bøverdalen*, 1933, reflecting local Norwegian tradition. More recent twentieth-century Norwegian art and that of other Scandinavian countries is also represented in the Gallery's collections.

The art of other European nations is not the major concern of the National Gallery, but three collections of non-Norwegian art deserve mention: a remarkable group of Russian icons, mostly of the fifteenth- and sixteenth-century Novgorod school, the Christian Langaard bequest of European Old Master paintings, and the collection acquired through contributions of the *Nasjonalgalleriets Venner* (Friends of the National Gallery). There is also a small collection of ancient Egyptian, Greek, and Roman sculpture.

The Langaard bequest is strongest in sixteenth- and seventeenth-century Dutch and Flemish painting, with works by Gerard David, *The Virgin and Child*; Lucas van Leyden, *The Virgin and Child*; Jacob van Ruisdael, *Landscape*; Jan Steen, *Oyster Feast*; and Frans Snyders, *The Game Shop*, with a sketch by Peter Paul Rubens, *The Lion Hunt*. Also included are Jusepe Ribera's *Boy with Flower Pot* and El Greco's fine *St. Peter Repentant* of about 1590.

In addition to having the Langaard bequest, the National Gallery has works by other pre-twentieth-century European masters including Lucas Cranach the Elder, *The Fountain Nymph*; Theodor van Baburen, *Christ among the Doctors*; Jacob Jordaens, *The Blessings of the Peace of Westphalia*; and Orazio Gentileschi, *Judith and Holofernes*.

Nineteenth-century artists represented in the collection include Eugène Delacroix, with five works including *Lion Killing an Arab*; Camille Corot; Thomas Couture; Caspar David Friedrich, with *Greifswald in Moonlight*; and Carl Friedrich Lessing, with *Scenery from the Rhine District*.

The Friends of the National Gallery was founded in 1917 for the purpose of raising money for the acquisition of non-Norwegian art. The organization's interest in modern art was demonstrated by its first purchase, Picasso's 1903 painting *Le pauvre ménage*. Subsequent acquisitions have included Manet's *The World's Fair of 1867* (1867), Gauguin's *Brittany Landscape* (1889), Renoir's

After the Bath (1885–87), and Monet's *Rainy Weather, Etrétat* (1886), the first of the artist's paintings to be purchased by a museum. The Friends group also has made possible the purchase of works by Delacroix, Rodin, Cézanne, Corot, Courbet, Degas, Bonnard, Braque, Matisse, Modigliani, Jorn, Appel, and Dubuffet. Through the generosity of the Friends organization the museum also has acquired its collection of Russian icons, a Roman portrait head, and two pieces of French Gothic sculpture.

The Department of Prints and Drawings specializes in works by Norwegian artists, and the Gallery also has a collection of casts of ancient, medieval, and Renaissance sculpture.

The National Gallery's library, containing 45,000 volumes and 150 current periodicals, is open to the public. The Gallery has no bulletin but has produced occasional publications on various parts of the collection, such as Norwegian paintings, foreign paintings, sculpture, and prints.

Selected Bibliography

Museum publications: *Nasjonalgalleriet: A Guide to the Collection*, 5th ed., 1977; *Nasjonalgalleriet: One Hundred Years of Norwegian Painting*, introduction by Magne Malmanger, 1980; Hals, Anna-Stina, *Katalog Over Skulptur Og Kunstindustri*, introduction by Sigurd Willoch, 1952; idem, *Supplement*, 1971; Nasjonalgalleriet, *Katalog Over Norsk Malerkunst: Tilvekst, 1968–1978*, 1979; idem, *Norsk Grafikk Fil 1970*, 1972; Ostby, Leif, ed., *Katalog Over Norsk Malerkunst*, introduction by Sigurd Willoch, 1968; idem, *Katalog Over Utenlands Malerkunst*, introduction by Sigurd Willoch, 1973.

Other publications: Engelstad, Eivind S., *Norwegian Museums of Art and Social History* (Oslo 1959); Shetelig, Haakon, *Norske Museers Historie* (Oslo 1944); Willoch, Sigurd, *Nasjonalgalleriet gjennem hundre år* (Oslo 1937); idem, *Nasjonalgalleriets Venner: Kunst i femti år* (Oslo 1967).

<div align="right">BRET WALLER</div>

Peru

Lima

NATIONAL MUSEUM OF ANTHROPOLOGY AND ARCHAEOLOGY
(officially MUSEO NACIONAL DE ANTROPOLOGÍA Y ARQUEOLOGÍA),
Plaza Bolivar s/n, Pueblo Libre, Lima.

The origin of the Museo Nacional de Antropología y Arqueología is closely linked to the development of museums in Peru. The idea of having a national museum through which the heritage of the Peruvian culture could be studied and preserved arose with the establishment of the Republic, and since then it has undergone several changes.

On April 2, 1822, before the Republic was formally established, the government decreed that no one was allowed to excavate archaeological sites, for they were patrimony of the state, and archaeological material had to be kept at the Museo Nacional. Unfortunately, during the years of the War of Liberation nothing was done to create such a museum.

In 1826, Mariano E. de Rivero worked hard for the establishment of the museum, but the difficult political and economic situation did not allow the fulfillment of the project. Meanwhile, some archaeological objects were already coming into private and public collections outside Peru.

The formal creation of a museum took place in 1836, when the Museo de Historia Natural (Museum of Natural History) was established. At that time, the secretary of the interior was appointed director of the museum—one of his many tasks—and the administration itself was entrusted to an associate director.

Many years of political instability and many site changes allowed the museum to remain in the hands of bureaucrats more than in the hands of researchers.

In 1872 the archaeological collections of the museum were displayed in the Industrial and Historical Exhibition, and in 1881, as a result of the defeat of

Peru in the war against Chile, the museum was looted and an important part of the collection was taken to Santiago, Chile. From then until 1905, part of the archaeological heritage of Peru was taken out of the country.

In 1905 the Museo de Historia Natural was established, and commissioned to take charge of the archaeological material was Max Uhle, a German archaeologist who had worked in Peru for several years. The museum was opened on July 29, 1906. It included two sections: history and archaeology. Max Uhle was entrusted with the archaeological section and J. A. de Izcue with the historical section. Uhle increased the museum collections to a large extent as a result of intensive work and purchases, and for the first time the museum had assembled a considerable collection of archaeological pieces: a total of 8,675 by 1911.

Uhle worked at the museum until 1911, when he was replaced by Emilio Gutierrez de Quintanilla, who was appointed director in 1912 but was unable to continue the work of the great German archaeologist.

During 1913 the government approved the formation of the Department of Archaeology in the Museo de Historia Nacional. Julio C. Tello, a Peruvian anthropologist, was appointed director and began to organize, classify, preserve, and display the archaeological and ethnographic collections.

At that time the department of the museum under the direction of Julio C. Tello was called Arqueología, Tribus Salvajes e Indios de la Sierra (Archaeology, Savage Tribes, and Indians of the Sierras). The other section, Colonia y República (Colonial and Republican Periods), was directed by Gutierrez de Quintanilla. The administrative policies of the two directors were completely different, resulting in several problems; therefore, in 1913 the government decreed the reorganization of the Museo de Historia Nacional. The anthropological and archaeological section was made independent of the Colonial and Republican Periods section and was known as the Museo de Arqueología y Antropología (Museum of Archaeology and Anthropology) under the direction of Julio C. Tello. Due to new problems, however, Tello was compelled to resign in 1915, and the Museo de Historia Nacional returned to its former administration, under Gutierrez de Quintanilla as director of both sections: archaeology and history. Poor administration by people incapable of handling archaeological material forced the government to hire a foreign expert, Philip Ainsworth Means, from Boston University. Means arrived in October 1919 and resigned in March 1920. The direction of the archaeological section, as well as the history section, was again in the hands of Gutierrez de Quintanilla, and for several years the archaeological collections of the museum were neglected.

In 1924 the government bought the important archaeological collection of Victor Larco Herrera, a cultivated and wealthy man who had acquired several private collections from all parts of Peru on the advice of Tello and Alex Hrdlicka in order to create a museum of Peruvian archaeology. The Larco Herrera Collection was classified, registered, and numbered. It had a total of 26,788 pieces and, when purchased by the state, became the Museo Arqueologico Nacional under the direction of Julio C. Tello. Tello requested authorization from the

government to move the archaeological collection of the Museo de Historia Nacional to the new museum in order to have all of the national archaeological materials under the control of a single institution. At the end of 1925, when all pieces of the collections were systematically registered and classified, they totaled 31,264 holdings.

Since little was known about the pieces in the collection, Tello was very interested in undertaking serious investigations by exploring and excavating the original archaeological sites from which the collections probably came. He accomplished his purpose to a certain extent and substantially contributed to the understanding of the prehistorical cultures of Peru, while increasing the museum collection.

In 1930, when Luis Sanchez Cerro became president of Peru through a military coup, Tello was replaced by Luis A. Valcárcel as the museum director. The Museum of Archaeology was reorganized and became part of the Museo Nacional together with other museums under the direction of Valcárcel.

Meanwhile, Tello began to work at the Instituto de Investigaciones Antropológicas (Institute of Anthropological Studies) and at the Museo de Antropología (Anthropological Museum), both of which he set up as part of the Universidad Nacional Mayor de San Marcos. The most important archaeological material of this new museum had been excavated and recovered by Tello and his students during the explorations and archaeological work at Paracas and Nazca on the southern coast. At this time Tello needed part of the collections of the Museo Nacional for his studies, so the Museo de Antropología of Universidad de San Marcos lent him several pieces for this purpose and for exhibition.

In a short time the Museo Nacional became such a large institution that it was very difficult to keep it under a single administration, and in 1945 the government enacted a supreme decree, whereby four National Museums were constituted. One was the Museo Nacional de Antropología y Arqueología. Under this new organization every institution related to any archaeological function in the country became part of this new specialized museum, and all of the public archaeological collections were centralized in a single institution.

The idea of centralizing archaeological collections grew from the need for a public institution that would be able to house them properly, since many of the objects that had been discovered and excavated were not adequately maintained in warehouses or were poorly exhibited. Therefore, a special building to house the numerous archaeological collections was built on an area of six thousand square meters in Pueblo Libre, a suburb of Lima, where it still stands. The museum was intended to keep archaeological material in adequate conditions to prevent their deterioration, to make them available to scientists for investigation, and to exhibit part of them to the general public.

The original purpose of the Museo Nacional de Antropología y Arqueología was to record all of the archaeological sites in Peru in order to map them and to establish cultural sequences. Only part of this project has been fulfilled so far due to a chronic shortage of economic resources. The museum is also a product

of the effort devoted to stop the flow of Peruvian archaeological objects into public and private collections outside the country.

At present most of the work of the museum staff is devoted to preservation, inventory, and exhibition of the archaeological material kept in the warehouses.

Today the Museo Nacional de Antropología y Arqueología (MNAA) is a branch of the Instituto Nacional de Cultura (INC), which controls all of the museums in the country, as well as every cultural institution. INC depends in turn upon the Ministry of Education for its administration and financing. The INC director is appointed by the government. In turn, the INC director appoints the MNAA director.

The MNAA is managed by a director and an assistant director, who serve indefinite terms depending on the INC policies. In the museum there are four curatorial departments: Metallurgy, Pottery, Physical Anthropology, and Textiles, each of which is responsible for the preservation, investigation, and exhibition of its own material and has its own department head. There are also other service offices in charge of supplying materials: carpentry, design, photography, archives, and library.

The present exhibition rooms of the museum are the result of a reorganization that began in 1972, when a well-known Peruvian archaeologist, Luis G. Lumbreras, was appointed director. Lumbreras believed the museum should be an educational center for the reconstruction of Peruvian social history and thus tried to show the archaeological materials in an informative context that could allow an easy understanding of their meaning and function. He wanted the general public not only to appreciate the aesthetic value of the objects exhibited but to understand them as a product of human ingenuity and social processes. The displays are organized according to a chronological order providing the public with an idea of the historical process that took place in prehistoric times in this part of the world.

In the first room of the museum the visitor is introduced to the ecosystems in which human groups probably lived twenty thousand years ago in this part of America. In a showcase, primitive human families can be seen the way they lived in caves, using lithic tools similar to those found in Chivateros (central coast) and which date from about twelve thousand years ago.

The second room presents the remains of the first agriculturists, who supposedly lived seven thousand years ago in Chilca, a village on the central coast.

The museum displays a very important authentic piece of a later period: a pair of crossed hands made out of mud that belongs to the Templo de las manos cruzadas, dated five thousand years ago. It was found near Huanuco (central Sierra) and was excavated by an archaeological expedition from the University of Tokyo (Japan) and is supposed to be the oldest temple in America.

Among the most important holdings, because of its great antiquity, is an engraved gourd. It was found by the American archaeologist Junius Bird at Huaca Prieta, a site on the northern coast. It is thought to be four thousand years old. The museum has some samples from the textile art of these early times.

The oldest ones are more than six thousand years old and were made with vegetable fibers without using any loom.

The next millennium is known as the Formative period. Pottery work was started between the year 2,000 and 1,000 B.C., and looms were beginning to be used for weaving. The most important remains of this period were discovered in the northern Sierra at Chavin de Huantar. The Templo de Chavin de Huantar is one of the best examples of the monumental architecture and lithic sculpture of this culture. One of the most famous stone sculptures of Chavin is the *Estela Raimondi* that was found near the temple more than a century ago; in 1874 it was moved to Lima, and it can now be seen in the museum. It is 1.95 meters high and dates from 600 B.C. The engraved image of the supernatural being is holding two staffs and appears as a combination of jaguar, human, bird of prey, and serpent.

The museum has, among the best examples of Chavin reliefs and carvings on stone, a replica known as the *Lanzon de Chavin*. It is a big monolithic sculpture, 4 meters high, representing a powerful deity with long fangs and hair made out of serpent bodies. It is one of the most fantastic pieces of Chavin art.

The *Obelisco Tello* is another superb sample of Chavin style. It is an engraved monolith 2.52 meters high that was brought to the museum by Tello in 1919. It is estimated to be three thousand years old, and the reliefs represent supernatural beings with zoomorphic and phithomorphic attributes.

Large stone heads are also displayed in one of the rooms of the museum. They are known as *cabezas clavas*; some are authentic and some are copies of the original ones left in place on the walls of the temple Chavin de Huantar. A temple with some stone stelae with engraved figures in Chavinoid style (from the Formative period), found at Cerro Sechin on the northern coast, is exhibited at the museum.

Several other Chavin pieces found on the southern coast can also be seen at the museum, most notably a superb pottery piece from Ocucaje in the Ica valley. The pot is a modeled jaguar figure with engraved and painted decorations and probably was made in the seventh century B.C. One of the finest pieces of the Formative period of the southern coast that can be seen at the museum is a fragment from a large cotton fabric with a depiction of a staff bearing deity in light and dark brown; the figure is decorated with serpent heads and framed in lozenges. It is dated approximately 600 B.C.

The next rooms of the museum show the regional developments that appeared after the decay of the influence of Chavin around 500 B.C. One of the most important cultures of this period is known as Paracas, because the richest site was discovered on a hill overlooking the Paracas Bay when Tello was exploring the region in 1925. It was a cemetery where more that four hundred funerary bundles were found. The bodies of the dead were wrapped in several layers of garments, mostly woven and exquisitely embroidered with alpaca and vicuña wool in bright colors. Two styles can be recognized in the technique and decoration of the textiles. The earlier one was named by Tello "Cavernas" and the

later "Necropolis." In addition to having these remarkable textiles, the museum also has on display diverse objects of the Paracas culture such as pottery, jewelry, and other artifacts that were found as part of the offerings to the dead.

One of the most important regional developments of the period known as Intermedio Temprano occurred in Rio Grande de Nazca valley, also on the southern coast. The best-known manifestation of the art of the people from Nazca is their ceramics, profusely decorated in bright colors. The museum exhibits several pieces that show the Nazca potters' mastery in using the colored slip decoration on which they painted all living things of their environment.

One of the best specimens of Nazca art in the museum is a small modeled ceramic; on a rectangular platform there are four men and one woman, with four dogs and three parrots, as if representing a family with its most beloved pets.

Among the most impressive monuments of Peruvian archaeology is the complex of long lines and large drawings traced on the Pampa del Ingenio in the Nazca valley. From the air it is easy to recognize the form of birds, monkeys, spiders, and fishes. Some researchers are studying the relation between these drawings and some constellations of crucial significance for the Nazca agriculturists. The museum offers the visitors some enlarged aerial photographs of these lines and drawings.

The Mochica culture is one of the most interesting of regional developments on the northern coast. Its dates are 200 to 700, and the best-known works of art of those people are their modeled ceramics. They represented in clay, in a masterly way, animals and humans. Some excellent samples of the Mochica art are exhibited in one room of the museum.

During the final phase of the Nazca period, a vigorous new culture developed in the highlands of the south-central region of Peru. It is known as Wari after an important archaeological site near Ayacucho, where a pottery of impressive style was found. Wari iconography is closely related to that of the Tiahuanaco culture, which developed in the highlands of Bolivia, and its features can be found in a large geographical area. The museum has a very beautiful pot in which the mythical figure from the Portada del Sol of Tiahuanaco is represented in a style known as Robles Moqo. It was found in a site called Pacheco on the southern coast and is supposed to have been made in the eighth century.

The Wari textiles are among the finest that were produced by pre-Columbian Peruvian weavers. Motifs are rendered in strong, straight, and curved lines accentuated by striking color contrasts. Finely woven tapestry designs often follow Tiahuanaco models closely. The museum has some exquisite pieces of this art.

After the collapse of the Wari culture, other regional developments appeared again in the period known as Intermedio Tardío. One of them is the Chimu culture on the northern coast. The museum collections have some examples of the Chimu people's mastery in working metals. The best-known pieces are ceremonial knives call *tumi*. Some of these pieces are decorated with turquoise inlays and have as a handle the figure of a special character wearing an elaborate

headdress. Other gold pieces are the *orejeras*, a kind of ear spool, necklaces, masks, breastplates, bracelets, and headdresses. To keep them safely, all of these gold objects are displayed in a special section of the museum with other gold and silver objects from different cultures.

The latest archaeological objects in the museum are from Inca times, the last imperial development before the Spanish invasion; they date from the fifteenth and sixteenth centuries. Stone carvings stand out in the Inca art. The museum has some beautiful examples of this art, one of which is a mortar decorated with carved serpents. The *conopas* are fine and generally small stone figures. They represent llamas and alpacas that were used as offerings in ceremonies for the reproduction of these animals.

Kipus are other interesting Inca objects. They are groups of knotted strings of different colors and sizes that were used for counting. The vessels known as *keros* are carved in wood and painted in bright colors. The museum has some beautiful prototypes. Among the Inca pottery, the most typical forms are flat dishes with a handle in the form of a bird head and bottles of a special form known as *aribalos* used for keeping and carrying *chicha*, the Andean beer.

From the material exhibited in the museum the visitor can grasp the general sequence of cultures that flourished in this part of the New World before the Spanish invasion.

The museum library is one of the latest acquisitions, made possible by a grant from the Peruvian bank. With these funds the private library of a former director of the museum, Jorge Muelle, was bought and housed in a new building especially designed for it. At present the museum library, which was increased by later gifts, purchases, and exchange of publications, is a valuable aid for study of Peruvian archaeology and anthropology. The library is open to the public, but it is noncirculating.

Another important building that was added to the museum in recent years is the textiles laboratory and warehouse. The establishment of this Textile Conservation Center was made possible by financing provided by the Peruvian Foundation and Augusto N. Wiese and UNESCO/PNUD Program through Proyecto Regional del Patrimonio Cultural Andino (Regional Project of Andean Cultural Patrimony). The textile collection of the museum is the largest collection of Peruvian textiles in the world. A special laboratory and storage room were built for its preservation with equipment using the most sophisticated technology.

Selected Bibliography

Museum publications: Tello, Julio C., and Toribio Mejía Xesspe, "Historia de los Museos Nacionales del Perú, 1822–1946," *Arqueológicas*, n. 10, 1967; *Boletin del Museo Nacional de Antropología y Arqueología*, n. 7, 1981.

Other publications: Wendell, Clark Bennett, *Ancient Arts of the Andes* (New York 1954); Bird, Junius B., "Pre-ceramic Art from Huaca Prieta, Chicama Valley," *Ñaupa Pacha*, vol. 1 (Berkeley 1963); Donnan, Christopher B., *Moche Art and Iconography* (Berkeley 1976); D'Harcourt, Raoul, *Textiles of Ancient Peru and their Techniques*

(Seattle 1962); Kauffmann Doig, Federico, *Arqueología Peruana* (Lima 1970); Kubler, George, *The Art and Architecture of Ancient America* (Baltimore and London 1975); Lapiner, Alan C., *Art of Ancient Peru* (New York 1968); Lothrop, S. K., *Treasures of Ancient America* (Geneva 1964); Lumbreras, Luis G., *De los Pueblos: Las Culturas y las Artes del Antiguo Peru* (Lima 1969); *Guía de Arqueología Peruana* (Lima 1975); *Arte Precolombino: Primera Parte, Arte Textil y Adornos* (Lima 1977); *Arte Precolombino: Segunda Parte, Escultura y Diseño* (Lima 1978); *Arqueología de la America Andina* (Lima 1981); Ravines, Rogger, *Tecnología Andina* (Lima 1978); Rowe, John Howland, *Chavin Art: An Inquiry into Its Form and Meaning* (New York 1962); ''Inca Culture at the Time of the Spanish Conquest,'' *Handbook of South American Indians*, vol. 2 (Washington, D.C. 1946); Tello, Julio C., ''Los descubrimientos del Museo de Arqueología Peruana en la Peninsula de Paracas,'' *Atti del XXII Congresso degli Americanisti*, vol. 1 (Roma 1928); *Paracas, Primera Parte* (Lima 1959); Ubbelohde-Doering, Heinrich, *El Arte en el Imperio de los Incas* (Barcelona 1952).

ADRIANA SOLDI

Poland

Cracow

NATIONAL MUSEUM IN CRACOW (officially MUZEUM NARODOW-EGO W KRAKÓWIE), Ul Manifesto, Cracow.

The National Museum in Cracow was founded in 1879 by the Municipal Council of Cracow as the result of many private donations given for this purpose by a group of Polish artists and collectors. Due to a more liberal Austrian policy after 1867, this presented the first opportunity of creating a Polish national museum on Polish territories, since Poland had lost its independence (at that time annexed by Russia, Prussia, and Austria). Cracow became a cultural center of Poland again; scientific and artistic life flourished in the historical capital of Poland.

A museum committee appointed by municipal authorities in 1879 set the statutes of the museum. Accordingly, the Polish National Museum was to collect first of all objects of Polish and European art, leaving the collections of objects from other domains to special museums. It was also to remain a municipal property in order to be independent of the Austrian government.

After the statutes had been accepted by all Poles, both from the entire former territory of Poland and from abroad, they were passed in 1883. On September 11 the first exhibition of the museum's collections took place in the rooms of the medieval town Cloth Hall, which became the museum's seat.

The Cloth Hall is one of the most famous and important architectural monuments of Cracow. It is placed in the center of the marketplace and was built in the fourteenth century for commercial storage. In the sixteenth century it was rebuilt according to plans by the Italian sculptor and architect Jan Maria Padovane, who decorated the building with a Renaissance attic and added light pillared loggias with staircases. In 1875–79 the building was renovated under the direction

of the talented architect Tomasz Pryliński in cooperation with the most famous Polish historical painter Jan Matejko. The Cloth Hall has remained unchanged to the present.

Until 1950 the museum had been administered by municipal authorities with the help of a committee, whose head was each consecutive town mayor and which assembled the most outstanding scholars and artists. The museum was managed by a director appointed by the committee. Władysłow Łuszczkiewicz, a painter and professor of the Cracow Academy of Fine Arts and an outstanding collector of old Polish art, was the director from 1883 to 1900. In that period the collections were increased through donation or purchase by ten thousand objects.

In the years 1901–50 the museum was managed by the director Feliks Kopera, a well-known museologist and art historian. During the half-century period of his activity the number of objects rose to three hundred thousand. The many collections then originated are of fundamental importance to Polish culture.

In 1901 the museum was given new status, which broadened the museum's control over cultural monuments. This led to a rapid increase in both craft and historical materials in the museum's collections.

In 1903 Emeryk Hutten-Czapski's collection became the first department of the museum. The collection was placed in the Czapski Palace and in a special annex with the library and the numismatic collection built according to plans of the famous architect Tadeusz Stryjeński.

In 1904 the second department was added, through the purchase of the home of Jan Matejko, the most outstanding Polish historical painter. In the same year Adam and Włodzimiera Szełayski donated to the museum a collection of native crafts. After their deaths in 1928, the museum took over their mansion in Szczepański Square and established there a new department of Asiatic art for the collection donated to the museum by the art critic Feliks Jasieński.

The rapid increase in the size of the museum's collection led in 1934 to a public subscription for a new building to be situated on the Third of May Avenue and was begun according to plans by a group of architects from Cracow and Warsaw: Czesław Boratyński, Edward Kreisler, and Bolesław Schmidt. The first part of the building was finished before 1939. During the Nazi occupation it was rebuilt to serve other purposes. From 1950 to 1957 it was restored to its original form. The extension of the building according to revised plans is now under construction.

On January 1, 1950, control of the museum was transferred to the state authorities, and the same year it gained one more department: the Princess Czartoryskis' museum was included as part of the National Museum.

The Czartoryski Museum, the oldest Polish museum, was founded outside Cracow, at Puławy, at the beginning of the nineteenth century by Izabela Czartoryska. The buildings, known as ''The Sibyl's Temple'' (opened in 1801), and ''The Gothic House'' (1809) housed works of both Polish and foreign artists. Among them were pictures by Leonardo da Vinci, Raphael, and Rembrandt.

After the suppression of the 1831 Uprising and the confiscation of the Czartoryskis' possessions, the collection was secretly transported to Paris and placed in the Czartoryskis' home at the Hôtel Lambert. While in Paris the collection was enriched by many objects of European art. Under propitious political conditions the collection was brought back to Poland and opened to the public in 1876. For this purpose the Town Arsenal and the neighboring building on Pijarska Street, bought by the Czartoryskis, were rendered accessible by the municipality.

The collection also included a library and family archives, which in 1960 were transferred to a modern building on St. Mark Street, built for this purpose by Marian Jareszewski.

The Czartoryski Collection, which for a long time had been the center of Polish art and science of international importance, suffered a severe loss during the Nazi occupation. Invaluable remembrances of Polish kings, a collection of antique gold jewelry and many paintings, among them *Portrait of a Young Man* by Raphael, were lost.

The present structure of the museum is defined by the new statutes of 1973. The museum remains under the supervision of the Ministry of Art and Culture, which is responsible for its funding. The National Museum is administered by a director-general and two assistant directors, with specialists in the field of documentation and conservation and curators of the various departments, which include several separate museums: the Cloth Hall Museum, Rynek Główny, the Czapski Museum, the Czartoryski Museum, the Jan Matejko House Museum, and the Karol Szymanowski Museum in Zakopane. Today the museum collections include more than 650,000 objects and as such are the second richest in Poland after the National Museum (q.v.) in Warsaw.

The Department of Polish Painting and Sculpture (twelfth-eighteenth century) consists of three sections: Polish painting and sacred sculpture of the fourteenth-eighteenth century, and architectural sculpture since the twelfth century. All sections are exhibited in the Szołayski House Gallery. Of the group of fourteenth-century wooden sculptures by monastery wood-carvers, the best example is a statue of the Virgin and Child found at Regulice. The greatest achievement of Cracow sculpture of about 1400 is the *Madonna of Krużlowa*, which originally constituted the middle part of a triptych. From the second half of the fifteenth century are a series of paintings that once embellished the altars in the churches of the Dominican and Augustinian Orders and the almost wholly preserved triptych of Mikuszowice from the Cracow Cathedral. Features of the so-called "broken style" can be observed in the sculpture of *Jesus Riding a Donkey* of Szydłowiec. The sculpture used to be carried around the church during the Palm Sunday procession. It is one of the most magnificent and best-preserved sculptures used in the medieval mystery plays.

The next stage in the development of the Cracow sculpture of the late fifteenth century is presented by the works connected with the atelier of Wit Stwosz. The most notable among them is *Ogrojec* (*The Garden of Olives*), which is thought to be the first stone sculpture made by the great master. The Stwosz style was

taken over by other Cracow sculptors, as seen in other pieces exhibited in the gallery (e.g., *Mary with the Infant Jesus* of Grzybów, *Christ on the Cross*, and the polyptych of Lusina in low relief), and by painters of the Little Poland, as seen in the *Annunciation* of Cięcina and the *Polyltych* of Dobczyce.

Religious paintings of the first half of the sixteenth century include the magnificent polyptych *St. Jan Jałmużnik* (1504), donated by Mikołaj Lanckoroński to the Augustinian church; the *Annunciation* (1517), signed by the painter Jerzy; and the beautiful picture *Mary's Family* of Ołpiny (1510).

In the gallery are also exhibited works of foreign painters connected with Cracow because of the contacts with the court of Sigismund the Old. Pictures by Michał Lancz of Kitzingen, Hans Dürer, and Hans Suess of Kulmbach are representative of German Renaissance painting. The influence of the German painting of that period on Cracow artists is apparent in the painting of *Mary Falling Asleep* from the Church of St. Michael in Cracow (c. 1525).

In the seventeenth and eighteenth centuries portrait painting played a very important role in Polish Sarmatian culture. The myth that Poles originated from ancient Sarmatians strengthened the snobbery of nobles, who wanted to eternalize their traditions in portraits of themselves and their ancestors. Both half-figure portraits of that period (e.g., portraits of Stanisław Żółkiewski and of Jan III Sobieski of the seventeenth century and of Karol Radziwiłł painted by Konstanty Aleksandrewicz in 1786) and full-figure portraits are presented. A separate group of portraits is formed by pictures painted on sheet metal. They were placed on the short side of a coffin during funeral ceremonies. This kind of strongly realistic portraits forms a specific type of Polish portrait painting.

The two large pictures representing victories of the Polish kings, Władysław IV and Jan III, are an announcement of the forthcoming flourishment of historical painting, which later reached its culmination point in Jan Matejko's monumental visions.

The earliest objects possessed by the Department of Polish Modern Painting and Sculpture were created soon after 1764, during a period of political turmoil but also of cultural growth. Polish art ceased to be influenced by foreign trends and began to acquire a national character. This continued into the nineteenth century, the time of Poland's bondage, and it added spirit to Polish patriotic feelings. The department is divided in two galleries: the gallery in the Cloth Hall, displaying works created between 1764 and 1890, and the gallery of Polish twentieth-century art in the New Building, 1, 3 Maja Avenue, exhibiting works created after 1890.

The gallery in the Cloth Hall consists of four parts, each placed in a separate room. In the first one, the so-called Enlightenment Room, are displayed pictures painted in the second half of the eighteenth century and at the beginning of the nineteenth century. In this part, portraits predominate, among them the portrait of King Stanislaus Augustus Poniatowski in coronation robes, by Marcello Bacciarelli. In the second room are exhibited academic works connected with the history of the Polish nation, works of Jan Matejko with his most famous *Hołd*

Pruski (*Oath of Allegiance of the Teutonic Order*), and pictures by Siemiradzki, Stattler, Rodakowski, Gottlieb, Grottger (among others, *Welcome and Farewell of an Insurgent*), and Jacek Malczewski (the Syberian series including the famous *Ellenai's Death*). The third room is devoted to genre and landscape painting. Of interest are *Four-in-Hand* by Chołmoński, *Fury* by Podkowiński, and numerous pictures by Józef Brandt, Witold Pruszkowski, Aleksander Kotsis, Aleksander Gierymski, Jacek Malczewski, and others. In the fourth and last room are shown works by Pietr Michałowski, the most outstanding Polish Romantic painter. The room contains the largest collection of his works in Poland, with the famous *Charge in the Somosierra Ravine*.

Since 1959 the New Building of the museum has been the location of the gallery of Polish twentieth-century art. On the two floors of the building are displayed works of art of the period after 1890. The gallery presents in detail the events and changes taking place in Polish art during the past eighty years, mainly stressing the situation in the Cracow art center. The exhibition is divided into three large parts: the art of the Young Poland movement, the art of the period between the world wars, and the Polish People's Republic's art.

Cracow was the main center of the Young Poland movement, and the art of this period is well represented in the gallery by works of the most outstanding artists of this striking movement. In the first part can be seen works by Stanisław Wyspiański, for example, his great, unrealized stained-glass designs for the Wawel Cathedral and his unsurpassed children's studies, portraits, and landscapes. There also can be seen a few pictures by Jacek Malczewski (among others, *Self Portrait in White* and *The Unknown Note*). Józef Mehoffer (*The Portrait of Wife*), Olga Boznańska, Witold Wojtkiewicz and Władysław Ślewiński, as well as works by Leon Wyczółkowski, Ferdynand Ruszczyc, and Jan Stanisławski. Sculptures by Xawery Dunikowski, Konstanty Laszczka, Wacław Szymanowski, and others are on display. Much attention is paid to the Polish avant-garde of the interwar period. Many works by Stanisław Ignacy Witkiewicz, the most prominent representative of these movements, are exhibited in this part of the gallery, among them, his famous compositions and a series of portraits. The group of Polish Expressionists, that is, formists, is represented by numerous works of Zbigniew Pronaszko, Tytus Czyżowski, and Leon Chwistek (*Fencing*). A separate portion of the exhibition is devoted to Tadeusz Makowski.

One of the rooms has been assigned to the exhibition of works of artists from the Cracow Group, active since 1931. In this room are shown paintings by Maria Jaremianka, Jonasz Stern, Aleksander Blonder, and Adam Marczyński. Polish post-war painting is represented by Tadeusz Kantor, Tadeusz Brzozowski, Jerzy Nowosielski, Andrzej Wróblowski, Jerzy Pawłowski, Janina Marziarska, Jadwiga Kraupe-Świderska, and Jerzy Tchórzewski, with sculpture by Jerzy Bereś and works by Władysław Hasior.

The Department of Prints, Drawings and Watercolors includes more than 120,000 items: prints (from the sixteenth century until the present), drawings, watercolors, miniatures, architectural plans, woodcut blocks, and engraving plates.

The Czapski Collection, which includes twenty-three hundred portraits of Polish personages, is of great importance to Polish portrait iconography. Feliks Jasieński's gift of May 2, 1920, included Polish and foreign prints. A large group of foreign prints consists of French engravings (among others, an almost complete oeuvre of Odilon Redon and works by Pierre Bonnard, Eugène Carrière, Henri Fantin-Latour, Paul Gauguin, Camille Pissarro, Pierre Puvis de Chavannes, Auguste Rodin, Paul Signac, Henri Toulouse-Lautrec, Suzanne Valadon, Édouard Vuillard) and American (James Abbott McNeill Whistler), German (Max Klinger), Italian, English, Scandinavian, Netherlandish, and Russian prints. Larger sets of works are represented by artists such as Daniel Chodowiecki, Jacques Callot, Stefano Della Bella, Jeremiasz Falck, Jean Pierre Norblin, and Aleksander Orłowski.

Works of nineteenth- and twentieth-century Polish artists dominate the collection of drawings, watercolors, and pastels. To the collection are added works of Polish contemporary artists. They are finished works, sketches, and studies, among others by Olga Boznańska, Artur Grottger, Pietr Michałowski, Aleksander Orłowski, Józef Pankiewicz, Zbigniew Pronaszko, Stanisław Ignacy Witkiewicz, Leon Wyczółkowski, and Stanisław Wyspiański.

In the miniature collection the most numerous are portraits from the eighteenth century to the beginning of the twentieth century by Polish artists or by artists working in Poland. European miniatures are represented mainly by works of French and Austrian artists. Most of the Polish artists (Jan Nepomucen Głowacki, Aleksander Kucharski, Franciszek Tepa) come from the Warsaw center; Józef Grassi and Aleksander Molinari were the foreign artists working in Poland.

The Department of Artistic Craft and Material Culture includes about 40,200 objects and contains several subdivisions according to material criteria. Goldsmithery consists of objects of gold, silver, and enamel. The most valuable objects of the collection are the tenth-century silver bowl, which was ploughed up near Włocławek, and the box reliquary of Kruszwica, twelfth-century work of Rhinelandish enamelers. Worth mentioning also are collections of the Polish Renaissance spoons, metal belts, and silver cutlery, mostly of the nineteenth century. The collection of objects of semiprecious stones includes, apart from several small objects of rock-crystal, malachite, and agate, a very valuable collection of glyptic gems (Babylonian cylinders, scarabs, Eastern talismans, intaglios, and cameos, from antiquity to the nineteenth century).

The ceramics subdivision is one of the largest collections of this type in Poland. It consists of a collection of Gothic and Baroque tiles, magnificent Polish faience vessels of the Belweder and Wolff factories in Warsaw, and Polish porcelain of Korzec and Baranówka. Foreign ceramics are represented mainly by French faience and Meissen, Berlin, and Vienna porcelain.

The glass collection is composed mainly of Polish works of the eighteenth century. They are table utensils and richly decorated palace mirrors. Among the glass of foreign production worth mentioning are a group of Czech Biedermeier glass objects and the nineteenth–twentieth-century Secession glass. The collec-

tion also includes a group of medieval stained-glass windows of the thirteenth-fifteenth century and the Secession ones designed by Józef Mehoffer and Stanisław Wyspiański.

The collection of furniture and musical instruments is not extensive but boasts the eighteenth-century Polish furniture of Gdańsk and Kolbuszowa and a large collection of chests and trunks and guild counters. Among later objects of some importance are the Empire and Biedermeier sets and Secession furniture, some of which was executed according to plans by Wyspiański. The musical instruments worth mentioning are the viola da gamba made by the Cracow violin-maker Maroin Grablicz in 1601 and a seventeenth-century music box.

In the period 1918–39 the museum was given the great collection of Feliks Jasieński (jewelry, clocks, porcelain, furniture), Erazm Barącz (furniture of different historical periods and metal objects), and Maciej Wenzel (glass, ceramics, jewelry, and remembrances from the period of national mourning in 1863). The most magnificent donation from the post-war period is Leon Kostka's collection (1949) of jewelry, clocks, furniture, and varia.

The collections of the Department of Far Eastern Art cover works of art from Japan, China, Korea, Mongolia, Tibet, and, to a lesser degree, from India and Indonesia.

From a total of 12,395 objects, the largest and most homogenous group constitutes the art of Japan, especially *ukiyo-e* prints (more than forty-five hundred full-size illustrations and illustrated books and albums) from the Feliks Jasieński Collection presented to the museum in 1920. Almost all of the greatest masters of the colorful Japanese print from the seventeenth to the nineteenth century are represented. Some prints are unique in the world. A second large and artistically valuable collection is of Japanese military accessories. The collection of 740 shield guards (*tsuba*), several dozens of decorated parts of the Japanese sword hilts (*fuchi, kashira, menuki*) and shafts of knives (*kozuka*) that accompanied swords, comes in the greater part from the Jasieński gift and represents all kinds of armorers' and jewelers' techniques and ornamental themes. Among the fifty swords (*katana, wakizashi, tanto*) some specimens, along with certain helmets, masques, and armors, are of the highest artistic quality.

A small but interesting collection of Japanese lacquer ware primarily contains seventy medicine boxes (*inro*) with buttons (*netsuke*) from the eighteenth-nineteenth century and various types of caskets, bowls, small tables, combs, and so on. Among the Japanese materials especially noticeable are thirty belts (*obi*), a couple of kimonos, and tapestries, mostly from the eighteenth and nineteenth centuries.

The set of Japanese ceramics (about two hundred items) includes mostly late-nineteenth-century artifacts produced for export to Europe. The collection of Japanese art is supplemented by paintings on silk and paper (*kakemono* and *makimono*), from which the earliest, painted in Indian ink, comes from the seventeenth century. Japanese sculpture is represented by bronze and wooden figures of deities and by small ivory objects (*netsuke, okimono*). From among

other products of artistic crafts one should also mention objects of enamel, artistically woven baskets, and musical instruments.

In the Chinese collection attention should be paid to a set of about four hundred ceramic objects from the Han to the Ch'ing Dynasty (second century B.C.–nineteenth–twentieth century A.D.), especially a group of the oldest stoneware artifacts of the highest artistic value from the gift of J. Nowak. Chinese textiles are represented by about sixty examples of men's and women's clothing, hand-woven or embroidered fragments, mostly from the eighteenth and nineteenth centuries. A small set of nephrites, enamels, lacquer ware, and ivories, as well as some shaft arms and swords, comes from the end of the Ch'ing Dynasty. The Chinese collection has been supplemented in the post-war period with a set of some four hundred examples of artistic craft from the gift of the People's Republic of China.

The collection of Korean art (the gift of the People's Republic of Korea) comprises, with the exception of some older objects, ninety examples of modern artistic craft. The art of Mongolia and Tibet is represented by the Lamaist temple paintings (*thang-ka*), bronze figurines of deities, and ritual vessels.

The Indian collection numbers some one hundred bronze figurines, second-century wooden and stone sculptures, and several folk paintings on paper and glass, from different gifts. The art of Indonesia is illustrated by a set of a dozen or so Javanese batiks (eighteenth-nineteenth century) and a few examples of the artistic folk craft.

The numismatic collection (225,000 objects), recognized as one of the most valuable in Poland, illustrates the history of European coins in ancient times, Early Middle Ages, and Middle Ages (with some gaps) and the history of the Polish coin. The group of antique coins consists of 6,700 objects. Worth noting are the oldest ones, Greek coins of the Archaic period (sixth to fifth centuries B.C.). The most numerous are the Roman Empire's coins, and the most interesting among them is the Alexandrian coin collection. Byzantine coins are less numerous (about 500), as is the collection of Celtic coins (40). Some of the coins originate from the Cracow environs, where they were found and probably made. European coins of the Early Middle Ages and the Middle Ages are numerous but not representative (German, Czech, Anglo-Saxon, Scandinavian). The collection lacks early French and Italian coins but is being completed by purchases and donations.

The collection of Polish coins and of coins of countries connected with Poland is one of the most complete in Europe. Its essential part is formed by E. Hutten-Czapski's coin collection listed in the five-volume catalogue. The most valuable objects are a group of the first Piasts' coins, King Mieszko III's brakteats, groszes of King Casimir the Great, donation coins of Gdańsk and Toruń, and many unique objects: King Chrobry's denarius "GNEZDVN CIVITAS," a brakteat with St. Adalbert, the Jaksa of Kopanica's brakteat, King Vladislaus Łokietek's ducat, and a hundred-ducat coin of King Sigismund III. The Polish coins have been collected through the present, including those of the Polish People's Re-

public (probationary and current). The collection of the Teutonic Order, Livonian, Saxe-Polish, and domanial coins is a rare group of coins of countries connected with Poland. Among the objects of the bank-note collection worth noting are the Kościuszko notes.

The collection of medals is similar to that of the Roman Empire's coins as far as the number is concerned. Several medals originate from the Czapski Collection and are listed in the catalogue mentioned above. The collection consists of Polish and related-with-Poland medals since the sixteenth century. The oldest are royal medals of Sigismund I, Queen Bona, and Sigismund Augustus made by Padovano and Hans Schwarz. The first private medals were executed also in that period. The majority of the seventeenth- and eighteenth-century medals add splendor to the reign of Polish kings and their marriages and victories; they also celebrate great Polish commanders. Among them are medals made by Dadler, Höhn, and Buchheim. The nineteenth- and twentieth-century medals show a variety of themes: the celebration of exhibitions and ceremonies and great Polish poets, writers, and painters. Private medals were made to celebrate outstanding members of various families. The collection also includes medals celebrating historical anniversaries or expressing a yearning for freedom. Contemporary medals are also included.

The Jan Matejko House is the biographical museum of the most prominent Polish painter of historical scenes. Its collections include a part of the artist's private collection, his works, remembrances, and tokens of the cult that surrounded him.

The Department of Orthodox Church Art (six hundred items) consists of an icon collection and of handicrafts. The objects have been collected since the 1880s by purchase. By 1900 the most interesting objects had been collected, which form the base of the collection. Later the museum was presented with a great number of art objects of the Orthodox Church. Now the museum's collection of icons includes Carpathian icons (fifteenth-twentieth century); Russian, Greek, and Romanian icons (seventeenth-nineteenth century); and a complete iconostasis (eighteenth century) painted, sculptured, and gilt, of an exceptionally large size. The most interesting objects in the collection are the fifteenth-century icon of St. Paraskevia, the most popular saint of the Eastern Orthodox Church; the Holy Trinity icon (eighteenth century); and icons of the Day of Judgment (sixteenth and seventeenth centuries).

The Department of Textiles is the richest in Poland, with a collection of old fabrics (thirteen thousand items) containing all kinds of textiles made in Poland and those that, although imported, were used in Poland and became a part of the material culture. The largest group of Polish artistic fabrics is a collection of embroideries, most often preserved on liturgical clothes, of the Middle Ages to the nineteenth century. Of this group, the red velvet stole decorated with embroidered figures of the apostles is the oldest (first half of the fourteenth century). The stole is a deposit of the St. Nicholas Church in Cracow.

The Czartoryski Library has been a branch of the National Museum in Cracow

since 1951. It contains two departments: the Czartoryski Library and the Czartoryski Archives and Collection of Manuscripts.

The Czartoryski Library consists of compact prints, periodicals, cartography, and musical works. Compact prints and periodicals are supplemented with current literature as new finds are obtained, whereas the collection of cartography and musical prints is closed. The collection of prints numbers more than 211,000 volumes (among them 314 incunabula and more than 4,000 sixteenth-century prints). Old prints, from before 1800, total more than 495,000 volumes. The cartographic collection embraces 3,435 objects (267 atlases). Chronologically, the collection contains 62 sixteenth-century, 299 seventeenth-century, 1,447 eighteenth-century, 1,333 nineteenth-century, and 284 twentieth-century objects.

The collections are of a general humanistic profile, with a predominance of political history, literature, art, education, military science, and related fields.

The Czartoryski Collection became a branch of the National Museum in Cracow in 1951, as a closed historical collection that is no longer enlarged. It encompasses five groups of works of art.

The Department of Ancient Art includes the collection of antiquities founded by Princess Izabela Czartoryska, enlarged by Władysław Czartoryski in Paris, and gradually completed after having been transferred to Cracow. Today it encompasses 1,687 items, including artifacts that belong to Mediterranean, Mesopotamian, Egyptian, Greek, Etruscan, and Roman cultures. Of special interest are Egyptian sarcophagi, urns, stelae and sepulchral figurines, amulets, bronzes, and papyruses. Greek vases (in Orientalizing, black- and red-figure style), terracotta figurines, Etruscan sarcophagi and vessels, jewelry, Roman marble sculpture, and lamps and glassware.

The Department of European Painting, although having fewer works (837 items including miniatures and sculpture), belongs to the most valuable in Poland owing to a few masterpieces and a beautiful collection of early Italian painting (e.g., the Clarist Master, Master of St. George's Codex, Giovanni di Marco dal Ponte, Carlo Crivelli, Leonardo da Vinci [*Portrait of a Lady with an Ermine*], Vincenze Catena, and Benvenute Garofalo). The most widely represented is the Netherlandish school by works of Albrecht Bouts, Joos van Cleve, Rembrandt (*Landscape with the Good Samaritan*), David Teniers the Younger, and others. Works of other European schools are less numerous.

Works in the Department of the European Artistic Craft are abundant (14,357) and varied. Apart from having European artifacts, the department also contains West Asiatic, Persian, Indian, Chinese, and Japanese works. They come in part from the old collections of the Czartoryskis and the Sieniawskis' treasury and also from the collections of Izabela and Władysław Czartoryski. The most precious groups of antiquities are medieval and Renaissance enamels from Limoges in France, objects of ivory and semiprecious stones, silverware, Italian and Spanish fifteenth- and sixteenth-century faiences, and Meissen and Polish porcelain.

The Czartoryski armory (1,064 items) originated in the Puławy Museum.

Izabela Czartoryska received many military accessories from friendly families and also had at her disposal a rich arsenal of the Sieniawski family. Numerous examples of more recent arms come from the gifts of Polish army officers. A separate group is composed of foreign armaments from different sources, even from famous arsenals of Vienna and Brussels.

The Department of Prints and Drawings goes back to the collection of Adam K. Czartoryski in the Blue Palace in Warsaw. Later the collection was systematically enlarged. Władysław Czartoryski added to its prints and drawings of foreign artists. Today the collection includes fifty-two thousand items. The most important works are portraits of Polish personages, historic scenes, and works of Norblin, Chodowiecki, and Norwid, with foreign works by Dürer, Callot, Stefano Della Bella, and others. The most important Polish artists here are Norblin, Orłowski, and Kwiatkowski, and the foreign ones include Gerard David, Sinibaldo Scorza, Jan van Goyen, and Tiepolo. The collection also has some Persian and Indian miniatures.

The only branch of the museum outside the city of Cracow is Karol Szymanowski Museum in the villa "Atma" in the mountain resort of Zakopane. The museum is devoted to the memorabilia of the famous Polish composer (1882–1937).

The National Museum has at its disposal a library with a reading room (open to the public), which contains twenty-six thousand volumes, with a complete set of Polish periodicals and a choice of European and international periodicals in art history and museology. Selections of slides, reproductions, and publications are on sale in all galleries of the museum. In the Department of Documentation one can purchase black-and-white photographs of all objects and their fragments and microfilms of documents (letter-orders are required). Also the museum helps in ordering special slides and color photographs for private specialists outside the museum.

The museum periodical *Rozprawy i Sprawozdania Muzeum Narodowego w Krakowie* (*Dissertations and Reports of the National Museum in Cracow*, the title in this form since 1952) has been issued since 1889. The Society of Friends of the National Museum in Cracow was founded in 1902.

Selected Bibliography

Sokołowski, M., "Muzeum XX Czartoryskich w Krakowie," *Kwartalnik historyczny*, 6 Lwów 1892 ("The Museum of the Princes Czartoryski in Cracow," *Historical Quarterly*); Szukiewicz, M., "Dzieje, rozwój i przyszłość Museum Narodowego w Krakowie," *Dopełnienie*, Kraków 1934 ("History, Development, and Future of the National Museum in Cracow," *Supplement*); Kopera, F., and K. Buczkowski, "Losy zabytków artystycznych Krakowa," *Biblioteka Krakowska*, nr. 104, Kraków 1946, pp. 48–65 ("History of Artistic Monuments of Cracow," *Cracow Library*, No. 104); Dobrowolski, T., "Zarys historii Muzeum Narodowego w Krakowie," *Sprawozdania i rozprawy Muzeum Narodowego w Krakowie, Kraków* 1952, pp. 12–50 ("Historical Outline of the National Museum in Cracow," *Dissertations and Reports of the National Museum in Cracow*); Lepiarczyk, J., "Dzieje budowy Muzeum Czartoryskich," *Rozprawy i Spra-*

wozdania Muzeum Narodowego w Krakowie, 3, Wrocław-Kraków 1957 ("History of Construction of the Czartoryski Museum," *Dissertations and Reports of the National Museum in Cracow*); Kopff, A., "Muzeum Narodowe w Krakowie," *Historia i zbiory*, Kraków 1962 (z bibliografia Muzeum za lata 1952–61) ("The National Museum in Cracow," *History and Collections* with the bibliography of the Museum for 1952–61); Żygulski, Z., Jr., "Dzieje zbiorów puławskich, Świątynia Sybilli i Dom Gotycki," *Rozprawy i Sprawozdania Muzeum Narodowego w Krakowie*, 7, Kraków 1962 ("History of the Paławy Collections, Sybilla's Temple, and the Gothic House," *Dissertations and Reports of the National Museum in Cracow*); Kocójowa, M., "Zarys historii zbiorów Emeryka Hutten-Czapskiego," *Rosprawy i Sprawozdania Muzeum Narodowego w Krakowie*, 11, Kraków 1976, pp. 124–82 (Historical Outline of the Emeryk Hutten-Czapski Collections," *Dissertations and Reports of the National Museum in Cracow*); Kołodziejow, B., "Miejskie Muzeum Przemysłowe im. dra Adriana Baranieckiego w Krakowie," *Rozprawy i Sprawozdania Muzeum Narodowego w Krakowie*, 11, Kraków 1976, pp. 186–229 ("The Municipal Industrial Museum in Cracow, Dr. A. Baraniecki Memorial Museum," *Dissertations and Reports of the National Museum in Cracow*); Banach, J., ed., *Kraków miasto muzeów*, Warszawa 1977, pp. 22–38 (*Cracow–City of Museums: The National Museum in Cracow*, edited by J. Banach); Rostworowski, M., ed., *Muzeum Narodowe w Krakowie: Zbiory Czartoryskich*, Warszawa 1978 (*The National Museum in Cracow: The Czartoryski Collection*).

TADEUSZ CHRUŚCICKI

——— Warsaw ———

NATIONAL MUSEUM (formerly NATIONAL MUSEUM OF FINE ARTS; officially MUZEUM NARODOWE), Al. Jerozolimskie 3, Warsaw.

The National Museum, previously known as the National Museum of Fine Arts, was established under the law of May 20, 1862, on public education in the kingdom of Poland. The core of the museum was the collection of the former Warsaw University Museum of Antiquities.

After the January uprising of 1863 there was a period of occupation by the Russians that prevented the growth of the museum. However, there were a few bequests from private persons. That situation lasted until 1915, when the Russians left Warsaw. The museum was taken over by the city, and in 1916 it was renamed the National Museum.

For its temporary premises it got a house at 15 Podwale Street. It was then decided that the National Museum in Warsaw should be an art museum only, and consequently, a collection of prehistoric archaeology, military exhibits, an ethnographic collection, and many other items were turned over to other museums. The construction of the museum's new building at 3, Jerozolimskie Avenue was started in 1926. On June 18, 1938, the fully completed building was solemnly inaugurated. It was designed by the well-known Warsaw architect

Tadeusz Tołwiński. In September 1939, when Warsaw was surrounded, the building was seriously damaged, and the collection suffered a severe loss. During the war and the years of occupation (1939–45), a large part of the collection was taken to Germany or destroyed by the German army. A part of the collection was repossessed after the war as a result of war reparations. After Warsaw was liberated in January 1945 a rebuilding of the museum's structure was started. In May 1945, in newly reconstructed halls, an exhibition titled "Warsaw Accuses" opened. It showed the losses and destruction of the Polish culture that were the result of the war operations and willful action of the German authorities. By the decree of May 7, 1945, the National Museum in Warsaw was nationalized and recognized as the central state museum of Poland. In the years 1965–72 an extension of the building on the south side took place.

The museum is managed by the director, his deputy, and two vice- directors. The museum consists of the following departments: Ancient Art, Medieval Art, Polish Art, European Art, Decorative Art, Contemporary Art, and Numismatic Cabinet, as well as the Documentation Service. Adjunct institutions are: the Museum at Wilanów, the Museum at Łazienki, the Poster Museum at Wilanów, the Museum at Nieborów and Arkadia, the Xawery Dunikowski Museum at Królikarnia, the Museum in Łowicz, and the Museum in Krośniewice.

The Department of Ancient Art was established in 1937. It comprises, among other work, relics from the eighteenth-century collections of Stanisław Kostka Potocki and Izabella Lubomirska and from the nineteenth-century collections of Działyńskis and Czartoryskis from Gołuchów. The main body of the collections comes from the excavations led by Kazimierz Michałowski at Tell Edfu in Egypt (1937–39), at Mirmeki Kalos Limen in the Crimea (1956–58), at Palmyra in Syria (since 1959), at Tell Atrib in Egypt (since 1957), at Faras in Sudan (since 1961), and in Cyprus (since 1965).

Significant in the Egyptian collection are bas-relief blocks from the Izi mastaba; from the Old Kingdom Period, a group of ceramics; from the Middle Kingdom Period, a group of case sarcophagi with hieroglyphic inscriptions; and from the New Kingdom Period, the *Book of the Dead* of the nurse Kai and a group of sarcophagi from Deir-el-Medineh. Also of note are the monumental granite statues of the goddess Sachmet and the bust of Amon. A portrait from Fayum dates from the second century.

In the Greek collection is a fine group of ceramics. A hydria with the image of Sappho is a unique piece. Sculpture is represented by Roman copies from the first-second century, such as *Resting Satyr* after Praxiteles and *Zeus on the Throne* after Phidias. Among the Etruscan works, the most important is an alabaster urn with the image of Odysseus and the sirens. In the Roman collection there is a fine group of glass vessels. Of sculpture, there are statues of men in togas, portraits, sarcophagi, and the piece *Dionysus on a Panther*. The Faras complex of sixty-five wall paintings is the most outstanding part of this department.

The collection of European art comprises a large group of paintings from the gallery of Stanisław August Poniatowski, as well as paintings from the collections

of Potockis from Krzeszowice, Potockis from Wilanów, and Radziwiłłs from Nieborów.

The collection contains about four thousand paintings. The best represented are the North European schools. North European painting is represented, for example, by the polyptych *St. Reinhold*, with paintings by Joos van Cleve, and German painting from the sixteenth century by a group of pictures by Lucas Cranach. Flemish paintings from the seventeenth century comprise landscape paintings by Joost de Momper, A. Goevaerts, Jan Bruegel, Roelandt Savery, and Jacob Jordaens. Dutch painting is represented in the collection with works by Gerard Ter Borch, Pieter Saenredam, and Hendrick Terbrugghen and the particularly fine *The Raising of Lazarus* by Carel Fabritius.

The Italian schools are represented by pictures such as the *Madonna and Child* by Pinturicchio and the *Madonna and Child* by Botticelli, as well as works by G. B. Tiepolo and Bernardo Bellotto. Among the paintings of the French school worth noting are the portraits *Cardinal Richelieu* by Philippe de Champaigne and *Guitarist* by Jean Baptiste Greuze and the equestrian portrait *Stanisław Kostka Potocki* by Jacques Louis David. Russian painting is represented by works of artists such as F. Rokotow, J. Ajwazowski, W. Wiereszczagin, and J. Levitan.

The department of European drawings comprises several thousand drawings by artists such as Andrea Meldolla, called Schiavone; Taddeo Zuccari; Ludovico Carracci; Guercino; G. D. Tiepolo; Fragonard; Hubert Robert; Bartholomeus Spranger; J. S. von Carolsfeld; and Peter von Cornelius. To the European art collection also belong about fifty thousand prints, a thousand graphic albums, and a collection of ex-librises.

The Department of Medieval Art comprises about 350 objects that include large painted and carved altars. Painted panels and wooden and stone sculptures, ranging from about 1200 to the midde of the sixteenth century, represent the artistic achievements of the main Polish cultural centers—Cracow, Toruń, Gdańsk, Wrocław—as well as the production of ateliers in minor provincial centers such as Mazovia. Among the altar complexes, the most important are the polyptych from the castle chapel in Grudziądz (c. 1390); the canopy altar from the Church of Our Lady in Gdańsk (1420–30); the polyptych from St. Elizabeth's Church in Wrocław (c. 1470); the *Jerusalem Altar* from the Church of Our Lady in Gdańsk (c. 1490); the altar with the *Legend of St. Stanisław* from Pławno, made in Cracow in the years 1514–18, with paintings by Hans Suess von Kulmbach; and the altar from Pruszcz, executed in Antwerp about 1500, with paintings by Colijn de Coter, and brought to Poland at the beginning of the sixteenth century. In addition, the collection has important fragments of altars, such as the Franciscan polyptych from Toruń (c. 1390), the triptych with the *Legend of St. Jadwiga of Silesia* (c. 1420), and the altar *St. Barbara* from St. Barbara's Church in Wrocław of 1447. Among the panels worth noting are the *Flagellation* and *Deposition* (1495) from St. John's Church in Toruń, as well as epitaphs, such as the *Epitaph of Barbara Polani* from the beginning of the fifteenth century.

Among the polychrome sculptures, the most noteworthy are the Romanesque

statue *Madonna and Child Enthroned* from Obłock (c. 1200); relics from the circle of the Master of the Madonnas on the Lion (Silesia, Pomerania, Great Poland) of the second half of the fourteenth century; the *Crucifixion Group* from St. Barbara's Church in Wrocław (c. 1350–60); the *Pietà* from Lubiąż (c. 1370); the *Mystical Crucifix* from the Christi Corpus Church in Wrocław (c. 1400); famous examples of the "Beautiful Madonna" type from Wrocław, Gdańsk, and Kazimierz upon the Vistula River; and a *Pietà* from St. Matthew's Church in Wrocław (c. 1430). A separate group is sculptures created under the influence of Wit Stwosz's works, i.e., *St. Luke Painting the Madonna* (c. 1500). The most interesting stone sculptures are the *Madonna and Child* from Legnica (c.1390) and *Vir Dolorum* from St. Dorothea's Church in Wrocław (c.1430).

The Polish Art Gallery contains painting, sculpture, drawings, graphic arts, and Polish miniatures from the sixteenth to the beginning of the twentieth century. There are more than six thousand paintings, two thousand sculptures, about fifty thousand drawings, eighty thousand works of graphic art, and a collection of miniatures that numbers about one thousand. The basis of the collection of paintings is made up by the former collection of King Stanisław August Poniatowski, especially his paintings made to decorate his residence in the Royal Castle in Warsaw, Ujazdowski Castle, and the palace in Łazienki. Worth noting are the numerous paintings by M. Bacciarelli and Bernardo Bellotto. These paintings were transferred back to the Royal Castle in Warsaw after its recent restoration.

As far as the paintings of the nineteenth-century artists are concerned, the main part of the collection comes from the collection of the Society for Encouragement of Fine Arts in Warsaw. A relatively small collection from the sixteenth to the early seventeenth century is made up by the portraits *Catherine Ostrogska neé Lubomirska, Jadwiga Mniszech neé Tarłów,* and *The Polish King, Stefan Batory,* as well as the *Marriage Portrait of Gregory and Catherine Przybyło* (second quarter of the sixteenth century). Particularly valuable is the painting of an unidentified Cracow artist of the beginning of the sixteenth century, *The Battle of Orsza.* The Polish painting of the seventeenth and the first half of the eighteenth century is represented by religious paintings made by, among others, Simon Czechowicz and, above all, a large complex of Polish portraits. Among them, the most important works are portraits painted by D. Schultz, B. Strobel, and J. E. Szymonowicz-Siemiginowski. A few first-class genre and allegoric paintings were made by T. Kuntze and K. and T. Lubienieckis. The so-called coffin portraits, typical for Poland of the seventeenth and eighteenth centuries, form a unique collection.

The museum has the richest collection of Polish painting of the Enlightenment period, mainly the paintings ordered by King Stanisław August and enlightened Polish magnates. The most famous is the series of twenty-four views of Warsaw painted in 1767–80 by Bernardo Bellotto, a complex of paintings by M. Bacciarelli (historical and allegorical paintings as well as portraits), paintings by J. P. Norblin (among others, *A Gathering by the Lake*), and portraits by A.

Kucharski, J. Ch. Lampi, J. Grassi, P. Kraft, K. Wojniakowski, J. Wahl, and
F. Smuglewicz. Similarly, the museum can boast of the richest collection of
paintings by Polish artists of the nineteenth and the beginning of the twentieth
centuries. Among the most interesting ones, the following should be noted: by
A. Brodowski, a grouping of paintings that includes *The Wrath of Saul*, *Oedipus
and Antigone*, *The Portrait of the Artist's Brother*, and *Self Portrait*; by P.
Michałowski, paintings of battle scenes and equestrian studies; by H. Roda-
kowski, portraits such as *Leonia Blüdhorn*, *Babetta Singer*, *Paweł Rodakowski*
(the artist's father), and *Maksymilian Rodakowski* (the artist's brother); by J.
Simmler, *The Death of Barbara Radziwiłłówna* and portraits of the Warsaw
bourgeoisie; by M. Gierymski, a complex of paintings of hunting scenes; by A.
Gierymski, *Italian Siesta*, *In the Bower*, and *The Feast of the Trumpets*; by J.
Matejko, *The Battle of Grunwald*, *King Batory at Pskow*, *Rejtan*, *Skarga's
Sermon*, *The Bell of King Sigismund* and *Stańczyk*, a cycle illustrating the history
of civilization in Poland and portraits; and by J. Chełmoński, *The Storks*, *The
Gossamer*, and *At the Head of the Village*. In addition, there are paintings by
W. Gerson, J. Brandt, J. Szermentowski, M. Gottlieb, and A. Grottger.

Among the most interesting from the turn of the century is a group of paintings
by W. Podkowiński that includes *The Children in the Garden* and *A View of
Nowy Świat Street in Warsaw*. Also notable are J. Pankiewicz's *Nocturne*, *The
Inside of the Cathedral in Chartres*, and *A Visit*. Other works of this period
include L. Wyczółkowski's *The Fishermen* and *Beet Diggers*; S. Wyspiański's
Self Portrait, *Straw Covers*, *Motherhood*, and *A View of Kościuszko's Mound*;
W. Wojtkiewicz's *Children's Crusade*, *Dolls*, and *Kidnapping the Queen*; J.
Mehoffer's *A Strange Garden*, *A Portrait of a Wife*, and *The May Sun*; J.
Malczewski's *Thanatos*, *The Polish Hamlet*, *The Death of Elenai*, and portraits.
In addition, there are paintings by W. Slewiński, J. Stanisławski, and O. Boz-
nańska. The collection of sculptures of the eighteenth century includes sculptures
by A. Le Brun and G. Monaldi that were in the collections of the numerous
Royal Castles in Warsaw. The Polish sculpture of the nineteenth century is
represented by the works of P. Maliński, J. Tatarkiewicz, W. Oleszczyński,
T. O. Sosnowski, W. Brodzki, P. Weloński, and A. Madeyski.

Among the large and artistically valuable collections of drawings and Polish
watercolors worth mentioning are large numbers of drawings from the eighteenth
and nineteenth centuries by M. Bacciarelli, J. P. Norblin, A. Orłowski, Z. Vogl,
P. Michałowski, A. Grottger, C. Norwid, W. Gerson, J. Matejko, M. and A.
Gierymski, H. Rodakowski, S. Wyspiański, J. Malczewski, S. Noakowski, and
J. Pankiewicz.

The collection of decorative art was established on the basis of collections of
various Warsaw institutions: the Warsaw University Museum of Antiquities, the
Society for Encouragement of Fine Arts, the Museum of Industry and Agricul-
ture, and the Society for the Preservation of Monuments of the Past. Another
very important source was the bequests and donations of private collections,
such as that of Roman Szewczykowski, Stanisław Ursyn-Rusiecki, and K. and

H. Tarasowicz. In 1946 the museum acquired a valuable collection of Polish noblemen's waist sashes of the collection of the Potockis from Krzeszowice. Because of a lack of space, the collections are presented only at temporary exhibitions.

The most valuable works of the medieval period are: the chalice and paten of Prince Konrad of Mazovia of about 1240; Limoges and Rhineland enamels of the twelfth and thirteenth centuries; a herma of St. Sigismund of 1350; a herma of St. Dorothea of 1420–30; Gothic embroideries, diptychs, and triptychs of ivory of the fourteenth and fifteenth centuries; Persian faience of the twelfth-fifteenth century; Spanish-Moresque faience of the fifteenth century; and Polish ceramics of the twelfth-fifteenth century. Among the collections of the Renaissance period, the most interesting are: the Brussels tapestries, four of which were made according to the order of King Sigismund Augustus; Marcin Kromer's chalice of 1568; and Italian ceramics. Of the Late Baroque period, the collection of Polish Kolbuszowa furniture is unique. The most interesting of the second half of the eighteenth century are: items made in France for Stanisław August Poniatowski, such as tapestries, bronze objects, furniture, and porcelain; a collection of three hundred Polish noblemen's waist sashes; and a collection of Warsaw silver and jewelry that includes the coronation regalia of Augustus III and Marie-Josephine, the coronation sword of 1764, and an aquamarine sceptre of 1792 of Stanisław August Poniatowski. Extremely valuable is the collection of Meissen porcelain, Polish ceramics (the factory of Wolff and the factory at Belweder), and a large collection of German, Bohemian, and Polish glassware (made in Lubaczów, Urzecz, and Naliboki). The museum possesses the largest collection of Polish porcelain of the turn of the eighteenth and nineteenth centuries, from the factories in Korzec, Baranówka, and Ćmielów.

The Gallery of Modern Art was formed in 1958. The gallery is continuously being enriched, mainly by purchases from living artists. It comprises painting, sculpture, graphic art, and decorative art from World War I to the present. The gallery has holdings of paintings by artists of the two decades between the world wars, including large groups of works by T. Makowski, T. Czyżewski, W. Wąsowicz, F. Kowarski, Z. Waliszewski, M. Włodarski, J. Cybis, and E. Eibisz, as well as the works of all of the most outstanding contemporary painters. It specializes in collecting paintings by Polish artists working abroad. In the area of sculpture, the gallery has works of all outstanding Polish artists, including W. Szymanowski, X. Dunikowski, H. Kuna, E. Wittig, A. Zamoyski, J. Szczepkowski, and S. Ostrowski, as well as the works of other non-Polish contemporary sculptors. In the gallery there is the largest collection of graphic art and contemporary drawings in Poland (more than fourteen thousand items); a collection of contemporary decorative arts, including tapestries, ceramics, glass, and metal objects; and a collection of ceramic works by Pablo Picasso, donated by the artist in 1949. Since 1978 the museum has had a special section devoted to objects of contemporary industrial design.

The Cabinet of Coins and Medals has two collections: a collection of ancient

coins and a collection of medieval and modern Polish and foreign coins and medals. The collection of ancient coins was established with the bequest in 1921 of Władysław Semerau-Siemianowski. It contained about thirty thousand Greek, Roman, and Byzantine coins. The collection was complemented with the purchase of I. Terlecki's collection containing coins of the Greek colonies on the Black Sea and of the kings of Kimmerian Bosphorus, as well as a gift received from J. Lewański. During World War II the collection was seized by the Germans and has been only partly recovered. The collection of medieval and modern coins and medals contains, among others, the collections of Kazimierz Sobański, Józef Weyssenhoff, and E. Phulla (medals only), as well as the collection turned over by the State Art Collections. That collection was also seized by the Germans and only partly recovered. After the war the collection was complemented by, among others, the bequests of B. Kantor and Jerzy Węsierski. The cabinet possesses many very rare and unique specimens.

The Documentary Department collects iconographic material and manuscripts dealing with art. The department consists of six sections: photographic prints, iconography of Polish art, iconography of foreign art, iconography of Polish material culture, material relating to Polish cultural life, and manuscripts relating to the history of Polish art. The library possesses publications of art, museology, auxiliary, and related disciplines. It amounts to about eighty-five thousand volumes, including about eighteen thousand periodicals, thirty-six hundred old prints, and about twenty-one hundred special items (maps, music).

The Museum at Wilanów is located in a palace-park complex. It has been a branch of the National Museum in Warsaw since 1945. The palace was erected in the last quarter of the seventeenth century as the suburban residence of King John III Sobieski after A. Locci's design; it was extended by its subsequent owners: Sieniawska, the Czartoryskis, Lubomirska, and the Potockis. In 1954–66 a thorough restoration was carried out. The palace was adapted for use as a contemporary museum. The interior furnishings are the most magnificent example of the Polish Baroque. A part of the collections is traditionally connected with the Sobieskis, Czartoryskis, and Izabella Lubomirska. The main body of the collections is those assembled by Stanisław Kostka Potocki at the turn of the eighteenth-nineteenth century. Among the fine furniture of the palace worth noting are a writing table of Jan III Sobieski; the boudoir of his wife, Marie-Casimire; a sofa after J. A. Meissonier's design; and a suite of French furniture of I. Lubomirska. Upstairs, there is the Gallery of Polish Portraits from the sixteenth to the nineteenth century. The gallery was opened in 1963. It houses, among other works, royal portraits.

In the former Orangery opened in 1977, there is a permanent exhibition of decorative arts from the Wilanów Collection comprising sixteenth-century Limoges enamels and French gold and bronze objects of the eighteenth and nineteenth centuries. In the former buildings adjacent to the palace (the guardhouse, kitchen building, stables, and coach houses) there are now offices, workrooms, and stores. The park consists of the geometrical garden laid out in the days of

Sobieski in the French style and the garden in the English style of 1799–1821. In the park there are pavilions and monuments.

The Museum at Łazienki is housed in the complex of the palace and the park. Since 1959 it has been a branch of the National Museum in Warsaw, consisting then of the Palace on the Isle, the White Cottage, and the Old Orangery. In 1977 the whole park and the rest of the monumental buildings were taken over by the museum. The Palace on the Isle arose from Stanisław, Herakliusz Lubomirski's former bath erected at the end of the seventeenth century by Tylman of Gameren, the architect. The bath was later extended and transformed into King Stanisław August Poniatowski's summer residence after D. Merlini's design in 1775–95. In December 1944 the palace was burnt down by the German army retreating from Warsaw. After the war it was rebuilt in strict accordance with its original appearance. The interior furnishings of the palace were partly plundered by the Germans. Of the former furnishings, only a portion was recovered, including the complete suite of furniture from the Solomon Room. The majority of the present furnishings comes from donations and post-war purchases. The print gallery comes largely from the former painting gallery of King Stanisław August. In the rotunda the statues of the Polish kings can still be found, as well as the statues of Apollo and Hercules by A. Le Brun in the Ball Room.

The White Cottage, a garden pavilion, was erected in 1774–77 after D. Merlini's design. The interiors are filled with furniture and objects of the end of the eighteenth century. The Old Orangery was erected in the years 1784–88 after D. Merlini's design. In the east wing there is a unique theater hall of King Stanisław August Poniatowski with a rich painting decoration made by J. B. Plersch. Upstairs there is a permanent exhibition of Polish and foreign sculpture from the sixteenth to the twentieth century. The Great Annex (the Officer-Cadet School) was erected in the first half of the eighteenth century and extended in 1788. During the November Uprising there was an Officer-Cadet School there; now, temporary exhibitions are organized in the halls of the building.

The park is the former hunting ground turned into an English-style park in 1774–80 and considerably enlarged after 1784. In the park there are many pavilions and buildings adapted to the outdoor purposes of the museum.

The Poster Museum at Wilanów has been a branch of the National Museum in Warsaw since April 4, 1968. The museum is situated in a modern pavilion, the front elevation of which is the facade of the former riding school of the palace, erected between 1848 and 1850. At present, the poster collection consists of about fifty thousand examples. The exhibitions are of changing character. The most important ones are those of the International Prize Winners of the Poster Biennial.

The Xawery Dunikowski Museum at Królikarnia is devoted to the prominent sculptor Xawery Dunikowski and has been a branch of the National Museum in Warsaw since January 26, 1965. The home of the museum is the palace built by D. Merlini in 1786. Burned down in 1939, it was rebuilt as a museum according to the original plan. In the museum there is a constant exhibition of

Dunikowski's most important sculptures and paintings connected with the artist's confinement at the Auschwitz concentration camp. In the halls upstairs, temporary exhibitions devoted to the creative work of Dunikowski's students are organized.

The Museum at Nieborów is located in a palace-park complex in Skierniewice Voivodship, seventy-eight kilometers from Warsaw. Since 1945 it has been a branch of the National Museum in Warsaw. The palace at Nieborów was built in the years 1690–96 by Tylman of Gameren for Michał Radziejowski, the primate. Until 1945 it was the property of the Radziwiłł family. The palace has preserved its interior decoration of the eighteenth and nineteenth centuries and a part of its old collections. The head of *Niobe* (first century) comes, among other objects, from the collection of Helena Przeździecka. Worth noting are the sets of Polish furniture of the eighteenth century, a collection of foreign paintings such as the portrait *A. Orzelska* by A. Pesne, the portrait *M. Radziwiłł* by A. Graff, and rich collections of tissue, silver objects, glassware, and china. In the palace is housed the library of 11,500 volumes and two unique globes made by the famous Italian geographer Vincenzo Coronelli. In the former factory erected in 1776 there is an exhibition of Nieborów ceramics that were made at the turn of the twentieth century. Beside the palace there is a French-style garden established at the end of the seventeenth century. It was extended by a landscape park in the second half of the eighteenth century. The park includes, among other works, four stone idols from the tenth-eleventh century. At a distance of four kilometers there is Arkadia, a Romantic park designed by Szymon Bogumił Zug for Helena Radziwiłł in 1778. In the park are some classic and neo-medieval edifices.

The Museum in Łowicz, also located in Skierniewice Voivodship, eighty kilometers from Warsaw, has been since 1959 a branch of the National Museum in Warsaw. It was established on the basis of two collections of the former Municipal Museum and the Ethnographic Museum. The museum is housed in the former missionaries building, erected in 1689. After the last war there remained only the Baroque chapel. The rest of the building was restored and adapted for museum purposes. The museum comprises five sections: archaeological, historical, ethnographic, natural sciences, and folk architecture, with original rural buildings assembled next to the museum.

The Museum Dunin Borkowski in Krósniewice, Płock Voivodship, 150 kilometers from Warsaw, has been a branch of the National Museum in Warsaw since 1979. The museum's collections are the result of the acquisitions of a man who has gathered objects of art all of his life and who has now donated them to the National Museum, which considers them examples of an amateur collection. There are valuable historical documents, several thousand old prints, a large collection of numismatics, about two hundred paintings (including the works of Bacciarelli), arms, orders, decorative art objects, and historical mementos in this collection.

Apart from the guides and catalogues of which the most important are listed

below, the National Museum in Warsaw publishes *The Annual of the National Museum in Warsaw* (vol. 1 appeared in 1938, vol. 23 in 1979) and the quarterly *Bulletin du Musée National de Varsovie* (vol. 1, 1960, vol. 19, 1979).

Selected Bibliography

Museum publications: *The Collections of the National Museum in Warsaw*, English ed., 1962; *La Galerie d'art antique*, 1975; *Catalogue of Paintings: Foreign Schools*, vol. 1, 1968; vol. 2, 1969, English ed.; *Polish Painting: Catalogue of Collections*, French ed., 1979; *Decorative Art: Gifts and Purchases, 1945–64*, 1964; *Collection of General Jerzy Węsierski: Catalogue of Coins and Medals*, 1974; Białostocki, J. and M. Skubi-szewska, *French, Dutch, and Italian Painting until 1600: Catalogue of Collections*, 1979; Chudzikowski, A., *Austrian, Czech, German, and Hungarian Painting, 1500–1800: Catalogue of Collections*, 1964; Dobrzeniecki, T., *Panel Painting*, 1972; Kaczmarzyk, D., *European Sculpture*, 1978; idem, *Polish Sculpture from the Sixteenth to the Beginning of the Twentieth Centuries*, 1973; Krassowska, H., *Polish Miniatures*, 1978; Piwkowski, W., *Nieborów and Arkadia*, guide, 1980; Świątkowskis, H. and A. Świątkowskis, *The Museum of Łowicz*, guide, 1980; Voise, I., and T. Głowacka-Pocheć, *Painting Gallery of Stanisław Kostka Potocki at Wilnów*, 1974.

Other publications: *Guide to Museums and Collections in Poland*, English ed., 1974; Fijałkowski, W., *The Artistic Collections of the Wilanów*, 1979; idem, *The Interiors in the Wilanów Palace*, 1977; idem, *Polish Portraits in the Wilanów Gallery*, 1978, idem, *Portraits of Polish Notables in the Apartments and in the Gallery of the Wilanów Palace*, 1967; idem, *Wilanów Palace: Garden and Artistic Collections*, guide, English ed., 1969; Kwiatkowski, M., *Królikarnia*, 1971; idem, *Łazienki*, 1972; Michałowski, K., *Faras*, English ed., 1974; Rottermund, A., *Catalogue of the Architectonic Designs from the National Museum in Warsaw*, 1970.

ANDRZEJ ROTTERMUND

Portugal

—— Lisbon ——

CALOUSTE GULBENKIAN MUSEUM (officially MUSEU CALOUSTE GULBENKIAN; alternately GULBENKIAN MUSEUM), Parque Calouste Gulbenkian, Lisbon.

The Calouste Gulbenkian Museum serves as the headquarters for the Calouste Gulbenkian Foundation, which was established in July 1956 according to the provisions of the will of Calouste Sarkis Gulbenkian, who died in Lisbon in July 1955. The foundation administers a wide range of cultural activities in the visual and performing arts and since its establishment has become an integral force in the intellectual life of Portugal. The principal function of the foundation's building in Lisbon is to serve as the repository for the vast art collection of its founder. Calouste Sarkis Gulbenkian, Armenian by birth, spent more than forty years amassing a collection of works of painting, sculpture, textiles, manuscripts, furniture, silverware, jewelry, and other objects that would represent the development of both Eastern and Western art from antiquity to the present century. Most of the collection was housed, during Gulbenkian's lifetime, in an elegant neoclassical palace that he had constructed on the Avenue d'Iéna in Paris between 1923 and 1924. This townhouse was built especially for the works of art and outfitted with carpets and wall hangings that would complement them.

Many of the paintings in the Gulbenkian collection had also been seen in other cities during the collector's lifetime. An important selection of works by Rubens, Rembrandt, Gainsborough, Guardi, Degas, Manet, and others was lent to the National Gallery of London and the National Gallery in Washington from 1936 to 1960. During the last years of his life Gulbenkian had resided in Lisbon, and he wanted to present his collection to his adopted country. In 1956, after the foundation had been established, negotiations were begun with the Board of

Trustees, the mayor of Lisbon, and the count of Vilalva, owner of the Parque Santa Gertrudis, to establish the organization's headquarters on that tract of land in the Palavhã district of the capital city. When a satisfactory agreement had been reached, an inventory of the Gulbenkian collection was begun, and the works were brought to Lisbon. While construction of the new museum was underway, the collection was on view in the palace of the marquis of Pombal in suburban Oeiras.

By 1959 a working plan had been devised for the foundation's headquarters by teams of Portuguese and foreign architects. The new building would include ample exhibition space for the permanent collection and temporary exhibitions, a library with reading and music rooms, several auditoriums and lecture halls, and an open-air auditorium for outdoor performances. The Calouste Gulbenkian Museum was officially opened to the public on October 2, 1969. The principal architects were Alberto Pessoa, Pedro Cid, and Ruy Athouguia. The building, which covers about twenty-five thousand square meters, is particularly noted for its simple, elegant lines and its successful integration of architecture and landscape. This is also true of the interior, where large windows consistently offer the visitor a multiplicity of views of the elegantly landscaped park.

The museum is administered by a board of trustees. The Library and Department of Exhibitions are administered separately, although both are housed in the same facility. There are six curators and two assistant curators.

Virtually all of the works in the museum were part of the original Gulbenkian collection. The museum does not have an ongoing acquisitions policy, although provisions have been made for the periodic purchase of contemporary works of Portuguese art.

The museum's collections may be divided into six major categories: Egyptian art, Graeco-Roman art, Oriental Islamic art, Far Eastern art, European art, and French decorative arts and sculpture from the eighteenth to the twentieth century. The Egyptian collection consists mainly of small sculptures and relief carvings. Although the pieces are few, they are high in quality and represent the major phases in the development of Egyptian culture from the Old Kingdom to the dawn of the Roman age.

An alabaster cup from the third dynasty and a fragment from a bas-relief from the tomb of Princess Merytytes (fourth dynasty) are the principal representatives of the Old Kingdom. There are few Middle Kingdom objects, with a polychromed wood funerary statuette from the eleventh dynasty and the *Head of Amenemat III* from the twelfth dynasty.

The true strength of the collection lies in the area of New Kingdom art. The approximately twelve objects from this period were formerly part of British private collections, including the MacGregor, Carmichael, and Amherst collections. Among the most impressive examples is a statuette of *Lady Henut Taoui* from the eighteenth dynasty, a small (29.2 centimeters) but extremely elegant polychromed wood object of the woman sporting an elegant golden necklace and complicated coiffure. The *Head of Amenhophis III*, also from the eighteenth

dynasty, is a delicately expressive work of blue glazed earthenware. In terms of relief sculpture, the fragment dating from the nineteenth dynasty showing a funerary priest of King Tutmos III is of special interest.

The Saite Dynasty (663–525 B.C.) is represented by a series of fifteen objects, including two painted ivory fragments from a coffer, several terracotta funerary ornaments, four small statuettes of the sons of the god Horus, the statuette *Osiris*, and several bronze cats. The mummy mask of gilt-silver from the thirtieth dynasty is one of the museum's treasures of late Egyptian art. The Ptolomaic era (332–30 B.C.) is represented by a bas-relief that served as a study for a portrait of a pharoah, a small image of Harpocrates in silver, and a head of a priest in green schist. There is only one object from the late Roman era in Egypt, a terracotta torso of Venus.

The Graeco-Roman division of the Gulbenkian Museum contains an Attic kylix-krater from about 440 B.C., attributed to the Coghill Painter. Found at Agrigento, it was formerly in the Coghill and Hope collections. The only example of Greek sculpture is a marble head from Athens of about 450 B.C., attributed to Phidias. The collection is extremely rich in Greek and Roman coins. The numismatic collection is periodically changed, and works not on view are available for study by scholars in a room adjacent to the antiquities galleries that also serves as a storage area for the coins.

The Gulbenkian collection of Graeco-Roman coins has been described as one of the most significant and beautiful collections ever assembled by one individual. It consists of more than four hundred examples from widely divergent ancient centers, from Carthaginian Spain to Alexandrian Persia. About three hundred of these coins were acquired from the famous Jameson Collection in 1946 with the advice of Gulbenkian's consultant E.S.G. Robinson, keeper of coins at the British Museum (q.v.). In addition to containing coins, the numismatic collection includes several Roman medallions with the bust of Alexander the Great that were formerly in the collection of J. Pierpont Morgan of New York. Eleven examples of Roman glass are included in the galleries of ancient art. There are six unguent jars from the eastern Mediterranean dating from the third-fourth century A.D., as well as several vessels used in funerary contexts. The only major objects from ancient Mesopotamia are a faience urn from the Parthian period (third to second century B.C.) and an alabaster bas-relief from Assyria (884–859 B.C.).

In the field of Islamic art, the Gulbenkian collection is exceptionally rich. Several hundred examples of glassware, metalwork, manuscripts, ceramics, and fabrics are on view dating from the twelfth to the eighteenth century. They give the visitor a broad view of the development of Islamic aesthetic taste in Syria, the Caucuses, India, Persia, and Turkey.

Among the most interesting of these objects are the rugs. A selection of carpets is displayed on long platforms, slightly raised from the floor in the Islamic galleries. They are changed periodically. There are two Caucasian (Armenian?) carpets from the seventeenth century, two from seventeenth-century India, eight

examples from Persia (from centers such as Herat, Tabriz, and Isfahan), and a seventeenth-century prayer rug from Turkey. In addition, freestanding cases and wall cases present a selection from the collection of smaller textiles that includes nine Persian and seventeen Turkish examples. Persian ceramics from the manufacturing centers of Ravy and Kashan and Turkish examples (ceramics, tiles, and porcelain) from Iznik are shown in display cases, where they are grouped according to chronology and stylistic affinity. Ten large mosque lamps produced in Aleppo, Syria, during the fourteenth and fifteenth centuries are the major glass objects in the collection. The Islamic book arts are also well represented by five sumptuous book bindings from the sixteenth- and seventeenth-century Persia and by manuscripts and drawings from Persia and India. They represent the schools of Shiraz, Tabriz, Herat, Bukhara, and the imperial court of Shah Abbas. Among the most important illuminated manuscripts is the anthology of thirty-six works of poetry and prose compiled in 1410–11 for the governor of Shiraz, Prince Iskandar ben Umar Shayk ben Timur.

The section of Islamic art leads the visitor into the galleries of Far Eastern art. With the exception of a porcelain cup of the fourteenth century (Yüan Dynasty), the Chinese objects date from the Ming and Ching dynasties (fifteenth through eighteenth century), and the Japanese objects are works of the eighteenth and nineteenth centuries. The large selection of highly ornate Chinese vases, jars, and plates is of very high quality. Many of the Japanese *inro* of the eighteenth and nineteenth centuries were previously owned by Sir Trevor Lawrence Bart. Jade, onyx, agate, crystal, and malachite gems from both countries are displayed. Among other noteworthy examples of Japanese art are prints by Hiroshige, Kuniyoshi, Sagakudo, Toyokuni, Hokusai, and Utamaro.

Gulbenkian's efforts in the area of book collecting were by no means limited to Oriental volumes, for the Gulbenkian Museum possesses an impressive collection of European manuscripts and early printed books, as well as medieval ivories displayed in the first galleries of Western art. Works from the twelfth to the sixteenth century by English, French, Flemish, Italian, and Dutch artists are seen. Included among this group are a missal from the Admont Abbey in Styria, with illuminations by Giovanni da Gaibana, a *Psalter* from northern France (second half of the thirteenth century); the *Book of Hours* of Marguerite of Cleves; the *Book of Hours* of Isabelle de Bretagne; the *Breviary* of Ercole de Ferrara (c. 1500); the *Book of Hours* of Alfonso III d'Este, duke of Ferrara and Modena; a thirteenth-century English *Apocalypse*; and a *Book of Hours*, dated about 1410–15, with illustrations by the Master of Bedford. Among the most significant examples of Gothic carving shown in the first galleries of European art are two figures from a Crucifixion attributed to Tilman Riemenschneider, a graceful French ivory triptych representing scenes from Christ's Passion and Death, and *Mary Magdalen* in limestone from the Champagne region of France.

Many of the major names of western European sculpture are represented in the collections of the Gulbenkian Museum. A particularly strong point is the work of the French eighteenth- and nineteenth-century artists. Among the mas-

terpieces of Baroque and Rococo sculpture are: the *Bust of Maréchal de Turènne* attributed to Antoine Coysevox, the *Bust of Molière* by Jean-Jacques Caffieri, and the terracotta *Satyr and Nymph* by Clodion. A place of honor in the European galleries is given to a statue of *Diana* by Jean-Antoine Houdon. This work, commissioned by the duke of Saxe-Gotha to decorate the garden of his palace, was executed in 1780. It was later acquired by the Russian royal family and was in the collection of Empress Catherine II. It is one of several works acquired by the museum's benefactor through a series of delicate negotiations with Soviet officials in the 1920s and 1930s.

Nineteenth-century sculpture is also well represented by five works of Antoine-Louis Barye, three by Jean-Baptiste Carpeaux, a small bronze of a child by Jules Dalou, and five sculptures of great importance by Auguste Rodin. Among the most striking of the Rodin works is the *Head of Legros*, which Gulbenkian bought directly from the artist in 1910. Also purchased from Rodin was the imposing figure of Jean d'Aire, one of the *Burghers of Calais*, a work that is exhibited in the garden patio. Italian sculptures are few in the Gulbenkian Museum. The collection includes the marble bas-relief *Virgin and Child*, attributed to Antonio Rosselino (fifteenth century); the ceramic roundel *Faith* by Luca della Robbia (fifteenth century); and a wooden bas-relief of an angel by an anonymous sixteenth-century master.

Italian medals of the Renaissance are a strong point of the Gulbenkian Museum. The following are some of the most important examples: Sperandio di Mantua's medallions *Bartolomeo della Rovere, Bishop of Ferrara,* and *Alessandro Tartagni;* Benedetto de Maiano's *Filippo Strozzi;* Pisanello's *Lionello d'Este* and *Alfonso V of Aragon;* Bartolomeo Meliolo's *Gianfrancesco II Gonzaga;* and Leone Leoni's *Hippolita Gonzaga.* All of these works are in bronze.

The paintings department of the Gulbenkian Museum, although not large, is extremely important. The principal European schools, with the exception of the Spanish, are represented, and the presence of major masterpieces by artists such as Rembrandt, Rubens, Fragonard, Degas, Renoir, and Manet invest the collection with true international stature. The German school is represented by one of the oldest paintings in the collection, a small panel by Stefan Lochner, the *Presentation of the Christ Child in the Temple* (1445). The scene that appears on the reverse of this panel is the *Stigmatization of St. Francis.* Among the other paintings displayed here are two works by Rogier van der Weyden, the *Bust of St. Catherine* and the *Bust of St. Joseph* (?). Also representative of the Flemish school is a *Virgin and Child* by Jan Gossaert, called Mabuse, and a *Portrait of a Man* by Anthony van Dyck. By Peter Paul Rubens are *Flight into Egypt, Centaurs,* and the sumptuous full-length portrait of his wife, *Helena Fourment.* This last work, one of the outstanding treasures of the Gulbenkian Museum, was painted between 1630 and 1635 and was formerly part of the collection of the Hermitage in Leningrad. It was acquired in the early 1930s by Gulbenkian, along with Rembrandt's *Pallas Athena* and *Portrait of an Old Man,* dated about 1655 and 1645, respectively.

Among the paintings of the Italian Renaissance are Ghirlandaio's *Portrait of*

a Young Woman, Cima de Conegliano's *Rest on the Flight into Egypt*, Francesco Francia's *Baptism of Christ*, and Giuliano Bugiardini's *Portrait of a Young Woman*. Although the Italian Baroque is not represented, the museum houses nineteen paintings by the eighteenth-century Venetian master Francesco Guardi, the majority of them being views of Venice or architectural caprices.

Of eighteenth-century English painting, there are Thomas Gainsborough's *Portrait of Mrs. Lowndes-Stone*, John Hoppner's *Portrait of Miss Frances Beresford*, George Romney's *Portrait of Miss Constable*, and Thomas Lawrence's *Lady Elizabeth Conyngham*. Two seascapes by Turner and two paintings of *Venus* by Edward Burne-Jones complete the selection of British art.

In both painting and the decorative arts, works by French artists form a large and important part of the collection. The earliest French painting is the *Portrait of Jean-Baptiste Colbert* by Sebastien Bourdon. Nicolas de Largillierre's *Portrait of M. and Mme. Thomas Germain* is signed and dated 1736. Although most of the paintings are displayed in their own galleries, François Boucher's *Cupid and Three Graces* and Jean Marc Nattier's *Portrait of Mme. de la Porte* are hung in the French furniture and decorative-arts galleries. Fragonard's *Fête at Rambouillet*, also known as the *Island of Love*, is one of the most exuberant and elegant works of the French Rococo in the Gulbenkian Museum and a landmark of this artist's career.

French nineteenth-century painting is also richly represented by seven landscapes by Corot, five works by Daubigny, Diaz de la Peña's *Forest at Fontainebleau in Autumn*, and Jean François Millet's *The Rainbow* and *Autumn*. Degas' early *Self Portrait* (c. 1862) and *The Artist and His Model* (c. 1880), which may be a portrait of Cézanne; Eduard Manet's *Young Boy with Cherries* (c. 1858) and *Boy Blowing Bubbles* (c. 1867); Monet's *Still Life* (c. 1876); and Renoir's *Portrait of Mme. Monet* (c. 1872) are among the masterworks by painters working in the later years of the nineteenth century. The only American painting in the Gulbenkian Museum is *Maternal Care*, a pastel by Mary Cassatt.

The section of textiles includes a Brussels tapestry of the sixteenth century relating the story of *Vertumnus and Pomona*, three Italian tapestries bearing the arms of Cardinal Ercole Gonzaga of Mantua (sixteenth century), and seven eighteenth-century French tapestries executed after designs by Boucher and Jean Pillement. The latter works are displayed in the galleries devoted to French decorative arts produced during the reigns of Louis XV, Louis XVI, and the Regency and Transitional periods. They are the largest galleries in the museum, containing works by the most outstanding ebonists, cabinetmakers, and workers in bronze such as Sene, Jacob, Oeben, Blanchard and Boulard and Riesner. Screens and fragments of silk from Versailles and St. Cloud also adorn the walls.

More than thirty examples of highly ornate gold and silver objects, including candelabra, tureens, bowls, and plates, suggest the brilliance of both the courts of the kings of France and that of Empress Catherine the Great of Russia, former owners of the precious objects displayed in their own gallery at the Gulbenkian Museum.

The Gulbenkian Museum also houses one of the world's most important

collections of Art Nouveau jewelry and decorative objects in its assembly of more than one hundred examples by René Lalique, who was a close friend of Gulbenkian.

The Gulbenkian Foundation Library is composed principally of the collection of books of the founder but does continue to add volumes.

The Gulbenkian Museum has an active publications' policy that includes catalogues of its holdings and the publication of the bimonthly periodical *Colóquio: Artes*, an illustrated magazine dealing with the visual arts, dance, and music.

Selected Bibliography

Museum publications: *Museu Calouste Gulbenkian* (handlist of works in the collection), 1975; *Roteiro I* (illustrated catalogue of Egyptian, Graeco-Roman, Mesopotamian, Islamic, and Far Eastern art), 1969; *Supplemento do Roteiro I* (Graeco-Roman coins), 1969; *Arte do Livro Frances dos Seculos XIX e XX*, 1976; *Arte do Livro Islamico*, 1968; *Colóquio: Artes; Francesco Guardi*, 1965; *Tecidos da Colecção Calouste Gulbenkian*, 1978; *Textiles and Laces of the Calouste Gulbenkian Collection*, 1978; de Azeredo Perdigão, José, *Calouste Gulbenkian, Collector*, 1969; *Exposição Evocativa de Calouste Gulbenkian*, 1976; *Tableaux de la Collection Gulbenkian*, 1960.

EDWARD J. SULLIVAN

NATIONAL MUSEUM OF ANCIENT ART (officially MUSEU NACIONAL DE ARTE ANTIGA; also MUSEU DAS JANELAS VERDES), Rua das Janelas Verdes, Lisbon.

The National Museum of Ancient Art was opened in 1911, although its origins can be traced to the nineteenth century. In May 1834, as a result of the Liberal Revolution, the Portuguese government passed a secularization act by which all religious orders were abolished and their holdings of land as well as works of art became the property of the state. Almost immediately after the nationalization of these institutions, it was decided that libraries and museums would be established with the goods seized.

In Lisbon, the former convent of São Francisco served as the headquarters for the first organization dedicated to the promotion of the fine arts that would eventually result in the founding of the national museum. The Academy of Fine Arts undertook to create a National Gallery of Painting in 1866. A National Museum of Fine Arts and Archaeology was later established and opened to the public in December 1883 in the palace of the Counts of Alvor, a building that was purchased by the state in the following year. The collection consisted of works of art from the secularized monasteries and convents, the collections of former Queen Carlota Joaquina and Kings Fernando II and Luis I, works acquired by the Academy of Fine Arts, and works donated to the museum by various private individuals (among them, the count of Carvalhido, the viscount of Valmor, and Luis Fernandes). When the Republic was proclaimed, the museum was formally inaugurated as the National Museum of Ancient Art in 1911. At that time it also received a number of works from the former royal residences throughout Portugal.

The eighteenth-century palace of the counts of Alvor remained the home of the museum, although a number of reforms and additions have been made. By the 1930s the palace was found to be too small to house the museum's large collections adequately, and plans were prepared for the construction of another building adjacent to the original structure. The former Carmelite convent dedicated to St. Albert was razed (with the exception of its church) for this purpose. Between 1937 and 1939 a new building was constructed on this site under the direction of the architect Rebledo de Andrade. It was inaugurated in 1940 with an important exhibition of Portuguese primitive painting. The new building has three floors: a lower floor that houses storage and study areas, a principal floor, and an upper floor with galleries radiating out from a central courtyard. Access to the chapel of the former convent is gained from the northern side of the first floor. The chapel has been integrated as part of the museum dedicated to religious art and ceremonial dress used in religious services.

From 1940 to 1942 the original palace was itself remodeled. A wing was added to the eastern side and a conference room, theater, library, print room, and five new galleries were constructed. In March 1945 the new metalwork galleries and the Luis Fernandes Collection of porcelain were opened in the exhibition rooms of the palace. Another series of two rooms was dedicated in 1953 to the Calouste Gulbenkian donation of painting, sculpture, and decorative arts.

The Museum of Ancient Art is under the direction of the Portuguese government and is an official institution of the Ministry of Culture. It has a director and curators for painting, decorative arts, and education.

The particular strengths of the museum's collections lie in several areas. Paintings from the Renaissance to the nineteenth century of the Portuguese, Spanish, Dutch, Flemish, German, Italian, French, and English schools are well represented. In the field of decorative arts, the museum is rich in metalwork, textiles (especially Portuguese ecclesiastical garb), furniture (principally Indo-Portuguese), Chinese ceramics, and Japanese screen painting.

The visitor to the museum enters the new building and finds a number of diverse objects displayed in the vestibule, including examples of seventeenth-century Portuguese furniture, figures from the eighteenth-century Christmas crèches of the Madre de Deus Monastery and the Desagravo Convent, and four Chinese vases of the eighteenth century. This area of the museum also serves as a shop for the purchase of photographs and the museum's publications.

The collection of ceramics is housed in the five galleries at the southern end of the new building. In the room devoted to Chinese and Japanese vases, two types of ware are found: examples of export porcelain and vessels for domestic use. Of the former type, most were commissioned by the Portuguese East India Company and are decorated with coats of arms, European figures, and other Western-design motifs. The objects in this collection are dated from the fifteenth to the eighteenth century.

Adjacent to the large hall of Portuguese ceramics is a small room containing a limited number of Hispano-Moorish vessels (sixteenth to eighteenth century),

Persian vases from Kashan and Sultanabad (sixteenth century), and an Italian majolica vase from Urbino (?) made about 1530–50.

In the Portuguese ceramic collection there are many plates, vases, and other porcelain objects representing the work of the porcelain factories in Lisbon, Porto, Gaia,and Viana do Castelo. One of the cases contains Vista Alegre porcelain and the collection of cameos also from the Vista Alegre donated to the museum in 1962 by Augusto Cardoso Pinto. Also in this category are the polychromed terracotta figures from the crèche of the Sacrament Convent in Lisbon (eighteenth century).

Among the western European ceramics are found faience and porcelain vases and other vessels from the workshops of Triana and Alcora (Spain); Capo di Monte, Savona, and Albisola (Italy); and Rouen, Marseilles, Sèvres, Delft, Meissen, and Vienna. Among the most significant treasures of western European porcelain are a plate and a vase made for the Medici family about 1580.

The museum's holdings in the area of Portuguese painting represent the most comprehensive collection of the work of native masters from the fifteenth through the nineteenth century. The masterpiece of the fifteenth century is by Nuno Golçalves. His celebrated series of six panels executed for the Church of São Vicente Fora in Lisbon are perhaps the best known of all works of Portuguese art. They are dated about 1467–70 and represent St. Vincent with contemporary political and religious leaders.

There are many significant paintings from the Portuguese sixteenth century. Among the largest works is a retable from the Madre de Deus Church in Lisbon attributed to the Master of the Retable of Santa Auta. It contains a central panel, the *Martyrdom of the Eleven Thousand Virgins*, as well as side panels relating scenes of the life of Santa Auta. By the so-called Master of the Paradise Retable there are eight panels from the altarpiece originally created for the Paradise Convent in the capital city showing scenes from the life of the Virgin. There are another eight panels by the Master of the Retable of St. James illustrating the life of that saint.

A triptych signed by Vasco Fernandes (c. 1475–1541–42), the *Deposition from the Cross*, *St. Francis Receiving the Stigmata*, and *St. Francis Preaching to the Fish*, was restored in the late 1960s. Among the major portrait painters of the Portuguese Renaissance, Cristóvão Lopes (c. 1516–94) is noted for his likenesses of royalty. Among such works in the museum's collection are the *Portrait of King João III* and the *Portrait of Queen Catherine of Austria*. The *Portrait of King Sebastian* is by Cristóvão de Morais (active between 1551 and 1571).

The museum also houses some Renaissance works by non-Portuguese painters working in Lisbon and other parts of the country, mainly in the "Luso-Flemish" style. Among such paintings are eleven panels by the Master of the Retable of São Francisco de Evora, which are close in style to the work of Francisco Henriques. From the workshop of Frei Carlos are paintings originally executed for the convent of Espinheiro near Evora and from the convent of Santa Maria

da Costa near Guimarães, including the *Apparition of Christ to the Virgin* (1529) and the *Annunciation* of 1523. Among the works of the later sixteenth century are *St. Matthew and Isaiah* by Antonio Vaz and *Birth of Christ* by Vasco Pereira Lusitano, dated 1575.

The master portraitist of the Portuguese Baroque was Domingos Viera (1600–1678). He is represented in the Museum of Ancient Art by several important works, including the *Portrait of Dona Isabel de Moura*; that of her husband, *Lopo Furtado de Mendoça*; and the *Portrait of Dona Maria Antónia de Melo*. Josefa de Ayala (also known as Josefa d'Obidos, c. 1630–84) is the only woman painter from seventeenth-century Portugal, and some of her best works are in the museum, including two small versions of the *Virgin with the Christ Child* painted on copper (one version dated 1657); the *Mystic Marriage of St. Catherine* (1647); the *Birth of Christ*, signed and dated 1669; and *Still Life with Flowers, Fruits, Cakes, and Candies*.

The neoclassical style is represented by the work of two painters, Francisco Viera, called Viera Portuense, and Domingos António Sequeira. Viera Portuense (1765–1805) was director of the Academy of Fine Arts in Porto and Painter to the King. He is represented by three paintings, *Leda and the Swan* (1798), *The Descent from the Cross* (painted in London in 1800), and *Portrait of a Gentleman* (1800). He was well traveled, and the museum possesses numerous sketchbooks recording his European journeys. Among the fifteen works of Sequeira (1768–1837), who also worked for the court in Lisbon, are the *Family of the First Viscount of Santarém*; the *Communion of San Onofre*, painted between 1798 and 1801 for the Charterhouse of Laveiras; and the *Portrait of the Count of Farrobo*, which is signed and dated 1813. The touching double portrait of the artist's children Domingos and Mariana Benedicta Victória was a gift to the museum from the descendents of the painter.

The museum's holdings in Northern Renaissance painting are particularly rich, with the Flemish school especially well represented. The triptych by Hieronymus Bosch, the *Temptation of St. Anthony*, is signed. It was formerly in the royal collection in the Palacio das Necessidades. There are six paintings by Quentin Metsys, including the *Presentation of the Christ Child in the Temple*, *Christ Disputing with the Doctors*, and *Our Lady of Sorrows*, paintings that were executed about 1500 for the retable of Our Lady of Sorrows in the Madre de Deus Church in Lisbon. In addition, there are three works by followers of Metsys. The *Landscape with St. Jerome in Prayer* by Joachim Patinir, the *Virgin and Child* by Hans Memling, and the *St. Jerome* by Adriaen Isenbrandt are among other notable Northern Renaissance paintings in the Museum of Ancient Art.

The seventeenth century in Flanders is represented by a large collection of paintings by secondary masters as Joos van Craesbeek, Jan van Kessel, Jan Fyt, Hendrick van Balen, and Jan Philip van Thielen. Three paintings of peasants by David Teniers the Younger are also included in the collection.

Many of the Dutch masters of genre painting are represented in the museum, including Nicolas Maes (*Portrait of a Man*, 1687), Aart van der Neer (two

landscapes), Adriaen van Ostade (*Peasant Dance*), Jan Steen (*Man Cooking*), Gerard Dou (*Interior*), and Pieter de Hooch (*Conversation*).

Among the most notable paintings of the small selection of German art are Hans Holbein's *Virgin and Child with Saints*, which was donated by Queen Christina of Sweden to King João IV of Portugal, who later gave it to his daughter Catarina, wife of Charles II of England. Albrecht Dürer's *St. Jerome* is signed with the artist's monogram and dated 1521. It was painted as a gift for the Portuguese merchant Rui Fernandes de Almada who was living at that time in Antwerp. Lucas Cranach's *Salome* is another notable German painting in the collection.

The selection of British art is small and consists of about five portraits, including Romney's *Portrait of Sir John Orde*; Thomas Lawrence's *Portrait of Queen Maria II*, which was in the Ajuda Palace until 1920; and Joshua Reynolds' *Portrait of General William Keppel*, which was presented to the state in 1949 by Calouste Gulbenkian.

Among the French paintings there is a replica of *Plague of Ashod* by Poussin, two paintings of the *Education of a Prince* attributed to Charles Alphonse Dufresnoy, the *Portrait of Cardinal Polignac* by Hyacinthe Rigaud, *Two Cousins* by Fragonard, *Venus Walking on the Waters* by Antoine Coypel, two seascapes by Claude Joseph Vernet, and five landscapes by Jean Pillement, who lived for three years in Portugal at the end of the eighteenth century.

Many of the outstanding masters of Italian painting from the sixteenth to the eighteenth century are represented in the Museu de Arte Antiga. An early work by Raphael, painted while still under the influence of Perugino, is the *Miracle of St. Cyril*, which was originally part of the predella of the large *Crucifixion* now in the National Gallery (q.v.), London. Piero della Francesca's *St. Augustine* was painted for the retable of the Church of San Agostino in Borgo San Sepulcro. Andrea del Sarto is represented by his *Self Portrait*. There are four Old Testment scenes attributed to Jacopo Bassano, the *Virgin and Child with Saints* by Carlo Maratta, a *Vision of St. Francis of Assisi* by Luca Giordano, *St. Cecilia* by Antiveduto Grammatica, and a sketch for a ceiling decoration in Bologna by Domenico Maria Canuti—all among the works representing the later Renaissance and Baroque in Italy. Among the eighteenth-century pictures are *Pentecost* by Corrado Giaquinto, *Monks at Prayer* by Alessandro Magnasco, *Flight into Egypt* by Giovanni Battista Tiepolo, *Ruins of Ancient Rome* by Giovanni Paolo Pannini, and six portraits and *Venus, Adonis, and Cupid* by Domenico Pelligrini, who worked in Portugal between 1803 and 1810.

Spanish painting from the Late Middle Ages to the seventeenth century is well represented. Among the earliest examples is a panel painting dedicated to the Virgin and Saints Anne, Catherine, and Barbara by the Catalan master of the later fourteenth century Ramon Destorrents. Other Catalan masters of this period represented, each by a single panel, are Bernardo Martorell, Luis Borrassa, and Bartolome Bermejo. The Renaissance in Spain can be studied in four paintings by Luis de Morales (d. 1586), an artist highly influenced by the manner of

Leonardo da Vinci. Among the Baroque masters, Jusepe de Ribera is represented by four paintings (*Martyrdom of St. Bartholomew*, *St. Jerome*, *The Denial of Peter*, and the *Vision of St. Francis of Assisi*); Bartolomé Estebán Murillo by the *Mystic Marriage of St. Catherine*; and Antonio de Pereda by two magnificent still-life paintings both signed and dated 1651. Francisco de Zurbarán's series of twelve apostles was painted in 1633 for São Vicente Fora in Lisbon and has remained intact. An *Immaculate Conception* by Juan de Valdés Leal represents the late seventeenth century.

The donation made by Calouste Gulbenkian to the museum in the late 1940s and early 1950s enlarged the scope of the collection to include the art of classical antiquity. The principal item is a large torso of Parian marble, dated about 450–400 B.C. Also of note in the Gulbenkian bequest was the figure of a lion in grey basalt from the Ptolomaic Period (332–30 B.C.), discovered at the site of the palace of Emperor Tiberius on the island of Capri. Finally, representing the Roman Republican period, there is a white marble bust *Apollo*. There were also several examples of Islamic ceramic ware donated by Gulbenkian, which include vessels from Isfahan and Iznik. A statue of a Bodhisattva from Japan, dated from the Asuka period (seventh century A.D.), is the principal work of Far Eastern art given to the museum by Calouste Gulbenkian.

The Gulbenkian donation also included many notable works of western European painting and sculpture, including *St. Catherine* by Lucas Cranach the Elder, the *Portrait of Lucas Vosterman the Elder* by van Dyck, and *Portrait of M. de Noirmont* by Nicolas de Largillierre. Nineteenth-century French paintings include a landscape by Jules Dupré, *L'Homme à la pipe*; the *Snow Scene* by Gustave Courbet; and *Roses* by Henri Fantin-Latour. Also included is a sculpture by Rodin, *Danaide*. These works have been integrated into the museum's collection.

Exhibited in the oldest part of the museum, that which corresponds to the former palace of the Counts of Alvor, is the extensive collection of Far Eastern and African art. This is a particularly noteworthy portion of the museum's holdings, for it represents the areas of the world with which Portugal had strong political and economic ties from the sixteenth to the twentieth century. There are several sixteenth-century Japanese screens in the Namban style. The *byobu* (screens) in the collection of the Museum of Ancient Art depict the arrival of Portuguese ships in a Japanese harbor and the life of the Portuguese sailors, traders, and priests in Japan. Also representative of the Namban style are several powder boxes and stirrups decorated with Oriental figures in Portuguese dress.

Among the significant works of Indo-Portuguese furniture is a delicately carved ivory writing desk set onto a gilt wood stand that dates from the sixteenth or seventeenth century, as well as an ebony cabinet from India from the seventeenth century, decorated with scenes of Portuguese hunters.

Another interesting example of Oriental art is the lacquer screen from the former Portuguese colony of Macao. It represents a view of that city and is inscribed "Macau Anno 1746." Important examples of the art of the African

kingdom of Benin include a sixteenth-century hunting horn in ivory and an ivory salt-cellar lid decorated with figures in Portuguese dress.

In the collection of applied arts are found many examples of Portuguese religious and secular objects fashioned in gold and silver and dating from the seventeenth and eighteenth centuries. Among the religious objects is the famous Monstrance of Belem, made in 1506 by Gil Vicente from silver brought to Portugal by Vasco da Gama. The many examples of French eighteenth-century silver made for Portuguese patrons include a number of pieces made by Thomas Germain for the service ordered by Archbishop Fernando de Sousa e Silva and sixteen statuettes executed in 1757 by Ambroise-Nicholas Cousinet for Dom José Mascarenhas, duke of Aveiro.

The textile collection contains many examples of ecclesiastical garb from the fifteenth to the eighteenth century, including several embroidered chasubles that formerly belonged to churches and monasteries in and near Lisbon.

The chapel of the former convent of St. Albert has been preserved intact as an integral part of the Museu Nacional de Arte Antiga. The visitor gains access to it directly from the museum. In the church, there is a beautiful selection of polychromed tiles from the sixteenth and the seventeeth centuries and many examples of polychromed wood sculpture from the Renaissance and Baroque periods.

On the ground floor at the Rua das Janelas Verdes entrance is found an area for temporary exhibitions. Also on this floor is the Education Department, an important division of the museum that coordinates an active program of events for the promotion of art to a wide public. Also on this level is the library, which contains extensive material relative to the areas of art traditionally collected by the museum.

The museum has published a number of catalogues and monographs on individual works or collections. Many of them are available for purchase in the museum as are photographs of some of the museum's principal objects.

Selected Bibliography

Museum publications: *Catálogo-Guia do Museu das Janelas Verdes*, 1938; *Catálogo-Guia da Exposição dos Primitivos Portugueses*, 1940; *Roteiro das Pinturas*, 1956; *Rotiero da Pintura Estrangeira*, 1966; *Roteiro da Pintura Portuguesa*, 1967; *Roteiro da Ourivesaria*, 1959; *Boletim dos Museus Nacionais de Arte Antiga*, 1939–43; *Boletim do Museu Nacional de Arte Antiga*, 1944–66; *O Apostolado de Zurburán*, 1945; *Azulejos*, 1947; *Catálogo da Exposição de Documentos a Obras de Arte Relativos a Historia de Lisboa*, 1947; *Rendas Portuguesas e Estrangeiras dos Seculos XVII a XIX*, 1948; *Exposição de Tapeçaria Francesa do Inde Media aos nossos Dias*, 1952; *A Virgem na Arte Portuguesa*, 1954; *Pintura Portuguesa*, 1956; *Temptation of St. Anthony, Jheronimus Bosch: Exhibition, Documentation of Treatment . . .* , 1972; *Embroidered Quilts from the Museu Nacional de Arte Antiga, Lisboa: India, Portugal, China, 16th.–18th. Century*, 1978.

EDWARD J. SULLIVAN

Romania

—— Bucharest ——

ART MUSEUM OF THE SOCIALIST REPUBLIC OF ROMANIA (officially MUZEUL DE ARTA AL REPUBLICII SOCIALISTE ROMANIA), Str. Stirbei Voda, 1, Bucharest.

The Art Museum of the Socialist Republic of Romania was founded in 1948 after the abdication of King Michael and the establishment of the socialist state. It is comprised of the National Gallery (Romanian art, medieval to modern) and the Universal Art Gallery (foreign painting, sculpture, and decorative arts). The recently established Museum of Collections at nearby Calea Victorie 111, housing works that formerly belonged to private collectors, is also a part of the Art Museum.

The history of the museum begins with the founding of the first public art collection in Romania in 1834. At that time the painter Carol Valstein, a drawing master at the St. Sava Gymnasium in Bucharest, opened the country's first picture gallery at the St. Sava Monastery, which included a number of his own works, portraits of Valachian noblemen, and several copies of Old Master paintings. In December 1850 the prince of Bucharest established a Paintings Gallery incorporating Valstein's collection with some works sent by Gheorghe Tattarescu, a Romanian painter working in Rome. In 1864 the modern Romanian state was born with the Union of Principates, and soon afterward, the State Pinacotheque was established as a branch of the School of Fine Arts.

In 1929 the Pinacotheque became a separate cultural institution open to the general public. Its collections formed the core of the present museum of art. To the 550 paintings and 127 sculptures (mostly by Romanian artists) were added the collections of several museums in the capital city, including the Anastase Simu Museum, the Ion Kalinderu Museum, the Bucharest Municipal Pinaco-

theque, and the St. George's Museum. By 1948 the collections of the former royal family, which had been dispersed to various parts of Romania (the majority of works having been housed in the Peles Castle in Sinaia), were incorporated with the holdings of the Art Museum.

The Art Museum of the Socialist Republic of Romania derives its support entirely from the Romanian government. There are a director and six curators. There is also the Institute for Conservation under the aegis of the Art Museum, which provides for the preservation and restoration not only of works in the museum's collection but for those in the extensive network of state museums in all parts of the country that are sent to Bucharest.

The opening of the National Gallery took place in May 1950; that of the Universal Gallery occurred in June 1951. Both divisions of the Art Museum are housed in a modern addition to the nineteenth-century royal palace, now known as the Palace of the Socialist Republic of Romania. The museum consists of three floors of exhibition and storage space. The first floor is primarily dedicated to exhibitions of medieval Romanian art (fourteenth to eighteenth century). Nineteenth- and twentieth-century Romanian painting and sculpture, as well as Italian, Spanish, Dutch, Flemish, German, and Austrian paintings, are displayed on the second floor; on the third floor are French, Russian, and Soviet paintings, French sculpture and decorative arts, and Oriental art. The exhibition space also includes several galleries devoted to temporary exhibitions of the work of young Romanian artists and that of the winners of the yearly national competitions. All of the galleries are spacious and well illuminated.

The objects exhibited in the section devoted to medieval (or "feudal") Romanian art are mainly religious and trace the history of the country's Byzantine and Romanian Orthodox heritage. The many gold and silver liturgical vessels from churches in all parts of the country, as well as embroidered vestments (copes, sashes, mitres, and so on), are a particularly strong point of the collection. Among the masterpieces of painting are several fragments of fresco from the church built under the royal patronage at Curtea de Argeş in the sixteenth century. They were probably done by the painter Dobromir of Tirgoviste and represent the last vestiges of Byzantine painting in the Balkan peninsula.

The royal doors from the Slatina Monastery in the region of Moldavia date from the reign of Prince Alexandru Lapusneanu (1552–61; 1563–68) and are significant for they demonstrate that the painters of the day also created the designs for the intricate and highly ornate brocade liturgical vestments of that time.

Icons form an integral part of the collection of medieval art. Among the most significant examples are two from a set of four royal icons from Bistriţa in Vîlcea County. These fifteenth-century works are reminiscent in style of icons created a century earlier in the Palaeologan Byzantine style. Two exquisite family icons, representing Saints Simeon and Sabba and the Descent from the Cross are dated from about 1512 because of the inclusion of representations of Princess Despina

in mourning garb, holding her son Teodosie, who died after a short reign that year.

Several large iconostases are exhibited, representing the styles of several centuries. The most notable is a large work of dark wood. It is a highly ornate Baroque example and dates from the eighteenth century.

The collections of the National Gallery continue in the eight large exhibition halls of the second floor of the Art Museum dedicated to Romanian painting and sculpture of the nineteenth and twentieth centuries. The first of these galleries houses examples of the works of the first "modern" painters of the nation. The *Self Portrait* by Carol Valstein (1836) portrays the founder of the first museum in Romania. There are nine paintings in the collection by Gheorghe Tattarescu, the first Romanian artist to study in Rome and the first to introduce western European academic styles to his country. The most important painting by this master is the well-known *Awakening of Romania* (1849), a picture of great historic significance for the nationalist movements in the mid-nineteenth century. This work, owned by the museum, is currently exhibited in the Tattarescu Memorial Museum in Bucharest.

The important mid-nineteenth-century master Theodore Aman (1831–91) is represented by forty-two works. Aman, who was the founder of the National Art School in Bucharest in 1864, played a significant role in Romanian cultural life. He employed a style that combined academic form with sparkling color, making his compositions reminiscent of works by Delacroix and Monticelli, whether they be elegant genre scenes (the *Fancy Dress Ball in the Studio* or dramatic historical compositions (*Noblemen Surprised during a Feast by Envoys of Vlad Ţepeş*).

The many works of Ioan Andreescu and Nicolae Grigorescu show a marked influence of Barbizon landscape and other styles of French art in the late nineteenth century. It was these artists who introduced plein-air painting (of which there are many examples in the National Gallery) into Romania.

Several paintings by Stefan Luchian (1868–1916) are exhibited, attesting to his study (in Paris) of Degas, van Gogh, and Vlaminck. Among other prominent painters of the Post-Impressionist era whose works are seen in the National Gallery are Gheorghe Petrascu (an admirer of Cézanne), Theodor Pallady (a close friend and correspondent of Matisse who studied with Puvis de Chavannes and Gustave Moreau), and Nicolae Tinitza, whose paintings (particularly the series of portrait heads) combine the sculptural solidity of Modigliani with the sense of bright color derived from Romanian folk art and Byzantine painting.

The most outstanding examples of modern Romanian sculpture to be seen in the National Gallery are the works of Constantin Brancusi, who often employed forms derived from national folk art to create his strikingly modern images. Among the most famous works in the museum's collection are *The Sleeping Muse* (1906), *The Prayer* (1907), *Wisdom of the Earth* (1908), and *The Kiss* (1912).

The Universal Gallery occupies twenty-four rooms on the second and third floors of the museum. The first four of them are reserved for the large collection of Italian paintings from the late fifteenth to the twentieth century. Many of the most important examples were formerly in the collection of the Romanian royal family, while others were transferred to Bucharest from the Brukenthal Museum in Sibiu at the time of the formation of the Art Museum. Among the earliest examples is the *Crucifixion* by Antonello da Messina dated between 1450 and 1455. Some of the most significant Italian paintings in the collection are by Venetian masters. One of the earliest of them is Domenico Veneziano (c. 1400– 1461), represented by a small panel of the *Virgin and Child*. The *St. Jerome in the Desert* by Lorenzo Lotto (c. 1506), the *Rape of Europa* by a follower of Giorgione, *Circumcision* by Antonio Vivarini (1461), and the *Return of the Prodigal Son* by Bernardino Licinio are among other Venetian paintings of the Renaissance. This category further includes an important early work by Tintoretto, *The Annunciation*, very similar to a painting of the same composition found in the Church of San Rocco in Venice.

There are several paintings by masters of the Renaissance in Ferrara. Of them the principal pictures include two panels of allegorical subjects by Ercole de Roberti, *The Good Omen* and *The Bad Omen*, as well as *The Holy Family with the Infant St. John* by Battista Dossi. One of the most beautiful of the Northern Italian Renaissance works is the *Crucifixion* by Jacopo Bassano (c. 1562), which was formerly in the royal collection at Sinaia.

The museum's Italian Baroque works are among the collection's strengths. The most notable examples include the *Portrait of Cardinal Galli* by Giovanni Battista Gaulli (called Il Bacciccio); *Young Mother* by Orazio Gentileschi; two paintings, *The Circumcision* and *The Battle of Hercules with the Centaur Nessus*, by the Neapolitan master Luca Giordano; *Saints Francis and Benedict Listening to a Musical Angel* (one of four versions of this composition) by Guercino; and the *Expressive Head* by Salvator Rosa. Other Baroque paintings include *Young Christ Child Holding a Cross* by Domenichino, *The Death of St. Joseph* by Carlo Maratta, *Hagar and Ishmael in the Desert* by Pier Francesco Mola, and *The Virgin and Child with the Young St. John the Baptist* by Ippolito Scarsella (called Scarsellino).

A portrait of the famous singer Carlo Broschi, called Farinelli, by Jacopo Amigoni is among the significant eighteenth-century Italian paintings. Others include *Landscape with Ruins* by Giovanni Paolo Pannini; *The Hospital* and *Monks in a Landscape* by Alessandro Magnasco; two works, *Head of a Franciscan Monk* and *Charitas*, by Giovanni Battista Piazzetta; and the *Holy Family with St. Anthony of Padua* by Giovanni Battista Pittoni.

Although the collection of Spanish painting is small, it includes several undisputed masterpieces, especially from the seventeenth century. Among the earlier works are three Late Gothic panel paintings: the *Virgin and Child with Musical Angels* attributed to Joan de Joanes, a major figure of the Valencian Renaissance; the *Holy Family* (1569–75) by Juan Fernández Navarrete, called

El Mudo; and a *Pietà* by a follower of Luis de Morales. There are two major late paintings by El Greco, the *Adoration of the Shepherds* and the *Marriage of the Virgin*. Also by El Greco (or a close follower) is a replica of the *Martyrdom of St. Maurice and the Theban Legion*, the original of which is in the Monastery of El Escorial (q.v.) near Madrid. Bartolomé Estebán Murillo's *Origin of Drawing*, painted in 1660 for the chapel dedicated to St. Luke in the church of San Andrés in Seville, is one of the few Spanish paintings to deal with this Greek legend. Luis Tristán, a painter from Toledo and a follower of El Greco, is represented by *The Descent of the Holy Spirit*, probably painted around 1620. *Christ at the Column* by Alonso Cano is a variant of similar works in the Prado (q.v.) and the Academy of San Fernando in Madrid. Jose Antolínez' *Ecstasy of Mary Magdalene* of about 1670–75 is a splendid example of the Late Baroque manner in the Spanish capital.

The selection of German art is not extensive; yet it does contain two interesting works by Lucas Cranach the Elder, *Venus and Cupid*, and *Virgin and Child*, the former signed and dated 1520, the latter signed and dating from the decade of the 1530s. There are several anonymous panel paintings from the Tyrol and Danube regions dating from the sixteenth century. Among the nineteenth-century masters represented are Friedrich von Uhde and Franz Xavier Winterhalter, who painted the impressive *Portrait of Maria Feodorovna*, wife of Tzar Alexander III of Russia.

From the Austrian Tyrol there are three Late Gothic panel paintings. The Italian-Austrian portraitist Giovanni Battista Lampi the Elder (1751–1830) executed the *Portrait of Empress Catherine II of Russia*, and his son Giovanni the Younger painted the *Venus and Cupid*, probably in the early nineteenth century.

The Dutch and Flemish galleries are rich in works from the fifteenth to the seventeenth century. Among the earliest paintings are the portrait *Man in a Blue Turban* (possibly a Burgundian nobleman) attributed to Jan van Eyck, which may be dated between 1430 and 1435, and two works by Hans Memling, *Portrait of a Woman Praying* and *Portrait of a Man Reading*. Important sixteenth-century paintings include *The Calling of St. Matthew* by Jan Sanders van Hemessen, *Noli me tangere* (signed with the artist's initials and dated 1591), by Bartolomeus Spranger, *Venus and Cupid* (possibly dating to the end of the artist's life in the mid-seventeenth century) by Abraham Bloemaert, *Susannah and the Elders* attributed to Joachim Wittewael, two still lifes and a landscape by Pieter Bruegel the Elder, and four paintings of the seasons and *Massacre of the Innocents* by Bruegel the Younger.

The Flemish seventeenth century is represented by a wide range of works, including *Hercules and the Nimean Lion*, generally accepted as an autograph work by Peter Paul Rubens and dated about 1615–35. The attribution to Anthony van Dyck of the small *Head of a Woman* has been strengthened by the recent discovery of the artist's signature. Jacob Jordaens' *Holy Family* and *Summer*, both brought to Romania by Count Samuel Brukenthal; five scenes of peasant life by David Teniers the Younger; and *Still Life with the Supper at Emmaus* by

Frans Snyders are among the other significant Flemish Baroque paintings in the collection of the Art Museum.

The museum also possesses a number of paintings by the Dutch "little masters," as well as the large *Haman Imploring Esther for Pardon*, which has been attributed to Rembrandt. *Vase of Flowers* by Rachel Ruysch, *Portrait of a Lady* by Aelbert Cuyp, and two landscapes by Philips Wouwerman are included in the selection of Dutch art.

The holdings in painting of the French Baroque and eighteenth century are very small. Two small battle scenes attributed to Jacques Courtois and a *Landscape with Ruins* by Gaspard Dughet are among the few seventeenth-century works. Three portraits by Nicolas de Largillière, Hyacinthe Rigaud, and Elizabeth Vigée-Lebrun, as well as the *Venus and Adonis* by Louis Jean François Lagrenée, represent the eighteenth century. Holdings in nineteenth-century French art are very rich. Although there are works by followers of Jacques Louis David and Antoine Jean Gros, the masters of mid-century are more prominent. Among the works by Realist painters are the late *Winter Landscape* by Gustave Courbet (from the collection of the composer Gheorghe Stephanescu, a friend of the artist), the painting *Saltimbanques* by Honoré Daumier painted about 1866–68, and the *Portrait of the Engineer Maigret* by Jean François Millet (c. 1840).

There are many works by artists associated with the Barbizon group, including landscapes and figure compositions by Corot, Daubigny, Díaz de la Peña, Dupre, Jacques, and Troyon. Among the Impressionist paintings are *Fishing Boats at Honfleur* by Monet, the *Flowering Orchard* by Pissarro, and the *Landscape with a House* by Renoir.

Some examples of French sculpture are also exhibited in the Universal Galleries, including a study *Hercules* by François Rude and a *Bust of a Child*, a *Neapolitan Fisher Boy*, and *Cupid* by Jean Baptiste Carpeaux. The French decorative arts are also represented by a sampling of furniture and other objects created for the elegant interiors of homes in Paris and other cities (such as Bucharest) in the eighteenth and nineteenth centuries.

Contiguous with the halls devoted to French art are those housing a selection of Russian and Soviet painting. Included in this collection are about thirty-seven icons from the seventeenth to the nineteenth century. Many of the painters of international fame who worked in various parts of Russia in the last century are represented here, including Ivan Konstantinovich Aivasovsky, a painter of the Art Museum's three marine scenes; Isaak Ilich Levitan (*The Mill*); Ilya Yefimovich Repin (*On the Lawn*); and Apollinari Mihailovich Vasnetsov (study for his *Mountain Landscape*). About eight paintings illustrate the twentieth-century style of Soviet Realism by painters such as S. A. Chuikov, M. S. Saryan, and Boris Yoganson.

The galleries of Oriental art contain objects from the Near and the Far East. From Persia there are numerous examples of ceramic ware representing the styles developed at Kashan, Sultanabad, and other centers. The textile collection includes Persian carpets and a particularly noteworthy selection of Kashmir shawls

dating from the sixteenth through the nineteenth century. Ceramics from the Ming and Ching dynasties in China and a large selection of Japanese *ukiyo-e* prints (many by Suzuki Harunobu) are among the highlights of the Far Eastern collection.

The Art Museum of the Socialist Republic of Romania has an extensive library principally for the use of the museum's curatorial staff, although other scholars and advanced students of the fine arts may be granted permission to use its facilities on request. Although few photographs of the objects in the collection are available for purchase, many are reproduced in the museum's numerous catalogues. Catalogues of most of the paintings have been published, and additional catalogues that will document the entirety of the museum's holdings are in preparation. The Art Museum also publishes *Muzeul de Arta*, a monthly periodical with articles concerning the permanent collection, restoration projects, interviews with contemporary artists, and news of artistic projects in Romania and other countries. The Art Museum organizes many exhibitions for showing in the different regions of Romania and in foreign countries.

Selected Bibliography

Museum publications: *Catalogue of the National Gallery: Painting, XIX Century, I*, 1975; *Catalogue of the Universal Art Gallery, I: Italian Painting*, 1974; *Catalogue de la Galerie d'art universel, II: Peinture espagnole, peinture allemande et autrichienne*, 1974; *Catalogue de la Galerie d'art universel, III: La peinture des pays-bas*, 1976; *Catalogue de la Galerie d'art universel, IV: La peinture française*, 1978; *Catalogue of the Universal Art Gallery, V: Russian and Soviet Painting*, 1977; *Repertoriul graficii româneşti din sec. XIX, I, II*; *Repertoriul graficii româneşti din sec. XX, I*; *Restaurarea ştiinţă şi artă*.

EDWARD J. SULLIVAN

Spain

—————— Barcelona ——————

MUSEUM OF CATALAN ART (officially MUSEU D'ART CATALUNYA; also MUSEO DE ARTE DE CATALUÑA), Parc de Montjüic, Barcelona.

The roots of the Museu d'Art de Catalunya are municipal: the Junta de Comercio of the city of Barcelona established a school of drawing, Escuela de Dibujo, in 1785 that eventually became the Escuela de Nobles Artes and subsequently the Academia de Bellas Artes. The Escuela housed a collection of works of school graduates and additional artworks acquired by the Junta de Comercio as models for the students. A larger number of works were added to this collection in the early nineteenth century as a result of Napoleon's suppression of the religious orders in 1813 and anticlerical movements in 1820 and 1835.

During the second half of the nineteenth century, local consciousness of Catalonia's artistic heritage grew; this was reflected in three great exhibitions, two of Gothic art (the exhibitions in Barcelona in 1867 and Vic in 1868) and one of Romanesque—Barcelona's Exposición Universal in 1888. This interest led to the establishment in 1891 of a museum in Barcelona to house the art collection of the Academia de Bellas Artes. It was housed first in the Palacio de Bellas Artes and in 1900 was moved to the Arsenal de la Ciudadel.la.

The new museum was administered by the Diputació Provincial of Barcelona. In 1907 the Diputació created the Junta de Museus, an independent body with executive functions, to administer this museum (now called the Museu de la Ciudadel.la) and several others that had been established in the city. The Junta was empowered to plan and implement amplification of museum collections, as well as to supervise field work and excavations at Catalan sites.

The Junta presently operates under rules set up in 1951 by the Dirección General de Bellas Artes of the Spanish government, and under the umbrella of

the Junta, the Museu d'Art de Catalunya was placed, along with several others in the city, under the Ajuntament of Barcelona. Other municipal museums were to be administered by the Diputació Provincial. But the proliferation of Barcelona's museums has made the Junta unwieldy; the new Catalan government, the Generalitat de Catalunya, was in 1981 working on a revision of the administration of the city's museum system.

The Museu de la Ciudadel.la's collection continued to grow during the period 1910–30. By 1931 the Arsenal had to be evacuated, and the museum had clearly outgrown its limited space. The Junta settled on the Palau Nacional as a new home for the museum. A large Neo-Baroque building recently housing the Exposición Universal of 1929, the Palau was originally designed by the Catalan architect Puig i Cadafalch for the Exposició de Industrias Electricas in 1913. It was completely redone for the 1929 exposition by the architects Mariano Rubió i Ballvé and Pere Domenech i Roura and given an elaborate Neo-Baroque facade. In 1932 the director of the museum Joaquin Folch i Torres and the architect Ramon Raventós made further alterations to accommodate the museum's collections.

On November 11, 1934, thirty-six galleries containing works of art from the pre-Romanesque to the neoclassic periods were opened to the public. Later, the second floor of the Palau was opened; these galleries contained the museum's nineteenth- and early-twentieth-century collections.

The museum was closed in 1937 and its collections removed due to the Spanish Civil War. It was reopened in 1941–43, but at this time the nineteenth- and twentieth-century collections were moved once again to the Arsenal de la Ciudadel.la, which became the present Museu d'Art Modern. The Museu d'Art de Catalunya now contains only the collections from the tenth to the eighteenth century.

The character of the museum is destined to change once again: although extensive remodeling was carried out in 1971 under the municipal architects J. Ros, I Serra Godoy, and J. Casanovas, the Ajuntament of Barcelona and the Poor Claire Nuns of the Convent of Pedralbes in the same city signed an agreement on November 29, 1972, that will provide significant changes. A new building is projected to house general services, plus the entire Romanesque collection and a selection of the holdings from the thirteenth through the eighteenth century. The remainder of the latter collection eventually will be housed at Pedralbes. Although the new building is still in the planning stage, the collections are set up on an ingenious system of moveable walls to facilitate a move to a new site and yet retain the same character in their future home.

The museum's collection of Romanesque art (practically all of it Catalan) is the largest, oldest, and highest in quality of any European or American museum. Its holdings in Gothic art, particularly painting of the thirteenth through the fifteenth century, is extensive. Aside from a few examples, most of this portion of the collection is Spanish, with the majority of works coming from what was the crown of Aragon. The works dating from the sixteenth through the eighteenth

century are both more diversified and in general lesser examples of their genre; they include European Renaissance and Spanish Baroque paintings.

The growth of the various collections has come about by an astute policy of purchase combined with various donations by individuals. The nucleus of the Romanesque collection was the purchase of several frontals in 1900, with more added during the first decade of the present century. The acquisition of wall paintings was initiated by an event that at first seemed disastrous: the publication of the Catalan murals by the Institut d'Estudis Catalans during the second decade of the present century led to several of the most impressive being removed from their churches and spirited abroad for sale. The Junta de Museus was able to save and purchase all but one important mural cycle (that of Santa Maria de Mur) and had them brought to the museum with the aid of Italian technicians.

The museum's holdings were significantly enhanced by the purchase of four great collections during the period 1930–60. They were the collection of Lluís Plandiura, rich in Romanesque and Gothic examples; the Muntadas Collection in 1937, which increased the Gothic holdings by one-third; the Gill Collection, on deposit with the museum since 1924, which contained important Renaissance and Baroque paintings; and portions of the Rómulo Bosch Collection, on deposit since 1934. One of the most impressive single donations was that of the Santiago Espona Collection, given in 1958. A second important gift, the Fontana Collection of fourteenth- and fifteenth-century panels, was made in 1975; pieces from this collection are housed in a separate gallery in the Gothic section of the museum. There are also several works on deposit with the museum, the most notable being the mural cycle from the chapter room of the Monastery of Sigena.

In addition, the museum has a cooperative agreement with the Diocesan Museum of Seu d'Urgell, in which fragments of wall paintings are being obtained to complete those cycles already in the museum (other finds are being diverted to the museum at Seu d'Urgell).

The arrangement of the galleries within the Museu d'Art de Catalunya are divided into two sections, the first encompassing the pre-Romanesque, Romanesque, and linear Gothic works; the second comprising works from the fourteenth through the eighteenth century (called the Gothic section in museum labels). In the case of the Romanesque wall paintings, apses and interior spaces are recreated as nearly as possible so that the viewer can get an idea of their original appearance. Plans, maps, and other visual aids (such as a small gallery with photographs of the removal and transferral of wall paintings from their original sites to the museum) are included where relevant. In the section dealing with fourteenth- and fifteenth-century retables, explanation of the retable format and technique of painting them are displayed, and an additional gallery relates works of art to contemporaneous social and political events.

Beginning with the best preserved pre-Romanesque example, a small apse and triumphal arch from Marmellar, the galleries proceed to some fine early Romanesque examples of both wall paintings and frontals, notably the frontal

of Saints Julita and Quirze from Durro, two by the same hand from Hix and Seu d'Urgell(?), and murals from Sant Joan de Boi and Sant Pere at Seu d'Urgell. The latter is particularly interesting, since side by side with the apse paintings is the underpainting layer from the zone of saints and apostles, which admirably demonstrates that these twelfth-century painters used a variety of techniques rather than true fresco. Examples of underpainting also are to be found in three other mural cycles, the apostles level from the parish church of Ginestarre de Cardós, the nearly complete apse of Santa Maria de Taüll, and a portion of the nave from Sorp.

In some cases, several examples by the same group of artists are found, such as the side apses from Sant Quirze de Pedret, the apostle zone of the apse of Sant Pere de Burgal, and related apses from Santa Maria d'Aneu, the Castle of Orcau, and Santa Eugenia de Argolell.

Probably the most impressive and best known of all Catalan Romanesque works are the paintings from the twin churches of Sant Climent and Santa Maria at Taüll. Sant Climent is considered the higher in quality of the two, with its imposing Christ in a mandorla with evangelist symbols, seraphim, and angels at the top of the apse, with apostles and the Virgin in the zone below, and with the hand of God and the Apocalyptic Lamb at the apexes of its two triumphal arches. But the cycle from Santa Maria is far more complete, with decorative bands below the apostles zone in the apse and portions of the murals from the south aisle and facade walls. The remains are extensive enough for the museum to have reconstructed the entire space of the nave and south aisle in a single gallery. In addition, there are other objects from Santa Maria, including a sculpted frontal of Christ with the four evangelist symbols and twelve apostles and the figure of Christ from a crucifix.

The only other mural cycle that approaches the comprehensiveness of Santa Maria de Taüll is that from the triumphal arch and the left side of the nave from Sorp—part was acquired by the museum in 1928 and the rest in 1964.

The museum also contains some fine examples of Romanesque sculpture, including the polychromed *Majestas*—Christ on the Cross—donated by Enric Batlló; other crucifixes from Cabdella and Organyá; a number of images of the Virgin and Child, such as those from Marquet and Ger; and, most impressive, two large wooden groups of figures, the *Descent from the Cross*, one from Boi, the other from Erill la Vall.

The museum has an important series of painted frontals from the twelfth and thirteenth centuries, including one from Valltarga depicting St. Andrew by Mestre Aleixandre and others from Santa Maria de Aviá, Sant Roma de Ullà (which includes its painted sides), Tost, Mosoll, and Alós de Isill. Other panels include painted components of a baldequin from Toses and an exceptionally long and elaborate frontal of St. Michael by the Master of Soriguerola.

There is also a large collection of metalwork, much of it enameled. Most of the pieces come from the Plandiura and Espona collections and include crosses,

caskets, censers, small images, and candlesticks. Some of the pieces are Catalan, some are from other Spanish regions, a few from Italy and France, but many are of unknown provenance.

The most important non-Catalan cycle of paintings is found in the large gallery that houses the remains of the Sala Capitular murals from the Monastery of Sigena (Aragon). The paintings on the fifteen great arches supporting the ceiling have been on deposit from the convent since 1936, those on the walls since 1960. The artist who painted them reflects the Winchester school of manuscript illumination. The same room houses four great tombs from the Matallana Monastery (Valladolid), with effigies on top and mourning figures around the sides of each.

Among the most interesting items of the Late Romanesque and Early Gothic periods are a series of painted beams and friezes that adorned private residences in Barcelona. They are secular in nature. The decorative frieze from a building near Lleida (c. 1200) contains the largest repertoire of secular themes in Catalonia. Although now reduced to fragments, the original frieze covered a band of 1.10 meters in height, which ran around a room of 8.80 by 3.74 meters. No less important are ceiling beams and wall paintings from the Aguilar family residence in the Carrer de Montcada, Barcelona. The main wall paintings depict the Battle of Porto Pi, pivotal in the Christian reconquest of Mallorca.

Several other non-Catalan works (mostly Aragonese) represent the very late manifestations of the Romanesque style, such as the frontal *St. John the Baptist* and an early retable dedicated to St. Michael from Tamarite de Litera.

The earliest Gothic pieces in the museum come from a variety of regions, such as the painted mourners from the tomb of Don Sancho Saiz de Carrillo from Mahamud (Burgos) and panels showing scenes from the life of the Virgin from Navarre. There are also several images of the Virgin and Child in alabaster and wood from different provinces.

The character of the later portions of the museum's collection shows a greater geographical diversity than the Romanesque. The Gothic collection is strongest in works from the three mainland regions of the crown of Aragon (Aragon, Catalonia, and Valencia) and admirably shows the development of paintings in these areas from 1350 to 1500.

Several galleries are also devoted to sculpture. Among the finest pieces are a large Calvary group; a large, although incomplete, retable dedicated to St. Michael; and a retable of the Virgin and St. Anthony Abbot from the circle of Bartomeu Rubió (c. 1370) from Gerb. From Gandía (Valencia) come a set of choir stalls by Joan and Pere Llobet, dated 1386.

The museum contains a representative cross-section of Catalan painting of the second half of the fourteenth century. The pieces include the *Annunciation* panel of Arnau Bassa's retable from Cardona, a St. Matthew by Ramon Destorrents, and several works by the brothers Jaume and Pere Serra, including a complete retable of the Virgin from Sigena (the work of Jaume) and sections from a retable

from Tortosa, the center panel of the Virgin and Child, and the lovely *banco* with half-length images of four saints, attributed to Pere.

The International Style is represented by works from various regions. Notable is the *Resurrection* by the Catalan Lluís Borrossà, *Nursing Virgin* by Ramon de Mur from Cervera, and several works by Bernat Martorell, including a complete retable dedicated to St. Vincent. From Valencia come two fourteenth-century nursing Virgins and Gonçal Peris II's retable of St. Barbara. Aragon is represented by *St. Michael* (from the Fontana donation) given to the Master of Lanaja, panels of Saints Vincent and Lawrence, and the *Madonna of Mercy* by Bonanat Zahortiga. A panel of St. Ursula, signed "Jacobo," is of Navarrese origin.

A star of the Gothic collection is Lluis Dalmau's *Verge dels Consellers*, depicting the enthroned Virgin and Child flanked by angels, Saints Anthony and Eulalia, and the counselors of Barcelona, documented 1444. It is in the style of Jan van Eyck and is one of the earliest examples of the Flemish style in Catalonia.

The later fifteenth century is again divided regionally. Most interesting of the non-Catalan works are those from Valencia. The museum possesses two complete retables by Joan Reixach, a signed and dated one dedicated to St. Ursula from Cubells (1468) and the retable of the Epiphany from Rubielos de Mora. A fine center panel from a retable dedicated to St. Peter is the work of Rodrigo de Osona. There are also panels from a retable dedicated to the Virgin by the Master of Xàtiva. The latest Italianate style of fifteenth-century Valencia is represented by the small triptych *Virgin, Child, and St. Anne* attributed to Master Martínez and a small retable dedicated to St. James in a similar style.

The great fifteenth-century painter Bartolomé de Cárdenas (Bermejo) is represented by two panels, the *Resurrection* and *Christ in Limbo*, certainly lateral panels of a retable (two others are in the Amatller Collection in Barcelona). They were probably painted during the early stage of the artist's career in Valencia. A later stage of Bermejo's style is reflected in the works of artists whom he influenced in Aragon. There are works by several of them, notably Martin Bernat, including a Crucifixion and a painted Crucifix with Passion symbols. Among the other notable Aragonese works from the later fifteenth century is a documented Crucifixion by Juan de la Abadía.

Two important late-fifteenth-century paintings come from Castile: an Epiphany by Fernando Gallego and two painted cloth panels that occupied the interior of organ doors in the chapel of St. Catalina, Toledo, by Pedro Berruguete. But as it is to be expected, the largest number of late-fifteenth-century paintings are Catalan. Paintings from the province of Lleida are represented by the work of Pere Garcia de Benabarre, most significantly in his signed *Virgin and Child*, the center of a retable from Bellcaire, panels from the *retablo mayor* of Sant Joan del Mercat in Lleida, and the *Virgin and Child with St. Vincent Ferrer and Two Donors* from Cervera. The museum has several examples of the sparse remains from the province of Gerona. Most striking are the Flemish-influenced *Annunciation and St. Jerome* by the Master of Seu d'Urgell.

The work of the best of fifteenth-century Catalan painters, Jaume Huguet, is present in many fine examples that illustrate diverse stages of his career, from the early Virgin and Child panel of a retable from Vallmoll, through panels of the retable of St. Vincent from Sarria and others from the retable of St. Michael, commissioned by the Retailer's Guild of Barcelona in 1456, to the fine, if damaged, panel of St. George. Certainly, the greatest example of Huguet's work is to be found in the museum, the magnificent *Coronation of St. Augustine* from the titanic retable of the Tanner's Guild (1463–86). Five other surviving panels in the museum are the work of the artist's shop. The last work of importance from fifteenth-century Catalonia is seen in panels from the retable of St. Stephen from Granollers, the work of the Vergós family, with several small images of prophets by Joan Gascó.

The collection of sixteenth-century art is considerably smaller. Here for the first time are a greater number of non-Spanish works, such as the *Nursing Virgin* by an anonymous Fleming and the triptych *Baptism of Christ* by the Master of Frankfort. There are relatively few works by Catalan artists, and those that have Catalan provenance are mostly by non-Spanish artists, such as the *Warrior Saint* and the *Martyrdom of St. Cucufas* (from a retable dedicated to him for Sant Cugat de Valles) by the German Ayna (or Anye) Bru and the doors of the retable of St. Eligius commissioned by the Barcelona Silversmith's Guild in 1524 by the Portuguese painter Pere Nunyes.

The seventeenth-century collection is most notable for the absence of Catalan artists, but the musuem does present a cross-section of Baroque art in Spain. There are paintings by El Greco, *St. Peter and St. Paul* and *Christ Carrying the Cross* (the latter from the Espona Collection). Among the most important Baroque examples are two paintings by Zurbarán, *Still Life* and *Immaculate Conception*, dated 1632 (*St. Francis* is a replica of the panel in the Boston Museum [q.v.]); *Immaculate Conception* by José Antolinez; and the fine *St. Paul* by Velázquez. There is also a version of the *Martyrdom of St. Bartholomew* by Jusepe Ribera, dated 1644. Both Ribaltas are represented, Francisco by a painting of *Ramon Llull* and Juan by a signed and dated *St. Jerome* (1618).

The eighteenth-century holdings include one important group of canvases: the museum preserves intact the only large painted cycle of a type that was very common in Spain. They are twenty paintings by the Catalan Antoni Viladomat, which depict the life of St. Francis. They originally adorned the cloister of the Franciscan Convent of Barcelona and were among the works that made up the original nucleus of the museum's collection, saved from destruction in 1835.

Facilities beyond the housing of the collection in the present museum are limited. There are offices and storage areas and an excellent restoration laboratory. Because of the present nature of the organization of the municipal museums in Barcelona under the Junta, various functions that would normally be housed within an autonomous museum are apportioned among many. Thus the museum has no library, but a reference library serving all of the museums under the Junta is located in the Museu d'Art Modern. There is a small gift shop that

sells postcards, some slides, and a few publications, but selection in all areas is limited.

Selected Bibliography

Museum publications: *Museo de arte de Cataluña, Barcelona*, 1967; Ainaud de Lasarte, J., *Arte Románico, Guía*, 1973; Farré, Maria C., *Museo de Arte de Cataluña, Guía*, 1973; *Butlletí dels Museus d'Art de Barcelona* (1931–37); *Anales y Boletín de los Museos de Barcelona* (started 1941; still publishing, although the last issue came out in 1967).

Other publications: Ainaud de Lasarte, J., "La nueva presentación de la sección romanica del Museo de Cataluña," *Goya*, no. 113 (1973), pp. 272–79; Cook, W.W.S., "Early Spanish Panel Painting in the Plandiura Collection," *The Art Bulletin* (1929), pp. 155–86; Elias de Molins, A., "La estátua gótica de la Figuera ingressada al Museu de Barcelona," *Anuari de l'Institut d'Estudis Catalans* (1921–26), pp. 187–88; Folch i Torres, J., "Adquisicions del Museu de Barcelona," *Anuari de l'Institut d'Estudias Catalans* (1913–14), pp. 885–918; (1915–29), pp. 755–80; Gudiol Ricart, J., "La colección Muntadas," *Gazette des Beaux Arts*, s. 6, vol. 48 (1956), pp. 11–22; Santos Torroella, R., "Una importante aportación al Museo de Arte de Cataluña: La donación Fontana," *Goya*, no. 113 (1973), pp. 181–83.

JUDITH BERG SOBRÉ

———— El Escorial ————

EL ESCORIAL (officially EL MONASTERIO DE SAN LORENZO EL REAL DE EL ESCORIAL; alternately THE ROYAL MONASTERY OF ST. LAW-RENCE OF THE ESCORIAL; also EL ESCORIAL, EL ESCURIAL), El Escorial.

The historian Fray José Sigüenza (1544–1606) ranked the monastery-palace complex known as the Escorial as the "eighth wonder of the world." It symbolized for many years the majesty of the Spanish empire and the epitomy of Spanish culture, as well as the power of Tridentine Catholicism and the Counter-Reformation.

The Escorial is located within a town of the same name in the foothills of the Sierra Guadarrama, about twenty-six miles (forty-five kilometers) northwest of Madrid. The name literally means the "slag heap" from the scoria residue of the mines there. The building dates to April 23, 1563, when its cornerstone was laid. It is a massive complex, known for its disciplined symmetry, that was designed by Juan Bautista de Toledo (d. 1567) and enhanced by his successor Juan de Herrera (1530–97) for Philip II (1527–98), king of Spain.

From its inception the Escorial was many things. First, it was a national shrine dedicated to St. Lawrence. It was also to be a royal mausoleum established by Philip II for his father Charles I (d. 1558), better known as Charles V, Holy

Roman Emperor after 1519. His remains were transferred to the Escorial from their original resting place at San Jerónimo de Yuste in western Spain, as were others of the royal family in 1573. The pantheon in the crypt below the basilica's high altar, completed in 1654 under Philip IV, contains niches in which all further Hapsburg and Bourbon monarchs and their queens are buried (with the exception of Philip V and Ferdinand VI).

The Escorial was also a royal residence, a palace with suites of rooms reserved toward the rear of the complex overlooking walkways, courtyards, gardens, an artificial lake, and a grand vista to Madrid. The most elaborate apartments, especially sumptuous because of their fine wood-inlay work, were refurbished by the Bourbons. The apartment of Infanta Isabel Clara Eugenia is today furnished with earlier period pieces, showing stark contrasts between the former Castilian style and the newer French influences. The most famous, however, are the austere quarters of Philip II himself—a mere three rooms, some ninety square yards, adjacent to the sanctuary where he could hear daily Mass.

Above all, the Escorial was a royal monastery, with an abbey with cells and dormitories for 100–150 friars, a refectory, and capitular chamber; cloisters and a sanctuary choir; a house of preparatory and advanced studies; a research library; a hospital; and numerous dependencies and factories for the Hieronymites who entered the Escorial in 1565.

Although the Escorial was in an upheaval with the rest of the country during the Napoleonic interregnum (1808–14), its fate turned on the whims of Spain's political instability for the rest of the century. The community swore allegiance to the new constitution of 1820 to no avail because of its association with the Restoration and Queen Isabel II (1833–68), only to fall prey again to the suspicious, anticlerical Republic (1873–75). Such turmoil eroded the rights of the community and its financial base, thereby causing general deterioration of the institution, and finally the community itself was destroyed. The Hieronymites remained at the Escorial until their expulsion in 1837. In 1854 they were suppressed for a second and final time.

In 1859 Queen Isabel II gave the monastery to Fr. Antonio Maria Claret and his following of secular priests, but communal life was not reestablished there. Alfonso XII bequeathed the Escorial to the Augustinians in 1885, but it was not until 1895 that they claimed the monastery for their order. The lands actually passed through the hands of several private landlords, the most recent of which were Nicolás and Eloy Caro Rodriquéz (after 1925). The church was ministered as a parish by royal chaplains, but the complex itself was for a time turned into a resort and miscellaneous shops. This was stopped only after the Civil War of 1930–33, when the state confiscated the Escorial. Then Generalissimo Franco entrusted it after 1940 to the National Patrimony Council of the Ministry of Culture, the official curator of the crown property, which has run it since as a national museum. The state and the church reached an agreement allowing the Augustinians to revive a community (now at nearly seventy members) at the monastery, where they took over the church and cloisters and the main library and reestablished a secondary school (the Royal College of Alfonso XII) and

their equivalent of a four-year university (the private Colegio Universitario de María Cristina).

The edifice today is heralded as an architectural masterpiece and a monumental achievement. The square enclave is a parallelogram measuring 207 by 161 meters, or about 680 by 500 feet, with four corner towers on an artificial leveled mound, so that its 1,800-foot-long terrace with its seventy-seven round arches rises 28 feet above the vault. The building contains fourteen apartments, thirteen cloisters, nine courts (actually sixteen courtyards), and turrets; more than eleven hundred windows in ordered series, with almost sixteen hundred more, or almost three thousand in the main complex and an estimated four thousand more in outbuildings; eight thousand doors (twelve hundred for people) and sixteen gates; eighty-six water conduits for plumbing, with eighty-eight fountains and eleven reflection pools; eighty staircases; rooms for many religious activities; eight galleries; three libraries; five halls; six dormitories; five infirmaries and a pharmacy; and two guesthouses. The 374- by 250-foot church contains a 93-foot-high altar, a high choir and two antechoirs, a main archway supported by eighteen jasper pillars, twenty-six side arches, seven aisles, a chapel, and forty-eight side altars, and there is an adjoining sacristy.

The main edifice was designed by Philip II's two chief architects, but their work was partially destroyed by the great fire of 1671. Reconstruction altered much of the building, and many great works of art were lost. Most noticeable were shifts in decorative styles from the simple, even austere, *estilo desornamento*, or "bare style," to more ornate tastes with the classical revival sponsored by Charles III (1759–88) and the addition of the pleasure houses beyond the main complex. Charles IV during the 1770s built two pavilions, those of the infantes and the principes, designed by Juan de Villanueva (1739–1811). This king also had several rooms redecorated. The Napoleonic occupation damaged the Escorial, but Ferdinand VII undertook the restoration. His historic preservation project was continued by Alfonse XIII and his designer José María Florit, who reverted to a neoclassical style. The last major restoration was undertaken by the Franco government in 1963 to celebrate the Escorial's fourth centenary. This work continues intermittently to the present, when funds permit, as one of the century's greatest experiments in historic preservation. The Escorial also contains several art galleries. Today a number of rooms are designated as showcases for period furnishings and decorative arts.

The facade and major plaza at the main gate were designed in 1576 by Herrera. Through it one enters the Courtyard of the Kings with its Old Testament monarchs associated with the construction of the Temple of Jerusalem. They were sculpted by Juan de Monego de Toledo, with ornamental work by Sebastían Fernández. The basilica facade is also Herreran, based on Paciotto's design (c. 1570). The original layout of the church was changed in 1575 from a Latin to Greek cruciform. Inside there are frescoes above the choir by the Genoese master Luca Cambiaso. He received the commission for the *Gloria* since Veronese had refused it. The wall frescoes are by the Forentine Romulo Cincinnati and the side-vault work, commissioned by Charles II, by the Neapolitan Luca Giordano. There are

finely crafted wood stalls by Giuseppi Flecha and the carvers Gamboa, Quesada, Serrano, and Aguirre. The two organs by the famed craftsman Gil Brevot are outstanding, as are the bronze, marble, and red jasper lecterns with their unique engineering and movable parts. The bronze statuary is by the Leoni studio in Milan, possibly designed by Leone Leoni (1509–90) and certainly cast by his son Pompeo (1533–1608), assisted by Giacomo da Trezzo, Giambattista Comane, Pietro Castello, and others. The twelve Apostles and three Calvary figures are noteworthy, as is the high altar with its tabernacle by Jacopo da Trezza (1514–89) after Herrera's design. The custody, made of 220 pounds of silver and 26 of gold, is decorated by beautiful jewels—32 emeralds, 127 rubies, 60 amethysts, 24 garnets, and 8 pearls—part of the Escorial's inventory of 9,400 precious gems. Above the altar stand cenotaphs of Charles I and Philip II by Herrera and the Leoni. The choir chapel houses the renowned marble Christ of Benvenuto Cellini (1500–71) of Florence.

The adjacent 330- by 26-foot sacristy has been converted to a gallery; paintings by Titian and Ribera overshadow the decor by Fabricio Castello (d. 1617) and Nicolo Granello (d. 1593), sons of "El Bergamasco" Giambattista (Juan Bautista) Castello (1509–69), who went to Spain in 1561. Its altar was designed by José del Olme, decorated by Francesco Filippini, and is topped with a crucifix by Pietro Tacca. The Holy Spirit altar predominantly displays Claudio Coello's masterpiece, the *Adoration of the Holy Ghost by Carlos II* (1635–93), which contains portraits of the court, including Fray Francisco de Los Santos, the king, the dukes of Alba, Medinacelli, Pastrona, and the artist himself. Next door, the Courtyard of the Evangelists is surrounded by the lower cloister with its thirty-three niches containing New Testament scenes painted in 1586–93 by Pelligrino Tibaldi (1527–96). Across the yard is the grand staircase to the upper level, designed by El Bergamasco and decorated in 1693 with archway paintings by Luca Cambiani (1527–86) and ceiling frescoes by Luca Giordano (1632–1705).

To the left of the church is another courtyard and the palace of the Bourbons, lavishly outfitted with wood-inlaid floors, walls, and fine furniture, an outstanding collection of decorative pieces, and several paintings. Instead of a cloister along the church wall, there is the Hall of Battles, a sixty-yard-long wall painting by Granello, Lazaro Tavaroni (1556–1641), and Labrizio Castello, who were commissioned by Philip II in 1584 to commemorate Juan II's victory over the African Muslims at Higueruela (July 1, 1431) in the Galerea del quarto de la Reyna, which today is the Sala de las Batallas. Behind the church is another gallery and the waiting room attending a plain, austere throne room made more attractive by its Flemish tapestries. In contrast to the underdecorated throne room, styled for a would-be-monk king, it is entered through an oversized, ornate German-carved doorway. The nearby quarters of Philip II still contain the original furnishings including his bed, artwork, personal items, library materials, and scientific instruments.

The two forward quarters of the Escorial's quadrangle are occupied by the college and offices to the left; to the right, close to the monastery itself, is the old hospital wing, now called the Gallery of the Convalescents. The main library

and archives also occupy this quadrant. The former is world famous for its Tuscan-styled bookcases by Guiseppe Flecha, designed by Herrera to hold its volumes with their gilt foredges outward rather than showing, as usual today, the spines of the books. Its grotesques are by Castello and Granello, the ceiling frescoes were executed in 1586–93 by Tibaldi, there are seven vaulted panels by him as well, assisted by Bartolome Carducho (1560–1608) of Florence, and ensconced among the books are portraits of Philip II and Charles V by Juan Pantoja de la Cruz (1533?–1585–86).

Since the Escorial was primarily a Hapsburg creation, typically Renaissance Spain with more borrowing from Italy than France, the Bourbon dynasty had sections remodeled to suit its more extravagant tastes. Closely associated with, but not really a part of, the Escorial is the Bourbon summer house at La Granja de San Ildefonso on the other side of the Guadarrama's Puerto de Navacerrada, nearer to Segovia, some eight-six kilometers north of Madrid. It was a hunting preserve on the headwaters of the Río Eresma, with a small medieval lodge once used by the Hieronymites as a retreat and then as a hostel—hence its name, a grange or outpost. Philip V in 1720 bought it from Prior Andrés of St. Maria del Parral and had his royal engineer Juan Ramón and architect Teodoro Ardemans convert the residence into a small-scale but sumptuous palace that was blessed on July 27, 1773. Its gardens were landscaped by René Cartier (d. 1778) of Versailles fame and Étienne Boutelore who did the fountains and statuary. Philip's queen, Isabela Farnese, retired there after his death and continued his building program with commissions to Abbé Filippo Juvara and his protegé Giovanni Battista Sacchetti. Charles II added more, including an artificial lake stocked with trout and after 1867 complete with its own boathouse. A fire on January 2, 1918, damaged La Granja's first floor, but Alfonse XII and his consort Victoria Eugenia von Battenberg restored it and there housed their fine collections of tapestries, porcelain, and furniture.

Among the art treasures at La Granja is the renowned tapestry designed for Charles V by Raphael Santi (1483–1520) just before the artist's death. This textile collection is supplemented by the rich vestments of the palace's collegiate church. La Granja's paintings are largely from the Flemish school, and it is also known for its dining room and so-called Marble Room painted by Bartolomeo Rusca. The Japanese Room is known for its imported laquer panels. The most important pieces hung in the palace are *Jesus and Scribe* by Giovanni Paolo Pannini (1691–1765), the portraits of Philip V and his queen by Louis Michel van Loo (1707–71), *Billiards* and *The Academy* by Michael Ange Houasse (c. 1680–1730), *Stag Hunt* by Frans Snyders (1579–1657), and the portrait of Carlos III by Jacopo Amigoni (1675–1752). It is difficult to capture in a résumé the essence of the Escorial's vast art holdings, more than twenty thousand, when the 1963 centennial volumes took nearly fifteen hundred folio pages to do so.

The Museo de la Arquitectura preserves the blueprints, sketches, and vast documentation associated with the Escorial's construction, as well as a collection of paintings and photographs illustrating details of the complex and changes through the centuries. It opened in 1962 with the restoration of an underground

vaulted cavern that reveals the foundation masonry and building technology of the sixteenth century. Its gallery contains eleven standing displays: (1) implements and tools; (2) views of the Escorial; (3) plans by Herrera and his successors; (4) engravings of the Escorial by Pierre Perret (1555–1625); (5–6) iconography used in the monastery's decor; (7) metalwork, especially wrought iron; (8) construction materials and supplies; (9) carpentry and woodworking arts; (10) documentation; and (11) machinery and equipment. Finally, this gallery also displays prominently the portrait of Philip V attributed to Pantoja de la Cruz, which belongs to Señora de Gonzalez Alvarez.

Paintings are distributed throughout the Escorial, but there is a special viewing gallery, the Museo de Pinturas, where exhibits are rotated regularly. Of the frescoes, many already mentioned, those of Giordano commissioned in the 1690s by Charles II deserve special note. The paintings, however, come primarily from the original collections of Philip II, who preferred Venetian art to any other, and to the king's inherited collections from Hapsburg possessions in southern Germany and the Lowlands. Subsequently the kings appointed court painters, and their works dominate the later collections. Several monarchs were avid collectors and patrons of some of Spain's best-known artists. Philip IV actively sought the works of Velázquez and Jusepe de Ribera, "Lo Spagnoletto," and Charles IV favored Goya. Works by Domenikos Theotocopoulos, El Greco, include the famous *Felipe II Adoring the Name of Jesus*, *Martyrdom of St. Maurice*, and depictions of St. Peter, St. Ildefonso, and St. Francis of Assisi in ecstasy.

Because of the preponderant influence of Italian masters in Renaissance painting and Italy's links with Spain in the sixteenth century, the Escorial holds a wealth of Italian treasures. Those who worked in Spain under royal patronage included Giovanni Maria and Francesco de Urbino; Luca Cambiaso (or Canghiasi), also known as "Luchetto" or "Luqueto," who died in 1585 at the Escorial leaving his masterpieces *The Martyrdom of St. Lawrence* (1581) and *The Virgin's Coronation* fresco; Nicolo and Fabricio Granello; the Florentine Romulo Cincinnati, known for his *Martyrdom of Pope Sixtus*, *St. Lawrence*, *The Last Supper*, and *The Transfiguration*; Pellegrino Tibaldi from Lombardy, whose grotesques in the library (*Mercury*, *Adoration of the Shepherds*, 1549) and his frescoes in collaboration with Bartolome Carducci prefigure Mannerism, for example, *Cenón de Elias*, *Tower of Babel*, and *St. Ambrose Converting St. Augustine*. Titian was among those to have been recruited, but his death robbed Philip II of his service; undaunted, the king avidly collected Titian's paintings: *The Last Supper* (1563), *St. Lawrence, Martyr* (1565–67), *The Adoration of the Magi* (1559), *St. Jerome as Penitent* (1575), *Christ before Pilate*, *St. John the Baptist*, and *The Crucifixion* are among the royal family's greatest acquisitions. The second most sought-after Italian master was Veronese (1528–88), known for his *Annunciation* (1583) and *Apparition of Christ*. The third master was Tintoretto, whose work is represented best in the Escorial's collections by his *Adoration of the Shepherds* (1583), *Queen Esther Fainting*, *Mary Magdalene's Conversion*, *Washing the Feet of the Savior*, and *The Entombment of Christ*. Other acquisitions were works by

Mariotto Albertinelli; the Neapolitan Andrea Vaccaro (1598–1670) acclaimed for his *Lot and Family*; Guercino; and Luca Giordano, whose works in addition to the frescoes include *Mary Magdalene*, *The Annunciation*, and *The Death of Julian the Apostate*.

The Escorial's collections naturally document Spain's own production as a result of both royal patronage and art collecting. Among the most notable are Juan Fernández de Navarrete, "El Mudo," known for his *St. Jerome* (1569), *The Burial of St. Lawrence*, *The Birth of Jesus*, and *The Holy Family* (the *Baptism of Jesus* is now in the Prado [q.v.]); Alonso Sánchez Coello, whose work is represented by *Saints Vincent and George, Martyrs* and *Carlos II and Court Adoring the Eucharist*; Ribera, who is represented by his *Entombment of Christ*, *Jacob*, and *The Liberation of St. Peter*; Luis Meléndez, who has several still lifes in the collection; and Francisco Lacoma, with many court portraits. Unquestionably valued most among these treasures are the works of Diego Velázquez, such as *The Presentation of Joseph's Tunic*, and Francisco de Goya's many productions, paintings, and tapestries.

Because of dominance by the Spanish Hapsburgs over the Lowlands, Flemish artists were well represented at the court and hence in the Escorial's collections. Besides many anonymous works, the most famous pieces are by Rogier van der Weyden (*Crucifixion*, *Descent from the Cross*), Hieronymus Bosch (*Los improperios*, or the *Mocking of Christ*), Frans Floris (*Crucifixion*), Gerard David (an altar triptych), Michael Coxie (*Birth of the Lord*, *David and Goliath*, and others), and the famed *Supper at Emmaus* by Rubens. In addition, there are numerous paintings, sketches, and prints by Albrecht Dürer.

Apart from the paintings and the building there are other outstanding art collections deserving brief description. The library is foremost among them. It dates from the time of Philip II, who took a personal part in its formation after 1564 by supervising its planning and providing its core from his own royal library. The royal and monastic library at the Escorial became so entwined that the latter may have seriously retarded the growth of the national library in Spain. His original gift in 1565 of more than four thousand, gold-tooled, black, Moroccan-bound volumes may otherwise have been destined for Madrid; included in the royal library were Cardinal Cisneros' *Complutensian Polygot Bible*, a landmark in biblical linguistic and textual research; of the historic collectables, perhaps most renowned was the *Codex Abeldense* from the tenth century; and from his personal books, there was his prayer book executed by the master illustrator Ambrosio de Salazar. The king's patronage spurred other acquisitions: the chapter library from Granada's cathedral; the Inquisition's archives of prohibited books; the private library (1576) of the Italian ambassador Diego Hurtado de Mendoza; and several monastic collections (Poblet, Murta, Barcelona, and others) and the Catalan corpus of Lulliana; and private scholars' libraries, such as the Hebrew manuscript collection of Benito Arias Montano (1524–98), the Escorial's first librarian, the research library and manuscripts of the annalist Jerónimo de Zurita, and the canon law books of Archbishop Antonio Augustín of Tarragona. In 1614 more than three thousand Arabic manuscripts from the

library of Muley Zaidan of Morocco were added to the Escorial—the spoils of war. When Montano first organized the library in 1570, it contained more than ten thousand volumes. Cataloguing was continued by Fray Juan de San Jerónimo and Fray José Siguenza in the novice's chambers, until 1577, when the library proper was operational. The main library, however, was not completed until 1593.

Philip II sought to put the library on a firm financial basis in 1573 by setting up a trust fund. By Philip IV's time it was augmented by two thousand ducats annually from the royal treasury; this funded both acquisitions and production at the scriptorium of the Escorial itself. The fire of 1671 destroyed an estimated three thousand valuable manuscripts and another thousand early printed codices, and the library suffered further losses after the Napoleonic invasion and riots of 1820–23. By 1859 the library's inventory listed thirty thousand volumes; an 1876 inventory, after the merger of the monastic and seminary libraries, listed forty thousand imprints, almost twenty-one hundred Latin and Romance manuscript codices, nineteen hundred in Arabic, seven hundred in Greek, and seventy-three in Hebrew. There survive today nearly fifty thousand rare books and more than seven hundred manuscript codices, a vast collection of loose manuscripts, the core of the monastery's archives, and two numismatic collections (one of more than two hundred eighteenth-century coins, the other from Classical Roman and medieval mints in Spain). The library is open during posted daytime hours Monday through Saturday and can be consulted by anyone with proper identification for registration (usually photo identification and preferably the national *tarjeta de investigador nacional*, which provides access to any of Spain's repositories that received federal aid). Intellectual access to the collections is through a card catalog (although nonstandardized, it still contains some of the original fifty-four hundred handwritten *ficheros*), sets of inventories, and several index files.

Among the library's artistic masterpieces are several world-famous medieval manuscript codices from the Holy Roman Empire: the *Ottonian Gospels* (*Evangelario*, or the *Codex Aureus*) of Eternach (c. 1033–39) given to Philip II by Queen Maria of Hungary, the Italian-influenced *Bible* of Archbishop Dalmace Mur of Tarragona, the *Decretals* of Gratian and several Roman *Breviaries*, French-based *Books of Hours* executed for Charles V and the emperor's *Missale*, and a thirteenth-century *Apocalypse* from Savoy. Of Spain's own productions there is the world-famous *Cantigas de Santa Maria* of Alfonse X (a thirteenth-century Gallegan-Portuguese compilation) and the king's Gothic-styled *Book of Games* (*Libro de los Juegos*, 1283), which is often cited for its attention to chess. The royal scriptorium is represented at the Escorial also by six romance Bibles, the *Lapidario*, and the grand chronicle *General Estoria*. Pre-Gothic treasures extend from the seventh-century *Antonine Itinerary* and include twenty-five Mozarabic codices such as Alfonse III's *Etimologia* of St. Isidore of Sevilla, and the *Liber Regularum*, as well as Visigothic exemplars such as the tenth-

century *Codex Emilianense* from Plasencia and the eleventh-century *St. Beatus de Liebana*.

The latter Middle Ages are more abundantly represented in the Escorial's collections of service books (*Breviaries, Pontificals, Missals, Antiphonaries*, and so on) and devotionals (*Hours*, sermons, biblical excerpts, and so on). Although many display no particular style, slowly production at the Escorial resulted in characteristics identified now with the Order of St. Jerome. This coalescence of regional styles at the Escorial's workshops is illustrated best by the magnificent *Misal rico* of Cardinal Ximinez de Cisneros. There was also a revival of classical forms and layouts showing Flemish and Italian Renaissance influences in the scriptoria, culminating in the miniaturist art of Simón Bening and Julio Clovio. Two other masters, Andrés de León and Julian de la Fuente el Saz, were mentors for a school including Juan Martínez de los Corrales and Esteban and Juan de Salazar and which produced from 1593 to 1604 a series of works. Among the most treasured masterpieces associated with this school are Philip II's *Breviary* of 1568; the *Capitulary* with its histories, sanctoral, and biblical extracts; and the three-volume *Passionario*. A keepsake of the monastery itself is a collection of 216 choir books from 1572–98, hand produced and uniformly bound as one commission. Much of the calligraphy therein is attributed to the masters Martín de Palencia and Cristóbal Ramirez, but other scribe illuminators from scriptoria at Burgos, Segovia, Valladolid, and Avila worked after 1572 at the Escorial atelier. A final period of productivity spanned the turn of the century, largely imitative of Clovio's work, before giving way to typography. The Escorial consequently preserves a large collection of incunabula and its early imprints collections contain outstanding examples from all of Europe's major presses. The legal deposit laws of 1619 ensured continual growth of the imprint collections, both from Spain and the New World vice-royalties, making it a major research center for historical bibliography.

The print collection (Amario 28) of more than seven thousand works was rated by Arthur Hind as one of Europe's best. The earliest prints date from 1488, by Francesco Domenech, but most are of the sixteenth century. Principal printmakers represented are Albrecht Dürer (126 prints, of which 73 are copper engravings; included are his portraits of Erasmus and St. Jerome); Lucas of Leiden (70 engravings, including his *Virgil* and *Pyramus and Thisbe*); Peter Bruegel (80 prints, incuding his series of ships and the *Good Shepherd*); Andrea Mantegna; Jerome van Aken (d. 1516) "el Bosco" (*Road to Calvary*); and especially, Pierre Perret (1555–1625), who after 1583 worked for Herrera and the Escorial's library, illustrating its books with innumerable architectural frontispieces and finishing a remarkable series of portraits now of particular historical significance.

The coin collections in the library document both minting and financial activities in Spain but also heraldry and genealogy with the inclusion of decorative metalwork such as seals, medals, and medallions—all catalogued by the Au-

gustinian Arturo García de la Fuente. The basis of this numismatic collection came from Archbishop Antonio Augustín of Tarragona (some 3,954 pieces in 1598). Felipe II added two thousand more. Other collections came from Ponce de León (598 pieces), Mariano Tamariz (300 pieces), and the Augustinians themselves (240 pieces). One hundred forty-four types of coinage are represented, including major holdings in Roman coins and Escorial issues. The library also holds several music collections, mostly originating with the monk Antonio Soler, a Catalan appointed in 1762 as the Escorial's chief organist and a master of the chapel. Its sheet music includes all of Europe's famous eighteenth-century composers, especially their Mass works.

Among the Escorial's most important decorative art collections are those in textiles, ceramics, and glassware, which augment the building's furniture. Its textile collections come from the royal acquisition of tapestries, both for private collecting and adornment of the building, such as those designed by Goya, Maella, and Wouwerman, and from the monastery's liturgical functions, mainly altar dressings and vestments. José de Sigüenza in 1586 described the formal liturgies at the Escorial, known widely for their spectacle created partly by the use of rich pontifical sets of vestments, candle-lit processions, and the church's gold and silver reliquaries and monstrances. Embroidered vestments feature the work of Fray Lorenzo de Montserrat (d. 1576) and the craftsmen *bordadores* such as Justo de Vozmediano, who oversaw a staff of fourteen to twenty embroiderers. The names of more than fifteen senior *obradores* are known. Taffeta and gold-spun cloth was imported from Florence, damasks from Granada and Valencia, silver-spun cloth and linen from Ulmayna and Ruán, velvets from Toledo and Granada, and gold and silver thread from Milan. After 1577 the workshop was dominated by Diego Rutiner and his son Daniel. Several chasubles and copes were designed by Diego López del Escorial and Miguel Barroso, as evidenced by the survival of their sketches for inset tapestries displayed on these vestments. The workshop's records illustrate their techniques and also for the whole spectrum of decorative arts and crafts for tailoring to embroidering, lace making, and fashion design.

The monastery's ceramic collections and glassware are documented as local products and imports. The earliest onsite fabrication dates from 1570, and the first royal gifts were made in 1571, which were augmented considerably in 1598. An inventory survives for 1577 that documents not only the artwork itself but the administration of the royal household. Talavera ware is well represented, as are ceramic tiles and dinnerware from Sevilla. Pottery comes from throughout Spain and some from Italy. One of the most treasured pieces is a plate preserving Perret's representation of the Escorial itself. Others were designed by Francis Andries, Jan Floris, and other sources of Flemish influence. Most of the hundreds of tiles in the Escorial are typically decorated in blue and white (hence the name *azulejos*). There is also a collection of jars, bottles, and other practical containers contrasting to the collections of polychrome vases, fine glassware (stained, painted, and cut), and richly decorated serving pieces, many of which are attributable to

members of the Escorial's religious community from the 1690s to the 1720s. Apart from these typically Spanish works, there are large collections of later china and porcelain from Sevres and Vienna, which was preferred by the Bourbons.

The Escorial library's reference section adequately supports research on these collections and is easily accessible to researchers. Broader, contextual research can be pursued in the university library of nearly 185,000 volumes, although this is primarily for the use of the community and students. Slides and photographs can be purchased individually or in sets at the Patrimonio Nacional's shop at the entry to the monastery, or these items and a host of guidebooks, curios, and souvenirs are widely available in most tourist shops and other museums in surrounding towns.

The Escorial's irregular publications are difficult to control bibliographically. Monographs are listed in the monthly trade journal *El Libro Español* under appropriate subject classifications and can be obtained easily through any jobber specializing in the Spanish booktrade. Special monographs about the Escorial or featuring its collections, often to promote the tourist trade, can be obtained from the Librería editorial Patrimonio Nacional, Pl. Oriente no. 6, Madrid–13. It publishes a quarterly journal, *Reales Sitios*, which regularly includes the Escorial. Included in the latter's series are the fourth-centenary volumes *El Escorial* and several guidebooks, facsimiles like the *Libro de Horas* of Isabel la Católica, and descriptions of Spanish art by type (such as collections of royal furniture), which feature Escorial pieces along with those of several other museums. Of the monastery's serials, the best known is *Ciudad de Dios*, published by the Augustinians. This publication began (1881–87) as the *Revista Augustiniana* and was merged with *España y America* (1928–35) to form *Religión y Cultura* (Madrid, 1928–36), only to be suspended (1936–41) and to be resurrected under its original name for publication three times each year. The Augustinians also publish monthly the *Escorial: La revista de cultura y litras* (1940-) from Madrid. The community also sponsors scholarly monographs, usually released through the library or one of the colleges and hence published in collaboration with Spain's Consejo Superior de Investigaciones Cientificas and its affiliate institutes. Among these academic journals are the annuals *Anuario Jurídico Escurialense* and *Nueva Etapa*. There is a considerable volume of literature about the Escorial scattered in journals devoted to art history, history, religion, education, and tourism.

Selected Bibliography

Guidebooks and popular surveys: Amo y del Amo, Bruno de, *Descripción del real monasterio de San Lorenzo de el Escorial* (Madrid 1940); Cable, Mary, *El Escorial*, ed. Newsweek Book Division (New York 1971), in *Wonders of Man* popular series; Contreras y Lopez de Ayala, Juan (Marquis de Lozoya), *The Escorial and the Royal Palace at La Granja de San Ildefonso*, trans. J. Brockway (New York 1965 and 1967), trans. into French by H. Taurnaire (Paris 1965); Davie, John, *The Monastery of El Escorial and the Prince's Lodge: The Eighth Wonder of the World*, trans. H. Williamson-Serra (Madrid

and New York 1952); García de la Fuente, Arturo, *Le Monastere de l'Escorial; guide du touriste*, trans. and ed. J. Zarco Cuevas (Escorial 1934); Gaya Nuño, Juan Antonio, *El Escorial* (Madrid 1947); Guinard, Paul Jacques, *Madrid: l'Escorial et les anciennes residences royales* (Paris 1935); López Serrano, Matilde, *El Escorial: el monasterio y las casitas del Principe y del Infantes, quía turística* (Madrid 1974); Marín Perez, Andrés, and Ildefonso Fernández y Sánchez, *Guía histórica y descriptiva del Monasterio de San Lorenzo de El Escorial* (Madrid 1912); Mélida y Alénari, José Ramón, *El Escorial*, trans. R. Tyler (Barcelona, 1915–27), vols. 1–2; Morales Vilanova, Jean, *El Escorial: monasterio y casa del principe* (Madrid 1933); Patrimonio Nacional, *El Escorial, octava maravilla del mundo* (Madrid 1967); idem, *El Escorial, 1563–1963* (Madrid 1963); Williamson-Serra, Herbert W., *The Eighth Wonder of the World* (Madrid-New York 1953); Zarco-Bacas Cuevas, Eusebeo Julián, *El Monasterio de San Lorenzo el Real de el Escorial y la Casita del príncipe*, 4th ed. (Escorial 1932).

Other publications: Alvarez Turienzo, Saturnino, *El Escorial en las letras españolas* (Madrid 1963); Cali, Maria, *Da Michelangelo del' Escorial* (Turin 1980); Calvert, Albert Frederick, *The Escorial: a historical and descriptive account* (London 1907); Iñiguez Almech, Francisco, *Casas reales y jardines de Felipe II* (Madrid 1952); Kubler, George, *Building the Escorial* (Princeton, N.J. 1981).

LAWRENCE J. MC CRANK

———— **Madrid** ————

PRADO MUSEUM (officially MUSEO DEL PRADO; alternately THE PRADO); Paseo del Prado, Madrid.

The Prado Museum was established in 1818 by decree by Spanish King Ferdinand VII (1808–33) to unite the royal collections of Spain, constituting the foundation of the museum. The Hapsburg monarchs, who ruled Spain in the sixteenth and seventeenth centuries, can be credited with collecting many of the masterpieces of non-Spanish painting owned by the Prado, which reflect their taste for Flemish and Italian art. Charles V (1516–56) acquired Rogier van der Weyden's *Descent from the Cross* and Hans Memling's triptych *The Nativity, The Adoration, and The Purification*. Both Charles V and his son Philip II (1556–98) commissioned portraits by European painters Antonis Mor and Titian, the latter who also produced religious and mythological works acquired by these monarchs. Also obtained by Philip II were works by Hieronymus Bosch, notably *The Adoration of the Magi* and *The Garden of Earthly Delights*. Upon the death of Peter Paul Rubens, Philip IV (1621–65) purchased works by the artist, such as *The Garden of Love*, *The Three Graces*, and *The Adoration of the Magi*, and works from the dispersed collection of English King Charles I, which included Andrea Mantegna's *Death of the Virgin*, Raphael's *The Holy Family (La Perla)*— also attributed to Giulio Romano, and Albrecht Dürer's *Self Portrait* of 1498. Philip IV also received as gifts Correggio's *Noli me tangere* and Dürer's *Adam and Eve*.

In addition to collecting works by prominent European artists, Philip IV had commissioned works by his Spanish court painter Diego Velázquez de Silva, including *The Forge of Vulcan*, *The Family of Philip IV* (*Las Meninas*), individual portraits of the king and other royalty, and *The Spinners*. He also commissioned the Spanish artist Francisco Zurbarán to paint the series *The Ten Deeds of Hercules* for the Salón de Reinos in the royal palace of Buen Retiro. Upon his death in 1665, Philip IV willed that all paintings formerly in his possession become crown property, called the Royal Patrimony.

The Bourbon monarchs of the eighteenth and nineteenth centuries continued to contribute to the royal collection, a legacy numbering 5,539 works when Philip V (1700–1746) took the throne. Philip V and his wife, Isabella Farnese, individually and jointly acquired works by European and Spanish artists. Among their most notable acquisitions are French paintings by Nicolas Poussin and Jean Antoine Watteau, as well as paintings by Louis Michel van Loo and Hyacinthe Rigaud, who was brought to Madrid from the court of Louis XIV, where Philip V was educated. From his father, the Dauphin, who was the eldest son of Louis XIV, Philip V inherited sixteenth- and seventeenth-century chalices, gems, enamels, and goldwork (the *Dauphin's Treasure*), which eventually entered the Prado's collection in 1839. Isabella's collection included genre and landscape paintings by Flemish artists David Teniers II, Frans Snyders, Jan Fyt, and Lucas van Valckenborgh and early religious works by the Spanish painter Bartolomé Estebán Murillo. Giovanni Bellini's *Virgin and Child between Two Saints* was among the Italian works purchased by Philip V.

Charles III (1759–88) acquired religious works by Corrado Giaquinto and portraits by Anton Rafael Mengs (both of whom painted at the king's court in Madrid), as well as works from other collections, including Rembrandt's *Artemisia*. Notable among non-Spanish works purchased by Charles IV are two panels by Robert Campin (Master of Flémalle), *St. Barbara* and *St. John the Baptist with Henry of Werl*, and Raphael's *Cardinal*. In addition, Charles IV purchased paintings by Spanish artists Juan de Juanes, Luis de Morales, Francisco Ribalta, Jusepe de Ribera, and Murillo. Works by Francisco de Goya, court painter of Charles III and Charles IV, that were directly commissioned by these monarchs include *The Family of Charles IV* and individual portraits of the royal family, as well as painted cartoons for tapestries, some of which were later executed at the Royal Factory of Tapestries in Madrid.

The royal collection suffered from losses due to fires at the royal residences of the Pardo Palace, the Escorial, and the Alcázar, Madrid, as well as thefts during the Napoleonic occupation (1808–13). It contained 4,717 paintings at the founding of the new museum after Ferdinand VII was restored to the Spanish throne.

The Prado Museum was officially opened to the public on November 19, 1819, although only for authorized visitors, copyists, and students. The museum was housed in a building designed by renowned Spanish architect Juan de Villanueva, where the collection remains today. Of two thousand items listed in

the first catalog published by the museum's first curator Luís Eusebi, 311 paintings were exhibited.

In 1826 Ferdinand VII transferred to the museum paintings and statues from the various royal residences. At his death in 1833, the museum and its contents, previously crown patrimony, were considered the king's private property, which was inherited by Isabel II (1833–68). During her reign, works of art continued to be transferred to the museum from various royal and religious residences, and the *Dauphin's Treasure*, moved to Paris during the Napoleonic occupation, was returned to the museum.

The Prado Museum was nationalized following the Revolution of 1868. In 1872 it merged with the Museo de la Trinidad, which was created in 1836 to house about seventeen hundred paintings largely expropriated from Spanish churches and convents in the 1830s, when religious orders were suppressed. Although the Trinidad collection was never physically transferred in its entirety to the Prado, the museum gained Spanish panels of the fifteenth and sixteenth centuries, including many by El Greco, in addition to Spanish, Italian, and Flemish paintings from the seventeenth and eighteenth centuries. A board of trustees known as the Patronato, which consisted of collectors, critics, art historians, and artists, was created in 1912 to modernize the museum. Its tasks included enlarging and reorganizing the exhibition rooms, reviewing the collection, and cultivating benefactors.

Since 1872 the Prado Museum has acquired works of art largely through donations and legacies. Until the Spanish Civil War (1936–39), major gifts included Goya's "Black Paintings," formerly in the artist's villa (1881); Rubens' sketches for a series of mythological subjects for the Torre de la Parada royal hunting lodge (1887); and fourteenth- and fifteenth-century Spanish panels, sixteenth-century Flemish paintings, and medals and coins (1915). In 1930 a special installation was made for the legacy of D. Pedro Fernández Durán, which comprised tapestries, armor, decorative objects, drawings, and paintings largely by seventeenth-century Flemish, Dutch, Italian, and Spanish artists, as well as several works by Goya. In the same year the museum purchased with donated funds paintings by numerous Spanish artists, including El Greco, Zurbarán, Juan de Valdés Leal, and Francisco Ribalta, as well as several hundred drawings by Goya.

The Prado was closed during the Spanish Civil War. The most valuable works in the museum were temporarily evacuated to a shelter by Valencia, and others were stacked and protected with sandbags in rooms with the most solid roofs. During the war, the museum became a hospital and clinic, although some restoration of paintings was undertaken.

From the end of the Civil War to the present, the Prado Museum has continued to add to its collection through gifts and purchases. Chief-of-State Francisco Franco (1939–75) transferred to the museum works of art from royal and religious residences, in addition to purchasing others for the museum. Panels by Tadeo Gaddi, Giovanni dal Ponte, Melozzo da Forli, and Sandro Botticelli were willed

to the museum in 1942. In 1947 the Prado acquired Romanesque fresco paintings from the Chapel of Maderuela, Segovia, which were installed in the museum and augmented in 1957 by fresco fragments from the Mozarabic church of San Baudelio de Berlanga, Soria. Among noteworthy museum acquisitions that increased the scope of the collection were Dutch paintings by Jan van Scorel, Jan van Goyen, Rembrandt (*Self Portrait*, c. 1663), and Meindert Hobbema; eighteenth-century portraits by English artists Thomas Gainsborough, Joshua Reynolds, and Thomas Lawrence; and numerous Hispano-Flemish and fourteenth-through sixteenth-century Spanish paintings, including works by Juan de Flandes, Fernando Gallego, and Fernando Yáñez de la Almedina. In 1965 the Prado acquired Antonello da Messina's *Dead Christ*. In the past fifteen years, museum purchases have diminished. However, the Prado has recently been trying to fill the gaps in its collection by balancing limited financial resources with selective criteria.

For most of the twentieth century, the top administrative posts of the museum were filled by individuals nominated by the Patronato, or Board of Trustees. In 1968 the Franco government named the minister of education president of the Patronato and the director-general of fine arts its vice-president. Although the Patronato continued to hold its statutory monthly meetings, museum affairs became an extension of ministry policies during the following decade. In 1978 the Prado Museum was integrated into the Patronato Nacional de Museos under the Dirección General de Bellas Artes. The following year, the Patronato of the Prado was revitalized, with new responsibilities covering the functioning and internal management of the museum, as well as its conservation and exhibition practices, promotion through cultural activities and publications, and acquisitions. The society of Friends of the Museum has recently been organized to reestablish ties with people of the Spanish and international cultural communities interested in the activities of the Prado.

The edifice of the Prado, designed by Juan de Villanueva, is one of the best examples of Spanish neoclassical architecture. Commissioned in 1787, the building was originally designed for the Academy and Museum of Natural Sciences before it was assigned in 1818 to house the Royal Museum. To adapt to the changing needs of the museum, architects have subsequently modified and enlarged the original structure. In the nineteenth century, medallions with portraits of Spanish artists and other relief sculpture by Valeriano Salvatierra, Ramón Barba, and Pedro Hermoso were added to the exterior of the museum. In 1899, the centenary of the birth of Velázquez, a statue of the seated artist by Aniceto Marinas was placed in front of the main entrance to the museum.

After the Patronato was established in 1912, it commissioned architect Fernando Arbós to expand Villanueva's original structure by adding twenty-four rooms, which were completed between 1917 and 1920, when the collection was reorganized and reinstalled. From 1923 to 1927 architect Pedro de Muguruza redesigned the main gallery, which was lined with fire-proof concrete, and directed the construction of the central staircase adjoining the Isabella Room

(later renamed the Velázquez Room), the apse on the central axis of the ground floor. The ground floor rotunda was opened in 1934 as a sculpture gallery and ten years later was given direct access after Muguruza reconstructed a nineteenth-century staircase. In the early 1940s, work was initiated to transform the entire building into a fire-resistant structure.

Architects Manuel Lorente and Fernando Chueca designed two new wings, adding sixteen rooms, which were constructed in 1955–56. In 1963–64 six more rooms were built after closing in Villanueva's original porticos. In 1968 an extension of equal size was constructed to house nineteenth-century paintings, which were removed in 1971 to the Buen Retiro Palace.

In 1980 the Buen Retiro Palace was annexed and then renovated by the Prado to include space for new exhibition rooms, reinstallation of its nineteenth-century collection, a library of prints and drawings, a photography laboratory, and offices. In addition, the palace will house the Centro de Estudios del Museo del Prado (Prado Museum Study Center), for students who want to become museum specialists, pending acquisition of funds for this program.

In the Prado Museum, a new climate-control system for regulating pollution, humidity, and temperature was installed by 1981 without affecting the lines of the architecture. At the southern end of the museum, new space has been appropriated for an expanded library, a modernized restoration studio, a cafeteria, and administrative and curatorial offices, as well as galleries.

The Prado's collection of Spanish painting is unequaled in terms of size and quality and includes, in addition to medieval wall frescoes, works that represent the major schools of the fifteenth through the nineteenth century. The museum's display of Romanesque art consists of twelfth-century fresco wall paintings from the province of Castile. The Chapel of Vera Cruz from the Church of Maderuelo, Segovia, was reconstructed in the museum with its original religious decoration, which is attributed to the Catalonian Master of Santa María de Tahull. The decoration includes the *First Sin*, the *Creation of Adam*, and *Christ Pantocrator*, as well as figures of the Virgin, the Evangelists, saints, prophets, and angels. In addition, religious and profane frescoes from the Mozarabic church San Baudelio de Berlanga, Soria, are exhibited. Most of the New Testament scenes from this church are also attributed to the Master of Tahull, and a number of the unusual hunting scenes and animals are ascribed to the so-called Third Master.

Fifteenth-century panel painting of the Late Gothic style is largely represented by works attributed to a variety of anonymous masters from the Spanish provinces. Among the large group of Hispano-Flemish paintings, works by artists from the province of Castile predominate. Most notable among them are several by Fernando Gallego, including *Christ on the Cross* and *The Martyrdom of St. Catharine*. Also noteworthy are panels by the Catalonian Bartolomé Bermejo, especially his monumental work *St. Domingo de Silos*.

Renaissance painting in Spain is represented by several notable examples of the Castilian school: Pedro Berruguete's *Trial by Fire Presided Over by St. Domingo de Guzmán (Auto-da-Fé)*, Juan de Flandes' *Raising of Lazarus*, Juan

Correa de Vivar's *The Annunciation*, and Juan Fernández Navarrete's *Baptism of Christ*. The best exponents of the Valencian school, characterized by its strong Italian orientation, are Juan de Juanes (son of Vicente Masip, who is also represented at the Prado) with his *Last Supper* and Yáñez de la Almedina with his masterpiece *St. Catharine*. The Andalusian school is exemplified by works of Alejo Fernández, the *Virgin and the Souls of Purgatory* by Pedro Machuca (signed and dated 1517), and the *Madonna and Child* by Luis de Morales (el Divino).

The favorite portrait painter at the court of Charles V, and later Philip II, was Antonis Mor. One of his most noteworthy works is his depiction of Philip's second wife, *Mary Tudor*. Alonso Sánchez Coello, another court portraitist for Philip II and one who trained with Mor, is best exemplified by his portrait *The Infanta Isabel Clara Eugenia*. Another portraitist at Philip's court was Juan Pantoja de la Cruz, student of Sánchez Coello, who also painted a number of saints, of which his *St. Nicolas of Tolentino* is one of the most notable.

The most unique artist of the Castilian school was the Greek, Domenicos Theotocopoulos, known as El Greco. The Prado's substantial collection (thirty-four paintings) consists of important works, including *The Annunciation* (c. 1570–80), *Portrait of a Nobleman with Hand on Breast*, *The Holy Trinity* (1577), *Saints Andrew and Francis*, *The Coronation of the Virgin*, *Christ Carrying the Cross*, and *The Resurrection*. Although El Greco's style had a negligible impact on the development of art in Spain, two of his disciples are represented at the Prado. They are Fray Juan Bautista Maino (*The Recovery of Bahia in Brazil*) and Luis Tristán (*Old Man*).

The collection of Spanish painting of the Baroque period and beyond is great in both scope and volume. In the seventeenth century, Francisco Ribalta of the Valencian school adapted a style akin to the Caravaggesque tenebrist manner and realism. He is represented at the Prado by *The Angel-Musician Appears to St. Francis*, *St. Matthew and St. John the Evangelist*, and several other works. Jusepe de Ribera (Lo Spagnoletto), although he lived most of his life in Naples, is originally from the region of Valencia. Several important works among the fifty-two paintings at the Prado include *Archimedes* (signed and dated 1630); *The Holy Trinity*; *Isaac and Jacob*; *The Martyrdom of St. Bartholomew*; *Jacob's Dream*, a masterpiece from his middle period (signed and dated 1639); and *St. Jerome* (1644), one of his numerous depictions of single saints.

The three great exponents of the Andalusian school represented at the Prado are Zurbarán, with twenty-three works; Velázquez, with fifty works, although his career shifts to Madrid and the court of Philip IV; and Murillo, with forty-three works. Although Zurbarán is best represented in his native Seville, his paintings include two that depict visions of St. Peter Nolasco, both of which are signed and one is dated 1629; *The Immaculate Conception*; *St. Casilda*; *The Defense of Cadiz against the English* (1634); *St. Luke as Painter before Christ on the Cross*; a still life (*bodegón*); and the cycle of the *Ten Deeds of Hercules*.

Of the many examples of work by Velázquez, some of the most noteworthy

include his early *Adoration of the Kings* (1619); *Christ Crucified*; *Portrait of Philip IV* (c. 1623); *The Triumph of Bacchus*; two small panels probably painted on his second trip to Italy of the garden of the Villa Medici in Rome (c. 1630); *The Forge of Vulcan* (1630); *The Surrender of Breda* (*Las Lanzas*) (dated 1635); various portraits of members of the royal family, including *The Infante Don Baltasar Carlos on Horseback*; *The Court Jester Don Diego de Acedo* (*El Primo*) (1648); *The Myth of Arachne* (*The Spinners*); and his masterpiece *The Family of Philip IV* (*The Maids of Honor*) (c. 1656).

Although Murillo is best studied in his native Seville, the Prado has many paintings by him, of which *The Soult Immaculate Conception* of 1678 is his most beautiful of this subject. Other noteworthy paintings by Murillo are *St. Ildefonso Being Rewarded by the Virgin*, *The Holy Family of the Little Bird*, *The Good Shepherd*, and two of the series *Founding of Santa Maria Maggiore in Rome*.

Other artists representing the Andalusian school are Francisco Pacheco, theorist and teacher of Zurbarán and Velázquez; Alonso Cano (*Angel Supporting Christ*); Francisco de Herrera the Elder and the Younger; Valdés Leal (*Christ Disputing with the Doctors*, a late work dated 1686); and Palomino (*The Immaculate Conception*)

Of the Castilian school, two students of Velázquez included in the collection are Juan Bautista Martínez del Mazo, who painted the *Portrait of the Empress Doña Margarita of Austria*, and Juan Carreño de Miranda, a portraitist at the court of Charles II, who painted the *Portrait of the Duke of Pastrana*. Other Castilian Baroque painters represented are Juan Bautista Maino (*Adoration of the Magi*) and Claudio Coello (*The Virgin with St. Louis of Toulouse*).

Francisco de Goya y Lucientes is the artist most extensively represented at the Prado, with 118 paintings and about 4,000 drawings and etchings. The museum owns numerous tapestry cartoons that Goya produced for the Royal Factory of Santa Barbara during his early years in Madrid from 1776. *The Dance of San Antonio de la Florida*, *The Parasol*, and *Boys Climbing a Tree* typify the largely whimsical subject matter of the cartoons. In addition to exhibiting Goya's portraits of individual royal figures at the court of Charles IV, notably *Queen María Luisa* of 1799, the Prado displays his group portrait *The Family of Charles IV* of 1800. The museum also exhibits *The Clothed Maja* and *The Naked Maja*, probably his two most famous companion pieces. More poignant and expressive paintings from his later years include *The Second of May 1808* and *The Third of May 1808*, which commemorate the Madrid insurrection against Napoleon. Others are the *Self Portrait* of 1815 and fourteen mural paintings, now transferred to canvas, with which he decorated the dining room and the main floor salon of his Quinta del Sordo (House of the Deaf Man) outside Madrid. These works include *Witches' Sabbath* and *Saturn Devouring One of His Sons*. Another artist who worked about the same time as Goya was Francisco Bayeu y Subías, who is represented by several tapestry cartoons, including *The Picnic* (*La Merienda*).

Among the earliest Italian paintings at the Prado are Tadeo Gaddi's two scenes from the life of St. Eloy. The earliest examples of Italian Renaissance painting are Fra Angelico's *Annunciation*, Antonello da Messina's *Dead Christ*, Melozzo da Forli's *Angel Musician*, Mantegna's *Death of the Virgin*, Botticelli's three panels *The Story of Nastagio degli Onesti*, and Giovanni Bellini's *Madonna and Child between Two Female Saints*.

Important among works by Raphael are *The Holy Family with the Lamb* (signed and dated 1507); *The Madonna of the Fish*; *The Holy Family* (*La Perla*), also attributed to Guilio Romano; *The Cardinal*; and the *Fall on the Road to Calvary*, allegedly done in collaboration with Giulio Romano and Gian Francesco Penni. Other later Renaissance works include Bernardino Luini's *The Holy Family*, Baldassare Peruzzi's *The Rape of the Sabines*, and Andrea del Sarto's masterpiece of his middle period, *The Virgin, the Child, a Saint, and an Angel*.

The Prado's collection of Italian Mannerist painting includes *The Holy Family* by Pontormo, *Don Garcia de Medicis* by Pontormo's pupil Bronzino, and *Lady with Three Children* by Parmigianino. Painting at the same time, Correggio, the proto-Baroque Emilian master, is represented by two works, *The Virgin, the Infant Jesus, and St. John* and *Noli me tangere*.

Italian artists of the Venetian school are extensively represented at the Prado, particularly Titian, Tintoretto, and Veronese. The museum's collection of paintings by Titian (thirty-six works) is substantial. His portraits include depictions of Charles V and Philip II, as well as other royal figures. *The Emperor Charles V on Horseback at Mühlberg* is an especially noteworthy equestrian portrait. In addition, the Prado owns a late self-portrait by the artist. Among Titian's mythological scenes are *The Worship of Venus*, *The Bacchanal* (1519), *Venus and Adonis*, and *Danaë and the Shower of Gold*. His religious paintings include *Adam and Eve*, *Salome with the Head of St. John the Baptist*, *The Sorrowful Virgin*, *Christ and Simon of Cyrene*, *The Entombment*, and *The Church Upheld by Spain*.

The twenty-six works by Tintoretto include *The Washing of the Feet*, *Judith and Holofernes*, *The Gentleman with a Gold Chain*, *The Woman Baring Her Breast*, *Venetian General*, and *A Venetian Senator*. Marietta Robusti (called La Tintoretta), daughter of Tintoretto, is the subject of one of his portraits at the Prado and is also represented by three of her own paintings.

Veronese (thirteen works) is exemplified by *Susanna and the Elders*, *The Dispute with the Doctors in the Temple*, *A Young Man Between Vice and Virtue*, *Venus and Adonis*, and *The Repentant Magdalen*.

Other Venetian painters not to be overlooked at the Prado include Giorgione, who is represented by one work, *The Madonna and Child with Saints Anthony of Padua and Roch*, sometimes attributed to Pordenone or the young Titian. Lorenzo Lotto is represented by two works, *Messer Marsilio and His Bride* and *St. Jerome*. Sebastiano del Piombo, although his career shifted to Rome, is represented by three works, which include *Descent of Christ to Limbo*.

Additional sixteenth-century Italian painters represented by single works at

the Prado include Perino del Vaga (*Noli me tangere*), Dosso Dossi (*The Lady of the Green Turban*), Palma il Vecchio (*The Adoration of the Shepherds*), and Daniele da Volterra (*The Annunciation*). Paintings by members of the Bassano family include Jacopo Bassano's *Animals Boarding the Ark of Noah*.

The two pivotal figures of the Italian Baroque, Annibale Carracci and Caravaggio, are represented at the Prado. *The Ascension* by Carracci typifies his classical mode of painting, and *David and Goliath*, a sometimes disputed work by Caravaggio, expresses the artist's realistic treatment of subject matter.

Among the three paintings at the museum by Il Guercino are two of his major works, *Susanna and the Elders* and *St. Augustine Meditating upon the Trinity*. Other Italian artists of the late sixteenth and seventeenth centuries represented by a few works each include Guido Reni (*The Madonna of the Chair*), Bartolommeo Manfredi (*Soldier Bearing the Baptist's Head*), Il Domenichino (*Abraham's Sacrifice*), Giovanni Lanfranco (*The Auspices*), Aniello Falcone (*Battle*), Artemisia Gentileschi (*Self Portrait*, c. 1630), and Salvator Rosa (*The Gulf of Salerno*). Luca Giordano is best represented by *Bathsheba in the Bath* among his approximately thirty works at the Prado.

Italian artists of the eighteenth century are represented at the Prado by Giovanni Paolo Pannini (*Ruins with a Woman Speaking to a Group*) and the Venetians Canaletto (*The Great Canal of Venice with the Rialto Bridge*) and Tiepolo (*St. Padua with the Infant Jesus*, an important work, and *The Immaculate Conception*).

The museum is noted for its large and comprehensive collection of Northern Renaissance and Baroque painting. Among works by early Flemish painters are Robert Campin's two companion panels *St. John the Baptist and the Franciscan Master Henry of Werl* and *St. Barbara*; Jan van Eyck's *Apollo Pursuing Daphne*; Rogier van der Weyden's *Descent from the Cross* (c. 1435), one of the most famous works at the Prado; and Hans Memling's triptych *The Adoration of the Wise Men* (central panel), *The Nativity*, and *The Purification* (c. 1470). The collection has more paintings by Joachim Patinir than any other museum and contains two primary examples of his work, *Charon Crossing the Styx* and *St. Jerome in a Landscape*.

Other paintings by Northern Renaissance artists include Gerard David's *Madonna and Child*, Bernard van Orley's *The Holy Family* (c. 1522), and Lucas Cranach the Elder's two works under the title *Hunting Party in Honor of Charles at the Torgau Castle*. Also exhibited at the Prado are paintings by Petrus Christus, Dirk Bouts, Mabuse, and Quentin Metsys.

Hieronymus Bosch is well represented at the Prado. There are more of his paintings there than in any other museum as a result of the fondness of Philip II for these bizarre works. *The Table of the Deadly Sins*, a signed but disputed work, is on loan from El Escorial (q.v.). Other paintings by Bosch include *The Temptations of St. Anthony* (c. 1470); *The Haywain*, with its fiery right panel of Hell; and his best-known work, *The Garden of Delights*. Also included in the collection of Netherlandish art are numerous works by the Bruegel family,

including *The Triumph of Death* by Pieter Bruegel the Elder and *Winter Landscape* by Pieter Bruegel the Younger.

The Prado's small holdings of German art of the late fifteenth and early sixteenth centuries contain four notable works by Dürer. They are the panels *Adam* and *Eve*, *Portrait of an Unknown Man*, and *Self Portrait*, which was painted in 1498, when Dürer was twenty-six. Other important works are by Hans Holbein the Younger, *Portrait of an Old Man*, and Hans Baldung Grien, *The Harmony; or, The Three Graces*.

The museum owns more than eighty paintings by the Flemish Baroque artist Peter Paul Rubens. They include significant works such as the *St. Matthew*, *The Adoration of the Magi*, *Marie de Medici, Queen of France*, *The Duke of Lerma*, *Diana the Huntress*, *Nymphs and Satyrs*, *Adam and Eve*, and *The Holy Family with St. Anne*. The Prado possesses eight of the remaining seventeen cartoons, *The Triumph of the Catholic Church*, that Rubens executed in 1628 for Infanta Isabel Clara Eugenia, ruler of the Netherlands. (Nine were destroyed in a fire in the Royal Palace of Brussels in 1731.) Also included are *The Cardinal Infante Don Fernando of Austria at the Battle of Nordlingen*, *The Garden of Love*, *The Rape of Persephone*, *The Pietà*, and *Saturn Devouring One of His Sons*. Among Rubens' paintings of mythological themes are two late masterpieces, *The Judgment of Paris* and *The Three Graces*, both dated about 1639.

The followers of Rubens are best represented at the Prado with works by two of his most distinguished followers, Sir Anthony van Dyck (twenty-five paintings) and Jacob Jordaens (eight paintings). Van Dyck's work is exemplified by *The Brazen Serpent* and the portrait of his wife, *Mary Ruthwen*. Paintings of Jordaens include *Three Itinerant Musicians*, *The Mystical Marriage of St. Catherine of Alexandria*, and his masterpiece *The Jordaen's Family in a Garden*.

Noteworthy examples of the Flemish genre and still-life painting are by Jan Fyt (*Still Life with a Dog and a Cat*), Frans Snyders (*Ceres and Two Nymphs*, a joint effort with Rubens, who painted the figures), and David Teniers II (*The Archduke Leopold Wilhelm in His Gallery at Brussels*).

The monarchs of Spain did not, for the most part, collect Dutch paintings. In recent times efforts to acquire a few works of this school have resulted in the addition of a portrait each by Jan van Scorel (*A Humanist*), Miereveld (*Dutch Woman*), and Cuyp (*The Adoration of the Shepherds*); with two paintings by Rembrandt, *Artemisia* and *Self Portrait* (c. 1663). Jacob van Ruisdael and Hobbema are each represented with a landscape.

Two of many paintings by Anton Raffael Mengs, a German artist from Bohemia who worked at the court of Madrid in the 1760s, are the portrait of his Spanish patron, *Charles III*, and the portrait *Maria Luisa of Parma, Princess of the Asturias*.

The Prado owns a number of important French paintings. The collection contains *The Virgin and Child with St. Elizabeth and St. John and St. Catherine*, one of two works by Simon Vouet. There are several paintings by Nicolas

Poussin, notably *The Parnassus* and *The Triumph of David*, as well as works by Claude Lorraine, whose *Landscape: Embarkation at Ostia of St. Paula Romana* is one of his masterpieces. Some of the French portraitists represented at the Prado are Philippe de Champaigne (*Louise XIII*), Sebastien Bourdon (*Christine of Sweden on Horseback*), and Hyacinthe Rigaud (*Louis XIV*). Other portrait painters include Jean Ranc, whose *The Queen Isabella Farnese* and *Philip V* are in the style of his mentor, Rigaud. The museum's holdings include one painting by Antoine Coypel, *The Indictment of Susannah*, and two small works by Watteau, *Capitulations of Wedding and Country Dance* and *Festivity in a Park*. There are also works by Louis Michel van Loo (five), Michel Ange Houasse (five), Nicolas Largilliere (one), and Jean Baptiste Greuze (one).

The Prado's small collection of British painting has been augmented in the last several decades by the addition of the *Portrait of a Clergyman* by Sir Joshua Reynolds; two portraits, *The Dr. Isaac Henrique Sequeira* and *Mr. Robert Butcher of Walttamstan* by Thomas Gainsborough; the portrait *An Englishman* by George Romney; the portrait *Miss Carr* by Thomas Lawrence; and the portrait *Mrs. Thornton* by John Hoppner.

The Prado has a very large collection of prints and drawings, which has been organized by the museum into three series. The first series, called the "Fondo Antiguo," consists of about 700 works by Spanish artists and artists who worked in Spain. These drawings date from the fifteenth to the eighteenth century, with the largest proportion falling into the last two centuries. Noteworthy examples are Juan Guas' drawing *Capilla Mayor de San Juan de los Reyes*, Gaspar Becerra's copy of Michelangelo's *Last Judgment*, Juan de Juanes' *Mary Magdalen*, and Bartolomé Carducho's two scenes from the life of St. Lawrence. There are a few works by Ribalta and Ribera, as well as Claudio Coello's *Martyrdom of St. John the Evangelist*. Also represented are Luca Giordano, Tiepolo, Mengs, Manuel de la Cruz, and Luis Paret. The greatest concentration of drawings in this series is about 450 works by Francisco Bayeu, including many architectural studies for projects such as the Royal Palace in Madrid, the Cathedral of Toledo, and the Palace of El Pardo.

The second series, called the "Fondo Goya," numbers at least 480 works and represents the largest single body of drawings by the artist Francisco de Goya. The set of etchings *The Caprices* (*Los Caprichos*), produced between 1796 and 1798, consists of savage attacks on manners and customs and on abuses in the Church. It comprises two volumes, the *Sanlucar Album* (A) and the *Madrid Album* (B), as well as a large set of ungrouped drawings for *The Caprices*. Another set called *The Disasters of the War* (*Los Desastres de la Guerra*), produced between 1810 and 1813 and first published in full in 1863, are etchings in which Goya records the atrocities of Napoleon's troops, who invaded Spain in 1808. Also at the Prado are Goya's two sets of etchings, *The Art of Bullfighting* (*La Tauromaquia*), produced between 1815 and 1816, and *The Proverbs* (*Los Proverbios*, or *Disparates*), dating from 1815 to 1825.

The third series comprises 2,785 drawings dating from the fifteenth century

that were received by the museum in 1931 as part of the Fernández Durán legacy. Although their artistic merit varies, they include additional works by artists from the Prado's own collection. Also worth noting are drawings by Antonio González Ruiz and Mariano Salvador Maella.

In addition to these three series, there is a collection of drawings by Rubens, which includes *The Birth of Apollo*, *The Annunciation*, and *Virgin and Child*.

The Prado has a collection of more than four hundred pieces of sculpture, mostly in marble or bronze. The earliest sculpture in the museum comes from Mesopotamia, Egypt, Spain, Greece, and Italy. It includes a Sumerian male bust (c. 2300 B.C.) and the kneeling Egyptian figure of Nectanebo II (358–350 B.C.), in addition to several male figures from the Roman period.

A large proportion of works belong to the Graeco-Roman era. From the Greek Archaic period is a torso of a male youth (*kouros*). From the Classical period, the head of a horse and a male torso are both marble pieces with affinities with the school of Phidias. The so-called San Ildefonso marble sculpture, thought to represent Castor and Pollux, is considered to be of the school of Praxiteles. Greek works from the Hellenistic period include the *Venus of the Shell* and the *Hypnos*. Roman copies of Greek models include *The Faun of the Kid*, *The Venus of the Dauphin*, and *Aphrodite*. Most noteworthy among the large group of Roman busts are representations of Alexander the Great, Pericles, Mark Antony, Cicero, and Caesar Augustus.

Sculpture of the Italian Renaissance is represented by several portraits by Leone and Pompeo Leoni, including the bronze *Emperor Charles V* with removable armor made by the latter. There is a diverse group of Mannerist sculpture, which includes *Venus* by Bartolommeo Ammanati, the *Charles V* bust by Baccio Bandinelli, and *The Four Seasons* by Giovanni Bologna. From the Baroque period is the bronze statue *Charles II on Horseback* by Bernini. Dating from the reign of Philip V is an equestrian portrait of the king by Lorenzo Vaccaro.

The Prado owns an impressive collection of furniture, tapestries and embroideries, ceramics and porcelain, miniatures, coins and medals, and weapons, most of which were received as legacies from private benefactors. A major bequest from Pedro Fernández Durán significantly augmented the museum's collection of decorative arts. A small sampling of his vast legacy includes Flemish tapestries; an eighteenth-century Flemish writing desk; numerous Wedgwood jars; various porcelain figurines of Chelsea, Chelsea-Derby, Bow, and Burslem; a variety of Sèvres and Meissen pieces; boxes made of hard stone; and suits of armor dating from the sixteenth century.

The *Dauphin's Treasure*, inherited by King Philip V in 1712, consisted of 120 jeweled chalices, cups, boxes, cameos, jars, and vases representing work by Italian and French craftsmen of the sixteenth and seventeenth centuries. According to a catalog of 1734, the collection included eighty-six diverse gems set in gold, enamel, or cameo, about half of which were worked in rock crystal. The treasure became part of the Prado's collection in 1839.

The Casón del Buen Retiro, the Prado's annex in the Real Sitio del Buen
Retiro in Madrid, contains the Nineteenth Century Section of the museum, which
was established in 1971. The collection consists of works that came primarily
from the now defunct National Museum of Modern Art, the Trinidad Museum,
and the Prado Museum. Since 1971, 171 works have been added to the collection.

Commissioned for Philip IV and designed by Alonso Carbonell, the Casón
was completed in 1657. Charles II later commissioned the Neapolitan painter
Luca Giordano to decorate the interior. The fresco on the vault of the Central
Room, *Institution of the Order of the Golden Fleece*, is his only remaining work
there. In 1881 the Casón was opened to the public. Its present facades dating
from the end of the nineteenth century were designed by Ricardo Velázquez
Bosco, Agustín Felipe Peró, Manuel Antonio Capo, and Mariano Carderera.

In 1981 renovation of the interior of the Casón was completed, and the col-
lection was reinstalled under architect José García Paredes. As in the Prado
Museum, the Casón galleries now have modern systems of lighting, air condi-
tioning, fire detection, security, and noise-prevention flooring. New services
include a restoration facility, a study-storage room for works not on permanent
display, a lecture hall, an enlarged specialized library, and a room for museum
courses and other activities.

The new installation features 305 predominantly Spanish works on exhibit,
ranging from nineteenth-century neoclassical painters to early twentieth-century
landscapists. Vicente López, a neoclassical portraitist from Valencia, is exem-
plified by the depiction of his brother-in-law in *The Painter Francisco Goya*.
Other Spanish nineteenth-century portraitists in the collection include the Mad-
razo family of painters, Zacarías González Velázquez, and J. M. Fernández
Cruzado. Among Romantic painters represented are Leonardo Alenza, Eugenio
Lucas, Antonio María Esquivel, and Valeriano Domínguez Bécquer.

Notable Spanish artists of the second-half of the nineteenth century include
Eduardo Rosales, a historical painter whose works include *The Testament of
Isabel the Catholic* and *Presentation of Juan of Austria to Charles V* of 1869,
and Mario Fortuny, who is represented by several Romantic subjects of Moroccan
themes and a Faust fantasy. The collection also includes works by Francisco
Domingo Marquéz, Ignacio Pinazo Camarlench, and Joaquín Sorolla, three Val-
encian turn-of-the-century painters.

In addition, Picasso's famous *Guernica* (1937) and many preparatory sketches
for the painting are located in the lower-floor gallery containing Luca Giordano's
ceiling fresco.

Sculpture at the Casón, which consists of neoclassical works shown together
on one floor, includes pieces by the Italian Antonio Canova (*Venus and Mars*),
the Danish Albert Thorwaldsen (*Hermes*), and Spaniards José Alvarez Cubero
(*The Huntress Diana*), Ramón Barba (*Mercury*), and Augustín Querval (*Tulia*).

The first bulletin of the Prado Museum (*Boletín del Museo del Prado*) was
published in early 1980, followed by issues regularly appearing three times a
year. Bulletins contain news about museum acquisitions and research on the

collection, as well as information about cultural activities, temporary exhibits, and publications. In successive installments in the bulletin, the Prado has been systematically publishing its inventory of museum-owned works on deposit in local and regional cultural and religious institutions.

A new edition of the museum's latest catalog of 1972 is being prepared for publication. Other scheduled museum publications include a volume of Goya's letters, a second volume of the inventory of Charles II, a second edition of the sculpture catalog, and a catalog of Italian drawings at the Prado.

Postcards, slides, photographs, and reproductions are available for purchase at the sales desks.

Selected Bibliography

Museum publications: *Museo del Prado: Catálogo de las Pinturas*, 1972; *Adquisiciones de 1969 a 1977*, 1978; *Catálogo de las Alhajas del Delfín*, 2d ed., 1955; *Catálogo de Dibujos I and II, Dibujos Españoles, Siglos XV-XVII*, 1972 and 1975; *Catálogo de Dibujos III, Dibujos Españoles, Siglo XVIII*, 1977; *Catálogo de la Escultura*, 1969; *Los Dibujos de Goya del Museo del Prado*, 1952; *Inventarios Reales I*, 1975; *Legado Fernández Durán*, 1974; *Pintura Flamenca del Siglo XVII*, 1975; *Studiana Rubenniana I and II*, 1977; *Boletín del Museo del Prado*, vol. 1, no. 1 (January-April 1980).

Other publications: Beroqui y Martínez, Pedro, *El Museo del Prado (Notas para su historia) I: El Museo real (1819–1833)* (Madrid 1933); Chueca Goitia, Fernando, *La vida y las obras del arquitecto Juan de Villanueva* (Madrid 1949); Harris, Enriqueta, *The Prado: Treasure House of the Spanish Royal Collection* (London n.d.); Jimenez, Lopez, *A Guide Book to the Prado Museum* (Madrid 1964); Lorente, Manuel, *The Prado Museum* (New York 1965); Madrazo, Mariano de and Federico de Kuntz, *Historia del Museo del Prado* (Madrid 1945); Onieva, Antonio Juan, *A New Complete Guide to the Prado Gallery* (Madrid 1960); Péréz Sánchez, Alfonso E., *Pasado, presente y futuro del Museo del Prado* (Madrid 1977); Rumeu de Armas, Antonio, *Origen y Fundación del Museo del Prado* (Madrid 1980); Sánchez Cantón, Francisco J., *The Prado* (London 1959); Wehle, Harry B., *Art Treasures of the Prado Museum* (New York 1954); Schwartz, Gary, "Can the Prado be reformed before its great pictures disintegrate?" *ARTnews*, vol. 79, no. 3 (March 1980), pp. 44–49; "Treasures from the Prado Museum," *Apollo*, vol. 91, no. 99 (May 1970), pp. 330–89.

<div align="right">RANDI E. SHERMAN and CARMEN QUINTANA</div>

———— Saragossa ————

MUSEUM OF SARAGOSSA (officially MUSEO DE ZARAGOZA; also MUSEO PROVINCIAL DE BELLAS ARTES DE ZARAGOZA), Plaza de José Antonio, Saragossa.

The origins of the Museo de Zaragoza are closely linked with the establishment of the Real Academia de Nobles y Bellas Artes de San Luis in the same city in 1772. The academy was housed in the Seminario de San Carlos and offered

courses in architecture, sculpture, and drawing. From the beginning, the academy also had an art collection, for Don Vicente Pignatelli donated to it his important collection of drawings, which included works by Tiepolo, Velázquez, and Goya. By the following century, the collection was enriched through the auspices of another source: the Spanish government. Following the large-scale destruction of Spanish convents in 1835, the government appointed commissions in various provincial centers to find and retrieve works from the decimated convents. Works recovered by the commission within the province of Saragossa were brought to the city of Saragossa, where they were housed in various buildings, including former convents. Additional objects were donated by the government and private sources throughout the nineteenth century. The primitive, often makeshift museum was administered jointly by the government-created Comisión de Monumentos Artísticos y Históricos de la Diputación Provincial de Zaragoza and the academy. By 1911 the collection had grown sufficiently large and was important enough to be housed in its present site, now called the Museo Provincial, which had been built three years before for the great Exposicion Hispano-Francesa of 1911.

Today the museum is government sponsored, although it still maintains connections with the academy. The Spanish government established the Junta de Patronato in 1913, which laid down the basic rules for the organization of provincial museums in various Spanish cities. The title of this organization was changed to the Patronato Nacional de Museos in 1967. The Museo de Zaragoza operates under the Patronato Nacional, from which it is eligible for state funds, but at the same time it retains its autonomy. Since 1950 the museum has been divided into two distinct sections: Archaeology and Fine Arts. The Archaeology section has its own director, although he is officially placed under the director-conservator of the museum, who is also director of the Fine Arts section.

The building, which houses the museum, designed by Ricardo Magdelena Tabuence and Julio Bravo Folch, is in the Aragonese tradition. It is of cast iron and brick, with a wooden roof and a patio. Medallions on the facade contain allegorical figures of Painting, Sculpture, and Architecture, as well as portraits of Goya, Francisco Bayeu, and the sculptor Damian Forment. The exterior of the building has remained basically unaltered, but the interior has undergone two restorations, the first in 1964, when the structure was threatened by termites, and more extensive modifications in 1974–76. At the latter time, a third story of offices was added by modifying the ceiling height of the original two floors, and gallery space was rearranged for better and more extensive display.

The split between the Archaeology and Fine Arts sections of the museum is reflected in the arrangement of the collections. The archaeological materials occupy the ground floor, and the fine arts materials are basically housed on the second floor. Objects are generally displayed in chronologically arranged galleries, with paintings, sculpture, and minor arts mixed in each gallery.

The archaeological section of the museum combines the Departments of Prehistory, Archaeology, and Ancient History. Most of the archaeological material

displayed comes from the region of Aragon, particularly from the province of Saragossa. Following the general Spanish guidelines for provincial museums, material is generally restricted as much as possible to the region. Objects from elsewhere have been acquired by donation. In addition, the Patrimonio Nacional de Museos has given objects to the museum to fill out displays where local material is lacking. The galleries also contain technical drawings, maps, photographs, and models to aid in the understanding of the often fragmentary archaeological objects. New additions are continually coming to the museum's archaeological collections as digs in the province of Saragossa continue. The museum has become the recognized object depository for such digs.

The first archaeological gallery is devoted to the Paleolithic and Neolithic periods, but since few remains have been found in the Saragossa area, most of the objects displayed are representative pieces from other parts of Spain and France. Many are on deposit from the Museo Arqueológico Nacional in Madrid. Some scrapers, stone cups, and blades from the Neolithic period on exhibit have come from local sites, such as the Cinco Villas area and Maella. Locally found objects increase as one progresses toward more modern periods. The Bronze Age artifacts include incised ceramic pottery, molds for casting metal, and bronze spearheads. The most important object from this period is a stone stela, found near Luna, with an incised moon design.

More extensive still are Iron Age objects, which reflect Iberian civilization in Spain. The richest finds in Aragon come from the province of Teruel, from sites near Alcañiz, Albalate, Palomar de Oliete, and Azaila (the latter destroyed in 49 B.C.). The museum has a large collection of pottery, some intact, some in sherds, from these sites. The most impressive object from this period is, however, a large bronze slab found near Botorrita, unique in Iberian art. It has inscriptions in the Iberian language on both sides, which are still only imperfectly deciphered.

Remains from Spain's Roman period are varied. The museum's collection from the Republican period include objects evidently imported to Aragonese sites from Rome itself, including a small ex voto from Calvi and red pottery from Arezzo, as well as locally made pottery in Roman style from Botorrita. Also of local manufacture is a female head found near Fuentes del Ebro. The gallery dealing with Republican Roman art also includes a large number of commemorative inscriptions of varying functions, including boundary stones and funerary inscriptions.

The city of Saragossa itself, known as Caesaraugusta, was founded by Roman legions in 24 B.C. Not surprisingly, the modest excavations in the city have yielded many Roman objects, and they are displayed in two galleries. The most interesting finds have been mosaics, of which the museum has six. The largest is a mosaic of satyrs, and a second, nearly as large, depicts Orpheus. Both were found in excavations around the Calle de la Zuda. In addition, there are four smaller mosaics in geometric designs. Other objects from Caesaraugusta include inscriptions, seals and coins with various emblems, several fragmentary statues, and Corinthian capitals from unknown buildings.

Perhaps the most important of Roman finds from sites other than Saragossa is a portrait of Tiberius found at Calatayud (the Roman Bilbilis) in 1664. It was originally a full-length statue, but improper excavation destroyed the torso. The museum also contains two Roman torsos, one a Venus, the other probably a portrait of a lady. They were purchased in Rome by Don Martín de Aragon, duke of Villanueva, and subsequently donated to the museum.

Objects from the Visigothic period are scarce, the only sizeable piece being a stone sarcophagus from Codo. More suprising is the relative lack of Moorish objects, considering the importance of Saragossa as a center of Muslim culture. The museum used to house many of the fragments from the great palace of the Aljafería (begun in 1050), but most of them have now been appropriated by the government for the extensive renovation of the palace as a national monument. The museum does preserve a few decorative friezes and arches from the Aljafería.

Romanesque remains in the museum date from the twelfth to thirteenth century and, for convenience, are placed on the first floor with the archaeological section. The most remarkable of these remains are the tombs of Pedro Fernández de Hijar and his second wife, Dona Isabel de Castro, which come from the monastery of Rueda. Of even later date (early sixteenth century) are the arms of the city of Saragossa, which decorated the doorway of the Torre Nueva, the spectacular mudéjar clock tower that was demolished at the end of the past century.

The Fine Arts section of the museum is also arranged in chronological order. The sources of the fine arts collection are more varied than those of the archaeological section. Many paintings found their way into the collection after the destruction of Spanish convents in 1835. They formed the nucleus of the original museum. A second group of paintings was deposited with the museum after the civil war of 1936–39 by the Servicio de Rescate del Servicio de Defensa del Patrimonio Artístico. Various other objects came from churches demolished within the province of Saragossa during the nineteenth and twentieth centuries. Still other works were given by private individuals, such as the fifteenth-century panels of *Saints Catherine, John, and Martin* donated by Valentín Carderera in 1881. The Prado museum has given the museum two portraits by Goya. The academy donated the drawing collection gathered by Pignatelli. Continuing acquisition of works of art is made possible by private donations, by moneys from the Patronato Nacional de Museos, and by funds from the Diputación Provincial and Ayuntamiento of Saragossa.

The collection of Gothic painting is of good quality, reflecting fourteenth- and fifteenth-century painting in the province of Saragossa. The earliest piece is one of the most important, the *Retable of the Holy Sepulchre* by Jaime Serra, a Catalan artist commissioned by the Canonesas de Santo Sepulcro of Saragossa in 1361. Important works by indigenous artists include two by the anonymous Master of Lanaja: fragments saved from the high altar retable of the parish church of Lanaja, destroyed in 1936, and the *Virgin of Archbishop Dalmau de Mur*. An *Annunciation* and *Epiphany*, of high quality, from the parish church of Alloza are variously attributed to Jaime Huguet or Martín de Soria. Two works by the

Huesca painter Juan de la Abadía are represented, the *Crucifixion*, perhaps from Santa Quiteria de Alquézar, and the *Retable of the Saviour*, from Puebla del Castro. The most impressive works in this section are panels from the huge *Retable of the True Cross*, documented as that of Martín Bernat and Miguel Ximenez (1486), which adorned the high altar of the parish church at Blesa until 1922, when the director of the museum, Hilario Gimeno, purchased it. Other works by the same painters include the *Deposition*, and the *Retable of Saints Michael, Fabian, and the Saviour* from Pastriz.

Of the small sculpture collection, the most interesting piece is the *Guardian Angel of Zaragoza*, a documented work by Gil Morlanes (1492), with polychromy by Martín Bernat.

Throughout the fine arts galleries are cases with displays of pottery from the Aragonese workshops of Muel and Teruel, as well as from the Valencian towns of Manises and Paterna and other areas of Spain. They are arranged chronologically to tie in with the works exhibited in each gallery, beginning with the fifteenth and continuing through the early twentieth century.

The sixteenth-century objects are less interesting than the preceding ones. The most important Aragonese work is the *Retable of the Jail of the Manifestation of the Kingdom* by Jaime Vicente Vallejo Cosido. Two Flemish paintings from this period have come to the museum, the *Madonna Embracing the Infant Christ*, attributed to Lucas van Leyden, and a second panel on the same theme from the Monastery of Veruela, attributed to Adriaen Isenbrandt. Sculptural pieces continue to be rare—a surprising thing considering the wealth of Aragonese sixteenth-century sculpture produced. The museum contains a *banco* (predella) from the high altar retable of Santa Maria de Gallego by Damian Forment, as well as two works by the Castilian sculptor Alonso Berruguete. Both of the latter came from the convent of St. Engracia: a tomb statue, *Vice Chancellor Antonio Augustin*, and the *Angel with the Arms of Carlos II* from the tomb of Juan Salvaggio, grand chancellor of Saragossa.

Baroque painting is also sparsely represented. The Valencian painter Jusepe Ribera's art is seen in two relatively minor works, the *Philosopher with a Book* and the *Blessing of Jacob*. There are two paintings by Claudio Coello, *St. Benedict* and *St. Bernard*. The Aragonese painter Jusepe Martinez is represented by *St. Cecelia* and *St. Peter Nolasco*. More unusual is a work by Martinez' son Antonio, which is a self-portrait of the artist painting a portrait of his father.

The weakness of the sixteenth- and seventeenth-century sections is compensated by the eighteenth-century collection. The two foreign painters at the Bourbon court, Anton Raphael Mengs and Giambattista Tiepolo, are both represented, Mengs by a *Portrait of an Infanta* and *Sanguena* and Tiepolo by two drawings (from the Pignatelli Collection), the *Triumph of Justice* and the *Triumph of Love*. Aragon produced some of the most interesting Spanish eighteenth-century painters: Goya was born at Fuentes del Ebro, south of Saragossa. From Saragossa itself came the extraordinary Bayeu family: Francisco (1734–95), a tapestry designer and court painter; Ramon (1743–93), a painter and engraver; and Man-

uel, also a painter who became a Carthusian monk. All are represented in the museum's collection, Francisco Bayeu by two exceptionally fine portraits, *Doña Feliciana Bayeu* and *Doña Sebastiana Merklein*, as well as several sketches. There are two religious paintings by Ramon Bayeu, *St. John the Evangelist* and the *Calling of St. Peter*, and three religious works by Manuel Bayeu, the *Virgin Mary*, as well as scenes from the life of St. Joseph.

An entire gallery is dedicated to Goya. The works displayed are generally from his earliest years, when he still maintained ties to Saragossa. There is a canvas of the *Dream of St. Joseph*, one of seven painted by Goya for the Palacio de Sobrediel in Saragossa in 1770–72. A small, unfinished portrait of high quality is sometimes called a self-portrait; it dates from about 1775. From about the same time are two rough oil sketches, the *Virgen del Pilar* and the *Invention of the Body of St. James*, possibly painted for the artist's family. The Prado museum donated the twin portraits *Charles IV* and *Maria Luisa*, painted in 1789. There are also a series of sketches from the Pignatelli Collection. But the best painting by Goya in the museum is the portrait *Duke of San Carlos* (1815), deposited by the Canal Imperial de Aragón. It is a full-length portrait of exceptionally high quality. Commissioned by the Canal Imperial, it is far superior to its companion piece, *Fernando VII*, of the same date, also in the museum.

The museum has a fairly representative collection of nineteenth-century Spanish painting, although most of it is of little interest to those who are not connoisseurs of Spanish art. Included among the more prominent works is Eugenio Lucas' *Aquelarre*, in the Goyesque tradition; the portrait *Tadeo Calomarde* by Vicente Lopez; and portraits by Antonio Maria Esquivel, Federigo Madrazo, and Eduardo Rosales. Romantic landscapes can be seen in the seventeen canvasses of Carlos Haes and a marinescape by Jenaro Pérez Villaamil. There are a large number of paintings in the *costumbrista* tradition, the most numerous being by the Aragonese artists Marcelino Unceta y Lopez and Manuel Barbasán. One gallery is devoted to history painting, and includes Ignacio Pinazo's *Testament of Don Jaime I* and José Moreno Carbonero's *Prince Carlos de Viana*.

The museum's collection does not extend to contemporary art, although there are paintings from the first half of the twentieth century, among them, Joaquín Sorolla's *My Friend Portillo*; one of Santiago Rusiñol's paintings, the *Gardens of Aranjuez*; and Ignacio Zuloaga's *Chulilla*. Two Aragonese Neo-Cubists are represented, the painter Luis Berdejo Elipe and the sculptor Honario Garcia Condoy.

In addition to holding the collections, the Museo de Zaragoza houses several other facilities, including a modest shop at the entry where postcards and catalogues are sold and a basement area in which archaeological objects not currently on exhibit are available for scholarly study. There is a library located on the third floor that has recently expanded with the donation of the library of Don Pío Beltran Villagrasa, and the same floor has conservation and photographic laboratories, offices, and a meeting room for the academy.

Selected Bibliography

Museum publications: Currently, the museum publishes no journal. *The Boletín del Museo Provincial de Bellas Artes de Zaragoza* was published from 1917 to 1950.

Other publications: Beltrán Lloris, Miguel, *Museo de Zaragoza: secciones de arqueología y bellas artes* (Madrid 1976); Beltrán Martinez, A., "El museo arqueólogico de Zaragoza," *Caesaraugusta*, vols. 7–8, 1956; *Catálogo del Museo Provincial de Bellas Artes de Zaragoza* (Saragossa 1964); Castillo Senzor, A., *La Real Academia de Nobles y Bellas Artes de San Luis* (Saragossa 1964); Lacarra Ducay, Maria del Carmen, *Primitivos aragoneses en el museo de Zaragoza* (Saragossa 1970); Serrano y Sanz, M., "El retablo de Blesa," *Boletín del Museo Provincial de Bellas Artes de Zaragoza*, 1922, pp. 1–9.

JUDITH BERG SOBRÉ

——— Seville ———

MUSEUM OF FINE ARTS OF SEVILLE (officially MUSEO DE BELLAS ARTES DE SEVILLA), Plaza del Museo, Seville.

A museum of art was established in Seville in 1820 in the abandoned College of St. Bonaventure, but little is known of this first museum. In 1835 the monastic establishments of Seville were disbanded, and a committee was established to examine, inventory, and collect the books, documents, and art left behind in the convents and monasteries. A direct result of this investigation was the understanding that an urgent need existed for a larger museum. On September 16, 1835, a new museum was established by a royal decree, and this mandate properly initiated the history of the Provincial Museum of Fine Arts of Seville, as it was then identified. After considering other locations, the monastery of the Shod Mercedarians was appropriated for the new museum on October 7, 1839. In 1840 the paintings gathered from Sevillian monastic establishments for display in the museum were transferred to this site. The church of the old monastery was annexed for the museum in the same year.

The work necessary to transform the seventeenth-century structure into a public museum was begun in 1841, the first of many such ambitious programs of renovation. By 1844 at the latest, the museum was open to the public; however, the date of the official opening is not recorded. In 1849 the Royal Academy of Fine Arts was established to serve, among other functions, as the governing body for the museum. In 1925 the museum was reorganized, and a museum board (Patronato del Museo) was established to govern the museum. This organization is still operational. The structure of the curatorial organization of the museum has been subject to frequent changes in recent years. During its 140-year history, the museum expanded periodically into renovated portions of the monastery as these areas became available. Other organizations that were housed originally in the monastery with the museum eventually moved to new quarters,

thus making available additional space for expansion. One such institution was the Museum of Archaeology, now splendidly housed in its own building in María Luisa Park. In 1976 the status of the museum was elevated from that of a provincial museum to the Museum of Fine Arts. The extensive renovations begun in that year greatly enhanced the museum's acknowledged reputation as Spain's second art museum after the Prado (q.v.). At the end of the 1970s an ambitious program of complete climate control was undertaken, and the exhibition spaces were reorganized once more.

The Museum of Fine Arts is located in the church and monastery built for the Shod Mercedarians of the Dominican order, which provides the museum with its unique setting. Juan de Oviedo y de la Bandera (1565–1625) was the architect of the church (1603–12) and the monastery (1602-c. 1650). The church is of a Latin cross plan, with a single nave of tall proportions and a domed crossing. The decorative ceiling fresco program painted in the first half of the eighteenth century by Domingo Martínez (c. 1690-c. 1750) has been carefully restored. The appearance of the church interior has been altered considerably by the removal of the altars (the original high altar was destroyed by the French in 1810), the destruction of the raised rear choir, and the opening-up of additional window space. Two of the three original cloistered patios of double elevations have been glassed in to serve as picture galleries. These patios with their lovely paintings and fountains serve as refreshing vistas for the museum visitor. A large imperial staircase is located in the center of the three patios and connects the lower with the upper level of the museum. The white marble of the staircase and the white stucco of the stairwell and vault create a cool open space in the midst of the warm red and yellow of the color scheme of the patios and museum exterior. The staircase is one of the most celebrated examples of its type. The elaborate stucco designs, with their dense manneristic surface decoration, allow the spirit of Juan de Oviedo's architectural style to be contemplated to its best advantage at this point. The present entrance faces the Museum Square, which is dominated by a large nineteenth-century statue honoring Bartolomé Murillo. In the early 1940s, the eighteenth-century church facade was moved to this side of the monastery to serve as the museum entrance. The handsome painted tiles that decorate the interior walls of the entrance area are splendid examples of sixteenth- and seventeenth-century Sevillian ceramic work.

The unique strength of the museum's collection is in its unequaled holdings of paintings by the great Sevillian masters of the seventeenth century. The museum has benefited also from large donations of the work of nineteenth- and early-twentieth-century Sevillian artists. The need for a more comprehensive collection of European painting has always been recognized. A significant deposit from the Prado in 1970 of representative canvases from a broad range of European schools has provided a major step toward this goal. In addition, several important bequests and recent purchases have increased the museum's holdings of Spanish art. The museum exhibits art ranging from an Iberian *Lion* to works from the twentieth century in all media, but the heart of the collections remains the

religious paintings from the Late Gothic through the eighteenth century, the original focus of the museum's formative collection. A small holding of prints and drawings and a fine collection of period furniture and fine arts are also displayed. The excellent Museum of Archaeology and the new and promising Museum of Contemporary Art in Seville cover between them the prehistoric through the early medieval periods and the contemporary field, thus freeing the Museum of Fine Arts to concentrate upon the areas of the Gothic through the early twentieth century.

The half-millennium of Moorish occupation of Seville ended in 1248 with the reconquest of the city. Considering this history, it is not surprising that early medieval art is not a strong point of the museum. However, a fine *Crucified Christ* sculpture of the mid-twelfth century of a type then popular in the Catalan regions does merit attention. Beginning with the Late Gothic of the fifteenth century, the major trends in Spanish art are represented well. The charming *Virgin and Child with Musical Angels* from the Valencian school of the second quarter of the fifteenth century is attributed to the Master of Almonacid. The admirable *Ascención* by Bernardo Martorell provides an example of the Catalan style from this same period. All three of these works were part of the important donation of Spanish medieval art given to the museum in 1971 by Virginia Harrison from the collection of her husband, Mario de Zayas. The stunningly colored *Jacob's Ladder* by an anonymous Spanish master who was familiar with the art of Dirk Bouts is a deservedly popular work. The lively *Resurrection* attributed to Pedro Berruguete, possibly of 1485, exhibits the beginning of Italian Renaissance influence in Spanish painting. The strength of the Spanish interest in Flemish realism is indicated by the small sensitive *St. John the Baptist in the Wilderness* by Bartolomé Bermejo of about 1484, a gift of Diego Angulo Iñiguez. The most important practitioner of the Hispano-Flemish style in Seville was Alejo Fernández, whose miniature realism is beautifully represented by the precious *Annunciation* of about 1500.

Another important bequest that enriched the museum's holdings of Spanish medieval art, especially in sculpture and the minor arts, was that of Rafael González Abreu in 1928. Included in this gift were the small fruitwood figures *St. Bartholomew* and *St. Matthew* of about 1500, which are excellent examples of the high quality of Sevillian Late Gothic sculpture. The most remarkable sculptor of the period was Pedro Millán, superbly represented by his *Entombment* and *Resurrected Christ with Angels and a Donor*, both from the cathedral. These large, unpainted terracotta groups date from 1485 to 1505 and must be considered among the major works in the museum.

The weakness of the idealizing style of the Renaissance in Sevillian painting is demonstrated by the painted organ shutters of 1575–80 by Pedro de Villegas Marmolejo, *The Holy Family with the Infant Baptist and Saints Thomas of Aquinas and Catherine of Sienna*. Mannerism was a far more impressive mode in Spanish art. El Greco's superb and touching portrait of his son, *Jorge Manuel*, of about 1600, donated by the duchess of Montpensier, is the museum's best

such example. The large and spectacular *Last Supper*, painted for the Carthusians of Seville, is an impressive problem piece, with its cold coloration and curious details. The painting has been attributed to widely different masters, but if it is by Alonso Vázquez, it may date from about 1585.

The museum's few examples of sixteenth-century sculpture are notable for their high quality. The *Penitent St. Jerome* was done by the peripatetic Italian Pietro Torrigiano in 1525, when he was resident in Seville. The ten carved wood panels, the *Retable of the Annunciation*, of 1556 are by the Fleming Juan Giralte and are from the Carmelite Convent in Aracena. The *Retable of the Virgin of Bethlehem* of 1588 came from the ex-Jesuit church in Seville and retains its gilt wood frame, which has been excellently restored.

The sixteenth century saw a spectacular growth in the importance of Seville, so much so that the population in the 1580s was double that of fifty years earlier. Seville was the monopolistic port of trade with all of the New World, and the riches that poured into the city formed the basis for the remarkable flowering of art in the seventeenth century. The museum is fundamental for a study of the lesser-known figures of the early seventeeth century, with their fascinating mixture of reactionary Mannerist traits and progressive Baroque tendencies. Painters such as the enigmatic Juan de Roelas, or Ruelas, and Francisco de Herrera the Elder are represented strongly with large works such as the *Martyrdom of St. Andrew* of about 1610–15 from the Chapel of the Flemings and the *Vision of St. Basil* of 1638–39 from the church of that dedication, respectively. Both artists are acknowledged to have played important roles in the development of the Baroque style in Seville, but their exact contributions have yet to be analyzed thoroughly.

Paintings by the most famous Sevillian artist Diego Velázquez have only recently been added to the museum's collection. The selection is challenging, even for specialists, and includes the *Imposition of the Chasuble upon St. Ildefonso* of about 1623, long inaccessible to the public in the Archepiscopal Palace, and the portrait *Cristóbal Suárez de Ribera* of 1620 from the church of St. Hermengild. The color and composition of the *Imposition* are unusual, but the canvas has been extensively restored. Suárez de Ribera was godfather to Velázquez' wife and died in 1618. If the date on the painting is original, the portrait was made posthumously, which would explain a certain awkwardness to the pose. It is fascinating to examine these paintings for the influence of Francisco Pacheco, who was Velázquez' teacher and father-in-law. Pacheco's dry but accomplished *Mystical Marriage of St. Catherine* of 1628, for example, was painted only five years after the *Imposition*; yet it is almost impossible to discern any stylistic similarities. Seville has more paintings by Pacheco than any other museum, as it does also for Roelas and Herrera, but the museum prudently exhibits only a few works. The two *Donor* paintings from a Sevillian convent by Pacheco have been interestingly identified, but not widely accepted, as portraits of Pacheco and Velázquez and their wives.

The incomparable collection of paintings by Francisco de Zurbarán is one of

the great delights of a visit to the museum. The range of the artist is displayed most impressively here. Formal public statements such as the classically composed *Apotheosis of St. Thomas Aquinas* of 1631 from the Dominican college dedicated to that saint may be studied next to the tiny and captivatingly charming *Rabbits and Guinea Pigs* of about 1640, which was acquired in 1973. Zurbarán's brilliant sense of color, which is all too often unjustly ignored, shines forth in the touching *St. Joseph Crowned by Jesus* of 1636, possibly from the Shod Carmelite College. The artist's more familiar abilities to paint in rich tones of white and his unequaled sense of pattern in cloth are superbly evident in the great *Virgin as Protectress of the Carthusians* from the Sevillian monastery of that order. A date of the mid–1630s seems likely for this painting, but the mid–1650s has also been proposed. The several *Crucified Christ* images also must be noted for their deep sense of tragedy, a darker emotion sometimes felt lacking from Zurbarán's oeuvre. An interesting series of *Female Saints* and an *Apostle* set, both products of Zurbarán's shop, demonstrate the ease with which his designs could be copied and the extent to which they become vapid when deprived of the master's brush.

The painter Murillo has rightly always been identified with Seville. The warmth, joy, and color of the city are immortalized in his art. It is difficult to single out paintings from this rich collection, which is second only to that of the Prado, but the superb *Saints Justa and Rufina*, patronesses of the city, with their pendant, *Saints Leandro and Bonaventure* of 1665–66 from the Capuchine monastery, are especially memorable for their calm beauty. A more excited spirit animates the equally lovely *Adoration of the Shepherds* of 1668, also from the Capuchine monastery. The range of Murillo's religious imagery is suggested by comparing the strong emotion of the heroic *Penitent Magdalen* of about 1660, donated by the marchioness of Larios, with the unforgettably intimate *Madonna and Child of the Napkin* of about 1668 from the Capuchine monastery. If this superb collection has a flaw, it is that none of Murillo's secular imagery is included.

Juan de Valdés Leal was Murillo's most serious rival, and he is by no means a less effective religious artist than Murillo. The vivid coloration, dramatic forms, and active compositions of the *Temptation of St. Jerome* and the *Flagellation of St. Jerome*, both of 1657 and from the Hieronymite monastery of Buenavista, demonstrate the opposite road that he took from Murillo. For powerful and original religious drama, few Baroque paintings can match Valdés' *Way to Calvary* of about 1658.

The seventeenth-century school of Seville is comprehensively represented in the museum's holdings, but the lesser artists need not detain us in this rapid survey. It should be noted, however, that a subsidiary House and Museum of Murillo is planned, which will occupy the site of Murillo's last domicile. The art displayed there will greatly encourage a more detailed examination of the Sevillian Late Baroque and the school of Murillo in particular.

Spanish seventeenth-century painting outside of Seville is adequately represented with examples by masters such as José Antolínez, Francisco Camilo,

Antonio del Castillo, and Jusepe de Ribera. The *St. Teresa of Avila* of 1630 by Ribera is an especially fine work.

Spanish seventeenth-century sculpture forms a small but choice collection. Juan Martínez Montañés was renowned as the "God of the Woodcarvers" for his excellence in the Spanish tradition of wooden sculpture, which was brightly polychromed. The *Penitent St. Dominic of Guzmán* of 1605 from the Dominican monastery of the Gate of Heaven and the *St. Bruno* of 1634 from the Carthusian monastery are two excellent examples of the genius of Martínez Montañés. A splendid *Virgin and Child* of 1623 from the Carthusian monastery by Juan de Mesa, with sculpture by Pedro Roldán and his daughter La Roldana and by Pedro Duque de Cornejo, demonstrates the continued strength of this native medium throughout the Baroque period.

Of Spanish eighteenth-century painting, the Seville Museum displays two fine Goyas, the somber portrait *José Duaso* and the spirited and fantastic *Scene of War*, acquired from Xavier de Salas, whch belies its small size with its power. Characteristic works by Luis Eugenio Menéndez, Mariano Salvador Maella, and Antonio de Palomino are also exhibited and provide a good sampling of the best of Spanish painting from the Century of Enlightenment. A series of eight canvases by Domingo Martínez of 1747 depicts the cavalcade that celebrated the opening of the tobacco factory in Seville and is of considerable historical interest.

Sevillian ninenteenth- and twentieth-century painting and sculpture are given ample exhibition space in the museum. The artists displayed were those approved of by the academicians who administered the museum. The technical quality of these works is often very high, but the images are frequently uninspired, and the styles are conservative. There are, however, enough enjoyable works to make the viewing of these many rooms both a pleasant surprise and a rewarding experience. Virgilio Mattoni's colossal (4.0 by 7.5 meters) *Death of St. Ferdinand* of 1887 is a spectacular example of late academic Romanticism, which comes as a real relief after the seemingly endless portraits and historical scenes by the stiffly academic Antonio María Esquivel, unfortunately, but undeniably, the most important painter of Seville in the first half of the nineteenth century. José Jiménez Aranda's splendid portrait of his daughter of 1889 is a loving tribute to a spirited child. Gonzalo Bilbao's *Cigarette Makers* of 1915 is a brightly colored and lively piece of easy popular appeal. Most memorable, however, are the excellent landscapes of Spain, such as those by Antonio Muñoz Degrain. Visitors may be surprised at the colorful *Grand Canyon* by José Arpa Perea, who worked in America. Unfortunately, examples of the best Spanish painters of these centuries are limited to one drawing by Mariano Fortuny and one sketch by Joaquín Sorolla.

Of other European schools, the museum now exhibits characteristic examples of English, Dutch, Flemish, German, Italian, and even Swedish painting from the fifteenth through the nineteenth century. Especially notable are the excellent *Crucifixion* of 1538 by Lucas Cranach; the splendid *Last Judgment* of 1570 by Marten de Vos, which was painted for a Sevillian monastery; the powerful and

unusual *Herod Accused by the Baptist* by Mattia Preti; and the lovely *Earthly Paradise* by Jan Bruegel, which, like the Preti work, is from the Prado.

The museum's considerable collection of decorative arts and period furniture is displayed in the relevant exhibition halls, but it has yet to be catalogued. The majority of these works came from abandoned monastic establishments. These objects include an interesting baptismal font of the early sixteenth century, ecclesiastical items of ivory and of silver, and eighteenth-century ceramic figurines. A special notice must be made of the very important collection of sixteenth- and seventeenth-century wall tiles from Sevillian churches and monasteries. This characteristically Sevillian art form is now best seen in the museum, not only because there are so many examples of such large formats, but because they are incorporated into their intended settings whenever possible. There is also an anomalous display of Japanese stone carvings, a gift of Martin Soria.

The small museum library is not open to the public, but the sales desk offers a wide variety of color slides, postcards, and reproductions, as well as an assortment of art historical literature. Catalogues and museum publications may also be purchased in the entrance hall. Black and white photographs of works in the museum collection may be ordered through the sales desk. Photography without flash attachments is permitted upon payment of a fee for the privilege.

Selected Bibliography

Museum publications: Brief catalogues of the collection were published in 1868 and 1888. The first important catalogue, containing 421 entries, was published by José Gestoso y Pérez, *Catálogo de las pinturas y esculturas del Museo Provincial de Sevilla*, Seville, 1912. Half a century later, José Hernández Díaz published his excellent catalogue, which contains some 854 numbered entries, *Museo Provincial de Bellas Artes: Sevilla, Guías de los Museos de España XXX*, Madrid, 1967. The present handbook, *Museo de Bellas Artes de Sevilla: Pintura y escultura, Siglos XIV al XX*, Madrid, 1971, leaves much to be desired. Two other museum publications should be noted: *Museo de Bellas Artes de Sevilla: Nuevas adquisiciones y restauraciones*, Seville, 1971; *Museo de Bellas Artes de Sevilla: Nuevas adquisiciones y restauraciones: Primeros fondos para la Casa Museo de Murillo*, Seville, 1973.

Other publications: Juan Antonio Gaya Nuño, *Historia y guía de los museos de España*, Madrid, 2d rev. ed., 1968, 713–27; José Gabriel Moya Valgañón, "Museo de Bellas Artes," *Reales Sitios*, Año 13, numero extraordinario dedicada a los museos de Sevilla, 1976, 17–32.

DUNCAN KINKEAD

Sweden

———— Stockholm ————

NATIONAL SWEDISH ART MUSEUMS (Includes the NATIONAL MU-
SEUM, MUSEUM OF MODERN ART WITH THE MUSEUM OF PHOTOG-
RAPHY, and the MUSEUM OF FAR EASTERN ANTIQUITIES; officially
STATENS KUNSTMUSEER, including NATIONALMUSEUM, MODERNA
MUSEET, ÖSTASIATISKA MUSEET), Box 16176, 103 24 Stockholm.

In 1976 the three museums were reorganized under the name of the National
Swedish Art Museums, Stockholm. Part of the three museums' permanent col-
lections was originally housed in the Nationalmuseum, which was opened in
1866. But the collections and the museums' history are considerably older than
this. As early as 1792 the Royal Art Collections had become the Royal Museum,
and two years later, in 1794, this museum was opened to the public in the
northeast wing of the Royal Palace, Stockholm. Thus as a public art gallery,
the Nationalmuseum is one of the oldest in the world.

From the beginning the Nationalmuseum included many different collections.
In 1958 the collection of twentieth-century art was moved from the National-
museum to the nearby island of Skeppsholmen. The Museum of Modern Art is
housed in a building that earlier belonged to the navy and was used as a drill
hall. The building was designed in the middle of the eighteenth century by
Fredrik Blom, and it has been rebuilt and enlarged several times, the last time
in 1974, when it was doubled in size, with architect P.-O. Olsson directing the
alterations. A workshop for children and adults and a hall for film shows and
lectures were added. In 1971 the Museum of Photography was annexed to the
museum.

In 1963 the Nationalmuseum's Department of Far Eastern Art was merged
with the Museum for Far Eastern Antiquities and moved to Skeppsholmen. The

museum is housed in what used to be one of the "Ordnance Stores" originally built in 1700 as quarters for King Charles XII's bodyguards. P.-O. Olsson also directed these alterations.

The National Swedish Art Museums are owned and funded by the state. The Nationalmuseum and Museum of Modern Art receive financial support from the Stockholm School Authority for educational programs. All of the museums have friends' organizations that support them with funds and special purchases.

The National Swedish Art Museums are governed by a board of trustees, consisting of fourteen members. Eight are appointed by the government, the remaining six are the head director, the directors of the Museum of Modern Art and the Museum of Far Eastern Antiquities, the director of the Department of Administration, and two representatives of the staff. The head director is also director of the Nationalmuseum. The Department of Administration is a collective unit for all three museums.

The Nationalmuseum's present building was designed by the German architect August Stüler, who is most famous for his various museum buildings in Germany. The architecture of the building is influenced by the Italian Renaissance, especially that of Venice. That is appropriate, since the Nationalmuseum is beautifully situated next to the waterway Strömmen. Six frescoes painted in 1896 by the Swedish artist Carl Larsson decorate the interior walls over the staircase to the first floor. They illustrate different aspects of the history of Swedish art. Carl Larsson has through his picturebooks on his home and family become the best loved and most popular of all Swedish artists.

The Nationalmuseum is the central museum for the collections of paintings, sculptures, prints, drawings, and applied arts belonging to the Swedish nation. The museum is administered by a director, with curatorial departments of Paintings and Sculpture, Prints and Drawings, Applied Arts, Royal Castles Collections, Photo-Collection, Long-Term Loans and Travelling Exhibitions, and Art Education. There are also a library, the Conservation and Photography studios, and other technical departments.

The Department of Paintings and Sculpture has a collection that originates from the Royal Art Collections begun in the sixteenth century. Important additions were made in the seventeenth century, partly in the form of war trophies removed from the Baltic provinces and the German courts, spoils from the Thirty Years War. The most significant coup was made in Prague in 1648. Emperor Rudolph II had amassed the finest collection of his day, and most of this, more than six hundred works by the great masters, fell into Swedish hands. When Queen Christina abdicated, she took the greater part of the collection with her to Rome but left many excellent works. A large part of the collection was formed in the eighteenth century by Carl Gustaf Tessin. While in Paris as Swedish ambassador, Tessin, acting on behalf of the Swedish royal family, bought the best contemporary French art available. He also purchased seventeenth-century Dutch and Flemish paintings. These acquisitions still stand out among the museum's collections. The monarch who did most to establish the museum and its

collections was Gustav III, who planned the museum already mentioned in the Royal Castle, which was opened in 1794 two years after the king's death.

The Nationalmuseum has the largest collection of Swedish paintings in the country. The department has about eleven thousand all told, but only a small part of them are exhibited in the museum, the rest being loaned or in storage.

The department has one of the biggest collections of icons outside Russia, most of them coming from a bequest made by the Swedish banker Olof Aschberg. The collection of southern European medieval and Renaissance paintings is small but includes significant works such as Perugino's *St. Sebastian* (c. 1500). Renaissance works from north of the Alps are well represented through large pieces like Cranach the Elder's *Financial Negotiations* from 1532 and Jan Massys' *Venus* of 1561.

The seventeenth-century Dutch and Flemish collection is substantial. It includes many works by two of the great masters, Rubens and Rembrandt. Two works by Rubens are *Bacchanal at Andros* and *Sacrifice to Venus*, both free copies of paintings by Titian. The museum owns ten paintings by Rembrandt, and his canvas *The Conspiracy of the Batavians* (1661–62) is undoubtedly the museum's most remarkable painting. Executed for the city hall in Amsterdam, it was not accepted at that time. It went to Sweden in the eighteenth century. There are also many other seventeenth-century works by French, Italian, and Spanish artists, such as Georges de La Tour's *Saint Jerome in Penitence* and Zubarán's *Veronica's Veil* from 1631–36.

The French eighteenth-century collection is one of the finest outside France, with outstanding works like *Love Lesson* by Watteau and as many as eight paintings by Chardin. By Boucher there are six canvases; *The Triumph of Venus* from 1740 is widely regarded as his finest work. There are also some sculptures in this part of the collection, such as Houdon's bust *George Washington*, 1785.

The museum also owns a representative collection of French nineteenth-century painting. Included are works by Courbet (*Jo, the Beautiful Irishwoman*, 1866), Manet (*The Pear Peeler*, 1868), and Renoir (*La Grenouillère*, 1868).

There has been a deliberate effort, especially at the end of the nineteenth and the beginning of the twentieth centuries, to complete the collection of Swedish art. Therefore, the history of Swedish art in all of its phases can be followed in the museum's collection. From the seventeenth century are many representative works such as those of First Court Painter David Klöcker Ehrenstrahl, usually referred to as "Father of the Swedish Painting Tradition." During the eighteenth century there were many excellent Swedish artists, and most of them are represented in the collection. For example, the large but uncompleted canvas *The Coronation of Gustavus III* from 1782–93, by Carl Gustaf Pilo, is considered one of the greatest masterpieces of Swedish art. There are also many paintings by Alexander Roslin, who spent most of his life in Paris, where he was a member of the Academy of Art. He is known for his fine portraits such as that of his wife, *The Lady with the Veil*, from about 1769.

Sweden's most renowned sculptor is Johan Tobias Sergel, and the museum

owns many of his works, the best known being *Amor and Psyche* from 1777. The last three decades of the nineteenth century were a period of activity and importance in Swedish art history. In the forefront were artists like Carl Fredrik Hill, the landscape painter, and Ernst Josephson, the portrait and genre artist. Many artists of the period are today greatly loved by the public and known for giving their art a national character. Carl Larsson is renowned for his description of domestic bliss and Bruno Liljefors for his depiction of nature and animals in all of their splendor. There are works by Anders Zorn, a cosmopolitan artist known for his worldly portraits and etchings, but who is best known for his portrayal of the rural life of his birthplace, the county of Dalarna.

The Department of Prints and Drawings has an impressive collection of works from the fourteenth century to the present, including more than 195,000 works. The collection of drawings is remarkably comprehensive for a museum of this size, with more than 65,000 works. More than half are original master drawings, and the rest are architectural and decorative drawings. The main part of the foreign master drawings were brought to Sweden by the same Carl Gustaf Tessin who played such an important part in the growth of the collection of paintings. Among the best items in the collection are drawings by Raphael, Dürer, Rembrandt, Rubens, van Dyck, and Poussin. There is also a large collection of French eighteenth-century drawings by, among others, Watteau, Chardin, and Boucher.

The collection of architectural and decorative drawings—also of international importance—covers to a large extent the French seventeenth and eighteenth centuries. In this collection, mainly consisting of the Tessin-Hårleman and the Cronstedt collections, is a great number of drawings originating from the "bureau des plans" of Jules Hardouin-Mansart and Robert de Cotte documenting the architectural structure of Versailles and Paris. There are also several hundred garden drawings for the French castles and *maisons de plaisance* by Le Nôtre and Desgots, with sequences of sketches for ceilings and wall decorations by Lebrun and Claude Audran. The Italian drawings are to a great extent studies and sketches done by the architects of the Royal Palace in Stockholm, Nicodemus Tessin the Younger and Carl Hårleman. Among the drawings by notable Swedish architects are those of Jean de la Vallé, Nicodemus Tessin (father and son), Carl Hårleman, Jean E. Rehn, and Carl Johan Cronstedt. These drawings richly illustrate the residences of the upper classes in Sweden in the seventeenth and eighteenth centuries.

The collection of prints and engravings is also considerable, containing more than 120,000 pieces, with the accent on the seventeenth and eighteenth centuries. Masters such as Dürer and Rembrandt are particularly well represented. There is an especially rich collection of works by Swedish draftsmen and engravers. Among them, drawings by Sergel and Elias Martin should be mentioned. Among the artists of the nineteenth and twentieth centuries, Anders Zorn has acquired an international reputation through his etchings of which the museum owns a rich collection.

The Department of Applied Art was organized in the 1880s, and the collection now includes more than twenty-seven thousand items from the Middle Ages to the present. Among the most outstanding early objects is an Alhambra vase, a piece of faience of Spanish origin dating from the fourteenth century and more than a meter high. There is also a woven table canopy ordered by Fredrik II for Kronoborg castle in Denmark. It was executed in 1568 by Hans Kneiper and is one of the war spoils taken during the seventeenth century.

The museum owns a very good collection of glass from Venice and Germany. Engraved German glass in particular is represented by some excellent examples, such as a glass goblet with a portrait of Emperor Charles VI, engraved by Georg Friedrich Killinger from Nürnberg about 1712. In the silver collection a gigantic gilt-silver goblet executed in Nürnberg in 1609 is noteworthy. The ceramics section is outstanding, with majolica, Delft ware, and, especially, eighteenth-century pieces from the Swedish Rörstrand and Marieberg faience factories. These factories are known for their excellent workmanship and beautiful wares. The collection of European porcelain is the largest in Scandinavia, with pieces from factories like Meissen, Sèvres, and Wedgwood.

In the representative collection of Swedish silver and glass, the items from the twentieth century are especially worth mentioning. These works show the well-known style and grace of modern Swedish design. The collection of furniture is also of high quality and includes the first-class works by Sweden's foremost ebonist Georg Haupt from the eighteenth century.

The department's collections from the present century are chiefly concerned with the development of the applied arts in Scandinavia. In recent years the individual pieces have been supplemented with industrial design.

On May 9, 1958, the Museum of Modern Art (Moderna Museet) was declared open by the director and artist Otto Sköld, who had long been one of the museum's most enthusiastic supporters. Backing Sköld in his plans was the Association for Contemporary Art, founded in 1937 and changed in 1953 to The Friends of the Moderna Museet, which at that time—as still today—had made important contributions to the museum's collections. The basis of these collections was the twelve hundred works that were transferred from the Nationalmuseum's department of contemporary painting and sculpture, while drawings, lithographs, handicrafts, and industrial design remained within their respective departments at the Nationalmuseum, as is still the case today.

The museum's activities are financed through state grants and entrance charges. In addition, certain funds are available through private donations, as well as the purchasing allowance made every year by the Association of Friends. The staff of the museum consists of nine curators and four administrators.

It is the task of the Moderna Museet to collect Swedish and international art of the 1900s and to organize exhibitions and arrange lectures and guided tours, discussions, film shows, and other activities that help make modern art available to a wider public.

Since the opening of the museum, the collections have grown to almost thirty-

five hundred works of which about a third are sculpture. Much of this collection covers Swedish art from the turn of the century to the present. This part of the collection affords a good opportunity to study, on the one hand, how modernism's different currents have influenced Swedish art and, on the other hand, how the latter has preserved and developed its own provincial character. A smaller part of the collection includes significant works by artists from other Scandinavian countries, such as the six important paintings by Edvard Munch.

Through the exhibition, "The Museum of Our Wishes" 1963–64, the Moderna Museet drew the attention of the authorities to the importance of establishing a meaningful collection of early modernism while the works were still available at reasonable prices. This led to a considerable grant being made available to the museum—five million Swedish crowns—which resulted in an excellent collection of works. To the Picasso works already in the possession of the museum—*Guitar Player* from 1916 and *Woman with Blue Collar* from 1941—now were added studies of heads in connection with the work on *Les Demoiselles d'Avignon* and a *papier collé* from 1912–13 that was acquired from Tristan Tzara's collection. About the same time the large concrete group *Luncheon on the Grass*, which stands in the garden of the museum, was acquired, while a slightly later purchase, *The Spring* from 1931, makes this artist very fully represented. Cubism is also represented by outstanding works by Braque and Léger.

In 1961 the art critic Ulf Linde created for an exhibition called "Movement in Art" the first copy of Marcel Duchamp's big glass picture *The Bride Stripped Bare by Her Bachelors, even* . . . and, in connection with it, several others of the same artist's works that were signed by Duchamp as "copie conformé." Thus the ground was laid for a rich Dada collection of first-class works by Ernst, Picabia, Man Ray, Schwitters, and others. The museum acquired essential Surrealist works such as Giorgio de'Chirico's *The Child's Brain*, which, with Miró's *The Red Figure*, came from the Breton Collection. Among the main Surrealist works may also be noted Dali's *The Enigma of William Tell* from 1933 and Magritte's *The Red Model* from 1935.

Pre-war art is completed by important Constructivist works by, among others, Mondrian and Vantongerloo. Expressionism and Fauvism are well represented by several early paintings by Matisse: *Notre Dame de Paris* from 1905, *Moroccan Landscape* from 1911, and the *découpage The Apollo* from 1953, as well as paintings by Nolde, Kirchner, Kandinsky, Klee, Kokoschka, and others. An important contribution to the museum came at the beginning of the 1970s, when the so-called New York Collection for Stockholm was added to the museum's collections: in it were included most of the leading American artists of the fifties and sixties. Among the larger permanent sculpture groups outside the building itself can be mentioned Alexander Calder's *The Four Elements* and Niki de Saint Phalle and Jean Tinguely's group of several figures, *Paradise*.

In addition, there is the photographic department's collection of about two hundred thousand prints and negatives from 1845 to the present. Central to this collection are the very fine Gernsheim and Bächström collections. The Photo-

graphic Museum also includes a special library of some fifteen thousand volumes. The library of the Moderna Museet is part of the Nationalmuseum and includes a comprehensive collection of literature on the history and theory of modern art. Photographs, posters, and other reproductions of works in the museum's collections, or being shown there at exhibitions, may be obtained from the museum's bookshop and press service. In addition, the museum publishes a wide range of its own exhibition catalogues, many of which are still in stock.

The new Museum of Far Eastern Antiquities was inaugurated in 1963. It houses one of the finest collections of Far Eastern art and archaeology in the world based on two state collections, namely, the former collections of Far Eastern antiquities, consisting of the Chinese Bronze Age material and the neolithic pottery and other objects collected by Johan Gunnar Andersson (Swedish geologist active in China in the 1910s and 1920s), and the Oriental art collection of the Swedish National Museum, consisting of mainly Chinese sculptures, paintings, ceramics, and other handicraft objects. Since the opening of the museum in 1963, several important private collections have been added, among which must be mentioned the collections of the late King Gustaf VI Adolf.

The museum's collection of Chinese objects from the Late Stone Age is the largest outside China and is therefore unique. This is mostly due to the work of J. G. Andersson, who excavated the important finds from the Yangshao culture (c. 4600–2000 B.C.) and brought to the museum an outstanding collection of Chinese neolithic painted pottery. Rich finds were particularly made in western China, Pan-shan, Ma-chia-yao, Ma Ch'ang and Hsin Tien. The undecorated black pottery named after the place of the first finds in Lung-shan in Shantung is also well represented.

The Chinese Bronze Age (Shang Yin, c. 1500–1028 B.C., and Chou, c. 1028–220 B.C.) is equally well represented in the museum. Most of the earliest bronze exhibits in the museum come from the ancient capital Anyang and include a large collection of sacrificial vessels. The Late Bronze Age is also very well represented both by ritual vessels and by an extensive collection of mirrors, belt hooks, and smaller objects. Characteristic of the museum's collection of bronzes is its wealth of utilitarian articles, such as weapons, harness and fittings for chariots, and various tools. There is also a good collection of jade, bone, marble, and pottery objects.

As a result of the systematic research made by Osvald Sirén, the museum owns an unusually eminent collection of Buddhist sculpture. It contains good examples from all important periods; the Early Archaic period (300–400 B.C), Sui (585–618 B.C), the classical T'ang period (618–906 B.C), and the concluding periods of Sung, Yüan, and early Ming (960–1500 B.C). The museum also houses a wide selection of tomb pottery figurines from the Han, Wei, and T'ang periods.

The museum has an extensive collection of Chinese paintings from the Sung Dynasty to modern times. It is especially strong in Ming and Ch'ing paintings. Following Chinese tradition there is no large number of paintings permanently

on view. Instead, some eighty hanging scrolls have been arranged in screen cases that can be pulled out one by one. The handscrolls are in drawers.

The collection of later Chinese ceramics consists of pieces from the T'ang period until the beginning of the twentieth century. Particularly strong is the collection of earthenware from the T'ang period, and the classical groups of the Sung period are also well represented. A good selection of blue-and-white and colored Ming and a rich selection of Ch'ing works complete the collection.

The museum also houses other types of work such as glass, lacquer work, enamels, and furniture and has a gallery devoted to Japanese painting, sculpture, and handicrafts, as well as smaller collections of Indian and Korean art.

The Nationalmuseum publishes the *Yearbook*; the *Bulletin*, three times a year; and the annual *Nationalmuseum Series*. *The Bulletin of the Museum of Far Eastern Antiquities* has been published annually since 1929.

Selected Bibliography

Museum publications: *Paintings and Sculptures of the Northern Schools before the Modern Period*, 1952; *Paintings and Sculptures of Foreign Schools before the Modern Period*, 1958; Birnbaum, B., *Paintings at the Nationalmuseum*, 1976; Bjurström, P., *Drawings in Swedish Public Collections*; *German Drawings*, 1972; *French Drawings*, 1976; *Italian Drawings*, 1979; idem, *Drawings of Johan Tobias Sergel*, 1979; *Drawings from Stockholm*, The Pierpont Morgan Library, New York, 1969; *Katalogen—Moderna Museet* (in Swedish and English), 1976.

NILS G. HÖKBY

Switzerland

—— Basle ——

BASLE ART MUSEUM (officially ÖFFENTLICHE KUNSTAMMLUNG— KUNSTMUSEUM BASEL; also ÖFFENTLICHE KUNSTAMMLUNG BASEL, KUNSTMUSEUM BASEL), St. Albangraben 16, Ch–4010 Basle.

The Basle Art Museum houses the oldest municipal art collection in Europe. Its holdings constitute perhaps the most prominent collection of art to be found in Switzerland. The growth of this collection through its nearly three hundred-year history is a remarkable testimony to the fervor for art collecting among Basle's citizenry, whose donations account for the vast majority of works in the museum today.

The history of the Basle public collection begins in 1662, when the city purchased the so-called Amerbach Kabinet, a collection of art and objects of curiosity that had been assembled during the Renaissance by a family of lawyers, the Amerbachs. The collection was started by Johannes Amerbach (1430–1513) and enlarged by his son Bonafacius (1495–1562), who was a friend of Erasmus and a patron of Hans Holbein the Younger. In 1586 Bonafacius' son Basilius inventoried the entire collection; it consisted of 49 paintings, 1,866 drawings, 525 woodcuts, 3,356 engravings, and numerous objects of historic, scientific, and ethnographic interest. The artists represented in the collection were nearly all Swiss and German, the most important of their day, including Holbein the Elder, Holbein the Younger, Urs Graf, Nikolaus Manuel Deutsch, Hans Baldung Grien, and Dürer.

The city purchased the Amerbach Collection at auction and installed it for pedagogical purposes under authority of the University of Basle in a building near the cathedral, where it remained until the nineteenth century. During its first two hundred years the collection of paintings expanded through purchase

and donations of more works by German and Swiss artists, mostly the Holbeins, and through the addition of archaeological finds excavated in Switzerland.

In 1823 another era of rapid expansion began with the donation of the Faesch Museum. Remigius Faesch, a lawyer like the Amerbachs, had put a collection of paintings together between 1618 and 1638, displaying it in his house on Petersplatz. Faesch's will stipulated that the collection should be passed down to the eldest male lawyer in the family, but if no male lawyer were alive to receive the inheritance it should go to the city. Such a condition occurred in 1823, and the family donated the entire collection to the municipality. The Faesch Museum included works by Holbein the Younger, Hans Baldung Grien, Martin Schongauer, and Lucas Cranach. In all, the city's collection gained more than forty paintings, mostly Swiss and German, and a number of drawings.

Following a wave of political changes in Switzerland in the late 1830s Basle City became a canton in itself, distinct from the surrounding Basle District canton. Within a few years the city began a building program that included the construction of a Museum of Natural History and Ethnography (built 1844 to 1849). Melchior Berri, a neoclassical architect trained in the Karlsruhe school, designed this three-story temple of knowledge destined to house all municipal collections. The art collection was formally dissociated from the university and in 1849 transferred to the top floor of Berri's neoclassical edifice, where it remained until 1936. During this same general period, a private art society was founded, the Basler Kunstverein, for the promotion of works by living Swiss artists. In 1870 to 1872 the Kunsthalle was built after designs by J. J. Stehlin as part of a downtown cultural center to provide space for the Kunstverein's exhibition activities. The Kunsthalle has continued to function in its original role until the present as a place for temporary exhibitions.

The extremely limited scope of the collection in 1849 was broadened significantly in the later years of the nineteenth century. One of the first donors to the new municipal museum was Emilie Linder, a Basle painter of independent means who patronized a number of Swiss and German artists who today are associated with the Nazarene School; among them were Frederic Overbeck, Peter Cornelius, and Joseph Anton Koch. Linder gave paintings and drawings by these artists and eventually donated the entire painting collection that she had inherited from her grandfather, Jean-Conrad Dienast (1741–1824). The Dienast Collection had been assembled after the French Revolution and included Dutch, Flemish, French, and Italian Old Master works. Another major step toward greater diversity in the collection was the legacy of Samuel Birmann, a landscape painter and art dealer who lived in Basle and died in 1849. The Birmann Collection, impressively cosmopolitan in scope, was composed of more than sixty works, with Dutch, Flemish, French, Italian, and Spanish compositions dating from the sixteenth through the eighteenth century, and included a few works by major contemporary Swiss landscapists.

To this day the Old Master collections of the Basle Museum are heavily weighted in the Swiss and German schools; however, acquisitions of modern art

since the early twentieth century have covered every significant art center in Europe and North America. The encyclopedic breadth of scope in the modern collection reflects Basle's position as a world-ranking center of modern technology. Many of the acquisitions of this century have been the result of increased government involvement in museum funding, but the private sources have continued to be important. For example, a trust fund left by Samuel Birmann for the purchase of contemporary Swiss art enabled the museum to buy important works in the early part of the century. Numerous cultural foundations such as the Freiwilligen Museumverein and the Gottfried Keller Stiftung have also supported the emphasis in collecting local contemporaries. The impressive international scope of the modern collection, however, has developed mostly since 1933, when the twentieth-century collection of Emanuel Hoffman first began arriving, with works predominately of the Paris School, but followed through the years by works as diverse in origin as Belgian Expressionists and Spanish Abstractionists. Works from the important collection of Richard Doetsch-Benziger have also bolstered the modern holdings since the collector's first donation in 1939. From this source came Basle's major collection of works by Paul Klee, as well as first-rate compositions by Kandinsky, Chagall, Picasso, Miró, and Matisse.

Basle's fine collection of French Impressionism and Post-Impressionism is largely due to the presence of the Rudolf Staechelin Collection, which first began to be exhibited in 1947. The museum's world-renowned holding of Cubist art was largely due to the generosity of the Paris collector and native of Basle Raoul La Roche. Private financial support has been both substantial and timely through the years, allowing the museum to buy works when prices were still relatively low. For example, Basle's first acquisitions of American Abstract Expressionists date from 1959, resulting in an enviable group of works by Rothko, Still, Newman, and Kline, as well as others acquired later.

Today the museum occupies its own building, which was completed in 1936. By the turn of the century the collection had grown to a point where the need for a real art museum was critical. By 1905 plans existed for the new building, but the project was not fully conceived and funded until 1926. Meanwhile, the Print Room had been forced to move out of the Berri museum to make room for additional exhibition space.

The present building was designed by Rudolf Christ of Basle and Paul Bonatz of Stuttgart. The architects' intent was to combine stylistic references to earlier periods of Swiss architecture with the functional and aesthetic concerns of recent architectural developments of the day. The exterior facade is decorated with an arcade supported by robust marble columns terminated by roughly hewn, blocky capitals reminiscent of the Swiss Romanesque. On the interior, however, the plan is organized around two courtyards that allow for the modernistic exploitation of large walls of glass, notably at the main entrance lobby and next to staircases. The top story is skylighted in all gallery spaces. Generally, the interior

embellishment is kept to a minimum, creating a sobriety typical of Art Deco design in large-scale buildings.

The principal attractions of the current collection are in two general areas: Late Renaissance art from Switzerland and Germany and modern art. Significant works of other schools have also been acquired but without the depth or breadth of the museum's strong areas.

The emphasis on Swiss and German art in the Amerbach and Faesch collections has made Basle one of the most important centers in that area. Among its many major works, the impressive ensemble of paintings by Conrad Witz and his school merits special note. More than twenty works, eleven of which are securely attributed to the master, have entered the collection, including nine panels from the Basle Heilspiegel-Altar of 1435. Other works of the fifteenth century include the intimate *Madonna and Child* (c. 1480) by Martin Schongauer and a large altarpiece from the Barfusserkirche in Basle, commissioned in 1480 by the burgermaster Peter Rot from an anonymous artist. The blunt naturalism of Hans Fries, a painter from Fribourg who spent much of his career in Basle and Berne, is in evidence in the six panels from an altarpiece devoted to the life of the Virgin (c. 1512) and the wings of an altarpiece to St. John the Baptist and St. John the Evangelist (1514), which Fries completed for a chapel in Fribourg, Germany. The extraordinary radiance of color in the work of the Berne master Niklaus Manuel Deutsch can be appreciated in *St. James and St. Roch Interceding with St. Anne for the Victims of the Plague* (c. 1517) and the large, yet subtle *Judgment of Paris*. The expressionistic side of Niklaus' temperament is displayed in the panel *Death and the Maiden* (1517) in which the popular German theme is treated in nervous, impulsive calligraphy. Other artists from the same period whose works merit special notice include Hans Leu, Urs Graf, Mathias Grünewald, Hans Baldung Grien, and Lucas Cranach.

Works by the Holbein family have been a specialty of the Basle museum since the collection was founded. The collection today has more than 30 paintings and more than 250 drawings. The most renowned member of the family is Hans the Younger, but works by the father, Hans the Elder; an uncle, Sigmund; and an elder brother, Ambrosius, are also included. Hans the Elder's debt to Flemish models is evident in his *Death of the Virgin* (c. 1501) and *Portrait of a Woman*. The work of the eldest son, Ambrosius, is characterized by soft modeling and gentleness as seen in works such as *Portrait of a Boy with Brown Hair* (c. 1516). The spaciousness of Ambrosius' *Christ Interceding with God the Father* makes it particularly regrettable that he died at the young age of twenty-five.

The majority of Holbein works are by Hans the Younger, the prolific portraitist who lived in Basle off and on between sojourns in the capitals of Europe. The twenty-three compositions held by the museum show his unsurpassed accuracy as a portraitist and less-familiar outlets for his talents as well. The small *Passion Altarpiece* (c. 1525), acquired in 1770, portrays the complete passion cycle in eight scenes. The 1521 diptych *Christ as the Man of Sorrows* and the *Virgin*

Mary contain backgrounds of intricate architecture reflecting Holbein's interests in building design. The large *Body of Christ in the Tomb* (c. 1521) is a stark life-size anatomical study. The Basle museum also possesses the unusually sensuous *Adam and Eve* (1517), the Raphaelesque *Lais of Corinth*, and the handsome *Portrait of Bonifacius Amerbach* (1519). Two fresco fragments from the Basle Town Hall depicting historical scenes have also been preserved.

Comparatively few French or Netherlandish works from the Renaissance have entered the collection. The paintings deserving to be singled out include the *Saint Jerome*, attributed to Hans Memling; the charming *Virgin and Child with Angel Musicians* by Gerard David; an *Adoration of the Magi* by an early sixteenth-century Antwerp Mannerist; and a panoramic *Landscape* by Joos de Momper. The Fontainebleau School is represented by the *Portrait of a Lady*, believed to portray Diane de Poitiers, mistress to the French king Henry II between 1547 and 1559. This last work was donated in 1954 by the Freunde des Kunstmuseums.

The Italian and Spanish Renaissance is represented mostly by panels from the Faesch Museum and the Bachofen-Burckhardt legacy; however, no major works from southern Europe are represented until those of the Early Baroque period. El Greco's *St. James the Apostle* (c. 1600) and Caravaggio's *John the Baptist*, which was bequeathed in 1874 by Gedeon Meyer, indicate trends that characterize the seventeenth century.

Northern Baroque centers are more amply represented, although works by major masters are also few. The excellent Jan Fyt *Still Life with Fruit, Dead Rabbit, Parrot, and Cat* from the Bachofen-Burckhardt legacy, is characteristic of the Flemish Baroque in its large size and opulence. Smaller compositions by David Teniers the Younger and Adriaen Brouwer show the work of Flemish painters of lowlife.

The Dutch school is more impressively represented. Of particular interest is an unusual Rembrandt composition of 1627, *David Kneeling before Saul with the Head of Goliath*, a small study influenced by the young master's teacher Pieter Lastman. A group of fine landscapes were included in the collection of Hans von der Muhll bequeathed to the museum in 1914; they include Salomon van Ruysdael's *Road to Emmaus* (1643), Jan van Goyen's *Canal with Fisherman* (1635), and Jacob van Ruisdael's *Landscape with a Cornfield*. The Bachofen-Burckhardt legacy contributed numerous landscapes by lesser-known artists, such as Hondecoeter, van der Cross, Ostade, and Cuyp. From this same bequest came genre paintings by Steen, Wouwerman, Berchem, and others. The museum also has Frans van Mieris' *Young Lady with Glove and Feather Fan*, reminiscent of the work of Vermeer in its composition and lighting effects. A portrait that should be noted is *Frederick Bannier* by Gerard Ter Borch, donated with the von der Muhll legacy. There are also numerous still lifes, although none by artists of major importance, and religious scenes, such as Thomas de Keyser's *Thief on the Cross* and Salomon Koninck's *Baptism by the Apostle Philip*.

The holding of French Baroque paintings is small but includes some notable works. Hyacinthe Rigaud's *Portrait of the Chevalier Lucas Schaub* (1722) pre-

sents with Rigaud's customary dash and brio this native of Basle who was knighted by the king of England. Jean-François de Troy's *Diana and Acteon* (1734) is a Rococo rendition of a time-honored myth, and Hubert Robert's *Waterfall with an Artist Sketching* reflects the enthusiasm for nature in later eighteenth-century French society.

The Swiss and German schools once again hold a dominant position in the late-eighteenth- and nineteenth-century sections of the museum. Noteworthy landscapes by Caspar Wolf and Alexander Calame embody the tradition of heroic Swiss landscapes. The more tempered character of later nineteenth-century Swiss realism is evidenced in a large number of landscapes by various artists and by an especially attractive group of genre and anecdotal scenes by Albert Anker, including *Sleeping Boy in the Hay*, given by Johann Schetty-Eisenlohr in 1922, and *The Quack* (1879), purchased in 1880 with funds from the Samuel Birmann Foundation.

A number of artists with strong penchants toward the fantastic and imaginative elements of art are particularly well represented in the nineteenth-century collection. The earliest of them is Johann Füssli, whose *Prince Arthur and the Fairy Queen* (c. 1788) and *Woman in Moonlight* (c. 1800) are typical manifestations of his eery visions. The unusual collection of Nazarene art is almost entirely due to the many donations by Emilie Linder between 1849 and 1867. The monumental work by Joseph Anton Koch, *Macbeth and the Witches* (1830) was one of the first works donated to the new art museum in 1849. In succeeding years, works by other artists of the Nazarene circle whom Linder patronized and befriended were given; they include paintings and drawings by Friedrich Overbeck, Peter Cornelius, and A. J. Carstens. Arnold Böcklin, a native of Basle, holds a special place of honor in the collection, which contains more than sixty of his paintings, including some of his most famous inventions, such as the heavily charged psychodrama *Odysseus and Calypso* (1883) and the first version of *The Island of the Dead* (1880). The full range of this eclectic master's oeuvre can be appreciated in the Basle museum, from the light-hearted Rubenesque *Naiads at Play* (1886) to the dry and serious *Self Portrait in the Atelier* (1893).

Another renowned, transitional figure in the late nineteenth century who is especially well represented in the Basle collection is Ferdinand Hodler. Nearly thirty canvases from all of the main phases of the artist's career can be seen. Among the highpoints of the group are *The Brave Woman* (1886), *Disillusioned Spirit* (1889), *Yearning for Infinity* (1892), and *Dents Blanches near Chambery in the Morning Sun* (1916). A third of the Hodler collection was left to the museum by the Max Geldner bequest of 1958, and seven pieces were purchased with funds from the Samuel Birmann Foundation. Other Swiss artists in the collection who, like Hodler, are now recognized to have been significant forerunners of contemporary trends include Felix Vallotton, Cuno Amiet, and Augusto Giacometti.

Important French paintings from the early nineteenth century are few. Of special note are the oil sketch *Roman Shepherd* (1825) by Eugène Delacroix and

Venus Wounded by Diomedes Returns to the Heavens (1803) by Ingres. Two attractive works of the Realist school are Corot's luminous Italian view, *Olevano, la Serpentara* (1827), and Gustave Courbet's still life *Asters* (1853), which bears the inscription "à mon ami Baudelaire."

The Rudolf Staechelin Collection provides the core of the high-quality holdings of Impressionist and Post-Impressionist art possessed by the Basle Museum. The Impressionist movement is represented by works of Manet, Monet, Pissarro, Sisley, and Renoir. The various currents of the Post-Impressionist years are impressively illustrated by works of the period's leading masters. A group of ten Cézanne oils spans the great artist's career, from the straightforward *House of Doctor Gachet at Auvers* (1873) to the nearly abstract *Mont Ste.-Victoire* (c. 1905). The Basle *Five Bathers* (1885–87) is one of Cézanne's most monumental pictures involving the human form and is a predecessor to the *Great Bathers* in the Barnes Foundation, Merion, Pennsylvania. The excellent group of canvases by Paul Gauguin includes two well-known works from the Tahitian period: *Ta Matete (The Market)* and *Nafea Faa Ipoipo (When Are You Getting Married?)*, both of 1892. The latest self-portrait known by Gauguin, dating from 1903, is also in this group. Five superb works by Vincent van Gogh are highlighted by *La Berceuse (Madam Roulin)*, a robust portrait of the wife of a mailman in Arles painted in 1893, and *Mademoiselle Gachet at the Piano* (1890), an affectionate yet nervous portrait done while van Gogh was visiting in the north shortly before his death. Works by Edgar Degas, Odilon Redon, Édouard Vuillard, Pierre Bonnard, Henri-Edmond Cross, Paul Signac, and Henri Rousseau further illustrate the diversity of trends in the French school at the turn of the century. Significant works by James Ensor and Edvard Munch, two contemporaries of the French Post-Impressionists, are also included in the holdings of this period.

With increased government financial support and ongoing support from private citizens, the museum's acquisitions of art since 1900 have been the most thorough and methodical of any period. No widely recognized major trend of modern art has been neglected, and in most cases major works have been acquired.

The French Fauves are represented by works of Henri Matisse, Georges Braque, and André Derain; of special note are two Matisse *papier découpé* compositions and the Braque *Port of Antwerp* (1905). Canvases by the French Expressionist Georges Rouault are also noteworthy, particularly his *Christ on the Cross* (1913) and *Portrait of Paul Verlaine*.

German and central European Expressionism is an area of considerable strength. The names Ernst Ludwig Kirchner, Paula Modersohn-Becker, Emil Nolde, Alexej von Jawlesky, Wassily Kandinsky, Franz Marc, Oscar Kokoschka, and Paul Klee are among the best-known artists associated with the movement. The Klee collection is impressive in itself, in great part because of sixteen works that were included in the Richard Doetsch-Benziger legacy. Kokoschka's famous *Bride of the Wind* (1914) is also of particular interest. In addition, a large number of Belgian Expressionist pictures were acquired in 1946 as part of the Emanuel Hoffmann Foundation; they include works by Gustave de Smet, Frits van den

Berghe, and Constant Permeke. An early Expressionist composition by Casimir Malevitch, *Red Houses* (c. 1910), was purchased in 1964.

The holding of Cubist art in the Basle collection is of pre-eminent importance. The lion's share of these works came from the renowned collection of Raoul La Roche, a native of Basle who lived in Paris and donated eighty-six twentieth-century canvases in three groups (1952, 1956, and 1962). Important works also came from the Emanuel Hoffman Foundation. The first-rate works currently held by the museum are too numerous to list; among the many that could be cited are Picasso's *Fruit Dish and Bread on a Table* (1908), Braque's *Landscape at Estaque* (1908), and Juan Gris' *Bottle, Newspaper, and Fruit Dish.*

Offshoots of Cubism in the Paris School and elsewhere are also well accounted for. This very diverse group includes works of the so-called Orphic Cubists, such as Robert Delaunay's "catastrophic" view of the *Eiffel Tower* (1910) and the exuberant *Hommage to Bleriot* (1914). Nine works by Fernand Léger are dominated by the raucous contrasts of form and color of *Acrobat in the Circus* (1918) and *Mechanical Elements* (1918–23). The fertility of Marc Chagall's imagination is delightfully in evidence in major works such as the early *My Fiancée in Black Gloves* (1909) and the fanciful *Cattle Dealer* (1912). Six austere still lifes in the purist mode by Le Corbusier, and the same number by Amadée Ozenfant, all painted in the early 1920s, manifest a concern for rigor akin to that of the geometrical abstraction movement that gained momentum throughout Europe in the aftermath of World War I. The Basle collection displays the extent of this movement in excellent works by Piet Mondrian, Theo van Doesburg, El Lissitzky, Max Bill, and Joseph Albers. Abstract works by Wassily Kandinsky, Sophie Tauber-Arp, Jean Arp, and Lionel Feininger reflect stronger penchants toward fantasy or decorative lyricism in the abstractionist movement.

The twentieth-century Italian school is represented by a small number of important works that demonstrate how significantly Italians contributed to the early stages of modern art. Two Giorgio de'Chirico compositions emphasize the uniqueness of this forerunner of Surrealism, particularly the triangular-shaped *Enigma of Fatality* (1914). The baroque energy of Umberto Boccioni's *Forces of a Street* (1911), and the emphatic compositional rhythms of Luigi Russolo's *Houses-Lights-Sky* (1912), a gift from Sonia Delaunay in 1949, demonstrate the expressive vitality of Futurism.

The small Dada and Surrealist collection is not comprehensive but contains notable pieces. They include two collages by Kurt Schwitters dating from 1920 and 1935 and two excellent Joan Mirós, *Painting* (1925) and *Personnages and Dog before the Sun* (1949). A dreamscape by Salvador Dali, *Perspectives* (c. 1932); a biomorphic fantasy by Yves Tanguy, *Rendezvous of Parallels* (1935); and a ghoulish nightscene by Max Ernst, *The Deep Forest* (1927), are other significant works by core members of the Surrealist movement.

The Lyrical Abstraction school of post–World War II Paris is represented by a gathering of works as cosmopolitan as the movement was itself. Paintings by native Frenchmen include Alfred Mannessier's *Nocturne* (1951) and Georges

Mathieu's *Cardinal Mathieu and St. Bernard*. Among the notable works by foreign-born artists are the large *Composition in Green and Blue* (1952) by Serge Poliakoff, a Russian by birth; the collage *Composition* by Nicolas de Staël, also Russian-born; and the calligraphic *Painting 51–12* by the German Hans Hartung. An excellent early work by the Hungarian-born Constructivist Victor Vasarély, *Tlinko II* (1956), donated in 1965 by Carl Laszlo, manifests the endurance of geometrical abstraction through the decades.

The Basle collection of works by Joseph Beuys, the enfant terrible of the German avant garde, capsulizes the neo-Dada tendencies of American and European art in the 1960s. A large percentage of the Beuys collection was donated by the Emanuel Hoffmann Foundation. The collection consists largely of objects that defy traditional categories; many are of relatively early date for this major artist's oeuvre and are, therefore, of special interest.

Recent American trends are unusually well represented for an European museum. Besides the Abstract Expressionist paintings acquired in 1959, significant works by Sam Francis—*Deep Orange and Black* (1954)—and Mark Tobey—*Traffic I* (1954)—have entered the collection. Color-field paintings include Ken Noland's target painting *Sun* (1957) and the stripe painting *Winter Sun* (1962), both gifts of the Emanuel Hoffmann Foundation. Other notable examples of recent American painting include Cy Twombly's *Delos, Study Presence of Myth* (1959), Jasper Johns' *Figure 2* (1962) and *Céline* (1978), and Andy Warhol's *Ten-Foot Flowers* (1967). Among the examples of Hard Edge abstraction are Al Held's vast mural *Genesis* (1963), measuring more than nine feet high by twenty-four feet wide, and two compositions by Frank Stella, *Ifafa I* (1964) and *Arpoador I* (1975).

Important sculptures have entered the collection throughout the years, especially examples from the nineteenth and twentieth centuries. The outstanding pieces from the nineteenth century are the Daumier *Self Portrait* (c. 1855) in bronze and five castings in bronze by Rodin. The Rodins include *The Burghers of Calais* (1884–86), *Bust Portrait of Victor Hugo* (1897), and *Walking Man* (1900). Two sensuous nudes by Aristide Maillol from the first decade of this century follow in the classical tradition; one is a female torso, *L'Action enchaînée* (1906); the other is an adolescent boy, *The Cyclist* (1907–8). Also traditional in form, but strikingly direct emotionally, is an unusual sculpture by Ernst Ludwig Kirchner, *Two Friends* (c. 1925), in painted wood.

Sculptures in a more modern idiom include two small reliefs and two small figural statues by Jacques Lipchitz, from the Cubist collection of Raoul La Roche. A bronze relief by Raymond Duchamp-Villon, *The Lovers* (1913), was placed in the museum in 1964 by the Association of Friends of the Museum. Three Constructivist works by Antoine Pevsner have also been acquired, including the early relief *Head of an Italian Woman* (1915) and the rectilinear *Construction $Y = ax^3 + bx^2 + cx$* (1935) by Georges Vantangerloo. The Max Bill *Construction in and with a Cube* (1944–45) was donated in 1966 by Hans Arp.

Works of an expressly more evocative character include two excellent creations by Alberto Giacometti—the abstract *Woman in Repose Dreaming* (1929), a gift of Marguerite Arp-Hagenbach, and *Town Square* (1948). An unusual item is Hans Arp's very early *Dada Relief* (1916), a small, droll assemblage that shows a fondness for the sort of biomorphic form that characterized later work such as the large, six-foot *Ptolemy III* (1958). Henry Moore's bronze *Internal-External Forms* (1950) similarly combines compositional ingenuity with sensuous forms to produce three-dimensional poetry. Alexander Calder's mobile, *Five Branches with 1,000 Leaves* (1948), a gift of the Emanuel Hoffmann Foundation, makes a more lighthearted statement.

Acquisitions in the sculpture collection have attempted to keep up with recent trends. Works by Joseph Beuys have stressed the unorthodox tendencies of recent years, including environmental work like his *Feuerstatte*, assembled in 1974. Bruce Naumann's neon *Window or a Wall Sign* (1967), with its dead-pan humor and loveless material, makes a similarly blunt statement; and minimalist productions such as Carl Andre's *Cedar Piece* (1959–64) and Donald Judd's *Stacks* (1970) show an attempt to communicate experience through the depersonalization of form, content, and material.

The Print Room of the Basle Museum has a major collection of graphics, drawings, and illustrated books. Its areas of strength parallel those of the painting collection, with major acquisitions of German and Swiss works from the Renaissance, particularly by the Holbeins, Elder and Younger; drawings by Swiss artists of the eighteenth and nineteenth centuries; and works by the Nazarenes. In 1934 the museum purchased two lots of drawings by Cézanne, numbering more than two hundred pieces, which constituted the contents of three sketchbooks and miscellaneous drawings.

The museum library contains more than thirty-two thousand volumes dealing with European art history. The library collection also includes many thousands of exhibition catalogs, and periodicals.

Selected Bibliography

Museum publications: Boerlin, Paul H., and Schmidt, Georg, *Öffentliche Kunstsammlung Basel: Katalog, I. Teil, Die Kunst bis 1800*, 1957, and *III. Teil, Vom Impressionismus bis Zur Gegenwart*, 1961; *Catalogue de la Galérie de tableaux et de dessins au Musée de Bâle*, 1894; Christ, Rudolf, and Fischer, Otto, *Kunstmuseum Basel*, 1937; Meyer, Franz, *Öffentliche Kunstsammlung—Kunstmuseum Basel: Katalog, 19./20. Jahrhundert*, 1970.

Other publications: Boerlin, Paul H., "Emilie Linder: painter and patroness of the arts," *Apollo*, vol. 104, no. 178 (Basle issue) (December 1976), pp. 491–95; Chappuis, Adrien, *Les dessins de Paul Cézanne au Cabinet des Estampes du Musée des Beaux-Arts de Bâle* (Lausanne n.d.); Lapaire, Claude, *Schweizer Museumsführer*, 2d ed. (Berne 1969); Schmidt, Georg, *Museum of Fine Arts, Basle: 150 Paintings, 12th–20th Century*, Trilingual Edition: German-French-English (Basle 1964).

STEPHEN H. WHITNEY

——— Bern ———

MUSEUM OF FINE ARTS, BERN (officially KUNSTMUSEUM, BERN; MUSÉE DES BEAUX-ARTS), Hodlerstrasse 8–12, CH 3011 Bern.

The Bern Museum of Fine Arts was established in 1879 as a corporation under the supervision of the canton of Bern. The collection, which is notable for works by Swiss artists, examples of Early Italian and Northern painting, and art of the twentieth century, traces its origins to the early nineteenth century. During the Napoleonic period, plaster casts of antique sculptures were brought to Bern from France and were exhibited in a room of Bern's newly founded Art Academy, named the Antiquities Room (1810). A group of landscape works (watercolors and engravings) was added to this core collection, and later, works by contemporary Swiss artists entered the collection. The Antiquities Room, open from 1810 to 1864, offered students the opportunity of studying original works of art.

In addition to works housed in the Antiquities Room at the Art Academy, works from Bern's public institutions were exhibited from 1839 in the city-owned Antonierhaus. The Antonierhaus collection changed locations several times: from 1843–47 it was housed in a building on the Munsterplatz and included the collections of both the city of Bern and of Bern's Art Society; from 1848–49 the collection was kept on the Marktgasse; and from 1849–64, in the Upper Choir of the French Church, where it was first named the Bern Museum of Fine Arts. According to inventories, the collection expanded from 106 pieces in 1852 to 165 pieces in 1863. In 1864 the collection was moved once again to eight rooms in the Bern Parliament Building, where works from the Antiquities Room were added.

The idea of constructing a building to house the growing art collection was first suggested in 1836 to the Art Academy Committee by Karl Anton von Lerber. In 1853 construction of a new building was announced, and architectural plans were submitted. From eleven proposals, a design by Johann Jenzer was selected but the building was never executed. A second proposal for a new structure came in 1864 from Walter Munzinger, professor of history at the University of Bern. Professor Munzinger's twenty-page "Proposition for a new Museum Building" suggested concert rooms, meeting rooms, and a café, as well as a paintings gallery and a drawings cabinet. In 1872 the city contributed a building site, and in 1875 funds were generously provided by an architect, Gottlieb Hebler, who bequeathed his entire fortune (350,000 francs) for the project. That year, the Bern Museum Corporation was formed, and a competition was held for the design of the new building. The corporation awarded the commission to Bern architect Eugen Stettler for his design, a magnificent, two-story, neoclassical building. Construction took place from the spring of 1876 to the fall of 1878. The facade decoration was completed with sculpted medallions representing Zeus

and Minerva by Bern artist Raphael Cristen. The opening ceremony for the museum was held on August 9, 1879.

In 1895 three allegorical marble figures representing Painting, Architecture, and Sculpture by the sculptor Alfred Lanz were placed in niches on the main facade. An annex was added to the original building in 1933–36, constructed after designs by the Bern architects Karl Indermühle and Otto Salvisberger. The facade of this new wing in a "modern" style was decorated in 1936 by Swiss painter Cuno Amiet, with a composition executed in *sgrafitto* technique, *The Apple Harvest*. On October 29, 1983, a new west wing, designed by the architectural team "Atelier 5," was inaugurated. It replaces the earlier annex from the 1930s and offers increased exhibition space, as well as a number of special facilities. The design of this new wing blends with the neoclassical style of the original museum building and architecturally offers a roomy environment that makes maximum use of daylight. A new library, a study room for the graphic arts collection, seminar rooms, and a 130-seat viewing room for film and video are housed in the wing, as are a café and a large bookstore.

The museum's collection expanded considerably in the twentieth century and benefited from generous gifts, including, in 1903, a collection of Italian paintings from Adolf von Stürler, as well as funds and artworks from the Gottfried Keller Foundation. In 1944 the plaster casts of antique sculptures, the core of the Bern collection, were moved to storage (in the Kirchenfeld Gymnasium). The Paul Klee Foundation was instituted at the Bern Museum in 1952 and in 1962, the Hermann and Margrit Rupf Foundation, an exceptional collection of Cubist and other twentieth-century works, was added to the museum. Subsequently, the Professor Max Huggler Foundation was set up (1967) followed by the Adolf Wöfli Foundation in 1975 (a collection of graphic art), the Othmar Huber Foundation in 1979, the Annemarie and Victor Loeb Foundation in 1981 (rich in contemporary art), and the Emil Bretschger Foundation in 1982.

Today, the Bern Museum, a corporation, is supervised by the city of Bern, the government of the canton of Bern, and the burghers of Bern, along with the Bern Art Society and the Association of Friends of the Bern Museum. The museum is headed by a director. His staff includes a curator of paintings and sculpture and a curator of the graphic arts collection. Four assistants, one for the Klee Foundation, aid these curators. The museum also houses the Art History Department of the University of Bern.

The museum's collection includes a group of Early Italian paintings that began with a bequest in 1903 from Swiss artist Adolf von Stürler. Stürler lived in Florence from 1829 to 1853, forming his collection of twenty-three paintings. The small *Maestà* by Duccio di Buoninsegna dates from 1285–95, a fine example of this artist's Late Gothic style. A portable altar by Jacopo del Casentino includes the *Coronation of the Virgin* on its central panel, with St. Martin, the Communion of Mary of Egypt (?), and the Angel of the Annunciation on the left wing and Christ on the Cross and Mary on the right wing. The enthroned *Madonna and*

Child with Four Angels and Eight Saints is by Taddeo Gaddi. Several compositions are by Bernardo Daddi, including two wings of an altarpiece with full-length representations, *St. Dominic* and *St. Paul* (probably wings for the half-length *Madonna* in the Vatican [q.v.]). *Christ on the Cross* is by Daddi, as is a portable altar with *Christ on the Cross and Saints* (left wing: Apostles Peter and Paul and the Angel of the Annunciation; right wing: Madonna and Child with Mary Annunciate).

A portable altar by Allegretto Nuzi (active in Florence 1345–72) includes *Christ on the Cross with Mary, John, and Mary Magdalene*; on the left wing are Saints Francis and James and the Angel of the Annunciation, and on the right wing, Bartholomew and Helen with Mary. The half-length *Blessing Christ* is by Nardo di Cione (c. 1335), and a small panel with the *Coronation of the Virgin* is by the Master of the Madonna of the Misericordia. Two triptych wings with *Saints Lawrence, Nicholas of Bari, and Julian* (left) and *Christ on the Cross, Mary, Mary Magdalene, and John* (right) were painted by Lorenzo di Nicolo. A delicate *Madonna and Child* from 1435–45 was executed by Fra Angelico. Filippi Lippi painted the *Saint in Cardinal's Robes*, a single panel that most likely was once part of a triptych. A fragment by Sandro Botticelli is the *Madonna and Child with an Angel Holding a Crown*, and a second fragment shows a group of four angels. These two works, characteristic of Botticelli's delicate, linear style, date from 1482–85. Giovan Antonio Boltraffio, a Milanese student of Leonardo da Vinci, painted the bust-length *Portrait of a Young Man*, an elegant and detailed work on panel. Venetian paintings include the *Procession of Men Carrying Crosses*, a work by an unknown artist with an intriguing yet unidentified subject, and a *Holy Family*.

A small group of Spanish paintings is in the Bern museum and includes two panels from an altarpiece, *St. Barbara* and *St. John the Evangelist*. These works by an unknown artist date from the second half of the fifteenth century.

Northern paintings of the fifteenth and sixteenth centuries are well represented at Bern with examples acquired through both purchases and as gifts. The core of the collection is composed of works purchased by the city of Bern in 1846 from collector Theodore von Hallwyl. Paintings include the *Portrait of Martin Luther* from the workshop of Lucas Cranach the Elder dating from 1529 and the representation *Judith with the Head of Holofernes* by Vincent Sellaer, a work influenced by the school of Leonardo. A *Portrait of a Woman* from about 1550 is by the Cologne artist Barthel Bruyn the Elder, and a *Last Judgment* from about 1570, from the Hallwyl Collection, is by Crispin van der Broeck.

The Bern Museum houses an excellent group of works by Swiss and South German artists that were at one time in the churches of Bern. Among them is an altar wing from 1496 with *Raising of Lazarus* and *Noli me tangere* by an anonymous artist. Hans Fries, a German artist, executed the *Christ Carrying the Cross* from 1502, a work originally in the Church of St. Anthony, Bern. The panel was acquired in 1932 through the generosity of the Gottfried Keller Foundation. The *All Souls' Altar* from 1505 is by the Bern Master and is from the

Altar of St. Catherine and St. Barbara in the Bern Cathedral (acquired 1935). A fragment, the *Departure of Christ from His Mother*, includes a marvelously detailed view of a castle and landscape and is by Jörg Ratgeb. The work was lent to the Art Museum by the Catholic Church Council of Bern from 1880 to 1932 and was then acquired by the city of Bern for the museum.

Niklaus Manuel Deutsch, an artist who worked in Bern in the early years of the sixteenth century, is represented in the Bern Museum by numerous works. Among them are two wings from the Altar of St. Anne (1515–20): the left wing includes, on the exterior, *St. Eligius in His Workshop* (dated 1515) and, on the interior, the *Meeting at the Golden Gate*; the right wing includes, on the outside, *St. Luke Painting the Virgin* and, inside, the *Birth of the Virgin*. The left wing was acquired by the museum in 1936 (formerly in the Gottfried Keller Foundation), and the right wing was in the collection of Theodore von Hallwyl (purchased in 1846). A left altar wing from about 1515–16 includes the *Martyrdom of St. Ursula* and the *Beheading of St. John the Baptist*; the richly detailed composition is typical of Manuel's Late Gothic style. A *Portrait of a Man* from 1515 by Manuel suggests in its bust-length format and flat, linear style the influence of Hans Holbein. This work, acquired through a descendant of the artist Carl Manuel, was purchased for the Bern Library in 1697.

Other works by Niklaus Manuel include two wings from the altar of St. Catherine (c. 1516) with the *Martyrdom of the Ten Thousand* and the images *St. Achatius* and *St. Barbara*. Four panels from the High Altar of the Dominican Church in Bern include the *Conversion of Saul* (c. 1516–17), the *Adoration of the Magi*, Pope Innocents III's Dream of St. Dominicus Supporting the Lateran Church, and the *Sending Out of the Apostles*. Among the other works by Manuel in Bern is a *Self Portrait* from 1520.

Paintings by other Bern artists include panels with *St. Christopher* and *St. Peter* from about 1480, a gift from the Burghers of Bern (formerly in a Bern church). Works by the Bern Master of the Carnation (''Berner Nelkenmeister''), who worked in the late fifteenth-early sixteenth century, include the *Annunciation to Zacharius*, part of the St. John Altar from about 1490. From the same altar are panels with the *Baptism of Christ*, the *Naming of St. John the Baptist*, and the *Presentation of John Before Herod*.

Swiss paintings from the late sixteenth century include works by Joseph Heintz the Elder, an artist born in Basel who worked in Rome and later Bern. The *Path of Man to Hell* dates from after 1592 and, in its complex arrangements of figures, includes a self-portrait of the artist (center right). The *Vision of Truth* is from 1590–96. Heintz's *Portrait of a Man* is from 1596, as is its pendant, *Portrait of a Woman*; the bust-length *Self Portrait of the Artist with His Brother and Sister* dates from 1596.

European paintings from the eighteenth century in the Bern collection include a small group of French works. Hyacinthe Rigaud's *Portrait of a Man* is executed on paper over canvas. Two portraits are by Jean-Étienne Liotard, his *Portrait of Catherine, Countess of Guilford*, and his *Portrait of Simon Luttrel of Lut-*

trellstown (Ireland). Élisabeth Vigée-Lebrun's *The Alphirten Festival in Unspunnen*, executed in 1808, is housed at Bern. Jacques Sablet painted his *Allegory of the Art City, Bern* in 1781.

German paintings from the seventeenth and eighteenth centuries include Johann Kupetzky's *Portrait of a Man with a Red Cap* and Johann Heinrich Tischbein's *Portrait of the Artist's First Wife*. Two landscapes by Caspar Wolf show the scenery near Weissenburg.

The museum holds a fine selection of works by Swiss artists in addition to works noted above. From the seventeenth century are still lifes by Joseph Plepp and Albrecht Kauw. Joseph Werner's *Allegory of Justice* is dated 1662. Also by Werner is a *Temptation of Christ*, a *Self Portrait*, and a mythological subject taken from Ovid's *Metamorphosis, Pan and Syrinx*. Johann Dünz's *Portrait of H. R. Nägeli* is dated 1677, and his *Portrait of Dorothea Berseth* is from 1706.

Swiss minor masters of the eighteenth century are well represented. Several canvases by Johann Ludwig Aberli include the *Portrait of Samuel Bernhard Walter* (1762) and the *Landscape near Thun*. Franz Niklaus König's *Portrait of Mr. Rohn Müslin and the Young Haller* is executed on panel and dates from 1806. Also by König is a winter scene, *Sledding on the Engistutz, Bern*.

Works from the nineteenth century include canvases by Adolf von Stürler (an early benefactor of the museum): the portrait *Artist's Mother* from 1828 is in the collection, as is a mythological subject representing *Arethusa* before she was transformed into a spring. Arnold Böcklin is represented by two haunting images, the *Pietà*, signed and dated 1877, and the *Mermaid* from 1886–87, both on panel. *The Antiques Dealer, Portrait of G. Borrer of Solothurn*, dated 1865, is by Frank Buchser, as is the *Portrait of General Sherman, Commander of the Armies of the North during the American Civil War* (1869). Numerous canvases by Albert Anker are in the collection, among them, the *Boy Blowing Bubbles* (1873), *Old Woman near the Hearth* (1885), and *The Tailor* (1885). Anker's theme of children in school is represented by several works, including *The Exam* and the *Children's School near the Church*. A still life by Anker is executed in the artist's clear, exact style, and a portrait *The Blond Girl* is rendered in that same style infused with delicacy. An idealistic portrait, *The Young Worker* (1880), is by Karl Stauffer, as is the *Portrait of the Artist's Mother* (1885).

Bern has a fine, representative collection of works by Ferdinand Hodler. Among them is his self-portrait *Angry Man* and his canvas *Praying in the Canton Bern*. *Girl with a Blossom* was executed by Hodler in 1880, and *Emotion* dates from 1894. Hodler's large works *Night* (1898/99) and *Day* (1899) are in the collection, as are the *Disappointed Souls* from 1892 and *The Chosen* of about 1893.

Swiss paintings of the twentieth century feature Cuno Amiet's works: *Adam in Paradise*, *Early Sun*, and *The Painter in the Garden*. Also by Amiet is an interior scene with a portrait of a fellow painter, *Giovanni Giacometti in His Paris Apartment*. Max Buri's scene of four men in a cafe, *After a Funeral at Brienz*, is from 1905, and his portrait *The Artist's Sister* is from 1913. The

Woman Reading (1906) is by Félix Vallotton, and the *Self Portrait* of the artist dates from 1923. The *Self Portrait* by René Auberjonois is from about 1940. Works by Paul Klee in the museum include *Flora am Felsen* (*Flora on a Rock*), executed in oil and tempera on burlap (1940), and *Ad Parnassum* from 1932. (Other works by Klee are held separately by the Klee Foundation at the museum.) A generous gift from Marguerite Arp-Hagenbach brought several works by Sophie Taeuber-Arp to Bern. Taeuber-Arp's works include *Composition Aubette*, a collage from 1927; *Composition with Circles, Small Circles, and Rectangles* (1930); and *Schematic Composition with Circles and Multiple Rectangles* (1933).

European paintings from the nineteenth and twentieth centuries at the Bern Museum include Eugène Delacroix's *Death of St. John the Baptist* (1856–58), a recently acquired canvas. *The Dream* is by Gustave Courbet and dates from 1866. Jean François Millet executed in 1845 his *Portrait of Friedrich Wanner, Swiss Consul at Le Havre*. Carl Spitzweg's *The Fragrance of a Rose, Remembrance* is dated about 1849, and Wilhelm Trübner painted the scene *Hemsbach Castle*. *A Butcher Shop in Dordrecht* was painted in 1877 by Max Liebermann.

French Impressionist works include Édouard Manet's *Path in the Garden* from 1882 and Claude Monet's *River in Winter* (1882). Camille Pissarro painted his *Landscape at La Varenne-St. Hilaire* about 1865 and his *Peasant Woman in an Interior* in 1882. *The Bay of Langland, the Rocks* is by Alfred Sisley (1897). The *Self Portrait* by Paul Cézanne from 1879–82 and a still life by that artist are in the collection, as are *Sunflowers* (1887) and a *Peasant Woman*, both by Vincent van Gogh. Three works by Édouard Vuillard are the *Woman Reading*, the *Portrait of Félix Vallotton* (c. 1900, oil on cardboard), and the *Salon of Félix Vallotton at Romanel*. *In the South Garden* is by Pierre Bonnard. Several works by Maurice Utrillo are in the collection, among them, *Faubourg de Paris*, a painting on wood from about 1910, and *Rue du Chevalier-de-la-Barre*, in oil on canvas from about 1911. Utrillo's *La maison rose rue de l'Abreuvoir* dates from about 1912. A number of works in oil on cardboard by Utrillo are also at Bern. Henri Matisse is represented particularly by works from the 1920s: *Reader at a Table* from 1921, *Carnival at Nice* from about 1921, *Landscape with a Tree* from 1922, *Anemones* from 1924, and *Still Life with Oysters* from 1926.

The Bern Museum houses a group of paintings by Surrealist artists that offer virtually a survey of that artistic style. Salvador Dali's *Atavism between Two Lights* is from 1933–34. Works by André Masson (*Composition*, 1933), Joan Miró, Kurt Seligmann, and the Swiss Surrealist painter Otto Tschumi are featured.

German paintings from the early twentieth century include Ernst Ludwig Kirchner's *Alpsonntag, Scene on the Brunner* from 1918–24, executed in oil on paper laid on cardboard. Franz Marc's *Blue Horse* from 1911, *Forest with a Bird* from 1912, and *The Dream* from 1913 are at Bern.

American painting is represented at Bern by a group of works by Abstract Expressionist and color-field painters. Canvases by Jackson Pollock, Frank Stella, Mark Rothko, Morris Louis, and Ad Reinhardt are featured.

The Graphic Art Collection at the Bern Museum includes more than seven thousand drawings and watercolors, fourteen thousand prints, and more than six hundred illustrated books. The collection is strong in works by Swiss artists, although some excellent examples by European artists are housed here as well. Among them are four drawings by Jean Auguste Dominique Ingres: *Study of an Angel*, rendered in crayon with white highlighting, is a preparatory sketch for the artist's painting *The Wish of Louis XIII* (1824); *Study of a Woman* is a preparatory drawing for the painting *L'age d'or* (1840–50). Also by Ingres are two portraits *Mathilda von Stürler* (1861) and *Adolf von Stürler* (1849). The *Portrait of a Woman* by Vincent van Gogh is a strong, almost geometric representation executed in crayon with color.

Swiss drawings include from the seventeenth century a pen-and-ink sheet by Hans Jacob Dünz and Conrad Meyer's ink drawing *Dietrich Meyer with the Portrait of His Son Conrad Meyer*. Works by Joseph Werner include the three-quarter-length profile *Portrait of a Woman* in pen and ink (signed and dated 1676) and his ink drawing *Allegory of War* (1668). Johann Ludwig Aberli's ink-and-watercolor scene *Berner Bauernhaus* and his *Study for a View near Tours* date from the eighteenth century. *The Surprise*, an ink study by Sigmund Freudenberger, is dated 1789. Also by Freudenberger is a black crayon drawing with white highlighting, *Young Woman*. A pencil sketch by Balthasar Anton Dunker is the *Woman Reading*.

Swiss drawings from the nineteenth century include works by Karl Stauffer. A *Self Portrait* was executed in black crayon as a study for an engraving by M. Lehrs. *Girl with Raised Arms* is a spare, linear rendering. A pencil sketch by Albert Anker is the *School Boy*. Several sheets in the collection by Ferdinand Hodler were executed as preparatory works for paintings now in the Bern Museum. Among them is a pencil study for the *Weariness of Life* and a pencil study of a figure for *The Chosen*. A *Head of a Woman* was executed as a study for Hodler's *Portrait of the Artist's Wife*. Prints in the collection include works by Swiss and other European artists. Among them are sheets by Pablo Picasso, Sophie Taeuber-Arp, and others.

The Bern Museum has a representative collection of nineteenth- and twentieth-century sculpture. Works include Aristide Maillol's bronze *The Three Nymphs* (1936–38) and Wilhelm Lehmbruck's *Female Torso* (1913–14). *June*, a bronze portrait bust, is by the Belgian sculptor Constantin Meunier. The bronze *Mother and Child (Madame Renoir and Their Son Pierre at Essoyes)* is by Pierre Auguste Renoir. The bronze *Head of a Girl (Marguerite)* is by Henri Matisse (1906). The Surrealist sculptor Meret Oppenheim is represented by *The Green Spectator*, in oil and wood (designed 1933). The bronze *Woman of Venice I* by Alberto Giacometti is from the artist's series *Women of Venice*, and a monumental piece, *For the Staircase*, is by Alexander Calder. A group of sculptures by Swiss artists of the nineteenth century includes Heinrich Imhoff's *Eve before the Fall* (1865), Karl Stauffer's *Adrian von Bubenberg* (1890), as well as works by twentieth-century Swiss artists Charles Albert Angst, Arnold Huggler, Milo Martin, Eduard

Bick, and others. Twentieth-century sculptures by Jacques Lipchitz, Julio Gon-
zalez, Kurt Seligman, George Sugarman, Louise Nevelson, and Isabelle Wald-
berg are also in Bern's small but fine sculpture collection.

The museum's collection of twentieth-century art was greatly expanded in
1964, when the Hermann and Margrit Rupf Foundation was established at the
museum. Hermann Rupf began collecting art in 1907 with prints by Bastien-
Lepage, Cézanne, Steinlen, Toulouse-Lautrec, and others and, through his
friendship with the Parisian art dealer Henry Kahnweiler, began to collect con-
temporary paintings.

Major artists of the Paris School are represented. Georges Braque's works
include *Houses at L'Estaque*, a Cubist canvas from 1902; *Guitar and Compote*
from 1909; and *Violin and Bow* from 1911. Works by André Derain feature *The
Road (Landscape near Cassis)*, from 1907, and *The Hills*, a Fauve work from
1908. Other examples of Derain's work include, from 1913, *The Ink Bottle*, a
still life. Numerous works by Juan Gris include *The Three Cards*, a Cubist
canvas from 1913, as well as the *Portrait of Mme. Josette Gris*, from 1916.
Several still lifes by Gris are in the collection, among them, *Guitar and Flacon*,
from 1921, and *The Open Book*, from 1925. A landscape from 1908 executed
in watercolor on paper is by Pablo Picasso, as is a mixed media piece, *Violin
Attached to a Wall*, from 1913. Picasso's *Head of a Young Girl*, from 1929, is
among the many other works by this artist in the Rupf Foundation.

Fernand Léger's Cubist period is represented by *Contrast of Forms*, an oil on
canvas from 1913. A still life from 1922 shows his change in style toward the
geometric, "mechanic" mood of the 1920s, and his still life from 1946 reflects
the artist's later interest in relationships between line and color. The American
painter Lyonel Feininger is represented by *Architecture with Stars* from 1917.
Paintings by French Surrealist André Masson include *Sous-bois* from 1923 and
Fish Drawn on Sand from 1927, a painted sand relief exemplifying the artist's
concept of "automatic writing," which he practiced from 1926 to 1929.

Wassily Kandinsky's paintings include an untitled work from his Blaue Reiter
period (1916, watercolor on paper). Also in the collection is *Color Sounds* (1929),
Divided Horizontal (1935), and *Light Constructions* (1940). Works by Paul Klee
in the Rupf Foundation are numerous and feature a watercolor on paper from
1915, *Niesen*, and from 1922, *Luftschloss*, executed in oil on plaster-grounded
gauze. Klee's *Kopf (vor dem Erwachen)* is a sensitive, abstracted portrait of a
woman dating from 1929.

The Rupf Foundation incorporates a large and excellent collection of prints,
monoprints, and illustrated books. Among them are works by Georges Braque
such as his color lithograph from 1921, *Still-life III, Glass and Fruit*. Cézanne's
lithograph *The Bathers*, from 1890–1900, is included, as is Derain's woodcut
Nudes in a Landscape, Five Figures (c. 1906). Printed books include Guillaume
Apollinaire's *L'enchanteur pourrissant*, with art by André Derain (1909). Graphic
works by Juan Gris include a lithograph, *Marcelle, the Blond*, from 1921, and
aquatints for Tristan Tzara's *Mouchoir de nuages, Tragedie en 15 actes*. An

engraving by Paul Klee, *Weib und Tier, 1. Fassung Juli 1903*, is in the collection, as are prints by Fernand Léger, Franz Marc, André Masson, Henri Matisse, and Pablo Picasso.

Examples of sculpture in the Rupf Foundation feature works by Hans Arp and Henri Laurens. Arp's *Collage*, about 1915, exemplifies the artist's *papier collé* technique. Wood reliefs by Arp include *Mme. Torse in a Hat* from 1916 and *Flower-Animal* from 1953. Henri Laurens' pieces include his stone sculpture *Woman with Earrings* (1921) and a bronze from the same year, *Reclining Woman*. A polychromed relief from 1922 is titled *The Basket*, and a white marble sculpture from 1949 is an example of Laurens' late, more linear style. Manolo (Manuel Martinez Hugue), the Barcelona sculptor, is represented by his sensuous bronze from 1912, *Leda*. Also in the Rupf Foundation are portraits by sculptor Max Fueter, *Margrit Rupf-Wirz* (1922) and *Hermann Rupf* (1935), as well as works by Othon Friesz, Oscar Lüthy, Ewald Matare, Louis René Moilliet, Ben Nicholson, and others.

The Paul Klee Foundation at the Bern Museum was established in late 1947, seven years after the death of the artist, and came to the museum in December 1952. Today, the collection includes 40 paintings, 163 color works, 2,253 drawings, 10 sketchbooks, 11 sculptures, 89 prints, and other works. Klee's paintings and works on paper are also housed in the museum's collection, as well as in the Rupf Foundation. The Klee Foundation's collection ranges from student works to pieces created the year of the artist's death.

Among the earliest works in the collection is Klee's *Baumgruppe* (*Group of Trees*) from 1899. Other early paintings and mixed media works include *Portrait of the Artist's Sister* from 1903. A watercolor done in 1913 is the *Im Steinbruch* (*In the Stone Quarry*), and from 1914 is a complex composition of forms, *Teppich der Erinnerung* (*Tapestry of Remembrance*). Klee's early sculptures in the foundation include a plaster piece from 1915, *Unruhe des Gedankens* (*Disturbance of Thought*), as well as an abstract, polychromed plaster *Figure*.

The period 1921–33 is represented by numerous works. *Perspective of a Room with Inhabitants* is from 1921, and *Puppet Theatre* from 1923 is executed in watercolor on a black ground. *Tor im Garten* (*Gate in the Garden*) is rendered in oil on paper and dates from 1926. Small sculptures, including two plaster reliefs, date from this period.

The mature period, 1934–40, includes Klee's pencil-and-watercolor on paper *Trauernd* (*Grief*). *Ruhende Sphinx* (*Sleeping Sphinx*), an oil on canvas, is from 1934. *Coelin-Frucht* (*Cerulean Fruit*) dates from 1938, as does *Vorhaben* (*Intension*), a mixed-media work. From 1940 is *Paukenspieler* (*Tympanists*), a composition of red, black, and white symbols.

The Klee Foundation's large collection of drawings includes the artist's early sketchbooks. Sketchbook I from 1892 includes observations of the landscape and cityscape, for example, number 21, *The Old Cathedral in Bern*, and number 35, *Church in Baumgarten*. Other sketchbooks include pencil drawings of the Swiss landscape. Single sheets, both finished drawings and preparatory works,

are housed at Bern. Prints include two etchings from 1903, *Two Men Meeting, Each Believing the Other to Be of Higher Rank* and *Young Woman in a Tree.* Etchings executed in 1905 include the *Senile Phoenix.*

The Anne-Marie and Victor Loeb Foundation, added to the museum in 1981, brought numerous modern and contemporary works of art. A construction by Alexander Archipenko in oil, wood, and metal on wood dates from 1912. Joseph Albers' *Study for "Hommage to the Square"* (two oranges against pale yellow, 1953–55) is in the collection, as in Sophie Taeuber-Arp's *Composition of Rectangles, Squares, and Circles* (1936). The English painter Ben Nicholson is represented by *White Relief* from 1935, an acrylic on wood. American artists represented include Mark Rothko (*Red over Black*, 1961) and Frank Stella (*Study for "New Madrid"*). Works by Jean Dewasne, Karl Gerstner, Jean Gorin, Alfred Jensen, Richard Paul Lohse, and Roland Werro are in the collection, as are several works by Victor Vasarély.

The Loeb Foundation is rich in works of contemporary sculpture, as well as in modern pieces. Marcel Duchamps' *Rotoreliefs* from 1935–65 are included, as are sculptures by Yaacov Agam, Pol Bury, Sergio de Camargo, Christo, Yves Klein, Piotr Kowalski, Louise Nevelson, George Rickey, and Jean Tingueley.

The facilities of the Bern Museum include in the new wing a viewing room for film and video. A library of more than twenty-eight thousand volumes is maintained by the museum and the Art History Department of the University of Bern and is open to students and scholars and, on Fridays, to the general public.

The museum has an active publications program. A news bulletin, *Berner Kunstmitteilung*, is produced six to eight times a year and provides information on works in the collection and offers articles on special exhibitions, recent acquisitions, and so on. A publication, *Paintings*, from 1983 lists and illustrates all of the works in the museum's various collections. The Bern Museum began publishing scholarly catalogues of works in the collection in 1974, and to date, three catalogues are complete: *Italian Paintings, 13th–16th Centuries; Paintings, 15th and 16th Centuries (except Italian)*; and *European Paintings, 19th Century (except Swiss)*. Forthcoming volumes include: *Paintings, 17th and 18th Centuries; European Paintings, 20th Century (except Swiss); Swiss Paintings, 19th and 20th Centuries; Sculpture*; and *Watercolors and Drawings*. A list of publications, including exhibition catalogues, is available from the museum.

A large bookstore in the new wing of the museum offers a wide selection of art reference books, as well as museum publications, posters, and postcards. A forty-seat café is also located in Bern's new west wing.

Selected Bibliography

Museum publications: *Aus der Sammlung*, 1940; Huggler, Max, *Aus der Sammlung*, 1960; *Berner Kunstmitteilungen*, 1955-present; *Gemälde des 15.–16. Jahrhunderts*, 1974; Glaesemer, Jürgen, *Paul Klee, Die Farbigen Werke bis 1920*, 1973; idem, *Paul Klee, Handzeichnungen I, Kindheit bis 1920*, 1973; idem, *Paul Klee, Handzeichnungen II, 1921–1936*, 1984; idem, *Paul Klee, Handzeichnung III, 1937–40*, 1979; *Hermann und*

Margrit Rupf-Stiftung, 1969; *Italianische Malerei 13.–16. Jahrhunderts*, 1974; Kuthy, Sandor, *Die Gemälde*, 1983; idem, *Gemälde des 19. Jahrhunderts (ohne Schweiz)*, 1983; idem, *Das Kunstmuseum Bern, Geschichte seiner Entstehung*, 1971; idem, *Paul Klee im Kunstmuseum Bern*, 1970; Meier, Andreas, *Graphische Sammlung*, 1983; *Verzeichnis der Kunstgegenstände des Kunstmuseums zu Bern*, 1879.

LORRAINE KARAFEL

──────── **Geneva** ────────

GENEVA MUSEUM (officially MUSÉE D'ART ET D'HISTOIRE DE LA VILLE DE GENÈVE; alternately THE MUSEUM OF ART AND HISTORY OF THE CITY OF GENEVA; also MUSÉE DE GENÈVE, MUSÉE DES BEAUX-ARTS DE GENÈVE), Rue Charles-Galland 2, Geneva.

The Museum of Art and History of the City of Geneva has the most comprehensive public collection of art in Switzerland. Economic and religious strictures in the "City of Calvin" inhibited municipal patronage and acquisition of art to some extent during the eighteenth and nineteenth centuries, but the cosmopolitan element of Geneva society managed to prevail during this period, and a significant collection was formed.

Administratively, the Museum of Art and History today is a complex of museum institutions covering a broad spectrum of subjects, some of which lie outside the visual arts. The member institutions are the following: the Museum of Art and History, known as the Geneva Museum, which houses the main collection of fine arts and archaeology; the Rath Museum, a neoclassical building erected in 1826, which served as the city museum until 1910 and is now used for temporary exhibitions; the Ariana Museum, formerly a private art museum, bequeathed to the city and later converted to a museum of ceramics; the Museum of the History of Science; the Museum of Watches and Clocks; and the Museum of Antique Musical Instruments. Two other museums are to be added in the near future. The Museum of Old Geneva, devoted to local history, will be housed in the city's oldest standing private residence, the Maison Tavel, which is currently being renovated. The Museum of Modern Art, whose future location is as yet undetermined, will exhibit art created after 1945.

The Museum of Art and History is also administratively responsible for the Art and Archaeology Library, a research collection originally established for the use of the museum staff. Since 1911, however, it has functioned as a public lending library and today contains about forty thousand volumes, twenty-five hundred periodicals, and eighty thousand slides. It is located in an annex near the main building.

The main building, which houses the archaeological and fine arts collections, was designed in a classical Beaux-Arts style by Marc Camoletti. Its construction

was completed in 1910. A large portion of the cost was paid for by the estate of Charles Galland, who died in 1901 bequeathing money to the city of Geneva specifically for the purpose of funding the construction. The new building made possible the consolidation under one roof of a number of fine arts, decorative arts, and archaeological collections dispersed throughout the city.

The first recorded acquisition of art by the city of Geneva took place in 1535. Workmen repairing a road in that year dug up a group of "antique medals," presumably Roman, and sold them to two local collectors. The city confiscated the medals and declared that all such finds were municipal property.

In the late nineteenth and early twentieth centuries, archaeological activities of the University of Geneva and purchases of antiquities by Geneva collectors abroad enriched the various municipal holdings. Growth in this area remained particularly intense throughout the first half of the present century while the museum was headed by a succession of archaeologists, among them the noted Waldemar Deonna.

The city's fine arts collection grew slowly until the mid-eighteenth century, when private citizens founded the Société des arts de Genève. By 1787 the society had established an art school and a museum to house the school's pedagogical collection. In 1810 the city of Geneva, then under French control, received a major donation of paintings through the interest of Emperor Napoleon, whose interior minister designated Geneva as one of three non-French cities to receive an allotment of art from Paris for public education. Geneva did not remain in the French Empire long, but the paintings consigned to it under Napoleon provided new and permanent substance to the municipal art collection.

The Société des arts and the city officially consolidated museological efforts in 1824 and began construction of the Rath Museum, one of the earliest public art museum buildings in Europe. Named after Henriette and Jeanne Rath, the principal donors of funds for its construction, this neoclassical edifice served as an athenaeum of the arts through the remainder of the nineteenth century. During these years, the majority of the museum's major works were acquired, many entering the collection as donations from artists and collectors. The area of most significant growth during this period was Swiss art, for which government encouragement was strong. Additions in other areas resulted from contributions by collectors such as Guillaume Favre (1770–1851), François Duval (1776–1854), Walther Fol (1832–89), and Gustave Revilliod (1817–90). The Revilliod bequest consisted of a large and varied collection of minor arts, as well as paintings and sculptures, and included the mansion Revilliod had erected to house his collection. Called the Ariana Museum in memory of Revilliod's mother, this sumptuous Italianate palace has been converted to a museum of ceramics and is slated for extensive architectural renovation.

The Department of Archaeology today oversees a collection of unusual breadth. From prehistorical periods, more than twenty thousand artifacts have been acquired, mostly from the region of Geneva and surrounding areas of France.

Objects of special interest include a bronze cuirass (tenth to eighth century B.C.) from Fillinges in the Haute-Savoie district of France and a wooden statue of a goddess (first century B.C.) that was excavated in Geneva.

The Egyptian collection numbers more than twenty-five hundred objects dating from the Predynastic through the Egypto-Roman periods. Most of the objects are small, but the collection includes colossal granite statues of the goddess *Sekhmet* (fourteenth century B.C.) and *Ramses* (thirteenth century B.C.). The Near Eastern section consists of some two hundred pieces, including examples of Luristan bronze works in the animal style typical of nomadic tribes from northwest Iran. The museum also has a published collection of Mesopotamian cylinder seals and a noted group of inscribed tablets pertaining to economic, administrative, and judicial aspects of Babylonian history.

The Greek and Roman section, numbering more than eight thousand objects, is highlighted by a considerable collection of vases, with examples of Mycenaean, Etruscan, Geometrical, black-figure, and red-figure ware. Noteworthy examples of statuary include Graeco-Roman copies of Praxiteles' *Cnidian Aphrodite* and the over-life-size *Head of Zeus*. Original Greek works include the *Torso of Achilles* from a Hellenistic sculpture group and smaller pieces such as the marble *Io*, believed to be from Paros. The fourth-century terracotta relief *Isis-Io* and the terracotta *Head of Demeter* are products of Greek colonies in Italy. Most of the Roman artifacts were excavated in the Geneva area and include many everyday objects and fragments of figural sculpture.

The Byzantine collection, although restricted for the most part to small liturgical vessels and the applied arts, is distinguished by a group of monetary weights that Lucien Naville donated in 1956. Comprising more than three hundred examples, the Naville Collection is by far the largest and most important of its kind in the world.

The core of the Department of Fine Arts is the museum's holding of about six thousand paintings from the Late Gothic to the contemporary period. The greatest depth is in Swiss art, of which the single most famous work is the *Miraculous Draught of Fishes* by Conrad Witz, an altar panel ordered in 1444 by the Bishop François de Mies for the Geneva Cathedral. Also noteworthy are the large panel *The Virgin Enthroned with Two Saints*, from the Chapel of Saint Martin in Evolène (Valais), and three tall panels from a late-fifteenth-century altarpiece, *The Angel Gabriel*, *The Virgin Mary*, and a *Female Saint*. Neighboring South German and Rhenish schools are represented, the most striking work being a large fifteenth-century Swabish panel, the *Flight to Egypt*, and the *Adoration of the Magi*, both drawn with verve and humor.

Works by the eighteenth-century portraitist Jean Étienne Liotard provide a major highlight in the Swiss collection. The museum possesses five striking self-portraits, ranging from the early, extroverted *Portrait of the Young Artist* (before 1738) to the somewhat cynical *Liotard Laughing* (c. 1770), where the artist's grin reveals his missing teeth, to the resigned, Rembrandt-like *Portrait of the Elderly Artist* (c. 1772). Liotard's keen sense of composition and color is par-

ticularly evident in the orientalizing *Portrait of the Countess of Coventry* (c. 1749), a reduced version in pastels of the well-known Rijksmuseum (q.v. Rijksmuseum, Amsterdam) portrait in oils. His *Madame d'Epinay* (c. 1759) is a spellbinding example of aristocratic portraiture.

Academic painting in Switzerland during the late eighteenth century was dominated by Jean-Pierre Saint-Ours, and the Geneva Museum has major examples of each stage of this very talented artist's work. *David and Abigail* (1778) is composed and colored with Baroque exuberance; the monumental *Olympic Games* (1789), painted during a stay in Rome, is imbued with Poussinesque grandeur. A family portrait, *Reading Fables* (1796), celebrates the virtues of hearth and home, and the late *Earthquake* depicts a family menaced by the forces of nature.

Numerically, the most important part of the Swiss collection is the holding of nineteenth-century painting, which includes significant works by all leading artists of the Geneva area. The exquisite pictures of horses and hunting dogs by Jacques-Laurent Agasse are particularly noteworthy, especially the large painting of two greyhounds, *Rolla and Portia*. The radiant work of Adam-Wolfgang Toepffer can be observed in idyllic country scenes such as *Picking Apples at Condrée* (1820). The grandiloquence of the landscapist Alexandre Calame is represented by a group of six large compositions, including the overpowering *Storm at Handeck* (before 1839) and the visionary allegory *Spring*, donated to the museum in 1873 by the artist's widow. The more serene work of Calame's contemporary, François Diday, also merits attention. The Geneva collection includes a number of significant Diday landscapes, including the very beautiful small canvas, *Mont Blanc Viewed from Sallanches*. The peaceful realism of Barthélemy Menn characterizes the general trend of Swiss art in the later decades of the nineteenth century. His *Colline de Tourbillon*, a view of the Valais region near Lac Léman, echoes the measured harmony of works by Corot.

Swiss artists from the German-speaking cantons are also represented, although more selectively. A large Henry Fuseli, *Cardinal Beaufort Terrified by the Ghost of Gloucester* (1808), was acquired in 1981. The exceptional, although littleknown, work of Albert Anker, a realist from Bern, can be appreciated in the large *Berne Canton Assembly* (before 1868). Ferdinand Hodler, certainly the most celebrated Swiss artist of his time, is represented by a major holding of more than sixty canvases from all stages of his career. A group of seven selfportraits indicates his development, from the moody, late Romantic version of 1872, to the abrasive, wildly colored rendering of 1916. The collection covers the entire range of Hodler's subject matter. Included are historical subjects, such as *The Retreat from Marignan* (1897), a preparatory work for the fresco in the Zurich Museum, as well as peasant genre scenes, portraits of Swiss citizens of all social classes, allegories, and landscapes. A number of these works are on extended loan from the Gottfried Keller Foundation, including Hodler's last painting, a serene view, *Lac Léman and Mont Blanc* (1981). A bronze sculpture, *The Sick Woman*, is also in the collection.

An important group of oil paintings by Félix Vallotton, another pioneer of

modern art, especially noted for his woodcuts, is on view. Canvases in the Geneva collection such as *Colloque Sentimental* (1898) and *Sleeping Nude* (1908) reveal the artist's advanced formal evolution in oils. Also noteworthy are strikingly abstract Neo-Impressionist compositions by Giovanni and Augusto Giacometti and Cuno Amiet.

The Old Master collection is less comprehensive in foreign schools than in the Swiss school, but a number of important works deserve mention. The best-known French work is the *Sabina Poppea*, a portrait of Emperor Nero's consort, painted by an unidentified artist of the sixteenth-century School of Fontainebleau. It was bequeathed to the city by the Geneva sculptor-decorator Jean Jacquet (1754–1839).

Important French compositions from the seventeenth century include Philippe de Champaigne's *Visitation* and his large *St. Leonard Refusing Gifts from the King* (c. 1640), which belonged to Notre-Dame Cathedral in Paris before being dispatched to Geneva by Napoleon. Nicolas Largillierre's late-seventeenth-century *Portrait of a Paris Notable* is typically elegant and luxurious in effect, but the same artist's *St. John the Baptist* is mundane, although it is notable for being one of the few religious works painted by the artist. A third Largillierre, *Portrait of the Miniaturist Jacques-Antoine Arlaud* (1714), represents the sitter at work copying Michelangelo's *Leda and the Swan*. Arlaud died in 1743, leaving this portrait to the Geneva Public Library.

Important eighteenth-century paintings include Jean-Baptiste Oudry's *Swans and Dogs*, Jean-Marc Nattier's two portraits of nobles, and Noël-Nicolas Coypel's Rococo *Bacchus and Venus* (1726). Particularly outstanding are five pastel portraits by Maurice Quentin de Latour, including his *Self Portrait Framed in an Oeil de Boeuf* (1737), *Portrait of a Black Man* (exhibited in the 1741 Paris Salon), and *Portrait of the Abbot Huber Reading* (exhibited in the 1742 Salon). The precursor of Romanticism, Joseph Vernet is aptly represented in his *Stormy Seascape* and *Shipwreck* (1762).

Nineteenth-century French painting is generally limited to works of the Barbizon School and the Impressionists. A very fine collection of eleven small canvases by Camille Corot is highlighted by *The Church of San Trinità dei Monte* (1826–28) and *The Moulin de la Galette, on Montmartre* (1840). A large study by Gustave Courbet, *The Banks of the Doubs River*, hangs on extended loan from the Gottfried Keller Foundation. Small but high-quality paintings by Théodore Rousseau, Henri Harpignies, Charles-François Daubigny, and Narcisse Diaz de la Peña round out the Barbizon collection. The Impressionist holdings consist of small works by Eugène Boudin, Claude Monet, Camille Pissarro, Pierre Renoir, and Alfred Sisley.

Flemish and Dutch painting is likewise incompletely represented, but certain strengths are noteworthy. The meticulous craftsmanship of Late Gothic panel painting is in evidence in the *Virgin and Child* by an unidentified follower of Rogier van der Weyden (Baszanger Collection). The *Beheading of John the Baptist* by Juan de Flandes, from the same period, achieves a similarly pleasing

balance between realism and decorative polish. Sixteenth-century paintings include Lucas Cranach's *Nude Woman*, as well as a Pieter Bruegel the Younger and Johann Rottenhammer's *Tower of Babylon in Construction*. Two large seventeenth-century Flemish canvases deserve particular attention: the vigorous *Boar Hunt* (1654), by Jan Fyt, and the anonymous *Singers*, painted by a Caravaggio follower in Rome about 1620. The latter was donated in 1826 by Jacob-David Duval to the newly completed Rath Museum.

Prominent works of Dutch artists include the powerfully drawn Mannerist *Allegory of Fortune* by Cornelis Cornelissen (van Haarlem) in the Baszanger Collection. Excellent landscapes by Salomon van Ruysdael, Jan van Goyen, Jacob van Ruisdael, and Meindert Hobbema are also on view. A sizable collection of small Dutch genre scenes, including works by Philips Wouwerman, Cornelis van Poelenburg, Gerard Dou, and Adrien and Isaac van Ostade, has also been formed over the years.

One of the museum's most interesting compositions is a genre scene of low-life, *Two Savoyards Playing the Triangle*, painted on an oak panel and attributed to the artist Jan Victors (died in India, 1676). The painting belonged to a Scottish collector, Quentin Crawford, who lived in Paris. Crawford's collection was seized during the Revolution, and the panel ended up in Geneva as part of Napoleon's donation of 1810.

The Italian collection was dramatically bolstered at the time of Napoleon and has continued to grow ever since, largely due to private donations. A fine altar panel by Neri di Bicci, *Virgin and Child* (1460s), was bequeathed by J. A. Holzer in 1938. A pair of panels, the *Annunciation* (c. 1511), executed by Fra Bartolommeo and Mariotto Albertinelli for the Charterhouse of Pavia, was taken from Milan by French troops in 1796. The Napoleonic donation also included Veronese's *Entombment of Christ* (c. 1575), which served as an overdoor decoration in the French royal collection at Versailles. Two works from the Mannerist period also deserve attention: the large *Portrait of Alexander the Great*, attributed to Giulio Romano (on loan from the Canton of Geneva), and the *Venus and Cupid*, probably done by a follower of the Florentine Michele di Rodolfo late in the sixteenth century. Of later Italian painting, a notable work is Crespi's preparatory study on copper, *St. Charles Borromeo*, executed in 1610. It was part of the Revilliod Collection in the Ariana Museum. Andrea Vaccaro's large *Triumph of David*, a fine example of Neapolitan classicism, about 1650, was bequeathed to the Rath Museum by Jean-Jacques de Sellon in 1839.

An attractive collection of eighteenth-century Italian works came from several sources. Francesco Trevisani's *Alexander before the Tent of Darius* and *Christ before the Elders* were both donated by the Geneva collector Walther Fol in 1871; Gaspare Diziani's Rococo *Hercules and Omphale* and *Deianira* were part of the Bodmer legacy of 1910; a major composition by Andrea Locatelli, *Rebecca and Eliezer* (1731), came from the Ariana Museum; and Francesco Guardi's *Putti and Swans* is also part of the collection.

The museum's holdings of twentieth-century painting consist largely of work

from central and eastern Europe, featuring important compositions by Paul Klee, Kurt Schwitters, Hans Richter, and the Russian Constructivists. Work of particular interest from the Paris School includes canvases by Albert Marquet, Fernand Léger, Le Corbusier, and André Masson. An unusual item is a marked proof copy, *La Prose du transsibérien et de la petite Jehanne de France*, the "simultaneous book" conceived about 1913 by the artist Sonia Delaunay and the poet Blaise Cendrars. A very fine painting by Pierre Bonnard was recently donated by the Greek collector Vassily Photiades of Lausanne.

The sculpture collection is limited in scope but contains some important works by French and Swiss sculptors. Of notable quality in the eighteenth-century French school are three portrait busts by Houdon—*Jacques Necker* (in marble), *Jean-Jacques Rousseau* (in tinted plaster), and *François Tronchin*, the Geneva banker and art collector (in marble). The *Bust of Voltaire* by Jean-Baptiste Lemoyne is also present. In addition, the museum possesses several small works by Rodin, including the unique casting of his bronze *Portrait of Henri Rochefort* (1892).

The nineteenth-century Swiss collection is dominated by the neoclassical work of Jean-Jacques (James) Pradier. The exciting diversity of Swiss sculpture of the twentieth century is richly attested to by the work of Alberto Giacometti, Max Bill, Jean Tinguely, and numerous lesser-known artists.

Several historic interiors have been reconstructed in the Geneva Museum. Four seventeenth-century rooms have been transported from the Chateau de Zizers (in the canton of Grisons), the most impressive of which is the *Salle d'Honneur* (c. 1680), which has a musicians' gallery, geometrically patterned ceiling decoration in wood, and large doors. The outstanding eighteenth-century period room is the elegant *Grand Salon* from Les Délices, a local mansion inhabited by Voltaire from 1755 to 1765. The Louis XVI décor, designed for François Tronchin, who purchased the property in 1765, is attributed to Jean Jacquet. Tronchin was a patron of Jean Étienne Liotard, whose pastels appropriately decorate the *Grand Salon* today.

The museum also possesses a collection of arms and armor that is strong in Swiss production of the sixteenth and seventeenth centuries. Since a large part of the collection was transferred directly from the state arsenal to the city for the purpose of public exhibition, most of the flint-lock pistols, hand weapons, and armor pieces are in serviceable condition.

The museum's drawing collection numbers more than seventeen thousand items and includes examples by the most notable draftsmen of western European schools. An exquisite collection of Persian miniatures was recently donated by Jean Pozzi, a former French diplomat who spent many years in Turkey.

The Department of Graphics includes some four hundred thousand items and is housed in an annex at 5, Promenade du Pin, near the main building.

A fully equipped and staffed conservation laboratory is housed in the main building for the preservation of the collections. Work on nearly every type of

object in the museum's possession can be done there: painting, sculpture, paper, metal, fabric, and so on.

A public association, the Society of Friends of the Museum of Art and History, has existed since the nineteenth century and today has about four hundred members. Another affiliated organization, the Modern Art Museum Association (l'AMAM), has worked during the past ten years for the creation of a museum devoted to art of the contemporary period (1945 to the present). Until site and funding problems can be resolved, this active group will continue to sponsor temporary exhibitions of current art trends in a gallery set aside for that purpose in the main building. L'AMAM is also acquiring contemporary art through purchase and donations for the future museum.

Genava, an annual review, has been issued by the museum since 1923, principally to publish articles on museum holdings, Geneva history, and current museum activities. Each issue includes a list of recent acquisitions.

Selected Bibliography

Museum publications: Bouvier, A., "La Société des Amis du Musée d'art et d'histoire de 1923 à 1959," *Genava* (1960), pp. 25–37; Cartier, Alfred, *Le Musée d'art et d'histoire de la Ville de Genève: Notice et guide Sommaire*, 1910; Deonna, Waldemar, *Au Musée d'Art et d'Histoire: Etudes d'archéologie et d'histoire de l'art* (vols. 1–15), 1933–48; Dürr, Nicolas, *Catalogue des Poids Byzantins*, extracted from *Genava*, vol. 12 (1964); Loche, Renée, and Pianzola, Maurice, *Les tableaux remis par Napoléon à Genève*, extracted from *Genava*, vol. 12 (1964); Natale, Mauro, *Le goût et les collections d'art italien à Genève*, 1980; idem, *Peintures italiennes du XIVᵉ au XVIIᵉ siècle. Musée d'art et d'histoire, Genève: Catalogue raisonné des peintures*, 1979; Sollberger, Edmond, *Le Musée d'art et d'histoire de Genève, 1910–1960: Album du Cinquantenaire*, 1960; Vollenweider, Marie-Louise, *Catalogue raisonné des sceaux cylindres et intaillés*, 1967; *Le Musée Rath à 150 ans*, 1976–77.

Other publications: Birot, Maurice, *Tablettes économiques et administratives d'époque babylonienne ancienne conservées au Musée d'art et d'histoire de Genève* (Paris 1969); Bruckner, Augusta, *Corpus Vasorum Antiquorum: Suisse, Genève, Musée d'art et d'histoire* (Berne 1962); Deonna, Waldemar, "Histoire des collections archéologiques de la Ville de Genève," *Mélanges publiés à l'occasion du 25ᵐᵉ anniversaire de la fondation de la Société auxiliaire du Musée de Genève* (Geneva 1922); Szlechter, Emile, *Tablettes juridiques de la Iʳᵉ dynastie de Babylone conservées au Musée d'art et d'histoire de Genève*, 2 vols. (Paris 1958).

STEPHEN H. WHITNEY

———— **Lausanne** ————

STATE MUSEUM OF FINE ARTS, LAUSANNE (officially MUSÉE CANTONAL DES BEAUX-ARTS; alternately LAUSANNE MUSEUM OF FINE ARTS), Palais de Rumine, Place de la Riponne, CH–1000 Lausanne.

The Musée cantonal des Beaux-Arts, Lausanne, is the official cantonese museum and center for the state art holdings. The canton maintains control of the institution through the Department of Public Instruction and Culture, which is responsible for its daily function and yearly budget. The director of the museum is in charge of all aspects of administration and acts in consultation with the department for exhibitions and acquisitions. There is a *conservateur* (curator) who oversees the actual collection. An archivist is employed to maintain the essential museum documents.

The origin of the museum dates from the first collection acquired officially by the canton in 1810, when the contents of Ducros' atelier were purchased. At that time there was no museum building, and the material was stored at the local drawing academy. In the next few years, the canton purchased some works by local painters, notably by Jean-Charles Müllener and François Kaysermann, but there was no official program for steady purchases.

In 1826 the head of the drawing academy, Marc-Louis Arlaud, a former pupil of David, envisioned a need for an actual museum; in 1834 he offered the canton a substantial sum of money and his own collection for the purpose of establishing a cantonal museum. The building itself, designed by Alexandre Wenger under Arlaud's supervision, was begun in 1836 and completed in 1839. In 1840 the collection was officially incorporated into the building. In essence, it contained the Ducros works, the Arlaud Collection (mostly works by his own hand), and plaster casts of antique sculpture.

From the outset, it was Arlaud's plan to use the museum as a showcase for contemporary Swiss art. The first purchase was François Diday's *View of the Rosenlui Glacier* (1841), followed by Alexandre Calame's *Lake of Brientz* (1842). Private donations of other contemporary works began to follow in accordance with the policy of acquiring modern art.

Arlaud died on May 1, 1845, leaving in his will a legacy of two thousand francs to be used as a commission for a large-scale painting from the most prominent Swiss artist Charles Gleyre, who was then living in Paris. The commission stated specifically that the work was to illustrate the execution of Major Davel, the eighteenth-century cantonal hero. When the painting was completed in 1850 and exhibited in the Musée Arlaud, it caused a sensation; until its destruction in 1980, the work was a symbol for the canton. So pleased were the museum officials with the success of the painting that they offered Gleyre another commission for a pendant, *The Romans Forced to March under the Yoke* (1858). With these two works began a long association between the painter and the museum.

Additional contemporary Swiss paintings were continually acquired through the latter half of the century until the original structure became too small to house the collection. With an extensive legacy from Gabriel de Rumine, who died at age thirty in 1871, the city built a large complex, known as the Palais de Rumine, to house the museum as well as university facilities. The building, designed in the Beaux-Arts tradition by the Lyonese architect Gaspard André,

was completed in 1906. With this expanded space, it was decided by the conservateur Emile Bonjour that an even more rigorous acquisition program should ensue, with still the same concentration on works by artists of local origin.

In 1908 the widow of Charles Clément sold their huge collection of Gleyre material to the museum. In total, almost 370 paintings, drawings, and watercolors by the artist entered the collection, almost all of which went on public exhibition in the newly created Salle Gleyre two years later. Even this substantial purchase was augmented in 1917–18 by the addition of Mathilde Gleyre's collection of her uncle's works, letters, and diaries. The museum has as a result the single largest holdings of Gleyre's works in the world.

Because the basic policy of the museum has always been to collect Swiss art, the collection is understandably weak in non-Swiss schools. Nonetheless, there are certain examples, either purchased or donated, that represent other areas of the history of art. There are some late Ptolemeic Egyptian statues, including a portrait of Nor-Nefer of the fourth to third century B.C. The singularly elegant *Madonna and Child* of the thirteenth century A.D., certainly of French origin, is one of the most important medieval works in the collection. A similar but later representation of *St. Anne with the Virgin* offers an interesting comparison. Of the early Italian Renaissance, an anonymous *Nativity* (fourteenth century), assuredly from Rimini, is an important example of the later Giotto school. The museum also owns a rare work by François Dubois, *The Massacre of the Saint-Barthélmy*, dated about 1580.

Various Baroque schools are also represented in the collection. There are two Luca Giordano scenes from the Old Testament, as well as various examples by minor Italian masters. Exhibited there as well is a remarkable portrait, *Mme. Fontevelle*, by Grimou; the portrait *Duchess de Nemours* by Hyacinthe Rigaud (c. 1699); and a *Self Portrait* of Nicolas de Largillierre (1706). An anonymous Spanish portrait of the seventeenth century shows the strong influence of Velázquez and may have been executed by a student.

The collection contains some important examples of eighteenth-century Swiss art. There are no less than six paintings by the Sablet brothers, including François' *Self Portrait* and Jacques' *Portrait of His Family in His Atelier* (1791). There is St. Ours' own reduction of his famous work *The Earthquake*, as well as a large portrait of a lion. Angelica Kauffmann's portrait *Dr. Tissot* is also in the collection.

The richest aspect of the museum's holdings is in the area of nineteenth-century Swiss art. Beside the collection of Gleyre's works, there are substantial examples of works by his Swiss students. The most important of them was François Bocion, who is represented by almost 150 paintings and drawings. The museum also acquired more than 100 landscapes by another pupil, Emile David, and has an outstanding representation of Swiss landscape art, especially in the paintings of Calame, Diday, Veillon, and Alfred Chavannes. Of the later nineteenth century, the museum owns 6 works by Albert Anker, including his *Young Girl with Straw-Berries* (1884) and his well-known canvas *Queen Berthe* (1888).

There are also 8 important works by Ferdinand Hodler, some donated by the artist himself, including his *View of Lake Léman* (1904). One of the most interesting examples of this period in which symbolism and realism intermix is the *Portrait of His Family* (1904) by the mystic painter Albert Welti.

But the most representative examples of *fin-du-siècle* art are to be found in the vast collection of the works of Félix Vallotton, born in Lausanne in 1865. The museum has acquired more than 30 paintings, 100 drawings, and almost 200 prints by the master; virtually every phase of his development is represented by the collection. Similarly, the museum contains the largest holdings of the work of Théophile Steinlen, also born in Lausanne in 1859. In total, about 250 of his works are housed in the collection. There are also more than 20 examples of the works of Ernest Biéler and a substantial number of paintings by the Intimist Marius Borgeaud. Examples of other important Post-Impressionist work include paintings and prints by Bonnard, Vuillard, and Roussel.

In 1924 Auguste Widmer sold the contents of his huge private collection, which comprised almost seven hundred items, to the museum. Included was a substantial number of non-Swiss art, thus augmenting this aspect of the museum holdings. Especially significant were the sculptural contents that contained, among other work, eighteen statuettes from ancient Egypt, twelve from the Far East, fifteen terracottas from the Graeco-Roman period, and diverse examples from the nineteenth century, including works by Rodin, Meunier, and Degas. The Widmer sale also added paintings by masters such as Courbet, Degas, Manet, Boudin, Renoir, and Cézanne and several examples by minor landscape artists.

The policy of collecting contemporary Swiss art, the essential policy established from the beginning by Arlaud, has continued to the present. The museum has energetically sought works from virtually every major school of the twentieth century as particularly practiced by Swiss artists. The result has been an outstanding collection of major works by René Auberjonois, Gustave Buchet, Rodolphe-Théophile Bosshard, Maurice Barraud, and many others. Of special significance is the deposit of the works of Louis Soutter, which at present number almost six hundred items, all of which have been catalogued in a publication by the former conservateur Michel Thévoz.

The non-Swiss holdings of modern art are also very strong and contain important examples from all principal artistic movements in all media. Particularly significant are the works by Picasso, Dubuffet, Gris, Marquet, Matisse, and others.

The museum library now contains almost five thousand books and journals on art, art history, and criticism. The library is open to students and scholars but is noncirculating.

Slides and photographs of all major works in the collection are available from the museum office. Works not yet photographed can be requested. The museum also maintains a stock of catalogues and museum publications, all available upon request.

The museum has begun a new organization, Les Amis du Musée, which will contribute in a variety of ways to exhibitions and acquisitions.

Selected Bibliography

Museum publications: Bonjour, E., *Catalogue du Musée de Lausanne*, 1887; idem, *Le Musée Arlaud, 1841–1905*, 1905; Berger, R., *Promenades au Musée cantonal des Beaux-Arts*, 1970; Lardy, Ch., *Catalogue des objets d'art exposés dans le musée*, 1847; Wild, H., *Antiquités égyptiennes de la Collection du Dr. Widmer*, 1956.

WILLIAM HAUPTMAN

——— Lugano ———

THYSSEN-BORNEMISZA COLLECTION, Villa Favorita, Castagnola, Lugano.

The formation of the Thyssen-Bornemisza Collection, one of the greatest private collections of art in the world, is the result of the efforts of two men, Baron Heinrich Thyssen-Bornemisza (1875–1947) and his youngest son Baron Hans Heinrich Thyssen-Bornemisza (b. 1921). The fortune on which the collection is based was established by August Thyssen (1842–1926), grandfather of the present baron, who made his fortune in iron and steel in Germany. Although he admired the French sculptor Rodin and discussed with him the execution of six large marble sculptures, August Thyssen was more interested in the family business than in art. The collector of the family was his second son, Heinrich, who acquired about two-thirds of the artworks now on view in Lugano, Switzerland, present home of the family. In 1906 Heinrich married the daughter of an Hungarian noble and went to live in Hungary. Shortly thereafter, he was adopted by his father-in-law, who had no male heirs, thus acquiring the second part of his surname. With the revolution of Bela Kún in 1919, the family fled to Holland, where Heinrich Thyssen-Bornemisza developed the Bank voor Handel en Scheepvaart in Rotterdam and the August Thyssen Bank in Berlin.

In 1933 the baron bought Villa Favorita, Castagnola, near Lugano, Switzerland, from Prince Leopold of Prussia and moved the family and his collection of art to the lovely lakeside location. The villa, built about 1750 by an unknown Ticinese master, had already undergone several transformations. During the last renovation, the baron had the Gloriette utilized as the entrance to a modern museum, built in honor of his father, whose twenty rooms can accommodate about three hundred paintings and other works of art, such as sculpture and ivories. The rooms of later paintings, such as the eighteenth-century French and Italian masters, are decorated in the style of the period, with silk wall hangings and examples of furniture to complement the paintings. A modern restoration

studio, where a conservator works on the Thyssen Collection for six months of the year, is also part of the complex.

Although various parts of the collection had been on special exhibition in different European locations ever since the first baron began acquiring works of art, it was only in 1949, after his death, that the collection in the villa was opened to the public on a regular basis.

The very existence of the Thyssen Collection, however, is a result of the efforts of the present baron, Hans Heinrich. When his father died in 1947, the collection was divided among his four children. The present baron wanted to bring the collection together again as a memorial to his father and thus began buying back the art from his brother and sisters and also filling in the gaps that existed in the various schools of painting. Today the collection of paintings comprises more than 1,300 pieces, in various private locations all over the world; the Villa Favorita alone houses 350 of the most famous Old Master paintings and some objects. Although many of these paintings are loaned to various special exhibitions, the principal pieces are on view from Good Friday to the second Sunday in October, on Fridays and Saturdays from 10 a.m. to noon and two to five p.m. and on Sundays from two to five p.m.

Although the decisions concerning the disposition, lending, and maintenance of the collection are made by Baron Thyssen-Bornemisza, the daily administration is conducted by a curator, a librarian, and two secretaries.

The Thyssen-Bornemisza Collection is best known for its European paintings from the fourteenth to eighteenth century, which actually comprise less than half of the canvases owned by the baron. The majority of paintings in the collection is composed of the nineteenth- and twentieth-century works, all collected, since 1960, by the present baron, who decided to select his own canvases, a collection of paintings whose spirit best typified the age in which he lived, as he saw it. Because of the personal nature of this collection, it is not housed in the public museum in Lugano (but in the baron's private residences) and thus is not treated in this entry.

Most of the Old Masters, the more famous portion of the collection, were acquired by the first baron, who wanted to form a collection that would comprise examples from all of the principal schools of Western painting.

His first love, however, was Early German paintings, of which there are more than seventy now in the collection. Of all of them, one of the most famous is Hans Holbein the Younger's *Portrait of Henry VIII*, the only completely authentic portrait of the monarch by this master. Another important German portrait, a canvas of an unknown young woman, by Albrecht Altdorfer, is noteworthy as only one of two such in existence and as the first to be recognized from the hand of this painter. An important Late Gothic German painter, Derick Baegert, is represented in the collection by five fragments of a *Crucifixion* altarpiece that had been cut in pieces during a period of iconoclasm and scattered, with some eventually reunited in Lugano. By Lucas Cranach the Elder there are five works in the Thyssen Collection: an early *Madonna and Child with Bunch of Grapes*,

a *Nymph Reclining by a Spring*, one of the finest versions of his popular reclining Venus subject, a *Portrait of a Young Woman*, and two wings of a triptych done for Duchess Barbara of Saxony. The two works in the collection by Hans Cranach, eldest son of Lucas, are *Hercules as Omphale's Slave* and *Portrait of a Bearded Man*, the only two known signed works by the painter.

The collection has several important examples of Northern painters who were instrumental in bringing the principles of the Italian Renaissance over the Alps. Albrecht Dürer, the most famous, is represented in the Thyssen Collection by an outstanding religious painting, *Jesus among the Scribes*, bought from the Palazzo Barberini Collection when Mussolini offered some paintings for sale. Although sold as a Bellini, the painting was soon discovered to bear a monogram "AD," a date of 1506, and the inscription "work of five days," indicating that Dürer considered this work a bravura piece painted in five days in Venice. The dissemination of Italian influence is also illustrated by Jan Gossaert's *Adam and Eve*, an original reworking of Dürer's 1504 engraving, which, by its treatment of the nudes, indicated a new attitude toward the human body as best exemplified by the Italian Renaissance. Maerten van Heemskerck, another important painter who felt the influence of Italy, is represented in the collection by the *Portrait of a Lady with Spindle and Distaff*, one of his greatest works before his 1532 trip to Italy.

Early Flemish painting was another of the first baron's early collecting interests, which, with the later Dutch paintings, number about 180. Jan van Eyck (c. 1390–1441) is represented by matching grisaille panels, the *Virgin* and *Archangel Gabriel*, which may have served as a private devotional diptych. The influential Rogier van der Weyden has two panels, the early *Madonna and Child Enthroned* and the later *Portrait of a Man*, whose identity is still disputed. Two of van der Weyden's most important pupils, Hans Memling and Dieric Bouts, are represented in the Lugano collection. Memling's unusual *Portrait of a Young Man* is decorated on the reverse with a still life of a jug of flowers, alluding to the Virgin, a painting sometimes considered to be the beginning of independent still life. Bouts' painting of the *Virgin and Child*, an early work that shows the influence of his teacher van der Weyden, portrays the Virgin in an enclosed garden, standing before a brocaded cloth, a composition based on the "Song of Songs." Another painting of note is Petrus Christus' unusual *Virgin of the Barren Tree*, depicting the Virgin and Child nestled in the branches of a leafless tree. This composition is probably a reference to a cofraternity, to which both Christus and his wife belonged, that venerated the Immaculate Conception.

The Baroque in both Flanders and Holland is well represented in the Thyssen Collection. Peter Paul Rubens, the great Flemish master, has three paintings in Lugano, one secular and two sacred. *The Toilette of Venus* is a copy of a lost Titian. *The Virgin and Child with St. Elizabeth and Infant John* was a favorite subject of Rubens and he probably used his two sons as models for the children. *St. Michael Overthrowing Lucifer and the Rebellious Angels* is his last and most mature representation of a subject that occupied him for several years.

The collection is particularly strong in Dutch seventeenth-century painting, with examples of major artists and major types of canvases. There is a rare work by Pieter Jansz Saenredam, one of the first architectural painters, *Façade of the Church of St. Mary in Utrecht*. Interior scenes are represented by two examples from Pieter de Hooch: *Lady with Needlework and Child* is a domestic interior, and *Interior of the Council Chamber in the Town Hall in Amsterdam, with Visitors*, one of his finest Amsterdam works, is the only painting to portray the original condition of this important seventeenth-century Dutch building, since then altered significantly.

One room is devoted to paintings by Jacob van Ruisdael. Of the six canvases exhibited there, one is an exceptional early work that portrays a landscape seen from above, another is a rare snowscape dating, probably, from his later years, and a third is a fine seascape, again from the end of his life. Jacob's uncle Salomon is represented by three waterscapes, from three different decades of his life.

Other Dutch landscape paintings in Lugano include Hercules Seghers' impressive *Landscape with Mercenaries*. Of the marinescapes in the collection, several deserve mention. Jan van de Cappelle, greatest of Dutch painters of this category, is represented by the *Calm Sea with Many Ships*, a seemingly haphazard composition that is actually carefully constructed to reveal his masterful use of light and color. The *View of a Port, with Motifs from Rome*, by Joos de Momper, is unusual for this artist, not only because of the subject, an amalgam of motifs from Rome and his imagination, but because it is one of six landscapes to bear the artist's monogram. It belongs to the same series as *View of a Village on a River*, also with a monogram, whose Italian scene mingles interestingly with the Dutch treatment of light and water.

Genre painting, another important aspect of Dutch seventeenth-century painting, is well represented by Jan Steen's *Village Wedding* and *Tavern Scene*. An extremely rare *Self Portrait* by Steen shows him dressed in the traditional costume worn by lovers in the contemporary Dutch theater. Frans Hals, a particular favorite of the first baron, is represented in the collection by *Fisherman Playing the Violin* and *Family Group with Negro Servant, in a Landscape*, both superb examples of Hals' portraiture, one lively and brash, the other sober and somber.

The other great portraitist of seventeenth-century Holland is Rembrandt van Ryn, who is represented in the collection by three paintings, all of different subjects. The *Portrait of a Man before an Archway* was executed probably in the early 1640s. *Stormy Landscape*, from about 1640, is an example of Rembrandt's early attempts to develop his own treatment of this subject. Rembrandt's *Self Portrait* in the Thyssen Collection is from the early 1640s, probably after the death of Saskia.

There are also admirable examples of still lifes. The lovely *Still Life* by Willem Claesz Heda, depicting an interrupted repast, is typical of his distinctive "breakfast pieces." Willem Kalf's *Still Life with Nautilus Cup*, 1660, is considered the finest of this great artist's *pronkstilleven*, or ostentatious, still lifes and an

excellent type of the popular Vanitas theme. Another possible rendering of this theme is found in *Still Life with Flowers* by Jan Davidsz de Heem, an excellent example of still another type of still life, one composed mainly of carefully arranged flowers and objects depicted with fine detail and luminosity.

One of the great strengths of the collection is the section of Italian paintings, begun late by the first baron but now numbering about two hundred works. The earliest is the Duccio *Christ and the Woman of Samaria* (1308–11), part of the predella of the *Maestà*, now in Siena (q.v.). Other Sienese painters represented are two of Duccio's pupils, Ugolino da Siena and Segna di Bonaventura, as well as Bartolo di Fredi and Giovanni di Paolo. Trecento Florentine painting is also well represented, with works by Niccolò di Tommaso, Bernardo Daddi, one of Giotto's first pupils, and Taddeo Gaddi and his son Agnolo.

In the collection, quattrocento Italian painting is best represented by the Florentine school: Paolo Uccello's panel of the *Crucifixion*; Fra Angelico's lovely *Madonna Enthroned with Angels*; Ghirlandaio's *Portrait of Giovanna Tornabuoni*, whose marriage with Lorenzo Tornabuoni sealed the reconciliation between the Medici and the Albizzi families; a very lovely portrait by Piero della Francesca of Guidobaldo da Montefeltro as a child; and a Crucifixion triptych by Bicci di Lorenzo, member of a well-known Florentine family of painters.

Examples of important local schools are also included in the quattrocento section of the collection. There is a fine portrait of about 1500 by Giovanni Antonio Boltraffio of Milan, most gifted pupil of Leonardo. Benedetto Bonfigli, one of the best Umbrian painters, is represented by an *Annunciation*. There are also two painters of Ferrara: Lorenzo Costa and Francesco del Cossa, whose paintings are two panels of St. Clare and St. Catherine and the excellent *Portrait of a Man Holding a Ring*, possibly a member of the Este family. An excellent *Portrait of a Man* by Antonello da Messina illustrates the work of a man who was influential among Italian portraitists and who brought the Northern use of oil painting to Italy.

The Thyssen Collection is particularly rich in Venetian painting. Carpaccio's *Young Knight in a Landscape*, portraying Francesco Maria della Rovere, heir to the Duchy of Urbino, is one of the first life-size, full-length portraits in European painting.

The High Renaissance Venetian paintings are extremely fine. The *Portrait of a Young Woman* by Palma Vecchio illustrates a typical Venetian beauty, and Titian's *Francesco Venier* is a late portrait that represents the master's power of characterization. Three other paintings by Titian illustrate his middle to late work. The four canvases by Tintoretto include two fine portraits and *Paradise*, recently recognized as the second model for his painting in the Assembly Hall of the Great Council, one of the largest paintings in the world.

Although the first baron thought that art ended with the eighteenth century, his son added to the collection; in the Italian section, he purchased some views of Venice by both Canaletto and Francesco Guardi, as well as the lovely Longhi *The Game of Tickling*, set in a nobleman's apartment. There are also two "quadri

turchi'' compositions by Antonio Guardi, fanciful depictions of an exotic culture. This was a subject popular in France, but these works were specially commissioned in Italy by Field Marshal Johann Matthias von der Schulenburg.

Other notable Italian paintings from the sixteenth century are a pastoral scene by Jacopo Bassano, one of the earliest examples of genre painting in Italy, and Lorenzo Lotto's important early *Bethrothal of the Virgin* and a self-portrait.

The Spanish section of paintings, which totals twenty, has eight El Grecos, one from every epoch of his work, including a very rare canvas executed while he was living in Rome. Two unusual sculptures by El Greco enhance this particular aspect of the collection. Other Spanish painters include Zurbarán, with his *Portrait of a Female Saint* and one of the earliest of his *Crucifixion* works, and Murillo, with two paintings. The Velázquez *Portrait of Maria Anna of Austria*, queen of Spain, was probably a preparatory study for *Las Meniñas*. Two paintings by Goya, one a sketch of King Ferdinand VII and another, the *Blind Beggar*, illustrate the two sides of this Spanish artist, the court portraitist and the recorder of the realities of Spanish life.

The eighteenth century in France is represented by excellent examples of the major masters. Antoine Watteau has two paintings in the collection. *The Rest* is one of his early military paintings, and *Pierrot Content*, a popular *fêtes galantes*, may be the first of this well-known subject. François Boucher's *La toilette* is a lively example of his sophisticated and popular genre scenes of life in pre-Revolutionary France. Another genre scene, by Jean Honoré Fragonard, *The Seesaw*, illustrates this master's work while he was still in Boucher's studio, under his influence, but beginning to find his own style. Fragonard's *Portrait of Mademoiselle Duthe* and another female portrait by Jean Marc Nattier, *Madame Bouret as Diana*, complete the record of courtly France. A *Still Life* by Chardin illustrates the contemporary taste for humbler subjects and rounds out the collection of eighteenth-century French painting.

Although best known for its paintings, the Thyssen Collection also contains many objects that are being catalogued and published. There are about 100 manuscripts, incunabulae, and rare books. The 100–120 pieces of sculpture range in date from ancient Greek to modern. Most notable are several French Gothic Madonnas, the El Grecos already mentioned, and a Houdon. About 400 pieces of furniture, from Italy, Germany, and England, are in the collection and include cassone, armadi, tables, and chairs. Except for the English pieces, which are in England, these pieces of furniture are generally used throughout the displays to augment the period of painting shown. There are about 100 antique Oriental carpets, some of the most celebrated carpets in the world. The medieval ivories are represented by a tenth-century Byzantine, an eleventh-century Italian, and a fourteenth-century French piece. Of the 100 Renaissance jewels, the majority are German, reflecting the original bent of the collection, with examples from Italy, France, Spain, and England, including a necklace from Henry VIII. About 30 Renaissance bronzes are also in the collection, as well as 300 pieces of gold and gilded silver, including some liturgical objects.

Housed in a building adjacent to the museum is a library for the use of the staff and visiting scholars. The holdings in Lugano itself comprise about four thousand volumes with extensive magazines, exhibition, and sales catalogues.

Photographs of objects in the collection may be obtained by writing to the Thyssen-Bornemisza Collection. Catalogues of the collection have been prepared at various times by request of both barons. In recent years, when parts of the collection have been on loan, catalogues of those sections have been written. Catalogues of the objects in the collection are being prepared by experts in the various fields represented.

Selected Bibliography

Museum publications: Borghero, Gertrude, *Thyssen-Bornemisza Collection—Catalogue of the Exhibited Works of Art*, 1981; Ebbinge-Wubben, Johann Conrad, Christian Salm, Charles Sterling, and Rudolf Heinemann, *The Thyssen-Bornemisza Collection*, 1969, 2 vols. (ed. Rudolf Heinemann—older editions by same editor exist from 1930, 1937, and 1958); Beattie, May H., *The Thyssen-Bornemisza Collection of Oriental Rugs*, 1972.

Other publications: Walker, John, and Allen Rosenbaum, *Old Master Paintings from the Collection of Baron Thyssen-Bornemisza*, 1979–81; Catalogues of the Thyssen-Bornemisza Collection: Somers-Cocks, Anna, and Charles Truman, *Renaissance Jewellery, Gold Boxes, and Objets de Vertu*, vol. 1 (London 1983); In Active Preparation: Levin, Gail, *Modern American Paintings*; Novak, Barbara, *Nineteenth-Century American Paintings*; Müller, Hannelore, *European Silver*; Radcliffe, Anthony, Malcolm Baker, and Paul Williamson, *Medieval and Renaissance Sculptures and Works of Art*; Forthcoming: *Italian, Spanish, and French Old Master Paintings*; *German, Dutch, and Flemish Old Master Paintings*; *Modern European Paintings*; *Nineteenth-Century European, Impressionist, and Post-Impressionist Paintings*.

MARY LOUISE WOOD

——— Winterthur ———

OSKAR REINHART FOUNDATION (alternately THE REINHART FOUNDATION), 7 Stadthausstrasse, 8400 Winterthur. OSKAR REINHART COLLECTION 'AM RÖMERHOLZ' (alternately THE REINHART COLLECTION), 95 Haldenstrasse, 8400 Winterthur.

Oskar Reinhart (1885–1965) was a prominent Swiss merchant responsible for both the Collection and the Foundation that bear his name in Winterthur. Born and reared in this town near Zurich, he spent most of his life in his home city and was active in the family business, including apprenticeships in Paris, London, and India. In 1924, at age thirty-nine, he retired from business to devote himself exclusively to art.

As early as 1939 Oskar Reinhart had decided to leave part of his collection to the public and informed the city of Winterthur that six hundred German,

Swiss, and Austrian paintings, drawings, and sculptures of the eighteenth to the early twentieth century would become their property. To house his gift, he purchased the "Old Gymnasium," a former high school designed by the Zurich classicist architect Lonhard Zeugheer (1838–42) and contemporary with most of the paintings. Reinhart himself supervised the renovation of the interior by Robert Sträuli and Ernest Rüeger; period salons, with appropriate furniture, were constructed to house the collection.

On January 21, 1951, the Oskar Reinhart Foundation was opened to the public for the first time as a complete entity, although parts of Reinhart's collection had been shown to the public in special exhibitions since he began collecting.

The Foundation is governed by a curator elected by the trustees. This curator is responsible for all administrative and artistic questions and is aided by an assistant and a housekeeper. According to Reinhart's bequest, the entire collection is on display in the Foundation. The exhibits cannot be changed, loaned, added to, or sold.

The character and importance of the Foundation today can be traced to the influence of the 1906 Berlin "Exhibition of the Century" on Reinhart. In an attempt to reevaluate German artistic activity, the organizers of this show avoided academic and anecdotal paintings in favor of little-known artists, the Romantics, and the Realists, a principle that Reinhart also followed.

Reinhart's aim was to amass a carefully chosen group of German paintings; his collection of German Romantics is the most important outside Germany. Caspar David Friedrich, key figure of the movement, is represented by several drawings and by three paintings, *Town at Moonrise*, *Woman by the Sea*, and *Chalk Cliffs, Rügen*, one of the best-known pictures by a nineteenth-century German artist. One of the most creative of the Romantics was Philipp Otto Runge, who is represented by a drawing for a set of mural paintings and by a painting, *Moonrise*, that illustrates his strong symbolic style. Reinhart also bought *Man Reading by Lamplight* by the important Romantic Georg Friedrich Kersting; the work is an excellent example of this artist's characteristic emotion-charged interiors.

The later German Romantics are each well represented in the Foundation through particularly characteristic works: by Ludwig Richter, a pencil drawing, *The Shepherd and His Girl*; by Moritz von Schwind, an oil, *The Angels Appear to Genoveva*; and by Carl Spitzweg, *The Painter in the Garden*.

For the generation after the Romantics, Reinhart used Realism and Idealism as the focal points for his collecting. Guided by his love of French art, he preferred Courbet-like works such as Hans Thoma's *The Artist's Mother in Her Room* and Wilhelm Leibl's *The Village Politicians*. In sharp contrast to these genre works is the work of Anselm Feuerbach, whose *Iphigenia II*, a study for a larger work, is an example of his attempts to give life to the antique. Hans von Marées is represented by an early self-portrait and by a later *St. Martin* that reveals the already monumental style of his paintings. The paintings and nature

studies of the Hamburg artist Friedrich Wasmann, a transition figure from Romanticism to Realism, are the best outside his native city.

The Prussian court painter Adolf von Menzel is represented by several small works, all from the first half of his creative life: *Berlin Backyards in the Snow*, *View from a Window*, and *Portrait of Mrs. Maercker*. This selection is illustrative of Reinhart's preference for intimate works with an affinity for nature, a taste influenced by his love of French art, particularly Impressionism. The works of Max Liebermann, a famous proponent of German Impressionism, *Child with Apple* and *On the Way to School in Edam*, are a fitting conclusion to this portion of the Foundation.

In one room of the Foundation, the Biedermeier Kabinett, is an enchanting collection of masterpieces by Austrian artists of the mid-nineteenth century. The works of Rudolf von Alt, the most significant Austrian landscape painter of the nineteenth century, illustrate how this artist developed. Ferdinand Georg Waldmüller, usually known for his realistic pictures that reflect the world of the court, is represented by two masterpieces from his landscape oeuvre: *Dachstein mit dem Gosausee* and *View of Arco*.

In collecting the works of Swiss artists, Reinhart chose little-known painters as well as acknowledged masters. Caspar Wolf, a pioneer in Alpine painting, was one of the first artists actually to venture into the mountains in winter to paint ice and snow. Practically forgotten until Reinhart began collecting his works, Wolf is represented by *The Staubbach Falls in Lauterbrunnental*.

The painters from the city of Geneva are particularly well represented. Jean Étienne Liotard, nicknamed "the Turkish painter," was well known as a portrait painter; his works occupy an entire room in the Foundation, with genre paintings hung next to his more characteristic portraits.

Jacques Laurent Agasse was best known in England, where he settled, as an animal painter; Reinhart, however, collected two genre scenes, *Landing Stage near Westminster Bridge* and *The Flower Seller*, as characteristic of other, less-known sides of this artist's creative personality. Another great Swiss artist of this period was Louis Léopold Robert, a pupil of David who is represented in the Foundation by *Girl from Procida*.

Also from this period is Henry Fuseli, the Zurich-born artist who settled in England and was known as writer, poet, art theoretician, literary critic, and professor of the Royal Academy; the Foundation owns an oil and several drawings by Fuseli.

The Realist Swiss painters of the second half of the nineteenth century are well represented in the Reinhart Foundation. One of the most popular painters was Albert Anker, who was particularly well known as a painter of everyday life in his village of Ins. His affinity for children is especially shown in the Foundation's works *The Artist's Young Daughter Louise* and *The Day Nursery*. The most important Swiss idealist painter was Arnold Böcklin, represented in the collection by four works: *Pan among the Reeds* and *Triton and Nereid*

illustrate his interest in mythological subjects; *Children Whittling May-Flutes* is a product of his love of children and music; and his masterpiece *Paola and Francesca* was inspired by Dante's *Inferno*. In concluding this aspect of Swiss painting, Reinhart acquired thirty paintings by Ferdinand Hodler, most from his early, realistic phase. They include self-portraits, portraits, and works that depict unfortunates, such as the *Convalescent Woman* and *Ahasuerus*.

While he was collecting the German, Swiss, and Austrian paintings that make up the Foundation, Reinhart was also acquiring the Old Masters and nineteenth-century French canvases that form the nucleus of his private collection. Upon his death in 1965, these 180 works and his home "Am Römerholz" were left to the Swiss Confederation (the Swiss state). The villa, built between 1913 and 1915 by Maurice Turrettini, a Geneva architect, was altered only slightly to provide for its new use as a public museum: security devices and safety exits were necessary. However, the paintings are hung as Reinhart had chosen. What strikes the viewer most forcefully about this arrangement is the juxtaposition of works from various epochs, all chosen by Reinhart and exhibited on the basis of their coloristic tendencies, a characteristic that becomes apparent upon close examination of the contents of the collection.

The Collection was opened to the public on March 7, 1970, and is led by a curator originally chosen by Reinhart himself. Future curators will be elected by the Cultural Department of the Swiss Confederation, to whom the Collection was left by Reinhart. The curator is assisted by a secretary and two housekeepers. According to the letter of donation, the entire collection is on display, acquisitions are not permitted, and individual works may not be loaned to other museums for inclusion in special exhibitions.

The small but significant group of early German and Dutch works indicates that Reinhart was extremely interested in the antecedents of the many eighteenth- and nineteenth-century works exhibited at the Foundation.

This portion of the collection is exhibited in the so-called Renaissance Room, in surroundings that evoke the atmosphere of that era. The oldest work is the *Annunciation* from the first quarter of the fifteenth century by an unknown master of the Upper Rhine. Gerard David, the most important painter of Bruges at this time, is represented by a characteristic *Pietà*. Matthias Grünewald's *Lamenting Woman with Folded Hands* is a study for the famous *Isenheim Altarpiece*. It also illustrates one of Reinhart's guiding principles, that of representing a painter by a work that illustrates his creative experience. By Lucas Cranach the Elder are the well-known portraits of Dr. Johannes Cuspinian and his wife, Anna Putsch, probably painted at the time of the couple's betrothal; the zodiacal signs in the backgrounds indicate the medieval tradition of such works, but the pictorial method is modern, deriving from Italian models and, possibly, Dürer. *The Adoration of the Magi in the Snow* by Pieter Bruegel the Elder is an excellent example of the artist's interweaving of religious subjects with the newly important observation of nature. Hans Holbein the Younger, the important German Renaissance portrait painter, is shown at the height of his powers by the *Portrait of*

Elizabeth Widmerpole, and religious works by Pieter Huys and Jan Provost illustrate the more mystical side of art at this time.

Spain is represented in the Collection by two of her greatest and most characteristic artists. By El Greco there is the *Portrait of the Inquisitor Cardinal Don Fernando Niño de Guevara*, the most powerful man in the Spanish church at this time. The antithesis of El Greco is Francisco José de Goya, Reinhart's favorite Spanish painter, who is represented by six works in the Collection, from all periods of his life, which include *The Washerwomen*, from the early phase, when he painted idyllic genre scenes; *Still Life with Salmon*, a characteristic work of mystery and demonic colors; and *Portrait of Don José Pio de Molina*, a portrait left unfinished at the painter's death.

Italian paintings in the Collection are limited to works by Venetian painters whose interest in color complements other choices made by Reinhart. Jacopo Bassano, *Adoration of the Shepherds*; Jacopo Tintoretto, *Portrait of Girolamo Grimani*; and Francesco Guardi, *Venice Riva degli Schiavoni* are all representative of their time and of the overriding Venetian interest in color.

The Reinhart Collection is best known for its choice selection of French paintings. By both Claude Lorraine and Nicolas Poussin there are distinctive landscapes.

In the light-filled, rush-green Louis XVI Salon are elegant examples of the eighteenth century: Watteau's oil, *The Light Refreshment*; Boucher's charcoal, *Female Nude*; and Fragonard's chalk drawings of Don Quixote all exemplify the elegant aspect of art at this time, and four paintings by Chardin are devoted to more humble subjects.

Honoré Daumier was a particular favorite of Reinhart, who collected twenty watercolors, paintings, and drawings that are all hung together in one room. From the Don Quixote cycle are three works, while the other paintings and drawings illustrate all phases of the artist's career: his impressive late oils, his rendering of themes from the fables of La Fontaine, and drawings of everyday Parisian life.

The major part of French nineteenth-century works is grouped together in the large gallery, with examples of artists who greatly influenced them. These works include Rubens' sketch for the tapestry *The Consul Decius Mus Consults the Augurs* and one version of John Constable's *Hampstead Heath*. Jacques Louis David is represented by the portrait *Baroness Pauline Jeanin*, his daughter, and by his famous pupil Jean Auguste Dominique Ingres are three portraits, one oil and two drawings, illustrating his mastery in this type. For contrast are ten works by Eugène Delacroix derived from various periods of the life of this leading Romantic. There are two from the time of the Greek struggle for freedom from the Turks; two are concerned with themes from literature—*Tasso* and *Ophelia*; three are religious, the *Magdalene, Samson and Delilah*, and *Tobit and the Angel*; one is pastoral, depicting a Roman shepherd; and two are inspired by his stay in North Africa, with *Arabs Riding an Attack* and *Fight between Lion and Tiger*. Also of the Romantic school are two oils by Théodore Géricault.

French Realism was as important to Oskar Reinhart as German Realism, and the Collection contains nine works by Gustave Courbet, from the early *Hammock* (1844) to *The Wave* (1870). Of the nine works by Jean Baptiste Camille Corot, three are figure paintings and six are landscapes, which the artist himself preferred. These latter works, especially *Dunkirk Harbor*, painted two years before his death, reveal Corot's characteristic method of exploring light and atmosphere. Other works by French artists include two landscapes of Camille Pissarro, an Alfred Sisley, and the winter scene of Claude Monet, *Ice Floes on the Seine*.

Other Impressionists are also in the Collection, each represented by characteristic works. The superb draftsmanship of Edgar Degas is demonstrated by the drawing of Giulietta Bellelli, a study for a group portrait today in the Louvre (q.v.); his *Dancer in Her Dressing Room* portrays one of his favorite subjects, ballerinas, offstage. Édouard Manet is represented by four works hung on one wall: a portrait, a still life, a seascape, and the famous late *At the Café*. Reinhart waited thirty years to acquire this last work, illustrative of the collector's taste, determination, and patience.

Nowhere is Reinhart's love of color seen more clearly than in the paintings of his favorite artist Pierre Renoir. The twelve paintings in the Collection cover the years 1864–1913 and include a *Portrait of M. Chocquet*, friend and first collector of his works; *Reclining Female Nude*, which exemplifies the best of his works of women; and several outdoor paintings in the Impressionist manner.

The Post-Impressionists are included in the Reinhart Collection as a fitting conclusion to the exploration of color. Cézanne's approach is exemplified in the still life *Fruit Dish and Apples* and an additional ten works, both oils and watercolors, that illustrate his various subjects: *Self Portrait* and landscapes such as Mont Ste.-Victoire. By Vincent van Gogh are four paintings and two drawings, the best of which relate to his time in Arles and Provence. The glitter of nightlife is chronicled by Henri de Toulouse-Lautrec, whose *Female Clown* expresses both his poster-like technique and his insight into human tragedy.

Pablo Picasso is the most recent painter in the Collection with a work from his Blue Period, *Portrait of Mateu F. De Soto*, and three drawings from 1919, about the time that Reinhart began to collect.

The twenty-one sculptures are housed in the winter garden, which connects the residential quarters with the gallery. Several nineteenth-century Swiss sculptors are represented, as well as Aristide Maillol, whose *Mediterranean* is one of his finest pieces. Works by Rodin illustrate the more dynamic side of sculpture at the turn of the century.

Both Foundation and Collection have libraries with publications relating to the nature of their collections; they are not open to the public. Photographs of the works in both Foundation and Collection are loaned for purposes of research. There is a catalogue in English of the Am Römerholz Collection, a small pamphlet concerning both, and extensive, well-illustrated booklets in German on both Foundation and Collection.

Selected Bibliography

Museum publications: Stähelin, Lizbeth, *Oskar Reinhart Collection, "Am Römerholz,"* 1970.

Other publications: Cooper, Douglas, *Great Private Collections* (New York 1973); Keller, Heinz, *Die Stiftung Oskar Reinhart, Verzeichnis der Gemälde und Plastiken,* 2d rev. ed. (Winterthur 1971); Koella, Rudolf, *Sammlung Oskar Reinhart Am Römerholz: Mit Beiträgen von Michael Stettler und Eduard Hüttinger* (Zurich 1975); *Meisterwerke europäischer Malerei des 15–19. Jahrhunderts aus der Sammlung Oskar Reinhart,* 4 portfolios (Bern 1940–41); Seiffert-Wattenberg, Richard, *Aus der Sammlung Oskar Reinhart* (Munich 1935); Vignau-Wilbert, Peter, *Stiftung Oskar Reinhart Winterthur,* vol. 2: *Deutsche und Österreichische Maler* (Zurich 1979); Zelger, Franz, *Stiftung Oskar Reinhart,* vol. 2: *Schweizer Maler des 18. und 19. Jahrhunderts* (Zurich 1977); Budry, Paul, "La Collection Reinhart et la peinture française," *Formes et couleurs* 2/3 (1940); Courthion, Pierre, "La Collection Oskar Reinhart," *L'Amour de l'Art,* vol. 7 (1926); Gantner, Joseph, "Oskar Reinhart Zum 80. Geburtstag am 11. Juni 1965," *National-Zeitung* (Basel), June 6, 1965; George, Waldemar, "Collection Oskar Reinhart: Topographie d'une collection," *Formes* 26/27 (1932), pp. 285–96; Häsli, Richard, "Die Sammlung Oskar Reinhart," *Neue Zürcher Zeitung,* March 9, 1970; Heise, Carl Georg, "Die Stiftung Oskar Reinhart in Winterthur," *Das Werk,* vol. 38 (1951), pp. 218–24; Holz, Hans Heinz, "Sein ist Farbe—Die Sammlung Oskar Reinhart," *National-Zeitung* (Basel), March 15, 1970; Huggler, Max, "Die Privatsammlung Oskar Reinhart," *Schweizer Monatshefte,* vol. 35 (1955); Huth, Arno, "A Swiss Collection of Masterpieces Exhibited at the Berne Museum," *The Studio,* vol. 119 (1940), pp. 194–201; Jedlicka, Gotthard, "An den Rand geschrieben: Divagationen über Bilder der Sammlung Oskar Reinhart," *Du,* vol. 16 (1956); idem, "Oskar Reinhart. 11. Juni 1885 bis 16. September 1965," *Neue Zürcher Zeitung,* September 21, 1965; Meier-Graefe, Julius, "Die Sammlung Oskar Reinhart," *Frankfurter Zeitung,* April 29 and May 12, 1932; Scheffler, Karl, "Die Sammlung Oskar Reinhart in Winterthur," *Kunst and Künstler,* vol. 25 (1926); Schmidt, Georg, "Die Sammlung Oskar Reinhart: Zur Ausstellung in der Kunsthalle," *National-Zeitung* (Basel), April 22 and May 3, 1932; Stähelin, Lisbeth, "Die Sammlung Oskar Reinhart. Am Römerholz,' " *Winterthur Jahrbuch,* 1970; idem, "Sammlung Oskar Reinhart. Am Römerholz,' " *Grosse Gemäldegalerien, herausgegeben von Erich Steingraber* (Munich 1980); Stettler, Michael, "Oskar Reinhart," *Rat der Alten, Begegnungen und Besuche,* 3d rev. ed. (Bern 1980); Vitali, Lamberto, "Le grandi collezioni. I: La raccolta Oskar Reinhart a Winterthur," *Emporium,* vol. 43 (1937); Keller, Heinz, "Art Museums at Winterthur," *Apollo,* vol. 110, no. 212 (n.s.) (October 1979), pp. 293–301.

MARY LOUISE WOOD

———— Zurich ————

ZURICH ART MUSEUM (officially KUNSTHAUS ZURICH), Heimplatz 1, CH–8001 Zurich.

Since the days of Zwingli, who abolished all figurative ornaments from the

churches in 1523, the visual arts had not received any notable support in the puritanical city of Zurich, apart from some handicrafts such as stained glass. The only portraitist of note, Samuel Hofmann, did not have enough commissions to earn a living. Even in the eighteenth century, Johann Heinrich Fuseli discovered his vocation as an artist only after he left Zurich and became famous as a professor at the Royal Academy in London.

Thus it is not surprising to find that the beginnings of the Kunsthaus Zurich were very modest. From 1787, an enthusiastic group of artists and dilettanti, the Zürcher Kunstlergesellschaft, gathered on Thursdays to exchange news and ideas about art. They started collecting slowly with prints and drawings contributed by the members and pasted in so-called Malerbücher, charming documents of provincial late Rococo and early Biedermeier taste, with exhibitions organized nearly every year beginning in 1799 in a guild hall. In 1803 a number of plaster casts and a small library were acquired—partly as a gift from the town—to serve as models for art students, and in the same year, the friends constituted themselves as an organized association called Zürcher Künstlergesellschaft.

In 1812 a modest suburban villa situated on a hill overlooking the town, the lake, and the Alps was purchased. To this "Künstlergüetli" a small exhibition wing modeled in miniature on the architecture of the Alte Pinakothek (q.v.) in Munich was added in 1847. More important gifts now began to arrive. Among them was an early painting by Fuseli, *The Artist in Conversation with the Old Bodmer*. Other noteworthy bequests included the collections of the Keller (1854) and Hess (1858) families, containing seventeenth- and eighteenth-century paintings from Zurich; with the Schulthess von Meiss legacy (1898), a number of pieces of artwork from other countries, mainly Germany, entered the collection for the first time.

In the second half of the nineteenth century, Zurich witnessed an enormous development: industry and commerce increased rapidly. Two universities and a number of other important cultural institutions including the historical Swiss National Museum were founded, but all proposals of the Künstlergesellschaft to build a museum of some size proved unsuccessful. Thus the exhibitions had to be arranged in rented rooms, or the collection was removed. Finally, another group founded the Verein Künstlerhaus and in 1895 opened a small building especially designed to house exhibitions in the center of the town. The following year the two societies merged into the Zürcher Künstgesellschaft, but only in 1910 was the first part of the present Kunsthaus opened.

A first competition for a museum building was held in 1902 but did not produce satisfying results. After a second competition, the commission was given in 1904 to Karl Moser, a distinguished Swiss architect working in Karlsruhe, who later taught in Zurich. Before building construction started in 1908, his plans developed from a style tinged by the Neo-Baroque and Viennese Art Nouveau to a more severe modern fashion typical of the Karlsruhe school. In a subtle balance, the two wings devoted to the collection and the exhibitions are linked and

contrasted, the former a largely closed cubelike block, the other a more ornate structure, recalling the form of a loggia in the upper story and the light vibration of tents in the slightly concave treatment of the walls. The ground floor is largely devoted to service areas; a spacious hall in the main floor links the two parts. Most exhibition rooms are provided with large central lights. The festive decoration, based mainly on a pattern of squares and classical profiles, was largely obliterated in 1925 but has now been restored as much as possible.

A first addition in 1924–26 connected the backside of the wing devoted to the collection with an old house situated in the same garden. The architect was again Karl Moser, who had adopted in the meantime the ideas of the "Neue Bauen"; thus the building was an unadorned cube, and the regularly shaped rooms lacked all decoration. The center of the building was occupied by the reading room; the empty space extending from the ground floor to the roof was later converted into two large exhibition galleries. A second important addition was opened in 1958 after many years of planning; in fact, the competition won by Pfister Bros. took place in 1944. Its main feature is a large hall measuring seventy by eighteen meters, which may be easily adapted to any temporary exhibition. A third extension was planned by Erwin Müller and Blumer after 1969 and opened in 1976; it occupies the site of the demolished house and contains three galleries in a large, irregularly shaped, open hall.

From 1910 the Kunsthaus grew steadily both in exhibition activity and in its collection. A society of sponsors, the Vereinigung Zürcher Kunstfreunde, was founded in 1917 to raise funds for notable purchases. Acquisitions were restricted to Swiss artists until 1920, when the bequests of Richard Schwarzenbach and Hans Schuler brought a series of important late-nineteenth-century German and French paintings into the collection. Largely due to regular gifts of Hans E. Mayenfisch (since 1929) and other friends, the most comprehensive collection of late nineteenth- and twentieth-century Swiss art was gathered. There were also important purchases of masterpieces of international modern art, medieval sculpture, and Late Gothic Swiss painting. Wihelm Wartmann, director of the Kunsthaus from its opening in 1910 until 1949, was able to bring together, among other important works, the largest group of paintings by Edvard Munch outside Scandinavia. Under Rene Wehrli, his successor until 1976, the Kunsthaus purchased two large *Nymphéas* by Claude Monet, as well as many other major pieces.

Since 1950 the foundation created by Leopold Ruzicka, 1939 Nobel Prize winner in chemistry, has enabled the Kunsthaus to display a selection of seventeenth-century Dutch paintings, including masterpieces by Rembrandt (*St. Simon*, 1661), Ruisdael (*View of Haarlem*, c. 1670), and van de Cappelle (*Boats in the Schelde—Mündung*). The second extension, consisting of a large exhibition hall that had been planned since 1938 and financed by E. G. Bührle, was opened in 1958. In 1959 the Stiftung Zürcher Kunsthaus was founded, and a substantial annual contribution by the city was approved. In 1965, after long and passionate public debates, the largest collection of works by Alberto Giacometti was secured

for the Kunsthaus by a society of subscribers through the Giacometti Stiftung. After small additions in 1966 and 1968, including a room given by Nelly Bär together with the sculptures displayed in it, the third large-scale extension was undertaken in 1976.

The Kunsthaus Zurich is still run by the Zürcher Kunstgesellschaft, a private association presently numbering about eighty-five hundred members. It is financed largely by public grants, mainly from the city. Smaller amounts are contributed by the canton and the surrounding communities. These different bodies are represented on the Board of Trustees, as are the local associations of artists. Two committees supervised the exhibition activities and the collection. The regular staff consists of about sixty individuals. The director is assisted by an administrative director. A vice-director is responsible for the department of prints and drawings and the library. Three curators are occupied with exhibitions, and a curator looks after the permanent collections of painting and sculpture. Further services include a conservation laboratory with three staff members, a group of eight craftsmen of different trades, and two art historians for educational activities.

The buildings are owned and managed by the Stiftung Zürcher Kunsthaus, a public foundation controlled by the city, and the collections are owned mainly by the Zürcher Kunstgesellschaft. There are substantial permanent loans from the Vereinigung Zürcher Kunstfreunde; the Gottfried Keller-Stiftung, the Swiss national heritage foundation active since 1892; the city and canton of Zurich; the Swiss Confederation; and the Ruzicka, Giacometti, and Koetser foundations.

Although the collection consists chiefly of nineteenth- and twentieth-century art, there is a small selection of medieval works. Most notable of the latter are nine panels by the The Masters of the Carnation, active in Switzerland about 1500. Of the seventeenth- and eighteenth-century painters, there are examples by Hans Asper, Samuel Hofmann, and Felix Meyer. The chief eighteenth-century masters represented are Johann Caspar Füssli, Anton Graff, Heinrich Wüest, Heinrich Freudweiler, Ludwig Hess, and Salomon and Conrad Gessner. From the nineteenth century we find Jacob Oeri, Ludwig Vogel, and Johann Jacob Ulrich. The highlights in this section are, however, the large group of works by Johann Heinrich Fuseli. Of particular note are his *Tatania from Shakespeare's Midsummer's Night's Dream* (1794), *Scene from Milton's Paradise Lost* (1794–96), and *John Jacob Bodmer Conversing with the Artist*. By Rudolf Koller are distinguished paintings of animals, and by Arnold Böcklin, dating mainly from his late period spent in Zurich, are several outstanding works, such as *Spring*, 1880; *Portrait of Gottfried Keller*, 1889; and *In the Garden*, 1891. There are also interesting works by his student Albert Welti.

The Swiss school of the nineteenth century is represented by masters like Calame, Zünd, Anker, Buchser, Stückelberg, and Stauffer-Bern, culminating in the more than one hundred paintings by Ferdinand Hodler. There are also a number of important works by Felix Vallotton, Giovanni Segantini, Cuno Amiet, and Giovanni and Agosto Giacometti. The same applies to the leading masters

of the following generation: Auberjonois, Maurice Barraud, Blanchet, Gimmi, Morgenthaler, Max Gubler, and Varlin.

The small collection of Dutch and Flemish seventeenth-century pictures on permanent loan from the Ruzicka Foundation contains very fine specimens of the art of Kalf (for example, *Still Life with Shells*), van de Cappelle, Emanuel de Witte, Brouwer, Molenaer, van Beyeren, Rubens, and others. The comparatively small but superb *View of Haarlem* by Jacob van Ruisdael and the *St. Simon*, one of Rembrandt's late portraits of old men, are to be counted among the highest achievements of this school.

One of the principal aims of the Kunsthaus since the early twenties has been to gather representative examples of nineteenth-century French painting. This group commences with the vigorous *Farrier* (*The Blacksmith*, 1813–14) and *La Cervara* (1830–31), a stormy Italian landscape, by Corot. There are paintings by Delacroix, Courbet (*The Trout*, 1871), and Manet (*La fuite de Henri Rochefort*, which was formerly in the collection of Max Liebermann). Impressionist and Post-Impressionist examples are works of Degas and Toulouse-Lautrec and six paintings by Claude Monet, including *Man with a Parasol* of 1867, an especially intense example of the *Haystack* series, and two beautiful, large *Nymphéas*. There are several characteristic early and important late canvases by Cézanne, such as his *Landscape in Provence* of 1875–78; by van Gogh, his *Thatched Roof in Auvers* of 1890; and by Gauguin, with his *La barrière*, a masterpiece from the Pont-Aven period, which was bequeathed to the museum in 1981. Although Pointillism is evoked only by one of Henry van de Velde's rare works in this style, there is a comprehensive group of paintings by Vuillard, including the notable *Large Interior with Six People* of 1897, and by Bonnard, with his *Summertime* of 1912, reflecting the predilection of Swiss collectors for the works of these Intimists.

The highlight of the twentieth-century collection is the ten paintings by Edvard Munch. They are grouped around the full-length portrait of his friend, *Dr. Wartmann*, the first director of the Kunsthaus, and range from the early *Musik auf der Strasse* to late landscapes, such as *Lübeck Harbor*, 1907. Among the paintings by the German school, there are notable examples by both Liebermann and Corinth. By the first is the especially fine *Gartenrestaurant Oude Vinck* and by the latter, the imposing *Selbstbildnis mit Modell* of 1903 and the moving last *Self Portrait*. Another favorite painter of Wartmann was Oskar Kokoschka. Of the group of six paintings by him, the early portraits are outstanding (*Adele Astaire*, 1926, and *Portrait of Else Kupfer*, 1910). There are also three works by Beckmann and four by Kirchner; other of the Expressionists—Macke, Marc, and Nolde—are represented only by a single, characteristic painting each.

Since collecting was always focused on contemporary art, most twentieth-century movements are well represented. Of the Fauve movement, there are works by Matisse (*Margot, the Artist's Daughter*, 1907) and Derain; of Orphism, there are two large canvases by Delaunay. Cubism is covered by works of Picasso, Braque (*The Fireplace* of 1923), de la Fresnaye, and Gris. Futurism is

notably present in the important and renowned *Velocità d'automobile + luce + rumori* by Balla.

During World War I Zurich was a center of émigré artists, and a number of them were responsible for creating the Dada movement. To commemorate this, a large collection devoted to the movement was bought for the museum by public subscription in 1980.

Works by artists of the Bauhaus and De Stijl group include canvases by Kandinsky, Klee, Moholy-Nagy, and Mondrian. The works of these artists influenced the Zurich painters Max Bill and Richard Paul Lohse, who in 1937 founded the L'Allianz with other avant-garde Swiss artists. The bequest of Mrs. Fritz Glarner, who died in 1979, left a group of works by her husband, the Swiss-born follower of Mondrian primarily active in New York, that permits a detailed study of the development of his abstract style. This bequest includes some sixty paintings (some unfinished), two hundred drawings, and many documents.

Surrealism, too, is represented by several international masters, including de'Chirico, Dali, Tanguy, Masson, and Miró. There are also the Swiss Surrealists Oppenheim, Wiemken, Bellmer, Tschumi, and von Moos. A link between these two groups is the large mural done for the Corso-Bar in Zurich by Max Ernst.

An impressive series of twentieth-century European paintings includes four works by Léger; six by Picasso, including the important Cubist *Guitar on a Gueridon* of 1915; and ten by Chagall, of which *The War*, 1964–66, is one of the most important. There are also several fine canvases by de Staël, including *Agrigert* of 1954, and a small but carefully selected number of works by American artists such as Jasper Johns, Mark Rothko, Robert Rauschenberg, and George Segal. The most recent acquisitions in the twentieth-century collection include paintings by Kiefer, Penck, Paladino, and Francis Bacon.

The collection of modern sculpture begins with eleven works by Rodin and continues with examples by most of the important sculptors of the time: Maillol, Bourdelle, Barlach, Brancusi, Lipchitz, Archipenko, Moore, Chillida, Calder, and Caro. Swiss sculptors who are extensively represented include Geiser, Hubacher, Aeschbacher, Robert Müller, and Tinguely, with several works. One of the highlights of the Kunsthaus is the large collection of works by Alberto Giacometti, including a number of plaster originals of his early Surrealistic period, and the large (144 by 62 by 70 centimeters) *Le chariot* of 1950 from the Alberto Giacometti Stiftung (1965).

The Department of Prints and Drawings contains the oldest holding of the museum, the so-called Malerbücher, to which artists contributed their own works, and amateurs gave pieces from their collections. It was an artist, however, Johann Jacob Ulrich, a distinguished landscape painter, who presented a sketchbook by Théodore Géricault. Systematic collecting started later and focused roughly on the same areas as the collection of paintings and sculptures. There is a small but fine selection of early German and Swiss drawings, including sheets by Hans Leu, Manuel Deutsch, and Urs Graf, with an *Apollo* by Dürer. The holdings of

works by artists from Zurich are extensive. There are prints by members of the Meyer family, watercolors by the Rococo celebrity Salomon Gessner, and other works. This section culminates in the several hundred drawings by Johann Heinrich Füssli, or Fuseli. There are large groups of drawings and prints by Swiss artists of the nineteenth and twentieth centuries, for example, more than one thousand drawings by Hodler and all of the prints by Dieter Roth. Other modern pieces include a representative selection of works by the "Zero," Minimal, and Conceptual artists. Attached to the department is a collection of video tapes and the independent Swiss Foundation for Photography.

The Kunsthaus publishes about a dozen exhibition catalogues a year, a comprehensive bibliography until 1979 may be found in *Schweizer Museumsführer*, Bern 1980, entry no. 520; catalogues published before 1968 may be found in the earlier editions of this book.

Selected Bibliography

Neujahrsblatt der Zürcher Kunstgesellschaft, 1805 ss; *Jahresbericht der Zürcher Kunstgesellschaft*, 1896 ss; *Mitteilungsblatt der Zürcher Kunstgesellschaft*, 1973 ss; *Inventarkatalog der Gemälde und Skulpturen*, 1958; *235 Werke aus der Sammlung Kunsthaus Zürich*, 1976; *Gemälde der Ruzicka-Stiftung*, 1949; Koella, Rudolf, *Félix Vallotton im Kunsthaus Zürich*, 1969; Baumann, Felix Andreas, and Dagmar Hnikova, *Der Skulpturensaal Werner Bär im Kunstshaus Zürich*, 1970; Meyenburg-Campbell, Bettina von, and Dagmar Hnikova, *Die Sammlung der Alberto Giacometti-Stiftung*, 1971; Perucchi-Petri, Ursula, *Bonnard und Vuillard im Kunsthaus Zürich*, 1972; Huggler, Max, and Dagmar Hnikova, *Otto Meyer-Amden im Kunsthaus Zürich*, 1974, Gempeler, Robert D., *Werke der Antike im Kunsthaus Zürich*, 1976; *Edvard Munch im Kunsthaus Zürich*, 1977; Kékkö, Marika, *Marc Chagall im Kunsthaus Zürich*, 1980; Hnikova, Dagmar, *Fritz Glarner im Kunsthaus Zürich*, 1982; *Festschrift zur Eröffnung des Erweiterungsbaus Kunsthaus Zürich*, 1976; Jehle-Schulte Strathaus, Ulrike, "Das Zürcher Kunsthaus," ein Museumsbau, von Karl Moser, Basel, 1982, (*Schriftenreihe des Institutes für Geschichte und Theorie der Architektur an der Eidgenössischen Technischen Hochschule Zürich* 22).

CHRISTIAN M. KLEMM

Taiwan

See CHINA, REPUBLIC OF (TAIWAN)

Thailand

Bangkok

BANGKOK NATIONAL MUSEUM (also NATIONAL MUSEUM, BANG-
KOK), Na Phra Dhat Road, Bangkok 2.

The Bangkok National Museum with its thirty-two branches designated as
local National Museums is the central museum of Thailand. The branches are
museums of art and archaeology, or national treasures of Thailand, and they are
classified by their origin into four categories: regional, provincial, site, and
monastery museums.

The first group is the national regional museums, located in different geo-
graphical regions. Their collections include archaeological artifacts and art ob-
jects related to the specific locales. The second group is the national provincial
museums, which are found in major towns where local antiquities had been
collected and preserved for a period of time. The third group is the national site
museums, established at historical and archaeological sites to present exhibits
of works discovered there. The final group is the national monastery museums,
which house antiquities and art objects donated to various monasteries.

The Bangkok National Museum has a long established history. It includes the
royal private collection of antiquities of King Mongkut (King Rama IV, 1851–
68). The first public museum in Thailand was founded by his son and successor
King Chulalongkorn (King Rama V, 1868–1910). This museum was located in
the compound of the Grand Palace. In 1887 the contents of this collection were
transferred by royal command from the Grand Palace to the palace of the prince
successor (the second king). Originally, this palace was built for the brother of
King Rama I (1782–1809). Following the royal tradition, King Rama I designated
his younger brother to be the second-in-command of the armed forces, and it
was recognized that he was the probable successor to the throne. His palace was

known as the Palace to the Front (Wang Na). The significance of this expression followed the Ayudhya tradition, whereby the palace of the prince successor was situated in the front of the main entrance to the king's palace in order to protect it. When the capital was moved from Dhonburi to Bangkok in 1782, the Royal Palace was built with its main entrance facing north, and the Palace to the Front of the prince successor was then built to the north of it.

The palace of Wang Na was occupied by the prince successors for five reigns, from King Rama I to V. During the reign of King Rama V (1868–1910), when the prince successor died, both the title and the position were abolished. Then the heir apparent became known as the crown prince.

When the public museum was moved from the Grand Palace to the Palace of Wang Na, the museum at first occupied only three ceremonial buildings at the front. Shortly after King Rama VII, or King Prajadhipok (1925–34), succeeded his father as king, he allowed the whole of the residential quarters of the palace to be called the Bangkok Museum (1926). It was placed under the jurisdiction of the Royal Institute of Literature, Archaeology, and Fine Arts. Prince Damrongrajanubhap, the president of the Royal Institute, and George Caedìs, the secretary-general, reorganized and enlarged the museum to form the basis of the present National Museum and the Research Institution of Art and Archaeology in Thailand.

The museum's administrative system developed over a period of time. In 1933 the Royal Institute was reorganized, and the Department of Fine Arts under the Ministry of Education was established. The Division of Archaeology, a component of the department, is responsible for museums, monuments, and archaeological work. Many archaeological sites have been explored and excavated during the past few decades, and as a result, a great number of artifacts and art treasures have been discovered. Site museums, provincial museums, and regional museums have been established throughout the country to preserve and exhibit the cultural heritage found in the country.

In an attempt to develop the National Museums to meet modern standards, the Department of Fine Arts reorganized the administrative structure in 1975. The Division of Archaeology was rearranged to enable it to expand its activities, emphasizing archaeological excavation and research and restoration and protection of monuments. National Museums were separated and placed under a new division called the Division of National Museums responsible for the Bangkok National Museum and its branches all over the country.

The first collection to be housed in the Bangkok National Museum came from the museum in the compound of the Royal Grand Palace. The transfer was made in 1887. This collection included King Mongkut's private assemblage of antiquities and items related to natural history and ethnography. For thirty-nine years the museum occupied only three buildings of the palace. The original exhibits included the zoological collection, stone and bronze sculpture, ceramics, and minor arts.

In 1926 the Bangkok National Museum was reorganized and enlarged. It was

changed from a general museum to a musuem of art and archaeology. The collection of stuffed animals and skeletons was distributed to other institutions. The museum collection was then enriched by art treasures from many sources. For instance, a collection was donated from the royal chapel of the Emerald Buddha Temple, which included stone sculptures from Java, Sarnath, and Cambodia. In addition, collections from the Ministry of the Interior and branch museums in Ayudhya and Lopburi containing stone and bronze sculptures were transferred to the Bangkok National Museum. The museum also purchased the art collection of Prince Piyaphakdinath, which included sculptures and miscellaneous works of art of high quality. Important gifts were presented to the museum by King Rama VII, Prince Damrongrajanubhap, Prince Nagara Svarga, and various ministers of state. Under the Division of Archaeology, the museum has since been collecting artifacts and art objects from excavations at sites throughout the country.

In an attempt to modernize the Bangkok National Museum, two double-story buildings were constructed to the right and left of the old central palace group, to provide a contemporary venue for presenting the sculptures of different periods and styles. The two new wings and the gallery of prehistory were opened by King Phumibol Adunyadet on May 25, 1967.

The new wings present, in chronological order, sculptures from ancient cultures found in Thailand that are arranged according to various schools of art. One building is devoted to exhibitions of prehistoric works and a brief history of Thailand as an introduction to the history and culture of the country.

Prehistoric specimens include archaeological finds from the Paleolithic period of 10,000 B.C. to the Bronze period. In northwest Thailand, plant and animal remains, chipped pebbles, and polished stone tools were discovered at the Spirit Cave in Mae Hongson (10,000–7,000 B.C.). Two major burial sites in northeast Thailand at Non Nok Tha and Ban Chiang have provided evidence of an Early Bronze Age people who had settled there at least 3,000 B.C. Extensive finds of pottery in particular were significant at Ban Chiang. They have distinctive painted designs in ochre-red and have attracted a great deal of public attention and interest. The Ban Chiang exhibits also include bronze tools, utensils, ornaments, and stone and glass beads. The most interesting bronze exhibits from various places are the bronze kettle drums and bronzewares that are representative of the Dongson culture of 600–100 B.C.

The art heritage of Thailand is predominantly religious, drawn from both Buddhism and Brahmanism. Ancient sculptures include images of the Buddha, Bodhisattvas, and Brahmanic gods that reflect influences from Indian culture. These influences began to reach Southeast Asia during the first century of the Christian Era. Indianization in the area that became Thailand developed slowly over many centuries.

In Thailand as well as in other countries throughout Southeast Asia, Indian elements were selected and integrated into existing local cultural patterns. The earliest signs of Buddhist culture have been found in central Thailand, with

satellite centers in the North, the Northeast, and the South, from the sixth to the eleventh century. This early culture has been designated as Dvaravati, or ancient Mon. The name "Dvaravati" was confirmed by two silver medals discovered at Nakhon Pathom with the word *Dvaravati* written on them. The name Dvaravati also appeared in Chinese records referring to it as a kingdom that existed between Burma and Cambodia. Since many stone inscriptions of this culture were written in Mon, it is assumed that the majority of the people of Dvaravati were Mon-speaking people. The museum has two galleries devoted to the art of Dvaravati, or Mon. The collection includes Buddhas in stone, bronze, stucco, and terracotta, with Indian prototypes evident. There are many big pieces of stone sculpture, including the stone wheels of the law with recumbent deer, unique to this school of art, since they represent the Buddha's first sermon delivered in the deer park at Sarnath. Terracotta and stucco figures and motifs are a subject of architectural decoration found in various Dvaravati sites.

The gallery of Srivijaya art presents mainly Buddhist sculptures from the southern peninsula. The most important site of Srivijaya culture is Chaiya in the south of Thailand, where the famous masterpiece, a bust of the bronze Bodhisattva, was found. Srivijaya art is generally designated as Mahayana Buddhist art of the eighth to the thirteenth century. Another fine image is the bronze Buddha sheltered by *nagas* (cobras) (160 centimeters high), which was also found at Chaiya. Most of the works of art of Srivijaya style were found in widely scattered sites in southern Thailand.

There are also stone sculptures of ancient Hindu gods displayed in the museum. The most notable is the statue of Vishnu from Ta Kua Pa in the south of Thailand, superbly modeled to reveal natural strength with a classic beauty.

A collection of sculptures of Khmer style is presented in two rooms, one for stone and the other for bronze pieces. The Khmer art style of Cambodia is comparable to most Khmer art found in Thailand. There are some remarkable bronze images of the pre-Angkor period dating from the eighth-ninth century exhibited in the Khmer gallery. Architectural fragments and stone lintels were collected from different Khmer sanctuaries in northeastern Thailand. The local style of Khmer art is generally called Lopburi art, referring to the town of Lopburi, which was the center of administrative control during the twelfth-thirteenth century. The art objects of the Lopburi period are objects of local art after the Khmer style.

The Thais also developed their distinctive style during the reigns of different cultures that existed in the country. In the thirteenth century Thais came into power in the north. Two schools of Thai art emerged and have been designated as "Chiangsaen," or "Lanna," and "Sukhothai." The art of Lanna dates from the thirteenth to the eighteenth century, during the period when Chiangmai was the center of the kingdom of Lanna. The finest image of Lanna, or Chiangsaen, style is the *Buddha Subduing Mara*, a royal gift to the museum.

Sukhothai art developed when Sukhothai was the capital in the thirteenth

century. It was the period of religious and artistic renaissance, drawing inspiration from the Indian, Mon, and Khmer art of the past and the new contact with Sri Langka. These elements can be traced in architecture, but in sculpture Thai craftsmen developed their own artistic style. Graceful images of the Buddha and Hindu gods were created by Thai craftsmen having the ideal of a supernatural spirit embodied in human form. The walking Buddha image, with its graceful flowing movement, was first created in the Sukhothai period. Many large bronze images of Hindu gods were cast in the Sukhothai kingdom. The museum has many fine examples of large bronze Buddhist and Hindu images created during the Sukhothai period.

Sukhothai ceramics were known in Southeast Asia and exported widely to Indonesia and the Philippines in the late fourteenth to the early fifteenth century. Two well-known types of Thai export ceramics are celadon and the painted wares with black or brown designs on a greyish white slip.

Ayudhya, or Ayutthaya, was declared an independent Thai kingdom in the central area in 1351. Later the first king of Ayudhya brought the Sukhothai kingdom under his control and lay siege to Angkor. The art of the early Ayudhya period, particularly the Buddha images, reflects in varying degrees characteristics of Dvaravati, Khmer, and Sukhothai. By the fifteenth century the Ayudhya national-style image had developed. This image shows Thai characteristics with a softness of expression more related to Sukhothai than to Khmer traditions. Toward the end of the period many crowned and highly ornamented Buddha images were cast. The museum presents the Ayudhya works in two rooms, including lacquer chests and cabinets of the period.

The Bangkok galleries include other sculptures and minor arts. The style of Bangkok sculpture is generally a mixture of Ayudhya and Sukhothai. The large standing Buddha by Silpa Bhirasri cast in 1951, in commemoration of the Buddha's Twenty-five Hundredth Anniversary, tends to follow the style of Sukhothai.

Museum galleries in the old palace buildings contain objects of art and culture, which are arranged by subject. Each room is devoted to a particular subject. There are ceramics, mother-of-pearl inlay, musical instruments, wood carvings, textiles and costumes, theater masks, marionettes, ivory, objects of Buddhist ceremonies and traditions, palanquins and howdahs, old military exhibits, emblems of royalty, royal funeral chariots, and miscellaneous objects including one strong room of gold and jewelry.

The museum tries to provide services to the community by means of educational projects and temporary exhibitions. The audience hall of the palace is used as a rotating gallery where special exhibitions are presented at least twice a year on a theme relevant to the museum's collections or on a topic of public interest. A publication or catalogue is printed as a handbook to each exhibition.

The Bangkok National Museum has well-organized educational services for schoolchildren. The museum also offers many educational programs based on various aspects of the collections. Some experimental programs have been in-

troduced in an attempt to ''bring the museum to the community'' in rural areas. The education service is extended to schools, and the museum will provide speakers to give talks on request.

The Bangkok National Museum has a program of volunteers to provide information on the art and culture of Thailand for foreign residents as well as for tourists. With the assistance of these volunteers, the Bangkok National Museum is able to offer guided tours in English, French, German, Spanish, and Japanese. The museum library and slide library are also staffed and maintained by volunteers. In addition, the museum volunteers organize a lecture series titled ''An Introduction to Thai Art'' twice a year, as well as a monthly public lecture program in English. Excursions to various monuments and sites in Thailand and out of Thailand are also provided.

Selected Bibliography

Museum publications: *Album of Art Exhibit*, vol. 1, 1954; *Guide to the National Museum, Bangkok*, 1970; *Masterpieces of Bronze Sculpture from Ban Fai*, 1973.

Other publications: Diskul, Subhadradis, *Art in Thailand*, 1970; Griswold, A. B., *Toward a History of Sukhothai Art*, 1967; Krairiksh, Piriya, *Art Styles in Thailand*, 1977; idem, *The Sacred Image*, 1980; idem, *Peninsular Art Prior to the 13th Century A.D.*, 1981; O'Conner, S. J., *Hindu Gods of Peninsular*, 1972.

CHIRA CHONGKOL

Tunisia

——— Tunis ———

BARDO MUSEUM (officially LE MUSÉE DU BARDO; also LE MUSÉE NATIONAL DU BARDO, LE BARDO), Tunis.

The Bardo Museum was opened on May 7, 1888, in the former palace of the Beys of Tunisia. It was called the Alaoui Museum, after the then ruler of Tunisia Ali Bey. In 1956, when the country achieved independence from France, its name was changed to the National Museum of the Bardo, the Bardo being the name of the quarter of the city in which the building is located. The museum is supported by the government and supervised by the Ministry of Cultural Affairs and Information, an administrative body that oversees all archaeological museums in Tunisia, and by a director.

The nineteenth-century palace was designed by Tunisian architects and still retains much of its original decoration, especially in stucco, tile, and wood. Of particular interest are some of the rooms on the second floor that served as the living and entertainment quarters. In these rooms, polychrome tiles, molded and pierced stucco, and carved wood create intricate surface patterns on some of the walls and ceilings. One room, formerly the harem and now called the Virgil Gallery after an exceptional mosaic panel, *Virgil with Clio and Melpomene*, is noteworthy because of its cruciform shape with vaulted arms and an octagonal cupola over the central crossing.

Whether in plain or decorative surroundings, the collection of the museum presents one of the most important visual records of the cultural and archaeological history of Tunisia. The works, housed in more than forty rooms, are divided into four general units: Punic, Roman, Christian, and Arabo-Muslim. The holdings comprises primarily works discovered by chance or uncovered during systematic excavations in the late nineteenth and the twentieth centuries

and augmented by gifts from private persons and some purchases. A fifth unit incorporates the finds from a shipwreck off the coast of Mahdia.

There are only a few works in the museum that date from the prehistory of Tunisia. To be noted are chipped flint and stone objects, stone balls, ceramic utensils, and an incised relief from El Mekta, possibly with an abstract female figure. More impressive and extensive is the museum's collection from the Punic and Neo-Punic periods, dating from the seventh to the first century B.C. Their original religious and funerary contexts are revealed by the innumerable carved and incised votive stelae, wooden and stone sarcophagi, jewelry, ceramic pots, and terracotta figurines, coming from Tophets, hypaethral sanctuaries, and from tombs. Although most of the objects were executed in local workshops, a sizeable proportion of the ceramic works from tombs was imported from Greece, Egypt, Italy, and Sicily. Of special interest are the first-century *Stelae from Ghorfa*, near Dougga, and some small prophylactic masks with grotesque features in polychrome glass paste and terracotta. The stelae, in the form of flattened obelisks, are carved on one side with scenes arranged in three superimposed registers. The central scene contains a seated or standing figure, perhaps the donor, placed in a doorway of a temple with a pediment decorated with a bust of Tanit-Caelestis, the goddess of fertility, or with a symbolic eagle. Below and above this central register there are scenes of sacrifice and scenes with gods, primarily derived from Greek and Roman mythology.

By far the largest holdings in the Bardo come from the Roman period when Tunisia reached its commercial, cultural, and agricultural apogee. As the bread basket of the western half of the Roman Empire, it enjoyed a remarkable growth in urbanization, as witnessed by the relatively well-preserved cities of Bulla-Regia, El Jem, Dougga, Mactar, Thuburbo Majus, and Utica. Excavations of these cities, and others, yielded many important examples of sculpture, mosaic pavements, and minor objects, now housed in the museum. Coming from the public and private sectors of the cities, these works reveal the tastes, beliefs, and daily activities of people living in a Roman province of North Africa.

More than 360 mosaic pavements, primarily from houses and villas, form the major strength of the Bardo's archaeological collection. Arranged in tiers on the walls or set in the floors of galleries and corridors, the works reflect the scope of the mosaic programs of interest to the Tunisians, especially in regard to the decoration of their town, seaside, and country residences. Thus living quarters, dining and reception rooms, porticoes, and courtyards with fountains, basins, and pools received polychrome figural and geometric mosaics. Popular scenes include mythological figures and stories depicted on land and sea; hare, boar, tiger, and deer hunts; combatants and competitors from the circus, amphitheater, and hippodrome; and agricultural, marine, and domestic activities. Even thresholds were not excluded from the decorative programs, containing, among other themes, prophylactic symbols to ensure the well being of the owners of the residences. Among the scenes with popular mythological personages is the well-known *Dionysus Giving the Vine to King Ikarious of Attica*, from Oudna. This

central panel is surrounded by delicate, undulating vine rinceaux laden with clusters of grapes. Similar rinceaux frame a scene with Dionysus driving a biga drawn by two tigresses, led by a satyr, and accompanied by Silenus and a Bacchante (El Jem). These same figures appear in *Dionysus and Ariadne* from Thuburbo Majus, representations semireclining on a panther skin beneath a grape arbor, and also in a lively marine scene from Dougga, *Dionysus Punishing the Pirates from the Tyrrhenian Sea*, based on a passage in the *Odyssey* by Homer.

Other prominent mythological figures, but ones more closely associated with the sea, are Neptune and Amphitrite. One very large mosaic from Sousse, *The Triumph of Neptune*, shows the god in a quadriga drawn by four hippocampi, surrounded by fifty-six medallions filled with Sirens, Nereids, Tritons, and sea monsters. A less spectacular and more subtle rendition of this theme contains a similar triumphant scene in the center, but the four corners of the field are decorated with personifications of the Four Seasons (La Chebba), another popular subject in mosaic pavements. Sometimes, the triumphant Neptune is accompanied in his chariot by Amphitrite (Utica). Lesser personifications like Oceanus and river gods are also associated with marine scenes, accompanied by Tritons, Nereids, various species of fish, and in one mosaic by different types of boats identified by Greek and Latin inscriptions (Althiburos). Other gods and goddesses are also represented in scenes such as the *Contest between Apollo and Marsyas* from El Jem, where once again the corners of the field are occupied by the Four Seasons, and in the panels *Diana the Huntress*, where she is shown with bow and arrow or spear. In a mosaic from Carthage both Diana and Apollo are represented as whitish statues in a shrine receiving a sacrifice from hunters who flank the temple. Above and below this central scene are registers showing the departure for the hunt and mounted hunters chasing wild animals.

Hunting scenes are as popular in Roman mosaics as ones with gods and goddesses. Many of them are presented, like the Carthage mosaic above, in registers with the departure for the hunt (Henchir-Toungar), and others include the return from the hunt with the animal wrapped in a net and carried by two servants. In most of these scenes, whether accompanying mounted hunters or their servants, dogs play an integral role in flushing, chasing, and sometimes attacking the animals (El Jem). One owner of a villa at Oudna went so far as to immortalize his favorite hunting dogs in the mosaic threshold of the room *Dionysus and King Ikarios* by identifying them by name, Ederatus and Mustela. Wild animals are also depicted in scenes with gladiators from the amphitheater (Thelepte), fighting or confronting each other, or isolated in adjacent geometric compartments. In most of these mosaics from Korba, El Jem, Thuburbo Majus, and elsewhere, the animals are shown in active poses. In some, however, as in *The Drinking Bout in the Arena* from El Jem, five Zebu bulls are shown sleeping, their rest protected by a servant who cautions five drinking gladiators in the upper register to "be still, let the bulls sleep." Other scenes referring to competitive sports between humans show hippodrome races with drivers and animals representing the four circus factions—the Blues, the Greens, the Whites, and

the Reds (Carthage, Dougga), as well as boxing (Thuburbo Majus) and wrestling (Gichtis, Utica).

Besides the mosaics with mythological figures in marine settings, the Tunisians enjoyed scenes that showed various kinds of littoral or sea activity from their everyday life, casting, angling, spearing, and seining, performed by young men in boats or along the shore. The sea, articulated by serrate or zig-zag lines, is usually depicted in vertical perspective, thereby covering the surface behind the fishermen with various species of fish, crustaceans, and mollusks. Sometimes, as in a mosaic from Sidi Abdallah, near Bizerte, and in one from Carthage, a view of seaside villa complexes is included.

Other scenes from daily life are no less interesting for the view they give of agricultural activity on large inland estates. The Sousse Gallery contains four mosaics showing agricultural and architectural scenes. In the *Dominus Julius* mosaic from Carthage a landowner, represented in the lowest of three registers, receives an account of his estate from a supervisor who rushes toward him. Nearby, his nonchalant and bejeweled wife leans on a column and extends her right hand to receive yet another bauble from her servant. This central vignette is flanked by two other servants coming forward with baskets laden with the produce of the estate. This agricultural theme is repeated in the top register, where three figures are shown offering ducks, olives, and a lamb to a seated figure fanning herself beneath cypress trees while, nearby, a shepherd tends his flock in front of a rustic hut. This mosaic, therefore, presents a vivid account of the seasonal activities and crops of a large estate in Tunisia and reflects the landowner's interest in recording in polychrome stones the bounty of his land. Another landowner from Tabarka was satisfied with showing various types of buildings on his estate: villa, stables, barns, and storehouses.

The collection of Roman art at the Bardo also contains many works in sculpture, ceramic, glass, and metalwork. Foremost among the sculptural examples are an altar dedicated to the *Gens Augusta*, from Carthage; a *clipeus* carved with signs of the zodiac (Utica); a Neo-Attic relief showing dancing maenads, also from Utica; and a statue of Emperor Hadrian as Mars from Carthage. A good collection of imperial portraits has been gathered in the Virgil Gallery, where busts ranging in date from 30 B.C. to A.D. 238 are displayed.

The most interesting and popular collection of sculpture at the Bardo was acquired between 1907 and 1913 from a shipwreck off the coast of the city of Mahdia, south of Sousse. The finds fill six rooms and date primarily from the third and second centuries B.C. They include marble and bronze statues, reliefs, inscriptions, vases, ship and bed fittings, and some fragments from the hull of a ship that sank perhaps in the first century B.C. The objects include a herm of Dionysus, signed in Greek "Boethos of Calcedon," a city in Bithynia; and a statue of Agon, originally all forming a group. Other sculpture, both large and small, shows Aphrodite, Hermes, Eros, a satyr, dancing dwarfs, candelabra, and four large bowls with Dionysiac scenes.

The Sousse Gallery contains a good survey of numismatic and lamp finds from the Punic through the Christian periods, and a gallery on the third floor

contains an interesting display of terracotta, glass, and bronze works in glass cases, many of them from tombs. Other examples of these minor objects are scattered throughout the museum.

The secular and religious works from the Roman period in the Bardo museum serve as extremely important documents of the beliefs and tastes of the inhabitants of a North African city. There are, to be sure, funerary objects, like sarcophagi, with or without images of the deceased, and the well-known statue *Portrait of the Deceased as Hercules* from Bordj-El-Amri, but the predominant image is one of vitality on land, sea, or in the arena with humans, gods, animals, and fish playing their respective roles. The Christian collection, on the other hand, conveys a completely different view of life, one filled with symbols and scenes of salvation. The majority of the objects are Early Christian tomb mosaics from places such as Tabarka, Carthage, Kelibia, and Sfax, dating primarily from the fourth through the sixth century. They contain epitaphs listing the names of the deceased, sometimes their age, and Christian symbols composed of the Chi-Rho, doves, peacocks, sheep, roses, vines, and candles. Many of the ones from Tabarka show the deceased, Victoria, Crescentia, Victor, or Perpetua, in orant poses, symbolizing salvation. Most of these mosaics are products of local work-shops and are, therefore, native in conception and style. Others, like the mosaic of Bishop Vitalis from Henchir Messadine, with a scene of two birds drinking from a vase with flowing water, is the product of a more sophisticated workshop, befitting the status of the deceased.

An unusual and important tomb mosaic from Tabarka contains a schematic cross-section of a three-aisled church with the name of the deceased, Valentia, inscribed on the epistyle of a colonnade. Other important Christian holdings include the very well-preserved cruciform baptismal font from Kelibia, decorated with trees, candles, fruit, and dolphins and containing the names of the donors, Aquinicus and his wife, Juliana, and an unusual collection of ceramic tiles from churches in Carthage, El Jem, and elsewhere, with scenes from the Old and New Testaments.

Although located in the same building as the Bardo, the Arab Museum, created in 1900, is a separate entity. The collection is located in about eleven rooms on two floors. Noteworthy are the tombstones with Kufic inscriptions; the ceramic tiles from Italy, Morocco, Tunisia, and Asia Minor; stucco decoration from palaces; early Tunisian carpets from the eighteenth and nineteenth centuries; and impressive examples of Bedouin metalwork in gold and silver. The collection was enlarged by the donation of H. H. Abdulwa-hab, with objects dating from the Coptic to the Mameluke periods (fifth to the fifteenth century).

Slides and photographs of some of the objects may be purchased, with great difficulty, by application to the Institute of Archaeology and Art and to the director of the Bardo. The last guide to the museum appeared in 1970, but it is now out of print.

Selected Bibliography

Museum publications: R. L. Blanchère and P. Gauckler, *Catalogue du Musée Alaoui*, 1897; A. Driss, *Treasures of the Bardo Museum*, trans. H. Saāda, 1962; L. Drappier,

P. Gauckler, and L. Hautecoeur, *Catalogue du Musée Alaoui: Premier Supplément*, 1910; R. Lantier and A. Merlin, *Catalogue du Musée Alaoui: Second Supplément*, 1922; Merlin, A. and L. Poinssot, *Guide du Musée Alaoui*, rev. ed., 1957; Picard, C. G., *Catalogue du Musée Alaoui: Nouvelle série*; *Collections Puniques*, vols. 1, 2, 1955; Yacoub, M. *Musée du Bardo: Musée Antique*, rev. ed. 1970.

Other publications: Merlin, A., and L. Poinssot, "Cratères et candélabres de marbre trouvés en mer près de Mahdia," *Notes et Documents de la Direction des Antiquities*, 1930; Quillard, Brigitte, *Bijoux Carthaginois. Les Colliers: d'après les collections du Musée National du Bardo et du Musée National de Carthage*, vol. 1 (Louvain 1979).

MARIE SPIRO

Turkey

Istanbul

MUSEUM OF TURKISH AND ISLAMIC ARTS (officially TÜRK VE İS-LÂM ESERLERI MÜZESI), Ibraham Pasha Palace, Sultanahmet, Istanbul.

The Museum of Turkish and Islamic Arts is the largest and most comprehensive collection of its kind in Turkey and is considered one of the finest museums of Islamic art in the world. The museum was founded in 1914 as the Evkaf-i Islamiye Müzesi and was housed in the *imaret* of the Süleymaniye Mosque in Istanbul. In 1923, after the Turkish Revolution, the museum's name was changed to the Türk ve İslâm Eserleri Müzesi, emphasizing its Turkish heritage. The original collection of Islamic objects had been taken from a large group of art and artifacts stored since 1846, first in the Byzantine church of St. Irene and then in the Çilini Kiosk. The collection at Süleymaniye grew considerably over the years with the addition of objects acquired from mosques, tombs, monasteries, and excavations. The *imaret* of Süleymaniye became too small to house the rich collections of carpets, metalwork, pottery, stonework, and woodwork, and a new home was sought. On May 14, 1983, the Museum of Turkish and Islamic Arts opened at the Ibraham Pasha "Sarayi" (palace) in the ancient Hippodrome.

The Ibraham Pasha Palace, the only palace of this type that has survived to the present, was constructed in the sixteenth century. It was used by Ibraham Pasha, a favorite vizier to Sultan Süleyman the Law-Giver. Subsequently, the palace was used as a lodge for the crown prince, a dormitory for palace trainees, and an administrative building. In 1938–40 part of the palace was unfortunately demolished to make way for a new courthouse, although much of the original building, including the men's quarters, and the *divanhane* (from which the sultan overlooked public ceremonies on the Hippodrome below) were preserved. The restoration and rediscovery of the original palace began in 1967 and continued

for fifteen years under architect Hüsrev Tayla, financed by the Turkish Ministry of Culture. Today, the palace houses exhibition galleries and rooms, storerooms, a photography studio, a carpentry workshop and other technical offices, office space, a library and reading room, a conference room, a café, and a sales area. The museum and the collections are overseen by a director, two assistant directors, and five researchers. A support staff includes restorers, technicians, office personnel, and attendants. The whole is supported by the Turkish government.

The museum includes specialized collections of rugs, manuscripts, wood objects, stonework, ceramics and glass, metalwork, and ethnographic material. The exhibits are arranged in chronological order in a series of galleries and smaller rooms on two floors.

The rug collection features more than fifteen hundred examples. Works from the Seljuk period, dating from the thirteenth century, are world renowned and include a Seljuk rug formerly in the Alaeddin Mosque at Konya. This large, wool rug features an overall pattern of red hexagons on a biege field. Early Anatolian carpets, known as "Holbein carpets," include a wool rug from the sixteenth century decorated with large, hexagonal medallions. Ottoman court carpets are featured, and a sixteenth-century example is highlighted by a colorful, central field of stylized flowers. Uşak rugs are well represented at the museum, forming an important group like the Seljuk carpets. An Uşak rug with a stylized all-over bird design dates from the sixteenth century, and a wool medallion rug is from the same period. Another Uşak medallion rug is decorated with a triple-ball design, and a multiple-niche prayer rug features seven niches in a horizontal format. Numerous other rugs from Bursa, Gördes, Konya, and elsewhere in both silk and wool, and in various sizes, are in this highly important collection.

Manuscripts in the Museum of Turkish and Islamic Arts include numerous fine Korans. A ninth-century Koran in cufic script is from the Abassid period. From the eleventh century is a Koran from Ummayid Spain, and from the same century is a Seljuk example from Iran. An elaborate fifteenth-century Iranian Koran from the Timurid period is ornamented with floral illuminations and gold leaf. A rare, hanging certificate of pilgrimage is inscribed with the name of Yusuf bin Eyyüb el-Irkil. Other Korans from Bagdad, Egypt, and Turkey are in the collection. A fine group of secular, illuminated books are in the museum. An album of portraits from the nineteenth century includes three-quarter-length representations of Sultan Murad IV and Sultan Ibraham, both Ottoman rulers.

The collection of wood objects includes several carved architectural elements. Window shutters from the Seljuk period from the Ilgin Mosque (thirteenth century) are decorated with interlaced, geometric patterns. An elaborate side panel from a wood *mimbar* (pulpit) dates from the fourteenth century and is carved with interlace motifs and an open-work design. Inlaid furniture for mosques and palaces dating from the Ottoman period is represented by fine examples. A wood table is inlaid with mother-of-pearl in a complex, geometric design, typical of Islamic art. A Koran stand from the seventeenth century is also exquisitely inlaid with mother-of-pearl, and another Koran stand is made of ebony with ivory. A

magnificent, standing Koran box (about five feet tall) is delicately inlaid with various contrasting woods.

The stonework collection includes inscriptions from various periods. A tombstone dates from the Abassid period (ninth century), and a distance marker was made during the Umayyad period (eighth-ninth century). Other inscriptions are from the Seljuk period (thirteenth century). An unusual tombstone with figural representations is also from the Seljuk period. A pair of elaborate, marble sarcophagi (fifteenth century) are carved with intricate geometric designs and are decorated with architectural details (small towers at each corner). A group of carved, stone architectural fragments includes floral capitals from the Abassid period. A highlight of the collection is a carved, marble plaque representing two intertwined griffons (Seljuk, thirteenth century).

The ceramics and glass collection offers a comprehensive group of Islamic objects in this media and is particularly rich in Turkish examples from Konya, Izmit, and Diyarbarkir. A group of early Islamic glass vessels painted with decorative motifs includes examples from the ninth to twelfth century. A large, blue glass jar was created at Rakka during the Abassid period (twelfth-thirteenth century). Mamluk mosque lamps decorated with inscriptions and geometric designs are from the fourteenth and fifteenth centuries. A large collection of ceramic tiles from the Ottoman period is housed at the museum. Pottery from Rakka (Abassid period) is characterized by its lustrous, dull green glaze. A fascinating group of unglazed ceramic vessels, all decorated with bands of relief, dates from the Seljuk period.

Metalwork includes inlaid metal candlesticks from the post-Seljuk period (late thirteenth and fourteenth centuries) and inlaid vessels from the Timurid period (fifteenth and sixteenth centuries). From the Ottoman period, an elaborate ewer and basin are inlaid with colored enamels. Lamps with enamel and semiprecious stones along with candlesticks, vessels, and other objects are also from the Ottoman period. A brass astrolabe is one of several scientific instruments in the collection. An enormous metal Koran stand decorated with applied and incised metal plaques is accompanied by two monumental candleholders. Smaller objects include a group of metal belts: a silver belt with semiprecious stones on velvet is from the mausoleum of Selim II (1566–74), and a belt of silver with semiprecious stones is from the Mausoleum of Ahmed I (1603–17). Elaborate gold turban ornaments decorated with precious and semiprecious stones are at the museum.

The excellent ethnographic collection includes objects related to daily life in Turkey and the Islamic world. Rugs, fabrics, embroideries, and so on are included. A series of rooms in the newly constructed museum are planned to display a traditional Turkish bath, with some rooms prepared for the important Turkish ceremonies of circumcision and marriage. In the courtyard of the palace, a black, goat-hair tent from the Anatolian nomads is set up complete with colorful rugs, pillows, eating utensils, and so on, reflecting the nomadic way of life in Turkey.

The Museum of Turkish and Islamic Arts organizes special exhibitions on a regular basis, with works loaned from public and private collections. Galleries specifically for these temporary exhibitions are on the museum's ground floor. A library and reading room with reference volumes on Turkish and Islamic art and culture are open for the museum staff and for visiting scholars and researchers. A coffeehouse-restaurant is located on the museum's first floor, adjacent to the courtyard. There, the decor recreates a traditional Turkish coffeehouse with sofas, carpets, and so on. An outdoor cafe is set up in the palace courtyard.

A Turkish "bazaar" on the museum's ground floor includes a large bookstore and a shop selling traditional Turkish crafts. The bookstore offers numerous volumes on Turkish and Islamic art and architecture from all periods. Postcards, notecards, and posters related to the collection are sold; guides to the various collections are anticipated.

Selected Bibliography

Museum publications: *Türk ve İslâm Eserleri Müzesi* (brochure in Turkish), 1984; *Türk ve İslâm Eserleri Müzesi* (guide to the collection), 1984.

Other publications: Gülersoy, Çelik, *A Guide to Istanbul* (Istanbul 1978), pp. 126, 205–9; Ölçer, Nazan Tapan, "The Museum of Turkish and Islamic Arts: rebirth of a sixteenth-century palace," *MUSEUM* (June 1984), pp. 42–48.

LORRAINE KARAFEL

United Kingdom

───── Cambridge ─────

FITZWILLIAM MUSEUM (alternately FITZWILLIAM), Trumpington Street, Cambridge.

The museum takes its name from Richard, seventh Viscount Fitzwilliam of Merrion, who founded it in 1816, when he bequeathed to the University of Cambridge, where he received the M.A. in 1764, his fine art collections, his library, and the sum of one hundred thousand pounds to provide "a good substantial convenient Museum Repository or other Building." His collections included 144 pictures, among them a Titian, Veronese, and Rembrandt; a series of etchings by Rembrandt, then considered the finest in England; and excellent collections of other important engravings. In his library were 130 medieval illuminated manuscripts, an outstanding collection of music autographs, and 10,000 books, mostly acquired between 1750 and 1815.

The collections arrived in Cambridge in the spring of 1816 and were housed temporarily in the Old Perse Grammar School. In 1821 the present site of the museum was bought from Peterhouse, but the building, after the designs of George Basevi, was not begun until 1837. After his death in 1845 it was carried on by C. R. Cockerell, and in 1848 the collections were installed and visitors were admitted. The entrance hall remained incomplete because of lack of funds until 1871, when building was recommenced under the direction of E. M. Barry, who finished it in 1875.

Extensions to the Founder's Building have been added as a result of the generosity of individuals or groups of private persons. Thus the bequest of C. B. Marlay in 1912 of 90,000 pounds, as well as his collections of works of art, enabled two new galleries named after him to be opened in 1924. At the same time a coin room and manuscript room were provided through the munificence

of W. N. McClean. In 1931 the Courtauld Galleries were opened, built for 104,000 pounds at the expense of W. J. Courtauld, S. I. Courtauld, and Miss S. R. Courtauld; in 1936 the Henderson Galleries and Charrington Print Room followed, the result of J. S. Henderson's bequest and John Charrington's gift of 5,000 pounds. The architect of all of these new buildings was the firm of A. Dunbar Smith and Cecil C. Brewer. In 1949 the executors of W. Graham Robertson gave 10,000 pounds toward the cost of an exhibition gallery and students' room for drawings and watercolors. With the aid of contributions from other benefactors, the Graham Robertson Rooms were built in 1953–55 after designs of Robert Atkinson and Partners and under the supervision of A.F.B. Anderson. Further extensions were necessitated by the constant expansion of the collections, and in 1966 the Twentieth Century Gallery was completed after the plans of David Roberts.

In 1969 the gift of one hundred thousand pounds by Sir Robert Adeane enabled a second stage to begin. The principal spaces have been named to commemorate the principal private contributions: the Exhibition Gallery for Sir Robert Adeane; the Lecture Room for Sir Hamilton Kerr; the Seminar Room for the Isaac Wolfson Foundation; the Rare Book Room for Mr. and Mrs. Paul Mellon; the Reading Room for Lord and Lady Butler; and the Long Gallery for the display of medieval works of art, for Anthony de Rothschild, were opened by Queen Elizabeth, the Queen Mother, in 1975. These spaces and the study galleries for the reserve collections, with accommodation for essential technical services, are designed to enable the museum to fulfill its function as a university museum, so that it can be used as a working laboratory for teaching in various faculties of the university.

The museum is under the management of the Syndics, a body of nine senior members of the university. Their first annual report appeared in 1850, and the first director, Sir Sidney Colvin, was appointed in 1876. Since him there have been eight directors; the first four were Sir Charles Waldstein (1883–89), John Henry Middleton (1889–93), Montague Rhodes James (1893–1908), and Sir Sydney Cockerell (1908–37), under whose long tenure the museum's displays were revolutionized. Exhibits were displayed in wall cases, and the picture galleries were enhanced with furniture, Oriental rugs, sculpture, and flowers, a type of display that has now become a permanent feature of the museum. After Cockerell's retirement, Louis C. G. Clarke was director (1937–46), followed by Carl Winter (1946–65), David Piper (1967–73), and the present director, Michael Jaffé.

Like the buildings, virtually all of the collections have been given by individuals or groups of private persons. Private persons have also provided the whole of its purchasing funds. In the nineteenth century benefactions were mostly from men who had received part of their education at Cambridge, but it is not without significance that during the twentieth century an increasing proportion of benefactors have had no academic connections with the university. In 1909 the Friends of the Fitzwilliam was founded. It is probably the oldest society of

the kind in the country, and in 1967 the American Friends of the University of Cambridge was formed. Many of the more recent acquisitions of the museum have been made possible by the generosity of the National Art-Collections Fund and the Grant-in-Aid system administered by the Victoria and Albert Museum (q.v.).

The collections cover the following subjects: Egyptian and Assyrian antiquities; Greek and Roman antiquities (antiquities and archaeological and ethnological materials from other cultures are housed separately in the Museum of Archaeology and Ethnography, Downing Street, Cambridge); coins and medals; medieval manuscripts; paintings, drawings, watercolors, and portrait miniatures; prints; pottery, porcelain, glass, textiles, arms and armor, medieval and Renaissance works of art, pewter, silver, and furniture; early printed books, illustrated books, bindings, autograph and printed music and literary autographs; and a working library. The museum staff is divided into seven departments: Antiquities; Coins and Medals; Applied Arts (European and Oriental); Manuscripts and Printed Books, which incorporates the Reading Room; Paintings and Drawings; Prints; and Administration.

Each department has benefited enormously from private benefactions, which have been continuous since the museum was founded, although it is possible to mention only the most outstanding.

The Department of Antiquities is divided into several concentrations. The antiquities of western Asia have had a gallery devoted to them only since 1965–66. The richest sources of the present collections have been excavations sponsored by the British Schools of Archaeology in Iraq and Egypt and by the British Museum and the Cyprus Exploration Fund. Much of the finest of Mesopotamian art is in miniature, and this is represented by a collection of seals. The art of the Phoenicians is well represented by fine furniture-ivories of the eighth century B.C., most of them from Nimrud, where they had been carried off as booty by the Assyrians. Their art is splendidly shown by a number of reliefs of gods and of King Ashurnasirpal II (884–859 B.C.) himself from his palace at Nimrud. A recent anonymous gift in memory of M. T. Boscawen is an imposing head of a roaring lion, part of a hollow-cast bronze gate statue from the Hadramaut, South Arabia, under strong North Syrian influence, about 750–650 B.C.

The Egyptian antiquities have also benefited from excavations sponsored by the Egypt Exploration Society, the Egyptian Research Account, and the British School of Archaeology in Egypt, in addition to private benefaction. The earliest gifts of coffins and sarcophagi were presented in 1822 and 1835. In 1823 G. B. Belzoni gave the magnificent lid of the sarcophagus of King Ramesses III (1198–1166 B.C.), the last great ruler of the New Kingdom, and other important benefactions have been made by C. S. Ricketts, C. H. Shannon, R. G. Gayer-Anderson, and Sir Robert Greg. All periods are represented, some more richly than others. From the Archaic Period (c. 3000–2700 B.C.) are some splendid ivories, including a lion and lioness of the thirtieth century B.C.

From the Middle Kingdom (c. 2052–1786 B.C.) are relief fragments from the

funerary temple erected at Deir el-Bahri, Thebes, by King Mentuhotep II, the most remarkable of which shows a fox raiding a bird's nest in a papyrus thicket. Wooden models representing boats with their crews, butchers at work, servants filling a granary, and others making bread and beer are from the same period. Realistic portraiture came into fashion in the nineteenth century B.C., and fine examples are a colossal granite head of King Sesostris III (1878–1843 B.C.) and a volcanic rock portrait of the young King Ammenemes III (1843–1797 B.C.). Similar realism appears in the features of the soldier Userhet on one of the earliest of Egyptian mummiform coffins known, found at Beni Hassan.

From the New Kingdom, in addition to Ramesses III's sarcophagus lid is a splendid sandstone shrine to the goddess Nekhbet from her temple at el-Kab built by Tuthmosis III (c. 1490–1436 B.C.) and the famous jubilee relief, probably from Akhanaton's early Temple of Aten at Karnak, Thebes (c. 1367–1350 B.C.). Fine priestly decorated coffins from the Third Intermediate Period are those of Espawershefi and Nekhtefmut. From later periods is a fine group of ushabti statuettes, and some of the finest of Egyptian bronze statuettes of deities in which the museum's collection is extremely rich come from the Late Period (664–525 B.C.). From the Roman Period are portraits painted on wooden panels in encaustic wax, and a fine example of the Coptic Period is a frieze block from Bawit of about A.D. 500 showing a calf and panther amid acanthus foliage.

Greek and Roman antiquities did not have a major place in the museum's collections until the mid-nineteenth century, although the *Pashley Sarcophagus* of about A.D. 140, showing the triumphant return of Dionysus from the East, was given by Admiral Sir Pulteney Malcolm in 1835. In 1850 John Disney presented his considerable collection of marble sculptures, which had been assembled in Italy a century earlier. In 1864 the purchase of W. M. Leake's fine collection added a wealth of bronzes, vases, terracottas, and engraved gems from Greece and Italy. In 1865 the University Collection, given by G. D. Clarke and J. M. Cripps in 1803, was transferred to the museum; this included a caryatid from the Inner Propylaea at Eleusis (c. 50 B.C.). Again the museum has benefited considerably from the excavations conducted by the British School of Archaeology at Athens, the Cyprus Exploration Fund, and the Egypt Exploration Society. A systematic acquisitions policy for Greek pottery, begun by E. A. Gardner, has been complemented by the gifts and benefactions of Winifred Lamb and the bequest of C. S. Ricketts and C. H. Shannon in 1937. Outstanding among the Greek pots is a scent bottle of about 630–620 B.C. from Corinth drawn by the Typhon Painter with a scene of Artemis with swans. From Athens are examples by the KX Painter (c. 590–580 B.C.), the C. Painter (c. 570–560 B.C.), and the Heidelberg Painter (c. 550 B.C.). Maturer technically are the "Little Master" cups (c. 550–530 B.C.) and the cup showing Herakles and the Nemean lion by Hischylos and painted by Sakonides (c. 530 B.C.).

From the Late Archaic period is a cup made by Hieron and painted by Makron (c. 490–480 B.C.), and the Berlin Painter can be seen through examples of his early, middle, and late work. Further examples of pottery are by the Niobid

Painter (c. 470–460 B.C.), the Villa Giulia Painter (c. 450 B.C.), and the Achilles Painter, who can be seen at the height of his powers on a red-figure oil flask of about 450–440 B.C. showing Hermes with a goddess, probably Hebe. Among the seal stones is a signed work by Dexamenos, the greatest of Greek engravers, showing a lady and her maid, and from the late first century B.C. is an example signed by Dioskourides, the leading engraver of his age. Terracottas, small bronzes, jewelry, all testify to Classical culture, and Roman realistic sculpture is represented by a sensitive portrait of Drusus the Elder, about 20 B.C., from Carthage and a colossal likeness from Tivoli of Antinous, boy favorite of Hadrian (emperor, A.D. 117–38).

The Department of Coins and Medals includes the university coin collection, founded by the bequest in 1589 by Andrew Perne, master of Peterhouse, of his cabinet of coins and seals. In 1856 the miscellaneous accumulations of coins belonging to the university were transferred from the library to the Fitzwilliam. In 1864 the purchase of the Greek coins and gems from the collection of W. M. Leake formed the nucleus of the extensive Greek coin collection. To these coins have been added by gift and bequest (1906–12) the Greek coins in the J. R. McClean Collection, as well as that of A. W. Young (1936) and H. St. J. Hart (1963), which, together with judicious purchases, made the collection of Greek coins among the finest in public collections. The Roman coin collection is fully representative, with outstanding imperial gold portrait pieces from A. W. Young's gift in 1936. The Byzantine collection comprises the C. D. Sherborn gift, 1939, and the C. W. Bunn Collection, 1950; it contains a long series of documentary bronze coins. Outside the ancient series is a representative collection of the coinage of Great Britain from Celtic times to the present. The museum has only a small collection of medieval and modern European coinage, but Philip Grierson has placed on deposit his own superb series of European medieval issues. The only important group of Oriental coins is that of continental India, which includes superb Mughal pieces, and an important specialist collection of Assamese coins bequeathed by A. W. Botham (1963).

There are also representative collections of English and foreign medals. Particularly fine is the English series; of the foreign medals, only the Italian and French series are extensive.

Admission to the Coin Room is for students only, who should apply to the staff of the department.

The Department of Applied Arts is the most extensive of all of the departments and covers both Europe and the Orient. The collections have representative coverage of pottery, porcelain, glass, arms and armor, ivory carvings, enamels, sculpture, metalwork, bronze, statuettes, furniture, textiles, jades, and lacquer.

The collection of European pottery and porcelain is now one of the best in the country, chiefly because of the bequest of J.W.L. Glaisher in 1928. His collection was particularly rich in English wares. Other collectors have made important contributions. The collection of Italian majolica has considerable range and scope as a result of receipt of the F. Leverton Harris Collection in 1926,

which included works of Nicola Pellipario, who was responsible for the plate from the service made for Isabella d'Este about 1519. The porcelain collection owes a great deal to the many gifts by Mrs. W. D. Dickson and Ralph Griffin, to the benefactions of the late Lord Fisher (an extensive group of Meissen figures, modeled by Kaendler), and to the bequest of Louis C. G. Clark. Rarities include works attributed to Bernard Palissy and an example of the fine white earthenware made at St. Porchaire, formerly known as "Henri II" ware, of which only some sixty pieces have survived. True hard-paste porcelain was first produced in Europe by Johann Friedrich Böttger about 1710, and the museum has several examples of his work. In addition to Meissen figures there are representative examples modeled by Franz Anton Bustelli at Nymphenburg and from the Capodimonte factory near Naples. English porcelain is well represented, and there is a small but very choice group of French wares from Chantilly, Vincennes, and Sèvres.

English glass is particularly well represented as a result of the receipt of the large and celebrated collection formed by Donald Beves in 1960. Rarities include one of only a dozen examples from the workshop of Giacomo Verzelini, the Venetian glassmaker granted a monopoly by Elizabeth I in 1575. This is decorated with diamond-point engraving and dated 1578. Specimens of lead glass by George Ravenscroft (active 1673–85) and enameled glass painted by William Beilby are also in the collections.

The arms and armor have a few rare Gothic pieces, but the finest example is a lion's head casque, made for parade armor about 1540 by the Negroli brothers of Milan, the greatest armorer artists of their time.

In the Rothschild gallery are displayed medieval and Renaissance treasures— among them, a Carolingian (ninth century) ivory of the enthroned Christ and an Ottonian (tenth century) panel of a pope or archbishop giving a blessing—of the highest quality. Champlevé and painted enamels are shown alongside a few choice pieces of metalwork, including a fragment of the cover of a German gold cup of the thirteenth century and an Italian chalice of the late fourteenth century, signed by Andrea Petrucci. The Renaissance work is mostly English and German, although there is a fine ewer and basin of the School of Fontainebleau. The Elizabethan pieces are of fine quality, and the seventeenth- and eighteenth-century silver is both English and Continental.

The collection of bronze statuettes is small but of high quality, including pieces by Riccio, Antico, Sansovino, Roccatagliata, Giambologna's studio, and Tacca. Furniture is displayed throughout the museum en suite with the paintings and sculpture. Particularly fine are clocks by Joseph Knibb and Thomas Tompion and furniture by Pierre Langois, Vile and Cobb, John Channon, and George Bullock.

The collection of textiles includes Oriental carpets and rugs, a large collection of fine Chinese textiles given by Mrs. Soame Jenyns (1977) and a particularly good group of samplers especially rich in later sixteenth- and early seventeenth-century English ones.

Most of the Islamic collections was acquired in 1935 with the purchase out

of the Glaisher Fund of the extensive Brangwyn Collection. Many additional fine pieces came with the Oscar Raphael bequest in 1941 and with the splendid series of Isnik dishes bequeathed by T. H. Riches in 1935. Three of the most outstanding examples were given by the late Sir Alan Barlow and Lady Barlow in 1967, 1969, and 1970.

The most important bequest to the Oriental department was Oscar Raphael's collection in 1941. This included Chinese ceramics, jades (including a buffalo from the Early Ming Dynasty, previously in the Imperial Collection), and bronzes, as well as Korean and Japanese ceramics. This collection greatly strengthened those received from Reginald Cory (1927) and L. D. Cunliffe (1936). Since then Lady Ward bequeathed a large collection of eighteenth-century porcelain birds in 1962. In 1968 eight pieces of Chinese ceramics, as well as bronzes and lacquers, of the highest quality were bequeathed by Mrs. Walter Sedgwick, and a magnificent group of blue-and-white ware was given by Sydney Smith (1978).

Between 1920 and 1932 a number of gifts by W. M. Tapp formed the basis of the Korean ceramic collection. A number of pieces have been deposited on loan by G. St. G. M. Gompertz.

Apart from the Founder's bequest of 130 medieval manuscripts, the greatest gift to the Department of Manuscripts and Printed Books was the 203 medieval manuscripts bequeathed by Frank McClean in 1904. These works have been added to by Charles Fairfax Murray, C. B. Marlay, T. H. Riches, and Lord Lee of Fareham. The Friends of the Fitzwilliam have presented manuscripts regularly since its formation in 1909, and the collection now totals more than eight hundred items, including manuscript cuttings and some Oriental manuscripts. Among them are a fine Ottonian Lectionary, probably from Reichenau; a Benedictional made in the late ninth century in a German monastery; and the most recent acquisition (1980), a Breton Gospel of the late ninth century. A Sacramentary of about 1140 was made for the Church of the Holy Sepulchre at Jerusalem. Made for Isabella of France, sister of St. Louis, is the richly decorated *Psalter and Hours*, from Paris before 1270, and there are two leaves by the Parisian illuminator Honoré from *La somme le roi*. An early English *Book of Hours*, about 1300, was probably written for the marriage of Sir Richard de Grey to Joan, daughter of Sir Robert FitzPayn, and another manuscript of historical interest is the *Book of Hours* from the Paris workshop of the Maître aux Boquetaux, commissioned by Philippe le Hardi, duke of Burgundy, toward the end of the fourteenth century.

The music collection contains more than nine hundred volumes, including a large number of autograph manuscripts. The largest group consists of compositions by Handel, but there are also compositions in the autographs of Blow, Purcell, Bach, Scarlatti, Haydn, Mozart, Beethoven, Elgar, and Britten. Other famous music books include the *Fitzwilliam Virginal Book* from the Founder's bequest, which is the finest contemporary collection of English seventeenth-century keyboard music extant, and the *Lutebook of Lord Herbert of Cherbury*, written by him between 1626 and 1640.

The collection of literary and other autographs covers a wide field of historical,

artistic, scientific, and literary interest. Perhaps the most famous is the original manuscript of the *Ode to a Nightingale* by John Keats. Other poets represented are William Blake, John Clare, Walter de la Mare, Thomas Hardy, Siegfried Sassoon, Lord Tennyson, and A. C. Swinburne. The autograph letters include a group to and from Voltaire and a special collection relating to William Hayley and his circle. Letters written by English artists are still being acquired, and the letters of Sir Thomas Lawrence, the ledgers of Sir Joshua Reynolds, the sitter-books of George Romney, and the account books of Sir Edward Burne-Jones are of particular interest. Admission to the Manuscript Room is for students only, who should apply in writing with references to the librarian.

The collection of paintings in the Department of Paintings and Drawings provides a representative illustration of the major European schools of painting: nearly one thousand with about two hundred Italian, three hundred English, four hundred Dutch and Flemish, and one hundred French, of which some are masterpieces of overwhelming impact.

The Founder's bequest included 144 paintings. Of them a number of the Dutch and Flemish schools had been inherited from his maternal grandfather, Sir Matthew Decker, Bt., an Amsterdam merchant born in 1679. The additions made by Lord Fitzwilliam included Titian's *Venus and the Lute Player* and Veronese's *Hermes, Herse, and Aglauros*, both probably from Rudolph II of Prague and certainly from Queen Christina of Sweden's collections, bought from the Orleans sale, and a Rembrandt, *Portrait of a Man in Military Costume*. The bequest of 243 pictures of Daniel Mesman in 1834 greatly enriched the Dutch and Flemish schools. Later acquisitions include the purchase of fifteen early Italian paintings from the Charles Butler Collection in 1893, including the Simone Martini three panels, *St. Geminianus*, *St. Michael*, and *St. Augustine*, in superb condition, from a polyptych of about 1320, probably from an Augustinian convent at San Gimignano. A series of gifts from Charles Fairfax Murray, starting in 1908, included Titian's late *Tarquin and Lucretia*, painted about 1571 for Philip II of Spain; three early Gainsboroughs; and a Reynolds. C. B. Marlay's bequest of 1912 added eighty-three paintings to the collection, twenty-nine of them Italian. An outstanding addition to the Florentine fifteenth-century paintings was the bequest by F. Fuller, received in 1923, of two works by Domenico Veneziano, *The Annunciation* and *The Miracle of St. Zenobius*, both part of the predella of the St. Lucy altarpiece now in the Galleria degli Uffizi (q.v.). In 1966 Major Henry Broughton gave an important part of his collection of flower paintings to which he added more by bequest in 1973.

In addition to the paintings already mentioned there are important examples by Lorenzo Monaco (before 1372–1422–24), represented by his tiny but impressive *Virgin and Child Enthroned* of about 1400. Cassone panels by Jacopo del Sellaio (1441–42–93) and Biagio di Antonio (active 1476–1504) are hung in the same gallery as l'Ortolano's *St. John the Baptist* and Pintoricchio's charming *Virgin and Child with St. John the Baptist* (c. 1500).

Apart from the Titians and Veronese, Venetian painting is well represented

with examples of striking clarity by Cima da Conegliano, his *St. Lanfranc of Pavia Enthroned between Saints*, which has a view of his home town, Conegliano, in the background, and Palma Vecchio, whose *Cupid and Venus* (c. 1520), which the Founder bequeathed, once belonged to Queen Christina of Sweden. Tintoretto and the Bassano family are also represented.

The Bolognese and Roman schools dominated the seventeenth century, and the museum possesses good examples by most of the important masters. A ravishing oil on copper, *Penitent Magdalene*, shows how important landscape was to Annibale Carracci, whose pupil Domenichino's *Landscape with St. John Baptizing* (late 1620s) carries on his master's precepts. Such landscapes inspired Claude Lorraine, whose gemlike *Pastoral Landscape, with Lake Albano and Castel Gandolfo* was painted for Pope Urban VIII in 1639. More Baroque tendencies can be seen in Guercino's *Betrayal of Christ* (c. 1621), with its flickering lights; in the emotional experience of Guido Reni's *Ecce Homo* (1575–1642); and in the obscure symbolism of Salvator Rosa's *L'Umana Fragilità* (c. 1651–43), as well as in the works of Bellotto (1720–80) and Francesco Guardi (1712–93), whose brother Gianantonio (1699–1760) is represented with a rare interior, the *Ridotto*.

Highpoints among the Dutch and Flemish paintings are the lovely *Virgin and Child* by Joos van Cleve and the humorous *Village Festival in Honour of St. Hubert and St. Anthony* by Pieter Bruegel II. Rubens is represented by a brilliant early oil on copper, *The Death of Hippolytus*, in which he sums up his experience of Italy, and the fine *Study of a Bearded Man* (1616–17). His later career is shown in a series of small preparatory sketches for a tapestry of luminous color and great charm, *Designs for the Eucharist Series of Tapestries*, and in *Achilles among the Daughters of Lycippus*. Van Dyck's *Madonna and Child* was bought by public appeal in 1976 from the duke of Sutherland. Portraits by van Dyck, *Countess of Southampton*, formerly at Althorpe, and *Archbishop Laud*, hang in the English galleries. Apart from the Founder's Rembrandt, Dutch portraiture is represented by a lively *Portrait of a Man* by Frans Hals of about 1660–63. Townscapes include two Berckheydes, *Amsterdam* and *Haarlem*, both in immaculate condition, and an excellent Jacob van Ruisdael, *Amsterdam* (c. 1675). The differing styles of landscape are well represented by artists ranging from Berchem, Breenbergh, Poelenbergh, Cuyp, and Karel du Jardin to Jan van Goyen, Hobbema, and Jan van Ruisdael. There are also examples of genre by Steen and Ostade, as well as an extensive series of flower paintings.

The strength of the French paintings is in the nineteenth century, which includes masterpieces by Corot, Degas, Boudin, Monet, Pissarro, Sisley, and Renoir, as well as representative examples of the Barbizon School. A few earlier examples by Simon Vouet (1590–1649), *The Entombment*, and Charles Lebrun (1619–90), *The Holy Family*, represent Baroque classicism, and landscape is present in examples by Sebastien Bourdon (1616–71) and Gaspard Dughet (1615–75).

The spirit of French Rococo is exemplified in a charming oil sketch by

Boucher, *Mars et Vénus*, for one of the series of tapestries "Les Amours des Dieux," an example of which, *Apollon et Clytie*, is also in the museum, and in works by Pater and Lancret.

Gauguin and van Gogh are each represented by an early landscape, and of the Post-Impressionists there are good examples by Seurat, Cézanne, Bonnard, Vuillard, and Matisse. An anonymous benefactor has given a Cubist *Portrait of a Girl* by Picasso and a portrait by Léger.

The two main branches of English painting, portraiture and landscape, are well represented. Ranging from exquisite miniatures by Hilliard and Isaac Oliver to the full-scale Baroque swagger of van Dyck's *Countess of Southampton*, the more human side is revealed in the penetrating portraits *George Arnold* and *Frances*, his daughter, by Hogarth. A charming early Gainsborough, *Heneage Lloyd and His Sister*, combines portraiture with landscape, as does Reynolds' *Braddyl Family* of 1789. The masters of landscape, Richard Wilson, Joseph Wright of Derby, Constable, Turner, and Bonington, are all represented, but perhaps the most delightful of all are the charming genre scenes *Before* and *After* by Hogarth. There is a cross-section of the Pre-Raphaelite work and good examples by Wilson-Steer, Sargent, and Sickert.

Of twentieth-century masters, the museum is especially rich in the works of Stanley Spencer, Sir William Nicholson, and Augustus John. Contemporary painting is not neglected, and recent acquisitions include Larry Rivers' *Camels*.

The drawings complement the paintings. Where there are gaps in the pictures, they are filled by drawings. As a result of the bequests and gifts of C. T. Clough (1913), Ricketts and Shannon (1937), C.J.F. Knowles (1959), Louis C. G. Clarke (1960), Sir Bruce Ingram (1963), and Andrew S. F. Gow (1978), there are superb examples ranging from Pisanello to Michelangelo, Raphael, Leonardo, and Titian to Rembrandt and Rubens. A fine group by Claude Lorraine and a magical series by Watteau stand beside splendid examples by Tiepolo and Francesco Guardi. Of the nineteenth century the department is particularly rich in Millet, Delacroix, and Degas.

In 1973 the bequest by Lord Fairhaven of the Broughton Collection of flower drawings made the museum pre-eminent in this field, and mention must be made of the album of specimens of the blooms at Malmaison made by Redouté for Empress Josephine.

The English drawings and watercolors are more comprehensive than the Old Master drawings and include fine series by Turner (twenty-five given by John Ruskin), Constable, and De Wint. Particularly strong are the Pre-Raphaelite drawings, many bequeathed by J. R. Holliday, with special emphasis on Edward Burne-Jones and Rossetti. There are numerous portrait drawings by John Downman; and four hundred drawings by George Romney, the greater part given by his son in 1816; and a particularly rich group by William Blake and his followers, all largely because of the generosity of T. H. Riches and Sir Geoffrey Keynes.

The Oriental miniatures, good examples of Persian and Turkish schools, were greatly augmented by the bequest of P. C. Manuk and Miss G. M. Coles in 1946, which included two pages from the *Hamza Nama*.

The Department of Prints includes the prints from the Founder's collection, which were probably as important as any part of his bequest. Not only numerous and varied, they were carefully picked impressions and show a remarkably full series of the masters represented. Most important of all were the etchings by Rembrandt, considered then to be unsurpassed by any collection in England. Important additions came from the collection of Thomas Kerrich, bequeathed by his son in 1873, and the transfer of the university collection in 1876; they were rich in German engravings and works of Rembrandt. Most recently, John Charrington, who died in 1939, gave extensively to the group of portraits and consolidated the rich and representative collection of mezzotints. In this he was followed by Louis C. G. Clarke, whose gifts, with numerous additions from other sources, give the museum one of the most important print rooms of Europe. In England it is surpassed by few, if any, collections outside the British Museum (q.v.).

Three galleries are devoted to a changing display of watercolors, drawings, and prints. Admission to the Print Room and to the Graham Robertson Room to examine drawings is for students only, who should apply to the keeper of prints and the assistant keeper of paintings and drawings, respectively.

Postcards in color and monochrome; color slides, posters, and replicas; plates from photographs by Andrew Morris and Paul Dixon; and numismatic and gem photographs by the Department of Coins and Medals are all available on request.

Selected Bibliography

Handbook to the Museum, 1971; *Forty items of outstanding interest: a tour of the Fitzwilliam*, 1979; *Catalogue of paintings*. Vol. 1: *Dutch and Flemish*, by H. Gersom and J. W. Goodison; *French, German, Spanish*, by J. W. Goodison and Denys Sutton, 1960; Vol. 2: *Italian Schools*, by J. W. Goodison and G. H. Robertson, 1967; Vol. 3: *British School*, by J. W. Goodison, 1977; Bindman, David, ed., *William Blake: an illustrated catalogue of works in the Fitzwilliam Museum*, 1971; Chamberlain, E. C., *Catalogue of the G. E. Beddington Collection of Colour-prints*, 1959; *Sylloge Nummorum Graecorum, Fitzwilliam Museum: Leake and General Collections*. Parts 1 and 2, reprint 1972; Parts 3–7, 1951–67 (out-of-print); Part 8, 1971; Budde, L., and R. V. Nicholls, *Catalogue of the Greek and Roman Sculpture*, 1964; Lamb, Winifred, *Corpus Vasorum Antiquorum: Fitzwilliam Museum*, 1936; Jaffé, Michael, and Duncan Robinson, *Cent Dessins français du Fitzwilliam, Cambridge*, 1976; Jaffé, Michael, Malcolm Cormack, and Duncan Robinson, *European Drawings from the Fitzwilliam*, 1976; Cormack, Malcolm, and Duncan Robinson, *Landscapes from the Fitzwilliam*, 1974; Wormald, F., and Phyllis M. Giles, *Illustrated Manuscripts in the Fitzwilliam Museum*, 1966; Medley, Margaret, *Korean and Chinese Ceramics*, 1976; Nicholls, R. V., "A Roman Couch in Cambridge," reprinted from *Archaeologia* 106.

———— Edinburgh ————

NATIONAL GALLERY OF SCOTLAND, The Mound, Edinburgh EH2 2EL Scotland.

A substantial portion of the National Gallery collection was acquired as gifts or bequests, but there are also works that owe their presence to organizations active several decades before the Gallery was founded. Chief among these groups was the Royal Institution for the Encouragement of Fine Arts in Scotland, which began in 1819 as a method of making available for public viewing works from important private collections. It developed its own permanent collection as well and, to house this collection, established a relationship with the Board of Manufacturers, a governmental agency founded for the purpose of encouraging the growth of industry in Scotland. The board was interested in art because it operated a school of design. Artists dissatisfied with this limited training developed their own school, however, which was founded in 1826 and chartered as the Royal Scottish Academy (RSA) in 1843. The RSA also developed a permanent collection, principally of Scottish art. These three organizations were sharing a building with the Royal Society of Edinburgh and the Scottish Society of Antiquaries when planning commenced for a new building in April 1850.

The building program, initiated by a bill introduced to Parliament and by the laying of the foundation stone by Prince Albert in August 1850, came to fruition when the museum building opened to the public March 22, 1859. It was designed in neoclassical style by William H. Playfair and stands below the castle at Princes Street Gardens. It continued to be administered by the Board of Manufacturers, which had been entrusted with the Royal Institution's collection. It further benefited from the activities of the Royal Association for the Promotion of the Fine Arts in Scotland, which purchased several works for the fledgling Gallery.

In 1889 a new Scottish National Portrait Gallery was opened, which removed some works from the National Gallery. More importantly, in 1906 the National Galleries of Scotland Act was passed, which substituted a board of trustees for the old Board of Manufacturers administration, created a full-time professional directorship, and for the first time provided the National Gallery with a purchasing fund. Since the Royal Scottish Academy had found quarters elsewhere and had left its collection with the Gallery, the building was remodeled to unify the plan and reopened in 1912.

Through the remainder of the twentieth century, the galleries have undergone a series of important changes. In 1940 the Conservation Department commenced operation, followed by the establishment of the Prints and Drawings Department in 1945 and the Department of Education and Information in 1975. The Gallery of Modern Art was founded in Edinburgh in 1960, which removed from the National Gallery collection most works dating from the twentieth century. The National Gallery building has been provided with complete climate control, and in 1978 a large addition, designed not to interfere visually with the existing structure, was completed to house offices, a print room, a museum library, and additional exhibition space.

The director who supervises the Scottish National Portrait Gallery and the Gallery of Modern Art in Edinburgh also governs the curatorial staff of the National Gallery. This staff is organized under either the keeper of the National

Gallery or the keeper of Prints and Drawings. The Conservation Department and the Education and Information Department report directly to the director's office and serve all of the Galleries.

The museum collections, which emphasize European pictorial arts from the fourteenth to the nineteenth century, include an impressive range of examples from the Italian schools, beginning with the Vitale da Bologna *Adoration of the Kings* panel of about 1350 and the Bernardo Daddi *Triptych with the Crucifixion* of 1338. Among the quattrocento works one finds Lorenzo Monaco's late *Madonna and Child*, as well as a small Filippino Lippi *Nativity*, an important Verrocchio *Madonna and Child*, and the large Cosimo Rosselli *St. Catherine of Siena as Spiritual Mother of the Second and Third Orders of St. Dominic*. Attributed and anonymous works represent several principal workshops of the Florentine Renaissance. Among them, the finest may be the *Adoration of the Infant Christ* from the studio of Botticelli.

Of the sixteenth-century works pride of place goes to the Raphael *Bridgwater Madonna*, one of several very important works placed on extended loan to the Gallery by the Duke of Sutherland in 1946. The loan also includes the *Holy Family with a Palm Tree*, known to be by Raphael; the *Madonna with the Veil*, after a lost original; and the *Madonna del Passeggio*, which may be an autograph work. Also from the Cinquecento come works of the Genoese school by Cambiaso, Paggi, and Scorza, as well as paintings by the Central Italian masters Bacchiacca, Perugino, and Andrea del Sarto, whose work may be a self-portrait. The art of Brescia is represented by Moroni's *Portrait of a Scholar* and that of Ferrara by an anonymous fifteenth-century *Madonna and Child* with a marvelous trompe l'oeil frame and Garofalo's panel *Christ Driving the Merchants from the Temple*. The small sculpture collection includes an anonymous bronze écorché horse of substantial size.

Of particularly fine quality is the selection of sixteenth-century Venetian works: Jacopo Bassano's impressive *Adoration of the Kings* joins an early Lorenzo Lotto and a Pittoni altarpiece in demonstrating the skill of the lesser masters. The great names are present as well: two sizable works by Veronese have the company of canvases by Tintoretto and Titian. Tintoretto's *A Venetian Family Presented to the Madonna* is owned by the museum, and his *Portrait of a Venetian* and *Deposition* are part of the duke of Sutherland's loan. Five more Gallery works are attributed to the Tintoretto studio. The duke of Sutherland's loan has brought to Edinburgh no fewer than five Titians, two of which, the *Diana and Actaeon* and *Diana and Calisto*, are from a group of seven original paintings executed for Philip II of Spain. Contrasting with these works of the master's late period is his very early *Three Ages of Man*, which also predates his small, atypical, yet justifiably famous *Venus*.

The Italian Baroque masters at the Gallery include the works of Caravaggisti Giovanni Serodine and Orazio Borgianni. Of the Bolognese school are Guercino's *Madonna and Child with St. John* and *St. Peter Penitent* and Elisabetta Sirani's charming *The Child St. John*. Also found in the collection are the fine

St. Jerome, attributed to Pier Francesco Mola, and the *St. Sebastian* by Francesco Furini.

Eighteenth-century Venice was the source for several works in the collection. One finds here a *Landscape with Monks* attributed to Marco Ricci, two small scenes of Venetian churches by Francesco Guardi, and two works by Tiepolo: a small oil sketch for a fresco and the very large *Finding of Moses*. Batoni's *Princess Giustiniani* is a product of eighteenth-century Rome.

The art of four of the greatest Spanish painters may be seen at the National Gallery of Scotland. By El Greco are *St. Jerome in Penitence* and *The Savior of the World*, both about 1600. An early Velázquez of importance is the *Old Woman Cooking Eggs*, demonstrating the dry realism of his Seville period. Rounding out the Spanish holdings are Zurbarán's large *Immaculate Conception* and Goya's tapestry cartoon *El Medico*.

Nearly a hundred significant French paintings are to be found in the museum's collection. From the seventeenth century is Claude Lorraine's 1652 *Landscape with Apollo and the Muses*, the largest known landscape by him. There are eight great paintings by Poussin, including (from the duke of Sutherland's loan) the series of the *Seven Sacraments* painted during the 1640s for Fréart de Chantelou. Eighteenth-century French works include Chardin's only known flower piece, Greuze's *Girl with Dead Canary*, and paintings by Pater and Lancret. The greatest French Rococo masters are represented as well: Watteau by his *Fêtes vénitiennes* and Boucher, or his studio, by the small but fine *Madame de Pompadour*.

The National Gallery has little of nineteenth-century French academic and neoclassical schools, but the Romantic school is represented by a Delacroix, the Realists by two Courbets and a diminutive Daumier, and the Barbizon painters by ten Corots and works of Daubigny and Diaz. Artists working on the fringe of the Impressionist movement, such as Fantin-Latour and Boudin, serve to introduce the collection of Impressionist works. They include a Renoir, two Monets from the series of poplars and haystacks and an important pre-Impressionist Pissarro, *The Marne at Chennevières*. Highlighting this collection are eight works by Degas, including three notable bronzes and the *Portrait of Diego Martelli*. Six of the Degas works came to the Gallery in the 1960s as gifts or bequests from Sir Alexander Maitland, as did most of the Post-Impressionist works. Of the three Gauguins, the exception is his landmark Breton work, *The Vision after the Sermon*. The three van Goghs illustrate his Dutch, Arles, and St. Rémy period. Cézanne and Seurat are also represented. By Rodin there are two bronzes and one marble sculpture in the Gallery. Bringing the French collection to a close at the beginning of the twentieth century are works by the Nabi artists Vuillard and Bonnard.

The painting of Germany is represented only by a *Venus and Cupid* of Lucas Cranach the Elder and two works, *Stoning of St. Stephen* and *Il Contento*, of Elsheimer. By contrast, holdings from the Netherlands are extensive, beginning in the fifteenth century with Hugo van der Goes' important *Trinity Altarpiece*,

on extended loan from Queen Elizabeth. It was painted for a church in Edinburgh, now destroyed. From the sixteenth century come works by major masters— Quentin Massys, Gerard David, Paul Bril, Jan Provost, Joos van Cleve, and Bernard van Orley—as well as several fine anonymous and attributed panels.

Even more impressive are the seventeenth-century works from the Low Countries. The Flemish Baroque is well demonstrated by Rubens' grand *Feast of Herod*, van Dyck's full-length portrait of a Genoese lady and his large *St. Sebastian*, and a small, early genre piece by David Teniers the Younger. Of the great Dutch painters, the rarest work is the largest and earliest known work by Vermeer, *Christ in the House of Martha and Mary*. The *Verdonck* is a particularly fine portrait by Hals, and Rembrandt's five oils at the Gallery include *A Woman in Bed* and a captivating *Self Portrait* executed at age fifty-one. Four of the Rembrandts were loaned by the duke of Sutherland. Also to be seen is Terbrugghen's early *Beheading of St. John the Baptist*. A large canvas by Emanuel de Witte, who was an architectural painter; a characteristic still life by Jan Davidsz. de Heem; two Jan Steen interiors; and many landscapes, painted by notable specialists such as Jan van Goyen, Jacob van Ruisdael, and Meindert Hobbema, represent other Dutch masters. Also worthy of mention is the Adriaen de Vries bronze *Samson Slaying a Philistine*.

As a major repository of the art of the British Isles, the National Gallery of Scotland offers a number of masterworks from English studios. Of special interest to students of Continental influence on English portraiture is the David Mytens 1629 *James, First Duke of Hamilton*. Eighteenth-century canvases include Gainsborough's *The Honorable Mrs. Graham* and *Landscape with Concord Village*, Reynolds' *The Ladies Waldegrave*, and Hogarth's *Sarah Malcolm*, in addition to paintings by Morland and Romney. From the nineteenth century come the three works by John Constable, among them the fine *Dedham Vale*, and an early Turner landscape. The British landscape is also treated in paintings by Cotman, Bonington, Ward, and the Anglo-French Impressionist Alfred Sisley.

In the collections of Scottish painting, the Gallery excels. It not only offers choice works as in other areas but adds the dimension of depth through numerous holdings by principal masters and little-known artists alike. One may see at the museum a 1626 work by the early portraitist George Jamesome. The National Gallery also offers picturesque and classicizing landscapes by Jacob More and James Norie, respectively, self-portraits by the important portraitists William Aikman and David Martin, a large group portrait by the principal practitioner of that genre David Allan, and several biblical works by John Runciman. Gavin Hamilton's large *Achilles Lamenting the Death of Patroclus*, 1763, exemplifies the mythological subject in neoclassical style.

The eighteenth century produced perhaps the two greatest Scottish artists, Allan Ramsay and Sir Henry Raeburn. Fifteen portraits at the museum are known to be by Ramsay. Among these masterpieces are the superb portrait of his second wife and his portrait of Jean-Jacques Rousseau. Ramsay worked in London as

did Raeburn, who is represented at the Gallery by no less than thirty-nine paintings. Raeburn's notable portraits are *Mrs. Scott Moncrieff*, *Alastair Macdonell of Glengarry*, and a *Self Portrait* of the artist in his fifties.

Landscapes in the collection reach from those by Alexander Nasmyth at the beginning of the century to the numerous works by William McTaggart, whose impressionistic seascapes heralded the fin de siècle. Paintings by Sir David Wilkie, twenty in all, are chief among the genre works in the Scottish collection. His *Pitlessie Fair* and *Distraining for Rent* are particularly important to this collection, which displays the earthy, sometimes humorous approach that earned him the nickname "The Scottish Teniers." With them may be contrasted the sophisticated *Master Baby* and other genre works by Sir William Q. Orchardson, who was painting under strong French influence fifty years after Wilkie. The variety of style and subject matter throughout the nineteenth century is further demonstrated at the National Gallery by religious works of William Dyce; Italian scenes by David Roberts, who worked in Rome; history paintings by Simson and Pettie; the extraordinary fantasy of Sir Joseph Noel Paton; the pre-Raphaelite style of William Bell Scott; and canvases by artists of the Glasgow school. The only American painting of note in the National Gallery of Scotland is the large *Niagara Falls* by Frederick E. Church.

Among the drawings are works by Italian masters as diverse as Gentile da Fabriano, Veronese, and Piranesi, as well as the Mannerists Giulio Romano, Rosso Fiorentino, and Beccafumi. This department also offers drawings by leading Northern artists from many schools, such as Rembrandt, Rubens, Gainsborough, and Ingres. The collection of graphic arts contains several significant series that demonstrate the major techniques: woodcuts in Dürer's *Life of the Virgin*, engravings in Blake's *Book of Job*, etchings in Tiepolo's *Flight into Egypt*, etching with aquatint in Goya's *Disasters of War*, and lithography in Delacroix's *Hamlet* and *Faust*. As might be expected, the Gallery is strong in prints and drawings by Scottish artists as well.

The library personnel operate a facility intended to serve primarily the museum's own needs, although anyone engaged in scholarly projects will be admitted. Reflecting the strengths of the Gallery, the library offers much material on Scottish art particularly and post-medieval European painting generally, although through its participation in a central index of art books in Edinburgh, it offers access to works in a broader range of subject areas. Black and white photographs of nearly all works in the Gallery are available by mail and to the visitor, as are color slides of the best-known works. The National Galleries issue an annual report and the *Bulletin*, which appears quarterly. The staff also maintains a mailing list for special events, there being no organized civic group that specifically promotes the Gallery. Changing shows usually deal with prints and drawings or with Scottish art, large special exhibitions being rare. The National Gallery of Scotland prefers, rightfully, to keep its splendid permanent collection on display.

Administrative offices of the National Galleries of Scotland are located at 17 Ainslie Place, Edinburgh EH3 6AU, Scotland.

Selected Bibliography

Museum publications: *A Guide to the National Gallery of Scotland*, 1977; *Shorter Catalogue: National Gallery of Scotland*, 1978; Andrews, Keith, *Catalogue of Italian Drawings in the National Gallery of Scotland*, rev. ed., 1971; Brigstocke, Hugh, *Italian and Spanish Paintings in the National Gallery of Scotland*, 1978; *Catalogue of Scottish Drawings*, 1960; *English Watercolours and Other Drawings from the Helen Barlow Bequest*, 1979; Holloway, James, and Errington, Lindsay, *The Discovery of Scotland: the appreciation of Scottish scenery through two centuries of painting*, 1978; *Old Master Drawings from the David Laing Bequest*, 1976; *Sir David Wilkie: Drawings into Paintings*, 1975; Thompson, Colin, *Pictures for Scotland: the National Gallery of Scotland and its Collection*, 1972; Thompson, Colin, and Campbell, Lorne, *Hugo van der Goes and the Trinity Panels in Edinburgh*, 1974.

Other publications: "The Alexander Maitland Gift to Edinburgh," *The Burlington Magazine*, vol. 102, no. 685 (April 1960), p. 161; Andrews, Keith, "Three Pontormo Drawings in the National Gallery of Scotland," *The Burlington Magazine*, vol. 100, no. 669 (December 1958), pp. 436–37, 439; Baxandall, David, "A Lorenzo Monaco Madonna," *Scottish Art Review*, vol. 9, no. 1 (1967), pp. 6–7; idem, "The Maitlands and their Taste," *Apollo*, new series, vol. 83 (April 1966), pp. 308–10; "Editorial: the National Gallery of Scotland," *The Burlington Magazine*, vol. 107, no. 751 (October 1965), p. 495; "Editorial: the National Gallery of Scotland," *The Burlington Magazine*, vol. 114, no. 833 (August 1972), p. 515; Eglington, Laurie, "Impressions of the Scottish National Gallery in Edinburgh," *The Art News*, vol. 32, no. 2 (October 14, 1933), pp. 8, 12; Gardner, Julian, "Copies of Roman Mosaics in Edinburgh," *The Burlington Magazine*, vol. 115, no. 846 (September 1973), pp. 583–91; Jost, Ingrid, "A Newly Discovered Painting by Adam Elsheimer," *The Burlington Magazine*, vol. 108, no. 754 (January 1966), pp. 2–7.

RONALD D. RARICK

───── Glasgow ─────

BURRELL COLLECTION, THE, 2060 Pollokshaws Road, Pollok Country Park, Glasgow G43 1AT Scotland.

The Burrell Collection was officially given to the city of Glasgow in 1944 by a wealthy shipowner, Sir William Burrell (1861–1958), and his wife, Lady Burrell. After searching for more than a decade for a suitable home for his collection of six thousand pieces of medieval decorative arts, European paintings, and Oriental ceramics and bronzes, Sir William gave the pieces to his native city, along with a gift of money to construct a suitable building. Several stipulations concerning the location of the building made choosing the site difficult: Sir William wanted it to be at least sixteen miles from the Royal Exchange in

the city center in Glasgow, to minimize the harmful effects of the extremely bad air pollution then prevailing in Glasgow, and within four miles of Killearn in Stirlingshire, to show his collection to the best advantage in a rural setting. A suitable location was finally found in 1967 when the Pollok House and estate were given to the city of Glasgow by Anne Maxwell Macdonald. From 1944 until 1957, Burrell continued to add to the collection, purchasing another two thousand pieces.

The building, designed by Barry Gasson, John Meunier, and Britt Andreson, was officially opened on October 21, 1983, although the commission for the building was actually awarded in 1972. The architect faced several major tasks in designing a home for Sir William Burrell's rich and diverse collection: the incorporation of three rooms from Hutton Castle, Burrell's home, into the fabric of the building; the siting of the construction in or near the woodland bordering the meadow to take full advantage of the interplay between nature and art; the use of many pieces of architectural stonework purchased by Burrell from the collection of William Randolph Hearst; and the considerations of displaying a major collection of tapestries, which are harmed by direct sunlight, and of stained glass, which requires sunlight to be seen to its best advantage.

To construct this building, Burrell left a sum that with accrued interest amounted to about 1.75 million pounds by 1978. The remainder of the cost was borne by the city of Glasgow and the Scottish Education Office. Sir William also left a bequest for additional acquisitions. The daily running cost of the museum is provided by the city of Glasgow, with a contribution from the Strathclyde Regional Council.

The museum is governed by a self-perpetuating board of trustees, whose members, according to the terms of the Deed of Gift, administer the purchase fund. As one of several museums under the aegis of the Glasgow Museums and Art Galleries, the Burrell is part of the city administration that provides for an overall director, deputy director, and assistant director, who also functions as keeper of the Burrell Collection in charge of the entire museum and its administration, and specifically oversees the medieval collections. He is assisted by a deputy keeper for ancient civilizations and three assistant keepers for Oriental art, paintings, and Middle Eastern art. An education department provides formal and informal activities for schoolchildren and arranges a lecture series. Space for seven conservators has also been provided in the new building. The Glasgow Art Galleries and Museums Association recruits a volunteer guide service, trained by the curatorial staff.

Sir William Burrell first collected Late Gothic art of Northern Europe (c. 1300–c. 1500), considered the most important section of the Collection. Although Burrell was buying medieval objects from the end of the nineteenth century until his death in 1958, most of the major tapestries were purchased in the 1920s and 1930s, and much of the important stained glass was added right before and after World War II. Of the 150 tapestries, regarded by Sir William as the most important part of this section of the Collection, the earliest is a fragment of an

altar covering of about 1300, probably from southern Germany. Two other fragments are almost certainly part of the famous *Apocalypse* series, woven in the late fourteenth century for the duke of Anjou and now displayed in Angers. Most of the other tapestries are from the late fifteenth and early sixteenth centuries, including many German examples of both sacred and secular objects. Those woven in the Netherlands of the same era, from Bruges, Tournai, and Arras, are more sophisticated; one of the finest examples of a tapestry of this period is the work depicting peasants hunting rabbits with ferrets. Other subjects represented in the Collection are: *Camel Caravan*, probably based on an actual parade organized in Antwerp; *Hercules Initiating the Olympic Games*, an oblique reference to Philip the Good and Charles the Bold; and *Charity Overcoming Envy*, probably one from the series of combats between the Virtues and Vices. An unusual example of the art of weaving is the *Luttrell Table Carpet*, one of two sixteenth-century tapestry-woven table carpets still in existence. A major consideration in designing the new building was how to execute Burrell's dictum that the construction resemble a home, not a museum. As a result, some of the tapestries are hung in a room whose dimensions approximate those of a great hall in a castle, with appropriate furnishings sparsely arranged in the interior space.

Other "medieval" rooms have dimensions more appropriate to the dwellings of the middle class, a feeling enhanced by additions such as a late-fifteenth- to early-sixteenth-century carved-oak ceiling from a church via a house in Bridgwater, Somerset, and linenfold paneling of about 1530 from a merchant's home in Ipswich. There are three "period" rooms, devoted to a particular theme or time but not a faithful reproduction of an era. Some of the five hundred pieces of early furniture, an outstanding section of the Collection, are displayed in these rooms (others are to be found in the Hutton Castle rooms). The Elizabethan Room contains a carved-oak fireplace and overmantel reputedly from the Tudor royal palace of Oatlands in Surrey, bought in 1953 from the Hearst Collection. This room also contains the Kimberley Throne, from Kimberley Hall in Norfolk, traditionally associated with a 1578 visit Elizabeth I made to that residence.

In addition to the medieval tapestries, Burrell collected about three hundred pieces of needlework, concentrating on English examples from the late sixteenth to the early seventeenth century. Articles of clothing, samplers, pictures, and decorated objects form the majority of the collection, housed in smaller rooms, away from the direct sunlight, both on the ground and on the mezzanine floors.

The collection of seven hundred pieces of stained glass, strongest in examples of the fifteenth and early sixteenth centuries from the Northern countries, is comparable with collections in the Victoria and Albert Museum (q.v.) in London and the Cloisters (Metropolitan Museum of Art, q.v.) in New York. The earliest and one of the most important pieces in the Collection is the fragment of the Prophet Jeremiah, from Abbot Suger's reconstruction of St. Denis, which Burrell purchased in Paris in 1923. Other sacred examples are mainly from Germany of the fourteenth and fifteenth centuries. A rare sixteenth-century Belgian frag-

ment was part of a series commissioned for the Charterhouse of Louvain by the bishop of Arras. Several other pieces are connected with the workshop of Arnoult of Nijmuegen, an important Flemish glazier established in Rouen. Several types of secular glass are represented in the Collection, including the Labour of the Month roundel from Norwich and a Dutch example showing a slate cutter at work. The most important secular pieces are the two series of English sixteenth-century heraldic glass, from Fawsley Hall in Northamptonshire and Vale Royal in Cheshire.

There are about three hundred pieces of medieval sculpture, in wood, stone, ivory, and alabaster, in the Collection, representing the main centers of production and styles from the late thirteenth to the early sixteenth century in Europe. Among the few examples from outside the North, from Spain, are a painted limestone tomb, said to be an effigy of a knight of the Espés family (mid-fourteenth century), and two polychromed wood figures of the Virgin and St. John of the late thirteenth century. French sculpture of the mid- to late thirteenth century, which sets the style for much medieval sculpture for the next century, is illustrated by several figures, and the next trend is found in an ivory diptych of 1360–70, French or Netherlandish, and a North German marble. The Collection contains numerous English alabasters, one of the best being a group of the Holy Trinity from 1375–85. Another alabaster of the *Pietà* may be from the workshop of the Master of Rimini of mid-fifteenth century. Fifteenth- and sixteenth-century sculpture was dominated by the production of composite altarpieces, of which the Burrell Collection contains many fine examples but no complete retables. Examples in the most popular media, oak and limewood, are represented, both polychromed and, after 1490, unpainted. Later English alabasters of the fifteenth century, also part of larger altarpieces, complete this section of the Collection.

Liturgical objects are represented in the Collection by chalices, reliquaries, and other examples of Limoges enamel work and several aquamaniles. A twelfth-century bronze group of three soldiers sleeping, known as the *Temple Pyx* from its reputed place of location in the Temple Church in London, is a rare fragment of a twelfth-century English reliquary.

Whereas the Burrell Collection is particularly strong in medieval objects, Sir William's dislike of Romanesque art is evident in the few pieces dating before the fourteenth century. He also did not care for illustrated manuscripts and purchased only a few examples.

Another aspect of the medieval collection from the thirteenth to the seventeenth century is the arms and armor, some bought from the Hearst Collection. Various types of helmets from Germany and Italy are displayed, as well as a complete suit of armor, about 1520, from the reign of the Emperor Maximilian. Different kinds of swords, in both iron and steel, as well as other types of weapons, are also on view.

A striking feature of the medieval collection is the series of stone doorways and windows incorporated in the fabric of the new construction. Bought in 1953–

54 from the estate of the late William Randolph Hearst, the pieces include three Romanesque windows and a doorway from Provence, seven French Flamboyant doorways and windows, a late twelfth-century doorway from a church near Chateau-Thierry, and the early sixteenth-century portal of Hornby Castle, Yorkshire.

The only true "reconstructions" in the building are the three rooms from Hutton Castle, Sir William and Lady Burrell's home near Berwick-on-Tweed. Purchased by Burrell in 1916, the fifteenth–sixteenth-century border fortress was heavily restored as a setting for his collection. Burrell stipulated in his Deed of Gift that the dining room, hall, and drawing room be reconstructed to scale in the new building and that the furnishings he had selected for these rooms be displayed there.

Sir William had amassed an interesting selection of European decorative arts after the Middle Ages. He collected important pieces in only two areas of European ceramics: Hispano-Moresque lusterware and English seventeenth-century slipware. He also owned a porcelain Chelsea figure of Isabella d'Andreini, dating from 1749–52, one of three in existence and a rare venture (for him) into the world of Rococo.

Two outstanding examples of "treen" or wooden household articles are an unusual Elizabethan posset cup and the Hickman Chalice, a rare early seventeenth-century standing cup. Distinctive shapes and types of European glassware are illustrated in the Collection, with German and English examples predominating. The development of the English glass industry in the eighteenth century is well represented by various examples of wine glasses and other vessels.

The pieces of silver in the Collection are mainly English and date primarily from the sixteenth to the eighteenth century. They include a few examples of early church silver, salts, three beautiful seventeenth-century steeple cups, and a quantity of eighteenth-century works of classic design, some showing the effect of Huguenot influences in their excellent engraving and cut-card decoration.

The collection of European paintings, prints, and drawings numbers about six hundred and was amassed during Sir Williams' entire collecting life. The small but choice group of early works includes the *Angel of the Annunciation* by Hans Memling; two paintings by Lucas Cranach the Elder, *The Stag Hunt* and *Cupid and Venus*; and several prints by Albrecht Dürer.

There are few Italian Renaissance and Baroque works, except for the Giovanni Bellini *Virgin and Child* and the marble bust of a young boy, possibly by Benedetto da Maiano.

The Collection has an assorted group of Dutch seventeenth-century paintings of which the most important are the Frans Hals *Portrait of a Gentleman*, about 1639, and the Rembrandt *Self Portrait*, 1632. Burrell also enjoyed English portraiture of the eighteenth century and bought several fine examples, including the Hogarth portrait *Mrs. Ann Lloyd* and the Raeburn work *Miss Macartney*. The Hague school, a group of Dutch painters contemporary with, but less revolutionary than, the Impressionists, was popular with Burrell in the early years

of his collecting, especially the works of the brothers Jacob, Matthijs, and Willem Maris.

The Collection is best known for its French paintings, particularly those of the nineteenth century. *The Prancing Grey Horse* of Géricault and an early Delacroix, *The White Horse*, illustrate Romanticism of the early part of the century. A more realistic strain is found in Courbet's large 1868 *The Charity of a Beggar at Ornans*; in Daumier's work, including several oil paintings and nine graphic pieces; and in the work of Millet, Bonvin, and Fantin-Latour. Representative works by Impressionists such as Manet, Boudin, Sisley, and Pissarro are also to be found. The Cézanne in the Collection, *Château de Médan*, actually took Burrell more than ten years to acquire. There are more than twenty works by Edgar Degas in Burrell's collection, including notable pieces such as the oil *The Rehearsal*, the pastel *Jockeys in the Rain*, and the tempera, with color and pastel, *Portrait of Edmond Duranty*. Complementing the nineteenth-century paintings is a group of bronzes, including works by Constantin Meunier and fourteen by Rodin. A favorite artist with Burrell seems to have been a relatively unknown animal painter, Joseph Crawhall (1861–1913), who worked with Sir James Guthrie and other members of the Glasgow school. In all, there are 132 works by Crawhall.

Sir William Burrell did not begin buying objects from the ancient world until 1947, when he decided to round out his collection by acquiring a representative group of objects from the ancient world, about seven hundred in all. Since most were purchased from dealers, not from sponsored excavations, provenance is often difficult to determine. There are about forty-five representative objects from the Sumerian and other South Mesopotamian cultures: cylinder seals, votive statuettes and heads, a figure from a temple foundation, and other statuary. A major section is the twelve Assyrian pieces, including eight relief fragments from the royal palaces at Nimrud and Nineveh. The thirty-five Luristan bronzes include examples of finials, horse bits, and cloak pins. Although small, this section of the Burrell Collection, because of its representative covering of the culture of the area, is one of the main collections in Britain. Of the nearly three hundred examples from ancient Egypt, only four had been purchased by Burrell before 1947. The Collection now contains representative pieces from each of the major divisions of Egyptian history.

Among the most memorable works are those from the Old Kingdom: an offering table and jars of alabaster, and a painted limestone relief; from the Middle Kingdom: a pearl-shell soldier's badge; from the New Kingdom: stelae, statuettes, shawabtis, and a relief of Ramesses II in granite; from the Late Period: core-wound glass vessels. The Greek and Etruscan section contains about two hundred objects, beginning with a stone palette from Minoan times. Mycenean culture is represented by pottery and a rare model chariot found in Cyprus. Geometric and Protogeometric pottery and Geometric bronze figurines of horses illustrate the beginnings of Greek art as we know it. Examples of various kinds of vases are also to be found, from Orientalizing to black- and red-figure. A

few examples of small stone sculpture from Classical and fourth-century sites are to be found. Etruscan pots that show the influence of Greek settlements in southern Italy are found in the Collection, including a bell krater by the Sydney Painter. There is also a typical fourth-century bronze *cista* from Praeneste, representative of Etruscan skill in metalworking. Of the one hundred Roman objects, examples of mosaic, porphyry sculpture, and bronze utensils should be noted, as well as a first-century B.C.–first-century A.D. bronze copy of a Greek fifth-century B.C. bust of Hermes, messenger of the gods.

One of the best-known pieces in the Classical collection, not part of the original bequest, is the Warwick Vase, named after the earl of Warwick, who acquired this 8.25-ton marble vase some time between 1776 and 1778 from Sir William Hamilton, British Envoy Extraordinary to the Court of Naples. Hamilton had obtained the pieces of the vase from excavations at Hadrian's Villa in Tivoli and paid for the extensive restoration necessary to reconstruct the krater. In 1977 the vase was sold to the Metropolitan Museum of Art in New York, but an export license was withheld, the equivalent amount was raised from several sources, and the vase was added to the Burrell Collection, thus remaining in Scotland.

The Oriental collection comprises about one-quarter of the items in the entire museum (two thousand), with the early Chinese ceramics and bronzes being Sir William's favorites, bought during most of his collecting life. Examples in the Burrell begin with fine pieces of neolithic painted pots, followed by many Han Dynasty burial objects: "hill jars" with molded decoration, a model of a storehouse, and other everyday objects. There are examples of Tang Dynasty three-color horses, camels, and attendant figures; guardian spirit figures; and pots of characteristic shape and decoration. The collection is also rich in celadon from various parts of China. Other early wares of characteristic decoration include: bubble bowls and black ware from both north and south Sung Dynasty; "papercut" decoration bowls from the Southern Sung Dynasty; *ding* white wares of the Northern Sung Dynasty. Early blue-and-white and red-and-white ware is represented in the Collection, with other fine examples of Ming polychrome ware. One of the best pieces bought by Sir William is the Ming Dynasty *lohan* figure, 1484, an excellent example of the enamel-on-biscuit technique. Other examples of this technique include pottery, glazed roof tiles in various shapes, and armored guardian figures. Monochrome ware, including oxblood, peach-bloom, and yellow examples, of the same period are also well represented in the Collection. Eighteenth-century polychrome ware found in the Collection is famille noire and famille verte; unexplicably, Sir William sold every piece of famille rose porcelain that he ever bought.

Sir William particularly liked early Chinese bronzes, expressing an appreciation for their lovely patina. He seemed to purchase these objects steadily during his collecting life. Most of the bronzes are from the Shang and Chou dynasties (sixteenth to eleventh century B.C. and eleventh to third century B.C.) and illustrate various shapes of ritual vessels used in burials: containers in all shapes

for food and wine as well as bells. One of the best examples in the Collection is a *lian* from the second or first century B.C.—too large for a toilet box, it was probably a storage container. Items from the Han Dynasty include ornaments, mirrors, vessels, and a crossbow mechanism. The later bronzes include a number of pieces made in deliberate imitation of vessels of the Warring States and Han periods, such as a *hu* vase and a "champion vase," with archaistic decorative elements.

The pieces of jade in the Collection, mainly bought in the 1940s, range in date from the Neolithic period to the early twentieth century. Different types of objects represented include: weapons, pendants, *zong* and *bi* items for ritual use, vessels (including a fine example of a "champion vase" of the thirteenth–fifteenth century), and small animal, vegetable, and human figures.

Sir William bought Japanese prints of the eighteenth and nineteenth centuries, including widely differing examples of the two artists best known in the West, Katsushika Hokusai and Utamaro.

The Collection is particularly rich in Near Eastern carpets, with about 150 examples of carpets from the sixteenth to the nineteenth century, covering a wide area from Turkey to India. The collection consists of pieces, such as the fragment of the Persian *Ardabil Carpet*, and whole carpets, like the *Wagner Garden Carpet*, from the first half of the seventeenth century.

The ceramics from the Near East also cover a wide range, from Turkey to Samarkand, dating from the ninth to the seventeenth century. The earliest examples are Persian, from the ninth and nineteenth centuries, followed by later pieces (twelfth–thirteenth century) from northwestern Persia, illustrating the *sgraffito* technique of decoration. Elegant silhouette ware, a variant of *sgraffito* ware, from northern Persia, is represented, as well as monochrome wares with incised or molded relief decoration. There are also examples of twelfth–thirteenth-century Persian *minai* ware and *lajvard* ware. Twelfth- and thirteenth-century lusterware from Rayy and Kashan is well represented in the group, including a wide variety of tiles, the most famous being the star and cross tiles, probably from a saint's tomb in Veramin. Examples of fourteenth-century Sultanabad ware in both bowls and star tiles can also be found in the Burrell Collection. Turkish examples in the Collection are sixteenth-century Iznik wares, with instances of both Chinese and Turkish elements in the decoration. Most of them were bought in 1947 and, along with the lusterware, were favorites of Sir William.

The Burrell Collection has an art library of about twenty thousand volumes concerned with various aspects of the collection. The library is open to those scholars who receive prior approval from the administration.

Photographs of the objects in the Collection may be obtained by writing to the keeper. The entire collection has been reproduced on microfiche, available from the publisher. During the time that the Collection was in storage, many special exhibitions of selected items were held in Britain and abroad; catalogues of some of these exhibitions are available from the Burrell. Small pamphlets on

selected topics are also published regularly. Although the collection itself does not have a regular journal, *The Scottish Art Review*, a publication of the Glasgow Museums and Art Galleries, regularly features objects from the Burrell Collection, as well as having an entire issue devoted to it.

Other facilities include a lecture theater, temporary exhibitions gallery, restaurant and bar, and accommodations for visiting scholars.

Selected Bibliography

Museum publications: *The Burrell Collection*, rev. rep., 1984; Marks, R., *Sir William Burrell, 1861–1958*, 1982; *Carpets and Tapestries from the Burrell Collection*, 1969; *Crawhall in The Burrell Collection*, 1953; *Stained and Painted Glass in The Burrell Collection*, 1965; *Stained and Painted Heraldic Glass in The Burrell Collection*, 1962; Bliss, D. P., "Tapestries in The Burrell Collection," *Scottish Art Review*, vol. 2, no. 4 (1949), pp. 2–7; Honeyman, T. J., "Degas in The Burrell Collection," *Scottish Art Review*, vol. 2, no. 4 (1949), pp. 8–12; Finlay, I., "The Burrell Collection Silver," *Scottish Art Review*, vol. 1, no. 2 (1946), pp. 6–9; Macaulay, W. J., "French 13th Century Painted Glass in The Burrell Collection," *Scottish Art Review*, vol. 2, no. 4 (1949), pp. 13–15; Pickvance, R., "Daumier in Scotland," *Scottish Art Review*, vol. 12, no. 1 (1969), pp. 13–16, 29; Scott, J. G., "Egyptian Stone Vases in The Burrell Collection," *Scottish Art Review*, vol. 2, no. 4 (1949), pp. 25–27; Wells, W., "Family Pride (Some Heraldic Tapestries in The Burrell Collection)," *Scottish Art Review*, vol. 7, no. 1 (1959), pp. 14–16, 28; idem, "Géricault in The Burrell Collection," *Scottish Art Review*, vol. 9, no. 4 (1964), pp. 13–17, 31; idem, "The Luttrell Table Carpet," *Scottish Art Review*, vol. 11, no. 3 (1968), pp. 14–18, 29; idem, "Sir William Burrell's Purchase Books," *Scottish Art Review*, vol. 9, no. 2 (1963), pp. 19–22; Wells, W., and A.V.B. Norman, "An Unknown Hercules Tapestry in The Burrell Collection," *Scottish Art Review*, vol. 8, no. 3 (1962), pp. 13–20, 32.

Other publications: Arts Council of Great Britain, *The Burrell Collection: Medieval Tapestries, Sculpture, etc.* (London 1977); Arts Council of Great Britain, *The Burrell Collection: 19th Century French Paintings* (London 1977); Marks, R., *Burrell: A Portrait of a Collector* (Glasgow 1983); Beattie, M. H., "The Burrell Collection of Oriental Rugs," *Oriental Art*, vol. 7, no. 4 (1961), pp. 162–69; Glancey, J., "The Burrell: Art and Nature," *The Architectural Review*, no. 1044 (February 1984), pp. 28–37; Kendrick, A. F., "Gothic Tapestries for Hutton Castle," *Country Life*, no. 1584 (May 1927), p. 48a; Kendrick, T. D., "The Temple Pyx," *Antiquaries Journal*, vol. 16 (1936), pp. 51–54; Kendrick, A. F., "A Tapestry Altar Frontal of the 15th Century," *Burlington Magazine*, November 1926, p. 211.

MARY LOUISE WOOD

──────── London ────────

BRITISH MUSEUM (alternately BM), Great Russell Street, London WC1.

The British Museum was founded by an act of Parliament in 1753, following the bequest by Sir Hans Sloane to the nation of his extensive collection of books and antiquities, in return for a payment to his daughters of 20,000 pounds. Two other important collections were added by the Foundation Act: the collection of

Sir Robert Cotton, the Elizabethan antiquary, which already belonged to the nation, and the manuscripts collected by Robert and Edward Harley, which were purchased for 10,000 pounds. The Royal Library of books collected by the kings and queens of England since Tudor times was presented to the museum by George II in 1757.

In 1782 Sir William Hamilton's collection of Greek vases and antiquities was purchased. Many monumental Egyptian sculptures and the *Rosetta Stone* were acquired as the result of the Treaty of Alexandria in 1801, three years after Nelson's victory at the Battle of the Nile. In 1816 the sculptures from the Parthenon were purchased from Lord Elgin. During these early decades the museum was housed in Montagu House, on the site of the present building, but as the collections grew it became necessary to plan a new building. Plans were prepared by Robert Smirke in 1824 and put into effect during the succeeding thirty years; the remaining walls of Montagu House were razed in 1845.

Significant additions were made to the antiquities collections during the middle years of the century as a result of excavations in the eastern Mediterranean and western Asia, and the pressure for space once again became acute. Additional storage and study facilities were provided for the printed book collection, by the construction of the circular Reading Room in the central courtyard between 1853 and 1857, but the natural history collections were moved from Bloomsbury to a new museum for natural history, now known as the British Museum (Natural History), in South Kensington between 1880 and 1883. More recently, in 1970, the ethnography collections also left Bloomsbury and are now displayed in the Museum of Mankind, 6 Burlington Gardens, W1.

The British Museum is governed by a body of twenty-five trustees, one appointed by the sovereign; fifteen appointed by the prime minister; four nominated by, respectively, the Royal Academy, the British Academy, the Royal Society, and the Society of Antiquaries of London; and five appointed by the trustees of the British Museum. Since 1963 the British Museum (Natural History) has been governed by a separate body of trustees, and in July 1973 the Library Departments were vested under the separate authority of the British Library Board, although the collections remain at present in the Bloomsbury building, where the library exhibition galleries are open to the public.

The museum is administered by a director and a deputy director, and its central services comprise a secretariat and administrative and public services. There are nine curatorial departments—Department of Coins and Medals, Department of Egyptian Antiquities, Department of Ethnography, Department of Greek and Roman Antiquities, Department of Oriental Antiquities, Department of Prehistoric and Romano-British Antiquities, Department of Prints and Drawings, and Department of Western Asiatic Antiquities—as well as the Research Laboratory and the Department of Conservation. Each department has a specialist library, with holdings of the major journals in its field.

The exhibition gallery of the Department of Coins and Medals is devoted to two thousand years of coins and medals in Great Britain. The earliest coins in

Britain were brought by people from Belgic Gaul; the types of the first coins used here were based on a gold stater of Philip II of Macedon (357–336 B.C.). The native British staters of the famous King Cunobeline carrying the names of himself and his capital Camulodunum (Colchester), ear-of-wheat and horse designs, are far more accomplished. For the four hundred years after the Roman conquest of Britain by Emperor Claudius in A.D. 43, Roman coins circulated. Some of the earliest Anglo-Saxon coins are based on Roman prototypes, although originating about two centuries later than the end of Roman rule. There is a good range of silver Anglo-Saxon pennies, and some rare gold ones, dating before the Norman Conquest of William I in A.D. 1066. Some magnificent pieces show the relative economic stability in medieval England and its influence on continental Europe. With the Renaissance came the revival of true coin and medallic portraiture, seen first on the silver groat of Henry VII of A.D. 1503–4 and perhaps best exemplified in the magnificent gold medal of Elizabeth I made on the occasion of the defeat of the Spanish Armada in A.D. 1588. Until the seventeenth century A.D. coins were made by hand by the hammered process; after the Restoration of Charles II, milled coinage was introduced in A.D. 1661, and all hammered coins were removed from circulation in A.D. 1733. All reigns are represented by coins and medals, and there are separate displays of the coinage of Ireland and Scotland in the gallery.

Small displays of relevant coins and medals are found in the galleries of other departments: Classical coins in the Greek and Roman Life Room; Indian, Chinese, and Islamic coins in the King Edward VII Gallery; coins from the Oxus Treasure and of the Parthians and Sassanians in the Iranian Room; gold solidi from the Water Newton treasure-trove in the Roman Britain Room; coins associated with the Sutton Hoo ship burial in the Early Medieval Room; and further groups of coins in the Palestine Room, the Iron Age Room, and the galleries of the Department of Medieval and Later Antiquities.

The collections in the Department of Egyptian Antiquities represent all stages in the development of ancient Egyptian civilization from the earliest times to the Christian era. The historical (Dynastic) period, which began about three thousand years before Christ, was preceded by a series of prehistoric (Predynastic) cultures, which are well exemplified in the department by groups of material acquired from the excavation of key sites. For the historical period, sculptures, paintings, and objects of all kinds and of many materials illustrate the achievements of the Egyptians in art, craftsmanship, and industry. The large collection of papyri contains examples of most categories of ancient documents, including literary compositions, business records, and official archives. Religion and burial customs are represented in rich detail by the well-preserved material derived from cemeteries and temples. The Early Christian (Coptic) collection includes inscribed gravestones, textiles, and ritual and domestic objects.

The nucleus of the great exhibition of sculptures seen in the Egyptian Sculpture Gallery was the collection of antiquities surrendered by the French at the capitulation of Alexandria in A.D. 1801. The sculptures are arranged generally in

order of date. There is a statue of the fifth dynasty (c. 2500 B.C.); statues of Sesostris III, a king of the twelfth dynasty (c. 1850 B.C.); a colossal limestone bust of Amenophis III (c. 1400 B.C.); red granite lions of Amenophis III, one of them completed by Tutankhamun (c. 1360 B.C.); statues of Ramesses II (c.1250 B.C.); and stone sarcophagi (c. 600–350 B.C.). At the south end is the *Rosetta Stone*, inscribed with a decree in two forms of Egyptian writing: the priest's writing, or hieroglyphic, and the people's writing, or demotic, and also in Greek, in 196 B.C. This inscription, which was found in Egypt in A.D. 1799 and brought to England in A.D. 1802, gave the clue through the Greek to the translation of the hieroglyphics.

The Egyptian rooms contain mummies and mummy cases, including mummies of sacred animals (cats, crocodiles, calves, and so on) and wooden coffins. There are also wall paintings of Dynasty XVIII (c. 1400 B.C.), as well as examples of funerary furniture, *Shabti* figures and boxes, canopic jars and boxes, wooden painted gesso and cartonnage masks, and collections of wooden figures of animal-headed underworld deities. Exhibitions of papyri illustrate all classes of Egyptian literature written in hieratic and demotic script, including temple records, mathematics (the *Rhind Papyrus*, c. 1580 B.C.), wisdom books, and business documents, and various editions of the *Book of the Dead*, from Dynasty XVIII to about the second century A.D., specifically chosen because of the paintings and drawings commonly called "vignettes." The fourth Egyptian Room is specially devoted to exhibits demonstrating aspects of everyday life among the Egyptians. Small sculptures and figures of gods are shown in the fifth Egyptian Room. The sixth Egyptian Room is devoted principally to objects dating from Predynastic and Early Dynastic times, pottery of all periods, scarabs, jewelry, faience, and glass. In the Coptic Corridor are painted portraits of the Roman period, carved stonework, and textiles of the first to ninth century A.D.

The exhibition of Greek and Roman antiquities starts beyond the Bookstall Gallery on the ground floor, where two half-columns from the so-called Treasury of Atreus at Mycenae, a royal tomb of the thirteenth century B.C., have been erected and are divided as follows:

Room 1: Bronze Age art of the Cycladic islands.

Room 2: Minoan and Mycenean art.

Room 3: Greek art of 1000–500 B.C., including a bronze horse of the Geometric era found near Piguleia.

Room 4: Two sixth-century marble figures of youths (kouroi).

Room 5: Greek arts of 500–430 B.C., the period of the "Classical revolution." The exhibits include the *Strangford Apollo*, the *Harpy Tomb*, and the *Chatsworth Head*.

Room 6 (mezzanine): The frieze from the Temple of Apollo at Bassae. The frieze dates from the end of the fifth century B.C.

Room 7: Sculptures from the Nereid Monument, a temple-type tomb at Xanthos

in Lycia (southwest Turkey), dating from about 400 B.C. A facade of the tomb has been reconstructed at the north end of the room.

Room 8 (Duveen Gallery): Sculptures from the Parthenon, the Temple of Athena built on the Acropolis of Athens in 447–432 B.C. The sculptures were brought to England between 1802 and 1812 by the seventh earl of Elgin. There were ninety-two metopes (panels on the outer face, above the columns) on the Parthenon. All fifteen in the British Museum are from the south side, where battles between Lapiths and Centaurs were depicted.

Room 9: Greek art of 430–330 B.C. This room contains the Caryatid and column from the Erechtheum, a temple built on the Acropolis of Athens between 421 and 405 B.C. and removed by Lord Elgin in the early nineteenth century.

Room 10: Provincial Greek art of 430–330 B.C., including South Italian vases and a reconstruction of the Tomb of Payava from Xanthos in Lycia (c. 350 B.C.).

Room 11 (mezzanine above Room 9, accessible from the balcony of Room 10): Etruscan antiquities.

Room 12: Fourth-century sculptures from two of the "Seven Wonders" of the ancient world: the Mausoleum or Tomb of Mausolus, prince of Caria, and the Temple of Artemis at Ephesus.

Room 13: Greek art of the Hellenistic period, including the Demeter of Cnidus (c. 330 B.C.).

Room 14: Roman art of the Republican and Imperial periods, especially noteworthy is the Portland Vase. The subject of the frieze of the Portland Vase is probably the encounter of Peleus and Thetis, but its precise interpretation is still in dispute. The virtuosity of its workmanship has inspired modern craftsmen, including the great Josiah Wedgwood. Its long and eventful history makes it a fascinating minor document in the "proper study of Mankind."

Room 15: Roman copies of Greek statues and Roman portraits.

Of the department's first-floor galleries the following are open: the Terracotta Room, which contains Greek, Etruscan, and Roman bronzes and terracottas; the Room of Greek and Roman Life, which includes objects illustrating everyday life in ancient Greece and Italy, as well as collections of jewelry, silver, and glass; the Fourth Vase Room Corridor, whose exhibition illustrates gods and myths of the Classical world; and the First, Second and Third Vase Rooms, which contain vases from the eleventh to the third century B.C. and an exhibition of Cypriot antiquities.

The Department of Medieval and Later Antiquities' exhibition galleries open beyond the Roman Britain Room with the Early Medieval Room. An important piece near the entrance is the *Lycurgus Cup*, a remarkable late Roman glass vessel of the fourth century A.D. In this first area of the room are to be found Early Christian antiquities, in particular, silver such as the Esquiline Treasure, ivory carvings, jewelry, and glass from both the eastern and western Mediterranean. In the center of the room are exhibited the seventh-century finds from the Anglo-Saxon royal ship burial at Sutton Hoo, Suffolk, the most important Germanic grave found in Europe, excavated in 1939 and given to the nation in

the same year by the late Mrs. E. M. Pretty, JP, on whose land the site was. It comprised a very rich Anglo-Saxon burial deposit contained amidship in an eighty-foot-long ship. There were no remains of a body in the ship, so the burial, which was that of a king who died in the middle of the seventh century, may have been made in honor of a dead man whose body was not recoverable. The treasure contained, as was supposed, all of the necessities for the dead man's life in the next world in accordance with his social standing: gold jewelry, silver plate, weapons and bowls, the remains of cauldrons, buckets, dishes of bronze and iron, textiles, leather, cups and drinking horns, and other miscellaneous objects.

Through the door and to the left is the Medieval Tile and Pottery Room. There the display is centered on the Canynges pavement from Bristol, dating from about 1461. The cases nearby show medieval pottery of everyday use, and the panels above are inset with further examples of decorated medieval tiles, including the mid-thirteenth-century mosaic pavement from Henry III's chapel at Clarendon Palace, Wiltshire, with the kiln in which it was fired.

The exhibition of the Gallery of Clocks and Watches has been designed to show the major developments of mechanical timekeeping in Europe from the Middle Ages to the beginning of this century. Displayed separately is a spectacular *nef*, or ship clock, of the late sixteenth century.

Beyond this gallery lies the Waddesdon Bequest Room, which houses the single collection of medieval and Renaissance treasures bequeathed by the Baron Ferdinand de Rothschild in 1898. Dominated by goldsmiths' work, the room reflects the taste for lavish patronage of the arts, ostentatious wealth, and the love of fine craftsmanship and the curious, which was a hallmark of so many of the Renaissance courts. In the corridor leaving the Waddesdon Room are objects from the Renaissance to the eighteenth century—European on the left, British on the right. There are a number of outstanding objects of historical and personal association, such as the signet ring of Mary, Queen of Scots, and the silver seal-dies of Sir Walter Raleigh. A fine collection of Huguenot silver is displayed toward the end of the corridor on the left. Beyond is a room with a display of choice examples of fifteenth- to eighteenth-century pottery and porcelain. In the center stands the 1589 Carillon clock by Isaac Habrecht of Strasbourg.

The primary galleries of the Department of Oriental Antiquities are Oriental Gallery I, which contains the collection from South and Southeast Asia, from the Islamic islands of the Near East, from Central Asia, and from the Far East; and Oriental Gallery III, which contains the Japanese collections. Oriental Gallery II, apart from the permanent display of a small group of famous sculptures and paintings, is devoted to periodic exhibitions of paintings and prints mainly from Persia, India, China, and Japan. The reserve collections, both of antiquities and paintings, are available to holders of valid tickets of admission to the Students' Room.

The collections of Oriental Gallery I, South and Southeast Asia, which occupy the west wing of the gallery, are arranged by cultural provinces. The collections

from the Indian subcontinent are perhaps the most comprehensive in the West and cover the period from the second millennium, B.C. to the nineteenth century A.D. Especially noteworthy are the rich series of Buddhist sculptures from Gandhara (first to sixth century A.D.), among which is the unique Bimaran gold relic casket; the female bracket figure from Sanchi (first century A.D.); Buddhist images in stone, bronze, and terracotta and gold coins of the Gupta period (fourth to sixth century A.D.); the seated sandstone figure of Ganesa from western India (eighth century A.D.); the sandstone group of lovers from central India (tenth century A.D.); the ivory and wood miniature shrine from Kashmir (eighth century A.D.); the stone sculptures, Buddhist and Hindu, from eastern India and Orissa, the finest collection outside India; the three female bracket figures (twelfth century A.D.) and the bronze image of Sarasvati, the goddess of wisdom (tenth century A.D.), from the southern Deccan; and an outstanding group of stone and bronze images from South India, of which the stone figure of Siva (c. A.D. 950) are masterpieces. The most important sculptures from Southeast Asia are the life-size gilt-bronze figure of Tara (twelfth century A.D.), the seated bronze Buddha from Burma (twelfth century A.D.), and the Raffles Collection of Javanese bronzes (eighth to fourteenth century A.D.).

The Islamic collections, which occupy the west end of Oriental Gallery I, include pottery, glass, jade, metalwork, and ivories from the eighth to nineteenth century. Of special interest are the Hedwig Glass (twelfth century), the Mosul inlaid brass ewer (1232), the inlaid brass astrolabe from Cairo (1236), the Syrian enameled glass pilgrim flask (c. 1250), the Turkish pottery mosque lamp from Jerusalem (1549), and the large jade tortoise from North India (seventeenth century).

A selection of the antiquities collected by Sir Aurel Stein on his three expeditions to Central Asia are exhibited in the center of the gallery on the north side.

The Chinese collections, which occupy the east wing of the gallery, are arranged in chronological order, from the Neolithic period to the Sung Dynasty (2000 B.C.–A.D. 1279) on the south side and east wall and from the Yüan to the Ch'ing Dynasty (A.D. 1279–1912) on the north. Of special interest are the bronze ritual vessels and weapons of the Shang and Early Chou dynasties (1300–700 B.C.), in particular the famous container formed by two back-to-back rams (twelfth to eleventh century B.C.); the chariot fittings and other ornate bronzes of the Late Chou Dynasty (500–206 B.C.), notably the large bell and two wine vessels (fifth century B.C.); an early lacquer box of the Han Dynasty (206 B.C.–A.D. 200); the large pottery tomb figures of the T'ang Dynasty (A.D. 618–906); a superlative display of porcelain of the Sung Dynasty (A.D. 960–1279), pre-eminent in which is the phoenix-headed ewer (twelfth century); the newly invented underglaze blue and red decorated porcelain of the Yüan Dynasty (A.D. 1279–1368); the superb blue-and-white porcelain, carved red lacquer, and cloisonné enamels of the first half of the Ming Dynasty (A.D. 1368–1644); and the good collections of porcelain, lacquer, and other minor arts of the Ch'ing Dynasty

(A.D. 1644–1912). The Korean collection is small but includes some small Buddhist bronzes of the Great Silla Dynasty (A.D. 668–918), excellent ceramics of the Koryŏ (A.D. 918–1392) and Yi (A.D. 1392–1910) dynasties, and one remarkable wooden box decorated with lacquer inlaid with mother-of-pearl and silver ware (thirteenth century A.D.). There is also a fine group of inlaid and painted lacquer from the Ryukyu Islands (fifteenth to seventeenth century A.D.).

Of special interest in Oriental Gallery III, Japan, are the three large bronze bells of the Yayoi period (300 B.C.–A.D. 250); the collection of grave-gods from the period of the Great Tombs (A.D. 250–552), the best outside of Japan; the gilt-bronze seated Bodhisattva (seventh century A.D.); the wooden mask used in the gigaku dances (eighth century A.D.); the colossal head of the Buddha exhibited in Oriental Gallery II and the beautiful box inlaid with grasshoppers in mother-of-pearl on black lacquer (twelfth century A.D.); the sword blades of the Ashikaga period (A.D. 1392–1573); and the very comprehensive collections of porcelain, netsuke, and *tsuba* of the Edo period (A.D. 1614–1867).

The galleries of the Department of Prehistoric and Romano-British Antiquities begin at the head of the main stairs. There is the Central Saloon, which houses a selection of outstanding later prehistoric and Romano-British antiquities. This includes fine examples of prehistoric British goldwork dating from between 1500 and 500 B.C., the beautiful Celtic Basse-Yutz flagons of the late fourth century B.C., fantastic wrought-iron furniture from burials of the first century B.C. at Welwyn, Hertfordshire, and the unique Early Christian Romano-British mosaic pavement. This outstanding mosaic pavement of the fourth century was discovered at Hinton St. Mary in Dorset in 1963. The mosaic, which is in general remarkably well preserved, measures about ten by seven meters and is designed as a continuous floor in two large panels to fit two interconnecting rooms. The smaller panel contains a damaged central roundel, which represents Bellerophon spearing the Chimaera, with hunting scenes on either side. The second and larger panel includes four lunettes, three showing hunting scenes and one a tree. The outer corners of the larger panel each contain a man's head and shoulders. These four human figures may represent the Evangelists, or the four winds, or indeed both. In the center of the panel is a roundel showing a male head with the Chi-Rho monogram set behind it. It is almost certain that this is a representation of Christ. The Chi-Rho monogram is formed of the first two letters of the name of Christ in Greek and was commonly used as a Christian symbol.

The Man before Metals Gallery, or First Prehistory Room, holds superb examples of paleolithic and neolithic art, which highlight the greater part of human prehistory from the emergence of man to the beginnings of metalworking.

The Second Prehistory Room gives access to the Third and Fourth Prehistory rooms. The exhibits in these three rooms demonstrate the development of technology and art and the increasing complexity of economic activity and political organization in Europe during the past two thousand years. Included in the Fourth Prehistory Room is a full-scale reconstruction of a rich Iron Age cremation burial from Welwyn Garden City, Hertfordshire, and an impressive display showing

the splendid gold neck rings, bronze shields, helmets, and other ornamental metalwork produced by British craftsmen in the two or three centuries immediately preceding the Roman invasion in 43.

The objects in the Roman-Britain Room date from the period when Britain was a province of the Roman Empire, between the first and early fifth centuries. A wide range of exhibits illustrates the main aspects of the life of the province, both civil and military. Perhaps the most spectacular single exhibit is the hoard of fourth-century silver tableware from Mildenhall. Other particularly striking exhibits are the reconstructed tomb of Classicianus, procurator of Britain after Boudicca's revolt; the Christian wall paintings from the Roman villa at Lullingstone, Kent; and the central roundel of a mosaic pavement from Leadenhall Street, London, depicting Bacchus riding on a tiger.

The Department of Prints and Drawings has no permanent exhibition in its gallery. Selections from the department's treasures, usually illustrating a particular theme or school, are, however, always on display in temporary exhibitions. These exhibitions are changed periodically.

The Print Room of the British Museum contains one of the great collections of European prints and drawings. The series of woodcuts, engravings, and etchings from their beginnings in the early fifteenth century to modern times is as representative as any in existence and includes almost the complete graphic works of, among others, Schongauer, Dürer, Lucas van Leyden, and Rembrandt. The collection of drawings of all schools illustrates the history of painting and of the graphic arts in general from the fifteenth century onwards. The representation of the English school is naturally the most complete; the Turner bequest, consisting of some twenty thousand watercolors left in the artist's studio at his death, is housed here. But there are few famous European artists whose drawings are not represented: among the highlights of the collection are groups of drawings by Leonardo, Michelangelo, Raphael, Dürer, Rubens, Rembrandt, Claude Lorraine, and Watteau. An exhibition of works selected from the permanent collection often illustrating a particular theme is usually on view. The Students' Room is adjacent and is open to students who want to study prints and drawings not on exhibition. Regulations and times of opening are displayed outside.

The Department of Western Asiatic Antiquities includes antiquities of the Sumerians, Babylonians, and Assyrians (Iraq); the Persians (Iran); the Canaanites, Phoenicians, Syrians, and Israelites (Syria, Lebanon, Jordan, Israel); the Carthaginians (Tunisia); the Hittites and Urartians (Turkey); and the South Arabians (Yemen, South Yemen, Saudi Arabia). The period covered is from the earliest permanent settlements, about 7000 B.C., until the advent of Islam in the seventh century A.D.

The Assyrian sculptures in the ground-floor and basement galleries were discovered during the last century in the great mounds that contain the ruins of the ancient capitals of Assyria: Kuyunjik (ancient Nineveh), Nimrud (ancient Kalhu, biblical Calah), and Khorsabad (ancient Dur-Sharrukin).

The Assyrian Transept displays the colossal human-headed winged lions from

the palace of Ashurnasirpal II (883–859 B.C.) at Nimrud, a statue of Ashurnasirpal and other sculptures from the temples near his palace, bronze gates of Ashurnasirpal and Shalmaneser III (858–824 B.C.) from an Assyrian temple at Balawat, the black obelisk of Shalmaneser III, and the white obelisk of Ashurnasirpal.

Sculptures from the palace of Ashurnasirpal II at Nimrud can be found in the Nimrud Gallery, and sculptures of Tiglath-pileser III (745–727 B.C.) are located in the Nimrud Central Saloon. The colossal human-headed winged bulls and other sculptures from the palace of Sargon (722–681 B.C.) at Khorsabad are in the Khorsabad Entrance. From Nineveh, the sculptures of Sennacherib (705–681 B.C.), such as the siege of Lachish, and of his grandson Ashurbanipal (668–626 B.C.), as well as sculptures of lion hunts, are found in the Assyrian Saloon; the reliefs showing the wars of Ashurbanipal, in the Assyrian Basement; and the sculptures from the palaces of Sennacherib and Ashurbanipal, at Nineveh, in the Nineveh Gallery. The Ancient Palestine Room shows the reconstructed rock-cut tomb from Jericho, the ossuary of Nicanor, and coins from Judah.

Bronzes and sculpture from the ancient kingdoms of Saudi Arabia, as well as ivories, mainly from Nimrud, in Phoenician, Syrian, and Assyrian styles can be seen on the South Arabian Landing and in the Ivory Room. In the Syrian Room are found Phoenician and Punic antiquities, sculptures from Tell Halaf and from Palmyra, and antiquities from Syria. The Room of Writing displays written documents in cuneiform and alphabetic scripts and seals, and the Prehistoric Room shows western Asiatic civilization between 7000 and 2800 B.C.

Antiquities illustrating the art and daily life of the Sumerians and Babylonians are displayed in the Babylonian Room. Among them are objects discovered during the excavations at Ur and particularly in the "Royal Cemetery" (c. 2600–2400 B.C.). They include the *Mosaic Standard*, with scenes of war and peace, the reconstructed royal sledge, harps and lyres, and examples of Sumerian jewelry. One of the most important pieces is a Sumerian statuette made about 2600 B.C. of a he-goat, rearing up on its hind legs to sniff the flowers on a tree. The tree is of gold leaf; the face and legs of the goat are of gold leaf; the horns, eyes, and shoulder fleece are of lapis lazuli, and the body fleece is made of white shell. It was originally mounted on a core of wood, now perished, and stands eighteen inches high. The pedestal is of silver, with mosaic work in shell, lapis lazuli, and red limestone. This figure is part of a symbolic composition in which two goats climb up toward the shoots of a sacred tree in the contrasting heraldic manner beloved by the Sumerians. The exact meaning of this composition is not known but is probably mythological. The companion goat to the present piece, found with it, is in the University Museum, Philadelphia.

Sculptures from Carchemish are displayed on the Hittite Landing. In the Anatolian Room are antiquities from Asia Minor and Hittite art from Asia Minor and Syria. Represented in the Iranian Room are bronzes from Luristan, Persian and Median art, sculptures from Persepolis, a Susa archer, the Oxus Treasure

(Achaemenid goldsmith's work of the fifth to fourth century B.C. and other pieces), and Sassanian metalwork.

The Museum of Mankind, a few minutes away from Piccadilly, at 6 Burlington Gardens, houses the British Museum's Ethnography Department. There is displayed a selection of outstanding specimens from the world's greatest collection of ethnographic material. In a number of changing exhibitions a variety of non-Western societies and cultures are represented. Some of these exhibitions portray the entire way of life of a particular people—their art, religion, social organization, and technology—and others concentrate on specific technologies or types of artifact. In addition, a selection of the museum's most important artistic treasures is constantly on display.

The collections as a whole contain about a quarter of a million specimens, both ancient and modern, originating in the indigenous cultures of Africa, the Americas, Australia and the Pacific, and parts of Asia and Europe.

The museum contains the world's largest collection of Benin bronzes. Created for the monarchy of Benin in Nigeria, they may date from as early as the fifteenth century. In addition, the museum has an excellent Benin ivory mask. Among the American material the pre-Columbian turquoise mosaics from Mexico are outstanding. Turquoise mosaic masks and other objects formed part of the regalia used in the service of the god Quetzalcoatl and some of the pieces displayed may have been sent by the Aztec ruler Montezuma to Hernando Cortés. Also from America is the life-sized Aztec rock-crystal skull. Many important items collected on the voyages of Captain Cook are in the Pacific and North American collections. The museum also possesses outstanding holdings from Asia, among which the textiles from Baluchistan and Borneo are especially noteworthy, as is the famous collection formed in Java by Sir Stamford Raffles at the beginning of the nineteenth century.

Owing to the vast number of objects in the collections, only a fraction of them can be exhibited at any one time. The rest are housed in a separate building where they can be seen on application by any member of the public engaged in serious study. The museum's other services include a regular program of film shows, and visitors may also have access to one of the largest anthropological reference libraries in the world.

There are information desks at both entrances of the museum, and the staff is pleased to answer visitors' questions about the museum's collections and special exhibitions. Lectures and gallery talks are given every day except Sunday and Monday. Books, replicas, and other publications are sold at the Bernard Shaw Bookshop in the Front Hall; there is also a shop at the North Entrance that has a special emphasis on books and items for children. Postcards, slides, and posters are available at the bookstall to the west of the main entrance. There is also a shop at the Museum of Mankind. Members of the public may order prints and transparencies of most of the objects in the museum. Ektachromes, but not slides, may be hired. Information and price lists are available from the

Photographic Service. Photography of museum exhibits (not material on loan) using a hand-held camera is permitted in the galleries. Permission must be obtained from the Photographic Service for photography in the galleries requiring a tripod and for all filming.

Membership of the British Museum Society is open to everyone interested in the museum and its activities, and members receive a magazine three times a year. The society's activities include special lectures, receptions, and visits to exhibitions and private collections at home and abroad.

Museum publications include the periodical *The British Museum Quarterly*, with its reports of new acquisitions and scholarly objects from the collection, as well as numerous monographs on the various sections of the departments, catalogues of the various departments, and a number of guidebooks. A complete bibliography of work published by and relating to the British Museum can be found in the *General Catalogue of Printed Books* and its supplements.

Selected Bibliography

Museum publications: *British Museum Guide*, 1975; *Report of the Trustees*, issued triennially.

Other publications: Francis, Sir Frank, *Treasures of the British Museum* (London 1971); Miller, Edward, *That Noble Cabinet* (London 1973); Mordaunt-Crook, J., *The British Museum: An Account of Architectural Features* (London 1972); Watson, Vera, *The British Museum* (London 1973).

NATIONAL GALLERY, Trafalgar Square, London WC2N 5DN.

When the heirs of Sir Robert Walpole, first earl of Orford, put up his collection for sale in 1777, John Wilkes suggested in the House of Commons that it be purchased by the nation and housed in a special gallery to be built in the garden of the British Museum (q.v.). Parliament rejected the idea and the Walpole Collection went instead to Russia. Although the seed that Wilkes had planted did not bear immediate fruit, neither did it die. Others began to cultivate it, among them Sir Joshua Reynolds, first president of the Royal Academy (who offered to lend his own collection to help get the museum started); James Barry, Reynolds' successor as professor of painting at the Academy (who suggested the name National Gallery); and Benjamin West, second president of the Royal Academy (who helped found the British Institution for the Promotion of the Fine Arts in the United Kingdom in 1805). The institution purchased an existing gallery (the "Shakespeare Gallery") and started acquiring paintings, but somehow the National Gallery as a physical entity never emerged.

Then, in 1823, Sir George Beaumont, one of the governors of the British Institution, formally offered to give his collection—which included two Rembrandts, three Claudes, Canaletto's *Stonemason's Yard*, and Rubens' *Chateau de Steen*—to the nation as soon as a gallery was built to house it. That same year John Julius Angerstein, a wealthy immigrant merchant, died, and his col-

lection of thirty-eight choice paintings—including a Titian, a Rubens, two Rembrandts, five Claudes, and Hogarth's *Marriage à la Mode* series—was put up for sale. When rumors began to circulate that a foreigner would buy that collection and take it out of the country, a clamor arose to save it. Out of the conjunction of these events finally came the National Gallery when Parliament voted on April 2, 1824, to purchase, preserve, and exhibit the Angerstein Collection for the nation.

The tradition, thus at last begun, of rising to meet a crisis became formalized in 1903, when the National Art-Collections Fund was formed with the specific charge of raising money to save for the nation as many works as possible. Holbein's *Duchess of Milan* (1909), the *Wilton Diptych* (1929), and Leonardo's cartoon, the *Virgin and Child with Saints Anne and John Baptist* (1962), are just a few examples of major works rescued from exile in this way.

In its first years, the Gallery was headed only by a keeper, William Seguier, and an assistant. Soon thereafter a "Committee of Six Gentlemen," which eventually evolved into a board of trustees, was added as a supervisory body. In 1855 Sir Charles Eastlake, who had been the second keeper and was then a trustee, was named first director with final authority over both the purchase of pictures and the management of the Gallery. Under his management and that of his two successors, William Boxall (1865–74) and Frederick Burton (1874–94), the Gallery acquired a wide range of paintings, primarily from the Italian Renaissance and the seventeenth century. With Burton's retirement, however, a new change gave ultimate authority over decisions back to the trustees.

As of 1980, the Gallery was governed by a board of eleven trustees, appointed at staggered intervals for terms of seven years. Ten of these appointments are made by the Treasury, one by the Tate Gallery (q.v.). The principal staff consists of a director, a keeper-deputy director, and several deputy and assistant keepers. Of the ten departments or sections, three are curatorial (Conservation, Scientific, Framing), and the rest are administrative (Education, Publications, Reproductions, Design, Library and Photographs, Enquiry and Archives, Building and Accommodations). An Honorary Scientific Advisory Committee provides additional expertise.

The Gallery was first opened on May 10, 1824, less than six weeks after Parliament had established it, by the simple expediency of making Angerstein's house in Pall Mall accessible to the public. Delighted by this action, Beaumont did not wait for a permanent building but turned his collection over to the nation in 1826, retaining only a few favorites until his death in 1828. The present quarters, designed by William Wilkins, opened in April 1838. Thought of simply as a visual link between important landmarks along the north side of Trafalgar Square, it was little more than a long, imposing facade, one room deep, with the center distinguished by a portico surmounted by a dome. Even that area was shared with the Royal Academy, the Gallery's quarters being only four rooms on the side to the west of the domed hall. The collection, however, was expanding

at a rapid rate, and the Royal Academy was soon moved out. Then successive alterations and additions were made until, by now, the building has more than quadrupled in size.

The original Angerstein purchase, along with the Beaumont Collection and the Reverend William Holwell Carr's bequest of 1831, was heavily weighted toward European painting of the sixteenth through the eighteenth century, as were the sporadic acquisitions of individual paintings that began to occur. Soon, however, the policy was formulated, and made official in a Treasury Minute of 1855, that the Gallery should have as complete a representation as possible of European painting from the Late Middle Ages on. Medieval painting was included, not because it was highly regarded (to the contrary), but because it was felt that the full genius of the Great Age of Art could not be appreciated without some understanding of its beginnings. Because of this long-range view, no period was completely neglected during the years of heavy buying, even though the nineteenth century might not consider that era's products worthy of acclaim. Thus despite its late start and relatively small size (a little over two thousand paintings), the Gallery's collection is choice.

About half of the collection is Italian, although the number of medieval works is relatively few. That there are as many early works as there are is primarily due to Eastlake's tenure. Through his efforts, thirty-one early Italian Primitives were bought in 1857 from the Lombardi-Baldi Collection, among them Margaritone's signed altarpiece the *Virgin and Child*, dating from the 1260s and the earliest work on display in the collection. The most important works from this period, however, are the three panels from Duccio's *Maestà*, acquired late in the nineteenth century by Burton. Also noteworthy from the fourteenth century are seven panels from Ugolino da Siena's only authenticated work, the *Santa Croce Altarpiece*. The early Italian holdings, however, are still well under a hundred and lack both a Cimabue and an undisputed Giotto.

All schools of the Quattrocento are fully represented. From Florence, Masaccio's *Pisa Madonna and Child*, his only fully documented altarpiece, heads the list. Of the many other works by Florentines, special mention should be made of Pollaiuolo's anatomical study *Martyrdom of St. Sebastian*, Uccello's perspective-mad, rocking-horse world represented in the *Battle of San Romano* and *St. George and the Dragon* (the earliest oil on canvas in the collection), Botticelli's lyrical *Venus and Mars* and his late *Mystic Nativity*, the delicate *Lady in Yellow* attributed to Baldovinetti, and Piero di Cosimo's so-called *Cephalus and Procris*. Three paintings, including the *Baptism of Christ* and the *Nativity* (with musical angels), by Piero della Francesca, lead the list of paintings from Umbria and give the Gallery the best collection outside of Italy of works by that master. Three more paintings, by Perugino, provide an insight into the milieu in which Raphael was first trained. The poetry of Siena's contribution to this century is highlighted by seven scenes from Sassetta's *Life of St. Francis* and four panels on the *Life of the Baptist* by Giovanni di Paolo.

The introduction of oil painting into Northern Italy can be studied in four of

Antonella da Messina's works, of which *St. Jerome in His Study* is believed to be the earliest. The *Agony in the Garden*, one of five works by Mantegna, was the obvious inspiration for the same scene as painted several years later by his brother-in-law Giovanni Bellini and provides an instructive insight into the artistic differences between Mantua and Venice. Of the seven other Bellinis, *Doge Loredano* marks a new development in Venetian portrait painting. From the Marches, Crivelli's *Annunciation with St. Emidius* is the most richly decorative and spatially sophisticated of his nine works in the collection.

Leonardo's famous *Cartoon*, acquired after the highly publicized money-raising campaign of the early 1960s, is undoubtedly the more famous of that High Renaissance master's two works, the other being the later version of the *Virgin of the Rocks*. Michelangelo is only represented by two unfinished works, both attributed but of interest because their incomplete state make them valuable documents on painting methods at that time. Works by Raphael are primarily from his pre-Roman period, but the Gallery also has a splendid seated portrait, *Pope Julius II*, whose authenticity was firmly established in 1970.

The great complexities of the Mannerist trends in Central Italy may be studied in the work of three masters: four small panels by Pontormo on the *Life of Joseph* (part of the decoration of a marriage chamber); Parmigianino's eleven-foot-tall altarpiece, usually called the *Vision of St. Jerome* (painted during the 1527 Sack of Rome); and Bronzino's stunning *Allegory of Time and Love*. Bronzino's painting was originally given by Cosimo de' Medici to Francis I and strongly influenced the direction of French painting for the rest of the sixteenth century.

The 1961 acquisition of Giorgione's *Sunset Landscape* has given the Gallery a fine representation of that master's pastoral subjects to go with its one Giorgione religious painting and its dozen Titians in presenting a cross-section of Venetian High Renaissance developments. The collection is especially strong in early Titians, of which the *Noli me tangere* and the *Man in Blue* are still very close to Giorgione. Early and late aspects of Titian's mythological pictures are the vigorous *Bacchus and Ariadne* of the 1520s and the six-foot glowing *Death of Actaeon* from the late 1650s. Of the nine Veronese paintings, the *Family of Darius* was one of the paintings most highly admired in the seventeenth-eight-eenth century, inspiring numerous variations on the theme of royal clemency. The dramatic compositional innovations of Tintoretto's late Mannerism reveal themselves in *St. George and the Dragon*, one of four works by him. Leonard-esque influence in Northern Italy is best seen in the eight paintings by Correggio: his tiny *Madonna of the Basket* was the first purchase made by the Gallery after the Angerstein acquisition.

The scope and quality of the Italian works diminishes as we enter the Baroque era. The school of Bologna is the best represented: Annibale Carracci's *Domine, Quo Vadis*, eight of Domenichino's *Story of Apollo* frescoes from the Villa Aldobrandini, and a colossal Reni altarpiece, the *Adoration of the Shepherds*, more than fifteen feet tall and the largest painting in the Gallery, deserve special mention. The masterpiece of the period, however, is Caravaggio's early version,

the *Supper at Emmaus*. The eighteenth-century holdings are somewhat richer, as a result of concerted efforts in recent years to close the most noticeable gaps. A lovely series of Tiepolos have been added, most notably the *Banquet of Cleopatra*. View painting in Venice is represented by several Canalettos (of which the most interesting is the early *Stonemason's Yard*) and more than a dozen Guardis (many of them caprices), which show a more evocative aspect. A handful of Longhis, including the famous *Rhinoceros*, are the most notable examples of the minor field of genre painting in Italy.

The earliest Northern work in the Gallery is the *Wilton Diptych* (*Richard II Presented to the Virgin and Child*), a late fourteenth-century example of the International Style in the North. The question of whether its artist was French or English—or some other nationality—is still vigorously debated.

The Flemish fifteenth-century collection is fairly small but contains a work of major importance: Jan van Eyck's famous *Arnolfini Wedding Portrait*, one of three works by that master. Of the two Campins and four van der Weydens, the coarse-featured *Virgin and Child before a Firescreen* by the former provides a striking contrast to his pupil's more delicately painted *Portrait of a Lady*. From the middle of the century are four works by Dieric Bouts and one by Petrus Christus. Toward the end of the century four Memlings and six Davids mark the beginning of Italian Renaissance influence, and the continuance of the indigenous Northern tradition finds its best representatives in Geertgen tot Sint Jans' foot-high, luminous *Night Nativity* and Bosch's harsh *Christ Mocked*. The sixteenth-century collection is much weaker, distinguished only by Bruegel's *Adoration of the Kings*, but seventeenth-century holdings are much richer. Of the twenty Rubens (one on extended loan from the Victoria and Albert Museum [q.v.]), a very early and a very late *Judgment of Paris* and the famous *Chapeau de Paille* deserve special mention, along with the huge (ten-foot-long) *Peace and War*—until recently the largest painting in the Gallery—and the lovely, late *Chateau de Steen*. In addition, the Gallery has seven van Dycks, including the splendid *Charles I on Horseback*, and three Jordaens.

The Dutch school is by far the richest of the seventeenth-century holdings. More than twenty Rembrandts head the collection, with portraits from all phases of his career, including an early and a late *Self Portrait*. On the borderline between portrait and genre painting is the richly glowing *Woman Bathing in a Stream*, probably a study of his common-law wife, Hendrickje. No late religious paintings are present, but there is a splendid one of *The Woman Taken in Adultery* from the mid–1640s. *A Man Holding Gloves*, from the 1640s, heads the list of seven Hals portraits, all from the 1630s and 1640s. Two Vermeers, from late in his career, both showing a *Lady at a Virginal*, round out the holdings of the three giants of the century. The wide range of the work of the Dutch "little masters" (its core coming from the sixty-nine Dutch and Flemish pictures purchased from Sir Robert Peel's collection in 1871) also shows to advantage, with all of the various schools and specialities, from portraits and genre to landscapes,

interiors, and still-life subjects, represented. Especially noteworthy are two rare paintings by Carel Fabritius (one—the tiny *View in Delft*—was probably painted for a peep show), de Hooch's *Courtyard*, the dramatically lit *Shore at Egmond-aan-Zee* by Jacob van Ruisdael, and Hobbema's famous *The Avenue, Middelharnis*.

The Germanic collection is small (partly reflecting the paucity of great masters from that area). The most interesting of the fifteenth-century works are the two wings from the *Werden Altarpiece*, the *Life of St. Hubert*. The best-known of the two Holbeins is undoubtedly the enigmatic *Ambassadors*—the other is the regal, life-size portrait *Christina of Denmark*. Only one Dürer, *The Painter's Father*, represents the master. Also to be noted are five Cranachs and Altdorfer's *Landscape with a Footbridge*, one of the earliest pure landscape paintings known.

Also small is the Spanish collection, but it is choicer, primarily because of the nine Velázquez paintings. Noteworthy is the number of his subject scenes present: four religious works (two are the *Immaculate Conception* and *Christ in the House of Mary and Martha*), a landscape, and the *Rokeby Venus* (the only really late work). The other three are portraits, including the life-size *Philip IV in Brown and Silver*. Only two El Grecos are present: one is a late version of the *Purification of the Temple*. Most of the other masters from this period are also represented: one Ribalta, two Riberas, six Murillos, and three Zurbaráns (two of them versions of *St. Francis in Meditation*). From the later period are five Goyas, including the early *Picnic* and the *Duke of Wellington*. In the late 1970s a Cubist Picasso *Still Life* was added.

Of all of the schools in the Gallery, the French school is the one that has been most expanded in recent years. Only Claude and Poussin were considered significant in the early years of the Gallery's history: nine Claudes were part of the Angerstein, Beaumont, and Carr collections (including the *Embarcation of the Queen of Sheba*, later imitated by Turner), and three Poussins were soon added, but most of the other French artists were neglected. A major campaign to remedy this deficiency began after World War II. Several more Poussins (among them the early *Adoration of the Shepherds* and the *Landscape with a Man Killed by a Snake* from his mature period) and a systematic selection of other members of the seventeenth-century School of Paris have been added. The *Ceres* by Vouet, the 8 1/2-foot *Cardinal Richelieu* by Philippe de Champaigne, and the *Adoration of the Shepherds* by Le Nain are noteworthy.

The extensive holdings of the Wallace Collection, which opened to the public in 1900, has enabled the Gallery to think only of presenting a small representation as far as the eighteenth century is concerned. It has a lovely Watteau to show the beginning of Rococo paintings and three Chardin genre scenes (the Wallace has no Chardins). Most of the Gallery's efforts have been to enrich the holdings for the later centuries. Delacroix, Ingres (a splendid *Madame Moitessier Seated*), Courbet, Corot, Daumier, Degas, Gauguin, Manet, Monet (eight paintings including a large *Water Lilies*), Renoir, Seurat (*Bathers, Asnières*, a major ac-

quisition), Henri Rousseau (*Tropical Storm with Tiger*), and Cézanne (seven, including a version of *Les Grandes Baigneuses*) now give the nineteenth century a better showing than before World War II, although more remains to be done.

The Gallery's efforts in this direction, however, are not intended to do more than provide a representative sampling of the art of this century, for the Tate Gallery has the primary responsibility for housing modern art, as well as being the major center for the nation's collection of British art. Originally opened in 1897, as an annex to the National Gallery, the Tate was made independent of the Gallery in 1955, and many paintings that once were the property of the latter were transferred to the younger institution. Thus the collection of British art at Trafalgar Square is consciously limited to only a representative sample, mostly for the period from Hogarth through Turner. Hogarth is represented primarily by the six paintings of his *Marriage à la Mode* series. Eight Gainsborough portraits—including the early *Mr. and Mrs. Robert Andrews* and the late *Morning Walk*—and two landscapes (*Gainsborough's Forest* is one) have been retained, along with six paintings by Reynolds. Of the five Constables, the *Haywain* deserves special mention. Nine Turners (including *Dido Building Carthage*, the Englishman's tribute to Claude, and the late *Rain, Steam and Speed*) complete this sampling.

Although the major purpose of the Gallery has been to collect only European painting from the Late Middle Ages on, it has from time to time been given a few works that fall outside of this area. They have been lent on a long-term basis to more appropriate institutions. Thus the British Museum has been lent more than a dozen Graeco-Roman portraits, 15 drawings by Rubens, and a Roman mosaic, and the 318 miniatures that formed the Alan Evans bequest have gone to the Victoria and Albert. The Gallery has, however, retained for display the few pieces of sculpture (most of them nineteenth-century bust portraits) that have been donated. In turn, an occasional painting, such as Rubens' *Coup de Lance* sketch (on loan from the Victoria and Albert since 1895), has been loaned to the Gallery from these institutions. In addition, a small selection of antique Roman sculpture was loaned from the British Museum in the late 1970s to enhance the decor of one of the large rooms.

The Gallery was damaged by bombs during World War II. The repair of this damage provided an opportunity to install air-conditioning in the west side of the building. In 1975 a new wing was completed to the north of the west wing. Designed to make the maximum use of natural light, the North Extension is also air-conditioned. A central display area makes possible a regular series of special exhibitions. One room has been designated the Historical Gallery, illustrating the National Gallery's history, and another is equipped with projection facilities for the showing of educational films. Other special facilities include two relaxation areas (smoking allowed in one of them) and a seminar room for visiting classes.

In preparation for the opening of the new wing, the Gallery's collection was rehung. All the North European paintings and the Spanish school, but excluding

the French school, have been placed in the North Extension, making possible an expanded showing of the Italian and French schools in the old area. By 1980 air-conditioning was installed in the east wing, completing this aspect of the renovation.

The Gallery has always had a policy of putting all of its paintings on display, and formerly, the ones that could not be accommodated on the main floor were either placed floor-to-ceiling on the lower floor or sent on long-term loan to various regional galleries. The expansion of the building enabled the Gallery to recall these paintings, and the lower floor galleries (ten rooms) were rehung. The entire collection was thus on view at Trafalgar Square for a short time, but in 1978 the Loan Program was revived in modified form with 130 paintings being sent to regional galleries for a minimum of three years. In addition, a series of small traveling exhibitions was begun in 1976.

Two important departments founded immediately after World War II are the Conservation Department (1946) and the Scientific Department (shortly thereafter). The Conservation Department has established a policy of routine inspections and first-aid treatment, along with a long-range program of cleaning and restoration. The Scientific Department, assisted by the Honorary Scientific Advisory Committee (all distinguished scientists), conducts research into the properties of both varnishes and the solvents needed to remove them, as well as into the nature of the materials (pigments, binders, supports) used by the old masters, and accurate ways of measuring color changes in pigments.

A small, private library exists to assist the curatorial staff in cataloging the collection. Its nucleus is Eastlake's books, purchased in 1870 and including many rare and first editions. As of 1980 the library contained 20,650 books and exhibition catalogs, 4,250 pamphlets and 155 periodical listings, in addition to a great many sales catalogs. An exchange arrangement with 230 museums and galleries around the world helps to keep current with these publications.

Black-and-white photographs of every picture are available. Frequently, one or more details of these paintings have been made as well. Also available are color reproductions, postcards, and color slides of almost every work. Large color transparencies, ten by eight inches, may be hired by publishers. Especially noteworthy is the series of scholarly catalogs of the collection, by school and (in the case of the Italian and French schools) by period. They were begun in their present form during World War II by Martin Davies, then keeper (later director) of the Gallery. Periodically updated, they present complete documentation on each painting and are models of scholarly thoroughness. The *Illustrated General Catalogue* was published in 1973 for those who do not want to be burdened with the wealth of detail found in the scholarly catalogs. Although the Gallery publishes no regular periodical, it does produce a series of *Themes and Painters* booklets, along with special publications for children. In addition, the trustees publish a regular report, every twenty-four or thirty months, detailing the major activities. New acquisitions are noted and reports from the Conservation Department are included.

Selected Bibliography

Museum publications: *Illustrated General Catalogue*, 1973; *The Working of the National Gallery*, 1974; Davies, M., *British School*, 1959; idem, *Earlier Italian Schools*, 1961; idem, *Early Netherlandish School*, 1968; idem, *French School*, 1957; Gould, C., *16th-Century Italian Schools including Venetian*, 1975; Gould, C., and M. Davies, *French School, 19th Century*, 1970; Levey, M., *German School*, 1959; idem, *17th/18th Century Italian Schools*, 1971; Martin, G., *Flemish School, ca. 1600–ca. 1900*, 1970; MacLaren, N., *Dutch School*, 1960; idem, *Spanish School*, 2d ed. rev. by A. Braham, 1970; The National Gallery, *Trustees Reports*.

Other publications: Hendy, P., *The National Gallery, London* (New York 1960); Potterton, H., *The National Gallery, London* (London 1977); Regoli, G., et al., *National Gallery, London* (New York 1969).

GERALDINE E. FOWLE

TATE GALLERY, Millbank, London SW1P 4RG.

In 1889 sugar tycoon Henry Tate offered more than sixty modern British pictures to the trustees of London's National Gallery (q.v.) with the stipulation that they be housed without unreasonable delay in Trafalgar Square. Upon public disclosure of this offer the following year, *The Times* printed an editorial demanding that Tate's pictures be housed not in the already crowded National Gallery but in an all new British Gallery, where they would form the nucleus of a representative collection of British art. This suggestion reflected a long history of public agitation for a new gallery in which to display the numerous works of British art received by the nation between 1840 and 1857 through the terms of the Chantrey bequest, the Robert Vernon gift, the Turner bequest, and the Sheepshanks gift. Recognizing the validity of the idea, Tate offered in 1892 to finance the construction of a separate new British Gallery. His offer was accepted, and in 1894 the Gallery was begun on the site of Jeremy Bentham's Model Prison in Millbank. The completed building was opened on July 21, 1897, by the Prince of Wales (afterward King Edward VII) as a department of the National Gallery in Trafalgar Square, and although it was to serve as the National Gallery of British Art, it was known simply as the Tate Gallery.

The building, which was to be enlarged no less than four times during the first forty years of its existence, originally consisted of a vestibule, seven galleries, and a sculpture hall and was designed by Tate's chosen architect, Sydney J. R. Smith. Its grandiose Roman revival portico and domed hall perfectly embodied the Victorian concept of an art gallery as a cultural palace. The structure enjoyed widespread popularity among Tate's contemporaries, including Millais, who expressed satisfaction with it shortly before his death.

Only five months after the original building was opened, work was begun on the first extension, which was also financed by Tate and which was taken from plans drafted by Smith at the same time as those for the original structure. This extension was opened on November 28, 1899, and added nine galleries to the original eight, making the Tate the largest art gallery in London. Less than a

decade later, in August 1908, J. J. (later Sir Joseph) Duveen gave money for the construction of a new wing to house the Turner Collection, which had been in storage at the National Gallery for more than fifty years. This wing, which was designed by Duveen's architect Romaine-Walker, was opened to the public in July 1910. It consisted of five rooms on the main floor, with several others below.

In 1915 a committee that was organized to investigate the state of the National Art Collection published a list of resolutions that were to have important implications for the physical growth of the Tate. Chief among them were the decision to convert the Tate from a gallery of modern British art to a gallery of British art of all periods, and the resolution to build a gallery of modern foreign art behind the existing building. The Lane bequest of 1915, which brought the Tate thirty-nine important modern foreign pictures, necessitated the prompt construction of the foreign gallery, which was commenced soon afterwards with funds given by Sir Joseph Duveen's son, later to become Lord Duveen. This extension was opened on June 26, 1926, by King George V, accompanied by Queen Mary.

In the early 1930s Lord Duveen's second major contribution to the growth of the Tate, the Duveen Galleries for sculpture, was commenced. The addition of these galleries, which made the Tate the largest art gallery in the British Commonwealth, necessitated the destruction of an important part of the original building and gave the whole a strongly axial plan for the first time. The galleries were completed in 1937, at which time the Tate was designated as the National Collection of Modern Sculpture, both British and foreign. With this, the physical growth of the Tate ceased for more than forty years.

In 1972 a new extension was begun in the vacant spot to the northeast of the existing building. Financed by the government and the Calouste Gulbenkian Foundation, this extension was opened in May 1979 by Queen Elizabeth II. Besides furnishing new conservation and photographic studios and new rooms for storage, this extension provided half as much space again for the display of works of art. Further facilities are planned on the Queen Alexandra Military Hospital site in Bulinga Street, which was allocated for expansion by Prime Minister Harold Wilson in the early 1970s. This new wing will be called the Clore Gallery (after Sir Charles Clore, who donated the funds) and will house the Turner Collection.

Although the Tate has depended largely on private support for the growth of its facilities and its collection, it is owned by the nation and voted money each year by Parliament. From this allotment the staff and administration are paid and purchases are made. Additional funds are raised through the Friends of the Tate Gallery, an independent society established to motivate interest in art and to raise revenue for purchasing new works for the collection.

The Tate was originally governed by the National Gallery, but in 1955 was formally separated from that institution by act of parliament and has since been governed by a board of ten trustees, four of whom must be practicing artists.

These trustees are appointed by the prime minister. Their duties include deciding, with the advice of the director, what works of art to purchase, what gifts to accept, and what works to lend. The director, who is directly responsible to the trustees, runs the gallery and takes care of financial matters. He is appointed by the prime minister upon the recommendation of the trustees and the Civil Service Commission.

At its opening, the Tate was chartered to exhibit only the works of British artists born after 1790. The original collection consisted of about 250 pictures and sculptures, including a number of purchases made under the terms of the Chantrey bequest, a collection of 18 pictures by G. F. Watts, the 67 paintings and 3 bronzes given by Tate, and 96 miscellaneous works, many of which had been transferred from Trafalgar Square.

Today the holdings of the Tate number more than ten thousand pieces and are organized in two distinct categories, the National Collection of British Art and the National Collection of Modern Art. The Historic British Collection is composed of some twenty-eight hundred works and is unique in Great Britain for collecting British art in a systematic way. It includes works of art from Tudor times through the Victorian era. Although it is strongest in eighteenth- and nineteenth-century holdings, it numbers among its earlier works several fine examples of British Renaissance and Baroque painting, all acquired since the 1915 decision to include pre-Hogarthian artists in the collection. Among their works are John Bettes' *A Man in a Black Cap* (1545), which is the earliest picture in the Tate; van Dyck's *A Lady of the Spencer Family*; William Dobson's *Portrait of Endymion Porter*; and Lely's *Two Ladies of the Lake Family*.

The British Collection is exceptionally strong in the works of Hogarth, whose career formerly constituted the Tate's point of departure. A room especially devoted to Hogarth contains examples of almost every phase of his career. Of particular note are *The Scene from "The Beggar's Opera"* (1729–30), his first successful picture; several portraits, including *The Graham Children*; and a number of satirical works, such as *O the Roast Beef of Old England! (Calais Gate)*.

The confident phase of later eighteenth-century English art is also splendidly represented in the British Collection. The career of Richard Wilson, who almost single-handedly legitimized the landscape genre in England, is epitomized by a Claude-like canvas titled *Rome: St. Peter's and the Vatican from the Janiculum*, while Gainsborough's genius is seen in his full-length portraits *Sir Benjamin Truman* and the ballerina *Giovanna Baccelli* and in his Arcadian landscape *The Market Cart*. The tremendously influential career of Joshua Reynolds is represented by pictures such as the monumental *Three Ladies Adorning a Term of Hymen* and the portrait *Admiral Viscount Keppel*. Works by Zoffany, Romney, and Joseph Wright of Derby are also included in the collection.

The Tate possesses the world's largest collection of works by William Blake. This collection, which consisted of only six pieces at the close of World War I, was considerably strengthened in 1918 with the purchase of a single lot of

twenty watercolor illustrations for Dante's *Divine Comedy* and since World War II has been gradually enlarged through the generosity of various friends, particularly W. Graham Robertson. Included are numerous examples from the powerful 1795 series of color prints, such as *Newton* and *Elohim Creating Adam*, as well as selections from Blake's illustrations for the *Bible* and the *Book of Job*.

The Turner Collection, which was bequeathed to the nation by the artist himself and installed in the Tate in 1910, is also unrivaled. Numbering some three hundred paintings, the collection includes works from every phase of Turner's long career. The early period is represented by pictures such as *The Shipwreck* and *Crossing the Brook*; the strongly Italianate middle phase can be seen in *The Bay of Baiae, with Apollo and the Sibyl* and *Pilate Washing His Hands*. Turner's late period is exemplified by the freely painted view of *Norham Castle* and the *Interior at Petworth*, which had never been exhibited before it was hung in the Tate.

Unfortunately, the Tate's collection of Constables is relatively small. This is due in large part to the fact that most of the pictures in the possession of Constable's heirs were bequeathed to the Victoria and Albert Museum (q.v.) almost a decade before the Tate was established. Those works not going to the Victoria and Albert were distributed among the National Gallery, the British Museum (q.v.), and the Royal Academy. Fortunately, ten of the pictures received by the National Gallery have since been transferred to the Tate, where they constitute the core of a collection that has been systematically developed since the end of World War II and that today boasts works from every phase of the artist's development. Among them are the *Scene on a Navigable River ("Flatford Mill")*, the *Admiral's House, Hampstead*, and *The Valley Farm*.

Although the Tate has five examples of nineteenth-century subject paintings and later Victorian works in the grand manner, such as William Powell Frith's immensely popular *Derby Day* and Lord Leighton's *And the Sea Gave Up the Dead*, its most important holdings from the latter half of the nineteenth century are the collection of Pre-Raphaelite paintings. A number of Pre-Raphaelite pictures were already in the possession of the Gallery at the time of its opening in 1897, including Millais' *Ophelia*, which formed part of Tate's original bequest. The collection has been steadily developed through the years, especially by the terms of the Chantrey bequest, which has made possible the purchase of both Holman Hunt's *Claudio and Isabella* and a group of pictures by Burne-Jones. Other important Pre-Raphaelite works are Rossetti's *Annunciation*, Millais' *Christ in the House of His Parents (The Carpenter's Shop)*, Henry Wallis' *Chatterton*, and Burne-Jones' large canvas *King Cophetua and the Beggar Maid*.

The second major division of the Tate's holdings is the Modern Collection. This includes about thirty-three hundred paintings, sculptures, and drawings by British and foreign artists from about 1870 through the present.

Among the earliest works in the Modern Collection are pictures such as Whistler's *Portrait of Miss Cicely Alexander* (1872–74) and Sargent's *Carnation, Lily, Lily, Rose* (1885–86), both of which were influenced by French Impres-

sionism. Unfortunately, the Tate's own selection of French Impressionist and Post-Impressionist pictures is small, due largely to the systematic removal of many of the finer examples in 1950 and again in 1961 to the National Gallery to constitute the final chronological phase of its collection. A number of those remaining at the Tate were acquired through the Courtauld Fund established in 1923. Despite their small number, these pictures effectively illustrate the roots of twentieth-century art, to which the Modern Collection is now almost completely devoted. Remaining are Sisley's *The Bridge at Sèvres*, van Gogh's *The Chair and the Pipe*, Monet's *Poplars on the Epte*, Gauguin's Javanese-influenced *Faa Iheihi*, and Cézanne's *The Gardener*.

The collection's holdings of pre-war British art were relatively weak up through the outbreak of World War II but since then have been significantly enhanced by the addition of several representative pictures purchased through the Chantrey bequest. They include Augustus John's *Portrait of W. B. Yeats* and Stanley Spencer's *Joachim among the Shepherds*. Other important British pictures of the pre-war period include Duncan Grant's *The Tub* and works by the Camden Town Group such as Sickert's *The Interior of St. Mark's* and *Ennui*. Later works from the pre-war era in Britain include Henry Moore's alabaster sculpture *Four-Piece Composition: Reclining Figure*, Ivon Hitchens' *Winter Stage*, and Graham Sutherland's powerful canvas *Green Tree Form: Interior of Woods*.

Every major Continental art movement of the early twentieth century is represented in the Modern Collection. The Nabi movement is exemplified by Bonnard's *The Bowl of Milk* and Vuillard's *Sunlit Room*, Fauvism by Derain's *Pool of London*, and Expressionism by Munch's *The Sick Child*. The collection also boasts numerous examples of Cubism, most of which have been acquired since the end of World War I. Among them are *Bust of a Woman* by Picasso and *Clarinet and Bottle of Rum on a Mantelpiece* by Braque. The early phases of abstract art can be seen in paintings such as Vanessa Bell's *Abstract Painting* of 1914 and Mondrian's *Composition in Grey, Red, Yellow, and Blue*; of Dada and Surrealism, there are de'Chirico's *The Melancholy of Departure*, Ernst's *Celebes*, and Dali's *Autumnal Cannibalism*.

The Tate's collection of post-war art, both British and foreign, is exceptionally large and for the most part occupies the extension opened in 1979. The rapid expansion of this collection has been made possible in part through government grants, which have been available on a regular basis only since 1946 and which today constitute a major source of purchasing funds.

The selection of works of European art from the post-war period is particularly strong. Included are Matisse's enormous paper cut-out *The Snail* and Dubuffet's *The Busy Life*. Examples of Op Art in the collection are Vasarély's *Supernovae* and Josef Albers' *Study for Homage to the Square: Departing in Yellow*. The Modern Collection's holdings in the field of contemporary European sculpture are exceptionally fine and include works by Marini, Giacometti, César, and Paolozzi. Particularly noteworthy pieces are *Man Pointing* by Giacometti and *16 Balls, 16 Cubes in 8 Rows*, a kinetic sculpture by Pol Bury.

The modern American school is also magnificently represented, especially in terms of the Abstract Expressionist movement of the 1950s. There are several pictures by Jackson Pollock, notably *Yellow Islands*, which is an important example of his drip technique. The Color Field painters are represented by Mark Rothko's large-scale Seagram series, which was donated by the artist himself and which hangs in a gallery of its own. Other modern American pictures in the collection include Frank Stella's irregularly shaped *Six Mile Bottom* and Jasper Johns' *Zero through Nine*. Sculptures from the period include the stainless steel *Cubi XIX* by David Smith and two compositions by Louise Nevelson.

Appropriately, the collection of contemporary British art has received special attention and contains works by every major British artist of the post-war era. Paintings of particular interest are Francis Bacon's *Three Studies for Figures at the Base of a Crucifixion*, Victor Pasmore's *Square Motif, Blue and Gold: The Eclipse*, and David Hockney's acrylic *Portrait of Mr. and Mrs. Clark and Percy*. Noteworthy sculptures of the period include Barbara Hepworth's *Pelagos*, Anthony Caro's painted steel construction *Early One Morning*, and Richard Long's *119 Stones*.

Through the interest of one of its trustees, Stewart Mason, the Tate established, within the organization of the Gallery, the Institute of Contemporary Prints, whose purpose was that of a voluntary *depot-legal*—to encourage print publishers to give an impression of each work published. In 1975 the Print Department was formed, through the donation of twenty-six hundred prints by the Institute of Contemporary Prints. These works include examples by Christopher Prater of Kelpra Studio, Paul Nash, Richard Hamilton, Kitaj, and Paolozzi.

The Tate contains a series of departments organized to answer the specific needs of the collection and the public. Its educational facilities are especially extensive. The Education Department directs a series of daily public lectures in the galleries or in the lecture theater, and offers a regular program of films and a variety of special evening lectures by art historians and artists. The department also offers advice to the public on privately owned works by Turner, Constable, Blake, and other artists represented in the permanent collection. In addition, although visitors to the Tate are freely allowed to make notes or sketches of works on display, the Education Department controls the copying of pictures from the collection in oils or acrylics.

Among the Tate's other educational facilities is the National Archive of Twentieth-Century British Art. It consists of manuscripts, sketches, prints, tapes, photographs, press cuttings, notebooks, videotapes, and microfilms relating to the entire field of British art and the lives of twentieth-century foreign artists. It is available only to those engaged in extensive research directly related to the collection. The Tate also possesses a library that, although primarily reserved for Tate staff members, is accessible to the public under special conditions and with the permission of the librarian.

Of equal educational value are the Photographic Department, which produces official copyright photographs of every piece in the collection, and the Publi-

cations Department, which furnishes the Gallery's catalogs, books, slides, color cards, and prints.

The Gallery Shop, on the main floor, offers for sale a broad selection of books, prints, postcards, greeting cards, and slides related to the collection. Its stock includes not only official Tate publications and products but also resources from other institutions and commercial publishers that are concerned with the themes of the Gallery's collections.

Selected Bibliography

Gallery publications: *The Tate Gallery: An Illustrated Companion to the National Collections of British and Modern Foreign Art*, 1979; *Guide to the Collections of the Tate Gallery*, 1975; *The Tate Gallery Collections* (comprehensive catalog), 1977; *The Tate Gallery Room by Room*, 1979; *The Tate Gallery "Little" Book Series; The Tate Gallery Complete Catalogue of Colour Prints*.

Other publications: Rothstein, John K., *The Tate Gallery* (New York 1963); Neve, Christopher, "Under the Double-Skin Diffusers: The Tate Gallery Extension," *Country Life*, June 7, 1979, pp. 1808–9.

PATRICK YOUNGBLOOD

VICTORIA AND ALBERT MUSEUM (also THE V & A, SOUTH KENSINGTON MUSEUM), South Kensington SW7 2RL London.

The Victoria and Albert Museum, known as the V & A, is considered the world's greatest museum of decorative arts. It was established by the British government in an attempt to raise standards of design in British industry through "the improvement of public taste in Design" and by "the application of fine art to objects of utility." Following a government inquiry in 1835, the first state-financed School of Design was established in 1837 at Somerset House in London. The school owned at that time a collection of casts and housed a library.

After the Great Exhibition of 1851, Henry Cole (one of the exhibition's chief organizers) persuaded the Board of Trade to create the Department of Practical Art. Cole became head of this office, administering the schools and establishing museums. A sum of 5,000 pounds was allocated by the Treasury to purchase contemporary design objects. These objects and those exhibited at Somerset House were combined in 1852 to form the Museum of Manufactures (later called the Museum of Ornamental Art) at Marlborough House. This museum, administered by Cole, was the ancestor of the V & A.

A building site in Brompton (now called South Kensington) was purchased for the museum with profits from the Great Exhibition at the suggestion of Prince Albert. In 1857 objects from the Museum of Ornamental Art were moved to a temporary iron structure at the site. This collection later became part of a group of museums known collectively as the South Kensington Museum. Works were added to the collection, first with a loan of historical works of art from the Royal Collection and subsequently, as today, with purchases and gifts.

The building program was haphazard until 1884, but the core of the present structure existed by the 1860s. This building was decorated by some of the best-

known painters of the day including Lord Leighton, Sir Edward Poynter, and artists associated with the firm of William Morris. In 1891 a competition was held to choose a design for an extension on the south front of the museum, and the commission was awarded to the architect Aston Webb. The foundation stone of Webb's structure was laid in 1899 by Queen Victoria, who directed that the museum be named the Victoria and Albert Museum. It was not until 1909 that the new buildings were opened by King Edward VII, and that same year the Victoria and Albert became solely an art museum; the scientific collections once housed at the V & A were organized to form a separate Science Museum.

In 1944 the exhibits at the V & A were reorganized into Primary Galleries and the Study Collections, a system that separated the most significant works by period from other, less distinguished, but representative, examples. This division is maintained today, and it is in the Study Collections (which comprise thousands of objects) that the Victoria and Albert has its most unique aspect as a museum.

The Victoria and Albert remained essentially unchanged until 1974, when it was decided to renovate a neighboring structure, the Huxley Building (formerly the School of Sciences, constructed in 1867–71), for additional gallery space. In 1978 work was begun to create new offices for the Department of Prints, Drawings, Photographs, and Paintings with new galleries for the Sheepshanks and Ionides collections of paintings, space for the V & A's outstanding group of Constable works, and facilities for a state-of-the-art conservation laboratory. The renovation was completed in 1981, and on March 17, 1982, the building opened as the Henry Cole Wing, named after the museum's first director. The Cole Wing has made possible, in turn, major renovations and improvements in the museum's Primary Galleries.

The V & A was, until recently, a national museum governed and financed by the British government through the Office of Arts and Libraries (an offshoot of the Department of Education and Science, a descendant of Cole's Department of Practical Art). Legislation in 1982, through the National Heritage Bill, established the Victoria and Albert as more independent, governed by a board of trustees. The museum is currently administered by a director and a deputy director and includes curatorial departments of Sculpture; Ceramics; Furniture and Wood-work; Far Eastern Art; Prints, Drawings, Photographs, and Paintings; Textiles and Dress; Theatre Museum; and the Library. Each curatorial department receives an allowance from the central purchase fund, and in accordance with the intention of the museum's founders that the V & A acquire contemporary design objects, each department has received since 1975 an additional fund to purchase objects from after 1920. Also in the spirit of the museum's founding, the V & A has established close links with the Craft Advisory Committee, a contact that is reflected in exhibitions, events, and in the museum's maintenance of the Craft Shop.

The museum galleries are divided into the Primary Galleries and the Study Collections. In the former, the finest works in all media are exhibited chrono-

logically by period and region. The Study Collections, on the other hand, are arranged by medium (metalwork, sculpture, and so on). The Primary Galleries include Early Medieval Art; Gothic Art; Italian Renaissance Art; Continental Renaissance Art; Continental Art, 1600–1800; Continental Art, 1800–1900; British Art, 1500–1750; British Art, 1750–1900; and Twentieth Century Art (newly opened). In addition to the museum's fine collections of European and British paintings, special collections include Portrait Miniatures, Musical Instruments, Costumes, and Jewelry.

Several other museums are administered by the Victoria and Albert: the Bethnal Green Museum of Childhood, Ham House, Osterly Park, and the Wellington Museum at Ardsley Park. The Theatre Museum, due to open in the former Flower Market, Covent Garden, as a branch of the V & A, will include material from the Victoria and Albert's renowned collection, as well as objects from the British Theatre Museum and the Museum of the Performing Arts.

The Victoria and Albert's collection of objects from the early medieval period is divided into three sections: Late Antique and Early Christian Art, Byzantine and Sassanian Art, and Early Medieval Art of the West.

From the Late Antique and Early Christian periods, ivories include the famous right leaf from the *Symmachorum Diptych* of about A.D. 400, showing a priestess of Bacchus making an offering to Jupiter. The *Miracles of Christ Diptych* is from A.D. 450–60, and an ivory leaf with an Apostle is from the fifth century. Portrait medallions from the second century and a large group of silver, gold, and enamel jewelry also date from this period.

Byzantine and Sassanian art includes the *Veroli Casket* carved with mythological scenes and made in the tenth century (formerly in the Cathedral of Veroli near Rome). Another casket with scenes of combat dates from the eleventh-twelfth century, and a Byzantine cloisonné enamel cross reliquary was made in the ninth century. St. John the Baptist and Four Apostles are represented on an ivory relief from the early twelfth century, and an ivory statuette of the Virgin is from the late eleventh century. Among the miniatures and examples of book arts is a miniature of St. Mark from a thirteenth-century *Gospel*. A collection of rock-crystal intaglios includes a portrait of Emperor Marcus Tiberius and a Nativity scene (late sixth century). Also from this period is a collection of jewelry including gold earrings from the sixth–seventh century.

Early medieval art in the West is well represented and is rich in objects from England. The *Gloucester Candlestick* of about 1110 executed in gilt-metal is in the collection, as are the *Warwick Ciborium* of gilt-copper, engraved and enameled, and the *Balfour Ciborium* dating from 1150–75. A tall, stone cross-shaft from Easby, Yorkshire, dates from the ninth century. Twelfth-century English objects includes a leaf from an illuminated psalter (c. 1130–50) and ecclesiastical ivories.

Other medieval works include Italian ivories from the eleventh to thirteenth century, enameled objects, and reliquaries, including a Limoges altarcross (thirteenth century). The *Eltenberg Reliquary*, a gilt-copper piece enriched with

enamels and set with walrus ivory carvings, is in the form of a church and dates from the twelfth century. The *Altron Towers Triptych* dates from the twelfth–thirteenth century, and a reliquary of the True Cross is an example of Mosan enamelwork from the same period. The *Sion Gospels* cover of cloisonné with precious stones was made in France or Germany about 1000, and the *Lorsch Gospel* cover, an ivory work, dates from the ninth century. Other pieces include stone capitals and wooden columns from Salerno, Italy, with various other architectural elements. A rich collection of Byzantine textiles and fabrics from various medieval centers is housed at the V & A.

The Primary Galleries of Gothic Art include examples from northern Europe, Italy, and Spain, with a large group of objects from England. The *Clare Chasuble*, an English embroidery worked in silver-gilt, silver thread, and colored silks, dates from about 1275. Other English textiles include the *Tree of Jesse Cope* and the *Steeple Aston Cope* (fragment, 1310–40). The *Studley Bowl*, a chased and enameled silver-gilt piece, is from the late fourteenth century. Other examples of English metalwork feature the *Ramsay Abbey Censer and Incense Boat* (silver-gilt) and a wrought-iron grille from Chichester Cathedral (mid-thirteenth century). An excellent stained-glass collection features a window from Winchester College of about 1399. Sculpture includes the *Tree of Jesse* in alabaster from the fifteenth century and panels from a Passion altarpiece.

A group of French and German ivories include the *Soissons Diptych* (thirteenth century), and French metalwork of the period is exemplified in the *Merode Cup*, a beaker worked in silver-gilt with enamels. German metalwork includes a reliquary of St. Boniface from Constance (late fifteenth century). Altarcrosses include a work by Hugo of Oignies from 1325–50 and an altarcross from the Basel Minster. A group of carved altarpieces features one probably from St. Bavon, Ghent (late fifteenth century). The oak statue *St. Anne* is from the fifteenth century and, like the painted oak *Angel of the Annunciation*, was executed in France. Textiles from France and Germany comprise fifteenth-century tapestries, vestments, and other works.

Italian Gothic art includes numerous objects and sculptures. A bust of the *Prophet Haggai* carved for the facade of Siena Cathedral (late thirteenth century) is by Giovanni Pisano. The tympanum of Istrian stone, the *Virgin and Child*, with kneeling members of the Brotherhood of the Misericordia, was sculpted by Bartolommeo Buon for the Scuola della Misericordia in Venice (c. 1441–51). Other sculptures include Nino Pisano's painted wood *Angel of the Annunciation* (1350–75) and, from the Ghiberti workshop, a terracotta *Virgin* (1425–50). A large group of ecclesiastical plate (fourteenth and fifteenth centuries), majolica (fifteenth century), and some fine North Italian ivories (fourteenth and fifteenth centuries) are also in the collection.

From Spain a fifteenth-century processional cross is executed in silver parcel-gilt over a wooden core. Ceramics include Hispano-Moresque ware (e.g., a drug jar, or *albarello*, painted in luster and blue), and among the Spanish textiles in the V & A is a fine group of carpets.

Works from the Late Gothic and Early Renaissance periods include metalwork from Germany, England, and Flanders. The *St. Hubert Crozier* is from sixteenth-century Flanders, and the *Campion Cup*, a hammered and engraved silver-gilt vessel, is English from about 1500. A Limoges triptych with the portraits *Louis XII* and *Anne of Brittany* (c. 1500) is among a group of enamels in the collection. A number of sixteenth-century Germany clocks are also at the V & A.

Sculpture from the Late Gothic and Early Renaissance features a Spanish altar frontal from Toledo, about 1530. Also from Spain are the recumbent effigies *Don Garcia Osorio and His Wife* (sixteenth century). German pieces include an oak *Entombment* (late fifteenth–early sixteenth century) and an alabaster *Head of St. John the Baptist* (late fifteenth century). A sculpted representation, *Angels Bearing Candles* (c. 1510), is by the German sculptor Tilman Riemenschneider, and a boxwood statuette, the *Virgin*, is by Veit Stoss (1520). Other wooden sculptures include scenes from the life of St. George in boxwood (Franco-Flemish, late fifteenth century) and the carvings *St. Mary Salome* and *Zebedee* (c. 1506). An altarpiece from Lirey near Troyes is of painted and gilded stone (c. 1525).

Late examples of stained glass from Bruges and Cologne are in the collection, as is a fine group of Gothic tapestries. These works, mostly Flemish dating from before 1515, include Pasquier Grenier's *Story of Troy*, dated 1472; woven originally for the city of Bruges to present to Charles the Bald, this example was acquired from the castle of Chevalier Bayard. Three large tapestries woven at Brussels present scenes from Petrarch's *I Trionfi*, and smaller Flemish weavings include the *Story of Esther, Susanna and the Elders*, and the *Three Fates*. The *Devonshire Hunting Tapestries*, associated with the marriage of Henry VI to Margaret of Anjou, are probably from Tournai, about 1450.

Other examples of Late Gothic and Early Renaissance art include vestments, small bronzes and medals, and sculptures in alabaster and various woods. Carpets from Germany, Spain, Persia, Poland, England, and elsewhere and the *Sheldon Tapestry Maps*, English weavings from the late sixteenth century, are in the collection.

The world's foremost collection of English decorative arts from the sixteenth through the nineteenth century is housed at the Victoria and Albert. Objects from the sixteenth century include a standing salt known as the *Mostyn Salt*, made in London in 1586. The *Vyvyan Salt*, also from London, dates from 1592. Furniture such as the ''Great Bed of Ware,'' a famous painted and carved Elizabethan bed from about 1580, is in the collection. A paneled room from Sizergh Castle, Westmorland, dates from 1575, and oak paneling carved with Tudor devices from a house at Waltham Abbey was made about 1520–30. Queen Elizabeth's *Virginals* of about 1570 are housed at the V & A, as are the *Oxburgh Hangings* worked by Mary Queen of Scots and Bess of Hardwich. A portrait bust *Henry VII* (?) is by the Italian sculptor Torrigiani.

Works from the seventeenth century include oak paneling from the Old Palace, Bromley-by-Bow, completed in 1606 for James I (with original plaster ceiling).

An upholstered chair in the collection may have been used by Charles I at his trial. Sculptures by Grinling Gibbons feature a relief, the *Stoning of St. Stephen*, and the limewood portrait bust *Cravat*. Embroideries from the sixteenth and seventeenth centuries are in the collection, as are a number of pieces of seventeenth-century silverware, including a wine cooler by Ralph Leake (1698–99). A state bedstead dates from the end of the seventeenth century, as does a paneled room from Clifford's Inn, London (1686–88). Also from this period are examples of furniture, clocks, ceramics, and silver.

Early eighteenth-century rooms include one from Henrietta Place, London, a room designed by James Gibbs (c. 1725); a pine-paneled room from Hatton Garden; and a music room from Norfolk House (1756) designed for the ninth duke of Norfolk by Matthew Brettingham. Also from the early eighteenth century are bookbindings, embroideries, and silver. The *Walpole Salver*, an important work by silversmith Paul de Lamerie, is enriched with engraved decoration, probably by Hogarth (1728).

Furniture, textiles, china and glass, silver, sculptures, and other objects made in England, 1750–1900, are in the collection. From the second half of the eighteenth century, rooms include the Library from Croome Court, Gloucestershire, designed by Robert Adam, with bookcases by Vile and Cobb carved by Sefferin Alben (1763). Part of the Glass Drawing Room from Old Northumberland House, Charing Cross, was designed by Adam and dates from 1773–74; the Lee Priory Room in Strawberry Hill Gothic Style was designed by James Wyatt about 1785 for Thomas Barrett. Furniture includes a "Chinese" bedstead from Badminton, probably made for William Linnell (1754), and a Chippendale bed from about 1775 fashioned for Garrick's Villa at Hampton. A chimney piece is from Winchester House, Putney (c. 1750), and a mantelpiece designed by Adam was made for 5 Adelphi Terrace, London. A large collection of silver includes Garrick's tea and coffee service (1774–75), and porcelain in the collection features examples of both Chelsea and Wedgwood.

From the nineteenth century are examples of Regency furniture, wallpaper designs, silver by Paul Storr, and Flaxman. An exceptional collection of Victorian art is held at the V & A. Sculptures from the period include M. C. Wyatt's bronze and marble *Bashaw*, which represents a dog trampling a snake, and E. H. Bailey's marble group *Maternal Affection* (1837). A plaster model by Sir George Gilbert Scott for the Albert Memorial dates from about 1863. Gothic furniture designed by Pugin and Salvin, Norman Shaw, and G. E. Street includes pieces created for the great international exhibitions. A cupboard and secretary by William Burgess with painted decoration by Poynter dates from 1858. Work by William Morris and his followers is given special attention at the V & A, with wallpaper, carpets, and tiles by Morris and furniture by artists in his circle. A wardrobe designed by Philip Webb with painted decoration by Burne-Jones was created as a wedding present for Morris.

Other furniture is by Alfred Waterhouse, J. P. Seddon, Rossetti, Thomas Jekyll, and E. W. Godwin. Rooms from the Victorian period include the Har-

borne Room from a house in Birmingham designed by J. H. Chamberlain (1877) and executed in a Late Gothic Revival Style. The original museum building boasts several rooms decorated in the second half of the nineteenth century: the Green Dining Room (or Morris Room) was created for the V & A by William Morris and Philip Webb in 1866, with stained glass and painted panels representing the months of the year by Burne-Jones; the Refreshment Room, or Gamble Room, was designed in a Renaissance style by Godfrey Sykes and James Gamble, students of Alfred Stevens; and the Dutch Kitchen, or Grill Room, was designed by Sir Edward Poynter, with Minton blue-and-white tiles depicting the seasons and the months of the year.

Also from the nineteenth century is furniture designed by Henry Boddington, A. H. Mackmurdo, Butterfield, and Voysey. Metalwork by Voysey, Webb, and Mackintosh is in the collection too.

European decorative arts are well represented and include examples from the Renaissance through the nineteenth century. The V & A houses an exceptional collection of Italian Renaissance art, with examples of sculpture, furniture, and majolica and other ceramics. A group of works by, after, or in the style of Donatello includes the master's *Ascension with Christ Giving Keys to St. Peter*, about 1450. A *Virgin and Child* is executed in gilt terracotta, and a representation *Dead Christ Tended by Angels* (1425–50) is in marble. Also by Donatello are the bronze *Lamentation* (1450–75) and the *Chellini Tondo*, a bronze rondel with the *Virgin and Child with Four Angels* presented by the artist to his doctor, Giovanni Chellini Samminiati.

Sculpture by other quattrocento sculptors includes Desiderio da Settingnano's *Virgin and Child*. By the same artist are a *Madonna* of about 1460 (a relief executed in *stiacciato* technique), and a chimney piece. The depiction *Madonna with Angels* is by Agostino di Duccio (mid-fifteenth century). A group of works by members of the della Robbia family is at the V & A. Two *Madonna*s and an *Adoration of the Magi*, all three in terracotta, are by Andrea della Robbia. A roundel with a garland of fruit and arms of René of Anjou is by Luca della Robbia, as is a series of twelve bronze roundels, the *Labors of the Months* (c. 1450–56); these pieces at one time decorated the ceiling of Piero de' Medici's study at the Palazzo Medici, Florence. Works by Giovanni della Robbia, Mino da Fiesole, Verrocchio, Rosellino, and Vecchietta are also in the collection, as are medals by Pisanello, Matteo de' Pasti, Bertoldo, and others.

Among the Renaissance bronzes in the collection is Il Riccio's *Warrior on Horseback*. North Italian sculpture is represented by Amadeo (*Two Angels with Shield and a Wreath*), Pietro Lombardo (*Christ Child*, late fifteenth century), and Antonio Lombardo (*Philoctetus on Lemnos*, marble relief), among others.

Architectural decorations and details include gray sandstone doorways from the Palazzo Ducale at Gubbio and inlaid folding doors also from the palace (fifteenth century). A majolica-tiled pavement is from the Palazzo Petrucci in Siena and dates from 1509. A ceiling with a representation of Apollo and the Muses was painted by Antonio della Corna for the Casa Maffi, Cremona, and

a walnut mirror frame carved with the emblems of good and evil along with the device of Alfonso d'Este, duke of Ferrara, is from the early sixteenth century. A marble doorway by Michele and Antonio Carlone was made in Genoa and dates from 1503.

High and Late Renaissance art at the V & A includes numerous scuptures and objets d'art. A marble tabernacle from about 1475 is by Civitali, and an altarpiece and tabernacle by Ferrucci (c. 1495) were originally in the church of St. Girolamo at Fiesole. A crystal altarcross and candlesticks were made for Francis I of France by Belli (early sixteenth century). Benvenuto Cellini is represented by his *Head of Medusa*, a sketch for the *Perseus* at the Loggia de Lanzi, Florence. A fountain by Giovanni Francesco Rustici is the only Florentine bronze fountain to survive from the sixteenth century. A series of sketches in red wax by Giambologna was prepared for the Grimaldi Chapel at St. Francesco di Castelletto, Genoa (c. 1579), and includes *Christ Led from Judgment*, *Christ before Caiaphus*, and *Christ Rejected by the Jews*. Also by Giambologna is his *Samson Slaying the Philistine* (c. 1565), prepared for a fountain at the Casino of the Grand Duke Francesco de' Medici, Florence. A *Story of Susanna* by Sansovino is in the collection. A group of *bozzetti* (sketches), many of them from the Gherardini Collection, which was purchased by the museum in 1854, includes works by Giambologna and by Michelangelo (a red wax study for the *Slave*, a figure on the projected tomb for Pope Julius II, c. 1513).

Furniture, tapestries, enamels, and plate, as well as majolica from Cafaggiolo, Deruta, and Gubbio, dating from the sixteenth century are also housed at the V & A. The V & A's collection of Continental art from 1570 to 1800 offers numerous examples of furniture, sculpture, ceramics, and objets d'art. Pieces from the sixteenth century include Limoges enamels, and Augsburg silver, Venetian glass, inlaid objects, and textiles. Furniture from the period features a cabinet from Augsburg, veneered in ivory (c. 1630), and a steel casket made for Cosimo II de' Medici. A globe by George Roll, Augsburg, dates from 1585. Also from Augsburg is a cabinet by Master H.S. (c. 1560) and a cabinet (c. 1555) that once belonged to William Beckford at Fonthill Abbey and may have been designed by Holbein for Henry VIII. Other cabinets are from France, Spain and the Tyrol. A spinet by Annibale dei Rossi (Milan, 1577) is inlaid with precious and semiprecious stones. Textiles include a series of Italian silk hangings (c. 1650–70) with scenes from Tasso's *Gerusalemme Liberata*.

Sculptures feature a group of portrait busts, among them, Algardi's *Cardinal Paolo Emilio Zacchia* (terracotta, c. 1650); Guidi's bronze of *Pope Alexander III*, from 1690; and an important work by Bernini, a portrait of Englishman *Thomas Baker* (1638). Other works by Bernini include his *Neptune and Triton* (c. 1560) made for a villa in Rome. Terracotta models by Bernini, Foggini, Algardi, and Cornacchini are in the collection, as are small bronzes by Soldani, Foggini, and others. A bronze equestrian statuette, *Louis XIII*, and another, *Henri IV*, are by Le Sueur (c. 1620–25). The representation *Achilles Dying* is by Veyrier (1638).

A large group of ivories from Flanders, Germany, and Italy is at the V & A, as is a selection of silver objects from those countries. A nautilus cup from Utrecht dates from 1613, and a silver ewer and basin from Genoa were made in 1621. Works by members of the van Vianen family include a silver dish by Christian van Vianen (1635). Turned ivory cups, one by Grand Prince Fernando of Tuscany (1681) and another by his teacher Philip Senger (c. 1680), are in the collection.

Furniture from the late seventeenth century includes a Parisian marquetry cabinet (c. 1670) and a cabinet-on-stand veneered in ebony and tortoiseshell with silver mounts from Germany or Flanders (c. 1675–1700). Other veneered and inlaid furniture is in the collection as well. Sculpture from this period features Dominique Lefebre's *Fall of Phaeton*, a marble from about 1700–1711, and a bronze by Slodtz, *Aristaeus Fettering Proteus* (1695). A group of fine book-bindings are in the collection, as are Italian silks, velvets, and lace. A room from La Tournieue, a chateau near Alençon (c. 1682–94), is at the V & A. Also from France is a silver and tortoiseshell tabletop (late seventeenth century). Ceramics, silver, Italian linens, and Portuguese tile panels date from this period.

Art of the eighteenth century is well represented at the Victoria and Albert and features the Jones Collection of French eighteenth-century art, an early bequest to the museum. A series of painted and gilded French panels from the late seventeenth–early eighteenth century were possibly made for the first duke of Montagu. A cupboard, attributed to A. C. Boulle, was probably made in the late seventeenth century for the Grand Dauphin. A group of French "japanned" commodes dates from the mid-eighteenth century. German and Dutch furniture includes a marquetry cabinet from 1716. Late-eighteenth-century furniture features work by Riesener: a commode from 1774 for the Château de Marly and other works, among them, a console table made in 1781 for Marie-Antoinette for Versailles. A marquetry desk top commissioned by Marie-Antoinette for the Petit Trianon dates from about 1776. Mme. de Sérilly's boudoir of carved, gilded, and painted pine dates from 1778–79 and is one of the V & A's treasures. Italian furniture includes a closet or cabinet of mirrors from about 1780 and an ornamental stand from Turin veneered with mother-of-pearl and mounted in gilt-bronze.

Sculpture from the eighteenth century includes Pajou's terracotta *St. Augustine* (1761) and Clodion's *Cupid and Psyche* (c. 1800). Houdon's famous bust *Voltaire* (1781) and *Benjamin Franklin* (1779) are in the collection, as is the artist's bust *Marquis de Miromesnil* (1775). A bronze by J. B. Pigalle from 1785 is titled *J.-R. Peronnet*.

Also from the eighteenth century is a harpsichord in the Chinese style by Pascal Taskin (1786), firearms, fans, ivories, clocks, and a charming collection of Swiss, French, English, German, and Austrian snuff boxes. An outstanding collection of Sèvres and Vincennes porcelain is housed at the V & A, and among the fabulous Meissen objects is a table fountain from about 1775 and a table service ordered by Frederick the Great in 1761 for presentation to the Prussian

general von Mollendorff. Porcelain pieces from Frankenthal, Nymphenburg, Berlin, Furstenburg, Ludwigsburg, Höchst, Chantilly, and St. Cloud are also in the collection.

Continental art of the nineteenth century is well represented at the Victoria and Albert. Sculpture by Auguste Rodin (exhibited at the Exhibition Road entrance to the Henry Cole Wing) includes the bronze *St. John the Baptist* from 1879–80. Works by Aimé-Jules Dalou include two terracottas, *Hush-a-Bye-Baby*, a naturalistic mother and child group, and *Bacchanales*, a tondo with a woman, two men, and a satyr shown at the Royal Academy in 1899. Antoine-Louis Barye is represented by the bronze *Elephant Running* from about 1855 and the bronze group *Theseus and the Minotaur* from about the same time, purchased by the V & A from the Paris exhibition of 1855.

Furniture includes a throne chair of carved oak and velvet by Thomas Hoffmeister and Behrens, a Gothic Revival piece made at Coburg, Germany, in 1851. From the same year is an Austrian bookcase of oak, designed by Bernardo de Bernardis and made by Leistler in Vienna; the bookcase, which resembles elements of a Gothic church, was presented to Queen Victoria by Emperor Franz Josef in 1851. An elaborate ebony cabinet with inlays of various woods was made by Henri Auguste Fourdinois in 1867.

Objects from the nineteenth century feature a silver- and parcel-gilt tea service from Berlin (1804–15) decorated with classical motifs. A tea service of a pseudo-Arabic design was created by A. Grayton of silver-gilt and champlevé enamel (1862). A silver lamp from about 1805 was designed in Italy by Belli, and a *tazza* of layered glass, cut and gilt, was created in Bohemia about 1850. Also from Bohemia is a jug of Lithyalin glass, a material meant to simulate various stones that had been invented by Friedrich Eigermann in 1828–29. Jewelry includes a necklace of cast iron and steel made in Berlin in the early part of the nineteenth century.

Decorative arts of the twentieth century, both English and foreign, receive special emphasis at the Victoria and Albert. English pieces are actively collected (as examples of contemporary design—in keeping with the founding principles of the museum), and the V & A houses probably the most comprehensive collection of British twentieth-century design in the world. Sculptures include, among other works, *Northwind*, a stonework executed by Eric Gill for the exterior decorative program of Broadcasting House (c. 1928). A bronze *Nude Girl* is by Frank Dobson.

Furniture includes a writing table by Sir Edward Maufe in gilded mahogany, camphor wood, and ebony, gessoed and faced with white gold. This elaborate piece was exhibited at the Paris exhibition of 1925. A lacquer screen by Eileen Gray from 1923 is one of many pieces by this designer in the collection. Omega Workshops, a collaboration among Roger Fry, Duncan Grant, and Vanessa Bell, created a decorated wardrobe at the V & A. Examples of contemporary furniture feature a maple and rosewood chair by Rupert Williamson (1976) and a column of drawers (1978) by John Makepeace.

English ceramics from all decades of the twentieth century are represented, especially hand-crafted pieces. Jacqueline Poncelet's bone china bowls feature carved surfaces (1972). Industrial pottery designed by Martin Hunt of the Royal College of Art and Colin Rawson for Hornsea Pottery, Yorkshire (1977), reveals the influence of Art Deco style during this period. Bernard Leach, one of the major English potters of the twentieth century, is represented by numerous pieces, including stoneware vases (1963) that indicate the artist's interest in traditional Japanese design.

Textiles include a rug with geometric motifs (1930) by Serge Chermayeff and a textile printed with large, monochromatic flowers by Marion Dorn (1938). Edward Bawden's *Farmyard Tapestry* was woven by the Edinburgh Tapestry Company (1950). Jewelry in the collection features a pendant brooch by George Hunt influenced by Egyptian motifs; the piece in gold and silver decorated with ivory, enamel, mother-of-pearl, rubies, pearls, and tourmaline was exhibited at the Royal Academy in 1935. Also in the collection is Anthony Hawkesley's silver-gilt collar from 1968.

Continental decorative arts of the twentieth century, both domestic and industrial pieces, are extensively represented at the V & A. A commode by Dominique of ebony and silver dates from 1928, and a hand-knotted wool carpet by Voldemar Bobermann, produced for the Maison de Decoration Intérieure Moderne in Paris, features a dark brown ground with a linear, figurative design of acrobats (1928–29). Other textiles include a printed cotton by Madame de Andrada with abstract forms made in Paris about 1925.

Scandinavian design is represented by furniture, including Poul Kjaerholm's ''Hammockchair 24'' manufactured in stainless steel and cane by E. Kold Christensen (1965). A teak and oxhide settee by Finn Juhl exemplifies the utilitarian aspects of most Scandinavian pieces.

The ''DS 25 Left-hand Seating Unit,'' designed by Swiss artist Ubalb Klug, was manufactured in leather and foam by De Sede (1974). Castelli's ''Planta'' hat stand designed in 1976 and made of brightly colored plastic suggests the ''colorful'' turn of office furniture design during the 1970s.

In addition to galleries devoted to the decorative arts of the twentieth century, the V & A houses the Boiler House Project. The Boiler House, made possible through the generosity of Sir Terence Conran, provides exhibition space for temporary shows of industrial design and is unique in its purpose of exhibiting the history of commercial objects.

The Far Eastern art collection at the V & A is particularly rich in Chinese examples, which span a period from about 1500 B.C. through the nineteenth century A.D. Bronze ritual vessels and jade objects from the Shang (1550–1025 B.C.), Chou (1025–249 B.C.), and Han (206 B.C.–A.D. 220) periods include a Chou wine vessel in the form of an owl and a group of small jade pendants. Tomb pottery from the Han and the Six Dynasties periods features painted earthenware horses, ducks, and birds. A jade horse's head dates from the Han Dynasty. From the T'ang Dynasty are pottery tomb figures, mirrors, and ex-

amples of the exquisite white stoneware developed during that period. Buddhist sculpture, mostly from the sixth century A.D., includes a head of Buddha, a torso of Buddha in Ting-chou marble from the seventh century, and several sandstone stelae.

Art of the Sung Dynasty (twelfth century) includes celadon ware from Lung-ch'uan, crackled-glaze Kuan ware, and a *fang hu* (square vase) inlaid with silver and gold. A carved wooden *kuan-yin*, the Bodhisattva of Mercy, dates from the late Sung period (thirteenth century). A fine collection of blue-and-white ware of the Ming Dynasty is in the collection. From northern China (seventeenth and eighteenth centuries) are examples of red-glaze porcelain, jade vases, and so on. An exquisite lacquered screen from the seventeenth century represents a Taoist paradise. From the eighteenth century is an imperial throne, and porcelain from this period includes famille verte, famille rose, and examples glazed in sang-de-boeuf. A group of red lacquer jars that belonged to Emperor Ch'ien Lung (1736–95) are housed, as are numerous objects in crystal, quartz, lacquer, and ivory. Textiles feature highly decorated robes from the Ch'ing Dynasty (1644–1912).

Art from Japan includes furniture, ceramics, sculpture, screens, and textiles. A landscape screen by Masunobu (before 1694) is in the collection, as is a screen, *The Battle of Uji River*, from the Tosa school (seventeenth-eighteenth century). The screen *Tigers in a Bamboo Grove* is from the Kano school (seventeenth-eighteenth century), and a fascinating representation of Portuguese traders and missionaries arriving in Japan on a painted screen dates from about 1600.

Japanese sculpture features a fourteenth-century mask of Buddha, the carved and lacquered wood *Amida Buddha* (thirteenth century), and the painted wood figures *Two Judges of Hell* (late fifteenth century). A Japanese chest from the seventeenth century, which was once in the Mazarin family, may have belonged at one time to Napoleon. The van Diemen box, worked in lacquer, is from about 1630–45. Ceramics from the fifth through the nineteenth century include vessels used for the ritual tea ceremony (e.g., a tea bowl with the mark of Kenzan, eighteenth century). Armor and swords are in the collection, with textiles, *inro*, *ojime*, and netsuke. Prints and drawings from Japan are housed in the Department of Prints, Drawings, Photographs, and Paintings.

The collection of Indian art is particularly strong in sculpture from all periods. Two early bracket figures of tree goddesses are from Mathura and date from the second century. A small, standing figure of a celestial beauty arranging her hair and a musician playing the flute are from Orissa (eleventh century). From Sanchi, a sandstone torso, the *Bodhisattva Avolokitesvara*, dates from about 900. Sculpture in the Gandhara style from northwestern India includes a head of Buddha and a relief with scenes depicting the Buddha's death. A group of South Indian tribal bronzes features a Ceylonese sculpture, *Hanuman* (a Hindu deity), from the fourteenth century, and from Madras, *Shiva as Lord of the Dance*, from the tenth-eleventh century.

Mughal paintings and other objects from that period (sixteenth-eighteenth

century) are well represented in the collection. Miniatures from Rajasthan and Central India, with Mughal jades, crystals, and jewelry, are at the V & A. An exquisite white jade cup made in 1657 once belonged to Emperor Shah Jahan, and a carpet from Lahore (1630) was presented to the Girdlers' Company of London.

Southeast Asian art includes traditional puppets from the region, and metalwork is exemplified in a betel nut container in the form of a goose (from Burma). Metalwork, jewelry, and other objects from Tibet and Nepal are also in the collection, as is a group of objects that once belonged to Tipoo Sahib of Mysore (c. 1790), among them, ''Tipoo's Tiger,'' a hand organ in the form of a tiger attacking a British army officer. A fine collection of textiles from India and Southeast Asia is housed at the V & A.

A representative collection of Islamic art from Asia, North Africa, and Spain is housed at the Victoria and Albert. Early ceramics from the ninth and tenth centuries include Abbasid pottery from Persia and Mesopotamia and lead-glazed earthenware from Nishapur. A collection of glass spans periods from the fifth to twelfth century. Hispano-Arabic ivories from the tenth to thirteenth century and Persian earthenware from the twelfth–thirteenth century are at the V & A.

A fine group of Islamic carpets includes two outstanding examples of the craft: The *Chelsea Carpet* (sixteenth century), which was purchased on the King's Road, Chelsea, in the late nineteenth century (hence its name), and the *Ardabil Carpet* (1539–40), perhaps the most famous carpet in the world.

Other Islamic objects include a pulpit (*mimbar*) inlaid with ivory and made in Egypt (late fifteenth century) and a carved marble basin from Hama (Syria) dated 1277. Brass mosque lamps inlaid with gold and silver date from the late fifteenth century, and a group of Turkish tiles dates from the Ottoman period. Syrian pottery, glass, and damascened work includes a basin with a late-thirteenth-century inscription and a beaker known as ''The Luck of Eden Hall,'' which dates from the thirteenth century and was brought to England during the Middle Ages. Fragments of twelfth-century tapestries from Syria and fabrics from Persia and Syria are among the examples of Islamic textiles at the V & A.

A special collection of musical instruments with a number of important examples is housed at the V & A. The group, particularly rich in keyboard instruments of the sixteenth century, features several Italian spinets, a harpsichord by Giovanni Baffo of Venice dated 1574, and a harpsichord by Jerome of Bologna dated 1521 (the earliest dated example in existence). An English harpsichord and organ is the earliest surviving English example of this type. In addition to musical instruments of all varieties, a charming collection of music boxes and musical clocks is at the Victoria and Albert.

The V & A's costume collection includes English and Continental examples from about 1580 to the present. Among the many examples is a cream satin lady's dress from 1780 made in France and embroidered with flowers in silks and chenille. An evening dress by ''Pontecorvo, Rome'' of pale green striped grosgrain trimmed with orchid pink chiffon and velvet is from about 1893. A

French or English day dress in brown silk dates from 1856–58. The early-twentieth-century designer Mariano Fortuny y Madrazo is represented by one of his most famous models, the ''delphos'' evening dress; the design, named after the tunic of the classical Delphic Augury, features a sheath of pleats that cling to the length of the body. Contemporary fashions are acquired on a regular basis by the V & A.

The Department of Prints, Drawings, Photographs, and Paintings currently housed in the Henry Cole Wing was created in 1977. At that time, the Departments of Prints and Drawings and of Paintings merged and the V & A's outstanding photography collection, formerly kept in the Library, was added.

The Prints and Drawings collection originated in the V & A library, where from 1852 all loose sheets and bound volumes of drawings were kept. In 1909 the Department of Engraving, Illustration, and Design was formed, and in 1960 the name of the division was changed to the Department of Prints and Drawings. The Old Master drawings collection is exceptional, rich in works of the Italian school. Three of Leonardo da Vinci's notebooks are housed in the library, and one of the largest holdings of drawings by Giovanni Battista Tiepolo (more than 300 sheets) is in the collection. Dutch and Flemish works by Rembrandt and Rubens, with more than 150 drawings by Willem van de Velde, father and son, are in the department.

British drawings include an important group of works by nineteenth-century illustrators. An emphasis of the department is on sketchbooks by English artists, and in the collection are twenty-five sketchbooks by J. Farington (1763–1811), fifteen by Peter de Wint, and forty-five by Wilson Steer (purchased by the V & A from Steer's estate in 1943). Works on paper by John Constable, including three sketchbooks and numerous watercolors, form the most comprehensive collection of that artist's work in the world. Drawings by Sir James Thornhill and William Kent, and E. Shepherd's pencil drawings for *Winnie the Pooh*, are in the department.

Drawings and sketches related to the applied arts are a strength of the collection, with a fine group of architectural sheets. Drawings by British architects Wren, Hawksmoor, Vanbrugh, Sir William Chambers, and Alfred Stevens are at the V & A. The department possesses probably the largest group of drawings for monuments and chimney pieces by British sculptors (seventeenth to twentieth century). Among them are works by Rysbrack and Joseph Nollekens. There are more than twenty studies by Alfred Stevens for his monument to the Duke of Wellington. Designs and working cartoons prepared by Eric Gill for his series the Stations of the Cross, in Westminster Cathedral, are at the V & A.

Prints in the department (which number more than 1 million) feature works by Dürer, Rembrandt, Piranesi, Whistler, Goya, and all other major masters. Caricatures from nineteenth-century Britain and France are well represented, as are prints related to special topics, such as social history from the sixteenth to nineteenth century. Topographical views of the British Isles from the eighteenth and nineteenth centuries are at the V & A. The department's policy is to build

up an extensive collection of modern prints, and in this area, the British school is well represented. Most of Eric Gill's work is housed at the V & A, and through the generosity of the artist's widow, proof copies of his wood engravings are in the collection. Works by Paul Nash and Schmidt-Rottluff and a large group of lithographs by Matisse are in the department. A collection of Far Eastern works on paper includes woodblock prints by Hiroshige, Utamaro, and Hokusai.

The V & A houses an outstanding collection of posters, both English and foreign. Classic examples from the 1880s and 1890s are included, and much of the work of Jules Cheret and Clive Gardner is represented.

An important collection of English wallpapers provides a comprehensive survey of the art from the sixteenth through the early twentieth century. Papers by William Morris and Company are in the collection, as are ten volumes of patterns by the Victorian designer Owen Jones. In addition, fine examples of American and European wallpapers, and an excellent collection of eighteenth- and nineteenth-century Chinese wallpapers are held.

A section is devoted to engraved ornament, one of the largest of its kind, with examples from almost every state in the development of ornamental engraving from the sixteenth through the twentieth century. British furniture designs from the eighteenth to the twentieth century are included. The museum holds forty-five plates etched by Frenchman J. A. Ducereau in the mid-sixteenth century, early examples of the art. A group of nineteenth-century designs is by A. W. Pugin. Ceramic designs include a vast collection of drawings for vessels and tiles by William de Morgan, probably the richest collection of the artist's work in existence, and three Leeds Pottery pattern books from the turn of the nineteenth century.

An enormous collection of drawings related to metalwork is at the V & A, with two large groups of sixteenth-century goldsmiths' designs: one Italian, the other Flemish. British design is shown at its best in the mature Regency period, with drawings by the royal goldsmiths Rundell, Bridge, and Rundell. Designs for jewelry include sheets by Arnold Lulls, a craftsman who created pieces for Queen Anne of Denmark, and by Santini, jeweler to the Medici Court in the first half of the eighteenth century. A large number of British jewelry designs from the second half of the nineteenth century are in the collection. Engraved designs for the decoration of firearms, daggersheaths, and so on feature a volume of thirty drawings made at the English royal Almain Armories at Greenwich between 1557 and 1587.

Costume designs in the form of brass rubbings, engravings, and the yearly series of fashion plates issued from the end of the eighteenth century are housed in the department with records from the House of Worth (1865–1956) and from the House of Handley-Seymour (1910–40). Material concerning textile design and techniques from the seventeenth century to the 1930s includes patterns for silk from early-eighteenth-century England and embroidery and lace designs. The department maintains a permanent exhibit on engraving techniques. All

designs and illustrations, in printed book form with a text, are kept and catalogued in the library.

The National Collection of Photography, housed in the Henry Cole Wing, originated with the founding of the museum. An extensive collection of Victorian photographs includes prints by Roger Fenton, Julia Margaret Cameron, Le Gray, and Camille Silvy. Albums of calotypes by Hill and Anderson, with the archives of Francis Frith and Company, are in the department. The oeuvre of Cartier-Bresson is well represented, and British photographers Bill Brandt and Sir Cecil Beaton are featured in the collection. American photographers such as Alfred Stieglitz, Paul Strand, Lewis W. Hine, and C.-J. Bellocq are represented. The department actively acquires work by younger photographers, and contemporary prints in the collection include work by British photographers Paul Hill and Chris Killip and American photographer Amy Bedick. The National Collection of Photography, which for the first time has its own storage and study facilities, also has four galleries in the Cole Wing, where temporary exhibitions are shown.

The Victoria and Albert's collection of paintings was established in 1857, when John Sheepshanks presented 233 British works to the museum. Major additions followed, including substantial bequests from C. H. Townshend (1868), John Jones (1882), and C. A. Ionides (1900). Other gifts were presented by the Reverend Alexander Dyce (1869), and in 1876 John Forster gave, along with books, manuscripts, prints, and drawings, a group of paintings (mostly British). Dutch seventeenth-century canvases were given in 1870 by John Parsons.

In addition, several important purchases were made in the early years of the collection: in 1857 the *Martyrdom of St. Ursula* by the Master of the St. Ursula Legend, a major example of painting from the Cologne school, about 1500, was added, and in 1859 the *Apocalypse Altarpiece* by a follower of Master Bertram of Hambourg was acquired. The Valencian altarpiece of St. George was purchased in 1864, and during this same period the collection of Jules Soulanges was purchased through subscription (including Giovanni Bellini's *St. Dominic*, on permanent loan to the National Gallery since 1895).

The V & A is strong in Italian works of the Renaissance and Baroque periods, Dutch seventeenth-century paintings, and French canvases from the eighteenth and nineteenth centuries, but it is the British school that is represented most comprehensively. The collection of British paintings, begun with the Sheepshanks bequest, was known as the National Gallery of British Art until the first decade of the twentieth century, when the Tate Gallery took over that role. The collection is today particularly rich in works of the nineteenth century, with more than one hundred canvases by John Constable. These works, with drawings, watercolors, and sketchbooks by the artist, are exhibited on the entire third floor of the Cole Wing. *Salisbury Cathedral from the Bishop's Grounds* (1820–23), *Dedham Mill*, *The Cottage in a Cornfield*, and two full-scale sketches from the Vaughn Collection (*The Haywain* and *The Leaping Horse*) are among the many important works by Constable in the collection. Six of the paintings at the V &

A are from the original Sheepshanks bequest, and a group of ninety-eight works (mostly sketches) was given by the artist's daughter Isabel in 1888.

Other English artists represented at the V & A include Turner (*East Cowes Castle, The Seat of J. Nash, Esq.*, c. 1828), John Sell Cotman (*The Road to Capel Currig*), and Frederick Lewis (*A Halt in the Desert*, 1885). Genre paintings by William Mulready dating from the nineteenth century comprise the most complete collection of that artist's work in England. The Victorian artists, among them Edwin Landseer, are well represented. A set of transparencies in oil on glass of landscapes is by Thomas Gainsborough and is displayed in a specially illuminated case. British paintings of the twentieth century include Paul Nash's *Eclipse of the Sunflower* from 1945. The Wellington Museum at Apsley House features a large collection of British works from the eighteenth and nineteenth centuries.

The National Collection of British Watercolors, housed at the V & A, presents the history of the medium and includes examples from the eighteenth through the twentieth century. A bequest from Joshua Dixon to the Bethnal Green Museum included numerous works from the second half of the nineteenth century. Works by Thomas Rowlandson, William Blake, John Constable, and others are in the collection, as are twentieth century sheets by Philip Wilson Steer, Wyndham Lewis, Paul Nash, Bridget Riley, and David Hockney.

Also at the V & A is the National Collection of Portrait Miniatures, the largest and most comprehensive collection of its kind in the world. Both British artists and foreign artists who worked in Britain are represented. The collection has recently been enhanced with the Evans bequest of more than three hundred miniatures. Hans Holbein's famous *Anne of Cleves* from about 1539 is in the collection, as is Holbein's *Mrs. Pemberton.* Hilliard is represented by the miniatures *Elizabeth I, A Young Man against a Background of Flames, A Young Man among Roses*, and portraits of his family (*Richard Hilliard*, the artist's father, and *Alice*, the artist's wife, 1578). Isaac Oliver's unfinished miniature *Elizabeth I* is a rare depiction of the sitter in old age. Also by Oliver is a full-length miniature, *Richard Sackville, Third Earl of Dorset*, 1616. Examples by Peter Oliver, Richard Gibson, Nicholas Dixon, Charles Beale, and others are included. Miniatures from the eighteenth and nineteenth centuries feature works by British masters, Cotes, Hone, Smart, Cosway, Engleheart, Linnell, and others.

The foreign paintings collection at the V & A benefited from several early gifts and purchases. In 1868 the Townshend bequest brought Italian eighteenth-century works by Canaletto (*Capriccio: Ruined Bridge with Figures*) and Bernardo Bellotto (*Capriccio with Two Bridges and Figures*, c. 1745). Dutch seventeenth-century works from Townshend included Adriaen van Ostade's *The Fiddler* and David Teniers the Younger's *Rocky Landscape with figures.* The collection was enriched with the Jones bequest in 1882 (French paintings, furniture, ceramics, and objects from the eighteenth century) and the Constantine Alexander Ionides Collection (1900), strong in seventeenth-century works and French paintings of the nineteenth century. Both the Jones and Ionides bequests

stipulated that each collection be exhibited as a separate entity, and today each collection is displayed in the Cole Wing in its own series of rooms.

The Jones Collection includes François Boucher's masterful *Portrait of Madame de Pompadour*, signed and dated 1758. The portrait *Marie-Antoinette at the Age of Seventeen* is by François-Hubert Drouais, and the *Unknown Girl Holding a Rose* is by Mademoiselle Dore. Nicholas Lancret is represented by his *Cavalier and Two Ladies* (*Le berger indécis*) and *The Swing* (*L'Escapolette*). A *Fête champêtre* is by Pater. Also included are canvases by Francesco Guardi, two *Capriccios* with ruins and figures. The Dutch school is represented by Frederick de Moucheron (*Rocky Landscape with Cattle and Figures*) and Willem van de Velde the Younger (*Shipping in a Calm*, 1658?). German paintings of the eighteenth century include Johann Friedrich August Tischbein's *Portrait of a Lady in a White Cap* (1793), and a group of paintings on copper by Austrian Johann George Platzer includes *Salome Dancing before Herod*. Also from the Jones Collection is Carlo Crivelli's exquisite *Virgin and Child* in tempera on panel.

The Ionides bequest comprises paintings from various periods. Italian works include Nardo di Cione's *Coronation of the Virgin* (fourteenth century) and Pseudo-Pier Francesco Fiorentino's *Virgin and Child*. Sandro Botticelli's delicate portrait *Smeraldo Bandinelli* represents the grandmother of sculptor Baccio Bandinelli. *Charity Surrounded by Her Children* is by Domenico Beccafumi and dates from about 1520. Tintoretto's *Self Portrait as a Young Man* (c. 1548) is in the collection, as is Domenico Tiepolo's *Sketch for the Ceiling at St. Lio, Venice* (1783–84). Dutch paintings feature the *Departure of the Shunamite Woman* by Rembrandt, signed and dated 1640. Adriaen Brouwer painted the *Interior of a Room with figures: A Man Playing the Lute and a Woman*. Philips Koninck's *A Dutch Landscape: View of a Flat District, Probably Rheden*, is dated 1647. *The Itinerant Musician*, a signed panel, is by Adriaen van Ostade, and *Cavaliers* is by Gerard Ter Borch. Two landscapes by Jan van Goyen (*River Scene with an Inn*, 1630, and *Landscape with Stream*, 1628?) are in the collection, as is Johannes Natus' *Interior with Cardplayers and a Blacksmith* (1661).

The Ionides bequest also includes French paintings of the nineteenth century, among them, J. F. Millet's *Wood-sawyers* from about 1850–52. From the second half of the nineteenth century is Edgar Degas' *Ballet Scene from Meyerbeer's "Roberto il Diavolo"*, one of the artist's theater paintings from about 1872.

The V & A's collection of foreign paintings includes a number of other examples acquired through purchases and gifts. Early Italian paintings feature Barnaba da Modena's painted processional banner from about 1370, the *Crucifixion with the Virgin, St. John, and St. Anthony Abbot*. Three panels (c. 1310) from a group of 125 surviving painted account book covers represents the Sienese school, and a painted *Crucifix* from the twelfth century was executed in Umbria. Venetian painting is represented by Vittore Crivelli's two altarpiece panels *St. Jerome* and *St. Catherine*. A *Tournament at Brescia* (fresco transferred to canvas) was painted by Floriano Ferramola (c. 1495) for the Casa Borgondio delle Corte

at Brescia. A group of painted *cassoni* panels is housed at the V & A, among them, *Scenes of a Marriage Ceremony* in gilt gesso and tempera on panel and a battle scene from classical history, *Horatius Codes Defending the Sublican Bridge*. The Umbrian painter Perugino is represented by a late work, *The Nativity: the Virgin, St. Joseph, and Shepherds Adoring the Infant Christ*, a work from the Oratory of the Confraternity of the Annunziata at Fontignano, near Perugia.

Italian compositions of the sixteenth century include Perino del Vaga's *Raising of Lazarus* (fresco transferred to canvas) commissioned by Angelo Massimi for the family chapel at St. Trinità dei Monti, Rome (c. 1538–40). The depiction *Diana Sleeping* is by Alessandro Gherardini. Lodovico Carracci's *Hercules and the Hydra* (1594), a fresco transferred to canvas, was given to the museum in 1863 by the Earl Granville. From the seventeenth century is Carlo Dolci's *Salome with the Head of John the Baptist*, and works from the eighteenth century include fifty-three studies in oil on canvas by the Venetian Lucas Carlevaris representing figures, costumes, and animals. Giovanni Antonio Pellegrini's *Design for the Decoration of a Dome: The Adoration of the Trinity* is signed and dated 1710, and a portrait by Pompeo Battoni, *Edward Howard with his Dog*, is from 1776.

Northern paintings include the *Apocalypse Altarpiece* by a follower of Master Bertram in tempera and gilt on panel. Two pine panels depict the *Betrayal of Christ* (reverse: *Agony in the Garden*) and *Christ Crowned with Thorns* (reverse: *Christ Carrying the Cross*); both works were presented to the museum in 1870 by John Parson. One of the highlights of the V & A's collection is the *Martyrdom of St. Ursula and the 11,000 Virgins* by the Master of the St. Ursula Legend, an influential work of the late fifteenth century. Hans Wertinger's portrait *Christoph von Laiming in His Fifty-ninth Year* is dated 1517, and a carved limewood altar from the Tyrolese school, the *Virgin and Child, St. Florian, and St. John the Baptist*, has on the interior and exterior wings scenes from the life of Christ (c. 1500).

Paintings of the Spanish school include the *Retable of St. George* by Marzal de Sas (?) executed in Valencia about 1410–20. The *Virgin Annunciate*, in ink on linen, was probably made as a hanging (Valencia, c. 1500). Rodrigo de Osona the Younger painted his *Adoration of the Magi* in the early years of the sixteenth century.

Dutch paintings of the seventeenth century feature works by Frans Francken II (*Witches' Sabbath*, 1606); Dutch painting is also represented by Roelant Savery's *Flowers in a Niche* from about 1500.

Also in the collection is a full-size copy of Raphael's *School of Athens* by German painter Anton Raphael Mengs. The work is one of five copies of famous paintings commissioned in 1752 by the earl of Northumberland for the long gallery at Northumberland house.

The highlight of the V & A's extensive collections is the series of cartoons by Raphael, seven of ten works executed in 1515–16 for Pope Leo X as designs for tapestries. The tapestries, woven at Brussels, were intended to decorate the Sistine Chapel on ceremonial occasions and are still in the Vatican's collections.

The cartoons are executed in distemper on paper, and their subjects are taken from the Acts of the Apostles: *Christ's Charge to Peter "Feed My Sheep"*, *The Miraculous Draught of Fishes*, *Elymas the Sorcerer Struck with Blindness*, *Paul and Barnabus at Lystra*, *Paul Preaching at Athens*, *The Death of Ananias*, and *Peter and John Healing the Lame Man at the Beautiful Gate of the Temple*. The works, highly significant examples of Renaissance art, were bought by Charles II in 1623 and are on loan to the museum from the queen.

The Victoria and Albert's theatrical collection is of international repute, and much of this material will be housed at the Theatre Museum, a new branch of the V & A at Covent Garden. Part of the collection is currently kept in the Print Room, including a large group of scene and costume designs and other material (which may remain in the Print Room, available to the Theatre Museum when required). In addition to providing a fascinating group of theater models and designs, several important bequests have brought more than two hundred thousand playbills, programs, and related material (Enthoven Theatre Collection), theater photographs (Guy Little bequest), and other items. A large number of drawings, engravings, and paintings of theatrical interest include a series of designs by Bernardo Buontalenti from the *Intermezzi* at Florence (1589). Twentieth-century designs for Diaghilev by various artists including Leon Bakst and Georges Braque are in the collection. A library of several thousand books related to the theater with numerous prompt books will be housed at the new Theatre Museum.

There are several other museums in London and the surrounding area administered by the Victoria and Albert Museum. The Bethnal Green Museum of Childhood, located on Cambridge Heath Road, was opened in 1872 as a branch of the V & A and today houses the largest collection of toys and related items in England. The building, a prefabricated structure of iron and glass, was designed by Young and Co. of Edinburgh with external brickwork and decorations by James Wild. The interior, composed of two levels of galleries and a basement, houses trains, rocking horses, and board games. A superb collection of dolls' houses includes the Nuremberg doll's house from 1673 and a house from 1887 owned and furnished by Queen Mary. A group of women's and children's costumes is highlighted by a collection of wedding dresses, among them designs by Worth and Liberty and Co. Other objects include marionettes, puppets from China and Burma, and traditional English Punch and Judy shows.

Ham House in Richmond, Surrey, a National Trust Property since 1935, is administered by the V & A. The house, built in 1610 by Sir Thomas Vavasour, was remodeled in 1637–38 by architect William Samwell. It has remained virtually unchanged since the seventeenth century, and the three-story brick structure today exhibits furniture from the seventeenth and eighteenth centuries, objects of art, and a fine collection of paintings. Among the canvases are two early works by John Constable and works by Dutch artists (Jacob de Gheyn II, Breenbergh, Dirck van den Bergen, Willem van de Velde the Younger, and others). A cabinet of miniatures features David des Granges' *Charles II as a*

Youth among other works. Architectural decorations include ceiling paintings attributed to Italian painter Verrio in the Duchess' Bedroom, White Closet, and the Duchess' Private Closet. The Queen's Closet, the most richly decorated room at Ham House, includes an oval ceiling painting, the *Rape of Ganymede*, by Verrio. The Long Gallery includes portraits by Johnson, J. M. Wright, and important canvases by Peter Lely, among them, the *Duchess of Lauderdale with a Black Servant* and the *First Duke of Rothes*. A guidebook and postcards of works in the collection are available and overlooking the seventeenth-century-style gardens is the Tea Pavillon.

Osterly Park in Isleworth, Middlesex, like Ham House, is a National Trust Property administered by the V & A. The house, originally constructed in the Elizabethan period (1560s), was remodeled in the late eighteenth century by Robert Adam. Much of the house, particularly the magnificent suite of State Rooms, preserves the original decoration and furniture by Adam. Rooms of special interest include Adam's Tapestry Room, which is hung with Gobelin tapestries woven for the room after designs by Boucher (1749–88). The Library (1766–73) features a ceiling in low relief with allegorical paintings by Venetian Antonio Zucchi set into the walls; their subjects include scenes from the lives of classical writers and philosophers. The State Bedchamber is notable for its domed state bed, a design Adam executed in 1776 and which is considered one of his most ambitious pieces. The furniture—a commode, chairs, and a painted chimney piece—are all by Adam. Osterly Park, which offers three lakes on its spacious grounds, has a shop and cafeteria.

Apsley House in Piccadilly houses the Wellington Museum. In addition to furniture and works of art, Apsley House, designed by Robert Adam (1771–78), exhibits an excellent collection of paintings. Some of the finest canvases from the Spanish Royal Collection, important Dutch seventeenth-century works, and portraits from the eighteenth century make up the Wellington Collection. Dutch paintings include Elsheimer's *Judith with the Head of Holofernes* (c. 1601–3), a work that once belonged to Rubens, and Maes' *Milkwoman* (1655–59) and *Lovers with a Woman Listening* (1655–59). A group of canvases by David Teniers the Younger includes the *Lime Kiln* (a rare industrial scene) and a *View of the Artist's House* (after 1662). Jan Steen's important *Egg Dance* from the 1670s is in the collection, as is *Dissolute Household* (1660s). A *River Scene* is by Pieter Bruegel the Elder and dates from about 1606. Flemish paintings include Rubens' *Head of an Old Man* from about 1620 and his *Ana Dorotea, Daughter of Rudolf II, 1628, a Nun in the Convent of Descalzas Reales, Madrid*. Van Dyck's *St. Rosalie Crowned with Roses by Two Angels* was painted at Palermo in 1624. Guido Reni's *Head of St. Joseph*, Guercino's *Mars as a Warrior* (1630), and Correggio's delicate *Agony in the Garden* (1520s) are among the Italian paintings at the Wellington Museum.

Spanish paintings, many of which were presented to the duke of Wellington by Ferdinand VII of Spain after the duke's defeat of the French at Vitoria (1813), include examples by Goya (*Equestrian Portrait of Wellington*, August-September 1812). Velázquez' *Two Young Men Eating at a Humble Table* (c. 1618–20), his

Portrait of a Man, Possibly Jose Nieto, Chamberlain to Queen Mariana, Wife of Philip IV, and a portrait, *Pope Innocent X* (ascribed to Velázquez), are in the collection. English paintings include Thomas Lawrence's *Portrait of the Duke of Wellington* (1814) and his portrait *First Marquess of Anglesey*. Canova's colossal marble statue *Napoleon Bonaparte* (1810) is exhibited, as is a large collection of presentation silver and ceramics (e.g., The Portuguese Service, more than one thousand pieces of silver and silver-gilt). A guidebook, postcards, and various publications are available at the Wellington Museum.

The National Art Library, named in 1868 by Henry Cole, is housed at the Victoria and Albert Museum and comprises the largest specialized collection of art literature in the world. The library began at the School of Design, Somerset House, and in the nineteenth century benefited from several major gifts (before it became exclusively an art reference library). In 1869 the Reverend Alexander Dyce bequeathed more than fourteen thousand volumes, including literary manuscripts and first and rare editions from the sixteenth and seventeenth centuries. John Forster presented in 1876 eighteen thousand books, among them, three of Leonardo da Vinci's notebooks, a collection of nineteenth-century English literature (including original manuscripts, proofs, and editions of Charles Dickens' novels and forty volumes of correspondence by David Garrick). In recent years bookbindings decorated with British armorial book stamps (illustrating the history of British book collecting from the sixteenth through the twentieth century) were given by H.J.B. Clements in 1940, and in 1973 L. Linder bequeathed a major collection of material related to Beatrix Potter and her family. An extensive collection of illuminated manuscripts is housed in the library, and an archive of contemporary design was recently established. The library presents exhibitions on the history and techniques of book arts. It is open to the public for reference use; special permission is required for access to the manuscripts and rare books.

The Department of Museum Services includes the Press Office, the Publications Office, and services related to education and exhibitions. The V & A maintains an extremely active publications program, and in addition to publishing a general book about the museum and its collections (1983), it has issued recent volumes on various aspects of the collection (ceramics, furniture, and so on). A catalogue of current and forthcoming publications is available from the Publications Office at the Victoria and Albert. In addition, the museum recently began publishing an annual, *The V & A Album*. This book includes reports on recent acquisitions, specialized articles on works in the collection or aspects of the collection, and reports on the government and activities of the museum. *The Album* is supported in part through advertisements.

Exhibitions at the V & A are varied and range from small departmental shows to major exhibitions (about one a year), which are usually accompanied by a catalogue. A major emphasis of the exhibition program is the history of decorative arts and design.

The Education Office presents lectures and organizes study days and school holiday events. Tours abroad are also organized by the museum.

The V & A has two main support groups: the Friends of the V & A and the

Associates of the V & A. The Friends was founded in 1979, and its aims are to help in the work and activities of the museum, particularly: "to purchase works of art; to maintain a lively exhibition program; to expand the museum's training schemes and research projects; and to contribute toward the cost of refurbishing the galleries." Membership is open to all interested persons and fees vary according to category of membership. The Associates of the V & A, founded in 1976, includes corporate members dedicated to supporting the museum.

The National Art Slide Library, administered by the Department of Museum Services, has a wide variety of slides related to the fine and decorative arts. These slides can be borrowed by persons outside the museum for lectures and other use; permission to borrow slides should be requested one week in advance.

The Photography Service provides, for a fee, black-and-white photographs of many of the objects in the museum's collection and lends, for a fee, color transparencies for reproduction.

The Museum Shop sells guides, catalogues of the collection, exhibition catalogues, monographs, facsimiles, and literature related to the collection. Art reference books by various publishers are also available. Postcards, slides, posters, and replicas are sold, and the Craft Shop sells work by contemporary craftsmen. Each of the branch museums has a shop with books, postcards, and other material related to its respective collections.

Selected Bibliography

Museum publications: Darby, Michael, Anthony Burton, and Susan Haskins, *The Victoria and Albert Museum*, 1983; Physick, John, *The Victoria and Albert Museum: The History of Its Buildings*, 1982; idem, *Designs for English Sculpture, 1680–1880*, n.d.; idem, *Masterpieces in the Victoria and Albert Museum*, 1952; Tomlin, Maurice, *Catalogue of Adam Period Furniture*, 1982; Reynolds, Graham, *Catalogue of the Constable Collection*, 1960; Kauffmann, C. M., *Catalogue of Foreign Paintings*, vol. 1, before 1800; vol. 2, 1800–1900, 1973; Lambert, Susan, *Drawing: Technique and Purpose*, 1981; Oman, Charles, *English Silversmiths' Work Civil and Domestic*, 1982; *Handbook to the Department of Prints and Drawings, and Paintings*, 1964; Ward-Jackson, P., *Italian Drawings*, vol. 1, Fourteenth–Sixteenth Centuries, 1979; Bury, Shirley, *Jewellery Gallery*, 1979; *Old and Modern Masters of Photography*, 1981; *Summary Catalogue of British Paintings*, 1973; Knox, George, *Tiepolo Drawings*, 1975; *The V & A Album*, 1983 and 1984; *The V & A Bulletin*, 1965–68.

Other publications: Hamilton, J., and L. Lambourne, *British Watercolors in the Victoria and Albert Museum: An Illustrated Summary* (London 1980); Oman, C., *Wallpapers in the Victoria and Albert Museum: A Complete Catalogue*, revised and expanded by J. Hamilton (London 1981); Strong, Roy, "The Victoria and Albert Museum—1978," *The Burlington Magazine* (May 1978); Wheen, A. W., "The Library of the Victoria and Albert Museum," *Libraries of London*, Great Britain and Ireland Library Association (1949); Rogers, Malcolm, "The Victoria and Albert Museum," "Ham House," "Osterley Park," "Wellington Museum," and "Bethnal Green Museum of Childhood," *Museums and Galleries of London* (Blue Guide), (London 1983); Cullen, Bonnie, "London's Grand Old Lady Puts on a New Face," *Museum News*, vol. 62, no. 4 (April 1984), pp. 5–14.

LORRAINE KARAFEL AND SUZANNE E. GAYNOR

WALLACE COLLECTION, Hertford House, Manchester Square, London W1M 1BN.

The Wallace Collection was bequeathed to the British nation in 1897 by Lady Wallace, widow of Sir Richard Wallace. She specified the Collection as the pictures and objects of art "placed on the ground and first floors and in the galleries at Hertford House." Hertford House, the London home of Sir Richard and Lady Wallace, was not left to the nation. Indeed, it was a condition of the bequest that the government should "agree to give a site in a central part of London and build thereon a special museum to contain the said Collection." A government committee advised that the Collection should remain at Hertford House, the premises being suitably altered for the purpose. The government adopted this scheme by buying the remaining lease and the freehold of Hertford House; the necessary alterations were carried out by Her Majesty's Office of Works. This office, now merged in the Department of the Environment, has continued to be responsible for the maintenance of the building, and the funds for staffing and for the care of the Collection are provided by Her Majesty's Treasury. The Collection is static, since new acquisitions and loans to other institutions are both excluded by the terms of the bequest.

The Collection is governed by a board of seven trustees, appointed by the government. The principal staff are the director and two assistants to the director; there is also a small conservation staff.

The Wallace Collection was formally opened by the future king Edward VII on June 22, 1900. The Office of Works did not substantially alter the appearance of Hertford House, formerly Manchester House, which had long been a landmark on the north side of Manchester Square. The lease of the site had been purchased by the fourth duke of Manchester, who began building in 1776. The duke died in 1788, and the house served briefly as the Spanish Embassy, before the lease was acquired by the second marquess of Hertford in 1797. Under him Manchester House became a center of conservatism, largely through the influence of the marchioness, who from 1811 until 1820 exercised considerable influence over the prince regent. The third marquess succeeded to the title in 1822. He did not live at Manchester House, which was used by his mother until her death in 1834. The third marquess has been amply portrayed in English literature as the marquess of Steyne in Thackeray's *Vanity Fair* and as Lord Monmouth in Disraeli's *Coningsby*. A number of paintings in the Collection belonged to him, notably Titian's *Perseus and Andromeda*, Rembrandt's *Good Samaritan*, and Gainsborough's *Mrs. Robinson*.

Most of the Collection was assembled by the fourth marquess who succeeded to the title in 1842. Most of his life was spent in Paris and was devoted to forming what is now the Wallace Collection. In Paris the works of art were kept either at his apartment at no. 2 rue Laffitte or at the Château of Bagatelle in the Bois de Boulogne. The works he bought in London were stored at Manchester House. The marquess was assisted in his collecting by Richard Wallace, his illegitimate son by Mrs. Agnes Jackson, née Wallace. The marquess died in

August 1870, leaving his collection and all of his unentailed property to Richard Wallace. The subsequent events in Paris during the siege of 1870 and the Commune persuaded Sir Richard Wallace, who was made a baronet for his philanthropic work during the siege, to move to London with a large part of his father's collection. To house it, he carried out alterations to Manchester House, which he renamed Hertford House, constructing picture galleries over the garden, raising the wings, and facing the whole house with red brick. Sir Richard, who died in 1890, discussed with friends the possible bequest of his collection to the nation but did not pursue the matter. It was his widow's knowledge of his intentions that led her to make her bequest. Sir Richard added only a few paintings to the collection, but he purchased the Italian majolica and the European arms and armor.

The paintings reflect the personality of the fourth marquess. The Collection is strongest in the period 1600–1800; Lord Hertford did not care for primitives. He was typical of his age in admiring Dutch seventeenth-century painting. The Rembrandts include *The Artist's Son, Titus*, from Rembrandt's maturity; two early portraits, *Jan* and *Susanna Pellicorne*; *The Good Samaritan* of 1630; and *Landscape with a Coach*. The Collection is also rich in works by Rembrandt's contemporaries. Among the genre paintings, *A Woman Peeling Apples* and *A Boy Bringing Pomegranates* by de Hooch are outstanding as are *A Lady Dressing Her Hair* and *A Lady Reading a Letter* by Gerard Ter Borch. There are also works by Gabriel Metsu, David Teniers the Younger, Nicolaes Maes, and Caspar Netscher. The five paintings by Jan Steen include *The Harpsichord Lesson* and *The Lute Player*. Landscape is also well represented. Of the five Hobbemas, *A Stormy Landscape* is the largest and finest, and by Jacob van Ruisdael, the *Landscape with a Waterfall* is outstanding. Of the works by Aelbert Cuyp, the two finest are *The Avenue at Meerdervoort* and *The Ferry Boat on the Maas*. Italianate Dutch landscape is represented by Berchem, Pynacker, and J. B. Weenix and the marine painters by Willem van de Velde the Younger and Ludolf Backhuysen.

The Flemish school includes two full-length van Dycks, *Philippe Le Roy* and a portrait of his wife, *Marie de Raet*, as well as the same painter's half-length self-portrait as the shepherd *Paris*. Outstanding among the paintings by Rubens is the *Rainbow Landscape*, probably a pendant to the *Autumn Landscape with a View of Het Steen* in the National Gallery (q.v.), London, but there are also the small *Christ on the Cross* and sketches for the *Adoration of the Magi* in Antwerp, *The Defeat and Death of Maxentius*, and three subjects from the History of Henri IV commissioned by Marie de' Medici (now in the Louvre [q.v.]).

The Southern European schools are less well represented than Holland and France. Lord Hertford did not buy trecento or quattrocento paintings, but he bought one or two early sixteenth-century Italian paintings, notably *St. Catherine of Alexandria* by Cima and *The Virgin and Child with St. John the Baptist and Two Angels* by Andrea del Sarto. The Italian seventeenth century is represented by Domenichino's *The Persian Sibyl*, Carlo Dolci's *St. Catherine*, and Salvator

Rosa's large late landscape *Apollo and the Cumaean Sibyl*, once the property of Cardinal Mazarin. The great French painters of seventeenth-century Rome, Claude, Poussin, and Dughet, are each represented by a painting, in Poussin's case *A Dance to the Music of Time*, and there are works by Philippe de Champaigne. In the Italian eighteenth century there is a group of Venetian views by Canaletto and Guardi.

The Spanish school is dominated by the group of ten paintings by Murillo, probably Lord Hertford's favorite painter; despite the generally secular character of the Wallace Collection, they are all religious subjects. Among the works by or after Velázquez, there is one of his undoubted masterpieces: *The Lady with a Fan*.

Lord Hertford showed his greatest originality in his admiration for the French eighteenth century long before that period regained favor. There are eight Watteaus in the Collection: the *Champs Elysées* was bought in 1848, and the larger version of the same composition, as well as *Fête in a Park*, *The Music Party*, and *The Music Lesson*, was acquired in the 1850s. It is not known exactly when *Gilles and His Family* was acquired. Of the eleven Lancrets, *The Italian Comedians by a Fountain* was highly regarded by Lord Hertford, and there are thirteen paintings by Pater. The twenty-two works by Boucher form one of the largest groups of works: the two finest are the large mythologies *The Rising of the Sun* and *The Setting of the Sun*, originally intended as tapestry designs for the Gobelins. In a more realistic vein are *The Modiste* and the small portrait *Madame de Pompadour*, dated 1759. Other French eighteenth-century painters represented in the Collection are François Le Moyne, Nattier, the still-life painters Desportes and Oudry, the landscape painter Claude Joseph Vernet, and the portrait painter Vigée-Lebrun. Mention must be made of Boucher's pupil Fragonard, whose works in the Collection include the exuberant *Swing*, an early landscape *The Gardens of the Villa d'Este, Tivoli*, as well as the more neoclassical *Fountain of Love*. Finally, there are twenty-one works by Greuze, mostly head and shoulders studies of young girls but including two moralizing genre subjects, *The Inconsolable Widow* and *The Broken Mirror*, as well as the important large mythology *The Votive Offering to Cupid*.

The French nineteenth-century artists most lavishly represented are Horace Vernet, with twenty-nine works, and Decamps, with twenty-eight. Their Eastern subjects probably recalled to Lord Hertford his period at the British Embassy in Constantinople. With Richard Wallace he shared a taste for the historical subjects of Delaroche and for the highly finished paintings of Meissonier. The dramatic Delacroix, *The Execution of Doge Marino Faliero*, was an expensive purchase in 1868, and *Faust and Mephistopheles* by the same artist relates to Lord Hertford's taste for Bonington. There are also a small oil and a watercolor by Géricault.

The English eighteenth-century paintings consist of portraits, some of which, like Gainsborough's *Mrs. Robinson*, belonged to the third marquess; both it and the fine Hoppner *George, Prince of Wales* were given to him by the prince. The

fourth marquess admired Reynolds; there are twelve paintings by Reynolds, including one *Mrs. Robinson* that hung in Lord Hertford's bedroom in Paris. The English nineteenth-century paintings include the largest group of works by one artist: eleven oils and twenty-five watercolors by Bonington. There are landscapes by Bonington, such as *The Seine near Mantes* and *Landscape with a Timber Waggon*; two beautiful oil sea pictures, *Sea Piece* and *Coast of Picardy*; and historical subjects such as *Henri IV and the Spanish Ambassador* and *Henri III and the English Ambassador*. There are also watercolors by Turner and works by Wilkie and David Roberts. Of the four Lawrences, the magnificent *Portrait of George IV* was acquired by Sir Richard Wallace.

The most important miniature in the collection is *Hans Holbein*, dated 1543, now considered to be by Lucas Horenbout. The sixteenth century in France is represented by the oil miniatures of Jean de Thou and his wife, Renée Baillet, attributed to François Clouet, and there is a miniature of Sir Richard Leveson by the Huguenot emigré Isaac Oliver. The few seventeenth-century French enamel miniatures are mounted on gold boxes of later date. The numerous French eighteenth-century miniatures include mythologies by Jacques Charlier, *scènes galantes* by Lavreince, portraits by Pierre Adolphe Hall, and genre scenes by the two van Blarenberghes, most of the latter mounted *en cage* in contemporary gold boxes. There is a fine group of Napoleonic miniatures by J. B. Isabey and his pupils and of post-Restoration miniatures by Mansion and others. The English seventeenth- and eighteenth-century miniatures include works by Nicholas Hilliard's son Laurence, John Hoskins, Samuel Cooper, George Engleheart, John Smart, and Richard Cosway.

Lord Hertford's sculpture consisted of sixteenth-eighteenth century French and Italian bronzes, with a few important French marble sculptures. Earlier works were added by Sir Richard Wallace when he purchased in 1871 the collection of the comte de Nieuwerkerke, which included sculpture as well as arms and armor. Sir Richard also purchased ivories, wood carvings, and waxes in the saleroom. Thus alongside the Renaissance and French bronzes the Collection has French Gothic and seventeenth-century ivories; Flemish and German Gothic and Renaissance wood carvings; Italian, French, and German medals; and wax portrait reliefs.

The outstanding Italian sculpture is the marble high-relief *Head of Christ* by Pietro Torrigiano, found by Sir Richard Wallace at Sudbourn Hall, Suffolk, but originally from Westminster Abbey. Other Renaissance works include bronzes by Riccio and his school, the *Seated Goddess* signed by Giovanni da Crema, the *Head of a Girl* by Tullio Lombardi, and works by or attributed to Francesco da Sant'Agata, in particular his boxwood *Hercules*. The dominant group of Italian bronzes, numerically, are the works after Giovanni Bologna and his school. There are few French bronzes earlier than the mid-seventeenth century, but they include the bust of Charles IX by Germain Pilon and the bronze relief *Dancing Maidens* after the *Borghese Dancers* in the Louvre. Louis XIV's leading sculptor, Antoine Coysevox, is represented by busts of the king in bronze and

marble and by his terracotta bust of Charles Lebrun. There is a group of small Louis XIV bronzes, including a pair of fire dogs, *Jupiter* and *Juno*, by Michel Anguier after Alessandro Algardi and reductions of the equestrian statue of Louis XIV by Girardon and of the great vases from Versailles by the same artist. Among the French eighteenth-century marbles are the remarkably forward-looking *Cupid and Psyche* by C. A. Cayot of 1706, the vase carved with infant bacchanals by Clodion, and the distinguished busts of Madame Victoire de France and Madame de Sérilly by Houdon. There are also numerous eighteenth-century small bronzes.

The Wallace Collection is noted for its French furniture. Included among it is the Rococo balustrade mounted on the front staircase that was formerly on the staircase leading to Louis XV's Cabinet des médailles in the Palais Mazarin, now the Bibliothèque Nationale. Boulle furniture is a speciality of the collection; it contains some seventy pieces ranging in date from the late seventeenth to the mid-nineteenth century. Among the pieces attributed to Boulle are the inkstand made for the Paris College of Surgeons in 1710, the toilet mirror that belonged to Saint-Simon's daughter, and two wardrobes with ormolu mounts. There is also much later eighteenth-century Boulle. Lord Hertford had an enthusiasm for clocks. There are several clocks among the Boulle pieces. The Rococo clocks include the *régulateur* clock with movement by Stollewerk, which belonged to Jean Paris de Monmartel, a cartel clock with bronze case by Charles Cressent, and two musical mantelpiece clocks of bronze. Foremost among the numerous Louis XVI clocks is that given by the city of Avignon to the marquis de Rochechouart, the bronze case of which is signed by Pierre Gouthière.

The Collection is not as rich in Louis XV as in Boulle or Louis XVI furniture. Mention must be made of the commode with dragon mounts attributed to Charles Cressent; of the commode made by Gaudreau, with mounts by Caffiéri, for Louis XV's bedroom at Versailles; of the two magnificent bronze chandeliers signed by Caffiéri; and of the desk signed by Riesener, formerly thought to have been made for Stanislaus Lesczinski.

The Louis XVI furniture is both of particular distinction and more numerous than that of the other periods. Several pieces were made for Queen Marie Antoinette, notably the *secrétaire* by Riesener made for her *cabinet intérieur* at Versailles in 1780 and the *secrétaire* with fret marquetry made by the same maker for the Petit Trianon in 1783. Mechanical pieces include the combined work, writing, and reading table stamped by Carlin and mounted with Sèvres plaques. The *cartonnier* and writing table, lacquered with green and gold *vernis Martin* and made by René Dubois, belonged to Empress Catherine II. The Collection is also rich in *bronzes d'ameublement*, such as candlesticks and perfume burners, the finest of the latter being the tripod one made by Gouthière for the duc d'Aumont.

There is no Empire furniture in the Collection, but there are nineteenth-century copies of eighteenth-century furniture, the most celebrated being the copy of the *Bureau du Roi Louis XV* made for Lord Hertford by Pierre Dasson.

The collection of ceramics consists largely of Italian majolica and of Sèvres porcelain. The majolica was acquired by Sir Richard Wallace. A number of pieces came with the Nieuwerkerke Collection in 1871. Others came from the Castellani Collection, sold in May 1871, from the Prince Napoleon sale in May 1872 and from the dealer Isaac Falcke. The collection is richest in the highly pictorial sixteenth-century wares from Urbino and the Duchy of Urbino; the thirty-three Urbino pieces include two signed by Francesco Xanto Avelli da Rovigo. The other Italian majolica centers are represented, but by fewer items, and there are nine pieces of Hispano-Moresque earthenware, eleven of German sixteenth–seventeenth-century stoneware, and fourteen of Palissy ware, variously attributed to Palissy or to his followers.

The Sèvres porcelain was collected much earlier, probably by the third marquess during the Napoleonic wars, although the fourth marquess also bought Sèvres. The collection is richest in large ornamental vases, such as the vase *vaisseau à mât* of 1755–60 and the four vases *candélabre à éléphants* of 1756. A famous piece is the inkstand of 1758 surmounted by two globes, bearing the arms of Madame Adélaïde de France, daughter of Louis XV. There are several *déjeuners* but no large service and few table wares. There are also hardly any figures. The Collection is rich in Sèvres plaques mounted on furniture, most notably on the work and writing table by Martin Carlin.

The European arms and armor, which number more than thirteen hundred items, were purchased by Sir Richard Wallace. They came from the Nieuwerkerke Collection and from that of Sir Samuel Meyrick, father of the study of armor in Britain. The Wallace Collection is thus particularly strong in sixteenth-century enriched armor made by the great armorers of Milan and South Germany, but there are earlier armors such as the complete German war harness for man and horse of about 1475. There are also earlier headpieces, notably a Milanese visored bascinet of 1390–1410. There are works from the Greenwich armory set up by Henry VIII, such as the Elizabethan suit of armor made for Thomas Sackville, earl of Dorset. The collection is rich in arms, with medieval and later swords, daggers, crossbows, and pikes and an extensive collection of firearms, many with distinguished historical associations.

The Oriental arms and armor were purchased by Lord Hertford and correspond to his taste for Eastern paintings by Decamps and Horace Vernet. The armor is Indo-Persian of the eighteenth and nineteenth centuries and includes two complete Indian sets of armor, as well as helmets, shields, and maces. There are scimitars, mainly eighteenth and nineteenth century, and Indian, Persian, and Far Eastern daggers and swords. A complete military dress of a Chinese mandarin dates from the mid-nineteenth century. The firearms include matchlock and flintlock guns from India and the Near East and pistols from Turkey and the Balkans.

The Wallace Collection has an art library of more than five thousand volumes; it also has a collection of nineteenth-century French sale catalogues. Scholars may consult the library by appointment.

Black and white photographs of nearly every object in the Collection can be

supplied. A selection of color transparencies is available for hire. A list of publications is available. In addition to providing detailed catalogues the Wallace Collection publishes picture books, postcards, color prints, and the Wallace Collection monographs, illustrated essays on aspects of the Collection.

Selected Bibliography

Museum publications: *General Guide to the Wallace Collection*, 1982; *Catalogue of Pictures and Drawings*, 1968; *Summary Illustrated Catalogue of Pictures*, 1979; *Guide to the Armouries*, 1982; Alexander, J.J.G., *Illuminated Manuscript Cuttings*, 1980; Laking, G. F., *Oriental Arms and Armour*, 2d ed., 1964; Mann, J. G., *European Arms and Armour*, 2 vols., 1962; Norman, A.V.B., *Ceramics, I—Pottery, Maiolica, Faience, Stoneware*, 1976; Reynolds, G., *Miniatures*, 1980, Savill, R., *Ceramics, II—Sèvres Porcelain*, 1984; Watson, F.J.B., *Furniture*, 1956; de Bellaigue, G., *Preferences in French Furniture*, 1979; Hughes, P., *Eighteenth-Century France and the East*, 1981; idem, *The Founders of the Wallace Collection*, 1981; Ingamells, J., ed., *The Hertford Mawson Letters*, 1981; idem, *Mrs. Robinson and Her Portraits*, 1978; idem, *Richard Parkes Bonington*, 1980.

Other publications: Issues devoted to the Wallace Collection, *Apollo* (June 1965); idem (November 1982); *Burlington Magazine* (June 1950).

<div align="right">PETER HUGHES</div>

Oxford

ASHMOLEAN MUSEUM OF ART AND ARCHAEOLOGY (also ASHMOLEAN MUSEUM), Beaumont Street, Oxford OX1 2PH.

The Ashmolean, opened on May 21, 1683, by the duke of York (later King James II), was the first museum accessible to the public in the English-speaking world. Its origins lie in the collection of natural history and ethnographic specimens formed by John Tradescant (d. 1638) and his son (1608–62), which was bequeathed to Elias Ashmole (1617–92) in 1659. This will was later ignored, since King Charles II and then the Oxford or Cambridge universities were favored as subsequent beneficiaries. Ashmole disputed the legality of these wills and gained complete possession in 1678. The previous year he offered these curiosities, with his own collection of coins, paintings, and antiquities, to Oxford University on the condition that a room be built to contain them. This was accepted, and the building, designed by Thomas Wood, a pupil of Christopher Wren, to house a chemistry laboratory and lecture theater as well, was erected in Broad Street at a cost of forty-five hundred pounds. It became the center of scientific studies in the university, but the collection itself grew only haphazardly until a series of redistributions in the nineteenth century, when the natural history specimens were transferred to the new University Museum (1855) and the ethnographic material to the Pitt Rivers Museum (1886). Ashmole's own collection

was removed to the Bodleian Library in 1858, and these changes allowed for the expansion of what remained along predominantly archaeological lines.

Meanwhile, the university collections of antique marbles and paintings, soon to be amplified by the Fox-Strangeways (1850) and Chambers Hall (1855) gifts, had been installed in a series of galleries on Beaumont Street in 1845. This building, known as the University Galleries, was designed by C. R. Cockerell and modeled on the Temple of Apollo at Phigaleia, making it one of the last, grandest, and most controversial of works executed in the neoclassic style. The east wing belongs to the Taylor Institute, the university center for the study of modern languages. The main feature of the Galleries is a long, ground-floor room designed for the Arundel Marbles and named after Francis Randolph, who helped finance the project. In 1894, under pressure from Arthur Evans, keeper of the museum from 1884 until 1908, the university decided to combine all of its art and archaeological collections on the same site, and so an extension was built behind the Galleries and opened in 1894. This would not have been possible without the financial backing and enthusiasm of Charles Drury Fortnum, who also donated his own large collection of art and antiques. The collection in Broad Street was transferred to the new exhibition area, and the Thomas Wood building now houses the Museum of the History of Science.

The administration was not unified until 1908, when the museum assumed its present name, the Ashmolean Museum of Art and Archaeology, and established two departments: Antiquities and Fine Art (now Western Art). In October 1922 the Heberden Coin Room, named after a university benefactor, was opened as part of the Department of Antiquities, gaining independent curatorial status in 1961. The last major change was in the following year when the university collection of Oriental art, previously housed in the Indian Institute, was transferred to new galleries created within the ground floor of the Fortnum extension.

Although owned and financed by the University of Oxford, the museum has been and still is heavily dependent on private gifts and bequests to maintain the standard of its collection. In the purchase of specific items constant help is given by the Friends of the Ashmolean, founded in 1969 for this very purpose; the National-Art Collections Fund; and the Victoria and Albert Museum Purchase Grant. The only other financial source is from individual donations of money, since the museum has to survive without direct aid from local or national government.

The Ashmolean is governed by the university through a body of trustees known as the Visitors and headed by the vice-chancellor. The traditional number of Visitors, which must include the University Senior and Junior Proctors, is sixteen. In 1970, on the recommendation of the Brunt Report, a university inquiry, a directorship was established to help centralize communication and coordinate financial and administrative actions. Until then the four curatorial departments (Antiquities, Western Art, Oriental Art, and the Heberden Coin Room) had existed in a state of near autonomy. The museum also incorporates the Cast Gallery, which is under the authority of the Lincoln Professor of Classical Art

and Archaeology, and the Griffiths Institute, established in the 1930s as the university center for the study of Egyptology. Each department houses a library belonging to the university; all of them are of exceptional quality for a museum of this size, and the main Ashmolean Library of Classical History, Art and Archaeology is one of the greatest of its kind in the world. This reflects the museum's first responsibility, which is toward the students and scholars of the university. To this end lectures take place in the museum, which is also the customary meeting place of the Oxford University Archaeological Society.

The Department of Antiquities owes its remarkable scope and quality both to the old tradition of collecting antiquities and the new discipline of archaeology. The ancient marbles of Sir Thomas Bodley and John Selden, given to the university in 1602 and 1654, respectively, formed the nucleus to which the largest addition has been items from the collection of Thomas Howard, earl of Arundel, also created in the seventeenth century. A long and close association with many archaeologists, combined with the policy of contributing to expeditions and participating in those mounted by the university itself, has ensured the museum a rich supply of excavated material.

Flinders Petrie and F. Ll. Griffiths have established the Egyptian collection as one of the most complete in the world. Especially notable are the finds from Predynastic Nagada (c. 4000–3000 B.C.), Proto-dynastic Abydos and Koptos (c. 3000–2600 B.C.), and the New Kingdom material from Amarna (c. 1370–1350 B.C.). Among the relics of the pharoahs is one of the museum's treasures—a fragment of a richly colored wall painting showing two daughters of Nefertiti and Akhenaten (c. 1360 B.C.). A small but comprehensive survey of Nubian history includes a reerected shrine of Taharqa (c. 700–600 B.C.). The collection is also known for its funerary cones, ostracea, papyri, and extensive collection of Coptic and early Islamic textiles and embroideries (Newberry gift, 1941).

The development of civilization in the Near East can be studied in depth from material collected during controlled excavations, among them, the great series by Charles Leonard Woolley (assistant keeper, 1905–7) in Mesopotamia and North Syria, and by Kathleen Kenyon at Jericho. Her finds included a small plastered skull (c. 7000 B.C.). The collection of cylinder and stamp seals from Mesopotamia and Assyria and of Luristan bronzes from ancient Persia are world famous. Cypriot antiquities, following the excavations of Sir John Linton Myres (Wykeham Professor of Ancient History, 1910–39), form the most comprehensive survey outside the island. A special feature is the large collection of pottery fragments from widely distributed sites, which is available for study on request. Likewise the Cretan antiquities are inferior only to those on the island due to the many gifts of Sir Arthur Evans, which include a pre-eminent series of Minoan gemstones and painted pottery from Knossos.

The Classical Greek collection is one of the most important in the country, not least for its rich endowment of painted Greek vases, part of the many and frequent gifts of Sir John Beazley between 1912 and 1966. Exhibits from Scythian tombs are important for their documentation of the partially Hellenized barbarian

cultures. Many of the Arundel Marbles are Roman copies of Greek originals, but there are several pieces of high artistic and historical value, such as the famous metrological relief (460–450 B.C.). Among later acquisitions are a pair of candelabra from Hadrian's Villa, restored and once owned by Piranesi.

Prehistoric Europe is represented in a collection unusual for its quality and comprehensive nature, spanning time and place from neolithic East Europe to Bronze Age Spain. Much of this material was given in 1927 by Sir Arthur Evans from his father's collection. An interesting dimension is given to the fine British section by a series of two thousand local aerial photographs taken by the pioneering G.W.G. Allen. Extensive examples of Iron Age culture in Italy and Britain set the background for the high standard of craftsmanship attained under the Roman Empire; the museum owns objects from most of the provinces, including fine examples of Arrentine wares from the Perennius workshop. The Anglo-Saxon invasion of England is well represented, and there is an unusual abundance of material from early sites, many of which were in Oxfordshire.

Most famous among the medieval exhibits are the *Alfred Jewel*, perhaps made for Alfred the Great, king of Wessex (873–99), which came to the collection in 1718; the *Minster Lovell Jewel*, perhaps made in the same workshop; and an Anglo-Saxon walrus ivory carving of the Virgin and Child (c. 1000), purchased in 1978. However most of the collection consists of objects and utensils in daily use and includes a complete sequence of Late Saxon and medieval pottery from Oxford. In honor of the founders of the collection, John Tradescant and his son, a special display was opened in 1978 containing surviving pieces from their "closet of rarities," among them, a ceremonial cloak belonging to Chief Powhatan (c. 1600), the earliest recorded piece of American history. One of the largest collections of brass rubbings in the world is held in reserve because of its fragility.

The Department of Western Art prides itself on a domestic atmosphere more reminiscent of a private house than a public institution. This is maintained by integrating its collection of decorative arts with paintings and furniture. The most important single aspect of this department is the Print Room, which is of metropolitan stature and is also remarkable for its accessibility to the public, works being immediately available on request. The origins of the Print Room lie in the group of 270 drawings by Raphael and Michelangelo bought from the estate of Sir Thomas Lawrence in 1846; the Raphaels are now the largest collection in existence. Following this priceless series, the Chambers Hall gift (1855) to the University Galleries of seventeenth- and eighteenth-century masters included fine sets of work by Claude, Ostade, Rembrandt, Canaletto, Guardi, and Wilson. The last major nineteenth-century expansion was in 1863, when, on the formal establishment of the Print Room, the Francis Douce bequest of watercolors and drawings was transferred from the Bodleian Library. His remarkably fine collection of Northern Primitives was rich in Holbeins and Dürers and included a rare Grünewald drawing, *Woman with Clasped Hands*. A brilliant acquisition policy under Sir Karl Parker, keeper of Western art from 1934 until 1962, tripled

the size of the collection and with the aid of several bequests created a magnificent Italian collection in which all of the great masters are well and often brilliantly represented. Private donations have also established strength in more unusual areas, the most colorful being Russian ballet designs from the Diaghilev years. Gifts from the Pissarro family from 1950 onwards included not only drawings and paintings but also documents, diaries, and letters of Pissarro and his relatives. The English drawings are outstanding, amply covering the whole history from Isaac Oliver to William Orpen and boasting of a fine group of rare early English drawings. Other notable material is of English watercolors from the late eighteenth century onwards, with the splendid Turner watercolors given by John Ruskin in 1862; of Samuel Palmer; and of the Pre-Raphaelites. The Print Room has a small display area. A gallery for temporary visiting exhibitions was opened in 1973 with funds from Sir Alistair McAlpine, who stated that at least two exhibitions a year are to be of contemporary artists.

In paintings the museum's strength is in Italian art 1300–1600, of which it owns about 160 examples, richest of all being the Early Primitive collection. Much of this comes from the Fox-Strangeways' gift (1850), which brought with it the famous *Night Hunt* by Paolo Uccello (post–1460). *The Crucifixion and Lamentation* attributed to Barna da Siena and *Virgin and Child* by Andrea Vanni illustrate the Sienese tradition; *The Birth of the Virgin* by Orcagna and *Forest Fire* by Piero di Cosimo, the Florentine. A late example of the latter school is Bronzino's *Portrait of Giovanni de' Medici* (c. 1560), but on the whole the Renaissance is best represented by examples from the Venetians. Most important are *St. Jerome in the Desert* by Giovanni Bellini and the *Virgin and Child* attributed to the young Giorgione. Small works by Tintoretto, Veronese, and lesser artists cover the High Renaissance; Tiepolo, Canaletto, and Guardi, the eighteenth century. Examples of the Roman school of historical landscape include *The Expulsion of Moses* by Nicolas Poussin (1654) and a work each by Domenichino and Gaspar Poussin. There are fewer French works of this period, but among them are two paintings by Claude, one being his last work, *Landscape with Ascanius Shooting the Stag of Silvia* (1682), as well as works by Watteau and Chardin. An unusual feature of the Dutch and Flemish collection is the group of ninety-four still-life paintings given by Daisy Linda Ward in 1940 on condition that they be shown intact. Other highlights are the twelve small sketches by Rubens, with two tiny but delightful landscapes, and *The Deposition* by van Dyck.

English eighteenth- and nineteenth-century artists represented encompass Hogarth, Wilson, Wright of Derby, Reynolds, Zoffany, and Romney, as well as Gainsborough in the unusual *Portrait of his Daughter Mary Gleaning*. Thomas Combe, an early patron of the Pre-Raphaelite Brotherhood, developed a collection of their works, among them Millais's *Return of the Dove to the Ark*. They were bequeathed by his wife in 1894 and form the nucleus of the paintings of this movement. There are also masterpieces by Hunt, Rossetti, and Burne-Jones. In the late 1930s the Weldon and Frank Hindley Smith bequests established a

small repertoire of French paintings from the second half of the nineteenth century and of works by contemporary French and English artists. They were well complemented by the Pissarro gift, which, in addition to nineteen canvases by that artist, many from his "pointilliste" phase, contained paintings by other artists including Picasso. Thus the museum has a modest but fine collection of a number of famous artists, such as Daumier, Daubigny, Courbet, Gauguin, and van Gogh.

Several important although small pieces of bronze sculpture by Degas and Rodin and a version of Daumier's *Ratapoil* are owned by the Ashmolean. They form a fascinating foil to the Renaissance bronzes given to the museum by Charles Drury Fortnum. The ceramics collection also benefited from his munificence in the guise of valuable sixteenth-century majolica and Hispano-Moresque ware. Two other donations added a comprehensive series of more than two hundred pieces of English delftware of superb quality (Warren gift, 1963) and more than a thousand pieces of Worcester porcelain and Bristol Lund manufactured between 1751 and 1783 (Marshall gift, 1957). Other European factories of the eighteenth century are also represented.

Work by Huguenot refugees in London between 1725 and 1750, and by Paul Lamerie in particular, is a feature of the silver collection. These works were donated to the National-Art Collections Fund by W. F. Farrer and given to the museum in 1946. A three-hundred strong collection of watches and clocks includes the most notable group of prebalance spring watches on public view. Other areas of strength are in glass; there is a special display of seventeenth- and eighteenth-century English work, Limoges enamels, and European finger rings. The Hill gift (1939) of early stringed instruments has as its most famous item the violin *Le Messie* made by Antonio Stradivari in 1716. Pieces of sculpture and furniture are scattered throughout the galleries, with Renaissance chests and eighteenth-century tables well in evidence.

The Heberden Coin Room is one of the great coin rooms of the world, with some two hundred thousand examples of almost every known currency, past and present. It houses one of the museum's greatest treasures, the unique Crondall hoard of Anglo-Saxon gold coins. Also under its jurisdiction are the medals, rich in examples from England and the Italian Renaissance. The department is only able to display a small, although changing, selection of exhibits, and its main purpose is the provision of material necessary for research and teaching, which is facilitated by the presence of a fine numismatic library.

The Department of Eastern Art, although the most recently established of the departments and comparatively small, has holdings of great importance. As a result of several major bequests, the collections of Islamic, Chinese, and Japanese ceramics are remarkable. Sir Alan Barlow's gift in 1956 of medieval pottery from Persia and Iraq, magnificently amplified in 1972 by the Near Eastern ceramics from the collection of Gerald Reitlinger, has made the Ashmolean's collection one of the finest in existence outside the Arabic world. The Persian

metalwork is also of outstanding artistic quality. Two massive bequests of recent origin from Reitlinger (1978) and Eric North (1979), combined with the large Ingram gift (1956), have created a Chinese ceramics collection of exceptional importance, and the range of Yüeh ware is unrivaled outside its native country. The T'ang, Sung, and Ming dynasties are all well represented, and the early blue-and-white ware previously belonging to Professor Sayce is of superb quality. Holdings are also strong in bronze artifacts of the Shang Dynasty (1766–1122 B.C.), snuff bottles, netsuke, and seals. An unusual feature of the Chinese collection is its planned expansion of works by contemporary artists that form most of the five hundred-piece print and drawing collection.

Except for the Kakiemon and Arita ware, the Japanese ceramics are less extensive and important. The department has about three thousand woodblock prints and paintings, the Maruyama-Shijo and Nanga schools having the best coverage, and highly prized examples of sword furniture and the craft of lacquerware.

Although the collection of objects from the Indian subcontinent came together in a haphazard way, it is surprising in its comprehensiveness. The founder's collection yielded a Burmese Buddha and a rare molded terracotta plaque of a goddess from eastern India (first century B.C.), which is in superb condition and came to Europe in the nineteenth century. The Gandhara, Mathura, and Gupta sculpture collection is small but notable, and the traditions of sculpture generally, both in stone and bronze, are amply illustrated until the fourteenth century A.D. The rich group of ceremonial and sumptuary objects from Tibet add a fascinating dimension to the department's range, as does the display of Indian folk art. It pioneered the idea of having a permanent exhibition area, created to house visiting exhibitions, as well as objects from the collection itself. A frequent theme in this gallery is contemporary Asian art.

The Cast Gallery, on an adjacent site in Pusey Lane behind the main museum building, holds more than 250 casts of Greek and Graeco-Roman sculpture, including many of the masterpieces of Classical statuary. Its main function is as a teaching instrument for the Lincoln Professor of Classical Archaeology, but visitors are welcome to experience its stimulating atmosphere.

All departments have rich reserve and study collections, and they can be consulted by appointment. Much of the conservation of objects is carried on in the museum, and in 1978 the conservation laboratory was refurbished and independent photographic facilities added, both helping the progress of research. Most graduate members of staff in the Ashmolean are concerned not only with the latter but also with teaching in various university faculties.

Photographs of most objects may be ordered by the public from the museum's studio, via the Publications Officer. In the main entrance hall catalogues, color slides, pamphlets, and postcards are available for purchase as well as reproductions of selected items and a wide range of other material concerned with art and archaeology.

Selected Bibliography

Museum publications: *A Summary Guide to the Collections*, ed. D. B. Harden, 1951; *Treasures of the Ashmolean*, 1970; *A Summary Guide to the Department of Antiquities*, 1951; Boardman, J., *The Cretan Collection in Oxford*, 1961; *Select Exhibition of Sir John and Lady Beazley's Gifts to the Ashmolean Museum, 1912–1966*, 1967; Boyden, D. D., *Catalogue of the Hill Collection of Musical Instruments*, 1969; Brown, A. C., *Catalogue of the Italian Terra-sigillata in the Ashmolean Museum*, 1968; *Catalogue of Paintings in the Ashmolean*, 2d rev. ed., 1962; Harden, D. B., *Guide to the Greek, Roman, English, and Chinese Coins*, 1948; Hermann, L., *Catalogue of the Turner Drawings in the Ashmolean Museum*, 1968; Kenna, V.E.G., *Catalogue of the Minoan Seals in the Ashmolean Collection*, 1960; Lloyd, C., *Catalogue of the Earlier Italian Paintings in the Ashmolean Museum*, 1977; Parker, K. T., *Catalogue of the Collection of Drawings, Vol. I: Netherlandish, German, French, and Spanish Schools; Vol. II: Italian Schools*, 1938, 1956; *British Plate in the Ashmolean*, 1962; Thompson, J.D.A., *Ashmolean Museum, Oxford, Part I: Anglo-Saxon Pennies*, 1967; Metcalf, D.M., *Part II: English Coins, 1066–1279*, 1969.

YVONNE A. LUKE

United States

—— Baltimore ——

BALTIMORE MUSEUM OF ART, THE (also BALTIMORE MUSEUM, BMA), Art Museum Drive, Baltimore, Maryland 21218.

In the aftermath of the devastating great Baltimore fire of 1904, a citywide congress, created to propose a master plan for this city of more than a half-million people, identified the lack of an art museum as one of Baltimore's most conspicuous deficiencies. The Committee on Founding an Art Museum was duly commissioned, and in 1914 the museum was established with the appointment of eight individual incorporators and a board of trustees, consisting of twenty-five members.

The museum first opened its doors to the public in 1923, initially housed in the Garrett-Thomas House on Mt. Vernon Square. The following year a referendum was placed on the ballot in favor of a million-dollar loan for construction of a permanent museum building on six acres of land in Wyman Park donated by the Johns Hopkins University. The city voters approved the measure and John Russell Pope, who later designed the National Gallery of Art (q.v.) in Washington, was selected as architect. The neoclassical edifice, completed in February 1929, officially opened on April 18, 1929. Over the years new wings were added: the Jacobs Wing in 1938, the May Wing in 1950, the Woodward Wing in 1956, and the Cone Wing in 1957; the American Wing was enlarged in 1970. The museum has recently undergone a major renovation and building program under the direction of Bower, Fradley, Lewis, Thrower/Architects. The enlarged museum contains supplementary galleries for modern art, American painting and decorative arts, arts from Africa, Oceania, and pre-Columbian Americas; an outdoor sculpture garden, a new print department with study room; and intimate

galleries designed specifically for the exhibition of prints, drawings, and photographs, as well as increased library facilities, a members' room, and a café.

Owned by the city of Baltimore, the museum receives appropriations from the municipal budget and income from museum endowment and membership dues. In addition, the museum often receives special grants from various governmental or cultural organizations such as Baltimore County Commission on Arts and Sciences, Anne Arundel County Commission on Culture and the Arts, Howard County, Maryland Arts Council, National Endowment for the Arts, National Endowment for the Humanities, and Institute of Museum Services. Private benefactors also contribute financial support.

Governed by a board of trustees (fifty members who serve two-year terms), the museum is administered by a director and two assistant directors. Curatorial departments include: Painting and Sculpture; Prints and Drawings; Photography; American and European Decorative Arts; Textiles; and Arts from Africa, Oceania, and Pre-Columbian Americas. Other departments are: Education, Program, Library, Rights and Reproductions, Public Information Services, Membership, and Publications. The museum also manages the Travelling Exhibition program, which organizes approximately six shows a year to tour the state of Maryland. The Women's Committee operates the Sales and Rental Gallery, which presents changing exhibitions and offers a variety of artworks for sale or rent to members of the museum. In the near future, it is anticipated that the museum will open a downtown branch to exhibit temporary shows.

In the decade following the opening of the permanent building, the museum received several important donations from private collectors. In 1925 Mr. and Mrs. Hamilton Owens presented the museum with a mid-eighteenth-century room from Eltonhead Manor in Calvert County. The Blanche Adler Collection of Graphic Art was first established in 1930 with a gift of 150 prints later augmented with purchasing funds as provided for in her bequest. That same year, the T. Harrison Garrett Collection of Graphic Art of about 17,000 prints, with emphasis on Old Master examples, was placed on deposit and later given to the museum. In 1933 Mrs. Miles White, Jr., gave a comprehensive collection of more than 200 pieces of early Maryland silver, dating from the eighteenth and nineteenth centuries. George A. Lucas, a Baltimorean who served as an art agent for various collectors such as William T. Walters and Samuel P. Avery, the latter from New York, purchased a diversified selection of nineteenth-century European paintings, drawings, and prints during his lengthy Paris sojourn. His collection, bequeathed to the Maryland Institute College of Art, has been on deposit at the museum since 1934.

Jacob Epstein lent his collection of Old Master paintings and nineteenth-century sculpture to the museum in 1929; these works entered the museum's permanent collection upon his death in 1946. Highlighting Epstein's selection is the major Anthony van Dyck *Rinaldo and Armida* painted for Charles I of England. The elegant portrait *Nobleman of the Medici Court* by van Dyck's Flemish compatriot Justus Sustermans also typifies Baroque aristocratic portrai-

ture. Renaissance paintings include Francesco Francia's *Madonna and Child with Donor* of about 1515, Titian's late *Portrait of a Nobleman*, and the intriguing *Portrait of Emilia Pia de Montefeltro*, thought to have been painted by the young Raphael. Bronzes by the French "animalier" sculptor Antoine-Louis Barye and Rodin's monumental *Thinker*, smaller versions of the *The Kiss*, *Eve*, and *The Benedictions*, complement the oils.

The presentation of the Mary Frick Jacobs Collection in 1935 greatly enhanced the quality and quantity of Old Master works, as evidenced by the Botticelli studio work *Madonna and Child with Angels*, Rembrandt's 1661 *Portrait of His Son Titus*, Frans Hals' *Portrait of Dorethea Berck*, and the early Fragonard *Rest on the Flight to Egypt*, composed in an oval format. Her collection also contains characteristic landscapes by seventeenth-century Dutch masters Jacob van Ruisdael and Jan van Goyen, as well as enchanting eighteenth-century vistas by Hubert Robert and the Venetians Canaletto and Francesco Guardi.

The museum's holdings, combining examples from the Jacobs and Epstein collections, as well as from the Elise Agnus Daingerfield bequest of 1944, present a rich survey of eighteenth-century portraiture. Artists working in this genre include Sir Joshua Reynolds, Thomas Gainsborough, George Romney, and Sir William Beechey of England. Several outstanding portraits represent an overview of French eighteenth-century styles ranging from Greuze's early Rococo *Portrait of the Marquis de Besons* to Vigée-Lebrun's neoclassical *Portrait of Princess Anna Alexandrovna Galitzin*, with charming examples by Maurice Quentin de Latour, Jean-Marc Nattier, Marguerite Gérard, and others.

Five individual paintings purchased by the museum further extend the Old Masters selection: Bacchiacca's Mannerist *Madonna and Child*, Cornelius van Haarlem's *Venus and Adonis*, Bernardo Strozzi's *St. Apollonia*, Giovanni Battista Pittoni's *Presentation in the Temple*, and Poussin's early *Moses Sweetening the Waters of Marah*.

Following the 1934 opening in Baltimore of the Walters Art Gallery (q.v.) with its outstanding collection of ancient, Classical, and medieval art, The Baltimore Museum of Art determined to concentrate its acquisitions on post-medieval art. One notable exception to this policy was the acceptance of more than thirty mosaic pavements from ancient Syria. Dating from the second to the sixth century, these mosaics adorned the floors of villas in Antioch and nearby Daphne. Along with Princeton University, the Worcester Art Museum in Massachusetts, and the Musées Nationaux de France, the Baltimore Museum helped support the Antioch Project excavations from 1932 to 1939 and thus received a portion of the uncovered mosaics. Installed in a courtyard surrounding a small garden, these multicolored panels represent simple geometric patterns as well as depictions of fish, animals, plant life, and figural scenes of pagan subjects such as Oceanus, Tritons, and Nereids, classical characters who inhabited the seas.

The major strengths of the museum's possessions fall into three categories: modern painting and sculpture, American painting and decorative arts including various period rooms, and prints and drawings.

Bequeathed in 1949, the Cone Collection of nineteenth- and early-twentieth-century French art emphasizes the work of Henri Matisse and the early production of Picasso. Through Gertrude and Leo Stein, the Cone sisters, Claribel and Etta, met Matisse and Picasso in Paris and purchased many paintings directly from the artists. Indeed, the Matisse holdings are one of the largest in the United States, surveying his oeuvre from an early 1895 *Still Life* to oils from the late 1940s, such as *Two Girls in Red and Green*. Major canvases include his famed *The Blue Nude—Souvenir of Breska* (1907), once owned by the Steins and later by John Quinn of New York; *The White Turban* (1916); *Girl in a Yellow Dress* (1929–31); *The Magnolia Branch* (1934); *The Pink Nude* (1935); and *The Purple Robe* (1937), as well as numerous oils executed in Nice during the 1920s. Exhibited with these paintings are Matisse bronzes, including the early *Slave* (1900–1903), which shows influence from Rodin; the serpentine *Madeleine I* (1901); *Reclining Nude* (1907), depicting the same figure envisioned in *The Blue Nude*; large *Seated Nude* (1925); and *Tiari with Necklace* and *Venus on a Shell* (both 1930).

Picasso is represented by the Blue Period *Woman with Bangs* (1902), *The Coiffure* (1905), and *Mother and Child*, painted in his "Classical" style of the early 1920s. From time to time superb early Picasso watercolors such as *Man on the Beach* (Carles Casagemas Collection), *The Monkey, Circus Family, Seated Saltimbanque with Boy* (a study for *Family of Saltimbanques* in the National Gallery of Art), *Nude with Raised Arm* (1907), and the gouache portraits of Leo and Allan Stein are hung with oil paintings in the Cone Wing. The outstanding array of Picasso and Matisse drawings, watercolors, and prints assembled by the Cones are housed in the Department of Prints and Drawings and may be viewed by appointment.

Further highlights of the Cone Collection are nineteenth-century French paintings, many of which Etta Cone purchased after Claribel Cone's death in 1929 to provide the background setting for their collection of early-twentieth-century art. Post-Impressionist works include two important Cézannes depicting favorite themes of his late period, *Bathers* (c. 1895–1900) and *Mont Ste.-Victoire* (c. 1898–1900); three van Goghs spanning the Dutch artist's brief career—the watercolor *Beach at Scheveningen* (1882), one of his earliest paintings, *Old Shoes* (1887), painted during his two-year stay in Paris, and a late *Landscape with Figures*, executed during the last year of his life; and Gauguin's *Woman with Mango*, dating from his first sojourn in Tahiti. Earlier paintings by Delacroix, Corot, Courbet, Manet, Monet, and Renoir supplement the selection.

Like the Cone sisters, Saidie A. May was a connoisseur of avant-garde art and a major benefactor of the museum. Her numerous gifts and later bequest included a potpourri of ancient sculpture, medieval art (fourteenth-century Burgundian *Virgin and Child* and the Master of St. Gudule, *Adoration of the Magi*, for example), Renaissance paintings (Italian tempera panel of an enthroned *Madonna and Child* of the late fourteenth-early sixteenth century and a Flemish *Portrait of a Young Woman*, sixteenth century), and various decorative arts and

textiles including a paneled room from a manor house in Shrewsbury, England. But May's most comprehensive donation consisted of twentieth-century paintings emphasizing late Cubist and Surrealist works. Represented are Synthetic Cubist oils of the 1920s by Juan Gris, Georges Braque, and Picasso, as well as Surrealist paintings by Joan Miró, Max Ernst, Matta, Yves Tanguy, and André Masson, the latter whom May supplied with funds to immigrate to the United States in 1941. During the 1940s May was attracted to the early Abstract Expressionists, purchasing their paintings when the artists were still unknown. As early as 1943, she bought Robert Motherwell's *Joy of Living* and William Baziotes' *The Drugged Balloonist*; her Jackson Pollock *Waterbird* of 1943 is one of his first experiments with the drip-paint technique.

The museum has continued to acquire contemporary art, with large paintings by Motherwell, Hans Hofmann, Clyfford Still, Helen Frankenthaler, Jasper Johns, and Frank Stella and sculptures by George Rickey and Alexander Calder. A major addition to the selection of twentieth-century art was the collection of modern sculpture established by the late Janet and Alan Wurtzburger during the 1950s and 1960s at their home "Timberlane" and subsequently donated to the museum. Exhibited in the outdoor Sculpture Garden, the collection includes Rodin's *Balzac-Nude*, Bourdelle's *Fruit* (c. 1903), Maillol's *Study for "Summer"* (1910–11), Lachaise's *Standing Woman* (1912–27), Lipchitz's *Mother and Child* (1941–42), and Henry Moore's *Three Piece Reclining Figure, No. 1.*

The Lucas Collection of nineteenth-century European art has been on deposit at the museum for several decades. Although not on permanent display, these paintings are exhibited from time to time, and featured are masters of the Romantic and Barbizon schools such as Bonington, Corot, Théodore Rousseau, Daubigny, and many lesser-known artists. In addition to the nearly three hundred paintings, the Lucas Collection contains almost seventy bronzes by Antoine-Louis Barye, a favorite artist of Lucas.

More recently, the Abram Eisenberg Collection, placed on loan and later bequeathed, continued the museum's acquisition of nineteenth century European paintings. Works displayed include two Monets, *Waterloo Bridge* and *Charing Cross Bridge*; a late Corot, *Crown of Flowers*; and a Millet, *Shepherdess*, as well as other Barbizon oils by Daubigny, Diaz, and Dupré. In addition, a jewel of the museum's nineteenth-century holdings is Degas' large *Ballet Dancer* with cloth tutu, the only sculpture Degas exhibited in his lifetime, which the museum purchased in 1943.

The galleries for American Art feature seven period rooms, including Eltonhead Manor cited above. The earliest rooms are a bed chamber from Weston in Dorchester County constructed about 1720–40 and a mid-eighteenth-century staircase from Cranberry Quarters in Harford County. Only slightly later (c. 1761) is the room from Habre-de-Venture, the most architecturally intact, since its paneled walls bear their first and only coat of paint, and the windows and hardware are also original. Built by Thomas Stone, one of Maryland's four signers of the Declaration of Independence, the room is furnished with portraits

of Stone family members by Robert Edge Pine and John Hesselius, purchased with the room by the city of Baltimore in 1928. The Chestertown Room from the Eastern Shore with its carved woodwork is representative of the high style of Maryland Georgian residences and was designed by William Buckland, the premier Chesapeake architect of the second half of the eighteenth century.

Dating from the turn of the eighteenth century, the beautiful oval room from Willow Brook was saved from razing in 1965 and transported to the museum. This Federal-style room contains its original elaborate plaster cornices, chair rails, and ceiling medallion, executed in a decorative style influenced by the work of the eighteenth-century English architect Robert Adam. The oval room's furnishings are also in the Adam style and include an English mirror, as well as chairs, settees, and a pier table made by John and Hugh Finlay, who specialized in Baltimore "fancy furniture." The latter pieces display painted views of local scenes, including a representation of the original Willow Brook facade. The elegant crystal chandelier is of English origin and contemporary with Willow Brook.

An entrance doorway, hall, and parlor from Waterloo Row were also rescued from twentieth-century demolition. Designed and built between 1816 and 1818 by the first American-trained architect, Robert Mills, Waterloo Row was a handsome group of twelve townhouses along the 600 block of North Calvert Street in downtown Baltimore. The refined Classical Revival rooms salvaged by the museum are furnished with fashionable furniture incorporating ancient forms and motifs as were popular in the early nineteenth century.

Among the American paintings frequently on view are portraits by Charles Willson Peale, his son Rembrandt Peale, Hesselius, John Singleton Copley, and Thomas Sully, as well as Thomas Moran's *Hiawatha and the Great Serpents*, landscapes by Jasper Cropsey and Washington Allston, and Thomas Cole's *A Wild Scene*. The latter, purchased by the museum in 1958 with the artist unattributed, was subsequently established to be the long lost oil commissioned by Baltimorean Robert Gilmor, one of America's earliest collectors, and the first version for Cole's *The Savage State*, one of his monumental paintings in the epic series *The Courses of Empire*.

Also displayed are silver and furniture created in the eighteenth and nineteenth centuries, with emphasis placed on works by Maryland or Baltimore craftsmen. Notable pieces include: a Hepplewhite sideboard by John Shaw of Annapolis and a classical-style secretary-bookcase from Baltimore, as well as furnishings made in New York or New England such as a lady's secretary with tambour shutters and a classical-style sideboard, both attributed to John and Thomas Seymour of Boston; an early eighteenth-century japanned high chest from Newburyport, Massachusetts; and a standing Tiffany lamp. Quilts, coverlets, and other American textiles from the same periods are also exhibited.

A separate gallery is devoted to European decorative arts. In recent years the museum has been actively collecting English examples: several outstanding pieces of eighteenth- and nineteenth-century English silver have been presented to the

museum in memory of Clifford Rathone Hendrix, and Mr.and Mrs. Kenneth S. Battye have donated a selection of English porcelain. Other important works include a large Delft punch bowl (1725), a Meissen swan service dish (1736–38), and an Austrian presentation tankard, which is signed and dated by Antonius Schultz in 1737.

The extensive holdings of the Prints and Drawings Department include about 65,000 prints and 2,500 drawings. This comprehensive collection surveys print-making from its beginnings in the fifteenth century to the present, including engravings and etchings by masters of the media such as Dürer, Schongauer, Rembrandt, Piranesi, and Goya, as well as recent works by Johns, Rauschenberg, and Dine. Of special note is the large Lucas Collection, containing nearly 15,000 nineteenth-century prints, with superb impressions of engravings, etchings, and lithographs by Delacroix, Daubigny, Corot, Manet, Whistler, and Mary Cassatt, among others. The museum also owns more than 150 lithographs by Toulouse-Lautrec (Nelson and Juanita Grief Cutman Memorial Collection) and numerous prints by Picasso and Matisse, as well as the German Expressionists.

Similarly, the drawings holdings are especially strong in the modern period, highlighted by a large number of outstanding works by Picasso and Matisse from the Cone Collection. Furthermore, the museum has actively collected nineteenth- and twentieth-century examples, with contemporary works frequently given to the Thomas E. Benesch Memorial Collection, established in 1959. This selection of more than a hundred drawings and watercolors includes important works by Johns, Vasarély, Lindner, and Kelly.

Also housed in the Prints and Drawings Department is the museum's collection of about twelve hundred photographs. Photographers represented include Alfred Stieglitz, Edward Steichen, Paul Strand, Edward Weston, Margaret Bourke-White, Alvin Langhorn Coburn, Walker Evans, Andreas Feininger, Paul Caponigro, and others. The museum also owns a complete set of Stieglitz's *Camera Work*, published in the early 1900s.

The museum also possesses important collections of arts from Africa, Oceania, and the pre-Columbian Americas. The late Janet and Alan Wurtzburger purchased the core of these works during the 1950s and early 1960s. In 1954 they donated their outstanding selection of more than one hundred African objects, including a Mendi mask, Baga headress, Bambara headpiece, Benin carved head, Bakota funerary figure, and various other carvings from the countries along the West Coast of Africa, such as Sierre Leone, Liberia, Nigeria, and the Ivory Coast. The following year, the Wurtzburgers acquired and gave to the museum an internationally known collection of nearly two hundred pieces of Oceanic art from Australia, Melanesia, and Polynesia. During the early 1960s, Alan Wurtzburger collected pre-Columbian art from Mexico and Central and South America, donating more than a hundred objects to the museum. These extensive stores of art from Africa, Oceania, and pre-Columbian Americas assembled by the Wurtzburgers and further augmented by individual gifts by others are on permanent display in new galleries in the renovated museum.

In 1956 Mrs. William Woodward presented her collection of "Cherished Portraits of Thoroughbred Horses" together with funds for galleries to exhibit these paintings. This collection, a tribute to the late William Woodward, owner of the famous Belair Stables, includes oils by George Stubbs and J. N. Sartorius and many works by the horse painter specialist J. F. Herring.

Although not extensive, the small collection of Oriental art, the majority of pieces purchased with funds donated to the Julius Levy Memorial Fund, contains works of high quality. The selection of Chinese ceramics includes examples from Neolithic to present times. Other distinctive works are a Bactrian camel from the T'ang Dynasty (A.D. 618–906); a thirteenth-century life-sized bronze, *Kuan Yin*, the Chinese Goddess of Mercy; the stone Gandharan *Bodhisattva* from Northwest India (second-fifth century A.D.); two Indian *Yaksi* figures from the eighth century; a carved panel, *Tribute Bearer*, from the fourth century B.C. Persian palace at Persepolis; and other art objects from the Near and Far East.

The Baltimore Museum has an art reference library containing about thirty-five thousand volumes. The library subscribes annually to sixty-seven journals and is on exchange with 250 institutions. Noncatalogued material fills more than forty cabinets with vertical files. The library is open to the public by appointment but is noncirculating.

Black-and-white photographs of museum objects may be purchased from the Department of Rights and Reproductions, and catalogues and other museum publications can be ordered through the Museum Shop, which also sells slides, postcards, and color reproductions, as well as books and gift items.

In addition to the collection catalogues listed in the bibliography below, The Baltimore Museum of Art publishes catalogues for its major loan exhibitions, as well as a regular bulletin. The latter, frequently containing scholarly articles on works in the collection, has been printed under the following names: *News of The Baltimore Museum of Arts* (1923–27), *News Record of The Baltimore Museum of Art* (1928–35, abbreviated to *News-Record*), *Museum Quarterly of The Baltimore Museum of Art* (1936–38, abbreviated to *Quarterly*), *The Baltimore Museum of Art News* (1939–69, abbreviated to *News*), and *The Baltimore Museum of Art Record* (1970–75, abbreviated to *Record*). The current publication, *The Baltimore Museum of Art Calendar*, issued monthly since 1975, lists exhibitions, film showings, and other special events conducted at the museum.

Selected Bibliography

Museum publications: *The Baltimore Museum of Art: A Collection of Collections*, n.d.; *A Picture Book: 200 Objects in The Baltimore Museum of Art*, 1955; *American Paintings, 1750–1900, from the collection of The Baltimore Museum of Art*, 1983; *The American Wing*, c. 1970; *Cone Collection: A Handbook with a Catalogue of Paintings and Sculpture*, 1955; *Eighteenth- and Nineteenth-Century Maryland Silver in the Collection of The Baltimore Museum of Art*, 1975; *Gallagher Collection Catalogue*, News 16, no. 2 (December 1952-January 1953); *The George A. Lucas Collection*, 1965; *The Great American Cover-Up: Counterpanes of the 18th and 19th Centuries*, Record 2, no. 2 (1971); *Italian*

Paintings from the 14th to the 18th Centuries in the Collections of The Baltimore Museum of Art, 1980; *Matisse as a Draughtsman*, 1971; *The Oval Room from Willow Brook*, 1966; *Paintings, Sculpture, and Drawings in the Cone Collection*, 1967 (rev. ed.); *The Perlman Bequest Catalogue, News*, 25, no. 1 (Fall 1961); *Picasso: Drawings and Watercolors, 1899–1907*, 1976; *Robert Mills' Waterloo Row, Baltimore, 1816, Record* 1, no. 12 (1971); *Saidie A. May Collection, Record* 3, no. 1 (1972); *Thomas E. Benesch Memorial Collection, Record* 1, no. 2 (1970); *The Wurtzburger Collection of African Sculpture*, 1958 (rev. ed.); *The Wurtzburger Collection of Contemporary Sculpture, News* 23, no. 3 (Spring 1960); *The Wurtzburger Collection of Oceanic Art*, 1956; *The Wurtzburger Collection of Pre-Columbian Art*, 1958; *Annual I, The Museum: Its First Half Century*, 1966; *Annual II, Studies on Thomas Cole, an American Romanticist*, 1967; *Annual III, Studies in Honor of Gertrude Rosenthal, Part One*, 1968; *Annual IV, Studies in Honor of Gertrude Rosenthal, Part Two*, 1972; Ashton, Dore, "*Summer Night Bliss*: A New Painting by Hans Hofmann," *News* 25, no. 3 (Spring 1962), pp. 4–8; Breeskin, Adelyn D., "The Benesch Collection of Drawings," *News* 24, no. 3 (Spring 1961), pp. 13–19; idem, "Picasso's 'Saltimbanques' in the Cone Collection," *News* 13, no. 3 (December 1949), pp. 1–4; "The Chestertown Room," *News-Record* 4, no. 6 (May 1937), pp. 2–3; Garlick, Kenneth, "Some English Portraits in the Museum's Collections," *News* 26, no. 1 (Fall 1962), pp. 4–13; Gray, Christopher, "Marie Laurencin and Her Friends," *News* 21, no. 3 (February 1958), pp. 6–13; Hoffman, Grace, "The Painter Greuze and His *Portrait of the Marquise de Besons*," *News* 12, no. 7 (April 1949), pp. 1–3; Lanier, Gloria, "Adler-May Collection of Textiles", *Quarterly* 1, no. 4 (October-December 1936), pp. 8–12; Merritt, Howard S., "American Landscape Paintings in the Museum Collection," *News* 21, no. 2 (Winter 1962), pp. 1–15; Milliken, William M., "*Moses Sweetening the Waters of Marah*," *News* 22, no. 1 (October 1958), pp. 3–11; Morey, C. R., "The Antioch Mosaics at Baltimore", *Quarterly* 2, no. 4 (Winter 1937–38), pp. 3–5; Munhall, Edgar, "Greuze's *Portrait of the Comtesse Mollien*: Study of a Motif," *News* 26, no. 1 (Fall 1962), pp. 14–23; Pope, John, "The Art of Gandhāra," *News* 18, no. 3 (February 1955), pp. 1–8; Rosenthal, Gertrude, "Gauguin's *Woman with Mango*", *News* 15, no. 6 (March-April 1952), pp. 1–6; idem, "Matisse's Reclining Figures: A Theme of Variations", *News* 19, no. 3 (February 1956), pp. 10–15; idem, "St. Catherine, A Swabian Sculpture of the Late Gothic Style", *News* 11, no. 5 (February 1948), pp. 1–3; idem, "Two Roman Garden Scenes by Robert", *News* 10, no. 1 (October 1946), pp. 3–7; idem, "The Van Dyck of the Epstein Collection", *News* 18, no. 6 (March 1946), pp. 3–7; Spencer, Eleanor P., "A Collection of Early Woodcuts", *News* 26, nos. 2–3 (Winter-Spring 1963), pp. 5–20; Zigrosser, Carl, "Drawings by Käthe Kollwitz", *News* 19, no. 3 (February 1956), pp. 1–9.

Other publications: Bell, Clive, *Modern French Painting in the Cone Collection* (Baltimore 1951); Carlson, Victor, and Smith, Carol Hynning, *Master Drawings and Watercolors of the Nineteenth and Twentieth Centuries, The Baltimore Museum of Art* (New York 1979); Cone, Etta, *Catalogue of Paintings, Drawings, Sculpture* (Baltimore 1934); Epstein, Jacob, *The Jacob Epstein Collection in The Baltimore Museum of Art* (Baltimore 1939); Jacobs, Henry B., *The Collection of Mary Frick Jacobs* (Baltimore 1938); Morey, Charles R., *The Excavation of Antioch-on-the-Orontes* (Read on April 24, 1936, before the American Philosophical Society; reprinted by The Baltimore Museum of Art, 1937); Perlman, Bennard B., "The Baltimore Museum of Art's 25th Anniversary", *Arts Digest*, 29 no. 16 (May 15, 1955), pp. 14–19; Vosburgh, W. S. *Cherished Portraits of Thoroughbred Horses from the Collection of William Woodward* (n.p. 1929).

<div align="right">CAROL HYNNING SMITH</div>

WALTERS ART GALLERY (also THE WALTERS), 600 North Charles Street, Baltimore, Maryland 21201.

The Walters Art Gallery is formed primarily of the private collections of William Thompson Walters (1820–1894) and his son Henry (1848–1931). Of the approximately twenty-seven thousand objects in the collection today, only about three thousand have been added since the Gallery was opened as a public museum in 1934, enriching but not changing the character of the museum's collections as formed originally by the very different interests of father and son.

William Walters went to Baltimore in 1841 from Pennsylvania and began to build his fortune as a commission merchant, liquor manufacturer, and railroad entrepreneur. He probably began collecting his first year in Baltimore and, until the Civil War, concentrated mainly on American art. Many of these paintings were sold at the Old Dusseldorf Gallery in New York in 1864, but the Gallery still owns more than 240 examples of American paintings, drawings, and watercolors by about one hundred artists, almost exclusively from the nineteenth century. Of them, about 120 were William's purchases, 80 were collected by his son, and the rest were later additions. There are examples, in various media, by many of the most famous nineteenth-century American artists: Frederick Church, Asher B. Durand, Thomas Cole, Charles Loring Elliott, Gilbert Stuart, Benjamin West, and Richard Caton Woodville.

In addition, the gallery owns two hundred watercolors of the Far West painted by Alfred Jacob Miller for William Walters between 1858 and 1860. These watercolors were based on sketches that Miller had made on a trip to the Far West in 1837 as artist to Captain William Drummond Stewart, member of an expedition of the American Fur Trading Company, and are the earliest visual record of the American West.

During the American Civil War, William Walters, whose loyalties were divided, moved to France, an experience that changed his interests in collecting. There he was introduced to prominent French artists by George Lucas, a Baltimorean living in Paris who acted as agent for Walters and other American collectors. Walters bought some of the most celebrated paintings of his day: Paul Delaroche's reduction *The Hemicycle*, Baron Leys' *The Edict of Nantes*, and Alphonse deNeuville's *The Attack at Dawn*. He also commissioned four watercolors from Daumier, the well-known transportation series of the three railroad carriages and the omnibus. Academic painters whose works attracted him were Gérôme, Meissonier, Gleyre, Bouguereau, Decamps, Detaille, and Bonnat. In addition, the Barbizon painters were also well represented in his collection, most notably Théodore Rousseau's *Le givre*, an oil sketch that caused such a furor when first exhibited in 1861 as a finished painting that it had to be withdrawn from the Salon.

Walters was especially interested in the work of Antoine-Louis Barye, a French animal sculptor by whom there are 150 examples in the collections. The most impressive of these works is the *surtout de table*, a group of five separate hunt pieces, commissioned in 1834 by the duc d'Orleans. Also exhibited in the Barye

Gallery are models in various media and a selection of watercolors, oil paintings, and more than three hundred drawings from the collection of Barye's daughter Madame Vildieu.

While serving as U.S. commissioner to the Vienna International Exposition in 1873, William Walters began to acquire examples of Oriental art. During the next two decades he visited other expositions, assembling the first comprehensively planned collection of Far Eastern art in America.

The purchases he made at the expositions are not recorded, except that at the Vienna Exposition of 1873 he acquired examples of porcelains dating before 1630 from the collection of an uncle of the shah of Persia. At his death, he owned about eighteen hundred pieces of Chinese ceramics; Henry's purchases brought the total of Chinese pieces to about two thousand and of Japanese to about five hundred. Many of these examples date from the seventeenth through the nineteenth century, since earlier examples were not well known to American collections before the end of the century. When possible, he acquired examples from earlier dynasties: three examples from the Han Dynasty (206 B.C.-A.D. 220), about a dozen from the Sung Dynasty (A.D. 960–1279), three or four from the Yüan Dynasty (A.D. 1260–1369), and about thirty from the Ming Dynasty (A.D. 1368–1644). Only the T'ang Dynasty (A.D. 618–906) was not represented, a deficiency since remedied by the acquisition of several pieces, including a large, three-color glaze camel.

One of the most splendid items in the collection is the K'ang Hsi peach-bloom vase (1662–1722), which William Walters bought in 1886 from the sale of the collection of Mary J. Morgan. This purchase caused a stir in the art world, since at that time the price he paid was the highest ever for a work of art.

The Oriental collection also includes small groups of ancient Chinese bronzes and early sculptures and about one hundred jade and fifty hard-stone carvings, mostly eighteenth century. The Japanese examples, also from the eighteenth and nineteenth centuries, include objects of silver and bronze, more than four hundred netsukes, four hundred lacquers, and more than one thousand swords and fittings.

Originally, Walters kept the collection in his house on Mount Vernon Place, which he had purchased in 1857. He first opened the collection to the public in 1876; thereafter, the collection was open on Wednesdays and Saturdays during the spring months. Admission fees were donated to The Poor Association of Baltimore. This practice was continued by his son Henry until his death in 1931, with only a short interruption during the construction of the large gallery on Charles Street between 1905 and 1908.

When William Walters died in 1894, Henry inherited the family interests in railroads and in collecting, expanding the scope of the collection to include works ranging from the Ancient Near East to the French Impressionists.

Early in his collecting life, Henry Walters found it necessary to construct a suitable building for his ever-growing collection. In 1902, after he had purchased the Massarenti Collection, he commissioned William Delano to plan a private gallery on the corner of Charles and Centre streets. The building, patterned after

the seventeenth-century Palazzo Balbi in Genoa, was opened to the public for the first time on February 3, 1909, and the already well-established practice of opening the collection at certain times during the year was continued.

Henry Walters died in 1931 and left the collection, the building on Charles Street, his house on adjacent Mount Vernon Place, and an endowment to the mayor and City Council of Baltimore. It was opened as a public institution in 1934.

In addition to receiving income from the endowment, the Walters Gallery receives support on a regular basis from the city of Baltimore, the state of Maryland, and the neighboring counties of Baltimore and Anne Arundel.

The original Gallery building was already too small for the collection when Henry died, but it was not until November 1974 that an addition was completed. This new wing provided one hundred thousand square feet of exhibition space, a new conservation laboratory, photography studio, library, manuscript and rare-book room, and curatorial offices. The addition was designed by Donald Tellalian of the firm Shepley, Bullfinch, Richardson and Abbot of Boston.

The museum is governed by a board of trustees, numbering eighteen members, elected for six-year terms. It is administered by a director, associate director, deputy director for development, and an administrative officer and includes curatorial departments of Egypt and the Ancient Near East, Greek and Roman Art, Medieval Art, Manuscripts and Rare Books, and Eighteenth and Nineteenth Century Art, as well as the Department of Education, the Library, the Museum Store, and the Department of Publications. The Conservation Department, established in 1934, is the third oldest in America, has developed many new techniques, and is also a major training center in the field. The Walters Art Gallery is aided in its operations by sixty volunteers, the Women's Committee, and the William T. Walters Association, a group of prominent young businessmen.

The collection of objects from the Ancient Near East, although one of the Gallery's smallest, is comprehensive, covering the major civilizations of that area from 3000 B.C. to 500 B.C.

Many of the objects were bought by Henry Walters, but notable additions since his death include the Balawat Gate fragments (859–824 B.C.) and the Tell Halaf reliefs (ninth century B.C.). Examples of writing, one of the major achievements of the cultures of the Ancient Near East, can be studied in a group of thirty-three cuneiform documents dating from about 3000 B.C. to late Babylonian times. The most famous of these objects is from the proto-literate period (c. 3200–2900 B.C.), illustrating both pictures and cuneiform signs. Closely connected with writing and art are the cylinder seals, of which the gallery's excellent collection spans all of the time periods and cultures of the area. Other important objects include two large, carved stone reliefs of genii from the palace of Ashurnasirpal (883–859 B.C.), a rare pair of bronze votive figurines from Syria (c. 3000 B.C.), two gold crowns of Phoenician origin (1000 B.C.), and a Hittite silver seal (4.1 centimeters diameter) from about 1400 B.C. that was instrumental in deciphering Hittite hieroglyphs. From the area of Iran there is a group of

Luristan bronzes, eighth century B.C., and a relief of a servant probably from the western staircase of the palace of Darius at Persepolis (fifth to fourth century B.C.).

The Egyptian collection is one of the most important in this country, numbering about 1,000 pieces, and illustrates major periods from Predynastic times to the Roman occupation. There are more than 700 pieces of sculpture; sculptures-in-the-round and relief, funerary stelae and offering tables, sculptors' models, and bronze figures. There are also Fayum mummy portraits, fragments of wall paintings, examples of core-wound glass objects, about 150 ivory pieces, and numerous examples of ceramic objects, including about 100 faience vessels and fragments.

The nucleus of both the Classical collection and the group of Italian paintings came with Henry Walters' acquisition in 1902 of more than fifteen hundred works owned by Don Marcello Massarenti, a priest and underalmoner to Pope Leo XIII, and his successor, Pius X. With the additions since Henry Walters' death, the Classical collection is probably the third largest in America.

Prehistoric and early historic Greece are represented by a chryselephantine snake goddess from Crete, several pieces of Mycenean pottery, and bronze animals and pottery from the Geometric and Orientalizing periods. There is also an eighth-century bronze statuette of a seated man and a seventh-century statuette of a woman from Boeotia.

The Greek pottery collection contains examples of many shapes and styles with ninety-six Attic black-figure pieces, twenty-one Corinthian black-figure pots, fifty-two Attic red-figure vases, and numerous other types, including a Greek cargo amphor.

The collection of Greek monumental sculpture includes examples that represent the fundamental developments in this area: the fragment *Athena Parthenos, Kniskos Crowning Himself* by Polyclitus, the torso *Diadoumenos* by Polyclitus (acquired 1968), the *Young Satyr* after Praxiteles, and a woman (formerly in the Hope Collection) whose body is a copy of an early fifth-century Greek original and whose head, not original to the statue, is a copy of an Archaic work. The fine collection of Hellenistic sculpture includes a life-size drapery statue of the Muse Clio, which was acquired in 1978 in honor of the former curator of Greek and Roman Art, Dorothy Kent Hill. The collection includes a fine grouping of about two hundred Classical bronze statuettes.

The Etruscan collection, although small, is notable and includes five unusual bronze *cistae* from Praeneste, about thirty metal implements, and two black-figure, six red-figure, and twenty-five bucchero pottery vases. There is also an interesting seventh-century B.C. ivory jewelry casket carved with motifs popular in the Orientalizing phase of that century.

Roman art is well represented by several media. Outstanding monumental stone sculptures include an excellent head of Augustus from a statue representing the emperor as Pontifex Maximus and a well-known Republican portrait head. A torso of a Julio-Claudian emperor is one of a few such cuirassed statues in

this country. Another unusual example of Roman sculpture is the over-life-size togate statue, purchased in 1969, dating from the mid-first century.

Two fragmentary bronze heads of the Julio-Claudian family are the only known Imperial portraits excavated within the city of Rome to be seen in America. They are thought to represent Augustus and the young Tiberius.

The collection also contains examples of Roman blown glass, silver utensils, mosaics, and pottery. Examples of furnishings include a bronze banqueting couch purchased at the Brummer auction in 1949, a folding tray stand, and lamp holders.

The chief treasures of the Massarenti Collection are the seven marble Dionysiac sarcophagi, part of a group of ten that had been excavated in 1884 from a tomb near the via Salaria in Rome. This unique group illustrates the development of Roman relief sculpture from the middle of the second century to the early years of the third century and also provides information about the beliefs and practices of the Late Roman mystery cult of Dionysos-Sabazios.

Henry Walters, often in the vanguard of collecting, acquired works representing the two great ages of Byzantine culture, the Justinian and Macedonian Renaissances, as well as later periods. In 1910 he purchased twenty-two pieces of a silver treasure discovered near Hamah in northern Syria. Today they form the most complete set of Early Christian liturgical vessels in existence. The Gallery also owns part of an important group of enameled and glazed tiles from the ruins of a church near Nicomedia (the rest are in the Louvre [q.v.]), which are excellent examples of Byzantine draftmanship during the Macedonian Renaissance. There are some thirty ivories and several examples of Byzantine gem carving, the most outstanding being the so-called Rubens Vase, an agate vessel probably carved in fourth-century Constantinople and once a prized possession of the painter Peter Paul Rubens.

Medieval art was one of Henry Walters' special interests, and the Gallery now possesses one of the finest collections of medieval objects in America. Two heads of kings from the Abbey of St. Denis (rebuilt by Abbot Suger in 1140) are the earliest examples of Gothic sculpture. The Gallery owns about thirty-five pieces of stained glass, from the thirteenth to the seventeenth century, of which the finest is the mid-thirteenth-century window of St. Vincent from the Parisian Abbey of St. Germain des Près. A particular strength of the Walters is more than eleven hundred carved ivories from all over the world. Some of the most notable early examples are a tenth-century plaque in the Carolingian tradition from a book cover depicting the Three Marys at the Tomb, a twelfth-century South Italian oliphant, and an early twelfth-century panel from Northern Italy illustrating the Last Supper, derived from Byzantine models. Some of the rarest works date from the late thirteenth century, such as a standing Virgin and Child and a seated Madonna. The Gallery is especially rich in examples of fourteenth-century Parisian ivories, such as the famous jewel casket with scenes of chivalry and Arthurian legends and a diptych leaf with scenes from the Passion of Christ by the Master of Kremsmunster. There are also examples of mirror backs, crozier heads, chessmen, and combs.

The collection of thirteenth- and fourteenth-century Limoges enamels is one of the best in the world, including a unique chanter's staff with the legend of St. Valerie. Other notable liturgical objects are the twelfth–thirteenth-century Flemish reliquary of St. Amandus, an early-thirteenth-century German arm reliquary, a fourteenth-century Bohemian reliquary of Christ as the Man of Sorrows executed for a thorn from the Crown of Thorns, and a thirteenth-century rock-crystal crozier head made for an abbess.

Late Gothic sculpture is represented by two outstanding pieces: a life-size limestone Virgin and Child from Besançon, in the style of Claus Sluter (bought in 1959), and a large oak altarpiece of the Passion of Christ, carved in Flanders around 1492 for a church in Normandy.

Henry continued his father's interest in fine books and established one of the finest collections of illuminated manuscripts in America. He began buying manuscripts in the late 1890s and by his death in 1931 had acquired about 730 items. The collection, enriched by purchases and gifts, includes some 800 manuscripts, more than two-thirds of Western origin and the remainder from the Middle East and the Orient. About a quarter of the collection represents the fifteenth-century Books of Hours, a reflection of Henry's taste. Highlights include a late eleventh-century South German treasure binding; the *Conradin Bible*, a magnificent mid-thirteenth-century South Italian production; the only surviving imperial menologium for January, dating from the mid-eleventh century; a superb French *Antiphonary* from Beaupré, dated 1290, a gift of the Hearst Foundation in 1957; and the foremost collection of Armenian manuscripts in America. The nucleus of the Walters' early printed book collection was formed by the purchase in 1902 of more than 1,000 incunabula from Leo Olschki in Florence. The collection formed by Henry also includes more than 700 printed books, ranging in date from the sixteenth to the early twentieth century. The manuscripts and books are housed in a special library that is open to scholars by appointment. They are displayed in regularly changing exhibitions in two galleries, one for Islamic and one for Western manuscripts.

Henry Walters was the first American to buy Sassanian art, beginning in the early 1920s. Some of the most important objects in that area of the collection today are a unique fifth-century silver plate showing a king and queen reclining on a dais, a partially gilt-silver vase depicting four nude female figures with various attributes, and an unusual bronze throne leg representing the forefront of a griffin.

The Islamic collection, one of the most interesting and diverse in the country, is particularly strong in ceramics of the High Middle Ages, jewelry, weapons, Mughal miniatures, and signed and dated metalwork. Some of the most important pieces are to be found in the latter category, which includes about sixty bronzes, about thirty gold and silver pieces, and about one hundred objects of arms and armor. Representative of the kind of rare objects are an eighth-century brass ewer inlaid with copper and silver; a unique late-twelfth-century round, domed ink pot; and a large inlaid silver ewer made in 1246.

The nucleus of the Walters painting collection was formed by more than five hundred pictures from the Massarenti purchase. There are great strengths in the area of thirteenth- and fourteenth-century Italian paintings, such as a late thirteenth-century Tuscan painted Crucifix and a late-twelfth–early-thirteenth-century fragment of a cross from the school of Spoleto depicting the weeping Virgin. The group of fourteenth-century paintings is unusually well represented by examples from all over Italy. Notable Florentine works include Bernardo Daddi's *Virgin* and an unusual triptych by Niccolò di Tommaso. Sienese examples are a *Virgin with Saints* by Pietro Lorenzetti, a *Crucifixion* by Barna da Siena, *The Massacre of the Innocents* by Bartolo di Fredi, and works by Niccolò di Segna, Lippo Vanni, and Andrea di Bartolo. Painting in the Marches is represented by an excellent triptych by Carlo da Camerino, and Venetian works include a polyptych by Caterino Veneziano.

The collection also offers excellent examples of fifteenth-century Italian painting. Most unusual is an altarpiece of the Annunciation from the workshop of Bicci di Lorenzo that still preserves its original baldacchino and frame. Other important works are Fra Filippo Lippi's *Virgin and Child*, a cassone panel of the story of Io by Bartolommeo di Giovanni, the panel *Sulpicia, a Roman Lady Famous for Her Virtue* by the Sienese artist Giacomo Pacchiarotto, a *Virgin* from Perugino's final period, and a *Virgin and Child* by Schiavone. One of the most unusual paintings is a panel by an unknown Central Italian artist, *Architectural Perspective*.

Raphael's *Virgin of the Candelabra* was Ingres' favorite Renaissance painting. Mannerist paintings of note include Pontormo's *Portrait of Maria Salviati*, Rosso Fiorentino's *Holy Family*, Vasari's *Dream of Jacob*, and Veronese's life-size portrait of the countess da Porto and her daughter.

The Walters collection of seventeenth- and eighteenth-century Italian paintings is one of the finest in America. For example, there is Bernardo Strozzi's splendid *Adoration of the Shepherds*, Tiepolo's *Jugurtha before the Roman Consul*, two Pannini views of Rome, a Guardi scene of the back streets of Venice, Pietro Longhi's *The Music Lesson*, and Pompeo Batoni's portrait of Cardinal Colonna di Sciarra, one of the finest examples of settecento portraiture. The Spanish Baroque is represented by nine paintings, the best known being a late El Greco, *St. Francis in Ecstasy*.

The collection of small Renaissance bronze sculptures that Henry Walters assembled from 1900 to 1931 is very distinguished. There are some 350 statuettes, reliefs, plaquettes, medals, and domestic utensils that range in date from the fifteenth to the eighteenth century. The gallery that houses this collection contains a magnificent mid-sixteenth-century wooden ceiling from the Palazzo Aliverti, Milan, bought in 1903.

The collection of Flemish and Dutch paintings is strongest in works of the fifteenth and sixteenth centuries. Important panels are the *Portrait of a Donor and St. John the Baptist* by Hugo van der Goes, *The Archdukes Albert and*

Isabella in a Collector's Cabinet attributed to Jan Bruegel the Elder and Frans Francken II, and *Panoramic Landscape with the Abduction of Helen of Troy* by Martin van Heemskerck. Although the nucleus of the Northern group also came from the Massarenti Collection, a gift of eighteen paintings from the James Murnaghan Collection in 1973 broadened the scope of this area and added works by the seventeenth-century painters Bloemaert, Terbrugghen, Lievens, Eeckhout, and Benjamin Cuyp.

During the years in which he collected, Henry Walters became increasingly interested in objects from the French eighteenth century. Several outstanding pieces of furniture are in the Gallery today: a model for the jewel cabinet of Marie Antoinette presented at her marriage in 1770; a three-tiered console table with bronze mounts inlaid with a central Wedgwood plaque and stamped by Adam Weisweiler. Acquisitions have increased the holdings. In 1974 a roll-top desk inlaid with mother-of-pearl by François-Gaspard Teuné was purchased (the Laura Delano Fund); in 1969 a lady's desk by Maurice Evald was bought through the Philip Perlman Fund; and in 1970 a pair of corner stands by Martin-Étienne L'Hermite in the Louis XV style and a marble-topped commode by Teuné were acquired through the Jencks Fund.

Other holdings from the eighteenth century are clocks, gold boxes, tapestries, and Boucher paintings. The Sèvres porcelain collection was also assembled during the 1920s, largely from the Hodgkins Collection purchased in 1928.

The Walters has major holdings in portrait miniatures dating from the sixteenth to the nineteenth century. During his lifetime, Henry Walters bought more than two hundred French, English, and Russian miniatures. In 1963 the A. J. Fink Foundation, Inc., enriched the holdings in this area by a gift of more than four hundred miniature portraits and paintings.

During a cruise to the Baltic Sea in 1900, Henry Walters became interested in Russian decorative works of art, another of his pioneering collecting efforts. In the Gallery today, there are about seventy examples of silver and gold work, including loving cups, boat-shaped bowls for ladling beer, porringer-shaped cups for liquor, a gold vase by Ador commissioned by Catherine the Second (late seventeenth-early eighteenth century), and rare examples of enameled silverware of the seventeenth century (usolsk enamels). The collection of Fabergé, including two imperial Easter eggs, totals eighteen pieces. There are, in addition, eighteen icons that illustrate Russian religious painting from 1400 to 1600, early examples that are practically unknown outside of Russia.

During the last ten years of his life, Henry Walters began collecting arms and armor, an outgrowth of his interest in the decorative arts. Several auctions in the 1920s of famous collections provided the opportunity to buy both European and Japanese arms and armor. Turkish helmets and cuirasses of the fifteenth and early sixteenth centuries were also purchased during these years. Some of the more famous pieces include the tilting breastplate of Emperor Maximilian II; the parade armor of Don Alonso Perez de Guzman, commander of the Spanish

Armada; a pair of seventeenth-century Brescian flintlock pistols signed on the locks, stocks, and barrels by their makers; and a rare camail head defense of the thirteenth century from Epernay.

Henry Walters also added to his father's already extensive holdings in the area of nineteenth-century painting, acquiring important works by Daumier, Millet, Corot, Ingres, and Delacroix. He also extended the collection to include works by the Impressionists. In 1903 he acquired from Mary Cassatt the Degas *Portrait of Estelle Musson Balfour* and the Monet *Springtime*, painted during the summer of 1874 at Argentueil. In 1909 he purchased Mary Cassatt's *L'Enfant à la robe bleue* and Manet's famous *At the Cafe*.

The jewelry collection, one of the finest in America, is illustrative of Henry Walters' admiration of fine workmanship. Comprised of about a thousand pieces, it contains examples from every major Western civilization. Some of the more outstanding pieces are the Phoenician gold crowns from Syria, a Hellenistic gold and garnet diadem, much Etruscan granulated jewelry, the first century B.C. Olbia Treasure from south Russia, the Visigothic eagle brooches, the Renaissance Esterhazy marriage collar, and the Tiffany sapphire iris brooch.

The Walters has an art library of more than seventy-five thousand volumes and complete sets of the major journals of art criticism and art and architectural history. The library is open to the public by appointment but is noncirculating.

Slides and photographs of objects in the collection may be purchased by writing to Photographic Services. In addition to containing the publications listed below, the Gallery has the *Bulletin*, founded in 1948, published from October through May, and the *Journal*, founded in 1938, an annual publication of scholarly articles concerned with objects in the museum.

Selected Bibliography

Museum publications: Boyer, Martha, *Catalogue of Japanese Laquers in The Walters Art Gallery*, 1970; Der Nersessian, Sirarpie, *Armenian Manuscripts in The Walters Art Gallery*, 1974; Hill, Dorothy Kent, *Catalogue of Classical Bronze Sculpture in The Walters Art Gallery*, 1949; Johnson, William R., *The Nineteenth Century Paintings in The Walters Art Gallery*, 1982; King, Edward S., and Marvin C. Ross, *Catalogue of the American Works of Art*, 1956; Lehmann-Hartleben, Karl, and Erling C. Olsen, *Dionysiac Sarcophagi in Baltimore*, 1942; McCracken, Ursula E.; Lilian M. C. Randall; and Richard H. Randall, Jr., ed., *Gatherings in Honor of Dorothy E. Miner*, 1974; Steindorff, George, *Catalogue of the Egyptian Sculpture in The Walters Art Gallery*, 1946; Verdier, Philippe, *Catalogue of the Painted Enamels of the Renaissance*, 1967; idem, *Russian Art—Icons and Decorative Arts from the Origin to the Twentieth Century*, 1959; Von Erdberg, Joan Prentice, and Marvin C. Ross, *Catalogue of the Italian Majolica in The Walters Art Gallery*, 1952; Zeri, Federico, *Italian Paintings in The Walters Art Gallery*, 2 vols., 1976; *Jewelry—Ancient to Modern*, 1979.

Other publications: Ross, Marvin C., *The West of Alfred Jacob Miller (1837) from the Notes and Water Colors in The Walters Art Gallery*, rev. ed. (Norman, Okla. 1968); Randall, Lilian M. C., ed., *The Diary of George A. Lucas—An American Art Agent in*

Paris, 1857–1909 (Princeton, N.J. 1978); idem, "Henry, Son of William: The Walters Rare Book Collection," *Grolier Club Gazette* (Fall 1979); *Apollo Magazine* (Christmas 1966); *Apollo Magazine* (November 1974); *The Art Bulletin* (June 1936).

<div align="right">MARY LOUISE WOOD</div>

———— Boston ————

ISABELLA STEWART GARDNER MUSEUM, 2 Palace Road, Boston, Massachusetts 02115.

The Isabella Stewart Gardner Museum, incorporated in 1900, is remarkable because it is the achievement of a single person. Isabella Stewart Gardner selected all of the objects, planned the building, supervised its construction, installed the collection, acted as the first director, and supplied funds for its endowment. By the terms of her will, nothing may be added to the galleries, and the general arrangement is to remain as she left it.

Isabella Stewart was born in New York City in 1840, the daughter of a successful businessman. At the age of twenty she went to Boston as the wife of John L. Gardner. The couple traveled widely, and Mrs. Gardner maintained a lively interest in the arts. They began to collect rare books and paintings by contemporary artists, and in the 1890s extended their acquisitions to Classical, medieval, and Renaissance sculpture; Oriental objects; European decorative arts; and, above all, Old Master paintings. By 1896 they had decided to establish a museum to accommodate their rapidly expanding collection. Mr. Gardner suggested the present site, and after his death in 1898 Mrs. Gardner went ahead with the plans. The museum was opened in 1903; Mrs. Gardner lived in an apartment in the museum, rearranging and adding to the collection until her death in 1924.

The museum is supported largely by Mrs. Gardner's endowment. A membership program, initiated in 1979, also contributes to the maintenance of the building and collections. The museum is governed by a self-perpetuating board of seven trustees. The director has full authority over the museum, the collection, and the staff. The staff includes an assistant director and curator, as well as conservators.

Willard Sears (1837–1920), a Boston architect, designed the museum, following Mrs. Gardner's specifications. There are three floors of galleries, with fourth-floor living quarters, all opening on a central courtyard. The museum has been designated a landmark by the Boston Landmark Commisssion and the Massachusetts Historical Commission and is included in the National Register of Historic Places.

The exterior of the museum gives no hint of its extraordinary character. The visitor enters through shadowy cloisters to come upon the interior courtyard filled with light and a brilliant display of flowers. Examples of Classical sculpture

stand about the periphery of the court, a Roman mosaic marks its center, while at the far end water trickles through a fountain. The courtyard is the core of the building, rising four floors to a glass roof. Decorative medallions are set into its mottled pink walls; Venetian windows and balconies give the impression of a Venetian palazzo turned in upon itself.

A wide marble staircase leads to galleries on the upper floors, where most of the collection is displayed. There the atmosphere is that of a private home where a family has lived and collected for generations. The galleries vary from great halls to intimate salons; each is furnished and has its own character. The walls of one are covered with red damask, another is hung with green silk, and a third gallery is lined with gilded leather and has a large painting set into its ceiling in the Venetian manner. Other rooms have a more rustic flavor with tiled floors, wood paneling, and high, beamed ceilings. The main galleries open onto the courtyard; their windows offer views across to other rooms or down to the central garden, enveloping the visitor in the transporting atmosphere of the building. Each room of the museum reflects not only Mrs. Gardner's taste but her theories on the exhibition of art. She spurned a didactic installation in favor of juxtapositions that spark the imagination and delight the viewer.

The collection consists of about three thousand objects. It is obviously personal, not intended to be encyclopedic, but it is, nevertheless, unusual in its quality and diversity. It spans thirty centuries, including examples of the art of the Classical world and the Orient, as well as Europe and America. Painting, sculpture, stained glass, textiles, furniture, ceramics, metalwork, rare books, prints, and drawings are all on permanent view, with almost nothing left in storage.

The museum is best known for its paintings. The collection is particularly strong in Italian Renaissance, with noteworthy examples of Dutch and Flemish art of the seventeenth century. Mrs. Gardner began to acquire Old Master paintings in the early 1890s, and although she continued to add to the collection until shortly before her death, most of the collection was assembled by 1906. She was advised in her purchases by Bernard Berenson, the great connoisseur of Italian paintings, whom she met when he was a student in Boston.

Paintings of the Renaissance are hung throughout the second- and third-floor galleries. They are not displayed in strict chronological order, but most of the Central Italian pictures of the fourteenth and fifteenth centuries are in the Room of Early Italian Paintings and the Raphael Room, and later works, primarily Venetian, are in the Veronese and Titian rooms. The collection includes a small panel (once part of a larger altarpiece) by Giotto and the *Assumption of the Virgin* by Fra Angelico. There are two paintings by Botticelli, the *Madonna of the Eucharist* and the *Tragedy of Lucretia*, and a pair by Raphael, a *Pietà* (once a predela panel in the Colonna Altarpiece, now in the Metropolitan Museum of Art [q.v.], New York) and a portrait *Count Tommaso Inghirami*. A large polyptych, *Madonna and Child with Saints Paul, Lucy, Catherine, and John the Baptist,* is the only complete altarpiece by Simone Martini outside of Italy.

Similarly, the fresco *Hercules* by Piero della Francesca is his only work in this medium outside of Italy. Titian's *Rape of Europa* was commissioned in the 1550s by King Philip II of Spain and is considered by many to be the finest picture ever to come to the United States. It was copied by both Rubens and Watteau—a watercolor sketch of the same composition, attributed to van Dyck, is exhibited with the painting.

The Dutch Room contains the museum's rich holdings of northern European paintings. They include a wide sampling of Rembrandt's early work: *Self Portrait* at the age of twenty-three; *Portrait of a Lady and Gentleman in Black*, painted shortly after the artist's arrival in Amsterdam; Rembrandt's only known seascape, the *Storm on the Sea of Galilee*; and one of the few landscapes he painted, the *Obelisk*. The Dutch Room also offers portraits by Rubens and van Dyck, pendant portraits of *Sir William Butts* and *Lady Butts* by Holbein, and *Concert* by Vermeer. The gallery is not, however, entirely devoted to Northern painting. It also contains one of the collection's eight paintings by Spanish masters, the portrait *Doctor of Law* by Francisco Zurbarán. (Velázquez' portrait *Philip IV* hangs in the Titian Room).

The modern pictures in the museum are an even more personal collection, largely the work of artists Mrs. Gardner befriended. There are portraits of Mrs. Gardner by John Singer Sargent: a painting of 1887–88 and a watercolor of 1922; by James McNeill Whistler: a small pastel dating from 1886; and by the Swedish artist Anders Zorn: drawings, an etching, and a painting. Sargent is particularly well represented; the museum offers at least one painting from every decade of his career and an example of each phase of his activity. The most famous is *El Jaleo*; completed in 1882, its enormous success established Sargent's reputation. There are eleven watercolors by Sargent, many of Venetian subjects. Although there are fewer works by Whistler, the group does include two important paintings, *Harmony in Blue and Silver: Trouville* and *Nocturne, Blue and Silver: Battersea Reach*.

Examples of modern European painting, the Impressionists and later schools, are limited to two striking portraits one by Edouard Manet, *Mme. Manet*, and another by Edgar Degas, *Mme. Gaujelin*, and, perhaps surprisingly, a small painting by Matisse, *The Terrace, St. Tropez*—the first painting by the artist to enter an American museum.

The Greek and Roman antiquities in the museum include figures of Greek goddesses, gods, and heros; herms and busts; and sarcophagi. The collection is particularly rich in Roman cinerary chests or urns of the first two centuries A.D. The most famous Classical statue is the *Gardner Peplophoros*, a representation of a youthful goddess, made in the time of Julius Caesar or Augustus after an original of about 455 B.C. Among eight sarcophagi is *Satyrs and Maenads Gathering Grapes*, perhaps the most important work of its kind in America. This large, rectangular coffin was exported from Athens to the area of Rome between A.D. 222 and 235 and was first seen in Rome in the 1550s. For more than 250 years it stood in the courtyard of the Palazzo Farnese, admired and

copied in sketchbooks and paintings from Renaissance times to the 1800s. The impressive mosaic that forms the pavement in the center of the courtyard also comes from the vicinity of Rome, from a bathing establishment of a villa near that of Augustus' wife, Livia, at Primaporta. The delicate design that centers about a Medusa's head is in the tradition of the Pompeian late second to third styles, that is, A.D. 25.

The collection of European sculpture includes the many decorative medallions, fragmentary reliefs, and architectural pieces that are incorporated into the building. Most of this sculpture was purchased in Venice and Rome between 1892 and 1897 and constitutes one of the first groups of early medieval and Renaissance sculpture to be brought to the United States. Most notable among the individual medieval objects are a twelfth-century Catalonian Christ from a Deposition group, a late-fourteenth-century Sienese Annunciate Angel, and a fifteenth-century retable from Lorraine with scenes of the Passion. There are also a number of German sixteenth-century polychromed wood sculptures. The most extraordinary example is the lavishly gilded *Altar of the Holy Kinship*, a Saxon work of about 1510–20. Among the Italian works are two large-scale, polychromed, terracotta groups, a *Virgin Adoring the Child* (c. 1480) by Matteo Civitali and an *Entombment*, with the Virgin, Christ, St. John, and the figure of the princess for whose tomb it was commissioned (c. 1483–87), by Giovanni Minelli. The most important single piece, however, is a large (1.05 meters high), bronze portrait bust of the Florentine banker Bindo Altoviti. Dating from 1550 and justifiably praised by Michelangelo, this bust is one of only two portraits firmly attributed to Benvenuto Cellini.

Mrs. Gardner's collection of books, manuscripts, and graphic art is small but, as in other areas, choice. There are examples of rare books from the fifteenth through the twentieth century. Among the finest works are three early editions of *The Divine Comedy*: the Landino commentary of 1481, with nineteen engravings after designs by Botticelli; the Brescia copy of 1487, with sixty-eight woodcuts; and the Aldine edition of 1502, the first book to bear the printer's famous mark, an anchor around a dolphin.

The museum has fewer than one hundred drawings. One-quarter of them are from the Renaissance and were purchased at a single sale, that of John Robinson, held at Christie's in 1902. The most outstanding of this group is a chalk drawing, the *Pietà*, by Michelangelo. Many of the drawings and virtually all prints are the work of Mrs. Gardner's contemporaries. The museum has a large number of etchings by Whistler and Zorn.

The museum's textile holdings consist of about four hundred pieces, largely of European origin, that date from the fifteenth to the nineteenth century. The core of the collection is a group of thirty-five Flemish tapestries, or tapestry fragments, including three exceptionally interesting fifteenth-century examples, *The Amazon Queens, The Story of Ahab*, and *Proverbs*, and ten tapestries from the Barberini Collection, dating from about 1550. Other areas of interest are sixteenth-century velvets, brocatelles from the sixteenth through eighteenth cen-

tury, and liturgical vestments. Fifty pieces of Italian and French lace offer a broad selection of technique and pattern.

Mrs. Gardner shared a love for the East with many Boston contemporaries, but her taste was certainly sharpened by a trip around the world in 1882, which included visits to China, Japan, Cambodia, India, and Egypt. The collection of Chinese objects is small; it includes a ritual *ku* beaker from the Shang Dynasty (c. 1200–1100 B.C.), a pair of bronze bears from the Han Dynasty (c. first century B.C.), and a large (1.42 meters high) Buddhist votive stele that bears a detailed inscription and the date 543. The art of Japan is represented by a number of folding screens from the early part of the Edo period (A.D. 1615–1868). The largest, *The Tale of Genji*, is a pair of six-fold screens of the seventeenth century.

Throughout her life Mrs. Gardner maintained a lively correspondence, exchanging letters with, among many others, Sargent, John La Farge, Henry Adams, Henry James, and T. S. Eliot. The letters and other momentos of friendship—photographs, calling cards, sketches—are now displayed in cases about the museum. Also in the museum archives are the literary, historical, and musical manuscripts Mrs. Gardner collected.

Slides and photographs of objects in the collection are available at the museum sales desk and may also be ordered by mail. In addition to publishing the guide and specialized catalogues listed below, the museum publishes an annual report, *Fenway Court*, which contains articles on objects in the collection.

Selected Bibliography

Museum publications: *Guide to the Collection, Isabella Stewart Gardner Museum*, 2d ed., rev., 1980; *The Isabella Stewart Gardner Museum*, 1978; *A Checklist of the Correspondence of Isabella Stewart Gardner at the Gardner Museum*, 1973; *Drawings, Isabella Stewart Gardner Museum*, 1968; *European and American Paintings in the Isabella Stewart Gardner Museum*, 1974; *Isabella Stewart Gardner and Fenway Court*, 3d ed., second printing, 1972; *Oriental and Islamic Art in the Isabella Stewart Gardner Museum*, 1975; *Sculpture in the Isabella Stewart Gardner Museum*, 1977; *A Short-Title Catalogue of Books and Manuscripts in the Isabella Stewart Gardner Museum*, 1980; *Textiles in the Isabella Stewart Gardner Museum*, 1981; *Titian's Rape of Europa*, 1960.

DEBORAH GRIBBON

MUSEUM OF FINE ARTS (alternately BOSTON MUSEUM OF FINE ARTS), 465 Huntington Avenue, Boston, Massachusetts 02115.

The Museum of Fine Arts, one of the oldest and largest art museums in the United States, was incorporated by the Massachusetts State Legislature on February 4, 1870. It was created to care for and exhibit the fine arts collection of the Boston Athenaeum, the Gray Collection of engravings from Harvard University, a collection of architectural casts from the Massachusetts Institute of Technology, and an assortment of art objects belonging to the city of Boston.

The museum has always been entirely financed by private funds. The only exception occurred in May 1870, when the city of Boston gave the museum a

tract of land in the area (later to become Copley Square) on which its first building was erected. The design for that museum was provided by the Boston architectural firm of John H. Sturgis and Charles Brigham. The first part, a Ruskinian Gothic structure, was opened to the public in July 1876.

In 1877 a portion of the building was set aside for instruction in drawing and painting. For the next twenty-four years, art classes were regularly held at the museum as an independent activity under the aegis of the School of Drawing and Painting. Throughout the years the school developed a highly respected faculty and curriculum. By 1901 its financial position was sound, and it was accepted as an integral part of the museum with the official description School of the Museum of Fine Arts.

Despite additions to the building in 1879 and in 1888 and 1889, by the later 1890s the location in Copley Square was no longer satisfactory. Thus in 1899 the museum acquired its present twelve-acre site between the Fenway and Huntington Avenue. Guy Lowell was the architect who designed a neoclassical building, the first section of which was completed in 1909, and provided seventy-three thousand square feet of space—nearly three times the room available in the old building. Five years later the addition of the Evans Memorial Wing increased the total exhibition area by 40 percent. Included in this expansion was a connecting rotunda, the dome of which was decorated with murals by John Singer Sargent. The main stairway leading to the rotunda was later remodeled, and the ceiling also decorated with Sargent murals.

In the 1920s the space available was further increased with the construction of the Decorative Arts Wing. This was enlarged in 1966–67 and another wing added in 1968–70 in memory of George Robert White. The newly completed West Wing, designed by I. M. Pei, with other recent additions, brings the total museum area to about 509,000 square feet.

The Museum of Fine Arts (MFA) is directly involved in activities at two other locations. Founded in 1968, the Museum of the National Center of Afro-American Artists has, since 1969, received financial support and technical and professional assistance from the MFA. The National Center's museum is located at 300 Walnut Avenue in Roxbury, Massachusetts. Its collection presently consists of 234 paintings and 172 other objects.

In 1979 the Museum of Fine Arts opened a satellite location at Faneuil Hall Marketplace in Boston. The new branch facility is open longer hours than is the Huntington Avenue building, and admission is free, thereby making the museum accessible to a broader segment of the public.

The governing body of the Museum of Fine Arts is a board of trustees, of which nine are appointed and from sixteen to a maximum of thirty are elected. Harvard University, the Massachusetts Institute of Technology (MIT), the Boston Athenaeum, and the Ladies Committee of the MFA each appoint one trustee. The remaining five appointments are ex-officio: the mayor of Boston, the superintendent of the Boston Public Schools, the president of the trustees of the Boston Public Library, the state commissioner of education, and a trustee of the

Lowell Institute. The trustees are elected by a board of overseers and serve overlapping terms of four years. They can be reelected continuously until age seventy-five. The museum is administered by a director, an associate director, and the curators in charge of the nine departments.

As a whole, the Asiatic art collection of the Museum of Fine Arts represents the finest assemblage of Asian art gathered in one institution anywhere in the world. Other museums may have greater individual collections of Japanese, Chinese, or Indian art, for example, but none is able to match the overall range, quality, and depth of the Museum of Fine Arts for representing the diversity and scope of the vast Asian continent throughout its long history.

The Asiatic Department may be subdivided into three sections: Far Eastern, including China, Japan, Korea, and Central Asia; Islamic art, including those far-flung areas under the influence of Islam from the Middle East extending west across North Africa to Spain and east to India and parts of Southeast Asia; and the art of the Indian subcontinent and those areas within its cultural sphere— Nepal, Tibet, and Southeast Asia.

The galleries of the Asiatic wing were closed in 1978 for much needed renovation and reinstallation under the principal supervision of the architectural firm of I. M. Pei and Partners. A generous grant for the Japanese galleries came from the Japanese government in tribute to the museum's outstanding collection of Japanese art; and the Korea-USA Centennial Program Committee also donated funds for the renovation of the Korean gallery. The magnificent new wing with twenty-six galleries was reopened in 1983 to much critical acclaim in conjunction with a major exhibition, the "Living National Treasures of Japan."

The Asiatic Department is, in many respects, the achievement of a remarkable group of men—extraordinarily gifted curators and erudite, exceedingly generous benefactors—who worked tirelessly together to build a magnificent collection of Asian art.

A discussion of the Asiatic Department must begin with the Japanese collection, where the department first began. The museum's Japanese collection is one of the most outstanding in the world, with objects dating from the Neolithic age to modern times. The collection encompasses paintings, sculptures, ceramics, lacquer, sword and sword fittings, netsukes, costumes, metalwork, and woodblock prints.

A recent count of the Japanese holdings estimated that the collection had about five thousand paintings, more than fifty thousand prints, seventy-seven hundred ceramics, twenty-five hundred *tsuba* (sword guards), six hundred swords, two hundred Nō masks, eight hundred costumes, and one thousand netsukes. Almost even more amazing than these formidable numbers is that many of these objects were collected by three men—Edward Sylvester Morse, Ernest Francisco Fenollosa, and William Sturgis Bigelow—before 1884.

The history of the collection begins with Edward Sylvester Morse (1830–1925), a self-educated zoologist. He had traveled to Tokyo in 1877 to continue his study of marine worms known as brachiopods, but during his stay in Japan

he became fascinated by Japanese ceramics. He pursued this avocation with the single-minded doggedness that characterized his scientific work and became an expert in this area, assembling more than five thousand examples of Japanese ceramics in the process. His collection, which was acquired by the museum in 1892, provides the most comprehensive view of nineteenth-century Japanese ceramics available anywhere.

Morse's enthusiasm for Japanese culture inspired Ernest Fenollosa and William Sturgis Bigelow. Through Morse's recommendation, Fenollosa received a two-year appointment as professor of philosophy and political economy at the Imperial University in Tokyo. Artistically gifted himself, Fenollosa became enamored with Japanese painting, especially the works of the elegant Kano school masters, and became an insatiable collector of paintings, as well as a student of painting under Kano Hogai. A descendant of the prominent Bostonian merchant William Sturgis, who had made his fortune in the China Trade, William Sturgis Bigelow was inspired to travel to Japan after attending lectures given by Morse at the Lowell Institute. In contrast to Fenollosa and reflecting his enormous personal wealth, Bigelow collected a wider range of objects, including paintings, sculptures, sword and sword fittings, textiles, lacquer, and woodblock prints.

In 1886 Bigelow decided to give his collection to the Museum of Fine Arts and also persuaded Charles Goddard Weld to purchase the Fenollosa Collection for the museum. Both of these great collections went to Boston in 1889, and Fenollosa himself followed his collection and joined the staff of the museum in 1890 as curator of the Japanese Department, serving in this capacity until 1896.

In 1905 Okakura Kakuzo was appointed advisor to the Asiatic Department. After much persuasion, he accepted the post of curator of the department in 1910. A student of Fenollosa in Japan, he was considered one of the greatest connoisseurs of Far Eastern art of the time. Following his deep belief that "Asia is One," not only did Okakura acquire works of Japanese art to augment the Bigelow and Fenollosa collections, but he was instrumental in encouraging the expansion of the Asiatic Department into other areas of Asian art, particularly Chinese art.

In 1921 the museum acquired another great collection of Japanese art, the Spaulding Collection of more than six thousand Japanese prints, considered to be one of the finest in the world. With the department's acceptance of this great gift, however, the museum agreed to comply with the Spauldings' stipulation that it never be exhibited in order to preserve the innate fragility of the prints.

The strength of the museum's Japanese holdings is its Japanese paintings, which is the foremost of collections of Japanese painting in the West. The depth of the collection is astounding with examples from almost every major period and school, ranging in date from the eighth century to the modern era.

The only Nara period painting ever to leave Japan, the earliest and perhaps rarest work is the eighth-century *Historical Buddha Preaching on Vulture Peak*, which was acquired in 1884 by Bigelow. Once the principal image in the Lotus Hall, or *Hokkedo*, of the Todaiji monastery in the ancient imperial capital of

Nara, this painting is recorded in an inventory dated 1726 as one of the treasures of the Todaiji.

The museum is particularly strong in Heian and Kamakura period Buddhist paintings, which dramatically depict the intense deities of the esoteric Buddhist sects. Of this group, the spectacular eleventh-century *Dai-itoku Myo-o*, once in Okakura's personal collection, was given to the museum posthumously in his honor by William Sturgis Bigelow.

Representing the rich tradition of the narrative scroll are two masterpieces of the Yamato-e school, the late twelfth-century *Kibi Daijin Nitto E-kotoba* (*Illustrated Handscroll of Minister Kibi's Trip to China*) and the *Sanjo-den Youchi no-emaki* (*Scroll with Depictions of the Night Attack on the Sanjo Palace*) from the *Heiji Monogatari-emaki* (*Illustrated Scrolls of the Events of the Heiji Period*) dating from the second half of the thirteenth century. Depicting the adventures of the Japanese ambassador to the T'ang court in 753, the former manuscript is considered one of the "lost" treasures of Japan. Its 1932 departure from Japan resulted in legislation that made the export of important art objects subject to governmental review and approval. Acquired by Ernest Fenollosa in 1884, the dramatic depiction of the night attack on the Sanjo Palace is the finest of the surviving three scrolls and isolated fragments from a larger work illustrating the saga of the wars between the Taira and Minamoto clans.

The collection also includes some rare examples of monochrome ink painting from the Muromachi period. A landscape attributed to the fifteenth-century painter Bunsei, which was acquired by Okakura for the museum, is an important early example of Japanese monochrome ink painting and is one of only six extant works associated with this artist. Only one other landscape by Bunsei is known and is in the Masaki Museum.

Fenollosa was a great admirer of the Kano school; consequently, the museum is particularly rich in examples from this school. A large early-sixteenth-century painting, *White Robed Kannon*, from his collection may be attributed to the founder of the school, Kano Motonobu.

The museum possesses some fine screens from the seventeenth and eighteenth centuries. One of the most dramatic is the *Dragon and Tiger* screen, dated 1606 and ascribed to Hasegawa Tohaku, another treasure of Japanese painting originally collected by Fenollosa. Tohaku was of the school of artists who opposed the academic tradition of the Kano school and, instead, drew inspiration from earlier masters of the monochrome ink painting tradition as the great artist Sesshu and the much-admired Sung painter Mu-chi. One of the most unusual screens in the collection is a rare early-seventeenth-century depiction, *European King and Members of the Court*, that follows the style of the European paintings brought to Japan by the Jesuit missionaries. An outstanding example of the sumptuous Rimpa school of the Edo period is the *Scenic View of Matsushima* by Ogata Korin, one of the most celebrated artists of that period. Acquired by Fenollosa in 1880, this screen was one of the first major Japanese works to be acquired by a foreigner.

The museum's collection of Japanese sculpture is exceptional with many fine works from the Heian and Kamakura periods.

Several rare statues may be attributed to known masters. Once in the collection of Okakura Kakuzo, a superb gilt wood sculpture, *Miroku Bosatsu*, originally housed in the Kofuku-ji in Nara, may date from 1189 and is ascribed to the sculptor Kaikei on the basis of a colophon added to a handwritten sutra found inside the figure. It is one of the earliest-known works by the artist, who was one of the leading proponents of the Kamakura style. A sensitively rendered wood sculpture of the Shinto god Hachiman is another ascribed work. An inscription inside the head dates it from 1328 and reveals that it was made at the Kofuku-ji in Nara by Koshun.

Perhaps the most striking sculpture of the collection, however, is the superb bronze *Sho Kannon* depicted seated in a meditative pose on an elaborate lotus throne. A dedicatory inscription on the hexagonal base of the throne dates the work from 1269 and ascribes it to the artist Saichi. In remarkable condition, this statue is one of the largest and finest examples of bronze casting to survive from the Kamakura period. It came to the museum from the collection of William Sturgis Bigelow. The museum is also renowned for its collection of woodblock prints, which is unsurpassed in the world for its size, balanced representation, and the extraordinary condition of the prints.

The William Sturgis Bigelow Collection of swords, sword guards, and sword fittings constitutes the core of the museum's collection in this area, which is considered the finest outside of Japan. One extremely rare sword handle and pommel dated from the fifth century is reportedly from the mausoleum of Emperor Nintoku (395–427). Early in this century, a landslide revealed part of the interior of the burial mound, and a number of funerary objects were uncovered. From this valuable cache, Okakura was able to acquire this sword handle in addition to a mirror, a bronze horse bell, and a bronze jingle bell.

As knowledgeable of Chinese art as he was of Japanese art, Okakura Kakuzo initiated the first efforts at the museum to assemble a collection of Chinese art. Accompanied by his nephew Hayasaki Kokichi, who later became the museum's agent in China, Okakura acquired many wonderful Chinese works of art for the museum.

Okakura's work was continued by Kojiro Tomita, who joined the museum in 1907 at the age of eighteen and became curator of the Asiatic Art Department in 1931. Although the fashionable trend of the 1930s was the acquisition of Chinese bronzes, Tomita shrewdly devoted his efforts to the collection of paintings.

During his years as curator, the collection's holdings of ceramics also benefited from several generous gifts. In 1946 the John Gardner Coolidge Collection of Chinese pottery and porcelain of 115 objects went to the museum. Although most of this collection consists of porcelain from the K'ang-hsi period, the earliest work is a remarkable black glazed T'ang Dynasty horse.

The Coolidge bequest was followed several years later by the Charles B. Hoyt Collection, which includes Chinese ceramics dating from prehistoric times to

the Ming Dynasty. His collection is distinguished by a highly refined aesthetic sensibility, which preferred the simple beauty of the basics of form and color. Although principally of Chinese and Korean ceramics, the Hoyt Collection also includes Chinese bronze mirrors; Sino-Siberian bronze and gold ornaments and plaques dating from the fifth through the first century B.C.; Chinese, Korean, Japanese, and Persian bronzes; Chinese and Japanese paintings; Japanese, Annamese, Persian, and Graeco-Roman ceramics; Syrian ceramics and glass; and Chinese sculpture.

The outstanding areas of the Chinese section are painting and ceramics. The paintings range in date from the Han Dynasty through the twentieth century, with works by the modern master Ch'i Pai-shih or Ch'i Huang. The earliest painting is on a lintel and pediment from a Han Dynasty tomb that was excavated about 1915 in the village of Pa-li-t'ai near Loyang, one of the two Han imperial capitals. Although heavily damaged, four tales depicting feudal loyalty and virtuous women on the lintel may be identified. Among the earlier paintings, most notable are a seventh-century painting, *The Thirteen Emperors*, attributed to Yen Li-Pen and two paintings attributed to the Sung emperor Hui-tsung.

Only one of a handful of scrolls associated with the great seventh-century painter and official Yen Li-Pen, this handscroll depicting thirteen emperors, who ruled from the second century B.C. to the early seventh century A.D., has been attributed to him on the basis of close similarities with seventh-century paintings and tomb figurines that have been uncovered in a number of recent archaeological excavations. At the very least, these new finds provide further support for a seventh-century date for this work. This masterpiece, which was featured in an exhibition of Chinese painting held in Tokyo in 1929, was acquired for the museum through the generosity of Denman Waldo Ross.

No other emperor surpasses the twelfth-century Sung ruler Hui-tsung in his reputation as a painter and collector of paintings, and the two works attributed to Hui-tsung from the museum's collection must be considered among its treasures. The handscroll *Court Ladies Preparing Newly Woven Silk* is thought to be Hui-tsung's copy of a work by the T'ang artist Chang Hsuan. Also attributed to the emperor is *The Five-Colored Parakeet*, which contains a colophon and poem written in Hui-tsung's elegant hand. The delicacy of the colors and brushwork epitomizes the style of the Imperial Academy.

Among the works from the museum's outstanding group of Sung paintings are ten paintings from a set of a hundred paintings, the *Five Hundred Lohans*, once in the Daitoku-ji temple of Kyoto. The set was executed by Chou Chi-ch'ang and Lin T'ing-kuei, specialists in Buddhist paintings. Other Sung masterpieces in the collection include *Bare Willows and Distant Mountains* by Ma Yuan, *Sailboat in the Rain* by Hsia Kuei, and the magnificent *Nine Dragons* by Ch'en Jung. Dated 1244, the Ch'en Jung work is considered the most outstanding example of Chinese dragon painting in the world.

The ceramics collection contains work dating from the Chou Dynasty. An Eastern Chou earthenware covered jar represents a rare example of pottery with

inlaid glass paste decoration, which reflects the influence of contemporary bronze decoration. Only two other pieces of this type of work are known—one in the collection of the late Walter Sedgwick in London and the other in The Nelson-Atkins Museum (q.v.) in Kansas City. There are also a number of "marbled" earthenware pieces from the T'ang and Sung periods, reflecting one of Charles Hoyt's predilections.

The museum possesses an important group of early Buddhist sculpture. The highlights of this group are a white marble altarpiece of about 560, from the Ting-chou area; the grey limestone Eastern Wei *Bodhisattva* of about 530, excavated from the famous White Horse Monastery (Pai Ma Ssu near Loyang); and a bronze Sui Dynasty altarpiece of 593, known as the *Tuan Fang Altar*. The magnificent Eastern Wei *Bodhisattva* was given to the museum in memory of Okakura Kakuzo by Denman Waldo Ross. Only one of two complete altars surviving from the Sui Dynasty, the Boston altarpiece is dated by an inscription, which states that the work was dedicated in 593 by a group of eight women of the Fan clan. At the time of its excavation shortly after the turn of this century, the guardian kings and lions on the base of the altar were removed and sold separately from the principal image. Happily, these pieces were reunited with the rest of the altar in 1947, twenty-five years after it went to the museum.

The museum's collection of Korean art is one of only a few collections of Korean art of any significance in the West and includes ceramics, paintings, sculptures, roof tiles, metalwork, and lacquer.

Due to the bequest of the Hoyt Collection of Chinese and Korean ceramics in 1950, the ceramics constitute the strength of the Korean holdings. The core of the Hoyt gift is a group of Koryŏ celadons of which a twelfth-century vase of the *maebyong* (plum blossom) type is most outstanding. This elegant work is covered with a design of cranes and bamboo in inlaid black and white slip.

A rare early object of the Korean holdings is a gilt-bronze crown of the Old Silla period (fifth-sixth century). Only two other crowns of this type are known to be in Western collections. Perhaps the centerpiece of the Korean section, however, is a superb gilt-bronze Buddha of the ninth century, which was once in the Okakura Collection. Reflecting the influence of the T'ang Dynasty style, this sculpture is closely related to a group of fifty-three gilt-bronzes that was once the focus of worship at the Yuchomsa Temple in the Diamond Mountains of North Korea.

The Indian collection of the Museum of Fine Arts is one of the finest and most comprehensive in the West, possessing examples of nearly every major period and school from the time of the Indus Valley civilization. The department's holdings include paintings, sculptures, jewelry, coins, ivory, carpets, and textiles.

Following Okakura's ideal that "Asia is One," the museum was the first in the United States to establish a section devoted exclusively to Indian art. Denman Waldo Ross, who served as a trustee for the museum from 1895 until his death in 1935, was a significant force behind the establishment of the section. His monumental efforts during several short years led to the museum's acquisition

of several significant collections. He helped negotiate the museum's acquisition of the celebrated Goloubew Collection of Indian and Persian miniatures in 1914. The following year, he donated a group of 151 Persian and Indian miniatures from his personal collection to the museum. Then in 1917, in a spectacular coup, Ross purchased the enormous Coomaraswamy Collection of Indian painting and sculpture for the museum. With the collection came Coomaraswamy himself, who was invited to be the keeper of the newly created Indian Art Section. Thus the museum's association began with yet another of the great pioneering scholars of Asian art history. Coomaraswamy remained at the museum until his death in 1947.

In recent times, following in the footsteps of Denman Ross as a generous benefactor and supporter of the Indian collections, is John Goelet, who served as field representative and fellow for research in Islamic art and was appointed a trustee of the museum in 1966. During the years of his association with the museum, he has contributed generously to the museum's holdings in Islamic, Indian, and Nepalese art.

The great strength of the museum's Indian section is its collection of paintings, which includes examples of pre-Mughal, Mughal, Rajasthani, Deccani, and Pahari miniatures. Forming the heart of the paintings collection are the Goloubew Collection and the Coomaraswamy Collection of about nine hundred drawings and paintings. In recent decades, this core has been greatly enhanced by John Goelet's gifts of Rajasthani miniatures.

The museum's earliest example of Indian painting is a rare fragment of a sixth-century fresco from Cave XVI at Ajanta, site of the cave temple complex in western India. The fragment is probably from a larger representation of a *jataka* tale and depicts four male figures seen from the upper torso and above and a portion of another head. Some characteristically exuberant foliage also appears in the fragment.

From the Coomaraswamy Collection came a number of paintings and manuscripts executed in the so-called Western Indian style. Because of the number of illustrated versions of Jain texts in this style, this pre-Mughal idiom is closely associated with this subject matter. Among the important dated works in the museum's collection are an illustrated *Kalpa Sutra* manuscript dated 1494 and an illustrated *Kalpa Sutra* dated 1497.

The museum owns a particularly fine group of Mughal paintings. From one of the earliest and certainly one of the largest illustrated manuscripts prepared under imperial Mughal patronage, the *Dastan-i Amir Hamza*, about 1562–77, is a painting illustrating the discovery of the infant Alexander. With the Goloubew Collection, the museum acquired several exquisite miniatures dating from the reign of the fourth Mughal emperor Jahangir (reigned 1605–27). Perhaps the most striking of this group is the sensitively rendered drawing of the *Dying Inayat Khan*, widely considered to be a masterpiece of Mughal draftsmanship. Dated from 1618–19, this miniature is a preparatory study of a finished painting now in the Bodleian Library in Oxford. Also from the Goloubew Collection are

two leaves from an illustrated imperial manuscript, the *Jahangir-nama*, the memoirs of Jahangir. One, attributed to Manohar, depicts a magnificent *darbar*, or court appearance, of Jahangir before a gathering of his courtiers, and the other, attributed to Bishn Das, depicts the birth of a prince. This painting represents one of a meager handful of surviving miniatures that may be assigned to this Mughal master, who was lauded by Jahangir for his skill at portraiture.

In addition to these masterpieces of the imperial atelier, the Museum of Fine Arts also has an early seventeenth-century *Rasikapriya*, an important manuscript executed in the so-called Popular Mughal style.

The collection of Rajasthani paintings includes examples from the major schools of Mewar, Malwa, Bundi-Kotah, and Bikaner.

One of the most important Rajasthani paintings in the collection is the *Bhairava Raga* from the dispersed *Ragamala* set, dated 1628, from Mewar, and ascribed to the artist Sahibdin. Most of the surviving leaves from this set are in the National Museum (q.v.) in New Delhi.

The dispersed *Ragamala* of about 1640–45 from Malwa was the focus of early studies of *Ragamala* painting by Coomaraswamy. Known as the *Boston Ragamala*, most of the surviving leaves from this manuscript are in the museum with other miniatures in the Freer Gallery of Art (q.v.), the Cleveland Museum of Art (q.v.), and the Metropolitan Museum of Art (q.v.).

The museum also possesses some fine examples of Pahari painting. There are some exquisite miniatures of the dramatically intense early Basohli style of the late seventeenth century, including leaves from the *Rasamanjari* of about 1660–75, and the miniature *A Lady at Her Toilette* of about 1690–1700. The museum also owns most of the surviving leaves from a set of paintings illustrating the "Siege of Lanka" section from the *Ramayana*. Attributed to either Nurpur or Basohli, the unusually large size of the individual paintings has led to speculation that perhaps the paintings were held before an audience as the epic was being recited. Another Pahari masterpiece in the collection is the often-published *Hour of Cowdust* of about 1790 of the Kangra school.

The Indian Department is also rich in sculpture. As a result of an expedition sponsored jointly with the University of Pennsylvania to the Indus Valley civilization site of Chanhu-daro, the museum was able to acquire a number of artifacts from the earliest years of civilization in India. The holdings of early Indian sculpture includes work from some important sites. There is a fragment of a Yakshi from the railing of the Great Stupa at Bharhut, one of the most famous early Indian Buddhist monuments. Much of what survives from Bharhut is currently on exhibition in the Indian Museum (q.v.) in Calcutta. From another early monument of Buddhism in India, the Great Stupa at Sanchi, dated from 25 B.C. to A.D. 25, is a sensuously modeled torso of a Yakshi from one of the *toranas*, or gateways, of the Stupa.

The North Indian city of Mathura appears to have been one of the major centers for sculpture from the second century B.C. through the Gupta period, and such is the depth of the museum's collection that the development of sculpture

in Mathura during these centuries may be charted by pieces in the collection. Especially outstanding are a Kushana period tympanum depicting a procession of monks and deer, a mid-fifth-century Gupta period Buddha head, and a powerfully modeled fifth-century sculpture of Vishnu.

Notable for its adoption of some Graeco-Roman stylistic and iconographical elements, the Gandharan school is represented by, among other fine works, a magnificent standing Bodhisattva in the characteristic gray schist from this region.

There are several fine Gupta period pieces, including the above-mentioned Vishnu and Buddha head from Mathura, a mid-fifth-century Ganga from Besnagar, and a delicately modeled early-sixth-century Bodhisattva from Sarnath.

Another outstanding area is the holdings of South Indian sculpture, especially a group of large stone sculptures from the Pallava and Chola periods. A particularly rare and beautiful South Indian work is a ninth-century gilt-bronze image of a seated Buddha from Nagapattinam, an important port in South India and one of the last outposts of Buddhism in India. This exquisite work went to the museum in two installments. The elaborately ornamented throne back was acquired from the Nasli and Alice Heeramaneck Collection in 1967. In 1970 an image of a Buddha, rumored to be the missing cult image from the Heeramaneck throne, surfaced. When the throne and Buddha were reunited, the association of the two was firmly established.

Astute detective work also enabled the museum to reunite the body of an exquisite eighth-century ivory Kashmiri Buddha with its head, which was in the Cleveland Museum of Art. Another fine example of ivory sculpture is an intricately carved sixteenth-century pair of throne legs from Orissa in eastern India.

One of the outstanding works of art in the Indian section is neither a painting nor a sculpture but a spectacular Mughal carpet that may date from the early seventeenth century. It was given to the museum in 1893 by Mrs. Frederick L. Ames in memory of her husband. The images woven into this carpet are familiar ones from contemporary Mughal paintings executed in the imperial atelier.

In championing all of Asia, Okakura Kakuzo did not overlook the arts of Nepal and Tibet. The Himalayan collection includes examples of painting, sculpture, ritual objects, clay votive implements, and jewelry and has greatly benefited from the generosity of donors, whose names have appeared throughout this entry: Denman Waldo Ross, William Sturgis Bigelow, and John Goelet.

Originally in the private collection of the renowned collector Nasli Heeramaneck, a small gilt-copper statue of a ten-armed Vishnu is one of the earliest surviving works of Nepalese art.

The museum's painting collection also includes a number of outstanding works. Reflecting a style found in palm-leaf manuscripts, the eleventh-century Nepalese painting *Amitayus Buddha* or *Buddha of Eternal Life* is similar to a painting now in the Los Angeles County Museum of Art (q.v.) that depicts the Buddha Ratnasambhava. Both paintings probably belonged to the set of paintings *Five Transcendental Buddhas*. A departure from the typical hierarchical, strict, formal compositions of Nepalese painting, a representation dated 1561, *The Assault of*

The Demon Mara, shows a sense of dramatic narrative atypical of Nepalese painting.

The museum also has several fine examples of work of the Nor school of southern Tibet. The Nor Monastery was founded in 1492 and developed a distinct style of painting during the sixteenth century that combined aspects of Tibetan and Nepalese painting.

Denman Waldo Ross also played a significant role in the development of the museum's collection of Southeast Asian art, which covers the art of Sri Lanka, Cambodia, Indonesia, Thailand, Burma, and Vietnam. He donated his fine collection of Khmer art to the museum, and, with Ananda Coomaraswamy, he worked to acquire several fine Javanese stone pieces for the collection.

The late-eleventh-century bronze *Dancing Apsara*, or celestial figure, from Cambodia probably adorned a votive lamp, making it one of the few fragments of Cambodian votive lamps to survive. Executed with great delicacy and elegance, the figure with upraised arms dances on a lotus flower, which springs from a gently curving stem.

Another rare piece of Southeast Asian art is the tenth-century head of a king or deity from Champa in what is now Vietnam. Only a few other sculptures from this important early Southeast Asian kingdom may be found in North American collections.

The vast panoply of art from Islamic cultures ranging from the Far Eastern outposts of Islam across western Asia to Spain is reflected in the museum's collection. An important source for the museum's Islamic holdings was an expedition, sponsored with the University of Pennsylvania, in 1933 to the ancient site of Rayy. The findings of the excavation were distributed among the Persian government, the University of Pennsylvania Museum, and the Museum of Fine Arts. The museum's share numbered 345 objects, including pottery, stucco, coins, and jewelry.

The museum's holdings of decorative arts, such as glassware, metalwork, bookbindings, and calligraphy, are substantial, but the principal strengths of the collection are the paintings and the ceramics.

The museum has a select group of early miniatures, including two leaves from a now dispersed manuscript of Dioscorides', *Materia Medica*, dated 1222–23, one of the earliest surviving illustrated Islamic manuscripts. There are also leaves from the Egyptian *Automata* dated 1354, most of which is in the Suleiymaniye Library in Istanbul, and a leaf from the so-called Demotte *Shah-nama* of about 1330–40.

One of the most sumptuously conceived examples of Islamic calligraphy, the final page of a manuscript of the *Shah-nama* dated 1562–83, is one of the outstanding possessions of the Islamic department.

One of the foremost American collections of Islamic ceramics, the museum's collection of ceramics is particularly rich in Rayy and Iznik works. A rare piece is a tile dated 1210 and ascribed to the artist Abu Rufaya. This tile represents one of the earliest examples of a lusterware tile. The star-shaped tile, depicting

a prince on horseback with two hounds, has an inscription that suggests that the image depicts a scene from the *Fables of Bidpai*.

In 1872, only two years after the museum was founded, it received as a gift the Way Collection consisting of numerous Egyptian objects. Three years later the Lowell family donated a large Dynasty XVIII statue, the *Goddess Sekhmet*, and other Egyptian sculpture. When the museum opened in 1876, General Charles Loring, a student of Egyptian art and archaeology, became its first curator and chief executive officer. Egyptian art did not receive departmental status until shortly after Loring's death in 1902. Nevertheless, Loring, as curator and later director of the museum, gave it his consistent attention and support. Joint sponsorship with Harvard University of the forty-year exploration and excavation of royal tombs in Egypt and the Sudan produced many of the museum's greatest treasures, especially in Old Kingdom sculpture. Two among many outstanding examples are the statue *Mycerinus and His Queen* and the painted bust *Vizier Ankh-Haf*—perhaps the finest surviving portrait from the Old Kingdom. The collection contains fine examples of the entire range of Egyptian art, such as the painted wooden group *Four Figures Bearing Offerings to Djehuty-Nekht*, about 1850 B.C., from the Middle Kingdom. New Kingdom artifacts include the Dynasty XVIII *Granite Falcon* from Soleb and the fragment of a wall painting, *Mourning Women*, from the Tomb of Neb-Amon at Thebes, about 1400 B.C. Notable among the later works is the famous "Boston Green Head" of about the fourth to second century B.C. The Department of Egyptian Art also includes objects from the Ancient Near East.

The Classical Department was given official independent status in 1887 with the appointment of a full-time curator. Nonetheless, the nucleus of the collection had begun to be formed much earlier with the purchase in 1872 of the Cesnola Collection. The period from 1895 to 1905 saw some of the greatest additions to the collection, mainly through the efforts of Edward P. and Samuel D. Warren. They included the exquisite fourth-century B.C. Greek gold earring, *Nike Driving Her Chariot*; the *Mantiklos Apollo*; and other superb examples of small Archaic objects. Greek and Roman portrait sculpture were also acquired in this period, as were some of the best examples of Attic red- and black-figure vases to be found anywhere. Notable additions of the "post-Warren" era are the gold and ivory statuette *Minoan Snake Goddess*, about 1600–1500 B.C. (a rare example of a sculptural piece from ancient Crete) and magnificent examples of Classical Greek vase painting by the Berlin Painter, the Altamura Painter, the Niobid Painter, Exekias and his circle, and other masters. The collection also includes terracotta figures, jewelry, glass, and coins of exceptional quality from all periods of Greek, Etruscan, and Roman art.

Due to the sizable Gray Collection of engravings borrowed from Harvard, as early as 1878 a curator of prints was appointed, although the collection was not given departmental status until 1887. The Gray Collection was withdrawn in 1897, but the loss was overcome by the purchase of the Sewall-Parker Collection, which is especially rich in the work of Rembrandt, Dürer, and the Italian masters

of the fifteenth century. Many notable additions have since been made, including one of the finest sets of Turner's *Liber Studiorum* extant and numerous other graphic works by the artist. Piranesi, Goya, and William Blake are also exceptionally well represented. The drawing and watercolor collection of about twenty-five thousand examples ranges from Lorenzo di Credi to Willem De Kooning. The most important large groups are by Blake, Tiepolo, J. F. Millet, Winslow Homer, Maurice Prendergast, and John Singer Sargent, as well as the Forsyth Wickes bequest of French drawings and the great Karolik Collection of American drawings and watercolors that comprises some three thousand works of the period 1800 to 1875. Among the major drawings given by the Karoliks in the late 1950s is John Singleton Copley's life-size study *Henry, Earl of Bathhurst*, in black chalk, highlighted with white on gray-blue paper. This was done for his 1779–81 painting *The Death of the Earl of Chatham*. Another important piece is the sensitive portrait *Robert Owen, a Study from Life*, 1833, by Rembrandt Peale.

The Print Department has a collection of books illustrated by printmakers that numbers about five thousand volumes dating from the fifteenth century to the present. Owing to the bequest of William A. Sargent, this section is especially strong in eighteenth- and early-nineteenth-century French books. In addition, the Print Department has a growing collection of original photographs from the mid-nineteenth century to the present. The most important groups are the Southworth and Hawes daguerreotypes and the Stieglitz and Strand photographs. The department currently estimates that it has a total of about a half million prints, drawings, illustrated books, and photographs.

In the Paintings Department, probably the greatest treasure of the early period is the triptych by Duccio and possibly Simone Martini, the *Crucifixion*, with *St. Nicholas* and *St. Gregory*. Unquestionably, one of the masterpieces of fifteenth-century painting in Northern Europe is *St. Luke Painting the Virgin* by Rogier van der Weyden. In addition, there is the anonymous *Martyrdom of St. Hippolytus*, a hitherto unknown and virtually flawless triptych from the last quarter of the fifteenth century. Among sixteenth-century Northern works, *The Crucifixion* by Joos van Cleve and *Moses Striking the Rock* (1527), a large and rare tempera on linen by Lucas van Leyden, are especially noteworthy. The collection is rich in seventeenth-century Dutch and Flemish painting as well, featuring several superb pictures by Rubens (the portrait *Mulay Ahmad, Hercules Slaying Envy, Mercury and Argus*, and the memorable *Head of Cyprus Brought to Queen Tomyris* in particular). Rembrandt is also well represented with the full-length, life-size early portraits *Reverend Johannes and Mevr. Johannes Elison* and the *Artist in His Studio* (1634). There are also many strong examples of seventeenth- and eighteenth-century French painting, including a magnificent portrait by Philippe de Champaigne, landscapes and allegorical compositions by Claude Lorraine and Nicolas Poussin (especially his *Achilles among Daughters of Cycomedes*), and brilliant work by Eustache Le Seur, Simon Vouet, Boucher, Watteau, Chardin, Greuze, and many others. Of the Spanish paintings, most important is El Greco's signed *Portrait of Fray Felix Hortensio Palaricino*, about 1609. Among

the many major Italian works are Rosso's *Dead Christ with Angels* (c. 1524–27) and Tiepolo's *Time Unveiling Truth*.

Owing to the influence of William Morris Hunt and others, nineteenth-century Bostonians were among the first Americans to appreciate "contemporary" French painting. Their enthusiasm is reflected in the museum's holdings of Barbizon, Impressionist, and Post-Impressionist works. These holdings include more than fifty paintings by Jean François Millet (the best known of which is *The Sower*), twenty-four Corots, six Courbets (among them, *The Quarry* from the late 1850s, one of the first works of his sold in the United States), forty Monets, twenty Renoirs (highlighted by his exquisite *Le bal à Bougival* of 1883), and five Gauguins (featuring his monumental masterpiece *D'où venons-nous? . . .*).

Eighteenth-century American painting is particularly well represented with the best work of John Singleton Copley (*Paul Revere, Boy with Squirrel, The Copley Family*) and outstanding examples by his contemporaries, such as Gilbert Stuart's Athenaeum portraits *George and Martha Washington* (owned jointly with the National Portrait Gallery in Washington, D.C.) and John Trumbull's *Death of General Warren*. Nineteenth-century American painting is equally strong because of the early interest in artists with New England connections such as Washington Allston, John Singer Sargent (especially his *Daughters of Edward Boit*), and Winslow Homer, with the later addition of the magnificent Karolik Collection. The M. and M. Karolik Collection was formed with the aim of bringing together the finest available pieces of American art from 1720 to 1820, including paintings, drawings, engravings, furniture, silver, needlework, and incidental objects. The first collection was given in the late 1930s and contained some 350 objects. Another collection formed and given in the 1940s concentrated on American paintings and numbered about 240.

Among the major paintings in this group are *Robert Gibbs*, 1670, by the Freake Limner (which is the only seventeenth-century painting); Erastus Salisbury Field's *Joseph Moore and His Family* of 1839; one of Martin Johnson Heade's most dramatic pictures, *Approaching Storm: Beach near Newport* of the 1860s; and John Frederick Peto's *The Poor Man's Store* (1885), one of four paintings in the Karolik Collection by this unique trompe-l'oeil painter.

The museum was founded at a time when New England was a center of textile production. It was thought that a comprehensive textile collection would be a great help to fabric designers and thereby assist local manufacture. Although textiles did not formally become a department until 1930, the collection grew steadily from the time the MFA was founded. This can be seen from the fact that the second object to enter the permanent collection was an early-eighteenth-century Flemish wall hanging, *Victoria (Victory)*, donated in 1871. Other notable early donations include the collection of laces, silk weavings, and embroideries from W. Paige and Mrs. George W. Wales and a group of forty-seven pre-Columbian Peruvian textiles given by Edward W. Hooper in 1878. Important subsequent bequests are the Lehman Collection of embroideries and laces, the McCormick Collection of costumes and costume accessories, and the Oldham

Collection—one of the world's great collections of fans. The result is one of the finest representations of textiles in the United States being both comprehensive (from ancient Egypt to the present) and of the finest quality (highlighted by several notable examples of fifteenth- and sixteenth-century French, German, and Flemish tapestries, as well as seventeenth- and eighteenth-century works created from designs by Jacob Jordaens, Rubens, François Boucher, and others).

An outstanding feature of the Department of American Decorative Arts and Sculpture is its great furniture collection. Through the generosity of the Karoliks and many others, almost all of the important phases of style and workmanship in the New England colonies (particularly the seventeenth century) are represented. Exceptional quality and quantity are concentrated in objects from the Salem, Boston, and Newport areas, but major pieces from later periods are also here. The Karolik gift of 150 pieces of American furniture contains, among other pieces, the superb Newport knee-hole bureau table, about 1765–75, by the master cabinetmaker Edmund Townsend. Benjamin Randolph of Philadelphia is represented by an elaborate side chair, and other major Philadelphia pieces are a highboy, two lowboys, and a bombay secretary. A Salem card table, about 1796, of mahogany and satinwood with neoclassical motifs on a semicircular frieze-like carved band is the work of Samuel McIntire. Another masterpiece of Salem Federal furniture is a chest-on-chest, about 1796, by William Lemon and McIntire. Matthew Egerton's six-legged sideboard, about 1790–1800, with its bold serpentine front and crotch-grained veneer should also be noted.

This department has an unsurpassed collection of New England silver, among which can be found the best work of Paul Revere (especially his famous *Liberty Bowl*). The museum was the first institution to recognize the artistic merits of American silver with its 1906 exhibition "American Silver." Partly because of this exhibition and the continuing generosity of donors, the museum displays the most comprehensive collection of New England silver in existence. The department also contains an unparalleled collection of American neoclassical sculpture, including major works by Greenough, Crawford, and Story. American glass is also a great strength with Sandwich, Amelung, and the New England Glass Company well represented. Stained glass designed by John La Farge is worth special notice.

Sculpture is one of the strong points of the Department of European Decorative Arts and Sculpture. Among the many choice pieces are the marble group *Deacon and Acolytes* by Nicola Pisano and Arnolfo di Cambio; the polychromed oak statue *Virgin and Child*, about 1200, from the Ile-de-France; and Donatello's marble relief *Virgin of the Clouds*. Distinguished later works include six Houdon busts (one is *George Washington*), with excellent examples by Carpeaux, Rodin, Degas, and Gauguin. The department is also responsible for the Leslie Lindsey Mason Collection of musical instruments.

The Department of Twentieth Century Arts, created in 1971, consists of European painting and sculpture from 1900 to the present and American painting and sculpture from 1945 to the present. Important paintings include Jackson

Pollock's *Number 10*, Picasso's *Head of a Woman*, Miró's *Nuage et Oiseaux* (1927), nine monumental canvases by Morris Louis, and representative works by Hans Hofmann, Robert Motherwell, Franz Kline, Kenneth Noland, Adolph Gottlieb, and Helen Frankenthaler. Sculpture by David Smith, Michael Steiner, Anthony Caro, Picasso, and others are also to be found here.

The museum's art library currently contains 108,000 books, 95,000 pamphlets, and nearly 23,000 auction catalogues. Material is available to the public for use on the premises and through interlibrary loans. Facilities consist almost entirely of closed stacks, and hours are restricted.

There is a large museum shop that sells slides and photographs of most of the objects in the collections. It also offers an extensive selection of art books and pamphlets including the museum publications. The museum publishes a quarterly, *Museum of Fine Arts Bulletin*, containing scholarly articles on items in the collections. There is also the *Annual Report*, which has useful information, especially about acquisitions.

Selected Bibliography

Museum publications: *Illustrated Handbook: Museum of Fine Arts, Boston*, 1975; *American Furniture in the Museum of Fine Arts, Boston*, 1965; *American Paintings . . .*, 2 vols., 1969; *American Silver, 1655–1825 . . .*, 2 vols., 1972; *Ancient Egypt as Represented . . .*, rev. ed., 1965; *Annual Report*, 1876-; *Attic Vase Painting . . .*, 3 vols., 1931–63; *Catalogue of Greek Coins . . .*, 1955 (reprinted 1974); *The Egyptian Department and Its Excavations*, 1958; *Eighteenth-Century American Arts: The M. and M. Karolik Collection*, 1941; *From Fibre to Fine Arts*, 1980; *Greek, Etruscan, and Roman Art: The Classical Collection of . . .*, rev. ed., 1972; *Greek, Etruscan, and Roman Bronzes . . .*, 1971; *Leslie Lindsey Mason Collection*, 1964; *M. and M. Karolik Collection of American Paintings: 1815 to 1865*, 1949; *M. and M. Karolik Collection of American Water Colors and Drawings: 1800–1875*, 2 vols., 1962; *Museum of Fine Arts, Boston*, 1969; *Museum of Fine Arts Bulletin*, 1903-; *She Walks in Splendor*, 1963; *Summary Catalogue of European Paintings in Oil, Tempera, and Pastel*, 1956; *Tapestries of Europe and of Colonial Peru . . .*, 2 vols., 1969; Coomaraswamy, A. K., *Catalogue of the Indian Collections in the Museum of Fine Arts, Boston. Part I: General Introduction*, 1923; idem, *Part II: Sculpture*, 1923; idem, *Part IV: Jaina Paintings*, 1924; idem, *Part V: Rajput Painting*, 1926; idem, *Part VI: Mughal Painting*, 1930; idem, *Portfolio of Indian Art: Objects from the Collections of the Museum*, 1923; Fontein, J., and P. Pal, *Museum of Fine Arts, Boston: Oriental Art*, 1968; Fontein, J., and T. Wu, *The World's Great Collections: Oriental Ceramics. Vol. 10: Museum of Fine Arts Boston*, 1980; Morse, E. S., *Catalogue of the Morse Collection of Japanese Pottery*, 1901; Pal, P., *Ragamala Paintings in the Museum of Fine Arts, Boston*, 1967; Tomita, K., *Portfolio of Chinese Paintings in the Museum (Han to Sung Periods)*, 1933; Tomita, K., and H. C. Tseng, *Portfolio of Chinese Paintings in the Museum (Yüan to Ch'ing Periods)*, 1961; Tseng, H. C., and B. P. Dart, *The Charles B. Hoyt Collection in the Museum of Fine Arts, Boston*, vol. 1., 1964; vol. 2, 1972.

Other publications: Whitehill, Walter Muir, *Museum of Fine Arts, Boston: A Centennial History*, 2 vols. (Cambridge, Mass. 1970); Coomaraswamy, A. K., "Les Miniatures orientales de la Collection Goloubew au Museum of Fine Arts de Boston," *Ars Asiatica*

13 (1929); Kishida, T., "Bosuton Bijutsukan Shushu no Nihon Kaiga Chosa Hokoku" ("A Survey of the Collection of Japanese Painting in the Boston Museum"), *Saga Daigaku KyoikubuKenkyurombunshu*, Part I (Ashikaga Idealistic School), 13 (1965), pp. 85–117; Part II (Post-Ashikaga Idealistic School), 14 (1966), pp. 77–96; Part III (Kano School), 15 (1967), pp. 105–35; Part IV (Kano School), 21 (1973), pp. 307–40.

ERNEST ROHDENBURG III AND MARSHA C. TAJIMA

———— Brooklyn. See New York City. ————

———— Chicago ————

ART INSTITUTE OF CHICAGO, THE (alternately THE ART INSTITUTE), Michigan Avenue at Adams Street, Chicago, Illinois 60603.

On May 24, 1979, The Art Institute of Chicago celebrated its centennial of incorporation. However, its roots date from the original Chicago Academy of Design, founded in 1866 by a group of local artists. In 1878 the struggling academy called upon prominent business and civic leaders for direction and assistance. They in turn incorporated a new institution, the Chicago Academy of Fine Arts, the following year. Like many nascent organizations during the American "cultural Renaissance," the academy's goal was "the cultivation and extension of the arts of design by an appropriate means." In December 1882 the academy was renamed The Art Institute of Chicago.

In its early stages the new academy occupied several sites in downtown Chicago. In 1882, the year of its name change, rented studio space at State and Monroe streets became inadequate, and property was purchased on Michigan Avenue at Van Buren Street. On November 9, 1887, a new building designed by John Wellborn Root in the Romanesque style finally opened on this site. The building housed studios, lecture halls, and galleries. But this building soon proved too small, and in 1893 the trustees of The Art Institute agreed with the planners of the Chicago's World's Columbian Exposition to help support the building of an exposition hall off Michigan Avenue at Adams Street for the World's Congresses. In exchange, The Art Institute took over the building following the exposition, in December 1893. This building, designed by the Boston firm of Shepley, Rutan, and Coolidge, forms the central core of The Art Institute building today. The building was conservative for Chicago at the time, but its classically inspired limestone pediment and arcaded facade formed a grand palace of the arts.

There have been a number of additions to the Michigan Avenue site. Two familiar elements of the original building, the bronze lions at the entrance and the grand central staircase, were added in 1894 and 1900, respectively. Several galleries, including Blackstone Hall, used as a sculpture gallery, were added

before 1910. The Ryerson Library was constructed in 1901, with the Burnham Library of Architecture, bequest of architect Daniel H. Burnham, added in 1919. In 1916 Gunsaulus Hall was added across the Illinois Central Railroad tracks, which had previously limited growth to the east. East of the tracks the Hutchinson Wing Galleries and McKinlock Court were built in 1924, and the Kenneth Sawyer Goodman Memorial Theatre was dedicated in 1925.

In 1958 the B. F. Ferguson Memorial Building was added north of the central building to house administrative, curatorial, and conservational functions; the architects were Holabird, Root, and Burgee. The Morton Wing, south of the central building, was designed by Shaw, Metz and Associates and finished in 1962, housing much of the twentieth-century painting collection and special loan exhibitions. The Ryerson and Burnham libraries merged in 1957 and were rehabilitated in 1967, with the Burnham Library of Architecture Gallery enclosed around the upper-level Ryerson Library reading room. The Department of Prints and Drawings underwent a major remodeling in 1973.

In 1974 ground was broken for a Centennial Fund project to expand the eastern facilities facing Columbus Drive. These expansions included a new east entry to the museum, an auditorium, and new galleries, dining facilities, and a unified area for the School of The Art Institute. The school facilities were dedicated in 1976, and the rest of the project was completed in 1977. Architects for the addition were Skidmore, Owings, and Merrill, with Walter Netsch as project designer. Within the Columbus Drive facilities, the Trading Room for the original Chicago Stock Exchange Building was reconstructed in 1977 under the direction of the firm of Vinci-Kenny. The original main archway of the Stock Exchange (designed in 1894 by Adler and Sullivan) marks the entrance to the gardens in front of the east entrance. A monumental fountain sculpture in granite and steel by Isamu Noguchi, *Celebration of the 200th Anniversary of the Founding of the Republic*, was dedicated in front of the new addition in 1976. Inside the new facilities stained-glass windows designed by Marc Chagall, called the *America Windows*, were dedicated in May 1977. These windows commemorate the United States Bicentennial and the late Richard J. Daley.

In 1977 the remodeling of the Department of Textiles was completed. In 1978 the primitive art collection and American art of the 1960s and 1970s were installed on the north and south sides of the upper level of the McKinlock Court galleries.

The collections and operations of The Art Institute are administered by a board of trustees, which is elected by the governing life members of the Institute. The collections of The Art Institute, like its administration, have always received the direct attention of its prominent benefactors. In the museum's early days a collection of plaster casts illustrating the historical development of sculpture formed the core of the collection. But the influential president of The Art Institute, Charles L. Hutchinson, with the man who was to become the greatest single benefactor of the museum, Martin Ryerson, had more ambitious goals. Ryerson and Hutchinson made numerous art-collecting trips, visiting European dealers and painters, including Monet. Their first major acquisition consisted of thirteen

Dutch and Flemish paintings, acquired with Ryerson's help from the collection of Count Demidoff in Florence. In 1894 Mrs. Henry Field gave in her husband's name his collection of Barbizon paintings. Thus began the strength of The Art Institute's collections—contemporary artworks bequeathed or personally selected by members for the museum.

As the president of the Board of Lady Managers of the Columbian Exposition and an important donor to The Art Institute, Mrs. Potter Palmer had a strong influence on culture in Chicago. Her friendship with the painter Mary Cassatt led to her interest in the Impressionists. In 1922 she bequeathed her own collection to The Art Institute. Her gift included a large group of Barbizon and Impressionist paintings. An innovative gift by Joseph Winterbotham in 1921 enabled the museum to acquire up to thirty-five modern European paintings that can be sold or exchanged to reflect new developments in art. In 1925 the painter Frederick Clay Bartlett gave a group of paintings in memory of his second wife, Helen Birch Bartlett, which included works by Cézanne, Gauguin, van Gogh, and Toulouse-Lautrec. From the Bartlett collection comes one of the best-known works in the museum, Seurat's *Sunday Afternoon on the Island of La Grande Jatte* (1884–86). In 1931 lawyer Jerome Eddy continued the tradition of giving contemporary art by bequeathing paintings including works purchased from the controversial Armory Exhibit of 1913, which was also shown at The Art Institute. Among paintings in the Eddy gift were four pieces by Kandinsky, a major early Manet, and portraits of Eddy by Whistler and Rodin.

Martin Ryerson's 1933 bequest was the largest received by the museum and one of the largest art bequests ever in the United States. The gift totaled 227 paintings, Oriental and European decorative arts, and some Greek vases. Others followed suit with gifts of Impressionist and Post-Impressionist work, including some by Monet, Degas, Cézanne, van Gogh, Gauguin, and Picasso in the 1933 bequest of Mrs. Lewis Larned Coburn. The tradition of support for the museum's strengths in nineteenth- and twentieth-century European paintings was recently continued by the gift of four paintings from the estate of the late trustee Mary Block, including works by Degas, Picasso, and Klee and an oil sketch by Seurat for *La Grande Jatte*.

Pre-nineteenth-century painting has also been fairly well represented in gifts to The Art Institute, even though it does not dominate the collection. In 1922 the Kimball bequest brought several important English paintings by Reynolds, Romney, and Constable into the collection. Charles Hutchinson's own bequest of 1925 included works by Flemish and Dutch painters. In 1906 the trustees of The Art Institute set a precedent for themselves, boldly (but not unanimously) voting to buy El Greco's *Assumption*, painted in 1577. This large work, El Greco's first major Spanish commission, was bought for $40,000 when few museums were collecting the work of the powerful sixteenth-century artist.

The Art Institute's decorative arts collections have benefited from the support of the Antiquarian Society, which was formed in 1877, before the incorporation of the Art Institute. The Oriental arts collection and the prints and drawings

collection got a strong start with the generous patronage of the Buckingham family. Clarence Buckingham's collection of Japanese prints, inspired by exhibits at the Columbian Exposition, was continued through gifts from his sister Kate Buckingham after his death in 1913. Kate Buckingham also began the extensive collection of Chinese ritual bronzes, in memory of her sister Lucy Maud Buckingham, in addition to donating a collection of medieval art artifacts. Later donors whose direct gifts stimulated the growth of the drawings collection were Mrs. Tiffany Blake in the 1940s and, more recently, Mrs. Joseph Regenstein.

As can be seen from this brief survey of patronage, The Art Institute's collection has diverse strengths. Today there are eleven curatorial departments in the museum: European Painting and Sculpture; Classical Art; Twentieth Century Painting and Sculpture; Prints and Drawings; Photography; Oriental Art; European Decorative Arts; American Arts; Africa, Oceania, and the Americas; Textiles; and Architecture.

The European Painting Department (pre-twentieth century) was essentially the first department of The Art Institute, with the museum's Director William M. R. French also serving as first curator of the department. In 1981 the department assumed responsibility for European sculpture as well as painting. (Scholarly catalogues of the collections are currently being prepared.)

Among the department's outstanding early works are the *Ayala Altarpiece* of 1396, one of the largest and most important Spanish medieval paintings to be found outside Spain. Notable Italian Renaissance works include six panels, the *Life of St. John the Baptist*, by Giovanni di Paolo and the scenes *Madonna and Child with St. John* by Correggio and by Jacopo da Ponte, called Bassano. The imposing El Greco *Assumption* of 1577 has been mentioned. Among Northern Renaissance painters represented are: Hans Memling, Lucas Cranach the Elder, and Quentin Massys.

The Baroque period is well represented by Caravaggisti Bartolommeo Manfredi and Cecco da Caravaggio, an early Rubens altarpiece, Guido Reni's *Salome with the Head of John the Baptist* (c. 1630–39), Nicolas Poussin's *St. John on Patmos* (c. 1650), and Rembrandt van Ryn's *Young Girl at an Open Half Door* (1645) and his early *Portrait of the Artist's Father* (c. 1631).

There is a wide variety of eighteenth-century paintings, including an altarpiece by Giovanni Battista Tiepolo and four panels illustrating scenes from Tasso's *Jerusalem Delivered* (c. 1740), the enigmatic *Pastoral Scene* (c. 1740) by G. B. Piazzetta, François Boucher's *Pense-t-il aux Raisins* (1747), and Jacques Louis David's *Madame Pastoret and Her Son* (c. 1791–92). The 1765 portrait by Sir Joshua Reynolds, *Lady Sarah Bunbury Sacrificing to the Graces*, is well known.

From the transitional mid-nineteenth century the collection has works by J.B.C. Corot, Jean François Millet, and Ingres; J.M.W. Turner's *Valley of Aosta, Snowstorm, Avalanche, and Thunderstom* (1836–37); Eugène Delacroix's *The Lion Hunt* (1861); and Gustave Courbet's *Mère Gregoire* (1855). A number of French nineteenth-century academic painters are also represented.

Among the rich collection of Impressionist paintings are numerous works by

Edouard Manet, including the *Mocking of Christ* (1865) and *Still Life with Carp* (1864); Frédéric Bazille's *Self Portrait* (1865); and Claude Monet's *Beach at Saint-Adresse* (1867), *The River* (1868), and *Old Saint-Lazare Station* (1877). There are a number of paintings by Renoir, including *Two Little Circus Girls* (1879), *The Rower's Lunch* (c. 1880), and *On the Terrace* (1881). Degas is represented by several ballet scenes and *The Millinery Shop* (1882), a carefully constructed composition. Caillebotte's masterpiece *Place de l'Europe on a Rainy Day* may also be seen. Among Post-Impressionist works in the collection are Vincent van Gogh's striking *Bedroom at Arles* (1888) and *Self Portrait* (1886–88); Henri de Toulouse-Lautrec's well-known *At the Moulin Rouge* (1892), and Paul Gauguin's *Day of the God* (1894). The works by Cézanne form a valuable record of his development, including the portrait *Madame Cézanne in a Yellow Chair* (1890–94), the *Basket of Apples* (1890–94), and a small version of his *Bathers* (1900). Seurat's *Sunday Afternoon on the Island of La Grande Jatte* has been mentioned.

The Department of Twentieth Century Painting and Sculpture emerged as a separate department in the 1950s and has actively collected and exhibited important trends in contemporary art. The collection contains a number of classic twentieth-century works, including Picasso's Blue Period *The Old Guitarist* (1903); a recently acquired Rose Period painting, *Girl with Pitcher*; his Cubist portrait *Daniel-Henry Kahnweiler* (1910); and his neoclassical *Mother and Child* (1921). There are early Cubist works by Robert Delaunay and Juan Gris and a Cubist-influenced piece by Kandinsky. Matisse's development is represented by the abstract *Apples* (1916), the monumental *Bathers by a River* (1916–17), and the *Interior at Nice* (1921), which suggests his later emphasis on patterns.

Twentieth-century works by American artists include Georgia O'Keeffe's *Black Cross, New Mexico* (1929), a large collection of works by Ivan Albright, and Edward Hopper's *Nighthawks* (1942). Important Abstract Expressionist works include Willem De Kooning's *Excavation* (1950) and Jackson Pollock's *Grayed Rainbow* (1953). Among recent acquisitions are works by Frank Stella, Claes Oldenburg's Cor-ten *Clothespin* (1975), and Sol LeWitt's *Nine Part Modular Cube* (1977).

One of the Twentieth Century Department's major activities is to organize the biennial American Exhibition. Formerly an annual juried event, this show still follows its original spirit, ''to keep the public of this region in touch with the current achievement in American art.'' Many pieces in the permanent collection have been acquired through purchase awards.

The Prints and Drawings Department of The Art Institute holds deserved acclaim for its breadth and for its particular strength in eighteenth- and nineteenth-century French drawings and nineteenth-century French prints.

Since the 1950s, the collection has been enriched by gifts from the Joseph and Helen Regenstein Foundation and by the generosity of Mrs. Regenstein. Included are drawings by Daumier (*The Three Judges*), Watteau, and Claude Lorraine (*Panorama from the Sasso near Rome*, c. 1649–55) and splendid wa-

tercolors by Manet (*Portrait of Berthe Morisot*) and Delacroix. Other outstanding French drawings in The Art Institute collection are: Antoine Watteau's *Study of Figures from the Italian Comedy*, Ingres' pencil *Portrait of Charles Gounod*, Renoir's study of a young girl for *The Bathers*, Degas, Cézanne, and Seurat's studies, and Picasso's silverpoint drawing *Nessus and Dejanira*. The Italian drawing collection, although lacking any of the master draftsmen of the Renaissance, contains a wide variety of types and styles of drawing, including a group of Piazzettas. An exhibition of Italian drawings in 1980 highlighted works by artists such as Fra Bartolommeo, Girolamo Genga, and G. B. Tiepolo.

The impact of the Buckingham gift on the print collection, which was formerly housed in the library, has been discussed. In addition to an extensive Japanese print collection, the Buckingham gift included fifty-seven prints by Dürer, fifteen prints by Lucas van Leyden, and ninety-five prints by Rembrandt. Carl O. Schniewind's curatorship from 1940 to 1957, followed by the judicious guidance of Harold Joachim from 1958 to 1984, has helped to expand the print collection. Today the collection includes works as diverse as the only print by the hand of Pieter Bruegel the Elder, Rembrandt's etching *Presentation in the Temple*, works by Redon, Gauguin's woodcut *Women at the River*, and Picasso's blue-inked etching *Frugal Repast* (1904).

The Photography Department began as an extension of Prints and Drawings but got a boost in its independent development after 1959. Notable examples of contemporary color photography are currently a focus of acquisitions. Earlier photographic works continue to be acquired, most recently as gifts from Jean and Julien Levy. New facilities for the department feature environmentally controlled storage vaults for the preservation of color photographs.

The Oriental Art Department was formally established in 1921, but the museum has housed an important collection of Japanese prints and Chinese bronzes, courtesy of the Buckingham family, before that time. Other notable pieces from the Chinese collection include tomb statuettes (two dancers from the late Han Dynasty), the striking T'ang Dynasty horse, and a ceramic standing warrior from the same period. There are a number of Chinese scrolls and an intricately carved painted bamboo chair from the Ch'ing Dynasty. Chinese and Korean ceramics predominate in the Russell Tyson Collection. From the Japanese collection, a Nara period wooden seated bosatsu figure and a Kamakura period wooden temple guardian statue stand out. There are also fourteenth-century Japanese scrolls and multifold screens from several periods.

The Japanese print collection contains a rich selection of works by Kabuki printmakers Kiyonobu I and Toshusai Sharaku, graceful geisha portraits by Kitagawa Utamaro, and scenes by Torii Kiyonaga, Sugimura Jihei, and others. Indian art is represented by outstanding pieces such as a Chola period standing Brahma in pink granite, an intricate bronze Shiva figurine from the eleventh century, and painted Moghal manuscript leaves. The department has recently added a number of Persian and Indian miniatures.

In 1905, before the formal establishment of the Oriental Art Department, the

architect Frank Lloyd Wright planned the installation of an exhibition of Japanese prints for the museum. Numerous exhibits of the department's Japanese print collection have followed.

Established in 1921, the Department of European Decorative Arts has long had the support of the Antiquarian Society, an ancillary body founded before the incorporation of The Art Institute. The Decorative Arts collection includes sculptural pieces such as the head of a prophet or apostle in limestone, possibly from the Cathedral of Notre-Dame in Paris (c. 1200); an ivory statuette, the *Virgin and Child Enthroned*, from northern France (c. 1240); and a terracotta model of St. Luke by Alessandro Vittoria (c. 1570). There are a number of fine pieces of French and English furniture and silver; the extensive English ceramics collection includes Wedgwood, porcelain, and other pottery pieces. The history of interior decoration, rather than appearing in period rooms, is illustrated by the unique Thorne Miniature Rooms. They were designed and donated to The Art Institute by Mrs. James Ward Thorne in 1941.

The American Arts Department combines painting, folk arts, and decorative arts through the twentieth century. Among important earlier paintings in the American Arts Department are the portrait *Mary Green Hubbard* (1764) and a pendant portrait of her husband, Daniel, done by John Singleton Copley before he left for England. The nineteenth-century American works complement the museum's collection of French Impressionists and include Mary Cassatt's *The Bath* (c. 1891–92), James McNeill Whistler's *Nocturne, Southhampton Waters* (1880–82), Winslow Homer's early *Croquet Scene* (1866) and *The Herring Net* (1885), trompe-l'oeil paintings by William Michael Harnett, and Thomas Eakins' sombre portrait *Addie, Woman in Black* (1899). Among the twentieth-century American decorative arts pieces is furniture by Frank Lloyd Wright, Eero Saarinen, and Noguchi.

The Department of Africa, Oceania and the Americas began as part of the Department of Decorative Arts, emerging independently as the Department of Primitive Art in 1956. The growing collection contains representative pieces from a variety of cultures. Recent emphasis has been on the collection of Southwest American Indian ceramics. North American works include an Anasagi Indian jar (c. 1400), a recently acquired Hohokom Indian bowl (c. 400–1200), and a Mimbres culture *Altar Group*, acquired in 1979. Pre-Columbian objects include a fragment of a Teotihuacan wall painting (400–700), a Maya wall relief showing a ceremonial ballgame (late eighth-early ninth century), a clay cylindrical vessel with painted scenes from the Late Classical Mayan period (c. 700–900), and a Mochica culture vessel in the form of a striking portrait bust (500–700). Among African objects are a late-nineteenth-century reliquary from Gabon; a graceful pair of antelope headpieces from Mali, made by the Bambara tribe; and a Yoruba female figure with offering bowl.

The Classical Art Department has recently become an independent department. There is a group of very fine pieces, including the Greek red-figure vase known as the *Chicago Vase*, as well as other smaller vases and glass objects. Sculptural

pieces include a portrait bust of Emperor Hadrian and a late Roman portrait bust of Gallienus (c. 260) and a Roman replica of the *Cnidian Aphrodite*, thought to be the only over life-size statue of its type in the United States.

The Textiles Department emerged from the Decorative Arts Collection in the 1960s. This department's recent remodeling and expansion has created new exhibition areas, study rooms, and a conservation laboratory. The collection includes an embroidered panel, the *Last Supper*, from early-fourteenth-century lower Saxony; a well-preserved complete set, *Altar Panels*, from Burgo de Osma in Spain (c. 1468); an Italian fifteenth-century chasuble with embroidered German Orphrey Cross; and a special collection of Turkish and Greek island embroideries. The department has recently augmented its collection of French eighteenth-century printed textiles; it also holds a selection of textiles from twentieth-century designers, including Mariano Fortuny and Natalia Gontcharova.

In 1981 the Department of Architecture was formed. Its principal holdings include more than forty thousand architectural drawings from the Burnham Library of Architecture and the architectural fragments from the American Arts Department. The Architecture Department selectively collects drawings and models from buildings and projects in the Chicago vicinity, and the Burnham Library retains an Architectural Archive of related manuscript material.

The Art Institute's Ryerson and Burnham libraries form a valuable research collection in art and architecture. The Ryerson Library was founded in 1901 and the Burnham Library of Architecture in 1912. They merged in 1957. As of June 30, 1981, the Ryerson Library volume count was 110,027, and the Burnham Library had 21,894 volumes. Special collections include Japanese and Chinese illustrated books, extensive periodical holdings, the library of Percier and Fontaine (architects to Napoleon), and an architectural archive featuring the D. H. Burnham Collection of letters and documents. The library has recently received grants to strengthen its book collection and to affiliate with the Research Libraries Information Network (RLIN), a bibliographic database for major research libraries. Through the RLIN data base, the library is undertaking the shared cataloguing of art auction catalogues with the libraries of the Cleveland Museum of Art (q.v.) and the Metropolitan Museum of Art (q.v.) Users of the library include students of the School of The Art Institute, the museum staff, members, and visiting curators.

Since the origin of The Art Institute as an academy of design, the School of The Art Institute has performed a significant role in the museum's organization. The original sculpture galleries were intended as didactic models for art students as much as displays for the general public.

Publications by The Art Institute of Chicago are numerous, although there is no comprehensive catalog or history of the museum. The *Annual Report* has been published in various forms since 1883; the *Bulletin* began in 1907, was renamed the *Quarterly* in 1951, and was superseded in 1965 by the *Calendar* and longer articles in the annual *Museum Studies*; in 1973 the *Calendar* was renamed the *Bulletin* and continues with brief announcements; *Museum Studies*

experienced a lapse in publication from 1973 to 1976, but issues appeared in 1976 and 1978. The more important guides and catalogs are listed below. The library of The Art Institute has incorporated a number of short historical accounts into a noncirculating volume, *Histories of The Art Institute of Chicago*. The library has also compiled scrapbooks of articles on the museum and on art activities in Chicago. A new publishing endeavor undertaken jointly by the museum and the University of Chicago Press will publish the entire drawing collection and twentieth-century painting and sculpture on color microfiche with brief catalog entries; the French, Italian, and Spanish drawing catalogs have appeared so far. The Art Institute also publishes catalogs of all major exhibitions.

Selected Bibliography

Museum publications: *Paintings in the Art Institute of Chicago: A Catalogue of the Picture Collections*, 1961; *General Catalog of Objects in the Museum*, 1901–14; *Catalogue of Paintings, Sculpture, and Other Objects Exhibited at the Opening of the New Museum*, 1893; *The Art Institute of Chicago: 100 Masterpieces*, 1978; *European Portraits, 1600–1900, in The Art Institute of Chicago*, 1978; *Descriptive Catalogue of Japanese and Chinese Illustrated Books in the Ryerson Library of The Art Institute of Chicago*, 1931, *Supplement*, 1963; *Archaic Chinese Jades from the Edward and Louis B. Sonnenschein Collection*, 1952; *Handbook of the Department of Oriental Art*, 1933;

Other publications: *The Clarence Buckingham Collections of Japanese Prints*, 2 vols., 1955-; Cummings, Kathleen Ray, *Architectural Records in Chicago: A Guide to Architectural Research Resources in Cook County and Vicinity* (1981); Joachim, Harold, *The Art Institute of Chicago: Italian Drawings of the 15th, 16th, and 17th Centuries* (1979) (Chicago Visual Library Text Fiche); idem, *The Art Institute of Chicago: Italian Drawings of the 18th and 19th Centuries and Spanish Drawings of the 17th through 19th Centuries* (1980) (Chicago Visual Library Text Fiche); idem, *French Drawings of the Sixteenth and Seventeenth Centuries; French Drawings and Sketchbooks of the Eighteenth Century; French Drawings and Sketchbooks of the Nineteenth Century* (2 vols.); Joachim, Harold, and Suzanne Folds McCullagh, *Italian Drawings in The Art Institute of Chicago* (1979); Marandel, J. Patrice, *The Art Institute of Chicago: Favorite Impressionist Paintings* (1979); Maxon, John, *The Art Institute of Chicago*, revised edition (1977); Naeve, Milo, *The Classical Presence in American Art* (1978); "The Art Institute of Chicago: A Centennial Perspective," *Chicago History* 8 (Spring 1979); Speyer, A. James (text), compiled by Courtney Donnell, *Twentieth-Century European Paintings* (Chicago 1980); *Society for Contemporary Art, The Art Institute of Chicago, 1940–80* (1980); Tedeschi, Martha, *Great Drawings from The Art Institute of Chicago; The Harold Joachin Years (1959–1983)* (1985).

VIRGINIA M. KERR

——— Cincinnati ———

CINCINNATI ART MUSEUM (officially CINCINNATI MUSEUM ASSOCIATION), Eden Park, Cincinnati, Ohio 45202.

Although there were many art schools and general museums in Cincinnati from 1812 on, the Cincinnati Art Museum was conceived by the Women's Art Museum Association in 1877, a continuation of the committee responsible for the successful showing of Cincinnati's women potters and other craftswomen at the Centennial Exhibition in Philadelphia. Their announced goal was to provide art classes, acquire collections, and present temporary exhibitions. At the opening of their internationally publicized exhibition in 1880, Charles West offered $150,000 for the founding of a permanent art museum, provided his gift would be matched in one year. One month later $160,000 had been pledged, and in 1881 the Cincinnati Museum Association was formed. The new Men's Board took over the Women's Association records, financial assets, and collections, and in 1882 the city of Cincinnati granted 19.7 acres in Eden Park, the hill nearest the downtown center. The new building, designed by James McLaughlin in Richardson Romanesque style, opened in May 1886 to acclaim as the "Art Palace of the West."

The Museum Association has 148 individual holders of $25 shares of nontransferable stock, as required in 1881 by Ohio law for "a private corporation not for profit." It is governed by a board of trustees, fourteen of whom are elected for four-year terms by the shareholders, three appointed by the mayor of the city, and the mayor himself, ex officio.

The original building has been enlarged several times as its collections and public activities have grown. The Schmidlapp Wing, designed with a Doric portico by Daniel Burnham in 1907, is now the main entrance. The Ropes Wing of 1910 added exhibition galleries to the first and second floors; the Emery, Hanna and French Wings in the Ecole des Beaux Arts neoclassic style were added in 1928–30, enclosing a garden court. In 1937 the Alms Wing matching the original Richardsonian exterior opened additional galleries on the second floor, library and office space on the first floor, and an auditorium and stack space on the ground floor. The Adams-Emery Wing of 1965 almost doubled the museum's exhibition space and added a lecture hall and social center, as well as extra stack space for the library on the ground floor.

Purchase endowments kept pace: the John J. Emery Fund came in 1902; the Herbert Greer French Fund for the maintenance and growth of the Print Department in 1940; an unrestricted and handsome endowment from Mary Hanna in 1956, part of which is used for accessions; the equally impressive Edwin and Virginia Irwin Memorial Fund for the purchase of paintings, "preferably American," in 1957; the Harry S. and Eva Belle Leyman Fund in 1944; and the Albert P. Strietmann Fund in 1951. These endowments are the chief sources of purchase funds, augmented by private donations, gifts, and bequests of works of art in all categories.

Operating funds come from general endowments; membership dues; appropriations from the Cincinnati Institute of Fine Arts and the Fine Arts Fund; and an annual solicitation for music, the performing arts, and the visual arts begun in 1949. In 1945 the city began small annual grants for operation but has been

much more generous in appropriations from its Capital Improvements Fund for the physical upkeep and rehabilitation of the building. Recently, the Ohio Arts Council also has provided annual grants for operational assistance.

The museum is administered by a director, an assistant director, and a business manager. Curatorial Departments are: Ancient, Near and Far Eastern Arts; Decorative Arts; Costume, Textiles and Tribal Arts; Painting; and Prints, Drawings and Photographs. There are also departments of Public Service, Education, Registration and Development; a conservation laboratory and a library.

The Egyptian Collection is small but inclusive, from Predynastic palettes and potteries through works of the Coptic Period, including a group of objects from Tel-el-Amarna, the fruit of limited but early support of the Egypt Exploration Society. Outstanding are two Dynasty V reliefs from Sakkara; a Dynasty XII scribe and head of a Nome God; a Dynasty XVIII bust of a noblewoman from Asiyut; a fragmentary rose granite head of Hatshepsut from Deir-el-Bahri; an unusually fine bronze lioness with rock-crystal eyes; a Dynasty XIX exceptional relief, *Seti I Offering Truth to Thoth, Abydos*; and a monumental bust of Sekhmet. Two notable bronzes from Dynasties XXV-XXX, a kneeling Horus and the largest-known seated Horus with a lion's head from Buto, precede a rose granite relief from Sebennytos, *Ptolemy Philadelphos Offering a Libation to Osiris*; many bronzes and canopic jars; a Dynasty XVIII mummy case; and a few notable ceramics from Dynasty XVIII through the Persian and Ptolemaic periods.

The collection of ancient Mesopotamian art is smaller but also of distinctive quality, beginning with a Sumerian alabaster, *Hero Bound with Serpents*, from Lagash, about 2800 B.C. It is followed by a bronze Sumerian votive calf, about 2300 B.C.; the bronze head of a Semitic vizier, from Azerbaijan, 1800 B.C.; and a remarkable Babylonian bronze of a seated, emaciated deity, late 1800s B.C. A small ivory figure of a priest said to have been found at Ziwiye and the upper part of an alabaster relief depicting a priest in ritual costume, from Calah, 883–859 B.C., represent Assyria, with an unsurpassed rock-crystal bowl carved with lions stalking and killing a bull, 800–700 B.C., possibly booty found at Persepolis.

The collection of works from the Classical world of Greece and Rome is also fine if not extensive. Ceramics begin with several Mycenean pieces from the "Potter's Shop" at Zygouries and continue with examples of most of the shapes in black figure and red figure, to Etruscan, Lucanian, and Roman vessels. Sculpture begins with an unusually fine and large Cycladic example and continues with examples from the Troad; early bronze and terracotta votive figurines; a Late Archaic marble head of Hermes from a herm, probably Attic; two marble heads of women from grave stelas of the fourth to the third century; a third-century B.C. life-size marble copy of Myron's bronze heifer from Athens; a large fourth-century marble lion from an Athenian tomb mound; and possibly the only complete example in America of a marble loutrophoros, also from the fourth-century Athens. A few outstanding bronzes include an early mirror with a figure of Artemis attended by lions, a noble bull variously dated from the late

sixth century to the Roman period, and a figure of Asklepios in the style of Skopas. Two gilt-bronze doe's head finials are said to come from Sybaris. A marble faun's head from Asia Minor and an Alexandrian marble Aphrodite represent the Hellenistic styles. Several of these Classical objects were bequests of Will T. and Louise Taft Semple, who supported Carl Blegen's excavations at Zygouries, Troy, and Pylos.

Etruscan art is represented by a fine early bronze warrior, several typical bucchero potteries, and a terracotta sepulchral urn. Roman art begins with a marble bust of a man from the late Republic; continues with the marble portrait of a youth of the Claudian family, a fine portrait of Julia Domna, and a mosaic revetment from Ostia; and reaches a climax with the relief *Mithras Sacrificing the Sacred Bull*, in marble, of the late second century, one of only two such depictions in America.

The diffusion of Graeco-Roman style is unusually well represented, including a funerary portrait from Palmyra; a fifth-century marble portrait head from the Byzantine world, probably of an emperor; and the unique, extensive collection of Nabataean antiquities from Khirbet-Tannur, a mountain-top site southeast of the Dead Sea in modern Jordan. They date from 125 to 200 and were excavated by Nelson Glueck of Cincinnati. They are a blend of Roman and Parthian styles. The shrine of Zeus-Hadad and a circular relief, *Atargatis with the Signs of the Zodiac*, are the best known.

A few examples of later Byzantine and pre-Romanesque sculpture introduce the European Middle Ages. A distinguished twelfth-century wooden Romanesque Virgin from the region of Toulouse, with its original polychrome, and several capitals of the same period are followed by the head of an angel from Rheims Cathedral of the mid-thirteenth century. The masterpieces come next: the full-size standing figure *Donateur de l'Hospice de Salins*, represented as St. John the Evangelist, by a master of Rheims, about 1260; and the tomb effigy of Don Sancho Saiz Carillo, from Santa Maria de Campo, Province of Burgos, in polychromed and gilded wood, about 1265. They are supported by other figures, capitals, and two superb ivory carvings of the Virgin, one mid-fourteenth century, the other a precursor of the détente, possibly by an Italian master of the late fifteenth century. A life-size, fully polychromed wooden figure of the Madonna and Child from late-fourteenth-century Siena is a fitting climax, as are two fine Limoges enamels of the thirteenth century. Although exhibited as part of the Spanish painting collection, the eight frescoes from the Hermitage of San Baudelio de Berlanga, Province of Soria, should be included. They date from the first half of the twelfth century, and since four of them adjoined each other in the apse of the small church, they are placed in a reproduction of their original setting.

The painting collection begins with Mary Emery's munificent bequest of 1927: Mantegna's grisaille *Mordecai and Esther*, long mistakenly called *Tarquin and the Cumean Sibyl*; Titian's studio portrait *Philip II*; equally exceptional works by Luini and Bronzino, augmented by a noted Tiepolo from Aranjuez; an early

Fra Angelico; Botticelli's *Judith*, related to the Uffizzi panel; and a Tintoretto, two Canalettos, Strozzi's *David*, and Guercino's impressive *Mars and Cupid*; as well as works by Matteo de Giovanni, Botticini, and others. A terracotta madonna by Mino da Fiesole, a small bronze by Giovanni da Bologna, and an anatomical horse of Leonardo's school represent the sculpture of the period.

The collection of Spanish painting begins with two large retables of outstanding quality as well as size: one is by Lorenzo Zaragoza of the early fifteenth century, and the other is the mid-sixteenth-century Tendilla retable. There are also works by Nicolas Francés, Jorge Ingles, Fernando Gallego, Pedro Berruguete, and Juan de Flandes. The *Crucifixion with View of Toledo* by El Greco, 1610–14; *The Legend of the Bell* by Zubarán; and *San Tomas de Villaneuva* by Murillo are outstanding. A late Velázquez portrait of Philip IV, works by Cano and Ribera, and a monumental still life by Alejandro de Loarte complete the display of the Baroque epoch in Spain. With an enormous leap in time, partly bridged by a Fortuny watercolor, the history of Spanish art resumes with two fine Sorollas, three Picasso oils (a Cubist masterpiece of 1910, a "classic" head of 1922, a semi-Cubist still life of 1937), and an early drawing, a Juan Gris still life of 1913, leading to Joan Miró's largest mural, commissioned for a Cincinnati hotel in 1947 and a gift of Thomas Emery's sons.

The collection is especially strong in paintings from the Lowlands, chiefly Holland. Masterpieces by Memling, Joos van Cleve, Rubens, and van Dyck parallel the large number of Dutch masters represented by distinguished works. Rembrandt, de Hooch, Ter Borch, Ruysdael, van der Neer, and Maes are especially noteworthy, among many others of superior quality. The fine *St. Helena* by Lucas Cranach and the *Man in Armor*, once thought to be by Dürer but now attributed to George Pencz, represent early German painting.

The roster of French artists is also impressive, beginning with a famous Claude, *The Artist Studying from Nature*, and a version of Simon Vouet's *Toilet of Venus* and continuing with a noted Lancret; two landscapes by Boucher and three by Hubert Robert; portraits by Nattier, Fragonard, and David; and two exceptional works by Vigée-Lebrun, with sculpture by Clodion and Houdon. The nineteenth century begins with Delacroix, Ingres' *Portrait of Cherubini*, and the chief Barbizon masters in major examples, including fifteen paintings by Corot, mostly from his middle period, but with one of his few early portraits dating from 1829. Three Courbets and *Orchestra Stalls* by Daumier lead to the Impressionists, most notably a small Manet, one of several studies for *Women at the Races*, and four pastels, three drawings, and a bronze ballerina by Degas. By Cézanne there are two early still lifes, a self-portrait drawing, and a famous watercolor, *The Bridge at Trois Sautets* from August 1906. By later artists working in France are two oils and a watercolor by van Gogh; several small sculptures by Rodin; three oils by Modigliani, including the *Portrait of Max Jacob*, and the large watercolor *Caryatid*, as well as watercolors, pastels, and drawings by Constantin Guys, Forain, and Odilon Redon. Many of them were in the bequest of Mary Hanna, as were several Dutch and earlier French paintings. The majority of the earlier

nineteenth-century canvases were the gift of Emilie Heine. Representing twentieth-century activity in France are two oil still lifes by Braque; two oils by Matisse; the well-known *Red Rooster* by Marc Chagall; an oil by Bonnard; seven oils by Rouault, Utrillo, and Arp; three works by Derain; a fine watercolor by Segonzac; three oils by de Staël; and works by Vieria da Silva, Léger, and Brancusi. Activity in other countries is seen in examples of Mondrian, van Doesburg, Klee, Nolde, Guttuso, Rufino Tamayo, and Diego Rivera. Many of their works were in the bequest of Mary Johnston.

Of English painting, there are several masterpieces. Of the thirteen oils by Gainsborough, portraits of *Mrs. Philip Thicknesse* and the *Earl of Warwick*, as well as three landscapes, are outstanding. Reynolds, Romney, Raeburn, Hoppner, Lawrence, and Beechey are well represented, with two Turner watercolors and a Constable oil, *Waterloo Bridge*.

Due to the Cincinnati Art Museum's early eminence as a "western" art center, American paintings form the largest section of the painting collection, with special emphasis on artists associated with Cincinnati. Of earlier American painting, however, there are examples by John Hesselius, two fine Copleys, a husband and wife pair of portraits by Charles Willson Peale, the huge *Laertes and Ophelia* by Benjamin West (one of the first paintings given to the museum and present in Cincinnati since the early 1830s), and two excellent Gilbert Stuarts, including the *Allibone Washington*. Later American artists represented include Fitz Hugh Lane, Asher B. Durand, Bierstadt, George Caleb Bingham, Frederick Church, Blakelock, Albert Pinkham Ryder, Inness, and William Merritt Chase, both with several examples. Theodore Robinson and Childe Hassam must also be mentioned. Representing the expatriates are two pastels and an oil by Whistler; three watercolors and two oils by Sargent, including a life-size painting of a Venetian model; an oil *Mother and Child* and a pastel *La Loge* by Mary Cassatt. Among many other nineteenth-century paintings are three watercolors, some drawings, and an oil by Winslow Homer, as well as two oils, including the life-size seated *Portrait of Archbishop Elder* by Thomas Eakins.

The largest repository of works by Frank Duveneck, most of them bequeathed by the artist, is the basis of the extensive collection of Cincinnati-associated painters. They include: James Beard; Miner K. Kellogg; Robert Duncanson, the first acclaimed black American artist; C. T. Webber and John Twachtman, both with several examples; Joseph DeCamp, Edward H. Potthast, Robert Blum, and Elizabeth Nourse; Henry F. Farny, the Indian painter; and a great many lesser-known figures. By Robert Henri, also born in Cincinnati, there are two paintings.

American painting of the twentieth century is represented by Grant Wood's *Daughters of the Revolution*, Saul Steinberg in his one large mural, and works by George Bellows, Arthur B. Davies, Niles Spencer, Yasuo Kuniyoshi, Edward Hopper, Marsden Hartley, Walt Kuhn, Louis Eilshemius, Josef Albers, Hans Hofmann, Maxfield Parrish, Richard Diebenkorn, Alex Katz, Helen Frankenthaler, Robert Motherwell, Stuart Davis, and R. B. Kitaj. Other artists represented are James Dine and Tom Wesselmann, both of Cincinnati origin; Julian

Stanczak; and, with a group of watercolors, John Marin, Charles Burchfield, and Andrew Wyeth, to name only a few outstanding figures. Sculptures by Saint-Gaudens, David Smith, Mary Callery, Wilfred Zogbaum, Charles Cutler, and George Rickey are included in this collection.

The Print Department parallels the painting collection, with its core of first works from the Herbert Greer French Collection. It has extensive holdings of Dürer, Rembrandt, Piranesi, and Blake, as well as two extremely rare color prints by Hercules Seghers. It is supplemented by the Ross Sloniker Collection of twentieth-century religious prints and the Albert P. Strietmann Collection of modern works in all graphic media, especially strong in colored lithographs. The drawing collection is not large but has several choice examples, including works by deMoustier, Watteau, Lancret, Parmigianino, Piazzetta, Tiepolo, Cambiaso, van Dyck, Gainsborough, and Samuel Palmer, with more than eight hundred drawings by Carl Friedrich Lessing, gift of Joseph Longworth.

The most exceptional of the museum's holdings in non-western art is the Near Eastern collection. It begins with a fine group of Luristan bronzes and a silver pectoral and continues with objects from the Amlash culture and Median and Mannaean gold objects, several of them from the Ziwiye Treasure. The Achaemenid period, represented by two reliefs from Persepolis, is also rich in silver and gold objects, including the libation dish of Darius the Great, with his name engraved in three languages on the reverse. The style of the Sassanian era from Ardashir to Firdausi is seen in nine silver vessels and four stucco reliefs. Islamic potteries cover the whole sweep of that art in more than a hundred examples, one of the most representative if not the largest group on public exhibition, culminating in a 9 1/2-foot-tall mihrab in the style of Isfahan of the late seventeenth century. Miniatures begin with more than forty illustrated folios from the Andarz Nama of the late eleventh century, gift of Audrey Emery, continuing through the late seventeenth century; a small but select group of textiles includes the signed tomb cover of the Imam Reza, from Kashan, of the late sixteenth or early seventeenth century. There is also a fully painted room of the early eighteenth century from Damascus.

From India there are many fine miniatures of the Mughal period. Of the earlier phases of Indian art, there are more than thirty examples of Gandharan sculpture in both stone and stucco from Swat, which were the bequests, as were many Indian works, of the Semple family. They include Nepalese gilt bronzes; a seventeenth-century Jain shrine in polychromed wood; possibly the largest extant Durbar cloth, from Golconda; and other textiles. Two stone sculptures from Khmer Cambodia and a Buddha head from Borobudur can also be seen.

Chinese art begins with prehistoric potteries, continuing through several distinguished ceremonial bronzes of the Shang and Chou dynasties. Sculptures from the Han through the Sung Dynasty precede the scroll and hanging paintings by Ma Yüan and Chiën Hsäan of the Sung Dynasty, Ku An and Chu-Ta of the Yüan Dynasty, and several others, some from the Ming Dynasty. The pottery collection is especially strong in examples from the Sung Dynasty. A few char-

acteristic Ming and Ching examples are shown with jades of the same periods. The "Cincinnati Carpet" may be one of the oldest (some experts dating it from the twelfth century), as well as the largest, examples known. Chinese export ware occupies two galleries of the Decorative Arts Department.

Japan is scantily represented by a few hanging paintings and a group of fine lacquers, court kimonos, and folding screens in the Edo style, given by the Emery family, which with the stimulus of John J. Emery, Jr., has been the most generous donor to almost every department of the museum. The Print Department has a large collection of Japanese prints from the beginning of this art, with an unusual emphasis on contemporary artists.

The Decorative Arts Department has the largest collection next to that of the Print Department and, like it, can show only a sampling at one time. Its tapestry collection begins with two fine mille-fleurs works, five of one of the earliest Gobelins series depicting the life of Diana, a Beauvais chinoiserie subject based on a painting by Boucher, and the four unique Beauvais tapestries of the de Berthier de Sauvigny family closely related to a series of watercolors by Fragonard. Several period rooms begin with a *studiolo* from the late years of Henri IV, with paintings in the Fontainebleau manner illustrating Tasso's *Aminta* and the *Emblemata Amorum* of 1608. A large *Régence* salon, a small Louis XV boudoir with singerie and chinoiserie paintings possibly by Christophe Huet, and a large Louis XVI salon are followed by a Jacobean room with a huge cheminée from Bristol and a small drawing room of about 1735 from Grosvenor Square. A paneled wall from the ballroom of "Soldier's Joy" in Nelson County, Virginia, leads to four rooms from the Cary House built in Cincinnati about 1816. In the parlor of the Groesbeck House, also of Cincinnati, 1871–72, costumed mannequins appear, followed by a series of costumes in period settings from Jane Austen's time to contemporary designers. Most of the huge costume collection is housed and available for study in a large hall nearby. German, English, and American silver is shown, as well as the William T. H. Howe Collection of American glass, which is especially strong in Ohio works but also has examples by artists from Tiffany to Dominick Labino. Continental ceramics, Rookwood pottery, and furniture from many countries and periods, including the twentieth century, is distributed through the department and the painting galleries.

Musical instruments, largely from the William Howard Doane Collection, are one of the few systematic presentations to be seen in the country. They range from all parts of the Orient and Europe, accompanied by an audio commentary. Two notable examples are the Amati "Nuremberg viola" of 1619 and a bronze Roman buccina said to have been found in Pompeii, one of the only three known with a tapered tube.

Tribal arts is another major part of the collection, with more than forty thousand objects from the United States alone. Oceania, pre-Columbian South and Central America, and Africa are all represented. The pre-Columbian United States section features one of the small but few collections of mound-builder objects, as well

as potteries from the Southwest. Later examples of the arts of the Southwest and the Pacific Northwest are, like the others, shown as works of art and not merely ethnological specimens.

The Library has more than forty-three thousand volumes and complete bound sets of the major professional journals. It is open to the public, but limited circulation is a membership privilege.

Catalogues of temporary exhibitions as well as other publications can be obtained from the Publications Clerk. Slides, color postcards, and poster orders can also be placed. A published list is available. Bulletins were issued quarterly from 1930 to 1941. The new series *Bulletins* has appeared irregularly from 1950.

Selected Bibliography

Museum publications: *Handbook to the Collection*, 1975; *The Golden Age: Cincinnati Painters of the Nineteenth Century Represented in the Cincinnati Art Museum*, 1979; *French Drawings, Watercolors, and Pastels, 1800–1950*, 1979; *The Mary E. Johnston Collection*, 1972; *Musical Instruments*, 1949; *The Sculpture Collection*; 1970; *Spanish Paintings*, 1978; *Masterpieces from the Cincinnati Art Museum*, 1984.

PHILIP R. ADAMS

———— Cleveland ————

CLEVELAND MUSEUM OF ART, THE (also CMA), 11150 East Boulevard at University Circle, Cleveland, Ohio 44106.

The Cleveland Museum of Art was founded and substantially endowed by four eminent citizens committed to elevating the city of Cleveland to cultural and artistic prominence: John P. Huntington, Horace Kelley, Hinman B. Hurlbut, and Jeptha H. Wade II. Toward the close of the nineteenth century, Huntington, Kelley, and Hurlbut, each probably acting without the knowledge of the others, made bequests in their wills for the building of a museum. In 1882 Jeptha Wade had given the city a large tract of land now called Wade Park, and ten years later his grandson J. H. Wade II set aside an area in the park as the site for the new museum.

In 1913 the trustees of the Huntington and Kelley funds cooperated to incorporate The Cleveland Museum of Art, endowed by the Hinman B. Hurlbut Fund, with the building cost financed by The John Huntington Art and Polytechnic Trust and The Horace Kelley Art Foundation. Construction began in 1914 and the neoclassical-style building, designed by the Cleveland architectural firm of Hubbell and Benes, with consultation by Edmund B. Wheelright of Boston, was formally opened to the public on June 6, 1916. Subsequent bequests, principally those made by Dudley P. Allen, Worcester R. Warner, Mr. and Mrs. Liberty E. Holden, John L. Severance, Elisabeth Severance Prentiss, J. H. Wade II,

Mr. and Mrs. William Marlatt, and Leonard C. Hanna, Jr., included both works of art and funds for operating expenses and purchases in the fields of Western and Oriental art.

A private institution operated for the public benefit, the museum continues to receive almost all of its support from trust and endowment income and individual and corporate contributions. The John Huntington Art and Polytechnic Trust and The Horace Kelley Art Foundation have also continued to make annual grants.

Four organizations affiliated with the museum provide further support. The Print Club of Cleveland, founded in 1919; The Textile Arts Club, begun in 1934; and The Cleveland Society for Contemporary Art, founded in 1961, not only offer programs for their members but help to build the museum's collections through gifts and funds for the purchase of works of art. The Musart Society, organized in 1946, provides financial support for the programs of the Musical Arts Department.

A 1958 addition, designed by Cleveland architects J. Byers Hays and Paul C. Ruth, doubled the size of the museum and provided much-needed gallery space for the growing collections. To accommodate the expanding schedule of educational programs, concerts, and exhibitions, another wing was added in 1971. Marcel Breuer and Associates was chosen as the architects for the Education Wing, which contains two large special exhibition galleries, the 750-seat Gartner Auditorium housing the P. J. McMyler Memorial Organ, two 150-seat lecture and recital halls, classrooms, audiovisual rooms, and the offices of the departments of art history and education, and musical arts. In 1984 the museum's book, photo, and slide libraries were moved into a smaller addition designed by Cleveland architect Peter van Dijk. The new building also provided nine additional galleries for the display of eighteenth-, nineteenth-, and twentieth-century European and American art.

The museum is known for the exceptional range and quality of its collections, now numbering more than forty-five thousand objects. The galleries present, generally in historical sequence, the arts of ancient Egypt, Greece, and Rome; the Near East; Europe; America; India and Southeast Asia; China, Japan, and Korea; Africa; and the pre-Columbian Americas. The paintings, sculpture, and decorative arts of a particular period are exhibited together, with works on paper and some textiles installed in cases with controlled lighting. Prints and drawings and many of the textiles are continually rotated in galleries fitted with low-intensity lights.

The collection of Western medieval art, one of the largest and most important in America, was built up under the direction of William M. Milliken, who joined the museum as curator of decorative arts in 1919 and served as director of the museum from 1930 to 1958. The Far Eastern collection, one of the finest outside of Asia, has been assembled principally through the efforts of a noted scholar in the field, Sherman E. Lee, director from 1958 to 1983.

The museum is governed by a board of twenty-one trustees who serve one-year renewable terms. It is administered by the director, aided by an assistant

director for administration and an assistant director for operations and finance. The curatorial departments are: Ancient Art (art of the ancient world west of the Indus River), Early Western Art (from Early Christian work to the year 1600), Later Western Art (from 1600 to those artists born before 1830), Modern Art (artists born in or after 1830), Oriental Art (all art produced in Asia east of the Indus River), Prints and Drawings, and Textiles. Except for prints, drawings, and textiles, curatorial departments embrace all media. The responsibility for Islamic art is currently with the curator of textiles; pre-Columbian, North American Indian, African, and Oceanic art are in the care of the department of Later Western Art. The Conservation Department was formed in 1958. The Department of Art History and Education, established in 1915, one year before the museum galleries opened, provides gallery talks, classes, films, and slide tapes for young people and adults and organizes educational exhibitions, usually drawn from and designed to interpret areas of the museum's collections; its Extensions Division designs loan exhibitions for schools, libraries, and other community institutions. The Department of Musical Arts, endowed by the P. J. McMyler family in 1920, annually offers a varied series of free and subscription concerts.

More than half of the works in the present Egyptian collection were purchased in the antiquities bazaars of Luxor and Cairo in the two years before the museum opened its doors. Among the objects acquired at that time were rare First Intermediate Period and Dynasty XXX limestone reliefs, two fine late New Kingdom anthropoid wooden mummy cases, a Dynasty XXVII black basalt bust of Ankh-hor, and Dynasty XVIII glass vessels.

For thirty years after that, the Egyptian collection was nearly dormant except for a few bequests of ancient bronzes. In 1947 the museum began to acquire major works of Egyptian art, first the gold Leontopolis lion necklace dating from the Roman Period (first to second century A.D.), then the gray granite torso of the general Amun-pe-yom from the Ptolemaic Period (c. 280–250 B.C.), and from 1949 to 1951 a group of limestone reliefs from the tomb of the vizier Mentuemhat dating from the early Dynasty XXVI (c. 670–640 B.C.). In 1952 Sherman Lee became curator of Oriental and ancient art and made a number of first-rate additions to the collection, including a granite coronation portrait of Amenhotep III (c. 1417 B.C.), a series of sandstone reliefs from the Aten Temple at Karnak (c. 1379–1374 B.C.), and a portrait in rose quartzite of an elderly Amenhotep III (c. 1380 B.C.). One of the museum's greatest purchases at this time (1961) was the brilliantly painted relief with nome gods from a temple of Amenhotep III (c. 1390 B.C.). Miraculously, fifteen years later an adjoining fragment with another nome god and part of the register above was found and added to the collection.

Under John C. Cooney, who succeeded Lee as curator of ancient art, a number of great objects were added: a Ptolemaic figure of an Apis bull in green serpentine, three second-century Faiyum portraits, a large Archaic Period (c. 3100 B.C.) alabaster sculpture of the frog-form goddess Heqat, and an extraordinarily fine bronze Harpocrates of the Roman Period (c. first century B.C.). More recent

purchases in this area include an extremely rare limestone portrait of Weserkaf, first king of Dynasty V, about 2490 B.C., and two bronze mirrors, one with a handle in the form of a concubine, the other the god Bes, dating from 1479–1425 B.C., the finest known of their type.

The Classical—Greek, Etruscan, and Roman—collections developed in a more even chronological pattern beginning in 1915. Under Director William Milliken the areas best developed were Greek and Etruscan bronzes. Although Cleveland's collection of Classical bronzes is small in number, it is in aesthetic quality one of the finest collections in the world. It includes an exceptionally spirited and beautifully cast Hellenistic mule-head couch ornament of the second century B.C.; a fine Greek nude athlete of the third century B.C.; an Etruscan *cista* handle, with figures of Sleep and Death carrying off a dead warrior, of the fourth century B.C.; and an exquisite Etruscan candelabrum of the late sixth century B.C. Notable among the bronzes are a small Archaic (sixth century B.C.) Etruscan kouros, a fifth-century B.C. Etruscan dancing satyr, and a fifth-century B.C. Polykleitan athlete, a small masterpiece of Greek bronze work. Recently, the museum acquired one of the finest early Roman bronzes in existence, a Winged Victory dating from the late first or early second century A.D.

Important large sculptures in the collection include a marble Archaic Greek kouros torso of the sixth century B.C.; a larger-than-life-size early-fifth-century B.C. limestone goat head suggested by Henry Robinson to be the head of the god Pan from his shrine on the Athenian acropolis; marble portraits of Lucius Verus (c. 170–180 A.D.) and Cornelius Gallus (c. 30 B.C.); and an extremely sensitive Late Republican bronze portrait of a man (40–30 B.C.).

During the first fifty years of the museum's history little effort was made to acquire fine Greek vases. Yet a few important purchases were made: the massive red-figured krater (c. 470–460 B.C.), which is the name-vase of the Cleveland Painter; a fine red-figured lekythos by the Oionokles Painter (c. 480–470 B.C.); and a red-figured krater by the Pig Painter (470–460 B.C.). The most outstanding vase in the collection is the delicately drawn, white-ground Atalanta lekythos by Douris (500–490 B.C.), acquired in 1966. That purchase, the beginning of an effort to strengthen the vase collection, was followed by a large, intact, black-figured dinos with battle scenes by the Antimenes Painter (c. 520–515 B.C.); one of the best known of Nikosthenes' amphorae (c. 530 B.C.); a famous red-figured kylix by Psiax (c. 520 B.C.); and several plastic vases, including a mule head rhyton (c. 475 B.C.), a janiform kantharos (c. 470 B.C.), and a Apulian cow-head rhyton (c. 340 B.C.). The most recent purchase in vases is an extraordinary squat lekythos decorated with a scene of the birth of Erichthonios by the Meidias Painter, the finest painter of the Classical period, dating from around 410 B.C.

The Near Eastern section is the smallest area of the three ancient collections. It is nonetheless well known for a few major pieces, such as a large Sumerian stone sculpture of a standing Gudea dating from the twenty-second century B.C., a basalt half-life-size figure of a Syrian seated prince from the early fifteenth

century B.C., a basalt Hittite priest-king (c. 1600 B.C.), a stone relief from the Nimrud palace of Ashur-Nasirpal II (ninth century B.C.), an outstanding group of Sassanian silver vessels, and a group of exceptionally fine Luristan bronzes.

The gallery devoted to Early Christian and Byzantine art contains a choice collection of marble, stone, and ivory carvings; mosaics; textiles; metalwork; and manuscript paintings. Among the most important objects are five marble sculptures of Early Christian subjects (one depicting the Good Shepherd, the others episodes from the story of Jonah) and three pairs of male and female portrait busts dating from the third quarter of the third century. The eleven sculptures, thought to be the products of a single workshop in the Eastern Mediterranean, continue Hellenistic and Roman sculptural traditions.

The Byzantine collection includes excellent examples of gold jewelry and a number of pieces of silver dating from the fourth to sixth century—bowls, spoons, chalices, and a superb vase with figural decoration. The art of ivory carving is represented by two pyxes, one carved in the sixth and the other in the eleventh century, with reliefs of New Testament subjects; a casket composed of ivory plaques depicting the story of Adam and Eve dating from the eleventh or twelfth century; and the masterpiece of the collection, an exquisitely carved eleventh-century ivory plaque, the *Madonna and Child Enthroned with Angels*, formerly in the Stroganoff Collection in Rome. Among the manuscript pages is an exceptional page from an eleventh-century Gospel book depicting the seated Evangelist Matthew.

Displayed with these works are textiles woven in Egypt between the fourth and ninth century. Particularly important is a remarkably preserved panel of a satyr and maenad, a fragment from a tapestry dating to the Late Roman or Early Byzantine Period. (Two other sections from this tapestry are in the Museum of Fine Arts [q.v.], Boston, and the Abegg-Stiftung Bern in Riggisberg, Switzerland.) Of great historic and aesthetic importance is a unique Byzantine tapestry, the *Icon of the Virgin*, woven in Egypt during the sixth century.

The medieval collection began to develop in 1920, when a trust fund established by J. H. Wade II enabled the museum to make significant purchases of medieval art. In 1931 Director William Milliken purchased the most famous of the museum's medieval works, a group of nine objects that had once been part of the treasury of the Cathedral of St. Blasius in Brunswick, Germany. The principal objects in this group, known as the Guelph Treasure for the ducal family that commissioned and presented many of the works to the cathedral, are a portable altar of gold, cloisonné enamel, and semiprecious stones and two reliquary crosses commissioned by Countess Gertrude of Brunswick and given to the Cathedral of St. Blasius around 1040. Two objects in the Treasure were made in Hildesheim around 1175, a gilt-silver arm reliquary commissioned by Duke Henry the Lion of Saxony and the gilt-silver paten of St. Bernward, archbishop of Hildesheim, which is mounted in a fourteenth-century monstrance of gilt-silver and crystal. Also part of the Treasure is an ivory plaque, the *Marriage Feast at Cana*, produced in Liège about 1000, which is set into a

fourteenth-century German silver-gilt, book-shaped reliquary; the twelfth-century Sicilian ivory *Horn of St. Blasius*; a Frankish cloisonné enamel medallion with the bust of Christ, dating from the eighth century; and a silver-gilt and crystal Gothic monstrance with a relic of St. Sebastian, made in Brunswick around 1475. The purchase of these objects was made possible by a gift from The John Huntington Art and Polytechnic Trust, by an appropriation from the Wade Fund, and by gifts from Mrs. E. B. Greene and Mrs. R. Henry Norweb. Their acquisition brought international recognition to the Cleveland Museum as a major museum intent on assembling exceptional collections. Shortly thereafter, in 1933, the museum purchased one of the finest examples of German Romanesque manuscript painting, a leaf from a *Gospel*, with miniatures of the Nativity and St. Matthew, executed in tempera, silver, and gold on parchment and produced between 1170 and 1190 in the workshop of Herimann, a monk of the abbey of Helmarshausen near Brunswick, who had illuminated the famous *Gospels of Duke Henry the Lion*.

The collection's many superb examples of medieval goldsmithing and enameling include a large number of enameled and gilt plaques, reliquaries, and crosses produced in Germany, France, and Italy during the twelfth and thirteenth centuries. Of particular importance is a late twelfth-century French processional cross of champlevé enamel and gilt-copper noted for its sensitive depiction of the crucified Christ. The cross, formerly in the Spitzer Collection, is attributed to the Master of the Grandmont Altar and is the largest, most complete, and finest known of its type.

The medieval ivory carvings also include some exceptional pieces: an Ottonian ivory relief from a Gospel cover, *Christ's Mission to the Apostles*, about 970, and two works purchased from the Robert von Hirsch Collection—a Romanesque plaque, the *Journey to Bethlehem*, from a South Italian workshop, about 1100–1120, and three panels from a casket with scenes from medieval romances made in Lorraine or the Lower Rhine in the fourteenth century.

The gallery of Romanesque and Early Gothic sculpture contains capitals and other architectural fragments of limestone and marble dating from twelfth- and thirteenth-century Italy and France. Particularly noteworthy are a twelfth-century limestone capital, *Daniel in the Lion's Den*, from the nave of a Romanesque church in France's Central Loire Valley and two heroic-sized limestone heads of apostles from the south portal of the Gothic Cathedral of Thérouanne in northern France, about 1235. The gallery also houses splendid examples of painted wooden sculpture dating from the twelfth through fourteenth century, including the rare twelfth-century French Romanesque *Crucified Christ* and the remarkably preserved fourteenth-century seated *Christ and St. John the Evangelist*, an example of German Gothic art. Exhibited in the same gallery is one of the museum's most important textiles, a large, intricately embroidered white linen cloth made by the nuns of Altenberg Abbey, Germany, between 1330 and 1350, and probably designed to separate the chancel of a church from the nave during the Lenten season.

The holdings of Gothic art include a large number of manuscript paintings, textile fragments, and panel paintings from thirteenth- and fourteenth-century Italy. A triptych, *The Madonna and Child with Saints*, by Berlinghiero, active in Lucca from 1220 to 1240, shows Byzantine influences. The most important of several fourteenth-century Sienese paintings is Ugolino di Nerio's polyptych of the Madonna and Child flanked by saints. A marble statuette, the *Madonna and Child*, attributed to the Pisan-Florentine sculptor Andrea Pisano, is of particular beauty and strength and reflects the figural style of Pisano's master Giotto.

The elegance of the International Gothic style is seen in a number of French sculptures, including a late fourteenth-century limestone *Madonna and Child* and a mid-fourteenth-century marble *Angel of the Annunciation*, whose companion piece, a standing Virgin, is in the Louvre (q.v.). The most celebrated sculptures from this period are three alabaster mourners from the tomb of Philip the Bold in Dijon, France, designed and executed by the Franco-Netherlandish sculptor Claus Sluter and his nephew Claus de Werve in the early fifteenth century.

A collection of Italian Gothic and Early Renaissance paintings formed by James Jackson Jarves and purchased by Mr. and Mrs. Liberty E. Holden was given by the Holdens to the museum in 1916. The Holdens subsequently established a fund that made possible other acquisitions in Italian painting, including the Sienese artist's Giovanni di Paolo's panel painting the *Adoration of the Magi*. Drawing upon funds from other donors, the museum purchased two additional works by Giovanni di Paolo—panels from an altarpiece depicting scenes from the life of St. Catherine of Siena—and other significant Gothic paintings, notably *Madonna and Child Enthroned*, a center panel from an altarpiece by the Master of 1419, and a small panel, *The Annunciation*, by an anonymous late-fourteenth-century French master, formerly in the Arthur Sachs Collection. The museum has some superb examples of the sumptuously illuminated books of the time: the *Gotha Missal* (Paris, around 1375), perhaps intended for the private chapel of Charles V of France; and the *Hours of Charles the Noble*, a remarkable collaboration of French, Italian, and Netherlandish artists (Paris, around 1405) for Charles III, king of Navarre. Later examples include the four Gospels, with miniatures of the Evangelists by the Master of the Hausbuch (Middle Rhine, around 1480), and the extraordinary *Book of Hours of Isabella of Spain* (c. 1492) and with it the jewel-like miniature paintings bordered by realistically observed flowers and insects, one of the finest products of Flemish illumination of the late fifteenth century.

Notable among the secular objects of the period are a silver-gilt and enamel Parisian table fountain of the mid-fourteenth century and a group of twelve medallions of enamel, gold, and pearls made in France around 1400. There is a fine representation of Italian and Spanish textiles of the late fourteenth and fifteenth century, including a fifteenth-century Spanish silk curtain, probably woven in Granada, the largest, most complete, and most ornate curtain to have survived from the Middle Ages.

The collection of northern European art in the Late Gothic style includes two small gems of Early Netherlandish painting dating from the early fifteenth century, a fragment of a panel, *St. John the Baptist*, by Robert Campin, and *St. John the Baptist in a Landscape*, attributed to Petrus Christus, a follower of Jan van Eyck. A group of Netherlandish paintings of the late fifteenth century includes works by Geertgen Tot Sint Jans, Gerard David, Hans Memling, Dieric Bouts, and Bouts' son Aelbrecht. *The Birth of St. John*, a panel painting from an altarpiece attributed to Juan de Flandes, the Hispano-Flemish court painter to Queen Isabella, was rediscovered just before its purchase by the museum in 1975. Also notable are two German paintings, a panel depicting a bridal couple by an anonymous South German master, about 1470, and *The Mass of St. Gregory* by Hans Baldung (called Grien).

The choice collection of Late Gothic German sculpture includes three works by the virtuoso sculptor Tilman Riemenschneider: an alabaster sculpture, *St. Jerome and the Lion*, about 1495, and lindenwood figures, *St. Lawrence* and *St. Stephen*, carved between 1502 and 1510. There is a sensitively carved pearwood figure, the *Virgin Weeping*, by Veit Stoss (active 1470–1533) and the large lindenwood *Corpus of Christ* dating from 1525–30, one of the finest works of the Bavarian artist Hans Leinberger.

The art of France during the late fifteenth and early sixteenth centuries is represented by paintings, sculpture, enamels, and a variety of other works, such as an abbot's stall of oak with an intricately ribbed and pinnacled canopy in the flamboyant Gothic style. The collection of Late Gothic tapestries includes German, Flemish, and French works. Most important are three excellently preserved and richly colored French tapestries with allegorical scenes illustrating the themes of the Triumph of Eternity, Youth, and Time. The set, which once hung in the chateau of Chaumont in the Loire Valley, was woven between 1500 and 1510.

From the Holden Collection came the *Madonna and Child with Angels*, a copy of a lost center panel of an altarpiece by Fra Filippo Lippi, commissioned by Giovanni de' Medici in 1457 as a gift for Alfonso V of Aragon. The painting is now flanked by two original panels from the altarpiece, *St. Anthony Abbot* and *St. Michael*, purchased by the museum with monies from the Leonard C. Hanna, Jr., bequest. Holden funds were used to acquire one of the museum's most important Italian Renaissance paintings, Filippino Lippi's tondo *The Holy Family with the Infant St. John and St. Margaret*, dating from the late fifteenth century. Among other significant fifteenth-century Italian paintings are the *Portrait of a Man*, attributed to the Neapolitan painter Colantonio, and *Portrait of a Nun*, attributed to the Venetian artist Jacometto Veneziano.

Holden and Hanna funds were also used to purchase most of the later Italian Renaissance paintings, notably Andrea del Sarto's unfinished masterpiece *The Sacrifice of Isaac*, Jacopo Bassano's huge canvas *Lazarus and the Rich Man*, Giovanni Girolamo Savoldo's *Dead Christ with Joseph of Arimathea*, two works by Paolo Veronese, and Tintoretto's *Baptism of Christ*. The *Adoration of the Magi* by Titian was acquired through the Mr. and Mrs. William H. Marlatt Fund

established in 1939, one of the main purchase funds for the painting collection. Northern European paintings of the sixteenth century include the *Madonna and Child in a Landscape* by the Flemish artist Jan Gossaert, called Mabuse, and *The Stag Hunt* by the German artist Lucas Cranach the Elder.

The collection of Italian Renaissance sculpture includes marble and terracotta statues and reliefs, as well as examples of the tin-glazed earthenware sculpture introduced by Luca della Robbia in the fifteenth century. Among the works in marble are two superbly modeled fifteenth-century reliefs of the Madonna and Child, one from the circle of Bartolommeo Bellano, the other attributed to the Neapolitan artist Miro del Reame, executed about 1461–64 for the church of St. Maria Maggiore in Rome. Classical subjects inspired two other marble reliefs: a bearded male nude, *Philoctetes on the Island of Lemnos*, by the Venetian sculptor Antonio Lombardo and a late fifteenth-century relief of Roman Emperor Aurelius Antoninus Pius. The finest of the glazed earthenware works are the *Figure of Plenty (Dovizia)*, executed by Giovanni della Robbia in the late 1520s, and an altarpiece of a Madonna and Child enthroned with saints by Benedetto Buglioni, a Florentine whose work parallels that of the della Robbias.

Another aspect of Renaissance sculpture and Renaissance taste is seen in a rich collection of bronze statuettes, plaquettes, portrait medals, and utilitarian objects, such as candlesticks, inkwells, scales, and doorknockers, produced in Italy, Germany, the Netherlands, and France from the fifteenth through the early seventeenth century. Particularly noteworthy are portrait medals by the Veronese artist Pisanello; works by the Paduan sculptors Riccio and Severo da Ravenna; a large group of superbly modeled statuettes of classical and religious subjects by North Italian artists, including Giovanni Bologna's powerful *Mars*; and two equally fine works by his followers, the Netherlanders Hubert Gerhard and Adriaen de Vries.

Renaissance decorative arts include choice examples of the goldsmiths' art—jewelry, tableware, and ceremonial cups; a large collection of sixteenth-century Italian majolica plates, drug bottles, and vases; some fine sixteenth-century French lead-glazed earthenware plates; a particularly fine jewelry casket with pastiglia decoration of classical motifs and scenes from Roman history, made in Venice in the late fifteenth century; Limoges plates and candlesticks in painted enamel on copper; and five examples of the rare French ceramic with inlaid ornamentation known as Saint-Porchaire ware.

In 1939 Leonard C. Hanna, Jr., gave some particularly fine Italian Renaissance credenzas and tables, and in 1942 John L. Severance bequeathed to the museum three sixteenth-century Italian marriage chests and superb pieces of sixteenth-century French furniture, including a richly carved walnut dressoir and marquetry table from Burgundy. Some of the Renaissance furniture is exhibited in the museum's Armor Court, which also displays the arms and armor collection of Mr. and Mrs. Severance, given in 1916. This collection includes a few battle pieces from the fifteenth century, a number of fine parade pieces from the

sixteenth and seventeenth centuries, and some good examples of eighteenth-century court swords and firearms.

The Armor Court is the setting for the museum's distinguished collection of Spanish painting from the late sixteenth through the eighteenth century. The collection contains two important paintings by El Greco, *Christ on the Cross with Landscape* and *The Holy Family*; Francisco de Zurbarán's masterpiece *The Holy House of Nazareth*; Velázquez's *Portrait of the Jester Calabazas*; and Bartolomé Esteban Murillo's monumental *Laban Searching for His Stolen Household Gods in Rachel's Tent*. There are two paintings by Jusepe de Ribera and three masterworks by Goya, including a portrait of his close friend, the architect *Don Juan Antonio Cuervo*. Still-life painting in Spain is represented by an early-seventeenth-century work by Juan van der Hamen Y Leon and *Still Life with Fish, Bread, and Kettle* by the eighteenth-century painter Luis Melendez.

The collection of Baroque art, in addition to the Spanish paintings just described, is especially strong, containing works by most of the major Baroque painters. A late masterpiece by Caravaggio, *The Crucifixion of St. Andrew*, hangs with paintings by his followers Orazio Gentileschi, Valentin de Boullogne, Gerard van Honthorst, and Hendrick Terbrugghen. Georges de La Tour's moving representation, the *Repentant St. Peter*, one of only two dated works by the artist, also reflects the influence of Caravaggio. Peter Paul Rubens is represented by the large-scale canvas *Diana and Her Nymphs Departing for the Chase*, an oil sketch of a bear hunt, and the celebrated portrait of his wife, *Isabella Brant*. Installed near these works are paintings by artists influenced by Rubens: Jacob Jordaens' *The Betrayal of Christ*, Bernardo Strozzi's *Minerva* (for which the museum also owns a preparatory drawing), and Anthony van Dyck's portrait *Genoese Lady with Her Child*.

The most important examples of Baroque classicism are Guido Reni's *Adoration of the Magi*, a monumental but unfinished painting, and Nicolas Poussin's *Holy Family on the Steps* of 1648. Other related works are Philippe de Champaigne's portrait *Charles II, King of England* and landscapes by Claude Lorraine and Gaspard Dughet.

The collection includes works by painters of the Neapolitan school: Bernardo Cavallino, Luca Giordano, and Francesco Solimena. The Neapolitan-born painter Salvator Rosa is represented by four scenes of witchcraft and a romantic landscape. *The Synagogue* by Alessandro Magnasco is a fine and representative example of the Genoese painter's imaginative style. There are also paintings by two German Baroque artists who worked mainly in Italy: *The Rape of the Sabines*, the only major painting in an American museum by Johann Heinrich Schönfeld, and *Amor* by Johann Liss.

In Baroque sculpture, Pierre Puget's terracotta study for the statue *Blessed Alessandro Sauli* exhibits the dynamism and emotionalism derived from Bernini, and his marble *Head of a Philosopher* reveals his close reliance on classical models. The classicizing Bolognese sculptor Alessandro Algardi is represented

by two works of about 1646, an impressive bronze bust, *Pope Innocent X*, perhaps cast slightly later by assistants, and a bronze sculpture, *Baptism of Christ*. A bust of a man attributed to Ercole Ferrata is a splendid example of the Italian Baroque portrait in marble. A small head, *Proserpine*, by Bernini is among a group of terracotta sculptures that served as models for larger works.

The holdings of seventeenth-century Dutch art include outstanding examples of portrait, landscape, genre, and still-life painting. Rembrandt is represented by three portraits and a late masterwork, *Old Man Praying*, and there is the dashing *Portrait of a Lady in a Ruff* by Frans Hals. Among a number of fine landscape paintings are Jan van Goyen's luminous *View of Emmerich across the Rhine* and four works, including the dramatic *Landscape with a Dead Tree*, by Jacob van Ruisdael. Also notable are landscapes by Esaias van de Velde, Salomon van Ruysdael, Aelbert Cuyp, and Meindert Hobbema and marine paintings by Willem van de Velde II and Allart van Everdingen. The remarkable technical skills of the Dutch still-life painters are illustrated in the opulent table arrangements of Willem Kalf and Abraham van Beyeren and a flower painting by Ambrosius Bosschaert the Elder. Other aspects of Dutch painting are seen in *The Music Party*, an interior scene by Pieter de Hooch, and Jan Steen's version of an episode in the biblical story of Esther, Ahasuerus, and Haman.

Eighteenth-century Venetian painting is well represented, beginning with works by Giovanni Battista Piazzetta—*The Supper at Emmaus*, which employs the chiaroscuro of Caravaggio, and a small rapidly brushed modello for a large altarpiece, *Assumption of the Virgin*, in the Church of St. James in Zbraslav, near Prague. The latter hangs with eighteenth-century central European Baroque art, along with Giovanni Battista Tiepolo's modello for the *Martyrdom of St. Sebastian*, an altarpiece in the Augustinian convent at Diessen, West Germany. *A Portrait of a Lady* is by his son Giovanni Domenico. There are also works by Giovanni Antonio Pellegrini and Giovanni Battista Pittoni, who, like Tiepolo, decorated palaces and churches throughout Europe.

The work of Giovanni Antonio Guardi can be studied in four paintings depicting episodes from the biblical stories of Abraham and Tobias and the Angel. His brother Francesco, who specialized in Venetian scenes so popular with contemporary English tourists, recorded a visit of Pope Paul VI to Venice in two paintings that hang in the galleries of eighteenth-century British art. Also in these galleries are works by other Italian painters favored by the English: Canaletto's crystalline view of Piazza San Marco, the Roman painter Giovanni Paolo Panini's *Interior of the Pantheon*, and Pompeo Batoni's large-scale modello for an altarpiece intended for St. Peter's, *The Fall of Simon Magus*.

The collection of German and Austrian sculpture dating from about 1650 to 1750 is probably the largest and best outside Europe. Most of the sculptures are of wood, with some painted and gilded; many were parts of larger decorative schemes in Baroque churches. The collection includes a finely carved male figure, a Madonna, and a kneeling saint by the great eighteenth-century Bavarian sculptor

Franz Ignaz Gunther, as well as works by Ferdinand Tietz and a number of other sculptors who worked in Austria, Germany, and Switzerland. Two of the finest works are small scale: the powerfully expressive gilt-bronze *Christ at the Column* by the eighteenth-century Austrian artist Johann Baptist Hagenauer and the exquisite ivory group *Descent from the Cross* by the seventeenth-century Austrian artist Adam Lenckhardt. The latter, a complex work less than eighteen inches high, consists of eight figures carved from a single piece of ivory.

The museum is noted for its collection of paintings, furniture, and decorative objects produced in France in the late seventeenth and eighteenth centuries. Some of the earliest acquisitions were gifts from John L. Severance (in 1942) and his sister Elisabeth Severance Prentiss (in 1944); many works subsequently added to the collection were purchased with funds from the Severance bequest.

Hyacinthe Rigaud's magnificent *Portrait of Cardinal Dubois*, painted in 1723, the year in which Dubois, as prime minister, proclaimed Louis XV King of France, and Jacques Aved's *Portrait of Jean-Gabriel de la Porte du Theil* are the most important in a group of portraits that also includes works by Nicolas de Largillierre, Jean-Honoré Fragonard, Jean Marc Nattier, and François Hubert Drouais. The Swiss artist Jean-Etienne Liotard's striking pastel portrait of François Tronchin shows this prominent Swiss government official and patron of the arts seated beside an important painting in his collection, Rembrandt's portrait *Hendrickje in Bed*, now in the National Gallery of Scotland (q.v.). François Boucher's large canvas *The Fountain of Venus*, dated 1756, is a major example of his work and of the decorative painting of the period; the collection also contains painted decorations by Nicolas Lancret, Jean-Baptiste Pater, and Pierre Rousseau. There are several fine still lifes, two by Jean Baptiste Siméon Chardin, *Still Life with Herrings* and *Kitchen Utensils with Leeks, Onions, and Eggs*, and Jean Baptiste Oudry's realistic depiction of a dead hare and leg of lamb. Other aspects of eighteenth-century French painting are seen in a pair of oval paintings of architectural subjects by Hubert Robert and in landscapes and paintings of mythological and religious subjects by François de Troy, Noël Nicolas Coypel, and Gabriel de Saint-Aubin.

The styles and varied types of furniture produced from the reign of Louis XIV until the Revolution are represented by some exceptional pieces. The earliest, dating from about 1695 and attributed to André Charles Boulle, is an ebony cabinet with veneers of tortoiseshell inlaid with brass and pewter, a form of decoration particularly associated with Boulle. Two clocks in the collection are also ornamented with boulle marquetry. One in the Louis XIV style was designed by Boulle himself. The other, a tall clock in Rococo style with elaborate gilt-bronze mounts, was made by Jean Pierre Latz in 1744. Notable among furniture in the Rococo style are a table-desk with wood marquetry and gilt-bronze mounts made by Bernard van Risenburgh II about 1750 and a rare Louis XV style desk decorated with straw marquetry. The revival after 1750 of classical motifs in French furniture is seen in the decoration of an ebony cabinet made by René

Dubois about 1765, a worktable with wood marquetry and a Sèvres porcelain top made by Martin Carlin between 1776 and 1785, and a mahogany secretary attributed to B. Molitor, about 1800.

The collection also includes tapestries from the looms of Gobelins and Beauvais, the latter designed by François Boucher. A pair of wall hangings woven at the royal looms at Savonnerie titled *Autumn* and *Spring* and a settee and four chairs upholstered in Savonnerie textile were made around 1717 in honor of the marriage of Isabella Maria de Merode to Count François Joseph Czernin. A remarkably preserved Savonnerie carpet was woven in 1735 for the royal chateau of La Muette.

In the collection of eighteenth-century European decorative arts is one of the most celebrated works in the museum, a large asymmetrical silver tureen ornamented with carefully detailed animal, vegetable, and marine motifs, designed by Juste-Aurèle Meissonnier and made between 1735 and 1738 for Evelyn Pierrepont, duke of Kingston. The tureen and its companion in the Thyssen-Bornemisza Collection (q.v.) constitute the largest and most ambitious extant examples of the picturesque Rococo style designed by the man who was largely responsible for its invention. The collection also includes some other superb examples of French metalsmithing. In the Rococo style is a gilt-bronze candelabrum in the form of a tree trunk embellished with birds, cupids, foliage, and scrollwork, attributed to Jean Joseph de Saint-Germain and once owned by the king of Saxony, as well as a pair of gilt-bronze firedogs with lion and boar heads by Jacques Caffieri, dated 1752. Especially interesting is a microscope with gilt-bronze mounts of Rococo design, probably made for a well-to-do eighteenth-century amateur scientist.

One gallery displays eighteenth-century European porcelains, including works produced in Meissen and Nymphenburg in Germany, Capo di Monte in Italy, and the royal French factories at Vincennes and Sèvres. Also exhibited in this gallery are seventeenth- and eighteenth-century European silver, engraved German and Bohemian glass, and eighteenth-century French faience and Dutch delftware. Much of the French faience and porcelain was a gift from R. Henry Norweb. A group of terracotta sculptures includes a bust of a woman by Jean Baptiste Lemoyne and six small sculptures by Clodion. Two pairs of gilt-bronze candelabra held by bronze figures on marble bases are after models by Clodion.

In 1970 the museum acquired a well-known and outstanding example of late-eighteenth century French interior architecture—a small sitting room from the Hotel d'Hocqueville in Rouen. Its original parquet floor and its walls and ceiling, which are richly ornamented with painted plaster and carved wood reliefs, are in an excellent state of preservation. Installed near this room is a display of eighteenth-century European gold and enamel boxes and scent bottles and the India Early Minshall Collection of luxury objects made by the firm of Carl Fabergé for the Russian court.

English portraiture of the eighteenth and early nineteenth centuries is represented by Thomas Gainsborough's *George Pitt, First Lord Rivers*, the double

portrait *The Ladies Amabel and Mary Jemima Yorke* by Sir Joshua Reynolds, and two works by Sir Thomas Lawrence, *Lady Louisa Manners, Later Countess of Dysart, as Juno* and *The Daughters of Colonel Thomas Carteret Hardy*. Displayed with these works are English earthenware, porcelains, and silver, including four works by the celebrated silversmith Paul Storr.

The early American collection contains three portraits by John Singleton Copley, including one of the silversmith Nathaniel Hurd, which is exhibited with a teapot made by Hurd, as well as portraits by Benjamin West, Charles Willson Peale, Gilbert Stuart, Thomas Sully, and Washington Allston. A representative collection of American silver is dominated by New England pieces.

Art of the nineteenth century is installed to reveal relations among painting and sculpture from England, the Continent, and America. Jacques Louis David's *Cupid and Psyche* and Baron Antoine Jean Gros's portrait *Comte Jean Antoine Chaptal* and his full-size lateral panels for the *Bataille des Pyramids* at Versailles share a gallery with a life-size marble *Terpsichore* by Antonio Canova. Nearby is another important sculpture in the neoclassic style—a marble standing figure of the young niece of Napoleon, *Napoleone Elisa Baciocchi*, by Lorenzo Bartolini. French painters of the mid-century include Eugène Delacroix and the Barbizon landscapists François Daubigny, Théodore Rousseau, and Jean Baptiste Camille Corot. French sculpture of the mid- to late nineteenth century ranges from small bronzes by artists such as Antoine-Louis Barye and Albert Ernest Carrier-Belleuse to larger works, notably a marble bust of the composer Rossini by David d'Angers, a realistically detailed marble portrait bust of a lady by Jean Baptiste Carpeaux, and a terracotta bust of a lady by Jules Dalou.

The most important English paintings are J.M.W. Turner's famous *Burning of the Houses of Parliament* of 1834, a gift of John L. Severance, and John Constable's *Branch Hill Pond, Hampstead Heath*. The museum has recently begun to purchase nineteenth-century German paintings; some notable acquisitions are Philipp Hackert's view of the Italian coasts below Naples, dated 1803, and a small, minutely executed painting of huntsmen before a view of Munich done in 1823 by Wilhelm von Kobell.

The American collection is particularly strong in landscapes from the mid-century with fine examples by Thomas Cole, Frederic Church, Jasper Cropsey, John Frederick Kensett, Albert Bierstadt, Martin Heade, and Sanford Gifford. Cleveland has a number of first-rate pictures by George Inness, two oils and several watercolors by Winslow Homer, the famous *Death on a Pale Horse* by Albert Pinkham Ryder, and works by John Quidor, John Frederick Peto, and Frank Duveneck. Paintings by Gustave Courbet, Alexandre-Gabriel Decamps, François Bonvin, Theodule Augustin Ribot, Leon Bonnat, and James Tissot show realist painting in France roughly contemporary with Thomas Eakins' *Biglin Brothers Turning the Stake* and William Merritt Chase's *Dora Wheeler*, two important American paintings in the museum. American Impressionism, related to French Impressionism but markedly different, is well represented in works by Childe Hassam, Maurice Prendergast, and J. Alden Weir.

Some of the museum's finest Impressionist, Post-Impressionist, and early twentieth-century paintings were gifts from Leonard C. Hanna, Jr., or were purchased with Hanna funds. At the heart of the strong and representative Impressionist collection are five Claude Monets from various periods of his career; they range from a large, floral still life (1864) and the richly colored view *Antibes* (1888) to a mural-sized canvas of his waterlily pond (c. 1920). In addition to these works are four excellent paintings by Pierre Auguste Renoir, notably a charming portrait of a young girl (1864) and the pearly *Three Bathers* (1897), and important works by Camille Pissarro, Alfred Sisley, Berthe Morisot, and Mary Cassatt. Of special note are five superior paintings by Edgar Degas—an early portrait, major pastels of race track and ballet scenes, and a large oil, *Frieze of Dancers*.

Artists allied to Impressionism, such as Henri Fantin-Latour and Edouard François Aman-Jean, are represented by important works, as are their more academic contemporaries such as Paul Albert Besnard and the independent Pierre Puvis de Chavannes. An outstanding group of early marble and bronze castings by Auguste Rodin form the core of a sculpture collection related to Impressionism; among other artists represented in this collection are Degas, Renoir, Medardo Rosso, and Antoine Bourdelle.

Three late landscapes by Paul Cézanne form a bridge from Impressionism to Post-Impressionism. *Montagne Sainte Victoire* and the unique *Pigeon Tower at Bellevue* are of major importance. The Post-Impressionist collection features three outstanding canvases by Vincent van Gogh, including the moving *Portrait of Mademoiselle Ravoux* painted during the year of his death; three works by Paul Gauguin from different periods of his career, including *Woman in the Waves* painted in Brittany; and important paintings by Henri de Toulouse-Lautrec, Pierre Bonnard, Edouard Vuillard, and Odilon Redon (especially the portrait *Mademoiselle Violette Heymann*).

A superb collection of decorative objects made at the turn of the century is exhibited with these paintings. Particularly noteworthy are a hand mirror with ivory handle designed by Felix Bracquemond with a gold relief by Rodin and enamels by Alexandre Riquet, executed around 1900, and a striking tea service of silver and ivory vessels in the form of fantastic animals, made around 1910 by Carlo Bugatti. There are also fine examples of glass by Louis Comfort Tiffany and Emile Gallé, jewelry by René Lalique, and a small group of Art Nouveau furniture, including a cabinet with gilt-bronze mounts by the French designer Louis Majorelle. Displayed with the early-twentieth-century paintings are decorative objects in various media from the 1920s and 1930s, notably superb examples of French glass by Maurice Marinot and René Lalique and Danish silver and ceramics.

Early-twentieth-century European painting boasts a collection of eleven works by Pablo Picasso dating from 1899 to 1924, including *La Vie*, the largest and most complex painting of his Blue Period; a major Rose Period canvas; two outstanding Analytical Cubist pictures—one early and one late; a great Synthetic

Cubist composition, *Harlequin with Violin*; and a classic still life from 1924. The strong collection of Cubist works also contains two paintings and a collage by Georges Braque, important canvases by Juan Gris and Fernand Léger, and a wooden sculpture by Jacques Lipchitz. Other major paintings of the period include an outstanding Fauve painting by André Derain, a jungle picture by Henri Rousseau, and important works by Henri Matisse, Georges Rouault, Chaim Soutine, Amadeo Modigliani, Piet Mondrian, and Frantisek Kupka.

The small German Expressionist collection is well represented with fine examples by Ernst Ludwig Kirchner, Karl Schmidt-Rottluff, Lyonel Feininger, and a late self-portrait by Lovis Corinth. The Dada and Surrealist movements are sparsely illustrated with paintings by Giorgio de'Chirico and Joan Miró, collages by Kurt Schwitters and Max Ernst, and a rare, early, painted wooden relief by Jean Arp. Among other early twentieth-century sculptors represented are Constantin Brancusi with *Male Torso*, Henri Matisse, Ernst Barlach, and Gerhardt Marcks.

The early-twentieth-century American collection is good and representative, the Ash Can School being delineated with paintings by William Glackens, John Sloan, and George Luks and by George Bellows' famous *Stag at Sharkey's*. Other artists of the period with important works in the collection are Marsden Hartley, Charles Sheeler, Preston Dickinson, John Marin, Georgia O'Keeffe, Edward Hopper, Stuart David, Milton Avery, Charles Burchfield (with a large group of early paintings), and the sculptor Gaston Lachaise.

The collection of Abstract Expressionist works contains Franz Kline's *Accent Grave*, as well as paintings by Hans Hofmann, Arshile Gorky, Jackson Pollock, Willem De Kooning, Mark Rothko, Robert Motherwell, Phillip Guston, and Jack Tworkov. There is a small collection of geometrical abstractions by artists such as Burgoyne Diller, Josef Albers, and Leon Polk Smith and three diverse paintings by the California artist Richard Diebenkorn.

Robert Rauschenberg's *Gloria* and a fine Jasper Johns represent Pop Art, and an outstanding Morris Louis serves color-field painting. Ellsworth Kelly, Larry Poons, Richard Lindner, and Fairfield Porter are among other artists with major paintings in the collection. There is also a group of works by twentieth-century British artists: Walter Sickert, Harold Gilman, Gwen John, Ben Nicholson, Lucien Freud, Frank Auerbach, Francis Bacon, and R. B. Kitaj, almost all acquired recently. Sculpture from this period includes important works by David Smith, Tony Smith, Theodore Roszak, Henry Moore, George Segal, and Louise Nevelson. Isamu Noguchi is represented by the marble *Woman and Child* and a monumental three-part sculpture, *Rock Carvings: Passage of the Seasons*, which is installed on the grassy lawn at the museum's north entrance.

The photography collection was started with a group of ten prints by Alfred Stieglitz given to the museum in 1935. The collection grew slowly during the next four decades, augmented almost entirely by gifts, including ten prints by Margaret Bourke-White given in the early 1970s. In 1973 the museum began to purchase works by prominent photographers, including the Americans Ansel

Adams, André Kertesz, Walker Evans, and Paul Strand; the English photographers Peter Henry Emerson, Julia Margaret Cameron, and Frederick Evans; and the French photographers Eugène Atget, Brassai, and Henri Cartier-Bresson. The photographer best represented in the collection is the Photo-Secessionist Clarence White of Newark, Ohio. Forty-seven of his prints were given to the museum in 1980 by the three children of one of his close friends and students, Julia McCune Flory.

A sixteenth-century mihrab and frieze decorated with faience mosaic from a mosque in Isfahan are prominent features of the galleries for Islamic art. These galleries house Iranian relief sculptures in stone and marble dating from the twelfth to the fourteenth century, a representative group of ceramics from Egypt, Iraq, Iran, and Turkey dating from the ninth to the seventeenth century, and superb examples of enameled glass from the Mamluke period (fourteenth century). There are also choice examples of metalwork, largely from medieval Iran, Iraq, and Syria; most important are an Iranian gold ewer, inscribed and dating from 985–98, and a bronze salver from Afghanistan (Ghaznavid period, twelfth century).

The Islamic collection is extraordinarily rich in textiles dating from the eighth to the seventeenth century of which only a few can be exhibited at one time. The collection of manuscript paintings and drawings, mainly from Iran, Iraq, and Turkey, dating from the thirteenth through the seventeenth century, is also rotated. Two of the finest of them are the illustration *Bahram Gur Slays a Dragon*, from an Iranian manuscript of the Shahnamah of Firdawsi, about 1340, and the fifteenth-century Turkish painting *Demon in Chains Led by Two Nomads*, from an album in the Topkapi-Serai in Istanbul. A fifteenth-century Iranian bookbinding, of leather chased and perforated over gold, is one of the most outstanding examples of its type in the world.

The textile collection consists of about thirty-seven hundred textiles from all parts of the world, dating from the second millennium B.C. to the 1970s. They represent many types of weaving and embroidery, as well as a variety of dyeing, printing, and painting techniques.

The collection of Coptic and Egypto-Arabic hangings, tunic ornaments, and *tirāzes* covers the major stylistic and chronological groups woven in Egypt between the fourth and twelfth century. Particularly outstanding are a remarkably preserved fourth-century panel of a satyr and maenad and the large *Icon of the Virgin* from the sixth century. The collection also includes silks from the Ayyubid and Mamluke periods (late twelfth to fourteenth century). The medieval Iranian and Iraqi embroideries and silks from the Abbasid, Buyid, and Seljuk periods (spanning the eighth through the twelfth century) comprise one of the most extensive and finest collections anywhere. The collection includes a complete tomb cover and caftan and many silks with inscriptions giving the date and sometimes the place of manufacture. Also from Iran are several fine silks and velvets from the Safavid period (sixteenth to seventeenth century).

The outstanding collection of Spanish medieval textiles contains many silks from known Spanish tombs and reliquaries, as well as a rare fourteenth-century

carpet and the largest, most complete silk curtain known to have survived from the medieval period. The collection of Italian Gothic silks and velvets represents the major styles woven during the fourteenth and fifteenth centuries and includes three extremely rare Florentine embroideries. Other exceptional textiles from the medieval and Renaissance periods are a fourteenth-century English orphrey embroidered with the Tree of Jesse, an early fifteenth-century Bohemian embroidered orphrey, and an extremely rare fifteenth-century Italian tapestry of the Lamentation designed by Cosimo Tura.

The later European material includes a very fine chasuble embroidered with the theme of Sacred and Profane Love made in Bavaria, presumably on the occasion of Marie Anne von Neuburg's marriage to Charles II of Spain in 1689. There is an embroidered bedspread and upholstery for a bed from the period of Louis XIV, as well as sixteenth- to eighteenth-century brocades, brocatelles, and velvets from France, Spain, and Italy. The lace collection is particularly strong in sixteenth- and eighteenth-century pieces from Italy, France, and Flanders but also includes nineteenth-century examples from Ireland, England, Russia, and Spain. From the nineteenth and twentieth centuries are textiles designed by William Morris, Raoul Dufy, and Frank Lloyd Wright, as well as fiber pieces by contemporary artists such as Jean Stamsta, Lenore Tawney, Olga de Amaral, and Luba Krejci.

From the Orient, the collection of sixth- to eighth-century Chinese textile fragments, once preserved in Shōsōin and Hōriuji collections, are among the very few textiles of the T'ang period preserved anywhere in the Western Hemisphere. Also notable are the thirty-eight printed and dyed pieces of cotton from twelfth-century India that were excavated at Fostat outside of Cairo. In addition, there are a number of woven, embroidered, printed, and dyed textiles and costumes of the eighteenth-twentieth century from India, China, Japan, and Indonesia. The Peruvian textile collection is strongest in South Coast textiles from the Paracas, Nazca, and Huari-Tiahuanaco cultures but also includes textiles from the North and Central Coasts.

The Prints and Drawings Department includes more than twelve thousand prints and nearly two thousand drawings ranging from late fifteenth century to contemporary works. The print collection emphasizes fine impressions. Highlights of the early-fifteenth-century Italian prints are the engraved large *Assumption* after Botticelli, a set of E series *Tarocchi Cards*, and the unique first state impression of Antonio Pollaiuolo's masterwork *Battle of the Naked Men*. Fifteenth-century northern European prints include nine engravings by the Master E.S. and a selection by Martin Schongauer, including an especially beautiful impression of the large *Christ Carrying the Cross*. Strengths from the sixteenth century are works by Albrecht Altdorfer, Hans Burgkmair, Albrecht Dürer, and Lucas van Leyden (especially woodcuts), as well as *The Apocalypse* of Jean Duvet. The collection is particularly well represented in the eighteenth century by British mezzotints and the Italian school, and there is a comprehensive survey of the nineteenth century. Printmakers like William Blake, Théodore Géricault,

Eugène Delacroix, Edgar Degas, Pierre Renoir, Camille Pissarro, Edouard Manet, and Mary Cassatt can be found as can large groups of works by Charles Meryon, Alphonse Legros, Auguste Lepère, Odilon Redon, Francisco Goya, Samuel Palmer, Seymour Haden, Winslow Homer, and James McNeill Whistler. Twentieth-century prints include works by masters like Pablo Picasso and Henri Matisse, a hand-colored woodcut by Edvard Munch, and numerous examples by Muirhead Bone, Joseph Pennell, George Bellows, Childe Hassam, and Lyonel Feininger.

The print collection has been enriched by the large donations of Mr. and Mrs. Ralph King, Leonard C. Hanna, Jr., and The Print Club of Cleveland. The lithographs assembled by Mr. and Mrs. Lewis B. Williams, including numerous examples of incunabula, and the group of Charles Meryon etchings from Milton Curtiss Rose were also sizable additions.

The drawing collection is comprehensive with works from the most important periods and styles. From the late fifteenth and sixteenth centuries there are metalpoint drawings by Pietro Perugino, Hans Holbein, Raphael Santi, and Lorenzo di Credi, as well as a red chalk, double-sided sheet of studies for the Sistine ceiling by Michelangelo Buonarroti, a chiaroscuro drawing by Albrecht Altdorfer, and three works by Albrecht Dürer. The largest single group is the seventeenth-century Netherlandish drawings, which includes many outstanding landscapes, four sheets by Rembrandt van Ryn, and a set of eighteen scenes of Rome by Lieven Cruyl. Other important seventeenth-century works are the ink-and-wash *Study for Extreme Unction* by Nicolas Poussin and two brown wash drawings by Claude Lorraine. The eighteenth century in Italy is well represented by nine drawings from Domenico Tiepolo's *Punchinello* series and eleven chalk figure drawings by Giovanni Battista Piazzetta. Other important examples from the eighteenth century in northern Europe include Johann Baumgartner's *The Large Boar Hunt*, Thomas Gainsborough's black chalk study for his portrait of Mrs. Sarah Siddons, and beautiful sheets by François Boucher, Jean-Honoré Fragonard, Jean Antoine Watteau, and Gabriel de Saint-Aubin. The highlights of the nineteenth century are a pencil portrait by Jean Auguste Dominique Ingres; seven drawings and three monotypes by Edgar Degas; a pastel rendering by Jean François Millet, *First Steps*; and two red chalk drawings of young women by Renoir. Particularly interesting selections from the twentieth century—three sheets by Picasso and two by Matisse, an India ink mountain scene by Ernst Ludwig Kirchner, and a watercolor landscape by Emil Nolde—complete the collection.

The arts of China, Korea, Japan, India, Southeast Asia, and Indonesia are exhibited in ten galleries on three levels of the renovated 1958 building. The Asian collection is organized chronologically and cross-culturally, with objects grouped to show international movements as well as national styles. Thus sections of the ground- and mid-level sculpture galleries trace the origin and expansion of Buddhist art from India through East Asia; the mid- and lower-level galleries display Chinese, Korean, and Japanese painting, with ceramics, jades, lacquers, and small sculptures contemporary with them. Although most principal objects

are permanently displayed, the considerable painting collections (Indian miniatures; Chinese and Japanese album leaves, handscrolls, and hanging scrolls; Japanese screens), as well as Japanese prints, are rotated periodically.

Chinese Bronze and Iron Age cultures are represented by bronzes, jade, and other hardstone carvings and by wood sculpture. Ritual Shang and Chou Dynasty bronze vessels most notable in style and quality of casting include a rare pre-Anyang (sixteenth to fourteenth century B.C.) libation cup (*chüeh*) with a low-relief animal mask, a square wine bucket (*fang-yu*) with high-relief birds (twelfth to eleventh century B.C.), and a bowl (*kuei*) with flaring open-work cover and dragon handles (seventh to sixth century B.C.), one of a set dispersed in several American, European, and Chinese collections. Decorative and representational styles of the Warring States period and Han Dynasty (fourth century B.C.-A.D. second century) can be studied in bronze mirrors, inlaid bronze fittings, jade weapons and pendants, ceramic tomb figurines, stamped and painted tomb tiles, and a unique pair of carved and painted clamshells. The most extraordinary fusion of both styles is a large (height, 132 centimeters), fragile, lacquered wood sculpture of phoenixes and serpents (fourth to third century B.C.) acquired in 1938 after discovery in a tomb in Ch'angsha, Hunan, an ancient center of the Ch'u culture (q.v. Hunan Provincial Museum). It remains today the pre-eminent example of Ch'u carpentry and painting outside of China.

Major styles of early Chinese Buddhist sculpture are exhibited in three Six Dynasties steles: the sandstone *Maitreya and Attendants* (A.D. 500), the limestone *Shakyamuni Trinity* (A.D. 537), and the marble *Maitreya as the Future Buddha* (late sixth century). The best known of several free-standing Kuan-yin is an eighth-century marble torso from Hopei province whose graceful stance and relief jewels exemplify the mid-T'ang Dynasty humanization of this compassionate deity. The more remote, esoteric eleven-headed Kuan-yin appears in four images, including a colossal eighth-century sandstone bust (height, 129.5 centimeters) and a twelfth-century wood figure with traces of polychromy and cut gold leaf preserved on its dynamically carved robes (height, 218.5 centimeters). These and other monumental Buddhist sculptures are accompanied by smaller gilt-bronzes dating from between the fifth and fifteenth centuries.

About two hundred Chinese paintings spanning the ninth through the nineteenth century place this collection among the four most important in the West (Museum of Fine Arts, Boston [q.v.]; Nelson Atkins Museum of Art, Kansas City [q.v.]; Freer Gallery of Art, Washington, D.C. [q.v.]). Acquisitions through 1979 are fully documented in a catalog of the exhibition, *Eight Dynasties of Chinese Painting*, jointly organized with the Nelson Museum (1980–81). Recent additions to this listing include works attributed to Mu-ch'i, Fang Tsung-i, and Ch'eng Hsieh. Sung (960–1279) figure painting is exemplified by *Ladies of the Court* by an unknown master of pure-line drawing, *Sericulture* attributed to the tremulous brush of Liang K'ai, and *The Knickknack Peddler* by Li Sung. Monuments of Northern and Southern Sung landscape painting include *Buddhist Retreat by Streams and Mountains* by Chü-jan, *Streams and Mountains without*

End by an unknown master of the eleventh-twelfth century and *Cloudy Mountains* by Mi Yu-jen. The Yüan Dynasty (1279–1368) collection of about thirty-five paintings, the most extensive outside of China, includes literati works by Chao Meng-fu, Wu Chen, Ni Tsan, and Wang Meng, as well as Buddhist and Taoist deities and bird-and-flower compositions by conservative "academic" masters. (Yüan paintings in particular have been enriched by loans of Mr. and Mrs. A. Dean Perry, whose collection is a life interest gift to the museum.) Ming (1368–1644) and Ch'ing (1644–1911) paintings are unusually comprehensive, representing almost all literati and professional masters (Shen Chou, T'ang Yin, Chou Ch'en, Ch'iu Ying, Wen Cheng-ming, Ch'en Hung-shou, Tung Ch'i-chang, the Four Wangs), as well as the so-called eccentrics and individualists (Wu Pin, Ch'u Ta, Tao-chi). Overall areas of particular strength are Sung and Yüan album leaves, bamboo paintings of Sung through Ch'ing, and portraits—the portraits best known for a handscroll depicting the Ch'ien-lung emperor (reigned 1736–95) and his consorts by the Italian Jesuit Castiglione (Lang Shih-ning).

Early Chinese ceramics include lead-glazed earthenwares, as well as white and celadon-glazed stonewares that culminated in imperial and popular wares of the Sung Dynasty. All major Sung types are well represented: Yüeh, Ting, Northern Celadon, Chun, *ch'ing-pai*, Lung-ch'uan, *kuan*, Chien, Chi-chou, and Tz'u-chou. The *kuan* ware collection of fifteen crackled celadons is the largest in the United States; there is one brushwasher of rare Ju ware. Fourteenth-century examples of celadon and *shu-fu* white porcelain, blue-and-white, and underglaze red wares complement the Yüan painting collection. Ming porcelains encompass beautiful examples of blue-and-white and overglaze enamels, with both techniques combined in a delicate *tou-ts'ai* wine cup of the Ch'eng-hua reign (1465–87). Artistic and technical virtuosity in Ch'ing (1644–1911) is exhibited in a collection of polychrome overglaze enamels and monochrome oxblood and peachbloom wares.

A smaller number of fine quality lacquers include plain monochrome, carved, and inlaid vessels and small pieces of furniture. Among them should be noted a Yüan mother-of-pearl table screen with mandarin ducks and a figural scene illustrating the poem "Peach Blossom Spring" and a Chia-ching (1522–67) marked jar carved with dragons and phoenixes in multicolored layers. Masterpieces of small sculpture and decorative arts in jade, ivory, metal, and wood are exhibited throughout the handscroll galleries: an eighth-century bronze mirror with beaten gold and silver inlays on lacquer ground, the tenth-century wood figure *Potala Kuan-yin*, a fourteenth-century cast-silver raft cup signed by Chi Pi-shan, and a group of Ch'ing Dynasty accessories for the scholar's table: brushes, ink cakes, seals, and miniature table screens, most datable to the reign of the Ch'ien-lung emperor. In contrast to these small and elaborately crafted arts in Ch'ing court taste are several pieces of seventeenth- and eighteenth-century domestic furniture made of precisely joined and finely polished hardwoods. A formal side table, game table, low table, and a pair of hoop-backed

armchairs are uniformly distinguished by simplicity and geometric purity in design and construction.

The Korean collection owes its inception to John L. Severance, an early museum trustee and patron of both visual and musical arts in Cleveland, whose father established a medical center in Seoul. The Severance gifts comprise primarily Koryŏ Dynasty (918–1392) celadons with decoration delicately incised or inlaid with slip. To them have been added slip-decorated gray *punch'ong* wares (fifteenth century) and sturdy bluish white porcelains patronized by the eighteenth-century court. Korean paintings, far scarcer in the West, have grown in number and stature through recent acquisitions of a Koryŏ *Lohan* and *Shakyamuni and Attendants*, a seventeenth-century portrait of an official, and two fifteenth-century landscapes exhibiting Chinese influence, including a pair of six-fold screens, *Landscapes of the Four Seasons*. This is one of three known works by Yi Su-min (Japanese: Ri Shūbun), who became a pivotal figure in the development of Muromachi ink painting in Japan.

The arts of Japan are especially distinguished for their representation of purely indigenous traditions, as well as those influenced by Chinese and Korean taste. These traditions, explicitly featured in exhibition cases devoted to the arts of Shinto ritual, the tea ceremony, and the Nō drama, are also implicit in paintings and sculptures inspired by esoteric Buddhist doctrines, in handscrolls illustrating popular narratives, in a large and diverse collection of screen painting, and in several recently acquired folk paintings from the vicinity of Otsu in Shiga prefecture.

An outstanding assemblage of Buddhist sculpture begins with two rare Asuka-Hakuhō (seventh-eighth century) bronzes and an early Heian (c. 800) figure of Nikko, the Sun Bodhisattva, which exquisitely details the emergence of a native aesthetic in wood carving. Its florescence in the Kamakura period (1185–1333) appears in a seated Nikko, an Amida dated 1279 with perfectly preserved cut gold leaf decoration, a benevolent Bato (horseheaded) Kannon, two colossal heads of *niō* guardian figures, a dynamic Thunder God, and a tranquil portrait of the Zen priest Hotto Kokushi (1207–98) seated in meditation. A pair of early Heian male and female *kami* deities are the earliest and rarest in a smaller group of Shinto wood sculptures, which also includes thirteenth–fourteenth–century images of the founder (Enno Gyoja) and guardian (Zao Gongen) of the esoteric Shugendō sect. Two painted mandalas schematically illustrate syncretic Shinto-Buddhist beliefs.

Kamakura (1185–1333) Buddhist painting ranges from iconographic drawings of single deities to a complex and luxuriously colored mandala (cosmic diagram) of the *Five Esoteric Ones* (*Gohimitsu*). Two unusual Kamakura formats are wood structures: a tabernacle or cylindrical sutra case (height, 160 centimeters) and a *tahoto* model representing the single-story pagoda in reduced scale (height, 35 centimeters). Doors on each reliquary open to reveal painted deities. *Niga Byakudō*, a hanging scroll depicting an Amidist parable, and *Yūzū Nembutsu Engi*,

relating the propagation of an early Amidist sect, are both inspired by late Kamakura faith in Pure Land Buddhism. In its handscroll format and lively treatment of folk elements, the otherwise serene *Yūzū* shares its narrative tradition with *Fukutomi Zōshi*, illustrating a bawdy secular tale. Another aspect of secular realism in Kamakura is exemplified by portraits of the poets Taira no Kanemori and Kakinomoto no Hitomito and the official Fujiwara no Muchinaro.

Japanese paintings of the Muromachi (1392–1573), Momoyama (1573–1615), and Edo (1615–1868) periods are notable for their stylistic diversity and for their large number (about forty) of well-preserved screens. The earliest screens in the collection are seasonal landscapes by Ri Shūbun, the Korean immigrant cited above; among his successors in monochrome ink painting (*suiboku-ga*), Sesson, Sōami, and Shūbun are each represented in both scroll and screen format. Sōami's single panel from the set *Eight Views of the Hsiao and Hsiang Rivers*, originally in the Daisen-in, Kyoto, is one of the best documented works; its traditional Chinese subject is reinterpreted in a narrow handscroll by Sesson. Other Muromachi *suiboku-ga* include flung-ink landscapes by Sesshū and Shūgetsu and figure paintings by the Zen eccentrics Mincho and Yamada Dōan. Contrasting their monochrome austerity are richly decorative bird-and-flower and figure compositions attributed to fifteenth-seventeenth century members of the Kanō school: Motonobu, Shōei, Hideyori, Eitoku, and Tan'yū. Edo paintings reflect the full eclecticism of their time. There are elegantly bold compositions by the Rimpa masters Kōetsu, Sōtatsu, Kōrin, Shiko, Roshu, and Hoitsu; spirited figures and landscapes by the literati painters Taiga, Buson, Baitei, Goshun, and Gyokudo; sensitive impressions of nature by the Maruyama-Shijo artists Maruyama Okyo and Nagasawa Rosetsu, and Western-influenced portraits by Kita Genki and Watanabe Kazan.

A separate gallery is devoted to selections from the museum's approximately four hundred *ukiyo-e* prints, displayed with prints and paintings loaned by the Cleveland collection of Mr. and Mrs. Kelvin Smith. Utamaro, Hokusai, and Hiroshige are each strongly represented in the permanent collection.

A Muromachi iron kettle cast at Ashiya in Fukuoka prefecture is the oldest in a significant group of tea-ceremony objects. Ceramics made expressly for storing, brewing, and serving tea include Seto, Bizen, Imbe, Oribe, Shino, and Shigaraki stonewares. Among them should be mentioned Momoyama (sixteenth century) examples of Shino and Yellow Seto and Edo pieces signed or sealed by renowned potters and painters: a Shigaraki tea-storage jar by Nonomura Ninsei, and a Kyoto ware dish codesigned by the Ogata brothers, Kenzan and Kōrin. A smaller group of refined seventeenth- and eighteenth-century porcelains—including Kakiemon, Kutani, Arita, and Nabeshima wares—has been augmented by loans from the life interest collection of Mr. and Mrs. Severance Millikin.

The earliest applied arts date from the Heian period and are primarily Buddhist in motif and function. They include a gilt-bronze incense jar and alms bowl, a

silver-bronze mirror with incised figural decoration, and a lacquer fragment (now remounted as a box lid) painted in gold with scenes of the Western Paradise. Other early lacquers include a fourteenth-century covered box, with sprinkled and painted gold chrysanthemums illustrating decorative precedent for several superbly crafted writing and cosmetic boxes of the Muromachi through Edo periods.

Masks used in religious processions and dance-dramas provide an enduring cultural focus for the Japanese collection. The three earliest masks, dated respectively to the Nara, late Heian, and Kamakura periods, are associated with Buddhist rituals (*gigaku, gyodo, bugaku*). Nō drama is represented by three character masks (old man, demon, young woman) as well as by fifiteen robes preserved by the Department of Textiles. The finest of them is embroidered with flowering cherry and iris on gold-painted silk and dates from the seventeenth century.

Indian art begins with masterpieces of miniature precision: steatite (stone) seals of the Indus Valley culture (3000–1500 B.C.), a Maurya steatite ring carved with animals and fertility figures (third century B.C.), and Shungna gold pendants that number among the earliest known Indian jewels (second to first century B.C.). The most exquisite pendants, worked in repoussé and granulation, symbolize the Buddhist *triratna*, which recurs as border motif along a sandstone railing fragment from the Great Stupa at Bharhut (second century B.C.).

Figural sculpture-in-the-round is introduced by a massive head of a *yaksha* of the first century B.C. from Mathura. The collection is rich in Kushan material from this area. A nearly life-size fertility goddess (*nāginī*) and female figures from stupa railings are joined by several male figures, including an early (second century A.D.) seated Buddha. The most intriguing Mathura work is a stupa railing pillar (second-third century A.D.) carved with bacchanalian figures whose Graeco-Roman features are traditionally associated with the Gandharan school of northwestern India and present-day Afghanistan. That unique blend of Indian Buddhist religion and Graeco-Roman style is shown in a number of stone and stucco pieces, including seated and standing Buddhas and richly adorned bodhisattvas. Gandharan narratives are illustrated in several deeply carved stone reliefs. The classical age of Indian sculpture, the Gupta period (c. A.D. 320–600), is found in several stone and metal sculptures from the two great centers of Mathura and Sarnath. A fine example of Gupta bronze casting is a standing Buddha dated A.D. 591.

The Himalayan region is well represented. The museum owns a rich cross-section of Kashmiri art, including terracottas from Harwan, ivories, and several significant metal sculptures, including the eighth-century *Thunderbolt Bearer* (*Vajrapani*) and the tenth-century standing *Buddha* of golden brass. From Nepal come the graceful eleventh-century bronzes *Padmapani* and *Umā*, an unusual fifteenth-century tantric deity of dry lacquer, and several paintings, including twelfth-century palm-leaf manuscripts and covers and a beautifully preserved

fourteenth-century image of the Green Tara. The Tibetan collection comprises a number of bronze figures and ritual objects, as well as several temple banners on cloth (*thankas*) of various Buddhist deities (fourteenth and fifteenth centuries).

South Indian art features numerous bronze figures from the Chola kingdom (tenth-fourteenth century) that idealize both human and animal manifestations of various Hindu gods. Since the large (height, 111.5 centimeters) and well-known figure *Shiva as Lord of Dance* (*Nātarāja*) was acquired in 1938, there have been added *Shiva as Lord of Music*; an unusual trident with Ardhanārī; and a number of examples depicting Shiva and his wife, Pārvatī, and their elephant-headed child Ganesha. A group of Chola stones includes the powerful relief *Shiva Killing the Elephant Demon* of about 900. Adjacent to the Chola stone sculptures are several medieval stones from various parts of India: the North, Rajasthan, Central India, the Deccan, and Mysore.

The oldest paintings from Greater India are wood covers and palm-leaf manuscripts, including an eleventh-twelfth century illumination of the Mahayana Buddhist text *Gandvyūha*, from Bengal, and thirteenth-century illuminations of the Jain *Kalpasutra*, from Gujarat. These works precede a large and distinguished collection of Mughal and Rajput miniatures illustrating religious texts, folktales, and imperial histories. In 1963 the museum's acquisition of 211 miniatures and text folios comprising an almost complete manuscript of the *Tuti Nama* (*Tales of a Parrot*) provided new and pivotal evidence for the origins of Mughal painting. The *Tuti Nama*'s stylistic mixture of native Indian and imported Persian modes dates from 1560–65 and is ascribed to more than thirty artists belonging to the royal atelier of the court of Akbar. As the earliest known imperial Mughal manuscript, the *Tuti Nama* antedates several of the museum's individual leaves from historical volumes commissioned by Akbar: the *Hamza Nama* (c. 1570), *Akbar Nama* (c. 1590), *Babur Nama* (c. 1590), and *Chingiz Nama* (c. 1596). Mughal paintings dating from the subsequent reigns of Jahangir and Shah Jehan include animal studies and portraits of nobles and ascetics. The Rajput painting collection, initiated by a few early purchases from the Indian scholar Ananda Coomaraswamy, now includes miniatures from all of the major Rajasthani and Pahari schools.

The Southeast Asian collection is especially distinguished by the foremost group of Cambodian sculpture in the United States. Almost all pre-Angkorean and Angkorean styles are represented in about thirty Hindu and Buddhist images in stone and bronze. Artistic and chronological priority belongs to the early sixth-century limestone figure of Krishna Govardhana from the Adolphe Stoclet Collection, one of eight known sculptures of the Phnom Da type. Other pre-Angkorean sculptures include a regal seventh-century standing Vishnu and two bronze figures of Maitreya and Avalokitesvara. The Angkorean collection includes examples of Bahkeng, Koh Ker, Baphuon, and Bayon (Angkor Thom) stones and a number of bronze images such as an eleventh-century kneeling male of Baphuon style and a twelfth-century *Buddha Sheltered by the Serpent King* in the Angkor

Vat style. Recent acquisitions include a monumental (height, 110 centimeters) tenth-century sandstone figure of Hanumān, the monkey god of Hindu mythology.

The Southeast Asian gallery also exhibits stone and bronze sculptures from Thailand and Indonesia, including a life-size standing Buddha of the Mon-Dvaravati period (seventh century), whose graceful contrapposto pose reflects Gupta Indian prototypes, and a head from the Great Stupa of Borobudor in Java dating from about 800. The earliest of three sandstone figures from the kingdom of Champa (present-day Vietnam) is a ninth-century seated Shiva from the Dong-duong Monastery at Indrapura.

The collection of art from pre-Columbian Central and South America is among the very best in a general art museum in terms of aesthetic merit and the stylistic variety of the material it contains. Director William Milliken began building the collection in the late 1930s, aided by gifts and funds from Mrs. R. Henry Norweb and Miss Helen Humphreys. From Mexico there are fine examples of Olmec stone sculpture and rare Olmec jades, particularly a small jadeite seated figure dating from before A.D. 300. A group of objects from a culture that flourished in the Veracruz region of Mexico between A.D. 600 and 1200 contains some of the masterpieces in the collection: a realistic and sensitively carved life-size terracotta head of a young man, a gray volcanic *palma* stone of complex design, and a massive serpentine yoke carved with realistically detailed serpents, feathers, and other motifs. Sculpture from the Classic period of Maya civilization (seventh and eighth centuries) is represented by two delicately carved limestone reliefs depicting human figures in ceremonial robes and a life-size stone head with elaborate headdress. Among other important Mayan works are a group of carved jades and a stone eccentric flint in human shape dating from the sixth to eighth century. There are a number of Aztec sculptures of high quality and significant objects from other Mexican cultures, such as a Zapotec earthenware seated figure from Monte Alban and a Colima earthenware dog. The collection is particularly rich in gold objects—jewelry, anthromorphic figures, plaques, and masks—from Panama, Colombia, and Peru. Although pottery is less abundant than objects in other materials, there are some fine pieces from Mexico, Central America, and Peru. The Peruvian examples include the Mochica stirrup jars shaped like human heads and a Chavin stirrup jar decorated with relief carvings of stylized jaguar heads dating from the first millennium B.C. Textiles, all from Peru, are included in the description of the textile collection.

The collection of North American Indian art is extensive for a general art museum, but only the finest pieces are on permanent exhibit. The collection began in 1917 with a gift from William Albert Price of 145 baskets woven by Southwest and Northwest Coast Indian tribes, still the strongest part of the collection. In 1937 Amelia Elizabeth White gave some two hundred objects in various media, including a large group of watercolors of the 1930s Santa Fe school, Navajo blankets, and jewelry. Although the museum has developed a very representative collection of pottery produced in the Southwest during the

first part of this century, except for a large group of bowls from the Mimbres Valley in New Mexico dating from 1100–1200, there are few examples of pottery from pre-contact times. There is a good selection of the leatherwork, quillwork, and beadwork of the Plains tribes but only a few objects from the Eastern Woodlands tribes, notably a handsome Chippewa bandolier bag with beadwork in floral design.

The small but choice Northwest Coast material includes some particularly fine pieces from the Tlingit tribe: an alderwood face mask, a chief's raven rattle of painted carved wood, an eagle effigy ladle of carved horn decorated with abalone, a painted storage box, and several Chilkat blankets.

The Cleveland Museum was one of the first general art museums to collect African art, the first pieces being acquired in 1915. The collection was considerably enlarged in the late 1960s and 1970s with gifts from Katherine C. White. It now contains objects from all of the important sculpture-producing tribes of Africa, principally carved wood ceremonial masks and figures, the earliest dating from the last part of the nineteenth century. There are also a number of utilitarian and decorative objects, such as eating utensils, pipes, combs, knives and axes, musical instruments, stools, and raffia textiles. Among a group of bronzes made in Benin City, Nigeria, are the earliest works in the collection, an altar portrait of a deceased *oba*, or king, and a plaque with a warrior in high relief, both dating from the seventeenth century. The art of ivory carving is represented by several objects, the most important being a magnificently carved elephant tusk from Benin City. The collection also contains intricately designed gold ornaments made by the Ashanti and Baule tribes.

Many of the works in the small Oceanic collection, all less than one hundred years old, were gifts of the Cleveland Museum's former director of art education, Thomas Munro, and his wife. Best represented are the arts of the Maori of New Zealand, with an intricately carved wood lintel, nephrite breast pendants, and other objects carved from wood, and the arts of New Guinea, particularly the Sepik River region, with carved and painted wood bowls, war shields, and ancestral boards, and a powerfully carved wood Kamanggabi spirit figure. Also notable are two Melanesian works, an elaborately carved and painted wood Malanggan memorial festival pole from New Ireland and a monumental fernwood Grade Society Figure from the New Hebrides.

The museum's art reference library is one of the three most important in the United States, with about 120,000 books and more than 400,000 slides and photographs. It serves the museum's curatorial staff, faculty and graduate students of neighboring universities, visiting scholars and curators, and museum members. Books and photographs do not circulate; however, slides may be borrowed for lecture or educational purposes for a nominal fee.

The museum's bookstore sells slides, postcards, and reproductions of major works in the collection. Black-and-white photographs or color transparencies of works in the collection required for reproduction or other uses may be requested for a fee through the Registrar's Office.

In addition to publishing guides and specialized catalogues such as those listed below, the museum publishes catalogues of all exhibitions it organizes, a bimonthly *News and Calendar* for museum members and *The Bulletin of The Cleveland Museum of Art*, a scholarly journal of articles on works in the collection, begun in 1914 and published monthly except in July and August.

Selected Bibliography

Museum publications: *Handbook: The Cleveland Museum of Art*, 1978; *Guide to the Galleries: The Cleveland Museum of Art*, rev. ed., 1981; *The First Fifty Years: The Cleveland Museum of Art, 1916–66*, by Carl Wittke, 1966; *European Paintings before 1500...*, Part 1 by Wolfgang Stechow et al., 1974; *European Paintings of the 16th, 17th and 18th Centuries...Part 3*, 1982; *The Guelph Treasure*, 1931; *World of Ceramics: Masterpieces from The Cleveland Museum of Art*, 1982; Czuma, Stanislaw, *Indian Art from the George P. Bickford Collection*, 1975; Fagg, William, *African Tribal Images: The Katherine White Reswick Collection*, 1968; Hawley, Henry, *Faberge and His Contemporaries: The India Minshall Collection of The Cleveland Museum of Art*, 1967; idem, *Neo-Classicism: Style and Motif*, 1964; Henning, Edward B., *Fifty Years of Modern Art, 1916–1966*, 1966; Ho, Wai-kam; Sherman E. Lee; Marc F. Wilson et al., *Eight Dynasties of Chinese Painting: The Collections of the Nelson Gallery-Atkins Museum, Kansas City, and The Cleveland Museum of Art*, 1981; Lee, Sherman E., *Japanese Decorative Style*, 1961; idem, *Reflections of Reality in Japanese Art*, 1983; idem and Wei-kam Ho, *Chinese Art under the Mongols: The Yuan Dynasty*, 1968; Spear, Athena T., *Rodin Sculpture in The Cleveland Museum of Art*, 1967; idem, *Rodin Supplement*, 1974; Weisberg, Gabriel P., and Phillip D. Cate et al., *Japonisme Influence on French Art, 1854–1910*, 1975; Wixom, William D., *Treasures from Medieval France*, 1967.

Other publications: Boulter, Cedric G., *The Cleveland Museum of Art* (Princeton, N.J. 1971); Kitzinger, E., *The Cleveland Marbles* (Rome 1978); Lee, Sherman E., *The Colors of Ink: Chinese Painting and Related Ceramics from The Cleveland Museum of Art* (New York 1974); idem, Michael R. and Ursula Korneitchouk, *One Thousand Years of Japanese Art (650–1650)* (New York 1981); idem, and Wen Fong, *Streams and Mountains without End: A Northern Sung Handscroll and Its Significance in the History of Early Chinese Painting*, Articus Asiae Supplementum XIV (Ascona 1955); Milliken, William M., *The Cleveland Museum of Art* (New York 1958); Rice, D. S., *The Wade Cup in The Cleveland Museum of Art* (Paris 1955); "Treasures from Cleveland" and six following articles, *Apollo*, vol. 78 (December 1963), pp. 432–93; Alsop, Joseph, "Treasures of the Cleveland Museum of Art," *Art in America*, vol. 54, no. 3 (May-June 1966), pp. 20–56, with foreword by Sherman E. Lee. Many booklets have been issued by the Department of Art History and Education on subjects in art history. A list of them can be obtained from the department.

ANN EDWARDS AND ELINOR PEARLSTEIN

———— Detroit ————

DETROIT INSTITUTE OF ARTS, THE (formerly THE DETROIT MUSEUM OF ART), 5200 Woodward Avenue, Detroit, Michigan 48202.

The Detroit Institute of Arts, known originally as The Detroit Museum of Art, grew out of the Art Loan Exhibition of 1883. A social and cultural event of considerable importance at that time, the Art Loan was organized by William H. Brearley, advertising manager of Detroit's *Evening News*, and an energetic committee of volunteers. Inspired by the overwhelming success of the exhibition, which included forty-eight hundred works of art and was seen by nearly 135,000 people in ten weeks, the prominent Michigan senator Thomas W. Palmer donated $10,000 toward the founding of a permanent art museum for Detroit on the condition that an additional $40,000 be raised and a corporation be formed to direct the institution. Within a year Brearley raised $1,000 each from forty Founders, and The Detroit Museum of Art was born. Incorporated on March 20, 1885, its first exhibition opened in a rented hall one year later. The apparently tireless Brearley then turned to raising funds for the museum's first building, a Richardsonian Romanesque structure on Jefferson Avenue. Opened to the public in September 1888, it served until 1927, when it was replaced by the Woodward Avenue building still in use.

In 1919, as a result of a new city charter and out of a need for tax support, the museum's building and collections became the property of the city of Detroit under the jurisdiction of the Arts Commission. At this time the museum was renamed The Detroit Institute of Arts, with the original corporation, now known as the Founders Society, remaining in existence as a private supporting body. This sharing of responsibility for the Institute by public and private sectors continues to the present: the city owns and maintains the building and grounds and pays certain staff salaries, while the Founders Society supports the acquisition of works of art and underwrites special exhibitions, publications, and educational and visitor services. In 1975 rising costs and a depleted city budget forced the Institute to close temporarily. Appealing to the state for support on the grounds that its stature and programs had made it a state, as well as a city, resource, it won its case and has received yearly state appropriations since that time.

The Institute is governed by the city Arts Commission, appointed by the mayor and by the Board of Trustees of the Founders Society, representing the private sector. Administered centrally by a director and deputy director, it is organized into curatorial departments of African, Oceanic, and New World Cultures; American Art; Ancient Art; Asian Art; European Painting; European Sculpture and Decorative Arts; Graphics; and Modern Art. Several of these departments receive significant support from auxiliary groups administered through the Founders Society. They include The Friends of African Art, The Antiquaries, The Associates of the American Wing, The Drawing and Print Club, The Friends of Modern Art, and The Friends of Asian Art. In addition to sponsoring lectures and programs related to the permanent collections, they raise funds for acquisitions and, in some cases, sponsor special exhibitions. The large Registrar's department oversees the innovative DARIS (Detroit Art Registration and Information System) record computerization system, in addition to the customary duties of that office. The Institute has, since 1971, operated as well the large

and well-equipped Conservation Services Laboratory. A considerable number and variety of programs and services are offered through the active Education Department. They include docent tours for groups of all ages, weekly gallery talks by staff members, studio and history of art classes, and teacher workshops. The department also prepares didactic exhibitions and coordinates the Statewide Services Program of touring exhibitions and speakers for Michigan communities.

The building now occupied by the Institute was designed by the French architect Paul Cret and opened to the public in 1927. A stately beaux-arts structure, in the Italian Renaissance style then preferred for buildings of civic and cultural significance, its interior plan reflected the philosophies of William R. Valentiner, director from 1924 to 1945. Trained in Germany as an art historian and museum professional, Valentiner believed in a contextual approach to the exhibition of works of art, arranging them by period and cultural group or national school rather than by medium as was the earlier custom. The Institute's plan was unusually comprehensive for its date and among the first in this country to stress historical context in the exhibition of works of art. Valentiner left a further mark on the architecture of the Institute; he was instrumental in bringing Diego Rivera to Detroit in 1931 for the purpose of creating a fresco cycle for the central garden court. The twenty-seven separate panels of Rivera's murals deal with the theme of man and industry; referring specifically to Detroit, they depend in great part on drawings Rivera made based on his experience in the city's factories. The Institute also owns a number of related documents and drawings including Rivera's full-scale cartoons.

Two wings were added to the original building in the 1960s necessitated by the enormous growth of Detroit's collections, staff, and programs. Reflecting the ongoing relationship between public and private sources of support, the South Wing, opened in 1966 and since 1977 named the Eleanor and Edsel Ford Wing, was funded by private and federal contributions; the matching North Wing, completed in 1971, was underwritten by city of Detroit bonds. The Institute has once more undergone major renovations as part of a five-year plan completed in 1985, the Institute's centennial. Again financed by both public and private funds, the project includes new and refurbished galleries and offices, a new entrance plaza, and a public park and sculpture garden.

The collections of The Detroit Institute of Arts are justifiably acclaimed for their exceptional quality and broad scope. Most extensive are its holdings of European art: painting, sculpture, decorative arts, and textiles that span the history of western European art from the Middle Ages through the nineteenth century (twentieth-century European art is discussed below as part of the modern collection). Among the first works of art acquired by the fledgling museum was a group of Old Master paintings given by newspaper editor and publisher James E. Scripps in 1889 and enlarged twenty years later by his widow's bequest. The Scripps Collection was particularly strong in works of the Dutch and Flemish schools and included Jan Provost's *Last Judgment*, Salomon van Ruysdael's *River Landscape* (1643), and a group of Dutch "little masters" for which the

Institute is known. The European collection grew impressively under the direction of Valentiner. In the years before the Depression he was able to secure city funds to purchase the tiny (7 7/8 by 5 inches) and exquisite Jan van Eyck *St. Jerome* (formerly attributed to Petrus Christus), Rembrandt's *Visitation*, Giovanni Bellini's *Madonna and Child*, Luca della Robbia's *Genoese Madonna*, and Pieter Bruegel the Elder's *The Wedding Dance*. Also during this period, Founders Society membership funds brought into the collection remarkable works such as Titian's *Man with a Flute* and Velázquez's *Portrait of a Man*.

Valentiner understood the need for a growing museum to cultivate patrons; through lectures, catalogues, loan exhibitions of national and international importance, and personal friendships, he undertook to educate Detroit's elite and was responsible for the development of a number of outstanding private collections. Detroit has never had a large endowment for acquisition, and since the early 1930s the collections have grown primarily through the gift of works of art or of funds for purchase by individual patrons. Of particular note were Mr. and Mrs. Edsel Ford, who, inspired and assisted by Valentiner, purchased for the Institute major works such as Andrea Pisano's marble *Madonna and Child*, two panels by Fra Angelico, Piazzetta's *Madonna and Child with Adoring Figures*, Holbein's *Portrait of a Woman*, and Ter Borch's *A Lady at Her Toilet*. Similarly, the Institute's strong holdings in late nineteenth-century French painting are in large part the result of the Robert H. Tannahill bequest, which included important works by Cézanne (*Portrait of Madame Cézanne, Mont Ste.-Victoire, Three Skulls, Bathers*), Seurat (*View of Crotoy*), Degas (*Violinist and Young Woman, Woman with a Headband*), Renoir (*Seated Bather, The Palm Tree, The White Pierrot*), and Gauguin (*Self Portrait*).

The Institute's collection of earlier French art is also strong. Of particular note are *Selene and Endymion*, about 1630 by Poussin; *A Seaport at Sunset*, 1643, by Claude Lorraine; and *Purification of the Virgin*, 1645, by Lebrun. The extraordinarily rich and diverse eighteenth century in France is represented by paintings such as Chardin's 1732 *Kitchen Still Life*, a picture of small size (6 3/4 by 8 inches) but monumental scale and power, and Fragonard's *Scenes of Country Life: The Shepherdess*, 1753. The Institute also has extensive holdings in eighteenth-century French decorative arts, due in great measure to the gift of an outstanding group of furniture, porcelain, sculpture, and tapestries collected by Mrs. Horace E. Dodge. Earlier nineteenth-century paintings include *Judgment of Paris*, about 1812, by Regnault; *Madame Louis-Antoine de Cambourg*, 1846, by Flandrin; and *The First Bath*, 1852–55, by Daumier. The Institute also has a fine collection of French sculpture including Rodin's *Eve*.

The Italian collections are equally rich and comprehensive. Particular interest in Renaissance sculpture is reflected in the bronze *Judith* by Pollaiuolo and rare terracotta modellos by Bernini. Among the paintings, one might note Perugino's *Madonna and Child; The Mystic Marriage of St. Catherine*, considered to be one of the finest Correggios in this country; and an impressive group of Mannerist pictures by Bronzino, Parmigianino, and Niccolò dell'Abbate. Italian painting

of the seventeenth and eighteenth centuries is magnificently represented by Caravaggio's *The Conversion of the Magdalen*, along with works by Orazio and Artemesia Gentileschi, Reni, Guercino, Tiepolo, Canaletto, and others. The Dutch and Flemish collections are particularly fine and include, in addition to works already cited, Ruisdael's masterpiece *The Cemetery* and six paintings by Rubens. The holdings in English painting are particularly rich in portraiture and, with works by Hogarth, Gainsborough, Reynolds, Wilson, Constable, Fuseli, and others, are complemented by excellent examples of British silver and ceramics. Similarly, important pieces of Meissen porcelain enhance the Institute's examples of German painting and wood sculpture. Finally, the small but select Spanish collection includes Murillo's *Flight into Egypt* and a Goya portrait.

Detroit's collection of American art, which began with the newly founded museum's first acquisition of a painting by Francis D. Millet in 1883, is, like its European collection, impressively comprehensive. Developed importantly by Edgar P. Richardson, director from 1945 to 1962, its richness is again due in large part to the generosity of individual patrons. Dexter M. Ferry, Jr., president of the Founders Society from 1920 to 1947, supported the acquisition of major nineteenth-century works such as Whistler's *Nocturne in Black and Gold: The Falling Rocket*, Bingham's *Trappers Return*, and Mount's *Banjo Player*. Robert H. Tannahill, who served as trustee, commissioner, and honorary curator of American art, contributed as well in this area by the donation of paintings, including Harnett's *American Exchange* and Sheeler's *Home Sweet Home*, and by helping to develop a strong collection of seventeenth- and eighteenth-century American decorative arts. The American Wing also houses a two-story reconstruction of rooms from Whitby Hall, an eighteenth-century Philadelphia residence; Vauxhall Gardens, built in the 1720s, in Salem, New Jersey; and Spring Garden Mansion, about 1770, from New Castle, Delaware. Among recent acquisitions of note are Copley's portrait *Hannah Loring*, Sargent's striking *Portrait of Mme. Paul Poirson*, and Church's impressive *Cotopaxi*.

The foundations of Detroit's modern collection, which includes American and European painting and sculpture from 1913 to the present, were laid early. Matisse's *The Window*, for example, was purchased in 1922, becoming the first Matisse to enter a public collection in this country. Similarly, Kokoschka's *The Elbe near Dresden*, painted in 1921, was acquired the same year and represented the beginning of what was soon to be an extraordinarily strong collection of the works of contemporary German and Austrian artists such as Heckel, Kirchner, Lehmbruck, Marc, Pechstein, and Schmidt-Rottluff. That this art, banned in Germany and much maligned elsewhere, was collected in Detroit in the 1920s and 1930s was due to the foresight and persuasive powers of Valentiner and to the courage of individual collectors. The modern collection is, by design, a broadly inclusive survey of modern art in Europe and America. The Friends of Modern Art, led by Hawkins Ferry, the leading patron in the field, has played a particularly active role in its development, sponsoring exhibitions from which purchases have been made for the permanent collection. Paintings by Albers,

Anuszkiewicz, Frankenthaler, Kelly, and Louis have entered the Institute in this manner, as have David Smith's *Cubi I* and Louise Nevelson's *Homage to the World*. The strong sculpture collection also includes important works by Maillol, Gabo, Moore, Calder, di Suvero, and LeWitt; the monumental Tony Smith *Gracehoper*, installed out of doors; and a group of rare and beautiful plaster works by Jean Arp.

Of many noteworthy modern European paintings, one might cite Kandinsky's *Composition: Painting with a White Shape*, Tanguy's *Shadow Country*, and Miró's *Self Portrait II*. In 1978 the Institute acquired Matisse's cut-out *The Wild Poppies* and the stained-glass window for which it was the maquette.

American painting since 1945 is particularly well represented in strong works by New York School painters Kline, Rothko, Still, and Motherwell and in later works by Rauschenberg, Warhol, Frank Stella, Newman, and others. The modern collection also includes the work of contemporary Michigan artists whom it supports through juried, invitational, and survey exhibitions as well as through purchases.

Detroit's collection of works of art on paper, primarily prints, drawings, watercolors, and, to a lesser extent, posters, photographs, portfolios, and artists' books, is the responsibility of the Department of Graphic Arts. Housed since 1980 in the renovated Schwartz Graphic Arts Galleries, the collection now has the well-deserved visibility that it had lacked previously. The range here is broad, as is the case with Detroit's other curatorial areas, and the intention is to chronicle the history of the graphic arts. Of particular note are an excellent impression of Dürer's *Adam and Eve*, Ugo da Carpi's rare chiaroscuro woodcut *Diogenes*, Rembrandt's etching and drypoint *The Descent from the Cross by Torchlight*, and a rare edition of Piranesi's *Carceri*. From the nineteenth century, among numerous important examples, one might cite Daumier's powerful lithograph *Rue Transnonain, April 15, 1834* and Manet's etching and aquatint *Dead Christ with Angels*. Printmaking in the twentieth century is represented by masters such as Picasso, Klee, Braque, Feininger, Munch, and Matisse and by a particularly strong group of German Expressionist woodcuts and etchings. The drawings collection is especially strong in nineteenth- and twentieth-century works by Fuseli, Ingres, Delacroix, Corot, Degas, Pissarro, Cézanne, Picasso, and Matisse and includes as well sheets by Michelangelo, Barrocci, Callot, and Tiepolo, among others.

The department has collected photographs systematically since 1971. The twentieth century is now well represented, and rare nineteenth-century examples by major figures such as Julia Margaret Cameron have also been added. Of particular note among the collection of artists' books is Robert Motherwell's *A La Pintura*.

Detroit has collected the arts of Africa, Oceania, and the Native Americas since the late nineteenth century when they were still considered curiosities. Among the earliest museum accessions were a group of Plains American Indian objects, including a Cheyenne shield, bequeathed to the city of Detroit by the

widow of George Armstrong Custer, and collections gathered from all over the world by Frederick Stearns, one of the original forty founders. Valentiner's conviction that ethnographic materials were essential to Detroit's increasingly comprehensive collection led to important purchases during his tenure as director and, later, to gifts from individuals whom he had encouraged to collect for themselves. An important Benin female head and a number of pre-Columbian textiles and ceramics were acquired during the 1920s; several outstanding private collections of Southwest American Indian art were donated during the 1930s. In 1975 the Department of African, Oceanic and New World Cultures was established. There followed systematic expansion and upgrading of the collections and the creation in 1980 of permanent exhibition space devoted to African and Native American arts. Significant recent accessions include a Djenne (1300–1400) terracotta bearded male figure from Mali, a spectacular Congo nail figure (*nkisi n' konde*) from Zaire, and an imposing Epa cult helmet mask by the Yoruba carver Bangboye of Odo-Owa, this last purchased for the museum by the Friends of African Art. Aside from individual purchases of important Native American art in recent years, such as a Tsmishian female mask and a large Apache basketry olla, among others, the Native American collections have been enhanced immeasurably by the recent purchase of the Chandler-Pohrt Great Lakes American Indian Collection. With this single accession of more than 650 objects, the Detroit Institute of Arts has become one of the half-dozen most important collections of central North American Indian arts in the world.

The development of Detroit's collection of Asian art, which now includes the arts of India, Southeast Asia, Indonesia, China, Korea, and Japan, from prehistory to modern times, was somewhat less systematic than that of other areas. Nonetheless, astute purchases and the generosity of individuals have brought major works into the collection. The Chinese collection includes the thirteenth–fourteenth-century handscroll *Early Autumn* attributed to Ch'ien Hsuan; paintings by masters such as Shen Chou, Wen Cheng-Ming, and Mei Ch'ing; the lacquered wood figure *Sakyamuni as an Ascetic* from the Yüan Dynasty; and a selection of lacquer objects dating from the Sung through the mid-Ming Dynasty. Japanese art is represented by wood sculptures and ceramics, particularly handsome lacquers from the Momoyama to early Edo period, and paintings such as *Reeds and Cranes*, a pair of six-fold screens by Suzuki Kiitsu, and a pair of elegant fan paintings by Ogata Korin. The South Indian bronze Parvati complements fine earlier acquisitions of Chola stone sculpture.

The earliest objects in Detroit's broad survey collection of ancient art are a group of paleolithic stone tools from Mt. Carmel in Palestine. Twelve pieces of Irish Bronze Age gold form a unique collection in North America. Mesopotamian material includes important Assyrian reliefs, especially one of Tiglath Pileser III; a glazed tile relief dragon from the Ishtar Gate at Babylon; seals; tablets; and related objects. Ancient Anatolia, Palestine, and Iran are represented. Particularly noteworthy are four stone reliefs from Persepolis and an important Sassanian silver bowl. A Thracian silver helmet is the only one of its type to

be found outside Romania. The Egyptian collection includes a decorated tomb wall from Giza and other important Old Kingdom reliefs and sculpture-in-the-round from the major periods of Egypt's artistic development, especially a small image of a seated scribe of Dynasty XVIII, as well as examples of the decorative arts ranging from the Predynastic Period to the Roman occupation. An encaustic portrait of a woman from the Roman Period is of outstanding quality. The art of Greece and the Aegean can be seen from Cycladic stone sculpture through the Hellenistic period. An important collection of red- and black-figure ceramics complements the survey of sculpture in Greek style, which includes a variant of the Cassel Apollo and an Aphrodite of the Venus Genetrix type. Etruscan art is represented by ceramics, stone carving, and bronze, including an important bronze rider of of the fifth century B.C. Roman art includes fine examples of portrait sculpture, a Republican head, a head of Augustus, and a *Togate Young Nero*, as well as coins, mosaics, pottery, glass, and metalwork.

The sixty-thousand-volume Art Research Library primarily serves to document the Institute's collections and includes monographs, periodicals, museum publications, and auction catalogues, as well as a slide rental collection. It is open to scholars and students and assists the public in identifying works of art. The Institute also houses the midwestern office of the Archives of American Art, originally founded in Detroit and now a branch of the Smithsonian Institution. The archives, which documents the history of the visual arts in this country, contains the records, letters, diaries, and sketchbooks of American artists, collectors, dealers, museums, and related institutions. An invaluable resource, it is open to anyone interested in the history of American art. Of interest to those concerned with the history of The Detroit Institute of Arts is the Museum Archives. Begun in 1977, it houses a variety of papers, correspondence, journals, photographs, and other materials and is open to the public by appointment.

The Institute's Publications Department is responsible for the production of the quarterly *Bulletin* containing scholarly articles on objects in the collection, and catalogues of the permanent collection and special exhibitions. These items are available in the museum shops, which also sell a variety of art books, catalogues, slides, reproductions, and crafts. The Rental and Sales Gallery offers paintings, drawings, and prints by Michigan artists.

Selected Bibliography

Museum publications: *Bulletin of the Detroit Museum of Art*, 1904–19; *Bulletin of The Detroit Institute of Arts*, 1919-present (both bulletins are devoted to scholarly articles on objects in the collection); Clayton, Wallace E., *The Growth of a Great Museum: An Informal History of The Detroit Institute of Arts*, 1966; Cummings, Frederick, and Charles Elam, *The Detroit Institute of Arts Illustrated Handbook*, 1971; *From the Inside: The Archives of The Detroit Institute of Arts, 1833–1945*, 1980; *Treasures from The Detroit Institute of Arts*, 1966; *Selected Works from The Detroit Institute of Arts*, 1979; *Catalogue*

of Paintings and Sculpture given by Edgar B. Whitcomb and Anna Scripps Whitcomb to The Detroit Institute of Arts, 1954; The Robert Hudson Tannahill Bequest to The Detroit Institute of Arts, 1970. Henshaw, Julia P., ed., 100 Masterworks from The Detroit Institute of Arts, 1985.

MARJORIE HARTH BEEBE

———— Fort Worth ————

KIMBELL ART MUSEUM, 3333 Camp Bowie Boulevard, Box 9440, Fort Worth, Texas 76107.

The Kimbell Art Museum is the public facility of the Kimbell Art Foundation, established in 1936 by the Fort Worth industrialist Kay Kimbell. Originally, the foundation consisted of Kimbell's private art collection from which works were lent to various regional institutions. Upon his death in 1964, Kimbell bequeathed his entire corporate financial interest to the foundation to provide for the building and endowment of an art museum of high quality in Fort Worth. His widow, Velma Fuller Kimbell, completed the bequest by donating her share of community property to the Kimbell Art Foundation for the sole purpose of supporting the art museum. In 1966 the foundation began implementing the projects stipulated in the will. A museum director was chosen by the Board of Trustees, also executors of the will. The city of Fort Worth allocated 9.5 acres of civic property for the building and gardens, and Louis I. Kahn of Philadelphia was selected as the architect. The Kimbell is situated in Amon Carter Square Park, a cultural complex that includes the Amon Carter Museum and the Fort Worth Art Museum.

The building of the Kimbell Art Museum is a celebrated masterwork of American architecture. It was one of the last structures designed by Louis Kahn before his death in 1974. It has received numerous prestigious architectural and engineering awards, including the Best Building Award of the National General Contractors Association (1972), as well as the Honor Award and the Bartlett Award from the American Institute of Architects (1975). The structure is composed of a series of self-supporting cycloidal vaults of post-tensioned concrete that encloses 120,000 square feet of space. The elimination of interior supports facilitates an unobstructed and very flexible use of the spacious interior. Works of art are viewed in natural light that enters by the expansive windows and through skylights that run along the apex of the vaults. Objects are protected from harmful ultraviolet exposure by specially designed filters that evenly diffuse sunlight throughout the galleries.

The museum is governed by a board of trustees whose members are elected to permanent positions. The museum director administers a full-time staff of about sixty members who are divided among the Curatorial, Business, Public

Relations, Registration, Library, Conservation, and Building and Security departments.

The original Kimbell Collection of nearly 250 works of art included a large number of British eighteenth-century portraits, as well as 50 scenes by painters of the American West. About 45 of these works were retained for the permanent collection to which were added another 200 objects acquired between 1965 and October 4, 1972, the date which marks the museum's official opening. Ongoing museum purchases are funded by the Kimbell Art Foundation, and many generous gifts from other donors enrich the collection.

In the spirit of cooperation, the three Fort Worth museums have adopted a noncompetitive acquisition policy. Thus the Kimbell collection does not acquire works of American art better suited for the Amon Carter Museum, and the approximate terminal date for the Kimbell acquisitions is 1940, in observance of the policy of the Fort Worth Art Museum, which concentrates on contemporary art. Rather than strive for a comprehensive or specialized collection, the Kimbell staff has sought to assemble a select group of objects on the basis of their definitive nature, aesthetic quality, and excellence of condition. The result is a small but diverse assemblage of choice artworks that date from the prehistoric era to the early twentieth century.

The era of antiquities is introduced by a Sumerian sculpture, *Head of a Ewe*, from 3200 B.C., the museum's oldest artifact, and also includes two stone reliefs from the Late Assyrian period, a pair of winged deities from the palace of Ashurnasirpal II at Nimrud, and an Egyptian statue of Rameses II as the god Osiris from the temple of Mut at Karnak. A Greek marble statue of a young female attendant from the Late Classical period is an outstanding example from the museum's small number of early Greek and Roman sculptures.

The European painting collection begins with an outstanding Duccio, *The Raising of Lazarus*, one of the eight surviving predella panels from the Maestà Altar commissioned for the Cathedral of Siena in 1308. Venetian fifteenth-century painting is represented by two works by Giovanni Bellini.

Sixteenth-century paintings include an important work by Annibale Carracci, *The Butcher's Shop*, painted in the early 1580s. Examples of the Mannerist school include a portrait by the Flemish painter Jan Gossaert, *Raising of Lazarus* by Tintoretto, and a portrait by El Greco done about 1600–1610. Domenichino's *Abraham Leading Isaac to Sacrifice*, an oil painting on copper painted in 1602, represents the beginnings of the classical landscape tradition of the seventeenth century.

The Kimbell's holdings in the Baroque are particularly noteworthy. A group of seventeenth-century pictures from the private Kimbell Collection has been enhanced by later museum gifts and purchases. Bought in 1976, Rubens' oil sketch *The Duke of Buckingham* (1625) was a preparatory study for the life-sized portrait destroyed by fire in 1949. Dutch portraits include a pair of portraits by Gerard Ter Borch and *Portrait of a Young Jew* by Rembrandt, a superb example of the artist's late style. The Dutch landscape tradition is represented

by Salomon van Ruysdael's *Landscape with Ruins of Egmond Abbey* (1644). To the Italian school belong Massimo Stanzione's *Madonna and Child* (1630s) and Salvator Rosa's *Pythagoras Emerging from the Underworld* (1662), as well as a more recent acquisition, Cavallino's *Mucius Scaevola Confronting King Porsenna* (1650s). Important Spanish works include *St. Matthew* by Ribera and *The Immaculate Conception* by Murillo. The portrait *Don Pedro de Barberana*, executed about 1631–32 by Velázquez, constitutes a landmark acquisition for 1981. French seventeenth-century painting is represented by Claude Lorraine's *Landscape with the Rape of Europa*, painted in 1634, and a *Pastoral Landscape*, which was completed when the artist was seventy-seven. Georges de La Tour's *Cheat with the Ace of Clubs* is thought to have been painted about 1620–30, thus making it the earlier of the two versions of the *Cheat*, the other being in the collection of the Louvre (q.v.).

The eighteenth-century paintings that made up the core of the Kimbell's original holdings were later augmented by further acquisitions. Italian paintings of this period consist of Venetian views by Guardi and Canaletto. A highly varied group of French paintings offers works by Hubert Robert, Jean-Honoré Fragonard, and Antoine Watteau. Three portraits by Vigée-Lebrun include a youthful *Self Portrait* painted about 1781. A major acquisition from 1972 is a series of four large Boucher canvases representing classical myths about the power of love, painted one year before the artist's death. The paintings, formerly in the Paris collection of Baron James de Rothschild, were originally intended as design for the Royal Gobelin tapestry factory but were never carried out in that medium. A rare Chardin, *Young Student Drawing*, depicts a favorite subject of the artist.

Among the English portraits in the collection are three portraits by Joshua Reynolds, including the full-length *Miss Warren (?)*, which previously belonged to William Randolph Hearst. The legacy of the Reynolds tradition is exemplified by two portraits from the early nineteenth century by Thomas Lawrence. Portraits by Gainsborough span the artist's career with examples from the Bath, Suffolk and London periods. Additional portraits include several significant works by George Romney, as well as two canvases by the Scotsman Henry Raeburn. Paintings by John Hoppner include a portrait of Sophia Fielding from 1787 and an unusual *Romantic Landscape* painted the same year.

French paintings are preponderant in the nineteenth-century collection. Exceptions are two portraits by Goya, including the portrait of his close friend *The Matador Pedro Romero*, Leighton's *Miss May Sartoris*, and Turner's *Glaucus and Scylla* from Ovid's *Metamorphoses*. Jacques-Louis David's major late work, *The Rage of Achilles*, executed in his exile in Brussels in 1819, begins the series of French works. Also included is Géricault's *Portrait of a Youth*.

Three works by Corot, Barbizon landscapes by Daubigny and Rousseau, and Courbet's *Roedeer at a Stream* from 1868 trace the development of the landscape in France before Impressionism. Sisley, Pissarro, Monet, Degas, Sickert, and Caillebotte are the Impressionist painters represented. Pissarro's *Near Sydenham Hill*, unseen by the public for seventy years in a private American collection,

was completed in England when the artist had fled from France to escape the Franco-Prussian War. *Pointe de la Hève, at Low Tide* from 1865 has the distinction of being one of the first two works submitted by Monet to the Paris Salon. The Kimbell holdings in nineteenth-century French paintings are capped by two Cézannes: a landscape, *Maison Maria on the Chateau Noir Road*, and a superb portrait, *Man in a Blue Smock*, both from Cézanne's late period.

Maillol's *L'Air* from 1938, a major piece from the sculptor's late career, is exhibited in one of the two courtyards. From the first decade of the twentieth century are a Fauve landscape, *The River Seine at Chatou*, by Derain; *Girls on a Bridge* by Munch; and two works by Picasso, a 1906 painting, *Nude Combing Her Hair*, and the analytical Cubist work, *Man with a Pipe*, from 1911. A major 1983 gift to the Kimbell is Mondrian's *Composition No. 7 (Facade)*, painted in Paris during the artist's most crucial phase of development.

Since the museum's opening in 1972, special efforts have been made to expand the prints and drawings collection. A small selection of first-rate prints includes one of the seven known autograph engravings by Mantegna, *The Risen Christ between St. Andrew and St. Longinus*. Fine impressions of Dürer's three *meisterstiche* were purchased in 1976, and four prints by Rembrandt are in the collection. The finest seventeenth-century drawing is Claude Lorraine's *River Landscape* from the Odescalchi Collection. To the eighteenth century belong Tiepolo's most ambitious etching, *The Adoration of the Magi*, as well as drawings by both him and his son Domenico. Other drawings include Fragonard's *Danae Visited by Jupiter* and Ingres' portrait *Alphonse-Pierre Hennet*. Nineteenth-century graphics include works by Pissarro, Degas, and Munch.

A substantial Asian collection has been assembled by the Kimbell staff since 1965, providing access in the Southwest to the arts of India, China, Cambodia, Korea, and Japan. Sculptures from India range from the second through the fifteenth century. A standing Buddha from Gandhara reveals Graeco-Roman influences, and a seventh-century Nepalese Buddha in gilt-bronze exemplifies the classical Buddha form in the Gupta period. A terracotta relief of Ganesa demonstrates the sensuous modeling characteristic of sculpture produced during the classical Gupta period, and a female goddess from Rajasthan is representative of the crisper medieval style in North India. From South India are two later Hindu images in bronzes of Vishnu and Parvati. Important Cambodian bronzes include an eighth- or ninth-century standing Maitreya Buddha that belonged to a burial chamber uncovered near Pra Kon Chai in 1964 and a magnificent seated *Buddha Enthroned*, which is one of the largest cast bronze images known from Southeast Asia.

Examples of Chinese art include stoneware and porcelain ceramics from the Tang, Sung, Yüan, and Ming dynasties and a number of paintings. A handscroll is the only Yüan Dynasty work, but the Ming examples include a large landscape by Wen Chia, the striking composition *Birds and Flowers of Early Spring* painted by Yin Hung about 1500, the *Landscape with Mountain Pavilion* painted in 1562

by Lu Chih, and *Steep Mountains and Silent Waters*, a scroll painted in 1632 by Tung Ch'i-Chiang.

Among the religious arts, the collection has acquired a wood sculpture from the Heian period, *Hachiman in the Guise of a Buddhist Priest*, which dates from the late tenth or eleventh century, and a fourteenth-century painting of Vimalakirti, which is a Shinto mandala. Among the Japanese paintings are some important screens, such as *An Exiled Emperor on Okinoshima*, which dates from the sixteenth century, and a brilliant pair, *Flowers and Fruits of Spring and Autumn*, that demonstrate the techniques and stylistic features of the Rimpa school. Added recently are works of other Edo period schools, such as a standing courtesan dressed in white, a fine example of *ukiyo-e* painting by Rekisentei Eiri, and an outstanding example of the Nanga school, *Landscape with a Solitary Traveler*, painted by the great master Yosa Buson.

The Kimbell's pre-Columbian artifacts, like the Asian ones, have been acquired since the appointment of the museum's professional staff in 1966. The oldest objects date from 1600 to 1200 B.C. and may be among the most ancient sculptures from the Olmec civilization. Mayan objects include two important ceremonial relief carvings that demonstrate the range and variety of Mayan sculpture from the Classical period. The single Aztec sculpture *Seated Man* from 1500 may possibly represent Huehueteotl, the Aztec patron of fire.

A small selection of tribal sculptures from Africa has been assembled by the Kimbell. Most of the works date from the nineteenth and twentieth centuries and were acquired in 1978 and 1979.

In addition to the artworks, the Kimbell possesses a continually expanding art library of some twenty-five thousand volumes. Although not open to the public, individuals engaged in serious research may gain access to the facility by contacting the librarian. Additional features include a 180-seat auditorium and a museum bookstore, which furnishes slides of the collection and museum catalogues. The Kimbell's active conservation department serves museums and private collectors throughout the Southwest, and the education services maintain cooperative programs with regional schools and colleges.

Selected Bibliography

Museum publications: *Kimbell Art Museum: Handbook of the Collection*, 1981; *Kimbell Art Museum: Catalogue of the Collection*, 1972; *Light is the Theme: Louis I. Kahn and the Kimbell Art Museum*, 1975; *Louis I. Kahn: Sketches of the Kimbell Art Museum*, 1978.

Other publications: Hoving, Thomas, "A Gem of a Museum," *Connoisseur* (May 1982), pp. 87–95; Kutner, Janet, "How to build a museum with diplomacy, guile, and charm," *Art News*, 76 (December 1977), pp. 87–90; Pillsbury, Edmund, "Recent Painting Acquisition: The Kimbell Art Museum, Forth Worth," supplement to *The Burlington Magazine*, 124, i-viii; idem, "The Rebirth of Venus," *Art News* (April 1983), pp. 109–10; Robb, David M., "Rembrandt's Portrait of a Young Jew," *Apollo*, 107 (January

1978), pp. 44–47; Shephard, Richard F., "After a six-year honeymoon, the Kimbell Art Museum," *Art News*, 71 (October 1972), pp. 22–31; Sutton, Denys, "Treasures for Texas," *Apollo*, 96 (October 1972), pp. 342–49.

MARLA PRATHER

———— Hartford ————

WADSWORTH ATHENEUM (also THE ATHENEUM), 600 Main Street, Hartford, Connecticut 06103.

The Wadsworth Atheneum is the oldest privately endowed public art museum in the United States. In 1841 Daniel Wadsworth, a Hartford philanthropist and patron of the arts, proposed the establishment of an art gallery in Hartford and offered his father's lot on Main Street for its site. Funds for the project were raised by public subscription. In the spring of 1842 the Connecticut General Assembly granted the Wadsworth Atheneum a charter and construction began. Ithiel Town and Alexander Jackson Davis designed the neo-Gothic-style building. The tripartite structure housed a central art gallery flanked on one side by the Connecticut Historical Society and on the other by the Hartford Young Men's Institute, later the Hartford Public Library. Both of these auxiliary institutions have since moved to different locations. The Atheneum opened to the public in the summer of 1844.

The original building, its interior gutted and renovated, still serves as the main entrance to the museum, but a series of additions have augmented the gallery space. In 1905 the bequest of Elizabeth Hart Jarvis Colt enabled the Atheneum to construct the Colt Memorial in memory of her husband, Samuel Colt, inventor of the Colt revolver. Two years later J. Pierpont Morgan funded an addition in memory of his father, Junius Spencer Morgan. Benjamin Wistar Morris designed both the Tudor-style Colt Memorial, built between 1906 and 1907, and the English Renaissance-style Morgan Memorial, constructed between 1908 and 1910. During the 1930s the Atheneum again expanded with the addition of the Avery Memorial, built on Daniel Wadsworth's homesite. This wing, designed by Morris and O'Connor of New York, was constructed with funds from the bequest of Samuel P. Avery, Jr., son of the renowned New York art dealer and collector. The latest addition to the Atheneum is the James L. Goodwin building, designed by Huntington, Darbee and Dollard of Hartford and built between 1965 and 1967. Today the Wadsworth Atheneum consists of these five interconnected buildings, which surround a central sculpture court. The complex houses thirty-six galleries, offices, a conservation studio, a three hundred-seat theater, an art library, a museum shop, and a restaurant. Much of the museum is currently being refurbished and modernized as part of a multimillion-dollar capital-improvement program.

The museum is governed by a board of trustees, composed of forty members

who serve three-year overlapping terms. Administered by a director, the museum staff is organized into three main sections—Collections and Interpretation, Development, and Operations and Finance.

The Atheneum's collection contains about forty-five thousand objects, ranging from Egyptian artifacts to contemporary painting and sculpture. The collection was begun with a group of paintings, plaster casts, and prints acquired in 1842 from the bankrupt American Academy of Fine Arts. The most important of these works was John Vanderlyn's painting *The Death of Jane McCrea*. From this modest beginning, the collection grew through a series of important gifts and bequests. Most significant among them were the bequests of Daniel Wadsworth and Elizabeth Hart Jarvis Colt of American paintings, J. P. Morgan, Jr.'s gift of the J. Pierpont Morgan Collection of ancient art and eighteenth-century ceramics, and his later gift of the Wallace Nutting Collection. Frank C. Sumner, a Hartford businessman, made a large bequest in 1927 that established the Atheneum's major fund to purchase paintings and enabled the museum to augment its collection with many masterpieces. Works purchased through this fund are designated as part of the Ella Gallup Sumner and Mary Catlin Sumner Collection in memory of the donor's wife and sister-in-law. Through generous gifts and careful acquisitions, the Atheneum's collection now includes examples of all major schools of painting and sculpture, as well as decorative arts, costumes, and textiles.

The Atheneum's small collection of ancient art contains examples of pottery, glass, marble, bronze, and painting. The highlights are a group of eighty-six Greek and Roman bronzes from the Morgan Collection; a pair of marble funerary lions attributed to the school of Lysippos under the influence of Scopas, about 320 B.C.; a Hellenistic torso of a maenad; a black-figure hydria attributed to Psiax, about 520 B.C.; and a red-figure lekythos by the Brygos Painter, about 480 B.C. Later developments in painting can be seen in a series of ten Roman fresco fragments from Pompei and a Fayum-style tempera painting of a man on horseback, a rare subject in Romano-Egyptian painting.

The Atheneum's collection of Early Christian and medieval art is limited but contains some interesting pieces. A marble figure of the Good Shepherd and a pair of Roman lamps with Christian symbols are the best examples of Early Christian art. The collection also includes a group of Romanesque architectural fragments and examples of metalwork from the thirteenth and early fourteenth centuries.

The Early Renaissance in Italy is represented by a few panel paintings, the most important of which are an exquisite *Head of an Angel* by the studio of Fra Angelico (a fragment from a *Madonna and Child* in the Rijksmuseum [q.v.]) and an altarpiece by Giovanni da Ponte. The monumental *Finding of Vulcan* by Piero di Cosimo is the most outstanding painting in the Italian Renaissance collection. There are three fine examples of Northern Italian painting—*Madonna and Child with Donor* by Andrea Previtali, *Combat between Roland and Rodomont* by Dosso Dossi, and *Hercules and Antaeus* attributed to Tintoretto.

Italian Mannerism is represented in works by Lelio Orsi, Bacchiacca, and Francesco Zucchi.

The museum's earliest example of Northern Renaissance painting is the delicate *Portrait of a Member of the van Busleyden Family* by an anonymous Franco-Flemish artist, about 1495–1505, and there are good later Northern Renaissance paintings by Bernard van Orley, Jan Sanders van Hemessen, and Lucas Gassel. The most outstanding German painting of this period is *The Feast of Herod* by Lucas Cranach the Elder. Northern sculpture of the fifteenth and sixteenth centuries can be studied in a selection of wood and polychrome figures from France, Germany, and Flanders.

One of the highlights of the Atheneum's holdings is the superb collection of Baroque paintings. The central piece is *The Ecstasy of St. Francis* by Caravaggio, dating from the early to mid–1590s and possibly Caravaggio's earliest landscape and his first attempt to let light represent divine power. Caravaggio's influence on Italian painting can be traced in Gentileschi's *Judith and Maidservant with Head of Holofernes* and Saraceni's *The Holy Family in the Carpenter Shop.* Other important Italian Baroque paintings include *St. Catherine* by Bernardo Strozzi, *St. Sebastian* by Guercino, and Salvator Rosa's portrait *La Ricciardi, Mistress of the Artist, as a Muse*, a pendant to his *Self Portrait* in the National Gallery (q.v.), London.

Caravaggio's influence in Spain is reflected in the magnificent *St. Serapion* by Zurbarán and in two paintings attributed to Ribera, *Portrait of a Philosopher* and *The Sense of Taste.* Other important seventeenth-century Spanish paintings are *St. Francis Xavier* by Murillo and the interesting *Vanitas* by Juan de Valdés Leal.

Flemish painting of the seventeenth century is well represented by the monumental *Return of the Holy Family from Egypt* by Rubens, two still lifes by Snyders (one executed with Rubens), and *Resurrection* by van Dyck. The most significant Dutch painting is Hals' *Portrait of Joseph Coymans*, a pendant to the *Portrait of Dorothea Berck* in the Baltimore Museum of Art (q.v.). There are also three fine portraits by Michael Sweerts, Thomas de Keyser, and Jacob Ochtervelt; notable paintings by Terbrugghen, Bloemaert, Berchem, van den Eeckhout, and Jan Baptist Weenix; and a number of works by Rembrandt's circle. The museum has a fine Flemish sculpture of this period, *Venus Attended by a Nymph and Satyr* by Pietro Francavilla, a student of Giovanni da Bologna.

Seventeenth-century French painting is more modestly represented, but there are a number of interesting works. Significant among them are Poussin's *Crucifixion* of 1645–46, Claude Lorraine's *Landscape with St. George and the Dragon*, and a pair of saints by Simon Vouet.

The Italian and French schools dominate the Atheneum's collection of eighteenth-century paintings. Italian landscape painting is represented in works by Guardi, Canaletto, and Bellotto. There are also four important works by Giovanni Battista and Giovanni Domenico Tiepolo. Of French eighteenth-century painting, there are examples by Watteau, Boucher, Fragonard, Flipart, Largillière, and

Greuze. English painting of this period is best studied in two portraits by Reynolds and Romney, a landscape by Gainsborough, and *The Old Man and Death* by Joseph Wright of Derby. Other important eighteenth-century works are an oil sketch by Maulbertsch for the altarpiece of St. John of Nepomuk and *Gossiping Women*, an early work by Goya.

All of the major artists and art movements of nineteenth-century France are represented in the Atheneum's collection. *The Lictors Bring Back to Brutus the Bodies of His Sons*, 1789, by David (a study for the large version in the Louvre [q.v.]), and the imperious portrait *Ferdinand Philippe, Duc d'Orléans* by Ingres are good examples of neoclassicism, and two paintings by Géricault and Delacroix illustrate French Romanticism. Impressionism is the most widely represented nineteenth-century style. Most notable among the Impressionist paintings are an early Degas, *Double Portrait—The Cousins of the Painter*; Manet, *Beach at Berck*; a Monet, *Beach at Trouville*; and a Renoir, *Monet Painting in his Garden*. The various trends of Post-Impressionist painting can be seen in works by Toulouse-Lautrec, Gauguin, Cézanne, Bonnard, Vuillard, and Redon.

Nineteenth-century English painting is represented in works by Landseer, Turner, Constable, and Lord Leighton. *Alone with the Tide* by the American ex-patriate Whistler is an unusual early work that shows the influence of Courbet. A highlight of the collection is William Holman Hunt's *The Lady of Shallot*, a superb example of Pre-Raphaelite painting.

Most of the major European art movements of the twentieth century can be studied in the Atheneum's collection. There are good examples of Fauve and Expressionist painting by Vlaminck, Munch, and Kirchner. The collection is especially rich in Surrealist paintings, including works by de'Chirico, Magritte, Tanguy, Miró, and Arp. The most outstanding of the group are Dali's *Apparition of Face and Fruit-Dish on a Beach* and *Paranoic Astral Image* and Ernst's *Europe after the Rain*. There are also fine bronzes by Maillol, Bourdelle, Marini, and Giacometti.

The museum's collection of American art is comprehensive. The earliest painting is the 1664 *Portrait of Elizabeth Eggington* by an anonymous artist. The Atheneum also has some outstanding examples of eighteenth-century portraiture—a pair, *Gershom Flagg IV* and *Mrs. Flagg*, by Robert Feke; *Mrs. Seymour Fort* by Copley; and *Chief Justice Oliver Ellsworth and His Wife* by Ralph Earl. There are notable historical paintings such as *Saul and the Witch of Endor* by West, *Samuel and Eli* by Copley, and about twenty historical paintings, portraits, and landscapes by John Trumbull.

The Atheneum's collection of nineteenth-century American landscape painting includes fourteen paintings by Cole, eleven by Church, and fine examples by Bierstadt, Durand, Bingham, Gifford, Heade, Kensett, and Inness. Other aspects of nineteenth-century American art are also represented: genre paintings by Eastman Johnson and Winslow Homer; trompe-l'oeil paintings by Harnett, Peto, and Haberle; still lifes by James and Raphaelle Peale; and portraits by Eakins, Cassatt, and Sargent. The modest collection of sculpture includes good neoclassic

pieces by Greenough, Powers, and Edward Sheffield Bartholomew, the Atheneum's first curator. A polychromed wooden funerary statue by Asa Ames is an excellent example of American folk sculpture.

Representational American art of the twentieth century can be traced in paintings by artists of the Ash Can School such as Sloan, Glackens, Lawson, and Bellows to Hopper, Marsh, Shahn, and Wyeth. Most of the major American painters of the 1950s, 1960s, and 1970s, such as Pollock, De Kooning, Kline, Rauschenberg, Poons, O'Keeffe, Stella, and Katz, are represented in addition to sculptures by Calder, Gabo, Tony Smith, Segal, and Hanson.

Since 1975, the Atheneum has devoted one gallery, MATRIX, to changing exhibitions of works by contemporary artists. Each exhibit is supplemented by an "artist sheet" containing an essay on the artist and bibliographic material. Many of the best-known contemporary artists, Eva Hesse, Sol LeWitt, Jasper Johns, Chuck Close, and Christo, for example, have been featured in MATRIX shows, but emphasis is also placed on new experimental art.

The Atheneum's small collection of drawings and watercolors includes some notable Italian Renaissance and French nineteenth-century works such as Vasari's *Study for a Deposition*, Lelio Orsi's *Walk to Emmaus* (a study for the painting in the National Gallery, London [q.v.]), Géricault's *The Coal Wagon*, Daumier's *Mountebanks Changing Place*, Courbet's *Self Portrait*, and two excellent pastels by Degas. The Serge Lifar Collection of ballet sets and costume designs, purchased in 1933, includes 173 designs for Diaghilev ballets in various media— watercolor, drawing, and oil—by de'Chirico, Bakst, Tchelitchew, Picasso, Matisse, Cocteau, Rouault, and most of the leading avant-garde artists of the time. Among the important American holdings are a number of watercolors by Marin, Demuth, and Hopper.

The museum's print collection includes all periods and graphic techiques. The collection is richest in nineteenth-century French and English and twentieth-century American prints. The graphic work of Whistler and Haden are particularly well represented. A small group of eighteenth- and nineteenth-century French and English and twentieth-century American prints. The graphic work of Whistler and Haden are particularly well represented. A small group of eighteenth- and nineteenth-century Japanese woodblock prints is another highlight of the collection.

Among its extensive decorative arts holdings, the Atheneum has excellent collections of eighteenth-century ceramics, nineteenth-century glass, English and American silver, and seventeenth- and eighteenth-century American furniture. The J. P. Morgan Collection contains superb examples of German, French, and English ceramics. Outstanding among them are examples of Vincennes and Sèvres porcelain and more than two hundred figures and groups of Meissen porcelain. A. Everett Austin, Jr.'s gift of eighteenth-century French and German faience and Mae Caldwell Rovensky's bequest of English ceramic figures and domestic ware have supplemented the collection. American ceramics are also well represented in the Albert Hasting Pitkin Collection, given to the museum by his widow.

The glass collection includes works by ancient craftsmen through contemporary pieces by Dale Chihuly and James Carpenter. The highlights are the more than three hundred examples of Mesopotamian, Greek, and Roman glassware acquired by J. P. Morgan from the collection of Julien Gréau and a few fine pieces of sixteenth- and seventeenth-century Venetian and Venetian-style glass. There are many excellent examples of eighteenth- and nineteenth-century American blown and molded glass, the largest selection of which is found in the Edith Olcott van Gerbig Collection presented to the museum in 1956.

The collection of metalwork includes some very good examples of seventeenth- and eighteenth-century German goldsmithing. Especially notable are a wood and silver cabinet attributed to Christophe Jamnitzer and a silver-gilt centerpiece by Bernhard Heinrich Weye. Sixteenth- through nineteenth-century English silver styles can be traced in the extensive collection formed by Elizabeth B. Miles and bequeathed to the museum in 1979. The bequest of Philip Hammerslough in the same year endowed the Atheneum with an equally fine collection of seventeenth- and eighteenth-century American silver.

The Atheneum has a small collection of European furniture from the fifteenth through the twentieth century and exceptional examples of seventeenth- and eighteenth-century American furniture. In 1926, J. P. Morgan, Jr., purchased the Wallace Nutting Collection and presented it to the museum. This collection includes 222 pieces of American furniture dating from 1620 to 1720 and numerous examples of seventeenth- and eighteenth-century wrought iron, pewter, tin, treen, and hooked rugs. The Atheneum has a number of fine examples of eighteenth-century Connecticut cabinetmaking and a few pieces from Boston and Philadelphia. Two of the more unusual pieces of nineteenth-century American furniture are an elaborate armchair and crib made by John H. Most of Hartford.

European textiles from the Middle Ages through the eighteenth century are the greatest strength of the Atheneum's textile collection. Among the more important holdings are ancient Mediterranean fabrics, including Coptic, from the fourth to the seventh century, five sixteenth-century Flemish tapestries, ten seventeenth- and eighteenth-century Gobelin tapestries, two rare Russian tapestries, and a set of English crewel-work bed hangings from the late seventeenth or early eighteenth century. American quilts are well represented, and there is also a fine lace collection including more than three thousand pieces.

The costume collection includes examples of American and European dress from the eighteenth through the twentieth century. Its strength is nineteenth-century American female fashion. Among the more unusual holdings are four ballet costumes by Giorgio de'Chirico and one by Juan Gris from the Serge Lifar Collection.

An unusual feature of the Atheneum is the Lions Gallery of the Senses. Founded in 1972, the gallery is sponsored by the Lions Club of District 23-B, Hartford and Litchfield counties. Exhibitions in the gallery are designed to broaden the visitor's artistic experience by encouraging imaginative use of the senses.

Special care is taken to make the exhibitions accessible to blind and other handicapped visitors.

The Auerbach Art Library has more than seventeen thousand volumes and subscribes to about 130 art periodicals. It is open to the public but is noncirculating.

Museum publications, slides, and photographs of objects in the collection may be purchased from the museum shop. In addition to the catalogs listed below, the museum also published the *Wadsworth Atheneum Bulletin*, a semiannual journal of scholarly articles on objects in the collection from 1922 through 1972. Catalogs of the European painting collection are currently being compiled. The first volume, *The Netherlands and German-Speaking Countries, Fifteenth-Nineteenth Centuries*, was published in 1978.

Selected Bibliography

Museum publications: *Wadsworth Atheneum Handbook*, 1958; *Bed Ruggs, 1722–1833*, 1972; *Connecticut Furniture 17th and 18th Centuries*, 1967; *Dress from Three Centuries*, 1976; *English Silver: The Elizabeth B. Miles Collection*, 1976; *Glass from Six Centuries*, 1978; *Jean-Baptiste Greuze, 1725–1805*, 1976; *John Trumbull: Five Paintings of the American Revolution*, 1975; *The Hudson River School: 19th Century American Landscapes in the Wadsworth Atheneum*, 1976; *The Netherlands and German-Speaking Countries, Fifteenth-Nineteenth Centuries*, 1978.

Other publications: Ahrens, Kent, "American Paintings before 1900 at the Wadsworth Atheneum," *Antiques*, vol. 114 (September 1978), pp. 508–19; *Apollo*, no. 82 (December 1968), pp. 406–87 (an issue devoted to the Wadsworth Atheneum's collection with articles by Cornelius Vermeule, John Paoletti, Paul N. Perrot, Graham Hood, Samuel Wagstaff, Jr., Henry P. Maynard, S. Lane Faiso, Jr., J. Herbert Callister, Janet Leeper); Johnston, Phillip, "Eighteenth- and nineteenth-century American furniture at the Wadsworth Atheneum," *Antiques*, vol. 115, no. 5 (May 1979), pp. 1016–27; Montgomery, Florence M., "A set of English crewelwork bed hangings," *Antiques*, vol. 115, no. 2 (February 1979), pp. 330–41; Silk, Gerald, *Museums Discovered: The Wadsworth Antheneum* (with twenty essays contributed by Alison de Lima Greene), (Fort Lauderdale, Fla. 1982).

ANNE GALONSKA AND KATE STEINWAY

——— Houston ———

MUSEUM OF FINE ARTS, HOUSTON, THE (also MFA), 1001 Bissonet at Main, Houston, Texas 77005.

The Museum of Fine Arts, Houston, is an outgrowth of the Houston Public School Art League. This organization, founded in 1900 to encourage an appreciation of art and architecture, circulated reproductions of famous paintings and monuments in public schools. By the time it was chartered in 1913 as the Houston Art League, the organization had formed a small art collection that was housed in the offices of the mayor and the City Council and in the homes of league members. Plans for a permanent museum building were begun, and in 1917 a

building site was acquired through the gift of Joseph S. Cullinan, the deed stipulating that a museum building be erected within ten years. Although the outbreak of World War I caused postponement of ground-breaking and construction until 1922, the museum opened to the public on April 12, 1924, under the direction of James Chillman, Jr. On May 7, 1929, the museum began to operate under a state charter, supported by annual appropriations from the city and private donations. At this time, its name was officially changed to The Museum of Fine Arts of Houston and subsequently was shortened to The Museum of Fine Arts, Houston.

The museum is privately supported and governed by a board of trustees, which includes the mayor of the city of Houston as an *ex officio* member. With the exception of the mayor, all trustees serve three-year overlapping terms. A director and an associate director, as well as curators of various departments, administer the museum.

The museum comprises three separate physical entities: the museum proper, Bayou Bend, and the Alfred C. Glassell, Jr. School of Art. The original museum building was designed by William Ward Watkin, with the central core of the building opening in 1924 and the east and west wings opening in 1926. A third phase of the building was realized when the Robert L. Blaffer Memorial Wing, designed by Kenneth Franzheim, was completed in 1953. In 1954 Nina J. Cullinan announced a gift for the construction of a new exhibition hall in honor of her parents, stipulating that an architect of "international reputation" be selected. The building committee unanimously chose Mies van der Rohe to prepare a master plan, and Cullinan Hall opened on October 9, 1958. In 1970 a gift from the Brown Foundation made possible the completion of Mies' master plan with the construction of the Brown Pavilion, which more than doubled the museum's gallery space. The Brown Pavilion, with its three floors of gallerys, opened in January 1974.

In 1957 Ima Hogg (1882–1975) gave the museum her residence, Bayou Bend, along with her collection of American painting and decorative arts. The twenty-eight room house, designed by John Staub in 1927, is located on the banks of Bayou Bend, five miles from the museum proper. The former residence was modified and opened to the public in March 1966 as The Bayou Bend Collection of The Museum of Fine Arts, Houston.

The Museum School, originally housed in the museum building, rapidly outgrew its quarters. Land was acquired directly across the street from the museum, and in 1977 ground was broken for the Alfred C. Glassell, Jr. School of Art. Designed by Eugene Aubry of S. I. Morris Associates, the school opened in January 1979.

In 1978 the museum commissioned Isamu Noguchi to design a formal sculpture garden for the land between the museum and the museum school. Made possible by a grant from the Cullen Foundation, the Lillie and Hugh Roy Cullen Sculpture Garden opened in 1986.

It has always been the goal of The Museum of Fine Arts, Houston, to develop

a comprehensive collection. From its inception, the growth of its collections was shaped by donors as well as by museum purchases. In the 1930s Annette Finnigan gave a series of gifts of fine laces and antiquities, which laid the ground work for the museum's collection of ancient art. In the museum today, the Early Bronze Age civilization that dominated the Cyclades (2800–1550 B.C.) is represented by a columnar marble statuette of a female idol, and pharaonic Egypt is represented by a limestone fragment of a relief from Tell el Amarna (c. 1363 B.C.), which probably depicts the pharaoh, *Akhenaten Visting the Temple*. The gypsum Assyrian *Eagle-Headed Winged Deity* (1883–859 B.C.) was excavated at the North-West Palace of King Ashurnasirpal II at Nimrud, near Mosul, in what is today modern Iraq. The eagle-headed deity was a beneficent protector to the Assyrians. Works from ancient Greece include a relief with a symposium scene carved in the convincing three-dimensionality of the Late Archaic style, and an Attic grave stela of a woman (mid-fourth century B.C.) whose balance between naturalism and idealism is a beautiful example of classic serenity. Roman holdings in the collection include a rare large marble torso of Aphrodite Anodyomene, a first-century A.D. Roman copy or adaptation of a Hellenistic original from the third or second century B.C.; and, from the Severan period (third century A.D.), a bronze *Portrait of a Ruler* and the marble sarcophagus front *The Return of the Body of Meleager to Kalydon*.

The development of Early Christian and medieval art can be studied in the museum's small but select collection of works from these periods, ranging from a Coptic male head of limestone (c. 400) to a beautiful early-fifteenth-century reliquary monstance from the Guelph Treasure in lower Saxony. Ivory works include a tenth-century Byzantine plaque depicting the Koimesis, or death of the Virgin, and an early-fifteenth-century figure of God the Father, one of the most important objects of its kind in the world. Other highlights of the collection include a Gothic stone *Head of an Apostle, St. Paul*, about 1235; a fourteenth-century French limestone *Virgin and Child*, unusual in its traces of original polychromy; and a marble funerary processional figure with prayerbook, which originated as a tomb decoration in the Mosan region of France.

In 1944 the museum was given the Edith A. and Percy S. Straus Collection, a gift of major importance and one that has shaped the collection to this day. Formed in New York with the guidance of the noted scholar Richard Offner, the more than eighty works of exceptional quality and importance are primarily Italian bronzes, among them works by Riccio, L'Antico, and Susini; trecento and quattrocento paintings by Fra Angelico, Giovanni di Paolo, and the Master of the Straus Madonna; and Northern Renaissance paintings by Rogier van der Weyden, Hans Memling, and Corneille de Lyon. The Straus Collection has provided an important core that has been supplemented by the acquisition through the years of major Renaissance works, among them *The Crucifixion* by the Master of George Mulich's Meisterlin Chronicle, *The Dead Christ* by Veronese, and *Tancred Baptizing Clorinda* by Tintoretto.

The museum's seventeenth-century holdings include a superb still life by the

Spanish master Juan van der Hamen y Leon, a landscape by Claude Lorraine, and the *Rape of Europa* by La Hire. Other highlights of the seventeenth-century collection include *Portrait of an Old Woman* by Frans Hals, the *Decollation of St. Paul* by Mattia Preti, and *Laban Searching the Belongings of Jacob* by Sebastien Bourdon.

Among the eighteenth-century works in the museum, the *Birdnesters* by Clodion, a portrait head by Houdon, and *Portrait of a Child* by Elizabeth Vigée-Lebrun entered the collection in 1944 as a part of the Straus gift. Throughout the years, *Pastoral Concert* by Pater and *Market Place at Pirna* by Bellotto were added, as were an important Angelica Kauffman, *Ariadne Abandoned by Theseus*, two views of Venice by Canaletto, and *Portrait of a Man* by Pompeo Batoni. *The Good Lesson*, about 1749–53, by Jean Baptiste Siméon Chardin has been recently added to the collection as the promised gift of Mrs. George R. Brown and family in honor of the late George R. Brown.

In early 1974 the superb group of Impressionist, Post-Impressionist, and early Modernist paintings collected by Mr. and Mrs. John A. Beck came to the museum on long-term loan. In addition, Mrs. Beck gave important nineteenth-century works by Daumier, van Gogh, Cassatt, and Signac to the museum and established a fund through which the museum was able to purchase paintings by Sisley, Bazille, Gauguin, de la Fresnaye, and others. The collection of nineteenth-century painting was also significantly enriched by the Blaffer family, whose gifts included *Madame Cézanne in Blue* by Cézanne, *Woman at Her Toilette* by Degas, *Still Life with Bouquet* by Renoir, and *The Promenade* by Vuillard. Outstanding among the museum's pre-Impressionist works are Isabey's *View along the Norman Coast* and Daubigny's *Sluice in the Optevez Valley*. American nineteenth-century painting is represented by works of Hicks, Kensett, Church, Bierstadt, Whistler, Homer, and Sargent. The museum also owns a large group of paintings by Frederic Remington, donated in 1943 by Mike and Will Hogg.

The museum's collection of twentieth-century art is especially strong. Early twentieth-century European masterpieces include Derain's *The Turning Road*, 1905, a key work of Fauvism; *Nympheas*, 1907, one of Monet's important water lily series; and two important early Cubist works: Braque's *Fishing Boats* and *The Rower* by Pablo Picasso. The museum also numbers among its collection five paintings by Matisse, including the Fauve *Landscape of Collioure*, 1905, and the superb *Portrait of Olga Merson*, 1921. Among the museum's outstanding examples of pre–World War II American art are Synchromist paintings by Morgan Russell and Stanton Macdonald-Wright, as well as works by Patrick Henry Bruce, John Marin, Georgia O'Keeffe, Stuart Davis, and Milton Avery. The collection also includes sculpture by Maillol, Brancusi, Picasso, Max Ernst, and David Smith and a magnificent set, *The Backs*, by Matisse, which spans the development of this great artist from 1909 through 1931.

Post–1945 paintings in the collection include works by Jackson Pollock, Clyfford Still, Mark Tobey, Hans Hofmann, and Franz Kline. Canvases by Morris Louis, Kenneth Noland, Mark Rothko, and Helen Frankenthaler represent stain

painting and color abstraction. Two outstanding additions to the post–1945 collection were thirty-three collages by Anne Ryan (a gift of the artist's daughter Elizabeth McFadden) and a group of thirteen paintings by Josef Albers, including those from his *Homage to the Square Series*, a gift of Anni Albers and the Josef Albers Foundation. Artists Frank Stella, James Rosenquist, Nancy Graves, and Neil Jenney are also represented. Post–1945 sculpture in the collection includes works by Alexander Calder, Alberto Giacometti, Herbert Ferber, Claes Oldenburg, and Louise Nevelson; contemporary sculpture is represented by the works of Robert Morris, Don Judd, and Mark di Suvero.

The Bayou Bend Collection of the museum (1 Westcott Street) is housed at Bayou Bend, some five miles from the museum proper. The twenty-eight room house designed in 1927 by Houston architect John Staub enables the visitor to enjoy seventeenth- through nineteenth-century American furniture, painting, silver, pewter, ceramics, and glass in period room settings. The only such collection of Americana in the Southwest, Bayou Bend's furniture and decorative arts range from early-seventeenth-century through mid-nineteenth-century Rococo revival, and it numbers among its paintings important works by Smibert, Copley (*Portrait of Mrs. Paul Richard*, 1771), Gilbert Stuart (*John Vaughan*, c. 1795), and Edward Hicks (*Penn's Treaty with the Indians*, c. 1830–1840).

The decorative arts area of the museum proper is characterized by strong holdings in European eighteenth-century ceramics, especially English porcelains from that period. The collection's holdings in English silver from the seventeenth and eighteenth centuries are also of high quality. The museum's growing collection of post–1840 American decorative arts is highlighted by art glass and silver by Tiffany and Company and a desk of superior quality by the famous New York decorating firm Herter Brothers. The collection is also strong in French art glass, particularly that of Gallé.

The collection of prints and drawings is small but rapidly expanding and includes both Old Master and modern works. A special strength is the selection of thirty-nine Dürer engravings, among them an especially fine impression, *St. Eustace*. Outstanding drawings include a Fragonard from the *Orlando Furioso* series, a Degas *Bather*, and a Redon *Tree*.

There are more than one thousand photographs in the museum's collection, acquired in large part after 1976, when the museum appointed its first curator of photography. The focus of the photography collection is on twentieth-century American works, and outstanding examples include works by Edward Weston, Robert Heineken, Alfred Stieglitz, Lewis Baltz, Edward Muybridge, Minor White, and Carlton Watkins. The museum is the only institution to own the complete portfolio of *The Americans*, by Robert Frank, a seminal body of work by one of the twentieth century's most important photographers. The museum is also fortunate to own ten photographs by Paul Strand, a large number of photographs by Geoff Winnigham, and works from Cartier-Bresson's *Galveston* series. A series of grants from Target Stores, a division of the Dayton Hudson

Corporation, have enabled the museum to build for its permanent collection the Target Collection of American Photography, which currently numbers more than two hundred photographs and is still growing. Another important impetus to the growth of photography in the museum has been the development of the Anthony G. Cronin Memorial Collection of Photography.

The museum's collection of Asian art is small but representative. Although the strongest holdings are in Chinese art, the collection also includes art objects from Japan and India. Outstanding among works in the collection from the early T'ang Dynasty (seventh and eighth centuries), is a pair of terracotta grooms, spirit objects placed in tombs to serve as replicas of beings who would accompany the deceased into the next world. Chinese painting is represented by an early-seventeenth-century scroll by Wang-Li that depicts two mynahs, rocks, narcissus, and plum blossom, with masterfully precise brushwork and attention to distinct character, and Japanese painting is represented by a magnificent late seventeenth–early eighteenth-century screen, *The Tale of Genji*. The museum's red sandstone relief, *Vishnu and His Avatars*, dates from the tenth century and is a summation of the style indigenous to the Mathura region of India's central heartland. The collection also includes examples of Indian miniature painting and Persian glass and ceramics.

The museum's tribal arts collection is housed in the Romansky/Lower Brown Galleries, which opened in 1974. The core of the pre-Columbian collection is formed by some 150 objects given to the museum in 1965 by Mrs. Harry C. Hanszen. Among the earliest of the museum's pre-Columbian works are a ceramic head from a figure, produced by the Olmecs of ancient Mexico during the turn of the first millennium B.C., and an Olmec straight-sided bowl with incised design from the same period. Other pre-Columbian works include five examples of Mayan covered bowls from the fourth to fifth century A.D., which were used as tomb offerings, and an important, eighth-century A.D. Mayan relief believed to be a part of a larger sculpture of which one other piece is known in the National Museum of Anthropology (q.v.), Mexico City.

Examples of the tribal arts of Africa include a Bakota helmet mask and a Bobo spirit mask, both from early-twentieth-century western Africa. Among the metal objects a late-sixteenth- or early-seventeenth-century brass plaque depicting Benin court life and a cast brass container (*kuduo*) used by nineteenth-century Akan notables in important ceremonies are noteworthy.

The art of Oceania is represented by carved house posts, one from the famous ceremonial houses of the Sepik River area of Papua New Guinea, congregating places of men for performance of rituals and storage of sacred objects, and another from a "custom house" in the Solomon Islands, used not only as a men's clubhouse and ritual center but as a store house for fishing canoes and as a shrine for the bones of important men.

One of the rarest Oceanic works in the museum is a twenty-three-foot-long wooden crocodile carved by the Kavawari people of Papua New Guinea, East

Sepek Province, and used in initiation ceremonies and in preparation for head hunting. The crocodile in The Museum of Fine Arts, Houston, is one of ten such extant sculptures.

In 1944 Ima Hogg gave the museum a large collection of North American Indian artifacts, which today forms the core of the museum's holdings in this area. The comprehensive collection includes prehistoric Anasazi, Mimbres, and Casas Grandes pottery, as well as historic jars by the Hopi, Zuni, Acoma, Cochiti, and Zia tribes. Additional North American Indian holdings include a Navajo chief's blanket; Navajo, Zuni, and Santo Domingo jewelry; and a collection of more than one hundred Hopi and Zuni Kachinas, used by ritual dancers. The museum has also been enriched by the acquisition of the McDannald Collection, donated in 1965, which contains a large group of objects and fragments representative of typical objects and artistic styles discovered at Spiro, a complex prehistoric (1000–1600) urban site discovered in Eastern Oklahoma.

The Museum of Fine Arts, Houston, has an art library of more than eleven thousand volumes and complete sets of major journals of art criticism and art history. The library is noncirculating and open to the public. The museum bookstore has a wide selection of important books and periodicals on art, as well as museum publications and exhibition catalogues. A handbook, *A Guide to the Collection: Museum of Fine Arts, Houston* (1981), illustrates and discusses 352 of the museum's most important works.

Selected Bibliography

Museum publications: *Bulletin of The Museum of Fine Arts, Houston*, 1930–59, 1970–present; *The Annette Finnigan Collection of Laces*, 1940; *Catalogue of the Edith A. and Percy S. Straus Collection*, 1945; *Robert Lee Blaffer Memorials*, 1953; *The Samuel H. Kress Collection at The Museum of Fine Arts of Houston*, 1953; *Spiro and Mississippian Antiquities from the McDannald Collection*, 1965; Thomson, Marjorie S., *Frederick Remington: Selections from the Hogg Brothers Collection*, 1973; Lee, Thomas P., *The Collection of John A. and Audrey Jones Beck: Impressionist and Post-Impressionist Paintings* (January 1974), pp. 14–18; Warren, David B., *Bayou Bend: American Furniture, Paintings, and Silver from The Bayou Bend Collection*, 1975; Kelsey, Mavis Parrott, *Winslow Homer Graphics from the Mavis P. and Mary Wilson Kelsey Collection of Winslow Homer Graphics*, 1977; Tucker, Anne, *The Target Collection of American Photography*, 1977.

Other publications: Offner, Richard, "The Straus Collection Goes to Texas: Comments on Its More Important Objects," *Art News*, vol. 44 (May 15–31, 1945), pp. 16–23, 30–31; Warren, David B., "American Decorative Arts in Texas: The Bayou Bend Collection of The Museum of Fine Arts of Houston," *Antiques*, vol. 90 (December 1966), pp. 796–815; idem, "The Empire Style at Bayou Bend: New Period Rooms in Houston," *Antiques*, vol. 97 (January 1970), pp. 122–27; Holmes, Ann, "A Reverence for the Past: de Montebello of the MFA," *The Art Gallery Magazine*, vol. 13 (May 1970), pp. 23–33; Warren, David B., "A Great Texas Collection of Americana: The Bayou Bend Collection at The Museum of Fine Arts, Houston," *Connoisseur*, vol. 178 (September 1971), pp. 36–55; Erdman, Donnelley, and Peter C. Papademetriou, *The Museum of Fine Arts, Houston: Fifty Years of Growth, 1922–1972* (Houston 1972); Bendig, William C., "Tribute to a

Young Director,'' *The Art Gallery Magazine*, vol. 17 (January 1974), pp. 14–18; Lee, Tom, "The Joy of Sharing,'' *The Art Gallery Magazine*, vol. 17 (January 1974), p. 59; "The Museum of Fine Arts, Houston: A New Showcase for Art,'' Supplement to *The Houston Chronicle* (January 13, 1974); Iscoe, Louise, "Bayou Bend,'' *Texas Highways*, vol. 25 (March 1978), pp. 4–9.

<div align="right">JUDITH A. MCCANDLESS</div>

———— Kansas City ————

NELSON-ATKINS MUSEUM OF ART, THE (formerly THE WILLIAM ROCKHILL NELSON GALLERY OF ART AND THE MARY ATKINS MUSEUM OF FINE ARTS; also THE NELSON GALLERY; THE NELSON), 4525 Oak Street, Kansas City, Missouri 64111.

First opened to the public on December 11, 1933, the William Rockhill Nelson Gallery of Art and the Mary Atkins Museum of Fine Arts traces its beginnings to the generosity of William Rockhill Nelson (1841–1915). The name of the museum was officially shortened to The Nelson-Atkins Museum in 1982. Muckraking newspaper publisher, philanthropist, and civic benefactor, Nelson donated the income from his entire estate for the purchase of "works and reproductions of works of the fine arts'' that "are not usually provided for by public fund.'' The terms of Nelson's bequest empowered the presidents of the state universities of Missouri, Kansas, and Oklahoma to appoint three university trustees who, in turn, were made responsible for administering the Nelson estate, acquiring art works, and exhibiting them. Independent of Nelson's vision of a major art collection for his city, four years earlier in 1911 another Kansas City benefactor, Mary Atkins, had also directed that a large portion of her estate be used for an art museum. In the years following Nelson's death, the fortunes of his widow, Ida Houston Nelson; his daughter Laura Nelson Kirkwood and his son-in-law Irwin Kirkwood; and Nelson's attorney Frank Rozzelle were combined with Nelson's original gift and that of Mary Atkins to build the present museum. In 1954 the Nelson Gallery Foundation was established to expand the mission of the museum and to broaden public support of its activities. In 1965 the Society of Fellows of the Nelson Gallery Foundation was formed to encourage the support of both private and corporate donors in augmenting the original Nelson endowment.

Apart from copies of Old Master European paintings that he commissioned (and made available to the public in 1897) and a few originals (including a portrait by Marcus Gheeraerts that found its way to the museum in 1934), Nelson himself was not a serious art collector. Consequently, an acquisition philosophy had to be created by the museum's first trustees, advisers, and curators. The individuals most responsible for the initial collection of the Gallery and the formation of its acquisition policies were Harold W. Parsons, Langdon Warner, Laurence Sickman, and Paul Gardner. Parsons served as an adviser to the trustees

between 1930 and 1947. Functioning as European buying agent for both the Nelson Gallery and the Cleveland Museum of Art simultaneously in the early 1930s, Parsons assisted the museum primarily in the acquisition of European paintings. Warner's advisory role and Sickman's long association with the museum resulted in purchases that directed the museum in developing its Oriental collections as a major strength. In 1932 Paul Gardner was named as assistant to the university trustees. When the museum opened in 1933, he became its first director, a position he held until his retirement in 1953.

The museum building is situated in a park of twenty acres in mid-town Kansas City. It was built on the original site of the Nelson family mansion, Oak Hall. With a total of fifty-eight galleries and eleven period rooms, the museum was designed around an open courtyard on two floors in a Greek-revival style by William D. Wight of the architectural firm of Wight and Wight. When the museum opened in 1933, the shell of the building and thirty-six exhibition galleries had been completed. Subsequent building campaigns allowed for the west wing of the museum to be opened with additional galleries in April 1941; eight more galleries were completed when the remainder of the second floor was opened in 1976 through the patronage of Renée Crowell in memory of her husband, Frank Grant Crowell. The Crowell wing of the museum contains an exhibition area for contemporary art (the Parker-Grant Gallery) and the Mrs. Kenneth A. Spencer Gallery of Impressionist paintings. In 1973 the Mr. and Mrs. Elmer F. Pierson outdoor sculpture garden was completed, and in 1978 the curatorial reference library was enlarged by a gift from Mrs. Kenneth A. Spencer. In 1981 the Rozzelle Courtyard (formerly an open atrium space) was transformed into an enclosed area housing a restaurant and providing space for a rotating exhibit of portions of the museum's large print collection.

The museum's collections of European and American art represent all major historical periods in Western art from the early developments of Egyptian and Near Eastern art through the art of the twentieth century. The vast majority of the museum's acquisitions was purchased through the Nelson Trust. These works have been augmented by the Burnap Collection of English pottery, the Starr Collection of miniatures, sculptures from the Elmer F. Pierson Collection, the Frances Logan and Robert B. Fizzell Collection of European and American prints, the Milton McGreevy bequest of Old Master drawings, numerous individual works acquired as gifts from private donors, and artworks donated to the museum by the Friends of Art, the gallery's most broadly based group of community supporters.

The ancient art galleries of the museum are dominated by large-scale sculpture; however, there are also strengths in other media, including gold jewelry, small bronzes, pottery, and mosaics. The museum possesses several examples of stone sculpture that are representative of Ancient Near Eastern and Aegean art; a Sumerian nobleman in gypsum from Mari (about 2500 B.C.), similar to those found at Tel Asmar; a large limestone Assyrian relief from Assurnasirpal II's palace at Nimrud dating between 883 and 860 B.C.; and a Cycladic idol from

the third millennium B.C. The life-sized Babylonian head of a king, about 1765 B.C., in diorite, has been identified as Hammurabi; this head is the largest portrait extant of the ruler. Two important free-standing Egyptian sculptures dominate the works around them. The monumental free-standing figure of the Old Kingdom nobleman Ra-wer (Dynasty V) presides appropriately over the ancient sculpture gallery from an elevated niche; originally from Giza, he was once flanked by the statues of his father, Ity-sen (now in the Brooklyn Museum [q.v.]); his wife, Hetep-heres (now in the Worcester Art Museum [q.v.]); and two children (one is now in the Metropolitan Museum of Art, New York [q.v.]). From the same dynasty, the wooden polychromed sculpture of Methethy from Sakkara, in an excellent state of preservation, is positioned between two sunken tomb reliefs of him with members of his family. Other significant examples of Egyptian art in the collection include a Middle Kingdom head of Sesostris III (Dynasty XII) in quartzite, a New Kingdom tomb painting of a banquet scene from the tomb of Nebamon and Ipuky at Thebes (painted during the reign of Amenhotep III), and a late porphyry torso of the nobleman Archibeios (250–220 B.C.) from the Ptolemaic Period. Works of Greek art of special note in various media include a head of a youth in Parian marble from the Attic school (c. 510 B.C.), a large Corinthian amphora from the seventh century B.C., a nude male statuette (perhaps Hercules) from the Severe period (480–450 B.C.), and several Hellenistic works, especially a bronze statue of Seleucus IV (the second-century B.C. king of Syria) in the guise of Hercules. There are few works in the collection from Etruria, but a small bronze warrior god (c. 480–60 B.C.) excavated at Apiro is representative of the period. The finest examples of Roman art in the museum are three sculptures from the reign of Hadrian: a second-century full-length *Portrait of a Young Patrician* in marble, identified as Polydeukes and discovered at Hadrian's Villa at Tivoli during the eighteenth century; an imperial portrait bust of the Emperor Hadrian himself (117–38); and a portrait bust of the tragic Antinous.

The Nelson Gallery's acquisition program has been perhaps the least successful in obtaining objects that reflect completely the major trends of Early Christian, Byzantine, and early medieval art. There are good examples from the Late Antique (for example, a Fayum period tomb portrait and a Syrian sculpture of a *Lady of Palmyra* in white limestone), but there are relatively few other works between the fourth and eleventh centuries to accompany them. Two exceptions are a Coptic sculpture of *St. Tecla* of the fifth century and a Byzantine ivory casket of the eleventh century.

The medieval wing of the museum is dominated by a stone cloister reassembled in 1941 from an Augustinian monastery of the fourteenth century near Beauvais. Two important capital fragments represent the vitality of Romanesque architectural sculpture: a historiated capital, thought to depict the dreaming Nebuchadnezzar and Daniel in the Lion's Den (Coulombs, 1119–74–75), and three Apostles from Vich (1140–70). Examples of Gothic sculpture include the head of a female saint (French, thirteenth century, perhaps from Notre Dame, Paris), a

Virgin and Child from the Lorraine (c. 1350), and an Upper Rhenish Virgin and Child from the late fifteenth century. Other works in the collection that reflect the wide spectrum of medieval art are: a reliquary casket from Limoges (second quarter of thirteenth century), an ivory diptych leaf of a Crucifixion (French, fourteenth century), a French stained-glass window perhaps depicting events from the life of St. Catherine (thirteenth century), and a gilded silver monstrance from the Guelph Treasure (German, 1400, the first of the museum's purchases of medieval art in 1931).

The museum's collection of Italian Early Renaissance panel paintings was bolstered considerably in 1961 with a gift of several pictures from the Samuel H. Kress Foundation. These works include three fourteenth-century panels. Among them are a small, half-length *Madonna and Child with Saints*, attributed to Lippo Memmi; a *Madonna and Child Enthroned with Saints and Angels*, ascribed to Bernardo Daddi and his assistant; and what may be the central portion of a small polyptych, the *Presentation in the Temple*, attributed to Jacopo del Casentino. A Kress panel from the late fifteenth century of a *Madonna and Child* by Giovanni Bellini provides an example of the Venetian Renaissance to accompany the Florentine figure style seen in the Nelson fund acquisition of the *Madonna and Child with the Infant St. John* by Lorenzo di Credi (a related drawing is in the Uffizi Gallery [q.v.]). Notable examples of quattrocento sculpture include a marble tondo, the *Madonna and Child*, by Francesco di Simone, and a delicately carved bust, *St. John the Baptist*, by the anonymous follower of Mino da Fiesole, called the Master of the Marble Madonnas. A large panel by Giuliano Bugiardini probably painted about 1505 is an exceptionally fine work in excellent condition from the Florentine High Renaissance. Sixteenth-century Venetian art is represented by a portrait, *Antoine Perrenot de Granvella*, governor of The Netherlands under Philip II, by Titian (or his shop), and a large canvas, *Christ and the Centurion*, by Paolo Veronese, another version of which is in the Prado Museum (q.v.), Madrid.

Art during the Renaissance north of the Alps is represented by some of the finest objects in the museum. Petrus Christus' *Madonna and Child in a Gothic Interior* was acquired in 1956. Also of exceptional quality is Jan Gossaert's portrait *Jean de Carondelet*, probably painted some ten years later than Gossaert's portrait of Carondelet in the Louvre (q.v.) of 1517. The Nelson Gallery portrait was originally part of a diptych; its pendant is the painting *St. Donatian* in Tournai. A small panel, *Penitent St. Jerome in a Landscape*, is a good example of the sixteenth-century Flemish landscape genre. The picture was acquired in 1961 as a work by Joachim Patinir, but it has been shown recently that the work is by an anonymous artist equally skilled in landscape or figure painting known to us only as the Master of the Female Half-Lengths. Sixteenth-century German art in the museum includes a diptych of betrothal portraits by Bartel Bruyn and three panels by Lucas Cranach: the 1538 *Portrait of a Bearded Man*, the *Last Judgment*, and the panel *Three Graces*, dated 1535. In 1964 the museum acquired a small statue, *The Mourning Virgin*, carved in lindenwood that originally formed

part of an altarpiece carved by Tilman Riemenschneider about 1510 for the Stiftskirche, Aschaffenburg.

The museum's Baroque and Rococo paintings form a collection of considerable depth, variety, and high quality, ranking them among the special strengths of the museum in Western art. The best-known of the Baroque paintings is Caravaggio's large canvas *St. John the Baptist*. Acquired in 1952, this picture has received considerable attention in the literature on the artist, ranging from Walter Friedlaender's suggestion that it is a version only derived from Caravaggio to more recent opinions that it is indeed authentic, perhaps a commission by Ottavia Costa for a church dedicated to the saint in Consconte. The influence of Caravaggio's tenebrist light on artists both in and outside of Italy can be traced in the gallery's paintings by Bernardo Strozzi (*St. Cecilia*), Domenico Feti (*The Pearl of Great Price*; a similar version is in the Kunsthistorisches Museum [q.v.], Vienna), Hendrick Terbruggen (the left fragment of *The Beheading of St. John the Baptist*), Simon Vouet (*Judith with the Head of Holofernes*), and a work from the circle of Georges de La Tour (*St. Sebastian Nursed by St. Irene*).

Dutch Baroque art figured in some of the earliest acquisitions by Harold Parsons for the museum in 1931 and 1932. The quality of Gerard Dou's 1663 *Self Portrait*, Frans Hals' *Portrait of a Gentleman* (a pendant of the sitter's wife is in the St. Louis Art Museum [q.v.]), and Rembrandt's 1666 *Portrait of a Youth in a Black Cap* has been maintained by subsequent purchases, such as Jan Steen's *Van Goyen Family*. Flemish art during the seventeenth century is represented by portraits by van Dyck and Jordaens, along with four panels attributed to Rubens, the best of which is a small sketch of 1622, the *Battle of Constantine and Lininius*, for tapestries commissioned by Louis XIII. The large *Sacrifice of Abraham* by Rubens acquired in 1966 can be accurately dated by an application document of 1614 requesting permission from the State General at The Hague that a reproductive print of this work be made.

Nicolas Poussin's large canvas *Triumph of Bacchus* is an important work known to have been in the collection of Cardinal Richelieu. Other examples of French art include two landscapes by Claude and the contemplative *Crucifixion* by Philippe de Champaigne painted as a gift for his sister Marie. The first purchase by the museum of a painting from the Spanish Baroque was a picture by Murillo, the *Virgin of the Immaculate Conception*, acquired in 1930. The *Penitent Magdalene* attributed to the Mannerist El Greco was obtained in the same year. Since then, the gallery has added significantly to its collection of Spanish art, including a *Portrait of Mariana* from Velázquez's workshop, an *Entombment of St. Catherine* by Zurbarán, and *The Good Samaritan* by Ribera.

The opulence and delightful excesses of the eighteenth-century French Rococo are apparent in several works, such as François Boucher's large canvas of 1740, *Landscape in the Environs of Beauvais* and his *Jupiter in the Guise of Diana and the Nymph Callisto* of 1759, as well as in Hubert Robert's ravishing *Terrace of the Chateau de Marly*. There is a still life by Chardin, several works by Pater, and a pair of *scènes de mode* by J. F. de Troy. Other excellent examples of

eighteenth-century European art include views of Venice by Canaletto and Guardi; the recently acquired *View of the Piazza del Popolo, Rome* by Giovanni Panini; a portrait bust of Benjamin Franklin by Jean Houdon and a terracotta bust by Pajou; a landscape with animals appropriately titled *Repose* by Gainsborough (the artist's wedding gift to his daughter); and an oil sketch by Hogarth, *Tavern Scene* (the final composition of which is in the Sir John Soane Museum). Trends in America during the same period are evident in Benjamin West's *Mr. and Mrs. John Custance* of 1778 and also works by Ralph Earl and Jeremiah Theus.

The museum's holdings from the nineteenth century are especially strong in French Impressionist and Post-Impressionist paintings; however, earlier nineteenth-century artists are also well represented. Goya's signed and dated portrait of 1815, *Don Ignacio Omulryan y Rourera*, minister of the Indies under Charles VII, presents an unusual technique of brilliant colors brushed over a black underpainting. Constable's large *Dell in Helmingham Park* of 1826 is the most dramatic of several examples of landscape art from the nineteenth century, along with paintings by Turner, Rousseau, Daubigny, Corot, and Courbet. American art includes paintings by Raphaelle Peale, George Catlin, Frederick Remington, and George Caleb Bingham, among the more noteworthy works in the collection.

The late-nineteenth-century French painting collection is the result of consistently acquiring works of exceptionally high quality over an extended period. In the first decade of the museum's acquisition program, significant purchases were made in this area between 1933 and 1938 of paintings by van Gogh (1889, *Olive Grove*, and 1884–85, *Head of a Peasant*), Pissarro (1895, *Market at Pontoise*), Manet (1878, *Portrait of Lise Campineanu*), Gauguin (1891, *Reverie*), Seurat (1883–84, *Study for "La baignade"*), and Cézanne (1904–6, *Mont Sainte-Victoire*). This direction was continued during the following decades with the addition of a winter landscape, *View of Argenteuil*, by Monet; a *Portrait of Paul Haviland* by Renoir; and a huge canvas by Monet in his late *Nympheas* series. The purchase of the *Nympheas* in 1957 and the acquisition in 1960 of Pissarro's *Le Jardin des Mathurins, Pontoise* (first shown in the Impressionist Exhibition of 1877) were especially important additions to the collection. In 1972 a highly significant early work by Monet, *Boulevard des Capucines, Paris*, was acquired. Important recent acquisitions include pastels by Cassatt, Morisot, and Degas and paintings by Gauguin and Signac.

A codicil in the Nelson bequest forbade the purchases of any artwork by an artist who had not been dead for at least thirty years. The reasoning behind Nelson's unusual directive seems not to have been the result of artistic conservatism so much as it was caused by his desire to free acquisition decisions totally from the influence of living artists. Regardless of Nelson's intentions, the effect of his interdiction placed obvious limitations on the museum's efforts to acquire works by early twentieth-century and contemporary artists. Nevertheless, the Gallery has managed to assemble a strong representative collection of modern art, primarily as a result of the sustained efforts of the Friends of Art, a support group of the museum created in 1934 to provide private funds for the purchase

of modern artworks in consultation with the curatorial staff. Modern sculptures run the gamut from the more classically conceived bronze figures of Rodin and Maillol, through the Cubist works of Lipchitz, to the Pop soft art of Oldenburg and the pristine Minimalist art of Donald Judd. Paintings and drawings in the Parker-Grant Contemporary Gallery trace the major movements of the century: Cubism (Juan Gris), German Expressionism (Kirchner, Nolde, Kandinsky), Dada (Klee, Arp), Surrealism (Miró, Tanguy), the Regionalists (Benton), Abstract Expressionism (Pollock, Kline, Gorky, De Kooning, Hartigan, Rothko), and Pop (Wesselmann, Lichtenstein, Warhol).

The nucleus of the decorative arts collection is the furnishings of eleven period rooms. In addition, examples of English Queen Anne and Georgian furniture from the private collection of Mrs. Kenneth A. Spencer and some eleven hundred objects from the Frank P. and Harriet C. Burnap Collection of English pottery (acquired in 1942) have augmented the museum's holdings. Some of the more striking period rooms include a French paneled room from the Louis XIII era, a carved walnut paneled room originally from the Hotel of Count Nicolai (Paris) during the regency of Louis XV, a Venetian alcove with brocaded silk damask (c. 1750), a mid-eighteenth-century red and gold lacquer room from North Italy, and four American interiors. Notable examples of furniture in the collections are a blue lacquered chinoiserie cabinet from the Queen Anne period, a large ebony Louis XIII cabinet, a mid-eighteenth-century secretary bookcase with elaborate marquetry from southwestern Germany, and an eighteenth-century commode by Adam Weisweiler with gilt-bronze mounts attributed to Pierre Gouthière.

Finally, mention should be made of several classes of objects that underscore the diversity and comprehensive nature of the Gallery's holdings. Prints, drawings, and photographs number well over four thousand items. Although the majority of the Old Master prints were acquired in the 1930s, nearly all of the photographs, several hundred prints, and numerous drawings have augmented the collection through private gifts, including items from the estates of Robert F. Fizzell and Milton McGreevy. Dispersed throughout the museum are splendid examples of Renaissance armor and Flemish tapestries of the fifteenth through the seventeenth century. Recently, a wide variety of ethnological art objects from Africa, Oceania, pre-Columbian South America, and the American Indian nations has been assembled in a special gallery in the Crowell wing.

The Chinese collection forms most of the Oriental holdings. One of the finest in the world, it ranges from ancient bronzes and jades through sculpture, paintings, and ceramics to decorative arts.

The earliest products of the bronze caster's art date from the Shang Dynasty (c. 1600–1127 B.C.) and include a number of classically proportioned and architectonically decorated ritual vessels. The more flamboyant Early Western Chou (eleventh to tenth century B.C.) style is also represented as is the massiveness characteristic of the Late Western Chou. Eastern Chou (sixth to fourth century B.C.) bronzes reflect increasingly worldly usage with intricate decoration

on vessels and the production of secular objects. Important Western Han Dynasty (206 B.C.–A.D. 24) bronzes consist of a lamp in the form of a ram and a Po-shan incense burner.

Jade has played a significant role in Chinese art since Shang times. An exquisitely carved bird plaque from the early Western Chou is noteworthy, as is a group of jades excavated at Chin-ts'un dating from the Eastern Chou period. The most famous of these works is a unique pi disc embellished with energetic feline beasts on the perimeter and in the center.

The collection of sculpture illustrates Chinese burial practices with tomb guardians and pillars and with slabs carved in low relief for tomb chambers or offering shrines. A pair of chimera dating from the third-fourth century is the best outside China. However, most of the pieces are Buddhist images made of stone, gilt-bronze, or wood. The earliest piece is a gilt-bronze seated Buddha made in the late fourth or early fifth century. Significant examples of the stylistic development within Buddhist stone sculpture date from the Northern Wei (386–535) through the T'ang Dynasty (618–906). The final creative output of Buddhist sculpture in China occurred in the northern provinces of Shansi and Hopei from the tenth through the thirteenth century. The best examples of this in the West are in the Nelson Gallery: *Kuan-yin on a Rockery* and a *Bodhisattva*, both polychromed wood.

The Chinese painting collection is widely renowned; the group of early landscape paintings are among the finest in the West. Didactic Confucian themes of filial piety are engraved on a stone sarcophagus from about 525. Early figure-painting styles are represented by paintings attributed to the eighth-century masters Chou Fang and Ch'en Hung. The development of Chinese landscape painting may be traced in major monuments from the ninth century, Northern Sung (960–1126), Chin (1115–1234), and Southern Sung (1127–1279) dynasties. *Travelers in a Mountain Landscape*, a monumental (4 1/2 feet high) landscape painting from the late ninth to early tenth century, is a key work in the study of the development of landscape as a subject in its own right, no longer subordinate to figure painting. Further documenting this development through the eleventh, twelfth, and early thirteenth centuries are the landscapes in the style of Li Ch'eng, by Hsu Tao-ning, Chiang Shen, and Hsia Kuei and attributed to Ma Yuan. The 1982 acquisition of the *Second Prose Poem on the Red Cliff*, attributed to the Northern Sung master Ch'iao Chung-ch'ang, further enhances this already superb collection of early landscape scrolls. Yüan Dynasty (1279–1368) masterpieces consist of paintings by Li K'an, Jen Jen-fa, Chang Yen-fu, Liu Kuan-tao, and Sheng Mou. The Ming Dynasty (1368–1644) paintings highlight the Suchou literati style with several works by Shen Chou, Wen Cheng-ming, Ch'iu Ying, Ch'en Shun, and Lu Chih. From the Ch'ing Dynasty (1644–1911) are creations by the conservative artists Wang Hui, Wang Yüan-ch'i, and Yün Shou-p'ing, as well as individualists like Chu Ta, Kung Hsien, Cha Shih-piao, and Lo P'ing.

The Chinese ceramic collection is broad in scope and high in quality. A neolithic jar of the Yangshao culture is the earliest piece. Three rare objects are

a high-fired stoneware jar with traces of an ash glaze dating from the middle Shang Dynasty, a covered *hu* with a lead glaze made during the Late Eastern Chou period, and a Northern Ch'i vase covered with appliqué ornament. Objects made for burial as imitations of accoutrements of daily life are impressive in their number and variety from the Han Dynasty (202 B.C.-A.D. 220) and the Three Kingdoms and Six Dynasties period (A.D. 221–581) through the T'ang Dynasty. Exceptional T'ang three-color glazed wares encompass animated horses and camels, figures, and vessels. Noteworthy pieces of later date to be used in daily life are a magnificent twelfth-century Tzu-chou vase with a dragon painted in black slip, the Ch'ing-pai ware *Water-moon Kuan-yin* inscribed with a date equivalent to 1298 or 1299, a fourteenth-century porcelain Tazza cup with a blue interior and brown-black exterior, and a unique matched pair of Hsüan-te period (1426–1435) porcelain Mei-p'ing vases decorated with dragons in underglaze blue. The Ch'ing Dynasty wares include a number of fine porcelains with overglaze enamel decoration as well as monochrome glazes.

Chinese decorative arts—lacquer, silver, and furniture—comprise one of the strongest areas of the holdings. Several examples of lacquer ware dating from the third to second century B.C. are from Ch'ang-sha, Hunan Province. The covered box with gilt-bronze fittings is unique. Several eighth-century silver objects are intricately ornamented. The extensive classic Chinese furniture collection is the largest public one in the West. Recently, it has been augmented considerably through the Kenneth A. and Helen F. Spencer Foundation Fund. The elegant proportions, meticulous joinery, and extraordinary golden-yellow tone of *Huang-hua-li* wood are revealed in a variety of chairs and tables primarily dating from the Ming Dynasty. The most spectacular and rare piece is the tester bed with alcove.

The Japanese collection emphasizes art that manifests the native Japanese spirit and taste rather than Chinese influences. Thus painting in the Yamato-e style, screens, wooden sculpture, Negoro lacquer, ceramics, and *ukiyo-e* prints are the highlights. Numerous gifts of paintings and ceramics by Mrs. George H. Bunting, Jr., have been crucial in the growth of the collection.

The most important early painting done in the late twelfth century, *Benzaiten*, depicts the subject as a court beauty. Kamakura period (1185–1392) paintings include Buddhist themes and sections from narrative handscrolls. An era of opulence, the Momoyama period (1568–1614) saw the flourishing of the golden-screen tradition. *The River Bridge at Uji* is finely rendered on a pair of six-fold screens. Two stunning pairs of six-fold screens reveal the genius of Kaihō Yūshō (1533–1614): *Pine and Plum by Moonlight* and *The Four Accomplishments*. The diversity of the Edo period (1615–1867) is illustrated by representative examples from several major traditions: Rimpa school paintings by Kōrin, Sōtatsu, Sōsetsu, and Hōitsu; a Shijō school screen by Maruyama Ōkyo; and an Unkoku school screen by Tōteki. The gallery has recently gone in a new direction by acquiring works by major Nanga artists such as Taiga, Buson, and Baiitsu. Early calligraphy is shown in a group of sutra fragments ranging in date from the Tempyō

(710–794) through the early Muromachi period, given by Mr. John M. Crawford, Jr.

The large number of woodblock prints covers all the major masters of the *ukiyo-e* school with particular strength in the primitives. Carefully selected under the guidance of the late Louis Ledoux, they are in excellent condition. *The Actors Ishikawa Danjurō I and Yamanaka Haikurō* by Torii Kiyomasu I and *Two Women* by Kitagawa Utamaro are unique impressions.

Japanese wood sculpture focuses on the Heian period. Several early pieces reveal the sculptor's appreciation of his material: a Kannon *bosatsu*, a *jizō*, and a guardian king. An immense gilded seated Amida Buddha dates from the late Heian to the early Kamakura period. A recently acquired lion mount for Monju dating from about the mid-thirteenth century vividly captures the elegance and vigor characteristic of that era. Further augmenting the collection of early Japanese Buddhist sculpture is the 1982 acquisition of a splendid twelfth-century dragon from a drum stand. Eleven feet high, this wood carving is among the very best examples of its kind.

Japanese ceramics in the Gallery cover a time span from the Momoyama through the Edo period. The influence of tea-ceremony taste is reflected in two Momoyama Shino ware dishes, a Muromachi period Shigaraki storage jar, and a set of five Oribe ware dishes from the second half of the seventeenth century. From the hand of Ogata Kenzan (1663–1743) are a square plate with a peony design, a flower container, and a set of five covered bowls named "Wide Plains of Musashi." Edo period porcelains are exemplified by the following wares: Nabeshima, Kutani, Hizen, Arita, and Kakiemon.

The rich sculptural tradition of India and Southeast Asia is displayed both in stone and bronze images for Buddhist and Hindu worship. The native Indian style is clear in the examples from Mathura dating from the second century. From the region of Gandhara in Northwest India, sculptures in gray schist done from the first through the third century reveal Roman influence. Mathura and Sarnath school pieces reflect the classicial Gupta period (320–660) style. Especially noteworthy is the acquisition (1983) of a terracotta relief of a *makara* dating from the Gupta period. The elaborate Pala period (750–1200) characteristics may be seen in several images. The exuberance of the dance is celebrated in two tenth-century pieces, one from Rajasthan and one from Central India. The variety produced in Southeast Asia is shown in the seventh-century Buddha from Thailand and Cambodian images embodying the styles of Koh Ker, Banteay Srei, and Baphuon.

Bronzes from Indian and Southeast Asia date from the second through the fifteenth century. The earliest piece, a Yakshi from the Deccan, is unique in Western collections. The most famous image is a Gupta period standing Buddha from Northwest India. The earlier Hindu image (ninth century) depicting Shiva Vishapaharana is a rare example of Andhra workmanship. The group of Chola period (about 850–1279) Hindu bronzes is particularly fine. There are also Indonesian Buddhist images dating from the late eighth through the tenth century. In 1974 the

bequest of Joseph H. Heil contributed examples of Tantric art from Tibet and Nepal. These works include tanka paintings, mandalas, gilt bronzes, ritual objects, and textiles.

The Indian painting collection is small but choice. Noteworthy are an illuminated Jain manuscript from Gujarat (fifteenth century), a rare page from the *Khamsa of Amir Khusrau Dihlavi* (Sultanate of the Delhi period, fifteenth century), *Lovers in a Pavilion* (Malwa, seventeenth century), *Krishna Playing the Flute* (Rajasthan, mid-eighteenth century), and a folio from an album made for Emperor Jahangir (Agra, sixteenth and seventeenth centuries).

Masterpieces of Persian art demonstrate skill in metalwork, ceramics, painting, and carpet weaving. A cup (c. eighth century B.C.) shows the goldsmith producing an object to satisfy aristocratic taste. A bronze stag from the same time is the largest one known produced at the Amlash bronze foundries. A bowl (seventh-eighth century A.D.) embossed with a heraldic griffin was made for the Sassanian court. Pierced bronze was popular during the Seljuk dynasty (A.D. 1037–1194) as seen in the incense burner in the form of a lion and a finial in bird form. A bronze candlestick (early fourteenth century A.D.) is elaborately engraved. Pottery is the strongest part of the Persian collection and includes various pieces from Nishapur and Rayy.

Exquisite Persian miniature paintings were executed both as book illustrations and as independent creations. The former include *Stag, Serpent, and Simple* from *De Materia Medica* by Dioscorides dated 1224, two pages from the *Demotte Shah-Namah* (fourteenth century), *The Armenian Clergy* from the *Majma al Tavarikh* (about 1425), and *The Meeting of the Theologians* by 'Abd Allah Musawwir (active mid-sixteenth century). More freely conceived works are a delightful tinted drawing, *Birds and Beasts in a Flowery Landscape*, attributed to Ustad Muhammadi (fourteenth-fifteenth century), *Couple Standing among Flowering Trees* (Herat, about 1430–40), *Hunting Scene* (sixteenth century), and a *Young Man with a Falcon* (c. 1520).

Two magnificent carpets deserve special mention. A Kashan silk tapestry rug was woven about 1600 with gold and silver threads for royal consumption. A "polonaise" carpet is one of the largest and most elegant woven for the court of Shah Abbas I (1587–1629).

Within the gallery are two architectural constructions. A porch from a Hindu temple in South India dates from the early seventeenth century. The Chinese temple room contains the ceiling of the Ch'ih-hua Temple in Peking. The central well of carved and gilded cypress dates from 1444; the surrounding painted panels date from the reign of Emperor Ch'ien-lung (1736–96). On the rear wall is a huge wall painting (fifty by twenty-five feet) depicting the *Tejaprabha Buddha* accompanied by the sun, moon, and planets shown as deities, as well as numerous guardians and attendants. Painted about 1300, it comes from the Kuang-sheng Temple in Shansi Province.

The Spencer Art Reference Library contains twenty-three thousand volumes on Western and Oriental art and subscribes to many major art journals. The

holdings reflect the particular strengths within the collection. The library is open to the public. Slides and photographs of objects in the collection are available for purchase through the slide library and the Registrar's office, respectively. The gallery publishes the *Bulletin*, begun in 1956, with scholarly articles on objects in the collection, and the monthly *Calendar*.

Selected Bibliography

Museum publications: Taggart, Ross E.; George L. McKenna; and Marc F. Wilson, *Handbook of the Collections in the William Rockhill Nelson Gallery of Art and Mary Atkins Museum of Fine Arts*, vol. 1, *Art of the Occident*, vol. 2, *Art of the Orient*, fifth ed., 1973; *Catalogue of the Samuel H. Kress Collection of Italian Paintings and Sculptures*, 1952; *Eight Dynasties of Chinese Painting: The Collections of the Nelson Gallery—Atkins Museum, Kansas City, and the Cleveland Museum of Art*, 1980; *Friends of Art Collection, 1935–68*, 1968; *The Robert B. Frizzell Collection of Old Master Prints*, October 7–28, 1962; Taggart, Ross E., ed., *The Frank P. and Harriet C. Burnap Collection of English Pottery*, 1967; idem, *The Starr Collection of Miniatures*, 1971; Branner, Robert, "A Romanesque Capital from Coulombs," *The Nelson Gallery and Atkins Museum Bulletin*, vol. 2, no. 3 (January 1960); Kantor, Helene J., "A Bronze Deer from Iran," *The Nelson Gallery and Atkins Museum Bulletin*, vol. 4, no. 2 (October 1962); Marshall, Suzanne, "The Poet and the Prince—A Moghul Painting from the Album of an Imperial Connoisseur," *The Nelson Gallery and Atkins Museum Bulletin*, vol. 5, no. 4 (November 1978); Sickman, Laurence, "Four Album Leaves by Li Sung (fl. 1190–1225)," *The Nelson Gallery and Atkins Museum Bulletin*, vol. 2, No. 1 (March 1959); Stokstad, Marilyn, "Three Apostles from Vich," *The Nelson Gallery-Atkins Museum Bulletin*, vol. 4, no. 2 (August 1970).

Other publications: "The Nelson Gallery-Atkins Museum, Kansas City," Special issue of *Apollo*, vol. 15, no. 130 (December 1972); "Oriental Art at the William Rockhill Nelson Gallery", *Apollo*, n.s., vol. 97 (March 1973); Addiss, Stephen, "Hills and Valleys Within: Laurence Sickman and the Oriental Collection," *Oriental Art*, n.s., vol. 24 (Summer 1978); Coe, Ralph T., "Rubens' Sacrifice of Abraham," *Art News*, 66 (December 1966), pp. 36–39; Huselton, H. E., "Kansas City's Art Museum Plan," *American Magazine of Art*, vol. 20 (September 1929), pp. 498–502; Koch, Robert, "A Rediscovered Painting by Petrus Christus," *Connoisseur*, vol. 140 (January 1958), pp. 271–76; Roth, James, "The Separation of Two Layers of Ancient Chinese Wall Paintings," *Artibus Asiae*, vol. 15, nos. 1–2 (1952); Sickman, Laurence, "Dragon Vase from Ch'ing Hohsien," *American Magazine of Art*, vol. 29 (October 1936); idem, "Cauldron of King Ch'eng of Chou," *Gazette des Beaux Arts*, s. 6, vol. 23 (March 1943); idem, "An Early Chinese Wall Painting Newly Discovered," *Artibus Asiae*, vol. 15, nos. 1–2 (1952); Stokstad, Marilyn, "Romanesque Sculpture in American Collections: Kansas City, Missouri, and Lawrence, Kansas," *Gesta*, vol. 16, no. 1 (1977), pp. 49–58; Vermeule, C., "Ten Greek and Roman Portraits in Kansas City," *Apollo*, vol. 99 (May 1974), pp. 312–19.

BURTON L. DUNBAR III AND ALICE R. M. HYLAND,
WITH CONTRIBUTIONS BY MARILYN GRIDLEY AND STANLEY W. HESS

———— Los Angeles ————

LOS ANGELES COUNTY MUSEUM OF ART, 5905 Wilshire Boulevard, Los Angeles, California 90036.

Originally founded in 1913 as part of the Los Angeles County Museum of History, Science, and Art, the Museum of Art did not become a separate county institution until 1961. By that time, the desire for a major art museum in the rapidly growing Los Angeles area had become so great that private citizens under the leadership of museum trustee Edward W. Carter rasied about $12 million from individuals, corporations, and foundations for construction of the present building. The Los Angeles County Board of Supervisors provided 5.5 acres of land in Hancock Park, adjacent to the famed La Brea Tar Pits, for the new museum complex. The complex consists of three buildings surrounding a central plaza: the Ahmanson Gallery to the west, housing the permanent collection; the Frances and Armand Hammer Wing to the north, housing major temporary exhibitions and the museum's new Conservation Center; and the Leo S. Bing Center to the east, housing the Bing Theater, Plaza Cafe, Research Library, Slide Library, and Art Rental Gallery. Administrative and curatorial departments are located throughout the three buildings. The B.G. Cantor Sculpture Garden surrounds the complex on the west, south, and east, and the museum shop is located on the plaza.

Upon completion of the building program in 1965, the buildings were deeded to the Board of Supervisors as a gift to the people of Los Angeles. The contract between the museum's board of trustees, acting on behalf of the Museum Associates, a nonprofit corporation, and the county provided that the Board of Supervisors would fund the operation and maintenance of the museum and that the trustees would be responsible for developing policy, overseeing operations, seeking private funding, and enriching the permanent collection.

The museum's Board of Trustees is a self-perpetuating body of thirty-six members and six honorary life trustees. The museum is administered by a director and three assistant directors; by curatorial departments of American Art, European Painting, European Sculpture and Decorative Arts, Far Eastern Art, Indian and Southeast Asian Art, Prints and Drawings, Textiles and Costumes, and Twentieth-Century Art; and by administrative departments of conservation, development and membership, education, exhibitions, film, graphic design, publications, press office, and social events, as well as an adjunct department of music. The museum's ten volunteer support groups, known as Councils, are active in fund raising, educational activities, programs to encourage local artists, and other services to the institution.

The museum was dedicated on March 30, 1965, and was opened to the public on the following day. The building complex was designed by William L. Pereira and Associates, and the builder was Del E. Webb Construction Company.

With funds provided by the Ahmanson Foundation, the Armand Hammer Foundation, and Occidental Petroleum, the museum has recently completed the first phase of a major expansion program. An addition to the Ahmanson Gallery, as well as a connecting bridge between the Ahmanson Gallery and the Frances and Armand Hammer Wing, increase the museum's gallery space by about thirty thousand square feet to accommodate the growing permanent collection. In the fall of 1983, construction began on the Robert O. Anderson Building, a new four-level building that will house the museum's collection of modern and contemporary art and will contain special exhibition galleries, as well as the museum's curatorial and administrative offices. The seventy-five-thousand-square-foot building will be located at the front of the museum complex on Wilshire Boulevard.

The Los Angeles County Museum of Art is the youngest general art museum in America; yet as the distinguished British journal *Apollo* stated on the occasion of the museum's tenth anniversary, "No other museum has come so far, so fast." As a division of the Museum of History, Science and Art, the permanent collection had consisted of numerous objects spread unevenly across the history of art. In 1918, Mr. and Mrs. Preston Harrison began a thirty-year career as donors that eventually added more than 150 paintings and drawings of the American Realist, Ash Can, and Impressionist schools. In 1939 Paul Rodman Mabury and his sisters Bella and Carlotta, and a bequest from Allan C. Balch, provided European paintings from the fourteenth through the nineteenth century. From 1946 until 1952 William Randolph Hearst added significantly to the collection of ancient, medieval, Renaissance, and Baroque sculpture and decorative arts and donated more than fifty Old Master paintings. In 1946 George Gard DeSylva provided funds for additions to the Impressionist and Post-Impressionist collections.

With the establishment of an independent art museum in 1961, the trustees determined that the museum would continue to develop its general scope, without duplicating areas of specialization of nearby museums. The collection now extends from prehistory to the present and encompasses most of the major civilizations of the world. When the museum opened its doors in 1965, modern art was strongest in breadth and quality. In addition to Ernst Ludwig Kirchner's important painting *Two Midinettes* (c. 1911–12) and Kurt Schwitters' monumental painted collage *Construction for Noble Ladies* (1919), works by Monet, Mondrian, Stuart Davis, Guston, and several German Expressionists were joined by paintings by Picasso, Gris, Léger, Kupka, Modigliani, Miró, Dubuffet, Gottlieb, Rothko, Kline, and Pollock in the bequest of David Bright. Since that time, the collection has grown to include Magritte's masterpiece *La trahison des images (Ceci n'est pas une pipe)* (1928–29), Matisse's *Five Heads of Jeanette* (c. 1910–13), Frank Stella's *Getty Tomb* (1959), and other contemporary works by Rauschenberg, David Smith, Warhol, Louis, Oldenburg, Diebenkorn, Ruscha, Caro, Kelly, Motherwell, Irwin, Kienholz, and many more.

Since 1965 the purchase of several collections has placed the museum among

the foremost in the world in their areas of specialization. The Nasli and Alice Heeramaneck Collection of Indian, Nepalese, and Tibetan art, which includes more than 345 paintings, sculptures, textiles, jades, and crystals, was one of the finest in America at the time of its acquisition in 1969. Augmented to fill lacunae, it is now one of the three greatest in the world, spanning the history of Indian art from the Indus Valley civilization of the second millennium B.C. to the Mughal courts of the eighteenth century. Indian works from the Heeramaneck Collection include a sixth-century *Goddess with Child*, a ninth-century bronze *Vishnu Chaturanana*, and the opaque watercolor *Krishna and Radha on the Bank of the Yamuna* (c. 1720). The Nepalese works include the thirteenth-century gilt and polychromed bronze *Bodhisattva Padmapani* and the opaque watercolor *Mandala of Vishnu* (1420). Tibetan works include the twelfth-century painting *A Tathagata Surrounded by Bodhisattvas* and the bronze *Vajrapani and Consort* (c. 1400).

Other important works in the area include a superb sixth-century *Buddha Sakyamuni* from the classical Gupta period; a majestic Indian *Nataraja* ("Siva, Lord of the Dance") (c. tenth century); a monumental, tenth-century, Cambodian sandstone *Vishnu*; a magnificent eighteenth-century Buddhist shrine from Sri Lanka; and the beautiful *Siva linga* from Nepal (twelfth century), the only example of this most eminent symbol of Siva in the museum's collection.

A second Heeramaneck Collection, the gift of Joan Palevsky, came to the museum in 1973. This collection includes more than 650 West Asian and Islamic paintings, ceramics, metalworks, and textiles. Combined with existing holdings, the collection formed the basis for an exceptionally strong group of Near Eastern objects. In addition, five Assyrian reliefs from the palace of Ashurnasirpal II (ninth century B.C.), a gift of trustee Anna Bing Arnold, form a monumental group that illustrates both the decorative and the political nature of Assyrian art. Other outstanding pieces include an ancient Sumerian *Worshipper* (c. 2800–2600 B.C.), carved out of alabaster; a ceremonial beaker (1000–900 B.C.) from Iran, shaped from a thin sheet of gold and decorated in low relief with a grazing gazelle; and an important collection of Luristan bronzes (800–700 B.C.), including votive objects, horse trappings, decorated vessels, and personal objects. These bronzes were part of the third Heeramaneck Collection to enter the museum, a gift of the Ahmanson Foundation.

The Hans Cohn Collection of Near Eastern and Islamic glass, a promised gift to the museum, displays a remarkable variety of Islamic glass types. In addition to having mold-blown and cut bottles, bowls, and beakers, the collection includes a number of pieces with applied colored-glass decoration and enameling. Among the highlights of this collection are an animal-form bottle (tenth-eleventh century) from Iran and a group of seven enameled, gilded, and molded bottles (eighteenth century) from India that are decorated with vignettes of women alone or with a man or child.

The most important collection of textiles and costumes in the western United States can be found in the museum. The department's holdings of about twenty-

five thousand items has a particular depth and range in Islamic and Peruvian textiles and Renaissance and eighteenth-century costumes and accessories. The collection includes the only complete sixteenth-century costume in any American museum, a man's red silk-velvet doublet and red velvet breeches lined with leather; a fourteenth-century Italian chasuble of brocaded satin; a carved-wood artist's lay figure (1769) with complete wardrobes for both men and women; an eighteenth-century English silver and silk court gown; a warrior costume by Henri Matisse, designed for Diaghilev's 1920 production of *La Chant du rossignol*; and a twenty-four-piece gown collection by Mariano Fortuny.

Also included among the museum's textiles and costumes holdings is an extraordinary collection of Peruvian textiles. Among the hundred unusually well-preserved examples, representing almost two thousand years of pre-Columbian weaving, are an embroidered alpaca fiber burial mantle and a brilliantly colored Inca feathered tunic (1470–1530).

Peruvian textiles are exhibited with the large and comprehensive Constance McCormick Fearing Collection of pre-Columbian art, a promised gift to the museum. The collection of more than one thousand objects includes stone and ceramic sculpture, pottery, and jade that reflect the high artistic quality and superior craftsmanship of ancient Mexico. Of particular importance in the Fearing Collection are a fine group of Middle Pre-Classic (1150–550 B.C.) Olmec stone sculptures and jade, a large collection of Late Pre-Classic (300–100 B.C.) stone sculpture and implements, a fine group of Proto-Classic (100 B.C.-A.D. 250) ceramic sculpture and pottery, and an impressive group of Late Classic (A.D. 550–950) stone sculpture, including carved yokes.

Chinese and Japanese screens, ceramics, scrolls, and sculpture form the core of the Far Eastern art collection. The ritual associations of the art of these cultures can be studied from a number of outstanding objects. A fifth-century B.C. covered *ting*, cast in bronze and inlaid with copper, is a superb example from the Late Chou Dynasty. The sumptuous tomb furnishings of the T'ang period are embodied in an early-eighth-century A.D. pottery horse and an exceptional pair of officials. The latter, almost four feet high, are exceptionally large. The introduction of Buddhism to Japan in the sixth century brought with it the rich civilization of China. A life-sized Bodhisattva Kwannon (897–1185) of carved wood shows the complete assimilation of this imported culture. A twelfth-century Jizo Bosatsu reflects the wide popularity of the Buddhist cult in Japan.

Far Eastern ceramics include a neolithic Chinese funerary jar; a Han Dynasty jar imitative of bronze; Ming Dynasty porcelains; a superb Japanese painted porcelain jar from the Edo period (1615–1868), the earliest period of porcelain-making in that country; and several Korean and Thai ceramics. Screens include a pair of monumental, six-panel, gold paper screens, each five feet high and twelve feet long, the *Battle of Ichinotani* and the *Battles of Yashima and Dan-no-ura*, dating from the mid-seventeenth century. Another fine pair of screens, *Plum Trees*, was painted by the Edo period master Watanabe Shiko.

Forty-five Far Eastern lacquers, donated to the museum in recent years, are

displayed in the Sammy Yu-Kuan Lee Gallery of Far Eastern Lacquer. These works, which range in date from the fourth century B.C. to the late eighteenth century A.D., come from China, Japan, and the Ryūkyūan Islands. Examples include a wide variety of forms and techniques, including trays, bowls, boxes, and bowl stands in carved, inlaid, polychromed, gold-engraved, and gilded lacquer.

The museum's collection of Oriental treasures has been enhanced recently through the donation by Mr. and Mrs. Joe D. Price of their collection of some three hundred Japanese scroll paintings and screens. The collection, known as the Shinen'kan Collection, is considered by leading Japanese scholars to be the most outstanding repository of Japanese painting of the Edo period in the Western world today. As part of the gift, Price has also agreed to donate $5 million to construct a twenty-three-thousand-square-foot pavilion for Far Eastern art that will also house a major study center for Japanese art and culture. The pavilion is expected to be completed in 1987.

Many of the major artists of the Edo period are included in the Shinen'kan Collection and are represented by works that are not only of excellent quality but display an important facet of each artist's work. About seventy of the paintings are considered among the best work by a particular artist.

Among the major masters in the Shinen'kan Collection are the highly imaginative Kyoto individualists Ito Jakuchu, Soga Shohaku, and Nagasawa Rosetsu, each represented comprehensively from their formative years to their maturity. The collection also includes works by these masters' students.

Paintings by virtually all of the leading masters of the Rimpa school are in the collection, with works of Sakai Hoitsu and Suzuki Kiitsu held in depth with key masterpieces. The artists of the Shijo school are strongly represented, and the works of Mori Sosen are especially notable for their stunning quality and brilliance.

In addition, the collection includes impressive holdings of *ukiyo-e* paintings and genre screens, comparable in quality to those in the Freer Gallery (q.v.), Washington, D.C., and the Museum of Fine Arts (q.v.), Boston. The collection also includes a few examples from the Buddhist school and the Nanga and Nagasaki styles, which were inspired by Chinese models.

The museum's European sculpture and decorative arts collections are strong in Baroque and nineteenth-century sculpture, but several earlier works are important. Medieval, Renaissance, and post-Renaissance works are represented by a Late Gothic *Virgin and Child with a Goldfinch* (fourteenth century), a remarkable *Colossal Head* (c. 1534) by Baccio Bandinelli, and the exceptional late-sixteenth-century *Allegorical Female Figure*, attributed to Dominique Florentin and one of the few large wooden statues remaining from the School of Fountainbleau. Another late-sixteenth-century wooden statue, the Neapolitan *Archangel Raphael*, is remarkable for the nearly perfect condition of its polychromed and gilded surfaces.

The seventeenth and eighteenth centuries are well represented in Italian, French,

and German sculpture. *The Triumph of Neptune and Europa* (1735–40) by Antonio Montauti, a recent gift of trustee Anna Bing Arnold, is considered the finest Italian Baroque relief sculpture in this country. The only known cast of Giovanni Battista Foggini's *Time Ravishing Beauty* (c. 1700) epitomizes the artist's contribution to Late Baroque sculpture in its freedom of space. Examples of monumental Bavarian Rococo religious sculpture are rare in the United States, but the museum possesses Ignaz Gunther's *St. Scholastica* (c. 1755), one of only a few known early works by this important eighteenth-century sculptor. Paul Heerman's marble *Allegorical Group of an Infant Female Genius Crowning a Male Infant with a Laurel Wreath* (1712) is a rare example of the artist's work. As a result of the bombing of Dresden during World War II, few of Heerman's works have survived in good condition. John Deare's neoclassical relief *The Judgment of Jupiter* (1786–87) is one of the most important reliefs of this type in America, and Jean-Antoine Houdon's marble *Bust of George Washington* (c. 1786) combines classical dignity with a quiet reflective visage. The often melancholic exoticism of nineteenth-century Romanticism is embodied in Jean-Jacques Feuchere's bronze *Satan*, and the apex of that century is well represented in thirty-nine casts of work by Auguste Rodin, including *Monument to Balzac*, *St. John the Baptist*, and *Jean d'Aire Nude*, all gifts of the B. G. Cantor Foundation. Other important gifts of the B. G. Cantor Foundation include Constantin Meunier's *Bust of a Peddler* (c. 1895), Pierre-Jean David d'Angers' *Philopoemen* (1837) and *Johann Gutenberg* (1839), and Jean-Alexandre-Joseph Falguière's *Revolution Holding the Head of Error and Striding over the Cadaver of Monarchy* (1893).

The artistry of European medals and plaquettes is well represented in the museum's David M. Daniels Medal Collection, comprised of 698 extraordinary pieces ranging in date from the fifteenth to the twentieth century. A group of thirty-six Limoges enamels from the fifteenth and sixteenth centuries draw their subject matter from the Old and New Testaments, ancient Greek and Roman mythology, heraldry, portraiture, and decorative designs from other art forms of the times. The collection was a gift to the museum of William Randolph Hearst in 1948.

Among the outstanding silver objects in the decorative arts collection is the sixteenth-century Scottish *Methuen Cup*, one of the oldest-known extant pieces of Scottish secular silver. The collection also includes the Gilbert Collection of Monumental Silver, a gift of trustee Arthur Gilbert and Mrs. Gilbert. Among the highlights are two pairs of gilded royal gates (1784) from two Kiev churches and works by English silversmiths Paul Jacques de Lamerie and Paul Storr.

Ceramics include one of the largest surviving examples of fifteenth-century majolica, the *Travulzio Basin*, depicting Adam in the earthly paradise; the English porcelain *Bust of George II* (c. 1750) from the Chelsea Porcelain Factory; and the porcelain *Shakespeare Service* (c. 1810), as well as examples of Sèvres and rare Palissyware. The department also houses the Gilbert Collection of Roman and Florentine Mosaics, dating from the seventeenth to the early twentieth cen-

tury, to which the only comparable collection is that of the Hermitage (q.v.) museum in Leningrad.

Glass works in the department's collection include the Quattlebottom Collection of American Glass, highlighted by the eighteenth-century South Jersey and Baron Steigel types of glasswork and the nineteenth-century pressed glass produced by Boston and Sandwich. The Hans Cohn Collection of Ancient and European Glass is an important recently promised gift to the museum. The collection, one of the finest and most comprehensive of its kind, includes more than 250 examples dating from the sixth century B.C. to the seventh century A.D. and from the sixteenth to the twentieth century A.D. Highlights among the ancient glass works include a blue-black bottle with zig-zag pattern (sixth to fifth century B.C.), an unusual dark blue jug with feather pattern (fourth to third century B.C.), and a small, gold-painted gilt beaker from the eastern Mediterranean (second century B.C.), decorated with theatrical scenes. Among the extremely fine examples of European glass are a Venetian *vetro a retorti* ewer with silver-gilt mounts (seventeenth century A.D.); two late-sixteenth-century A.D. enameled beakers, both early examples of Bohemian enameled glass; an engraved portrait goblet (A.D. 1712) by Christoph Dorsch of Nuremberg, which is thought to be the companion piece to the only known signed work by this little-known master; and a pink and black overlaid and acid-etched vase (A.D. 1890–95) by the French glass artist Emile Gallé.

Among the most difficult tasks facing a young museum is the development of a significant collection of European paintings. The museum has been helped enormously by the promised gift of three of the Armand Hammer Collections: the paintings collection, which includes works by Rembrandt, Rubens, Fragonard, Corot, Moreau, van Gogh, and many other European masters; the Daumier collection, which includes a comprehensive selection of nine paintings, twenty drawings and watercolors, and thirty-eight sculptures; and the Leonardo da Vinci manuscript the *Codex Hammer*. The museum's collection also includes a number of Italian, French, Dutch, Flemish, and English paintings of particular importance.

Among the early panel paintings is the *Virgin of the Annunciation* by Bartolo di Fredi, the most important Sienese painter of the late fourteenth century. A late fifteenth-century triptych by the Master of the St. Lucy Legend depicts the enthroned Madonna and Child in a style representative of Early Netherlandish painting, and Fra Bartolommeo's *Holy Family* (1498) is a superb example of Florentine-Roman High Renaissance painting.

Florentine Mannerism is embodied in Il Rosso Fiorentino's dramatic and disturbing *Virgin and Child with St. Anne and Young St. John* (c. 1521). This unfinished work is one of the relatively few known works by the artist. Veronese's two monumental *Allegories of Navigation* (sixteenth century), gifts of the Ahmanson Foundation, typify the emphasis on luminous color, grandeur of design, and atmospheric realism of Venetian painting of that century. El Greco's *The Apostle St. Andrew* (c. 1595–1600) fuses Venetian and Mannerist principles into the artist's uniquely personal vision.

Peter Paul Rubens' sensuous atmospheric effects, derived from Veronese, are evident in *The Israelites Gathering Manna in the Desert* (c. 1625–28). Georges de La Tour's *Magdalen with the Smoking Flame* (1630s), believed to be the earliest of the artist's four versions of the subject, is an outstanding example of de La Tour's meditative, candle-lit style. In striking contrast is the extraordinarily well-preserved oil painting by Simon Vouet, *Virginia de Vezzo, the Artist's Wife as the Magdalen*, about 1627, also a gift from the Ahmanson Foundation. This painting depicts the subject as a sensual and wordly Magdalen, one of Vouet's most personal and sensitive statements. Other seventeenth-century works donated by the Ahmanson Foundation are the *Portrait of Cardinal Roberto Ubaldino (1581–1635), Papal Legate to Bologna*, 1625–27, by Reni Guardi, a monumental portrait in near-perfect condition, and an oil sketch, the *Mystic Marriage of St. Catherine*, about 1680, by Bartolomé Esteban Murillo, a modello for one of the five paintings made for the altarpiece for the Abbey Church of the Capuchins in Cadiz, Spain.

Two Rembrandts, *The Raising of Lazarus* (c. 1630) and *Portrait of Marten Looten* (1632), depict both biblical and secular approaches to the human experience, while Frans Hals' *Portrait of a Man* (c. 1635–38) is the most classic of his portraits. Tranquil Dutch genre scenes are exemplified by Gerard Ter Borch's *The Card Players* (c. 1660), while their influence on later French painting is evident in Jean Siméon Chardin's famous *Soap Bubbles* (late 1730s). Two other versions of this, his earliest genre painting, are known, one in the National Gallery of Art (q.v.) in Washington, D.C., the other in the Metropolitan Museum of Art (q.v.) in New York.

Rococo painting is exemplified in two mid-eighteenth-century works. Jean Baptiste Pater's *The Fortune Teller* (1751), painted at the height of the artist's career, represents the genre known as *fêtes-galantes*; Jean-Honoré Fragonard's *Winter* is an overdoor painting for the Hôtel Matignon in Paris. Another mid-eighteenth-century work, *Capriccio: Piazza San Marco Looking South and West* (1763), by Giovanni Antonio Canale, called Canaletto, is thought to be this famous view painter's last scene of Venice. The work is the first view painting to enter the museum's collection.

Nineteenth-century Romanticism is prefigured in Henry Fuseli's *Satan, Sin, and Death* (c. 1790), and Baron Gros' *Portrait of Second Lieutenant Le Grande* (c. 1809–10) partakes of both neoclassical and Romantic attitudes. Late-nineteenth-century paintings include examples by many Impressionist and Post-Impressionist artists, including Claude Monet's *View of Vetheuil* (1880), Edgar Degas' *Bellelli Sisters* (1862–64), Camille Pissarro's *Place du Theâtre Français* (1898), and Paul Cézanne's *Still Life with Peaches and Cherries* (1883–87). Also on view are Jean François Millet's *Norman Milkmaid* (1871) and Jean Baptiste Camille Corot's *Seine and Old Bridge at Limay* (1870–72).

American art of the eighteenth, nineteenth, and twentieth centuries is represented by a number of important works, most notably George Bellow's widely known portrayal of urban America, *Cliff Dwellers* (1913). Reginald Marsh's

Third Avenue El (1931), also depicting America's urban poor, portrays New York's subway riders in a monumental and sympathetic light. The influences of European art on earlier periods is evidenced in Thomas Cole's Italianate landscape *L'Allegro* (1845) and its recently discovered companion piece *Il Penseroso* (1845), Emmanuel Leutze's *Mrs. Schuyler Burning Her Wheat Fields on the Approach of the British* (1852), and William Wetmore Story's *Cleopatra* (1858). Transcendentalist interests are captured in Jasper Cropsey's *Sidney Plains* (1874), Sanford Gifford's *October in the Catskills* (1880), and George Inness' *October* (1886); Winslow Homer's *Cotton Pickers* of 1876 translates French depictions of field hands into a purely American idiom. Among the outstanding portraits in the collection are John Smibert's *General Paul Mascarene* (1729), John Singleton Copley's *Hugh Montgomery, 12th Earl of Eglinton* (1780), Gilbert Stuart's *Richard, 4th Viscount Barrington* (c. 1794–1803), and John Singer Sargent's *Mrs. Livington Davis and Her Son Edward L. Davis* (1890).

The Robert Gore Rifkind Collection of German Expressionist prints, drawings, and illustrated books, considered the largest and the most comprehensive collection of its kind in the world, was acquired by the Los Angeles County Museum of Art in 1983. The Rifkind Collection consists of about five thousand prints and drawings and a catalogued library of more than four thousand volumes.

The collection contains works by every major German Expressionist artist including extensive examples of most of the artists active in the second wave of German Expressionism after World War I. It also contains important examples of Expressionism's Jugendstil antecendents and Expressionism's outgrowths of New Objectivity (*Neue Sachlichkeit*), Bauhaus, and Dada. The collection follows the movement into the 1930s, when the Nazis declared modern art, and especially German Expressionism, degenerate, thus causing the ultimate demise of the movement. The infamous Degenerate Art exhibitions of 1937 and "approved" Nazi art are thoroughly documented in the Rifkind Collection.

The collection is particularly rich in the works of the Brücke artists, with about 300 works by Ernst Ludwig Kirchner, 70 works by Erich Heckel, and 100 works by Emil Nolde, including many unique examples. Ernst Barlach, whose accomplishments span the graphic arts, poetry, theater, and sculpture, is represented by about 250 works, including all of his major portfolios. The Viennese artist Oskar Kokoschka is represented by 1,500 works, and Max Beckmann's achievements from the early part of the century until his death in 1950 can be traced by almost 90 prints.

The collection includes among its four thousand volumes complete or nearly complete sets of ninety-five periodicals, including *Pan, Der Sturm*, and *Die Aktion*. These periodicals, which are rarely seen in complete runs, contain hundreds of important original graphics and are a valuable research tool.

The Robert Gore Rifkind Center for German Expressionist Studies at the Los Angeles County Museum of Art is now (1984) in temporary quarters at the museum and is available for study by art historians and scholars by appointment only. The center will eventually be housed in a specially designed space by

Hardy Holzman Pfeiffer Associates, New York. It will be constructed by the museum in conjunction with the Robert O. Anderson Gallery for Twentieth Century Art, scheduled to open in 1986.

In addition, about forty-five thousand works comprise the collection held by the Department of Prints and Drawings, with particular depth in German, Dutch, Flemish, and modern prints and drawings. German graphic art focuses on Albrecht Dürer and his contemporaries, including Martin Schongauer, Hans Sebald Beham, George Pencz, and Hans Sebald Grien. Among the well-known Dürer engravings are *Adam and Eve* (1504), *Knight, Death, and the Devil* (1513), and *Martyrdom of St. John* (1498). German Expressionist prints and drawings of the early twentieth century include works by Erich Heckel, Karl Schmidt-Rottluff, Käthe Kollwitz, and the American-born Lyonel Feininger. Perhaps the finest Dutch print in the collection is Rembrandt's *Christ Presented to the People*, 1655, and van Gogh's drawings, *The Bridge at Langlois* and *The Postman Roulin*, both of 1888, are superb works from the modern era. Included in the sizable collection of contemporary prints are virtually every work produced between 1960 and 1970 at Los Angeles' Tamarind Lithography Workshop.

In 1984 the Los Angeles County Museum of Art received $1 million from the Ralph M. Parsons Foundation to establish a photography program. The grant will be used for exhibition galleries, endowments, exhibitions, acquisitions, lectures, and educational programs. At present the museum's collection is small, most noted for one hundred vintage Edward Weston prints.

The Los Angeles County Museum of Art has a noncirculating reference library of more than seventy-five thousand volumes available for scholarly research, as well as specialized libraries in the fields of textiles and costumes and prints and drawings, open by appointment.

In addition to providing guides to the collection and specialized catalogs, such as *The Los Angeles County Museum of Art Handbook* and *A Decade of Collecting, 1965–1975*, the museum publishes catalogs of all major exhibitions, the annual *Los Angeles County Museum of Art Bulletin*, the biennial *Los Angeles County Museum of Art Report*, and the monthly *Members' Calendar*. A list of twenty-five museum publications, with instructions for ordering, is available from the Museum Shop.

Slides of the collection may be rented by teachers and scholars from the museum's Slide Library. In addition, a selection of slides and photographic posters of objects in the collection may be purchased in the Museum Shop.

Selected Bibliography

Museum publications: *Los Angeles County Museum of Art Handbook*, 1977; *An Elegant Art: Fashion and Fantasy in the Eighteenth Century*, 1983; *Ancient Bronzes, Ceramics, and Seals*, 1981; *American Portraiture in the Grand Manner*, 1981; *Art in Los Angeles*, 1981; *Art of the Embroiderer*, 1983; *Art of the Mosaic: Sections from the Gilbert Collection*, 1983, rev. ed.; *Avant Garde in Russia, 1910–30*, 1980; *Bizarre Imagery of*

Yoshitoshi, 1980; *California: Five Footnotes to Modern Art History*, 1977; *Elephants and Ivories in South Asia*, 1981; *Far Eastern Lacquer*, 1982; *Golden Century of Venetian Painting*, 1979; *Islamic Art from the Nasli and Alice Heeramaneck Collection*, 1973; *Joy of Collecting: Far Eastern Art from the Lidow Collection*, 1979; *Los Angeles Prints, 1883–1980*, 1980; *Mirror of Nature: Dutch Painting from the Collection of Mr. and Mrs. Edward William Carter*, 1981; *Monumental Silver: Selections from the Gilbert Collection*, 1977; *Old Master Drawings*, 1976; *Romantics to Rodin*, 1980; *Sensuous Line: Indian Drawings from the Paul F. Walter Collection*, 1976.

CHRISTOPHER A. KNIGHT

——— Minneapolis ———

MINNEAPOLIS INSTITUTE OF ARTS, THE (alternately THE INSTITUTE, THE ART INSTITUTE), 201 East 24th Street, Minneapolis, Minnesota 55404.

The Minneapolis Society of Fine Arts was founded by a group of twenty-four local citizens in 1883, seventeen years after the incorporation of the city of Minneapolis. Overseen by a board of fifty-seven elected trustees, the society is now the governing and supporting body for The Minneapolis Institute of Arts and the Minneapolis College of Art and Design. The society's collection was housed in the Minneapolis Public Library from 1889 to 1915, when it moved to the newly constructed Minneapolis Institute of Arts. This original structure was designed by the architectural firm of McKim, Mead and White; its classical facade is typical of monumental museum buildings of the day. A new wing, constructed in the Beaux-Arts style, was added in 1927. Between 1972 and 1974 further additions were made to the structure that increased it to twice its original size. The newest portions of the building were designed by Kenzo Tange of Tokyo in association with the architectural firm of Parker Klein in Minneapolis. The museum reinstalled its collection in late spring 1974 and officially opened this new facility on October 6, 1974. Its collections comprise some seventy thousand objects that represent all periods of art.

In the 1880s a generous gift of paintings from the railroad magnate James J. Hill served as a starting point for the collection. Joseph Breck, the Institute's first director (1915–17), added to this core of paintings by negotiating the purchase of a number of works, including *On the Beach at Trouville* by Boudin, *Portrait of an Ecclesiastic* by Moroni, and *The Rest in the Flight into Egypt*, attributed to Joachim Patinir. Under Russell Plimpton's long directorship (1921–56), the museum's painting collection became one of the most significant in the country. John Van Derlip's private collection was bequeathed in 1935 in memory of his wife, Ethel Morrison Van Derlip, and the fund that bears his name is still the largest of the museum's endowments. This fund was used to buy a *Pietà* by the Master of the St. Lucy Legend, *Princess Charlotte of France* by Clouet, *The Fallen Tree* by van Dyck, and *Portrait of Mlle. Hortense Valpinçon* by

Degas, as well as other significant works. In the 1960s and 1970s, under the directorships of Anthony Clark and Samuel Sachs II, the museum acquired important Italian Baroque, English Victorian, and French academic paintings. These daring acquisitions in somewhat unfashionable areas have helped establish the painting collection as one of the most important in the country. It is particularly strong in the nineteenth- and early-twentieth-century works, although it is also noted for its strength in Italian painting (1600–1800) and German painting (1900–1945).

Among the masterpieces in the Institute's painting collection are Ancona's *Madonna and Child*, Titian's *The Temptation of Christ*, El Greco's *Christ Driving the Moneychangers from the Temple*, Rembrandt's *Lucretia*, Poussin's *Death of Germanicus*, Castiglione's *Immaculate Conception*, Chardin's *Attributes of the Arts*, Goya's *Self Portrait with Dr. Arrieta*, Delacroix's *Fanatics of Tangiers*, Degas' *Mlle. Valpinçon*, Bonnard's *Dining Room in the Country*, and Beckmann's triptych *Blindman's Bluff*.

In addition, there are important works by Tintoretto, Batoni, Girodet, Prud'hon, Corot, Manet, Braque, Cézanne, van Gogh, Gauguin, Seurat, Matisse, Derain, Schiele, Léger, de'Chirico, Miró, Mondrian, and others. The American collection includes major works by Copley, West, Jarvis, Cropsey, Moran, Sargent, Bellows, and Parrish. The modern European and American collection contains works by Gorky, Bacon, Magritte, O'Keeffe, Rivers, Stella, Close, and Reinhardt.

The Department of Decorative Arts and Sculpture includes the museum's holdings in ancient and medieval art, Renaissance and later sculpture, and American and European decorative arts. Many of the objects in the department were acquired during the early years of the museum under the directorship of Joseph Breck and Russell Plimpton. The collection of ancient art is strongest in Greek and Roman sculpture. Among the notable holdings are the Greek marble *Crouching Lion*, about 300 B.C.; the *Tiber Muse*, Greek, second century B.C.; the bust *Aphrodite*, Greek, 200 B.C.; and a standing Roman matron, about A.D. 59. The medieval collection includes a Romanesque fountain from southern Italy and the thirteenth-century Limoges gilt-copper *Anointing of Christ*. The late medieval and Renaissance decorative arts collection contains a small group of German and French Gothic sculptures, a fifteenth-century German acquamanile of a seated warrior on horseback, a drinking cup by Joerg Ruel (c. 1598), an ostrich egg cup by Hans Petzoldt (1594), and the gilt-silver *Aldobrandini Tazza* (c. 1575). The sculpture collection includes a fourteenth-century wood *Virgin Annunciate* from Siena, a late-fifteenth-century Italian bronze *Portrait of a Patrician*, the small bronze *Florence* by Giovanni Bologna (c. 1560), the terracotta bozzetto for *Pope Liberius Baptizing the Neophytes* (a study for a fountain in the Courtyard of St. Damascus in the Vatican) by Alessandro Algardi, and the ivory *St. Jerome* (c. 1635) by Adam Lenckhardt. The large collection of eighteenth- and nineteenth-century sculpture includes Joseph Chinard's terracotta *Bust of General Guillaume Brune*, Bertel Thorvaldsen's *Ganymede and the Eagle*,

and important works by Alfred Gilbert, Carrier-Belleuse, Cordier, Clésinger, Barye, and Degas. The twentieth century is represented by Aristide Maillol's *The Three Nymphs* (c. 1936) and a number of bronzes by Matisse and Renoir.

During the 1920s and 1930s the museum installed a group of period rooms. These rooms include a late-sixteenth-century oak room from Hingham Manor in Suffolk; a drawing room (c. 1740) from Stanwick Park, the Yorkshire seat of the dukes of Northumberland; and a small French drawing room (c. 1780). The four American rooms include two rooms from the John Stuart House in Charleston, South Carolina (c. 1764); a room from the Russell House in Providence, Rhode Island (c. 1772); and a small room from a house in Foxon, Connecticut (c. 1740). Much of the museum's furniture collection is displayed in these rooms.

The Institute has acquired a small but fine collection of Italian decorative arts. These pieces were purchased mostly in the 1960s and include a Roman late-seventeenth-century gilt side table from the circle of Giovanni Paolo Schorr, a gilt side table designed by Piranesi for Cardinal Rezzonico (c. 1769), and a silver-gilt and marble inkstand by Vincenzo Coaci, made for Pius VI in 1792. The important English and American silver collection was primarily a gift of the local collector James Ford Bell. It includes a complete tea service by Paul Revere and a large wine cistern by Paul de Lamerie, about 1735. An outstanding collection of French Strasbourg and Niderviller faience was donated by Mrs. John Rutherford in 1954. The museum continues to add to its collection of Continental decorative arts. It has recently purchased a German marquetry table by Hans Daniel Sommer, about 1690, and has received various pieces of French furniture and decorative arts through the generosity of the Groves Foundation. They include a commode attributed to Charles Cressent, about 1735; a gilt-bronze clock, also by Cressent; a writing desk by G. Stumpff; and a pair of gilt-bronze, mounted, Sèvres-covered vases with chinoiserie decoration, about 1780.

The American furniture collection includes examples from Pennsylvania, New York, Connecticut, Massachusetts, and Rhode Island. Among them are an outstanding Philadelphia lowboy, about 1770; a New York Chippendale side chair from Johnson Hall; a Connecticut blockfront chest-on-chest from the Colchester area; a Newport, Rhode Island, card table of the 1770s, a particularly fine Massachusetts card table of the Federal period; and a signed John White, stenciled secretary desk and bookcase (New York, dated 1830).

The Department of Prints and Drawings was established at the time of the museum's opening in 1916, when Herschel V. Jones donated five thousand prints collected by William M. Ladd of Portland, Oregon. This collection was encyclopedic in scope, containing Old Master prints from Schongauer and Mantegna to Dürer and Rembrandt. It was also strong in its modern holdings, with large groups of works by late-nineteenth-century artists, such as Bracquemond, Buhot, Lepère, Whistler, Haden, and Legros. Herschel Jones was fortunate to benefit from the dispersal of certain great print collections after World War I. He acquired some five hundred prints of rare quality and distinction, half of which he gave

to the museum in the years before his death in 1927. The remainder entered the collections through the bequest of his daughter.

Throughout the years the print collection has increased to about forty thousand works. They include three thousand Daumier lithographs collected by Sarah Bernhardt and donated by Mrs. Charles Bovey in 1941; one thousand French prints of the early twentieth century, bequeathed by Mrs. Charles Pillsbury in 1958; and a collection of ten thousand prints of botanical, zoological, and fashion subjects from the fifteenth to the twentieth century, amassed by Helen and Dwight Minnich and acquired in 1966. Major works have been purchased, including one of the highest quality impressions of Dürer's *Adam and Eve*. The Institute's Prints and Drawings Department continues to receive important gifts; Jasper Johns' fine lithograph *Ale Cans*, 1964, from Bruce B. Dayton is an example.

In the early 1920s the DeLaittre family's gift of funds for the purchase of drawings gave the drawing collection its first impetus. Numerous modern European works were acquired at that time, including fine works by Matisse and Picasso. The drawing collection, which now numbers some fifteen hundred works, is concentrated mainly in the nineteenth and twentieth centuries and in recent years has benefited greatly from the generosity of David M. Daniels, whose numerous gifts include the study *The Violinist* by Degas.

The Minneapolis Institute of Arts was one of the first American museums to announce its commitment to photography. It has had a curator of photography since the late 1960s, and its collection of photographs now numbers about three thousand. The first purchase, made in 1964, was a complete set of *Camera Work*. The standards of artistic excellence demonstrated in the fifty issues of that publication have guided the Institute in its acquisition of works by artists such as Lewis W. Hine, William H. Fox Talbot, Walker Evans, Imogen Cunningham, Diane Arbus, Lee Friedlander, Edward Weston, Ansel Adams, and other lesser-known but distinguished photographers. Most recently, the bequest of a substantial collection of Edward Steichen's photographs has enhanced the Institute's holdings. This group of one hundred prints, dating from 1924 to 1937, contains many outstanding portraits that Steichen did for *Vanity Fair* magazine.

The Department of Asian Art was established in 1976 as the result of the Richard P. Gale bequest, which provided an operational endowment for a curator of Asian art. The department represents some of the most important collections within the museum. Owing to the generosity and specialized interests of a few local collectors, the Far Eastern collections are well known for their ancient Chinese bronzes, jade, gold, silver, monochrome ceramics, carved rhinoceros horn, and Japanese paintings and prints. These collections, some donated as early as the 1920s, form the nucleus of the museum's Asian art collection.

The Chinese art collection is strongest from the earliest periods of the Shang and Chou dynasties. It includes more than 150 ancient bronzes of exceptional quality and a large selection of ancient jades collected primarily by Alfred F. Pillsbury and donated in 1950. There is a small group of stone sculptures dating from the Six Dynasties period. These fine pieces include a Lung-men head; the

epitaph stone of Prince Cheng-ching, dated 524; and an extraordinary statue of Kuan-yin, dated 571, from Shensi Province. The collection also contains T'ang ceramics, as well as a superb tomb retinue of ten figures, dating from the early eighth century and excavated in 1949.

The small Chinese painting collection contains an important twelfth-century wall painting of Kuan-yin from Shansi Province, a painting of bamboo by the Yüan Dynasty artists Shih Jin-jieh, some representative Ming academic works, and good ink paintings by Wang Chien and Shao-mi. The decorative arts are represented by an important collection of later jades, including several eighteenth-century pieces from the imperial collection, donated by Augustus Searle during the 1930s, and a large and comprehensive collection of gold and silver donated by Mrs. Charles S. Pillsbury in 1951. A few selections from the Institute's notable collection of Chinese textiles are on permanent view, as are other representative pieces such as Ch'ing Dynasty carved lacquer, cloisonné, carved rhinoceros horn, and snuff bottles.

The museum's collection of Japanese art is not as extensive or varied as the Chinese collection, but its greatest strength is in pictorial arts. The museum owns a fine Raigo painting and a superb complete set of twelve late Kamakura period scrolls illustrating the twelve celestial beings (*Juniten*). The Japanese screen collection includes a famous pair of screens by the Muromachi painter Kai Sesson and an equally well-known set of four *fusuma* attributed to Kano Sansetsu. An outstanding part of the Japanese collection is the group of about 100 *ukiyo-e* paintings, including 4 Kaigetsudo paintings, donated by Richard P. Gale in 1974. The Japanese print collection totals more than 1,500 works. The core of the collection, acquired through the Gale bequest, contains 230 prints, including extraordinary groups of work by Harunobu, Utamaro, and Enyo. It also contains one of the three known complete sets of 10 "Large Flower" prints by Hokusai. The rest of the collection is comprehensive, with a strong selection of prints by Hiroshige and an exceptional group of 270 Shijo school *surimono* woodblock prints.

Contained in the Japanese sculpture collection is a small group of *haniwa* and bronze artifacts from the Tumulus period. An important bronze kwannon of the seventh century represents the beginnings of Buddhist art in Japan, and an excellent, large, wood image of Amida Nyorai, dating from the twelfth century, exemplifies late Heian sculpture. Rounding out the Japanese collection are several examples of lacquerware and ceramics, with about two hundred sword guards (*tsuba*).

In addition to having Chinese and Japanese works, the Asian collection includes Indian and Southwest Asian art, with examples from Chola, Cambodian, and Thai sculpture and a small but comprehensive group of Korean ceramics dating from the Silla, Koryŏ, and Yi dynasties. A number of good Persian miniatures donated by Margaret McMillan and ceramics donated by Alfred F. Pillsbury comprise the Islamic collection. Also included is a small group of Middle Eastern textiles and glass.

Acquired throughout a seventy-five-year period, the Textile Department's holdings represent the development of textile technology and design. Among the most important works in the textile collection is a group of tapestries dating from the fifteenth, sixteenth, and early seventeenth centuries. *The Falconers* and *Queen Esther*, two Flemish tapestries, about 1615, are perhaps the most notable examples in this group. Other areas of interest are sixteenth- and seventeenth-century Italian lace, nomadic rugs, Kashmiri shawls, ecclesiastic vestments, Guatemalan weaving, Islamic embroidery, and North American Indian baskets and beadwork. French brocades and printed fabrics, Italian damasks and velvets, Indonesian batiks, Indian costumes, pre-Columbian textiles, and American quilts and coverlets are also represented in the Textile Department's collection.

Although the art of African, Oceanic, and New World cultures has been represented since the Institute's founding, the museum did not own a significant collection until the 1940s. The earliest accessioned objects were chiefly native American—baskets, textiles, and pots. In 1928 twenty Northwest Coast objects were donated, and in 1942 the Institute received a major gift of fifty Southwest baskets. In the 1940s the museum began to enjoy a steady stream of donations of pre-Columbian ceramics, which has continued to the present. Although holdings in pre-Columbian metalwork and stone sculpture are not as broad, there are some important pieces, notably the Teotihuacan travertine mask, a 1971 gift, and the Piedras Negras stele, donated in 1966.

The first African piece was acquired in 1953 with the gift of a large Luba helmet mask, a major work by any standard and one of three known examples of its type. Through the 1950s and 1960s pieces were slowly added by gifts and purchases, the most remarkable being the 1958 purchase of a Benin bronze leopard from Kaiser Wilhelm II's collection via the Munich Völkerkunde Museum. By the 1970s, through numerous gifts and purchases, the African collection had achieved a very high standard of quality. Works of considerable importance are an Ijo funerary screen, a Yoruba ivory carving, and a Djenne terracotta figurine.

The Oceanic collection was started in 1942 with the gift of an Austral Island canoe paddle. It was not until the 1970s, however, that other pieces were acquired, nearly all by purchase. The collection is still small, containing no more than twenty objects, but some of them are remarkable, particularly an Astrolabe Bay mask, an Asmat bispole, and an Easter Island ancestor figure.

The Minnesota Artists Exhibition Program (MAEP) was formed in 1975, when several Minnesota artists pointed to the need for professional exhibition space in the state. The department acts upon the recommendation of a panel of ten artists who are elected in an annual meeting of the Minnesota artist community. The panel recommends and selects exhibitions for presentation in the MAEP gallery and occasionally in other exhibition spaces throughout the state. Two staff members (a program coordinator who must be an artist and a program associate) implement the overall activity of the program. In addition to exhibitions, MAEP activities include artist-led public tours, artists' publications, a

slide resource library, critical reviews, videotapes, and a film-video component—MovingImageMakers.

The museum includes a twenty-five-thousand volume noncirculating library with an adjacent reading room, where small exhibitions of fine and rare books are shown. The Art Resource and Information Center (ARIC) provides brochures and booklets on specific areas of interest in the arts and serves as a clearinghouse for information on visual, literary, and performing arts in the state.

Slides of objects in the collection may be purchased by application to Slide Sales, Audio-Visual Center, The Minneapolis Institute of Arts. Catalogues of exhibitions and guides to the collections may be purchased from the Museum Shop, which will send a list of publications available.

In addition to providing the guides and catalogues listed below the museum has published *The Minneapolis Institute of Arts Bulletin* since 1905.

Selected Bibliography

Clark, Anthony, *Catalogue of European Paintings in The Minneapolis Institute of Arts* (Minneapolis 1970); Foster, Edward, *The Jones Collection: Bequest of Herschel and Tessie Jones* (Minneapolis 1968); Hillier, J., *Gale Catalogue of Japanese Paintings and Prints*, 2 vols. (London 1970); Joachim, H., *Prints: 1400–1800* (Minneapolis 1956); Joachim, H., and J. Flint, *Prints: 1800–1945* (Minneapolis 1966); Kup, Karl, *The Minnich Collection* (Minneapolis 1970); Sachs, Samuel II, *Favorite Paintings from The Minneapolis Institute of Arts* (New York 1981); Shissler, Barbara, *A Guide to the Galleries of The Minneapolis Institute of Arts* (Minneapolis 1970); Wentworth, Michael J., *James J. Tissot: Catalogue Raisonné of His Prints* (Minneapolis 1978).

MICHAEL P. CONFORTI

Newark

NEWARK MUSEUM, THE, 49 Washington Street, Newark, New Jersey 07101.

The Newark Museum was established in 1909 largely as a result of the vision and efforts of John Cotton Dana. Dana, director of the Newark Free Public Library from 1901, had instituted a policy of changing exhibitions of artistic and scientific materials on the top floor of the library building. As interest and attendance at those exhibitions grew, it became apparent that a continuing exhibition program required special planning and administration. Dana worked to secure the support of the library trustees and other influential citizens for the establishment of a new museum of art, science, and industry to be housed temporarily in the Public Library. In 1909 a chartered corporation, The Newark Museum Association, was established by the city of Newark holding the museum property in trust for the people. At that time, the city purchased the George T. Rockwell Collection of Japanese prints and other Oriental art objects as the foundation of a permanent institution.

The museum continued to function in the Public Library building, with Dana as its unpaid director and many library employees doubling as its unpaid staff. The new museum grew by gifts and acquisitions until it was clear that a larger, separate space would be required. In 1922 the City Commission purchased the Marcus Ward property on Washington Street as the site for a museum when sufficient outside money for a building could be found. Louis Bamberger, a prominent Newark merchant and supporter of Dana and the museum, donated the funds, and the new museum was completed in 1925 and officially opened to the public on March 27, 1926. In 1937 the museum acquired the adjacent Ballantine House and its addition to provide more needed space.

The museum is governed by a board of trustees consisting of sixty-three elected and six ex-officio members. It presently receives most of its operating funds and all of its capital improvement funds from the city of Newark, with additional funds coming from the state of New Jersey and the county of Essex, in which it is located.

Other than the initial $10,000 given by the city to buy the Rockwell Collection, public funds have not been used for acquisitions, except several matching purchase grants received from the National Endowment for the Arts. Acquisitions are made primarily through membership fees, a small endowment, and private donations.

The Newark Museum is administered by a director, an assistant to the director, two administrative assistants, and a business manager. It is organized into the Registrar's Department; curatorial Departments of Oriental Art, Painting and Sculpture, Decorative Arts, Ethnology, Classical Art, and Coins, Medals and Currency; the Science Department, with curators of zoology, earth science, and botany; the Planetarium; the Department of Education; the Lending Department; the Junior Museum; the adult Arts Workshop; the Library; and Departments of Membership, Public Relations, Programs and Publications, and Exhibitions.

John Cotton Dana's greatest contribution to museum thought was to conceive of the museum as an "institution of visual instruction," of service to all of the people in the community, not as a repository uniquely of rare or costly objects accessible only to an elite few. These then revolutionary ideas about the role and function of a museum became the guiding philosophy behind The Newark Museum's programs and collections and remain so to the present.

The Oriental collections are among the largest holdings of The Newark Museum. Their general scope covers all of the arts of Asia and Islam, with particular emphasis on the art and ethnology of Tibet. As with the other museum departments, acquisitions policy follows Dana's emphasis on the decorative arts and the objects of everyday life.

As noted above, The Newark Museum was founded with the purchase in 1909 of the Rockwell Collection of about three thousand objects of Japanese art. The Japanese collections have continued to grow and are a good, comprehensive group of objects depicting Japanese culture, with special emphasis placed on lacquer ware, textiles, pottery, metal, and woodwork. The museum has superb

holdings of netsuke and *ojimi*, numbering some fifteen hundred pieces, coming primarily from the Jaehne gifts in 1938–41. In addition, more than fifteen hundred eighteenth- and nineteenth-century *ukiyō-e* woodblock prints, reflecting Dana's great personal interest in this art form (he was a collector of Japanese prints and designed a book label for himself in the *ukiyō-e* style), constitute one of the major strengths of the collection. Recent acquisitions have included Japanese Buddhist paintings and sculpture and decorative paintings.

The Chinese collections, numbering some one thousand objects, also reflect early interest in the decorative arts or objects made for everyday use. Most of the Chinese holdings, among the magnificent Jaehne gifts previously noted, emphasize pottery, textiles, and lacquer ware. Among the most outstanding are a glazed stoneware, Huang-tao ware jar from the T'ang Dynasty and a rare stoneware pillow of northern celadon ware in the form of a sleeping child from the Northern Sung Dynasty. About thirty Korean ceramics of high quality, including a superb and very important large Koryŏ inlaid celadon vase from the twelfth-fifteenth century, constitute a small but fine group.

Its world-renowned Tibetan holdings, however, are the most important aspects of the Oriental Department and constitute an extraordinarily comprehensive selection of everyday, religious, and fine-arts objects, as well as archival documents and photographs of historical and traditional Tibet.

The Tibetan collections went to Newark when Edward N. Crane, a founding trustee of the museum association, met Albert L. Shelton, a medical missionary stationed on the Western China-Eastern Tibet border area, on board the steamship *Mongolia* sailing from Japan to America in 1910. Shelton had made a collection of about 150 Tibetan objects, and Crane arranged to have them exhibited at the Newark Free Public Library under the sponsorship of The Newark Museum Association. That exhibition was a great success, but although Shelton wanted to sell the objects to the museum, the trustees hesitated to purchase them because Tibet appeared so unrelated to Newark. When Crane died suddenly in 1911, however, his family purchased Shelton's Tibetan collection and presented it to the museum as a memorial. When Shelton and his family returned to eastern Tibet, Dana asked him to continue to collect Tibetan material for the museum. Shelton brought a larger group of objects to Newark in 1920, and the museum then assumed active leadership in Tibetan acquisitions and scholarly research.

Among the treasures of this vast amount of superb material can be mentioned a group of eighteenth–twentieth-century liturgical silver objects; a unique twentieth-century appliquéd tent used for summer outings; a painted *tanka* showing the Wheel of Existence, said to be the symbol of office of the sixteenth Panchen Lama from the eighteenth century; sixty manuscript volumes of the Kanjur, or sacred scriptures; a group of official costumes from Lhasa; correspondence with the thirteenth and fourteenth Dalai Lamas; archival film from the 1930s; and about one thousand historic photographs. On permanent display in one gallery is a Tibetan Buddhist altar (made in 1935 as a Works Progress Administration project), used for worship by visiting Tibetans, which is part of the collection.

The Newark Museum's outstanding collections of American art and sculpture, remarkable for both their quality and breadth of coverage, have their foundation in John Cotton Dana's firm support of American art and culture at a time when American art was not generally sought by museums. In addition, the Department of Painting and Sculpture includes a significant representation of French and other European paintings and sculpture of the nineteenth and twentieth centuries and works by important Latin American artists. The museum's policy is to accept gifts selectively from many periods and countries of origin, but purchases are limited to American works.

Among the most important eighteenth-century American paintings are the *Portrait of Catherine Ogden* of Newark (c. 1730) by Pieter Vanderlyn (The Gansevoort Limner), the *Portrait of the Reverend Ebenezer Turrell* (1732) by John Smibert, *New York Family Group* (c. 1750) by John Wollaston, *Mrs. Joseph Scott* (c. 1765) by John Singleton Copley, *Col. Elihu Hall* and *Mrs. Elihu Hall* (1773) by Charles Willson Peale, *Mrs. Nathaniel Taylor* (c. 1790) by Ralph Earl, and *The Grecian Daughter Defending Her Father* (1794) by Benjamin West.

Nineteenth-century American paintings are exceptionally well represented by many notable works, including *Still Life—Watermelon and Balsam Apple* (1822) by Raphaelle Peale; *Roman Lady Reading* (c. 1831) by Washington Allston; *The Arch of Nero* (1846) by Thomas Cole; *The Fort and Ten Pound Island, Gloucester* (1848) by Fitz Hugh Lane; *Twilight, Short Arbiter 'Twixt Day and Night* (1850) by Frederick Church; *Western Landscape—"Mount Whitney"* (1869) by Albert Bierstadt; *The Arch of Titus* (1871), painted in collaboration by Healy, McEntee, and Church; and works by Winslow Homer, John Singer Sargent, George Inness, Albert Pinkham Ryder, Ralph Blakelock, and Thomas Eakins, among many others.

The museum's twentieth-century American paintings, reflecting Dana's policy of collecting works of living American artists, include works by the Ash Can School, such as Henri, Sloan, Glackens, Bellows, and Prendergast; by Impressionists such as Childe Hassam and Ernest Lawson (a painting by Lawson was one of the earliest acquisitions in 1910); and by Max Weber, John Marin, Charles Burchfield, William Gropper, Edward Hopper, George Luks, Charles Sheeler, Stuart Davis, Charles Demuth, Reginald Marsh, Georgia O'Keeffe, and Yasuo Kuniyoshi, among many others. More contemporary works include paintings by Jim Dine, Jack Youngerman, Morris Graves, Hans Hofmann, Josef Albers, Theodore Stamos, Ad Reinhardt, Mark Rothko, and artists working in New Jersey such as Richard Anuszkiewicz, Darby Bannard, Adolf Konrad, and Clarence Carter. Although the collections include some works by the New York School, representation is generally weaker than in other areas.

The celebrated five-panel work by Joseph Stella, *New York Interpreted* (1920–22), with other works by Stella, was purchased in the 1930s. In 1971 a large collection of thirty-one paintings and studies by Niles Spencer was bequeathed by his widow, and in 1972 other family members donated twenty-nine drawings

and other archival materials in the Spencer Collection. Sixteen works by the major New Jersey artist Lee Gatch was added to the collection in the 1970s. Recent acquisitions of paintings by Geometric Abstractionists such as Ralston Crawford, Burgoyne Diller, and Ilya Bolotowsky add to an already large collection of abstract painters from the 1930s and 1940s.

A group of works by black artists include early examples of paintings by Hale Woodruff and Henry Ossawa Tanner and have continued to grow with additions by Romare Bearden, Ben Jones, and Barbara Chase-Riboud, among others. Many watercolors by American Indians of the Southwest, given by Amelia White in 1937, supplemented earlier museum purchases of Indian paintings.

The distinguished American sculpture collection contains nineteenth-century works such as the outstanding neoclassical marble figure *Greek Slave* (1847) by Hiram Powers; *John Alden and Priscilla* (1885) and other plaster groups by John Rogers; *Hero* and *Leander* by William Rinehard; bronzes in the Western idiom by Frederick Remington and Charles Schreyvogel; and a set of five rare plaster sculptures by Thomas Eakins, studies for his painting *William Rush Carving His Allegorical Statute of the Schuylkill* (1877).

Beaux-arts period sculptures from the later nineteenth and early twentieth centuries include examples by Gutzon Borglum, August Saint-Gaudens, and Daniel Chester French. Other early-twentieth-century works are by Anna Hyatt Huntington and Mahonri Young, and the more modernist style is represented by sculptors such as William Zorach, Reuben Nakian, Gaston Lachaise, and John Flannagan.

Among more contemporary twentieth-century sculptures are a Calder mobile and pieces by Louise Nevelson, Chaim Gross, and José de Rivera, and monumental additions installed in the museum garden include works by David Smith, Tony Smith, James Rosati, and George Segal.

The folk art collection has its origins in two historic exhibitions organized by Holger Cahill for The Newark Museum—*American Primitive Painting* (1930–31) and *American Folk Sculpture* (1931–32), the first major exhibitions of this material in the country. The nuclei of The Newark Museum's own collection were a nineteenth-century wooden cigar-store figure called *Captain Jinks of the Horse Marines*, given to the museum in 1924, and two eighteenth-century portraits, *James Van Dyck* (1787) and *Catherine Van Dyck* (1787), by John Vanderpool.

Among the most notable of the paintings in the folk art genre in the museum's collections are the portrait *Woman in a Black Dress* (c. 1843) by Ammi Phillips, the Newark *House and Shop of David Alling* (c. 1840–50), *Washington under the Council Tree* by Joseph Pickett, and *The Grave of William Penn* (1847) by Edward Hicks. There are also numerous watercolors, paintings on velvet and glass, embroideries, mourning pictures, and Pennsylvania and New Jersey *frakturs*.

Sculptural folk art includes ships' figureheads, cigar-store figures, trade signs, decoys, and carved smaller figures and animals, such as a wooden Schimmel eagle. An exceptionally large eighteenth-century iron eagle weathervane, a nine-

teenth-century copper eagle and a twentieth-century dragonfly weathervane are three outstanding examples of this form of folk art.

The Department of Decorative Arts, now consisting of more than twenty thousand items, began modestly under Dana as "a collection of objects of applied art of all countries and all periods." In addition, Dana stressed collecting "objects illustrative of a manufacturing process including raw materials of the city and state" and "objects of historic interest." The present acquisitions policy of the department still reflects Dana's philosophy. The collections are regarded as educational in intent and are, in general, more comprehensive than in-depth, although they contain many fine and important pieces. There is an emphasis upon the decorative and applied arts of New Jersey and the United States, but the collections do not limit themselves geographically.

The earliest gift to the department, in 1911, was a Sèvres porcelain tea set presented by Mrs. Robert Ballantine, a neighbor in Washington Park. The museum now has a fine collection of English pottery and porcelain and an outstanding collection of New Jersey ceramics, including a 1793 redware sgraffito plate by Phillip Durrell of Elizabeth, the only known New Jersey example of sgraffito ware.

The museum also has one of the most complete collections in the United States of American art pottery, consisting of almost two hundred pieces from more than fifty-six potteries and kilns. Perhaps the most outstanding item is a Rookwood iris vase, (c. 1910), purchased by Dana, unusual because of its black and dark blue colors.

The glass collection covers the general history of Western glass from the sixteenth to twentieth century, including American art glass from the end of the nineteenth century and modern Scandinavian art glass from 1930 to 1950. The rarest piece in the collection is a mid-eighteenth-century Wistarburg sugar bowl from southern New Jersey.

Several hundred pieces of American and English silver from the seventeenth to twentieth century are highlighted by a silver creamer and sugar bowl by Henry Luff of Brunswick, New Jersey (1790), the only known cream pitcher with a gallery; a seventeenth-century tankard by New York silversmith Gerrit Onckelberg; and a tankard made by Joseph Richardson, Sr., of Philadelphia.

The Bliss Collection of nearly one hundred European clocks from Germany and France, dating from the late sixteenth to the early nineteenth century, was an estate gift in 1967. In addition, the horological collection includes sand glasses and fine eighteenth-century New Jersey tall clocks.

About two hundred pieces of furniture, mostly from New Jersey, include rare seventeenth-century William and Mary style chairs from southern New Jersey and about twenty examples by John Jelliff, a nineteenth-century furniture maker of Newark.

The Newark Museum also has a well-known and extensive collection of eighteenth-, nineteenth-, and early twentieth-century quilts and coverlets, many of which are made in New Jersey and emphasize state themes. In 1914 the museum

held the first exhibition in the United States of quilts and coverlets as an art form, and subsequent exhibitions have continued throughout the decades.

An unusual and comprehensive collection of almost six hundred crosses, given by Mrs. Robert de Forest in the 1950s and by Mrs. Roger Young in 1961, includes processional crosses and folk and jewelry crosses from Europe.

A small Victorian jewelry collection and extensive costumes, consisting mostly of nineteenth-century women's clothing and ornaments, as well as folk costumes from other lands, are also part of the department. There is an important group of toys, dolls, and dollhouses, of which the Newark Wheeler dollhouse, dating from 1882, intact with all furniture and in very fine condition, is an outstanding example. In addition, textiles, tiles, arms and armor, and twentieth-century German industrial arts all constitute important parts of the extensive decorative-arts collections.

The crowning jewel of the Decorative Arts Department is the Ballantine House, located adjacent to the museum. The Ballantine House, a typical upper-class house of Newark in the late nineteenth century, is now the only example extant in the city of restored high Victorian architecture and decoration. Purchased by the museum from an insurance company in 1937, it was opened to the public as a decorative arts museum in 1976. Five rooms on the first floor and a large room on the third floor used for private museum functions are furnished in period pieces obtained from Newark and New Jersey families, with some pieces original to the house. Present plans are to restore some bedrooms on the second floor and to use the rest as additional gallery space. The music room presently contains small changing exhibitions of aspects of the decorative arts collections.

Period-room reconstructions in the museum building, consisting of a parlor, an entry hall, and a kitchen representative of a Newark house in the 1820s, are used primarily for teaching purposes. A stone schoolhouse dating from 1784, the oldest surviving Newark schoolhouse, now stands in the museum garden and reflects The Newark Museum's focus on education. The Newark Fire Museum, also in the museum garden, administered jointly by the Newark Fire Department Historical Association and The Newark Museum, contains objects and historical documents from both organizations.

The Ethnology Department concentrates on objects of material culture from the native peoples of the Americas, Africa, and Oceania. The origins of the collections lie in Dana's deep interest in the world and the people around him and from his desire to educate and instruct. To this end, acquisition of objects of daily use and the processes by which they were made, highlighted by note-worthy and artistic pieces, is stressed. Contemporary objects, as well as those from the past, are still being collected.

The foundation of the American Indian collection, which constitutes broad, comprehensive coverage of ethnographic objects and archaeological artifacts, began in 1914 and has increased steadily so that the materials are useful for both exhibition and teaching. Indian baskets of the nineteenth and twentieth centuries are particularly well represented and constitute a study collection in some depth.

Material collected in the 1940s by Alason Skinner, an archaeologist, added objects from Eastern Woodland Indians. A Lenhni Lenapi hafted celt from New Jersey, dated before 1700, was a significant later acquisition. Paintings, textiles, and pottery of Indians of the southwestern United States are an important focus. A semipermanent Indian gallery for teaching purposes features exhibitions concentrating on one particular medium or technique, such as basketry or textiles, and are rotated about every two years.

Early and contemporary Eskimo objects from Alaska and Canada, although not on permanent display, provide a solid introduction to Eskimo life and art. Of particular interest is a group of utilitarian objects, masks, and sculpture from the Kuskokwim River area of southwestern Alaska.

Central and South American objects, primarily from Mexico, Costa Rica, and Peru, include pre-Columbian sculpture and textiles. Textiles and decorative embroidered folk costumes of more recent date are also represented.

The ethnological collections from the African continent are particularly rich and date almost from the museum's inception. North Africa, especially Morocco, has been represented since Dana personally brought back material. Sub-Saharan African art is well represented by objects from the Yoruba tribe in Nigeria but also covers most African tribes and art styles, including some fifty to sixty textiles. A permanent African gallery is maintained and used for teaching school groups. Particularly notable examples include a large Baga shoulder mask from Guinea and a Kota reliquary figure from Gabon.

The Pacific Islands, particularly New Guinea and nearby Melanesia, are broadly represented by fine objects purchased from Colonel Frank Roller in the 1920s. Of particular note is a carved and painted memorial board dated 1924 from New Ireland. There is a small but comprehensive collection of Australian material and a larger and significant group of textiles, wood carvings, and metalwork from the Philippine Islands acquired from the Benjamin E. deRoy Collection. No permanent display presently exists of this material from Oceania.

The Classical Department consists of objects of Egyptian, Greek, Etruscan, and Roman antiquity, as well as an outstanding collection of ancient glass. The Egyptian collection contains interesting examples of writing, Late Period bronzes, a fine Dynasty XXI mummy case lid, and a small but representative group of Coptic textiles, sculpture, and small objects. Two dozen cuneiform tablets from the Ancient Near East; some good examples of Greek pottery and molded terracotta statuettes; a small but representative collection of Cypriot sculptures and vases from the excavations of Colonel Cesnola, purchased from the Metropolitan Museum of Art in the 1920s; Etruscan pottery and representative Roman pottery; and a fine marble bust of a woman constitute holdings of particular interest.

The Eugene Schaefer Collection of ancient glass, acquired in 1950s, ranks among the best collections in the United States. It ranges from the fourteenth century B.C. Egyptian New Kingdom through the tenth century A.D. Islamic period. Its particular strength is Roman glass of the Eastern Mediterranean. Notable pieces include a rare Egyptian pomegranate flask from the twelfth century

B.C., an Ennion cup from the first century A.D., and an especially fine Islamic rhyton. Most of the Classical collection is on display in a permanent gallery arranged for teaching purposes as well as exhibition.

The Coins, Medals and Paper Currency Department collects good, typical items, worldwide in scope. In keeping with Dana's philosophy, objects are appreciated in their historical context, for their artistic quality, as objects of manufacture, and for their relation to other aspects of the museum's collections. The emphasis is on having a representative coin from every country in the world rather than having every variety of one type of coin. Preference, however, is in collecting objects from Newark, from New Jersey, and from the United States. Objects of current production are steadily acquired, but attention is also given to filling in gaps in the existing collections.

The establishment of the coin collection dates from 1919, when more than five thousand pieces were purchased from William S. Disbrow, and 1925, when almost six thousand pieces were received as a gift from Frank I. Liveright. Liveright's contributions continued until his death in 1971. Outstanding and most comprehensive areas of the collections include: (1) more than five hundred obsidianal, emergency, and necessity coins, especially of the Netherlands; (2) Newark and New Jersey banknotes and coins, including medals, plaquettes, and sculptures by John Flannagan, Newark-born medalist and sculptor; (3) U.S. gold coins; (4) U.S. commemorative half dollars, a 1966 gift from Ralph E. Lum, Jr.; (5) Notgelt, or German emergency money of World War I; and (6) oversized German thalers.

Administered by the Registrar's Department, the Russell Kingman Collection of more than twenty ancient musical instruments is used yearly in concerts. Material of an industrial nature, or showing the technological processes of man-ufacture, include the Herpers jewelry industry shop from Newark, the Pioneer Mills Coffee shop, clay products of New Jersey, the Seth Boyden Collection, the Eagle-picher lead process, implements from the fishing industry of New Jersey, the Albert H. Sonn Collection of fine ironwork, and a popular collection of push-button-activated mechanical models that are on permanent display.

The Science Department collections are used primarily for exhibit and teaching rather than research. They are strongest in the fields of zoology, earth science, and botany and have particularly good examples of rocks and minerals, insects, birds, shells, and economic botany.

A twenty-six-thousand-volume research library, open to the public for use, does not normally lend its materials. In addition to having books supporting the museum's areas of interest, the library contains bound and current issues of many art and science periodicals; artists' and other information files; a collection of more than eighteen thousand photographs of the museum's objects and activities, as well as historic and other photographs of Newark and New Jersey, which can be purchased from the library; and a large number of slides are are maintained for teaching purposes.

An active publications program is followed. A quarterly bulletin, founded in

1917 and published regularly from 1925, expands upon aspects of the museum and its collections, and a monthly calendar of events, "News Notes," describes current exhibitions and programs. Occasional catalogs of special collections or exhibitions are also published. A publications list of current in-print works and prices may be obtained through the Publications Department.

Selected Bibliography

Museum publications: *American Art in The Newark Museum*, 1981; *Catalogue of the Tibetan Collection and Other Lamaist Articles in The Newark Museum*, vols 1–5, 1950–71; "2,000 Years of Chinese Ceramics," *NM Quarterly*, vol. 28, nos. 3 and 4 (Summer-Fall 1977); Auth, Susan, *Ancient Glass at The Newark Museum*, 1977; Curtis, Phillip, "The John H. Ballantine House," *NM Quarterly*, vol. 27, no. 4 (Fall 1976); "American Quilts in the Newark Museum Collection," *NM Quarterly*, vol. 25, nos. 3 and 4 (Summer-Fall 1973); Lipton, Barbara, "John Cotton Dana and The Newark Museum," *NM Quarterly*, vol. 30, nos. 2 and 3 (Spring-Summer 1979); idem, *Survival: Life and Art of the Alaskan Eskimo*, 1977; Wait, George W., *New Jersey's Money*, ed. Dorothy Budd Bartle, 1977.

Other publications: Reynolds, Valrae, *Tibet: A Lost World* (New York 1978).

 BARBARA LIPTON

———— New York City ————

BROOKLYN MUSEUM (also Brooklyn), Eastern Parkway, Brooklyn, New York 11238.

The Brooklyn Museum, located on Eastern Parkway, Prospect Park, Brooklyn (a borough of New York City), houses important collections of American paintings and decorative arts and a world-renowned collection of Egyptian art. The museum, a division of the Brooklyn Institute of Arts and Sciences, is a public corporation supported in part by the city of New York (which owns the museum's landmark building). A board of governors oversees the activities of the Brooklyn Museum and appoints a director. Today, curatorial departments include: Egyptian and Classical Art; Oriental Art; African, Oceanic, and New World Cultures; Paintings and Sculpture; Prints and Drawings; Decorative Arts; and Costumes and Textiles. Administrative and other museum departments include: Conservation; Registrar; Financial/Personnel; Education and Program Development; Publications and Marketing Services; Development; Photography; Operations; and the Libraries.

The Brooklyn Museum traces its beginnings to 1823, when Brooklyn was an independent and rural town. Its citizens formed the Apprentices Library (forerunner of today's Brooklyn Institute of Arts and Sciences) with the purpose of "shielding young men from evil associations, and encouraging improvement

during leisure hours by reading and conversation.'' The library opened in a rented room with 180 members. But by July 4, 1825, when General Lafayette laid the cornerstone for the library's own building, the Apprentices Library was definitely established.

The library grew slowly and in 1843 moved to a new building in the elegant, classical style on Washington Street. Under the leadership of Augustus Graham, the library changed its name to the Brooklyn Institute and added an art gallery, chemical experiments, lectures, reading, and courses in drawing and French. According to *The Brooklyn Museum Handbook* of 1967, the exhibitions (precursors to the shows of today) included ''models of machinery, curious specimens of nature and art, a fine collection of prints and flowers, a large number of pieces of sculpture, with many superior works in painting.'' The Institute became headquarters for a number of local clubs, including The Dredging Club, which looked for curious objects on the floor of New York Harbor. During the next several years, American pictures were purchased for the art gallery from well-known artists of the day such as Asher B. Durand, Daniel P. Huntington, and Jasper F. Cropsey. Space was rented for an art school and for artists' studios.

In 1890 the name of the Brooklyn Institute was changed to the Brooklyn Institute of Arts and Sciences, and a magnificent new building was planned and designed by the famous architectural firm McKim, Mead and White. The first wing was completed in 1897, just before Brooklyn was to be incorporated into New York City as a borough (1898). Despite the political changes, the museum building progressed, and by 1906 the north facade and the first of the four planned enclosed courts were finished. The institute's activities at this time included lectures by Booker T. Washington (1896) and Woodrow Wilson (who gave a series of lectures in 1900–1901) and art courses taught by painters John H. Twachtman and William Merritt Chase. The institute, in accordance with its encyclopedic concept, took in both objects of art and objects from the natural world. Plaster casts and sculptural reproductions were exhibited in galleries surrounding the second-floor rotunda together with photographs of French and Italian architecture. Indian art, antiquities, and Oriental objects were shown on the third floor. On the fourth floor, natural history installations were presented. ''Modern art'' together with Renaissance casts and European and American paintings were exhibited on the fifth floor. During this period of expansion, the museum began its expeditions throughout America, the South Sea Islands, the Far East, and the Caribbean, which would yield numerous objects for the collections. In 1916 the Wilbour Collection of Egyptian antiquities was presented to Brooklyn, forming the core of today's outstanding collection.

The south wing of the museum was completed in 1925, with an exhibition rotunda and permanent installations, including a Chinese hall of state and an entire Hindu street on the first floor. The costume collection was added, as were numerous European and American period rooms. Textiles, particularly examples from Czechoslovakia, Hungary, and Rumania, were added in 1920.

The 1930s proved to be a period of reassessment: objects were weeded out,

and the primary focus of Brooklyn became art. In 1931 an annual income restricted to the purchase of Egyptian art was given by Charles Edwin Wilbour together with his valuable library, notes, and papers. In 1934 the ambitious building program, with only one-quarter of the planned space completed, stopped. As if to underscore this abandonment of the building, the monumental staircase of the north facade was removed. Today, the Brooklyn Museum stands incomplete.

During the following fifty years, the Brooklyn Museum benefited from individual donors and foundations (e.g., Avalon, Ford, Kress) and had built outstanding collections in selected areas: Egyptian art, American art including pre-Columbian art (with perhaps the best collection of Peruvian textiles outside Peru), and American Indian art. In recent years, the Edward C. Blum Design Laboratory was opened offering designers, students, and manufacturers access to the design collections. The Paintings Study Gallery opened on the fifth floor. The Brooklyn Museum Print Biennial was instituted to present outstanding examples of this medium by contemporary artists, and The Frieda Warburg Sculpture Garden opened with its fascinating collection of American architectural sculpture. Plans for the future include a new two-story structure atop the four-story wing of the museum which will house state-of-the-art storage facilities. This will allow outside scholars and researchers easier access to the museum's collections. Space on the second and fourth floors vacated by the Art School will eventually be used for additional exhibition space

The Brooklyn Museum houses an important and comprehensive group of Egyptian antiquities. The first acquisitions in this area were made in 1902, when objects were given to the museum by the Egyptian archaeologist Sir William Flinders Petrie. At this time, the museum became involved with the English Exploration Fund (later called the Egypt Exploration Society) and during the following thirty-six years, in return for financial support, received objects from Abydos, Amarna, Lahun, and other sites. A major acquisition was made in 1907, when Jacques De Morgan arranged for the stele of Senres to come to Brooklyn. In 1906–7 and 1907–8 Brooklyn sent its first expeditions to Egypt under the direction of Henri De Morgan, which yielded numerous finds. The private collection of Armand De Potter, rich in Theban objects collected during the 1880s, was obtained in 1908, and in 1916 the large collection of Charles Edwin Wilbour was presented to Brooklyn. Wilbour's children continued the generous support begun by their father and gave a number of gifts, including in 1931 an endowment to maintain and develop the Egyptian collection. They also gave Wilbour's personal library, which was installed at Brooklyn in 1934. This was completed just after the first major exhibition of Egyptian art was presented in a third floor gallery (The Charles Edwin Wilbour Memorial Hall). In 1937 a number of Egyptian pieces from the New-York Historical Society were loaned to Brooklyn. This collection was subsequently purchased (1948), adding more than two thousand objects, including works from the Abbott Collection, to Brooklyn's holdings. Since 1948 the department has actively acquired objects and has resumed its support of field work under the Egypt Exploration Society. In 1976 Brooklyn

began a new expedition to the Precinct of the Goddess Mut at South Karnak (assisted by the Detroit Institute and conducted under the auspices of the American Research Center in Egypt). The department continues to present its permanent collection in galleries on the museum's third floor and to organize international loan exhibitions.

One of the oldest and most important objects in the Brooklyn collection is a painted bird deity excavated by Henri De Morgan at El Ma'moriya, which dates from the Early Predynastic Period (c. 4000 B.C.). Other early objects include a painted terracotta abstract male figure from about 3350–3300 B.C. A black-topped vase is also from this period, and a clay jar painted with a river scene is from about 3300–3200 B.C.

From the Early Dynastic Period, a knife of a hunter made of flint and ivory is decorated with rows of animals. A palette in the form of a bird is made of slate and shell or bone. A pegmatite head of a lion dates from about 3000–2900 B.C. and a colossal head of a king in red granite is from the end of Dynasty III (c. 2600 B.C.).

A limestone relief representing the inspection of cattle from Saqqara dates from the Old Kingdom, Dynasty V. The museum has three sculptures identified as an Old Kingdom administrator, Methethy, including a carved and painted wood representation of Methethy as a mature man (Dynasty VI). A relief with desert animals is made of painted limestone and dates from about 2430–2290 B.C., and a calcite sculpture, *King Pepy II and His Mother*, is from 2221–2157 B.C. Works from the First Intermediate Period include a painted limestone stele of Maaty.

The Middle Kingdom, which ushered in a more realistic style in art, is exemplified by the portrait *King Sesostris III*, a black granite work noted for its sensitive modeling. A female bust of black, mottled granite is from early Dynasty XII. Other pieces include a stele of Amenemhat, a limestone work of 1991–1892 B.C., and a brown quartzite block statue of Senwresret-Senbefny (1878–1785 B.C.). From the Second Intermediate Period, a terracotta "Hykos" female figure dates from 1650–1525 B.C.

The collection features important objects from the New Kingdom, including the limestone stele of Senres. A statue of Senenmut, an official during the reign of Hatshepsut, is of gray granite and dates from 1490–1469 B.C., and a statue of Amun (or the king as Amun?) is of brown quartzite. A colossal head of King Amenhotep III made of diorite and characterized by elegantly rendered features dates from about 1415 B.C. Paintings include a fragment on mud plaster from Thebes, Tomb 181, *Lady Thepu* (reign of Amenhotep III, Dynasty XVIII). Decorative pieces include a multicolor glass *krateriskes* from Saqqara and a bronze mirror with a female figure as a handle. Several works are from the Amarna Period, including the famous *Wilbour Plaque* which represents in sculpted limestone Akenaten and his queen Nefertiti. Another limestone relief, *Royal Couple Offering*, is from Amarna, and the brown quartzite sculpture *Princess Meket-aten* represents the second daughter of Akenaten.

A painted limestone relief from Abydos is titled *Ramesses the Great*, and a painting on limestone from Thebes shows a cat and mouse playing the parts of human beings. The Third Intermediate Period is represented by a faience bas-relief, King Iuput (818–720 B.C.); a deluxe perfume vessel made of alabaster with the figure of a lion; and an open-work vase made of blue frit.

Ptolemaic and Roman period pieces include the black steatite *Cippus of Horus* (third century B.C.) and *The Brooklyn Black Head* from Memphis (47–44 B.C.), which shows Classical influence in its elegant styling. A bust of Alexander the Great is formed from Egyptian alabaster (first century B.C.-first century A.D.). Classical influence is also evident in a statue of a goddess of good fortune made of black basalt dating from the Meroitic Period (second-third century A.D.). A fired clay vase is ascribed to the Antelope Painter and depicts representations of animals.

Coptic art, the art of Christian Egypt, is well represented, and objects include a painting in tempera on cypress wood of a boy of the Isis cult from El Rubiyat, Fayoum. A woman with a cross from Shiekh Iboda is sculpted in limestone and features the large eyes typical of this period. A limestone relief with traces of polychromy represents a New Testament story, *The One Cured of Paralysis* (A.D. 400). A stone mosaic represents a menorah and is from Hammam Lif, Tunisia; worked in *opus tessellatum*, the work dates from the third-fifth century A.D. Architectural sculpture includes a limestone sculpture, probably a lunette from a church, depicting the archangel of holy wisdom (fifth-sixth century A.D.).

The Egyptian and Classical Department also incorporates art of the Ancient Near East, displayed on the third floor. Most important among these pieces are twelve large alabaster slabs from the Northwest Palaces of the Assyrian King Assur-nasir-pal II (883–859 B.C.) at Nimrud. These reliefs (removed to London in 1853) were among the objects lent to Brooklyn in 1937 by the New-York Historical Society; they were purchased in 1955 with funds from Hagop Kevorkian. From Persia, the gray limestone *Persian Guard* is a fragment from a relief that once stretched across the parapet of the audience hall at Persepolis. This work in low relief depicts a soldier bearing a shield and (at one time) a spear.

Classical pieces from Greece and Rome include an amphora with a depiction of the death of Orpheus. This red-figured vase is from Vulci, Italy, and is attributed to the Niobid Painter. The museum also houses a large selection of Greek and Roman jewelry.

The Oriental Art Department incorporates art from Islam, India, Southeast Asia, China, and Japan and maintains permanent installations on the museum's second floor. A fine collection of Islamic ceramics is housed at Brooklyn with examples that span the almost twelve centuries of active pottery production in the Islamic world. Objects include a white jar from Kashan (?), Iran, and a decorative band of Kufic calligraphy is painted in black and worked in raised relief. A rare ceramic globe from Turkey's Ottoman period (second half of the sixteenth century) is painted with an underglaze decoration and was originally

meant to hang on a chain suspended from a mosque ceiling. Manuscripts in the collection include the fourteenth-century *Shah-Namah* (*Book of Kings*) from Shiraz, Iran. Worked in watercolor on paper, this example is known as the "second small Shah-Namah." A brush drawing by Riza-i-Abbasi of the Shah Abbas school, Isfahan, the *Hunters in a Landscape*, is in color and gold; the painting is notable for its particular shades of purple and brown characteristic of this artist. A carpet fragment from Tabriz dating from the Safavid period (c. 1550) is one example of Islamic textiles in the collection; the carpet is patterned with figural and floral motifs worked with Sehna knots.

Indian art at Brooklyn includes several large-scale sculptures. *Tara*, a stone carving from Orissa (eighth century A.D), represents the goddess who is believed to help man cross the "ocean of existence." A South Indian bronze is titled *Siva Nataraja, Lord of the Dance* (twelfth-thirteenth century). Manuscripts such as *Hamzah-Namah*, a Persian romance from Agra (1567–87), are in the collection, as are miniatures (e.g., *The Concert*, a watercolor on paper from the Rajasthan school depicting the *Bilawal Ragini*, a series of poems describing musical modes, seventeenth century). Indian textiles are represented by a curtain from Golconda or Northern Madras (1630–40); seven panels painted on cotton are believed to have decorated the Amber Palace in Jaipur.

Art of the Himalayan region is well represented with a number of acquisitions during the 1970s and 1980s. The seated *Gautama Buddha* from Swat Valley is of bronze and in the style typical for Buddhist images in this region. A rare cast-copper medallion with Buddha image from Afghanistan is an early work (sixth-seventh century). A mandala of Vajrasattva from Tibet represents the cosmic universe of Vajrasattva, who is shown in a yoga posture at the center; the work is rendered in opaque watercolor on cotton and was acquired by Brooklyn in 1981.

From Nepal, a copper representation of Vishnu, fire-gilt and set with gems, exemplifies the formal qualities of the period (ninth century?). A seated sculpture of Indra, believed in Tantric Buddhism to be the Buddha of one of the Six Spheres of Existence, dates from the fourteenth or fifteenth century.

Monumental sculpture from Cambodia's ancient Anghor period includes a brown sandstone masculine figure. The figure, perhaps *dvarapala* or a deified guardian, dates from the First Anghor period (ninth-thirteenth century) and is executed in the blocky style highlighted with low relief common to the period.

Chinese art features some early pieces, including a duck-shaped vessel of cast bronze from the Late Chou period (perhaps a wine container) and belt hook of bronze with gold, silver, and turquoise inlay from the Han period. Ceramics are well represented and include a phoenix-headed ewer of glazed porcelaineous stoneware with a molded and incised design (tenth century). A wine jar of terracotta-colored clay with emerald-green glaze exemplifies a type excavated in Inner Mongolia and western Manchuria from Liao Dynasty graves (407–1125). Sung Dynasty art includes a Buddhist painting in ink and color on silk, *Buddha Attended by Two Bodhisattvas*. The work is attributed to the painter Chiang Ssu

Kung. The delicacy of Sung ceramics is suggested by a celadon bowl formerly in the Imperial Collection, Peking.

Some fine examples of blue-and-white ware, the blue underglazed ceramics developed during the Yüan Dynasty, are at Brooklyn, including an oviform jar decorated with fish and plant motifs. Also from the Yüan Dynasty is a painting by Hsüeh Ch'uang in ink on paper, *Orchid, Bamboo, and Thorn*; the orchid here supposedly symbolized the artist's attachment to the philosophical Sung period and his rejection of Yüan (Mongol) rule. The Ming Dynasty, too, is represented with ceramics and paintings: a blue-and-white plate is decorated with peonies (the symbol of spring) and lotus-flower scrolls that suggest summer fruits and flowers and encircle the central motif. A landscape scroll by Ch'ien Ku, rendered in ink and color on paper, shows a scholar approaching Ping Po Pavilion, where another scholar and servant are seen waiting.

Korean art is included in Brooklyn's collection. A glazed stoneware (celadon) ewer decorated with an incised pattern of lotus leaves exemplifies the superior celadon ware produced during the Koryŏ Dynasty (981–1392). A painting of a local god by Kim Myong-kuk (Yun Tam) is rendered in ink on paper and dates from the Li Dynasty (1623–49); the Korean god of good fortune, Po Dai, may be represented here.

Early Japanese sculpture in the collection includes a Bodhisattva carved from a single block of wood in the ninth-century style. The drawing *Kayosei*, a star, dates from the Heian period, (eleventh-twelfth century). A painting from the Kamakura period shows the *Taizokai Mandara* ("womb-world"), with Buddhist deities. A rare narrative scroll fragment from the fourteenth century is a copy of the *Kitano Honji Engi*, tales of the founding of Kitano temple. From the Monoyama period, a pair of magnificent screens, the *Four Seasons*, includes delicate motifs such as drying fish nets; this work, by Kaiho Yusho, is made of color on paper pasted over gold foil. A screen from the Edo period, *Group of Bathing Women*, shows the subjects in colors and ink on paper with gold, being taken on an outing to the country. Ike-no Taiga, the first painter of the Nariga school, created a landscape (section of a six-fold screen) in a calligraphic black-ink style derived from China. Bold Japanese characters adorn another image by Ike-no Taiga. A pair of small screens with landscape scenes are by Maruyama Okyo and represent the realistic trends of the Maruyama Shijo school in the eighteenth century. From the late seventeenth or early eighteenth century is a magnificent Nō robe of painted silk with an orange lining, a work made to contrast with the severely controlled action, subtle text, and restrained movement of the classic Nō play. The design, a pine, bamboo and prunus motif known as "The Three Friends," is ascribed to a major painter of the period, Ogata Korin.

Art of African, Oceanic, and New World cultures is exhibited on the first floor of the museum and is arranged by geographical area; the collection was begun in the early twentieth century when ethnologist Stewart Culin led museum expeditions to Texas, New Mexico, California, the Queen Charlotte Islands, the Bahamas, and elsewhere, returning with hundreds of objects. The Brooklyn's

collection is especially strong in American Indian art of the Southwest. In 1922 Culin negotiated in London and Belgium and obtained for Brooklyn an excellent group of Central African objects that today forms the core of a fine African collection.

Examples, presented in a series of rooms, offer a survey of African cultures. From Central Africa, a Kongo wooden figure, perhaps a fetish symbol, is studded with nails and a mirror (Zaire or Congo); a terracotta vessel has as a spout a figural head (Mangbeh, Zaire); a transverse horn of ivory and fiber is finely carved with figures (Yombe Group, Kongo, Zaire, or Congo); and a cloth patterned with a geometric design in beige and brown is made of bark and raffia (Kuba, Zaire). An elaborately carved chair from the Chokwe or Loena (Zaire or Angola) derives in form from European chairs of the seventeenth century. The sculpted scene on a top splat is associated with the Chokwe rite of passage, *mukanda*; on the lower rungs, scenes focus on the mortal world, with images of childbirth, two men playing a slit drum, and so on. A decorative dance costume is also from the Chokwe or Loena, and a carved figure of wood, brass, and raffia cloth is from Zaire. One of the finest pieces in the collection is a seated carved figure, *King Bom Bosh*, from Kuba, Zaire, acquired by the museum in 1961.

Other regions represented include the Ivory Coast, with several carved wooden figures, masks, and gold ornaments. Carved figures and wooden headdresses are from southern Africa, and a woven cotton textile with a geometric pattern is from Gola, Liberia. The ancient Benin civilization of Nigeria is represented by several pieces including a bronze head and an ivory gong, both from the seventeenth century. From the Eastern Horn (Ethiopia) examples testify to the influence of Christianity on this region with several crosses of silver and/or brass. A triptych depicts the Madonna and Child with scenes from the life of Christ.

Art of Oceania is exhibited in cases by geographical region. From Melanesia is a large wooden feast bowl (Admiralty Islands). A "Ship of the Dead" textile is made of woven cotton and exemplifies the high level of this craft in Indonesia. Several wooden figures are also from these islands. From New Guinea, carved canoe prows, shields painted boldly with geometric patterns, a cult house post, and carved wooden figures are exhibited. A rattan house gable mask representing a face is from the Middle Sepik River region. Objects from New Zealand include a carved door lintel, sculpted wooden figures , and a tapa cloth made from dark paper and pigments, among other objects. Examples of the smoothly formed bowls particular to Polynesia are in the collection together with carved figures from these Pacific islands.

Pre-Columbian cultures in America are represented by numerous works of art forming an outstanding collection. From South America, embroidered textiles and pottery are exhibited. Ceramic vessels are from the Inca Empire and date from 1430 to 1532. A set of panpipes is from Mazca (100–800), as is a double-spouted vessel painted with abstract representations of fish. From Chiu Chiu (1000–1400) is a carved snuff tray and metalware, including a silver beaker carved with a figure, gold ear ornaments, and fanciful silver clasps fashioned

as sea creatures (a lobster, a crab, and so on). A group of ceramic burial urns sculpted with figures are from the Magdalene River Valley (1200–1500) in the northern Andes.

Brooklyn houses perhaps the finest collection of ancient Peruvian textiles outside that country. Examples of the craft, the oldest and most important means of communication in the central Andes, includes *The Paracas Textile*. This important work found at the Paracas Necropolis (South Coast of Peru) combines a loosely woven central field patterned with stylized faces and a multicolored wool border decorated with a procession of more than ninety intricate, three-dimensional figures. An embroidered mantle also from the Paracas Necropolis is fashioned of alpaca wool and decorated with woven pairs of whales that swim around each other (first century B.C.-first century A.D.). Pottery from the Paracas Necropolis includes a funerary mask that would have been attached to a mummy bundle. Other examples of Peruvian pottery include a stirrup-spout jar from Mochura IV (North Coast of Peru), which is notable for its utilitarian form (easily attached to a belt), a form difficult to produce. The ancient Peruvian art of featherwork is represented by a hat considered to be one of the finest surviving examples of the craft: a mosaic-like decoration is created with colored feathers glued to either bark or fiber cloth.

Art from Costa Rica and Panama is well represented in the collection, forming a comprehensive group of objects from this region. Monumental stone stelae are from Costa Rica, as is a group of small stone figures (e.g., the *Dancing Figure*). Almost four thousand pieces in the collection are from the Minor C. Keith Collection, gathered in the late nineteenth century at Keith's Costa Rican hacienda. Elaborate gold and silver ornaments include a cast gold pendant in the form of a pair of crocodile gods; this piece was created by the intricate lost-wax process most frequently employed by master Panamanian goldworkers.

Art of the Mayan civilization, which flourished between A.D. 400 and 600 is included at Brooklyn. A tripod vase is decorated with Mayan hieroglyphs, and a jade pendant from the Ornate Phase of the Late Classical period (eighth century A.D.) exemplifies the Mayan regard for this precious material. Other pieces from Mesoamerica include a mask from the ancient metropolis of Teotihuacan made of white onyx and sculpted to represent a human face (A.D. 250–750). A jade Olmec plaque dates from 800 B.C. to 700 A.D., and from Jalisco, a terracotta figure of a seated woman is from A.D. 250–500. Aztec monumental stonework includes a carved relief representing the goddess Chicomecoatl, in volcanic stone; this goddess of maize (or corn), descendant of ancient fertility goddesses, is shown with her two attributes, two maize ears in her headdress and her serpent staff. A limestone freestanding sculpture of Quetzalcoatl is an important example of late Aztec style: cut-out areas offset the blocky solidity of the statue. Five pictorial manuscripts from Mesoamerica are in the collection, including the important *Lienzo of Ihuitlan*, a map-like geneological record of families that ruled southern Puebla and northern Oaxaco (painted on cotton cloth).

Brooklyn exhibits a comprehensive collection of American Indian art, much

of which was gathered during museum expeditions. From 1905 to 1908 Stewart Culin obtained objects from the Far West, including woven baskets, jewelry, and costumes. The Northwest Coast region yielded monumental totem poles made of wood and carved with mythic animals and figures representing ancestral crests. Beaded costumes and a robe of elk skin painted with images of buffalo, elk, and deer, with an illustration of a religious festival, the Sun Dance, are from the Plains Indians (nineteenth century).

Art from the Southwest was collected by Culin. A large group of kachina dolls is exhibited, including a kachina doll and mask from the Kwakiutle representing Saya tasha, the rain priest of the North, a member of the Council of Gods. Carved wooden masks are fashioned as animals and include a wolf and a whale, from the Zuni tribe. An elaborate "corn maiden headdress" decorated with images of Payatumu, god of music, flowers, and butterflies, is also from the Zuni.

The ancient Mississippian culture that flourished in the area that stretches from present-day Texas to Florida (1200–1700) has yielded a number of objects. A ceremonial pipe from Tennessee or Georgia is made of sandstone, and a carved figure forms the pipe's bowl. This civilization, which erected courts and pyramid-based temples paralleling those built in Aztec Mexico, is represented at Brooklyn by numerous objects, including examples of pottery.

From the Far North, Culin brought back, between 1905 and 1911, costumes and objects of everyday life. A painted wood mask from the Kuskokwin region of Alaska was meant to be worn at spring ceremonies related to hunting. Engraved ivory teeth from the sperm whale are decorated with simple scenes of boating, fishing, and other activities.

The Paintings and Sculpture Department maintains galleries on the museum's fifth floor. European paintings from the fourteenth to twentieth century are arranged chronologically in a series of rooms refurbished and reinstalled in 1983.

Italian paintings in the collection include some excellent examples. A triptych, the *Madonna and Child with Saints*, with the *Annunciation*, *Nativity*, and *Crucifixion*, is by Maso di Banco and dates from about 1335. The *Madonna of the Humility* is by Lorenzo Monaco (c. 1415), and *God the Father with Four Angels and the Dove of the Holy Spirit* is by Giovanni Francesco da Rimini. A panel, *St. Francis of Assisi*, is by Bartolomeo Vivarini, and a *Madonna and Child with Angels* is by Pseudo Pier Francesco Fiorentino (late fifteenth century). Lorenzo d'Alessandro da San Severini produced the double-sided processional standard *Christ on the Cross with Saints Thomas Aquinas, Catherine of Siena, Dominic with Worshipping Nuns, James Major, and an Unidentified Saint. St. James Major*, a panel by Carlo Crivelli, was originally part of the polyptych *Madonna and Child Enthroned with Four Standing Male Saints* and was acquired by Brooklyn in 1978. This work, like many others in the collection, was originally in the collection of Frank L. Babbott, who served as president of the Brooklyn Institute from 1920 to 1928. Other works from Babbott's collection at Brooklyn include *The Adoration of the Magi* by Bernadino Butinone (c. 1480); a predella

panel, the *Annunciation*, by Nicola di Maestro Antonio d'Ancona; *Mars and Venus* (which some scholars believe to be by Giorgione), by Palma Vecchio. *Portrait of a Man* by Giovanni Bellini is from about 1500, and *Portrait of a Young Man as St. Sebastian*, by Jacometto Veneziano is from about 1485.

From the sixteenth century, a canvas, *The Battle of Asolo*, is by Jacopo Tintoretto; the grandiose scene executed about 1545 commemorates the presentation of the city's standard to Federico Contarini, who had in 1516 successfully defended this Veneto city against forces of the Holy Roman Empire. A delicate painting by the eighteenth-century Italian Giovanni Paolo Pannini is titled the *Adoration of the Magi*.

Dutch paintings from the seventeenth century include Adriaen van Ostade's *Peasant at a Window*. Landscapes by Meindert Hobbema feature *Hamlet in a Wood* of about 1660–65 together with other works. Portraits include Frans Hals' early canvas *Portrait of a Man Holding a Medallion*, from about 1614–16; Gerard Ter Borch's *Portrait of a Man* and its pendant *Portrait of a Lady*, both from about 1660; and Gerard Dou's *Burgomaster Hasselem and His Wife*.

French paintings of the nineteenth and twentieth centuries are very well represented at Brooklyn. Delacroix's *The Disciples at Emmaus* from 1853 and his *Desdemona Cursed by Her Father* from 1839 are exhibited. The *Study for a Wounded Courassier* by Géricault is from about 1812, and an Orientalist picture by Gerôme is titled *The Carpet Merchant of Cairo*, from about 1870. Works by Corot include *Landscape-Ville d'Avry* from 1865, *Young Women of Sparta* from 1868–70, and an elegant portrait, *L'Albanaise*, from 1872. *The Silent River* is a lush landscape by Courbet (1868), and Daubigny's *The River Seine at Nantes* is from about 1865. Other works in the collection are by Millet and Fantin-Latour.

In March 1921 Brooklyn opened an exhibition, "Paintings by Modern French Masters—The Post-Impressionists and their Predecessors," establishing a commitment on the museum's part to more avant-garde painters. Many of the works were loaned by Dirkan Khan Kelekian, and from this fine collection, Brooklyn acquired in 1922 van Gogh's *Self Portrait*, Matisse's *Interior*, Pissarro's *The Climbing Path, The Hermitage, Pontoise* from 1875, and Toulouse-Lautrec's *Portrait of Paul Sescau* and *Seated Woman with a Cigarette*. A year earlier, the museum had acquired important works by Edgar Degas, including *Mlle. Fiore in the Ballet "La Source"*, *Portrait of a Man*, and *Woman Drying Her Hair*.

Other works of the Impressionist and Post-Impressionist schools include a landscape by Renoir, *Vineyards at Cagnes*, from 1906 and canvases by Monet, *Church at Vernon* from 1894, *Rising Tide at Pourville* from 1882, *Houses of Parliament*, and *Effect of Sunlight* from 1903. A landscape by Cézanne is the *Village of Gardanne*, dating from 1885–88. A small pastel by Gauguin was painted during the artist's Tahitian period.

From the twentieth century, works by Matisse include *Nude in a Wood* from 1905, the flower *Still Life* from about 1905, and the landscape *Carrefour de Malabi* from 1916–17. A bold landscape by André Derain dates from about

1910, and the portrait *W. S. Davenport* is by Kees van Dongen. Other paintings include Odilon Redon's *Jacob Wrestling with the Angel* (c. 1908), Pierre Bonnard's *The Breakfast Room* (1927–30), and Jacques Villon's portrait *The Philosopher* (1930).

Brooklyn houses an excellent collection of American paintings, with works from the eighteenth through the twentieth century. American works were first collected in the mid-nineteenth century, when Augustus Graham, head of the Brooklyn Institute, set aside funds for the acquisition of works by "native artists with the purpose of forming a gallery of Fine Arts." Additional funds were allocated by Graham in 1851, and in 1855 Asher B. Durand was commissioned to paint *The First Harvest in the Wilderness* as a memorial tribute to Graham. The art gallery expanded slowly, and in 1887 only fifteen paintings were in the collection. The collection began to expand only after 1897, when the Department of Fine Arts moved to quarters in the museum's newly constructed West Wing. Today, American paintings are exhibited on the fifth floor.

A number of important early paintings are at Brooklyn, including from before 1750 several anonymous works: the portraits *Lavinia Van Vechten* (c. 1720), *William Taylor* (c. 1730), *Pierre van Cortlandt* (c. 1731, formerly attributed to Peter Vanderlyn), and others. Joseph Blackburn's portrait *Mrs. Wyseman Clagett* is from about 1760, and Jeremiah Theüs' portrait *Elizabeth Rothmaler* is from 1757. Portraits of *William Allen* and *Mrs. William Allen* from about 1760 are by John Wallaston, and the full-length portrait *Deborah Hall* is by William Williams (1764). Works by Joseph Badger include the three-quarter-length representation *John Haskins* and *Mary Haskins* (1754) and, by John Smibert, the portraits *Captain James Gooch* and *Mrs. James Gooch* (c. 1740).

John Singleton Copley is represented by the portraits *Mrs. Benjamin Davis* (c. 1764) and *Mrs. William Eppes* (c. 1769) and by other works. Portraits by Charles Willson Peale include *Mrs. William Strachan* (c. 1771–72), *Mrs. David Forman and Child* (c. 1784), and the full-length painting *George Washington* (1776). Gilbert Stuart's full-length portrait *George Washington* in an interior is from 1796. Other works by Stuart include the portraits *Colonel Isaac Barre*, 1785, and *Mrs. Robert Nicholls Auchmuty*, about 1815.

Paintings from the early nineteenth century include two charming scenes by Francis Guy, *View of Baltimore from Chapel Hill* (c. 1803) and *Winter Scene in Brooklyn* (c. 1817–20). The Peale family is represented by several works, including the portrait *Richard Harwood* by James Peale (c. 1795–1805), still lifes by Raphaelle Peale (e.g., *Still Life with Peaches*, 1821), and Rembrandt Peale's portraits *George Taylor of Philadelphia* (c. 1820–28) and *Eleanor and Rosalbe Peale* (1826). Ammi Phillips, who continued to work in a more "primitive" style, is represented by the portrait *Mrs. John Vincent Storm*, about 1835–40. Portraits by Thomas Sully include *Anne W. Waln* (c. 1808), *Cumberland Dugan*, and *Lady with a Feather Fan*. Benjamin West's canvas *The Angel of the Lord Annunciating the Resurrection to the Three Marys at the Sepulchre* is from 1805. William Sidney Mount, known for his genre scenes of

American life, is represented by *Boys Napping in a Field* (1848) and the portraits *Barnet Johnson* and *Mrs. Barnet Johnson* (1832). A version of Edward Hicks' *Peaceable Kingdom* dates from about 1840–45.

Paintings by adherents of the Hudson River School are exhibited at Brooklyn: Albert Bierstadt's monumental canvas *A Storm in the Rocky Mountains—Mount Rosalie* from 1866 is among the works by that artist; an atmospheric scene by Frederic Edwin Church is the *Tropical Scenery*, 1873. Several canvases by Thomas Cole are in the collection: *Castle and River*, about 1832; *View of Two Lakes and Mountain House, Catskill Mountains, Morning*, 1844; and *The Pic-Nic*, 1846 (which represents the artist and his wife, Maria). In addition to *The First Harvest in the Wilderness*, works by Asher B. Durand include *A Catskill Stream*, 1867, and *Beech and Maples*, an undated woodland scene. George Inness' *On the Delaware River*, 1861–63; *Homeward*, 1881; *Montclair Landscape*, 1892, and numerous other paintings are at the Brooklyn Museum.

The Tonalists captured the pristine light of upper New York State, and this group is represented by Martin Johnson Heade's *Summer Showers* (c. 1862–65), John Frederick Kensett's *Lake George* (1870), and Fitz Hugh Lane's luminous *Off Mount Desert Island* (1856).

From the second half of the nineteenth century, genre paintings include George Caleb Bingham's rousing *Shooting for the Beef* of 1850. Domestic quietude, on the other hand, is captured in Eastman Johnson's *Not at Home*, one of a series of Victorian interiors where the artist's concerns were for pictorial design and light effects. Several works by Philadelphian painter and teacher Thomas Eakins include *Oarsmen on the Schuylkill* (1873), *Home Scene* (c. late 1870–71, a depiction of the artist's sisters Margaret and Caroline), and a penetrating portrait *Letitia Wilson Jordan* (1888). *William Rush Carving His Allegorical Figure of the Schuylkill River* from 1908 represents the artist Rush in his studio.

In the Mountains, a landscape highlighted with areas of broad color, was painted by Winslow Homer in 1877. William Morris Hunt's *Study of a Female Head* from 1872 is a lovely, idealized rendering. Several works by the enigmatic painter Albert Pinkham Ryder include *The Sheepfold* (late 1870s), *Evening Glow, The Old Red Cow* (1870s-early 1880s), *Summer's Fruitful Pasture* (1870s-early 1880s), and *Marine Moonlight* (1880s).

Emanuel Leutze's historical scene *Columbus before the Queen* from 1843 is exhibited. A country scene by Ralph Albert Blakelock is *The Farmhouse of T. B. Guest* (c. 1865). A work by the trompe-l'oeil master John Frederick Peto, *Still Life with Lanterns*, is from after 1889. Classical art and mythology were the inspiration of John La Farge in *Woman Centaur* of 1887 and for the representations *Adoration (No. 1)* and *Adoration (No. 2)* from 1899. Works by Elihu Vedder include *The Music Party* (also known as *Five Figures on a Balcony*, 1868). Edwin Lord Weeks painted *The Old Blue-Tile Mosque Outside Delhi, India*; *Red Sandstone Arches, Fort Agra, India*; and other works.

Brooklyn houses an excellent group of works of the American Impressionist school. Mary Cassatt's *Mother and Child* ("Baby Charles Looking over His

Mother's Shoulder No. 3'') from 1900 is exhibited. Several works by William Merritt Chase include the *Study of a Girl in a Japanese Dress*, the portrait *Lydia Field Emmet* (c. 1893), and a representation of the artist's studio in the famous Tenth Street Studio Building, *In the Studio* (c. 1880). Frank Duveneck's *Villa Castellani*, an impressionistic Italian landscape, and his portrait *Mary Cabot Wheelwright* (1882) are in the collection. A late portrait by Frederick Frieseke is *The Artist's Daughter* (1927). Paintings by Childe Hassam include *Late Afternoon: Winter 1900* and *A Back Road* (1880s). Light-filled landscapes by Ernest Lawson include *Winter, Garden Landscape*, and *Winter Landscape: Washington Bridge*. *Death of the First Born* (1888) is by Robert Reid, as is *The Old Gardener*. Edward H. Potthast's scenes of the seashore are in the collection: *Bathers*, about 1913; *On the Beach*; and *Rocks and Sea*. Theodore Robinson's *La Roche Buyon*, an oil on panel, shows a woman reading (1891), and his *Willows (En Picardie)* is also from 1891.

John Henry Twachtman's *Niagara* is from 1894, and *The End of the Rain*, an oil or gouache on paperboard, is from about 1890–1900. *Union Square* is by J. Alden Weir, as is *The Willimantic Thread Factory*, 1893, and a country landscape, *A French Homestead*. A number of works by John Singer Sargent include *Paul Helleu Sketching with His Wife* from 1889, an informal portrait of Helleu on his wedding trip. The portrait *Augustus Healy* dates from 1907. Landscapes by Sargent include *Dolce Far Niente*, a picnic scene from 1909–10, and *Val d'Aosta (A Stream over Rocks)* from about 1910.

Early twentieth-century paintings include William Glackens' *Nude with Apple* (1910), *Bathing at Belport, Long Island* (1911), and *Children Roller Skating* (c. 1918–21). Robert Henri is represented by *Laughing Girl* (1910) and *Woman in a Manteau* (1898). George Luks' *Hester Street* is a lively scene from 1905, and his *Prospect Park*, rendered in oil on panel, is distinguished by loose and broad brushstrokes. *Pennsylvania Station Excavation* is by George Bellows, as are *A Morning Snow—Hudson River* (1910) and *The Newsboy* (1916). A theater scene by Everett Shinn is *Keith's Union Square* (c. 1906). John Sloan's *Haymarket* from 1907 represents a dance hall formerly on Sixth Avenue and 14th Street, a hangout for underworld figures in Sloan's time.

Other paintings in the collection include Thomas Hart Benton's *Louisiana Rice Fields* from 1928 and Reginald Marsh's *The Bowl*, executed in egg tempera on press-wood panel (1933). *Automobile Tires*, an oil on panel, is by Guy Pene du Bois, who also painted *The Confidence Man*, 1919. Marsden Hartley's *Painting No. 48* is from 1913, and his *Ghosts of the Forest* is executed in oil on academy board. Edward Hopper's *Macomb's Dam Bridge* is from 1939, and Arthur Dove's *Flat Surfaces* is from 1946. Morgan Russell's *Abstraction* is an undated work. Charles Sheeler's fascination with machines is captured in *Incantation* from 1946. Works by Raphael Soyer include portraits of artists, *Arshile Gorky* (1943–44) and *Abraham Walkowitz* (1940). The portrait *Moses Soyer*, the painter, is by Joseph Stella (1944), as is an earlier canvas, *The Virgin* (1922). Paintings by Abraham Walkowitz include a *Self Portrait* from 1903 and *Fishing*

Port from 1905. An abstract landscape with figures is by William Zorach (c. 1913), and works by Georgia O'Keeffe include *Pansy* (1926) and *Brooklyn Bridge* (1948).

Art from post–1945 includes works by Willem De Kooning (*Woman*, 1953–54, an oil on paperboard) and Hans Hofmann (*Towering Spaciousness*, 1956). *Sunset* (1952) is by Milton Avery, and *Lorelei* (1957) was executed by Helen Frankenthaler. Ilya Bolotowsky's *Opalescent Vertical* dates from 1955. An untitled work by Jim Dine is an abstract expressionist oil and collage on paper (1959). A large abstract canvas by Richard Diebenkorn is titled *Ocean Park #27* and dates from 1970. Lee Krasner's *Mysteries* from 1972 features bold, abstract forms. Jules Olitski's *9th Loosha* (1970) is a minimal work in acrylic on canvas. *Untitled-Composition #104* is by Ad Reinhardt (1954–60), and Larry Rivers' *July, 1956* is a suburban scene purposely arranged as a snapshot. James Rosenquist is represented by *Hello, Hello, Hello*, an acrylic on canvas from 1973, and works by Frank Stella include The "Miniature Benjamin Moore Series," a group of six canvases: *Palmito Ranch, Sabine Pass, Hampton Roads, Island 10, New Madrid*, and *Delaware Crossing*.

Examples of sculpture at Brooklyn include, from the early nineteenth century, the bronze *Satyr and Nymph* by Théodore Géricault and, from the twentieth century the bronze *Standing Woman* by Gaston Lachaise (1932). American pieces from the the nineteenth century include Hiram Power's marble statue *The Greek Slave* and Daniel Chester French's monumental allegorical figures *Manhattan* and *Brooklyn* (commissioned for the facade of the Brooklyn Museum). Several works by Auguste Rodin were recently presented to the museum, including *The Age of Bronze* (1876–77).

The Frieda Schiff Warburg Memorial Sculpture Garden presents architectural sculpture, most of which was retrieved from demolished buildings within the five boroughs of New York City. The garden began about 1959 with a gift from the late Walter Rothschild in memory of his mother-in-law. Objects did not begin to arrive until 1960, when the Anonymous Art Recovery Service headed by Ivan Karp offered Brooklyn a collection of architectural ornaments salvaged from New York structures. The city of New York elected to share the cost of transforming the museum's backyard into a parking lot with the Florence A. Blum Forsythia Gate to the adjacent Brooklyn Botanical Gardens and the Warburg Memorial Sculpture Garden as an entrance to the Brooklyn Museum.

The garden, designed by Ian McKibbin White along with members of the museum staff, benefited from several key gifts: a clock figure from the demolished Pennsylvania Station was presented by Irving Felt; railings from the Police Gazette Building, San Francisco, were given by William Zeckendorf; corbels from San Francisco were presented by Melvin Belli; six capitals from the Bayard Building on Bleecker Street designed by Louis Sullivan were donated to the museum; and from Frederick Field, objects from Coney Island's Steeplechase were presented.

The garden is unique in that it gathers fascinating but often little-known and

anonymous examples of sculpture. Pieces include a nineteenth-century keystone in the shape of a grotesque mask; a nineteenth-century limestone Atlantis figure; a formed zinc American eagle from the early twentieth century; a limestone keystone from the Park Lane Hotel, about 1925; a brownstone cartouche in the shape of a young woman's head from the early twentieth century; and numerous columns, capitals, keystones, cornices, moldings, and architraves from nineteenth- and twentieth-century buildings.

The Prints and Drawings Department offers a survey of works on paper from the fifteenth through the twentieth century, with special emphasis on contemporary works (post–1945). The Study Room is maintained by the department, and exhibitions are installed on a rotating basis in galleries on the first and second floors.

Albrecht Dürer's engravings *St. Eustace* from 1501 is one of the many works by Dürer in the collection; recently, the *Great Triumphal Chariot of the Emperor Maximilian I*, an eight-sheet woodcut panel, was presented to Brooklyn by the Roebling Society. Rembrandt van Ryn is represented by more than fifty-three prints, including an etching from 1643, *The Three Trees*, a characteristic scene by the seventeenth-century Dutch artist. Tiepolo's etching *The Magician Seated Observing Three Sculls* is from the artist's late series "Scherzi di Fantasia." Jean-Honoré Fragonard's pencil and sepia drawing *The First Lesson in Horsemanship* is one of several family scenes and portraits the artist created in the 1780s. Goya's famous 1799 series of etchings "Los Capriccios," is represented at Brooklyn, and among the more than sixty-four prints by Honoré Daumier is his comic lithograph from 1834, *Lafayette! . . . Attrapé Mon Vieux!* James A. McNeill Whistler is represented by more that ninety-five prints, including *Drouet*, a portrait in drypoint from 1859.

Impressionist works on paper include Edgar Degas' drypoint and aquatint *At the Louvre: Mary Cassatt at the Etruscan Gallery*, a rare impression of the fifth state (of six). Toulouse-Lautrec's charcoal drawing *Portrait of Comtesse Adele Toulouse-Lautrec* is a strong image of the artist's mother. A pencil study, *L'Amour de Puget*, was executed by Cézanne after Puget's sculpture at the Louvre (q.v.) (which Cézanne kept, as a plaster cast, in his studio). Vincent van Gogh's drawing *Cypresses*, executed in reed pen and ink, was done in 1889 during the artist's stay at the asylum at St. Remy. A lithograph by Pierre Bonnard, *La Blanchisseuse*, suggests in its use of flat color and pattern the influence of Japanese prints on this artist's work. Mary Cassatt's *La Toilette*, a drypoint and aquatint with color, employs the same Japaneselike patterns and flat areas.

Edvard Munch's lithograph *Eve Mudocci* from 1903 (also known as *Lady with Brooch* or *Madonna*) is in the print collection, as is a color lithograph by Georges Rouault, *Le Conducteur de Cheveux* (1910). Georges Braque's drypoint and etching *Fox* is in the Cubist style. Works by Pablo Picasso include a conte crayon drawing from his neoclassical period, *Head of a Young Man* (1923), and an impression of his etching *Minotauromachy* from 1935. An important early drawing by Paul Klee, *Portrait of a Pregnant Woman (Lily)*, from 1907 was a study

for a later composition. Ernst Ludwig Kirchner's lithograph on yellow paper, *Woman with a Black Hat*, is a bold portrait, as is Max Beckmann's *Self Portrait in a Bowler Hat* (a drypoint from 1921). Prints by John Marin include an etching, *The Woolworth Building, New York, No. 3*, from 1913. A crayon drawing by Arshile Gorky, *Study for "They Will Take My Island,"* includes many of Gorky's abstract symbols and forms.

Contemporary prints and drawings are numerous at Brooklyn. In recent years, works on paper by Will Barnet, Red Grooms, Robert Indiana, Donald Judd, Larry Poons, Robert Rauschenberg, and Andy Warhol, among others, have been acquired.

Photographs are also collected by the Prints and Drawings Department, and in recent years the department has presented several exhibitions. Among the additions to the collection are photographs by Margaret Bourke-White.

The Decorative Arts Department includes both European and American works of art, from small objects to entire rooms. The first European period rooms were installed in 1925 in the south wing of the museum and include a Swiss Gothic room, a Venetian mirrored salon, an entire full-size Dutch house, and two halls from an Italian Renaissance palace that were recreated or assembled. European decorative arts are today exhibited on the museum's fourth floor.

Renaissance and Baroque furniture includes a walnut buffet from Dijon, France (c. 1600), its richly carved surface decorated with architectural ornaments. A walnut armoire from Peru (c. 1650) reveals the taste for Baroque flamboyance in colonial South America. Glassware such as an English goblet (1680–90), perhaps produced by George Ravenscroft, is embellished with applied decoration. A tea caddy from Delft, Holland, is glazed in the blue and white associated with this pottery center, with a scene of a lady and gentleman at tea. From Staffordshire, England, a saltglaze stoneware bowl features applied relief decoration with the battle of Porto-Bello from about 1740. A blue and white jasperware plaque with four Muses and Apollo from the house of Wedgwood and Bently (England) represents Erato, Muse of Erotic Poetry; Euterpe, Muse of Lyric Poetry; Apollo; Clio, Muse of History; and Calliope, Muse of Epic Poetry. A permanent installation of Wedgwood ware from the Emily Winthrop Miles Collection was completed on the museum's fourth floor in 1982. Also from the eighteenth century, a set of four porcelain figures representing four continents are from Frankenthal, Germany (c. 1780). Metalware includes a silver tray designed by Paul de Lamerie (England c. 1720) and a wrought-silver spice container, a Jewish ritual object from mid-nineteenth-century Poland.

A gallery is dedicated to twentieth-century design, and examples include a chaise lounge by architect-designer Le Corbusier from 1928 made of chrome-plated steel with ponyskin and a tea table by Carlo Molino from about 1950.

American period rooms were first installed in 1925 in the newly completed south wing of the museum; these same rooms are currently being refurbished, a long-term project. Originally, the nineteen rooms that opened to the public in 1929 presented interiors from the 1720s to the 1820s; today, the rooms range

in date from 1675 to 1928 and are organized geographically by region on the museum's fourth floor. The Brooklyn Museum exhibits not only rooms but, in some cases, entire ground floors for a comprehensive picture of American domestic life.

The *Jan Martenz Schenck House* dates from about 1675 and is reconstructed in its entirety (two rooms), exterior and interior. This small building was located until the mid-twentieth century in the Flatlands section of Brooklyn and includes a parlor-bedroom and kitchen-dining room. The parlor features a panel-enclosed bed and other pieces.

The ground floor of the *Henry Trippe House* was acquired by the museum in 1917 and dates from 1724–31; the house was originally located in Secretary, Maryland. The ground floor from the *Cupola House*, Edenton, North Carolina, dates from about 1758 and features elaborate woodwork and wainscotting in the hall. The *Doctor Ezekial Porter House*, Wethersfield, Connecticut, about 1755, includes a bedchamber and first-floor bedroom. A dining room from Danbury, Connecticut (c. 1755), features paneled walls with corniced windows, and a New England "chamber" from the *Reuben Bliss House*, Springfield, Massachusetts (c. 1754), is furnished with a Queen Anne high chest from Connecticut and a "pencil post" bed. The *Joseph Russell House*, Providence, Rhode Island (c. 1772), was acquired in 1920; the house was built by a prominent merchant, and its handsome architectural details are believed to have been inspired by designs in architectural handbooks of the eighteenth century. The parlor of this three-story structure is furnished with American Chippendale pieces from the 1770s, including a block-front chest and a claw-foot card table. The *Robert J. Milligan House*, Saratoga, New York (c. 1853), was built as a "Renaissance villa" by an affluent merchant and features a suite of parlor furniture in the Victorian style by Galusha Brothers of Troy, New York (1850s).

The Brooklyn Museum presents an excellent collection of American decorative art from all periods. Special galleries such as the Folk Art Gallery, Empire Corner, Nineteenth-Twentieth Century Gallery, and Contemporary Decorative Arts Gallery focus on specific styles or periods. The Study Gallery is open by appointment to view silver, pewter, glass, ceramics. and other items.

Silver, made in America from the earliest colonial period, includes a tankard by Jacob Boelen, New York (c. 1685). A spool-shaped salt by Jacobus Vander Spiegel, New York (c. 1690), is considered an important piece, the single known example of a Dutch-style standing salt in America. A cherry-wood table from New York or New Jersey (c. 1690) features a fold-down top, and a walnut-veneered high chest from New England (1680–1710) is designed in the William and Mary style. An oak and pine chest-on-frame also from New England (c. 1680) features turned legs and painted front panels. A chest from Hadley, Massachusetts, 1706, is carved with abstract floral designs, and a pine book box (New York?, c. 1675) is decorated with geometric patterns associated with the Dutch settlers.

Early-eighteenth-century metalware includes a silver beaker by Henricus Boe-

len, New York (c. 1730), made as a communion cup for the Dutch Reformed Church, Flatlands, Brooklyn. A silver coffee pot by Daniel Christian Fueter, New York (c. 1765), features a tall pyriform shape. A rare pewter writing stand was designed by Henry Will, New York, and a pewter teapot that takes its shape from English silver pots was designed by the well-known American pewterer William Will, Philadelphia (1764–98). A silver can or mug by Thomas Underhill, New York, about 1780, features an ear-shaped handle with a leaf decoration. From the eighteenth century, a mahogany dressing table made in New York, about 1770, includes details derived from earlier English models (e.g., Chippendale's *Director*). A cherry desk-bookcase (lined with chestnut wood) is decorated with abstracted classical motifs and simple geometrical forms (Connecticut, c. 1770).

Pottery and glassware from the eighteenth century include a sapphire-blue glass sugar bowl attributed to Henry William Stiegel (1765–74); a porcelain sweetmeat dish by Bonnin and Morris, Southwark, Philadelphia; and a pie plate of red earthenware with sgraffito decoration, about 1800, depicting a race between two men on horseback. A bed rug from the Connecticut River Valley (1790) is worked in blue crewels on a homespun, dyed, and woven plaid blanket with a clam shell motif. A wool and cotton coverlet is woven in an entirely reversible "summer-winter" weave (early nineteenth century).

Nineteenth-century objects include a silver tea set in the Empire style by William Thomson, New York (c. 1820), and a porcelain pitcher with a scene of Philadelphia (?) by Tucher and Temphill, Philadelphia (1832–38). A white earthenware plate in a "Canova" pattern is an American form of decorated Staffordshire creamware (American Pottery Company, Jersey City, c. 1840). Rococo Revival style is exemplified by a rosewood bed designed by John Henry Belter, New York (c. 1860), a craftsman known for his use of this material. Among the many objects by Louis Comfort Tiffany and his studio is a favrile glass vase that takes its form from Near Eastern models and is decorated with embedded striations in a feather pattern.

The Costume Galleries first opened in 1925 and were reinstalled in 1972. Examples of the collection (particularly rich in American costumes) include an American evening dress from about 1805 and a day dress in the high-waisted style of about 1815. A morning visiting dress from 1843 is a one-piece costume of striped red, purple, and gray satin. A luxurious ball gown in cream satin embroidered in a sprig motif with gold and silver wire coils dates from 1815. From the second half of the nineteenth century are an afternoon dress, full-skirted but without hoops (c. 1865–67), and an elaborate dinner dress of silver-blue and pale peach striped silk with a gold silk-taffeta runching (c. 1877). A French ball gown from the House of Worth (c. 1892) is made of blue silk-satin embellished with ribbons and butterflies and studded with brilliants. The tea gown from the House of Doucet (c. 1903–5) is of pearl-gray chiffon with ribbons and lace in alternating panels. A dinner dress from about 1913 reveals the influence of earlier

styles (Louis XIII, Empire, Second Empire) in its slim silhouette and layered effect with tunic. A tea gown and coat from about 1910–39 were designed by the Spaniard Mario Fortuny y Madrazo and include a pleated silk-satin afternoon dress and a coat of apricot velvet. More recent American fashions include a suit by Ren-Eta Gowns from 1942 of navy rayon-crepe and a black and brown three-piece suit by Norman Norell from about 1960. The French design house Christian Dior is represented by a coat with sculptural collar (known as the "oblique collar") from 1950. Fashions by Courrèges, Jacques Griffe, and numerous others provide a reference collection for students, designers, and manufacturers.

Textiles, embroideries, and lace are also part of the Costume Collection. An early seventeenth-century bed valance from England is worked in plain embroidery and knotted threadwork. A suite of crewel work embroideries was made in Holland for Richard San[d]ford of Nynehead Court, Wiltshire, England, and includes chair sets, valances, a quilt, curtains, and other pieces (c. 1688). A Russian embroidered net panel (eighteenth century) is part of a large group of Russian textiles, costumes, and folk art from the collection of Countess de Shabelsky, now housed at Brooklyn.

The Brooklyn Museum's Art School, which began in 1844 with a bequest from Augustus Graham, today offers studio classes taught by professional artists and craftsmen. In the past, teachers have included American painters John Twachtman and William Merritt Chase. Today, courses such as painting and drawing, printmaking, calligraphy, basic photography, and watercolor are offered for a small fee.

The Art School, formerly located in the museum's main building on the second and fourth floors, was moved in 1985 to the Pratt Institute in Brooklyn. Classes sponsored by the museum will be held permanently at Pratt.

The Brooklyn Museum emphasizes its role in the community and operates as a cultural center for the borough. Concerts, dance performances, and poetry readings are held at the museum. Gallery lectures for adults and programs for children (e.g., drawing and creating artwork in the galleries) are regularly offered.

The Art Reference Library of the Brooklyn Museum is located on the second floor and is open to interested persons by appointment. The Wilbour Library of Egyptology, an important research collection, is open Wednesday through Friday by appointment (located on the third floor).

The Brooklyn Museum's publications program is coordinated by the Department of Publications and Marketing Services. The *Brooklyn Museum Calendar* is a monthly newsletter of upcoming programs, exhibitions, and news about the museum. The *Brooklyn Museum Annual* is produced yearly and gives a financial report on the past year (or years), the activities and acquisitions of the curatorial departments, and lists staff, donors, lenders, and so on. The department is also responsible for producing handbooks and guides to the museum's collections as well as exhibition catalogues. The Brooklyn Museum Gallery Shop, located off the museum's lobby on the first floor, sells guides to the collections, postcards,

slides, art books by various publishers, and a large number of hand-made crafts, textiles, jewelry, and so on from around the world. A branch shop is located in Manhattan at the Citicorp Center (Lexington Avenue and 53rd Street).

Selected Bibliography

The Brooklyn Museum Handbook, 1967; *The Brooklyn Museum Annual Report*, 1959–82; *The Frieda Schiff Warburg Memorial Sculpture Garden*, 1966; *The Brooklyn Museum—American Paintings* (a complete illustrated listing of works in the museum's collection), 1979; *Masterpieces of American Painting from The Brooklyn Museum*, 1976 (introduction: Linda S. Ferber); *American Painting in The Brooklyn Museum Collection*, 1953; *The Brooklyn Museum is for Everybody*, n.d. (brochure); *You haven't seen New York until you have seen the Brooklyn Museum*, n.d. (brochure); Bothmer, Bernard V., and Jean L. Keith, *Brief Guide to the Department of Ancient Art*, 1970; Coleman, Elizabeth Ann, *Changing Fashions, 1800–1970*, 1972; Oppenheimer, Herbert, *Brooklyn Museum Architecture—A Community Art Center*, 1964; Schwartz, Marvin D., *American Interiors, 1675–1885: A Guide to the American Period Rooms at The Brooklyn Museum*, 1968; idem, *The Jan Martensz Schenck House*, 1964; Walker, Barry, *The American Artist as Printmaker*, 23rd National Print Exhibition, The Brooklyn Museum, 1983; *Neferut Net Kemit: Egyptian Art from The Brooklyn Museum*, 1983 (introduction Richard A. Fazzini, Robert S. Bianchi, and James F. Romano); "The Brooklyn Museum," *Apollo*, (April 1982), pp. 218–81 (several articles on the collections).

LORRAINE KARAFEL

FRICK COLLECTION, THE, One East 70th Street, New York, New York 10021.

The Frick Collection reflects the refined tastes of Henry Clay Frick, coke, steel, and railroad tycoon and lover of the arts, who began collecting in 1870. His collection was founded as a public gallery in 1920, one year after Frick's death. It is housed in a mansion that served as a residence for its owner but was envisioned by him from its concept to serve eventually as a public museum.

In his will, Henry Clay Frick bequeathed in trust, to a board of trustees, his residence and his works of art to establish a public gallery to be known as The Frick Collection "for the use and benefit of all persons whomsoever." It was his wish that the collection should continue to be displayed in the setting he had created for it.

According to the terms of his legacy, the collection is governed by a board of trustees that is empowered to make his bequest "a study of art and kindred subjects." The income from the endowment of this nonprofit, tax-exempt organization was to be used for the maintenance of the collection and for necessary alterations of the building. An unusual provision permitted the use of portions of the endowment for continued acquisitions.

The Board of Trustees that governs the collection is self-perpetuating. It is headed by a president and has nine members. The museum is administered by a director, assisted by a curator and a research curator. A librarian in charge of the Frick Art Research Library and a business administrator complete the staff.

In 1970 the Friends and Fellows of the Frick Collection were organized. Their support and financial assistance further the educational programs, such as lectures, special exhibits, programs for graduate students, and the Sunday concert series, offered to the public.

The mansion's construction began in 1913 and was completed in 1914. Situated on the site of the former Lenox Library, it was designed in classic eighteenth-century French style by Thomas Hastings of Carrere and Hastings, the architectural firm that also designed the New York Public Library. The sculptured decorations on the facades were created by the Piccirilli Brothers to fit into the architectural and stylistic scheme. Sir Charles Allom, of White Allom, London, was responsible for the concept of the ground-floor interiors.

The whole residence was planned as a setting for paintings and art objects, with ample galleries and a spacious floor plan that allowed for later additions. The major change in the layout of the mansion occurred in 1931. In preparation for its future function as a public gallery, the house was remodeled extensively. The carriage court was converted to form an interior garden court. This court, with its barrel-vaulted skylight, fountain, and coupled columns, is the work of John Russell Pope. It serves as a display area for sculpture and also accommodates the overflow audience that usually attends the Sunday afternoon concerts. Added at the same time were the beautifully proportioned Oval Room, the East Gallery, and a small assembly room. With the work of remodeling completed, The Frick Collection opened its doors to the public on December 16, 1935.

A highly selective group of superb paintings, spanning the fourteenth through the nineteenth century, forms the nucleus of the collection. Assembled are some of the finest examples of Dutch seventeenth-century, French fifteenth- through nineteenth-century, German, Italian Renaissance, Spanish, and American art.

This extraordinary collection has its proper setting in elegant rooms and galleries in the style of English and French eighteenth-century interiors, furnished with outstanding examples of the works of French and Italian master craftsmen. Shown with the paintings is a particularly noteworthy collection of sculptures, of which the Italian Renaissance bronzes are most numerous and of greatest significance. The drawings and prints are closely related to the paintings and are therefore of particular value to the study of the development of individual artists' work.

A small gallery is devoted to the luminous French Limoges enamels from the fifteenth, sixteenth, and seventeenth centuries and includes signed pieces by masters such as Leonard Limosin. Decorative arts are represented by French and Chinese porcelains and fine English silver, as well as some sumptuous Herat rugs.

The rooms serve to complement the paintings and are arranged with a freedom and flexibility aimed at retaining the character of a private residence. Thus display is not by the usual classification found in museums but in a personal eclectic fashion. Periods and styles, objects and countries, are mixed freely, and art is arranged in complete harmony with the room setting. There is an easy flow of

beautiful vistas from the moment one enters the vestibule with its two Vermeers and its Turner, where one gets the first glimpse of the courtyard with a fountain, sculptures, and greenery. The rooms and galleries are arranged around this courtyard.

A brief review of Henry Frick's forty years of intensive collecting traces his changing perceptions and interests in art. It began with an attraction to the Barbizon School of the late nineteenth century. One example of this period, *The Washerwoman* by Charles François Daubigny, is still in the collection. But soon his horizon expanded. The next few years he added English portraiture by masters such as Reynolds, Romney, Hoppner, and Gainsborough and important Dutch masters such as Vermeer with *Girl Interrupted at Her Music* and Rembrandt with *Portrait of a Young Man*. The year 1905 was decisive, marked not only by acquisitions such as El Greco's *St. Jerome*, van Dyck's *Ottaviano Canevari*, and Titian's *Pietro Aretino* but by Frick's decision to abandon the idea of building a home and gallery in Pittsburgh. He had decided that Pittsburgh's heavy smoke pollution presented a potential hazard to his treasures. Thus New York was chosen for the location of his future museum.

In rapid succession one masterpiece followed another—Rembrandt's brooding late *Self Portrait* (painted in 1658) and John Constable's serene *Salisbury Cathedral from the Bishop's Garden* (painted in 1862). Among the numerous important portraits are *Philip IV of Spain* by Velázquez, *Sir Thomas Moore* (painted in 1527) by Hans Holbein the Younger, and others by Frans Hals, Romney, van Dyck, and Reynolds. One must not fail to mention the acquisition of landscapes by van Ruisdael, Cuyp, and Hobbema.

In the next decade, the collection assumed its present character with the purchase of forty masterworks that range from one of the greatest Venetian Renaissance paintings, Giovanni Bellini's *St. Francis in Ecstasy* (completed in 1470), a large-scale landscape panel (49 by 55 7/8 inches), to the panels from Fragonard and the Boucher Rooms, including examples by Goya, Manet, Degas, Renoir, Whistler, and Turner.

Much has been made of the influence of the art dealer Joseph Duveen in guiding Frick in his purchases, but some of the finest pieces were bought at the recommendation of Roger Fry while the latter was curator of painting at the Metropolitan Museum. On his advice Frick bought the mysterious French fifteenth-century *Pietà with Donor*. In 1910 it was Fry who was commissioned by Frick to travel to Poland to buy Rembrandt's *The Polish Rider* and who also recommended the purchase of the Holbein and the two large (84 1/2 by 66 inches) Veronese allegories *The Choice of Hercules* and *Wisdom and Strength*. Nevertheless, Duveen was responsible for some of the finest acquisitions, most importantly, the Fragonards and Bouchers and the enamels and sculptures from the Morgan estate.

The earliest painting in the French group is the *Pietà with Donor*, a fifteenth-century tempera panel of the Avignon school. It continues with the *Sermon on the Mount* by Claude Lorraine set in a large landscape (67 1/2 by 102 inches)

and a gentle scene by Jean Siméon Chardin, *Lady with a Bird* (1751), both added by the trust after Frick's death.

French eighteenth-century Rococo is enchantingly represented by the works of Jean Honoré Fragonard and François Boucher, both in their own, special room settings.

Boucher's eight panels *The Arts and Sciences* depict cherubic children personifying various artistic and scientific subjects. They were painted for Madame de Pompadour for the Chateau de Crécy and are now set in an intimate room, all soft blue and gold, with furnishings that illustrate the mastery of craftsmen such as Jean Henri Riesener, Martin Carlin, and Louis Noël Malle.

In contrast, Fragonard's *Progress of Love*, romantic garden scenes, and ensemble of eleven canvases, is displayed in an airy, lofty room, paneled in pale grey and gold. The four largest panels, *The Pursuit*, *The Meeting*, *Love Letters*, and *The Lovers Crowned* (each about 125 by 90 inches) painted from 1771 to 1773, were commissioned and rejected by Madame du Barry for her chateau at Louveciennes. Their exuberant Rococo style was found unsuitable in the face of the neoclassical taste of the chateau. Fragonard later added the other panels, including the tall, narrow hollyhock panels that complete the ensemble. There, too, one finds a remarkable assemblage of other treasures of the period—a portrait bust by Houdon, Sèvres porcelains, splendid examples of fine furniture by Riesener and Jean Dupré, and two Beauvais tapestry chairs with designs by Boucher.

Nineteenth-century neoclassicism is introduced with a portrait by Jacques Louis David, *Comtesse Daru*, painted in 1810. The superbly drawn, richly textured portrait *Comtesse d'Haussonville*, done in 1845, is by David's pupil Jean Auguste Dominique Ingres. Landscape painting is noteworthy, with one of the period's most influential artists represented by paintings such as *The Pond* and *The Boatman of Montfontaine* by Jean Baptiste Camille Corot, precursor of the Barbizon School and Impressionism. The latter movement is illustrated by Édouard Manet's *Bullfight*, painted in 1864, which shows Goya's influence on the early work of this artist; Edgar Degas' *The Rehearsal*; and Renoir's *Mother and Children*. It leads to Post-Impressionism, with the works of Cézanne, Monet, and Gauguin, all post-Frick acquisitions that enhance the depth and scope of the French holdings by extending them into this century.

Of especially high quality are the works of the Dutch and Flemish school, with emphasis on the masters of the seventeenth century. Beginning with Jan van Eyck's *Virgin and Child, with Saints and Donor* (c. 1422) and Gerard David's *The Deposition*, there are eight portraits by Sir Anthony van Dyck (1599–1641) of which the portrait *Frans Snyders*, painted in 1620, is of striking elegance. Several of Frans Hals' portraits enrich the holdings of this period and include his boldly black and white *Portrait of a Man* (c. 1652). Jan Vermeer is represented with three genre scenes of which *Mistress and Maid* (unfinished) is said to have been one of Frick's favorites and his last purchase. Rembrandt's *The Polish Rider*, painted in 1654, is in stark contrast with the brooding, penetrating *Self Portrait*, created just four years later. Representative of Dutch landscape painting

are the works of Jacob van Ruisdael, with his *River Scene—Men Dragging a Net*; several Aelbert Cuyps; and the lively and luminous work of Meindert Hobbema, possibly a pupil of van Ruisdael, with his *Village among Trees* and *Village with Water Mill among Trees*.

The most delightful aspects of British portraiture, beautiful women and children in gracious settings, can be found here with the full range of leading eighteenth-century British artists. Among their works one finds Thomas Gainsborough's full-length (92 1/4 by 61 inches) portrait *The Honorable Frances Duncombe*; Sir Joshua Reynolds' delightful *Lady Hamilton as "Nature"*, painted in 1782; John Hoppner's *Ladies Sarah and Catherine Bligh* of 1790; the cooly elegant *Julia Lady Peel* with large feathered hat, as painted by Sir Thomas Lawrence; and William Hogarth's *Miss Mary Edwards*.

Particularly noteworthy is Gainsborough's *The Mall in St. James Park*, painted in 1783, and John Constable's *Salisbury Cathedral*, done in 1826. Several fine examples of the work of Joseph Mallord William Turner include his *Fishing Boats Entering Calais Harbor* and *Mortlake Terrace* of 1826.

It is interesting to note that some of the most significant Italian paintings, namely, those of the early Primitive schools, were added after 1920 to strengthen the collection's Italian holdings. Thus the earliest Italian painting, by Duccio di Buonisegna (c. 1255 to 1319), *Temptation of Christ*, a fantastic and powerful panel from the Siena Cathedral, was a later addition, as was one of the most important works in the United States by Piero della Francesca—his monumental *St. John the Evangelist* (c. 1466–70).

The *St. Francis in Ecstasy* by Giovanni Bellini, considered one of the most beautiful paintings of the Quattrocento, shows the lone figure of the saint in a detailed landscape that dominates as in no other painting before that time. Titian is represented with the portrait *Pietro Aretino*, painted about 1548 and remarkable for its sensuous subjective approach. One of the best portraits by Agnolo Bronzino is his smoothly eloquent *Lodovico Cappone*. Mythology and allegory are presented in Veronese's *The Choice of Hercules* and *Wisdom and Strength* and also in Tiepolo's *Perseus and Andromeda*.

A small but distinctive group of Spanish painters includes El Greco with the *Portrait of Vincenzo Anastagi* as well as *St. Jerome* and the *Expulsion from the Temple* of 1598. Baroque painting at its best can be found in Diego Velázquez's *Philip IV of Spain* (1644). Francisco Goya makes a strong impression with three portraits and the powerful *Forge* (1818).

American painting is limited to a Gilbert Stuart portrait of *George Washington* and several fine examples of the work of James Abbott McNeill Whistler. Showing the strong Japanese influence of the time are *The Ocean*, painted in 1866 in Chile, and the portrait *Mrs. Frederick R. Leyland* (who commissioned Whistler to design the famous Peacock Room, now at the Freer Gallery (q.v.), Washington, D.C. Typical also is the full-length *Valerie, Lady Meux* in silver greys and pinks, painted in 1881. In all, Frick acquired 131 paintings, and the trust has added another twenty-eight.

Prints and drawings are on display for special exhibitions only. The relatively small group includes the work of Pisanello, Rembrandt, Gainsborough, Rubens, Goya, Ingres, and Corot. Some of them are preliminary sketches for the paintings in the collection.

Throughout the galleries one finds pieces of exceptionally fine furniture. From France are examples from the seventeenth- and eighteenth-century workshops of Pierre Dupré, Louis Noël Malle, and André Charles Boulle (1642–1732). The latter's work is exemplified in a flat-top desk and a pair of chests decorated with brass ornamentation depicting Orpheus and beasts. Intricate fruitwood marquetry is found in the charming small *poudreuse* by Martin Carlin (d. 1785) and in Jean Henri Riesener's eighteenth-century chests of drawers and writing table, embellished with brass decoration. Intricate carving characterizes the Italian Renaissance coffers and tables in the West Gallery.

Having assembled the major portion of his paintings by 1915, Frick turned to sculpture and, after J. P. Morgan's death in 1913, acquired many of the Renaissance bronzes and other small sculptures that eventually became one of the finest collections of its kind in the United States. It was in that period that he also developed a greater interest in prints and drawings and turned to collecting enamels and other fine objets d'art.

Of the sculptures that are seen throughout the museum, the majority are small bronzes of the Italian Renaissance period. Originally loaned to the Victoria and Albert Museum in London, the owner at that time, J. P. Morgan, brought them to the United States after passage of the Payne Bill in 1909, which exempted works of art from duty (and initiated a steady flow of masterworks from Europe). They were on loan at the Metropolitan Museum at the time of Morgan's death. Florentine, Roman, and Venetian in origin, several are works after Michelangelo and after Cellini.

Outstanding are the small (twelve inches) statuette *Hercules* by Antonio Pollaiuolo, the relief *The Resurrection* by Vecchietta, *Neptune on a Sea Monster* by Severo da Ravenna and a most unusually shaped oil lamp by Riccio, all fifteenth- to early sixteenth-century works. A fine marble *Bust of a Lady* by Francesco Laurana is another important piece.

Among the German, Netherlandish, and French sculptures, the beautifully severe *Angel* by Jean Barbet now graces the garden court and may originally have come from the interior of the Church of Sainte Chapelle in Paris. Most appropriate in their setting are the portraits and statues of Jean Antoine Houdon, among which the *Comtesse du Cayla* and the life-size terracotta *Diana* are particularly effective.

A major attraction at the Frick is the small Enamel Room. Allegory, mythology, themes from the Bible and ancient history, and fine portrait plaques distinguish this extraordinary assemblage of French Limoges enamels from the fifteenth and sixteenth centuries. Among the wide variety of objects are plaques and small coffers, ewers, and candlesticks. A triptych with scenes from the Passion is by a member of a prominent family of enamelers, Nardon Penicaud.

Others are by the anonymous Master of the Large Foreheads, with a casket depicting Old Testament subjects by Pierre Reymond and one by Pierre Courteys (both sixteenth-century artisans) in a vigorous, colorful style, with the panels finely framed in decorative silver-gilt. Leonard Limosin, the craft's greatest exponent, shows strong Italian influence in the portrait plaque *Guy Chabot, Baron de Jarnac*. Jean de Court (Master I.C.) turned to mythology as evident in his tall candlesticks *Olympian Deities* and *The Labors of Hercules*.

The Chinese porcelains are so numerous that only a small fraction of them are on display. They fall into three groups: enameled wares, monochromes, and blue-and-white pieces. Most of the porcelains were purchased from the Morgan estate, but the blue-and-white pieces, 147 in all, were bequeathed to the collection in 1965 by Mr. and Mrs. Childs Frick. They date from the seventeenth and eighteenth centuries.

Chinese porcelains from the periods of highest refinement, namely the K'ang Hsi (1662 to 1722) and the Ch'ien Lung (1736 to 1795) periods and enameled wares of the Ch'ing Dynasty, which spans from 1644 to 1912, are all represented. The famille noire, famille rose, and famille verte classifications are highlighted with pieces such as a pair of tall (fifty-one inches) covered vases with bird-and-flower design and lotus finials.

Among the vases, bowls, and figurines, a female figure with an elaborate base is a fine example of the K'ang Hsi period, and typical of the Ch'ing Dynasty is a group of squared vases decorated with the flowers of the four seasons. Blue-and-white pieces include a small melon-shaped jar from the Ming Dynasty (1600) and a lovely set of four matched ginger jars with plum-blossom design from the eighteenth century.

French pottery and porcelains begin with a Saint Porchaire ceramic Renaissance ewer. Most notable among the Sèvres porcelains, which joined the collection after Mrs. Frick's death, is an unusual garniture consisting of a pot-pourri in the shape of a masted ship with two matching vases, dated 1759, on display in the Fragonard Room. Jean-Louis Marin created a water jug and basin with marine scenes, and a set of three pot-pourris by Myrte are decorated with Flemish scenes after Teniers. Both date from the late eighteenth century.

A small group of fine French and English silver is distinguished by the inclusion of two outstanding wine coolers, the work of William Pitts and of Paul Storr, who created the pair of grape-festooned wine coolers in 1811. Oriental rugs from the second half of the sixteenth century and the seventeenth century add to the rooms' sumptuousness. They include floral Herats (Isfahan) and Mughal rugs from India.

The ever-growing popularity of museums in general, and of The Frick Collection in particular, necessitated further expansion, which was completed in 1977. Eager to maintain the same pure classical style of the original mansion, the trustees commissioned John Barrington Bayley to undertake the design of the additions. His concept for the reception gallery, which had to be added because fire laws do not permit more than 250 persons at a time in the museum

itself, and an adjacent garden with its arched and relief-ornamented wall follow the style of the original so closely that it becomes difficult to tell the old from the new. Extensive improvements to the mechanical systems were undertaken at the same time.

The Frick Art Reference Library, founded in 1920 by Helen C. Frick in memory of her father, has research facilities for students, scholars, and connoisseurs interested in the history of European and American painting, sculpture, drawing, and illuminated manuscripts. The original library building, situated around the corner, was designed by Hastings and opened in 1924. It had to be torn down to make way for the extension of the gallery, but in 1936 the present library, constructed after the classical design of John Russell Pope, opened its doors again.

The library contains more than 80,000 volumes, 60,000 exhibition catalogs and pamphlets, 450,000 photographs, and 50,000 sales catalogs. Admission is by special pass only, obtainable upon application. Educational activities are planned for the adult public, especially for advanced students of art history. Annual symposiums are held jointly with the nearby Institute of Fine Arts, New York University. Lectures, related to the Collection, are given on a regular basis. Chamber music concerts are presented free to the public and are held on Sunday, about twelve times a year, in the 180-seat music room. Slides, catalogs, postcards, and books about the Collection are sold at the museum's sales and information center.

Selected Bibliography

The Frick Collection, an illustrated catalog, 8 vols. (Princeton, N.J. 1968–77) (catalog of prints and drawings in preparation); *The Frick Collection Handbook* (New York 1968); *Masterpieces of the Frick Collection*, introduction by Harry D. Grier, text by Edgar Munhall (New York 1970); Harvey, George, *Henry Clay Frick, the Man* (New York 1928); Knox, Katherine McCook, *The Story of the Frick Art Reference Library* (New York 1979); Meiss, Millard, *Giovanni Bellini's St. Francis in the Frick Collection* (Princeton, N.J. 1964); Holmes, Sir Charles John, "Rembrandt and Van Dyke in the Widener and Frick Collection," *Burlington Magazine*, vol. 13, no. 65 (August 1908), pp. 306–16.

<div align="right">RENATA RUTLEDGE</div>

METROPOLITAN MUSEUM OF ART, THE (alternately THE METROPOLITAN, THE MET, MMA), Fifth Avenue and 82nd Street, New York, New York 10028.

The Metropolitan Museum of Art is a public institution chartered in 1870 by the New York Legislature. It was founded, according to its charter, with the purpose of "encouraging and developing the study of the fine arts, and the application of the arts to manufacture, of advancing the general knowledge of kindred subjects and to that end of furnishing popular instruction and recreation." Today, the museum is encyclopedic in scope, presenting outstanding examples of fine and decorative arts from all periods.

A board of trustees, defined in the museum's *Charter Constitution and By-Laws*, oversees the administrative and curatorial activities of the Metropolitan. The members, elected because of their past service to the museum, appoint a director. There are seventeen curatorial departments, each run by a department head: American Art, Ancient Near Eastern Art, Arms and Armor, The Costume Institute, Drawings, Egyptian Art, European Paintings, European Sculpture and Decorative Arts, Far Eastern Art, Greek and Roman Art, Islamic Art, The Robert Lehman Collection, Medieval Art and The Cloisters, Musical Instruments, Primitive Art, Prints and Photographs, and Twentieth Century Art. The department head is assisted by a professional staff of associate curators, assistant curators, research associates and assistants, technicians, and support staff. Each department maintains a library and study facilities available to scholars and students by appointment. The Metropolitan Museum of Art presents a comprehensive permanent display of art from all periods and also organizes major loan exhibitions on an international scale.

In addition to having curatorial departments responsible for the acquisition and exhibition of objects, the museum also includes a number of service departments: The Conservation Department includes Object Conservation, Paintings Conservation, Paper Conservation, and Textile Conservation. Education Services include Community Education, High School Programs, Young Peoples' Programs, and Public Education. Library facilities include The Thomas J. Watson Library and The Photograph and Slide Library. The Administrative departments include the Office of the Vice President and Council, which oversees the Museum Archive and is involved in other activities. The Office of the Vice President for Public Affairs includes Concerts and Lectures, Development, Membership, and Public Information. The Office of the Vice President and Publisher oversees Editorial, Financial, Mail Order, Merchandise Production, and Retail and Institutional Sales Departments. The Office of the Vice President for Operations supervises the office of the Registrar (which maintains a card catalogue available to scholars and students with an appointment) and other internal services such as security.

The idea of a "metropolitan" museum was first voiced in Paris in 1866, when John Jay at a Fourth of July luncheon said it was "time for the American people to lay the foundation of a National Institution and Gallery of Art." In 1896 the concept was again presented by William Cullen Bryant at an address to the Union League Club in New York, and by January 31, 1870, a board of trustees was elected. The first gift was offered to the new museum, a Roman sarcophagus from J. Abdo Dabbas.

The Metropolitan Museum of Art, now located at Fifth Avenue and 82nd Street, had several locations before its present home. With the purchase of William T. Blodgett's collection of European paintings (the core of today's extensive collection), the museum was temporarily set up at 681 Fifth Avenue and opened to favorable reviews in 1872. Various gifts were added to the small collection.

In 1873 the purchase of six thousand ancient sculptures from the American consul in Cyprus, Luigi Palma di Cesnola, added to the collection considerably and necessitated the move to new quarters on West 14th Street. In 1874 ground was broken for a building in Central Park at 82nd Street, and the structure designed in the Gothic Revival style by Calvert Vaux was dedicated in 1880. In 1888 the building was enlarged to the south, which doubled the exhibition space and created a new entrance. A North Wing was added in 1894, and in 1895 the Great Hall with its wide stairway and a sculpted limestone facade were made possible with New York City funds. This section was completed in 1905. The museum was again expanded to the north in a wing designed by architects McKim, Mead and White in 1909. With the museum's centennial, a comprehensive Building Expansion Plan was formed. Under the direction of architects Kevin Roche John Dinkeloo and Associates, additional wings were constructed: the Lehman Pavillon, the Sackler Wing, the American Wing, and the Michael C. Rockefeller Wing for Primitive Art. A new wing to house Twentieth Century and European Sculpture and Decorative Arts is under construction and expected to be completed before 1986. With the Building Plan, most of the departments reinstalled their collections, including Egyptian Art and the European Painting Collection.

The entry to the Metropolitan Museum is known as the Great Hall. The Visitors' Information Desk offers information on daily events, lectures, films, and concerts at the Metropolitan. Free brochures are available there and include a Floor Plan, the museum's monthly Calendar, and miscellaneous current material. There is an admission fee to enter the collections, but it is "pay what you wish" with suggested amounts for both adults and children.

Egyptian art is exhibited in galleries on the first floor. The installation arranged chronologically from the Predynastic Period through the Coptic Period is preceded by the Orientation Gallery and was completed in 1983. Examples of Egyptian art in the collection range from architectural elements, sculpture, and reliefs to funerary objects, manuscripts, and objects of daily life.

Many of the objects in the collection were excavated during the museum's expeditions in Egypt. In 1895 the Metropolitan subscribed to the Egypt Exploration Fund and thereafter received objects found by Flinders Petrie and others. Albert M. Lythgoe, another archaeologist, who had been digging in Egypt, began to excavate for the museum in 1907. Lythgoe continued to work for the museum and in 1910 began excavations at Luxor that continued until 1936. These excavations were first financed by J. P. Morgan and then by Edward S. Harkness, with contributions from the Rogers Fund. The Egyptian collection profited greatly from these excavations not only in the objects received for the collection but with a large number of excavation and site photographs documenting the work. These photographs are maintained today in the department's photograph archive and are available for study to scholars and students with advance appointments.

The department received several important gifts in its early years. In 1913

Edward Harkness bought the Mastaba Tomb of Pernebi, an Old Kingdom monument that is now installed at the entry to the Egyptian Galleries. In 1915 Theodore Davis bequeathed a thousand objects found during his personal excavations in Egypt, and in 1926 Harkness gave an exquisite collection of small and precious objects gathered by Lord Carnarvon (the organizer of the Tutankhamun expedition). Many significant purchases made by the museum include jewelry belonging to princesses of the Middle Kingdom, Hyksos Period, and eighteenth dynasty.

The Egyptian Galleries begin with the Orientation Gallery; a map and time charts of Egyptian art are shown. Examples of Predynastic art include a Gerzean jar painted with gazelles and ostriches from about 3400 B.C., as well as numerous examples of pottery from that period. In addition to the Mastaba tomb of Pernebi with its handsome painted reliefs, Old Kingdom art includes a wooden sculpture group of Mitry and his wife from a tomb at Sakkara (Dynasty V).

Two Middle Kingdom portraits of King Sesostris from Dynasty XII are presented: one a forceful sculpture in diorite representing the king as a sphinx, the other a quartzite fragment of a face modeled with lines of care and worry in a typically Middle Kingdom style. A number of models representing scenes of daily life in Egypt were discovered in the Theban tomb of Mekutra by Herbert Winlock in 1920. They include a model of a garden court and a model of a traveling boat. Also from the tomb of Mekutra is a painted wood sculpture of a girl bearing offerings.

From the New Kingdom Period, a blue faience sphinx of King Amenhotep III (Dynasty XVIII, c. 1397–1360 B.C.) conveys the monumentality of kingship despite its small size. The collection includes several pieces from the reign of Amenhotep IV (known as Akenaten), who moved his capital from Thebes to Amarna and discarded traditional Egyptian beliefs for the monotheistic worship of the Sun God Ra. A head of King Akenaten from a sculptor's workshop at Amarna is carved from dark red quartzite. A section of pavement from the Great Palace at Amarna is painted with flowers and plants in the naturalistic style of the Amarna Period. A sculptor's study, *The Head of a Nubian*, a relief work in limestone, shows the naturalistic trend in sculpture. Also from the New Kingdom Period is a white limestone sculpture of Queen Hatshepsut from her temple at Deir el-Bahri (Dynasty XVIII). A limestone relief, *King Ramesses I Offering to Osiris*, is from a chapel erected to Ramesses by his son Seti I (Dynasty XIX).

The Metropolitan's collection is especially rich in small funerary objects and in objects of everyday life from all periods: alabaster vases, carved headrests, objects of personal adornment, and so on. Among the many examples of fine jewelry is the necklace of Princess Sit Hathor-yunet from her tomb at El Lahun, Lower Egypt (Dynasty XII). Made of gold and semiprecious stones, the necklace is marked with the name of her father, Sesostris II. A headdress of a queen or lady of the court of Thutmose III (Dynasty XVIII) is from the tomb of Thutmose's Syrian wife near Deir-el-Bahri. It is elaborately constructed of gold, colored glass, and semiprecious stones. Examples of furniture in the collection include

a chair of the scribe Ren-Sonbe (Dynasty XVIII) made of ebony wood finely inlaid with ivory.

Art from the Ptolemaic Period, the time of Roman occupation, includes the Temple of Dendur (23–10 B.C.). The temple was a gift from the Egyptian people to the people of the United States. In the 1960s, when work began on the Aswan Dam in Egypt, it was realized that the small temple would be flooded and lost when construction of the dam was completed. The temple was disassembled and reconstructed in a wing built especially for it, the Sackler Wing. The original Nile location of the temple and its gateway structure is recreated at the museum.

Art from the Coptic Period, or Christian Egypt, includes woven fabrics, a processional cross, and an ivory object perhaps used to decorate furniture carved with the ascension of Christ in an Eastern Christian format (sixth-seventh century). Several architectural elements include a limestone archivolt with capitals said to be from Bawit (sixth century).

Art of the Ancient Near East is displayed in galleries located on the second floor of the Metropolitan, South Wing. The galleries, which opened to the public in 1984, present examples from the Metropolitan's large collection. The department was officially formed in 1956, although gifts of Ancient Near Eastern art had been added to the museum's collection much earlier. In 1932 John D. Rockefeller, Jr., gave reliefs and guardian figures from the palace at Ashurnasirpal currently installed at the entry to the Ancient Near Eastern Galleries. By the 1950s the department was participating with the British School of Archaeology in Iraq to excavate Nimrud. Many objects, particularly ivories, were added to the collection as the result of these excavations.

The collection includes valuable examples of Ancient Near Eastern Art. The *Gazelle Cup*, a gold repoussé vessel for use as a royal drinking cup or for votive offerings, dates from about 1000 B.C. It was found at Guilan in northwest Iran. Early works include a prehistoric ceramic pot painted with images of an ibex from Sialh in north-central Iran (c. 3500 B.C.). Examples of sculpture feature a Sumerian worshipper from Abu Temple, Tell Asmar, Iraq, which functioned as a substitute for the actual worshipper. A seated statuette of Gudea, governor of Lagash (southern Iraq), is from about 2150 B.C. and is made of diorite. Metalwork, besides the famous *Gazelle Cup*, includes a gold ewer decorated with spiral designs from Anatolia, about 2100 B.C. Also in the collection are numerous cylinder seals, ivories, and examples of ceramic ware and metalwork, much of which was excavated by the department at sites such as Al-Hiba, capital of ancient Lagash (now southern Iraq).

The Greek and Roman art collection at the Metropolitan are displayed in galleries on the first and second floors of the South Wing. Major works of sculpture, vase painting, metalwork, pottery, glass, and so on from the second millennium B.C. through the fourth century A.D. are exhibited. Classical sculpture was the first collection in the museum to receive international attention when in 1874 and 1876 Luigi Palma di Cesnola purchased a large number of Cypriot statues for the museum. Highly important early purchases enriched the Greek

and Roman collection: in 1903 ancient glass was purchased, forming the nucleus of a comprehensive collection; Etruscan bronzes, including a ceremonial chariot, that were found near Spoleto were acquired; and Roman frescoes from Boscoreale near Naples were added to the collection. In the following years, purchases and gifts expanded the Greek and Roman Collection to one of the most comprehensive.

Greek art from the Early Cycladic period includes a marble figure, *The Seated Harp Player* (c. 2500 B.C.), as well as a number of marble Cycladic figurines. Decorated pottery from Minoan times and early Cypriot pottery and bronzes are exhibited with the Cycladic sculpture.

From the Geometric period (eighth century B.C.), a bronze horse is only one example of the small bronzes in the collection. A krater with prothesis scenes depicting a funeral is one of the painted vases dating from the Geometric period. An important kouros (statue of a youth) dates from the Archaic period (late seventh century B.C.). Pottery from the Archaic period includes an important black-figure neck amphore with a representation of a marriage procession. The vase, from about 540 B.C., is attributed to the painter and potter Exekias. A painted red-figure calyx krater, *The Death of Sarpedon*, is signed by the potter Exitheos and the painter Euphronius. An exceptionally large group of fine Greek vases from all periods is exhibited on the second floor with examples of Roman glass. Sculpture from the Classical period of Greece includes a Parian marble grave stele representing a girl with doves. This exceptionally delicate work dates from about 450 B.C. and was a major purchase by the museum in 1927. A number of other Greek grave stelae and free-standing figures are in the collection. The *Old Market Woman*, a marble work of the second century B.C., is a highly important example of Greek Hellenistic art. From the same period, the bronze *Sleeping Eros*, believed to be from the island of Rhodes, captures the naturalism of a child sleeping.

Italic art includes art from Etruscan to Late Roman times. A large group of Etruscan bronzes includes a finial from a candelabrum decorated with a warrior giving support to a wounded comrade (early fifth century B.C.). Roman sculpture from the Augustan period is represented by a marble *Aphrodite*. This work, a copy of a Greek original dating from 300 B.C., is based on the same source as the famous *Medici Venus*. A number of portrait busts exemplify that highly developed Roman art form. Roman painting is well represented with a group of frescoes from a villa near Boscoreale. These works of about 40–30 B.C., which had been buried in A.D. 79 by Vesuvius, are notable for their subject matter and for their rich coloring and include the *Kithara Player (Possibly Demas, Mistress of Demetrios Antigonas) and Child*; *Man and Woman (Perhaps Demetrios Poliorketes and His Wife, Phila)*; and *Girl with a Shield (Perhaps Daughter of Demetrios Poliorketes)*. The paintings are notable for their depictions of architectural vistas, a preferred subject for domestic decoration.

The Islamic art collection of the Metropolitan is presented in a series of galleries opened in 1975, located on the second floor of the museum. The Department of Islamic Art was not established until 1963, but works of Islamic

art began to enter the museum's collection in 1891, when outstanding examples of Persian and Hispano-Mauresque pottery and Egyptian, Syrian, and Mesopotamian metalwork and glass were bequeathed by Edward C. Moore. Other gifts followed, including important donations of manuscripts from Alexander Smith Cochran in 1913 and from N. M. Grinnell in 1920. Arthur A. Houghton, Jr., presented, in 1970, seventy-eight leaves from the *Shad-nameh* illuminated at Tabriz by the best painters of the early 1500s, and it is one of the department's greatest treasures. Significant purchases include a monumental brass incense burner in the shape of a feline cast in Persia in 1181. Two Islamic pieces were acquired from the Hapsburg Collection: an enameled bottle and a sixteenth-century carpet abandoned by a Turkish general after the last siege of Vienna in 1683, called the "Emperor Carpet." The Islamic Galleries are arranged chronologically and are prefaced with the small Orientation Gallery.

From 1935 to 1940 the museum participated in excavations at Nishapur, an important early Islamic city, and gathered a large collection of tenth-twelfth-century ceramic wares, glass, and metalwork. They are exhibited in the first galleries. Many of the ceramic pieces from Nishapur are decorated solely with elegant Arabic calligraphy. Stucco panels from an *ivan* (domed hall) from Sabz Pushan at Nishapur are carved with complex, interlaced motifs and date from the late tenth century.

Arts of the early Islamic period (700–1500) are presented and include ceramics, glass, and architectural elements. A pair of carved wood doors are from ninth-century Iraq. From the Seljuk and Mongol periods, the *Two Princely Figures* of painted stucco (Iran, c. 1200) document the appearance of medieval Islamic costume. A molded chess set of the Seljuk Period is from Iran. A brass astrolabe was produced for Pasulid Sultan Omar and is from Yemen (1296–97). This instrument, used for observing positions of visible stars, is one of many scientific instruments and manuscripts in the collection. A magnificent glazed tile *mirab* (focal point of a mosque) is from Madrasa Imami in Isfahan and dates from about 1354. A group of mosque accessories are exhibited and include lamp and Koran stands. Korans and leaves from Korans are exhibited: a Koran leaf from Persia, late tenth century; a leaf from Iran (twelfth century); and a small volume from Iran dated 1427 and executed in ink, gold, and color on paper, with an elaborate floral border.

The Ayyubid, Mamluk, and Nasrid periods (1171 on) include art from throughout the Mediterranean, especially Spain. A carved, painted, and gilded wooden ceiling is from southern Spain and dates from the Nasrid period of rule in Granada. An armorial carpet from Letur or Alcarat in Spain is from the fifteenth century. Other architectural elements include four columns with impost blocks of carved marble from the Nasrid period. A textile panel from the Nasrid period is woven with Arabic inscriptions in Kufic script. Mamluk glassware includes a free-blown bottle from Syria (c. 1320) with a tooled, enamel foot.

Islamic manuscripts are displayed so that viewers may sit and study separate leaves. Works in the collection include leaves from the *Mantiq al Tayr* (*Language*

of the Birds) of Farid ad Din Attar illuminated at Isfahan about 1600. Leaves from the *Khamseh* of Nizami date from the Safavid period and were probably executed at Herat in 1524–25. A scientific text on the medicinal use of plants is from the Baghdad school and is dated 1224. A manuscript of the *Bustan* (*Fragrant Orchard*) by Sa'di was illuminated at Bukhara in 1522–29, and the *Shah-nameh* of the Mongol school dates from the early fourteenth century.

Several carpets are exhibited, including an arabesque and animal carpet from seventeenth-century Iran. A carpet, possibly Kerman, from the late sixteenth century is considered an outstanding example of a medallion and animal carpet. Carpets from the Timurid and Safavid periods include "The Seley Carpet," one of the finest Persian carpets known. A wool-pile work with wool warp and cotton weft, the all-over pattern, features medallions and cartouches. A renowned textile, the "Simonetti Carpet" was probably produced in Cairo during the Mamluk period and features geometric medallions that relate to pre-Islamic Coptic designs.

From Ottoman Turkey, an Anatolian prayer rug from 1768 is designed as a variation of the traditional arch prayer rug. An Ottoman period carpet from Cairo or Istanbul is woven with characteristic motifs of the period, including feathery lancelotte leaves and rosette-like flowers. A group of earthenware glazed tiles is decorated with arabesques, stars, and floral motifs, all typical Islamic decorative patterns.

The opulence of the Ottoman Empire is suggested in the Nur ad-Din Room from 1707. The Winter Reception Room, installed near the entrance to the Islamic Galleries, is constructed of inlaid marble and lined with cushioned banquettes. It was originally two rooms: the winter courtyard with a bubbling fountain leading through an archway to the reception room proper. Islamic lamps, books, and other objects from Ottoman period furnish the Nur ad-Din Room.

The Mughal period in India (seventeenth-nineteenth century) produced, among other art forms, sophisticated miniature paintings. Examples at the Metropolitan include a leaf from the *Shah-Jahan* album attributed to Mansur, which depicts a black buck. The delicate and realistic style of this leaf is again found in another leaf from the same album representing royal lovers. A carpet from the Mughal period features pictorial representations of trees, birds, and animals in repeat designs. An opulent velvet textile from the seventeenth century employs a Safavid design in its silk-velvet on satin weave. Jewelry and curio boxes created of precious materials include a nephrite box with a cover inlaid with gold, and inset with sapphires, mother-of-pearl, emeralds, rubies, and pearls (nineteenth century). In addition to nine galleries with permanent installations, a small gallery is reserved for special exhibitions of Islamic art.

The medieval art collection is exhibited at the Metropolitan Museum on the first floor and at The Cloisters, an annex located at Fort Tryon Park in upper Manhattan. The nucleus of the museum's medieval art collection was formed in 1917, when J. Pierpont Morgan, Jr., gave more than seven thousand objects to the museum that his father had loaned in 1907. They included ivories, Limoges enamels, the George Hoentschel Collection of woodwork, and the Svenigorodsky

Collection of Byzantine enamels on gold, with six of nine late antique silver plates sculpted with the story of David (made possibly for Emperor Heraclius c. 630). Other gifts followed, including in 1921 the Romanesque stone figures from Michael Dreicer and in 1941 the highly important ivory plaque representing *Emperor Otto II dedicating Magdeburg Cathedral* (c. 970) from George Blumenthal. In 1945 Harold Irving Pratt presented an early fifteenth-century Franco-Flemish tapestry of the *Annunciation*, and in 1938 The Cloisters opened with an endowment from John D. Rockefeller, Jr. That endowment included highly important works of art such as the *Antioch Chalice*.

Early Christian and Byzantine art is shown in a small gallery off the Great Hall. An important silver and gilt chalice from Antioch (c. 500–550) is carved in deep relief with a grapevine motif. Sculpture includes busts of the Byzantine period and sarcophagi carved with Christian motifs. A marble bust of a lady of rank probably from Constantinople (c. 500) exemplifies the idealized style of the period. A large group of fine Byzantine jewelry includes a necklace and bracelet made in Constantinople of gold, sapphires, and pearls (seventh century) and earrings of gold, sapphires, and pearls from the same period.

Western art includes a Frankish *Spangehelm* (chieftain's helmet) of iron and bronze dating from the seventh century. An Ostrogothic fibula (brooch) of gold leaf and jewels over silver dates from about 450–500 and may be from Transylvania. A large Langobardic fibula from North Italy is made of silver, gilt, and niello and designed with an interlaced animal motif (c. 600–650).

In addition to having the ivory plaque of Otto II, the Metropolitan's collection includes other outstanding examples of ivory work. The famous *Bury St. Edmunds Cross* from about 1150–90 is intricately carved with more than a hundred figures and sixty inscriptions in Latin and Greek.

Metalwork in the collection includes a Limoges tabernacle from about 1200, with reliefs: the *Crucifixion*, the *Three Marys at the Tomb*, and the *Virgin Enthroned with St. Peter and the Angels*. A Limoges crozier head, *St. Michael Fighting the Dragon*, was probably made for a bishop (c. 1200). A chalice of silver, parcel gilt, niello, and jewels dates from the early thirteenth century and is from the Abbey of St. Trudpert (Freiburg in Breisgau), and a thirteenth century reliquary head of St. Yrieux of silver with cabochons is from the Church of St. Yrieux (Limoges).

A number of sculptures from the Middle Ages, particulary the Romanesque period are exhibited at the Metropolitan. The polychromed oak *Madonna Enthroned* is from the Auvergne and typifies the abstract wood sculptures produced in that region (1150–1200). A limestone *Angel* from St. Lazare, Autun (Burgundy), is an architectural fragment from the church's north transept (c. 1130). A representation of King Solomon (?) from St. Denis near Paris is the only full-length statue from the Early Gothic church to have survived from this period (1145–50). A head of a king (Philippe-August?) is from the Portal of the Virgin on the west facade of Notre Dame, Paris.

Several important manuscripts are in the collection, including *The Hours of*

Jeanne d'Evreux, a work in grisaille and color on vellum, attributed to Jean Pucelle. *The Cloister Apocalypse* is a Norman manuscript executed in paint, gold, silver, and brown ink on vellum (c. 1310–25).

The Cloisters houses a comprehensive selection of medieval art in a medieval-style building that incorporates sections of actual medieval structures. The Cloisters began in 1906, when an American sculptor, George Gray Barnard, bought Romanesque and Gothic ruins in France. In 1913 he brought the ruins to New York and assembled them near Fort Tryon Park. Barnard's museum was acquired in 1925 by John D. Rockefeller, Jr., who rebuilt it at Fort Tryon overlooking the Hudson River. Architect Charles Collings designed the structure, which opened to the public in 1938.

The architectural elements at The Cloisters include the cloister from the Benedictine Abbe of St. Michel-de-Cuxa (about half the size of the original cloister, which had probably been built before 1150 under Abbot Gregory). A chapter house from Notre Dame-de-Pontaut (Gascony) dates from 1151 and is decorated with numerous moldings, a continuous stringcourse, and carved corbels in the Romanesque manner. An apse interior is from San Martin, Fuentidueña, Spain. A cloister recomposed of elements from the upper gallery of the cloister, St. Guilhem-le-Desert (Montpellier) takes its form from extant twelfth-century examples such as Arles. A Romanesque chapel from Notre Dame-du Bourg, Longdon (Bordeaux), includes a marble ciborium from St. Stefano, a church near Fiano-Romano (Rome). A cloister reconstructed from fragments of the Carmelite convent at Trie-en-Bigorre (Toulouse) and from the monastery St. Sever-de-Rustan (where some of the fragments from Trie had been reused) is an example of Late Gothic style.

Many of the important objects in the Metropolitan's medieval art collection are housed at The Cloisters. The *Unicorn Tapestries*, a group of seven textiles woven of silk, wool, silver, and silver-gilt threads, date from about 1500. Five of them may have been created to celebrate the marriage of Anne of Brittany to Louis XII in 1499. The first and last tapestry in the series were made when François I married Anne's daughter and heir in 1514.

Paintings exhibited at The Cloisters include the highly important Early Netherlandish painting *The Mérode Altarpiece* by Robert Campin. This work in oil on wood represents a very early use of oil as a painting medium, and its composition secularizes the religious scene of the Annuciation to Mary by setting it in a contemporary interior that is filled with complex iconographic symbols. A tempera painting on wood with gold ground, the *Lamentation*, is by the Master of the Codex of St. George, a follower of the Sienese artist Simone Martini.

Numerous other medieval objects, including those from daily life, are exhibited at The Cloisters. In addition, several gardens tended by a horticulture staff recreate medieval flower and herb gardens. First planted in 1938, when The Cloisters was opened, the gardens include the Cuxa Cloister Garth Garden (flowers), the Bonnefont Cloister Herb Garden, and the Trie Cloister Garden (with plants depicted in the hunt of the *Unicorn Tapestries*).

The Metropolitan houses an outstanding collection of European paintings. This collection, with examples from the thirteenth through the nineteenth century, is considered one of the most comprehensive collections in the world.

The European Paintings Department is the direct descendant of one of the first departments in the museum. In 1870, a few months after the museum was founded, 174 European paintings were purchased by subscription. Several other works were acquired including Poussin's *Midas Bathing in the River Pactolus*. Early gifts brought works by Delacroix, Goya, Daumier, Vermeer, and van Dyck. In 1889 the first works by Manet to enter a public collection were acquired. In 1907 Renoir's *Madame Charpentier and Her Children* was purchased, as were major works by Veronese, Tintoretto, Rubens, Botticelli, and Giotto. Throughout the years many gifts of entire collections added greatly to the Metropolitan's holdings. In 1913 Benjamin Altman bequeathed a collection to the museum that included works by Botticelli, Vermeer, and Memling. In 1929 the Havemeyer bequest brought Bronzino's *Portrait of a Young Man*, El Greco's *View of Toledo*, and other significant works, especially of the Impressionist school. In recent years, highly publicized purchases included Rembrandt's *Aristotle Contemplating the Bust of Homer* and Velázquez's *Juan de Pareja*.

Early Italian paintings are exhibited in the Stephen C. Clark Galleries, a corridor of rooms with works arranged chronologically from the thirteenth to the sixteenth century. *A Madonna and Child* is by the Lucchese painter Berlinghiero and dates from about 1240. A number of Sienese panels include Simone Martini's *St. Andrew* of about 1326, Pietro Lorenzetti's *Two Angels*, and Sassetta's miniature-like *The Journey of the Magi*. Additional Sienese works by Sano di Pietro, Paolo di Giovanni Fei, Giovanni di Paolo, and others are exhibited. Early Florentine paintings such as *Epiphany* by Giotto and small panels by Bernardo Daddi and Niccolò di Tomasso are also shown.

Italian Renaissance works in the collection include *Portrait of a Man and Woman in a Casement* by Fra Filippo Lippi and *Francesco Sassetti and His Son Teodoro* by Domenico Ghirlandaio. *The Goddess of Chaste Love* represents a humanist theme and is by Francesco di Giorgio. The Venetian family of painters, the Bellini, is represented with *Madonna and Child* by Jacopo Bellini and the tempera panel *St. Bernardino* by the same artist. Works by Giovanni Bellini include *Madonna Adoring a Sleeping Child* and *Madonna and Child* (probably late 1480s). A small panel by Mantegna is titled the *Adoration of the Shepherds* (c. 1450). *Madonna and Child* by Carlo Crivelli features the encrusted exaggerated figures associated with that artist. Michelino da Bezozzo's *Marriage of the Virgin* is one of only two paintings known by this Lombard illuminator. Other Venetian paintings include Vittore Carpaccio's *The Meditation of the Passion*, about 1510. *Christ Crowned with Thorns* is by Antonella da Messina. Italian Renaissance manuscript illumination is represented by musical manuscripts painted by Girolamo dai Libri and other works. The room in which they are exhibited contains ceiling panels from the Palazzo del Magnifico in Siena. Painted by Pintoricchio in 1503 for Pandolfo Petrucci, they represent scenes

from classical mythology. Wall panels are decorated with signs of the zodiac and allegorical representations.

Large-size Renaissance paintings are grouped together. Fra Filippo Lippi's *St. Lawrence Enthroned with Saints Cosmas, Damian, and Donors* was commissioned by Alessandro Alessandri. A curious architectural structure dominates the light-filled work *The Birth of the Virgin* by the Master of the Barberini Panels. Botticelli's *Three Miracles of St. Zenobius* was originally one of a group of four panels and is a late work. Two panels by Perugino are *St. John the Baptist* and *Lucy*, painted in 1505 for the high altar of Santissima Annunziata in Florence. Fra Bartolommeo's *Madonna and Child with the Young St. John the Baptist* is an early work reflecting influences of both Ghirlandaio and Leonardo da Vinci. Piero da Cosimo's *A Hunting Scene* and its pendant *The Return from the Hunt* are probably part of the series painted for Francesco de Pugliese in Florence noted by Vasari. The scenes represent the growth of civilization and man's use of fire, probably derived from the writings of Vitruvius. A large fresco by Domenico Ghirlandaio is *St. Christopher and the Infant Christ*; it is perhaps from the chapel of the Michelozzi family in San Miniato-fra-le-Torri in Florence.

Paintings of the High Renaissance include a celebrated altarpiece by Raphael painted for the church of the Convent of Saint Antonio at Perugia: the *Madonna and Child Enthroned with the Young Baptist and Saints Peter, Catherine, Lucy, and Paul*. Andrea del Sarto's delicate *Holy Family with the Infant John* is from about 1530. Bronzino's *Portrait of a Young Man* from about 1540 is one of the artist's masterpieces. Jacopo del Conte's *Portrait of Michelangelo* is believed to be one of two life portraits of the famous sculptor-painter described by Vasari (one by del Conte and the other by Bugiardini).

Venetian paintings of the High Renaissance include Titian's *Venus and the Lute Player*, the last in a series of four Venus paintings by the artist. *Venus and Adonis* (one of two versions painted of the subject) and the portrait *Filippo Archinto, Archbishop of Milan* (mid–1550s) are also by Titian. A painting by Tintoretto, *The Miracle of the Loaves and Fishes* was painted about 1545–50. Two portraits by the same artist include the rare *Self Portrait* (c. 1546–48) and the *Portrait of a Man*, which reflects the influence of Titian. Also by Tintoretto is *The Finding of Moses* from about 1570. Veronese's *Portrait of Alessandrio Vittorio* represents the noted Venetian sculptor with a model for his work, *St. Sebastian*. North Italian paintings include Correggio's *Saints Peter, Martha, Mary Magdalene, and Leonardo*, one of two major works by the artist in American collections. Several works by the Milanese artist Andrea Solario (or Solari) include *Salome with the Head of John the Baptist*. Dosso Dossi's *Three Ages of Man* is considered one of the artist's finest surviving landscapes.

Italian paintings of the seventeenth century include Salvator Rosa's *Self Portrait*, Guercino's *The Vocation of San Luigi Gonzaga*, Guido Reni's *Charity* and Annibale Caracci's *The Coronation of the Virgin*. Three large-scale canvases by Tiepolo are exhibited at the entry to the European Paintings Galleries: *The Capture of Carthage* (?), *The Triumph of Marius*, and *The Battle of Vercellae*.

They were prepared for the salone of the Ca'Dolfin in Venice and commissioned by Dionisio Dolfin, patriarch of Udine (for whom Tiepolo worked in Udine, 1725–28), and represent a series of classical subjects. Also shown are ceiling studies by Tiepolo for Wurzburg, including the study for a ceiling at Wurzburg, an *Allegory of the Planets and Continents*, of about 1752–53. Among the recent additions to the museum's collection is Pompeo Battoni's *Diana and Cupid* executed in Rome in 1761.

Eighteenth-century paintings of the Venetian school include works by Francesco Guardi: *View of the Villa Loredan near Paese* and *View of the Courtyard of the Palazzo Contarino dal Zaffo, Venice*, as well as a series of fantastic landscapes. Pietro Longhi's series of small paintings done for the Gambardi family of Florence represents daily life in Venice: *The Meeting, The Letter, The Visit*, and *The Temptation* (1746). Two small paintings are by Giovanni Domenico Tiepolo, son of the painter Giovanni Battista Tiepolo: *The Departure of the Gondola* and *A Dance in the Country* (c. 1756).

The Metropolitan houses an excellent collection of early Flemish paintings. They are arranged in rooms placed parallel to those of the early Italian paintings and were newly installed in 1978. *The Annunciation* is believed to be by the Flemish master Jan van Eyck, who also painted the small pair of panels *The Crucifixion* and *The Last Judgment*. Works by Petrus Christus, follower of Jan van Eyck, include *Lamentation over the Dead Christ* and *Portrait of a Carthusian Monk*, dated 1446. The *Vrgin and Child in an Apse* is from the workshop of Robert Campin and is a copy of a lost composition attributed to that artist. A delicate *Virgin and Child* is an early work by Dieric Bouts. Rogier van der Weyden's *Christ Appearing to his Mother* was part of a triptych commissioned by Isabella of Castille. Also by Rogier van der Weyden is his *Portrait of Francesco d'Este*, executed during the artist's sojourn in Ferrara, Italy. The powerful *Portrait of a Man* is by Hugo van der Goes. Several works by Gerard David include the *Rest on the Flight into Egypt*, set in an extensive landscape. Larger works by the same artist include *The Angel of the Annunciation* and *Mary*, two panels that were originally part of a triptych. The small but fascinating *Adoration of the Magi* is attributed to Hieronymus Bosch. Joos van Ghent's *Adoration of the Magi* of 1467 was executed with a thin glue medium on fine linen and has a muted effect.

Works of the sixteenth century include Jan Gossaert's *Virgin and Child* and *Portrait of a Man*, both tempera on wood. Quentin Massys' *Adoration of the Magi* reflects an interest in human physiognomies. The *Virgin and Child with St. Joseph* is one of Joos van Cleve's earliest pictures of the Holy Family. Portraits by Hans Holbein, Lucas Cranach, and other Northern artists are grouped together. Holbein's *Edward VI When Duke of Cornwall* is one of many portraits of Englishmen exhibited. Other works by Holbein include his *Portrait of a Member of Wedigh Family*. Cranach's *John, Duke of Saxony* and *Portrait of a Man with a Gold Embroidered Cap* are shown, as is Jean Clouet's small portrait *Charlotte of France*, about 1524. Albrecht Dürer's important but unfinished

Salvador Mundi reveals a detailed preparatory drawing beneath the surface. Other paintings of the sixteenth century include Pieter Bruegel the Elder's *The Harvesters*. This work is one of five known paintings from a cycle by Bruegel devoted to the months of the year. A *Judgment of Paris* by Lucas Cranach is one representation of the artist's favored subject. An exquisite *Judith with the Head of Holophernes* is also by Cranach. A folding triptych by Joachim Patiner has *The Penitence of St. Jerome* on its central panel. The exterior is painted with the grisaille panels *St. Anne with the Virgin and Child* and *St. Sebald.*

Flemish paintings of the seventeenth century include outstanding works by Rubens and van Dyck. Rubens' *Venus and Adonis* is from the 1630s, and other paintings by the artist include the action-filled *Wolf and Fox Hunt* and the *Holy Family with St. Frances.* An important self-portrait, *Rubens, His Wife Helene Fourment, and Their Child*, was recently donated by the Wrightmans. Paintings by Anthony van Dyck include the elegant portrait *James Stewart, Duke of Richmond and Lennox* and the portraits *Henrietta Maria, Queen Consort of Charles I of England* and *Robert Rich, Second Earl of Warwick.* An oil sketch by Rubens, *The Triumph of Henri IV*, is a study for one of the paintings in his famous Marie de' Medici cycle in the Louvre (q.v.). Also on view is *Holy Family* by Jacob Jordaens.

French paintings of the seventeenth century feature works by Poussin, Claude Lorraine, and others. Poussin's *Rape of the Sabine Women* from about 1634–35 is an earlier version of the painting now in the Louvre. Also by Poussin is his famous *Midas Bathing in the River Pactolus*, pendant to the *Arcadian Shepherds*, and his *Blind Orion Searching for the Rising Sun* (1658). Poussin's scene *The Companion of Rinaldo* takes its subject from Torquato Tasso's sixteenth-century heroic poem *La Gerusalemme liberata.* Several pastoral landscapes by Claude Lorraine include *Sunrise* and *View of La Crescenza. The Trojan Women Setting Fire to Their Fleet* was commissioned by Girolame Farnese. The Metropolitan is fortunate also to have works by Georges de La Tour, including *The Fortune Teller* and *The Penitent Magdalene* given by the Wrightmans.

The Metropolitan has an excellent selection of seventeenth-century Dutch paintings. Prefacing this group are works by the sixteenth-century Dutch painters, the Utrecht Caravaggisti: Hendrick Terbrugghen's *Crucifixion with Virgin and St. John* and Mattheas Stomer's *Old Woman Praying.* Genre scenes of the seventeenth century include works by Jan Steen such as *Merry Company on a Terrace* and *The Itinerant Quack Doctor.* Detailed interiors by Pieter de Hooch, Gerard Ter Borch, and Nicholas Maes are exhibited. Several important paintings by Vermeer are also in the collection: *Young Woman with a Water Jug, Portrait of a Young Girl, The Allegory of Faith, Woman with a Lute,* and *Girl Asleep.* Religious scenes include Nicholas Maes' *Abraham Dismissing Hagar and Ishmael* of 1653. Landscape paintings include Aelbert Cuyp's *Landscape with Cattle* and *Piping Shepherds.* Meindert Hobbema's *A Woodland Road* was painted after 1670. Works by Philips Koninck include the extensive *Wooded Landscape*, of about 1670, and *Wide River Landscape.* Two river scenes by Jan van Goyen

are shown: *Country House near the Water* and *View of Haarlemner Meer*, both 1646. Works by Aert van der Neer include two skating scenes and a night scene, *The Farrier*. Landscapes by Jacob van Ruisdael include the powerful *Landscape with Village in the Distance* and his canvas *Grainfields*. A group of paintings by Frans Hals include his famous *Young Man and Woman in an Inn* (known as *Yonker Ramp and His Sweetheart*) from 1623 and *Merrymakers at Shrovetide (The Merry Company)*, as well as several portraits.

The work of Rembrandt van Ryn is exceptionally well represented in the Metropolitan. Two galleries house portraits, biblical scenes, and mythological scenes by the artist. A *Self Portrait* dates from 1660, and the sensitive *Toilet of Bathsheba* is from 1643. *Flora*, a work painted in the mid–1650s, was perhaps inspired by Titian. *A Lady with a Pink* and its pendant *Man with a Magnifying Glass* date from the mid to late 1660s. A *Portrait of Hendrickji Stoffels* dates from the 1650s. *The Rape of Europa* from 1632 is one of the artist's first mythological pictures. One of the highlights of the collection is Rembrandt's powerful *Aristotle Contemplating the Bust of Homer*.

A number of Spanish seventeenth-century paintings are in the Metropolitan. A gallery is devoted to the work of El Greco and features the famous *View of Toledo*, the only landscape by El Greco now extant. The portrait *Cardinal Don Fernando Niño de Guevara* is from 1599–1601. Other works include two representations titled *The Adoration of the Shepherds*; *The Vision of St. John* is a late work. Paintings by Velázquez include the remarkable portrait of his assistant *Juan de Pareja*, the portrait *Philip IV of Spain*, and the portrait *Don Gaspar de Guzman, Count Duke of Olivares*, about 1635. Works by Zurbarán include the poignant painting the *Young Virgin* and the lively *The Battle between Christians and Moors at El Sotillo* from a large altarpiece executed about 1637–39. Also exhibited is Murillo's *Portrait of Don Andreas de Andrade y Lalal* from 1665–72 and the enchanting *Virgin and Child* from the same period.

French paintings from the eighteenth century include excellent examples by Watteau, Boucher, and Fragonard. Watteau's *Mezzetin* represents a character from the Italian commedia dell'arte. *The French Comedians* is a very late work from 1720–21. François Boucher's *The Toilet of Venus* is dated 1751 and was commissioned by Madame de Pompadour, mistress of Louis XV. Fragonard's romantic work *The Love Letter* of about 1770 is exhibited, as is his painting *The Stolen Kiss* (executed during his first Italian sojourn, 1756–61). Also by Fragonard are two small landscapes, *The Cascade* and its pendant *The Shady Avenue*, of about 1773. French genre painting is represented by Chardin's *Boy Blowing Bubbles* and Greuze's *Broken Eggs*, an allegorical scene of 1757. Greuze's portrait style is exemplified by the *Portrait of Jean Jacques Caffieri*, depicting a sculptor known for his historical busts and portraits of contemporaries (c. 1865), and the *Portrait of Charles Claude de Flahaut de La Billarderie, Comte d'Angiviller*, who was a member of the royal households of both Louis XV and Louis XVI (1763). Also by Greuze is the portrait *Young Peasant Boy* and an unfinished mythological scene, *Aegina Visited by Jupiter*. Several pastoral land-

scapes by Hubert Robert are shown, as well as a number of eighteenth-century French portraits. Elizabeth Vigée-Lebrun's portrait *Madame de la Châtre* is from 1789, and there is the masterpiece by her rival Adelaide Labille-Guiard, *Self Portrait with two Pupils, Mademoiselle Gabrielle Capret (1761–1818) and Mademoiselle Carreaux de Rosemond*, signed and dated 1785 and exhibited at the Salon of 1785. Portraits by George Romney (*Edward Wortley Montague in Turkish Dress*) and Thomas Gainsborough (*Mrs. Grace Dalrymple Elliott*) and works by Sir Joshua Reynolds are exhibited. A painting by Hogarth is titled *The Wedding of Stephen Beckingham and May Cox* (dated June 9, 1729).

In 1913 an important collection of paintings and sculpture was given to the Metropolitan by Benjamin Altman. This collection is exhibited separately in two galleries. Early Flemish paintings include Hans Memling's portrait *Tomasso Portinari* and *Maria Magdalene Baroncelli*, his wife, as well as Memling's *The Mystic Marriage of St. Catherine* and *Portrait of an Old Man*. A *Portrait of a Man* by Dieric Bouts is exhibited, as is Albrecht Dürer's *Virgin and Child with St. Anne*, a work that shows the influence of Giovanni Bellini. Dutch seventeenth-century works include Pieter de Hooch's *Interior with a Young Couple* and Gerard Dou's *Self Portrait*. Italian paintings from the Altman bequest include Antonella da Messina's *Portrait of a Young Man*, Botticelli's *Last Communion of St. Jerome*, Fra Angelico's *Crucifixion*, Andrea Mantegna's *Holy Family with St. Mary Magdalene*, and Titian's *Portrait of a Man*.

Nineteenth-century paintings are exhibited in the André Meyer Galleries on the second floor of the Rockefeller Wing. Works of the French, Spanish, and English schools are presented, with a particularly excellent group of works by the French Impressionists.

French paintings include work by Jacques Louis David and feature his powerful *Death of Socrates* from 1787. Also by David is the portrait *General Etienne Maurice Gerard, Marshall of France* (1816). Portraits by Ingres include *Jacques Louis Le Blanc* and *Madame Jacques Louis Le Blanc (Françoise Poncelle)*. Eugène Delacroix's *Basket of Flowers* and the landscape *George Sand's Garden at Nohant* (1840s) are exhibited. A number of works by Gustave Courbet are in the collection, including *Woman with a Parrot* from 1866 and the large canvas *Young Ladies from the Village* (1851–52). Other works by Courbet include *Portrait of Jo (La Belle Irlandaise)*, 1866; *Portrait of Madame de Brayer*, 1858; and *Portrait of Alphonse Proget*, used as a model for the artist's canvas *The Painter's Studio*. A number of other portraits and several landscapes by Courbet are also at the Metropolitan. Barbizon School landscapes by Théodore Rousseau and Charles Daubigny are exhibited. Rousseau's *Sunset near Arbonne* and Daubigny's *Apple Blossoms* of 1873 are among them. Pastoral works by Jean François Millet include *Autumn Landscape with a Flock of Turkeys*, *Woman with a Rake*, and *Haystacks: Autumn*. The work of Honoré Daumier is represented with *The Third Class Carriage* and the small panel *The Laundress*. Corot's paintings include a large scene, *Hagar in the Wilderness*; *The Letter*; and a half-length portrait, *Sibylle*. Included with the French Romantic paintings is a work by the

Swiss painter Arnold Böcklin, *Island of the Dead* (1880). Academic paintings of the nineteenth century by Ernest Meissonier, Jules Bastien Lepage (*Joan of Arc*), Alexandre Cabanal, Pierre August Cot (*The Storm*), and others are exhibited. Orientalist scenes include Alexander Decamps' *The Good Samaritan and* Charles Théodore Frère's *Jerusalem Seen from the Environs*. Works by the Symbolist painter Gustave Moreau include *Oedipus and the Sphinx* of 1864. Two canvases by Puvis de Chavannes represent scenes of classical life.

Spanish paintings of the early nineteenth century include Francisco Goya's *Majas on a Balcony*, painted during the Spanish War of Independence; *The Bullfight*, dating from 1810–12; the *Portrait of Jose Costa y Bonells, called Pepito*, with a representation of a pony and toys in the background; and the *Portrait of Don Manuel Osorio Manrique de Zuniga* (b. 1784), which includes cats and birds in the background.

A group of English nineteenth-century works include Turner's *The Grand Canal, Venice* of 1833. The *Portrait of Mrs. James Pelham, Sr.* and *Salisbury Cathedral* are by Constable. Late nineteenth-century paintings include Sir Edward Coly Burne-Jones' *The Love Song (Le Chant d'Amour)* and Frederic, Lord Leighton's *Lachryme (Tears)*, a work of neoclassical elegance.

The Metropolitan houses one of the world's greatest collections of French Impressionists and Post-Impressionists. Important works by Manet include *Torero Saluting, Mlle V . . . in the Costume of an Espada* (1862), *Dead Christ, Woman with a Parrot*, and *Boating*. Claude Monet is represented by his well-known *Terrace at Sainte Adresse* (1867), *The Green Wave* (1865), *Poplars* (1891), *Haystacks in the Snow* (1891), *Rouen Cathedral* (1894), and *Waterlilies* (1905), as well as other landscapes, portraits, and flower pieces. Major works by Paul Cézanne include *The Cardplayers, Portrait of Dominique Aubert (Uncle Dominic), Madame Cézanne in a Red Dress*, and *Madame Cézanne in the Conservatory*. Other paintings include *A Still Life: Apples and Pot of Primroses* and *Bathers* (one of Cézanne's first paintings on the subject dating from 1875–76). Landscapes such as *Rocks in the Forest* (1896–1900) and *The Gulf of Marseille Seen from L'Estaque* of about 1876 are shown. A large group of works by Edgar Degas includes sculpture, paintings, pastels, and drawings exhibited in three galleries. Paintings such as the portrait *Jacques Joseph Tissot* (1858), the *Woman with Chrysanthemums* (1865), and a *Self Portrait* (c. 1894) are shown. Fan mounts representing ballet scenes are presented along with a number of pastels depicting dancers. *Nude Combing Her Hair* of about 1885–86 is one of Degas' several pastels of female nudes in the Metropolitan. *The Dancing Class*, a small pastel executed on wood, is seen as Degas' "first essay in the orchestration of a group in an interior" (1871). *The Ballet from "Robert le Diable"* of 1872 reveals the artist's fascination for the audience as well as for the performance. Auguste Renoir is represented by the large canvas *Madame Charpentier and Her Children* of 1878 and a number of portraits. By Camille Pissarro are *Boulevard Montmartre on a Winter Day* and *The Garden of the Tuileries on a Winter Afternoon*. Paintings by Vincent van Gogh include the *Self Portrait with a Straw*

Hat of 1887 (verso: *The Potato Peeler*, February-March 1889). The famous portrait *Madame Ginoux (L'Arlesienne)* is exhibited. *Cypresses*, from June 1889, was painted during van Gogh's stay at the Asylum of Saint Paul in Saint Rémy, as was the canvas *Irises*. Paul Gauguin's *A Farm in Brittany* was executed after his trip to Tahiti. His work *Two Tahitian Women* from 1899 was done on his final return to the Islands. Important paintings by Georges Seurat include *Study for a Sunday Afternoon on the Island of La Grand Jatte*, the final sketch for his masterpiece now at the Chicago Art Institute (q.v.). *Invitation to the Sideshow (La Parade)* is another major work exhibited. Oil sketches by Henri Toulouse-Lautrec are shown: *The Sofa* (one of numerous representations of brothel scenes done by the artist) and *The Englishman at the Moulin Rouge*, as well as other works.

The Department of European Sculpture and Decorative Arts oversees the museum's largest collection. Its holdings include all Western sculpture from the Renaissance through the nineteenth century, porcelain and other ceramic ware, metalwork, furniture, and period rooms. Galleries are currently located in the center of the museum on the first and ground floors, but a new wing is planned, which will include a selection of European sculpture and decorative art objects.

The Department of Decorative Arts was founded in 1907, incorporating the earlier Department of Sculpture and Casts. That same year, J. P. Morgan gave eighteenth-century French porcelains, woodwork, and furniture from the Hoentschel Collection so that "it should be made the nucleus of a great collection of decorative arts." Following this, numerous gifts and purchases were added. In 1910 Rodin sculptures were presented by Thomas Fortune Ryan, and in 1913 the Altman bequest brought fine Italian Renaissance and French eighteenth-century sculptures. In 1920 the first of many examples of French royal furniture was presented to the museum when William K. Vanderbilt gave a black lacquer commode and secretary made by Riesener for Marie Antoinette. Other gifts included furniture from Mr. and Mrs. Charles Wrightsman and furniture inlaid with Sèvres plaques from the Samuel K. Kress Foundation. In 1937 the ceramic and porcelain collection was filled out with a gift from R. Thornton Wilson, and today that collection includes examples from every major factory from the fifteenth to eighteenth century. In 1974 English silver, woodwork, furniture, and other objects were presented by Irwin Untermeyer. Throughout the years, the original Department of Decorative Arts grew, and various departments were developed from it, including American Art, Far Eastern Art, Ancient Near Eastern Art, Medieval Art, and Twentieth Century Art.

Sculpture from the Italian Renaissance includes Antonio Rossellino's marble *Madonna and Child with Angels* of about 1460, Luca della Robbia's *Madonna and Child in a Niche* of about 1440–60, and a polychromed terracotta *Madonna and Child* from the school of Andrea Verrocchio of about 1470. The bronze *Triton* is by Giovanni Bologna. Tullio Lombardo's *Adam* is a key work in the development of Venetian cinquecento sculpture and was executed about 1490–95. The bronze *Kneeling Satyr* by Il Riccio (Andrea Briosco) and its companion,

a *Satyress*, are recent additions to the sculpture collection. Pietro Torrigiano's *Bust of an English Ecclesiastic (John Fisher, Bishop of Rochester?)* is one of three terracotta busts formerly in the main room at Whitehall. A work by Gian Lorenzo Bernini, *Bacchanal: A Faun Teased by Children*, from about 1616 is a relatively recent discovery. *St. John the Baptist* by Juan Martinez Montañes of about 1630 is a realistically carved and painted example of Spanish sculpture. Nineteenth-century sculpture is exhibited with contemporary paintings in the André Meyer Galleries. They include Antonio Canova's *Perseus with Head of Medusa* from 1806–8, the second version of a statue in the Vatican. Antoine-Louis Barye's *Theseus Fighting the Centaur Bianor* represents an episode from Ovid's *Metamorphoses*, and *Ugolino and his Sons*, a marble by Jean Baptiste Carpeaux (executed 1865–67), derives its subject from Dante's *Divine Comedy*. A large group of works by Rodin includes the bronzes *Adam* (modeled 1880–81; cast 1910); *The Bronze Age* (modeled 1876); and *The Martyrs* (modeled 1884). Small bronzes and models are also on view. Sculptures by Degas are exhibited with other works by the artist. The *Little Fourteen-Year-Old Dancer* (modeled 1880–81; cast c. 1922) and studies of dancers and horses in motion are also represented.

Objets d'art in the Metropolitan's collection include a chalice from southern Germany of gold, enamel, and jewels from 1609, with an engraved design by Hans Collaert and Daniel Mignot. Etienne Maurice Falconet's *The Schoolmistress* of about 1762 is one example of Sèvres porcelain figurines in the collection. A fountain with a Meissen basin from about 1727–78 has a hard-paste porcelain basin with a silver fountain; it is decorated with figures by Johann Gottlieb Kirchner, and the basin is in the style of Johann Gregor Herald. A gilt-silver, thuya wood and cut-glass dish with cover of about 1805 was part of Napoleon Bonaparte's traveling service, and its handle is in the form of an eagle. Also in the collection are 140 Neapolitan Christmas tree decorations fashioned of terracotta that are displayed during the holiday season. Numerous other ceramic and pottery objects, clocks and examples of orfèvrerie, decorative pieces, and so on are in the collection.

Furniture in the European decorative arts collection includes an Italian Renaissance cassone decorated with the painting *The Conquest of Trebizond* by Marco del Buono Giamberti and Apollonio di Giovanni di Tomaso. A Burgundian walnut armoire is in the manner of Hugues Sambin and was carved and painted about 1552. The Farnese table of about 1565–73 attributed to Jacopo Barozzi da Vignola stands at the entrance to the European Paintings Galleries. It is marble intricately inlaid with colored marble, and semiprecious stones. A commode of about 1740 is an example of German Late Baroque furniture and was designed by François de Cuvilliers or Joseph Effner.

A number of period rooms installed complete with appropriate furniture, objets d'art, and so on are on exhibition. They include the studiolo from the Ducal Palace at Gubbio, about 1479–83, with paneling of walnut, oak, beech, and other woods, designed probably by Francesco di Giorgio Martini. A patio from

the castle of Los Velez, Velez Blanco, Almerie, Spain, is of carved marble. Grinling Gibbons or Edward Pearce designed the seventeenth-century staircase from Cassiobury Park, Watford (Hertsford, England), made of pine and carved with symbolic oak leaf and acorn decorations. A bedroom from the Palazzo Sogredo, Venice, features a ceiling painting *Dawn*, probably by the Venetian eighteenth-century painter Gaspare Diziani. The Sèvres Room is taken from an unknown eighteenth-century setting and is furnished with Sèvres objects, including vases, figurines, and clocks. A room from the Hôtel de Cabris, Grasse, France, is in the eighteenth-century French style, as is the Grand Salon from the Hôtel de Tesse, Paris (completed 1773). The Crillon Room from the Hôtel at 10, Place de la Concorde, features a mechanical table by Reisener. A room from the Hôtel de Varangeville, Paris, was commissioned about 1735 by the duchesse de Villars and has gilt oak panels designed by Nicolas Pineau. A Shop Front from 3, Quai Bourbon (Ile St. Louis), Paris, of about 1785 shows another aspect of French eighteenth-century design. Robert Adam's Tapestry Room from Croome Court (Worcester, England) of 1760–71 is hung with Gobelins tapestries after designs by François Boucher.

The textile collection and study room preserve rare and historic textiles, European weavings and carpets, lace, and other goods. Founded in 1909, the textile study room was the first study room established at the Metropolitan. In its early years, the textile collection profited from several gifts. In 1906, in response to a plea in the *Museum Bulletin*, several collections of lace were give to the Metropolitan. The collections of Mrs. Magdalena Nuttall and the Blackthornes formed the center of one of the world's finest lace collections. In 1907 a purchase of historic textiles from Friedrich Fischbach was the museum's first acquisition in this area. Other important purchases included the Sangiorgi Collection of Renaissance and Rococo silks and velvets.

The Metropolitan holds a wide selection of European drawings with several important sheets by major artists. Drawings are presented in rotating exhibitions in galleries located on the second floor of the Rockefeller Wing. A study room is open by appointment to scholars and students. The Drawings Department was established officially in 1960, but early gifts to the museum formed the nucleus of the collection. In 1880 Cornelius Vanderbilt gave 670 drawings from the seventeenth and eighteenth centuries, gathered in Florence by James Jackson Jarves. Mrs. George Blumenthal presented three drawings by Matisse in 1910, the first sheets by the French artist to enter a public collection. In 1929 the Havemeyer Collection brought works by Rembrandt, Daumier, and Barye, and in 1949 Georgia O'Keeffe gave the Alfred Stieglitz Collection, which included a number of Fauve and Cubist drawings. Purchases included drawings from Degas' estate in 1917, and in 1924 major sheets by Leonardo da Vinci and Michelangelo were added. In 1937 fifty works by Goya entered the collection.

Old Master drawings in the collection include Leonardo da Vinci's pen and brown ink *Studies for the Nativity* and Michelangelo Buonarotti's red chalk *Studies for the Libyan Sibyl*. A sheet by Raphael has, in red chalk, the *Madonna*

and Child with Infant St. John on the recto and, in pen and brown ink, *Nude Male Figure* on the verso. The religious scene *Nathan Admonishing David* is by Rembrandt rendered in pen and brown ink. Rubens' sheet *The Garden of Love* was created about 1630–32 as a model for woodcuts executed by Christoffel Jegher. French drawings include Fragonard's *View of Pincio, Rome* and Watteau's *Study of a Man's Head*, similar in style to the artist's painting *Mezzetin* in the Metropolitan. More recent works include Edgar Degas' *Portrait of Edmond Durant*, executed in charcoal, heightened with white chalk, and Seurat's *Portrait of Edmond François Aman Jean*, in conté crayon, from 1883. Picasso drawings in the collection include the Cubist sheet *Nude Woman*, done in charcoal in 1910, and *Portrait of Ambrose Vollard*, dated 1915 and executed in lead pencil in a linear style.

The Department of Prints was founded in 1916, when a print collection and purchase fund were bequeathed to the Metropolitan by Harris Brisbane Dick. In 1919 a large collection of prints by Albrecht Dürer was added as part gift, part purchase, from Junius Spencer Morgan. The Print Department under the curatorship of William M. Ivins, Jr., was planned to resemble the library of a professor of literature, with a collection of prints that are in themselves works of art together with prints that are interesting for their historical and/or technical value. The plan was followed over the years with important gifts and bequests such as Gothic woodcuts and prints by Rembrandt, Dürer, Mary Cassatt, and Currier and Ives. In 1928 the first photographs were presented by Alfred Stieglitz, and the department expanded and began to acquire early photographs by Fox Talbot and D. O. Hill, among others.

Prints in the collection include, among early works, a German woodcut, the *Virgin and Child*, from about 1430–50, handcolored and heightened with silver and gold in the manner of an illumination. Albrecht Dürer's work is well represented with impressions of his 1514 engraving *Melancholia*, his woodcut *The Four Horsemen of the Apocalypse* and his etching *Christ on the Mount of Olives*. A woodcut *Christ on the Mount of Olives* is by Lucas Cranach and is the only impression known of this print. Italian prints include an impression of Antonio Pollaiuolo's engraving *Battle of the Naked Men*, the only known print by the Florentine Renaissance artist. A group of prints by Rembrandt includes the drypoint *The Three Crosses* of 1653, the etching and drypoint *Landscape with Three Gabled Cottages Beside a Road* of 1650, and the etching and drypoint *St. Francis Beneath a Tree Praying* of 1657. Works by the innovative printmaker Hercules Seghers include the etching *Rocky Landscape with a Plateau*. Other prints in the collection include an aquatint by Francisco Goya, *The Giant*, and a complete set of Piranesi's series of architectural etchings, *The Prisons*.

Important photographs in the collection include Alfred Stieglitz's gum print *The Steerage*, from 1907. Edward Steichen's *Flatiron Building-Evening* of 1909 is gum-bichromate print from a 1904 negative. *Indian Head* (c. 1898) and *A Sioux Chief* are among several portraits of American Indians taken by Joseph T. Keiley. Other photographs in the Metropolitan's collection include Gertrude

Käsebier's portrait of a mother and child, *Blessed Art Thou among Women* (1899); a print by Frederick H. Evans, *York Minster* (c. 1900); and works by F. Holland Day, Heinrich Kuehn, and the French photographer Robert Demachy. Photographs of the twentieth century include Charles Sheeler's 1917 image *Bucks County House Interior*, representing a staircase in his Doylestown house; Paul Strand's *From the El* (1915); and an early nature study by Ansel Adams, *Winter Yosemite Valley* (c. 1933).

The Robert Lehman Collection, a selection of European paintings, drawings, furniture, and decorative arts, is housed in The Lehman Pavilion. The Pavilion, completed in 1975, is located on the west side of the museum, facing Central Park. Several rooms recreate the original setting of Lehman's house on West 54th Street; larger galleries enclose a sky-lit atrium. The Lehman Collection was created as a small, private museum within the larger Metropolitan Museum, as specified by the donor.

Highly important paintings of the early Italian and Early Netherlandish schools are preserved in the collection. A *Crucifixion* is by a follower of the Florentine, Duccio di Buoninsegna. Several works by Ugolino da Nerio include a *Last Supper* and a *Madonna and Child*. Barna da Siena's *St. Peter* is exhibited, as are several paintings by the Sienese Paolo di Giovanni Fei. Two paintings are by Sassetta, an *Annunciation* and the *Temptation of St. Anthony*. A *Virgin and Child* is by Bernardo Daddi, and two panels are by Lorenzo Monaco, a *Nativity* and a *Crucifixion*. Among the treasures of the Lehman Collection is Sandro Botticelli's *Annunciation*. Venetian paintings exhibited include the representations *Madonna and Child* by Giovanni Bellini, Bartolomeo Vivarini, and Carlo Crivelli. Netherlandish paintings include Petrus Christus' masterpiece *St. Eligius*. Two works are by Hans Memling, including the *Portrait of a Young Man*. Gerard David's *The Rest on the Flight into Egypt* is one of the paintings by the artist in the collection. A manuscript illumination, the *Descent of the Holy Ghost upon the Faithful*, is by Jean Fouquet, and the exquisite *Portrait of a Young Princess (Margaret of Austria)* is by the Master of Moulins. A selection of paintings from the later periods includes El Greco's *Christ Carrying the Cross* and Francisco Goya's portrait *The Countess of Altamira and Her Daughter*. Two paintings are by Rembrandt, *Portrait of an Elderly Man* and *Portrait of Gerard de Lairesse*. A charming interior scene is by Pieter de Hooch, *Interior with Figures*. The Lehman Collection includes an excellent group of modern paintings of the French School. Jean Auguste Dominique Ingres' famous *Portrait of the Princesse de Broglie* hangs in the Special Gallery. Claude Monet's *Landscape near Zaandam* and Cézanne's *House behind Trees on the Road to Tholonet* are two of the landscapes in the collection. *Mme. Rolin and Her Baby* is a notable work by van Gogh, and a Gauguin work is titled *Tahitian Women Bathing*. An unusual *Landscape* is by Edgar Degas. Other works include André Derain's *Houses of Parliament at Night*, and He·ri Matisse's *Promenade among the Olive Trees*, as well as paintings by Braque, Signac, Vlaminck, Vuillard, and others.

A large selection of North German and Mosan aquamanile are among the

decorative arts in the collection. Renaissance furniture includes a Lombard choir-stall, various North Italian and Roman carved cassone, and a French high chest probably from Fontainebleau. Other pieces include tapestries, majolica, and Limoges enamels.

Highly important drawings with examples from all periods are preserved in the Lehman Collection. Early Northern drawings include a sheet, *Man Shoveling Chairs*, after Rogier van der Weyden and *Two Pharisees* by Hieronymus Bosch. Excellent works by Albrecht Dürer include his *Self Portrait at the Age of Twenty-Two* and the *Holy Family in a Trellis*. Rembrandt's *Last Supper after Leonardo* and a typical landscape, *Cottage near the Entrance to the Woods*, are in the collection. Also by Rembrandt is a *Self Portrait*. Italian drawings feature Antonio Pollaiuolo's *Study for the Equestrian Statue of Francesco Sforza*, Leonardo da Vinci's *Study of a Walking Bear*, and Francesco di Giorgio's *Kneeling Humanist with Angels*. A detailed sheet by Canaletto is *The East Front of Warwick Castle*. Other works are Rubens' *Bust of Seneca*, Claude Lorraine's *View of the Villa Doria Pamphili*, and Fragonard's *Le Dessinature*. Modern drawings include van Gogh's *Road at Nuenen* and Goya's *Self Portrait*. Drawings are presented in rotating exhibitions on the lower level of the Lehman Pavillon but may be viewed by appointment.

American art is housed in the American Wing. A comprehensive history of the arts in America is presented with examples of painting, sculpture, architec-ture, and decorative arts. In 1909 the museum exhibited American paintings and house furnishings (with Dutch paintings in America) to celebrate the anniversary of Henry Hudson's exploration of the Hudson River (1609) and Robert Fulton's introduction of steam navigation (1809) and "to test out the question whether American art was worthy of a place in an art museum." The exhibition was well received, and gifts of American art began to come to the Metropolitan, among them, six hundred pieces of seventeenth- and eighteenth-century Amer-ican furniture from Mrs. Russell Sage. In 1924 the first American Wing opened with a series of rooms dating from 1670 to 1820. Other additions followed, including, in 1931, the entry from the Van Rensselaer House in Albany with its hand-painted wallpaper. In 1970 a major exhibition opened at the Metropolitan, "Nineteenth Century America," which reacquainted viewers with art of the recent past. For the American Bicentennial in 1976, a new expanded wing was planned. It opened to the public in 1980, with additional installations constantly being added. Most recently, the Frank Lloyd Wright Room was completed (1982).

The American Wing consists of the original three-story building, which opened in 1924, surrounded by a new structure of masonry, steel, and glass. The building includes the Engelhard Courtyard, displaying architectural elements and sculp-ture; the courtyard balcony, where glass, ceramics, pewter, and silver are ex-hibited; period rooms and furniture galleries; and galleries for paintings, sculpture, and special exhibitions.

American sculpture is exhibited in the Engelhard Courtyard and includes works

by Augustus Saint-Gaudens. *Diana*, a gilded bronze, is a reduced replica of an original sculpture created as a weathervane for Madison Square Garden. A marble relief, *Mrs. Stanford White (Bessie Smith)*, is from 1884, and *Victory* is a reduction of the figure in the equestrian monument to General Sherman at the Plaza entrance to Central Park. Augustus Saint-Gaudens and John La Farge created the *Vanderbilt Mantelpiece* in 1884, a marble with gigantic caryatids. *Memory* is by the American beaux-arts sculptor, Daniel Chester French (1919). French also sculpted the *Milmore Memorial, Angel of Death and a Young Sculptor*. *The White Captive* of 1859 was done by Erastus Dow Palmer, and the bronze *Bacchante and Infant Faun* is by Frederich William MacMonnies.

Architectural elements exhibited in the Garden Courtyard include the facade of the Branch Bank of the United States, Wall Street, New York City (1822–24), designed by Martin E. Thompson in Greek Revival style. Louis Comfort Tiffany created the limestone entrance loggia for his home Laurelton in Oyster Bay, Long Island. The pulpit from All Angel's Church, New York, was designed in 1900 by Karl Richter, a Viennese architectural sculptor who worked in New York. A pair of staircases in cast iron with electroplated copper finish and mahogany railings was designed by Louis H. Sullivan for the Chicago Stock Exchange.

The Courtyard Galleries on the second floor exhibit glass, ceramics, silver, and so on. Tiffany lamps and other glass include his decorative "favrile" glass vases. Examples of American art pottery of about 1900 are shown. A silver tea set by Paul Revere, Jr., dates from about 1790 and is designed with a gouged "bright cut" design. A silver tea kettle made in New York by Cornelius Kierstede is from about 1710–15. Pewter includes a chalice created by Timothy Brigden in Albany, New York, about 1800.

Period rooms from the seventeenth and eighteenth centuries are located on the third floor of the American Wing. An Orientation Gallery treats the theme "Wood Frame Construction," and rooms include the Hart Room from before 1674, the Newington Room of 1740–60, the Hampton Room of 1740–60, the New York Alcove of about 1750, the Hewlett Room of 1740–60, and the Bowler Room of about 1763. An installation of eighteenth-century period rooms and galleries of eighteenth-century furniture is located on the second floor. Clocks and Philadelphia furniture (including highboys, sidechairs, and a tilt-top table) are exhibited. The Verplanck Room from about 1767 was the left front parlor in a house in Goldenham, New York. The Marmion Room from a Virginia plantation house (paneled 1735; painted 1770–80) features Rococo and neoclassical motifs. Eighteenth- and nineteenth-century period rooms are on the first floor. The Federal Gallery is from 1790–1810, and the Baltimore Room of about 1810 reflects the English style of Robert Adam. The Neoclassical Gallery of about 1810–20 is furnished with Greek Revival style furniture. The Decorative Arts Orientation Gallery presents the "Reconstruction of the Richmond Room," detailing procedures of the room's removal and reinstallation at the museum. The Richmond Room, a sitting room of about 1810 from Virginia, shows the

influence of French Napoleonic design in its furnishings and style. The Haverhill Room of about 1805 is a bedroom in the style of Robert Adam. Federal furniture and decorative arts of 1780–1865 are presented in several galleries and include a selection of painted furniture and decorations from 1790–1850. Painted Windsor and Fancy chairs, chests, mirrors, and other pieces are shown. A gallery of American folk art includes an Amish quilt from Pennsylvania (c. 1910), a simple patchwork of red and blue with elaborate quilting in diamond and feather patterns. Several paintings such as Rufus Hathaway's *Lady with Her Pet* of 1790 and Edward Hicks' *The Falls of Niagara* (1825) exemplify the folk-art style in painting. A Shaker Retiring Room from New Lebanon, New York (c. 1830–40), presents the spare simplicity preferred by this group of religious settlers. The Frank Lloyd Wright Room, a living room from the Little House in Wayzata, Minnesota (1912–14), continues the Prairie style architecture of Wright's earlier houses, and the oak furnishings reflect an interest in the Arts and Crafts Movement.

Examples of American furniture in the American Wing include a rare "Turned Chair" from Massachusetts, dating from about 1650–60, made of hickory and ash. A Queen Anne-style highboy from Boston of about 1735 is japanned in the English style, and a mahogany highboy from Philadelphia of about 1765 is considered an outstanding example of Philadelphia Chippendale furniture. It features carved details illustrating the fables of La Fontaine, based on fifteen engravings in Chippendale's *Director*. A parlor suite created by the Duncan Phyfe workshop for Samuel A. Foot's house at 678 Broadway, New York, is from about 1837. A cupboard (*kas*) from the Hudson River Valley, New York, is painted in grisaille, with representations of fruit and garlands, and reflects the eighteenth-century Dutch influence in New York.

American paintings are exhibited in galleries on the second floor of the American Wing. American painters had been involved in the founding of the Metropolitan Museum (four were among the original trustees), but during its first thirty years, very few examples of American painting were purchased by the museum. Several important gifts were presented, though, including the portrait *Alexander Hamilton* by Trumbull from Henry Gurdon Marquand in 1881 and the portrait *George Washington* by Gilbert Stuart presented by H. O. Havemeyer in 1888. Other gifts included, in 1896, Charles Willson Peale's full-length portrait *George Washington* from Collis P. Huntington and, in 1897, Matthew Pratt's *The American School* from Samuel P. Avery. Several purchase funds enabled the Metropolitan to collect American painting on a larger scale, and today the collection is considered the most broadly representative group of American paintings.

In addition to works by Gilbert Stuart, Charles Willson Peale, and Matthew Pratt are eighteenth-century portraits by John Singleton Copley (*Mrs. John Winthrop* and other works). Primitive paintings include *The Abraham Pixler Family* by an unknown artist executed in watercolor on paper about 1815. Joseph Badger's portrait *James Badger* represents the small boy holding a bird. Nineteenth-century paintings include Samuel F. B. Morse's well-known canvas *The Muse-*

Susan Walker Morse. Works from the early Hudson River School (1830s–1860s) include Thomas Cole's *The Oxbow (The Connecticut River near Northampton)* of 1836 and *View from Mount Holyoke, Massachusetts, after a Thunderstorm* of 1836. The *Rocky Mountains* is by Albert Bierstadt (1863) and *In the Woods*, a forest landscape, is by Asher B. Durand (1855). Late Hudson River School paintings include Martin Johnson Heade's *The Coming Storm* and works by John Frederick Kensett, including *Lake George*, a painting of 1869. Albert Pinkham Ryder's *Moonlight Marine* is executed in oil on wood and dates from about 1870–90. The work of Winslow Homer is well represented in the collection, and a gallery is devoted to the paintings of the New England artist. *Snap the Whip* (1872) is one of the schoolboy subjects Homer painted, and *Prisoners from the Front* was painted in 1866, the year after the Civil War. Seascapes such as *Northeaster* (1895) and *The Gulf Stream* (1899), which represents a lone man in an open boat, are exhibited. A notable painting in the American collection is the monumental canvas by Emanuel Leutze, *Washington Crossing the Delaware*, painted in 1851. Post-Civil War art includes Thomas Eakin's *Max Schmitt in a Single Scull* of 1871. Works of Western art, tromp-l'oeil painting, and Visionary painting are exhibited.

Late nineteenth-century works are exhibited in the American Paintings Galleries with examples by the American Impressionists. Several works by Mary Cassatt include *The Cup of Tea*, a portrait of the artist's sister Lydia that reveals stylistically the impact of French Impressionism. *Young Mother Sewing* was painted at Cassatt's country house near Beauvais with a village girl as model, and *Lady at the Tea Table* (1885) represents Mrs. Robert Moore Riddle and as a painting was considered by Edgar Degas "the very essence of distinction."

James McNeill Whistler is represented by a number of full-length portraits, including *Arrangement in Flesh Color and Black: Portrait of Théodore Duret*, the Parisian art collector and critic (1883), and *Mr. and Mrs. I. N. Phelps Stokes* (1897). Also in the Metropolitan is one of Whistler's most dramatic works, *Portrait of Madame X* (1884).

Paintings by John Singer Sargent include his important portrait *The Wyndham Sisters: Lady Elcho, Mrs. Adeane and Mrs. Tennant* of 1899. *The Hermit*, an oil painting dating from 1908, is distinctive because of its loose brushwork and sense of spontaneity that characterize Sargent's watercolors. Two paintings by Theodore Robinson were painted at Giverny, where the American artist worked closely with Monet: *A Bird's-Eye View* of 1889 and *The Old Mill* of 1892. John Twachtman's *Arques-la-Bataille* of 1885 reveals the influence of the Munich school in its muted, gray palette, and flat areas of color are most likely connected to the Oriental prints so important to contemporary French painters. Three paintings titled *Horseneck Falls*, a waterfall on Twachtman's property in Cos Cob, Connecticut, are in the Metropolitan's collection. Another American influenced by the Impressionists was Edmund Charles Tarbell, who is represented by his family portrait *Women in Pink and Green* of 1897.

Childe Hassam's depictions of New York include *Spring Morning in the Heart*

of the City (1890) and *Winter in Union Square* (n.d.); the artist's patriotic image, *Avenue of the Allies: Great Britain in 1918* is also in the collection. *Central Park* (1910) is one of several paintings by Maurice Prendergast in the Metropolitan, and Cecilia Beaux's *Ernesta (Child with Nurse)* of 1894 exemplifies the painter's superb and sensitive portraits of children.

The Department of Twentieth Century Art was founded in 1967 with the idea of gathering together paintings, sculpture, drawings, and decorative arts of this century. In 1970 the curator of the department, Henry Geldzahler, assembled more than four hundred works for the exhibition ''New York Painting and Sculpture: 1940–1970,'' which committed the museum to contemporary art and to an active acquisition program in this area. A new wing with galleries for twentieth-century art, named the Lila Acheson Wallace Wing of Twentieth Century Art, is expected to open in 1987. Among the major examples of twentieth-century painting at the Metropolitan, works by Pablo Picasso include *The Blind Man's Meal*, a Blue Period canvas from 1903; the *Portrait of Gertrude Stein* from 1906; and *A Woman in White*, a Classicist work of 1923 with his wife, Olga Koklova, as the model. Henri Matisse's *Odalisque* of about 1923–25 shows the artist's fascination with the harem motif. A bronze sculpture by Constantin Brancusi is titled *Sleeping Muse*. Wassily Kandinsky's *Improvisation 27* dates from 1912. Abstract Expressionist paintings include *Easter Monday* by Willem De Kooning (1955–56) and *Autumn Rhythms* by Jackson Pollock (1950). The sculptural equivalent to Abstract Expressionism is found in works such as David Smith's stainless steel *Becca* (1965). Drawings in the collection include preparatory works such as Smith's *Study for Becca*, ink and collage. Other paintings in the collection include works by Josef Albers, Hans Hofmann, Jasper Johns, Franz Kline, Robert Motherwell, Barnett Newman, and Clyfford Still. Sculpture by Louise Nevelson, Theodore Roszak, and others is included.

Decorative arts from the twentieth century feature Art Nouveau furniture such as Emile Gallé's hanging cabinet (c. 1900), Louis Marjorelle's dressing-table sink (1900–10), and Gustave Serrurier-Bovy's cabinet vitrine of red narra wood (1899). A table lamp by Louis Comfort Tiffany has a ceramic base by Pierre Adrien Dalpayrat and dates from about 1900–1902. Works in the Art Deco style include an elevator from the International Building at Rockefeller Center, constructed of canaletta wood and various metals. A desk chair is by Emile Jacques Ruhlman. A magnificent screen commissioned for the music room of Mr. and Mrs. Solomon R. Guggenheim's Long Island home was designed and sculpted by Seraphin Soudbinine and lacquered by Jean Dunant. The screen, executed in 1925–26, is *The Battle of the Angels: Crescendo and Pianissimo*.

The Department of Far Eastern Art preserves paintings, sculpture, and decorative arts from China, Japan, India, and Southeast Asia, spanning a period of four thousand years. The department was founded in 1915, but by 1879 about 1,300 Chinese porcelains had already been purchased by subscription. Early gifts such as a Han Dynasty bronze presented by the Chinese diplomat Chang Yen Hoon in 1887, more than 1,000 jades from Heber R. Bishop in 1902, and

ceramics from J. P. Morgan and Benjamin Altman in 1913 formed the core of the outstanding collection. Additional gifts of Oriental ceramics from Samuel T. Peters and John D. Rockefeller, Jr., have made the Metropolitan's one of the foremost collections. Important later purchases of Chinese paintings, particularly recent acquisitions, have created an important collection. A major purchase of Japanese art from the collector Harry Packard was undertaken in 1975 with an agreement to half purchase, half receive as gift, a group of 412 objects.

Chinese art was recently installed in the Douglas Dillon Galleries on the second floor of the Sackler Wing. Monumental sculpture includes a gilt-bronze standing Buddha from the Northern Wei Dynasty (477), the largest work of its kind known to have survived. A stone stele with scenes from Vimilakirti Sutra is from the Eastern Wei Dynasty (533–543). From the Sui or early T'ang Dynasty, a seated Buddha made of dry lacquer on cloth and wood with paint and gilt is a serenely meditative figure. Early bronzes in the Metropolitan's collection include a vessel (*li-ting*) of the later Shang Dynasty decorated typically with *t'ao t'ieh* (ogre) masks in bold relief. A ritual grain or wine vessel (*fang-i*) is from the early Western Chou Dynasty and is said to be from a tomb uncovered in 1901 near Pao chi-tsien.

Chinese ceramics are exhibited in galleries overlooking the museum's Great Hall. From the T'ang Dynasty, a painted and gilded clay pottery standing horse was made in Ch'ang an (Shensi Province) and Lo-yang (Honan Province), important porcelain centers. A bowl with carved foliate designs is probably from the Chien tz'u Ts'un kilns, Hopei Province, and dates from the Northern Sung Dynasty. This delicate piece is typical of the Sung wares that were later very influential. A porcelain covered vase (*mei p'ing* type) painted in an underglaze blue is one of many blue-and-white wares from the Yüan Dynasty in the collection. A porcelain vase (Ching te-chen ware) with an oxblood glaze is only one example of porcelain from the K'ang-hsi period. Famille verte and famille rose porcelains from that period are also exhibited. A number of important Chinese paintings are included in the extensive Sackler Wing installation. A handscroll, *Night Shining White*, is by Han Kan and dates from the T'ang Dynasty (c.740–756). *The Tribute Horse*, a magnificent hanging scroll from the Sung Dynasty, is rendered in colors on silk and features a typical Sung landscape. Ch'ü Ting's handscroll *Summer Mountains* is an important work from the mid-nineteenth century and is done in ink and color on silk. A hanging scroll by Ni Tsan titled *Woods and Valleys of Yü-shan* (dated 1372) makes effective use of voids and creates a sense of two unrelated spaces. Other works include scrolls from the Yüan and Ming dynasties and album leaves from the Ch'ing Dynasty. Complementing the installation of paintings is a selection of calligraphers' tools dating from the Ch'ing Dynasty. "The Scholars' Table" includes pen holders, brushes, and other objects exquisitely fashioned for use in the day-to-day business of writing and painting. A number of jade vessels and objects are exhibited, as are several elaborately embroidered robes from the Ch'ing Dynasty.

The Dillon Galleries are arranged around the Ming Scholar's Retreat, a garden

court and reception hall created by the craftsmen and engineers of Soochow Garden Administration in the People's Republic of China. The garden, an orchestration of splashing water and immovable rocks, exemplifies the Chinese philosophical concepts of yin and yang. The Ming Room follows the design described in a late Ming garden building manual, *Yüan Yeh*. The wooden structure is completed with examples of Chinese furniture such as a pair of rosewood armchairs from the sixteenth or seventeenth century, a sixteenth-century rosewood wardrobe with brass details, carpets, hanging scrolls and so on.

Japanese art, which will be installed in new galleries, includes a selection of paintings, sculpture, screens, and objects. The lacquered wood sculpture *Jizo Bosatsu* seated on a lotus petal dates from the Kamakura period (early fourteenth century) and presents the guardian of warriors and travelers as a youthful monk. The lacquered wood *Portrait of a Zen Monk, Abbot of a Monastery*, with the figure in *Dhyama mudra*, a position of meditation, is from the Muromachi period. Paintings in the collection include a handscroll, *Kannon Kyo (Miracles of Kannon or Kuan-yin)*, from the Kamakura period. This work, rendered in watercolor and gilt on paper, is in an early Japanese style and reflects the strong influence of Chinese Sung painting. From the late Kamakura period, a hanging scroll, *Aizen Myoo*, presents the king of passion with a lotus flower that symbolizes the teachings of Buddha. Japanese screens include Ogata Korin's two-fold *Rough Waves*, considered the finest painting outside Japan. Also by Ogata Korin is a six-fold screen, *Yatsuhashi (Eight-plank Bridge)*, a subject referring to a passage from *Tales of Ise* (Edo period, early eighteenth century). An earlier work by Soami (Kangaku Shinso) is *Landscapes of the Four Seasons*, done in ink on paper.

A number of Indian and Southeast Asian sculptures are in the collection. A bronze standing Parvati from South India, Chola Dynasty (c. 900), stands in *tribhanga* (or "three-bends-in body") pose, a sinuous form typical of Indian sculpture. A bronze standing Buddha from the Late Gupta period (c. 600–650) holds his hands in *abhaya mudra*, a gesture of reassurance. The *Mithene Couple* is from the temples constructed at Orissa in the eighth and thirteenth centuries. The bronze *Adoring Figure* from Cambodia's Angkor period was probably cast in the Imperial Workshop or at the temples of Angkor.

The Michael C. Rockefeller Wing of Primitive Art, which opened in 1981, houses art of Africa, the Pacific Islands, and pre-Columbian and Native America. During the 1880s and 1890s the Metropolitan had gathered Peruvian and Mexican antiquities, but they were lent for many years to ethnological collections on the assumption that their interest was more ethnological than artistic. In recent years major gifts from Nathan Cummings, Alice K. Bache, and others enriched the museum's holdings considerably, and in 1969 the Department of Primitive Art was established. That same year, the Metropolitan hosted an exhibition of objects from the Museum of Primitive Art, which had been founded in 1956 by Nelson A. Rockefeller, who pledged the entire collection to the Metropolitan on the completion of a new wing in honor of his son Michael. Today the

Department of Primitive Art has extensive galleries, the Robert Goldman Library, and a photographic archive. The galleries are organized by region. An Orientation Area, with maps and comparative time charts, and a bookstore are at the entrance.

From the western Sudan, African sculpture, such as a pottery seated figure made by the Djenne of Mali, is displayed. Architectural elements include a Bamana, or Bozo door made of wood and metal and carved with alligators and snakes. A large wooden container is by the Dogon people of Mali and is one of the many objects in the Lester Wunderman Collection of Dogon Art on display. Also exhibited are several antelope headdresses of the Bamana people. Equatorial Africa is represented by examples of art from Nigeria's Court of Benin, whose culture dates from the sixteenth and seventeenth centuries. An exquisite pendant mask from the early sixteenth century is carved of ivory. A group of bronze plaques represents court scenes: mounted king and attendants, a king and attendants, and a chief and attendants. A bronze head from the late seventeenth century features the high necklace favored by the Benin. Central African art includes reliquary figures from Gabon of both the Ambete and Kotu peoples. Stools, symbols of kingship, are exhibited and include a wooden stool with a female figure by the Buli Master, Zaire, Luba Hemba people. A chair from the Chockwe people of Angola is elaborately carved on the back with female and male figures, and the leg rungs are decorated with female figures pounding grain and male figures tending animals.

The art of Mesoamerica includes a Huastic figure, *Hunchback Holding a Staff*, a sinuous figure made of sandstone. A large Maya-Toltec figure, *Warrior with a Club*, is an unusual freestanding work. A Maya-Toltec stone head, *Rain God*, has a traditional fierce expression. Pottery vessels in the form of humans, animals, and vegetables are from the second and third centuries. These vessels, used for funerary offerings, include a horned-figure vessel, a hunchbacked-figure vessel, and an acrobat-figure vessel, from Colima, Mexico. A Mayan limestone stele is from the eighth century and depicts an enthroned ruler. These commemorative monuments were traditionally placed in front of major temples. The Nathan Cummings Collection features a number of pre-Columbian ceramics. Also exhibited is a magnificent feathered hanging from Peru (Wari Tiahuanaco) that dates from the early eighth century. Made of feathers on cotton, luxurious hangings of this sort were presumably used to decorate walls of large compounds or courts on special occasions. Several fourteenth-century silver beakers and other vessels from the kingdom of Chimu in nothern Peru are shown. The Treasury is an installation of gold objects and precious jewelry from the Americas. A pair of earplugs from Peru (third-sixth century) featured representations of a bird-headed runner rendered in stone and shell mosaics. A group of gold beakers from Lambayeque, Peru, date from the twelfth to fourteenth century. They are decorated in repoussé with faces, animal motifs, and abstract patterns and were probably used as mortuary offerings. Other examples of jewelry are from Costa Rica, Peru, and Panama.

Objects from North America include a Mississippian stone seated figure (Adam)

from the Southeast United States (thirteenth-fourteenth century). Nineteenth-century art from the Pacific North Coast includes a headdress frontal of painted wood and shell from British Columbia and a raven rattle and an ivory Shaman's charm from Alaska.

Art of the Pacific Islands is exhibited. From Australia a bark painting, *Two Kangaroos*, is treated as an "x-ray" of the animals. An Iatmul canoe prow, from Papua New Guinea (East Sepik) is fashioned as a crocodile; crocodiles and other reptiles were believed to be the creators of the world. A large number of Asmat objects reflect Michael Rockefeller's activities in that area and include monumental *Mbis* poles that were of central importance in ceremonies for the dead. An Asmat canoe from Irian Jaya carved in the twentieth century by Chinsapitch represents two human figures: a young man who had been killed and eaten by the enemy and a seated female representing the carver's dead sister Banditis. Other Asmat objects include elaborate masks, ancestor poles, canoe prows, and shields carved and painted boldly with symbolic designs. Enormous musical instruments, called slit gongs, representing figures are from New Hebrides. They were used in the complex rituals of sacrifice and initiation rites. A small model temple made of sennit wood and shells is from Fiji (early nineteenth century) and was used to house sacred objects.

The Metropolitan's collection of musical instruments is one of the most comprehensive in the world. A cross-section of European and non-Western instruments are installed in the André Mertens Galleries on the second floor of the museum (opened in 1971). The gathering of musical instruments goes back to the earliest years of the museum. In 1884 a Spanish church bell was presented to the Metropolitan, and by 1889 gifts from Joseph Drexel had enriched the collection. In 1889 Mary Crosby Brown presented 276 instruments, many of which were non-European. In the 1930s, under the supervision of Curt Sachs, many instruments were restored to playing condition, and in recent years, the Metropolitan has produced recordings of music played on the rare and original instruments in the collection. Treasures such as a virginal made for the duchess of Urbino in 1540 and the oldest extant piano made by its inventor Bartolommeo Cristofori in Florence in 1720 are in the collection. A Stradivari violin is the only one known to have been restored to its original condition. Instruments from tribal Africa, from the Pacific North Coast of America, and from the Far East are also in the Metropolitan's collection.

The Department of Arms and Armor preserves a large collection of medieval and Renaissance metalwork with more types and styles of armor than any other collection. An installation is located off the Medieval Hall on the first floor of the museum. In 1875 the newly formed Metropolitan Museum hosted an exhibition of the Cogniat Collection of armor, and in 1896 a gift of 166 pieces of arms and armor essentially began the collection. In 1904 the valuable Parisian collection of the Duc de Dino was purchased and throughout the years various important donations, including whole collections, were added to the museum's holdings. Examples of arms and armor include a suit of armor attributed to

Martin van Royne, with decorations probably by the artist Hans Holbein. The armor is made of etched and gilded steel with brass, leather, and green velvet (sixteenth century). A parade shield designed by Étienne Delaune, court artist of Henri II of France, is made of steel damascened with gold and silver. A parade rapier was created for Christian II, duke of Saxony and elector of the Holy Roman Empire, and was executed by Israel Schnech, swordcutter and hiltmaker to the Electoral Court of Saxony (1590–1610). The elaborate rapier is made of steel with gilt-bronze, various jewels, seed pearls, and traces of enamel and is an example of the high state of this art.

The Costume Institute at the Metropolitan is dedicated to preserving examples of clothing. It is located on the ground floor of the museum, where a series of galleries are used to present rotating exhibitions. The Costume Institute was started in 1937 as a separate museum. Irene Lewisohn opened the Museum of Costume Art in a loft on West 46th Street to help theater designers in the area. In 1939 the collection was moved to Rockefeller Center and in 1946 became part of the Metropolitan. As the Costume Institute, the collection reopened in 1971 with galleries, a library, a study room, and a collection of more than thirty thousand items. The collection includes an English gown of about 1690 made of wool and embroidered with gilt-silver yarns. This is believed to be the only everyday gown that has survived from the seventeenth century. A silk damask man's dressing gown of about 1780 and a silk man's dress suit of 1775–80, both from England, are included, as is a silk embroidered lady's robe à la française from the same period. Modern designs are acquired, such as Elsa Schiaparelli's woman's theater suit of 1937. This costume includes a velvet jacket embroidered with gold, tinsel, and red stones in a sea anemone motif, with a silk skirt, a document of 1930s nightlife.

The Metropolitan Museum of Art sponsors an exceptionally active education program. In 1908 a series of weekend lectures was initiated. This began a tradition of adult museum education that is carried on today in lecture programs, films, daily gallery talks, and other events. In 1941 the Junior Museum was founded by F. A. Taylor and headed by Louise Condit as a special center for children. A gallery and classroom introduced them to art and helped them look at paintings and sculpture. Facilities such as a coat room, a lunchroom, and restrooms made visits for children easy and comfortable. Today high school programs offer art and art history classes for teenagers and sponsor museum internships for these students. Young peoples' programs host gallery talks and creative projects for children as young as five years old. Community Education, another branch, brings art out of the museum by giving slide lectures in New York schools and community centers. The Uris Center for Education, a complex completed in 1983, offers a desk for Visitors' Information and an Orientation Theater, Exhibition Gallery, Library and Resource Center, Media Center, Auditorium, Classrooms, and Staff Offices.

The Thomas J. Watson Library is a major art research library. It is open to scholars and graduate students and offers rare and scholarly volumes on art,

current art periodicals, and auction sale catalogues. It is located on the first floor of the museum.

The Photograph and Slide Library is located in the Uris Center for Education (ground floor) and houses a large selection of photographs and slides for research and documentary purposes.

A large bookstore featuring volumes on or related to art and architecture is located on the first floor, off the Great Hall. The wide selection offers exhibition catalogues and catalogues of the Metropolitan's collections, issues of the museum's *Bulletin*, and books from a range of publishers. The bookstore also carries postcards of objects in the collection. An information desk is located in the bookstore to answer questions about books in stock.

The Metropolitan maintains a complex of gift shops located off the Great Hall. Reproductions of objects in the collection, produced by a staff of experienced craftspeople, are sold. Posters and printed reproductions are available in a shop located on the second floor.

The Photo Studio of the Metropolitan Museum is responsible for visual documentation of all objects in the collection. Black-and-white photographs of specific works of art can be ordered for a small fee through the department (processing usually takes six to eight weeks). Color transparencies are available for rental, and the museum publishes a catalogue of transparencies available. If a work has not been photographed, new photography may be requested for a substantial fee.

An active publishing program is administered by the Office of the Vice President and Publisher. The free *Calendar* of events with exhibitions appears monthly. *The Metropolitan Museum of Art Bulletin* (begun in 1905) is produced four times a year, and each issue is devoted to some aspect of the collection or to a special exhibition. *The Metropolitan Museum of Art Journal* is an annual scholarly publication with original research related to objects in the collection (first produced in 1968). *The Metropolitan Museum of Art Annual Report* is a fiscal year review highlighting acquisition activities, special departmental activities, major exhibitions, and publications, as well as the financial status of the museum. The *Annual Report* also includes updated lists of trustees and staff members.

For convenience of visitors, the Metropolitan maintains a cafeteria, restaurant, bar, and cafe on the first floor of the museum for meals and refreshments. A second cafe is on the second floor of the Sackler Wing.

Selected Bibliography

Guide to the Metropolitan Museum of Art, New York, 1972 (2d ed., 1983); The Metropolitan Museum of Art, *Charter Constitution ByLaws*, 1977; *The Second Century: The Comprehensive Architectural Plan for the Metropolitan Museum of Art*, 1971; Howe, Winifred E., *A History of the Metropolitan Museum of Art*, 1913 (vol. 1) and 1946 (vol. 2); Tomkins, Calvin, *Merchants and Masterpieces: The Story of the Metropolitan Museum of Art*, 1970; Baetjer, Katharine, *European Paintings in the Metropolitan Museum of Art by Artists Born in or before 1865*, 3 vols., 1980; Bean, Jacob, *17th Century Italian Drawings in the Metropolitan Museum of Art*, 1979; Fahy, Everett, and Francis Watson,

The Wrightsman Collection, 1963; Fong, Wen, and Marilyn Fu, *Sung and Yüan Paintings*, 1973; Gardner, Albert Ten Eyck, *American Sculpture: A catalogue of the Collection at the Metropolitan Museum of Art*, 1965; idem, *American Paintings: A catalogue of the Collection of the MMA, Painters Born before 1810*, 1964; Hayes, William C., *The Scepter of Egypt*, 2 vols. (Cambridge, Mass., 1953 and 1959); Hibbard, Howard, *The Metropolitan Museum of Art*, 1981; Mayer, A. Hyatt, *Prints and People: A Social History of Printed Pictures*, 1971; Newton, Douglas, *The Nelson A. Rockefeller Collection: Masterpieces of Primitive Art*, 1978; Parker, James and Clare Le Corbeiller, *A Guide to the Wrightsman Galleries at the MMA*, 1979; Rorimer, James J., et al., *The Cloisters* (3rd ed.), 1963; Szabo, George, *The Robert Lehman Collection*, 1975; Sterling, Charles, *A Catalogue of French Paintings XV-XVIII Centuries* (Cambridge, Mass., 1955); Sterling, Charles, and Margaretta M. Salinger, *French Paintings: A Catalogue of the Collection at the Metropolitan Museum of Art, II, XIX Century*, 1966; idem, *French Paintings: XIX-XX Centuries*, 1967; Zeri, Federico, and Elizabeth E. Gardner, *Italian Paintings, Florentine School: A Catalogue of the Collection at the Metropolitan Museum of Art*, 1971; idem, *Italian Paintings: Sienese and Central Italian Schools*, 1980; idem, *Italian Paintings: Venetian School*, 1973, reprinted, 1979.

LORRAINE KARAFEL

MUSEUM OF MODERN ART, THE (alternately MOMA), 11 West 53rd St., New York, New York 10019.

The Museum of Modern Art was founded in 1929, when in May Lillie P. Bliss, Mrs. John D. (Abby Aldrich) Rockefeller, and Mrs. Cornelius J. Sullivan invited A. Conger Goodyear to be chairman of a committee to organize a new museum. He accepted and was joined by Mrs. W. Murray Crane, Frank Crowninshield, and J. Paul Sachs. The committee then appointed its first director, Alfred J. Barr, Jr. That same year the seven founders issued a brochure, *A New Art Museum*, that stated their goals: They "would attempt to establish a very fine collection of the immediate ancestors, American and European, of the Modern movement; artists whose paintings are still controversial for universal acceptance. . . . This was to be an institution dedicated to the arts of our time, one of whose primary purposes was to help people enjoy, understand and use the visual arts of our time."

It was Alfred Barr who, as early as 1929, proposed in the same document that "the museum would expand beyond the narrow limits of paintings and sculpture in order to include departments devoted to drawings, prints, and photography, the arts of design in commerce and industry, architecture (a collection of *projets* and maquettes), stage designing, furniture and decorative arts. Not the least important collection might be the *filmothek*, a library of films."

During the summer of 1929, the museum opened its doors, in six rooms, rented for the galleries, offices, and library in the Heckscher Building at 730 Fifth Avenue. The public's response was overwhelming, and within the next ten years, the museum was obliged to move to progressively larger temporary quarters. On May 10, 1939, the museum opened the doors of the building it still occupies in mid-town Manhattan on West 53rd Street, midway between Fifth

venue and the Avenue of the Americas. The new International Style building was designed by the architects Philip L. Goodwin and Edward D. Stone.

The museum's collections presently number more than one hundred thousand works. To accommodate the perpetually increasing collection of the arts and the evergrowing number of visitors, the museum launched a major building program that was completed in the spring of 1984. The architect for this project was Cesar Pelli. The completed museum now has twice the exhibition space formerly available and can display a considerable number of works that were never exhibited before.

The museum-expansion program was a combined-use project involving the construction of a new museum West Wing, the complete renovation of all of the museum's existing facilities, and the construction of a forty-four story residential tower developed separately by a private developer. The new West Wing occupies the first six floors of the combined-use structure that also includes the residential tower. One of the major alterations to the original 1939 building is the new Garden Hall, a four-story steel and glass structure overlooking the Sculpture Garden, that houses a new system of escalators and greatly improves circulation throughout the galleries. The painting and sculpture collection is installed in roughly chronological order on the second and third floors, including the renovated East Wing, the new West Wing, the original 1939 building, and the Garden Hall. Special galleries have also been added for the museum's important collection of works by Picasso and Matisse, as well as a special room for Monet's *Water Lilies* and one for Matisse's large work *The Swimming Pool*. The photography gallery is located on the second floor and separate galleries for prints, illustrated books, and drawings on the third floor. The architecture and design collection is situated on the fourth floor of the new West Wing. The two Roy and Niuta Titus theaters are located underground, the new smaller theater in the lower level of the West Wing and the larger renovated auditorium in the basement of the original building. The Abby Aldrich Rockefeller Sculpture Garden has been newly planted and restored.

The museum is a nonprofit educational institution, supported primarily through admissions, membership dues, and contributions. The museum's program is also supported in part by special grants from corporations, foundations, the New York State Council on the Arts, the National Endowment for the Arts, the National Endowment for the Humanities, and private philanthropy.

Governed by a board of fifty trustees, the museum is administered by a director. The curatorial departments include: Painting and Sculpture; Prints and Illustrated Books; Drawings; Photographs; Film; and Architecture and Design. Other departments are: Education; Library; Registrar; Rights and Reproductions; Public Information; and Membership. The museum also directs a national and international exhibition program. Each year the museum makes a selection of important exhibitions available to other institutions in the United States and Canada, as well as abroad. The Department of Film has a circulation program that serves universities, high schools, and film societies across the country. The Associate

Council (formerly the Junior Council) was founded in 1949: it sponsors exhibitions and special presentations related to museum programs and also operates the Art Lending Service, which was established in 1951. This service enables museum members to borrow original works of art, many of which are made available through the cooperation of the New York galleries. The museum's education program includes services designed specifically to provide access to the museum's facilities for individual students and faculty members, as well as lecture programs and symposia arranged in conjunction with various exhibitions. The New York City Public School Program was begun in 1937, and 121 public high schools in New York City receive annual museum passes for teaching. Staff and single-visit student admission passes are also available. There are also special study hours at the museum for college art and art history classes.

Since the founding of the Museum of Modern Art, the collections have been built by important donations from private individuals and artists. In 1929 the museum acquired its first work, Aristide Maillol's bronze *Île de France* (1910). The following year the museum acquired Edward Hopper's *House by the Railroad* (1925), a gift of Stephen C. Clark. But it was in 1931 that Lillie P. Bliss died and bequeathed to the museum a major part of her collection: thirty-three oils, fourteen watercolors, and two pastels, which were to form the nucleus of the museum's painting collection including *The Bather* (c. 1885), *Oranges* (1902–6), *Pines and Rocks* (c. 1900), and *Still Life with Apples* (1895–98) by Cézanne, with eleven of his watercolors. Other works of exceptional importance were Gauguin's *The Moon and the Earth (Hina Te Fatou)* (1893), Matisse's *Interior with a Violin Case* (1918–19), Modigliani's *Anna Zborowska* (1899), Picasso's *Green Still Life* (1914), Redon's *Roger and Angelica* (c. 1910, a pastel) and *Silence* (c. 1911), Seurat's *Port-en-Bessin, Entrance to the Harbour* (1888), and Henri Rousseau's *Jungle with Lion* (1904–10).

During the next decade the museum shifted the emphasis of the collection away from the nineteenth century and began to acquire works by twentieth-century artists representing the pioneering modern styles. This goal was aided by generous purchase funds provided by Abby Aldrich Rockefeller and Mrs. Simon Guggenheim. In 1935 Rockefeller's gift of her collection—which represented many important modern artists and included Beckmann's *Family Picture* (1920) and Blume's *Parade* (1930), as well as works by Stuart Davis, Otto Dix, Juan Gris, Marsden Hartley, Georgia O'Keeffe, and Wassily Kandinsky—substantially slanted the collection toward the twentieth century. A fund was also established by Mrs. Guggenheim in 1938 "to acquire works of the highest excellence," and it was continuously replenished until her death in 1969. This fund enabled the museum to purchase many of its most important paintings and sculpture, among them: Rousseau's *The Sleeping Gypsy* (1897); Picasso's *Girl before a Mirror* (1932), and *Night Fishing at Antibes* (1929), as well as the bronze *She-Goat* (1950); Matisse's *The Red Studio* (1911), *Piano Lesson* (1916), and *Memory of Oceania* (1953), as well as the bronzes *The Back* (1909) and four versions of the head *Jeanette* (1910–11); two mural-size late Monets, *Water*

Lilies, from 1920; Boccioni's *The City Rises* (1910); Tchelitchew's *Hide and Seek* (1940–42); and Peter Blume's *The Eternal City* (1937). Other seminal works to enter the museum collection during this period were: van Gogh's *The Starry Night* (1889), Beckmann's triptych *Departure* (1932–33), Dali's *Persistence of Memory* (1931), Braque's *Oval Still Life* (1914), and *L'Homme à la guitare* (1911), and Mondrian's last completed work *Broadway Boogie Woogie* (1942–43). The collections of Matisse and Picasso were also taking shape and were to become the most complete and important collections of works by these artists in a public museum.

The focal point of the Picasso collection is *Les Demoiselles d'Avignon* (1907), purchased in 1939 from the Bliss bequest. Other masterpieces that trace Picasso's development are *Boy Leading a Horse* (1906), which reflects his interest in Greek art and in Cézanne's bathers. *"Ma Jolie"* (1912), also acquired through the Bliss bequest is an important example of Analytic Cubism. His *Guitar* (spring 1912), donated by Picasso to the museum in 1971, is a Cubist relief construction of sheet metal and wire; *Violin and Grapes* (1912) illustrates the transition from Synthetic to Analytic Cubism. His *Man with a Guitar* (1913), *Card Player* (1913–14), and the whimsical *Student with a Pipe* (1913) exhibit the fully de-veloped Synthetic Cubist style. Picasso's *Harlequin* (late 1915), a major work from a long series based on this theme, marked the redirection within Synthetic Cubism that was to culminate in *The Three Musicians* (1921), whereas his *Sleeping Peasants* (1919) anticipates compositions in the "colossal" style of the following years, such as *Three Women at the Spring* (1921), a monumental neoclassical composition of three giant frieze-like figures. Two different versions of the "studio" theme are represented in the collection: *The Studio* (1927–28) and *Painter and Model* (1928); his *Seated Bathers* (early 1930) is an example of the "hard bone style," with its menacing mantis head that was a favorite Surrealist image. Picasso's *Pitcher and Bowl of Fruit* (1931), a large decorative still life, is in a curvilinear Cubist style, and his *Girl before a Mirror* (1932) combines the black tracery and organic forms of the 1931 still life in a meta-morphosis of a traditional vanitas image.

The museum's collection of works by Matisse offers a remarkable overview of the development of his artistic career, beginning with an early still life from 1896, *Lemons and Bottle of Gin*, and culminating with major works such as his large environmental cut-out of 1952, *The Swimming Pool*. Presently, the museum collection of Matisse works contains twenty-six paintings, sixteen sculptures, six cut-outs, nineteen drawings, nearly two hundred prints, and design objects. Major works of the artist include: *Girl Reading* (1905) from the Fauve period, the monumental work *Dance (first version)* (1909), *Bather* (1909), *The Blue Window* (1913), and the *Gourds* (1916). Two of Matisse's greatest works are in the museum's collection, *The Red Studio* (1911) and the *Piano Lesson* (1916), as are *Goldfish and Sculpture* (1911) and *The Moroccans* (1915–16). The museum also possesses three major paintings from the artist's great experimental period: *Woman on a High Stool* (1914), *Gold Fish* (1914–15), and *Variation on a Still*

Life by de Heem (1915). Of great importance are the examples of Matisse's sculptures, including *Backs I, II, III, and IV* (1909, 1913, 1916, 1931) and *Jeanette I, II, III, IV, V* (1910, 1910, 1911, 1913). Paper cut-out maquettes for a set of vestments Matisse designed for use in the Vence Chapel and the stained glass window *Nuit de Noël* (1952), designed for *Life* magazine, are further examples of the depth and range of the museum's holdings with regard to one artist. Through purchases and gifts the museum has formed one of the most comprehensive collections of Matisse prints, including nearly all of his illustrated books.

The Katherine S. Dreier bequest came to the museum in 1953, enhancing the quality of the collection, as well as filling in many gaps of the vanguard movements from the years 1915–1925—Expressionism, Post-Cubist Abstraction, Dada, and Surrealism. In 1920 Katherine Dreier, with Marcel Duchamp and Man Ray, founded the *Société Anonyme—Museum of Modern Art*, which was devoted to collecting these works. This collection was presented to Yale University in 1941, but Dreier's private collection of 102 works was bequeathed to the museum. Included in this group are works of exceptional quality: Brancusi's *Magic Bird* (1912); Léger's *Propellers*; Duchamp's Proto-Dada construction *3 Stoppages étalon* (1913–14), *To Be Looked At (From the Other Side of the Glass) with One Eye, Close to, for Almost an Hour* (1918); and the Dada object *Fresh Widow* (1920), signed with Duchamp's pseudonym Rose Sélavy; Mondrian's *Painting I* (1926); Pevsner's *Torso* (1924–26), a three-dimensional construction of plastic and copper; Lissitzky's *Proun 19D* (1922?); Ernst's *Illusion* (1929); Kandinsky's *Blue (Number 393)* and three watercolors from 1913; eight works by Paul Klee; and nineteen small *Merz* collages by Schwitters.

In 1961 an exhibition was held of works pledged and given to the museum by James Thrall Soby. The collection comprises sixty-nine paintings, sculptures, and drawings, many of which reflect Soby's interest in artists who worked in the neoromantic or surrealist manner. Works of exceptional importance to the museum's collection include eight incomparable works by de'Chirico: *Gare Montparnasse* (1888); *The Duo* (1915); *The Enigma of a Day* (1914); *The Double Dream of Spring* (1915); *The Amusements of a Young Girl* (1916?); *The Faithful Servitor* (1916 or 1917); *The Condottiere* (1917), and *Grand Metaphysical Interior* (1917). Among the other Soby gifts are Balthus' early masterpiece *The Street* (1933); Miró's *Self Portrait* (1937–38), *Portrait of Mrs. Mills in 1750* (1929), and *Still Life with Old Shoe* (1937); and Picasso's *Nude Seated on a Rock* (1921), *The Sigh* (1923), and *Seated Woman* (1927). The sculpture collection includes: Calder's mobile *Swizzle Sticks* (1936), Joseph Cornell's *Taglioni's Jewel Casket* (1940), Giacometti's *Tall Figure* (1949), and Marini's *The Horseman* (1946–47).

The rich collection of Dada-Surrealist works was augmented by further donations. In 1963 Mrs. Yves Tanguy (Kay Sage) left the museum a generous purchase fund for paintings and sculpture, as well as works by Breton, Calder,

Delvaux, Helion, and Miró. One of her earlier gifts, Magritte's *Portrait* (1935), is one of the highlights of the Surrealist collection. In 1966 Magritte's *The Menaced Assassin* (1926) was purchased using funds bequeathed by Kay Sage Tanguy. In 1965 Mr. and Mrs. Pierre Matisse gave Miró's *Object* (1936), an assemblage described by Soby as "one of the classic surrealist images." Other acquisitions include a replica of Duchamp's *Why Not Sneeze, Rose Sélavy?* (1964, replica of 1921 original) and three works by Man Ray: *Cadeau* (c. 1958, replica of 1921 original), a flatiron bristling with tacks; *Emak Bakia* (1962, replica of 1926 original), a cello fingerboard and scroll with horsehair; and *Indestructable Object (or Object to Be Destroyed)* (1964, replica of 1923 original), a metronome with cut-out photograph of eye on a pendulum.

Alfred Barr's pioneering interest in the Russian avant-garde is reflected by the fine examples included in the collection. Barr's visit to the Soviet Union during 1927–28 provided the catalyst for forming the collection. In 1935 the museum purchased seven works by Malevich, including *Suprematist Composition: White on White* (1918). In 1936 Rodchenko gave several of his nonobjective paintings, among them, *Non-Objective: Painting Black on Black* (1918). Two years later Gabo's famous celluloid and metal construction *Head of a Woman* (c. 1917–20, after a work of 1916) entered the collection.

The museum's collections have also benefited from gifts by artists. Aristide Maillol was one of the first to donate works, the bronze *Spring* (1910–11) and a tinted plaster relief *Desire* (1906–8). One of the most famous gifts from an artist was Picasso's 1971 gift of his 1912 construction *Guitar*. Alexander Calder in 1966 made a generous donation of his sculptures, including *Josephine Baker* (1927–29); two wood pieces, *Shark Sucker* (1930) and *Gibraltar* (1936); the mobile *Spider* (1948); the stabile *Morning Star* (1943); *Snow Flurry* I (1948), a hanging mobile for the huge *Teodelapio* built for the Spoleto Festival in 1962; and the monumental *Sandy's Butterfly* (1964).

During the 1940s and 1950s the museum became increasingly interested in the works of the American avant-garde. Between 1947 and 1952 the museum acquired works by the New York-based Abstract Expressionists. Among them were *Agony* (1947) by Arshile Gorky, *Painting* (1948) by Willem De Kooning, and works by Baziotes, Kline, and Motherwell. Jackson Pollock's important *The She-Wolf* (1943) entered the museum's collection a year after it was painted. In 1950 the museum acquired Pollock's *Number 1, 1948*, one of a series of drip paintings executed in the year 1947 through 1950 and acknowledged to be one of the artist's most important works. During this period works by Gottlieb, Rothko, Stamos, Tomlin, and Hofmann also entered the collection.

The museum began to acquire work by younger contemporary artists. In 1958 Jasper Johns' *White Numbers* (1957) and *Green Target* (1955) were purchased from Johns' first exhibition. Works by Frank Stella, such as *The Marriage of Reason and Squalor* (1959); works by Helen Frankenthaler; the majestic "veil" paintings by Morris Louis; and large paintings by Motherwell, *The Voyage* (1949)

and *Elegy to the Spanish Republic, 54* (1957–61), joined the museum's collection of contemporary art. Painted wood constructions by Louise Nevelson, such as *Sky Cathedral* (1958), entered the collection the same year as its creation.

Donations by Philip Johnson and Sidney Janis in 1967 helped the museum's collection of American contemporary art attain distinction. That year Johnson, the well-known architect, asked the museum to choose potential gifts from his collection. He had been associated with the museum since its opening in 1929 and was responsible for founding the Department of Architecture. The 1967 gift included works by major contemporary American artists not yet represented in the collection, such as Jim Dine's *Still Life Painting* (1962) and Robert Rauschenberg's *First Landing Jump* (1961), as well as works by Judd, Robert Morris, and di Suvero. Also included was Johns' *Flag* (1954–55) and works by Kline, Samaras, Stella, Stankiewicz, Bacon, Giacometti, Klee, and Moholy-Nagy.

Sidney Janis' donation of 103 works from his collection was a major gift ranging over several generations of artists, from Cubism and Futurism, Hard Edge Abstraction, Dada and Surrealism to Abstract Expressionism and Pop Art. This collection enriched and complemented the museum's existing holdings. The contemporary American artists included in this collection represent different styles: Hard Edge Abstraction: Albers' *Homage to the Square: Broad Call* (1967) and Ellsworth Kelly's *Spectrum III*, as well as works by Stanton Macdonald-Wright and Anuszkiewicz; Abstract Expressionism: Kline's *Two Horizontals* (1954), Barnett Newman's *The Voice* (1950); Jackson Pollock's monumental drip painting *One (Number 31)* (1950) and *White Light* (1954); and Rothko's *Horizontals, White over Darks* (1961), as well as works by De Kooning, Kline, Still, and Tobey; figurative or Pop Art: Johns' *0 through 9* (1961), an aluminum relief; Oldenburg's *Pastry Case I* (1961–62) and *Giant Soft Fan* (1966–67); Lichtenstein's *Modern Painting with Bolt* (1966); Wesselmann's *Mouth 7* (1966); Rosenquist's *Marilyn Monroe I* (1962), as well as works by Marisol and Segal and two portraits of Sidney Janis by Andy Warhol. Other works of importance to the museum's collection were *Dynamism of a Soccer Player* (1913) by Boccioni; *Painter and Model* (1925) by Picasso; *Actor's Mask* (1924) by Klee; works by Léger; and four paintings by Mondrian, including *Composition V* (1914); as well as works by other European artists: Schwitters, de'Chirico, Duchamp, Arp, Magritte, Dali, Giacometti, Dubuffet, Jawlensky, Kandinsky, and Lissitzky.

The museum's collection of painting and sculpture continues to grow, with the acquisition of works by new artists such as Jennifer Bartlett, Richard Bosman, and Sandro Chia. These and other works by young contemporary artists will be shown on a rotational basis in the museum galleries. The museum's pioneering multidepartmental concept provides a comprehensive vision of the modern arts.

The collections of the Drawings and Print Department are of particular importance from both an historical and documentary point of view. In 1929 Paul Sachs presented a drawing and eight prints consisting of works by Beckmann, Feininger, Grosz, Kokoschka, and Pechstein. These works became the nucleus of the Print Department collection. A few years later the collection grew when

fifty prints were included with the important bequest of paintings and drawings of one of the museum's founders, Lillie P. Bliss. In 1940 Abby Aldrich Rockefeller, another founder of the museum, who had been collecting prints since 1927, gave her collection of more than sixteen hundred works to the museum with the understanding that an area be set aside for the study of prints. The Abby Aldrich Print Room opened in 1949. The collection presently consists of almost forty thousand works, dating from 1855 to the present, and is continuously growing through new acquisitions of prints by contemporary printmakers. Highlights of the department's collection include its extensive holdings of prints by Munch, Matisse, Picasso, Klee, Dubuffet, and Johns. Of special note is the museum's collection of *livres du peintres*, or illustrated books. It was a 1936 exhibition organized by Monroe Wheeler, "*Modern Painters and Sculptors as Illustrators*," that was to inspire the American collector Louis E. Stern to amass a superb collection of *livres du peintres* which he bequeathed to the museum's Print Department.

The holdings of the Drawings Department have also increased from a single drawing to nearly six thousand works on paper, ranging from works in the traditional media of pencil, ink, and charcoal to those of oil, watercolor, gouache, pastel, and collage, as well as newly invented processes. However, it was not until 1971 that the museum established a separate curatorial department for drawings.

The drawings collection features extensive holdings in the theater arts and in the works of Dubuffet, Kupka, and Feininger. Highlights of the collection include the Joan and Lester Avnet Collection, which was formed with the Museum of Modern Art specifically in mind. This collection consists of 180 sheets ranging in date from 1901 to 1969. Forty of the drawings were donated in the late 1960s, and the remainder have been on deposit at the museum since 1970. The Avnet Collection can be divided into four categories: (1) drawings by British artists from the first two decades of the twentieth century; (2) theatrical designs; (3) an idiosyncratic choice of American artists; and (4) drawings by European artists, including sculptors. The British artists featured in the Avnet Collection include: Walter Sickert, Henry Moore, David Hockney, the Vorticists, and Roger Fry and Duncan Grant of the Bloomsbury group. The highlight of the theatrical designs in the Avnet Collection is Leon Bakst's drawing for the *Firebird* (1913). Other theatrical designs in the collection are by Delaunay, Larionov, Léger, and Grosz. Some of the American artists represented in the Avnet Collection are Johns, Rivers, Rothko, and Pollock. Nearly one-third of the Avnet Collection is devoted to artists of the School of Paris. Included in this group are works by Derain, Rouault, Valadon, Gris, Marcoussis, and Braque. There are five drawings by Picasso that span six decades of the artist's career. German artists are also represented with works by Corinth, Klee, Kirchner, Feininger, and Kokoschka. Drawings by sculptors such as Giacometti, Lipchitz, and Chillida are also included.

The Department of Photography was established in 1940 and was the first

such department in a museum. MOMA has been exhibiting photographs since 1932, when it presented "Murals by American Painters and Photographers." The art of photography has now become a regular part of the museum's program. The museum's first photograph, a Walker Evans photograph of a Lehmbruck sculpture, *Head of a Man*, was given in 1930. Today the photography collection contains more than twenty thousand works beginning with master photographs from the 1840s. Photographers represented in the collection include: Julia Margaret Cameron, Edward Weston, Paul Strand, Berenice Abbott, Brassai, Walker Evans, Bill Brandt, Cartier-Bresson, Edward Steichen, Alfred Stieglitz, Richard Avedon, and Alfred Eisenstaedt. Of special interest is the Abbott-Levy Collection of more than five thousand prints and one thousand negatives by the French photographer Eugène Atget (1857–1927).

The museum's Department of Architecture and Design was established in 1932 under the directorship of the architect Philip Johnson. The extensive architectural collection contains more than twelve hundred drawings and more than sixty models. The design collection includes more than eighteen hundred objects, consisting of utensils, articles of furniture, and mass-produced and craft objects. These objects have been carefully selected on the basis of their quality and historical significance to illustrate the development of design from the nineteenth century to the present. The rich graphic design collection includes more than twenty-five hundred posters.

The Museum of Modern Art was the first museum to recognize the motion picture as an art form. It was in 1935 that a film library (now known as the Department of Film) was established to collect and preserve significant films, many of which otherwise would have been lost forever. In recognition of its ongoing program of film preservation and its continuing support of the motion picture as an art form, the museum received an Honorary Award (Oscar) from the Board of Governors of the Academy of Motion Picture Arts and Sciences in 1979. The Film Department houses some eight thousand films and boasts one of the strongest international collections of films in the United States.

The Museum of Modern Art has an art reference library containing eighty thousand volumes and periodicals. The library is open to the public by appointment and is noncirculating.

Black-and-white photographs of the museum's works can be ordered from the Department of Rights and Reproductions, and catalogues and other museum publications are available through the museum's bookstore. The Museum of Modern Art has published more than five hundred books and publishes catalogues for its major exhibitions.

Selected Bibliography

Museum publications: Barr, Alfred, *Painting and Sculpture in The Museum of Modern Art, 1929–1967. An Illustrated Catalog and Chronicle*, 1977; Elderfield, John, *Matisse in the Collection of the Museum of Modern Art*, 1978; Legg, Alicia, ed., *Painting and Sculpture in the Museum of Modern Art: Catalog of the Collection, January 1, 1977*,

1977; Leiberman, William S., *A Treasury of Modern Drawing: The Joan and Lester Avnet Collection*, 1978; Rubin, William, ed., *Pablo Picasso: A Retrospective*, 1980.

Other publications: Castleman, Riva, *Prints of the Twentieth Century: A History* (New York and Toronto 1976); Hunter, Sam, Introduction, *The Museum of Modern Art, New York: The History and the Collection* (New York 1984); Rose, Berenice, *A Century of Modern Drawing from the Museum of Modern Art* (London 1982).

TARA K. REDDI

SOLOMON R. GUGGENHEIM MUSEUM, THE (also THE GUGGEN-HEIM, THE GUGGENHEIM MUSEUM), 1071 Fifth Avenue, New York, New York 10028.

The Solomon R. Guggenheim Museum was established in 1939 as the Museum of Non-Objective Painting under the aegis of The Solomon R. Guggenheim Foundation, which had been founded two years earlier to administer Guggenheim's growing collection of twentieth-century paintings. The foundation received an additional endowment in Guggenheim's will, with a portion thereof earmarked for the construction of a permanent museum to house the collection. In fact, a permanent museum was not completed until 1959; until that time, the collection occupied a number of temporary homes. The museum, which is owned and operated by The Solomon R. Guggenheim Foundation, also receives assistance from private, New York State, and federal sources; it has also enjoyed several major bequests of collections and objects and continues to rely on such gifts as a major source of new acquisitions. The museum maintains a membership program, the Society of Associates. Its dues help make possible the acquisition of important works by living artists for the permanent collection; the presentation of internationally significant exhibitions, education programs, performing-arts events, films, and lectures; and a reduced admission price for students.

The museum is governed by the Board of Trustees of the foundation. Each member serves for an indefinite term. In addition, three principal benefactors of the museum collection, Solomon R. Guggenheim, Justin K. Thannhauser, and Peggy Guggenheim, were elected trustees in perpetuity. The museum is administered by a director and deputy director and a curatorial department. The curatorial department also includes the museum library and archives, as well as the editor for all museum publications.

The museum was officially opened on June 1, 1939, as the Museum of Non-Objective Painting, a name that was changed in 1952 to The Solomon R. Guggenheim Museum. The museum's permanent home at 1071 Fifth Avenue opened on October 21, 1959. Designed by the American architect Frank Lloyd Wright, it had been commissioned by Guggenheim in 1943, and the design had been approved before Guggenheim's death in 1949, but the search for a suitable site and restrictions imposed by the Korean War delayed completion of the building until several months after the architect's death in April 1959. The Guggenheim Museum was and still is one of the most controversial buildings in the United States and is certainly one of the most controversial museum buildings in the

world. Built of cast-in-place concrete, its spiral shape is formed by a cantilevered ramp that curves unbroken from the ground level to the skylit dome ninety-two feet above. The building's circular shape is echoed in the shape of the galleries, the auditorium, the elevators, and in the decorative motifs in the floor and sidewalks outside the museum.

The museum's interior has been likened to that of a chambered nautilus, with seventy-four niche-like bays lining the ramp for the display of works of art. Wright's original design was modified at the request of the museum's first director, Hilla Rebay, to include a high-ceiling gallery for the display of large-scale artwork. Adjacent to the exhibition wing of the museum is its administrative wing, also circular in plan, with a light well, surrounding the utility core, that extends from the ground to the skylight above. In the exhibition wing, Wright had originally specified that the walls be painted in neutral colors of beige and brown and that natural illumination would be supplied by skylights and clerestory windows. Wright also planned for paintings to be displayed leaning against the walls of the ramp, as if they were seen on an easel. This entire arrangement proved ultimately unsatisfactory, and shortly after the building opened, artificial lighting was installed, the walls were painted white, and the paintings were suspended three feet from the walls on metal rods, so that they could be viewed from a closer distance.

What was successful about Wright's design was the continuity of the gallery sequence, which establishes a progression of works that not only clarifies the aesthetic developments of a given exhibition but also eliminates the principal cause of museum fatigue: the visitor's confusion about where to turn next. Another unique aspect of viewing works of art in this museum is that the viewer is able to focus on a particular work and then turn away from it and take in a large portion of both the building and the rest of the exhibition at the same time, which results in a less fragmented, more concentrated aesthetic experience. The ground-floor space of the museum, a circular interior "courtyard" that soars ninety-two feet up to the dome, is a particularly impressive space for the display of large-scale sculptures and affords the visitor an inclusive view of the "inside" of the museum spiral, providing a complement to the exterior view. The Guggenheim is the only design by Wright ever to be built in New York and, years after its opening, continues to be a source of attention and debate.

The difficulties of and subsequent alterations to the original museum design are in many ways symptomatic of the Guggenheim's evolution from a relatively small permanent collection of twentieth-century avant-garde painting to that of a comprehensive museum of contemporary art with changing exhibitions and a collection that was broadened to include an overview of the historical development of modern art. When Solomon R. Guggenheim, a member of an illustrious family who had created a financial empire in mining, first began to collect paintings, he bought mainly Old Master works. However, in the mid–1920s his taste and subsequent purchases were influenced by his friendship with Hilla Rebay (Baroness Hilla Rebay von Ehrenwiesen), a young German artist of

considerable talent and taste in the area of avant-garde European art of the time. She introduced Guggenheim to many of the prominent members of this movement, and under her guidance, he began buying, steadily and in increasing quantities, paintings by Kandinsky, Léger, Gleizes, Delaunay, Chagall, and Rudolf Bauer. As the size and fame of his collection grew, Guggenheim began to lend works to exhibitions, and Hilla Rebay was placed in charge of the collection. By 1937 the collection was incorporated into a foundation, which was empowered to operate a museum. The collection was heavily slanted toward what she called "non-objective painting," painting that is devoid of any recognizable imagery. Acquisitions and exhibitions continued to support this philosophy, although the strongly European slant of the collection was gradually mitigated by the inclusion of increasing numbers of works by American avant-garde painters. In 1948 the collection was enlarged with more than seven hundred items by the purchase of the estate of Karl Nierendorf, a well-known New York dealer of German paintings. Among the best-known works in the estate was Kokoschka's *Knight Errant*. Also included were 18 Kandinskys, 110 Klees, 6 Chagalls, 24 Feiningers, and 54 Kirchner watercolors and prints.

After Hilla Rebay retired in 1952, greater efforts were made to broaden the scope of the collection and especially to remedy the obvious lack of sculpture. The rise of Abstract Expressionism in America was recognized in the acquisition of important works from that movement, further diluting the previously strong European bias of the original collection holdings. In addition, notable examples of late-nineteenth-century art were purchased to provide an historical background to twentieth-century movements already represented in the collection. The collection was further enriched in 1953 by a substantial gift of twenty-eight works from the estate of Katherine S. Dreier. Most important among the objects donated were a Brancusi oak sculpture, an Archipenko bronze, two paintings by Mondrian, one by Gris, a Calder string mobile, and three collages executed by Kurt Schwitters in the early twenties.

In recent years, further gaps in the collection have been filled through the acquisition of works such as Matisse's *The Italian Woman* (the museum's first major Matisse), Schiele's *Portrait of an Old Man*, and Kupka's *Large Nude*. There were also substantial additions of works by artists already well represented in the museum collection, such as Miró, Léger, Calder, Klee, and Giacometti. The effort to enrich the collection with works of principal artists of our time led to the acquisitions of works such as Dubuffet's *Nunc Stans* and *Bidon l'Esbroufe*, as well as six other works by this artist dating from the 1930s to the 1960s, purchased by Baron Elie de Rothschild; Francis Bacon's *Crucifixion*; David Smith's *Cubi XXVII*; Miró's *Tilled Field*; and Klee's *Hat, Lady, and Little Table*. Important works by American artists obtained during the past few years include Morris Louis's *Saraband*; Helen Frankenthaler's *Canal*; Richard Diebenkorn's *Ocean Park No. 96*; Louise Nevelson's *Luminous Zag*; *Night*; and Kenneth Noland's *Coal*.

A significant development since the museum's move to the Frank Lloyd Wright

building was the opening of the Justin K. Thannhauser Wing. Thannhauser's collection had been on loan to the Guggenheim since 1965 and was formally deeded to the museum at his death in 1978. The wing houses a selected part of his private collection—seventy-five paintings and sculptures. There are two major areas of strength in the collection. The first is a group of forty-one Impressionist masterpieces that antedate the museum's original holdings and therefore serve as an historical background for the museum collection as a whole. Works from the Impressionist period include the great Pissarro *Les Côteaux de l'Hermitage, Pontoise*, two major Manets, and three important Renoirs. In the Post-Impressionist group are four Cézannes, including the *Portrait of Mme. Cézanne* and *Bibemus*; two van Goghs, *The Viaduct* and *Mountains at Saint Remy*; two Gauguin Tahitian landscapes; a Toulouse-Lautrec pastel; and splendid Degas pastels and bronzes. The second important group of works in the Thannhauser Wing contains thirty-four Picassos dating from 1900 to 1960. Particularly famous are the *Moulin de la galette*; the *Woman Ironing*; and the *Woman with Yellow Hair*. Although nearly every period of Picasso's oeuvre is represented, the collection is richest in early works; there are fourteen that date from before the artist's Cubist period. Other notable works in this wing include Modigliani's *Young Girls Seated*, Vuillard's double panel painting *Place Vintimille*, Braque's Fauve work *Landscape near Antwerp*, Soutine's *The Venetian*, Rouault's *Christ and the Fishermen*, Matisse drawings, and a Maillol bronze sculpture.

In the museum's collection, early twentieth-century works include Cubist paintings by Braque and Picasso, such as the former's *Violin and Palette* and the latter's *Accordionist*. Léger is well represented by paintings such as *The Smokers* (1912), *Study for Contrast of Forms* (1913), *Mural Painting* (1924–25), *Woman Holding a Vase* (1927), and *The Great Parade* (1954). Two notable paintings by Gleizes are the *Portrait of an Army Doctor* and *Brooklyn Bridge*. Other artists from this period whose works are represented in the collection include Gris, Picabia, Duchamp, Kupka, Duchamp-Villon, and Delaunay.

The various German Expressionist movements are represented by works such as *Woman with Black Hat* by Kirchner, *Young Horses* by Nolde, *Knight Errant* by Kokoschka, and works by Schiele and Jawlensky. A large number of oils by Kandinsky, such as the *Painting with White Border* (1913), *Composition 8* (1923), and the important *Dominant Curves* (1936), and an extensive collection of the artist's watercolors make up the most qualitatively comprehensive collection of works by Kandinsky in the world, the museum having continued to build on the substantial number of his works that were part of Guggenheim's original collection. Also included in the area of German painting are works by Marc and a sizable number of works by Klee, including *The Bavarian Don Giovanni* (1919), *Runner at the Goal* (1921), *Night Feast* (1921), *Red Balloon* (1922), *In the Current Six Thresholds* (1929), and *Hat, Lady, and Little Table* (1932). Feininger is well represented, notably by *Gelmeroda IV*.

Various European developments in response to the Paris Cubists are repre-

sented in the Futurist Severini's works; Chagall's *Birthday* and *Green Violinist*; Brancusi's wood sculpture *The Sorceress* and the marble *The Seal (Miracle)*; Modigliani's limestone *Head* and his paintings *Nude* and *Young Girl Seated*; Malevich's *Morning in the Village after the Snowstorm*; Mondrian's *Blue Chrysanthemum* and geometric De Stijl works such as his *Composition* (1929); Gabo and Pevsner's Constructivist sculptures; and Moholy-Nagy's paintings and sculpture.

Dada and early Surrealism are represented in the collection by works such as Schwitters' *Mountain Graveyard*, Ernst's *Landscape*, Miró's *The Tilled Field*, and Giacometti's bronze *Spoon Woman* (1926). The collection also includes later works by Giacometti such as the portrait *Diego* (1953), the artist's brother.

Examples of movements in Europe and Latin American art since the 1930s include *Paris Society* by Beckmann; the wood sculpture *Upright Figure* by Moore; works by Nicholson, Hélion, Herbin, and Torres-Garcia; *Paranoiac-Critical Study of Vermeer's "Lacemaker"* by Dali; works by Tanguy, Matta, Brauner, Tamayo, Bissière, Wols, Michaux, and Kolář; *Three Studies for a Crucifixion* by Bacon; *Nunc Stans* and *Bidon l'Esbroufe* by Dubuffet; and works by Alechinsky, Corneille, Tàpies, Chillida, Hartung, Soulages, Fontana, Burri, Impostéguy, Soto, Pol Bury, Richard Hamilton, and José Luis Cuevas.

The older generation of American artists is represented by the works of Calder, including wire sculptures and the mobile *Red Lily Pads*; Stuart Davis; Josef Albers, including one of his *Homage to the Square* series; Hans Hofmann, *The Gate*; Bolotowsky; Richard Lindner; and Joseph Cornell.

The Abstract Expressionist painters are represented by works such as De Kooning's *Untitled*, Pollock's *Ocean Greyness*, Baziotes' *Dusk* and *Aquatic*, Rothko's *Violet, Black, Orange, Yellow on White and Red*, Gottlieb's *Mist*, Kline's *Painting No. 7*, Guston's *Duo*, Krasner's *Past Continuous*, Marca-Relli's *Warriors*, Okada's *Solstice*, Francis' *Shining Back*, and Diebenkorn's *Ocean Park No. 96*.

The collection's outstanding sculptures from this period include Noguchi's *The Cry*, Nevelson's *Luminous Zag; Night*, Smith's *Cubi XXVII*, and Rickey's *Two Open Rectangles Excentric VI, Square Section*.

Works by Pop artists in the collection include Rauschenberg's *Red Painting*, Jim Dine's *Pearls*, Warhol's *Orange Disaster*, Lichtenstein's *Preparedness*, Chamberlain's *Dolores James*, Stankiewicz's sculpture *Untitled*, and Segal's sculpture *Picasso's Chair*.

Among the works by color-field painters in the collection are Frankenthaler's *Canal*, Louis' *Saraband* and *I–68*, and Noland's *April Tune*. Among the works by Minimalist painters are Ellsworth Kelly's *Blue, Green, Yellow, Orange, Red*, Agnes Martin's *Untitled No. 14*, Robert Morris' sculpture *Untitled*, and Carl Andre's wood sculpture *Trabum*.

Conceptual sculptures include de Maria's *Cross*, *Museum Piece*, and *Star*; Eva Hesse's *Expanded Expansion*; Dan Flavin's fluorescent light sculpture *Un-*

titled; and Larry Bell's glass and stainless box *Untitled*. Finally, the Photo-Realist school is represented by Richard Estes' painting *The Solomon R. Guggenheim Museum* (1979).

The Guggenheim's exhibition program consists of eight to twelve shows a year. They are loan exhibitions or are drawn from the museum's permanent collection of nearly four thousand paintings, sculptures, and works on paper. Group and one-person shows feature established modern masters, as well as younger artists.

Several modifications and additions to the original Wright building have been made since its opening in 1959. An annex to the museum structure, envisioned by Wright but completed in 1968 by his successor William Wesley Peters, houses storage and conservation areas. In 1974 the driveway under the building that had separated the annex and administrative wing from the exhibition wing was partially enclosed to make room for a new restaurant and bookstore. In 1978 a space that opens immediately off the second ramp of the museum, which had been unused for many years, was converted into the Aye Simon Reading Room as a result of a gift from the Esther A. Simon Charitable Trust; this room was designed by the American architect Richard Meier. More recently, a new galley has been formed in what was formerly a storage vault on the sixth ramp, and a new gallery has been created to house the permanent display of forty of the finest and most famous paintings in the collection. The Pioneers of Abstract Art Gallery includes works by Picasso, Braque, Léger, Delaunay, Kandinsky, Klee, Chagall, and Mondrian.

A recent addition to the Guggenheim Foundation's holdings is The Peggy Guggenheim Collection, housed in the Palazzo Venier dei Leoni in Venice, Mrs. Guggenheim's home from 1951 until her death in 1979. The Collection is a branch of The Solomon R. Guggenheim Foundation analagous to that of the Guggenheim Museum and was designated for ownership by the foundation by Mrs. Guggenheim in 1974, with the proviso that it continue to be administered in her name, as a public museum. Comprising more than three hundred works of art, the collection constitutes a comprehensive survey of the major artistic movements of the twentieth century.

Unlike Hilla Rebay, Peggy Guggenheim's tastes were wide ranging, enabling her to collect both abstract and representational art with equal enthusiasm. She acquired her first modern paintings and sculpture in Europe, under the guidance of Sir Herbert Read, Marcel Duchamp, and Nellie van Doesburg. Having left Europe at the onset of World War II, Mrs. Guggenheim settled in New York, where she founded Art of this Century, a gallery that existed from 1942 to 1949, during which time she discovered the American Abstract Expressionists. By the time she purchased her Venetian residence, Mrs. Guggenheim had already amassed most of her collection.

The Peggy Guggenheim Collection includes works from most of the important periods of twentieth-century art. Cubism is represented by works such as Picasso's *The Poet*, Braque's *The Clarinet*, and Gris' *The Bottle of Martinique*

Rum. Futurist works by Severini and Boccioni are included, and the emergence of Abstraction is chronicled by paintings such as *Landscape with Church* by Kandinsky, Suprematist works by Malevich, the Constructivism of El Lissitzky, Neo-Plasticist paintings by Mondrian and van Doesburg, and the sculpture *Bird in Flight* by Brancusi.

Metaphysical painting is represented by de'Chirico's *The Red Tower*, and Ernst's *Attirement of the Bride*, Miró's *Dutch Interior*, and Magritte's *Empire of Light* are some of the notable Surrealist works.

Post-war European art includes works by Nicholson, Sutherland, Bacon, Dubuffet, and Alechinsky, and Abstract Expressionism is represented by paintings such as Gorky's *Painting*, Pollock's *Alchemy*, Rothko's *Sacrifice*, and Clyfford Still's *Jamais*.

The museum's library was created for the purpose of documenting the museum's collection and loan exhibition, as well as the history of modern art, and is open to the general public by appointment. The Aye Simon Reading Room contains international periodicals that pertain to modern art and is open to members of the museum.

Slides of objects in the collection may be purchased at the museum bookstore, along with exhibition catalogues and guides to the collection. Catalogues are published for every major exhibition.

Selected Bibliography

Museum publications: Barnett, Vivian, *Handbook: The Guggenheim Museum Collection, 1900–1980*, 1980; Flint, Lucy, *Handbook: The Peggy Guggenheim Collection*, 1983; Rudenstine, Angelica, *The Guggenheim Museum Collection: Paintings, 1880–1945*, 1976; *Acquisition Priorities: Aspects of Postwar Painting in Europe*, 1983; Rudenstine, Angelica Zander, *The Peggy Guggenheim Collection, Venice*, 1985; Barnett, Vivian, *The Guggenheim Museum: Justin K. Thannhauser Collection*, 1978; *Masterpieces of Modern Art*, 1972; *60 Works: The Peggy Guggenheim Collection*, 1982; *The Solomon R. Guggenheim Museum, New York: Frank Lloyd Wright, Architect*, 1980.

Other publications: Lukach, Joan M., *Hilla Rebay: In Search of the Spirit in Art* (New York 1983); Goldin, Amy, "Present Tense: New Art and the New York Museums," *Art in America* (September/October 1977), pp. 99–102; Hennessey, W. J., "Frank Lloyd Wright and the Guggenheim Museum: A New Perspective," *Arts* (April 1978), pp. 128–33; Mumford, Lewis, "What Wright Hath Wrought," *New Yorker* (December 5, 1959), pp. 105–29; Rowell, Margit, "Frank Lloyd Wright's Temple to Human Creativity," *Art News* (March 1982), pp. 126–27; "Guggenheim Realigns," *Art in America* (December 1980), p. 192; Scully, Vincent, Jr., *Frank Lloyd Wright* (New York 1960), pp. 30–31; Sweeney, James Johnson, "Chambered Nautilus on Fifth Avenue," *Museum News*, vol. 37, no. 5 (January 1960), pp. 14–21; Wright, Frank Lloyd, *The Solomon R. Guggenheim Museum* (New York, 3d ed., 1980), pp. 1–72.

PILAR VILADAS

WHITNEY MUSEUM OF AMERICAN ART (also THE WHITNEY, THE WHITNEY MUSEUM), 945 Madison Avenue, New York, New York 10021.

The Whitney Museum of American Art was officially founded on January 6,

1930, by Gertrude Vanderbilt Whitney with a collection of about six hundred paintings, works on paper, and sculpture. It was the final result of Whitney's long and active promotion of American art.

A sculptor herself, Whitney rented a studio in 1907 in Greenwich Village, then the center of liberal artistic activity. In 1914, at 8 West Eighth Street, she organized the Whitney Studio to exhibit work by new and progressive artists. She and her director, Mrs. Juliana Force, functioned as both dealer-promoters and as an alternative academy. In 1915 The Friends of Young Artists was formed and renamed the Whitney Studio Club in 1918. While providing additional exhibition space, the Studio Club functioned as a social arena and open house for a growing society of artists and amateurs. It was located at 147 West Fourth Street until 1923, when it moved next door to the Whitney Studio. From 1924 to 1928, annual exhibitions of members' work were circulated to American museums and abroad. Both the Whitney Studio and the Whitney Club were replaced from 1928 to 1930 by the Whitney Studio Galleries, where more formal and selective exhibitions were held.

On November 18, 1931, the Whitney Museum of American Art officially opened at numbers 8, 10, and 12 West Eighth Street, the site of the previous Whitney organizations. The three brownstones were remodeled by Noel and Miller (architects) and Bruce Buttfield (interior designer). In 1949 the Museum of Modern Art donated land at 22 West 54th Street, where the second Whitney opened on October 26, 1966. The design is by Marcel Breuer, the Bauhaus architect, and Hamilton Smith. Michael H. Irving was consulting architect. The space of the three main exhibition floors can be partitioned to serve the Whitney's commitment to constantly changing installations.

Until 1961 the Board of Trustees included only Whitney family members; they now number less than a fourth. There are twelve trustee committees: executive, nominating, finance, operations and budget, development, ethics, house, education, sales, permanent collection, drawings, and film and video. The four presidents have been Flora Whitney Miller, David M. Solinger, Howard Lipman, and, since May 1977, Flora Miller Irving, granddaughter of Gertrude Vanderbilt Whitney. There are twenty-six active trustees. Funding is received through private and corporate donations (under the aegis of Friends of the Whitney Museum of American Art, founded in 1956), entrance fees, publications and sales, and state and federal grants.

Staff departments include: Administrative, Personnel, Controller, Curatorial, Registrar and Art Handlers, Development, Public Relations, Library Education, Film and Video, Publications and Sales, Building Maintenance and Security, Restaurant, and Student Interns and Volunteers. There is a director and a head curator. There are associate curators of the Hopper and Permanent Collections; assistant curators of Exhibitions and Eighteenth and Nineteenth Century Art; adjunct curators of Drawings and Eighteenth and Nineteenth Century Art; and an advisor for Prints. The Department of Film and Video, founded in 1971, is overseen by a curator and an assistant curator. Its new American Film Makers

series is famous for providing the same showcase opportunity Whitney intended for painters; screenings last a full week. The Education Department oversees the afternoon Downtown Branch, located in a Wall Street office building since 1973. The space is used both for art exhibits and for performances. They also oversee an Independent Study Program for Studio Art and the Helena Rubenstein Fellows in Art History and Museum Studies. There are weekend lectures, an Artreach program for elementary through high-school grade students, the Goodson Symposium for young scholars and graduate students, Seminars with Artists (one seminar for the Independent Study students, which includes lectures from critics, and one for other students), and a program of performing arts at the Whitney.

The original ideas of Gertrude Vanderbilt Whitney still guide museum policy. Exhibitions change frequently and are often lent to other institutions, as are numerous works from the collection. The Whitney has remained a museum for fine arts, essentially of the twentieth century. So strong was this direction that in 1949 the trustees sold all works done before 1900, an attitude reversed only in 1966. Acquisition funds are devoted solely to the twentieth century, mainly contemporary works. Acquisition funds amount to only $20,000 annually, and help is actively sought from donors who have a direct interest in collecting art. New acquisitions maintain the Whitney's stature as a representative survey, rather than a focal point for the established and esteemed. The Whitney Biennial continues the tradition of the Whitney Studio as a showcase for current talent, although it hardly carries the egalitarian context of its predecessor. The small first-floor gallery is often used to present new artists.

Sixty works comprise the selection of eighteenth- and nineteenth-century painters. There is one canvas each by Bierstadt, Heade, Inness, Sargent, Cassatt, and Chase; works on paper by Homer and LaFarge; and a selection of eighteen American naive paintings given by Edgar William and Bernice Garbisch in 1968–69.

The artists of The Eight or Ash Can School are very well represented; many were known to Whitney as contemporaries and friends. There are 12 paintings by Sloan and 131 etchings, 105 of which belong to the original Whitney bequest. There are 7 paintings by Luks, 6 oils and 4 watercolors by Prendergast, 5 oils each by Davies and Henri, 4 works by Glackens, 1 work by Shinn, and 9 and 7 works, respectively, by Guy Pene du Bois and Walt Kuhn.

The early American modernists are also well represented. There are four oils each by O'Keeffe and Dove, both members of the Stieglitz circle. The many approaches to Cubism can be seen in four watercolors by Marin; eight works by Marsden Hartley; the 1915 oil *Chinese Restaurant* by Weber; five Synchromist works by Stanton MacDonald Wright and Morgan Russell; works by the illustrator James H. Daugherty and the expatriate Patrick Henry Bruce; works by the German-Americans Feininger and Bluemner (six oils); eight paintings grouped under the Precisionist banner, including Demuth's *Little Egypt* (1927); thirteen works by Sheeler; and five canvases by Preston Dickinson. The American-scene phase is covered in both its rural and urban aspects. There are oils by Benton,

Curry, and Wood and a promised drawing by Wood almost seven feet long, a study for the Ames Library mural at Iowa State University. The tradition of The Eight continues in *Dempsey and Firpo* of 1924 by George Bellows, works by Reginald Marsh, and three works by Soyer. Other urban-oriented examples range from Kuniyoshi's works to Ben Shahn's *Passion of Sacco and Vanzetti* of 1931– 32 and from the ninety-nine lithographs of the later Precisionist Ralston Crawford to the sixty-seven prints by the Social Realist William Gropper. Edward Hopper was this period's special genius, and the bequest of his wife, Josephine N. Hopper, of more than two thousand works by her husband is the jewel of the permanent collection.

There were also realists who added touches of the fantastic and the psychologically dramatic. The Whitney covers a wide area by including works of Eilshemius, Evergood, Cadmus, Blume, Guglielmi, Ivan Le Lorraine Albright, and Joseph Cornell. There are also works of the naturalized Americans Tanguy and Tchelitchew.

European immigrants and expatriots were important to the abstract art of the 1930s. John Graham, Jan Matulka, Jean Xceron, and Arshile Gorky are all represented.

The selection of Abstract Expressionists is comprehensive. Examples include works of Baziotes; an important Pollock, *Number 27, 1950*, a classic all-over painting; four De Kooning oils; two early Rothko watercolors from 1945–46; an excellent Barnett Newman, *Day One*, of 1951–52; six Gottliebs spanning 1948–69; an early Motherwell of 1947; two Hofmanns dated 1950 and 1952; and examples of Ad Reinhardt's many talents. Other familiar names include Still, Kline, Guston, Pousette-Dart, Bradley Walker Tomlin, Hedda Sterne, Tworkov, and Stamos. Works of the independently motivated Tobey are also present. Representing the second generation of Abstract Expressionists are Sam Francis, Helen Frankenthaler, Joan Mitchell, Conrad Marca-Relli, Paul Jenkins, and Morris Louis. The Bauhaus master Josef Albers; two Mondrian followers, Glarner and Bolotowski; and the Op artist Anuszkiewicz succinctly cover what has been labeled Hard Edge painting.

Many painters continued in the sixties and seventies to paint in a lyrically abstract vein, for example, Larry Poons, Jules Olitski, Richard Diebenkorn, and Walter Darby Bannard. Other artists simplified where Abstract Expressionism was complex. In the collection are early examples by Ellsworth Kelly (1956), Kenneth Nolan (1958), Gene Davis (1960), and Frank Stella (1962).

Not constrained to labels, two important associates of Merce Cunningham— Robert Rauschenberg and Jasper Johns—are both represented by early works: Rauschenberg by *Yoicks* (1953) and *Summer Rental Number 2* (1960); Johns by *White Target* (1957), *Studio* (1964), twenty-one prints from 1963–69, and the most recently acquired *Flags*.

Under the broad umbrella of Pop Art can be found a rich and diverse group. It begins with a Rube Goldberg *Spring Sale of European Nobles* and four early Rivers, including *Portrait of Frank O'Hara* of 1952. Jim Dine is well repre-

sented, and the list continues with d'Arcangelo, Grooms, Indiana, Krushenick, Lichtenstein, Oldenburg, Price, Rosenquist, Ruscha, Steinberg, Thiebaud, Warhol, and Wesselmann.

The Whitney continues to collect work of talented realists: Will Barnet, Jack Beal, Chuck Close, Richard Estes, Alex Katz, Alfred Leslie, Alice Neal, Phillip Pearlstein, and Fairfield Porter. At the other extreme, important Minimalist artists include Sol LeWitt, Robert Mangold, Brice Marden, and Agnes Martin.

The Whitney also contains art by persons known for other activities: thirty-two drawings by e. e. cummings; works by the dealers A. E. Gallatin, Julien Levy, and Betty Parsons; and an oil by Edward Steichen done in 1905, *Landscape*.

The collection of twentieth-century American sculpture is excellent. Its breadth is similar to the painting selection, being strongest in works done after 1960. To this end the great generosity of the Howard and Joan Lipman Foundation, Inc., is to be credited.

The first thirty-five years of production are represented by artists who opposed the grand style of the Beaux-Arts (Saint-Gaudens) and the later suave historicism of Manship. The carve-direct aesthetic rebelled against less personal bronze casting and its use of studio assistants. It is represented by John Flannagan, Robert Laurent, William Zorach, and Jo Davidson, who sculpted Gertrude Stein (1920) instead of a general or a statesman. Leonard Baskin, José de Creeft, Chaim Gross, Raoul Hague, and Herbert Haseltine believed that the material must exert some discipline on the form. A sleek, modern look appears in Nadelmann's turn-of-the-century smoothness and Archipenko's toned-down European sophistication. Both Hugo Robus and Gaston Lachaise adapted this manner. Lachaise (eleven examples) also concerned himself with a radical iconography, the sexual woman. Equally radical for sculpture was work confronting the common man. The Whitney's examples include works by Abastenia St. Leger Eberle, Harry Wicke, and Mahonri Young. The expatriate John Storrs' new iconography was modern form. Gertrude Vanderbilt Whitney herself is represented by five works in a humanized Beaux-Arts style.

During the 1930s and 1940s, Americans continued to try new styles that might fit the changing times, social situations, and moralities. The Surrealist influence is represented by Joseph Cornell, David Hare, and Frederick Kiesler. Richard Lippold, Isumo Noguchi, and Theodore Rozak are all represented by period works, but Peter Grippe, Ibram Lassaw, Seymour Lipton, and David Smith have only later examples present. If ever the collection is permanently displayed, the same depth found in Calder (seventeen examples, most notably his *Circus*, which is always on display) can then be hoped for this period.

The abstract work of the 1950s is well shown with sixteen works by Louise Nevelson; one by Louise Bourgeois; works by Gabriel Kohn, Barnett Newman, Richard Stankiewicz, and David Smith; and four works by Herbert Ferber.

The wide influence of Constructivism is treated with works by Lippold, George Rickey, José de Rivera, and Kenneth Snelson. The effect of Abstract Expressionism on sculpture is shown by Larry Bell, Lee Bontecou, John Chamberlain,

Marca-Relli, and Mark di Suvero. A great range of sculpture was produced in the sixties that can very loosely be grouped as Pop. The following give some idea of the range: Peter Agostini, Chryssa, Frank Gallo, Robert Indiana, Edward Kienholz, Roy Lichtenstein, Claes Oldenburg, Niki de Saint Phalle, Kenneth Price, Lucas Samaras, George Segal, and Ernest Trova.

Artists sometimes known as Minimal, Conceptual, or Process related also receive good exposure: Dan Flavin, Robert Grosvenor, Eva Hesse, Donald Judd, Sol LeWitt, Robert Morris, Bruce Nauman, Richard Serra, Robert Smithson, Keith Sonnier, and Anne Truit.

Each *Whitney Annual* and its successor since 1978, the *Bulletin of the Whitney Museum of American Art*, lists the year's acquisitions. Specific pieces may be viewed by contacting the registrar. For information regarding the slide collection, contact Publications and Sales. The library is available to scholars who have specific requests that can not be filled by other sources. A complete list of available publications may be obtained from Publications and Sales. This includes books pertaining to past exhibitions and catalogues accompanying shows that originated at other institutions.

Selected Bibliography

Museum publications: *Selections from the Lawrence H. Bloedel Bequest and Related Works from the Permanent Collection*, 1977; *Catalogue of the Collection*, 1975; *The First Five Years* (Acquisitions by the Friends of the Whitney), 1957–62; *The Friends Collect*, 1964; *The Museum and Its Friends* (20th Century Art from Collections of the Friends of the Whitney Museum), 1958; *Three Decades of American Art Selected by the Whitney Museum*, 1976; *Whitney Annual*, 1960, 1961, 1963, 1965–76, 1969, 1970; *Whitney Review*, 1961–62 through 1976–77; *The Whitney Museum and Its Collection* (History, Purpose, and Activities: Catalogue of the Collection), 1958; *The Whitney Studio Club and American Art, 1900–1932*, 1975; *20th Century American Drawings: Five Years of Acquisitions*, 1978; Alloway, Lawrence, *American Pop Art*, 1974; Levin, Gail, *Synchromism and American Color Abstraction, 1910–1925*, 1978 (in association with George Braziller); *The Theatre Collects American Art*, 1961; Hills, Patricia, *Turn-of-the-Century America: Paintings, Graphics, Photographs, 1890–1910*, 1977; Armstrong, Tom, et al., *Two Hundred Years of American Sculpture*, 1976; Feder, Norman, *Two Hundred Years of American Indian Art*, 1971; Agee, William, *1930's: Painting and Sculpture in America*, 1968.

Other publications: Frankenstein, Alfred, *The Reality of Appearance* (Berkeley, Calif. 1970); Lipman, Jean, *Calder's Circus* (New York 1972); Stebbins, Theodore, *American Master Drawing and Watercolors* (New York 1976).

THOMAS J. DENZLER

——— Norfolk ———

CHRYSLER MUSEUM, THE, Olney Road and Mowbray Arch, Norfolk, Virginia 23501.

The impetus to form the Norfolk Museum of Arts and Sciences (later The

Chrysler Museum) came from the students of Irene Leache, a popular teacher who died in 1900. She had encouraged a lively interest in art and literature, and by 1918 two organizations had been established to honor her memory and pursue these interests. The parent group was the Irene Leache Memorial, whose purpose was to purchase works of art and sponsor annual literary and artistic competitions. An offshoot of the memorial was the Norfolk Society of Arts, which sought to support all of the arts but was specifically dedicated to the building of an art museum. The society was incorporated in 1922, and a building fund was also established. Two years later the city of Norfolk agreed to appropriate annual funds toward the maintenance and operation of the proposed museum. The first meeting of the museum Board of Trustees was held in 1926, and the raising of funds commenced, only to be severely curtailed by the Depression. A building on the plan of a Florentine Renaissance structure had been designed by two local firms, but due to the shortage of funds, only one section of this was at first completed and opened to the public on February 12, 1933. A second unit was built in 1939 with the aid of the Public Works Administration. In 1967 the Willis Houston Memorial wing containing a four-hundred-seat auditorium was added.

As the name implied, the Norfolk Museum of Arts and Sciences was a combination art and natural history museum. The art collection, although of limited scope, did have some notable areas of strength. They included a collection of several hundred pieces of Chinese ceramics, primarily of the Han and Tang dynasties, given to the museum in 1936 by James Perry of San Francisco in memory of his wife who had been born in Norfolk. Through purchase other notable Oriental works were added, such as a bronze *hu* (c. 500 B.C.) of the Eastern Chou; the scroll painting *Scholars in a Grove* by Wang Fu (A.D. 1362–1414), one of the finest early Ming painters; and a set of four anonymous Japanese watercolors commemorating Commodore Matthew Perry's 1852 expedition. In 1955 more than 150 pieces of Chinese export porcelain from the Helena Woolworth McCann Collection came to the museum. A major acquisition that same year was an Assyrian alabaster bas-relief of a standing monarch from the palace of Asshurnazirpal at Nineveh (c. 875 B.C.), brought to America in 1856.

Also of note was the purchase in 1950 of a large group of Old Master drawings, among which was a group from the distinguished collection of Dan Fellows Platt of Englewood, New Jersey. Particularly fine are four sheets by Guercino, all studies for known paintings. There are also several Tiepolos, two Rosas, a Cigoli, and, of English nineteenth-century artists, a number of Burne-Joneses. The museum also received a large collection of American prints from the estate of the printmaker John Taylor Arms.

The museum purchased a few notable paintings such as a signed Anthonie Palamedesz, *Gathering in an Interior*, and a handsome Monnoyer flower piece, as well as a Hendrick de Clerck, *Venus and Adonis*. Several fine paintings, including a still life by Weenix, portraits by van Veen, and *June Placing the Eyes of Argus in the Peacock's Tail* by Balestra, were generously presented to the museum by Emile Wolf.

A major addition to the grounds of the museum came in 1954, when the monumental cast aluminum sculpture *The Torchbearers* was donated to the museum by its sculptor Anna Hyatt Huntington.

Within the museum the Irene Leache Memorial had and continues to have a separate gallery for its collection, which includes several fine sixteenth-century Flemish tapestries, a Flemish polychromed wood sculpture of the Archangel St. Michael, and the most recent addition, the triptych *Virgin and Child with Saints* by Tommaso da Modena.

In 1971, by contract between the city of Norfolk and the Chrysler Art Museum of Provincetown, Massachusetts, the collections of the latter institution were transferred to the Norfolk Museum, which then assumed its present name and became exclusively an art museum. This extraordinary influx of art was in large measure a result of the fact that the founder and director of the Chrysler Art Museum, Walter P. Chrysler, Jr., had married a resident of Norfolk.

The Board of Trustees that governs the museum was expanded at this time to eighteen members, of which twelve are appointed by the Norfolk City Council and two by the Norfolk Society of Arts; four are elected by the trustees. The museum is administered by a director, and the professional staff is composed of an administrator, curator of European painting and sculpture, curator of glass, curator of decorative arts, a registrar, a photographer, a director of education, and a director of development.

The immense collection of artworks transferred from Provincetown and subsequent gifts to the museum by Chrysler have raised the museum to its preeminence as one of the leading art museums in the country and one with an encyclopedic collection spanning almost all cultures and periods and all varieties of art.

The chief collection is that of paintings, and especially outstanding are the fields of Italian, French, and American art. Of the Italian Renaissance, two Venetian examples are noteworthy, since in both cases their original locations are known. Veronese's monumental (112 by 66.5 inches) *Virgin and Child with Angels Appearing to Saints Anthony Abbot and Paul the Hermit* was painted in 1562 for the monastery church of San Benedetto in Po near Mantua, and Tintoretto's *Allegorical Figure of Spring* was executed about 1560 as part of the decorative scheme at the Casa Barbo at San Pantaleone, Venice.

The Italian Baroque paintings are of especially high quality and of a scale and richness rare in American museums. Most of the major schools are represented. From Bologna there are Guercino's *Samson Bringing Honey to His Parents* (probably commissioned by the Barberini family whose crest of three bees is prominently shown), Guido Reni's *David and Abigail*, and Giuseppe Maria Crespi's *The Continence of Scipio*. Among the Neapolitan works there are Bernardo Cavallino's *Procession to Calvary*, Salvator Rosa's *Baptism of the Eunuch* (formerly in the Ashburnham collection), and Luca Giordano's signed *Bacchus and Ariadne*. Of Genoese-born masters there are paintings by Castiglione, Mag-

nasco, and Strozzi and of Venetians, Sebastiano Ricci, Giambattista Tiepolo, and Bellotto.

Two splendid Italian paintings of the eighteenth century are Giovanni Battista Pittoni's *Imaginary Memorial to James, First Earl Stanhope* (c. 1720), one of twenty-four allegorical tombs of "British worthies" commissioned from various Italian painters by the Irish impresario McSwiney, and Giovanni Paolo Panini's lively *Celebration of the Marriage of the Dauphin* of 1745.

Throughout the Italian painting galleries are also to be found examples of Italian Renaissance and Baroque sculpture. There are bronzes by Algardi and Vittoria, and most impressive is Bernini's marble *Bust of the Saviour*. This bust, completed in 1679, was the sculptor's final work and was willed by him to Queen Christina of Sweden.

The collection of French paintings commences dramatically in the seventeenth century with Vignon's *Judgment of Solomon* and de La Tour's *St. Philip*, given to the museum by Chrysler in 1978. The collection continues with Vouet's *Virgin of the Oak Branch*, La Hire's *Job Restored to Prosperity*, and Largillierre's *Artist in His Studio with Two Assistants*. The Rococo era is represented by Boucher's pastorale *The Vegetable Vendor*, Chardin's *Still Life with Plums*, and Natoire's *Mythological Scene (Psyche Stealing the Fleece)*.

The nineteenth-century French galleries begin with one of Greuze's last great paintings, *The Repentance of St. Mary of Egypt* (c. 1800), and Baron Gros' *Acis and Galatea*, a work so critically received at the Salon of 1833 that the artist committed suicide. The Chrysler Museum's collection of later nineteenth-century paintings is notable for the strength of the academic or salon paintings. There are works by Gleyre, Bouguereau, Doré, Couture, Gérôme, and Fantin-Latour. Equally impressive are a group of Barbizon School paintings—*Sleeping Child* by Millet and large-scale landscapes by Rousseau, Jacque, Troyon, Corot, and Harpignies. Of Impressionist paintings, the most characteristic are Renoir's *Portrait of the Daughters of Durand Ruel*, Degas' large (seventy-one by sixty inches) *Dancer with a Bouquet* and Tissot's notable *The Artists' Wives*, done in 1885 after his ten years' sojourn in London. A remarkable Symbolist painting is Gauguin's *La Perte du pucelage (The Loss of Innocence)* of about 1890. Twentieth-century developments in French painting are captured in Matisse's *Apples on a Table* of 1916 and Braque's *The Red Tablecloth* of about 1933.

In 1976 the city of Norfolk built a new wing for The Chrysler Museum to house offices, a gift shop, and eighteen new galleries. Since it was the bicentennial year, these galleries were devoted to the museum's extensive collection of American painting. The collection begins with a group of American naïve paintings given to the museum by Edgar William and Bernice Chrysler Garbisch. Among them are works by Joseph Badger, Ammi Phillips, and Joshua Johnston and two historical scenes by Edward Hicks. By later eighteenth-century American painters there is a portrait by Copley, one by West, and one by Rembrandt Peale of his painter wife, Harriet Cany.

Nineteenth-century American landscapists on view include Cropsey, Bierstadt, Cole, and Heade, and by still-life painters there are examples of Harnett, Peto, and Roesen. Two unusual works are Asher B. Durand's only religious painting, *God's Judgment upon Gog*, painted for the artist's patron Jonathan Sturges, and Albert Ryder's *Diana*, a painting on leather that was exhibited in the famous Armory show of 1913.

American Impressionism receives its due with works such as Mary Cassatt's *The Family*, Childe Hassam's *Chez la fleuriste* (exhibited in the Salon of 1890), and John Singer Sargent's *Portrait of the Countess of Lathom*. Representing the more realistic school of painting from the early part of the twentieth century are Robert Henri's *Gypsy with Guitar*, painted in Spain; George Bellows' superb painting of his wife, *Emma at the Piano*; and William Glackens' *The Shoppers*, his largest painting and one shown in the 1908 exhibition at the Macbeth Gallery in New York from which the group known as The Eight took its name.

Among paintings of the 1930s, most impressive is Thomas Hart Benton's mural *Unemployment, Radical Protest, and Speed* from the series "The Arts of Life in America," which Benton painted in 1932 for the library of the original Whitney Museum. Other artists of the period represented in the collection include Reginald Marsh, Philip Evergood, Guy Pene du Bois, Charles Demuth, and Stuart Davis.

The abstract art of the 1950s is best illustrated by Franz Kline's *Zink Yellow* and Hans Hofmann's *Into Outer Space*. There is also a strong representation of more recent abstract artists, as well as those of the Pop, Op, and Neo-Realist schools, such as Larry Rivers, Robert Rauschenberg, Andy Warhol, Frank Stella, Morris Louis, and Alfred Leslie. American sculpture of the twentieth century receives ample attention with examples by Nadelman, Lachaise, Manship, David Smith, Calder, and Chamberlain.

Other schools of painting are also represented, if not as fully, in The Chrysler Museum's collection, and worthy of mention are several paintings of the Northern European schools: paintings of the *Virgin and Child* by both Gossaert and Lucas van Leyden and a signed painting of *Parnassus* by Martin van Heemskerck. Of seventeenth-century work there is a fine Teniers; a van Dyck, *Martyrdom of St. Sebastian*; and two portraits by Rubens. In the galleries devoted to English paintings are outstanding portraits by Gainsborough, Raeburn, and Beechey.

Aside from the paintings, The Chrysler Museum's most remarkable collection is that in its Institute of Glass. Comprising about ten thousand pieces of which about half are on permanent view in 133 cases, it presents one of the most comprehensive displays on the history and techniques of glassmaking to be found anywhere in the world. It commences with Near Eastern core-formed vessels and continues into the ancient world with one of the most significant pieces, a delicate mold-blown bowl of the first century inscribed with the name of its maker, Ennion of Sidon.

The glass collection proceeds through sixteenth-century Venetian tazzas to

seventeenth- and eighteenth-century engraved pokals from Germany and Holland and on to a large selection of Chinese "Peking" glass. The greatest strength, however, is in glass of the late nineteenth and early twentieth centuries. A remarkable English piece is Woodall's Antarctic vase commemorating Scott's expedition to the South Pole. From America there is a great collection of Sandwich glass, as well as many examples by other companies such as Mt. Washington and New England. There is an entire gallery containing more than two hundred diverse lamps, vases, windows, and other objects produced by Louis Comfort Tiffany and his company. Of great rarity are several vases and bowls of blue and clear intarsia glass designed by Frederick Carder for Steuben in 1930. The makers of French art glass also have a prominent place, and among those represented are Gallé, Daum, and, from the Art Deco period, Lalique, Argy-Rousseau, and Marinot.

The extensive glass collection is complemented by a collection of decorative arts and furniture especially strong in Art Nouveau and Art Deco works. They include lamps by Larche, chairs by Sué and Mare, vases by Marty and Cazaux, and a remarkable centerpiece of silver, crystal, lapis lazuli, and marble by Jean Puiforcat.

Also of note among the decorative arts is the collection of silver. Included in the English section are an Elizabethan covered goblet of about 1572 by the maker A.B., a James I beaker, George II and George III epergnes, and a racing trophy by Paul Storr. An outstanding American piece is the martele centerpiece made by the Gorham Company for the Paris Exposition of 1900.

Of other furniture in the collection, notice should be taken of a George II mahogany bookcase from Rokeby Hall, Yorkshire, which is probably by William Kent. American furniture of distinction includes a Newport chest on chest in cherry wood of about 1760, a Chippendale highboy from Pennsylvania of about 1770, a Federal sofa of about 1800 from New York, and a suite of sofa, armchairs, and sidechairs in steel and cane by George Hunzinger.

Of the wide variety of English porcelains on display, there is a superlative group of first-period Dr. Wall Worcester blue-scale and wet-blue work.

In 1978 The Chrysler Museum dedicated two new specialized galleries. The Jack Tanzer Gallery of Pre-Columbian Art houses a collection of New World material, much of which was donated by the New York collector for whom the gallery is named. The finest pieces in this group are of Mexican origin produced by the cultures of Nayarit, Tlatlico, Jalisco, Colima, and Veracruz. Chrysler has contributed several notable Mayan pieces, and a fine group of pre-Columbian Peruvian textiles have been donated to the museum by Virginia Morris Pollak and Lillian Malcove.

The Sol B. Frank Memorial Gallery of Photography also opened in 1978 and provides the museum with a permanent display of photography drawn either from the museum's own collection or borrowed from other institutions.

The Chrysler Museum administers three historic houses. In downtown Norfolk is the Moses Myers House built by the wealthy merchant of that name in 1792.

It has Adam-style interiors with elaborate plaster decoration, with many of the original furnishings including glass and silver on display, as well as family portraits by Gilbert Stuart and Thomas Sully. The nearby Willouby-Baylor House was built two years later and has Federal additions to the original Georgian structure. It is furnished with Virginia and Southern pieces, including a table that reputedly belonged to President Monroe. In Virginia Beach is the Adam Thoroughgood House. Built in 1636 by a former indentured servant, it is one of the oldest brick residences in America and is now restored to its seventeenth-century appearance with many worthy examples of English furniture.

The Chrysler Museum has an art library of more than fifty thousand volumes, of which an important collection of monographs, sale and exhibition catalogues, and a microfiche unit stem from the acquisition of the London library of M. Knoedler and Co. in 1977. The library at present is only available to museum staff.

Slides and photographs of objects in the collection may be purchased through the registrar's office. In addition to providing the catalogues listed below, The Chrysler Museum on occasion publishes special exhibition catalogues and leaflets. A monthly members bulletin provides information on current activities and articles on various aspects of the collection.

Selected Bibliography

Museum publications: The Chrysler Museum, *Selections from the Permanent Collection, Norfolk, Virginia*, 1982; Amaya, Mario, and Zafran, Eric, *Veronese to Franz Kline: Masterworks from The Chrysler Museum at Norfolk*, New York, 1978; Anderson, Dennis R., *Three Hundred Years of American Art in The Chrysler Museum*, 1976; Doros, Paul E., *The Tiffany Collection of The Chrysler Museum at Norfolk*, 1977; Ganse, Shirley H., *Chinese Art in The Chrysler Museum at Norfolk*, 1976; Zafran, Eric M., *One Hundred Drawings in The Chrysler Museum at Norfolk*, 1979.

Other publications: Articles on Italian, French, and American paintings; glass; Art Deco; and Oriental works, in *Apollo*, vol. 107, no. 194 (April 1978), pp. 1–51.

ERIC M. ZAFRAN

Pasadena

NORTON SIMON MUSEUM OF ART AT PASADENA (formerly PASADENA ART INSTITUTE [1924–70]; PASADENA MUSEUM OF MODERN ART [1970–74]), Colorado and Orange Grove Blvds., Pasadena, California 91105.

The complex and controversial history of the Norton Simon Museum and its predecessors in Pasadena began with the Pasadena Art Institute, which from its inception in 1924 was housed in a modest wooden structure in the suburban Carmelita Park laid out by John Muir. In 1942 the institution moved to the

Nicholson mansion, a pseudo-Chinese building in downtown Pasadena, where it continued to function as a small community museum of the arts. Its focus began to shift with the receipt in 1953 of the Galka E. Scheyer bequest of several hundred works of modern art, including major holdings of paintings and drawings by the Blue Four—Klee, Feininger, Kandinsky, and Jawlensky. During the following years the museum became increasingly committed to the acquisition and exhibition of twentieth-century art, eventually changing its name in 1970 to the Pasadena Museum of Modern Art.

An overly ambitious building program embarked upon in the 1960s proved to be the museum's downfall. A costly new building, designed by Thornton Ladd and John Kelsey and set in what had been Muir's Carmelita Park, was dedicated in 1969. A large building debt, coupled with mounting operations deficits, forced the museum's board of trustees to seek financial aid through a variety of channels. The Los Angeles County Board of Supervisors was approached with a proposal to make the Pasadena museum the "modern" branch of an expanded Los Angeles County Museum of Art system. This effort failed, as did an overture to The Museum of Modern Art in New York to make the Pasadena Museum a satellite in a national consortium of "modern" museums. Efforts to enlist the financial support of the industrialist and collector Norton Simon, although at first successful, resulted in April 1974 in Simon's offer of what would be in effect a takeover of the museum's operations: in return for assuming most of its considerable debt, he would gain control of its governing board. He agreed to commit for five years 25 percent of the gallery space to the exhibition of the permanent collection and of traveling shows of modern art, while reserving the remainder for the display of the Old Master collection, which for twenty years he had been building through the Norton Simon Foundation and the Norton Simon, Inc. Museum of Art. The board of trustees of the Pasadena Museum of Modern Art acceded to Simon's conditions and was disbanded; a smaller board, dominated by Simon and his appointees, was set in its place. The museum, to be renamed the Norton Simon Museum of Art at Pasadena, closed its doors for a number of months while much-needed interior remodeling of the Kelsey and Ladd structure was undertaken. By the time of its reopening early in 1975, most of the problems in the original design had been alleviated.

Simon's eventual appointment of himself as director of the museum and his wife, actress Jennifer Jones, as chair of its board of trustees occasioned widespread criticism. His redirection of the museum's energies from twentieth-century art to the Old Masters—a policy that led to considerable deaccessioning from the "inherited" collection—angered many in the contemporary art community, leading to a suit brought by three former trustees alleging breach of charitable trust, which was resolved in Simon's favor in 1981. The attention given by the press to clashes of personality has obscured the greatest oddity of the museum's operations: save for the few galleries devoted to the exhibition of the Pasadena Museum's collections, virtually none of the painting and sculpture on view at the Norton Simon Museum forms part of its permanent collection. Although not

so labeled, the Old Master and early modern painting and sculpture; the graphic art of Rembrandt, Claude Lorraine, Goya, and Picasso; and the large collection of Indian and Southeast Asian sculpture all are on loan from the two Simon foundations. The museum's international reputation rests almost exclusively upon its loan collection.

The casual visitor to the Norton Simon Museum would not be aware of the controversies that stem from the blurring of the distinction between public and private on the one hand and permanent collection and loaned works on the other hand. Such a visitor would be struck only by the extraordinary richness and depth of the art on display. As more than one critic has observed, even a brief visit to the thoughtfully installed galleries serves to diffuse much of the diffidence one might bring to the museum. Norton Simon and his foundations have brought to the West Coast a collection of truly outstanding character. (The visitor is forewarned, however, that in keeping with the foundations' long-standing educational goals, a sizable number of their paintings will be at any given time on loan to other museums across the country.) The following survey will make clear the museum's significance.

Although the importance of the Old Master collection truly begins only with the fifteenth century, the small group of trecento works includes some notable pictures. Chief among them are two panels by Pietro Lorenzetti with *St. John the Baptist* and *The Prophet Elisha*; an impressive polyptych, the *Coronation of the Virgin* (1344), by the Paduan master Guariento di Arpo; and the *Madonna and Child* (c. 1340) by Paolo Veneziano. The quattrocento holdings include a number of highly important works by both Sienese and Florentine painters. The Sienese works are dominated by Giovanni di Paolo's magnificent *Branchini Madonna* of 1427, an unrivaled masterpiece of his early years. Giovanni's *Baptism of Christ* (early 1450s?) reveals the harsher forms of his later style in a strikingly abstract landscape. Other aspects of the elegant linearism of Sienese painting can be seen in Neroccio de' Landi's *Madonna and Child with Saints* and Francesco di Giorgio's *Fidelity*, a fresco transferred to canvas. Florentine paintings of the Quattrocento begin with Lorenzo Monaco's delicate *Virgin Annunciate* (c. 1410–15), whose pendant *Angel of the Annunciation* has yet to be discovered. From later in the century are the *Madonna and Child with an Angel* by Botticelli, an important work despite the considerable abrasion of its surface, and two striking panels by Filippino Lippi, one with *Saints Benedict and Apollonia*, the other with *Saints Paul and Frediano*. Fragments from an altarpiece for St. Ponziano, Lucca (c. 1483), they reveal the naturalism and richness of color and texture often found in Florentine paintings of the late Quattrocento.

Dating from the first years of the sixteenth century is Raphael's *Madonna and Child with a Book*, a superb example of his work on this theme painted shortly before his arrival in Florence in 1504. Bernardino Luini's seven panels, the *Torriani Altarpiece* (1525), reveal a flair for somewhat naïve narrative and an appreciation of bright, rich color not often associated with this follower of

Leonardo. Venetian painting of the period is well represented in the collection, beginning with Giovanni Bellini's portrait *Joerg Fugger* of 1474. The *Bust of a Courtesan*, considered by the museum to be from the hand of Giorgione, is more likely an early work of Titian. Giorgione's influence can be seen as well in Vincenzo Catena's *Rest on the Flight into Egypt* and Palma Vecchio's exceedingly pretty *Venus and Cupid in a Landscape*. Such works pale beside Jacopo Bassano's large *Flight into Egypt* (c. 1540–45), which dramatically fuses elements of Mannerist design with a characteristically Venetian naturalism and brilliance of color. This group of Venetian paintings also includes portraits by Carpaccio and several lesser works and leads to El Greco's *Portrait of an Old Man with a Fur Collar*, painted about the last decade of the sixteenth century.

The museum's small but growing collection of Northern paintings of the fifteenth and sixteenth centuries includes a recently acquired masterpiece by Dieric Bouts, the *Resurrection* of about 1455. Hans Memling's *Blessing Christ* (1478), a small and tranquil work, and Gerard David's *Coronation of the Virgin*, in which realistically handled figures are placed before an anachronistic gold ground, are also to be noted. Northern paintings of the sixteenth century include two large panels by Lucas Cranach the Elder with life-sized figures of *Adam* and *Eve* and strongly Mannerist works by Maerten van Heemskerck, Jan Metsys, and Cornelis van Haarlem. Another aspect of Netherlandish art of the period can be seen in the museum's small collection of tapestries. The earliest of them is a substantial fragment of about 1480, probably woven at Tournai and representing *The Surrender of Rome to Brennus, King of Gaul*. Also of high quality are three tapestries, *The Story of Troy*, woven about 1500 at Tournai or Brussels.

Perhaps the Norton Simon Museum's greatest strength lies in its collections of seventeenth- and eighteenth- century paintings from Italy and Spain, Flanders, the Netherlands, and France. These works present the visitor with an excellent introduction to the nature and scope of Baroque and Rococo art and include a significant number of undisputed masterpieces.

The earliest of the Italian works is Guido Reni's *St. Cecilia* of 1606, an important document of the short-lived Caravaggesque phase at the start of his career. Guercino's *Death of Cleopatra* (c. 1621) and Baciccio's *St. Joseph with the Christ Child* (c. 1680) reveal in their rich colors and dynamic compositions aspects of the most fully Baroque current in seventeenth-century Italy, as do the six large tapestry cartoons by Giovanni Francesco Romanelli, *Aeneas and Dido*. Executed in gouache on paper (since laid on linen), these works retain much of their warm, bright color and are a fine example of a dominant stylistic trend in Rome in the 1630s and 1640s.

Italian painting of the eighteenth century is highlighted by a superb Tiepolo oil, *The Triumph of Virtue and Fortitude*, which originally decorated a ceiling of the Palazzo Manin in Venice. Characteristic of his style in the 1740s, this work lays fair claim to being the finest Tiepolo in America today. Among works by Tiepolo's Venetian contemporaries are topographical view paintings by Carlevaris and Canaletto and two more fluid, sketchlike views by Guardi. Genre

painting in Venice is represented by Pietro Longhi's *Artist Sketching in an Elegant Company*, and the strength of its religious painting can be seen in a *grisaille* by Pellegrini, *Christ at Calvary*. Other Italian works of the eighteenth century include most notably Magnasco's spectral view, *Interior with Monks*, and Panini's meticulously rendered *Interior of St. Peter's*.

The museum's collection of Spanish Baroque painting, although small, is distinguished by its high quality. Jusepe Ribera's *Sense of Touch* is an excellent example of a type of realistic half-length figure popular in his adoptive Rome and Naples in the 1620s and 1630s, and two works by Murillo are indicative of the highest achievements of religious narrative in Baroque Spain. The most important of the four works by Zurbarán is his *Still Life with Lemons, Oranges, and a Rose* (1633), a hauntingly simple arrangement of objects on a single plane in the foreground. His brilliantly colored *Birth of the Virgin* (1629) reveals the lingering traces of Mannerism in his early works, and the portraits *Fray Diego Deza* and *St. Francis in Prayer* exemplify two of the fundamental subject types in his oeuvre.

The museum's limited Flemish holdings include several important works by Rubens. Of them, the most impressive is the rapidly executed oil sketch *The Hunt of the Calydonian Boar* (c. 1619), a revelation of Rubens' vitality and masterful brushwork. The relatively classical *Holy Women at the Sepulchre* and the far more dramatic *David Slaying Goliath* also stand out among the paintings by Rubens. Other Flemish works in the collection include collaborative efforts by Jacob Jordaens and Jan Wildens (*Mercury and Argus*) and by Frans Snyders and Cornelis de Vos (*Still Life with Fruits and Vegetables*), as well as a fine *Flower Still Life* by Jan Bruegel.

The museum's collection of Dutch painting affords a comprehensive survey of the major genres practiced in the Netherlands in the seventeenth century. The most important of the three Rembrandts is the *Portrait of a Boy*, which although considered by some a work of the late 1650s is most likely an unfinished portrait of the artist's son Titus executed a decade earlier. His *Portrait of a Bearded Man* (1633) reflects the polished style that Rembrandt adopted for commissioned portraits upon his arrival in Amsterdam, and his *Self Portrait* of the late 1630s is more painterly in technique and more penetrating in its analysis of character. Other Dutch portraits in the collection include Frans Hals' *Portrait of a Painter* (*Jan van de Capelle*?) of the early 1650s and works by Nicolaes Maes, Thomas de Keyser, and others.

Among the many Dutch genre paintings in the collection, scenes of peasants and low-life characters by Adriaen van Ostade and his brother Isaac reveal in varying degrees the influence of the Flemish master Adriaen Brouwer. Gabriel Metsu's *Woman at Her Toilet* is indicative of the taste after mid-century for more meticulously finished genre paintings with seemingly more elevated characters. Of the three works by Jan Steen, only one—*Wine is a Mocker*—is truly a genre scene; the other two are religious scenes treated as if contemporary

subjects. Other religious paintings in the collection include Matthias Stomer's *Mocking of Christ*, which derives its realism and lighting at least indirectly from Caravaggio, and the lovely, more classical *Denial of St. Peter* by Karel Dujardin.

The history of Dutch landscape painting is illustrated admirably in the museum's collection, beginning with Roelandt Savery's Mannerist *Landscape with Animals and Birds* of 1624. Jan Lievens' *Panoramic Landscape* of 1640 is strongly Rembrandtesque in character, and Aert van der Neer's *Winter Scene* renders more realistically a group of figures playing golf beneath a dramatically lit sky. The tonal phase of Dutch landscape painting is represented with works by Jan van Goyen and Salomon van Ruysdael, whose early *Landscape with a Sandy Road* (1628) is notable for its close harmonies of browns, greens, and grey. The classical phase of Dutch landscape painting can be seen in two works by Jacob van Ruisdael, including the large and important *Three Old Beech Trees*, and in Aelbert Cuyp's pastoral *Evening in the Meadow*.

French painting of the seventeenth century is not well represented in the museum's collection, despite the presence of *Camillus and the Schoolmaster of Falerii* and *Chatsworth Holy Family* (jointly acquired in 1981 with the Getty Museum in nearby Malibu) by Poussin and two fine landscapes by Claude Lorraine. The eighteenth-century French works are by contrast more numerous and on the whole more impressive. Watteau's diminutive *Reclining Nude* (c. 1715) deserves close attention for its marvelous technique and controlled eroticism. His creation of the *fête galante* can be seen at least indirectly in a work by his pupil and closest follower Jean-Baptiste Pater. The main line of French Rococo development can be traced in works by Boucher (including his splendid *Vertumnus and Pomona*) and Fragonard. Standing apart from them are Chardin's early masterpiece *Dog and Game*, of 1730, and his pair of richly textured, realistic still lifes of about the same period. French portraiture of the early eighteenth century is admirably represented with major works by Hyacinthe Rigaud, whose *Antoine Pâris* of about 1703–5 is still Baroque in its dramatic movements and attention to rich surfaces and textures, and by Nicolas de Largillierre. The highpoint of Rococo portraiture is found in Maurice Quentin de Latour's ebullient *Self Portrait*, a pastel of 1764, and in works by Louis Tocqué and Antoine Vestier. Vigée-Lebrun's *Theresa, Countess Kinsky* (1793) already reflects an essentially neoclassical attitude.

The Norton Simon Museum's collection of nineteenth-century painting, although somewhat uneven and unbalanced, contains a number of highly important works. Neoclassicism is slighted, with only Louis Ducis' *Sappho Recalled to Life by the Charm of Music* to represent the style. Romanticism fares somewhat better; highlights include Goya's *St. Jerome* (1797) and a major work by Delacroix, *Abd Er Rahman, Sultan of Morocco, Reviewing His Guard* (1856). The several landscapes by painters of the Barbizon School include most notably Daubigny's striking *Hamlet on the Seine near Vernon* (1872). Of the six paintings by Courbet, the most important is his large *Stream of the Puits-Noir at Ornans*

(1868). Other major French painters of the period with works in the collection include Corot, Daumier, and Manet, whose *Rag Picker* of about 1869 ranks among the finest of his figure-studies.

Landscapes by Boudin, Jongkind, and other minor masters of the mid-century lead to the works of the Impressionists. Of particular note are the light-filled *Artist's Garden at Vetheuil* (1881) by Monet and one of his studies of the facade of *Rouen Cathedral* (1894), the early *Le Pont des Arts, Paris* (c. 1868) by Renoir, two landscapes by Sisley, and other paintings by Pissarro, Cassatt, and Morisot. The museum's collection of paintings, drawings, and sculpture by Degas is exceptionally strong. The oils and pastels feature works on most of Degas' characteristic themes. Of the boudoir scenes, *After the Bath* (1885, pastel) and *Woman at Her Toilet* (1886–90, pastel over monotype) are outstanding. The most striking of the theatrical scenes is *Dancers on the Stage* (c. 1879, pastel), which in its composition and fan-shaped format reveals the profound impact of Japanese decorative style on a French artist of the late nineteenth century. A Degas of major importance is a signed pastel, about 1882, of a ballet scene, *L'Attente*. It was acquired (1983) jointly with the Getty Museum from the collection of the late Doris D. Havemeyer.

The museum's collection of Post-Impressionist paintings includes examples of the work of all of the major and many of the minor figures in the movement. The most notable include van Gogh's *Portrait of a Peasant* (*Patience Escalier*) of 1888, a brilliantly colored figure study executed in broad strokes of heavy impasto, and Cézanne's *Farmhouse and Chestnut Trees at Jas-de-Bouffan* (c. 1885). Also of importance are several works by Toulouse-Lautrec and *Tahitian Woman and Boy* of 1889 by Gauguin. The collection also includes works by Seurat, Vuillard, and Bonnard, as well as others by Emile Bernard, Paul Serusier, and Ker-Xavier Roussel.

Although all of the paintings noted thus far are on loan to the museum from the Norton Simon foundations, many of the twentieth-century works form part of the permanent collection. At the core of this is the large bequest that reached the museum in 1953 from Galka E. Scheyer, a child psychologist who was acquainted with and collected the works of several German Expressionist painters. The bequest is especially notable for paintings and drawings by the so-called Blue Four—Klee, Feininger, Kandinsky, and Jawlensky—and includes as well miscellaneous works by other artists.

Among the museum's twentieth-century paintings, Edvard Munch's *Girls on a Bridge* (1902) stands out for its striking colors and evocative shapes, while Rouault's *Two Nudes* of 1906–8 and Vlaminck's *Still Life with Lemons* (1907) reveal the parallels between Fauvism and the German Expressionist art so well represented in the collection. Henri Rousseau's *Exotic Landscape* of 1910, the last year of his life, stands apart from these and other works of the period by virtue of its "naive" character. The museum's Cubist holdings afford a view of Picasso's major developments from the early teens through the thirties and include his Analytic Cubist *La Pointe de la Cité* of 1912, among several other

important works. Braque is represented by four paintings, including a major work of 1939, his *Artist and Model*. Other significant works by artists of the pre–World War II period include four paintings by Matisse, *Jeanne Hebuterne* (1918) by Modigliani, *Composition with Red, Yellow, and Blue* by Mondrian, and works by Frans Marc, Kokoschka, and Soutine. Post-war paintings in the permanent collection include representative examples of the Americans Frank Stella, Helen Frankenthaler, and Ellsworth Kelly.

The collection of graphic art at the Norton Simon Museum makes no attempt at comprehensiveness; rather, it concentrates on the works of a limited number of artists whose oeuvre is presented in considerable depth. The collections of prints by Rembrandt, Goya, and Picasso are among the finest in the country, and Fragonard's 139 drawings after earlier paintings and an album of landscape drawings by Claude Lorraine stand among the most important graphic works by these French artists.

Although the museum's collection of modern sculpture is extensive, works from earlier periods are few. Among them, the most important are Desiderio da Settignano's *Beauregard Madonna* (c. 1455?, marble) and Clodion's *Bacchante, Bacchus, and a Faun* (1795, terracotta). Among the works of the late nineteenth and early twentieth centuries are several pieces by Rodin, including a cast of his *Burghers of Calais* and a collection of Degas bronzes of unrivaled importance. (These works include a significant number of *modèles* on the basis of which all later casts were made.) The conservative current of figural sculpture in the early twentieth century is represented by a large number of bronzes by Maillol and by two late works of Renoir. In contrast to them are works by several of the great innovators of the period: *Four Backs* (c. 1909–29) by Matisse, *Head of a Woman* (1909) by Picasso, and bronzes by Henri Laurens and Jacques Lipchitz. The collection also contains several works by Henry Moore, including his *King and Queen* (1952–53), which is placed with Rodin's *Burghers* on the path to the museum's entrance. Varieties of abstraction are seen in three works by Brancusi and others by Jean Arp, Isamu Noguchi, Barbara Hepworth, and David Smith.

Although the Norton Simon Museum makes no pretense of being comprehensive in scope, its collection of European painting and sculpture since the Renaissance is complemented by a large and highly important collection of Indian and Southeast sculpture on loan from the foundations. The history of Indian sculpture is admirably illustrated, beginning with two railing pillars from Barhut (c. 100 B.C.), on one of which is represented a voluptuous Yakshi, a female fertility symbol. Indian sculptures of the following centuries include works of both Mathuran and Gandharan origin. Among the several Mathuran pieces, executed in soft red sandstone, are a well-preserved pillar with Buddhist scenes from the second century A.D. and a fine fragmentary relief with Apsaras flying about the tops of pipal trees. Three Gandharan works in grey schist are of exceptional quality: a standing Buddha (second century A.D.), a standing Bodhisattva (second-third century A.D.), and a small, seminude *Winged Atlas*

(second-third century A.D.), which like the other works points to the distant Hellenistic origins of this style. A small bronze standing Buddha (c. A.D. 550–600) from the Gupta period gives some indication of the heights achieved in what some consider the "classical" period of Indian art. Later epochs of Indian stone sculpture are well represented. Among the most notable works because of their exceptional quality are a Central Indian *Shiva and Parvati* of about A.D. 1000 and a Pala Dynasty *Manjushri* of the eleventh century A.D. In the large collection of Indian bronzes the earliest piece is a Kashmiri *Gautama Buddha Enthroned* (c. A.D. 700–725) with copper and silver overlay. Of the greatest importance is the large and finely cast image *Shiva Nataraja* (c. A.D. 950, Chola Dynasty), now on loan from the Union of India following resolution of its disputed ownership. Other Chola bronzes from the same period include most notably a *Standing Parvati* and a *Shiva Vrishvahana*; later bronzes include the well-cast *Vishnu* and *Krishna Playing a Flute* of the fourteenth century A.D.

Many pieces in the small collection of Cambodian sculpture are of the highest quality. The earliest of them is a limestone image *Harihara* (eighth century), the combined form of the Hindu gods Shiva and Vishnu. Three tenth-century pieces also are outstanding: a *Shiva* and a *Dvarapala* in the Koh Ker style and a *Vishnu* in the pre-Rup style. In a group of twelfth-century bronzes, the *Makara*, a mythical crocodile, is notable for its striking design.

The collection of Thai sculpture also is limited in scope but includes several works of considerable importance. The earliest of them is a *Vishnu* or *Surya* of the late sixth century in the Si Tep style. Other works in stone include a small torso of Bodhisattva (c. seventh century) and a graceful large standing Buddha (ninth century). This collection is rounded out by three bronze figures, of which the finest is an *Avalokiteshvara* of the eighth century, and by five gold repoussé plaques of the seventh century. Among Tibetan and Nepalese works are a number of gilt bronze images ranging in date from the tenth through the seventeenth century. The most outstanding of them are the large images of a standing Buddha (c. eleventh century), a standing Tara (c. fourteenth century), and a seated Lokeshvara (c. 1600).

The museum's limited research facilities are not at present open to the public. Its large and well-stocked bookstore is among the most important of its kind in the Los Angeles area.

Selected Bibliography

Museum publications: *The Blue Four: Galka E. Scheyer Collection*, 1976; *Selected Paintings at the Norton Simon Museum*, 1980.

Other publications: Princeton University Art Museum, *Selections from the Norton Simon, Inc. Museum of Art*, (1972); Röthlisberger, Marcel, *The Claude Lorrain Album in the Norton Simon, Inc. Museum of Art*, (Princeton, N.J. c. 1972); Coplans, John, "Pasadena's Collapse and the Simon Takeover, Diary of a Disaster," *Artforum*, 13 (February 1975), pp. 28–45; *The Connoisseur*, 193 (November 1976 issue devoted to the museum); Failing, Patricia, "The Norton Simon Museum: It's Really Impressive," *Art News*, 77

(February 1978), pp. 73–77; idem, "Is the Norton Simon Museum Mismanaged? Or Are the Former Trustees Misguided?," *Art News*, 79 (October 1980), pp. 136–42.

DONALD RABINER

------- Philadelphia -------

PHILADELPHIA MUSEUM OF ART (originally THE PENNSYLVANIA MUSEUM AND SCHOOL OF INDUSTRIAL ARTS; also PENNSYLVANIA MUSEUM OF ART), Benjamin Franklin Parkway and Fairmount Avenue at 26th Street, P.O. Box 7646, Philadelphia, Pennsylvania 19101.

The Philadelphia Museum's origins stem from the vastly popular celebration of the United States Centennial of 1876. For that occasion, the city of Philadelphia borrowed a collection of European paintings to be hung in Memorial Hall, a Centennial Exposition building. This exhibition met with great enthusiasm, and in February 1876 The Pennsylvania Museum and School of Industrial Art was chartered. In May 1877 Memorial Hall became the official residence of the city's new art collection.

The museum (known since 1937 as the Philadelphia Museum of Art) was founded as a private, charitable corporation existing under a Pennsylvania charter granted in 1876 and amended and changed in 1877, 1885, and 1929, when the name was shortened to Pennsylvania Museum of Art. Shortly after the museum was chartered, its collections began to grow as a result of munificent donations from the citizens of Philadelphia. The museum's day-to-day operations (up to 50 percent of its operating budget) are supported by funds from the city of Philadelphia. The allotment received from the city funds the security and maintenance of the building and grounds, which are the property of the city. The annual budget runs to about $4.4 million.

The museum is governed by a board of trustees that holds ultimate responsibility for the museum's operations, acquisitions, exhibitions, publications, and fund raising. The board, numbering sixty members, may also hire and fire the director. The museum contains the following departments: Twentieth Century Paintings; Painting Before 1900; Costumes and Textiles; Medieval and Renaissance Decorative Arts; Decorative Arts After 1700; American Art; Prints, Drawings and Photographs; Far Eastern Art; Indian Art; a library and conservation facilities; a gift shop; and the Wintersteen Student Center.

In 1919 overcrowding of Memorial Hall led to the development of plans to construct a new building in Fairmount Park on the site of the Fairmount Reservoir. The resulting museum by architects Horace Trunsbauer, C. C. Zantzinger, and C. L. Bone, Jr., is Graeco-Roman in style with polychrome pedimental decoration executed in glazed terracotta by C. Paul Jennewein. The building is constructed of Kasota and Mankato dolomite quarried in Minnesota. Other details executed in polychrome are the cornice, Ionic and Corinthian column capitals,

all portico ceilings, and the ceiling of the five-hundred-foot groined vault extending under the building. The Grecian tile roof covers more than four acres. The east entrance is particularly notable for the monumental staircase rising from the parkway. The interior of the main entrance continues the Grecian influence of the exterior. Although some galleries were opened in 1925, the building was not completed until 1928, when the first major segment of gallery space opened. In 1975 the museum was closed for ten months for a controversial and extensive $9 million renovation and improvement program, including addition of air-conditioning, rewiring, painting, and reinstallation of the collections. The museum reopened in February 1976, in time for a major exhibition in celebration of the Bicentennial of the American Revolution.

The museum was founded to provide the public an encyclopedic survey of the history of art in both Western and Eastern cultures. Since 1941, the museum has had an agreement with the University of Pennsylvania Museum by which it restricts itself to Western post-Christian art and to Oriental art after 500. In its ten acres of space, the museum houses five hundred thousand works of art from the beginnings of the Christian era to the present, from ancient China, India, Japan, and Latin America. The nearly two hundred galleries comprise two floors. The upper floor is arranged to display the decorative arts, painting, and sculpture against the frequent backdrop of period architectural reconstructions and furniture. The museum has about thirty such period rooms and architectural reconstructions. The first floor galleries are devoted to the display of specialized collections and house the administrative offices, the Division of Education's studios, the lecture hall, and the classrooms.

The richness of the museum's collections is a result of an extraordinary series of bequests dating from its earliest history. In 1893 Mrs. William F. Wilstach willed 150 paintings to the commissioners of Fairmount Park, in addition to a purchase fund to be known as the W. P. Wilstach Collection. In 1895 this fund was used to purchase additions to the seventeenth-century Spanish and Dutch collections, as well as a Whistler (*Arrangement in Black: Lady in Yellow Buskin* c. 1883) and Inness (*Short Cut, Watchung Station, N.J.*, 1883), to enrich even further the growing collection of American paintings. In 1921 important French Impressionist paintings were purchased with Wilstach funds from the Alexander J. Cassatt family. In 1924 the collections of William L. Elkins and his son George W. Elkins were donated to the museum. The former collection emphasized seventeenth-century Dutch works, eighteenth- and nineteenth-century English paintings, and works of the nineteenth-century French Salon. The son's collecting taste was more limited, ranging from eighteenth-century English portraiture to the fashionable English portraiture of the nineteenth century. The Elkins Collection of paintings (among which is Gainsborough's *Miss Elizabeth Linley*, later the wife of the playwright Richard Brinsley Sheridan) is hung throughout the English period rooms.

In 1928 the John H. McFadden Collection further enriched the museum's collection of English works. His bequest of forty-three paintings included works

by Turner (*Burning of the Houses of Parliament*), landscapes by Constable (including *Hampstead Heath: Storm Coming Up*), and portraits by George Romney (*Rev. John Wesley*), Lawrence, Gainsborough, and Reynolds. In 1929 and 1930 Mrs. Thomas Eakins and Mary Adeline Williams donated twenty-six paintings and sixteen sketches by Thomas Eakins. These works were added to an American collection earlier augmented by the gifts of Walter Lippincott and Alex J. Simpson. The John G. Johnson Collection of 1,279 paintings, formed and donated by the well-known nineteenth-century Philadelphia lawyer to the city of Philadelphia, constitutes a small museum within the museum. By specific terms of the donation, the collection, which covers the broad history of Western art from fourteenth-century Sienese and Florentine Primitives through the nineteenth century, remains intact and distinct from the other holdings of the museum. John D. McIlhenny, a business associate of William Elkins, bequeathed a distinguished collection of furniture, Oriental rugs, and paintings, in addition to an endowment of $200,000.

Beginning in 1949 the Philadelphia Museum made a series of brilliant acquisitions in the field of modern art. The Alfred Stieglitz bequest introduced major post–1913 American paintings into the collection, including works by Marsden Hartley (*Painting No. 4, Black Horse*, 1915) and numerous watercolors by John Marin. The collections of Louise and Walter Arensburg and Albert E. Gallatin were added in 1950 and 1951. With those two collections, the Philadelphia Museum became an undisputed center for the study of Proto-Cubist, Cubist, and abstract art of the 1920s. The Arensburg Collection of one thousand objects includes more than two hundred paintings and sculptures of the modern period, with thirty-eight works by Marcel Duchamp. Other artists amply represented in the collection are Georges Braque (*Still Life, Guitar*, 1913, and *Violin and Pipe, with the Word Polka*, 1920–21); Juan Gris (*Man in Cafe*, 1912); Paul Klee (*City of Towers*, 1916; *Fish Magic*, 1925; and *Village Carnival*, 1926); Wassily Kandinsky (*Improvisation, no. 29* and *The Swan, no. 160*, 1912); Pablo Picasso (fifteen works); Joan Miró (nine works); and Henri Rousseau, called le Douanier (four works, including *Merry Jesters*, 1906). Besides these twentieth-century masters, the Arensburgs had, since 1915, collected pre-Columbian artifacts and sculpture, including an Aztec Indian sculpture and pottery. As a stipulation of the gift, these works were not to be exhibited ethnographically but displayed as a complement to the European paintings and sculpture.

The Albert E. Gallatin Collection of 175 works came to the museum shortly after the Arensburg gift. Among them were additional paintings by Braque (10 examples, including *Still Life: Flute and Harmonica*, 1911), Juan Gris (12 works), Jean Arp (10 examples), and Picasso (23 works, including *Self Portrait*, 1906, and *Three Musicians*, 1921). In 1963 Mr. and Mrs. Carroll S. Tyson bequeathed 23 works from the Impressionist and Post-Impressionist periods, including 1 Monet (*The Japanese Foot Bridge and the Water Lily Pond, Giverny*, 1899), 2 Manets, 5 works each by Cézanne and Renoir, and 1 van Gogh (*Sunflowers*, 1888). In the same year the Louis E. Stern Collection added similar

paintings of the late nineteenth and early twentieth centuries to the museum's collections, as well as many other works reflecting the wide and varied interests of the collector. The 250 objects include Oriental and African sculpture, as well as monuments of modern art such as Cézanne's *Mme. Cézanne* (1885–87) and Henri Rousseau's *Carnival Evenings* (1886).

In 1968 a major gift of eight monumental pieces of sculpture was presented to the museum by R. Sturgis Ingersoll and Marion B. F. Ingersoll. These works, originally placed in the private sculpture garden of the Ingersolls, were: Henry Moore's *Reclining Figure*; Henri Matisse's *Seated Nude* and *Serpentine Woman*; Aristide Maillol's two bronze figures *Ile de France*, 1925, and *Pomona with Lowered Arms*, 1937; Jacques Lipchitz's *Prayer*; Gaston Lachaise's *Standing Woman*; and Picasso's *Man with a Lamb*.

The greatest strength of the Philadelphia Museum's collection lies in its comprehensive chronicling of western European fine and decorative arts. The presentation of the objects emphasizes the interrelationships of all of the arts within the time periods. The medieval collection, for example, incorporates a major group of armor from the Kretzschmar von Kienbusch Collection. (This grouping includes predominantly Gothic and Renaissance examples of arms and armor but also contains some pieces dating from the Bronze Age.) There are also numerous significant examples of Gothic and Romanesque sculpture and manuscripts; an eleventh-century cloister from Saint Genis-des-Fontaines in the Pyrenees and a Romanesque facade and portal from the Abbey of Saint Laurent. Other medieval reconstructions are fifteenth-century Gothic-style rooms from Florence, Le Mans, and the Palazzo Soranzo, Venice. There is an Early Gothic chapel from Pierrecourt, France, containing a silver reliquary from the Guelph Treasure.

The museum's European art collection contains significant and comprehensive representations of the Italian and French Renaissance. The John G. Johnson Collection contains examples of the work of Lorenzetti (*Virgin and Child Enthroned*), Sassetta, Carlo Crivelli, Veronese, Titian, Tintoretto, and Pontormo, in addition to lesser-known names. Early French paintings of the school of Picardy and many Flemish and Dutch paintings by artists such as van Eyck, Dieric Bouts (*Nativity* and *Moses before the Burning Bush*), Hieronymus Bosch, Pieter Bruegel, and Rubens trace the history of Northern European painting. Most notable is the great Rogier van der Weyden *Crucifixion with the Virgin and St. John*. Among Northern works from the Baroque period are Rubens' *Prometheus Bound* and Poussin's *Triumph of Neptune*.

There is also a representative sampling of Dutch genre, still-life, portraiture, and architectural paintings, with works of Rembrandt (*Man with Turban*, c. 1629), Steen (*Lady at the Harpsichord*), Teniers (*The Royal Feast*), Ter Borch, Ruisdael, and Saenredam. A large Spanish gallery contains three El Grecos and many examples of primitive Spanish painting. The German collection includes works by Cranach, Holbein, and Huber.

The museum is especially rich in subsidiary works of art from the Renaissance

and Baroque periods. There are rooms devoted to Italian sculpture and decorative art, including bronze statuettes from the Foulc Collection, majolica, chests, and tapestries, as well as architectural elements. Among the major sculptural pieces of the Italian Renaissance is the Luca della Robbia *Virgin in Adoration*. The French Renaissance hall contains other relics from the Foulc Collection, one of the most sizable and important groups of decorative arts in the country. It includes a major altarpiece from the Barnard Collection and numerous other sculptural and wood pieces of the period. There are, in addition, period rooms decorated in the manner of the German and Spanish Renaissance and seventeenth-century Holland.

The representation of English art and architecture begins with a Tudor room reconstruction of 1529. There are four rooms from the Georgian period hung with English paintings and furnished from the Elkins Collection and the J. H. McFadden Collection. The rooms display the architectural styles of Grinling Gibbons, Sir Christopher Wren, and Robert Adam. The furniture is that of the William and Mary, Queen Anne, and Rococo periods and contains examples by Thomas Chippendale and Robert Adam. Predictably, there are portraits and landscapes of the period by Romney, Gainsborough, Reynolds, Hogarth, and Morland adorning the walls.

Several rooms are devoted to the opulence of the reigns of Louis XIV, XV, and XVI. The exceptional furnishings and decorative objects in these rooms include a Savonnerie carpet woven for the Grand Galerie of the Louvre and a set of five tapestries, the *Story of Psyche*, woven at the Beauvais factory after designs by Boucher. The furniture includes signed pieces by Riesener, Carlin, and Jacob; among the decorative items are a set of Sèvres porcelain and *rose du Barry*.

Because of Philadelphia's pivotal role in the transition from colonial to federal government, the Philadelphia Museum's collection of American art is particularly notable. In addition to its holdings of paintings by Thomas Eakins, a native of Philadelphia, the museum presents a comprehensive view of the finest decorative arts of America, especially of eighteenth-century Philadelphia. The architectural reconstructions also include a room from the Ezekiel Hersey Darby House of Salem, Massachusetts, dated 1799. This room represents the collaboration of Charles Bullfinch, architect, and Samuel McIntire, ornamental wood-carver. The drawing room of the Powel House, Philadelphia, dates from 1768 and is furnished in Chippendale style. The furniture collection contains exemplary pieces of Philadelphia mahogany. The craft and folk traditions of Pennsylvania Dutch art are expressed in the Millbach Rooms: a bedroom and kitchen furnished with items from the Stokes Collection. The major portion of Pennsylvania Dutch and related arts and crafts comes from the Titus C. Geesey Collection and numerous smaller gifts of furniture, painted chests, cupboards, *fractur* drawings, primitive paintings, pottery, and utilitarian items.

Aside from the period rooms, the American collections include important eighteenth-century paintings by John Wollaston (*Mrs. Perry and Her Daughter*

Anna, c. 1758), Jeremiah Theus, Gilbert Stuart, Benjamin West (including the well-known portrait *Benjamin Franklin Drawing Electricity from the Sky*, c. 1805, and the major work *Elisha and the Shumanite's Son*, 1774), John Singleton Copley, and John Trumbull. The nineteenth century is thoroughly covered, with twenty-two Thomas Sully portraits ranging from 1808 to 1859; examples of Winslow Homer (*The Life Line*, 1884), George Inness, and William Harnett from mid-century; and six works of John Singer Sargent (in addition to the many Eakins and Cassatts) highlighting the turn-of-the-century collection. Many important lesser names who made significant contributions to landscape, genre, and portraiture are also represented. Philadelphia and Pennsylvania regional artists are especially well represented from the Quaker primitive painter Edward Hicks (noted for his *Peaceable Kingdom* of which the museum has two versions, one of 1826 and one of 1848, as well as his *Noah's Ark* of 1846) to Thomas Sully, Jacob Eichholtz, the Peale Family (the most renowned example being Charles Willson Peale's *Staircase Group*, 1795), and Mary Cassatt (*Alexander J. Cassatt and His Son Robert Kelso Cassatt*, 1884, and *Woman and Child Driving*, 1879, are notable among the several works by her in the collection).

In the decorative arts, the museum's collections also emphasize the contributions of Philadelphia artisans: special galleries and corridors are devoted to the display of Tucker china, the first porcelain commercially manufactured in America; to Philadelphia furniture in the Chippendale style; and to silver of both Continental and Philadelphia craftsmen. Prominence is given to the work of a native Philadelphian, William Rush, acknowledged to be the first American sculptor. Two of his most celebrated works are housed in the Rush Court: his wood carvings *The Schuykill Chained* and *The Schuykill Freed*.

The museum's holdings of paintings and sculpture trace the origins of the modern period in the nineteenth century and include examples of all of the prominent names of the French Impressionist, Post-Impressionist, and modern periods. Outstanding examples are Renoir's *The Bathers*, Cézanne's *Mont Ste.-Victoire*, van Gogh's *Sunflowers*, Picasso's *Three Musicians*, and Degas' *Ballet Class*. The Louise and Walter Arensburg Collection displays masterpieces by Picasso, Braque (*Violin and Pipe*), Juan Gris (*Man in the Cafe*, 1912), Léger, Matisse (*Mlle. Yvonne Landsburg*), Kandinsky, Klee, Mondrian, Dali (*Soft Construction with Boiled Beans*), and de'Chirico, with twenty works by Brancusi and thirty works by Marcel Duchamp, including three versions of *Nude Descending the Staircase*. The Arensburg Collection intermingles modern with pre-Columbian works and finished works with preliminary drawings. There is also a small but representative sampling of modern Mexican masters, including David Siqueiros (*The Giants*, 1939), Juan Soriano (*The Dead Girl*, 1938), Rufino Tamayo (*Man and Woman*, 1926, and *Mad Dog*, 1943), and Julio Castellanos (*Three Nudes*, 1930, and *Soldier and Girl*, c. 1936).

The Gallatin Collection of modern works includes a *Self Portrait* by Picasso, as well as *The Three Musicians*. Examples of Braque, Gris, Mondrian, and Miró are also included. Early-twentieth-century American painting includes works by

Georgia O'Keeffe (*Peach and Glass*, 1927), Marsden Hartley, and Arthur Dove. The Louis E. Stern Collection—overall a melange of styles and periods reflecting the collector's versatility of interests—contributes twenty-six works by Chagall and Rousseau's *Carnival Evening*, among others, to the museum's superlative presentation of modern art. Contemporary art is less well served, although the museum's collections include representative examples of Abstract Expressionism such as Hans Hofmann's *Lumen Naturale*, 1962, and the movements of the 1960s such as Pop artist Tom Wesselman's *Bedroom Painting No. 7*, 1967–69.

The museum's Department of Prints and Drawings contains fine and important examples of Northern and Southern Renaissance masters. The Pennsylvania Academy of Fine Arts transferred its graphic collection of about 75,000 prints from the fifteenth century to the present to the Philadelphia Museum in the 1970s. Among the special collections are the *ARS MEDICA* Center of medical prints created in 1968 and the Samuel S. White and Vera White Collection of Japanese prints, a collection of 145 prints by Jean Dubuffet, Picasso's *Suite Vollard*, and 12 woodcuts by Lyonel Feininger. In 1978 the museum received a bequest of 378 Old Master drawings and 204 prints (as well as assorted coins, medals, and sculpture) from Anthony M. Clark, a leading connoisseur of eighteenth-century Roman painting. Prints and drawings not on display from the museum's massive collections may be examined in the Print Study Room.

The Alfred Stieglitz Center of the Philadelphia Museum of Art was inaugurated in 1968. Dorothy Norman donated a collection of Stieglitz photographs and memorabilia to complement a group given by Stieglitz' wife, Georgia O'Keeffe, in 1949. Funds were also given to assist in supporting the center's program of exhibitions and acquisitions. In the period since its inception, the collection has grown to include six thousand photographs by virtually all of the major photographers of the nineteenth and twentieth centuries. The center received a considerable part of the estate of Sir Frederick H. Evans, the English photographer best known for his *A Sea of Steps (Wells Cathedral)* of 1903.

Costumes and textiles comprise another major division of the museum. Fashion galleries display examples from the eighteenth century via tableaux, once again mixing a cross-section of furnishings with costumes of the period. There is, in addition, a study collection for use by researchers.

The Philadelphia Museum of Art possesses an impressive collection of Asian art, which bespeaks a continuing interest in the arts of Asia in the city of Philadelphia from the time of the exhibition of Chinese "antiquities" at the Centennial International Exposition to the present. The Asian art collections are currently administered by two departments—the Far Eastern Art Department and the Indian Art Department.

The Far Eastern Art Department's holdings include about eight thousand objects from China, Japan, Korea, Southeast Asia, and the Near East. Nearly one thousand objects from the permanent collection are exhibited at any given time in galleries that are planned around seven so-called period rooms. These rooms are the legacy of Fiske Kimball, the dynamic third director of the museum from

1924 to 1954, who believed that art objects should be viewed within an aes-
thetically appropriate architectural context. He designed a plan for the Far Eastern
wing, incorporating these rooms, which he unveiled in the museum's *Bulletin*
in 1934.

The first curator of Oriental Art at the museum was Horace H. F. Jayne, who
joined the museum in 1921. He played a major role in helping Fiske Kimball
fulfill his vision for the Far Eastern galleries, for he traveled to China and Japan
with his assistant Isobel Ingram to purchase the *Shofukuji*, the Japanese temple;
the *Sunkaraku*, the Japanese teahouse; the Chinese temple interior based on the
Chih-hua Ssu; and the *Chao Kung Fu*, the Chinese ducal palace reception hall.
The period rooms of the Chinese galleries represent three important aspects of
Chinese culture: the Buddhist heritage, the courtly tradition, and the tradition
of the venerable gentleman-scholar.

The Chinese temple hall was given to the museum by Mr. and Mrs. Joseph
Wasserman in 1930. Most of the hall is actually a careful reconstruction of the
Chih-hua Ssu (Temple of Wisdom), which was one of the great Buddhist temples
erected in Beijing during the Ming period (A.D. 1368–1644), but the elaborate
wood ceiling is from the original building. With most of the original red lacquer
coating intact, the dramatic focal point of the ceiling is an octagonal cupola with
elaborately carved beams and panels. In the center of the cupola is a writhing
imperial dragon with its head carved entirely in-the-round. Unfortunately, the
overlay of gold leaf that once covered the ceiling is almost all lost.

The *Chih-hua Ssu* was part of a temple complex built in 1443–44 by the
infamous Wang Chen, a powerful eunuch who served under three Ming emperors.
The ceiling from the *Ju-lai* (Buddha Hall) of this same temple complex is now
in The Nelson-Atkins Museum of Art (q.v.) in Kansas City, Missouri.

The grand reception hall of an early seventeenth-century Peking palace was
presented to the museum in 1929 by Edward B. Robinette. According to tradition,
this hall, known as *Chao Kung Fu*, was part of a large palace compound built
by the chief eunuch of the last Ming emperor T'ien Ch'i (reigned 1621–27).
The heavy wood beams of the ceiling are exposed, as is characteristic of Chinese
architecture, and are decorated with conventional floral and animal motifs. Ex-
hibited in the hall are examples of imperial rock crystal from the Crozier Col-
lection and the popular Ch'ing cloisonné and brass dog cage. The fine intricate
workmanship of the sumptuous dog cage reflects an imperial provenance, which
is confirmed by the four-character mark of Emperor Ch'ien Lung (reigned 1736–
95) found under the central finial of the roof of the cage.

Another piece displayed in the hall from the collection of Ch'ien Lung, who
was an avid patron of the arts, is a superb rock crystal, which represents a legend
of the moon. According to a Taoist legend, the moon is inhabited by a white
hare, who pounds drugs that make the elixir of life. The crystal depicts a cloud-
flecked full moon supported by a base in the shape of the hard-working hare.
A poem about the moon by Hsieh Chuang (421–66) is inscribed on the surface
of the moon by Chao P'ing chang.

A very elegant period room is the late eighteenth-century Chinese scholar's study from Beijing. It was given in 1928 by Wright S. Ludington in memory of his father Charles H. Ludington, who was one of the most generous donors to the Oriental Art Department, as it was called then, during its early history, and was most notably responsible for the museum's acquisition of the outstanding George H. Crofts Collection of Chinese ceramics.

Representing work from prehistoric times through the Ch'ing Dynasty, the holdings in Chinese art are particularly strong, covering a wide range of objects from the fine arts of sculpture and painting to various types of decorative arts. The breadth of the collection is reflected in the six galleries devoted to Chinese art, which display examples of wood, marble, and stone sculpture; paintings; ceramics; jades; rock crystals; lacquer; cloisonné; snuff bottles; and furniture.

The Chinese collection has been the fortunate recipient of several key gifts. In 1928 the Osvald Siren Collection of early Chinese sculpture was acquired by the museum. The thirty pieces, the majority of which date from the fifth and sixth centuries, were collected by the noted scholar of Chinese art during his travels in China. A beautiful addition to this group of sculpture is a marble bust of a Bodhisattva of about 530 from Ting Chou, which was given by Mr. and Mrs. John S. Jenks.

The Philadelphia Museum of Art has a particularly outstanding collection of Chinese ceramics. The Chinese ceramics shown at the Centennial Exposition of 1876 were widely admired, and since then the museum's holdings have strongly benefited from the generous gifts of several donors.

More than two thousand ceramics were given during a period of fifteen years, from 1882 until 1897, by Mrs. Bloomfield Moore, who was probably counseled in her acquisitions by Edwin Atlee Barber, the museum's director from 1907 to 1916, an expert on ceramics who contributed to the study of Chinese porcelain.

While the eminent scholar of Asian art Langdon Warner was director, the museum acquired the outstanding George H. Crofts Collection of Han, T'ang, and Sung ceramics, which number more than eight hundred pieces, with funds contributed by Charles H. Ludington. George H. Crofts and his brother were fur traders in China during the 1920s and were able to acquire a group of T'ang tomb figurines shortly after they were discovered. One gallery is devoted to a display of these figures.

The museum was the recipient of the Crozier Collection of Chinese ceramics, rock crystal, textiles, and jade in 1944. This collection of more than a thousand objects includes many works that were once in the Imperial Palace collection.

The last great contribution to the Chinese ceramic holdings of the Far Eastern Department was the Alfred and Margaret Caspary memorial gift of 422 examples of Ch'ing Dynasty porcelain. The nucleus of this collection was the renowned Leonard Gow Collection, which was acquired by Alfred Caspary in 1938. The Chinese collection is also noted for its Ch'ing Dynasty costumes and its collection of Ming furniture, perhaps second only to the collection of the Nelson-Atkins Museum.

Also reflecting a wide range of work, the Japanese holdings of the Far Eastern Art Department include sculpture, painting, swords, textiles, ceramics, lacquer, cloisonné, and netsukes. There are three galleries set aside for the display of objects from the permanent collection.

One large room houses the *Shofukuji*, a temple dating from the mid-seventeenth century, and the *Sunkaraku*, a Japanese ceremonial teahouse. Placed in a setting of Japanese-style gardens with naturalistic lighting, these rooms are among the most popular of the museum.

The *Shofukuji* was originally located in the village of Katagiri in Nara prefecture, seven miles from the city of Nara, Japan's first capital city and the site of the pre-eminent Buddhist temple of Japan, the Horyuji, which was founded in 607 by Prince Shotoku. The history of the temple is fairly well documented in temple records, which date its founding in 1398. By the mid-seventeenth century, however, the temple's *hondo*, or main hall, which housed the principal image of the Yakushi Nyorai, had fallen into such a state of disrepair that extensive repairs were conducted under the supervision of the priest Ennin, who earned the name Chuko Shonin (Restoring Priest) for his labors. The building was dismantled in 1928, when it was replaced by a contemporary structure, and subsequently acquired by the museum.

A seated Amida Butsu of wood covered with black lacquer dating from the early seventeenth century is placed on the main altar. To the left is a standing lacquered and gilded Kamakura period image of Amida Butsu, and to the right is a lacquered and gilded standing Kannon Bosatsu.

Erected next to the *Shofukuji* is the ceremonial teahouse, the *Sunkaraku*, whose name may be translated as "The Enjoyment of the Slightest Leisure" or "Evanescent Joys." The *Sunkaraku* was shipped to the museum in 1928. Consisting of two structures, one housing the tearoom and pantry and the other the waiting room and toilet, the teahouse and garden were originally built in 1917 on the grounds of a private home in Tokyo.

Among the examples of Japanese sculpture at the Philadelphia Museum, perhaps the most important work is a wood sculpture of a standing Shinto deity dating from the eleventh-twelfth century. From this same period, the collection also possesses an exquisite example of calligraphy from a poetry anthology dated 1108–12.

The collection also possesses several fine examples of Japanese painting, including a fourteenth-century illustration of a scene from the biography of Konin Shonin mounted as a hanging scroll and a painting, the *Flowers of the Four Seasons*, by Sosen, who was active during the second quarter of the seventeenth century. A later example of Japanese painting is a beautiful screen painting, *Flowering Plum Trees in Mist*, by the famous eighteenth-century artist Ike no Taiga. The six-fold screen is in ink with a slight gold wash.

Of Japanese decorative arts, the collection features a sumptuous Edo period Nō robe with an embroidered and gold-stamped asymmetrical design of garden

boxes and autumnal flower arrangements. Of the more recent acquisitions of Japanese art, the most outstanding piece is a wood sculpture of a seated Monju from the Kamakura period of about 1325.

There is a small collection of Korean art, most of which consists of ceramic ware. Perhaps the most significant work is a wood sculpture of a standing Buddha. A Japanese inscription on the reverse dates this image in 1338. A particularly charming example of a Korean painting from the collection is a hanging scroll in watercolor and ink on silk, *Puppy Playing with a Pheasant Feather*, by the artist Yi Om (b. 1499).

One gallery is set aside for the exhibition of work from Southeast Asia. The centerpiece of the collection and the focal point of this gallery is the extremely rare exquisite Khmer stone sculpture, the standing *Avalokitesvara Bodhisattva*, dating from the late seventh century. This sculpture is one of the largest and finest surviving examples of Khmer sculpture from the pre-Angkor period. The head and body were discovered separately but were reunited when the Phila-delphia Museum acquired both in 1965. Unfortunately, the arms, feet, and base of the figure are missing, but the delicate, serene beauty of the *Avalokitesvara* does not seem diminished by its incomplete condition. The Southeast Asian collection also includes ceramics and gold jewelry.

The Near Eastern galleries consist of two period rooms, one of Sassanian stuccos and the other of Persian tiles. Sponsored jointly by the Philadelphia Museum of Art and the University of Pennsylvania Museum, a 1931 expedition to Damghan in Iran under the directorship of Erich Schmidt uncovered a Sas-sanian palace complex. The stucco portal to a hypostyle hall from this site, which led into what was probably a great reception room, has been installed in the Near Eastern galleries. Dating from the third to fifth century, the fragmented portal with restored elements is reproduced in a reconstruction of the original appearance. Characteristic features of Sassanian stucco architectural decora-tion—leaf-floral squares, female heads in high relief, and boars' heads in circles of dots—are depicted in the plaques of the portal.

The second Near Eastern period room is the so-called *Safavid Court*, which features mosaic panels in the brilliant turquoise and intricate, kaleidoscopic patterns characteristic of the ornamental tradition of fifteenth-century Iran. These panels are said to be from a mosque in Isfahan.

The museum also has an important collection of Turkish and Persian rugs, which are displayed in three galleries. Among the treasures of the rug collection is the late-seventeenth-century ''Dragon'' carpet attributed to the famed work-shops that produced carpets for the Shah Abbas (1587–1628). This type of carpet takes its name from the stylized dragon patterns that are used in the bold patterns of the overall design, and this example is considered one of the most outstanding in American or European collections.

The rug collection has also benefitted from two generous bequests. The McIlhenny gift presented the museum with a selection of sixteenth-century car-

pets, and the Joseph Lees Williams Memorial Collection consists of a group of more than forty rugs from Persia, India, Asia Minor, the Caucasus, Egypt, and Spain.

One of the major collections of Indian art in the United States, the Indian Art Department has holdings of 225 pieces of sculpture, 160 separate miniatures, 4 complete manuscripts, 320 costumes and textiles, 45 pieces of jewelry, and about 100 miscellaneous objects, which include folk toys, ritual objects, armor, swords, and amulets. Art from Tibet and Nepal are also under the auspices of the Indian Art Department, with about 70 pieces of sculpture and 65 paintings.

The dramatic centerpiece of the exhibition area for Indian art is the *mandapam*, or pillared hall, from a seventeenth-century temple complex in Madurai. Darkly lit, evoking the dim interiors of Indian temples, the hall was given to the museum in 1919 by Susan Pepper Gibson, Mary Gibson Henry, and Henry C. Gibson in memory of their sister Adeline Pepper Gibson, who had acquired the constituent members of the columns that comprise the hall from the Madana Gopala Swami Temple in 1912.

The installation of the temple was celebrated with an impressive musical pageant called "The Building of the Temple" with original music and words written by Langdon Warner. Langdon Warner described the event in the museum's annual report for 1928 as being of "such distinction that we have reason to believe it will not soon be forgotten by the few who were able to see it." He considered the temple one of the museum's most significant gifts, representing a strong impetus for the museum to strengthen its holdings in Indian art.

Architectural elements from two, possibly three, temples of the mid-sixteenth century were incorporated into this hall. The elaborately carved ten central pillars depict Vaishnava imagery—representations of the god Vishnu in his various incarnations and scenes from the *Mahabharata* and *Ramayana*. The museum has recently acquired a bronze eleventh-century Chola sculpture of Rama, which is dramatically installed in the temple hall.

An examination of the Indian art collection, particularly the sculpture holdings, shows that Langdon Warner's hope that the Indian *mandapam* would inspire the development of a strong collection of Indian art was fulfilled. Perhaps the generous gift in 1931 of twenty-eight pieces of sculpture, dating from the first through the fifteenth century, from one of the foremost private collectors of Indian art, Nasli M. Heeramaneck, was in response to his plea.

Examples of the department's large sculpture collection range from the first century B.C. through the nineteenth century A.D., with most of the material being from the seventh through the thirteenth century from the great temple regions of Bhuvaneshwar in Orissa, Khajuraho in Madhya Pradesh, Rajasthan, and Madurai in South India.

Many of the major schools and periods of Indian sculpture are represented in the collection by fine examples. An early stone relief of a worshipper from the first-second century B.C. is an Orissan expression of the style of early Indian sculpture epitomized by the reliefs of the railings of the Bharhut stupa. One of

the department's most outstanding pieces of Kusana sculpture is a red sandstone Ekamukhalinga from Mathura dating from the first-second century A.D.

Examples of sculpture from the classical age of Indian art and culture, the Gupta period, are a stone Varahi of about 550–600 and the torso of a standing Buddha from Sarnath dating from about 475. This late-fifth-century phase of sculpture at Sarnath is generally considered to be the epitome of the classic Gupta style.

The department acquired a superb South Indian granite sculpture of a Tirthankara Mahavira in a meditative posture of about 1000 from the National Museum of India in a novel exchange for four pieces of Gothic sculpture from its European collections. Another South Indian piece of a slightly later period, a sensitively rendered stone sculpture of Siva's steed, Nandi the bull, exemplifies the almost whimsical extravagance of the Hoysala style of the twelfth century.

The collection of paintings also presents a fairly representative selection of different schools and periods, with work from pre-Mughal, Mughal, Rajasthani, Pahari, and Deccani ateliers. One gallery is set aside for the exhibition of paintings. Among the most outstanding paintings on display is an illustration from one of the most celebrated Mughal manuscripts, the *Hamza-nama* of about 1562–77, prepared in the imperial workshops for the young emperor Akbar.

Also exhibited is one of the four complete manuscripts of the collection, the *Nusrati Gulshan-i isq* (*The Garden of Love*), from Hyderabad in the Deccan, dating from 1742. The illustrations of this work feature the bold luminous palette and exuberant foliage characteristic of Deccani painting. The highlight of the large collection of Indian textiles is the Gujarati embroidery of about 1500–1550, depicting a noble couple with guardians and dancers.

The nucleus of the museum's holdings in Nepalese and Tibetan art is the collection of Natacha Rambova, which was given to the museum during the 1950s and 1960s. She also donated an extensive library of Himalayan source materials in conjunction with her collection. Unfortunately, the gallery displaying Nepalese and Tibetan art has been closed for public viewing and may be seen only by prior appointment.

The most important work of the Himalayan portion of the Indian Art Department is the eighteenth-century Tibetan painting *The Banquet of the Dharmapalas*. An unusually large size, this painting is remarkable for its intricate composition, featuring numerous figures.

The Philadelphia Museum administers several subsidiary museums and historic houses. The Rodin Museum located on Benjamin Franklin Parkway houses the gift by Jules E. Mastbaum of Rodin sculpture and drawings. The following colonial houses in Fairmount Park are maintained by the museum: 1761, Mount Pleasant; 1721, Cedar Grove; 1785, Solitude; and 1760, Hatfield. There is, as well, the Thomas Eakins House at 1729 Mt. Vernon Street. The Samuel S. Fleisher Art Memorial founded in 1898 provides free instruction in the visual arts. Its faculty is drawn from the Philadelphia artist-teaching community. The memorial contains gallery space where works from the permanent collection and

group and one-man shows are displayed. Works by students are also included in an Annual Student Exhibition. The sanctuary of the memorial displays ikons, primitive religious works, and medieval sculpture and incorporates a Portuguese chapel.

The museum's art reference library of ninety thousand volumes is available for use on the premises and through interlibrary loan; photographs of museum objects are available for sale at the museum's shop or from the Photographic Department. The Division of Education Office offers art classes for adults and children, film rental or purchase, and an active program of lectures, gallery tours, concerts, and art festivals. The museum publishes the *Bulletin*, monthly newsletter, yearly calendar, and exhibition catalogues, as well as monographs on its permanent collection, some of which are listed below.

Selected Bibliography

Museum publications: *Handbook of the Philadelphia Museum of Art: A Guide to the Museum and Its Collections*, n.d.; *The Louise and Walter Arensburg Collection: 20th-Century Section*, 1954; idem, *Pre-Columbian Sculpture*, 1954; *A. E. Gallatin Collection*, 1954; *The Louis E. Stern Collection*, 1964; Brown, W. Norman, *A Pillared Hall from a Temple at Madura, India, in the Philadelphia Museum of Art*, 1940; Gardiner, Henry, *Checklist of Paintings in the Philadelphia Museum of Art*, 1965; idem, *The Samuel S. White, 3rd and Vera White Collection*, 1968; d'Harnoncourt, Anne and Walter Hopps, *Etant Donnes: 1 La Chute d'Eau, 2 Le Gaz d'Eclairage*, 1969; Hiesinger, Ulrich W., and Ann Percy, ed., *A Scholar Collects: Sections from the Anthony Morris Clark Bequest*, 1980; Jacobowitz, Ellen S., and George H. Marcus, *American Graphics, 1860 to 1940*; Kramrisch, Stella, *Art of Nepal and Tibet*, 1960; idem, *Manifestations of Shiva*, 1981; idem, *Unknown India: Ritual Art in Tribe and Village*, 1968; Lee, Jean Gordon, and Horace Jayne, *Handbook of the Far Eastern Wing*, 1958; Miller, Barbara, ed., *Exploring India's Sacred Art: Selected Writings of Stella Kramrisch*; Siegl, Theodor, *The Thomas Eakins Collection*, 1982; Sweeney, Barbara, after Bernard Berenson, *John G. Johnson Collection: Catalogue of Italian Paintings*, rev. ed., 1966; Tancock, John L., *Rodin Museum Handbook*, 1969.

Other publications: Kramrisch, Stella, "South India Sculpture," *Apollo* (July 1974), pp. 12–17; Lee, Jean Gordon, "The Tate for Chinese Ceramics," *Apollo* (July 1974), pp. 62–66.

MARTHA SHIPMAN ANDREWS AND MARSHA TAJIMA

—— Ponce, Puerto Rico ——

PONCE ART MUSEUM (officially MUSEO DE ARTE DE PONCE, FUNDACIÓN LUIS A. FERRÉ; alternately PONCE MUSEUM, THE LUIS A. FERRÉ FOUNDATION; also MUSEO DE PONCE), Avenida de las Américas, P.O. Box 1492, Ponce 00733–1492.

The present Ponce Museum in Puerto Rico has been in existence for some twenty years, having opened its doors for the first time on December 28, 1965. Founded by the noted industrialist and former governor of the island, the Honorable Luis A. Ferré, it is the only major museum in Puerto Rico and undoubtedly the finest in the Caribbean area. Attendance is presently more than one hundred thousand visitors a year.

Originally funded by a substantial gift of shares in one of the founder's industrial enterprises, the museum currently meets its operating and other expenses primarily through entrance and other fees, private donations, and an annual grant from the Puerto Rican legislature. Its governing body consists of a board of trustees of seven members whose terms of office have no set limits. The museum is administered by a director with the help of an assistant, a personnel officer, and a professional conservator.

The building, inspired by the traditional form of the classical temple, was designed by the late Edward Durell Stone. Of symmetrical plan, a feature unusual in contemporary architecture, the museum is noted for the clarity of its lines and the elegance of its proportions; at the same time, it is relatively free of the stylistic mannerisms usually associated with much of Stone's work. In 1967 it was granted an Honor Award by the American Association of Architects.

The building has two stories with an ample balcony running around the upper floor. On this level the exhibition rooms take the form of seven interlinked hexagons. Although the works of art here are illuminated partly by side lighting entering through openings in the angles of the hexagons, the light mainly comes from above through seven glass cupolas situated in the roof. The central hexagon houses the staircase, which is opposite the main entrance and is in the form of a double curve. Two of the intermediate hexagons incorporate open wells that permit the daylight to filter down to the rectangular exhibition rooms located on the ground floor. At the extremities of the building on the lower level are the library facing east and the temporary exhibitions rooms facing west. Both have the advantage of natural lighting, which enters through massive wrought-iron grilles of impressive design. The museum structure is complemented by three gardens.

The permanent collection consists mainly, but not exclusively, of paintings and sculpture of the European and American schools purchased by the founder. At present the museum possesses more than one thousand items, of which about one-third are on display. The arrangement is not by schools as is generally the case. Instead, the following arrangement has been adopted. The entrance hall is devoted mainly to portraits, a feature that emphasizes the human scale of the building. Upstairs the central hexagon and those toward the west are dedicated to religious works. The three remaining hexagons contain works that have non-religious themes, such as history, mythology, landscape, genre, and still life. The lateral gallery and rooms immediately to the right of the ground-floor entrance are occupied by European and American works of the nineteenth and twentieth

centuries, and on the left, towards the west, are examples of Latin American art, including those of the Puerto Rican school . Works are rotated with some frequency to maintain an element of variety on the walls.

Although the Ponce Museum has always aspired, within its limited means, to achieve as balanced a collection as possible, inevitably it has specialized in certain fields. In 1962 the museum received from the Samuel H. Kress Foundation fifteen works of art enabling it to exhibit a small but choice collection of Italian Primitives. Particularly fine are the *Virgin and Child* by the Sienese master Luca di Tommè, the *Anunciation* by Jacopo di Cione, and the *Virgin and Child with an Angel* by Biagio di Antonio Tucci. On the opposite walls, across the well of the staircase, as if to complement these works from Italy, is a notable group of paintings from the Northern schools. Of outstanding interest among them are two panels by Lucas Cranach the Elder. They are *Christ as the Man of Sorrows* and *Judith with the Head of Holofernes*. Both display the artist's winged dragon signature.

Although the collection contains works by notable sixteenth-century masters such as Granacci, Sebastiano del Piombo, Bronzino, and Jacopo and Leandro Bassano, it is the Italian painters of the seventeenth century that constitute its main strength. Outstanding among the fifty or more canvases of the Italian schools of this period are the sketch *The Four Doctors of the Western Church* by Gaulli for one of the four pendentives of Il Gesù in Rome and the superb *The Torture of Ixion* by Langetti, in which the influence of Rubens is clearly evident. Other artists in this part of the collection are Guido Reni, Guercino, Sassoferrato, Carlo Dolci, Caracciolo, and Strozzi. There is a superb early Furini, *Cephalus and Aurora*, and various canvases by Luca Giordano. Of the latter, the most outstanding are *St. Luke Painting the Virgin*, an early work in which the Evangelist is a self-portrait of the artist, and *The Death of Seneca*, notable for its borrowings from Raphael.

Holdings of French paintings of this century include works by Philippe de Champaigne, Gaspard Dughet, Trophime Bigot, Claude Vignon, and Monsù Desiderio. Perhaps the most interesting French example of this period is Charles Le Brun's *Venus and Minerva Clipping Cupid's Wings*, one of the few canvases by the artist in American collections. Painted for Nicholas Fouquet, Louis XIV's one-time finance minister, it used to hang in Fouquet's mansion, Vaux-le-Vicomte. The figure of Venus is a portrait of his wife.

The art of the Low Countries during this period is particularly well represented. The masterpiece of the Flemish section is undoubtedly *The Greek Magus* by Rubens, an autograph work, being one of the *Three Wise Men* set painted for his friend Balthasar Moretus. Other notable examples are van Dyck's *St. Rosalie of Palermo* and David Teniers' *The Temptation of St. Anthony*. Prominent among the numerous Dutch painters in the collection are Cornelius van Haarlem, Jan Both, Jacob van Ruisdael, van der Helst, Ferdinand Bol, van Ostade, and Nicholas Maes. Although the Spanish holdings are not as numerous as those of other countries, they include notable works by José de Ribera, Juan Bautista del

Mazo, Pereda, Claudio Coello, and Murillo, whose *Immaculate Conception* graces the westernmost hexagon.

Notable among the works of the eighteenth century are a large fantastic landscape by Magnasco; the impressive *Aeneas Fleeing Troy* by Sebastiano Ricci; an anonymous canvas *The Origin of Painting*, attributed to Natoire but actually painted later; and the masterpiece *Antiochus and Stratonice* by Pompeo Batoni, in which his preoccupation with a return to classicism is fully evident. These works are supplemented by a fine group of portraits by Largillierre, Nattier, Vigée-Lebrun, Reynolds, Gainsborough, Romney, Gilbert Stuart, and others, most of which are exhibited in the entrance vestibule.

The Ponce Museum possesses a number of nineteenth-century works by artists of diverse tendencies such as Claude Vernet, Prud'hon, Girodet-Trioson, Benjamin West, Lawrence, Raeburn, and Constable. One of the masterpieces of the collection is Delacroix's sketch for *The Two Foscari*, donated by the former Banco de Crédito y Ahorro Ponceño.

The museum also has become notable throughout the years for its foresight in acquiring examples of the Pre-Raphaelite, Academic, and Symbolist schools. Consequently, Gustave Moreau's *Salome* is one of the few paintings by this artist in the Western Hemisphere. The Pre-Raphaelites with their own particular brand of nostalgic Romanticism are present in strength: Rossetti, Holman Hunt, Millais, and even Ford Madox Brown, although Brown was never a formal member of the Brotherhood. The museum possesses Burne Jones' largest canvas and one of his undoubted masterpieces, *The Sleep of King Arthur in Avalon*. More than twenty feet long, it was intended originally for the library of the earl of Carlisle but was never finished. Today it fills one entire wall of the Ponce Museum library. The alternative classicizing tendency is represented by Lord Leighton's exuberantly colored *Flaming Jane*, which, since its inclusion in the exhibition of English Victorian painting at The Minneapolis Institute of Arts and The Brooklyn Museum some years ago, has become one of the most popular paintings in the entire collection.

With regard to French academic and realist art, it is interesting to note that the painters of these tendencies, once overlionized but then subjected to every kind of uncritical vilification, have now come back into their own. An outstanding example of this group in Ponce, which includes works by Bouguereau, Gérôme, Bonvin, Doré, Breton, and Tissot, is Firmin Girard's *La Toilette Japonnaise* of 1873. Not only is it of exquisite quality, but it also demonstrates that the influence of the Far East, particularly Japan, was no less present in these masters than in those of so-called progressive tendencies.

Artists from the United States include Church, Peto, Ulrich, Chase, and Inness. Noteworthy among these works is a large Impressionist canvas by Edward Vonnoh, dated 1892, *The Engagement Ring*. As was to be expected, emphasis has been placed on the art of Spanish-speaking America, specifically on that of Puerto Rico. In this section are to be seen works by the mestizo painter José Campeche, notably his *Lady on Horseback*, identified as a portrait of Isabel

O'Daley, and Francisco Oller, the Puerto Rican friend of Cézanne, Pissarro, and avant-garde French artists of the time, who introduced into the Western Hemisphere the new pictorial trends of the School of Paris. As for the art of the rest of Latin America, although the Ponce Museum possesses a number of paintings of the colonial period, its strengths are in the production of the contemporary schools. They are represented by figures of such caliber as the Mexicans Rufino Tamayo, Carlos Mérida, and Rafael Coronel; the Argentinian Fernández Muro; and the Colombians Alejandro Obregón and Omar Rayo.

Although not as numerous as its holdings of paintings, a notable selection of works of sculpture, executed in diverse materials, is at the Ponce Museum. These works range from a limestone pharaonic head and a Lysippian torso in Parian marble to works by Rodin and Epstein. Of particular note are a terracotta portrait of a lady of the school of Verrocchio; a spirited bronze bust, heightened with touches of gilding, representing Marechal Turenne, the most famous of Louis XIV's generals; two examples of Spanish polychrome sculpture by Pedro de Mena; and a fine marble group, *Venus and Cupid*, by Carrier Belleuse. By his pupil Rodin, the museum has a large bronze, *Apollo Conquering the Serpent Python*, the crowning motif of the sculptor's monument to President Sarmiento of Argentina in Buenos Aires.

The holdings of the Ponce Museum are by no means confined to painting, sculpture, and the ancillary crafts of the western schools. It has also been the fortunate recipient of a number of striking donations by friends and benefactors of the art of other regions and periods, thus enabling it to broaden its scope and acquire a new dimension. There is, for instance, a small but choice selection of stone artifacts of the Taino Indians, donated by the late Vincente Casals. Notable is the collection of more than one hundred objects of ancient Peruvian origin, including stoneware, metalwork, ceramics, and textiles, given in 1978 by Mr. and Mrs. Lawrence Duff. In the following year Timothy S. Reed donated to the museum a fine collection of masks and artifacts of African, mainly Yoruba, origin. This gift is of particular significance for Puerto Rico because of the island's ethnic ties.

A small but exquisite collection of Oriental porcelain, chiefly Chinese, was donated to the museum in 1980 by Mr. and Mrs. Fred Rosseland in memory of Mrs. Rosseland's father, the late Edwin O. Raabe. It includes a number of T'ang, K'ang Hsi, Ch'ien Lung, and Ming pieces, as well as some Hirado, Awata, and Satsuma wares from Japan.

No Puerto Rican museum, devoted to the plastic arts, would be complete without its collection of *santos*, small religious effigies carved out of local woods by untutored native craftsmen and painted in a few bold colors. They can represent subjects as ambitious as the life of Christ but, more often, consist of single images of popular saints or small groups such as the three Magi. The Ponce collection of santos, some carved by famous *santeros*, is relatively small (seventy-eight pieces) but makes up in quality what it lacks in quantity. The collection was donated by the late Richard Nicholson in memory of Cedric T. Severn, who first formed the collection and after whom it is named.

Very different is the group of sophisticated French cameo glass of the nineteenth and early twentieth centuries. Mostly by Gallé, Christian, Daum, and others, this collection is due to the generosity of David and Gloria Kaplan.

The Ponce Museum does not confine itself to exhibiting only its permanent collections. One of the principal rooms is dedicated to holding temporary exhibitions. They have included painting, sculpture, architectural drawings and models, graphics, ceramics, children's art, tapestries, and photography, the last always very popular.

A contributing, fee-paying body, known as the Friends of the Ponce Art Museum, sponsors lectures, discussions, recitals, concerts, theatrical performances, mime, and ballet. In addition, the museum is now in the process of creating an art school on its premises. Initially, it will be confined to graphics but later will include other forms of artistic activity.

Two important ancillary services of the Ponce Museum are the library and the conservation laboratory. The latter, the only serious center of its kind in the Caribbean, includes facilities for examining and treating paintings, stone, metal, and woodwork. Although this center is mainly devoted to the conservation of the holdings of the Ponce Museum, it is open to all who want to avail themselves of its facilities. The library, which is noncirculating, is devoted exclusively to the fine arts and is also the only one of its kind in Puerto Rico. It contains source books, basic texts, and works of serious scholarship. It is, however, still in its infancy and has little more than three thousand volumes to date. They are supplemented by a good collection of color slides, mainly of painting, sculpture, architecture, graphics, and the decorative arts.

Selected Bibliography

Museum publications: Held, Julius S., *The Samuel H. Kress Collection of Italian and Spanish Painting*, 1962; idem, *Museo de Arte de Ponce (Fundación Luis A. Ferré). Catalogue 1. Paintings of the European and American Schools*, 1965 (revised edition in press); Taylor, René, *El Museo de Arte de Ponce*, 1972 (revised edition in press); idem, *Museo de Arte de Ponce, Pintura Puertorriqueña*, text with English translation, 1977.

Other publications: Chanis, E. Pérez, "El Museo de Arte de Ponce," *Urbe*, no. 15 (1965–66), unpaged Supplement; Taylor, René, "The Ponce Art Museum," *Antiques* (November 1966), pp. 681–85; Wittkower, Rudolf and Margot Wittkower, "Puerto Rico's Museum," *Apollo* (March 1967), pp. 182–91; Dávila, Arturo, *José Campeche, 1751–1809*, nos. 2, 17, 23, 47 (San Juan 1971); Nissman, Joan, and Howard Hibbard, *Florentine Baroque Art from American Collections*, nos. 10, 27, 37, 57 (New York 1969).

<div align="right">RENÉ TAYLOR</div>

St. Louis

ST. LOUIS ART MUSEUM, THE, Forest Park, St. Louis, Missouri 63110. The St. Louis Art Museum (originally the St. Louis City Art Museum) was

established in 1909 as one of the first municipally tax-supported cultural institutions in America. This came about largely through the personal efforts of Halsey Cooley Ives, an administrator of the arts program at Washington University, who campaigned for many years for the creation of a public art museum. Today the museum is supported by a city and county tax district created by the Missouri State Legislature in 1971. The limited acquisition monies provided by the city and county are augmented by the fund-raising efforts of the Friends of the St. Louis Art Museum (1952) and its subsidiary organizations: The Decorative Arts Society (1967), The Contemporary Art Society (1968), The Primitive Art Society (1976), and The Print and Drawing Society (1977).

The museum's governing body, the Board of Commissioners (1971), is a self-perpetuating board consisting of five members from the city and five from the county who may serve two consecutive four-year terms and then must resign for one year to become eligible for re-election. A director administers the museum, and the collections are presently under the supervision of curators in nineteenth- and twentieth-century art; the decorative arts; the arts of Africa, Oceania, and the Americas; prints, drawings, and photographs; and Oriental art.

The museum building is a legacy of the 1904 St. Louis World's Fair. It was designed as the core of the fair's fine arts pavilion complex and was presented to the city in 1906 by the Louisiana Purchase Exposition Co. The architect was Cass Gilbert, a leading exponent of the Beaux-Arts style in America. The museum is distinguished by a great central hall modeled after the tepidarium in the Thermae of Caracalla, and the exterior is ornamented with sculpture by many leading artists of the period, including Louis Saint Gaudens and Daniel Chester French.

During 1975–78 the architectural firm of Hardy, Holzman and Pfeiffer renovated the Cass Gilbert building. They chose to emphasize the clarity of the original floor plan and the monumental interior proportions while installing sophisticated security, lighting, and climate-control systems.

Founded for the purpose of public education, the museum has followed the policy of acquiring quality representative works from as many periods and cultures as possible. The composition of the museum's collections owes much to wise purchases made early in the museum's history and to the generous gifts of private collectors in St. Louis.

The W. K. Bixby Oriental Art Trust Fund, established in 1919, provided the basis for the Chinese, Japanese, Indian, and Islamic collections, which are small but contain individual pieces or groups of objects of outstanding character. Of them, the Chinese collection is the most comprehensive. One of the first purchases made with the Bixby funds was the fine Sung Dynasty scroll painting *Fish Swimming amid Falling Flowers*, attributed to the painter Liu Ts'ai (1068–85) and formerly in the imperial collection. However, the major strength of the Chinese collection resides in ceramics, particularly those from the T'ang and Sung dynasties. The latter is distinguished by examples of Tz'u Chou ware of the highest quality. The Chinese collection also includes bronze vessels from

the Shang and Chou dynasties, funerary artifacts from the Han Dynasty, and some examples of Buddhist sculpture.

The still fledgling Japanese collection, begun in the late 1950s, is also most remarkable for its ceramics. It contains examples of Ko-Imari ware from the first half of the seventeenth century and some fine late-seventeenth-century–early-eighteenth-century porcelains. The Indian and Islamic collections include examples of sculpture, distinguished by a small group of bronzes from the Chola period (South India, tenth-eleventh century), Mughal miniature paintings, and a sample of decorative artifacts from seventh–eighteenth-century Iran and Iraq. The outstanding strength in this area is a group of 129 Near Eastern carpets received from the James F. Ballard Collection in 1929, a gift enhanced by the subsequent donation of 45 carpets from Nellie Ballard White in 1972.

A special asset of the museum is the extensive collection of textiles and fabricwork dispersed throughout the various departments. The holdings in this medium include Coptic fabrics, Renaissance liturgical vestments and cloths, early-sixteenth-century Flemish tapestries, a collection of European and American religious embroideries, seventeenth–nineteenth-century laces, American quilts, Peruvian textiles, Chinese silks, and a nineteenth-century Polynesian feather cloak. Of additional interest is the Cook Collection of 125 Greek Island and Middle Eastern embroideries.

The Decorative Arts Department, whose collections were initiated in the 1930s, has holdings ranging from the medieval period to the present in the general categories of furniture, ceramics, glass, textiles, and metalwork. Aside from the textiles, the greatest breadth may be found in eighteenth-century ceramics, American and English furniture, and nineteenth-century glass. Eighteenth- and nineteenth-century silverwork in England and France is represented with some fine pieces, as is American silver.

The ceramics section includes examples of sixteenth-century Italian majolica ware; fine Meissen pieces such as a part tea and coffee service (1733) embellished with the arms of the ninth duke of Norfolk and a figure of Augustus III (1744) by Johann Joachim Kändler; some representative pieces of English Staffordshire, Wedgwood, and Worcester production; and some examples of eighteenth-century French porcelains.

The holdings in European furniture date from the seventeenth through the twentieth century. Especially worthy of mention is the mahogany and marble corner cabinet (1785) by Jean Henri Riesener. The American pieces date from the colonial period to the twentieth century. Two important objects acquired in recent years are a sofa table (c. 1830) by Anthony Quervelle and a Renaissance revival library table (c. 1850) by Alexander Roux. Outstanding and unique objects in the category of glass include a rock-crystal, silver-gilt, and lacquered wood casket (1600) from Venice and a pair of leaded-glass hollyhock and peony windows (1885) designed by John LaFarge.

The cultures of the ancient world are represented by collections of artifacts and sculpture from Egypt, Mesopotamia, Greece, and Italy. Many of the pur-

chases for this section were made in the 1920s and 1930s and include some individual objects of distinction. From Egypt there is a Dynasty XVIII limestone fragment of a tomb relief showing the head of an African prisoner (c. 1370 B.C.).

Outstanding pieces from Mesopotamia include a copper, shell, and lapis lazuli head of a bull (c. 2800–2600 B.C.) from Sumer, an alabaster relief of a genius (Assyrian, 885–859 B.C.) from the Northwest Palace of Nimrud, and a fragment of a limestone relief from Persepolis representing a man with a kid (Achaemenid period, 359–338 B.C.).

The Greek section is distinguished by its ceramics beginning with earthenware figurines (1300–1200 B.C.) from Mycenae and including ten fine vessels dating from the early sixth century B.C. to the late fifth century B.C. The latter group represents the Corinthian Orientalizing style and the Attic black- and red-figure styles.

The Roman collection includes examples of ornamental Etruscan bronze work and Hellenistic to early Empire sculpture, notably a marble portrait bust of the priest Yedi Bel (139–140) from Syria. Coptic vessels, fabrics, and ornaments represent the late Roman Empire period.

The small medieval collection was also begun in the late 1920s and 1930s. From the Gothic period there are textile fragments, enamel work, metalwork, stained glass, manuscript illumination, ivory reliefs, and sculpture in the International Style. Of particular interest is a lancet window of the Crucifixion from Montreuil-sur-Loire (1200) and a bust-torso fragment of a Burgundian sculpture of St. Christopher (1450).

The collection of Western paintings was inaugurated with two works of French Impressionists, a small number of nineteenth-century American paintings, and some seventeenth-century Dutch paintings in the first decade of the museum's history. Today the American section, the French nineteenth century, and the School of Paris comprise the major strengths of this collection, with an especially fine selection of post–1960 contemporary works.

The Old Master paintings begin with fourteenth-century Italian panel paintings and continue into the fifteenth century. Outstanding is an altarpiece in tempera and oil by Piero di Cosimo, the *Madonna and Child Enthroned with Four Saints*, the so-called *Pugliese Altar*. From the sixteenth century in the North, there is the *Portrait of Lady Guldeford* by Hans Holbein the Younger and *The Judgment of Paris* by Lucas Cranach the Elder; from the South, a major recent acquisition is *Judith and Holofernes* by Vasari.

The collection of seventeenth-century Flemish and Dutch paintings is strong in representative genre, landscape, and portrait works. These works include landscapes by Hendrik Averkamp, Jan van Goyen, and Roelant Savery and genre paintings from Willem Kalf, Nicolaes Maes, and Adriaen van Ostade. Portraits include works by Rembrandt (*A Young Man*, 1662), Gerard Ter Borch, Frans Hals, and Gerard van Honthorst (*A Smiling Girl*, 1625). The single example of

the monumental historical mode from this section is also a singularly fine example of the work of Jacob Jordaens, *Suffer the Children to Come unto Me*.

There are some good examples of the Italian Baroque. Among them are *The Castaways* by Alessandro Magnasco; *Judith with the Head of Holofernes*, 1709, and *The Discovery of the Body of Holofernes* by Luca Giordano; and works by Longhi, Panini, Canaletto, and Batoni. Tiepolo is represented by *The Crucifixion* and a number of drawings.

The character of eighteenth-century English portraiture can be seen in works by Reynolds, Romney, Joseph Wright of Derby, and Raeburn; a full-figure portrait by Copley; and *Lords John and Bernard Stuart* by Gainsborough after Anthony van Dyck. An additional conception of portraiture from this period is provided by the Frank Spiekerman Collection of Miniatures bequeathed in 1933.

In the collection of nineteenth-century French painting one may study the development of Realism, the Barbizon School, and Impressionism in portraits by Corot, Fantin-Latour, Manet, and Renoir. The Impressionists are also exemplified in a pastel by Degas and works by Sisley and Pissarro and, most importantly, in the monumental *Les Nympheas* by Monet (1920–22, 200.0 by 426.2 centimeters). Of the Post-Impressionists there are works by Gauguin (*Madame Roulin*), van Gogh (*Stairway at Auvers*, one of four paintings in the collection), Seurat, Cézanne, and Vuillard.

The twentieth-century European collection includes a number of works by Picasso including the early *The Mother* (1901), and two later paintings, dating from 1934, *The Bull Fight* and *Mandolin and Vase of Flowers*, and *Seated Woman* (1953). There is also a major early canvas by André Derain, *At the Suresnes Ball* (1903, 180.0 by 144.9 centimeters), and an important painting by Henri Matisse, *Bathers with a Turtle* (1908, 179.1 by 220.3 centimeters), gift of Mr. and Mrs. Joseph Pulitzer, Jr., in 1964.

The German Expressionist Max Beckmann, who taught at Washington University in St. Louis in the late 1940s, is represented extensively as a result of the 1983 bequest of Morton D. May. The bequest consists of 110 European and American works of art, mostly German Expressionist paintings, and about 1,500 works of art from Africa, Oceania, and the Americas, all now housed at the museum.

The German paintings in the May Collection date from about 1900 to 1930. There are thirty-seven works by Max Beckmann, often considered the greatest German painter of this century, including *Der Traum* (*The Dream*) of 1921 and *Stadtnacht* (*City Night*) of 1950. Beckmann's 1949 portrait of May, the late merchant and civic leader, is among the works included in the bequest. There are also six paintings by Max Pechstein, five by Ernst Ludwig Kirchner, four by Lovis Corinth, and three each by Erich Heckel, Paul Kleinschmidt, Ernst Wilhelm Nay, Emil Nolde, and Karl Schmidt-Rottluff.

There are also paintings in the collection by Picasso, Georges Rouault, Lyonel Feininger, Wassily Kandinsky, Franz Marc, Oskar Kokoschka, Alexis von Jaw-

lensky, Otto Mueller, Christian Rohlfs, and Paula Modersohn-Becker, as well as five sculptures. The museum also shows from its original holdings of Expressionists the well-known Beckmann work of 1917, *Christ and the Woman Taken in Adultery*.

A gift of a large group of German Expressionist watercolors and drawings, received in the late 1950s, lends additional depth to this area. Outstanding pieces such as Otto Dix's *Man with Spectacles* (1927–30), Ernst Kirchner's *Two Nudes*, and Franz Marc's *Landscape with Animals* are included.

A second-floor gallery built in 1964 houses the collection of American paintings. The colonial portrait group includes a John Smibert and a portrait pair by John Singleton Copley. From this early period there is also a rare genre piece, *Sea Captains Carousing in Surinam*, by John Greenwood. A number of major nineteenth-century landscape painters are represented, and the midwestern genre pieces are particularly strong, with several works by George Caleb Bingham. These works include major paintings such as *The Jolly Flatboatmen in Port*, 1857; *The Wood Boat*, 1850; and *Raftsmen Playing Cards*, 1847, as well as the early *Self Portrait*, 1834–35. From the end of the nineteenth century is Thomas Eakins' *The Fairman Rogers Four-in-Hand*.

Of American twentieth-century painting, Georgia O'Keeffe's *Dark Abstraction* is outstanding among the early moderns. In the contemporary section there are excellent works by Frank Stella, Vasarély, Rothko, Noland, Morris Louis, Ellsworth Kelly, and Lucas Samaras.

The museum acquired its first holdings in Western sculpture in 1915 with the gift of a group of bronzes from the artist Paul Manship. Today the museum's significant works belong to the modern masters of the nineteenth and twentieth centuries. This group includes Rodin's walking figure *St. John the Baptist*, the bronze *Ballet Dancer* with tutu by Degas, and the large-scale bronze *Venus Victorious* by Renoir. There are large-scale pieces by Maillol, Marino Marini, and Jacques Lipchitz and small bronzes by Matisse, Kirchner, and Rudolf Belling. Other artists represented include Giacometti, Henry Moore, Kollwitz, Gerhard Marcks, David Smith, and Calder. In the post–1960 group one finds works by Trova and Nevelson, as well as monumental outdoor pieces by Claes Oldenburg and Mark di Suvero.

The collections of the Department of Art of Africa, Oceania and the Americas are among the finest in the country both in quantity and quality. The museum's interest in this area was determined by the purchase of some superb African objects in the 1930s and 1940s, notably two Benin bronze heads, one dating before 1550, the other 1550–1650. In the 1950s the collections in African art, pre-Columbian art, and North American Indian art were further enhanced, and in the 1970s the museum acquired major portions of the Morton D. May Collections of pre-Columbian art and Oceanic art. In 1983 the museum was the beneficiary of some fifteen hundred works of art from Africa, Oceania, and the Americas from the estate of Morton D. May. About one-third of the collection is Oceanic, one-third pre-Columbian, and the rest African and American Indian.

Among the notable examples are a superb Fijian breastplate and a Maori canoe stern, both formerly in the James Hooper Collection; a Batak magic horn; a Hawaiian god stick; a Maya deer effigy; and significant groups of objects, including sixty-six pieces of Casa Grandes pottery, as well as Zapotec urns, West Mexican funerary vessels, and a collection of South African beadwork.

The pre-Columbian collection also contains more than three thousand other objects. Significant groups include more than a hundred Zapotec urns, some two hundred examples of west Mexican shaft tomb pottery, seventy-five outstanding pieces of gold and silverwork, and examples of Paracas culture (Peru, 500–200 B.C.) textiles and ceramics.

The Oceanic collection numbers some nine hundred pieces from New Guinea, the Melanesian Islands, Polynesia, and the Indonesian Islands. The African section, although not as comprehensive, has five hundred pieces.

A second-floor skylit studio was renovated in 1975–77 to provide a gallery, study, and preparatory room for the new Department of Prints, Drawings and Photographs. The development of the Western print holdings, dating from the mid-fifteenth century to the present, and numbering more than six thousand, began with Joseph Pennell's gift of thirteen of his etchings in 1909. In 1956 the museum received the extensive collection of prints by Jacques Callot formed by Henry V. Putzel. Due to the interest of private donors, contemporary American graphics have recently emerged as a strength of this department.

The holdings in drawings, watercolors, and pastels number about eight hundred and range in date from the twelfth century to the present. The greatest strength occurs in the nineteenth- and twentieth-century American section, and the museum is the repository of fifty-seven George Caleb Bingham drawings on loan from the citizens of Missouri.

In 1967 the Martin Schweig Memorial Fund for Photography was established and the museum began actively collecting photographs. Holdings include examples from 1850 through the present, with groups of works by Ansel Adams, Paul Strand, Laura Gilpin, and André Kertesz.

A new administration building, southwest of the museum, was completed in 1979. It houses the Education Department, the book shop, the library, and a restaurant, as well as the administrative and curatorial offices.

The Richardson Memorial Library, founded in 1915, is a general art-history library with holdings of thirty thousand volumes, exhibition catalogues, auction catalogues, periodicals, museum archives, and a slide collection. Areas of special strength include Oceanic art, the decorative arts, and graphics. The library is nonlending but open to the adult public.

Photographs and slides of objects in the collection may be purchased through application to the registrar's office. The museum publishes the bimonthly *Bulletin* and the *Annual Report*.

Selected Bibliography

Museum publications: *Museum Monographs I*, 1968; *Museum Monographs II*, 1970; *Museum Monographs III*, 1974; *The St. Louis Art Museum: Handbook of the Collections*,

1975; Kidder, J. Edward, Jr., *Chinese Bronzes in the City Art Museum*, 1956; Neilson, Nancy Ward, *Five Centuries of Master Graphics in the Collection of The St. Louis Art Museum*, 1977–78; Parsons, Lee A., *Ritual Arts of the South Seas: The Morton D. May Collection*, 1975; idem, *Pre-Columbian Art: The Morton May and The St. Louis Art Museum Collections*, 1980.

Other publications: Diamond, Maurice S., *Ballard Collection of Oriental Rugs in the City Art Museum of St. Louis* (St. Louis 1935).

NOVELENE ROSS

——— San Francisco ———

ASIAN ART MUSEUM OF SAN FRANCISCO (formerly CENTER OF ASIAN ART AND CULTURE; officially ASIAN ART MUSEUM OF SAN FRANCISCO, THE AVERY BRUNDAGE COLLECTION; also AVERY BRUNDAGE COLLECTION), Golden Gate Park, San Francisco, California 94118.

The Asian Art Museum of San Francisco opened officially in June 1966. It is unique in the United States, the only museum devoted entirely and exclusively to the arts of Asia (from Anatolia to Japan and from Mongolia to Indonesia.) It was established with the expectation of becoming "the outstanding center of Asian art and culture in the Western world, with the Avery Brundage Collection as its nucleus" (Administrative Code of the City and County of San Francisco, Sect. 28.13, Ordinance 192–69).

Events leading to the 1966 opening began in 1958, when a group of scholars founded The Society for Asian Art "to encourage the study and appreciation of the arts of Asia." Not incidentally, the society's first objective was to help in the acquisition of the Avery Brundage Collection for San Francisco.

Avery Brundage, American businessman, Olympic contender, and president of the International Olympic Committee for twenty years (1952–72), became a serious collector of Asian art after he visited the International Exhibition of Chinese Art in London (1935–36). During world wide travels in connection with the Olympic Games, he was able to acquire many important artworks. He continued to augment his world-renowned collection until the time of his death in 1975 at the age of eighty-eight. His will left the museum all of the Asian works he acquired from 1969 to 1975.

In 1959 Avery Brundage made his first forty-five hundred-item gift to the city and county of San Francisco. The following year, a $2.7 million bond issue to construct a specially equipped museum for the collection was passed by an overwhelming vote of the people of San Francisco. Ten years later Brundage was able to offer another huge collection of Asian objects to San Francisco, and the Second Supplemental Agreement was confirmed between him and the city.

Until this time, administrative responsibility for the museum had remained

with the Board of Trustees of the city-owned M. H. de Young Memorial Museum, to whose building the new museum, designed by Gardner Daily, had been attached. With the new agreement and an amendment to the San Francisco Administrative Code, the museum in 1969 became an independent entity, revising the original name (Center of Asian Art and Culture) to Asian Art Museum of San Francisco, The Avery Brundage Collection, in 1973, and establishing its own twenty-seven-member governing body, appointed by the mayor for one- to three-year terms. One of the new contractual obligations specified that this governing body, the Asian Art Commission, would develop an adequate acquisition fund. Initially, it was to raise $1.5 million in eighteen months for the purchase of the second collection of Asian art objects reserved by Brundage, which would double the size of the museum's holdings. The commission was also morally committed to raise an additional $1.5 million by June 1973. Both of these commitments were met.

The Asian Art Museum has a director, a chief curator; a curatorial staff of five, whose specialties are in Chinese, Japanese, Indian, Southeast Asian, and Korean arts; an administrative staff; its own library; registration and photographic departments; and a fully equipped conservation laboratory that was the first of its kind in the western United States. The museum has its own budget from the city and county of San Francisco. It provides building maintenance and security (in conjunction with the city's responsibility for the adjacent de Young Museum building) and funds for registration, conservation, research, library, exhibition, and an outreach publication.

A creation of a nonprofit charitable foundation, the Asian Art Museum Foundation was established, and through endowment encourages continued growth of the collection. The foundation is comprised of fourteen trustees, most of whom are also members of the Asian Art Commission, although this is not a requisite. The foundation raises funds for education, the library, special exhibitions, and acquisitions and to augment basic operations and staff requirements.

The Society for Asian Art is a nonprofit independent organization, free from any official association with the city and county of San Francisco. It continues its strong support of the Asian Art Museum, with special emphasis on the library, acquisitions, education, and special exhibitions.

In 1973 the membership organizations for the city's "Fine Arts Museums" (formerly the M. H. de Young Memorial Museum and the California Palace of the Legion of Honor in Lincoln Park) combined and also began to support the Asian Art Museum. The Museum Society, as it was called, is a nonprofit corporation that derives funds primarily from membership dues and bookshop net sales. Although the society's support substantially augments the city's annual allocation to the three city museums, it is primarily a service-oriented organization.

The Avery Brundage Collection did serve as a nucleus for the Asian Art Museum and still comprises about 95 percent of its holdings, but despite grave space limitations for actual exhibition of objects and other museum activities,

holdings have increased dramatically since the museum opened to the public in 1966. The collection now numbers more than ten thousand objects, many of which were acquired through the generosity of foundations or groups of dedicated citizens. The Asian Art Foundation, the Atholl MacBean Foundation, the de Young Museum Endowment Fund, the de Young Museum Society, and The Society for Asian Art are among these institutions. The collection periodically receives Asian objects transferred from the other city museums.

In addition, financial support from individuals has played an important role. Among those outstanding contributors who have museum galleries named for them are Adrian Gruhn, T. A. Soong, Osgood Hooker, Babette G. Lurie, Lenette and William Caro, Frederick Faudé, Lucy and George F. Jewtt, Jr., Richard B. Gump and the Cyril Magnin family, whose members funded the construction and appointments of a special Jade Room. The objects in these galleries are from the Avery Brundage Collection and other museum holdings. However, individual donors such as Walter and Phyllis Shorenstein have also contributed works of art of considerable importance. Some outstanding collections that have been donated to the museum include: the Roy Leventritt Collection of Chinese blue and white porcelain; the Effie B. Allison Collection of *Kosometsuke* (Chinese seventeenth-century porcelain produced for export to Japan); and the Ed Nagel Collection of Asian sculpture. On long term loan (and on display, on rotation, in the galleries), are the Hans and Gretl Popper Collection of Chinese ceramics and bronzes (dating from the fifteenth century B.C. to the fourteenth century A.D.), and Chinese ceramics and lacquers and Southeast Asian sculpture from the Christensen Fund.

China is the major department of the Asian Art Museum, in size, with about 4,750 items, some 2,000 of which are ceramics, earthenware, stoneware, and porcelain. Particularly noteworthy are the series of Han and Wei tomb figurines and models, T'ang three-color wares, Sung monochromes, and Ming and Ch'ing blue-and-white and enameled porcelains.

The jade section of the Chinese holdings, with more than twelve hundred pieces, constitutes one of the most comprehensive and diversified collections of Chinese jades in the world. One of its main attractions rests with the unusually large number of carved animals it contains, including a substantial group of figurines of the so-called medieval period (third-fourteenth century). The scope of the jade collection is broad, ranging from Neolithic times to the present. Jades are displayed in the special gallery mentioned earlier, which exhibits about three hundred items at a time, with other jade pieces incorporated into the Chinese gallery areas.

Ancient bronzes rank among the most important collections of the world in terms of quality, diversity, and quantity, with 750 vessels, belts, weapons, chariot fittings, and mirrors. This group represents a well-balanced selection from the most sophisticated Shang and Chou workshops (sixteenth to third century B.C.). There are also many unique objects, such as the eleventh-century B.C. rhinoc-

eros-shaped wine vessel. This nine-inch-high bronze, Avery Brundage's favorite, has become the emblem of the museum.

The sculpture section of about 250 items consists essentially of stone and gilt-bronze effigies of Buddhist inspiration. It contains objects dating from the fourth to the eighteenth century and is particularly strong in pieces illustrating the Wei, Northern Ch'i, Northern Chou, Sui, and T'ang periods, when Buddhist sculpture was at its best. A unique object in this section is a gilt-bronze Buddha, internationally famous as the earliest dated Buddha image from China known in the world. It was made in North China, not far from present-day Peking. An inscription on the rear dais dates it 338.

Chinese painting and calligraphy comprise about 200 works, ranging from the tenth to the twentieth century, with special emphasis on Ming and early Ch'ing masters. A group of about 350 pieces of lacquer, cloisonné, ivory, bamboo, tortoise shell, rhinoceros horn, and other exotic materials add colorful touches to the Chinese department.

The Korean department is relatively small, with 350 objects, but it includes a few examples of each of the main art forms throughout the ages. Its strength lies primarily with a large group of Silla pottery, Koryŏ celadons, and Yi porcelains.

The Japanese department contains about 2,400 items. Netsuke and *inro* constitute the most numerous series, with some 1,654 pieces. Japanese paintings include 186 screens and scrolls dating from the Kamakura through the Edo period (1185–1867). *Tartars Playing Polo and Hunting*, attributed to Kano Soshu (1551–1601), is one of a pair of six-fold screens frequently put on display.

Japanese ceramics, comprising 184 vessels and figurines, cover the entire span of the evolution of Japanese pottery from Jōmon (3000–2000 B.C.) period to the twentieth century. Included are fine examples of *haniwa*, such as a sixth-century A.D. pottery warrior, and seventeenth-century Ko Kutani platters.

Japanese sculpture, which is mainly of Buddhist inspiration, is represented by more than 70 pieces in clay, lacquer, bronze, and wood, including a particularly fine Nyoirin Kannon (900–950). There are other bronzes, such as 52 mirrors and about 20 swords. A substantial group of lacquers, ranging from the Kamakura to the Meiji period (1885–1912) count as another 70 items, and miscellaneous works in ivory, metal, textile, and wood total 157.

The arts of India and Southeast Asian countries (Burma, Thailand, Laos, Cambodia, and Indonesia) are mainly represented by more than 450 pieces of temple sculptures, reliefs, stelae, bronze effigies, and wood carvings. Ranging from over life-size to diminutive items, they reflect the main trends in Buddhist, Jain, and Hindu statuaries during the period of about two thousand years. Among the most outstanding pieces are a stone Ganesha (twelfth-thirteenth century) and a large granite Nandi (fifteenth century), both from South India; a granite Brahmani of the Chola period (ninth century); and a second-third century Gandharan Bodhisattva Maitreya of schist. The museum has the largest inventory of Gan-

dharan art outside of Asia itself. The Kushan and medieval series for India proper and the pre-Khmer and Khmer sequences for Southeast Asia are also particularly rich and diversified. In the Southeast Asia galleries, many of the sculptures have been significantly mounted to emulate the architectural positioning they occupied in the original sites.

The Himalayan cultures developed special forms of Buddhism based on local beliefs and Tantric Buddhism, imported from India. There are 309 objects, with special emphasis on gilt-bronze statuettes and temple banners of the seventeenth and eighteenth centuries, which exemplify the pictorial, sculptural, and decorative aspects of these special Buddhist concepts.

The arts of Iran and neighboring countries are represented by more than three hundred pieces of pottery, ranging from the Neolithic period to the end of the nineteenth century. A group of 130 Luristan bronzes is especially outstanding.

The Asian Art Museum originated the most important exhibition of Korean art to be shown in the United States. "5,000 Years of Korean Art," opened in May 1979 and continued through September 1981 in major museums of the country. In 1982 the Asian Art Museum originated its second international exhibition, "Treasures from the Shanghai Museum: 6,000 Years of Chinese Art," which opened in May. It traveled to Chicago, Houston, and Washington, D.C., completing its U.S. tour in November 1984. Other such international exhibitions are being planned.

The Asian Art Museum has a library comprised of fifteen thousand volumes in several languages. Its nucleus in 1967 was four thousand volumes drawn from three major sources: from collections assembled by The Society for Asian Art and the previous librarian at the de Young Museum and from Brundage's personal library. It is one of the most complete collections of materials on Asian art in the country, especially those published since 1967, and is particularly strong in exhibition catalogues from the 1930s to the present.

The library's special indexes and analytical entries in the catalogue files give greater access to materials than those of other libraries. In addition to serving the museum staff and related groups (such as the docents and members of the society), the library is open on a noncirculating basis to the public.

Slides and photographs of objects in the collection may be purchased by application to the museum's Department of Photographic Services, which can also provide a complete list of museum publications and instructions for ordering. Publications on many aspects of the Asian Art Museum's collection have been made. However, many are now out of print and available only in reference form in the library. Additional publications are now in progress. Listed in the selected bibliography are among those available at this time.

Selected Bibliography

Museum publications: Kakudo, Yoshiko, *The Effie B. Allison Collection: Kosometsuke and Other Chinese Blue-and-White Porcelains*, Asian Art Museum of San Francisco, 1982; idem, *Nagasaki and Yokohama Prints from The Richard Gump Collection*, 1981;

idem, *Netsuke: Myth and Nature in Miniature*, The Avery Brundage Collection, Asian Art Museum of San Francisco, 1981; d'Argencé, René-Yvon, *Bronze Vessels of Ancient China in The Avery Brundage Collection*, 1977; idem, *Chinese Jades in The Avery Brundage Collection*, 2d rev. ed., 1977; idem, *Chinese, Korean, and Japanese Sculpture in The Avery Brundage Collection*, 1974; *A Decade of Collecting*, an Exhibition Celebrating the 10th Anniversary of the Asian Art Museum of San Francisco, The Avery Brundage Collection, Winter 1976-Spring 1977, 1977; *5,000 Years of Korean Art*, 1979; *Treasures from the Shanghai Museum: 6000 Years of Chinese Art*, 1983.

Other publications: Schobel, Heinz, and d'Argencé, René-Yvon, *The Four Dimensions of Avery Brundage* (Leipzig c. 1968); "Asian Art Museum of San Francisco, The Avery Brundage Collection," *Apollo Magazine*, New Series, vol. 112, no. 221 (July 1980), and vol. 112, no. 222 (August 1980); "Asian Art Museum of San Francisco, The Avery Brundage Collection," *Oriental Art Magazine*, New Series, vol. 22, no. 4 (Winter 1976).

LORRIE BUNKER

FINE ARTS MUSEUMS OF SAN FRANCISCO, THE (also THE M. H. DE YOUNG MEMORIAL MUSEUM, THE DE YOUNG; THE CALIFORNIA PALACE OF THE LEGION OF HONOR, THE LEGION OF HONOR), de Young: Golden Gate Park, San Francisco, California 94118; Legion: Lincoln Park, San Francisco, California 94121.

The M. H. de Young Memorial Museum and the California Palace of the Legion of Honor were joined administratively in 1972 through the establishment of The Fine Arts Museums of San Francisco. Each has had a long and colorful history.

The de Young Museum had its origin in the California Midwinter International Exposition of 1894. At the end of this event, the exposition's director-general, newspaper publisher Michael de Young, was responsible for turning the Fine Arts building into a permanent museum. His personal contributions, along with those of his friends, resulted in architectural expansion and the development of a permanent collection. Founded as the Memorial Museum, it added de Young's name in 1921 to honor his role as benefactor.

Like the de Young Museum, the California Palace of the Legion of Honor developed chiefly from the generosity of a single benefactor. Alma de Bretteville Spreckels, wife of the sugar magnate Adolph B. Spreckels, decided in 1924 to create a museum that represented her personal enthusiasm for French art. She had greatly admired the French Pavilion at the Panama-Pacific International Exposition held in San Francisco in 1915, which was a free replica of the Palais de la Légion d'Honneur in Paris. At the end of the 1915 exposition, Mr. and Mrs. Spreckels obtained permission from the French government to duplicate the pavilion in San Francisco. World War I delayed construction, and the building was not completed until 1924, when it was dedicated to Californians who died in that war. The glistening white structure is dramatically situated in Lincoln Park, overlooking the Golden Gate Bridge.

Both the de Young and the Legion of Honor now belong to the city of San

Francisco. In the past it has provided the budget that supported most museum personnel costs and basic operating expenses. Currently, the Fine Arts Museums Foundation receives and distributes these additional funds. In addition, the foundation receives and manages endowment funds, as well as funds for capital improvement and acquisitions. In 1971 The Museum Society was established as a membership organization. Its income is used primarily to fund exhibitions, public programs, and some staff positions. In addition to benefiting The Fine Arts Museums of San Francisco, The Museum Society also represents and supports the Asian Art Museum, which is housed in the same building as the de Young but is administered separately. The Museum Society's funds substantially augment the city's budget. It also provides the volunteer Docent Council, which conducts tours for the general public and special groups, including the deaf and visually handicapped. In addition to operating the Docent Council, The Museum Society administers the Volunteer Council, the fund-raising Auxiliary, and the Graphic Arts Council.

The Fine Arts Museums of San Francisco are governed by a self-perpetuating board of trustees and administered by a director and a chief administrative officer. The curatorial division of the museums consists of the following departments: American Paintings, European Paintings and Sculpture, Decorative Arts, Prints and Drawings, African and Oceanic Art, Publications, and Registration. In addition to the curatorial division, there is an education and exhibitions division that includes these departments: Exhibitions, Technicians, Design, Interpretation, Programs, Art School, and Library. A third division is devoted to administration.

Subsequent additions and renovations to the de Young Museum throughout the years have resulted in the present two hundred thousand square feet of exhibition area, a reference library, two garden courts, an auditorium, classrooms, offices, and a cafe, making it one of the largest municipal art museums in the West. The de Young's permanent collection of European art is housed in galleries surrounding a spacious central court with the portal of a twelfth-century monastery as its centerpiece. Paintings, sculpture, stained-glass windows, furniture, and decorative arts, as well as several original period rooms, illustrate the cultures of the Western world from the time of ancient Egypt, Greece, and Rome to the beginning of the twentieth century. This section contains masterpieces such as *The Tribute Money* by Rubens, *St. John the Baptist* and *St. Francis* by El Greco, and a marble sculpture by Benvenuto Cellini.

Earliest of the period rooms is one with a fifteenth-century Spanish mudejar ceiling and furnishings of the period. The Elizabethan period in England is represented by an original paneled oak room. There are six eighteenth-century interiors, one from Germany with richly carved panels and Brussels tapestries, one representative of the Rococo with elaborate carvings and gilt from a chateau near Rouen, a Louis XVI room from Paris, another carved and paneled French room dating from 1765, a painted Italian interior from the Italian Alps, and a George III dining room. The French rooms look out on a formal garden with a

fountain and are richly decorated with appropriate furniture, paintings, and sculpture.

The Samuel H. Kress Collection is housed in three galleries in the North Wing and includes Spanish, Dutch, and Italian masterpieces dating from the fourteenth through the eighteenth century by masters such as Fra Angelico, Titian, El Greco, Pieter de Hooch, and Goya. Further outstanding examples of the great schools of Dutch, Flemish, and English art are found in the Roscoe and Margaret Oakes Collection. Artists represented there include Rembrandt, Hals, van Dyck, Rubens, Gainsborough, Reynolds, and Raeburn.

In 1977 a new suite of galleries was opened for the Fine Arts Museums' collection of American art, the most comprehensive in the western states. The collection was further enriched the following year when Mr. and Mrs. John D. Rockefeller III gave their collection of American painting to the museums. Among the highlights of the Rockefeller bequest are the 1670 *Portrait of the Mason Children*, John Singleton Copley's *William Vassal and Son*, and George Caleb Bingham's *Boatmen on the Missouri*.

Another major part of the de Young's collection is found in its specially designed gallery housing the arts of Africa, Oceania, and the Americas. The East Wing of the de Young, renovated in 1979, is used for temporary exhibits.

The Legion of Honor, located several miles northeast of the de Young Museum, contains twenty-two galleries, a fully equipped theater seating 345, administrative offices, and a cafe. A pipe organ is built into the loft areas of the building, and free public concerts have been performed on it for more than fifty years. The collections are predominately French, fulfilling the intent of the building's donors. Mrs. Spreckels formed the museum's unique collection of the works of August Rodin, about eighty pieces, including some forty bronzes and more than thirty plasters. Many of the plasters were bought directly from Rodin's studio. Among the bronzes are masterpieces such as *The Thinker*, *The Age of Bronze*, and *St. John the Baptist Preaching*.

During the early years of the Legion of Honor, Mrs. Spreckels was instrumental in enlisting the interest of Archer M. Huntington (connected by marriage with the Spreckels family), who presented to the Legion of Honor the major portion of its outstanding eighteenth-century French paintings, sculpture, tapestries, and porcelains and an especially choice selection of furniture, which he donated in the name of his father, Collis P. Huntington. The Legion's French collection continued to grow when, in 1940, Mrs. Spreckels persuaded Mr. and Mrs. Henry K. S. Williams to deed the contents of their Paris house to the museum, together with the institution's first substantial purchase fund. Through prudent use of this endowment, the museum was able to augment the original Williams Collection with outstanding examples of European masters such as LeNain, Nattier, Degas, Renoir, and Manet. The collection was further augmented in 1972, when the Legion of Honor merged with the de Young Museum and the latter's French collection was transferred to the Legion. Its French character recently has been emphasized further by a complete reinstallation of the collections. Among ac-

quisitions on view for the first time are Mary Cassatt's touching portrait of her
mother, Baron François Gerard's double portrait of the countess de Morel-Vinde
and her daughter, and the terracotta sculpture *Diana* by Jean-Alexandre-Joseph
Falguière. Added to the Legion of Honor's distinguished collection of furniture
is a secrétaire made for Napoleon's second wife, Marie-Louise of Parma. The
present installation features works by French masters such as Georges de La
Tour, Boucher, Boudin, Bouguereau, Corot, Courbet, Fragonard, Greuze, Mor-
isot, and Pissarro.

An important part of the Legion of Honor's collection is represented in the
Achenbach Foundation for Graphic Arts. Its nucleus was provided in the early
fifties, when Mr. and Mrs. Moore S. Achenbach donated their vast collection
of prints and drawings to the Legion. In the intervening years the collection has
been added to by numerous donors, making it the most important collection of
its kind west of Chicago. The Achenbach Collection now offers a systematic
representation of the history of graphic art, which is evident in its series of
changing exhibitions.

One of the Fine Arts Museums' most important activities is its educational
program, which includes studio courses at the de Young Museum Art School,
workshops, lectures, and seminars.

The de Young Museum also houses the West Coast Area Center of the Archives
of American Art, a bureau of the Smithsonian Institution. The archives has
assembled the world's largest collection of material documenting the history of
the visual arts in America. Seven million items of original source material are
available on microfilm to researchers in five regional centers; the San Francisco
office is the most recently established of these centers, opening in 1973. There
students can study the papers of artists such as Thomas Cole, Winslow Homer,
Mary Cassatt, Louise Nevelson, and William Wiley.

Adjoining the archives at the de Young Museum is the Library of the Fine
Arts Museums. It consists of a reading room, a stack area, a small reference
section, and an office for the librarian. The library has some twenty thousand
volumes, with sales and auction catalogues, bound periodicals, and thirty thou-
sand slides. This facility primarily serves the staff in research for acquisitions
and publications. Questions posed by the public are answered by phone and
letter.

Both the de Young Museum and the Legion of Honor have bookshops on
their premises that contain slides of works in the collections, museum publica-
tions, and current art literature. A bimonthly magazine *Triptych*, is pubished by
The Museum Society for its membership.

Selected Bibliography

Museum pubications: *The Fine Arts Museums of San Francisco, Report, 1976–1978,
1978–1980*; Bennett, Anna G., *Five Centuries of Tapestry in The Fine Arts Museums of
San Francisco*, 1976; de Caso, Jacques, and Patricia B. Sanders, *Rodin's Sculpture: A
Critical Study of the Spreckels Collection*, 1978; Frankenstein, Alfred, *Guide to the*

American Galleries . . ., 1980; Hattis, Phyllis, *Four Centuries of French Drawings in the Fine Arts Museums of San Francisco*, 1978; Johnson, Robert Flynn and Joseph R. Goldyne, *Master Drawings from the Achenbach Foundation for Graphic Arts*, 1985.
DIANNE SACHKO MACLEOD

——— Sarasota ———

RINGLING MUSEUM OF ART (officially JOHN AND MABLE RINGLING MUSEUM OF ART; also THE RINGLING, THE RINGLING MUSEUMS, THE RINGLING MUSEUM OF ART), 5401 Bayshore Road, Sarasota, Florida 33580.

In 1925 John Ringling, mightiest of all circus magnates, dreamed of creating a magnificent center of the arts on his thirty-eight-acre Sarasota estate. That dream came true in 1930, when the John and Mable Ringling Museum of Art opened to the public. Upon his death in 1936 (seven years after his wife Mable's death) Ringling bequeathed the museum and his residence to the state of Florida; after ten years of litigation, the museum was again opened. Today the Ringling is among the few museums in the world that exist as the gift of one individual.

Funded principally by the state of Florida, the museum receives additional support from the John and Mable Ringling Museum of Art Foundation, Inc., as well as private sources and the income from admissions. The foundation, which has existed since 1968 and was incorporated in 1978, serves as a direct support organization for the museum to fund programs, exhibitions, catalogues, and special events. With a current membership of about three thousand, the Members Council, which began in 1958 and was incorporated in 1965, functions as a nonprofit organization under the auspices of the foundation. The council's responsibilities include providing hospitality and volunteer services at exhibit openings, lectures, and all special events. The Docent Program, which operates as a division of the Education Department, originated in 1966 and provides tour guides for museum visitors.

A nine-member board of trustees governs the museum, each member serving a four-year overlapping term. It is administered by a director and two associate directors (programming and administrative); the curatorial staff includes the curator of collections, curator of decorative arts, and curator of twentieth-century art. Departments include Education, Information, Conservation, Registration, Graphics, and the Library.

The museum building was designed by a New York architect, John H. Phillips, who had helped design a section of the Metropolitan Museum of Art (q.v.). Styled after a fifteenth-century Florentine villa, the Ringling is an outstanding example of Italian Renaissance architecture in the United States. Three wings rise around a huge central courtyard with loggias lined with more than ninety columns of varying design. The materials come from a variety of sources,

including the estate of Stanford White; fifteenth-century paneling and doorways from the Villa Palmieri in Florence, where Giovanni Boccaccio had written the *Decameron*; and ancient stone Cypriote statues of the seventh century B.C.

By the 1920s John Ringling had purchased more than five hundred paintings from galleries and collections throughout Europe and America. The majority of works were of the Baroque period. Well advised by the Munich dealer and art expert Julius Böhler, Ringling nevertheless exercised his own taste and judgment. At the time it was purchased, Baroque art was relatively unpopular, and Ringling was able to assemble the foundation of what is now America's largest collection of art from that period. His first two purchases were a fine Veronese, *Rest on the Flight*, and a Luini, *The Madonna and Child with Saints Sebastian and Roche*.

Ringling had the galleries designed for big paintings; the walls are more than eighteen feet tall. Several large English paintings that had been difficult to sell due to their size were purchased by Ringling at "bargain prices" from Lord Duveen. They include Gainsborough's *General Philip Honywood*, Reynolds' *Marquis of Granby*, and Lawrence's *Mrs. G. F. Stratton*.

There are eighteen galleries in the north and south wings and space for temporary exhibitions in the New Wing. Starting with the Introduction Gallery and followed by a special Rubens room, the galleries thereafter are arranged chronologically: ancient to medieval European works, seventeenth-century Italian and Flemish art in the north wing; seventeenth-, eighteenth-, and nineteenth-century Dutch, Spanish, German, French, and English art in the south wing; a separate, newly dedicated gallery for twentieth-century art; and the New Wing, which opened in 1967 and is used for temporary exhibitions of items from the permanent collection and works on loan.

The collections contain about one thousand paintings, two thousand prints and drawings, and five hundred pieces of sculpture and decorative-art objects such as furniture, tapestry, ceramics, and silver. About one-third of the collection is on display at one time; the rest is in storage or circulating to affiliate museums around the state. Many works are in storage because there is not sufficient gallery space to exhibit them, some because they need restoration.

The development of various cultures dating from 3000 B.C. to A.D. 500 is represented in an exhibition of selected objects from the Mediterranean world. Included are displays of Egyptian statuary, Cypriote pottery, Greek vases, and Roman glass. Highlighted in the exhibit is a grouping of Cypriote head sculptures, a small portion of the thousands of archaeological objects acquired by John Ringling in 1928, when he purchased parts of the Luigi Cesnola and Julien Greau collections offered at auction by the Metropolitan Museum of Art. Much of the Cesnola material, which includes pottery, glass, bronze, and gold and silver artifacts, has never before been exhibited and the museum staff is currently in the process of cataloguing the collection.

The museum's most important collection of works by a single artist is unquestionably that of Peter Paul Rubens. In 1926 Ringling heard that four Rubens

cartoons (full-scale studies) for the tapestry series "The Triumph of the Eucharist," originally ordered by Archduchess Isabella of the Netherlands, had gone unsold at auction due to their tremendous size (up to fourteen by nineteen feet), and he purchased them. The works are titled *The Gathering of the Manna*, *Abraham and Melchizedek*, *The Four Evangelists*, and *The Defenders of the Eucharist*. The cycle may have consisted of twenty separate wall hangings. The cartoons were executed in oil on canvas rather than the customary tempera on paper. Four of the original cartoons were lost in a fire at the Archducal Palace in Brussels in 1731. Ringling built a special gallery to house his four, and in 1980 the museum was able to purchase yet another cartoon from the series, *The Triumph of Divine Love*, which had been in England since the early nineteenth century. The two remaining cartoons from the *Eucharist* cycle are in the Louvre (q.v.).

Another Rubens in the collection, the *Portrait of the Archduke Ferdinand*, is a notable example of the artist's official portrait style. It was the first painting to be purchased by the state after Ringling's death. In addition, the museum has nine other works by Rubens and/or his studio: *Departure of Lot and His Family from Sodom*, *A Scholar Inspired by Nature* (executed with Osias Beert the Elder), *Danae and the Shower of Gold* (studio), and a series of four large tapestry cartoons (tempera on paper) from the *Aeneas* series. Two oil-on-panel works by Rubens are *Achilles Dipped in to the River Styx* and *Portrait Head of a Young Monk* (studio).

Among the museum's collection of sixteenth-century Italian works are Piero di Cosimo's detailed *Building of a Palace* and Gaudenzio Ferrari's *The Holy Family with a Donor*. An outstanding Veronese, *Portrait of Francesco Francheschini*, is now recognized as the earliest dated portrait by the artist (1551), although it was purchased as a Romanino. Other paintings from the sixteenth century include *Christ on the Cross* by El Greco and *Cardinal Albrecht of Brandenburg as St. Jerome* by Lucas Cranach the Elder. The Cranach work is a free copy of Dürer's 1519 engraving of St. Jerome and draws interest to the museum's seventeenth-century *lusterweibchen* (handing chandelier) that is exhibited with it, for a very similar chandelier appears in the painting.

The museum has exceptionally strong holdings in Dutch paintings of the seventeenth century, including the following: the powerful Frans Hals *Portrait of Pieter Jacobsz. Olycan*; the early Salomon van Ruysdael *A River Scene*; the Frans Post *A Brazilian Landscape in La Varzea*; the Paulus Potter *Cattle Resting in a Landscape*; the Adam Pynacker *Landscape with a Silver Birch*; the *Portrait of a Woman*, attributed to Rembrandt; the Jan Steen *Rape of the Sabine Women*; and the Jan Davidsz de Heem *Still Life with Parrots*. The Flemish collection of paintings from this period includes, in addition to the Rubenses, important works by Frans Snyders, Jan Fyt, van Dyck, David Teniers the Younger, and Jan Bruegel the Elder. An excellent example of Nicolas Poussin's mature style, *The Holy Family with the Infant St. John*, is part of the French seventeenth-century collection. Other French works include *Venus and Mars with Cupid and Chronos*

by Simon Vouet, the series "The Seven Acts of Mercy" by Sebastien Bourdon, and an example of the Late Mannerist style, *The Banquet of Anthony and Cleopatra*, by Claude Vignon. In 1966 the museum acquired Francesco del Cairo's *Judith with the Head of Holofernes*, an outstanding Baroque work painted during the artist's first Milanese period. Among the many other seventeenth-century Italian works that the museum owns are several by Salvator Rosa, two by Sassoferrato, *An Act of Mercy: Giving Drink to the Thirsty* by Bernardo Strozzi, *Susannah and the Elders* by Agostino Carracci, and *The Annunciation* by Guercino.

Three of the museum's finest portraits by English artists of the eighteenth century are *Portrait of Miss Mary Lillias Scott* by Allan Ramsay, *Portrait of George, Prince of Wales* by John Hoppner, and *Portrait of Mrs. Oliver* by George Romney. From the collection of eighteenth-century French works are *The Lover's Pilgrimage* by Pierre Gaudreau; a drawing, *Vaulted Garden*, by Jean Honoré Fragonard; and another drawing, *Two Putti*, by Jean-Antoine Watteau. A noteworthy German painting from this period is *The Dream of Joseph* by Anton Raphael Mengs. The collection of Italian works from the eighteenth century includes two Canalettos, two Paninis, two Guardis, and a Gaspare Traversi, *The Detected Love Letter*.

Although limited, the museum's collection of American nineteenth-century paintings includes Benjamin West's neoclassical *Agrippina and Her Children Mourning over the Ashes of Germanicus*, Daniel Huntington's *Portrait of Major Philip Schuyler*, and Frederick Remington's *The Salute* and *An Indian Trapper*. English works of this period include those by Thomas Lawrence, Edward Burne-Jones, William Powell Frith, James Webb, John Ruskin, and Arthur Severn. Nineteenth-century French paintings include a replica by Rosa Bonheur of her famous *Labourage Nivernais*. In addition the museum owns *A Cottage on the Hill* by Jules Dupré, *A View of Dunkirk* by Eugene Boudin, a landscape by Jean Baptiste Camille Corot, and paintings by Detaille, Meissonier, and Stevens. The collection of nineteenth-century works also has holdings in the Dutch, Italian, German, Austrian, Belgian, and Spanish categories.

The museum trustees resolved in 1972 to acquire modern and contemporary works of art through gifts and purchases, and this area has since grown steadily, with recent acquisitions by Philip Pearlstein and Stephen Shore. An outstanding watercolor by Edward Hopper, *Jenness House Looking North*, was purchased in 1976. Within the collection are paintings by Duchamp, Henri, Hartley, Marsh, Marin, Benton, Dove, Tanguy, Nesbit, Berman, Stella, Olitski, Anuszkiewicz, Gene Davis, and Jack Beal. Also included are works by Mark Tobey, Chaim Gross, Morris Graves, Adolph Gottlieb, Alexander Calder, Ernst Barlach, and Marisol. In 1977 the museum purchased works by Jasper Johns, Ellsworth Kelly, Claus Oldenburg, Christo, and Louise Nevelson. An impressive and growing collection of photographs includes works by such masters as Ansel Adams, Wynn Bullock, Edward Weston, and Minor White.

The grounds and courtyard of the Ringling Museum abound with both bronze and limestone garden sculpture. Most of the bronzes are twentieth-century casts

made from Roman copies of ancient Greek marble works from the Hellenistic period. The most renowned of the outdoor sculpture is the fourteen-foot copy of Michelangelo's *David*, which is the focal point of the courtyard.

Displayed in their own gallery are several of the objects from the Karl A. Bickel bequest. Included is a group of Greek and Russian icons dating from the sixteenth through the nineteenth century, a sixteenth-century Italian reverse-painting on glass, and a terracotta bozzetto for a marble angel by Bernini. From the Mary Sisler Collection have come donations of paintings, sculpture, and several French decorative-art objects. The late A. Everett Austin, the Ringling's first director, was a collector himself and donated many pieces of fine furniture to the museum.

Within the museum are two completely reconstructed Regency-style rooms from the New York residence of John Jacob Astor that were purchased by John Ringling. These rooms, which were probably a ballroom and a library, currently serve as the museum's gift shop and lecture-conference room, respectively.

Items within the decorative arts collection range from furnishings to ceramics and include: an early-sixteenth-century Italian *trono* (throne-bench) from the Strozzi Palace in Florence; a Flemish reliquary chest, about 1600, attributed to Frans Francken II; a French harpsichord signed by Jacquet, 1652 (the earliest-known piece of its kind); a seventeenth-century tapestry by John Guillaume van Leefdael; a large collection of Georgian silver; bronze and silver medals from the sixteenth through the eighteenth century; and the well-known Émile Gavet Collection, which includes French, German, and English watches; miniature wax medallions; Italian majolica; and French and Italian liturgical objects of the thirteenth through the sixteenth century.

At the rear of the complex, situated on Sarasota Bay, sits Ca'd'Zan (Venetian for "House of John"), a thirty-two-room mansion that was the Ringlings' home. Completed in 1927, the residence is a museum in itself, housing much of the decorative arts collection. Designed by the New York architect Dwight James Baum in the Venetian Gothic style, it is one of America's great historic houses. Constructed of terracotta, it is a cleverly conceived jigsaw puzzle, fitting together architectural components imported from around the world. Many of the furnishings were acquired from the Vincent Astor and Jay Gould mansions and reflect the influence of the Italian and French Renaissance.

In addition to the New Wing built in 1967, the state of Florida has made three other major changes to the former Ringling estate. In the late 1940s the state acquired thirty acres, nearly doubling the size of the complex. In 1948 the Circus Museum was constructed to serve both as a memorial to John Ringling and as a storehouse of memorabilia and documents that illustrate the history of the circus in a manner both educational and entertaining.

In 1958 the Ringling Museum opened the Asolo Theater within its own building on the grounds. The small, horseshoe-shaped theater was originally built in 1798 for the queen of Cyprus, Catherine Conaro, in her castle at Asolo, a small town near Venice. Threatened by demolition in 1930 to make way for a modern movie

theater, the Asolo theater was purchased by an Italian art dealer, dismantled, and stored for twenty years until the state of Florida purchased it in 1950. Today it is the only original eighteenth-century Italian theater in America. Exhibited in the theater from the museum's collection is a group of paintings by Ferretti in which Harlequin, one of the best-loved figures of commedia dell'arte, appears in many disguises and situations. This series once belonged to the famous director Max Reinhart.

Holding about eight thousand volumes, the library at the Ringling Museum is the state's foremost source for research in Renaissance and Baroque art. Although it remains a noncirculating library, it is open to the public and contains not only books and periodicals but sales, auction, and exhibition catalogues and several art encyclopedias.

The Information Department is responsible for all public relations, press releases, and publications for the members, which include an annual program guide, a quarterly newsletter, and a calender of events published ten times a year.

The museum's Conservation Department was appropriated funds for staff and equipment by the state legislature in 1979. Since then, several paintings that had been in storage due to their poor condition have been restored and presented to the public.

Thousands of young people are brought to the museum annually in school groups for guided lecture tours, workshops, and art classes. Movies, filmstrips, slide lectures, and exhibitions of original works of art, prints, photographs, and sculpture are circulated by the museum's Education Department to schools, colleges, art centers, and other museums throughout Florida.

Slides and photographs of objects in the collection may be purchased through the Registrar's Office, if available. Exhibition catalogues may be ordered from the Ringling Foundation.

In 1980 the Ringling was designated as the State Art Museum by the Florida legislature.

Selected Bibliography

Museum publications: Suida, William, *A Catalogue of the Paintings in the John and Mable Ringling Museum of Art*, 1969; *Your Tour Guide to the Ringling Museum*, 1979; Gilbert, Creighton, *The Asolo Theater*, 1959; Murray, Marian, *The Ringling Museum: A Magnificent Gift to the State of Florida*, 1953; *The Museum of the American Circus*, 1951; Robinson, Franklin, and William H. Wilson, *Catalogue of the Flemish and Dutch Paintings, 1400–1900*, 1980; Tomory, Peter, *Catalogue of the Italian Paintings before 1800*, 1976; Wilson, William H., *Dutch Seventeenth Century Portraiture: The Golden Age* (1980).

Other publications: *Christopher Gibbs Limited: An Illustrated Catalogue* (London, n.d.); Koltun, Frances, "A Quartet of Ringling Museums: Sarasota's Great Showplaces," *Museum Magazine* (March-April 1980), pp. 90–97, 104; Wernick, Robert, "The Greatest Show on Earth Didn't Compare to Home," *Smithsonian* (September 1981), pp. 63–71.

WENDY H. MCFARLAND

———— Seattle ————

SEATTLE ART MUSEUM (formerly SEATTLE FINE ARTS SOCIETY; ART INSTITUTE OF SEATTLE), Volunteer Park, Seattle, Washington 98112. **SEATTLE ART MUSEUM PAVILION,** Seattle Center, Seattle, Washington 98109.

The Seattle Art Museum is an outgrowth of the Seattle Fine Arts Society, which was organized in 1906 and incorporated in 1917. That name was changed to Art Institute of Seattle in 1928, when the organization moved into its first permanent home on Capitol Hill. In 1932 Margaret MacTavish Fuller and her son Richard E. Fuller offered to give the Institute $250,000 to build an art museum if the city of Seattle would agree to provide a site for the building and public funds for its maintenance. The offer was accepted, and the city offered Seattle's forty-four-acre Volunteer Park as the site. The park, listed on the National Register, was acquired by the city in 1876 and designed by the famous Olmstead brothers of New York's Central Park fame. The name of the organization was changed to the Seattle Art Museum in 1933, and the building was dedicated and opened to the public in June 1933. The city continues to provide for the maintenance of the Volunteer Park building, as well as for the museum's Pavilion at Seattle Center.

The Volunteer Park building was designed by Carl F. Gould of the firm of Bebb & Gould, a well-known regional architectural firm best known for the Gothic buildings on the campus of the University of Washington. The 1933 building is known as one of Seattle's finest examples of Art Deco style. On either side of the central Garden Court are wrought-iron gates designed by Samuel Yellin of Philadelphia. Outside the building, as one approaches, there are ten large marble figures and animals from Chinese tombs of the late Ming (1368–1644) and Ch'ing (1644–1912) periods. The building has had four additions to the original structure: an addition to the basement for offices and darkroom (1949); the addition of the Norman Davis Gallery for the Samuel H. Kress Foundation Collection (1954); the addition of a large exhibition gallery on the main floor in memory of architect Carl F. Gould, as well as the addition of the Activities Room and kitchen facilities on the lower level underneath the Gould Gallery (1955); and the enlargement of the sub-basement for additional library storage and elevator to same (1969).

The Seattle Art Museum Pavilion at Seattle Center opened in 1965 in the building that originally housed the United Kingdom and Republic of China Pavilions during the 1962 Seattle World's Fair. Funds for renovation of the building were provided by PONCHO and from a bequest of Richard Dwight Merrill. Architect for the renovation was Paul Thiry.

The Seattle Art Museum Guild was created in 1934 as an outgrowth of the Junior Fine Arts Study Group, organized in 1925. Membership in the museum

has been the only requirement for participation in the guild. It is the principal volunteer arm of the museum, aiding various departments and contributing through its fund-raising projects to acquisitions, library books, and special projects. In addition to the guild, five major art councils have been created to stimulate interest in and support for specific areas of interest: Contemporary Art Council (1964), Pacific Northwest Arts Council (1974), Asian Art Council (1974), Ethnic Arts Council (1976), and the Photography Council (1977). A sixth council for the decorative arts was organized in 1981.

The museum is governed by a board of fifty-six elected trustees who serve three-year overlapping terms. It is administered by the director and the associate director for art and the collections. There are four curatorial departments: Asian and Near Eastern Art (1968), Modern Art (1975), Ethnic Art (1979), and Japanese Art (1978). The museum's twenty-two departments are organized into six divisions: Museum Services, Curatorial Services, Educational Services, Information Services, Development Services, and Business Services.

The museum's founding family, the Fullers, began collecting Japanese netsuke in Asia as early as 1919. Throughout the years, Richard Fuller continued to expand the Asian art collections, which today include the Eugene Fuller Memorial Collection, named for his father. Sherman E. Lee joined the staff in 1948 as assistant director and later as associate director. During this period, many fine pieces were brought into the collections, including the famed Kōetsu-Sōtatsu deer scroll. Lee remained on the staff until 1952. Succeeding him as associate director was Millard B. Rogers (1952–61). In 1968 Henry Trubner joined the staff and is now associate director for art and the collections, as well as curator of Asian and Near Eastern art. William Jay Rathbun joined the staff in 1972 and is now curator of Japanese art.

The Seattle Art Museum's comprehensive holdings in Asian art, notably its broad representation of Japanese art, are recognized universally. Of the more than one thousand objects in the Japanese collection, the handscroll *Deer and Poems* by Tawaraya Sōtatsu and Honami Kōetsu is indisputably the most important single piece. It is, in fact, one of the most important paintings outside Japan. This collection has strong holdings in sculpture, paintings, ceramics, and lacquer of various periods.

Among the objects that, were they still in Japan, would likely be registered by the government of Japan are: a late Kofun period Haniwa warrior, of reddish pottery with traces of polychrome decoration; Tobatsu Bishamonten, guardian figure, wood, Heian period; a figure of Prince Shōtoku as a child, wood, Kamakura period; an ink landscape painting, style of Shūbun, Muromachi period; an ink painting, *Sakyamuni Coming Down from the Mountain*, Kamakura period; a painting, *Black Bull*, from the Shungyū E-kotoba, Kamakura period; a poem page from the *Ishiyama-gire*, Heian period; an ink painting, *Poet Tu Fu on His Donkey*, Muromachi period; and a gold lacquer (*maki-e*) toiletries case, Kamakura period.

Several hundred netsuke of various materials and a number of *inro* form a

memorial collection named for Richard Fuller's brother Duncan MacTavish Fuller. In the years soon after World War II, many fine pieces of Japanese art were added to the collection. In recent years, fine examples of eighteenth- and nineteenth-century literati painting have been added. There are also a number of very fine screens and scrolls of later centuries, as well as excellent examples of tea-wares and porcelains from the sixteenth to eighteenth century. The most recent acquisition to the Japanese collection is a large tray of *negoro* lacquer from the Muromachi period, dating from the mid-fifteenth century, probably the single most important example of *negoro* lacquer outside Japan today.

The museum's holdings in Chinese art number more than two thousand. The collection is widely varied and ranges from painting, sculpture, ritual bronzes, textiles, ceramics, and lacquer to tomb figurines and the well-known jade carvings and snuff bottles. In such a collection, it is difficult to identify a single outstanding piece. From the standpoint of rarity, condition, and aesthetic significance, however, the following individual pieces are among the most important: a Ch'ang-sha lacquer bowl, late Chou Dynasty; a standing Buddha from Hopei Province, Northern Ch'i Dynasty; a standing limestone Buddha, Six Dynasties-early T'ang Dynasty; a three-color ware tomb figure of a wine merchant, T'ang Dynasty; a wood sculpture of a seated Kuan-yin, Sung Dynasty; a foliate lacquer plate, Sung Dynasty; *Hawk and Pheasant*, the painting by Li An-Chung, Sung Dynasty; *Orchids in First Bloom*, the painting by Hsueh-ch'uang, Yüan Dynasty; a sculpture of a Buddhist monk, Yüan Dynasty; a foliate carved lacquer tray, Yüan Dynasty; an underglaze blue decorated porcelain plate, Yüan Dynasty; a cloisonné pricket candlestick, Ming Dynasty; *River Landscape with Towering Mountains*, the painting by Wen Pô-jên, Ming Dynasty; an album of landscapes illustrating *The Road to Ling Ching* by Shao Mi, Ming Dynasty; a handscroll painting by Lan Ying, Ming Dynasty; and a snuff bottle of glass with enameled overglaze decoration in Ku-yüeh-hsüan style, Ch'ing Dynasty, mark and reign of Ch'ien-lung.

The Chinese collection includes important holdings of ancient jades from the Shang and Chou dynasties and a number of rare jades from the Han through the Sung Dynasty. One of the famous treasures of the Chinese jade collection is the *Reclining Camel*, T'ang or early Sung Dynasty. The majority of the collection of carved jades are later pieces from the reign of Ch'ien-lung, and some are of nineteenth century date. There are various pieces that are truly outstanding and very rare examples of Chinese jade carving. Among the early jades, the large Chou Dynasty *pi* is especially important. Both the snuff bottles and the carved jades—together with the netsuke—formed the initial gift to the Seattle Art Museum by Richard Fuller and his mother.

Of the 249 objects in the Indian art collection, 108 are sculptures. Among them are many superlative pieces, of which 4 are indisputably of the first rank: the red sandstone Yakshi figure from Māthura, Kushan period; the sandstone Devī figure from Deogarh (late sixth century); the bronze figure, *Śākyamuni on Lion Throne* from Kashmir (eighth century); and the sandstone figure of Kama,

God of Love, from Bhuvaneśvara, probably from a Siva temple in the Bhuva-neśvara region (eleventh century). Second only to the sculptures are two illustrated manuscripts, 53 miniatures, and 13 paintings of various types. A page from the *Hamza-Nama*, the romance of the Muslim hero Amire Hamza (c. 1556), surely ranks as the most important piece of this grouping.

The Asian art collections also have important holdings of Cambodian, Thai, Javanese, and other examples of Southeast Asian and Indonesian art, including Sri Lanka, Burma, and Ceylon. There are 174 objects formerly catalogued under the grouping of Further India, which are now catalogued according to country of origin. Of these objects, the finest piece (and one of the museum's greatest treasures) is the limestone Buddha figure from Thailand, Dvāravatī style, Mon-Gupta type (seventh-eighth century). A second very fine piece is the stone Buddha head from Borobudur, Java (c. 800).

Separate categories have also been created within the Asian collections for the art of Nepal, Tibet, Kashmir, Central Asia, and other areas bordering India. The finest piece in the Nepalese group is the *Eleven-Headed Avalokiteśvara*, which dates from the eleventh century. In the Tibetan group, the first place goes to a sculpture, the dancing Vāsya-Vajravārāhī, which dates from the fourteenth century. Both figures are of gilt bronze. All of the objects in the Nepalese and Tibetan group are religious works and include small gilt-bronze sculptures, altar paraphernalia, tankhas, and mandalas, or votive paintings.

Another category within the Asian collections is that of Korea, which includes only fifty-eight pieces but some of great importance and rarity. Of these objects, the finest are ceramics and probably the rarest and most difficult to obtain is the sixteenth–seventeenth-century faceted porcelain bottle with underglaze copper-red decoration. Two other strong contenders for recognition as the principal works are the twelfth–thirteenth-century celadon *mae byŏng* vase and the fifteenth-century Punch'ŏng ware wine flask. Recently, an important fifth–sixth-century Silla Dynasty gray pottery jar was added to this collection.

The museum's ethnic art collections began with its founder, Richard Fuller, who expanded his interests into African and other art after years of extensive purchases in the Orient and Europe. What began as a modest accumulation of African pieces is now taking shape as a major facet of the museum's collections. An unexpected variety of African, pre-Columbian, and Oceanic artwork and a small number of American Indian objects have been joined by the internationally recognized Katherine White Collection of African art, acquired in 1981.

The White Collection surveys the history of African art during the past four hundred years. As a group of masterpieces, the collection is irreplaceable. The works have documented historical significance. They are often rare and always of superb quality. Combined, these characteristics make individual pieces acknowledged keystones in the history of African art and culture. The entire collection is professionally catalogued. The nearly 1,800 objects can be broken down generally as 322 African sculptures of major significance, 975 African

decorative art objects, 205 African textiles, and 241 ethnic sculptures from Oceania, pre-Columbia, and the Americas. The collection represents more than sixty-six African cultures from Ashanti to Zulu and virtually every material and skill open to the African artist-craftsperson: major ivories; 170 pieces of worked and solid gold; many bronzes; and wood, iron, and various fibers and textiles.

In addition to new holdings in the White Collection, the pre-Columbian collection includes ceramic vessels and sculptures, textile fragments, stone and metal sculptures, jades, and masks. A gift of seventy significant objects from John H. and Anne Gould Hauberg added distinction to the collection. Indeed, one of its premier objects is from the Hauberg Collection: a Mayan miniature stela, Proto-Classic, made of limestone. The stela exemplifies the best features of Mayan art and is recognized as one of the finer examples of Mayan carving in the United States.

In addition to having new holdings in the White Collection, the African art collection includes wood sculptures and masks, metal sculptures, ivory sculptures, textiles, ceramics, and several pieces of stone sculpture. The general quality of the collection was enhanced in 1968 by a gift of fifty small and unusual pieces from Nasli and Alice Heeramaneck.

In addition to having the new White pieces, the Oceanic collection includes wood sculpture, stone-jade sculptures, wood and fiber masks, and textiles. The premier object is a food bowl in the form of a frigate bird on a shark from the Solomon Islands, formerly in the Beasley Collection.

Northwest Coast Indian art is an area of primary interest to the Pacific Northwest. A number of important museums in this region have large collections of such material. The Seattle Art Museum's collection is small, but growing. Forty stone, horn, and metalwork pieces, as well as one Chilkat blanket, presently comprise the collection.

In a relatively short period, the modern collection has become an integral and important part of the museum. The department's active exhibition program and its commitment to regional art and artists continue to grow.

From its inception, the museum has acquired modern works of art, while also forming a significant collection of works by artists of the region, including Mark Tobey and Morris Graves. The museum has also received important works such as Jackson Pollock's *Sea Change, 1947* from Peggy Guggenheim and a large group of European and American paintings from the collection of Sidney and Anne Gerber. The Gerber gift included paintings by European artists such as Léger, Albers, and Chagall and by American Abstract Expressionists such as Hofmann, Frankenthaler, Stamos, Mitchell, and Tworkov.

In recent years, many donors have added significantly to the collection's holdings in American art, post–1940. Special acquisitions in this area include: David Smith's stainless steel sculpture *Fifteen Planes*, a gift of the Virginia Wright Fund; Arshile Gorky's *How My Mother's Embroidered Apron Unfolds in My Life* (1944), given by Bagley and Virginia Wright; and Andy Warhol's

Double Elvis, which was purchased with funds from the National Endowment for the Arts. Also in the collection are fine works by Derain, Duchamp, Kirchner, Archipenko, Lichtenstein, and Kelly.

The museum's photography collection has also been significantly enhanced through a National Endowment for the Arts purchase grant and the ongoing generous assistance of Joseph and Elaine Monsen. A strong base is being developed in nineteenth- and twentieth-century photography, which will eventually enable the museum visitor to understand better the importance and impact of photography as a fine arts medium.

The modern art collection is also a major public repository for the arts of the Pacific Northwest and enjoys an unparalled collection of works by Tobey, Graves, and Callahan. Recipient of a major portion of the Mark Tobey estate, the museum is also an important research center for scholars interested in this artist. This aspect of the collection continues to grow through the active solicitation of gifts and purchases.

The museum's collection of pre-twentieth-century European and American painting and sculpture includes about 151 paintings, of which 33 make up the Samuel H. Kress Foundation Collection; 61 examples of European sculpture; and 18 American paintings. Premier pieces from the Kress Collection include Peter Paul Rubens' *The Last Supper* and Giovanni Battista Tiepolo's fresco on canvas, *Glorification of the Porto Family*. Another important European painting is Domenico Ghirlandaio's *The Virgin Adoring Her Child*, a gift of the estate of Ivan Best. Primary works of American painting include Frederick Edwin Church's *Landscape* and John Singer Sargent's *Coming Down from Mont Blanc*.

The museum's collection of Old Master drawings and prints is a small but regionally important collection of European works from the fifteenth to nineteenth century. More that fifty examples of Old Master drawings from seven countries of origin are included in the collection—British, Dutch, Flemish, French, German, Italian, and Spanish. The earliest drawing, and one of the most important, is Martin Schongauer's *The Annunciation*, done early in the artist's career. Other outstanding examples in the drawing collection are Albrecht Altdorfer's *The Lamentation of Christ*, Thomas Gainsborough's *Landscape*, and Théodore Géricault's *Cuirassier on Horseback*. The Old Master print collection includes more than five hundred prints from the same period done by Dutch, Flemish, English, German, French, Italian, and Spanish artists. Strengths of the collection are Dutch seventeenth-century graphic works, including twenty-eight Rembrandt etchings, and fifteenth–sixteenth-century German prints, with fifteen examples of engraving by Albrecht Dürer.

The museum's pre-twentieth-century sculpture collection includes some fine Italian small bronzes, examples of della Robbia, Houdon, Clodion; and several fine pieces of wood sculpture by unknown fifteenth- and sixteenth-century German masters. A primary European piece is Massimiliano Soldani's bronze *Pietà* (c. 1740) from the Kress Foundation Collection.

The museum's decorative arts collection is centered on seventeenth–nine-

teenth-century European and American decorative arts. The collection has particular strengths in eighteenth-century European porcelain. In Continental porcelains, the collection's special emphasis is on Meissen, with major holdings from the following factories: Du Paquier, Höchst, Ludwigsburg, Frankenthal, Limbach, Fulda, and Fürstenberg. There is also a small but excellent representation of pieces from the factories of Ansbach, Kloster, Veilsdorf, Kelsterbach, Volkstedt, Copenhagen, Vegely Berlin, Berlin, Tournai, Strasbourg, Chantilly, Vincennes, and Sèvres. Of English porcelains in the collection, the major holdings are Chelsea, with fine holdings also from the factories of Worcester, Derby, Longton Hall, Liverpool, Plymouth, and Bristol. There are twenty-two seventeenth-century European faience pieces as well, of which twelve are Dutch delftware, and ten are Italian majolica. The decorative arts collection also contains ten pieces of seventeenth–nineteenth-century European earthenware, twenty pieces from the medieval period, and thirty objects from the sixteenth century.

The museum's holdings of Greek and Roman antiquities represented by the Norman Davis Collection, which is displayed in a small permanent gallery at Volunteer Park, are limited but strong in artistic quality and importance. A Cycladic marble figure (c. 2500–2000 B.C.), red- and black-figure-style painted Greek pottery, an Etruscan bronze mirror, and a superb collection of Greek and Roman coins are some of the highlights of this important collection given to the museum by Davis.

The museum's collection of Egyptian art has several hundred objects and covers a span of more than three thousand years. This is the only major collection of Egyptian art on the West Coast outside the University of California at Berkeley. It contains many inscribed objects, including several superb examples of Old Kingdom and early First Intermediate Period stelae. The collection's holdings of Late Period bronzes are also important. Perhaps the most significant object in the Egyptian collection is the large granite *Head of Amun*, from the eighteenth dynasty, New Kingdom.

The museum's Islamic collection includes art from Turkey, Syria, Iran, and other countries of what is generally described as the Middle East, dating since the seventh century. There are 251 objects in this collection, of which the rarest and most valuable is the ninth-century blue-dyed vellum *Qur'an* page with gold Kufic calligraphy. Other key pieces in the collection include a pottery bowl with Kufic inscription from northeast Iran (tenth century); a gold bracelet from west Iran (tenth century); an open-work and engraved Persian bronze lampstand (twelfth-thirteenth century); a Syrian glass mosque lamp from the first half of the fourteenth century; a tile panel from the Haft Dasht Palace in Isfahan, Iran (seventeenth century); and a glorious miniature by famed Persian artist Riza 'Abbasi (seventeenth century).

The museum's art reference library holds more than twelve thousand books, four thousand exhibition catalogues, fifty journals and other serials, and a range of clippings. The museum's slide collection contains more than seventy-two thousand slides that document general art history and the museum's collections.

Both the library and the slide collection are open to the public. In fact, the slide collection is the Northwest's only such collection of its kind that loans to the public at no charge.

Selected Bibliography

Museum publications: *Asiatic Art in the Seattle Art Museum*, 1973; *Japanese Art in the Seattle Art Museum*, 1960; *Korean Ceramics in the Seattle Art Museum*, 1957; *Old Master Drawings: Seattle Art Museum Collection Guide*, 1980; *Samuel H. Kress Collection: Italian Art*, 1952; *African Mask and Muses: Selections of African Art at the Seattle Art Museum*, 1977; *American Art: Third Quarter Century*, 1973; *American Photographs: Past into Present; Prints from the Monsen Collection of American Photographs*, 1976; *China's Influence on American Culture in the 18th and 19th Centuries*, 1976; *Greek Coins and Cities*, 1967; *Near Eastern Civilization through Art*, 1977; *Northwest Traditions*, 1978; *The Old Masters, 1475–1875: An Exhibition of Prints from the Collections of Albert A. Feldman and the Seattle Art Museum*; *Song of the Brush: Japanese Paintings from the Sansō Collection*, 1980; *Treasures of Asian Art from the Idometsu Collection*, 1981; *Yo Nō Bi: The Beauty of Japanese Folk Art*, 1983.

—————— Toledo ——————

TOLEDO MUSEUM OF ART, THE, 2445 Monroe Street, Toledo, Ohio 43697.

The Toledo Museum of Art was founded by Edward Drummond Libbey and other community leaders in 1901. As the head of the New England Glass Company, which he moved to Toledo in 1888 and renamed Libbey Glass Company, Libbey was one of America's most successful glass manufacturers. The first meeting for organization of The Toledo Museum of Art was held on the evening of April 10, 1901, with the first exhibition opening to the public on December 2, 1901. From the year of its founding until his death in 1925, Libbey served as the museum's first president. For many years thereafter, the museum was principally funded by Libbey's estate, which stipulated that a minimum of half of the estate income must be used for acquisitions, so that only up to one-half could be used for the operations of the museum. Additional support comes today from gifts, bequests, museum memberships, and government grants for special projects. Other early benefactors included Libbey's wife, Florence Scott Libbey, and Arthur J. Secor and Nettie Poe Ketcham. During those early years the museum's program included special exhibitions, studio art classes, and musical programs in addition to the growing permanent collection. The imposing museum building was constructed in three stages: 1910 to 1912, 1924 to 1927, and 1930 to 1932. The building is located on the site of the homestead of Mrs. Libbey's family, and the campaign for funds for the first phase of the building program was launched by Mr. Libbey's challenge of one-half of the cost of the building

program. The second phase amplified that which was accomplished earlier and included the expansion of the hemicycle into an auditorium. In the early 1930s, at the height of the Depression, spatial needs were already becoming acute, and Mrs. Libbey pressed for a building schedule that would assist economically hard-hit construction craftsmen and their families. Much space was left unfinished in anticipation of future needs and a 750-seat peristyle was included for a growing music program. The dedication of these completed wings took place in the Museum Peristyle on January 10, 1933, with an inaugural concert by the Philadelphia Orchestra, Leopold Stokowski conducting. All three building programs were designed by Edward B. Green, the Buffalo architect who also designed the Albright-Knox Art Gallery in Buffalo and the Dayton Art Institute, with the assistance of Harry W. Wachter of Toledo.

In the past fifty years the museum's grounds have been expanded to include a park across Monroe Street and one east of the Peristyle, so that almost twelve acres of land surround the museum.

A recent renovation project provides the museum with a new entrance on the Grove Place side of the building, a lobby, and public amenities on the ground floor. About seventy-five hundred square feet of special exhibition galleries have been added to the main floor. The two levels are linked by a new main staircase. The architect was the New York firm of Hardy, Holzman, Pfeiffer Associates. This renovation has been funded by gifts from individuals and foundations that were used to match a challenge grant from the National Endowment for the Arts.

In 1949 the Junior League developed the museum's first volunteer group to provide tours to school groups and adult visitors. Since 1969 the docents have been administered by the museum. These volunteers have introduced hundreds of thousands of visitors to the museum's permanent collection and special exhibitions. The Art Museum Aides conduct the museum's fall campaign for new members, serve as hostesses at museum special events, and operate the Collectors Corner. The Art Museum Friends are membership campaign workers who secure five or more new members during any one year. The Performing Arts Committee advises the museum on programs in the performing arts and promotes sales of tickets to the Museum Peristyle events, which feature internationally prominent orchestras, performing artists, and dance companies.

The museum is governed by a board of trustees that operates through Executive, Finance, Art, and Endowment Development committees. Under the leadership of its director, the staff is administered through several department heads: assistant to the director, comptroller, manager of personnel and administrative services, chief curator, assistant director for education, librarian, supervisor of music, and manager of building and security services.

The museum's comprehensive collection is considered to be among the foremost in the United States in quality. The museum was one of the first in America to combine sculpture, furniture, and other decorative arts in the same galleries with paintings.

The museum's collection of ancient art of the Mediterranean basin concentrates

on four areas: Egypt, the Ancient Near East, Greece, and Rome. The Egyptian collection, begun in 1901, contains objects from the Upper Palaeolithic period (20,000–15,000 B.C.) to the end of the period of Roman domination in the third century A.D. Of special note among these objects are two Old Kingdom limestone reliefs from the mastaba of Akhet-hotep in the Northern Cemetery at Sakkara (early Dynasty IV, 2680–2560 B.C.) and limestone statues of Rerem, an official of Dynasty VI (2420–2280 B.C.), and Rerem and his wife, Amphet, excavated by the Harvard University-Museum of Fine Arts (Boston) Egyptian Expedition. A limestone stele of the early First Intermediate Period (about 2200 B.C.), showing Zezen-nakht, overseer of the army of Pepy II, retains much of its original polychrome paint and is among the best-preserved monuments of this period outside Egypt.

The Toledo collection is strong in works of art of the New Kingdom, particularly Dynasties XVIII and XIX. Highlights of these objects include three diorite statues of Sekhmet dedicated by Amenhotep III to the Temple of Mut at Karnak, a sunk-relief portrait of Akhenaten from Tel el Amarna, and a limestone manger with a relief of two onyx antelopes from the North Palace at Amarna, excavated by Sir Flinders Petrie and assigned to Toledo by the Egypt Exploration Society. A Dynasty XIX relief from the tomb of Amenhotep, scribe lector priest and physician to Rameses II, at Dier Durunka, near Asyut, is a particularly fine example of the Ramessid style.

The most impressive Egyptian sculpture at Toledo is a black granite sculpture of the pharaoh Tanwetamani (664–653 B.C.) from the Great Temple of Amen at Gebel Barkal. This monumental statue is one of only three known representations of this Dynasty XXV king and ranks as one of the outstanding examples of sculpture from Egypt's Late Period (1085–332 B.C.). Toledo's portrait of a woman from the Roman Period, painted in tempera on a linden wood panel, from the lake of the Fayum, is among the most insightful portraits to survive from the ancient world.

The museum's collection of works of art from the Ancient Near East is small, although distinguished. The most important objects include a Sumerian alabaster head of a turbaned worshiper from Khafaje, Mesopotamia (third millennium B.C.); reliefs from the palaces of the Assyrian kings Ashurnasirpal II (860–855 B.C. [Kalah]), Sennacherib (704–681 B.C. [Nineveh]), and Ashurbanipal (668–627 B.C. [Nineveh]); and numerous objects of ceramic, stone, bronze, and gold from the excavations of the Parthian site of Tel Umar, Selucia (Iraq), conducted jointly by the museum, The Cleveland Museum of Art, and the University of Michigan between 1927 and 1930.

Outstanding in the collection of ancient Greek art at Toledo is its acclaimed collection of Greek vases, which outlines the development of ceramics in the Aegean world from Mycenaean period in the fourteenth century B.C. to the time of Alexander the Great. Among some 250 vases is a Lakonian amphora of about 560 B.C. by the Naukratis Painter, the only vessel of this shape known to survive from ancient Sparta, and a lidded black-figure Athenian amphora of about 550–

530 B.C. signed by the potter Exekias. Also noteworthy are Toledo's collection of Corinthian vases, examples of Athenian red-figure wares by masters such as Makron, the Triptolemos Painter, and the Foundary Painter, and vases from the Greek colonies of Southern Italy. The painter of a set of three fourth-century Gnathia vases at Toledo from Apulia has been named "The Toledo Painter."

Greek metalwork includes examples of statuettes and vessels from Archaic to Hellenistic times. A bronze hydria of the fifth century B.C., an elaborate drinking cup of silver and gilded silver, and a large silver kalpis from Macedonia are among the most remarkable vessels of their respective periods.

Roman art is principally sculpture. A life-size bronze statue of a youth dated about 50 B.C. shows strong influences of the work of the fifth-century B.C. Greek sculptor Polyclitus and is among the most outstanding works of Classical sculpture in America. Marble portrait busts of Emperor Lucius Verus and his wife, Lucilla, daughter of Marcus Aurelius, date from the second half of the second century A.D. and are particularly fine examples of Antonine portraiture. Roman metalwork from Syria includes a unique silver parade helmet of the mid-first century A.D. and an unusually large second-century silver statuette of the goddess Isis-Fortuna, dating from about A.D. 150–230.

The greater part of the medieval collection is housed in the Cloister. Included are important medieval objects such as a fourteenth-century French ivory with scenes of the Passion; a thirteenth-century gilt-bronze, enamel, and gem-encrusted reliquary base from Trier, Germany; late-fifteenth-century Flemish tapestries with vineyard scenes; and a French (Troyes) early-sixteenth-century limestone Virgin and Child.

The museum has collected extensively Italian Renaissance paintings, with some of the more important works being Pesellino's *Madonna and Child with St. John* (c. 1455); Piero di Cosimo's *Adoration of the Child* (1490); two rare Signorelli panels, *Figures in a Landscape* (1498); and a della Robbia glazed-terracotta *Madonna and Child*. A major acquisition in 1964 was *Ulysses and Penelope* (c. 1560) by Primaticcio, among those primarily responsible for establishing the Mannerist Fontainebleau style. Flemish Renaissance painting is represented by Jan Gossaert, called Mabuse, *Wings of the Salamanca Triptych* (1521), and French and German Renaissance portrait painting by Clouet, *Elizabeth of Valois* (1556), and Hans Holbein the Younger, *A Lady of the Cornwell Family* (c. 1535–40). A particularly important example of sixteenth-century Mannerism is the El Greco *Christ at Gethsemane*.

Seventeenth- and eighteenth-century Baroque masters of Italy, Spain, and France are represented by Mattia Preti's *Feast of Herod*, considered to be one of the most important Baroque paintings in America; Guido Reni's *Venus and Cupid*; and Valentine de Boullogne's *Fortune Teller with Soldiers*. Murillo's *Adoration of the Magi* (c. 1655–60) and Jusepe de Ribera's portrait *Giovanni Maria Trabaci, Choir Master, Court of Naples* are significant Spanish Baroque works. Among the important eighteenth-century Italian paintings in the museum are Solimena's *Heliodorus Expelled from the Temple*, Pellegrini's *Sophonisba*

Receiving the Cup of Poison, Sebastino Ricci's *St. Paul Preaching*, and Canaletto's *The Riva degli Schiavoni, Venice*.

Flemish and Dutch painting of the seventeenth and eighteenth centuries is considered a particular strength of the Toledo Museum of Art. The museum owns the impressive *Crowning of St. Catherine*, which many scholars consider to be the finest Rubens of a religious theme in the United States. There is also a fine Anthony van Dyck, *Portrait of a Man*. The museum owns an outstanding Flemish cabinet of the period done in ebony, tortoise-shell, ivory, and gilt-bronze. The Dutch paintings of the seventeenth and eighteenth centuries include paintings by de Heem, van de Velde, van Goyen, van Ruysdael, de Hooch, Hobbema, and Ruysch. *The Music Lesson* by Ter Borch was once in the collection of Catherine the Great. The museum has a fine Avercamp, *Winter Scene on a Canal*, and a rare group portrait by Thomas de Keyser, *The Syndics of the Amsterdam Goldsmiths' Guild*, the only such portrait outside the Netherlands. Maes' early masterpiece *The Happy Child*, Cuyp's *The Riding Lesson*, and Rembrandt's *Young Man with Plumed Hat* and *Old Man in a Fur-Lined Coat* are also included in this world-famous part of the collection. The museum has an extensive collection of works, primarily drawings by Anton Mauve, a leading member of the nineteenth-century Dutch Hague school. In the galleries, the museum also displays Dutch cabinets containing delftware and glass and a cabinet organ from the late eighteenth century attributed to Johannes Strumphler.

Seventeenth-century French classicism is represented by Poussin's *Mars and Venus* and *The Holy Family with St. John*, Michel Anguier's sculpture *Amphitrite*, and Claude Lorrain's *Landscape with Nymph and Satyr Dancing*.

Eighteenth-century French painting at the museum is greatly enhanced by a particularly important David, a smaller version of his *Oath of the Horatii*. There are also fine examples by Watteau (*La Conversation*, 1712–15), Fragonard (*Blind-Man's Buff*, 1750–52), and Boucher (*The Mill at Charenton*, 1758, and *The Footbridge*, 1760). In addition, galleries adjacent to the seventeenth- and eighteenth-century French galleries have exceptional examples of French enamels, silver, and porcelain.

The eighteenth- and nineteenth-century English gallery include portraits by Hogarth and Hoppner, as well as paintings by Reynolds, Lawrence, Raeburn, and Constable. Works of particular note include Gainsborough's *The Road from Market* and one of Turner's masterpieces, *The Campo Santo, Venice*.

In 1912 Florence Scott Libbey, wife of Edward Drummond Libbey, dedicated the Maurice A. Scott Gallery in memory of her father. The gallery was intended to show the historical development of American painting. The museum's collection of eighteenth-century American portraiture is noted for its works by Smibert, Feke, and Greenwood, as well as Gilbert Stuart's *Portrait of John Ashley* and *Commodore Oliver Hazard Perry*, John Singleton Copley's *Young Lady with a Bird and Dog*, and Earl's *The Taylor Children*. The gallery displays, too, a large sideboard from the John and Thomas Seymour workshop, a pair of Duncan Phyfe chairs, and an eighteenth-century silver tankard by Myer Myers.

The Hudson River School is represented by Thomas Cole's monumental *Architect's Dream*, as well as Doughty's *View of the Hudson Near Cornwall*, Cropsey's *Starrucca Viaduct, Pennsylvania*, and two Sanford Giffords. The collection also includes a painting of particularly local interest, Harnett's *Still Life with the Toledo Blade* (1886), which was a gift of Mr. and Mrs. Roy Rike. The collection of nineteenth-century paintings includes Homer's first seascape, *Sunlight on the Coast*; William Hunt's portrait *Francisca Paim da Terra Brum da Silveira*; two portraits by Eakins; and Childe Hassam's *Rainy Day, Boston*. John La Farge is represented by eight South Seas watercolors and more than forty drawings bought from his 1911 estate sale. Through the bequest of Arthur J. Secor, the museum received paintings by Hunt, Inness, Wyant, Chase, Sargent, Blakelock, and Dangerfield.

The museum has a notable collection of Barbizon paintings, three Rousseaus, and a remarkable painting by Jean-François Millet, *The Quarriers*. The museum also owns significant paintings by Delacroix, Courbet, Manet, and Tissot. French Impressionist and Post-Impressionist paintings include works by Renoir, Degas, Monet, Cézanne, Gauguin, and van Gogh.

Twentieth-century and contemporary painting at the Toledo Museum of Art is a growing collection of works by major artists, including a Blue Period Picasso gouache and paintings by Matisse, Mondrian, Braque, Bonnard, and Modigliani. The museum continues to collect American post-war paintings and has been aided by gifts from the Toledo Modern Art Group and private patrons. Among the artists with significant paintings exhibited are Rauschenberg, Rothko, De Kooning, Kitaj, Stella, and Gottlieb. Twentieth-century sculpture includes a Calder mobile, a Henry Moore *Reclining Figure* in bronze, and a red painted-steel sculpture by Anthony Caro. The museum owns a distinctive rocking chair designed by Carlo Bugatti and has a notable collection of the works of Richard Estes, the painting *Helene's Florist* (1971) and eight screenprints from his series *Urban Landscapes No. 2*.

The Cloister is composed of three French arcades dating from the mid-twelfth to the late fourteenth century, acquired in 1929 and installed in 1933. The room (1640) from the Chateau de Chenailles is decorated with painted panels depicting scenes from the story of Rinaldo and Armida. It came from the Loire Valley near Orleans and was the gift of Mr. and Mrs. Marvin S. Kobacker. Three adjacent octagonal galleries display precious European metalworks, enamels, glass, ceramics, and jewelry from the sixteenth through the eighteenth century. Some of the rare and special pieces include a Renaissance pendant of a Neptune with a large baroque pearl forming the torso, a Nereid centerpiece from the famous Meissen swan service, and two rare French silver-gilt toilet services.

The Toledo Museum of Art is internationally famous for its glass collection. The museum has more than sixty-five hundred pieces of glass and is particularly strong in the fields of Roman cast and blown glass, Islamic enameled glass, nineteenth-century American pressed glass, and Libbey cut glass of the late nineteenth and early twentieth centuries. The collection has been built from the

purchase or gifts of the collections of Campe, Barber, McKearin, Duckworth, Curtis, Neuburg, and Owens-Illinois. The glass collection is exhibited in two locations in the museum. The Art in Glass Gallery, a gift of Mr. and Mrs. Harold Boeschenstein in 1970, contains more than nineteen hundred pieces of glass from all periods and is arranged chronologically from 1500 B.C. to the present. At the entrance to the gallery is a glass mural created by one of the leaders of the revival of the studio glass movement, Dominick Labino. The John D. Biggers Glass Study Room opened in 1975 and was a gift of Libbey-Owens-Ford and the National Endowment for the Arts. The Study Room displays more than forty-five hundred pieces of glass and has easily accessible documentary information available. In the autumn of 1969, the museum became the first institution to construct a building and studio for the teaching of glass blowing. The Glass Crafts Building contains studio space for metalsmithing, sculpture, glass blowing, and ceramics. It was a gift of the Owens-Corning Fiberglass Corporation, Libbey-Owens-Ford Company, and Owens-Illinois, Inc.

A rapidly growing part of the museum's collection, the graphic arts, including prints, photographs, drawings, and illustrated books, are featured in numerous exhibitions in the Print Galleries and are available for individual and class study in the Grace J. Hitchcock Print Study Room.

The print collection, a virtual survey of the history of printmaking, includes particularly rich holdings of the work of Rembrandt, Dürer, Goya, and Meryon and of eighteenth-century Italian printmakers and eighteenth-century English mezzotint engravers. Many recent acquisitions bring the art of printmaking into the present day.

The museum has early-twentieth-century Photosecession photographs, as well as representative examples of American photography since World War II. To be found in the small drawing collection is a fine survey of British eighteenth-century watercolors.

Beginning with the first director, George W. Stevens, the museum traditionally has collected books and manuscripts. Selections from this collection are on view in the Stevens Gallery and trace the history of the written and printed word from cuneiform (the cylinder of Nebuchadnezzer) and hieroglyphics (an Egyptian stele) to the modern book, including examples of printing by Gutenberg, Jenson, Caxton, and Morris. The museum has further added major twentieth-century books illustrated by Matisse, Miró, and Maillol, among others, and an important collection of Dada and Surrealist books.

The museum began collecting African art in 1958. By 1972 the collection had grown to such an extent that a gallery was devoted to African art. The collection includes masks, figures, textiles, and metalwork from fifteen tribes. Particularly outstanding are an Epa Society headdress by Areogun of the Yoruba tribe, and ivory female figure by the Owo tribe, a Bakota janiform reliquary figure, a fetish figure of the Basogne tribe, and a Fang spirit mask that once belonged to the artist Maurice Vlaminck.

The Oriental collection at Toledo includes examples of works in various media from China, Japan, Korea, Cambodia, and India. Noteworthy are Chinese bronzes

of the Chou period, T'ang Dynasty ceramic sculpture, Japanese lacquers, Cambodian stone sculpture, and an Indian bronze statue of Parvati from Tanjore, dating from the late twelfth or early thirteenth century A.D.

Since 1903 the museum has offered free art classes for children. It is the largest and first free program of its kind in the world, offering Saturday classes to thirteen hundred children from the second grade through high school. Florence Scott Libbey gave special endowments to build music education programs, which began in 1917 with music appreciation for fifteen hundred children each Saturday. Through the Saturday music and art classes and tours for schoolchildren given by more than eighty volunteers, the museum reaches more than fifty thousand children each year. The concert programs include the Peristyle Series, Sunday free concerts, and Friday noon Gallery Gigs by musicians of the area. The Toledo Museum of Art has had a unique association with the University of Toledo since 1920 and offers three baccalaureate programs in art in the College of Arts and Sciences and two degrees in the College of Education. The museum also offers adult daytime and evening courses for more than three hundred adults annually. Timeframes, an adult lecture series, attracts as many as one thousand participants. There is also an active outreach program featuring corporate lectures, area membership groups, and a speakers bureau.

The Museum Library is open to the public and lends to museum members, Museum School of Design students, staff and visiting scholars. The library contains about forty-five thousand books, catalogues, and bound periodicals and maintains vertical files on artists. A separate slide department maintains more than twenty-five thousand slides.

The Museum Bookstore sells museum publications, art history books pertinent to the collection, and quality reproductions.

Selected Bibliography

Museum publications: "Toledo Museum News," quarterly, o.s., 1907; n.s., 1957 to date; *Art in Glass: A Guide to the Glass Collections*, 1969; *Corpus Vasorum Antiquorum*, 1976; *The Toledo Museum of Art: A Guide to the Collections*, 1976; *European Paintings*, 1976; *American Paintings*, 1979.

Other publications: Barclay, Morgan J., *The Toledo Museum of Art and the Urban Community, 1901–1912* (Master's thesis at the University of Toledo), 1972; Schulze, P., "Consistently Discriminating Connoisseurship," *Art News* 76 (April 1977), pp. 64–67; Strickler, S. E., "American Paintings at The Toledo Museum of Art," *Antiques* 116 (November 1979), pp. 1110–19; Sutton, D., "Otto Witmann and Toledo," *Apollo*, n.s. 105 (April 1977), p. 307; "Treasures of Toledo, Ohio," *Apollo*, n.s. 86 (December 1967), pp. 414–512.

JULIA F. BALDWIN

——— Washington, D.C. ———

DUMBARTON OAKS LIBRARY AND COLLECTION (includes ROBERT WOODS BLISS COLLECTION OF PRE-COLUMBIAN ART; alternately DUMBARTON OAKS), 1703 32nd Street, N.W., Washington, D.C. 20007.

The Dumbarton Oaks Library and Collection, its buildings and gardens, as well as collections and libraries, were formally conveyed to Harvard University by its founders Mr. and Mrs. Robert Woods Bliss in November 1940. The institution serves as a center for scholarly research and publication in the humanities in the following fields: Byzantine studies, pre-Columbian studies, and the study of the history of landscape architecture.

Dumbarton Oaks and its grounds were acquired by Mr. and Mrs. Bliss in 1920. The simple brick Georgian style mansion was built in 1801 for William H. Dorsey. Its shell is incorporated in the present structure, which underwent major reconstruction in 1923 from architectural designs by Frederick H. Brooke. Extensive alterations and additions were required to house the collections of the founders and to carry out their plans for libraries and offices necessary for the time when Dumbarton Oaks was to be handed over to Harvard. A wing that houses the Garden Library was added and completed in 1963, after a design by Frederick Rhinelander King. The pavilion for the pre-Columbian collection, designed by Philip Johnson, was opened to the public in 1963, and the Byzantine collection became a museum about 1946.

Aside from scholarly research and activities, music also plays an integral part at Dumbarton Oaks. Mr. and Mrs. Bliss' fondness for music prompted them to add a large Italian Renaissance-style music room and initiate a concert series that continues to the present under the auspices of the Dumbarton Friends of Music.

Dumbarton Oaks is governed by the Trustees for Harvard University and supported by an endowment donated by Mr. and Mrs. Bliss. The administration is headed by a director. There are separate directors for each of the centers of study; a curator for the Byzantine collection, another one for the pre-Columbian collection, and librarians for the libraries for these departments; and a librarian for the Garden Library.

Dumbarton Oaks consists of three departments: the Center for Byzantine Studies and its collection, the largest of the three; the Pre-Columbian Center and collection; and the Studies and History of Landscape Architecture with its Garden Library. They represent the chief interests of its founders.

The Byzantine collection and Center of Studies offers students what are undoubtedly the most comprehensive and complete facilities in the field in the world today. The collection itself illustrates the arts of Byzantium (326 to 1453) and also includes objects relevant to the period, its antecedents, and examples from countries adjacent to the empire. Thus one finds, side by side, works from Byzantium and those of Classical Greek, Roman, Hellenistic, and Persian and Near Eastern origin. The present installation, designed in 1965, displays sculpture, silver, metalwork, ivories, mosaics, manuscripts, glass and pottery, jewelry, and glyptics, with some paintings and textiles.

Mr. and Mrs Bliss began to focus their interest on the Byzantine field after lending some important pieces they already owned to the Exhibition of Byzantine Art in Paris in 1931. By that time, they already had acquired some of the fine silver pieces that are the outstanding feature of the collection. A large sixth-

century silver paten with Apostles in gilded repoussé is one of several fine examples; others are a Sassanian repoussé bowl, various fragments of Byzantine crosses, a fragment of a bowl with a Bacchic procession from Asia Minor, and a remarkable group of gold and silver jewelry dating from the fourth to seventh century.

Ivories, manuscripts, and enamels represent the middle period (ninth-twelfth century). Some of the finest achievements of Byzantine art are exemplified by two miniature fourteenth-century mosaics, *Forty Martyrs of Sebaste* (formerly at the Monastery of Mount Athos) and *St. John Chrysostom*, representing the late period.

The holdings of illuminated Byzantine manuscripts and manuscript fragments comprise just three intact volumes and three single leaves, the latter having a fascinating history as courtly gifts. Among them is the *Catherine Comnene Lectionary*, an almost foot-high tempera portrait of the Evangelist Mark, dated 1063 and given to the Monastery of Chalki by Empress Catherine Comnene.

Jewelry of gold and semiprecious stone is distinguished by fine workmanship and fine condition. The *Olbia Treasure* (late fourth-fifth century) is a twelve-piece set, inlaid with garnets. The so-called *Piazza della Consolazione Treasure* (early fifth century) found in Rome in 1910, is a combination of gold, pearls, emeralds, and sapphires. Unusual is the gold *encolpium* (pendant) with Virgin and Child, commemorating the baptism of Theodosius (584). Other examples are from Egypt, such as an early-seventh-century necklace with a pendant depicting Aphrodite.

Among the glyptics, a twelfth-century Byzantine cameo in bloodstone with a bust of the Virgin is outstanding. Others are in carnelian, quartz, crystal, and amethyst from a variety of sources.

Ivories are fashioned into caskets, figurines, boxes, and plaques, mostly Egyptian and Byzantine, including a tenth-century carving, the *Virgin between St. John and St. Basil*, which is of particularly fine quality. A relief depicting St. Constantine also dates from the same period.

The group of Greek, Roman, and other antiquities, relevant to the Byzantine holdings, comprises objects ranging from the fifth century B.C., such as limestone reliefs of Achaemenian origin from the palace of Darius in Persepolis, to the exceptionally large (2.24 meters by 1.16 meters) *Barberini Sarcophagus* from the early fourth century A.D., depicting the then very fashionable theme of the four seasons. An interesting bit of research went into the marble revetement (facing) fragment with a relief carving of an antelope from the Syrian sixth-century *Rivers of Paradise*. Its counterpart was discovered at the Baltimore Museum (q.v.). The two pieces, fitted together, are now shown on a rotating basis by both museums.

The assemblage of bronzes commences with a Scythian pectoral and an Achaemenian oil lamp. Classical in origin are the statuette of Hephaistos (Greek, 460 B.C.) and the small (11.5 centimeters) bronze of an emancipated man (Rome, first century A.D.).

Glass and ceramics date from the sixth century B.C., with an Athenian terracotta

amphora and a blue glass cameo of Augustus from the first century B.C. Enamels from Byzantium, as well as Russia and Egypt and the Near East, are shown in the form of jewelry, medallions, and frames, some in cloisonné, such as a reliquary cross, dated from the twelfth to thirteenth century and found in Salonika.

From Antioch excavations of the 1930s, several mosaic pavements from this late Roman-early Byzantine city have been installed in the wing housing the collection. Fourth–sixth-century hunting and fishing scenes are set into the floor and walls and can be seen in the open courtyard of the wing. Textiles are mostly fragments and include examples such as the eighth-century silk twill tapestry known as the *Elephant Tamer* and the large Coptic wool tapestry of Hestia Polyolbos.

Since 1948 Dumbarton Oaks has owned a superb collection of Byzantine coins, numbering about 11,600, acquired from the Heyford Pierce Collection. In addition, the collection includes the largest group of lead seals and sealings and 8 fine Byzantine gold seals.

Of special importance is the Dumbarton Oaks Music Room, where the first meetings that led to the establishment of the United Nations took place in 1940. The Italian Renaissance room with its carved, coffered ceiling, and French Renaissance chimney piece provides the setting for some European paintings, furniture, sculpture, and Flemish tapestries. There hangs El Greco's *Visitation* and the early Florentine *Madonna and Child* by Bernardo Daddi. Among the sculptures is a late-fifteenth-century wood carving by Tilman Riemenschneider, a T'ang stone head of Buddha, and an Egyptian cat. Most of the furniture is of Italian and Spanish sixteenth- to seventeenth-century origin. This room is also used for the concert series held at Dumbarton Oaks by its Friends of Music.

Bliss purchased his first pre-Columbian artifact, a small Olmec figurine, in 1912, but most of the collection of about six hundred objects was assembled between 1940 and 1960. In 1947 the collection was placed on exhibition at the National Gallery of Art, where it remained until the newly completed pavilion for pre-Columbian art was opened to the public in December 1963. This pavilion, unique in design with its eight cylindrical glass pavilions ranged around an open circular fountain court, was designed by Philip Johnson. In this setting, surrounded by greenery, the objects are displayed on plexiglass shelves and pedestal that make them appear as if suspended in mid-air. About two-thirds of the collection is on view, arranged according to periods and cultures.

Earliest are the Olmec (1200 B.C.) figurines and jadeite masks. The great Classic period is well represented. From Teotihuacán there are a mural, carved stone masks and pottery; the Maya civilization is exemplified by charming pottery figurines, pottery, and delicate ornaments in jade and shell. Typical are the painted clay pottery pieces of Michoacan origin from the coastal region of Peru. The same country produced the magnificent, beautifully preserved textile in the form of a robe, an inlaid shell pendant, and a mosaic mirror.

Hachas and other game equipment are from Vera Cruz. From the Mixteca Puebla culture of Oaxaca there is a display of splendid cast-gold jewelry. New acquisitions are some rare examples of gold work from Peru from the early

Chavín civilization in the form of a hammered feline figure and three Inca figurines. A wide variety of gold objects also originated in Costa Rica. Other pieces are the cast-gold ornaments, gold pendants cast in the lost-wax process from Panama, and examples from Colombia and the Canal Zone. From the Aztecs, just before the time of the Conquest, there are stone sculptures and animal-shaped effigy jars. The objects in gold, silver, bronze and copper, and stone and the textiles range in date from the very early Chavín civilization to the last pre-Columbian people in Peru, the Incas.

The three programs of study and research allow Dumbarton Oaks Fellows, who are selected by a rotating committee, advanced graduate or doctoral studies lasting one or two years, with research at the libraries, as well as colloquia, discussions, and publication of papers, as part of the program. At the Byzantine Study Center research is carried on in art, history, literature, theology, liturgy, music, and law. Furthermore, field work in Istanbul and elsewhere has been carried out by Dumbarton Oaks since the early 1950s. A regular part of the program is the publication of the *Dumbarton Oaks Papers* (since 1941) and the *Dumbarton Oaks Studies* and *Dumbarton Oaks Texts*.

Further research aids are a card index listing every title in the bibliographies on Byzantine culture and the photographic copy of the *Princeton Index of Christian Art*. The Byzantine Library contains about eighty-five thousand volumes, thirty-eight thousand photos, seventy-five hundred slides, seven hundred periodicals, and microfiche and microfilms of literature relevant to research. The library is available by special permission only. The Pre-Columbian Library has about ten thousand volumes, forty-three hundred slides, and thirty-eight hundred black-and-white photographs.

Planning the magnificent Dumbarton Oaks Gardens inspired Mildred Bliss to establish a library that would extend the interests of scholarship at Dumbarton Oaks to include the field of garden design and landscape architecture. The library covers a period of more than four centuries and contains materials of concern to historians of garden design and architecture.

The special collection of twenty-four hundred rare books and incunabula such as early herbals and rarities like the folios of Pierre Joseph Redouté and some of his original watercolors are in closed cases. In addition, there are several thousand books, pamphlets, bound manuscripts, and periodicals in open stacks for research needs.

The rare book room, with its lovely French furnishings, also serves as a gallery for a small group of French Impressionists and American paintings. Included are the Degas *Répétition de Chant*, a Renoir pastel, and the early Seurat *Portrait Head*. American Impressionists such as Childe Hassam and John Twachtman are also represented. There are also works by Matisse and Picasso, a still life by Redon, and a group of paintings by the turn-of-the-century Belgian artist Alfred Stevens. The library mounts special exhibits and is open to the public on weekends, whenever possible.

Generally considered the finest in the country, the Dumbarton Oaks Gardens

are a monument to the efforts of Mildred Bliss. After the house was completely remodeled, the grounds with their multiple-terraced, separate gardens began to take shape under the direction of landscape architect Beatrix Farrand. Inspired by French and Italian garden architecture of the seventeenth and eighteenth centuries, the carefully planned plantings, chosen to afford beauty year-round, become more informal as the gardens recede from the house. A multitude of sculptures, urns, benches, fountains, and balustrades were individually designed for the gardens.

Handbooks and books related to the collections, postcards, and jewelry reproductions are on sale at the entrance.

Selected Bibliography

The Dumbarton Oaks Collection Handbook, 1955; *Handbook of the Robert W. Bliss Collection of Pre-Columbian Art*, 1963; *Handbook of the Byzantine Collection*, 1967; *Dumbarton Oaks Colloquium on the History of Landscape Architecture*, 1976; Masson, Georgina, *Dumbarton Oaks: A Guide to the Gardens*, 1968; Richter, Gisela M. A., *Catalogue of Greek and Roman Antiquities at Dumbarton Oaks*, 1956; Vikan, Gray, *Gifts from the Byzantine Court*, 1980; "An Introduction to Dumbarton Oaks," reprinted from the *Harvard Library Bulletin*, vol. 19, nos. 1 and 2 (January and April 1971).

RENATA RUTLEDGE

FREER GALLERY OF ART (also THE FREER), Mall, South Side at 12th Street, S.W., Washington, D.C. 20560

The reason for the establishment of the Freer Gallery of Art was its founder's desire to make his important Oriental collections available to the people of the United States and to promote and encourage continuing research into the civilizations that produced the objects in his collection.

Its founder, Charles Lang Freer, prophetically recognized the aesthetic and spiritual significance of the art of the Orient and the impact it was to have on the West. Thus he accumulated some of the most meaningful examples of that art and added another dimension to his collecting by including the works of Whistler and some of his contemporaries who had come under the influence of the Orient.

Visualizing the Gallery not only as a place for aesthetic enjoyment but also as a major research institution, he provided for a center devoted to scholarship, research, and conservation related to his collections.

The Freer Gallery, its building, and an endowment were given to the American people by Charles Lang Freer, a retired railroad magnate. He first offered this generous gift in a letter to President Theodore Roosevelt in 1905. It was officially accepted by the regents of the Smithsonian Institution on behalf of the United States government with a Deed of Gift, executed on May 5, 1906. In accepting the gift, the government agreed to care for and maintain the Gallery and its contents at public expense. Freer stated in the first paragraph of the deed that "the building shall be constructed and equipped by the said Institution with

special regard for the convenience of students and others, desirous of an opportunity for uninterrupted study of the objects embraced thereunder.''

Freer was the first American to donate to the nation his private art collection with a building to house it and an endowment to provide support for its programs. The bequest contains several specific stipulations. The endowment income was to be used to add works of art of the highest quality to the Oriental holdings only, subject to approval by the secretary of the Smithsonian Institution, by members of the National Commission of Fine Arts, and, during their lifetime, by four personal friends (now deceased). Other specific activities covered by the endowment included the program to be designed for the study of civilizations of the Far and Near East. Thus the Freer Training Program for graduate students was created through a fund specifically bequeathed to the University of Michigan for the widening of knowledge and appreciation of Oriental Art, in aid of research to be conducted by experts, and for the publication of the results of such research.

Loans to and from the collections were specifically forbidden by the terms of the deed and objects once incorporated in the collection could never be removed. Also, under the terms of the deed, Freer could keep his collection during his lifetime. Only after his death was it to be moved to Washington and placed in a building on the Mall to be designed and erected in accordance with his wishes.

Serenity and dignity characterize that building, lovingly planned in collaboration with the architect Charles A. Platt of New York. Constructed of Stony Creek granite, it is designed in the style of a Florentine Renaissance palace. The eighteen exhibition galleries, organized according to specific cultures and periods, and the Whistler Peacock Room are all on the main floor, surrounding an open, landscaped court. The lower floor, at ground level, contains the library, offices, study and storage rooms, laboratories, and auditorium. The building construction was completed in the spring of 1921, eighteen months after the founder's death, and it opened to the public on May 2, 1923.

The Freer is governed by the Board of Regents of the Smithsonian Institution under the office of the assistant secretary of history and art. The administration is entrusted to a director, assisted by two associate curators of Chinese art, two for Japanese art, and one for the art of the Near East, as well as a registrar and two librarians.

The original Freer bequest consisted of an inventory of 2,250 objects. But through continuous collecting during the last twenty years (he retired from business at the age of forty-four) of the donor's life, it expanded considerably, so when it was transferred from his home in Detroit to Washington, it had grown to 9,500 objects.

Most numerous and of particular importance are the Chinese and Japanese holdings that cover almost every period and medium imaginable. Other objects are from Korea, with strong holdings in celadon pottery; from Tibet, India, and Indochina; from Iran with remarkable Sassanian pieces; from Iraq, Syria, and Asia Minor. Byzantium and Egypt (represented with a large group of ancient glass objects, that Freer bought as complete collection) deserve mention, and

the collection is not confined to those particular areas: surprisingly, it also includes Greek, Aramaic, and Armenian biblical manuscripts, as well as some Early Christian paintings, gold, and crystal.

Although Charles Freer pioneered in the study and collecting of Oriental art, he did not neglect American art. James McNeill Whistler, so strongly under the spell of Japanese *ukiyo-e* masters, was his favorite. Consequently, the Freer contains the most extensive assemblage of "Whistleriana" of any museum. His body of work, paintings, drawings, etchings, watercolors, and lithographs and the famed Peacock Room form the nucleus of the Western department. It is augmented by representative examples of the work of Whistler's contemporaries, such as Dewing, Tryon, Hassam, Sargent, Twachtman, and Thayer.

The collection began with Freer's purchase of a Whistler etching in 1883 and a painted Japanese fan, attributed to Ogata Kōrin, of 1887. Whistler later became a lifelong friend and served as a catalyst to further Freer's interest in Japanese art in all of its forms. During the nineties Freer continued to concentrate on American artists but also increased his collection of Japanese objects, particularly in the field of *ukiyo-e* prints.

This led to an interest in the older arts of Japan, such as painted screens and pottery; these, in turn, pointed the way to the arts of China. From 1903 on, Freer traveled extensively in Europe and the Far and Near East, constantly seeking to expand his collections with ever-growing discernment and with plans for their ultimate donation to the public.

In the spirit of Freer's vision of his Gallery as an educational institution, there is also an ever-growing study collection, not used for exhibitions but kept in the study rooms for research and comparison.

An inventory reveals that the Gallery owns about thirty-seven hundred objects from China of which the group of extraordinary bronzes number more than one thousand. It proceeds from a Shang Dynasty (1500 B.C.) elephant-shaped ceremonial vessel to an early Chou Dynasty (1100 B.C.) ceremonial wine vessel, famous for its long inscription worked into an exquisite design of historical significance. Also included is a large fifth-century A.D. "Chung" bell with intaglio decoration typical of that period. Other bronze objects are in shape of weapons, mirrors, food containers, wine goblets and servers, garment hooks, and carriage fittings.

Among the 890 paintings and drawings one finds scrolls and albums, large figure paintings, and works in ink on paper, such as calligraphy. From the Sung Dynasty comes a rare work on silk, *Clearing Autumn Skies over Mountains and Valleys*, by the eleventh-century Kuo Hsi and the famed small landscape *Hostelry in the Mountains* by Yen Tz' u-Yü. *Man and Horse* by Ch'ien-Hsuan, a master of figure painting, is typical of a popular subject of the Yüan Dynasty (fourteenth century).

Outstanding examples of the strong holdings of Chinese pottery and porcelains include a typical T'ang ceramic piece of a woman on horseback, Ming porcelains and the blue-and-white pieces from the Yüan Dynasty, the crackled glazes char-

acteristic of the Ch'ing Dynasty during the reign of K'ang Hsi, the soft greyish green wares of Yüeh, and porcelains from the Chekiang Province. Stone sculptures, primarily Buddhas, lacquer ware, wood carvings, and an important group of fine textiles (including K'ossu) round out the Chinese holdings.

The arts and crafts of Japan encompass a superb assemblage of painted screens, fans, scrolls, and books; rare lacquer ware and Buddhist sculpture; porcelains; and pottery. Life in Japan and Japanese landscape from the early days of Heian (eighth century) through the great periods of Kamakura and Momoyama and up to Edo and Meiji are depicted in the splendid collection of painted screens, a collection that is unsurpassed in the Western world. Represented are the Buddhist Kamakura, Yamato-e, and Rimpa schools, with dramatic examples such as the screen *The Four Accomplishments* by Kanō Eitoku in ink on paper, measuring five by eleven feet. More baroque, in the spirit of the Rimpa school, is the *Waves of Matsushima* of his student Sōtatsu from the Edo period. The anonymous Namban screens in the style of Momoyama (sixteenth-seventeenth century) depict the landing of the first Portuguese merchants on Japanese soil in 1541. Mishikawa Horanobu (d. 1694) gives us a glimpse of daily life with his *Autumn at Asakusa and Cherry Blossom Viewing*. The rhythmic parade of proud *Cranes* was created by the famed Ogata Kōrin, and his student Watanabe Shiko painted hollyhocks in a delightfully realistic style for a double-fold screen.

Ink paintings such as *The Monk Kanzan* by Kaō from the fourteenth century and the long, narrow *Panorama of the Yangtze River* by Shugetsu Tōkan (1510) are examples of ink paintings ranging through the Meiji period. Beautiful women and their life-style are depicted by masters such as Andō, Harunobu, Kiyonaga, Hokusai, and Hiroshige. Early portraits include the one painted on silk of Tendai Daishi, dated from the fourteenth century, and the realistic *Portrait of Sato Issai* by Watanabe Kazan, which shows some European influence.

The full range and glory of *ukiyo-e* (Floating World) woodcuts is offered in all of its forms from exquisite *surimonos* (commemorative prints) to a Toyokuni I pentatych, *Courtesans in the Daymo Procession*. It includes eighteenth- to nineteenth-century Edo period treasures such as Utamaro's *Treasure Ship* and two superb Hiroshige triptychs: *Awa No Naruto (Whirlpools)* and *Kisoji No Sansen*, a magnificent snowscape. There are also prints by Bunchō, Eishi, and Eizan.

Eleven centuries of the great craft of lacquer maki-e, the technique of sprinkling designs of gold and silver on lacquer, are reflected in a group of various objects. This collection was considerably augmented in 1944 by the acquisition of the Alex G. Mosle lacquer artifacts. Among the many bowls, cases, trays, boxes, and exquisite group of twenty *inros* (small containers), a particular rarity is the *suzuribako* (inkstone case) with a mercury waterwheel set into the landscape design on the lid. It dates from the Edo period. Superb examples of the Momoyama period (sixteenth century) are to be found in a writing table and a toilet case. Negoro ware of the fourteenth to sixteenth century is shown with an elegantly shaped ewer and a footed basin combining lacquer and wood.

The earliest of the many Buddhas dates from the Suiko period (552–645) and is carved of wood, lacquered and covered with gold leaf. The gentle *Miroko Bosatsu* of the Heian period (794–1185) is in strong contrast with the two *Guardians* of Kamakura times, dynamic wood sculptures, ferocious in expression and 92 inches tall (233.5 centimeters). Bronze objects of that same period include a kettle and a mirror with delicately wrought symbolic designs taken from nature.

Japan's varied styles of pottery and porcelains can be studied in a collection of about nine hundred examples. They can be traced from the Sué wares of the Tempyō period, to Beni Shino of the age of Momoyama, through the starkly simple pieces of Raku with their deep glazes found in humble objects such as the all-important tea bowls to the more elaborate and decorated jars, vases, and dishes of Kakiemon and Kutani of the seventeenth-century Edo period.

For those interested in the decorative arts, the Freer offers a rare opportunity for study and comparison. One can trace the progress of China's famed blue-and-white porcelain designs and its impact on other cultures. China's Ming, Ch'ing, and Yüan blue-and-white wares are shown along with Japanese versions of the Edo period, in the grape plates of the Ottoman period (sixteenth century) of Turkey, in Safavid pieces from Iran, and in Korean pottery of the Yi Dynasty. Similarly, one can study the many forms of Buddhist sculpture that are spotted throughout the Gallery. However, one room is particularly noteworthy in which are assembled exclusively superb examples of this figure. Included are Buddhas from the T'ang Dynasty, the Momoyama period, and the Northern Ch'i Dynasty, represented in a massive bas-relief of the life of Buddha, and various Buddhist images from Thailand, Pakistan, and India, with a particularly fine head carved of black lavastone from Java (ninth century).

From Korea a distinctive group of celadon pottery of the Koryŏ Dynasty (thirteenth century) shows an unusual delicacy of line and color in the subtle inlaid slip decoration on objects that range from tiny boxes to stately vases.

The flowering of Persian miniature painting reached its height in the sixteenth century with the art of the court of Shah Tahmasp, a great patron of the arts. More than forty pages of the albums, their elaborate bindings, and beautiful pages of calligraphy are on display, showing the work of masters such as Sultan Muhammad, Aqu Mirah, and Shah Mahmud. Complementing this collection is a remarkable assemblage of Islamic Near East calligraphy and illumination.

Three albums of the Imperial Mughal (seventeenth century) show the relationship of Indian art with that of Persia. These miniatures painted for Jahagin and Shah Jahan are richly embellished and include portraits of exquisite calligraphy, illuminating the social and political conditions of their time.

Predating the miniatures from Persia are some extremely rare artifacts dating from the fifth century B.C., such as a pair of Achaemenid goats fashioned in gold and a group of Sassanian (Persian fourth century A.D.) pieces that rival those at the Hermitage (q.v.). They include a silver dish decorated in relief with gilded areas and, from the same period, a head of a king.

The extraordinary and unique beauty of the ceramics of the world of Islam is represented in pieces from the twelfth and thirteenth centuries and the Safavid period (1502–1722). The golden age of pottery was the Seljuk period, when some of the technically unsurpassed pieces at the Freer were produced in the town of Kashan. The technique involves figure, floral, and calligraphic decorations with glowing underglaze painting that is particularly effective in black and turquoise Minaï ware. One of the outstanding pieces is a magnificent double shell ewer with open-work calligraphy decoration, a typical work showing the greatest skill and inventiveness. In addition, another group of brownish gold lusterware from the twelfth to fourteenth century also shows great distinction.

Freer's collection of works by James McNeill Whistler consists of 119 oils, watercolors, and pastels, 100 drawings and sketches, 600 etchings, and 165 lithographs, representing the whole span of Whistler's creativity. Fine examples of painting "à la Japonnaise" such as *Caprice in Purple and Gold #2* (1864) show his model in a typical *ukiyo-e* pose, surrounded by Oriental objects. *Variations in Flesh Color and Green: The Balcony* (1868) is based on a Kiyonaga print; *Variations in Pink and Grey: Chelsea* (1873) is inspired by Hiroshige.

Other American artists, whose works were collected by Freer, also expressed that same spirit and refinement he admired in the art of the Far East. His choice focused on works that would hang harmoniously alongside his Oriental art. He added paintings such as *Four Sylvan Sounds* (1893) by Thomas Wilmer Dewing, a series of four panels characterized by the asymmetric figure composition and awareness of pattern derived from the Japanese. Among the other eleven artists one also finds a trend toward French Impressionism such as in the soft, cool landscapes of Dwight William Tryon in his *Sunrise: April*. Of the several Abbot Thayers, *Capri* stands out with its dramatic lighting. Other artists are John Twachtman, Childe Hassam, Winslow Homer, John Singer Sargent, and Augustus Saint-Gaudens, with two sculptures.

Pewabic pottery created in the early twentieth century in Detroit shows very clearly that its originator, Mary Chase Stratton, made a study of Freer's Oriental pottery, which is reflected in the fine glazes and elegant simple shapes of the pottery.

Installed within the museum is Whistler's Peacock Room. Painted in 1876 and 1877 and named *Harmony in Blue and Gold* by Whistler, it was originally designed as a dining room for the London residence of Fred R. Leyland to serve as a background for the owner's collection of blue-and-white china. The decor is dominated by large canvases (14 by 33 by 20 feet) depicting stylized golden peacocks. They were placed over the original leather wall covering. Carved and gilded shelves were meant to hold the china collection. The peacock theme (the eye of the feather) decorates the ceiling, imposing an Oriental character on its Tudor design. Dominating the mantlepiece is Whistler's *La Princesse du Pays de la Porcelaine*, in typical Japanese S-curve pose. Two fighting peacocks on the opposite wall represent the artist and his patron (Whistler's revenge after

quarreling with Leyland at the completion of the room). Freer purchased *La Princesse* in 1903 and the room in 1904. It was installed in his Detroit home and later reinstalled in the Gallery.

A relatively small portion of the Gallery's holdings is displayed at any time. However, changing special exhibitions offer the public a chance to view the many facets of the collections. Futhermore, stored artifacts may be viewed upon special request.

The Gallery's relationship with the University of Michigan is perhaps unique among museums. Freer's will included a bequest to that university stipulating that designated funds be used to add knowledge and appreciation of Oriental art. Originally, these funds were used haphazardly, but since 1946 a plan that provides for Freer Fellowships for graduate students is in operation. Furthermore, Freer scholarships have been created, and funds are available for trips from Michigan for annual student visits. The university and the Gallery also jointly publish *Ars Orientalis*, a scholarly periodical.

As part of the Gallery's educational efforts, there is a publication program known as the Freer Gallery of Art Oriental Studies. These publications are monographs devoted to various phases of the collection, written by both staff members and by invited outside scholars. Shorter studies and more informal are the Freer Gallery of Art Occasional Papers, now amounting to some ten volumes. In addition, other publications on special subjects, picture books, outlines, and chronologies appear from time to time. All Freer publications are distributed without charge to five hundred interested museums and libraries throughout the world before going on sale. A full-time editorial secretary is employed to carry out this work.

Special services and activities at the Freer offer the public services such as "E & R," namely examination and report on Oriental objects brought in by their owners for the purpose of finding out the origin of the pieces.

The technical laboratory has developed into an outstanding center of research into the materials and methods of ancient craftsmen. A traditional Japanese craft is practiced by the museum's Oriental picture mounter. With a staff of three, he is engaged in cleaning, repairing, restoring, and remounting Chinese and Japanese works on silk and paper.

The focus of the Freer Library is on the collections. Its forty thousand titles, about half of which are in Oriental languages, cover literature related to the objects in the collection and the cultures that produced them. In addition to having books and periodicals, the library owns some thirty thousand slides (lending three thousand to four thousand every year) and more than eight thousand study photographs. The library is available to the public.

In 1946 the Freer Library accepted the archives of the late Ernst Herzfeld, who spent his lifetime as an archaeologist in the Near East and is recognized as one of the foremost scholars in this area. The material, some six thousand items, is in the process of being classified and indexed to be housed eventually in a study room for the use of students and researchers.

The sales desk at the entrance to the Gallery offers a selection of publications, slides, postcards, reproductions of objects, and color prints.

Selected Bibliography

Museum publications: *Masterpieces of Chinese and Japanese Art: Freer Gallery of Art Handbook*, 1976; *The Freer Gallery of Art*: Vol. I, China, Vol. II, Japan, 1971; Artil, Esin, *Art of the Arab World*, 1974; idem, *Ceramics from the World of Islam*, 1975; Stubbs, Burns A., *Paintings, Pastels, Prints, and Copper Plates by American and European Artists with a List of Original Whistleriana in the Freer Gallery of Art*, 1967; Koyama Fujio, and John Pope, *Oriental Ceramics: The World's Great Collections*, 1974; Lippe, Aschwin, *The Freer Indian Sculptures*, 1970; Meyer, Agnes E., *Charles Lang Freer and His Gallery*, 1970; Pope, John Alexander, *Chinese Bronzes*, 1976; Yonemura, Ann, *Japanese Lacquer*, 1979.

Other publications: Saarinen, Aline, *The Proud Possessors* (New York 1958).

RENATA RUTLEDGE

HIRSHHORN MUSEUM AND SCULPTURE GARDEN, SMITHSONIAN INSTITUTION (alternately THE JOSEPH H. HIRSHHORN MUSEUM AND SCULPTURE GARDEN, THE HIRSHHORN MUSEUM, THE HIRSHHORN, HMSG), Independence Avenue at 8th St., S.W., Washington, D.C. 20560.

The Hirshhorn Museum and Sculpture Garden (HMSG) was created by an Act of Congress on November 7, 1966, and opened to the public on October 4, 1974. Public Law 89–788, enacted by the Eighty-ninth Congress of the United States, signaled the acceptance of a gift to the nation by Joseph Herman Hirshhorn (1899–1981) of his art collection, which had been built up for forty years and which consisted, at the time of its presentation, of about fifty-six hundred pieces. This gift came about primarily through the efforts of the secretary of the Smithsonian Institution, S. Dillon Ripley, and the president of the United States, Lyndon Baines Johnson, and his wife. An instrumental part in the negotiations was played by President Johnson's adviser on the arts, Roger L. Stevens, and special counsel to the president, Harry C. McPherson, Jr.

The Hirshhorn Collection was sought by the Smithsonian to fill one of its major deficiencies, a lack of examples of both contemporary American and European art, particularly sculpture. This lack had been recognized as early as 1938, when Congress first authorized the Smithsonian to establish a museum for contemporary art to complement the collection of the already established National Gallery of Art (q.v.), the strength of which, based on the important bequest of Andrew Mellon, lay in the field of Italian Renaissance and other pre-twentieth-century periods. In 1939 a competition was held to design a building to house a Smithsonian modern art collection. The competition was won by noted Finnish architect Eero Saarinen, but the entire project was shelved after opposition arose to Saarinen's plans.

Twenty-five years later the secretary of the Smithsonian Institution, S. Dillon Ripley, realized that it was too late to begin a collection of modern art and, instead, turned to the last of the really important American art collections in

private hands, that of Joseph H. Hirshhorn, and negotiated its transformation into a public museum under the auspices of the Smithsonian Institution.

Hirshhorn, born in 1899 in Latvia, had come to America at the age of six and was already acquiring art at seventeen, while working as a stockbroker. He had moved from collecting nineteenth-century Salon painters, whose art he had first admired in the form of calendar reproductions as a child, into modern art by the mid–1930s.

The acceptance of Hirshhorn's collection as a gift to the nation, which he gave in gratitude for the opportunities America had afforded him as an immigrant, excited a great deal of controversy in many congressional circles. President Johnson, however, wrote to the president of the Senate and the Speaker of the House enthusiastically supporting the establishment of the Hirshhorn museum. President Johnson wrote that the Hirshhorn Collection "affords Washington a brilliant opportunity to broaden and strengthen its cultural offerings. . . . The Hirshhorn Collection is the fruit of a life-time of dedicated effort and discerning judgment, and its presentation to America is a testament to the generosity and public spirit of its donor."

Later, when he accepted the gift on behalf of the nation, the President emphasized, "We must begin to build a museum that is worthy of our highest aspirations for this beautiful city, the Capitol of our country."

The Enabling Act passed by Congress also authorized a site on the Smithsonian Mall for a building to house the Hirshhorn gift. The designated site on 8th Street, S.W., between Independence Avenue and the Mall, was then occupied by a three-story brick building, constructed in 1863, that housed the Armed Forces Medical Museum and elements of the Air Force Institute of Pathology. Since the significance of these organizations to the nation was judged to reside in the collections primarily, and only secondarily in the building, the contents were moved by the Department of Defense and the building razed to make way for the Hirshhorn Museum and Sculpture Garden.

The architect, chosen jointly by Joseph H. Hirshhorn and the Smithsonian Institution to execute the new museum, was Gordon Bunshaft, partner-in-charge of the New York office of the distinguished architectural firm Skidmore, Owings and Merrill. Other notable works by Bunshaft include Lever House, New York, the Beinecke Rare Book Library, Yale University, and an addition to the Albright-Knox Museum in Buffalo, New York. Bunshaft was also a member of the District of Columbia Commission of Fine Arts, which approved his plan.

Construction began in March 1970, on Bunshaft's design, a cylindrical building, 231 feet in diameter, which, in plan, comprises two circles, one inside the other. The two circles are not exactly concentric, and the 4-foot eccentricity was intended to add variety to the overall design. The open interior courtyard is graced by a shallow bronze disc foundation sixty feet in diameter. The deliberate patterning of stones in the plaza surrounding it adds texture in contrast to the smooth building facade.

There are three above-ground stories 15 feet high, two for exhibition and the

top one comprising office space and picture storage. The exhibition space is organized in the form of an outer circle or ambulatory, 32 feet wide, in which sculpture rotated from the permanent collection is always exhibited, that is ringed on the inner side by another concentrically circular ambulatory-type gallery. In addition, there is a rectangular temporary exhibition gallery 103 feet long, a museum shop, a two-hundred-seat auditorium, museum work areas, and sculpture storage below the plaza level. In all, there are about 168,000 square feet of usable museum space. Access from one floor to another is achieved by escalators and an elevator in one of the hollow piers.

To enable large numbers of visitors to move from one area to another, the architect used the dramatic device of alternating narrow spaces with wider, open areas. On the second and third floors, corridors near the building's outer walls open out into galleries 32 feet wide by up to 127 feet long.

A major problem associated with the design of the building was how to show rectangular paintings effectively on curved walls that are concave near the outside and convex near the inner ambulatory. The same solution used by the Solomon R. Guggenheim Museum (q.v.) in New York City, designed in a spiral configuration by Frank Lloyd Wright, was employed in the Inaugural Exhibition at the HMSG: hidden armatures to give the works the effect of floating on the walls.

Some have remarked that the shape of the HMSG echoes the dome of the U.S. Capitol not far away. The Sculpture Garden, however, is rectangular, more similar to the facades of the other Smithsonian and federal buildings that surround HMSG. It is 356 feet by 156 feet and covers 1.7 acres adjacent to the building. The Sculpture Garden is multiterraced and is sunk 6 to 14 feet below Mall level.

Some of the notable pieces exhibited in the Sculpture Garden are Dame Barbara Hepworth's *Figure for Landscape* (1960) and Auguste Rodin's *Burghers of Calais* (1886) and *Blazac* (1892). There are several works by David Smith in the northwest corner and large bronze reliefs by Thomas Eakins depicting Revolutionary War subjects along the north embankment. In addition, numerous sculptures are placed on the plaza around the exterior of the museum building. They include Anthony Caro's *Monsoon Drift* (1975), Alexander Calder's *Two Discs* (1965), and Mark di Suvero's *Isis* (1978), a work specially commissioned by the Institute of Scrap Iron and Steel for the Hirshhorn.

The Hirshhorn Museum and Sculpture Garden opened officially to the public on October 4, 1974. Formal opening ceremonies were held October 1 during which an original musical composition from noted American composer William Schuman, ''Prelude for a Great Occasion,'' was performed live. Special posters for the opening were commissioned by the Smithsonian Resident Associates. Two, by Willem De Kooning and Kenneth Noland, reproduced works in the Hirshhorn Collection, and two, by Robert Indiana and Larry Rivers, were original designs.

The Inaugural Exhibition was on view one year (October 1, 1974-September 15, 1975). It consisted of five hundred sculptures and four hundred paintings

chosen by Abram Lerner, director of the museum. The exhibition was organized and hung chronologically, starting with the mid-nineteenth century in the basement and culminating in works of the present day on the third floor.

Since the inaugural show, the exhibition policy of the HMSG has been to alternate exhibitions from its permanent collection with special loan exhibitions from public and private sources, as well as group and comprehensive one-man exhibitions of American and international artists. One-man exhibitions drawn from the HMSG collection have included Thomas Eakins, Philip Evergood, George Grosz, Henry Moore, Oscar Bluemner, Reuben Nakian, Samuel Murray, and Louis M. Eilshemius. One of the strengths of the collection is the unusual opportunity to study in depth the careers of many individual artists. For example, the collection includes almost two hundred works by Eilshemius, more than one hundred works by Thomas Eakins, fifty-three sculptures by Henry Moore, and forty-two sculptures by Honoré Daumier.

Although the HMSG is administered by the Smithsonian Institution Board of Regents, advice and assistance on operation, maintenance, and presentation are furnished by a board of trustees as designated in the Enabling Act. The trustees have sole authority to purchase, loan, exchange, sell, or otherwise dispose of works of art in the collection. The trustees also determine policy about the method of display. The board has eight general members and the chief justice of the United States and secretary of the Smithsonian Institution as ex-officio members. The original board was comprised of four members appointed by the president from nominations submitted by Joseph H. Hirshhorn and four from nominations submitted by the Smithsonian Institution regents. These terms expired yearly from July 1, 1968, through July 1, 1975. Successive general members have been serving terms of six years, all vacancies being filled by a vote of the active members of the board.

The staff of the museum is organized into the Office of the Director; the Department of Administration and Museum Support Services (including library, public affairs, photography laboratory, and building services), the Department of Painting and Sculpture; the Department of Education, Exhibits, and Design; the Department of Conservation Laboratory, and the Registrar's office. The Department of Painting and Sculpture is divided into the archival (i.e., permanent collections) and special exhibitions staff. It is not divided chronologically or by medium except in the case of a special curator for prints and drawings.

In the inaugural book, director Abram Lerner noted about the general character of the collection, ''The Hirshhorn Museum like most museums, has lacunae which will be reduced in time. However, Joseph Hirshhorn's catholicity has provided us with an unusual record of American painting from about 1870 on, European and American sculpture from the middle of the nineteenth century on and European painting of the past three decades.''

An exhibition held in May 1977, ''The Thomas Eakins Collection of the Hirshhorn Museum and Sculpture Garden,'' gives some idea of the breadth and depth that Hirshhorn devoted to certain individual artists. His first Eakins ac-

quisition was a portrait, *Miss Anna Lewis* (c. 1898), purchased in 1957. Most of Eakins collection is the result of purchases made in 1961 and 1965 of collections belonging originally to two of Eakins' former students, Charles Bregler and Samuel Murray. Included are not only oil paintings but also sketches for major compositions such as *The Crucifixion* (1880), completed sculptures and sculptural models, juvenilia, portraits rejected by their sitters, momentoes, documents, and studio paraphernalia, including Eakins' palette and camera. Photographs taken by Eakins that relate directly to many of his paintings are also part of the HMSG collection.

Among the other notable nineteenth-century American artists represented in the HMSG collection are Eastman Johnson, Albert Bierstadt, William Merritt Chase, John Singer Sargent, Albert Pinkham Ryder, and Mary Cassatt. The early twentieth century is represented not only by paintings of the Ash Can School such as John Sloan's *Carmine Theater* (1912) and Robert Henri's *Woman in White* (1904) but touches all of the major movements of the early part of the century, including academic figure studies of the 1920s by Leon Kroll and Maurice Sterne; Abraham Walkowitz's famed pen, ink, and watercolor studies of Isadora Duncan dancing; American Cubist works by Max Weber and Henry Fitch Taylor; synchromies by Stanton Macdonald-Wright and Morgan Russell; Futurist-related works by John Marin and Joseph Stella; and Precisionist paintings by Charles Demuth and Charles Sheeler.

European works of the early twentieth century represent movements from which many of the American developments took their impulse. Included are works by Fernand Léger, Robert Delaunay, Joan Miró, and Piet Mondrian.

Hirshhorn, by his own admission, was slow to respond to the most important American development in the first half of the twentieth century, the Abstract Expressionist movement, which began in the 1940s. He did not acquire his first Abstract Expressionist works until the late 1950s. The collection does include, however, some representative American paintings of the period before Abstract Expressionism, the 1930s, including Kenneth Hayes Miller's *Fourteenth Street Style*, Ben Shahn's social protest painting, and Stuart Davis' synthesis of Cubism and Realism. It moves into the area of early Abstract Expressionism with several oils by Arshile Gorky of the period about 1925–43, notably the *Portrait of Vartoush* (c. 1932) (his sister), and *Waterfall* (c. 1943).

The work of Surrealists who influenced the American Abstract Expressionists is represented by painters such as André Masson and Yves Tanguy. Hirshhorn was most sympathetic to the work of Abstract Expressionist giant Willem De Kooning, whose career is well represented, starting with early figurative paintings such as *Queen of Hearts* (1943–46) through his present work. In all, there are more that forty works by De Kooning in the HMSG collection.

Other Abstract Expressionists now in the HMSG collection include Adolph Gottlieb, Franz Kline, Mark Tobey, Barnett Newman, William Baziotes, Hans Hofmann, Clyfford Still, Bradley Walker Tomlin, and Mark Rothko. The HMSG does not lack examples of other types of painting done in the 1950s, primarily

in a more realistic style, such as Edward Hopper's *Hotel by a Railroad* (1952) or Andrew Wyeth's *Rail Fence* (1950). Larry Rivers, Philip Evergood, and Richard Diebenkorn also exemplify the fifties' figurative trends.

European works of the 1950s include paintings by noted English artists Ben Nicholson, Graham Sutherland, and Francis Bacon; painters of the Danish CoBrA school such as Karel Appel; and the enigmatic figurative works of Balthus and Magritte, notably the latter's *Delusions of Grandeur* (1948). *Tachisme*, the European version of Abstract Expressionism, is represented by works such as Wols' *Root* (1949).

Hirshhorn seems to have responded to the post-painterly abstraction of the 1960s much sooner than he did to its predecessor, Abstract Expressionism. Works by Kenneth Noland, Frank Stella, Morris Louis, Richard Anuszkiewicz, Larry Poons, and Helen Frankenthaler are representative. Op is seen in the paintings and painted constructions of the European artist Yvaral and the Israeli Yaakov Agam, and Pop is evident in the works of Americans Robert Indiana, Roy Lichtenstein, Tom Wesselmann, and Andy Warhol (*Marilyn Monroe's Lips* of 1964). The New Realism movement is seen in both its American and European manifestations.

Major new gifts of American paintings, as well as sculpture, intended to round out the museum's collection of contemporary art, were given by Joseph Hirshhorn in 1972, 1974, and 1979. In addition, the HMSG has received many gifts from other collectors, galleries, and contemporary artists themselves since the opening of the museum. Hirshhorn's bequest of 1981 has brought more than five thousand additional works to the collection, deepening its basic character and scope.

The Hirshhorn Collection of sculpture includes examples dating from Etruscan to modern times. The antique works were all chosen with an eye to the parallels and relationships with contemporary styles. About twenty-four African sculptures, particularly a superb group of Benin bronzes, are also included. The sculpture collection consisted of about two thousand pieces when it was first given.

Highlights of that collection included the opportunity to study in depth forty-two pieces by Honoré Daumier, seventeen by Auguste Rodin, twenty-two by Edgar Degas, twenty-three by Alberto Giacometti, twenty-one by Henri Matisse, twenty-two by David Smith, and twenty-six by Giacomo Manzù. Some of the more interesting and unusual examples include Picasso's *Woman with a Baby Carriage* (1950), of which only two casts were made and the other belongs to the artist's estate; Brancusi's *Sleeping Muse* (1909–11), the only marble version of this theme; and Rodin's *Burghers of Calais* (1888), a casting that barely escaped confiscation by the Nazis during World War II.

As with the paintings, the major strength of the sculpture collection begins in the late nineteenth century. Important earlier European sculptors, however, include Clodion, Lemoyne, and Houdon of the eighteenth century and Daumier, Antoine-Louis Barye, Carpeaux, Degas, Dalou, and Renoir of the nineteenth century. These pre-twentieth-century works culminate in the important examples

by Auguste Rodin such as *Mask of the Man with the Broken Nose* (1864) and the third architectural model for *The Gates of Hell* (1880).

Nineteenth-century American sculpture is represented most notably by Hiram Powers, Thomas Eakins, John Sargent, and Samuel Murray. Early-twentieth-century works include those of Elie Nadelman, Gaston Lachaise, Hugo Robus, Arthur B. Davies, John Storrs, Robert Laurent, and William Zorach. The first sculpture Hirshhorn ever bought (in 1930) belongs to this period, a John Flannagan work.

Early twentieth-century European pieces by artists such as Constantin Meunier and Emile-Antoine Bourdelle are included as a prelude to Cubist sculpture, which is well represented by Raymond Duchamp-Villon (*Horse*, 1914), Roger de la Fresnaye, Henri Laurens, Alexander Archipenko, and Pablo Picasso (including a cast of his famous *Head of a Woman* of 1909). In all, there are sixteen Picasso works going beyond Cubism into innovative works such as *Woman with Baby Carriage*, 1950, in which casts of a stove plate and cake tins are incorporated. Othe notable sculptures by painters are several of Georges Braque's *Little Horses* (1939) and a disc relief by Robert Delaunay. By Matisse there are the five *Heads of Jeannette* (1910–13) and four bronze reliefs *Backs* (1909–30), which are exhibited in the outdoor sculpture garden.

Italian Futurist sculpture is represented by modern reconstructions of several works by Giacomo Balla. Subsequent European styles include Constructivism (Gabo, Pevsner), Surrealism (Giacometti, Magritte, Ernst), and German Expressionism (Barlach, Lehmbruck, Köllwitz). American work of the mid-twentieth century is primarily represented by a large number of pieces by David Smith, which were shown for the first time as a group in a special exhibition in the summer and fall of 1979. Also representative of this period are mobiles by Alexander Calder, enigmatic boxes by Joseph Cornell, Abstract Expressionist pieces by Theodore Roszak and Seymour Lipton, and a great many large pieces by English artists Henry Moore and Dame Barbara Hepworth.

Moving into the past two decades are sculptures by Louise Nevelson, the plaster *Bus Riders* (1964) by George Segal, several stainless steel kinetic constuctions by George Rickey, and major works by Kenneth Snelson, Mark di Suvero, Tony Caro, Robert Smithson, and John Chamberlain. The Minimal movement of the 1960s, also known as Primary Structures, is represented by Donald Judd, one of its main practitioners and theorists. Contemporary Europeans such as Gio Pomodoro and Eduardo Paolozzi are also present in this comprehensive modern sculpture collection.

The HMSG has an art library of about ten thousand volumes and sets of all of the major art journals relating to the periods covered by its collections. A separate archive contains extensive in-depth files on each artist in the collection that are constantly kept up to date by the curatorial staff. A representative sampling of slides of objects in the collection may be purchased in the museum shop below plaza level. Other slides and photographs may be purchased by application to the photo-archivist's office.

The museum's publications include not only the inaugural book and a shorter 116-page guide to the collection put out at the time of the opening but catalogues of all special exhibitions that are available for purchase in the museum store.

The Hirshhorn does not have any museum organizations connected specifically with it alone. As with all of the other Smithsonian museums, membership is handled by the Smithsonian Associate Programs. By joining the Resident or National Associates, one receives privileges at all Smithsonian facilities including the Hirshhorn.

Selected Bibliography

Museum publications: Beardsley, John, *Probing the Earth: Contemporary Land Projects*, 1977; Fox, Howard, *Directions*, 1979; idem, *Metaphor: New Projects by Contemporary Sculptors*, 1981; Gettings, Frank, *George Grosz: Selections from the Hirshhorn Museum and Sculpture Garden*, 1978; idem, *Raphael Soyer: Sixty-Five Years of Printmaking*, 1982; Lerner, Abram, *Gregory Gillespie*, 1977; idem, *Soyer Since 1970*, 1982; McCabe, Cynthia Jaffee, *Fernando Botero*, 1979; idem, *The Golden Door: Artist-Immigrants of America, 1876–1976*, 1976; idem, *Directions*, 1981; Millard, Charles W., *Friedel Dzubas*, 1983; idem, *Miró: Selected Paintings*, 1980; McClintic, Miranda, and Edward Fry, *David Smith: Painter, Sculptor, Draftsman*, 1982; idem, *Directions*, 1983; idem, *The Fifties: Aspects of Painting in New York*, 1980; idem, *The Thomas Eakins Collection of the Hirshhorn Museum and Sculpture Garden*, 1977; Shannon, Joseph, *Edwin Dickinson: Selected Landscapes*, 1980; idem, *R. B. Kitaj*, 1981; Taylor, Kendall, *Philip Evergood . . .* , 1978; idem, *"The Noble Buyer": John Quinn, Patron of the Avant-Garde*, 1978.

Other publications: *An Introduction to the Hirshhorn Museum and Sculpture Garden* (New York 1974); Hyams, Barry, *Hirshhorn: Medici from Brooklyn* (New York 1979); Lerner, Abram, ed., *The Hirshhorn Museum and Sculpture Garden* (New York 1974); Kramer, Hilton, "The Hirshhorn," *New York Times* (Sunday, October 6, 1974); Lewis, JoAnn, "Every Day Is Sunday for Joe Hirshhorn," *Art News* (Summer 1979); Lynes, Russell, "Modern Art Arrives on the Mall," *Smithsonian* (December 1974-January 1975); Richard, Paul, "Joe Hirshhorn: An Appreciation," *Washington Post* (September 2, 1981); Russell, John, "Joseph Hirshhorn Dies" (obituary), *New York Times* (September 1, 1981); Rosenberg, Harold, "The Art World: The Hirshhorn," *The New Yorker* (November 4, 1974).

ELLEN G. LANDAU

NATIONAL GALLERY OF ART (also NATIONAL GALLERY), 6th Street at Constitution Avenue, Washington, D.C. 20565.

The founding of the National Gallery of Art in Washington, D.C., was due to the interest, determination, and generosity of one man—Andrew W. Mellon. While living in Washington, as secretary of the treasury beginning in 1921 under President Harding and continuing in the administration of Presidents Coolidge and Hoover, he was keenly aware of the lack of any outstanding public collection of Old Masters. As early as 1927 Mellon mentioned the idea of an American National Gallery to David E. Finley, then his special assistant and later to be

the first director of the National Gallery. This notion was strengthened by the impression made upon him by the National Gallery in London with which he familiarized himself when he served as American ambassador to the Court of St. James from 1932 to 1933.

Mellon's personal collection was the finest in Washington; he proposed to give this to the nation, with an endowment and funds to erect a gallery building, if the United States Congress would appropriate the funds for upkeep and staffing. President Roosevelt supported this plan, and on March 24, 1937, a joint resolution of Congress established the National Gallery. Mellon refrained from having his name used for the building, and the name "National Gallery of Art" was appropriated from the small collection then housed in the Museum of Natural History, which became, for the time, the National Collection of Fine Arts.

The construction of the National Gallery was begun in 1937 on a plan by the architect John Russell Pope and was completed after his death by his associates, Eggers and Higgins. On March 17, 1942, President Roosevelt accepted the building on behalf of the American people. It has a symmetric classical design to harmonize with the federal city and is reminiscent of the neoclassical American architecture of the early nineteenth century. In the center of the structure is a rotunda with a great coffered dome supported by towering columns of dark green Tuscan marble. This is flanked on the main floor by the painting galleries arranged around the axis of two monumental sculpture halls and two garden courts. The exterior is of rose-white Tennessee marble, and with its 780-foot length and more than 500,000 square feet, the National Gallery became one of the world's largest marble structures.

Pope's building was purposely larger than the existing collection, thus allowing for future growth. So dramatic was the Gallery's expansion that there was a need for an additional structure in the early 1970s. Fortunately, the trapezoidal block bordering the east end of the original building had been reserved for this purpose and ground breaking for the new East Building took place on May 6, 1971. Construction of this new building was funded by The Andrew Mellon Foundation and the children of Andrew Mellon, Paul and the late Ailsa Mellon Bruce. The New York firm of I. M. Pei and Partners designed the new building and connected it to the original structure by an underground concourse. On the irregular plot, Pei planned a trapezoidal building that is divided into two triangular sections. The larger, rising around an immense skylighted core, houses the galleries and auditorium, and in the other section are offices, a library, and a research center. The quarry of Tennessee marble used in the original building was again employed for the exterior. On June 1, 1978, President Jimmy Carter accepted the building on behalf of the American people from Paul Mellon.

Although technically a bureau of the Smithsonian Institution, the National Gallery of Art is an autonomous organization governed by its own Board of Trustees. According to Mellon's stipulations, the National Gallery has nine trustees. Representing the federal government are the secretary of state, the

secretary of the treasury, the chief justice of the Supreme Court, and the secretary of the Smithsonian Institution. The remaining five trustees are distinguished private citizens who elect their successors.

Once he determined to establish a museum Mellon began dramatically to increase his collection; ultimately, his donation consisted of 126 European paintings, ranging from Byzantine icons to nineteenth-century French works; 26 pieces of sculpture; and the Thomas B. Clarke Collection of American portraits, many of which were to form the basis for the National Portrait Gallery. The most significant purchase made by Mellon was that of 21 paintings from Hermitage Museum in Leningrad, which were sold by the Soviet government in 1930–31 to raise desperately needed foreign currency. Among these treasures were Raphael's *St. George and the Dragon* and *The Alba Madonna*, Botticelli's *The Adoration of the Magi*, van Eyck's *Annunciation*, Titian's *Venus with a Mirror*, and Rembrandt's *Joseph Accused by Potiphar's Wife*.

Although Mellon died a few weeks before the dedication of the National Gallery in 1941, he had been proved correct in his hope that his example and the presence of the building in Washington would inspire other collectors to donate works to the museum. There were, in addition to Mellon, nine founding benefactors, and it is to their taste in collecting that is owed so much of the particular flavor and quality of the National Gallery.

One of the most spectacular American collections to come to the National Gallery was that given by Peter A. B. Widener and his son Joseph of Lynnewood Hall near Philadelphia. Formed mostly before 1920, this collection included remarkable decorative arts (bronzes, furniture, tapestries, jewelry, and porcelains), of which the most famous piece is undoubtedly the chalice of Abbot Suger. Among the masterpieces of painting in the Widener Collection were Castegno's *The Youthful David*, painted on a leather shield; Mantegna's *Judith and Holofernes*; Bellini's *Feast of the Gods*; Rembrandt's *The Mill*; notable works of the English school, especially Turner and Constable; and Monet's remarkable *Dead Toreador*, purchased in 1894. To effect the presentation of this collection to the National Gallery in 1942, it was necessary for President Roosevelt to ask Congress to pay the gift tax to the state of Pennsylvania.

The third founding collection of the National Gallery was that of the department store magnate Samuel H. Kress, who formed perhaps the largest collection of Italian paintings ever assembled. Works by masters such as Duccio, Domenico Veneziano, Botticelli, Piero di Cosimo, Giorgione, and Titian were included. Kress was succeeded by his brother as director of the Kress Foundation, and under him the collection added not only later Italian paintings but also Dutch, Spanish, and French masterpieces. There were in all more than 1,300 paintings in the collection; 377 were deeded to the National Gallery in 1961. Those works that were not placed with the National Gallery were given to more than twenty museums and educational institutions throughout America.

The collector Chester Dale first loaned some works of the American school to the National Gallery in 1941. By the time he died in 1962, he had become

so involved with the Gallery that he bequeathed it his entire collection of 252 paintings and sculptures. Dale, under the guidance of his first wife, Maud, who was a painter, specialized in collecting French paintings, and his bequest brought to the Gallery an outstanding collection of Impressionist and Post-Impressionist paintings, as well as many Corots and one of the Gallery's first twentieth-century works, Picasso's *Family of Saltimbanques*.

Lessing J. Rosenwald presented his collection of prints and drawings to the National Gallery in 1943 and continued to add to it until his death in 1979, so that there were now more than twenty thousand items, including rare early Italian engravings, many from the collection of August Frederick, king of Saxony; fifteenth-century wood and metal cuts; outstanding German and Dutch prints; and the Linnell Collection of Blake.

Other benefactors are Mellon's children. Paul Mellon has given masterpieces such as Cézanne's *Portrait of His Father*; a recent gift of ninety-three works of art, including six Monets, two Gauguins, two Cassatts, a Renoir, a van Gogh, and a Seurat; and an extensive collection of oils by American Indian painter George Catlin. From Ailsa Mellon Bruce, Mellon's daughter, who died in 1969, has come a collection of small-scale nineteenth-century French paintings and, from the fund established by her, treasures such as Leonardo's *Genevra de' Benci* and Fragonard's *Young Girl Reading*.

The National Gallery is governed by a board of nine trustees and is administered by ten executive officers, including the chairman, president, vice-president, director, and assistant director-chief curator. The curatorial departments are: American Painting, Modern Painting, Graphic Art, Twentieth Century Art, Sculpture, Baroque Painting, Northern Renaissance Painting, and Southern Renaissance Painting. In support, there are the Departments of Tours and Lectures, Installation and Design, and Conservation and Extension Programs. Additionally, there are the Photographic Archives, the Library, the Center for Advanced Study in the Visual Arts, the Photographic Laboratory Services, and the Offices of the Editor and the Registrar.

The paintings collections of the National Gallery, both European and American, are outstanding. Undoubtedly, due to the combined interests of Mellon and the Kress Foundation, the Italian paintings represent the most comprehensive holdings of the museum. An introduction to this school is made by two *Enthroned Madonna and Child* of the Byzantine school. One is the gift of Otto Kahn, and the other is from Mellon, and both were discovered in a Spanish church in the early part of this century, although there is still debate about their place of origin. The Byzantine tradition continued to flourish in Siena as exhibited by its greatest exponent, Duccio di Buoninsegna. Two panels from his masterpiece the *Maestà*, painted for Siena's cathedral, are reunited there: *The Calling of the Apostles Peter and Andrew* from the Kress Collection and the *Nativity with the Prophets Isaiah and Ezekiel* from the Mellon. Of succeeding early Italian painters, there are two works attributed to Cimabue, two by Bernardo Daddi, and a *Madonna and Child* by Giotto, dated 1320–30. The Kress Collection provided several rare

Sienese works, notably a predella panel, *The Annunciation*, by Giovanni di Paolo and four enchanting predella panels by Sassetta depicting legends of St. Anthony Abbot.

Fifteenth-century Florentine art is also well represented. The tondo *Adoration of the Magi* attributed to Fra Angelico and Fra Filippo Lippi, which may have belonged to Lorenzo de' Medici, is complemented by Botticelli's treatment of the same subject in the former Hermitage painting. By both Fra Angelico and Fra Lippi there are several other works as well. Other significant Florentine paintings are Domenico Veneziano's *St. John in the Desert*, Gozzoli's *Dance of Salome*, and Castagno's *Youthful David* painted on a processional shield. There are three works by the eccentric Piero di Cosimo, most important of which is the *Visitation with St. Nicholas and St. Anthony Abbot*, painted for the Capponi Chapel in Santo Spirito in Florence, which was described in detail by Vasari.

The Umbrian school finds representation in four paintings by Perugino, especially the triptych *Crucifixion*, painted about 1481–85, given by Bartolomeo Bartoli to the church of St. Domenico in San Giminiano, later in the collection of Prince Galitzin and then passing into the Hermitage in 1866, where it remained until purchased by Mellon in 1931. The Kress Collection has supplied two works by Signorelli.

The tradition of portrait painting in Florence and Siena is also well documented in the National Gallery, beginning with Masaccio's *Profile Portrait of a Young Man* and continuing with Castagno's *Portrait of a Man*, Neroccio de' Landi's *Portrait of a Lady*, Filippino Lippo's *Portrait of a Youth*, and two fine Botticellis: *Portrait of a Youth* and *Giuliano de' Medici*, painted with a turtle dove and half open door, allusions to death and mourning, that suggest this was a commemorative portrait painted shortly after Giuliano's assassination. Also painted in Florence was one of Leonardo da Vinci's rare portraits, *Ginevra de' Benci*, which had for several centuries belonged to the princes of Liechtenstein before being purchased by the National Gallery in 1967. By Leonardo's follower Bernardo Luini there is a *Portrait of a Lady*.

From the highly individualistic Ferrarese school there are works by Cosimo Tura and Francesco del Cossa; by Ercole Roberti, *Portrait of Giovanni and Ginevra Bentivoglio*; and the most original of all by Dosso Dossi, the lovely *Circe and Her Lovers in a Landscape*.

From the sixteenth century, the National Gallery is especially rich in its holdings of paintings by Raphael. There is the early *St. George and the Dragon* (1505–6) painted for the duke of Urbino, sent to England as a gift for Henry VII, and ultimately housed in the Hermitage before being purchased by Mellon. There are three characteristic treatments of the Virgin and Child theme by Raphael—*The Alba Madonna*, named for the Spanish collection where it was located in the nineteenth century; *The Niccolini-Cowper Madonna* of 1508; and *The Small Cowper Madonna* from the Widener Collection. Also by Raphael is the portrait *Bindo Altoviti* (c. 1515). Commissioned by this banker, it remained in his family palace until early in the nineteenth century.

Of Mannerist painting in Florence, there are portraits by Bronzino and Il Rosso and several by Pontormo. The development of Venetian and North Italian painting is also extremely well illustrated. By Andrea Mantegna is the small *Judith and Holofernes*, once in the collection of King Charles I and formerly owned by the Pembroke family. It went to the National Gallery from the Widener Collection. Of Vittore Carpaccio there is *The Virgin Reading* and by Lorenzo Lotto the *Allegory*, which served as the cover for his 1505 portrait of Bishop Treviso. Also by Lotto are the allegorical *The Maiden's Dream* and two religious subjects.

By Giovanni Bellini there is the portrait *Giovanni Emo*, the charming *St. Jerome Reading*, and, most importantly, from the Widener Collection, *The Feast of the Gods*, a signed and dated work of 1514 painted for Alfonso I, the duke of Este's castello at Ferrara. This work was, according to Vasari, finished by the young Titian. Later works by Titian are the *Venus with a Mirror* (c. 1555), sold by the artist's son to the Barbarigo family of Venice, and the portrait *Doge Andrea Gritti*, which may have been in the collection of Charles I and was formerly in the Czernin Collection, Vienna. Paolo Veronese is represented by five paintings, most notably the lovely *The Finding of Moses*, and Jacopo Tintoretto by nine paintings, including *Christ at the Sea of Galilee* and the allegorical *Summer*, painted as part of the decoration of the Casa Barbo at San Pantaleone, Venice.

The collection of Italian Baroque and Rococo paintings is small but choice. By the two leading artists working in seventeenth-century Venice are Domenico Fetti's illusionistic *Veil of Veronica* and Jan Lys' *Satyr and the Peasant*. By the Florentine Orazio Gentileschi are two fine works, *St. Cecelia and an Angel* and *The Lute Player*. Of the Bolognese school there is Giuseppe Maria Crespi's *Lucretia Threatened by Tarquin*, and of the Genoese Alessandro Magnasco, a pair of religious works, *Baptism of Christ* and *Christ at the Sea of Galilee*. Eighteenth-century Venetian painting is especially well represented. By Giovanni Battista Tiepolo are nine works, including *Apollo Pursuing Daphne*, *Queen Zenobia Addressing Her Soldiers*, *The World Pays Homage to Spain*, and one of the most charming treatments of a familiar religious subject, *The Madonna of the Goldfinch*. More unusual is the large biblical subject *Elijah Taken Up in a Chariot of Fire* by Giovanni Battista Piazzetta. The Venetian spirit is captured most effectively in the selection of paintings by Pietro Longhi, Francesco Guardi, and Canaletto.

Early Northern paintings in the collection commence with the Franco-Flemish *Profile Portrait of a Lady*, which was once attributed to Pisanello, but her costume is Burgundian, attesting to the international character of Late Gothic portraiture. Also anonymous are the school of Amiens *Expectant Madonna with St. John* and the Hispano-Dutch *Adoration of the Magi*, both from the Kress Collection. Identifiable artists begin in spectacular fashion with Jan van Eyck's *Annunciation*, probably painted for Philip the Good, duke of Burgundy, and one of Mellon's most notable purchases from the Hermitage. By van Eyck's follower Petrus Christus, there are a *Nativity* and a pair of portraits, *A Donor and His Wife*. By

van Eyck's contemporary Rogier van de Weyden is the exquisite *Portrait of a Lady*, possibly Marie de Valengin, the illegitimate daughter of Philip the Good. Also attributed to Rogier is the small (5 5/8 by 4 1/8 inches) *St. George and the Dragon*.

The next generation of Early Netherlandish painters is represented by Memling's *Presentation in the Temple* and Gerard David's *Rest on the Flight into Egypt*, formerly in the J. Pierpont Morgan Collection. Subjects of horror and imagination are found in Bosch's *Death and the Miser* and *The Temptation of St. Anthony*, now attributed to a follower of Pieter Bruegel the Elder. Notable are works by two anonymous masters. Most impressive is the Master of the St. Lucy Legend's large *Mary, Queen of Heaven* from a convent near Burgos, Spain, and *The Baptism of Clovis* and *St. Len Healing the Children*, which contains some of the earliest accurate views of Paris, by the Master of St. Gilles. Early sixteenth-century Netherlandish painting is seen at its best in *The Card Players* after Lucas van Leyden and *Rest on the Flight into Egypt* by Jan van Scorel.

Of the German school, the Master of Heiligenkreuz's *Death of St. Clare* is outstanding. It is the mate to a *Death of the Virgin* in the Cleveland Museum of Art (q.v.). Also anonymous is the St. Bartholomew Altar Master by whom there is a *Baptism of Christ* of about 1500. By Albrecht Dürer, the greatest of the German painters, there is the *Portrait of a Clergyman* and the *Madonna and Child*, which has, curiously, on the back side the painting *Lot and His Daughters*. Of Dürer's contemporaries there is Grünewald's *Small Crucifixion*, a vivid small work once in the collection of Duke Maximilian I of Bavaria. Cranach the Elder's activity as a painter of portraits and erotic mythologies is well illustrated. Also German born was the painter Hans Holbein the Younger, who is, however, best known for his works painted for the English court, and the National Gallery has both the portrait *Edward VI as a Child* and the portrait *Sir Brian Tuke*, the latter from the Methuen Collection at Corsham Court.

Of the seventeenth century there are many glorious Dutch and Flemish works. By Rubens there are the oil sketches *Decius Mus Addressing the Legions* and *The Meeting of Abraham and Melchizedek*, both for tapestry projects. In addition there is the portrait *Deborah Kip and Her Children*, painted for her husband Sir Balthasar Gerbier, first earl of Radnor, and the very large painting *Daniel in the Lions' Den*, which was traded by Rubens to the English ambassador Sir Dudley Carleton. By Rubens' pupil van Dyck there are more than a dozen portraits covering the full development of his short career. An impressive early work is the portrait *Isabella Brant*, who was Rubens' first wife. The most magnificent example of work from van Dyck's Genoese sojourn in the early 1620s is the portrait *Marchesa Elena Grimaldi*, and from his English period there is the portrait *Philip, Lord Wharton*.

The galleries of seventeenth-century Dutch paintings feature works by Hals, Rembrandt, and Vermeer. Of the many portraits by Hals, outstanding are the *Portrait of an Officer*, formerly in the Walpole Collection; the *Portrait of an Elderly Lady*; and the 1645 portrait of Willem Coymans. The Rembrandt holdings

were greatly benefited by the Widener Collection. From it came the *Portrait of a Lady with an Ostrich-Feather Fan* and the recently cleaned *The Mill*, formerly in the duc d'Orléans' collection. From Mellon's collection came the *Self Portrait* of 1659, *Lucretia*, and *Joseph Accused by Potiphar's Wife*, which had belonged to Catherine the Great of Russia. Likewise, both collections were responsible for contributing to the remarkable group of Vermeers. From Mellon came *The Girl with a Red Hat* and from the Wideners, *Woman Holding a Balance*. Another Vermeer, *A Lady Writing*, was given by the children of Mr. and Mrs. Horace Havemeyer in their father's memory.

The Dutch school of landscape painting is seen at its best in Jacob van Ruisdael's *Forest Scene* and several works by Hobbema and Cuyp, especially the latter's *The Maas at Dordrecht*. The genre paintings include Gerard Ter Borch's *The Suitor's Visit*, once in the collection of the duc de Morny; Nicolaes Maes' *Old Woman Reading*; and Pieter de Hooch's *Dutch Courtyard*. There are excellent still lifes by Kalf and de Heem.

The National Gallery's survey of French paintings begins in the sixteenth century with François Clouet's so-called *Diane de Poitiers*. This is one of only three signed portraits by the artist. Also a rare work is *The Repentant Magdalen* by Georges de La Tour. Of the seventeenth-century French artists who worked primarily in Italy, there are a number of examples: Claude Lorraine's *The Judgment of Paris*, several works by Simon Vouet, and two masterpieces by Poussin, *The Assumption of the Virgin* and *Holy Family on the Steps*. A great example of seventeenth-century portraiture is Philippe de Champaigne's *Omer Talon*. A work of the same period that is both more rustic and mysterious is Louis Le Nain's *Landscape with Peasants*.

French Rococo painting is one of the National Gallery's strongest areas. By Watteau there is *Ceres*, one of an original series of four seasons that were in the Crozat Collection. Painted shortly before the artist's death is the melancholy *Italian Comedians*. It was Watteau who introduced the subject of the *fête galante*, and there are treatments of this theme by both Lancret and Pater. Of the numerous works by Boucher, especially notable is *Venus Consoling Love* of 1751, which was probably painted for Madame de Pompadour. There are also by him the *Allegory of Music* and the portrait *Madame Bergeret*.

Certainly one of the most justly famous paintings of the National Gallery is Fragonard's ravishing oil *A Young Girl Reading*, given by Mrs. Mellon Bruce in memory of her father, Andrew W. Mellon. Also by Fragonard are a number of decorative paintings, depicting idyllic landscapes and amorini.

Of eighteenth-century portraits there are many excellent examples by Greuze, Vigée-Leburn, Nattier, Largillière, and Drouais. The master of genre subjects, Jean Siméon Chardin, finds ample representation in his *House of Cards*, *Soap Bubbles*, *The Kitchen Maid*, *The Young Governess*, *Still Life*, and the work known as *The Attentive Nurse*, which was purchased from the artist by the prince of Liechtenstein when he was Austrian ambassador to France.

Spanish painting in the National Gallery begins with an entire gallery devoted

to the works of El Greco (Domenikos Theotocopoulos). The earliest work is *Christ Cleaning the Temple*, which is signed. There is also a *St. Jerome*, two versions of *St. Martin and the Beggar*, and the *Madonna and Child with Saints*, which was in the chapel of San José in Toledo until 1906. *The Laocoon* shows a classical theme set in front of a view of Toledo.

Of the seventeenth-century Spanish masters there is the delicate genre piece *The Needlewoman* by Velázquez, as well as his portrait *Pope Innocent X*, one of the former Hermitage paintings, which is probably a variant study for the finished portrait in the Doria Pamphili Gallery (q.v.) in Rome. By Velázquez's contemporaries there are Murillo's charming *A Girl and Her Duenna* and *The Return of the Prodigal Son*, Zurbarán's two paintings of saints, and a wonderful still life by Juan van der Hamen y Leon. Eighteenth-century Spain produced Goya, and the National Gallery has an outstanding group of works by him beginning with the portrait *Marquesa de Pontejos* and her dog. There are paintings of the royal family, notably the king, *Carlos IV as a Huntsman*, and the queen *María Luisa*. Also by Goya is the charming portrait of a boy, *Victor Guye*, and the pendant portraits of Don Bartolomé Sureda and his wife, Doña Teresa, given by Mr. and Mrs. P.H.B. Frelinghuysen of New York in 1941.

English painting of the eighteenth and nineteenth centuries is documented primarily by a major collection of portraits. Of the nine by Thomas Gainsborough, *Mrs. Sheridan*, wife of the playwright, is particularly outstanding. By Reynolds there are six, including the youthful *Lady Caroline Howard* and *Lady Elizabeth Delmé and Her Children*. By George Romney there are eight, of which the best known is the little girl *Miss Willoughby*. By Raeburn there are nine, of which one notes especially *Miss Eleanor Urquhart* and *Colonel Francis James Scott*, both from Andrew Mellon's collection. Distinguished also are the Joseph Wright of Derby's *Portrait of Richard, Earl Howe* and George Stubbs' *Colonel Pocklington with His Sisters*, in which the horse plays as prominent a part as the people.

In the category of English landscape painting there are two examples by Gainsborough and typical works by Constable, such as *Wivenhoe Park, Essex* and *A View of Salisbury Cathedral*. Turner is represented by the dramatic sea picture *The Junction of the Thames and the Medway* (1805) from the Widener Collection, the peaceful *Mortlake Terrace* (1826), and several other exquisite sea pictures and Venetian views.

Nineteenth-century French painting is another one of the National Gallery's outstanding areas, due in large measure to the extensive Chester Dale Collection, which is permanently installed, and by the terms of the bequest can never be lent. Jacques Louis David was born in 1748, but his 1812 portrait *Napoleon in His Study* shows his role in molding the image of the emperor. This and the *Portrait of Madame David*, dated 1813, are both from the Kress Collection. There is also the portrait *David* by Georges Rouget.

Romantic painting is exemplified by Géricault's *Trumpeters of Napoleon's Imperial Guard* and Delacroix's *Columbus and His Son at La Rabida* and *Arabs*

Skirmishing in the Mountains. By Delacroix's arch rival Ingres there is the brilliant portrait *Madame Moitessier* and also *Monsieur Marcotte*, as well as the elaborately detailed *Pope Pius VII in the Sistine Chapel* of 1814. The National Gallery has eighteen paintings by Corot, including both landscapes and figure studies such as the beautiful *Agostina*. Corot was also the original owner of one of the paintings in the collection by Daumier. Known as *Advice to a Young Artist*, it was given by Duncan Phillips. By J. F. Millet there are three works and by Courbet, eight.

Probably the most important single body of works by a nineteenth-century artist is that by Édouard Manet. *The Old Musician* of 1862 shows his debt to Spanish painting. *The Dead Toreador*, probably of 1864, is a fragment cut from a larger picture that received a poor reception at the Salon of 1864. In addition to several still lifes and portraits, there is also the work known as *Gare Saint-Lazare* of 1873. It depicts a woman and young girl at the train station, and it belonged originally to the opera singer and early supporter of the Impressionists, Jean-Baptiste Faure, later to the Havemeyer family and was presented to the Gallery by Horace Havemeyer in 1956. By Manet's friend Berthe Morisot there are also many paintings, most notably *The Sisters*, showing two women seated before a framed fan.

Of the Impressionists Renoir is perhaps the best represented, beginning with his *Diana*, which was refused for the Salon of 1867, and the *Odalisque* of 1870, which was exhibited. There are also landscapes, views of Paris, and some striking studies of children, such as the often-reproduced *Girl with a Watering Can*. By Monet there is also a representative group of works and examples of his Rouen Cathedral, Venice, and Houses of Parliament series. The full range of Degas' mature artistry is revealed in portraits such as *Madame René de Gas* and *Mademoiselle Malo*. Also by him are both oils and pastels of dancers. By Cézanne there is the fine early *Portrait of His Father* and several powerful landscapes. The National Gallery also possesses representative paintings by both Pissarro and Sisley.

Of other painters active at this time Boudin is extremely well represented. There are both fine portraits and flower pieces by Fantin-Latour and several flower pieces by Redon. From the Widener Collection, the National Gallery received the large-scale pair of paintings by Puvis de Chavannes, *Rest* and *Work*. A single, beautiful work by Jean-François Raffaëlli, *The Flower Vendor* is a Chester Dale bequest.

Of the Post-Impressionist works, there is the notable Georges Seurat *Seascape at Port-en-Bessin, Normandy*. Painted in 1888 it is one of his first attempts to paint the border of the canvas to form a frame. Originally owned by the artist's mother, it eventually passed to the collection of the writer and critic Félix Fénéon, one of Seurat's most fervent admirers. A number of works document the creativity of van Gogh and Gauguin. By the former is the Japanese-style treatment of a Provençal girl, *La Mousmé*, and the *Farmhouse in Provence, Arles*, both of 1888; *The Olive Orchard*, 1889; and *Girl in White*, painted in 1890, the last

year of his life. By Gauguin are the *Self Portrait* (1889), the *Haystacks in Brittany* (1890), and the portrait *Madame Alexandre Kohler* (1887–88), all painted before his departure to the South Seas. There are four later works painted in Tahiti, of which the most important, *Fatata te Miti*, dates from 1892, only a few months after Gauguin's first arrival there. The title means "by the sea." There are a good many characteristic works by Toulouse-Lautrec, such as the *Quadrille at the Moulin Rouge* and *Corner of the Moulin de la Galette*.

In January 1983 Mr. and Mrs. Paul Mellon donated to the National Gallery a significant group of nineteenth-century French paintings, including works by Bazille and Gauguin, the exquisite *Woman with a Parasol* by Monet, and the *Little Girl in a Blue Armchair* by Mary Cassatt.

Of the French artists born in the nineteenth century who founded the Nabis movement and in the twentieth century became known as the Intimists, the National Gallery has a very large collection. This is because the works, especially the small-scale ones, of Bonnard and Vuillard had great appeal to Ailsa Mellon Bruce. In addition, there are from the Chester Dale Collection Bonnard's *The Letter* of about 1906 and Vuillard's portrait *Théodore Duret* of 1912.

A French artist who also spanned two centuries and was to have a great impact on the younger generation was Henri Rousseau. His naïve genius is evident especially in the *Equatorial Jungle* of 1909. The leading avant-garde painters of the era, Picasso and Braque, were both fond of Rousseau, and their work is well represented in the National Gallery. By Picasso there are paintings from most of his significant periods, beginning with the large *Family of Saltimbanques* of 1905. Also from the same year is the *Lady with a Fan* that once belonged to Gertrude Stein. An example of the revolutionary Analytical Cubist style is *Nude Woman* of 1910. A later more colorful phase of Cubism is seen in Picasso's *Still Life* of 1918, and one of the best known of the painter's neoclassical-style works is *The Lovers* of 1923.

From the Fauve movement the National Gallery has a variety of works by Henri Matisse, including the voluptuous *Odalisque with Raised Arms* of 1923, but perhaps the most impressive is the enormous (116 by 60 inches) paper construction *Beasts of the Sea*, created when the artist was eighty-one.

Various other artists and movements representative of Paris in the early part of the twentieth century are also to be seen, none more spectacularly than the Italian-born Amadeo Modigliani. The Chester Dale Collection boasts as many as ten magnificent canvases by him. One of the most forceful is the 1917 portrait of the painter Chaim Soutine, whose own *Portrait of a Boy* is also an impressive work in the Dale Collection.

Twentieth-century non-French European masterpieces include Lyonel Feininger's *Zirchow VII*, Piet Mondrian's *Lozenge in Red, Yellow, and Blue*, and Salvador Dali's very popular *The Sacrament of the Last Supper* painted in 1955.

The American paintings collection of the National Gallery, which has become of major significance, begins with examples of the somewhat stiff early American portraits such as those of the *Chandler Family* by Winthrop Chandler. They

were part of the extensive Garbisch Collection of American naïve paintings given throughout the years to the National Gallery by Edgar William and Bernice Chrysler Garbisch. The transformation of American portraiture wrought by John Singleton Copley is evident in the comparison between his portrait *Jane Browne* of 1756 and his portraits *Epes Sargent* of about 1760 and *Eleazer Tyng* of 1772. Copley moved to London in 1775 and there painted the complex depiction of his own family, revealing the influence of the English portrait tradition. There, too, he exhibited his *Watson and the Shark* at the Royal Academy in 1778. Purely in the English manner are Copley's *The Red Cross Knight* and *Colonel Fitch and His Sisters*.

Another American who had great success in London was Benjamin West; by him there is the portrait *Colonel Guy Johnson*, the English superintendent of Indian affairs in the American colonies, shown with the idealized figure of an Indian who holds a peace pipe. A large-scale historical subject by West is *The Battle of La Hogue*, which belonged to Richard, first earl Grosvenor, and his descendants, the dukes of Westminster. Also of interest is West's *Self Portrait*.

Perhaps the most intrinsically American painter of the eighteenth century was Gilbert Stuart. While working in England, he painted his famous *The Skater*, a portrait of William Grant of Congalton, which was a sensation at the 1782 Royal Academy. His fine portrait style is also seen in *Mrs. Richard Yates*. Returning to America in 1793 he painted many portraits of George Washington, including the so-called Vaughan Portrait of 1795. The National Gallery has many other portraits of distinguished Americans by Stuart, such as *Mr. and Mrs. John Adams*. Other American portraitists represented in the National Gallery's impressive collection are John Trumbull, with the impressive portrait *Patrick Tracy*, and Thomas Scully, with his full-length portraits *Lady with a Harp: Eliza Ridgely* and *Captain Charles Stewart*.

American artists interested in a different type of subject were George Catlin, who as a young man traveled throughout North and South America recording the life of native Americans, and James J. Audubon, who studied the wildlife of America. The former is represented by the extensive collection of Indian images in the Paul Mellon Collection and the latter by both paintings and prints of birds and animals.

Nineteenth-century American landscape painting features extremes such as Edward Hicks' *Cornell Farm*, a naïve but visionary image, and George Inness' *The Lackawanna Valley*, commissioned by the railroad line for $75. There are also landscapes by Cropsey, Cole, Doughty, and Church. The Luminists branch of American landscape painting is exceptionally well represented in examples by Fitz Hugh Lane, John F. Kensett, and Martin Johnson Heade. American eccentrics include Albert Ryder with *Siegfried and the Rhine Maidens*, John Quidor with *The Return of Rip van Winkle*, and Ralph A. Blakelock with *The Artist's Garden*.

The leading American still-life painters, Harnett and Peto, are each represented by major examples of their trompe-l'oeil work. Likewise present are America's

two most original artists: Winslow Homer with his *Breezing Up* of 1876 and *Right and Left* of 1909 and Thomas Eakins with *The Biglin Brothers Racing* of about 1873 and *Portrait of Archbishop Diomede Falconi* of 1905.

Justifiably, the most famous portrait is James McNeill Whistler's *The White Girl (Symphony in White, No. 1)*, the portrait of his mistress Joanna Hefferman, of 1862. Rejected both by the Royal Academy and the Paris Salon, it gained tremendous notoriety at the Salon des Refusés. It came to the National Gallery in the Harry Whittemore Collection, along with another Whistler portrait, *L'Andalouse*, in 1943. The other notable portraitists in the National Gallery's collection include John Singer Sargent and Thomas Wilmer Dewing. Works of nineteenth-century genre painters run from Eastman Johnson's *The Brown Family* of 1869 to William Merritt Chase's *A Friendly Call* of 1895.

The successive movements of American painting can be studied in the National Gallery's collection. Of the American Impressionists, there is an impressive array of paintings by Mary Cassatt, most notably *The Boating Party*, which was painted in 1893 and remained in the artist's possession until 1914. There are also paintings by Childe Hassam (*Allies Day, May 1917*) and a typical snow scene by John Henry Twachtman (*Winter Harmony*). Members of the so-called Ash Can School of American realism include Robert Henri, William Glackens, John Sloan, George Luks, and George Bellows (e.g., his fine fight subject *Both Members of This Club*). American modernism of the twentieth century is reflected in paintings such as Max Weber's *Rush Hour, New York* and Marsden Hartley's *The Aero*.

With the completion of the East Building, the National Gallery has been able to add and display great examples of the American Abstract Expressionist school. Outstanding are two works by Arshile Gorky, *The Artist and His Mother*, on which he worked between 1929 and 1936, and *Organization* of about 1933–36; Mark Rothko's *Orange and Tan* of 1954; and, most impressive, Jackson Pollock's *No. 1, 1950 (Lavender Mist)*, one of the artist's great "drip" paintings. For the opening of the East Building, a special Collectors Committee was formed to provide outstanding large-scale examples of works by living artists. Among those of importance are the large Calder mobile and Robert Motherwell's mural-like acrylic on canvas, *Reconciliation Elegy*.

The National Gallery has an extensive sculpture and decorative arts collection. The greatest concentration of the sculpture collection is in the Italian Renaissance. Among the masterpieces are *The Madonna of Humility* attributed to Jacopo della Quercia; two marble reliefs, *Charity* and *Faith*, by Mino da Fiesole; marble busts and reliefs by Antonio Rossellino and Desiderio da Settignano; and terracotta portraits of Lorenzo and Giuliano de' Medici by Andrea del Verrocchio.

Proudly installed in the courtyard of the rotunda of the West Building is the exceptional bronze *Mercury* attributed to Adrien de Vries, a Dutch master who worked in Florence. Of purely Northern sculpture, a particularly significant piece is Tilman Riemenschneider's wood *St. Burchard of Würzburg*, about 1520, from the Kress Collection.

In February 1983 the National Gallery opened the remodeled galleries of the ground floor of the original West Building. They are now devoted to the graphic arts, sculpture, and decorative arts dating from the twelfth century to the present. Commencing with these ground-floor galleries at the northern end of the building, one discovers a small gallery devoted to the ecclesiastical arts of the Middle Ages and the Renaissance. These works, given in 1942 by Joseph Widener in memory of his father, Peter A. B. Widener, include some of the most outstanding surviving examples of liturgical treasures. Most famous is the chalice of Abbot Suger of Saint-Denis. The cup of this object is made of sardonyx, probably carved in Egypt during ancient Roman times. About 1144 the Abbot Suger had it set in a gold and silver setting adorned with gems, and the chalice was used for nearly six centuries as the sacramental cup for the coronation of French queens. Other works in this room include an aquamanile, a pyx in the form of a dove (French 1200s), and a morse (a brooch worn by a bishop), which is sculpted and enameled with a representation of the Trinity and reflects the Franco-Burgundian International Style of about 1400.

Adjoining this gallery are others devoted to Renaissance tapestries and furniture also primarily from the Widener Collection. Most notable is the so-called Mazarin Tapestry, *The Triumph of Christ*, a thirteen-foot-long work that is generally considered the finest surviving example of tapestry-making from Brussels (c. 1500). It was first recorded in the inventory of the Cardinal Mazarin.

The next and very extensive suite of galleries is given over to the National Gallery's remarkable collection of smaller sculptures and medals. One of the most distinguished pieces is a Renaissance version of the *Capitoline She-Wolf*. Through the generosity of the Widener and Kress families, the collection of medals and plaques, primarily in bronze, numbers well over a thousand examples. One of the earliest and rarest pieces is the bronze self-portrait plaque of Leone Battista Alberti, one of the few sculptures attributed to the great fifteenth-century architect. There are also plaquettes by Moderno and Valerio Belli, the fantastic *Neptune on a Sea-Monster* by Severo da Ravenna, and the moving *Entombment* relief by Riccio.

Early-seventeenth-century Italian sculpture is introduced with Pietro Tacca's impressive *Pistoia Crucifix*. French sculpture is also well represented with notable examples, such as the equestrian *Louis XIV* after Desjardins and François Coudray's *Saint Sebastian* of 1712.

The greatest of French eighteenth-century sculptors, Claude Michel (called Clodion) and Jean-Antoine Houdon, are present in a significant collection of marbles and terracottas that allows one to trace the movement from Rococo playfulness to neoclassical high-mindedness. By Clodion there is the early *Silenus Crowned by Nymphs*, a signed and dated terracotta of 1768. Nearby is the large marble *Vestal* commissioned from him in 1770 by Baron Grimm for Empress Catherine the Great of Russia. Of the Houdon works, the most remarkable are the portraits. They include the children *Louise* and *Alexandre Brongniart* (marbles of 1777), two busts of Voltaire, and the extraordinary *Cagliostro* of 1786.

Also of the eighteenth century are four French period rooms. The furniture, primarily from the Widener Collection, is work by known cabinetmakers. The most historically important piece is Marie Antoinette's writing desk from the Tuileries Palace.

The survey of sculpture continues with a wide variety of works from the nineteenth and twentieth centuries. The artists include Carpeaux, Daumier, Rodin, Gauguin, and the American Saint-Gaudens. Several Barye bronzes were recently donated to the museum by Mr. and Mrs. Paul Mellon, who have also lent a number of Degas wax sculptures and the bronzes made from them.

Of twentieth-century sculpture, there are works by the American Paul Manship (*Diana and Hound*), as well as the composite tinted plaster *Seated Youth* by German Expressionist Lehmbruck. Found within the East Building are monumental sculptures by Henry Moore, Max Ernst, Noguchi, and David Smith, as well as the Calder mobile, Giacometti's *The Invisible Object*, and Brancusi's *Bird in Space*.

Also now on view in the renovated lower-floor galleries of the West Building are the Chinese porcelains from the Widener Collection. They include notable examples from the Kang'hsi period, such as oxblood vases, and others with designs of dragons and phoenixes from the Ch'ing Dynasty of the 1700s.

The Department of Graphic Arts has a collection that numbers more than fifty thousand works. The first gift of graphic arts to the National Gallery was primarily Old Master prints donated in 1941 by Ellen Bullard, Philip Hofer, and Paul Sachs. This was followed by the first gift of drawings in 1942 consisting of works by Rodin from Mrs. John W. Simpson. That same year the Widener Collection brought to Washington outstanding works by Dürer, Rembrandt, and Boucher, as well as an extraordinary group of eighteenth-century French illustrated books. The most substantial contribution to the graphic arts collection, commencing in 1943, was made by Lessing J. Rosenwald. In addition to incunabula and rare prints from all eras, this collection ranged from medieval illuminations to drawings by Schongauer, Fra Bartolommeo, Rembrandt, Blake, and Matisse. Promised to the National Gallery is the drawing collection of Armand Hammer, which includes notable works by Dürer, Watteau, and Ingres. In recent years the museum has actively acquired major drawings with funds from the Ailsa Mellon Bruce Fund, especially several sigificant examples by Rubens, including a chalk *Lion* and *Pan Reclining*. In memory of her husband, Ruth K. Henschel has given several wonderful watercolors by Winslow Homer.

The National Gallery is also developing a collection of photography and as a core has the approximately sixteen hundred works of Alfred Stieglitz donated by his widow Georgia O'Keeffe.

The Center for Advanced Study in the Visual Arts is an integral part of the new East Building. In addition to offices for the curatorial staff and visiting scholars, it houses the six-story library and also photographic archives.

A unique feature of the Gallery is the Index of American Design, which is a collection of watercolor renderings of objects of popular art in the United States

from before 1700 until about 1900. There are some seventeen thousand renderings of ceramics, glassware, furniture, and other types of American craftsmanship that are available for study by appointment.

The National Gallery Library is an excellent research collection of some eighty-seven thousand volumes (monographs, bound serials, pamphlets, microforms) and provides an array of services appropriate to the specialized needs of the Gallery staff, fellows of the Center for Advanced Study in the Visual Arts, and outside readers. Beginning in 1981 the library installed its first exhibition designed to complement concurrent displays throughout the Gallery. An extensive (some 110,000) slide library can be found in the Department of Tours and Lectures. The department also provides audio-visual services, summer intern programs, radio talks, painting-of-the-week texts, and an art information service. Color reproductions, note cards, and calendars based on the Gallery's permanent collection, as well as a variety of art books, may be purchased in the sales area in the West Building. The increasing interest in commercial publications related to the National Gallery's collection has resulted in a special request service being implemented to fill these requests. Music concerts are also held during the year in the garden courts and are open to the public. The National Gallery of Art publishes an *Annual Report* as well as a scholarly journal.

Selected Bibliography

Museum publications: *The National Gallery of Art: A Twenty-Five Year Report*, 1966; *American Paintings, an Illustrated Catalogue*, 1980; *National Gallery of Art, European Paintings, an Illustrated Summary Catalogue*, 1975; Finley, David Edward, *A Standard of Excellence, Andrew W. Mellon Founds the National Gallery of Art at Washington, D.C.*, 1973; Shapley, F. R., *Catalogue of the Italian Paintings*, 1979.

Other publications: Walker, John, *The National Gallery of Art, Washington*, rev. ed. (New York 1985).

<div align="right">ERIC M. ZAFRAN</div>

PHILLIPS COLLECTION, THE (alternately PHILLIPS MEMORIAL ART GALLERY, PHILLIPS MEMORIAL GALLERY, PHILLIPS GALLERY), 1600–1612 21st Street, N.W., Washington, D.C. 20009.

Founded in 1918 and incorporated in the District of Columbia July 23, 1920, The Phillips Collection first opened to the public three afternoons a week in the late fall of 1921. Originally called the Phillips Memorial Art Gallery in 1922, the museum's name was shortened to the Phillips Memorial Gallery in 1922 and shortened further in 1948 to the Phillips Gallery. Finally, in 1961, the present title, The Phillips Collection, was adopted.

The Collection was established by Duncan Phillips (1886–1966) and his mother, Eliza Laughlin Phillips, in memory of Duncan's recently deceased father, Major Duncan Clinch Phillips, and brother James Laughlin Phillips. Duncan and his brother James were born in Pittsburgh. Their father had been a Civil War veteran and later a glass manufacturer (Beck, Phillips and Co., Pittsburgh); their mother

was the daughter of James Laughlin, a banker and cofounder of the Jones and Laughlin Steel Company.

The Phillips Collection is classified as a privately operated foundation and from its establishment in 1918 until 1979 was funded by the Phillips family. When Duncan Phillips died in 1966, he left an endowment for the Collection's continued care and maintenance, but inflation, the need for renovation of the original 1897 building and the 1960 annex, adequate storage facilities and temporary exhibition space, conservation, and a larger staff forced the family to seek outside funding.

Since 1979, grants have been sought for special projects such as conservation, research for a permanent collection catalogue (the last having been prepared in 1952), and an increasingly active and ambitious exhibition program. In 1981 a $6.5 million campaign for The Phillips Collection was officially announced, with the objectives of doubling the museum's endowment and providing funds for renovation of its facilities. In addition to beginning the capital campaign, the Phillipses initiated the Corporate Membership Program in 1982 and the Patrons Membership Program in 1983 to provide the museum with increased annual operating support. Both capital and annual programs have been highly successful.

The Phillips Collection is governed by a board of trustees of nine members, four of whom are of the Phillips family. Trustees are appointed for an indefinite term. The museum is also guided by two national advisory bodies—the twenty-four-member Council of The Phillips Collection, which advises and assists the trustees on matters of management, fund raising, and substantive art programs, and the thirty-four-member National Committee for The Phillips Collection, which provides national support for development efforts. Compared with other museums, the Phillips' staff is still very small, consisting of twenty-one full-time and two part-time staff members. There are three major departments (Administrative, Curatorial, and Public Affairs), as well as a small Music Department, Library, and Registrar's Office, under the overall supervision of the director. The Curatorial Department has a curator of collections, and associate curator, two research curators, an assistant curator assigned to the research curators, an installer, and an exhibitions coordinator, as well as several adjunct curators. The Public Affairs Department consists of officers responsible for development, special events, publications, the sales shop, and coordination of the docents program.

When the Phillips family moved to Washington in 1896, Major Phillips commissioned the architectural firm Hornblower and Marshall to build a Georgian Revival-style home at the corner of 21st and Q streets, N.W. The three-story, red brick house with sandstone and terracotta trim was completed the following year. A single-story, T-shaped wing, added to the north in 1907, was also designed by Hornblower and Marshall. This room, originally intended as a library, is decorated in a Renaissance Revival style with coffered ceiling and ornately carved wooden paneling. (This is now the Music Room where free concerts are given every Sunday, September through May, a tradition since 1941.) In 1920 McKim, Mead and White remodeled some parts of the original

building and added a second story to the north wing (now the main gallery). A fourth story with mansard roof was added to the main structure in 1923 by the architect F. H. Brooke. (The fourth floor, recently extended over the main gallery, now houses a skylit library, administrative offices, and a research office, but the floor was originally designed as additional family living quarters and as studio space for Marjorie [Mrs. Duncan] Phillips, a painter. From 1938 to 1950 the present library space was used as a studio for the Phillips Gallery Art School.) In 1930, due to the increased size of the Collection, Duncan Phillips and his family moved to another residence in Washington and turned over the furnished Georgian Revival home entirely for museum use. An extensive annex was constructed in 1960. Designed by Frederick King, it is a separate three-story building containing galleries and a museum shop and is connected to the original house by glass walkways.

Renovations on the 1897 building were begun in July 1983 by the architect Arthur Cotton Moore. This phase of the renovations, completed in 1985, provides slightly expanded gallery spaces, additional offices on the third and fourth floors, and entirely new climate-control, electrical, and security systems. This has been achieved without mitigating the quiet atmosphere of the original private home. In fact, many are pleasantly surprised by some of the restorations, notably, the ceiling of the music room and all of the fireplaces. A second phase of renovation will begin in 1986 on the annex built in 1960. There, special gallery space will be provided for temporary exhibitions; there will be better storage facilities and, again, new climate-control and security systems.

When The Phillips Collection was established in 1918, Duncan Phillips was already an amateur collector and art critic with several publications to his credit. A graduate of Yale University in 1908 with a degree in English, Phillips had already recognized the need for the study of art history and wrote an article in the June 1907 issue of the *Yale Literary Magazine*, "The Need for Art at Yale." After graduation, Phillips continued his studies in art at his home in Washington and then abroad, meeting with artists and attending exhibitions. In 1916 Duncan and his brother convinced their parents to set aside $10,000 a year for the acquisition of paintings. Duncan continued to write on art and, according to *A Collection in the Making*, as he later told his class secretary, "I have attempted to act as interpreter and navigator between the public and the pictures, and to emphasize the function of the arts as means for enhancing and enriching living."

This became Duncan Phillips' life concern, particularly after the tragic loss of his father and brother, when he channeled all of his energies into creating a "beneficent force in the community." In *A Collection in the Making*, he wrote: "I would create a Collection of pictures—laying every block in its place with a vision of the whole exactly as the artist builds his monument or his decoration. . . . I would live with such a Collection, learning from the mistakes I made—eliminating the dross—enshrining the pure gold. Why not open the doors to all who would come and watch the building of the edifice—watch the laying of stone upon stone—pass through the portals and share the welcome of art at home,

art in its own environment of favorable isolation and intimate contentment?''
Above all, Phillips wanted his collection to be a ''joy-giving, life-enhancing
influence assisting people to see beautifully as true artists see,'' a place where
visitors could be intellectually stimulated and spiritually refreshed.

The Phillips Collection was the first museum of modern art in this country,
but Duncan Phillips acquired it cautiously. He was, in fact, a vociferous critic
of the Armory Show but later recanted and, following his own advice, kept an
open mind and learned from his mistakes so that his collection would be con-
tinually ''in the making,'' ever growing and changing. Not only did Phillips
begin to defend modern art, but by 1925 he began to acquire it. The Collection
was never avant-garde, and by today's standards it is conservative. But there is
a long list of ''firsts'' in the history of Duncan Phillips' collecting, and through
the enormous body of writings that he produced on artists ranging from Giorgione
to Rothko, many were discovered or reevaluated and found acceptance.

Phillips' concepts and philosophies still govern all aspects of the museum
today—from the home setting to the generous lending policy of The Phillips
Collection. Since he refused to use any agents or advisers and sought only his
wife's opinion on acquisitions, the character of the Collection mirrors that of its
creator. Phillips once said in a 1953 radio address that he collected personalities—
''not what can be put into a picture but what cannot be left out—that quintessence
of self-captured in some expressive correspondence of esthetic form.'' The Col-
lection was never intended as a comprehensive survey in a historical sense; yet
there is a unity in its diversity, and as a museum of modern art and its sources,
it reflects a ''continuity of tradition.''

The Collection today consists largely of nineteenth- and twentieth-century
European and American paintings with sources from earlier centuries. Of the
approximately 2,500 paintings in the Collection, there is only enough gallery
space to view 250 at any time. Thus there are frequent rearrangements of the
Collection, with paintings being rotated from storage or as they have returned
from loan. This brings into play one of Phillips' key philosophies in viewing
works from the Collection, for he delighted in creating exciting visual juxta-
positions of similar or diverse artistic temperaments across broad expanses of
time.

When one enters the 1897 building, the first drawing room features a large
group of paintings by Ryder, works ranging from the clear palette of *Gay Head*
(1890) to the darkly majestic *Moonlit Cove* (1880–90). On the opposite wall is
usually *Lake Albano* (1869), a work by Ryder's spiritual antecedent, George
Inness. Homer's *To the Rescue* (1886) often dominates an end wall, and two
portraits, one by Whistler, *Miss Lillian Woakes*, and one by Eakins, *Miss Amelia
Van Buren*, both about 1890–91, invite comparison—the one, enchantingly del-
icate, the other mesmerizing in its psychological intensity. In the next room are
often a pair of Puvis de Chavannes—*Marseilles, Port of the Orient* and *Massilia,
Greek Colony*, both of 1868, studies for a mural commission for the Musée de

Marseilles; a Courbet, *Rocks at Mouthiers* (c. 1850); and over the mantel, a late oil by Degas, *Dancers at the Practice Bar* (c. 1884–88). Flanking the Degas are Morisot's *Two Girls* (c. 1894) and a painting by the American Impressionist Twachtman, *Emerald Pool* (c. 1895). Two tiny paintings complete the circle— a Boudin, *Beach at Trouville*(1863), and an early Seurat, *The Stone Breaker* (1883). Van Gogh's *The Road Menders* (1889) is often an alternate in this room, sometimes replacing the Courbet.

In the wing built in 1960, an El Greco, *The Repentant Peter* (c. 1600), hangs near a *Repentant Peter* (c. 1820–24) by Goya to contrast each artist's interpretation of the saint—the El Greco, rapturously spiritual, the Goya, powerfully human. Nearby, Picasso's *The Blue Room* (1901) offers visual testimony to the El Greco in color, attenuation of forms, and mood. A transitional work by Manet, *Ballet Espagnol* (1862), fittingly takes its place near the Spanish masters. With the addition of two van Goghs, *Entrance to the Public Gardens at Arles* (1888) and *House at Auvers* (1890), one recognizes an emotional thread that links these artists across centuries.

The Phillips has a particularly fine group of Daumier oils, among them, *The Uprising* (c. 1860). Purchased in 1925, it was Duncan Phillips' personal favorite. Strategically placed in a gallery next door to the El Greco, it is a powerful emotional statement that transcends time. In this room is a wall of the smaller oils, including *On a Bridge at Night* (1845–48), *The Strong Man* (c. 1865), *The Artist at His Easel* (c. 1870), *Three Lawyers* (1870), and *Two Sculptors* (1870–73). On the opposite wall, the Chardin *Bowl of Plums* (c. 1728) balances Cézanne's *Still Life with Pomegranate and Pears* (c. 1895–1900), and on another wall, the Constable *On the River Stour* (c. 1834–37) complements a Monet *Road to Vétheuil* (c. 1880). Sprinkled throughout are usually paintings by Corot, *View from the Farnese Garden, Rome* (1826) or perhaps a work from his third trip to Italy, *View of Genzano* (1843); and by Delacroix, *Horses Coming Out of the Sea* (1860) or *Paganini* (c. 1832).

Renoir's *The Luncheon of the Boating Party* (1881), undoubtedly the Collection's most famous and beloved painting, dominates another gallery on the same floor. Purchased in 1923 from the private collection of Durand-Ruel in Paris, it gloriously represents Renoir at the height of his career, and it is one of the monuments of the Impressionist period. In the same room with the Renoir are often two works by Degas, *Women Combing Their Hair* (c. 1875–76) and *After the Bath* (c. 1895). Another Monet, *On the Cliffs, Dieppe* (1897), hangs over the mantel, and in the corner, an example by the master whom Degas worshipped and to whom Renoir later turned, is Ingres, represented by the small *Bather* (1826).

On another floor in the same wing, Matisse's *Studio, Quai St. Michel* (1916) and *Interior with Egyptian Curtain* (1948) are often displayed with Diebenkorn's *Interior with View of the Ocean* (1957). In the same room may be a late Cézanne, *Jardin des Lauves* (1906), near de Staël's *Fugue* (1952). There may also be a

La Fresnaye, *Emblems* (c. 1913); and an elegant Gris, *Still Life with Newspaper* (1916); a Modigliani, *Elena Pavlowski* (1917); and perhaps a Soutine, *Dead Pheasant* (1926–27).

Proportionally, the Collection has about four American works to every one by a European artist. Among the 240 paintings Phillips had acquired by the time the gallery opened in 1921 were examples by Chardin, Constable, Daumier, Courbet, Puvis de Chavannes, Boudin, Monticelli, Degas, Fantin-Latour, Sisley, and Monet. The Americans represented at that time were Inness, Whistler, Homer, Weir, Ryder, Chase, Robinson, Twachtman, Carlsen, Hassam, Prendergast, Davies, Luks, Myers, Tack, Sloan, Lawson, Dougherty, Robert Spencer, and Gifford Beal. Even then, Phillips showed a propensity for one of his favorite collecting policies, that of the exhibition unit. All of the above artists are still represented in the Collection, but the size of each unit may have fluctuated throughout the years, for Phillips was a zealous trader if he thought that he could acquire a better example of an artist's work. A unit may consist of as few as four paintings, as in the case of Degas, or as many as fifty, as in the case of Arthur Dove. The reasoning behind each unit was to show the artist at his best; thus a certain period from an artist's career may dominate a unit, or in other cases, a unit may consist of a survey of the artist's entire career. There are several important units that are on permanent display: Daumier, Ryder, Bonnard, Klee, Braque, and Rothko. Periodically, other rooms may be devoted to artists in the Collection represented by a unit, such as Weir, Prendergast, Davies, Eilshemius, Tack, Marin, Rouault, Lawson, Dufy, Dove, Kokoschka, Burchfield, or Knaths; but more often, they are seen in smaller numbers in intriguing visual groupings.

The twenties and thirties were undoubtedly the richest and most exciting years of Duncan Phillips' collecting, but he came to acquire modern art cautiously. In 1925 he purchased his first Cézanne, *Mont Sainte-Victoire* (1886–87), and his first Gauguin, *Idyl of Tahiti*. Phillips now owns six Cézannes and, besides those previously mentioned, there are the *Fields of Bellevue* (1892–95), a superb *Self Portrait* (1878–80), and the *Seated Woman in Blue* (1902–06). The Gauguin was later traded for a Goya, but another Gauguin, *Still Life with Ham* (1889), was purchased in 1951.

Also in 1925 Phillips purchased his first Bonnard, *Woman with Dog* (1922). He was a decade ahead of other collectors and museums in his appreciation of Bonnard, and eventually he collected sixteen of his paintings. Among them are *The Terrace* (1918), *The Open Window* (1921), *The Palm* (1926), and the charming *Circus Rider* (1894).

Phillips began collecting the work of Arthur Dove and John Marin in 1926. Both artists enjoyed Phillips' patronage and friendship, and both are represented by significant units—Dove with fifty and Marin with twenty-one. The Doves include the whimsical collage *Goin' Fishin'* (1925), *Golden Storm* (1925), *Cows in Pasture* (1935), and *Flour Mill Abstraction* (1938). Among the Marins are *Maine Islands* (1922), *Grey Sea* (1924), and *Fifth Avenue at Forty-second Street* (1933).

There are smaller units of artists from the Stieglitz circle, O'Keeffe, Hartley, and Weber.

Paintings by Braque, Matisse, and Picasso were first added to the Collection in 1927. Phillips preferred Braque to Picasso, and of the twelve Braques now in the Collection, most are still lifes from the twenties and thirties, among them, Phillips' favorite, *Still Life with Grapes* (1927). Several date from Braque's later years, *The Wash Stand* (1944) and *The Philodendron* and *The Shower* (both 1952). *Music* (1914), a work from Braque's Synthetic Cubist period, came to the Collection in 1953 as part of the bequest of Katherine S. Dreier. The noblest of the unit, however, is *The Round Table* (1929), a monumental still life, one of the finest of Braque's "Gueridon" series.

The Klee unit in the Collection is outstanding. Phillips began acquiring Klee's work in 1930 with *Tree Nursery* (1929). Since Phillips was an early admirer of Klee's later work, all of the paintings date in the mid-twenties to the late thirties. They include *Cathedral* (1924), *Arab Song* (1932), *Figure of the Oriental Theatre* (1934), and *Way to the Citadel* (1937).

Other artists' works also begun in the thirties were those of Burchfield, Rouault, Kokoschka, and Dufy; and beginning in the fifties, works by Alfred Maurer, Soutine, Avery, Graves, and Kandinsky were collected; the fifties saw additions by de Staël, Nicholson, Gatch, Rothko, Schwitters, and Calder. The pace slowed considerably by the sixties, although significant pieces were added by Diebenkorn, Giacometti, Tobey, Gottlieb, Lipchitz, and Motherwell. After Duncan Phillips' death in 1966, his wife, Marjorie, became director. During her tenure, examples by Daumier, Nicholson, Still, and Picasso were added. Mrs. Phillips resigned in 1972, and her son Laughlin became the current director. Acquisitions are still being made but on a very limited basis until the building renovations and capital campaign have been completed.

In 1953 seventeen works came into the Collection from the estate of Katherine S. Dreier. Besides Braque's *Music* (1914), the bequest included an early plaster relief by Archipenko, *Standing Woman* (1920); another plaster relief by Duchamp-Villon, *Gallic Cock* (1916); by Kandinsky, *Composition-Storm* (1913); by Mondrian, *Painting No. 9* (1939–42); by Pevsner, *Plastic Relief Construction* (1929); by Marc, *Deer in the Forest I* (1913); and by Schwitters, both 1920, the handsome *Radiating World* and the small *Merz Collage-Tell*.

Although the Phillips is far richer in paintings, there are a few significant examples of sculpture. The earliest is an Egyptian limestone head from Tel-el-Amarna (c. 1350 B.C.); a Romanesque head from St. Gilles du Gard (twelfth century A.D.); a Maillol, *Head of a Woman* (1898); a Renoir, *Mother and Child* (1916); three Lachaises, *Sea Lion* (1917), *Peacocks* (1922), and *Head of John Marin* (1928); an Antoine Bourdelle, *Virgin of Alsace* (1920); a Despiau, *Head of Mme. Derain* (1922); two Picassos, *The Jester* (1905) and *Head of a Woman* (1950); a Gabo, *Linear Construction, Variation* (1942–43); a Moore, *Family Group* (1946); three Calders *Helicoidal Mobile-Stabile* (c. 1932), *Red Flock* (c. 1949–50), and *Only Only Bird* (1952); a Giacometti, *Monumental Head* (1960);

and two Penalbas, *Small Dialogue* (1962) and *Annonciatrice* (1963). There are about one thousand works on paper in the Collection as well. They are currently being inventoried, but artists from the sixteenth century to the present are represented.

In 1979 a research office was created specifically to prepare a new catalogue on the permanent Collection. This office, in turn, has inaugurated an internship program of graduate students to assist with the project. This office also coordinates an annual George Washington University graduate seminar in art history that is held at the Collection.

A full-time librarian (also a newly created position) coordinates additions to the library with the research effort. The library has about twenty-eight hundred volumes, mostly on artists represented in the Collection. It is open to the public by appointment Tuesday through Friday, ten to five o'clock, but is noncirculating.

Black-and-white photographs of works in the Collection can be purchased and color transparencies rented for three-month periods by contacting the Office of Rights and Reproductions. Slides can be ordered from Rosenthal Art Slides, 5456 South Ridgewood Court, Chicago, Illinois 60615. A list of 468 slides is available in their catalogue.

Duncan Phillips' correspondence from 1920 to 1960 was put on microfilm by the Archives of American Art in 1979. Due to the volume of material, there are only two microfilm copies, one at The Phillips Collection in Washington and another at the Achives of American Art in Detroit. The original papers are housed at the Archives of American Art in Washington. Special written permission is needed from the director, Laughlin Phillips, to see these papers, either in the original or on microfilm.

Selected Bibliography

Museum publications: Phillips, Duncan, *A Collection in the Making*. Washington D.C.: Phillips Publications No. 5, 1926; idem, *The Artist Sees Differently*, 2 vols. Washington D.C.: Phillips Publications No. 6, 1931; *The Phillips Collection: A Museum of Modern Art and Its Sources*, Catalogue 1952; Phillips, Marjorie, *Duncan Phillips and His Collection*, 1970; Grogan, Kevin; Sareen Gerson; and Bess Hormats, *The Phillips Collection in the Making: 1920–1930*, 1978; Green, Eleanor, *Master Paintings from The Phillips Collection*, 1981; Newman, Sasha, *Arthur Dove and Duncan Phillips: Artist and Patron*, 1981.

Other publications: Hormats, Bess, *Retrospective for a Critic: Duncan Phillips* (College Park Md. 1969); exhibition catalogue containing a list of Duncan Phillips' published w ,s from 1909 to 1967.

JAN MERLIN LANCASTER

—— Worcester ——

WORCESTER ART MUSEUM, THE, 55 Salisbury Street, Worcester, Massachusetts 01608.

The Worcester Art Museum, a private, independent institution, had its inception on February 25, 1896, when Stephen Salisbury III asked a group of prom-

inent Worcester citizens, gathered at his home, to form a corporation to maintain and administer an art museum, for which he proposed to donate a tract of land and a building fund. Upon Salisbury's death in 1905, most of his considerable fortune went to the museum to form the endowment, which has subsequently been augmented by other gifts and bequests. Additional income derives from membership donations, and certain specific projects have been implemented by special grants. Acquisition of works of art has been mainly by purchase, but donations of individual objects or entire collections have enriched the museum's holdings.

The corporation is still the ultimate governing body, from which fifteen trustees are elected to serve up to three consecutive three-year terms. They oversee the institution's operation through nine standing committees. The museum is administered by a director and an administrator; a curator and an associate curator of the collection; curators of Prints and Drawings, Photography, and Museum Education; and administrative heads of Conservation, Development and Membership, Public Relations, the Library, the Museum Shop, and the School of the Worcester Art Museum.

The original building, a large structure with a Renaissance flavor, was opened on May 10, 1898. To accommodate the growing collection, additions were completed in 1921 and 1933. The second of these additions houses the major part of the permanent collection. It incorporates, on the ground floor, the chapter house from the Benedictine Priory of Le Bas Nueil, near Poitiers, which the museum acquired in 1927. It is unique in America in retaining, except for minor replacements, the original ribs and webs of its Romanesque vaulting. Its cloister facade now faces a graceful Italianate court around which the main galleries are arranged on two levels. In 1970 the Higgins Education Wing was opened. Sponsored by the family of Aldus C. Higgins to house the museum's professional art school and other educational activities, it was designed by The Architects Collaborative in a contemporary style that harmonizes with the older structures. Another addition, the Frances L. Hiatt Wing, opened in 1983. It contains a twentieth-century gallery, temporary exhibition galleries, and space for the exhibition, study, and storage of prints.

The collection of ancient art comprises a modest number of representative pieces of high quality from Egypt and the Ancient Near East and more extensive holdings from Greece and Rome. An Egyptian masterwork from the Old Kingdom (2680–2280 B.C.) is a life-size torso of a woman, part of a funerary group (c. 2440 B.C.). Egyptian representational conventions are typified in the limestone relief *A Nobleman Hunting on the Nile*, also from the Old Kingdom. There are a number of smaller Egyptian works, prominent among them a tense bronze cat from the Saite Period (663–525 B.C.). Ancient Sumerian art is represented by a votive statuette from Khafaje, dating from the Early Dynastic period (3000–2500 B.C.). Two reliefs illustrate later developments in the Ancient Near East, a powerful winged genius from Ashurnasirpal's palace at Nimrud and a Persian (Achaemenian) fragment with spearmen from Persepolis.

The main periods of Greek art may be studied in significant examples of

sculpture and vase painting, along with smaller works in bronze, terracotta, and glass. The colossal head from a votive statue (Cypriot, c. 500 B.C.) embodies the sharp definition and ebullient smile of the Archaic phase; the Classic period is represented in three stelae or stele-fragments from the fifth and fourth centuries B.C. The small group of vases illustrates the main shapes and styles and features a splendid, late, black-figure amphora attributed to the Rycroft Painter. Hellenistic influence is combined with Italic realism in an Etruscan terracotta sarcophagus from Chiusi (160–140 B.C.).

Roman sculpture and mosaics are well represented. Especially notable is the group of nine portrait heads, including marbles of Nero and the young Marcus Aurelius and a grim Diocletian in black basalt. A rare and well-preserved bronze bust of an unknown Roman woman (c. 165–183) was purchased in 1966, and a large standing portrait in marble of a Republican woman (c. 40–30 B.C.) went to the museum in 1978. The later development of Roman painting and the genesis of the Byzantine style is reflected in an exceptional series of a dozen pavement mosaics from excavations at Antioch-on-the-Orontes and Daphne, in which the museum participated from 1932 to 1939. The great hunting mosaic, the most dramatic by reason of content and size (more than twenty by twenty-three feet), occupies the center of the courtyard floor. In number and quality these mosaics are outstanding in America.

The collection of Western painting is the most important segment of the museum's holdings. It had grown throughout the years through judicious purchases and with gifts such as the Theodore T. and Mary G. Ellis Collection of European and American painting and decorative arts received in 1940. Among the medieval paintings are four transferred frescoes or fresco-fragments of the late thirteenth century, which came from the chapel of a former convent near Spoleto, Italy. There is also a significant group of small Italian panel paintings ranging from the Italo-Byzantine to the late Giottesque. The International Gothic is epitomized in *The Virgin and Child with Angels in a Garden with a Rose Hedge*, a rare panel ascribed to Stefano da Verona. Of singular interest among the fifteenth-century Italian panels is Piero di Cosimo's *The Discovery of Honey by Bacchus*. There are also early Netherlandish panels by Albert Bouts and Quentin Massys, as well as several rare French panels of the fifteenth century. Transitional to the High Renaissance is the considerably overpainted but still impressive *Virgin and Child (The Northbrook Madonna)*, assigned to Raphael's early period (c. 1505).

International Mannerism is exemplified in several sixteenth-century Italian portraits and a sophisticated picture from the School of Fontainebleau, *Woman at Her Toilette*. The transition from Mannerism to Baroque, on the other hand, is clearly seen in *The Repentant Magdalen*, an important work from El Greco's early Spanish years.

Worcester has few examples of the more florid Baroque; yet seventeenth-century painting is generally well represented. From Italy comes Bernardo Strozzi's *The Calling of St. Matthew* and works by Luca Giordano and Sebastiano

Ricci. Spanish Baroque paintings include Alonso Cano's *Christ Bearing the Cross* and Ribera's *The Astronomer*. The paintings from the Low Countries, Holland in particular, are especially strong. Prominent among them is Rembrandt's *St. Bartholomew*, a work of the early Amsterdam period, which the museum acquired in 1958. Dutch landscape and seascape painting is seen in representative works by van Goyen, Salomon van Ruysdael, Jacob van Ruisdael, and the younger van de Velde. Paintings by de Hooch and Saenredam exemplify the former's domestic interiors, *Woman with a Child* and a *Man in an Interior*, about 1670, and the lucid geometry of the latter's rendering of church interiors, *Interior of the Choir of St. Bavo's Church at Haarlem*, 1660. The collection also includes fine examples of Dutch still life. Notable are the vigorously painted *Still Life*, 1643, by Pieter Claesz and *Still Life with a Male Bullfinch* by Jan Vonck. *Still Life with Lobster*, the largest and most ambitious of Johannes Hannot's known works, is an excellent example of the use of the trompe-l'oeil effect. An important French Baroque picture was added in 1977, Poussin's *The Flight into Egypt*.

The visitor to The Worcester Art Museum may survey the range of eighteenth-century painting from the delicate Rococo to the picturesque and romantic. Pietro Longhi's *Visit to a Library* is typical of his engaging genre scenes, and the imaginative landscape painting of contemporary Venice is seen in pictures by Canaletto and Guardi. French eighteenth-century paintings include Pater's *The Dance*, Fragonard's *The Return of the Drove*, and Hubert Robert's impressive *Shipwreck*, as well as works by Greuze and Oudry.

The great names of English eighteenth-century portraiture are well represented in examples by Gainsborough, Hogarth, Raeburn, Reynolds, and Romney. Particularly notable are Hogarth's sparkling portraits *Mr. and Mrs. William James*. English landscape is best represented by Gainsborough's *A Grand Landscape*, Wilson's *Lake Avernus*, and Turner's *A View Looking over a Lake*.

The holdings in nineteenth- and early-twentieth-century European painting effectively exemplify various major artists and movements. Works of Impressionists such as Renoir (*The Jewish Wedding*, after Delacroix), and Monet (*Waterloo Bridge*, 1903, and *Waterlilies*, 1908) are outstanding. Post-Impressionist developments are well represented with *Brooding Woman* by Gauguin, the glowing *Sunset* by Rouault and paintings by Braque, Cézanne, Matisse, Signac, and others.

The collection is strong in American art, especially in early American portraiture. Of special significance is the pair of Freake portraits by an anonymous artist, of which *Mrs. Elizabeth Freake and Baby Mary* (c. 1674) is justly famous. There are fine later portraits by Copley, Feke, Earl, Harding, Stuart, and others. The collection includes a good selection of nineteenth-century landscapes. There are, to name only a few of the strong points, two large oils by Homer, *The Gale* and *Coast in Winter*, and eighteen watercolors, as well as nine watercolors by Sargent and five by Prendergast. American Impressionists include Benson, Hassam, and Twachtman, and many of the leading Amer-

icans active before World War II are also present—Bellows, Hartley, Sheeler, and others. There is a small but growing contemporary collection, emphasizing the Americans.

The collection of Western sculpture is strongest in works of the medieval and Renaissance periods. Representing transition from Romanesque to Gothic is a rare twelfth-century French portal sculpture of the Virgin and *The Virgin and Child* in polychrome wood from the Cathedral of Autun. Among later European sculptures, Houdon's bust of his daughter at the age of one year is outstanding. Early modern sculpture is represented by pieces such as *Young Girl Holding a Bird* by Ossip Zadkine and *Prometheus Strangling the Vulture* by Jacques Lipchitz. Important among recent sculptures are David Smith's untitled composition in painted welded steel and Arnaldo Pomodoro's *Rotante dal Foro Centrale* in gleaming burnished bronze, the latter handsomely situated in the outdoor garden court.

The Worcester Art Museum has not made a major collecting effort in the area of decorative arts. It does possess, however, certain important examples, such as the great Brussels tapestry *The Last Judgment* (c. 1500), possibly designed by Hugo van der Goes, which now graces a wall of the courtyard, and a distinguished series of late sixteenth- or early-seventeenth-century Brussels tapestries, depicting the exploits of Emperor Titus. The silver collection is also important, comprising work of high quality of English and American silversmiths, such as Paul Revere.

The museum has a small collection of drawings, the best of which are from the eighteenth and nineteenth centuries. The print holdings are much more extensive and contain representative European and American examples in all of the principal graphic techniques, from Schongauer and Rembrandt to Cassatt and Picasso. A number of important private print collections have come to the museum, such as the John Chandler Bancroft Collection of Japanese prints, donated in 1901, which with subsequent gifts, has created a noteworthy collection in this particular field. There are also the Mrs. Kingsmill Marrs Collection of fourteen hundred European prints, mostly color, that came in 1926 and the important Charles Goodspeed Collection of Early American prints. In 1977–78 the museum acquired sixty-seven contemporary American prints through a grant from the National Endowment for the Arts.

Worcester's holdings in Asian art include major sculpture from Greater India, China, and Japan. The Gandharan phase of Indian style is represented by a standing Buddha in gray schist of the second or third century A.D. The complex iconography of Hinduism is embodied in outstanding sculptures of Brahma, Vishnu, and Shiva, as well as Parvati and lesser manifestations of divinity. These works illustrate various styles and techniques from the so-called medieval period of Indian art. There is also a small group of Mughal and Rajput miniature paintings of high quality, most of which came to the museum through the generosity of Alexander H. Bullock. In the Chinese collection an elegant *yu* from Shang Dynasty (1766–1027 B.C.) manifests the superior skill of the ancient

Chinese in casting bronze ritual vessels. A large polychrome limestone stele from the Northern Wei Dynasty (A.D. 346–534) demonstrates the modifications of style and iconography that occurred as Buddhism traveled north into China. There are several wooden sculptures from the Sung Dynasty (A.D. 960–1208), including a colossal head of Kuan Yin (four feet high) and small bronzes, animated tomb figurines in unglazed terracotta, and exemplary objects in jade and other hard stones. Of the small but excellent group of painted scrolls, that of *Ming Huang and Yang Kuei-Fei Listening to Music* from the Ming Dynasty (A.D. 1368–1644) is particularly fine. The Bancroft Collection of prints is probably the strong point of the Japanese holdings, but there is also a large wooden sculpture, the *Eleven-Headed Kannon*, from the Jogan period (A.D. 859–877) and a number of representative scroll and screen paintings.

A special feature of The Worcester Art Museum is a superior collection of pre-Columbian art from Central and South America, which is housed in its own gallery. It includes large and small sculptures in stone and terracotta and small objects in gold. Among major works in the collection are a Hacha from Mexico, about 500; a statuette of a warrior of the Totonac culture, 400–800; and a Mayan carved column that once flanked the door of a temple and depicts the zenith of that civilization. Other important works are a monumental rabbit with manacled legs from Vera Cruz (500–800), a Costa Rican gold pendant in the form of an eagle-headed winged figure of 1000–1122, and out of onyx marble a subtly carved pendant of classic Teotihuacan style in the form of a mask (500–700).

The Worcester Art Museum has the largest art reference library in central Massachusetts. Its holdings include 35,000 volumes and 625 current and retrospective journal titles. It is open to the public but is noncirculating. Current museum publications may be obtained from the Worcester Art Museum Shop, and requests for slides and photographs of objects in the museum collections should be addressed to the Curatorial Department.

The museum publishes catalogues of selected exhibitions. It also publishes the quarterly *Calendar* and *The Worcester Art Museum Journal*, which replaces the *Worcester Art Museum Annual* (abbreviated below as *Annual*), as well as the *Worcester Art Museum Bulletin* and *Annual Reports*.

Selected Bibliography

Museum publications: *A Handbook to the Worcester Art Museum*, 1973; Buhler, Kathryn C., *American Silver from the Colonial Period through the Early Republic in the Worcester Art Museum*, 1979; *European Paintings in the Collection of the Worcester Art Museum*, 2 vols., 1974; Vey, Horst, *A Catalog of the Drawings by European Masters in the Worcester Art Museum*, 1958; Welu, James A., *Seventeenth Century Dutch Painting*, 1979; Cott, Perry B.; Calvin S. Hathaway; and Charles H. Sawyer, "The Theodore T. and Mary G. Ellis Collection," *Annual*, vol. 4 (1941), pp. 7–63; Panofsky, Erwin, "The 'Discovery of Honey' by Piero di Cosimo," *Annual*, vol. 2 (1936–37), pp. 33–43.

Other Publications: Levi, Doro, *Antioch Mosaic Pavements*, 2 vols. (Princeton, N.J., 1947), especially vol. 1, pp. 21, 287, 295–304, 363–65; *Apollo*, vol. 94, no. 118

(December 1971); Rowley, George A. (with a foreword and addendum by Alexander C. Soper), "Ming Huang and Yang Kuei-Fei Listening to Music," *Artibus Asiae*, vol. 31 (1969), pp. 5–31.

SAMUEL P. COWARDIN III

USSR

—— Leningrad ——

HERMITAGE (officially GOSUDARSTVENNY HERMITAGE; alternately STATE HERMITAGE; also ERMITAGE), 34–36 Palace Embankment, Leningrad 191065.

The Hermitage, the Soviet Union's largest museum of non-Russian art, was established by Catherine II in 1764. Although the museum today includes works of major importance that were acquired by Peter I in the early eighteenth century, the collections were established by Catherine as an art gallery in the Small Hermitage, a building specifically commissioned to house her growing private collection. The collection increased under the rule of succeeding tsars, but the museum remained a court collection until the mid-nineteenth century, when Nicholas I opened the Hermitage to the public in 1852. Acquisition continued under the direction of the museum's curators until the Revolution in 1917, when the court collections, as well as many notable private collections, became the property of the state. Since 1917, the museum and its collections have been owned entirely by the Soviet government. The collections continue to grow by acquisition through the State Purchase Commission, by transfer from other Soviet museums, and through the series of archaeological expeditions and projects sponsored by the Hermitage in several areas of the Soviet Union. All of the museum's support derives from the state through the Ministry of Culture of the USSR.

The Hermitage is administered by a director and his staff, and the museum is divided curatorially into six major departments: Russian Culture, Prehistoric Culture, Art and Culture of the Peoples of the East, Art and Culture of Antiquity, Western European Art, and Numismatics. In addition, there are the conservation department, the library, and the education department. The conservation de-

partment has sections devoted to the restoration and research of various media and materials. The library, one of the largest art libraries in the Soviet Union, contains books, pamphlets, and periodicals relating to all aspects of fine and applied art. The library was established in the eighteenth century and continues to acquire material today, especially through an exchange program with other Soviet and foreign museums. A large education department provides trained guides for the more than 3 million visitors annually, in addition to organizing lectures, study groups, clubs for youth interested in art and archaeology, and traveling exhibitions. The importance of art education, and the exceptional services provided by the Hermitage in this area, led the Presidium of the Supreme Soviet to award the Order of Lenin to the museum in 1964, when the Hermitage celebrated the two-hundredth anniversary of its founding.

The Hermitage is housed within five interconnected buildings. The Winter Palace, largest of the five buildings, was designed by Bartolommeo Rastrelli and constructed between 1754 and 1762 during the reigns of Elizabeth (daughter of Peter I) and Peter III, her nephew. The palace, originally designed throughout in the Baroque style, today retains only the appearance of the original exterior, a combination of blue-green stucco, white columns and architectural accents, and a row of sculptured figures and vases along the cornice line. The interior of the palace underwent some changes during the eighteenth and early nineteenth centuries but was completely rebuilt and redecorated after a major fire in 1837. Most of the rooms were redesigned at that time in the neoclassical style, but the main staircase was restored in the opulent Baroque style.

The first building added to the residence was the Hermitage (now Small Hermitage), built for Catherine II as a place of refuge and to house her private art collection. It was designed by Jean-Baptiste Vallin de la Mothe and Yuri Velten in 1764–75. Velten also designed the Old Hermitage between 1771 and 1787 to provide additional gallery space for Catherine's growing collection. Catherine's architect for the Hermitage Theater was Giacomo Quarenghi. The theater, built between 1783 and 1787, is connected to the Old Hermitage by a closed passage set above the Winter Canal. The three smaller buildings, all in the classical style, extend along the Palace Embankment next to the exuberant Baroque Winter Palace. Together they create an impressive architectural complex facing the Neva River.

The final structure completing the Hermitage was added in 1842–51. The New Hermitage was erected behind the Old Hermitage with an entrance on Khalturin Street between the Winter Canal and Palace Square. This building, designed primarily by the German architect Leo von Klenze and constructed under the direction of N. Yefimov was intended as a special museum building. It has a handsome portico at its entrance, decorated with ten grey granite atlantes sculpted by A. I. Terebenev, each figure more than sixteen feet high.

When the Hermitage was opened to the public in 1852, the galleries were located in the New Hermitage. It was not until after the Revolution in 1917 that the Small and Old Hermitages and a portion of the Winter Palace also came into

use as public galleries. The theater remains in use today as a lecture hall. The Hermitage has been open to the public since the Revolution with the exception of a period during World War II (1941–45), when most of the collection was evacuated to the Ural Mountains. Today about four hundred rooms are open to the public, with many of the 2.7 million pieces from the collections on display.

The Hermitage was for nearly one hundred years a private palace museum. The collection had its beginnings during the reign of Peter I, when he acquired a sizable group of Dutch, Flemish, and French paintings. The first Russian ruler to collect non-Russian art seriously, Peter reflected in his collection his desire to bring Western European culture to Russia. The paintings purchased for Peter at The Hague, Anvers, Brussels, and Amsterdam were intended for the art gallery in Monplaisir at Peterhof (now Petrodvorets). In 1882 twenty of the most significant works at Montplaisir were transferred to the Hermitage, including Peter's first purchase, Rembrandt's *The Parting of David and Jonathan*, 1642, acquired in 1716 from the sale of J. van Beuningen's collection in Amsterdam.

Peter also collected antique statues and was responsible for the beginning of the archaeological collection of the Hermitage. He ensured the development of this aspect of the museum's holdings when in 1718 a decree established the government's right to "everything old and unusual" collected from the earth or from the water within the Russian territories.

Peter's niece Anna Ivanovna was not very active in continuing the art collection he began, but his daughter Elizabeth was responsible for the appointment of Rastrelli as architect for the Winter Palace and for many of the other superb buildings throughout St. Petersburg (now Leningrad). There were very strong ties between Elizabeth's court and the court in France, and much of the Russian society followed the French example in art, decoration, and furnishings.

It was, however, during the reign of Catherine II, who ascended to the throne following the short-lived rule of her husband Peter III, that an extensive program of acquisition and building established the Hermitage as a major art collection. Catherine's agents throughout Europe consistently secured for her the finest private collections available. The Hermitage dates its founding in 1764 with the arrival of 225 paintings, primarily Dutch and Flemish, originally acquired for Frederick II but sold to Catherine by the dealer J. E. Gotzkowski. Prince Dmitri A. Golitsyn, Catherine's ambassador to Paris in 1765 and later her ambassador to The Hague, played a central role in the acquisition of major works for Catherine's collections. In 1766 he acquired Rembrandt's *Return of the Prodigal Son* in Paris, and in 1768 he purchased from Count Philipp Cobentzl, the Austrian plenipotentiary in Brussels, Cobentzl's collection, which included five paintings by Rubens, several Dutch paintings, and six thousand drawings.

In 1769 the rich collection of drawings, engravings, and six hundred paintings owned by Count Heinrich von Brühl was purchased in Dresden by the Russian ambassador. In addition to a strong group of Dutch and Flemish works, including Rembrandt's *Portrait of an Old Man in Red*, 1652–54, and Rubens' *Perseus and Andromeda*, 1620–21, there was in this collection a small group of French

and Italian paintings, including two by Watteau and *Maecenas Presenting the Arts to Augustus*, about 1745, by Tiepolo.

Golitsyn, with the assistance of Diderot and the collector François Tronchin, was able to acquire in 1772 the superb collection of Pierre Crozat from his nephew Baron de Thiers. About four hundred paintings were purchased, the group rich with Italian and French works not already well represented in the Hermitage. Also included were many major Dutch and Flemish works. The purchase included *Judith* by Giorgione, *The Holy Family* by Raphael; five paintings by Rubens; six paintings by van Dyck; eight by Rembrandt; four by Veronese, including the *Dead Christ*; five by Poussin; three by Watteau; and *Visit to the Grandmother* by Louis Le Nain.

Catherine II continued to acquire large private collections during the 1770s, adding in 1778–79 the 198 paintings assembled by Robert Walpole. Lord Walpole had died in 1745, and the sale was arranged with Walpole's heirs by the Russian ambassador to London. Among the works in Walpole's collection were one piece by Rembrandt, a large number by Flemish artists, and twenty-two by French painters, including Poussin and Claude.

The last major collection to be purchased for Catherine was acquired in 1784, when the Comte de Baudouin Collection entered the Hermitage. Among the 119 paintings that were part of the sale were 9 by Rembrandt, 4 by Adriaen van Ostade, 2 by Rubens, and 4 by van Dyck.

Catherine also commissioned many individual paintings by European artists and acquired a group of Classical marbles from Lyde Browne's collection for the Hermitage. Her contributions toward the architectural, artistic, and intellectual enrichment of St. Petersburg were extensive and of lasting importance.

The rulers of Russia during the nineteenth century continued to add to the rich collection formed by Catherine II, but through the acquisition of smaller groups of works and individual masterpieces to fill gaps in the collection rather than by pursuing the policy of purchasing extensive collections.

Paul I, following the death of Catherine II, appointed Prince N. B. Yusupov as administrator of the gallery, established a commission under Franz Labensky to catalogue the collection, and transferred a number of the nearly four thousand paintings to his residences in the environs of St. Petersburg. Few works were purchased for the collection, with one major exception, Rubens' *The Union of Earth and Water*.

Alexander I continued during his reign to acquire collections for the museum, adding in 1814 both a group of paintings and sculptures from Empress Josephine's collection at Malmaison (including four by Claude) and a strong group of Spanish paintings from the collection of the banker W. G. Coesvelt (adding depth to the holdings of Velázquez, Zurbarán, and Ribalta). Several individual works of importance were also purchased, including Botticelli's *Adoration of the Magi* in 1808 (now in the National Gallery of Art [q.v.], Washington, D.C.) and a panel by Rosso Fiorentino purchased in 1810 with the assistance of Alexander's artistic adviser Vivant Denon, director of the Louvre. Alexander I was also responsible

for establishing the National War Gallery (1812 Gallery) within the Winter Palace.

Nicholas I provided the impetus toward the Hermitage as a public institution when he commissioned the New Hermitage to be constructed in order to open the collection to public view in 1852. Nicholas also set aside one-fourth of the painting collection to be sold and acquired individual works of high quality for the museum. He purchased the Raphael tondo *Alba Madonna* (now in the National Gallery of Art, Washington, D.C.) at auction from the W. G. Coesvelt Collection and added five major Titians from the sale of the Palazzo Barbarigo in Venice. Nicholas also purchased thirty paintings from the collection of William II in The Hague (including Sebastiano del Piombo's altarpiece *The Entombment*).

The collections continued to grow during the last half of the nineteenth century. Alexander II left the operation of the museum to his curators, but a major catalogue of the collection was prepared, and the acquisition of several major masterpieces occurred during his rule. Purchases were made in 1865 of Leonardo's *Madonna Litta* and in 1870 of Raphael's *Madonna Conestabile*. Fra Angelico's fresco *Madonna and Saints* was acquired from a Dominican convent at Fiesole and transferred to canvas in 1879. Of great importance to the ancient collection was the acquisition in 1861 of a major part of the antique sculpture and vases owned by the marquis de Campana.

The primary acquisitions made during the reign of Alexander III came as a result of the transfer of paintings and applied art from the imperial residences of Gatchina, Monplaisir, and Tsarkoye Selo (now Pushkin) and the acquisition of paintings from a private museum in Moscow. During the late nineteenth and early twentieth centuries a number of major works were given or bequeathed to the museum from important private collections. In 1885 Basilewsky's collection of twelfth- to sixteenth-century applied art was received by the Hermitage, greatly enlarging this aspect of its collections.

The Hermitage collections were greatly refined during the reign of Nicholas II when the Russian Museum was established in 1895. The collection of Russian works of art and craft was separated from the work of non-Russian artists, thus establishing the future collecting policies of both museums. Among the major acquisitions preceding the Revolution was the purchase of Leonardo da Vinci's *Benois Madonna* in 1914 from Madame Leon Benois (né Sapozhnikova). Traditionally, the painting was said to have been brought into Russia by itinerant Italian musicians and had been in the collection of the merchant Sapozhnikov's family in Astrakhan by 1824. In 1915 a major addition to the collection occurred through the bequest of 730 Dutch and Flemish paintings from the collection of the Russian geographer P. Semionov-Tyanshansky.

The Revolution, which began in October 1917 (old style calendar), touched the Hermitage directly, as the leaders of the provisional government were arrested within the Winter Palace. Very little damage to the buildings and the collections was sustained during the fighting, and Lenin immediately emphasized his feeling that all of the cultural legacy from imperial Russia should be preserved for the

people. By 1918 a special decree was issued relating to the registration and preservation of all privately owned artworks and objects of antiquity. Thus many works from nationalized private collections entered the Hermitage, particularly works from the important families in Leningrad, the Yusupovs, Shuvalovs, Stroganovs, and Sheremetyevs. The collections of two Moscow businessmen, Sergei Shchukin and Ivan Morozov, formed the core of one of the world's finest collections of French Impressionist and Post-Impressionist painting. The art in all of the imperial residences also became state property, with many works subsequently being transferred to the Hermitage.

The collections have continued to grow since the Revolution with one major setback. During the late 1920s and early 1930s, a group of works was sold through public auction and private sale in an attempt to raise foreign currency needed by the Soviet government. The most significant private sales were in 1929 and 1930. In 1929 Calouste Gulbenkian purchased Houdon's *Diana*, Rubens' full-length *Portrait of Helena Fourment*, two Rembrandt paintings, two Hubert Robert paintings, Dierck Bouts' *Annunciation*, and several pieces of furniture and applied art. In 1930 twenty-one paintings were sold to Andrew Mellon through M. Knoedler & Co.; these paintings are now in the National Gallery of Art, Washington, D.C.

Despite the loss of a number of major works from the collection, it remains one of the most broadly based and important art collections in the world. The museum collection today is vast, including more than 2.5 million objects. Although about 1.0 million objects are part of the numismatics department, there are more than 15,000 paintings, 12,000 sculptures, and 600,000 prints, drawings, and watercolors. The applied arts sections include more than 220,000 items, and the archaeological exhibits contain more than 600,000 artifacts.

The first of the major departments of the Hermitage, the Department of Russian Culture, is the newest curatorial area created within the museum. The department was established in 1941 and is devoted to the cultural history of Russia from the sixth through the nineteenth century. The department includes the major halls or state apartments of the Winter Palace as part of its exhibitions. These rooms are located on the second (in Russia, the first) floor of the Winter Palace, in the two wings of the palace at the head of the main staircase, known as the Jordon staircase. This staircase retains the appearance of Rastrelli's eighteenth-century design with only minor alterations. When Vasily Stasov redesigned the staircase after the 1837 fire, he substituted grey granite columns and a marble balustrade for the original pink imitation marble and gilded wood.

The Small Throne Room or Memorial Room of Peter the Great, redesigned by Stasov in 1839, was originally designed by Auguste Montferrand in 1833. The wall covering is of silver-embroidered red Lyons velvet, and the throne of the Russian tsars stands on a dais below a painting depicting Peter I and Minerva that was executed by Jacopo Amigoni (Italian, eighteenth century).

The Amorial Hall is the design of Stasov and is highlighted by large gilt-

bronze chandeliers decorated with the coats of arms and heraldic devices of the Russian provinces. Other standing lighting devices in white and gilt, as well as paired gilt columns, combine to form an opulent setting for the receptions and balls that were held here.

The 1812 Gallery was designed in 1826 by Carlo Rossi for Alexander I to commemorate the generals participating in the War of 1812. The gallery was restored by Stasov after the 1837 fire, but the paintings had been removed and thus were saved from the fire. More than three hundred portraits were painted by George Dawe, an Englishman, with the assistance of two Russian artists. Full-length portraits of Alexander I, Frederick William III of Prussia, and some of the commanding generals are surrounded by smaller portraits of all of the generals. Some of the frames are filled with green fabric denoting a general who fell in battle and whose portrait it was impossible to produce.

One of the most impressive major public rooms is the St. George Hall, or Large Throne Room. Designed in 1795 by Quarenghi, the room was redesigned completely by Stasov in 1842. Of special note is the parquet floor. The pattern, formed of sixteen varieties of valuable wood, exactly mirrors the bronze pattern set in the ceiling panels. The central feature of this room is now the enormous map of the Soviet Union (290 square feet) that occupies the area originally occupied by the throne directly under the marble bas-relief of St. George and the dragon, which gives the hall its name. Created by Russian craftsmen, the map consists of fifty-five thousand pieces of semiprecious stones, each color of stone representing an individual physical characteristic of the landscape. Moscow is marked on the map with a ruby star, which is decorated with a hammer and sickle formed of diamonds.

The series of state rooms in the wing facing the Neva River includes an antechamber designed by Stasov that leads to the Great Hall, or Ballroom, which is the largest room in the Winter Palace (12,716 square feet). This room was originally designed by Quarenghi but was redone by Stasov. The hall is now used for the display of temporary exhibitions.

The large Concert Hall is currently used for the display of Russian silver from the Hermitage collections. Designed by Rastrelli in 1762, the room was redesigned by Quarenghi in 1793 and by Stasov in 1839. The room is decorated with white three-quarter engaged Corinthian columns against white walls. An elaborate cornice and paired sculptural figures beneath an elaborate ceiling of painted false relief complete the architectural decoration. The focal point of the silver display is the tomb of Alexander Nevsky. The richly ornamented sarcophagus was made from about 1.5 tons of silver at the St. Petersburg Mint in 1750–53.

Among the cluster of the former family living rooms is one of the most famous of the Winter Palace's halls. The Malachite Hall was designed in 1839 by A. Bruillov for Charlotte, wife of Nicholas I. The room is decorated with more than two tons of malachite in the form of columns, pilasters, fireplaces, tables,

and other decorative objects. The doors, mirror frames, column capitals, chandeliers, and molded ceiling design are in gold leaf, completing an exceptionally lavish interior.

The Gilt Drawingroom, one of the family rooms in the Admiralty side of the Winter Palace, is also an example of the opulent design of the interior. The room, also designed by Bruillov in 1839, was redecorated in 1853 by Schreiber. The doors and walls, pilasters, columns, and molded ceiling design are all covered with gold leaf. An extremely complex parquet floor pattern complements the ceiling design. This and other rooms from the former living quarters are used to display works from various museum departments, as well as from the Department of Russian Culture.

Archaeological research in old Russian cities during the twentieth century has provided much of the material within the department covering the period up to the seventeenth century. Most of the eighteenth-century exhibits relate to Peter I and include many of his personal belongings, which were formerly housed in his study in the Kunstkammer (now Museum of Anthropology and Ethnography). Of special interest is the life-size seated figure of Peter I, which was created after his death by Rastrelli. The face and hands were molded from Peter's body in wax, and the clothing was his as well. The hair on the figure is supposed to have been taken from Peter's head. Additional displays include a small group of Russian paintings, drawings, and prints, and examples of Russian clockwork, porcelain, steel, furniture, crafts, and folk art.

Also included in this department, but displayed throughout the museum's buildings, is a collection of vases, tabletops, candelabra, and bowls cut from the semiprecious stones mined in the Ural Mountains and in the Altai. The most famous piece in the collection is the Kolyvan vase, which is on display on the ground floor of the museum. Cut from a huge jasper block, the vase stands eight and one-half feet high and weighs nearly nineteen tons. The oval bowl of the vase is cut from a solid block of stone, and its finished width is about sixteen and one-half feet.

The Department of Prehistoric Culture contains material relating to the development of various prehistoric societies within the territory of the Soviet Union. The department was established in 1931 by combining the prehistoric collections of the tsars with the increasing numbers of artifacts being unearthed by Soviet archaeological expeditions. The depth of the collection is due in great part to the role of Peter I, who established in 1718 the government's right to all ancient objects found within the Russian territories.

Many of the objects from this department are housed in the Hermitage's Gold Room, with reproductions on view and the rest of the collection in its ground-floor exhibit area. Among the superb examples of the stylized animal forms created by the Scyths are two large plaques, or shield decorations: a gold stag from the Kostromskaya burial mound and a gold panther from the Kelermesskaya mound, both sixth century B.C. From the Solokha mound, excavated in 1912–13, a rich burial of a Scythian chief from 400–300 B.C. was uncovered. A gold

comb (4.7 inches high) of Greek origin, surmounted by a sculptured relief ornament of Scythian warriors in battle, was one of the major finds. The corpse of the chief in his royal attire was found intact.

Included in this department are the materials excavated from the Altai burial mounds of 500–200 B.C. These extraordinary finds at Pazyryk include many objects that normally would have decomposed but were preserved in the permafrost. The corpses, fabrics, furs, food, and leather were in excellent condition, as were two large rugs. One is of felt and appliqued, showing an enthroned goddess and a horseman. The second, forty-two square feet in area, was woven from wool, perhaps in Persia, and is more than two thousand years old.

The department also includes a section devoted to the artifacts and culture of the nomadic groups from the southern steppes during the period from 300 B.C. to A.D. 1200, including the Sarmatians and nomadic tribes from Turkey, as well as a section devoted to the artifacts and culture of the Finno-Ugrians, Balts, and Slavs, from 700 B.C. to 1200 A.D., the settlers of much of the Baltic and northern regions of the Soviet Union.

The Department of the Art and Culture of the Peoples of the East was established in 1920 under the guidance of the Soviet Orientalist J. Orbeli. The department exhibits materials from both the eastern regions of the Soviet Union, Central Asia, and the Caucasus, as well as materials from ancient Egypt, Babylonia, and Assyria and from Byzantium, Persia, Syria, Iraq, Egypt, Turkey, India, China, Mongolia, Japan, and Indonesia. The department, which includes more than 140,000 objects, contains literary documents and the fine and applied art of these regions. Of particular note among the Central Asia collections is a large bronze cauldron (two tons, sixty-three inches high, and ninety-six inches in diameter) cast in 1399 by Abd Al-'Aziz of Tabriz, which was presented by Timur (Tamerlane) to the mosque of Khwaja Ahmad Yasevi in what is today Turkestan.

The Hermitage has small representative holdings of artifacts from the Egyptian, Babylonian, Assyrian, Sumerian, and Akkadian cultures, as well as Syrian, Iraqi, Indian, Chinese, Japanese, and Indonesian fine and applied art. The strengths of the non-Soviet Eastern collections, however, are found in the Byzantine and Sassanian collections. The Hermitage has an exceptionally diverse collection of Byzantine artifacts dating from the fifth to the fifteenth century. A fine group of silver objects found in the region of the Ural Mountains and the Ukraine highlights the collection. A group of ivories (particularly an ivory diptych of men fighting lions, c. 500) and a group of icons from the twelfth to the fourteenth century are also of note.

Included within the Persian collection of works from the third to the eighteenth century is an exceptional collection of Sassanian silver. Many of the pieces were brought to the area of the Ural Mountains and the Kama river by traders bartering for Russian furs. This trade factor also resulted in the rich collection of fifteenth- to eighteenth-century Turkish applied art, particularly ceramics, carpets, and weapons, now held by the Hermitage.

The Department of the Art and Culture of Antiquity, one of the oldest departments of the Hermitage, includes an outstanding collection of objects from ancient Greece, Italy, and the northern Black Sea coast. The collection of painted vases includes outstanding examples of the Geometric style of the ninth and eighth centuries B.C., the Corinthian carpet style of the seventh and sixth centuries B.C., the sixth-century B.C. Athenian black-figure style, and its successor in the late sixth and early fifth centuries B.C., the red-figure style. In the collection is one psykter signed by Euphronios (late sixth to early fifth century B.C.) and one extremely fine example, *Vase with a Swallow*, attributed to the same artist.

In addition to the ceramics collection, there is a group of sixth- and early-fifth-century B.C. bronze sculptures and an outstanding collection of antique sculptures, primarily Roman copies of lost Greek statues. One of the finest works in the collection is the *Tauride Venus* (first- to second-century A.D. Roman copy of a 300–200 B.C. Greek statue). This marble was given to Peter I by Pope Clement XI in 1720 and was the first antique statue to enter the Russian collections. Roman copies of Greek works from 500–300 B.C. give a full picture of the styles of the most important Greek sculptors. Of special note are works after the originals by Praxiteles (*Resting Satyr* and *Satyr Pouring Wine*) and Lysippus (*Heracles Slaying the Nemean Lion* and *Eros Stringing the Bow*). An important group of Tanagra terracottas (fourth to third century B.C.) is also included in the collection, as are an exceptional group of carved gems. One of the finest examples in the gem collection is the Gonzaga Cameo (300–200 B.C., 6.14 by 4.65 inches), a double portrait of Ptolemy Philadelphus and his wife, Arsinoë, carved from a three-layered sardonyx in Alexandria.

One area of the collection is devoted to artifacts excavated in settlements founded by Greeks along the northern Black Sea coast. The materials found in these Bosporan burials reflect the interaction of Greek and local artisans. One of the most exceptional finds came from a fourth-century B.C. burial at Kul-Oba near Kerch. Three bodies, a warrior, his wife, and a slave, were found in a stone vault along with a gold vase showing Scythian warriors in camp formed in relief, a particularly fine *grivna* (neck ornament) ending in figures of Scythian warriors on horseback, and a hoard of gold ornaments and jewelry. All of these pieces are on exhibition in the Gold Room. Another mound, Bolshaya Bliznitsa, on the Taman Peninsula, was the burial place for the priestesses connected with the cult of Demeter, goddess of fertility, an important aspect of Bosporan agricultural life. A rich treasure of golden crowns, dress ornaments, and jewelry, now in the Gold Room, was among the finds. Additional objects relating to the cult of Demeter were found during excavations at Nymphaeum, a trading town on the Bosporan coast, where remnants of an earlier Scythian settlement were found, as well as a shrine to Demeter.

The Etruscan and Roman collection is strongest in Roman portrait sculpture, including more than 120 examples from the second century B.C. to the third century A.D. Two fine examples are the statue of Octavian Augustus, first century

A.D. (depicting him seated on a throne holding a small winged victory in his right hand), and the large marble statue of Jupiter adorned with gilt clothing, mid-first century (11 1/3 feet high). An outstanding collection of Roman portrait busts is enhanced by examples of relief sculpture, mosaics, mural fragments from Pompeii, Roman glass, ceramics, and household articles.

The largest department in the Hermitage in terms of its holdings is the Numismatic Department. Included in the more than 1 million items are coins from many areas within Russia, Europe, and the East, from both ancient and modern periods, as well as medals, decorations, and badges. Coins and medals are included with displays of various cultures throughout the museum, and three rooms on the second floor of the Winter Palace are devoted to the exhibition of decorations and badges.

Perhaps the best-known area of the collections is the Department of Western European Art. Included in this department are paintings, sculptures, drawings, graphics, and applied art dating from the eleventh through the twentieth century. The department, which includes works acquired by Peter I, is the oldest department within the Hermitage.

Among the extensive holdings of this department are sections devoted to applied art, arms and armor, furniture, tapestries, carved stone, porcelain, and jewelry. The furniture and tapestries are seen throughout the exhibition halls, usually on view with paintings from the same country of origin. The tapestry collection is of particular note and includes examples from the sixteenth to the nineteenth century. Of special interest are sixteenth-century Netherlandish tapestries depicting episodes from the *Roman de la Rose* and from *The History of the Knight of the Swan*, Flemish seventeenth-century tapestries made after cartoons by Rubens, French seventeenth-century Gobelins depicting episodes from *The Hunt of the Duke of Lorrain* and *The Golden Fleece*, and an English nineteenth-century tapestry from an Edward Burne-Jones drawing for *The Adoration of the Magi*.

The porcelain collection includes work from the early eighteenth century to the twentieth century. Of special note are the two large Meissen banquet services and decorative pieces in the form of fruits, vegetables, and flowers; a dessert service manufactured in Berlin and presented to Catherine II by Frederick the Great in 1772, which includes decorative figures representing the different nationalities within the Russian territory surrounding an enthroned Catherine; a Wedgwood dinner service, the Green Frog Service, produced for Catherine II in 1774, with each of the 952 pieces ornamented with a small green frog and with landscape views of Britain; and the Sèvres Cameo Service made to order for Catherine II in 1778, which includes more than seven hundred pieces decorated with antique cameos. The collection of sixteenth- to nineteenth-century jewelry is especially fine. The jewelry, snuffboxes, watches, and walking sticks, many from the collection of Catherine II, are on display in the Gold Room.

The painting collection is one of the museum's great treasures. Included are representative examples from most of the western European countries. The col-

lection of Italian art covers the major schools of painting from the thirteenth to the eighteenth century and is the third largest section of the department. Of the earliest works, a superb example is the *Madonna* by Simone Martini, 1339–42. (This work is half of a diptych, the gift of the heirs of Count Gregory Stroganov. The *Angel* of this *Annunciation* is in the National Gallery of Art (q.v.), Washington, D.C.) Fifteenth-century Florentine art is represented by numerous works, including a fresco by Fra Angelico, *Madonna and Saints*, early 1440s; *The Vision of St. Augustine* by Filippo Lippi; the large majolica *Nativity* by Giovanni della Robbia; and the terracotta bust *Infant John the Baptist* by Luca della Robbia. Other examples of fifteenth-century painting include the *Annunciation* by Cima da Conegliano, 1495; *St. Dominic* and *St. Jerome* by Sandro Botticelli; the tondo *Adoration of the Child* by Filippino Lippi, about 1480 (originally purchased in Arezzo by Prince Vasily Trubetskoi, it eventually became the property of Count Paul Stroganov, who bequeathed the painting to the Hermitage in 1911); and *St. Sebastian* and *Portrait of a Young Man* by Perugino.

The highlights of the fifteenth-century collection are, however, the two paintings by Leonardo da Vinci. The earlier work is *Benois Madonna*, 1478, which was recognized as a Leonardo when it was loaned to an exhibition of Old Master paintings in St. Petersburg in 1909 and then purchased for the Hermitage. The later painting, the *Litta Madonna*, about 1490, entered the collection by purchase in 1866.

The sixteenth-century works are by far the strongest section of the Italian collection. Included are Francesco Melzi's *Flora*, about 1510 (purchased by Nicholas I from the collection of William II, The Hague); Andrea del Sarto's *Madonna and Child with Saints*, about 1513 (purchased by Alexander I in 1814 from Empress Josephine's collection at Malmaison); Palma Vecchio's *Portrait of a Man Holding a Glove*, about 1515; Corregio's *Portrait of Ginevra Rangone*, about 1517 (to the Hermitage in 1925 through the nationalization of the Yusupov Collection but attributed to Lorenzo Lotto until 1958); and an altarpiece by Sebastiano del Piombo. The Mannerist painters are represented by the superb *Holy Family with the Young St. John* by Pontormo, about 1522 (acquired in 1923 through the nationalization of the Mordvinov Collection but originally attributed to Rosso Fiorentino or Bronzino); and an oil on slate by Primaticcio, *Madonna and Child with Zacharias, Elizabeth and John the Baptist*, about 1543 (purchased in 1773 by Catherine II from the Crozat Collection and a rare small-scale example of his School of Fontainebleau Mannerism).

Of special note are two early paintings by Raphael, the *Conestabile Madonna*, 1500–1502 (purchased in 1870 from Count Conestabile) and the *Holy Family*, 1505 (purchased in 1772 by Catherine II from the Crozat Collection). The Hermitage also has a copy of Raphael's loggia from the Vatican Palace. Commissioned in 1778 by Catherine II, Christopher Unterberger spent eight years copying the original in Rome. They are installed in the Old Hermitage, the building erected to house Catherine's art collection.

Sixteenth-century Venetian painting is particularly well represented. One of

the chief treasures of the museum is *Judith* by Giorgione, about 1504. (Originally attributed to Raphael when the painting was purchased by Catherine II in 1772 from the Crozat Collection, the painting was cleaned and restored in 1968 revealing the exquisite Venetian palette and the atmospheric quality of the background landscape.) Also of note is the group of paintings by Titian. Although none of his formal portraits are included in the collection, the eight paintings from the 1530s to about 1570 are balanced by the *Flight into Egypt* from the early 1500s. Of special note are the *Portrait of a Young Woman*, about 1530s; *Danaë*, 1550s; and *The Repentant Magdalene*, 1560s (acquired by Nicholas I at the auction of the Palazzo Barbarigo, Venice). The work of Paolo Veronese is represented by five canvases, including *The Adoration of the Magi*, early 1570s; *Dead Christ with the Virgin Mary and an Angel*, about 1580 (purchased from Crozat Collection); and *The Conversion of Saul*. Only one work by Tintoretto is included in the Hermitage, *The Birth of John the Baptist*, painted between 1562 and 1566.

Of the artists of Bologna there are several works by Annibale Carracci, Guido Reni, Domenichino, and Guercino on view. From the late sixteenth century is the early work by Caravaggio, *The Lute Player*, about 1596 (purchased in 1808 by Baron Vivant Denon for Alexander I from the Giustiniani Collection, Rome).

The Italian painters of the seventeenth and eighteenth centuries are also strongly represented. Among the numerous canvases of the Baroque painters are works by Castiglione, Crespi, Giordano, Magnasco, and Strozzi and three canvases by the eighteenth-century Venetian painter Guardi. The large-scale eighteenth-century paintings are displayed in the opulent top-lighted Hall (New Hermitage, decorated by Stasov in 1852 after the designs of Leo van Klenze). Hanging in this room are five of the six paintings by Tiepolo owned by the Hermitage. Included in this group are five of the ten paintings by Tiepolo commissioned for the Dolphino Palace, Venice. Each of the works relates to an aspect of ancient Roman history. Also on view here is Canaletto's *Reception of the French Ambassador in Venice*, about 1740.

Italian sculpture is also well represented throughout the exhibition halls with an especially strong collection of classical sculpture by Canova, including *Hebe* (1801), *Cupid's Kiss*, and *Cupid*. Many of these works came to the museum through the nationalization of the collection of Prince Nicolai B. Yusupov, a patron of Canova. An unfinished carving, *The Crouching Boy*, of the early 1530s has been attributed to Michelangelo, and it has been suggested that it was carved for a Medici tomb.

The collection of Spanish paintings is small but includes several fine works, particularly those dating from the seventeenth century. They were acquired primarily through the purchases by Alexander I from Coesvelt and by Nicholas I from the collection of Don Manuel Godoy. Highlights of this collection include the sixteenth-century works by Luis de Morales, *Mater Dolorosa* and *Madonna and Child*, and Francisco Ribalta, *Raising of the Cross*, 1582 (his earliest dated painting), and *Portrait of Lope de Vega*. From the seventeenth century are El

Greco's *The Apostles Peter and Paul*, 1614; Diego Valázquez's *The Repast (Luncheon)*, about 1617, and *Portrait of Count Olivares*, about 1638; José de Ribera's *St. Jerome Listening to the Sound of the Trumpet* and *St. Sebastian and St. Irene*; Francisco de Zurbarán's *St. Lawrence* and *The Young Virgin Praying*, about 1660; and twelve paintings by Bartolomé Esteban Murillo, including both religious and genre pieces such as *The Assumption of the Madonna*, 1670–80, and *Boy with a Dog*, about 1661 (to the Hermitage in 1772 from the auction of Duc de Choiseul's collection, Paris, and a companion to *A Girl Selling Fruit*, State Pushkin Museum [q.v.], Moscow). A major gap in the Spanish collection was not filled until 1972, when Armand Hammer donated to the Hermitage its only painting by Goya, *The Portrait of the Actress Antonia Zarate*, about 1807. The museum, however, does have a considerable number of Goya's prints.

A small but choice collection of fifteenth- and sixteenth-century Netherlandish art prepares one for the superb collections of seventeenth-century Dutch and Flemish painting. The strength of this part of the collection dates from the earliest years of the Hermitage, including as it does many works acquired by Peter I and by Catherine II. The section was greatly strengthened in 1915 with the arrival of about seven hundred Dutch and Flemish paintings through the bequest of the Russian geographer P. P. Semionov-Tyanshansky. The depth of the collection is extraordinary, including examples of most of the major and minor seventeenth-century artists.

Important works from the fifteenth and sixteenth centuries include Robert Campin's *The Virgin and Child*, 1430s (part of a diptych received in 1845 by bequest from D. P. Tatischev, High Chamberlain to Nicholas I); Rogier van der Weyden's *St. Luke Drawing the Virgin*, 1435–40; Hugo van der Goes' *Lamentation over the Dead Christ* and the triptych *The Adoration of the Magi*; Lucas van Leyden's *The Healing of the Blind Man of Jericho*; and Pieter Bruegel the Younger's copy of his father's painting *Kermess*. A large collection of Netherlandish drawings and engravings (especially the work of Lucas van Leyden) complements the painting collection.

The seventeenth-century Flemish collection is highlighted by a major group of the works by Peter Paul Rubens. Included among the twenty-two paintings and nineteen oil sketches are examples of the full range of Rubens' work. Among the finest are *The Union of Earth and Water*, between 1612–15; *The Carters (Landscape with a Wagon)*, about 1618–20; *Perseus and Andromeda*, 1620–21; five sketches for the painting cycle commissioned for the Luxembourg Palace, Paris, *The Life of Marie de' Medici*, 1622–25; *Portrait of a Lady in Waiting*, 1625; and *Bacchus*, about 1640.

Also well represented is the work of Anthony van Dyck, Rubens' best-known contemporary. Twenty-five paintings from various periods of his career illuminate his outstanding work as a portraitist. Included are *A Family Group*, about 1620–21 (formerly thought to be a portrait of Frans Snyders but now believed to be Jan Wildens and his family); *Self Portrait*, late 1620s-early 1630s; and a

group of portraits including full-length paintings of King Charles I and Queen Henrietta Maria from his stay in England between 1632 and 1641.

The three major seventeenth-century Flemish painters after Rubens and van Dyck are also well represented. The fourteen canvases by Frans Snyders include a series of five large-scale works, *The Shops*, depicting fruits, vegetables, fowl, and fish displayed for sale. They are complemented by a group of smaller still-life paintings such as *Fruit in a Bowl*. There are ten paintings by Jacob Jordaens, including the *Portrait of the Artist with His Parents and His Brothers*, about 1615, and *The Bean King*, about 1638. David Teniers the Younger is represented by thirty-seven paintings. This is an exceptional survey of his work, illustrating all of its aspects: animal painting, genre, landscape, and portraiture. *Monkeys in the Kitchen* is one of the best of his animal paintings.

The Flemish collection has fewer works but by many painters, including fine works by Adriaen Brouwer, *Peasant in a Tavern*, about 1635; Paul de Vos, *The Bear Hunt*; and Jan Fyt, *Still Life with Fruits and a Paroquet*, after 1640. A rich selection of prints and drawings completes the Flemish section and includes an especially fine group of works by Rubens.

The Dutch collection is one of the oldest and most complete sections within the department. Portrait painting is well represented by Michiel Mierevelt's *Portrait of a Man*, 1630–35; Paulus Moreelse's *Portrait of a Young Woman*; Thomas de Keyser's *Portrait of a Man*, about 1632; Jan Verspronck's *Portrait of a Young Woman*, 1644; and Frans Hals' two superb examples: *Portrait of a Young Man with a Glove*, about 1650, and *Portrait of a Man*, about 1650–60.

Landscape and marine painting are represented with examples by all of the major painters, highlighted by twelve canvases of Jan van Goyen, including *Winter Landscape near The Hague*, and *The Coast at Scheweningen*, both 1645. Additional works of interest include *Landscape with a Windmill*, about 1645–50 by Aert van der Neer; the important work *The Ferry*, 1651, by Salomon van Ruysdael; three paintings by Isaack van Ostade (brother of the better known Adriaen), including *Landscape in Winter*; and eleven paintings by Jacob van Ruisdael, including *Peasant Cottages in the Dunes*, 1647, and the masterpiece *Marsh*, 1660s.

There is a rich selection of Dutch genre painting. Twenty-four paintings by Adriaen van Ostade reveal the full range of his work from *The Scuffle* of 1637 to mature paintings such as *The Village Musicians* of 1645. Nine canvases by Jan Steen include *The Revellers* and *Physician Visiting a Sick Girl*, both about 1660. A superb group of works by de Hooch, Metsu, Mieris, and Ter Borch highlight the collection with these notable examples: Pieter de Hooch's *Woman and Her Servant*, about 1660; Gabriel Metsu's *Physician Visiting a Sick Girl*; Frans Mieris, *Young Lady in the Morning*; and Gerard Ter Borch's *Glass of Lemonade*, 1663–64.

Complementing the genre works is a major collection of still-life paintings by Willem Claesz. Heda, Pieter Claesz, and Willem Kalf. Particularly fine examples

are Heda, *Still Life with Crab*, 1648, and Kalf, *Dessert*, about 1660. The Dutch animal painters are also well represented. Three canvases by Paulus Potter—*A Bull*; *The Farm*, 1649; and *The Watchdog*—are the highlights of this area.

The Hermitage owns one of the finest and most complete collections of Rembrandt's work, encompassing twenty-five paintings from all phases of his career, drawings, and a nearly complete set of his etchings. Early portraits include *The Old Warrior*, about 1629–30, and *Flora*, 1634 (a portrait of his first wife, Saskia van Uylenborch). The exquisite *Danaë*, 1636–46, is one of the highlights of the group and *The Descent from the Cross*, 1634, one of the most important of the works on biblical themes. Others of note include *The Farewell of David and Jonathan*, 1642, and *The Return of the Prodigal Son*, about 1669 (one of the last works painted by the artist). The late portraits, considered to be among Rembrandt's finest work, include *Portrait of an Old Man in Red*, about 1652–54. The works of Rembrandt are hung with paintings by his teacher Pieter Lastman and his pupils and followers.

The collection of German painting is very small and devoted primarily to the fifteenth and sixteenth centuries, with some representation of seventeenth- through twentieth-century work. The fifteenth century is represented primarily by sculpture, including a *Virgin and Child* by Tilman Riemenschneider; applied art, including silver, porcelain, wood, and ivory; and a sizable collection of prints and drawings by Albrecht Dürer and his contemporaries. The strength of the collection is the sixteenth-century portraiture. One of the finest is *Portrait of a Young Man*, 1518, by Ambrosius Holbein (his brother Hans Holbein the Younger is represented only by his graphic art). The highlight of the German collection is, however, the five paintings by Lucas Cranach the Elder. The earliest is *Venus and Cupid*, 1509, with four works from 1525–26, including *Virgin and Child under the Apple Tree* and *Portrait of a Woman*. A group of his prints completes the holdings of Cranach's work and provides a good overview of the first half of his career.

Most notable of the seventeenth- and eighteenth-century German collection is the work of the neoclassical artist Anton Raffael Mengs. *Perseus and Andromeda* and *Judgment of Paris* typify his academic painting; his portraiture is represented by a *Self Portrait* and the *Portrait of Winkelmann*. Of the nineteenth-century works there are six canvases by the great Romantic landscape artist Caspar David Friedrich (brought to Russia in part by the poet Zhukovsky). Of note from this group is *Riesengebirge*, 1835.

English art from the seventeenth to the nineteenth century is also represented sketchily but with a number of masterpieces included. Many of the works came to the Hermitage through the purchase of Robert Walpole's collection in 1779 and in 1916 with the bequest of the Khitrovo Collection. Seventeenth-century portraiture is highlighted by the work of Godfrey Kneller, particularly the *Portrait of the Sculptor Grinling Gibbons*. William Hogarth is represented by a large collection of prints, and the outstanding eighteenth-century painter Joshua Reynolds is represented by four works, including *The Infant Hercules Strangling*

the Serpents, 1786–88 (commissioned by Catherine II and intended to represent Russia defeating her enemies). The major portraitists are all included, with the following works of special interest: Thomas Gainsborough, *Portrait of the Duchess of Beaufort* (?), 1770s; George Romney, *Portrait of Mrs. Greer*, 1781; and Henry Raeburn, *Portrait of Eleanor Bethune*. English landscape painting is represented by a few works, especially those of George Morland, the most notable being *Approaching Storm*, 1791. Nineteenth-century painting is represented by a small group of works, but of special note is the portraiture by George Dawe for the 1812 Gallery in the Winter Palace.

Other European and Scandinavian countries and the United States are represented by very small groups of works in no way fully covering the arts of these countries. Examples are found of eighteenth-century Swedish and Danish art; eighteenth- and nineteenth-century Austrian art; nineteenth-century Dutch art; nineteenth- and twentieth-century Belgian, Finnish, and Spanish art; and twentieth-century American, Czechoslovakian, Hungarian, Italian, Norwegian, Polish, and Rumanian art. Of interest among these works is a large group of prints and twenty-six paintings by Rockwell Kent, a gift of the artist to the museum; a *Still Life* by Giorgio Morandi; and a collection of prints by Käthe Kollwitz.

The last section of the Department of Western European Art to be discussed is its most comprehensive—French art. A product of great interest in French art from the earliest years of the Hermitage collection, the section includes major groups of sculpture, prints, drawings, furniture, textiles, and other applied art, in addition to the superb painting collection.

Fifteenth- and sixteenth-century art is represented primarily by the applied arts, including a rich collection of Limoges enamels and Palissy faiences. In addition to the work of Primaticcio already mentioned, there are examples of the work of the School of Fontainebleau such as the carved medallion *Venus and Cupid* by Jean Goujon. Completing the holdings of fifteenth- and sixteenth-century art is a large group of drawings including the work of François Clouet.

Beginning with the seventeenth century, the French collection develops into a thorough and comprehensive collection. Of particular note are paintings by Valentin de Boullogne, a follower of Caravaggio; an extensive collection of prints and drawings by Jacques Callot (850 drawings were acquired by Catherine II at the sale of Jean de Julienne's collection); and a group of paintings by the Le Nain brothers, notably *Visit to the Grandmother* and *Milkwoman's Family*, both 1640s, by Louis Le Nain.

The work of the great neoclassicist painter Nicolas Poussin is represented by significant examples of his historical, mythological, literary, and biblical subjects. Among more than ten of his paintings is the early *Joshua's Victory Over the Amalekites*, about 1625 (a companion to the painting is Pushkin Museum [q.v.], Moscow); the superb *Tancred and Erminia*, 1630s; and the later works, *Moses Striking the Rock* and *Landscape with Polyphemus*, both 1649. The other leading classical painter was the landscape artist Claude Lorraine. He is equally well represented, having eleven major works in the Hermitage. Of special note

is the group of four paintings traditionally referred to as the cycle on the times of day. (Although painted at various times they were assembled as a group by the Landgrave of Hesse, came into Empress Josephine's collection, and were purchased for the Hermitage by Alexander I.) An earlier work, *View of a Port*, 1649, is noteworthy for having the figures as well as the landscape painted by Claude.

Academic art in the late seventeenth century is well represented. Pierre Mignard's *Magnanimity of Alexander the Great*, 1689, commissioned by Louis XIV's minister Louvois, is a major work. Mignard's portrait of Colbert is only one of a group of portraits from this period, which also includes the work of Nicolas Largillierre and Hyacinthe Rigaud.

The early eighteenth century is highlighted by eight paintings of Antoine Watteau, including both scenes of everyday life and his *fêtes galantes*. Of the former type, *Savoyard with a Marmot*, 1716, is a splendid example, and of the latter style, *Embarrassing Proposal*, about 1716, and *Capricious Woman*, about 1718, are typical. The Hermitage also owns a relatively rare religious subject by Watteau, *The Rest on the Flight to Egypt*, about 1717. Both of Watteau's best-known followers, Nicolas Lancret and Jean-Baptiste Pater, are well represented.

The fashionable painters and sculptors active during the mid-century are included in numerous examples, highlighted by the brilliant collection of drawings and paintings by François Boucher. In addition to the sparkling early *Pastoral Scene*, there are a number of fine landscapes, including *Landscape near Beauvais*, about 1742. Also of interest is a group of sculptures and statuettes by Étienne-Maurice Falconet (the sculptor of the *Bronze Horseman*, an equestrian statue of Peter I commissioned by Catherine II and memorialized in the poem by Alexander Pushkin).

There are three canvases by Jean Baptiste Siméon Chardin. *The Washerwoman*, about 1737, and *Grace before Dinner*, 1744, are typical of his genre paintings, and there is also an exquisite still life, *The Attributes of the Arts*, 1766. Commissioned by Catherine II for the Academy of Fine Arts, St. Petersburg, it was sold at auction in 1854 by Nicholas I, and reacquired by the Hermitage in 1926. (A replica of this painting is in the Minneapolis Institute of Arts [q.v.], Minnesota.) Several paintings by Jean Baptiste Greuze, a favorite of Catherine II and her friend and adviser Diderot, are also included in the collection. *Paralytic Helped by His Children* is representative of the moralizing and sentimental paintings typical of his oeuvre. Several portrait heads, including the fresh and lively *Head of a Peasant Girl*, are also in the collection. The masterpiece of the Hermitage's collection of sculptures by Jean Antoine Houdon is the seated marble portrait of Voltaire, 1781. This, too, was commissioned by Catherine II and was installed in her summer palace at Tsarkoye Selo until the 1830s, when it was moved to the Winter Palace.

The later eighteenth century is marked by the work of Jean Honoré Fragonard and the landscapes of Joseph Vernet and Hubert Robert. Of three canvases by

Fragonard, *The Stolen Kiss*, 1780s, is the finest example (acquired in 1895 by Nicholas II from the Laziensky Palace, Warsaw). Vernet's *Villa Ludovisi*, 1749, is a typical example of the twenty-six canvases in the Hermitage (a companion piece, *Villa Pamphili*, is in Pushkin Museum, Moscow) and *Terrace at Marly*, about 1783, is representative of the fifty-four views of parks and ruins by Hubert Robert that were extremely popular among the rulers and nobles in Russia in this period.

Nineteenth-century French painting was only slightly represented in the Hermitage until the years following the Revolution, when nationalization brought many works from private collections to the gallery. Even so, there is only a scant representation of the painters from the first half of the century. Most notable are a late work by Jacques Louis David, *Sappho and Phaon*, 1809, and the small canvas *Arab Saddling His Horse*, 1855, by Eugène Delacroix. The single work included by Jean Auguste Dominique Ingres is a formal portrait of a Russian diplomat, Count Guryev, painted in 1821.

It is, however, with the works of the Barbizon School that the French collection begins to expand in size once more. First-quality landscapes by Théodore Rousseau, Charles François Daubigny, and Diaz de la Peña are in the collection, as are numerous paintings by Camille Corot and single examples by François Millet and Gustave Courbet.

The well-known collection of Impressionist and Post-Impressionist paintings of the last quarter of the nineteenth century and the early twentieth century is one of the major strengths of the Hermitage. Many of these works came from the private collections of the Moscow businessmen Morosov and Shchukin, who were acquainted with and bought directly from a number of the artists of this period. The lack of a canvas by Manet is compensated for in the early portion of the collection by a wide range of works by Claude Monet, Pierre Auguste Renoir, Edgar Degas, Alfred Sisley, and Camille Pissarro, among others.

By Monet there are paintings from all periods of his career. The early *Lady in the Garden*, about 1866, is followed by *River Bank*, 1873; *Haystack*, 1886; and *London Fog*, 1903. At least twenty canvases by Monet are divided between the collections of the Hermitage and the Pushkin Museum. Renoir and Degas are also well represented in both collections. In the Hermitage, Renoir is shown primarily by his portraits, notably *The Woman in Black*, about 1874; the nude *Anna*, 1876; *Portrait of the Actress Jeanne Samary*, 1878; and *Girl with a Fan*, 1881. Degas is shown solely through his pastels, particularly his nudes from the mid–1880s such as the *Woman Combing Her Hair*. A small number of sketches in gouache and oil such as the *Portrait of Yvette Guilbert*, 1894, by Henri Toulouse-Lautrec is enhanced by a large group of his lithographs. A small but choice selection of Impressionist landscapes and city views by Sisley and Pissarro is highlighted by *Village on the Bank of the Seine*, 1872, and *The Boulevard Montmartre à Paris*, 1897, respectively.

The work of Paul Cézanne is shown through eleven paintings (with an additional fourteen works in the Pushkin Museum). They cover all aspects of his

career both in subject and in style. Of note among the works are *Girl at the Piano*, 1867–69; *Banks of the Marne*, 1888; *Still Life with Drapery*, 1898–99; and *Mont Sainte-Victoire*, 1898–1902.

The Hermitage has four paintings by Vincent van Gogh. Notable among them are *Bushes* and *Promenade at Arles*, both 1888. Far better representation is given to Paul Gauguin, whose fifteen canvases date, however, only from his Tahitian periods. Typical of the works by Gauguin are the *Woman Holding a Fruit* and *Tahitian Pastoral*, both 1893, and from his second trip to Tahiti, the *Woman Carrying Flowers*, 1899.

In the broad representation of French art of the early twentieth century there are works by Pierre Bonnard, Maurice Denis, André Derain, Henri Rousseau, Albert Marquet, Paul Signac, Maurice Utrillo, Maurice Vlaminck, and Edouard Vuillard.

The extraordinarily rich French painting collection is crowned by the holdings of the two major painters of the early twentieth century, Henri Matisse and Pablo Picasso. Thirty-five paintings by Matisse dating from 1897 to 1913 and thirty-six canvases by Picasso dating from 1901 to 1907 at the Hermitage, as well as about twenty additional works by each artist at Pushkin Museum, Moscow, attest to the impact of these two painters on the collectors Morosov and Shchukin.

Shchukin was an especially active patron of Matisse, and the Hermitage collection is highlighted by a number of major works, such as the interiors *Harmony in Red (Red Room)*, 1908, and *The Painter's Family*, 1911, with their rich use of color and pattern; the two large panels *Dance* and *Music*, both 1910, commissioned as decorations for the stairwell of Shchukin's home; and *Portrait of the Artist's Wife*, 1913, one of the last works acquired before the war.

Matisse introduced Shchukin to Picasso in 1908, and within the short period before World War I, Shchukin was to purchase fifty of Picasso's works. He also interested Morosov in Picasso's work, and Morosov was especially drawn to the early Cubist works. Among the strengths of the holdings are the early *Absinthe Drinker*, 1901; *The Visit (Two Sisters)*, 1902, from the Blue Period; *Girl on a Ball*, 1905, from the Rose Period; and *Dryad*, 1908, and *Portrait of Vollard*, 1910, both Cubist works.

The Hermitage publishes many catalogues in Russian covering temporary exhibitions and the collections, but they are infrequently available. General guides to the museum, monographs, and special collections have been published in English and are available for sale in the museum and more readily from booksellers in the United States who specialize in Soviet publications. A series of monographs, *Masters of World Painting*, has also been published in English and in some instances illustrates the Hermitage's complete holdings of individual artists.

Selected Bibliography

Museum publications: Persianova, Olga, *The Hermitage, Room-to-Room Guide*, trans. John S. Heyes, 4th ed., 1979; Shapiro, Yuri G., *The Hermitage: Plans of the Exhibition*, 1976; Voronikhina, Lyudmila N., *The Hermitage*, 1968.

Other publications: Descargues, Pierre, *Art Treasures of the Hermitage* (New York 1961); Dukelskaya, Larissa, *The Hermitage: English Art, Sixteenth to Nineteenth Century* (Leningrad 1979); Fahy, Everett, *The Legacy of Leonardo: Italian Renaissance Paintings from Leningrad* (New York 1979); Grigorieva, I.; I. N. Novoselskaya; J. I. Kuznetsov; A. S. Kantor-Gukovskaya; M. A. Nemirovskaya; and E. M. Zhukova, compilers, *Hermitage and Tretiakov, Master Drawings and Watercolours* (Sydney 1978); Gubchevsky, P. F., *The State Hermitage: Paintings* (Leningrad 1968); *Impressionist and Post-Impressionist Paintings from the U.S.S.R.* (New York 1973); Karpovich, Irina, *Art Museums of Leningrad* (Leningrad 1975); Komelova, Galina, and Vladimir Vasilyer, Introduction, *Masterpieces of Russian Culture and Art: The Hermitage, Leningrad*, trans. Era Mozolkova (Moscow 1981); Levinson-Lessing, V. F., *L'Ermitage: École Flamande et Hollandaise* (Prague 1962); Piotrovski, Boris, Introduction, *The Hermitage Picture Gallery: Western European Painting* (Leningrad 1979); Richardson, John, and Eric Zafran, eds., *Master Paintings from the Hermitage and the State Russian Museum, Leningrad* (New York 1975); Sterling, Charles, *Great French Painting in the Hermitage*, 2d ed. (New York 1958).

MARTINA R. NORELLI

STATE RUSSIAN MUSEUM (officially GOSUDARSTVENNYĬ RUSSKIĬ MUZEĬ (alternately RUSSIAN MUSEUM), 4 Inzheneraia ulitsa, Leningrad.

The State Russian Museum, founded in 1895 by decree of Nicholas II in honor of his father, Aleksandr III, is the USSR's largest museum devoted entirely to Russian art. In addition to its collection of paintings, which complements that of the State Tret'iakov Gallery (q.v.) in Moscow, the Russian Museum houses a vast quantity of Russian sculpture, graphic art, and applied and folk art.

The Russian Museum comes under the purview of the USSR Ministry of Culture. Internally, the museum functions under a director and assistant director with curatorial departments of Old Russian Art, Painting (subdivided chronologically into early and mid-eighteenth century, late eighteenth and early nineteenth centuries, mid-late nineteenth century, early twentieth century, and Soviet), Sculpture, Graphics, Applied Art, and Folk Art. Its noncuratorial support departments include a library specializing in the history of Russian art, photograph and slide collections, a restoration department, and museum education and traveling exhibition sections.

The complex housing the Russian Museum exemplifies St. Petersburg architecture at the beginning of the nineteenth century. The central section, formerly known as the Mikhailovskiĭ Palace, was constructed in 1819–26 for Aleksandr I's son Prince Mikhail by Italian-born architect Carlo Rossi (who also designed Leningrad's Palace Square, the Aleksandr [Kirov] Theater, and the Public Library). Rossi's plan extended Sadovaia Street to Mars Field, paralleled Engineer Street to Nevskiĭ Prospekt, and placed the palace at the resultant axis. His plan detailed every aspect of the structure, from doorknobs, furniture, and the magnificent iron and gold-plated fence to the buildings adjacent to the palace along Brodskiĭ (formerly Mikhailovskaia) Street as it opens into Nevskiĭ Prospekt. From 1826 through the 1840s the palace was the scene of Petersburg's most

celebrated social events, hosted by Prince Mikhail. In the 1850s his widow, Elena Pavlovna, organized recitals at the palace, at which pianist-composer Anton Rubinshteĭn was a regular performer. The recitals led to regular classes, and in 1862 the Mikhailovskiĭ Palace housed Russia's first conservatory of music. After Elena Pavlovna's death the palace was abandoned and deteriorating until 1893, when it was purchased by the Treasury. Between Nicholas II's decree in 1895 and the museum's opening in 1898, the building underwent a radical renovation directed by architect V. Svin'in. As a result, little has remained of the original Rossi interior.

When the museum opened in 1898, it contained objects transferred from the St. Petersburg Academy of Arts, the Winter Palace, and other royal houses in the city. The first permanent exhibition was organized to complement the building's new interiors and constituted a potpourri dominated by portraiture, second-rate landscapes, sculpture (arranged as background for the paintings), and mementos of the personal estate of Aleksandr III. During the next twenty years the museum's holdings increased rapidly through the donation of major St. Petersburg private collections (notably, those of M. F. Golitsyna, E. A. Evreĭnova, V. A. Argutinskiĭ-Dolgorukov, M. C. Tenishev, P. A. and V. A. Biullov, and A. A. Maĭkov). Following nationalization of private estates in 1918, the Russian Museum became the central depository for the finest examples of Russian art in Leningrad and the surrounding northern regions. Its holdings currently exceed 360,000 objects, spanning the earliest extant Russian icons through contemporary Soviet painting and sculpture. In 1920–21 the museum's displays underwent a total reorganization, replacing the earlier decorative plan with one arranged chronologically, following the development of Russian art. In 1934 the collection was designated a state art museum, and its cultural section was made independent and was moved to the Russian Culture section of the Hermitage (q.v.), and the ethnographic section was housed next to the central structure. Following World War II the museum again reorganized its exhibit in the central palace and Benois Wing (constructed in 1912 by the architect L. Benois, extensively restored in 1948–1953, and annexed to the main structure in 1958). The Benois Wing now houses Soviet art and temporary exhibitions.

The Russian Museum's collection of Old Russian art originated in the Aleksandr III Museum's icon collection donated by the historian M. Pogodin. It was supplemented in 1913 through the acquisition of the collection of the art historian N. Likhachev. Following the Revolution, icons from confiscated church properties in Arkhangel'sk, Pskov, Iaroslavl', Vologda, and other northern provinces surrounding Leningrad were sent to the museum. Since the 1950s the museum's staff has participated in expeditions throughout the North in search of additional artifacts. As a result, the Old Russian Section of the museum offers a historically comprehensive, if not opulent, survey of Russian icon painting, with particular strength in the northern schools. It contains representative icons from the early Kievan period (tenth-twelfth century) through the seventeenth-century Muscovite schools. Of exceptional value are its icons from Novgorod: *Angel with Golden*

Hair (twelfth century, discovered in 1961 as a window board in an abandoned church-turned-grain warehouse near Novgorod), *St. Nicholas with Scenes from His Life* (thirteenth century), *Saints John Climacus, George, and Blasius* (last third of the thirteenth century), and *The Descent into Hell* (Dionysius, 1500–1502); from Iaroslavl': *The Virgin of Tolg III* (first half, fourteenth century) and *The Miracle of Theodore of Turon* (late fifteenth century, Likhachev Collection); from Rostov the Great: *St. Nicholas of Zaraĭsk with Scenes from His Life* (early fourteenth century); and from Vladimir-Suzdal': *The Virgin Hagitria* (late fourteenth century) and *St. George and the Dragon*.

Secular painting in Russia accompanied the late-seventeenth-century and early-eighteenth-century reforms of Peter I. For the next 150 years portraiture would dominate the visual arts. The Aleksandr III Museum's original collection from the St. Petersburg Academy and royal estates, in conjunction with intensive curatorial efforts, has resulted in the current ownership of the most complete collection of eighteenth- and early-nineteenth-century Russian painting assembled under one roof. The anonymous *Portrait of Ivan Turgenev* (1690s) demonstrates the transition from religious to secular painting. Assimilation of Western techniques by Petrine artists commissioned by the czar to study abroad can be seen in representative works by I. Nikitin (*Portrait of a Field Hetman*, 1720s) and A. Matveev (*Self Portrait with Wife*, 1729).

By mid-century painting was developing independently in the St. Petersburg "Painting Command," headed by Matveev, and later in the newly founded Academy of Arts (1757). The museum displays a unique collection of late-eighteenth- and early-nineteenth-century academy painting, providing a survey of increasing technical refinement, experimentation in genre painting, and variation of individual styles. Included are: A. Losenko's *Vladimir and Rogneda* (1770), characteristic of Russian neoclassicism's combination of classical motifs with Novgorodian history; P. Sokolov's *Mercury and Argus* (1775), typifying the popularity of mythological subjects at the end of the 1770s and early 1780s; G. Ugriumov's *Trial of Ian Usmar'* (1797) and A. Ivanov's *Feat of a Young Kievan during the Pecheneg Siege of 968* (1810), both products of the intensified nationalism evoked during the Napoleonic Wars. Side-by-side hang examples of Russian portraiture at its pinnacle in the late eighteenth century under the brushes of three masters: F. Rokotov (*Portrait of Elizaveta Santi*, 1785, and *Portrait of V. Surovtseva*, second half, 1780s); D. Levitskiĭ, especially his seven portraits of students from the Smolny Convent, displayed in a single hall (*Portrait of Khovanskaia and Khrushcheva*, 1773, from Peterhof, considered the best), and V. Borovikovskiĭ, best known for his poetic, Sentimentalist-influenced, female portraits (e.g., *Portrait of E. Arseneva*, 1796 and of *Catherine the Great at Tsarskoe Selo*, 1794). A variation of this latter portrait is housed in the Tret'iakov (q.v.), and is significant for its incorporation of the then predominating notion of the benevolent monarch. Concurrently, Russian artists began to experiment in landscape painting. The museum offers an uneven, but interesting overview of the major innovators—S. Shchedrin's poetic images of St. Peters-

burg and the Italian countryside, F. Alekseev's architectural paintings of Petersburg, and F. Matveev's classical Italian landscapes.

Returning to portraiture from the post-Napoleonic period, the Russian Museum owns several high-quality canvases by O. Kiprenskiĭ, among which his *Portrait of E. Davydov* has been the center of considerable controversy. Only in the mid–1960s was attribution of the subject assigned to E. Davydov, reversing more than a century of belief that Kiprenskiĭ had painted D. Davydov, a poet and participant in the Decembrist Uprising of 1825. The revitalization of portraiture in the Academy in the early nineteenth century is best measured by the museum's collection of the work of K. Briullov, considered the highlight of the museum's entire painting collection. Included are his best Italian subjects: *A Girl Harvesting Grapes in the Environs of Naples* (1827) and *An Italian Noon* (1828), his masterpiece *The Last Day of Pompeii* (1833, transferred in 1850 from the Academy to the Hermitage and later to the Russian Museum), which caused a furor in Italy and Russia and influenced later monumental canvases by F. Bruni (*The Brazen Serpent*, 1826–41) and A. Ivanov (*The Appearance of the Messiah to the People*, housed in the Tret'iakov with preparatory sketches shared with the Russian Museum). There also is Briullov's series of canvases devoted exclusively to female figures (e.g., *Portrait of Iu. Samoilova Leaving a Ball*, about 1840; the unfinished *Portrait of Baronness Iu. Samoilova with Her Adopted Daughter Amacillia Paccini*, about 1839; *Portrait of Princess E. P. Samoilova*, 1837–38; and *Portrait of U. M. Smirnova*, 1837–40).

Contemporaries of Briullov working outside the Academy on subjects drawn from Russian daily life contributed to the rise of realist painting, which would dominate the second half of the century. The leader of this school, himself accepted by the Academy in 1811 for his *Portrait of K. Golovachevskii*, was A. Venetsianov. He and his numerous students are well represented in the Russian Museum. Characteristic of the school are its rural idylls (Venetsianov's *The Threshing Floor*, 1821; *Beet Cleaning*, 1823; and *A Sleeping Shepherd*, 1824; N. Krylov's *Russian Winter*, 1827, among the first Russian winter landscapes; A. Tyranov's *Scene on the River Tosno*, 1827; and E. Shchedrovskii's *Landscape with Hunter*, 1839), intimate interiors (Tyranov's *Studio of the Chernetsov Artists*, 1828; S. Zarianko's *Classroom in the School of Jurisprudence with a Group of Students and Teachers*, c. 1840; A. Alekseev's *Venetsianov's Studio*, 1827; and G. Soroka's *Study at Ostrovki*, 1844), and images of craftsmen and their shops (L. Plakhov's *The Bricklayer* and *In the Smith*, 1840s).

The museum's holdings of realist painting for the second half of the century complement the collection of the Tret'iakov in Moscow and offer a fine survey of the "Itinerants" (*Peredvizhniki*) and their contemporaries. As is true of the Tret'iakov, it is this part of the Russian Museum's collection that is best known in the West and whose extensive holdings cannot be done justice by any partial listing here. Among the better known are: Ivan Aiva'zovskii's spectacular seascapes, I. Repin's *The Zaporozh'e Cossacks Write a Letter to the Turkish Sultan* (1880–91), V. Perov's *Dinner at the Monastery* (1876), I. Kramskoĭ's *Portrait*

of Mina Moïseev (1882), A. Savrasov's *The Thaw* (1874), V. Surikov's *The Capture of the Snowfort* (1891) and *Stepan Razin* (1906), and M. Nesterov's *Vespers* (1895), with major landscapes by A. Kuindzhi, whose experimentation with light and color led many to suspect he illuminated his canvases with candles (*Evening in the Ukraine*, 1878), and I. Shishkin (*Mordvin Oaks*, 1891); and numerous works by I. Levitan.

Completing the painting collection are selections from the experimental pre-Revolutionary movements of the World of Art, Union of Russian Artists, Primitivism-Furturism, post-Revolutionary Constructivism, and LEF (M. Vrubel's *Venice*, 1893; A. Golovin's *F. Chaliapin in the Role of Ivan the Terrible*, 1912; N. Goncharova's *The Cyclist*, 1912–13; M. Larionov's *Rayonnist Landscape*, 1912; K. Malevich's *Black Square, Black Circle, Black Cross*, c. 1913, and *Suprematist Composition*, 1916–17; and V. Tatlin's *The Sailor*, 1911–12). The Soviet section contains more than three thousand canvases by artists who began their careers before the Revolution and contributed to the development of Socialist Realism (especially strong are the museum holdings for K. Petrov-Vodkin, A. Rylov, P. Konchalovskii, and A. Deĭneka), as well as the best examples of later generations of officially sanctioned painting and sculpture.

Sculpture achieved prominence in Russia in the second half of the eighteenth century through the acceptance of Western neoclassicism. The Department of Sculpture, which achieved its independence in the 1920s, shares with painting a wealth of objects from the eighteenth and early nineteenth centuries. Since nationalization and reorganization of the department, the collection has been supplemented to provide the most complete survey of Russian sculpture available anywhere, with separate galleries devoted to the major artists. The museum's proximity to the architectural complexes on which many of the sculptors worked and the Leningrad Museum of Municipal Sculpture further enhances the collection's value.

During the first decade of the eighteenth century, Peter I invited European masters to Russia to train native sculptors. Among them was a follower of Bernini, C. Rastrelli of Florence, who spent the remainder of his life in Russia. Rastrelli is well represented in a series of court portraits, including his famous bust *Peter I* (bronze, 1723). Sculpture reached its apex in Russia in the second half of the century, first through the portrait bust as developed by F. Shchedrin, which is extensively displayed, and later combined with mythological subjects, as executed by a group of young artists trained at the Academy: M. Kozlovskiĭ (*Catherine the Great as Minerva*, marble, 1875; terracotta statuettes on motifs from the *Iliad*), F. Shchedrin (*Venus*, marble, 1792, and *Diana*, marble, 1798), and I. Prokof'ev, remembered primarily for his reliefs but represented in the museum by two terracotta busts (*A. F. and A. E. Labzin*, 1800). Monumental sculpture, which flourished in Russia after the Napoleonic Wars, was related to contemporary architecture through collaborations such as that of the Mikhaĭlovskiĭ Palace architect Rossi and sculptor V. Demuth-Malinovskiĭ, who executed the reliefs on the palace's central facade. Within the museum's collection, post-

Napoleonic nationalism is evident in B. Orlovskiĭ's *Ian Usmar'* (bronze, 1831), S. Pimenov's monument to Kozlovskiĭ (plaster model, 1802), and a series of medallions by F. Tolstoĭ (late 1820s). The remainder of the museum's collection of nineteenth-century sculpture traces the decline of monumental work in the 1830s and 1840s in favor of small genre pieces: P. Klodt's animal series (sculptor of the equestrian group at Anichkov Bridge), N. Pimenov's *Boy Playing Babki*, P. Stavassev's *Little Fisherman and Rusalka*, A. Ivanov's *Young Lomonosov at the Seashore*, and A. Terebenev's remarkable iron statuette of the poet Aleksandr Pushkin.

The second half of the century produced only a handful of noteworthy sculptors. The most prominent is M. Antokol'skiĭ, a retrospective of whose work occupies a central place in the museum's collection, from early genre pieces (*The Tailor* and *The Beggar*, mid–1860s) through his mature historical subjects (*Ivan the Terrible*, *Peter I*, and *The Death of Socrates*, 1870s, and *Spinoza* and *Mephistopheles*, 1880s). Finally, the influence of Impressionism on Russian turn-of-the-century sculpture can be measured in the museum's collection of works by A. Golubkina (e.g., *Portrait of A. Belyi*, 1907, and *Sleep*, 1912), L. Shervud (*Man Sitting*, 1907), and P. Trubetskoĭ (*Bust of L. Tolstoĭ*, 1899, and *M. K. Tenisheva*, 1899). Special attention is given to the work of S. Konenkov and A. Matveev, the so-called father of Soviet sculpture.

The Russian Museum's Department of Prints and Drawings is the largest collection of Russian work in these media in the USSR. The collection was formed on the basis of a small, unsystematically collected group of works contained in the original Aleksandr III Museum. After the Revolution and nationalization of private collections, the museum obtained valuable private collections from the estates of A. Tomilov (mostly early-nineteenth-century artists), V. Argutinskiĭ-Dolgorukov, L. Zhemchuzhnikov, and S. Botkin. In 1926 the museum acquired six thousand drawings from the Academy of Arts. Since then the collection has absorbed more than seventy thousand original works, primarily sketches and preparatory studies for major canvases. The highlights of the department are its holdings for the second half of the eighteenth and early nineteenth centuries. The second half of the nineteenth century is somewhat weaker with scattered works by Perov, Kramskoĭ, Shishkin, Vasil'ev, and Repin. From the late nineteenth and early twentieth centuries are many notable drawings by Benois, Somov, Kustodiev, Lansere, and A. Ostroumova-Lebedeva. Book illustrations and landscapes dominate the Soviet portion of the collection.

When it was founded, the Russian Museum inherited fine decorative objects originally housed in the Mikhailovskiĭ Palace. On the basis of this and with massive acquisitions in the 1920s from estates of the royal family and the nobility, the Department of Applied Art developed into an independent section. It opened in 1960. The museum displays a permanent exhibit of its most valuable objects, with temporary special shows arranged for its unparalleled collections of porcelain, ceramics, glass, furniture, fabrics, shawls, precious metals, and samovars. The Great White-Column Hall recreates in extensive detail the Empire

interior of the palace as designed by Rossi in the 1820s, complete with gilt furniture, decorative vases, and an elaborate chandelier. A significant portion of the collection consists of eighteenth- and early-ninteenth-century porcelain: 250 items of Vinogradov porcelain from the Imperial Porcelain Factory (especially Catherine II's Orlov Service); 4 services (St. George, St. Aleksandr Nevskii, St. Andrei, and St. Vladimir, 1770–90s) produced by the Gardiner factory, and assorted objects from the Batenin factory (identified by trademark scenes of St. Petersburg). M. Lomonosov founded Russian glass production in the mid–1700s, and the Russian Museum contains most of his extant mosaic portraits. Noteworthy among the hundreds of glass objects from the eighteenth and early nineteenth centuries are a transparent blue teapot with gilded ornament (1730s) and a collection of glasses commemorating the defeat of Napoleon. The museum's collection of 40 samovars, acquired in 1965, attracts hundreds of viewers. It includes a rare example of eighteenth-century Nizhni-Novgorod (Gor'kii) craftsmanship and a variety of famed Tule pieces from the nineteenth century.

The Department of Folk Art contains the richest single collection of Russian handicrafts in the USSR. Founded in 1937, the department owns a broad sampling of wood and metal carvings (among which are several extremely rare examples from the late seventeenth century), Kirov and Tula ceramic vessels and toys, homespun cloth, embroidery and crocheted lace, and exquisite Palekh boxes. The department's forte lies in its collection of wooden distaffs from the eighteenth century through the present from European Russia and colonies in Siberia and Altai.

The Russian Museum also functions as a central research institution for the history of Russian art. Its staff includes noted specialists in all periods who have published extensively, especially in the areas of sculpture, Old Russian art and folk art. In addition to publishing catalogues and monographs, the museum regularly issues its scientific *Communications* (*Soobshcheniia*).

Selected Bibliography

Alianskii, Iu., *Rasskazy of Russkom Muzee* (Leningrad-Moscow 1964); Ivanova, E., *Russian Applied Art* (Leningrad 1976); Lapina, I. P., *The Russian Museum, Plans of the Exhibitions* (Leningrad 1978); Lebedev, G. E., *Gosudarstvennyĭ Russkiĭ Museĭ, 1895–1945* (Leningrad-Moscow 1946); Lebedev, P., *Russkaia sovetskaia zhivopis'. Kratkaia istoriia* (Moscow 1963); Novouspensky, N. N., *Paintings from the Russian Museum Collection* (Leningrad 1975); Polovtsov, A. V., *Progulka po Russkomu Muzeiu Imperatora Aleksandra III v S-Peterburge* (Moscow 1900); Pushkarev, N., ed., *The Russian Museum, A Short Guide* (Moscow 1955); idem, *Treasures of the Russian Museum* (Leningrad 1975); Richardson, J., and E. Zafran, eds., *Master Paintings from the Hermitage and the State Russian Museum Leningrad* (New York 1975); *The Russian Museum, Watercolours and Drawings, Twenty-four Reproductions* (Leningrad 1972); Rybakova, L., and S. Sherman, *Gosudarstvennyĭ Russkiĭ Muzeĭ. Grafika* (Moscow 1958); Sarabyanov, D., *Russian Painting of the Early Twentieth Century (New Trends)* (Leningrad 1973); Savinov, A. N., *Gosudarstvennyĭ Russkiĭ Muzeĭ. Al'bom* (Leningrad 1959); *The*

State Russian Museum—20 Reproductions (Moscow-Leningrad 1939); Taranovskaia, N. V., and N. V. Mal'tsev, *Russkie prialki/Russian Distaffs* (Leningrad 1970); Vrangel', H., comp., *Russkiĭ Muzeĭ Imperatora Aleksandra III. Zhivopis' i skul'ptura*, 2 vols. (St. Petersburg 1904).

DIANE M. NEMEC-IGNASHEV

—————— Moscow ——————

RUBLEV MUSEUM (officially MUZEĬ DREVNERRUSSKOGO ISKUSSTVA IMENI ANDREIA RUBLËVA; alternately ANDREI RUBLEV MUSEUM OF OLD RUSSIAN ART), 10 ulitsa Priamikova, Moscow.

In the brief twenty years of its formal existence, the Andrei Rublev Museum of Old Russian Art, among the USSR's youngest and smallest major art museums, has emerged as a vital center for the study of Old Russian culture. Its collection, although sparse by comparison to that of the Kremlin, the State Russian Museum (q.v.) and the State Tret'iakov Gallery (q.v.) brings together years of expeditions and restoration that have brought to light hundreds of artifacts until recently considered lost or nonexistent. At present the museum owns more than fifteen hundred objects, of which about two hundred are on display. It offers a survey of originals and copies from the late fourteenth through the seventeenth century, with particular strength in the Moscow and Central Russian schools of painting of the sixteenth and seventeenth centuries.

The Rublev Museum evolved from the Andronikov Monastery Historical Preserve, established in 1947, the octocentennial of the city of Moscow. Its founders recognized early the need for a museum devoted solely to the history of Old Russian art and collaborated with a small group of accomplished restorers from other museums and the central restoration laboratories in Moscow. Concentrated collecting of icons and other objects commenced in the mid–1950s. The museum opened officially in 1960 to mark the six-hundredth anniversary of the birth of its namesake. It operates under the auspices of the USSR Ministry of Culture and is headed by a director, with a small staff of curator-art historians specializing in Old Russian art. The museum has a small but accomplished restoration department, a growing photograph and slide collection, and a museum-education support section.

The Rublev Museum is housed in the Andronikov Monastery on the banks of the Iauza River on the outskirts of central Moscow. Initially a fortress that defended the city's northeastern approaches, the monastery complex is significant as a compilation of the architectural styles that evolved in Moscow from the early fifteenth century through Petrine reforms. The Savior Cathedral (c. 1425–27), the oldest structure in Moscow, predates the stone buildings of the Kremlin. It demonstrates early attempts by Moscow architects to elaborate an original church style. At first glance highly reminiscent of the churches of neighboring

Vladimir, the cathedral combines severity of line and massive walls in its lower half with innovative and elegant recessive rows of corbelled arches that support the central cupola drum. The resultant decorative pattern obviated the need for exterior relief bands traditional at the time in Vladimir. The cathedral's design inspired later architects and is mirrored in the Church of the Deposition of the Robe in the Kremlin. Besides the cathedral, the monastery contains an early-sixteenth-century stone refectory (1504), of which the severity and heaviness echo that of the cathedral's lower half. Adjacent to the refectory is the early-seventeenth-century Church of the Archangel Michael, which typifies the ornamentalism of the Moscow Baroque. The monastery's present stone walls and towers were constructed in the late seventeenth century and are stylizations of the fifteenth-century manner.

The Rublev houses a varied collection of applied art (jewelry, wood carving, textiles, and metalwork) but concentrates on icon painting of the Moscow schools. The icons have been collected primarily from the medieval cities of Dmitrov, Vladimir, and Aleksandrov and from villages in the Iaroslavl', Kalinin, and Kirov regions surrounding the capital. Since it is of recent origin, the museum cannot boast original major compositions by masters such as Rublev, Dionysius, and Ushakov (most of which were inherited by older museums from nineteenth-century private collections). But it compensates for this deficiency with several pieces tentatively ascribed to the above masters, high-quality reproductions of their major compositions (e.g., of Rublev's *Trinity* and Dionysius' frescoes, executed by V. Kirikov and N. Gusev, respectively) and an assortment of school pieces that attest to the strength of the masters' influence in areas as far from the capital as the Solovetskiĭ islands.

The exhibit opens with paintings from the fourteenth century, when Muscovite princes began their rise to political dominance over other principalities. Of particular interest is a late-fourteenth-century *Crucifixion*. One of the oldest pieces in the collection, the icon was renovated at the beginning of this century, when the central extant portion was extracted from its original wood frame and placed in another. The process destroyed the figures' proportions, but rescued the work from certain destruction. Ascribed to a Russian painter, the *Crucifixion*'s pale coloring and simple structure provide a standard against which to measure the innovations of the Rublev school only two decades later. Also from the late fourteenth century are two extremely rare examples of the Tver' school: *St. Nicholas the Miracle-Worker* and *St. John the Baptist*. Despite having been burned severely in the eighteenth century, the latter illustrates well the bold hand and spiritual pensiveness characteristic of Tver'.

As Moscow's princes gained wealth and power, the arts flourished. The fifteenth century signaled Moscow's development as a major center for Russian architecture and painting. The museum's exhibition illustrates the extent to which this development was dominated by the school of Russia's most famous master, Andrei Rublev (1360–1430). Within the Savior Cathedral are fragments of frescoes currently ascribed to Rublev and his chief collaborator, Daniĭl Chernyĭ.

The museum proper contains copies of Rublev's masterworks owned by other museums, the early-fifteenth-century *St. John the Baptist* believed to have been executed by Rublev, and an embroidered chalice cover bearing the descent of the Virgin into hell, created for the Andronikov Monastery in 1439 and clearly influenced by Rublev. (It was acquired by the museum in 1969.) Although lacking uncontested works by its namesake, the museum displays several high-quality pieces executed by his students. *Saints Cosmos and Damian* (from a church honoring the two saints in Dmitrov) offers a classic example of the Moscow school of the fifteenth century: its clarity of composition, purity of color, sharp silhouette, and flowing lines all evidence of Rublev's influence. It is one of a group of icons, the backbone of the young collection, brought from Dmitrov in 1958 by the museum's co-founder N. Demina. The same group includes a series of icons dedicated to the contemporaneously popular theme of the Virgin as protectress of and intercessor for Russia. Technically inferior and poorly pre-served, the early-fifteenth-century *Virgin Hodigitria* recalls the mood and phil-osophical depth of those executed by Rublev and his immediate circle. It is echoed in a better preserved *Virgin of Tikhvin* (second half, fifteenth century) and continued, although with greater attention to the human form, in the *Virgin Hodigitria* (third quarter, fifteenth century). Finally, from the end of the fifteenth century is a *Dormition of the Virgin*, securely ascribed to the workshop of Dionysius and tentatively assigned to Dionysius himself.

Several of the museum's discoveries have contributed significantly to recent scholarship in the field of Russian painting. Among them is the late-fifteenth-century *Deposition of the Robe* (from the village of Borodava, near the Ferapont Monastery). On the basis of this icon, painted by an anonymous master trained by students of Rublev and similar in style to early works by Dionysius, scholars now have established a concrete link between the two masters, previously be-lieved isolated from each other. Also, two hagiographic icons of St. George (from the Dormition Cathedral and the Church of St. Paraskeva Piatnitsa, re-spectively, in Dmitrov, late fifteenth century) demonstrate how adherence to prescribed canons of representation of the major saints initially enhanced, not inhibited, the development of individual styles, especially in the use of color. In this respect the above-mentioned paintings collected by the museum's staff in Dmitrov serve still another purpose: they show that Rublev and Dionysius not only were not isolated in their mastery but were surrounded by numerous talented, although to this day anonymous, contemporaries.

Among historical periods of Russian painting, the sixeenth and seventeenth centuries are the least studied. However, the Rublev Museum has assembled a collection of considerable art historical value. For example, as Moscow grew and strengthened its position as an European power, it launched an ideological campaign against adverse political and flourishing sectarian religious movements. Moscow's efforts toward political centralization and religious orthodoxy led to an increase in the popularity of native Russian saints as subjects for painting. The most frequently depicted of them was St. Sergius of Radonezh. Although most fifteenth- and early-sixteenth-century images of St. Sergius closely imitate

one another, the Rublev owns a rare, very well-preserved work in which the content and order of the hagiographic border scenes depart sharply from the standard, and the enlarged figures of that border, as they interlock, form a unique frieze-like chain. More typical of sixteenth-century painting in its attention to literary sources (both in content and style) and monumentality are *The Trinity* (early sixteenth century); *St. Nicholas of Zaraĭsk*, with hagiographic border scenes (1551, Novgorod); and two mid-century icons of St. John (patron saint of Ivan IV)—*Winged St. John*, from the Trinity-Makhryshchensky Monastery near Aleksandrov, and *St. John the Baptist*, from the Domition Cathedral in Dmitrov.

Following the upheavals of the late sixteenth and early seventeenth centuries, the so-called Time of Troubles, painters attempted to revive the monumental spirit of the preceding epoch. They did so through orthodox imitation of the style of the reign of Ivan IV and through a heightened aestheticism, leading into the Stroganov school. In the Rublev Museum collection, the first manner is well illustrated by the early-seventeenth-century *Birth of the Virgin*. The icon displays greater attention to individual human emotions and details from everyday life. Another example is an altar door from the early seventeenth century, uncovered in a village near Moscow in 1965. A series of Old Testament scenes relates the icon's practical function to its literary sources. Also from the early part of the century are two icons of the patriarchs from the iconostasis of the Cathedral of the Transfiguration of the Solovetskiĭ Monastery.

At present the Rublev Museum does not display any examples of the Stroganov school. Nonetheless, the influence of that school's founder, Simon Ushakov, can be measured in an immense display of sixty-eight icons from the Cathedral of the Transfiguration of the Savior-Efimiev Monastery in Suzdal'. Painted by several masters (probably in commemoration of the monastery's tricentennial), the icons vary individually in their use of color, architectural backgrounds, and mastery of the human form. Together they form an impressive, five-layer ensemble, exemplifying the organizational principles of the iconostasis and the dramatic effects of seventeenth-century church decoration.

By the end of the seventeenth century, painting and literature had succumbed to greater secularization. Unfortunately, the Rublev owns only a few pieces from this period, the majority of which are mediocre. The *Virgin of Tikhvin*, dated 1680, stands above the rest for its technical refinement and its detailed incorporation of events from the history of the city of Tikhvin in the twenty-four border scenes.

At present the museum does not issue a regular series of its scientific findings. It has published a few albums of reproductions.

Selected Bibliography

Ivanova, I. A., *Muzeĭ drevnerusskogo iskusstva imeni Andreia Rublëva* (Moscow 1968); *Muzeĭ drevnerusskogo iskusstva imeni Andreia Rublëva* (Moscow 1968); Wagner, G. K., *Spaso-Andronikov Monastery* (Moscow 1972).

DIANE M. NEMEC-IGNASHEV

STATE PUSHKIN MUSEUM (officially GOSUDARSTVENNYĬ MUZEĬ IZOBRAZITEL'NYKH ISKUSSTV IMENI A. S. PUSHKINA; alternately THE STATE A. S. PUSHKIN MUSEUM OF FINE ARTS, THE PUSHKIN MUSEUM, THE PUSHKIN), ulitsa Volchenka 12, Moscow 12109.

The collection of the State Pushkin Museum represents more than two hundred years of acquisitions. The museum was founded in the 1770s at the Moscow University. It began with an anonymous gift of Lipert's *Dactylioteca* and of Swedish and Russian medallions. In the first decade of the nineteenth century these works were supplemented by gifts of coins, medallions, and other items of artistic value from Princes Iablonskii and Urusov. Following the Napoleonic Wars, the collection, now the University's Munz-Kabinett, a laboratory for students of aesthetics, continued to expand in directions paralleling the development of the Department of Art History and Theory. In the 1850s and 1860s the predominantly numismatic collection expanded to include objects obtained during the archaeological expeditions of professors Leont'ev and Gerts in Tanais and Phanagoria, respectively. At the same time, through the benefaction of V. P. Botkin, the Kabinett acquired fifty-eight plaster replicas of ancient through Renaissance sculpture from the Berlin Museum. According to an inventory taken in the early 1880s, the university's collection included the casts, 108 original antique vases, 2,800 ancient Greek coins, 5,671 Roman coins, and a variety of Western European, Russian, and Egyptian coins and medallions.

The need for a separate structure to house the collection grew along with now rapid acquisitions. As early as the 1830s, the salon circle of Princess Voronskaia had discussed the funding and construction of a building. Only in the early 1890s, under the supervision of Moscow University professor I. Tsvetaev, were sufficient private funds raised to finance the present museum. The architect, R. Klein, who also designed Moscow's TSUM department store and the Borodino Bridge, coordinated his plan to the predominantly pedagogical function of the collection. Klein's design included the period halls still extant in the present museum. Construction of the building was completed in 1912. That same year the museum officially opened as the Aleksandr III Museum of Fine Arts of the Moscow University.

When it opened, the museum contained relatively few original works of post-Classical Western art. Immediately before its opening, it received the collection of Egyptologist V. Golenishchev, which today comprises the majority of the museum's Egyptian holdings. With the addition of the collection of N. Prakhov, donated in the 1940s, the museum developed an extraordinary display of Coptic textiles. Further private contributions immediately thereafter brought examples of thirteenth- and fourteenth-century Italian painting, the cornerstone of the present painting gallery. The Revolution of 1917 and subsequent nationalization of private collections had an immense effect on the Pushkin Museum. In 1923–24 the museum acquired the Western art collections of the Tret'iakov Gallery and of the Rumaniantsev Museum—masterworks such as Rembrandt's *Ahasuerus, Haman, and Esther*, Ter Borch's *Portrait of a Lady*, David's *Portrait of*

a Young Man (*Portrait of Ingres*), and Corot's *Gust of Wind*, as well as works by Delacroix, Millet, Géricault, and Courbet. That same year the museum became independent of the Moscow University and was renamed the Government Museum of Fine Arts.

In the late 1920s-early 1930s exchanges were arranged between the Pushkin and the Hermitage (q.v.) in Leningrad. From the Hermitage the Pushkin received Poussin's *Rinaldo and Armida* and *Landscape with Hercules*, Watteau's *Bivouac*, Rembrandt's *Portrait of the Artist's Brother* and *Portrait of the Artist's Sister-in-Law*, Rubens' *Bacchanal* and several sketches, Cranach the Elder's *Madonna*, Jordaens' *Satyr Visiting a Peasant*, Murillo's *Flight into Egypt*, and Feti's *David with the Head of Goliath*. In addition to receiving the Hermitage contributions, the Pushkin again benefited from nationalized private collections, from which it simultaneously obtained *St. Sebastian* by Boltraffio, *The Rape of Europa* by Claude Lorraine, *Hercules and Omphale* by Boucher, *View of the Village of Egmont* by Jacob van Ruisdael, and a still life by Chardin. By 1937, the twenty-fifth anniversary of the museum and the centenary of the death of poet Aleksandr Pushkin (whose name it acquired that year), the museum's current collection of ancient through early French art was secure. Only in 1948, following the dissolution of the former Moscow Museum of Modern Western Art, did the Pushkin acquire its spectacular collection of late-nineteenth- and early-twentieth-century French art, its current foothold in the ranks of major world museums. Since the 1950s the museum has continued its acquisitions through the contribution of private collections still in the Soviet Union, gifts by sympathetic Western artists (such as Rockwell Kent and Frank Brangwyn), and occasional purchases.

The Pushkin Museum operates under the auspices of the USSR Ministry of Culture. Internally, it is organized into curatorial departments of the Classical Orient, Ancient Art, Western European Art, Prints and Drawings, and Numismatics. Each of the curatorial departments is headed by a director, with senior curators for subdivisions within the departments, and with a general museum director and assistant director. Noncuratorial support departments include the Archaeological Section (which oversees expeditions and the preparation of excavated materials), the Library (the largest and best collection on Western art history and theory in Moscow), the Photo-Reproduction Department (organized in 1945 and charged with the photograph and slide collection), the Restoration Department (with sections specializing in painting, graphics, furniture, metalwork, and ceramics), the Museum Archive, and the Museum Education Department.

The Department of the Classical Orient is based on the collection of V. Golenishchev, supplemented in 1940 by acquisition of the N. Prokhov Collection. At present the department occupies two halls within the museum: the Art of Ancient Egypt and the Art of Ancient Civilizations (both radically reorganized in 1969). The Hall of Ancient Egyptian Art is a stylization of Egyptian architecture: lotus-shaped columns reproduce those at Luxor, topped by a painted ceiling. The entrance to the room is flanked by a large sarcophagus and father-

daughter group statues. The main exhibit opens with Predynastic objects—artists' palettes, stone and clay vessels, and implements used in the Egyptian funerary cult. Highlighting the exhibit are reliefs from the tomb of Isi (a treasurer of the fifth dynasty), handicrafts from the Three Kingdoms (grouped in cases by medium to accentuate stylistic differences), a collection of painted vases, and a luxurious sacrophagus. The Hall of Ancient Civilizations displays objects from Mesopotamia, Uartu, Iran, Parthia, and Cyprus, as well as a selection of terracotta vases from Peru and Mexico. There, too, an attempt has been made to recreate period architecture: the ceiling reproduces the overhead cover of an Assyrian courtyard, and enormous winged bulls stand at the hall's entrance. At the center of the exhibit is a group of Uartu vases excavated at Erebuni in the 1920s by the museum's staff. They are flanked by originals and reproductions of Assyrian relief. The displays in both halls are oriented heavily toward functional objects, depend on copies, and are of mixed value.

The Department of Ancient Art originated in the Moscow University Munz-Kabinett. It occupies seven period halls in the museum: the Art of the Aegean and Ancient Greece, Greek Art of the Fifth Century B.C., the Art of Athens, Greek Art of the Fourth Century B.C., the Hellenistic Epoch, the Art of Ancient Rome, and the Art of Ancient Black Sea Civilizations (Phanagoria, Panticapius, Scythian Naples, Tiritaka). In the Aegean-Ancient Greek collection are original Mycenaean and Cypriot vases; a krater from Melos; Greek vases of the Protocorinthian, Corinthian, and Italo-Corinthian times, and Attic black-figure vases, surrounded by extensive reproductions. The central exponents of the Fifth Century Greek Hall are authentic Attic red-figure vases surrounded by reproductions of the sculpture of the Early Classical period. The Hall of Hellenistic Art presents that of Pergama, Rodosso, Alexandria, and Attica through a series of copies and original works, among the latter, the *Torso of Aphrodite* from the Khvonshinskii Collection and the *Head of a Goddess* from Alexandria; terracotta statuettes; and Partheanic ivory rhytons.

The Art of Ancient Rome, like the preceding sections, combines reproductions with originals to survey the major Roman periods. Among original objects are a series of portrait heads and busts, sarcophagi decorated with relief, and a mosaic slab bearing images of Theseus and the Minotaur. There also are fragments of Pompeian frescoes and two shields with fragments of sarcophagal relief. The final and most abundant collection of original objects is that of the Art of Ancient Black Sea Civilizations. It contains artifacts excavated in Panticapius (Kerch), Tiritaka (near Kerch), Phanagoria (near Taman'), Gorgipia (Anapa), and Scythian Naples (Semfiropl') and remnants from the ancient cities of Ol'via, Kharakhs, and Khersones. Among the objects on display are clothing, weaponry, furniture, small terracotta sculptures, and coins. Of particular note are the exceptionally rich objects brought from Scythian Naples: gold ornaments, weapons, and ceramics from a woman's grave in the municipal mausoleum. The Departments of Ancient Art and Numismatics share the museum's extensive collection

of antique coins from the Archaic, Classical, and Hellenistic Greek periods; the Black Sea civilizations; and Rome (the Republic through Imperial periods).

The youngest department of the museum, that of Western European Art, contains the most outstanding part of the collection. Until 1948 the department's holdings extended only through early-nineteenth-century French art. Its offerings derived in part from private collections and from the 1930s exchange with the Hermitage Museum in Leningrad. At present the central painting collection ranges from Faiyum portraits through contemporary Western European and American art. Acquisitions from the dissolved Moscow Museum of Modern Western Art (1948) draw on a compilation of the private collections of Shchukin, Morozov, and Tret'iakov. Holdings in sculpture and furniture are scattered and of varying value.

The Painting Gallery opens with a series of Faiyum portraits from the Golen-ishchev bequest. Among them are two fine examples of early craftsmanship: *Portrait of a Young Man in Blue Toga* (late first or second century) and *Portrait of a Dark-Skinned Woman* (second half, second century). Remaining examples are from the ensuing two centuries and include the fine *Portrait of a Middle-Aged Woman* (third century). Byzantium is represented scantily with a few objects taken from the Tret'iakov and historical museums. Of particular interest are the rare eleventh-century Macedonian dynasty *St. Pantheleimon* and the fourteenth-century *Twelve Apostles* (from the "Paleologue Renaissance").

The Italian school, Early Renaissance through the Baroque, is presented selectively with objects ranging from the anonymous thirteenth-century Pisa school *Madonna and Child* to Segna di Bonaventura's early *Crucifixion* (rare for its signature), Botticelli's *Virgin of the Annunciation* (c. 1490), Perugino's *Virgin and Child* (early sixteenth century), Dossi's *Landscape on the Thebaid with Scenes from the Lives of the Saints*, Bronzino's *The Holy Family* (1555–60, tempera on wood, transferred to canvas in 1857), and Paolo Veronese's preliminary sketch of *Minerva* (the companion *Diana* is in the Hermitage). The collection, drawn largely from the Hermitage, is richer in eighteenth-century works, with Tiepolo's *Death of Dido* (sketch, c. 1757), Canaletto's *The Betrothal of the Doge and the Adriatic* (its companion *Reception of the French Ambassador* is in the Hermitage), Pietro Longhi's *Lobby of a Gambling House*, and Francesco Guardi's copy of Langetti's *Priam Asking Achilles for the Body of Hector* (*Alexander Views the Body of Darius*) and *View of a Venetian Courtyard*.

From the Spanish school the Pushkin offers but a small selection, among the most notable of which are Jusepe Ribera's *St. Anthony the Anchorite* (1647), Bartolomé Murillo's *The Fruit Seller*, and Goya's sketch *A Dead Nun* (tentatively dated 1828). The German school is very poorly represented, revealing the Push-kin's dependence on the Hermitage for its few exponents, for example, Cranach the Elder's *Virgin and Child*. The same is true of the Pushkin's survey of art of the Netherlands, the Flemish and Dutch schools, of which the first is the weakest. Included there are Mabuse's *Portrait of a Man*, Pieter Pieters' *Woman Selling*

Fish, Rubens' two sketches *Mucius Scaevola* and *Study for Triumphal Arch*, Rembrandt's *Ahasuerus, Hamen, and Esther* (1660) and his *Portrait of the Artist's Brother* and *Portrait of the Artist's Sister-in-Law* (both 1654), de Hooch's *Young Man Dressing* (presented to Alexander I by Prince Trubetskoi as a portrait of Peter I, later ascribed to an anonymous sitter), and Jacob van Ruisdael's *View of the Village of Egmont* (whose attribution is still debated, despite discovery of the artist's monogram during a recent restoration).

The museum's uncontested strength lies in its collection of French painting, especially of the late nineteenth and early twentieth centuries. Early French art came to the Pushkin primarily through the Rumiantsev, Iusupov, and Tret'iakov collections. The museum acquired them in the mid-1920s, following nationalization and the statewide reorganization of museums, which did away with the Rumiantsev. In the early French collection hang Poussin's *Joshua's Victory Over the Amorites* (Rome, 1625); Claude Lorraine's *The Rape of Europa* (1655); an example of Chardin's still lifes, *The Attributes of the Arts*; Fragonard's *Savoyard with Kerchief* (a sketch for which is housed in the Albertina [q.v.], Vienna); and the Pushkin's only Delacroix, *After the Shipwreck*. Fourteen pieces by Corot introduce the Pushkin's collection of works by the artists of the Barbizon School (which it shares with the Hermitage).

The Pushkin owes its collection of late-nineteenth- and early-twentieth-century French art to the taste of two noted pre-Revolutionary Moscow collectors, S. I. Shchukin and I. A. Morozov. The majority of its holdings in this area were purchased and commissioned before the construction of their present home. Of the major artists of the period, only Seurat is missing. Representing Édouard Manet is his study *The Café* (1879). There are four works by Degas, including *Dancers at Rehearsal* and *Dancers in Blue* (1900-1905). The museum also offers examples of the mature Renoir, five paintings, of which *Under the Arbor at the Moulin de la Galette* (1876) and *Female Nude* (1876) are undisputed masterpieces. The Pushkin owns eleven of Claude Monet's canvases, tracing his development in exceptional detail. Of particular note are *Breakfast on the Grass* (1866), *The Cliffs of Belle-Isle* (1886), *Water Lilies* (1899), and *The Town of Vetheuil* (1901). Similarly, Cézanne is exceptionally well represented with fourteen canvases in all genres from his entire career. For example, *The Aqueduct* (1887–90), *Study of Bathers* (c. 1890), *The Smoker* (1896–98), *Mont Sainte-Victoire* (1896–98), and *Blue Landscape* (1900–1904) are outstanding. The five van Goghs owned by the Pushkin all were created within a single two-year period (*Portrait of Doctor Rey*, 1889, and *Cottages, Auvers*, 1890, among them). Similarly, Gauguin's five works in the museum belong to his post–1886 oeuvre (e.g., *The King's Wife*, 1896, and *The Parrots*, 1902). There is a single painting by Toulouse-Lautrec, *Yvette Guilbert*, 1894. Pierre Bonnard, whom Morozov commissioned to paint panels for the foyer of his Moscow mansion, can be seen in five canvases, three of which are devoted to the seasons (a fourth companion piece is in the Hermitage). Vuillard, Rouault, Sisley, and Signac also are represented in the collection, although usually with a single canvas.

Matisse and Picasso are strongly represented. By the former, the Pushkin owns *Still Life* (1910), *Spanish Woman with Tambourine* (1909), *Tangier: View from Window* (1912), *Nasturtiums and the Panel "Dance"* (1913), and several still lifes and interiors. Picasso is represented by works from 1900 through 1910, including his Pink and Blue periods and an early Cubist partnership with Braque, for example, *The Embrace*, 1900; *Two Acrobats*, 1901; *Majorcan Woman*, 1905; and *Girl on a Ball*, 1905. The *Girl* was purchased by Morozov from Henri Kahnweiler, who, in turn, had obtained it from Gertrude Stein. The Pushkin's collection of twentieth-century art declines following the Post-Impressionist period. This, in part, reflects limited purchases by the Soviet Union in the 1930s–50s, as well as a general preference now given the Hermitage in Leningrad for contemporary masterworks.

The Department of Prints and Drawings also draws heavily on pre-Revolutionary acquisitions, of both Western European and Japanese works earlier housed in the Rumiantsev Museum. It has particular strength in the German Baroque and in native, post-Revolutionary Soviet poster graphics.

The Department of Numismatics began with the original Moscow University Munz-Kabinett. It has its own exhibition area as well as those shared with the various departments of ancient art.

Besides exhibition catalogues, guides and catalogues to the permanent collection, and numerous albums of reproductions, the Pushkin Museum publishes serialized *Trudy* (*Scientific Works*).

Selected Bibliography

Museum publications: *Pushkin Museum of Fine Arts: 20 Reproductions*, 1939; *Picture Gallery: Sixteen Reproductions*, 1977; Sedova, T. A., *Frantsuzskaia zhivopis' kontsa deviatnadtsatogonachala dvadtsatogo veka, v sobranii Gosudarstvennogo muzeia izobrazitel'nykh iskusstv imeni A.S. Pushkina*, 1970; idem, *The Pushkin Museum of Fine Arts in Moscow: Painting*, 1978; idem, *The Pushkin Museum of Fine Arts: Western European Painting*, 1974.

Other publications: Libman, M. Ia., *Zhivopis', skul'ptura, prikladnoe iskusstvo* (Moscow 1956); Malitskaya, K. M., *Great Paintings from the Pushkin Museum* (New York 1965?); Markova, V. E., *Vystavka novykh postuplenii GMII 1959–1969 gg. Zhivopis', grafika, skul'ptura, prikladnoe iskusstvo, monety, medali* (Moscow 1970); Shuninovoĭ, P., *Kopticheskie tkani* (Leningrad 1967); Vipper, B. R., ed., *Antichnoe iskusstvo; Katalog* (Moscow 1963); idem, *Katalog Kavtinnoĭ Gallerei: Zhivopis', skul'ptura* (Moscow 1957); idem, *Kratkiĭ putevoditel' po muzeiu Iskusstvo drevnego vostoka i antichnosti* (Moscow 1956); idem, *Zapadnoevropeĭskaia zhivopis' i skul'ptura; Al'bom* (Moscow 1966); *Chefs-d'oeuvre de la Peinture française dans les Musées de Leningrad et de Moscou* (Paris 1966).

DIANE M. NEMEC-IGNASHEV

STATE TRET'IAKOV GALLERY A (officially GOSUDARSTVENNAIA TRET'IAKOVSKAIA GALEREIA; alternately THE TRET'IAKOV GALLERY, THE TRET'IAKOV, TRET'IAKOVKA), 10 Lavrushinskiĭ pereulok, Moscow.

The State Tret'iakov Gallery houses the most significant collection of Russian painting from its origins through the present day. Developed from the private collection of a nineteenth-century Moscow merchant, Pavel Mikhaĭlovich Tret'iakov (1832–98), and still housed in the Tret'iakov house in the Zamoskvarech'e region of the capital, the Gallery offers an intensive survey of the Russian artistic tradition.

The Tret'iakov Gallery is a government-funded institution operated under the auspices of the Ministry of Culture of the USSR. Internally, the Gallery is organized into five curatorial departments—Old Russian Art, Russian Art of the Eighteenth and First Half of the Nineteenth Centuries, Russian Art of the Second Half of the Nineteenth and Early Twentieth Centuries, Soviet Painting, and Soviet Sculpture—overseen by a general director. The curatorial departments consist of "collectives" of specialists, each responsible for individual genres within the period, supervised by a senior curator. In addition to operating the curatorial departments, the Gallery maintains an extensive library on Russian art history, a photograph and slide collection, a restoration department, and a museum services section, which trains Gallery guides and organizes traveling exhibits, tours, and lectures within the Gallery and at its subsidiaries.

The Gallery's founder, Pavel Tret'iakov, began collecting Russian painting in the mid–1850s. His first purchases were N. Shil'der's *Temptation* (1856) and V. Khudiakov's *Finnish Contrabandists* (1853). Tret'iakov initially limited his acquisitions to contemporary painting, offering financial support to the Peredvizhniki (Itinerants) in their movement against the Russian Academy. Tret'iakov's collection grew quickly. By the 1860s it was well known in Russian art circles as a compilation of contemporary masterworks, from which three were lent to the London International Exhibition of 1862 (V. Iakobi, *The Lemon Seller*; M. Klodt, *The Dying Musician*; and K. Trutovskiĭ, *A Village Dance*). In the early 1870s Tret'iakov expanded his acquisitions and bought paintings from the preceding century and intensified his efforts in the contemporary field. As a result, the collection, initially accommodated in his private study, filled the remaining rooms of the family house. In 1872 a separate wing (south) was constructed, followed by a second (west) in 1882, a third (northwest) in 1885, and a fourth (north) in 1892. Further additions—separate buildings for heating and custodial facilities, the central marble staircase, and, finally, the building's present facade—were constructed after Tret'iakov's death. A stylization of Russian Baroque architecture designed by V. Vasnetsov, the facade bears the former seal of Moscow, St. George and the Dragon, and the inscription "Moscow City Art Gallery named in honor of Pavel Mikhaĭlovich and Sergeĭ Mikhaĭlovich Tret'iakov. Founded by P. M. Tret'iakov in 1856 and presented by him as a gift to the City of Moscow in 1892, together with the collection of S. M. Tret'iakov, also willed to the City."

The present collection still reflects strongly its founder's tastes and involvement in the Russian intellectual movements of the second half of the nineteenth century. In addition to having an exquisite selection of the work of the Itinerants, (*Per-

edvizhniki) whose art spanned the 1860s through the 1890s, Tret'iakov commissioned a portrait gallery of contemporary cultural figures (e.g., F. Dostoevskiĭ, V. Garshin, N. Leskov, V. Stasov, and L. Tolstoĭ), which is a central attraction for Russian viewers.

The Gallery was first opened to the public on a limited basis after construction of the south wing, which afforded a separate entrance to the building. In 1892, following the death of his brother Sergeĭ, Pavel Tret'iakov incorporated the latter's collection of Western painting into his own and donated the entirety to the Moscow City Duma. The number of visitors to the Gallery increased steadily after renovation of the facilities in the late 1890s and achieved unprecedented numbers after the Revolution of 1917 and the nationalization of private collections. Since 1975 the Gallery has recorded more than eight million visitors annually. As a result of the Tret'iakov's popularity and limited exhibition space, the Gallery has been plagued with problems in its physical plant: the objects accommodated in the permanent exhibit are hung too close together and often too high on the walls; lighting, especially on the first floor, is inadequate, and the air-quality-control system, which must contend with the unusually high humidity of the Moscow River region, as well as severe continental temperatures, has undergone several major renovations but remains inefficient. Since the 1920s the Gallery staff has sought better facilities but without success.

Until 1913, organization of the permanent exhibit followed that designated by Tret'iakov. Under curator-art historian I. Grabar' the collection was reorganized to follow the chronological development of Russian art. Grabar' then published the first comprehensive catalogue of the collection in 1917. His system has been maintained with only minor alterations. In 1925 the Western art of S. Tret'iakov was transferred to the Pushkin Museum (q.v.) and Russian objects from nationalized private collections (e.g., the Tsvetkov) were added to the Tret'iakov. The Gallery since has been supplemented with objects from other private collections (e.g., those of the Ostroukhov and Nosov families) and now exhibits Old Russian icons, graphic art, selected eighteenth- and nineteenth-century sculpture, and representative objects from the Soviet period in all media.

Russia's inheritance of the Byzantine religious tradition and gradual development of independent styles of icon painting are traced in the Tret'iakov's impressive collection of the nation's most treasured icons (excelled only by those housed in the Moscow Kremlin), arranged in order of chronological and geographical provenance. The art of Kievan Russia (eleventh through thirteenth century) features the *Vladimir Virgin*, which was brought to Kiev from Constantinople in the early twelfth century, later transported to Vladimir in 1155 by Prince Andrei Bogoliubskii, and eventually placed in the Dormition Cathedral of the Moscow Kremlin in 1395 by Prince Vasilii Dmitrievich. Other icons from Kiev, Novgorod, Dmitrov, and Moscow illustrate the beginnings of Russian icon painting in its various schools as it followed the burgeoning principalities in the North.

The second portion of the Old Russian section focuses on artifacts from the

fourteenth and early fifteenth centuries, when the tradition reached its apex in Central Russia. Noteworthy are those ascribed to Theophanes the Greek (fl. 1350–1410), whose severe dramatism bespeaks the influence of the Paleologues. In contrast are the sublime pastel icons of Russia's most renowned painter of the period, Andrei Rublev (fl. 1360–1430). The Tret'iakov houses Rublev's, indeed Russia's, best-known icon, *The Trinity*, painted for the Trinity Cathedral of the Trinity-Sergius Lavra in Zagorsk in 1411. (*The Trinity* was the first masterpiece of Russian religious painting to undergo radical restoration in the early twentieth century and, along with other primarily Novgorodian icons shown at the 1913 Moscow Exhibition of Russian Medieval Art, sparked an interest in Old Russian art that still flourishes in the USSR.) The diversity of style among Moscow painters continues into the third section of the Tret'iakov's Old Russian collection, which focuses on the schools of Novgorod, Pskov, and northern Russia. Of special interest is the *Miracle of Saints Laurus and Florus* (Novgorod, first half of the fifteenth century), considered the finest example of this school housed in the Gallery. This section also offers examples of the Moscow school of the sixteenth and seventeenth centuries, of the Stroganov school, and of the religious art of the Far North.

Although less significant than its holdings for earlier and later periods, the Gallery houses a small but exemplary collection of eighteenth- and early-nineteenth-century painting. (The abruptness with which Russia switched from religious to secular portraiture is somewhat obscured by placement of the icons at the end of the permanent exhibition.)

The Petrine period is represented by only a few canvases of I. Nikitin (*Portrait of Count Golovkin*, 1720s) and A. Antropov. The portraits *M. A. Diakova* (1778) and *Ursula Mnishek* (1782) executed by D. Levitskii, a student of Antropov, demonstrate the refinement and versatility of Russian portraiture at its peak. V. Borovikovskiĭ, considered by many the most subtle master of the century, reflects in his canvases the sentimentalist attitudes concurrently dominating intellectual circles. The Tret'iakov owns several of Borovikovskiĭ's finest works: The portraits *M. I. Lopakhina* (1797), *A. B. Kurakin* (c. 1801), and *A. G. and V. G. Gagarin* (1802). It also has major canvases by turn-of-the-century landscapists S. F. Shchedrin (*View of Gatchinskiĭ Palace from Dlinyĭ Island*, 1796), F. Matveev (*A View in Sicily*, 1811), and F. Alekseev (*Palace Embankment Seen from the Petropavlosk Fortress*, 1794, and *Voskresenskie and Nikitskie Gates Seen from Tverskaia Street in Moscow*, 1811).

The new lyricism of European Romanticism as it penetrated Russian art can be measured in the Tret'iakov's fine collection of portraits and drawings by O. Kiprenskiĭ. Kiprenskiĭ's attempts to capture the spiritual world of his subjects emerge in full perspective in the exhibit's central exponent, *Portrait of Aleksandr Pushkin* (1827). Romanticism's exploration of genre painting is well expressed in the Gallery's collection of the work of A. Venetsianov (*Plowing, Spring*, 1820s) and his extra-Academy students, whose orientation tended toward the elements of everyday life (e.g., the interiors of F. Slavianskiĭ and K. Zelentsov;

Square in a Provincial City by E. Krendovskiĭ, 1830–40s; and renderings of craftsmen at work by L. Plakhov).

Completing the Tret'iakov exhibit for the first half of the nineteenth century are selected works by K. Briullov (definitively displayed in the Russian Museum [q.v.] in Leningrad) and the monumental canvas by A. A. Ivanov, *The Appearance of the Messiah to the People* (1823–58). The latter was acquired in 1932 from the Rumiantsev Museum and is housed along with preparatory sketches in a separate, specially constructed hall.

The Tret'iakov's uncontested forte, first developed by its founder, is its vast and fine collection of painting from the second half of the nineteenth century. Although he died a full decade before the Itinerants broke from the Academy, P. Fedotov's satirical paintings mark the threshold of the Realist movement. The Tret'iakov owns several of Fedotov's finest pieces, including *The Major's Courtship* (1848) and *Encore, Encore!* (c. 1850). From Fedotov through the remainder of the Tret'iakov's nineteenth-century exhibit, one is provided a visual overview of Russian intellectual and art history of the post-Reform period. Lesser artists who took up Fedotov's call in the 1850s and early 1860s (e.g., Shil'der, Ia. Sharvin, A. Iushanov, and K. Flavitskiĭ) are represented only by single paintings, but the nuclear members of the Itinerants are exhibited comprehensively, illustrating experimentation in a variety of genres. Of special note are works of V. Perov (among them, *Rural Peasant Stations of the Cross*, 1861; *Tea at Mytishchi, near Moscow*, 1862; *The Troĭka*, 1866; and *Portrait of Fedor Dostoevskiĭ*, 1872), I. Kramskoĭ (*Christ in the Desert*, 1872; *Portrait of Lev Tolstoĭ*, 1873; *Moonlit Night*, 1880; and *The Stranger*, 1883), and N. Ge, who incorporated contemporary political philosophy into his historical canvases (e.g., *Peter I Interrogates Prince Alekseĭ Petrovich at Peterhof*, 1871).

Besides mounting social criticism, the Itinerants experimented considerably in landscape painting, of which the Tret'iakov collection offers superb examples: A. Savrasov's *The Rooks Have Arrived* (1870–71), exhibited at the first Itinerants show in 1871; I. Shishkin's *Noon. In the Vicinity of Moscow* (1869); and V. Polenov's *A Moscow Courtyard* (1878). Concluding the movement and the Tret'iakov collection from the period are exquisite and broad retrospectives of the work of I. Repin (including *Stations of the Cross in the Kursk Region*, 1880–83, and *Ivan the Terrible and His Son, 16 November 1581*, 1885), V. Surikov (*Morning of the Streletskiĭ Execution*, 1881, and *Boiarinia Morozova*, 1887), V. Vasnetsov (*Alienushka*, 1881, and *The Bogatyrs*, 1881–98), I. Levitan (*Evening Bell*, 1892, and *Spring. High Water*, 1897), and V. Serov (*Girl with Peaches*, 1887, and *Portrait of Actress M. N. Ermolova*, 1905). Repin's *Ivan the Terrible*, which has suffered chronic problems including a slashing in 1906, documents several generations of Russian restoration practices.

The end of the nineteenth century brought a new wave of experimentation in the arts that gradually rejected the realist strivings of the Itinerants. Beginning with the Tret'iakov's holdings from the World of Art (*Mir Iskusstva*) school and proceeding through the next two decades, the scope of the collection narrows

(a function of anti-formalist campaigns in the USSR in the 1930s and 1940s). From the World of Art school are selected works by A. Benois, K. Somov, E. Lansere, A. Riabushkin, and N. Rurikh. as well as works by the Symbolist M. Vrubel', Impressionist-influenced K. Korovin, and nonaligned artists such as B. Kustodiev and V. Borisov-Musatov. The Gallery also exhibits a limited number of paintings from the "Jack of Diamonds" (R. Falk, A. Lentulov, and I. Mashkov), of Futurist-Primitivists N. Goncharova and M. Larionov, of V. Kandinskiĭ, and of Constructivists K. Malevich and V. Tatlin. Painters more closely aligned with the realist tradition and whose work led into Socialist Realism of the post–1920s are better represented. Of them the Tret'iakov's holdings are particularly strong for A. and S. Gerasimov, K. Maksimov, F. Reshetnikov, B. Ioganson, P. Konchalovskiĭ, and P. Korin. In the 1950s overtly topical canvases from the Stalinist period were removed from the public exhibit. Evocative of the spirit then dominating the Soviet art world and still on display are M. Nesterov's *Portrait of Sculptor V. Mukhina* and S. Gerasimov's *Mother of a Partisan*.

Primarily a painting gallery, the Tret'iakov also offers only limited examples of Russian sculpture. But the sculpture exhibited mirrors, proportionately, the relative status of the medium in Russian art history. From the late eighteenth and early nineteenth centuries, during which sculpture most rapidly developed, the gallery selected examples of the work of F. Shubin, M. Kozlovskiĭ, F. Shchedrin, B. Orlovskiĭ, and N. Pimenov. By the late 1840s monumental sculpture succumbed almost completely to painting's dominance, and the Tret'iakov displays only a few objects from the period. Notable among them are S. Ivanov's *Boy Bathing* (1858), L. Pozen's *The Beggar* (1886–87), A. Ober and E. Lansere's animal sculptures (especially *The Bogatyr*, 1885), and M. Antokol'skii's historical subjects (e.g., a marble duplicate of his *Ivan the Terrible*, 1871, and *Peter I*, 1872). Since the Revolution, sculpture has reemerged as a viable medium for Socialist Realist artists and is so represented in the Soviet section. Among the displays are V. Mukhina's familiar bronze *Worker and Farmer* (1936, reproduced in mammoth proportions near Moscow's Agricultural Exhibit) and a series of bronzes by I. Shadr.

The Tret'iakov's Print and Drawing Collection was developed in the 1920s and 1930s from P. Tret'iakov's bequest, supplemented by works from the Tsvetkov and Ostroukhov musuems. Today it offers an invaluable, albeit uneven, survey of graphic art since its introduction to Russia in the late seventeenth century through the present. The strongest components of the collection are sketches and drawings by painters from the second half of the nineteenth century, preparatory sketches by A. Ivanov for his *Appearance of the Messiah to the People*, and portfolios by O. Kiprenskiĭ and K. Briullov.

The Tret'iakov also functions as a central research institution for the history of Russian and Soviet art. The library contains all post-Revolutionary publications on the subject, rare treatises by nineteenth-century critics, the archive of P. Tret'iakov (including his correspondence with the Itinerants), sketchbooks, and albums.

The Tret'iakov annually issues or reissues albums of photo-reproductions of the various parts of its collection, almost all with English or French translations in addition to the Russian.

Selected Bibliography

Antonova, K., and I. Rostovtseva, *Masterpieces of the Tretyakov Gallery* (Leningrad 1972); Chesnokova, V., *Gosudarstvennaia Tret'iakovskaia Galereia* (Moscow 1964); *Gosudarstvennaia Tret'aikovskaia Galereia: Katalog sovetskoĭ skul'ptury, 1917–1952* (Moscow 1953); *Gosudarstvennaia Tret'iakovskaia Galereia: Katalog sovetskoĭ zhivopisi (1917–1952)* (Moscow 1953); *Katalog khudozhestvennykh proizvedeniĭ gorodskoĭ galerei Pavla i Sergeia Tret'iakovykh*, 6th ed. (Moscow 1912); Kovalenskaia, T., *Albom "Gosudarstvennaia Tret'iakovskaia Galereia." Iskusstvo vtoroĭ poloviny XIX i nachala XX vv.* (Moscow 1970); Lebedev, P., *Putevoditel'—Iskusstvo vtoroĭ poloviny XIX veka* (Moscow 1959); idem, *Putevoditel'—spravochnik. Sovetskoe iskusstvo v Gosudarstvennoĭ Tret'iakovskoĭ Galeri, 1917–1957* (Moscow 1959); idem, *Sto let Tret'iakovskoĭ Galeree. Sbornik stat'eĭ* (Moscow 1959); idem, *Russkaia sovetskaia zhivopis'. Kratkaia istoriia* (Moscow 1963); Sarabyanov, D., *Russian Painting of the Early Twentieth Century (New Trends)* (Leningrad 1973); Zharkova, I., and Ev. Plotnikova, *Albom "Gosudarstvennaia Tret'iakovskaia Galereia": Iskusstvo XVIII. Iskusstvo pervoĭ poloviny XIX veka* (Moscow 1969); Kovalenskaia, T., "The Tretyakov State Art Gallery, Moscow," *Museum* (UNESCO), vol. 16, no. 1, pp. 33–34.

DIANE M. NEMEC-IGNASHEV

The Vatican

———— Vatican City ————

VATICAN MUSEUMS (officially MUSEI VATICANI; alternately THE VAT-ICAN), Viale Vaticano, Vatican City.

The Vatican Museums comprise a complex of galleries and archaeological and ethnological collections. This complex is administered by a director with the assistance of a secretary-business manager and curators of Oriental antiquities, Etruscan-Italic antiquities, Classical antiquities, Paleo-Christian art, medieval and modern art, the Missionary-Ethnological Museum, and the collection of modern religious art. The Apostolic Library has a separate staff with a prefect and curators of prints and medals. The entire complex of permanent installations devoted mainly to religious art is funded through the pontifical government.

The nucleus of the collection was formed by Pope Julius II in 1503, when he installed several ancient sculptures in the courtyard of the Belvedere Palace. These works were the *Apollo Belvedere*, the *Venus Felix*, and statues representing *Ariadne*, the *Nile*, and the *Tiber*; the *Laocoon* was added in 1506. These highly significant pieces of Graeco-Roman art are still part of the collection. From the time of Julius II on, works of art were added to papal collections either through commissions, acquisitions, or gifts to the pope and the Roman Catholic Church.

The history of the collection is long and involved and is affected not only by religious but by political events. For example, in 1515, soon after the collection was begun, Francis I of France, conquerer of the Papal States, requested that Pope Leo X send him the *Laocoon* group, which was subsequently returned. In 1530 the *Belvedere Torso* was acquired from the Palazzo Colonna by Clement VII. Care of the collection involved restoration in 1532 by G. A. Montorsoli of the *Laocoon* and the *Apollo Belvedere*. In the seventeenth century, a plan was formed for the collecting of pagan and Christian inscriptions to be housed in the

gallery between the Apostolic Palace and the Vatican Library. Further expansion took place in 1756, when the Christian Museum of the Apostolic Library was founded by Benedict XIV; in 1761 the Profane Museum was initiated. Works of art formerly in the Fusconi and Mattei collections were added in 1770, and between 1771 and 1773 the Clementine Museum was founded. At this time also the North Loggia of the Belvedere Palace became the Gallery of Statues. The Courtyard of the Statue of the Belvedere was enlarged with the Octagonal Courtyard, an eight-sided portico designed by Alessandro Dori and Michelangelo Simonetti. The collection was administered by Giambattista Visconti, commissioner for antiquities, and Gaspare Sibila, restorer.

In 1776–84 the Clementine Museum was expanded to the Pio-Clementine Museum by Pope Pius VI, and the Courtyard of the Statues became part of the Apostolic Library. With the expansion of the museum, administration also increased, and two assistants to the commissioner were added, as well as two additional restorers. In 1786–88 the Gallery of the Candelabra was initiated under the direction of architects Michelangelo Simonetti and Giuseppe Camporese. The Atrium of the Four Gates was completed in 1797 as a museum entrance, although in 1797 the works of art were removed by Napoleon to Paris, a result of the Treaty of Tolentino.

In 1801 Pius VII acquired Antonio Canova's *Perseus*, and in 1805 that artist was appointed inspector general of antiquities. Between 1807 and 1810 the Chiaramonti Museum was arranged by Canova and the Inscription Gallery by Gaetano Marini. In 1816, with the downfall of Napoleon, works were returned from Paris, and acquisition activities continued with the addition in 1818 of the Roman fresco the *Aldobrandini Wedding*. In 1820 the Pacca Edict for the control of excavations was passed, and in 1822 Pius VII opened the Braccio Nuovo designed by Raffaele Sterni and Pasquale Belli, creating additional space for the collection of mostly antique sculpture.

During the period from 1827 to 1836, acquisition activities included the addition of antiquities (Etruscan and other) from the excavations at Etruria and Latium; Greek ceramics were also added. At Vulci excavations of Etruscan material were sponsored financially by the pontifical government in association with Secondiano Campaniano. The important bronze sculpture, the so-called *Mars of Todi*, was added to the collection in 1835, and in 1836–37 an excavation of the Regolini-Galassi Tomb in Caere yielded rare Etruscan funerary material. Expansion of the museum complex in the 1830s saw the opening of the Etruscan Museum in 1837, and in 1839 both the Egyptian and the Profane Museum of the Lateran Palace (devoted to Christian art) were opened. The Roman landscape frescoes with scenes from Homer's *Odyssey* were added in 1851, when they were presented to Pius IX by the city of Rome. The Early Christian Museum (today the Pio-Christian Museum) was founded by Pius IX in 1854, and between 1855 and 1870 excavations at Ostia began under the direction of Pope Pius IX.

With the turn of the century, acquisition activities of the museums increased. In 1900 the Falconi Collection was added by Leo XII, and in 1907 the works

formerly in the Sancta Sanctorium were accessioned to the Christian Museum. The 1925 Missionary Exhibition marked the founding of the Missionary-Ethnological Museum in the Lateran Palace, a major collection of primitive art. Building modifications were continually introduced, and the entrance to the museums was moved in 1932 to the Avenue of the Vatican (Viale Vaticano), designed by Giuseppe Momo with sculptural decoration by Antonio Mariani.

In 1933 the Pinacoteca, a comprehensive collection of Renaissance and Baroque paintings mostly from the Italian school, was opened by Pius XI, in a building designed by Luca Beltrami of Milan. Additional acquisitions were through the donation of the Guglielmi Collection in 1935 and the Carlo Grassi Collection in 1951. During the 1950s, the Gregorian Etruscan Museum expanded, and in 1960 the Rooms of the Greek Originals were opened.

In 1963 the three collections housed in the Lateran Palace (Gregory Profane, Pio-Christian, and Missionary-Ethnological) were brought to the Vatican to be housed in a building under construction by the architects, the Passerelli brothers. In 1967 the Asturita Collection of Greek, Italian, and Etruscan ceramics was presented to Pope Paul VI.

In 1970 the new wing of the museum complex opened to house the Gregory Profane and Pio-Christian museums, a modern structure making full use of functional exhibition space. Sections of the new wing housing the Missionary-Ethnological Museum were opened in 1973 in the lower levels, and the Historical Museum and Collection of Modern Religious Art were also arranged.

An active history of collection and expansion has created a comprehensive collection of art from all periods noted especially for the high quality of the collections of antique and Early Christian sculpture.

The Gregorian Egyptian Museum was founded in 1839 by Gregory XVI and was first installed by an early Italian expert in Egyptology, Father L. M. Ungarelli. Many of the rooms preserve their nineteenth-century arrangements, originally designed by G. DeFabria in the "Egyptian Style." A tomb from the ancient Egyptian burial site, the Valley of the Kings, is reconstructed and arranged with sarcophagi (some inscribed), funerary vases, and implements. At the entrance of the tomb is placed a *serdab*, a sort of watch-tower for the deceased pharoah. Funerary and commemorative stelae and two seated statues of the Egyptian goddess Sekhmet are displayed. Also in the tomb are wooden coffins painted with scenes of funerary rituals and excerpts from the *Book of the Dead*. A statue of a woman called *La Bella* dates from the Ptolemaic Period and a colossal sculpture of Queen Tuia, mother of Ramesses II (eighteenth dynasty), is represented. Also in the collection are various scarabs, papyri of different periods, and objects from the Christian Coptic period in Egypt. A statue of a priest holding a small temple is important for its inscriptions describing the priest's life during the reign of Cambyses, the Persian conquerer of Egypt (525 B.C.).

The Gregorian Etruscan Museum comprises a large representative collection of Italic and Roman antiquities. The museum was founded in 1937 by Gregory XVI, and most of the objects are from the excavations administered by the

pontifical government in the necropolises of southern Etruria (a former territory of the Papal States). The objects were then acquired by the Camerlengate on the suggestion of the General Consultory Commission for Antiquities and Fine Arts. With the termination of the Papal States and its territorial rights, the museum received thereafter only a few additions to its collection, although they were of high quality. The Falconi Collection was purchased in 1900, a gift from Benedetto Gugliemi was received in 1935, and ancient ceramics from Mario Astarita were added in 1967. A large collection of Greek and Italic vases and Roman antiquities housed separately are also part of the collection.

The entrance is flanked by sculpted lions in *nenfro*, a type of tufa stone used by Etruscans, from the tomb of the Vulci (sixth century B.C.). Various sarcophagi are exhibited in the first room of the museum, including two in *nenfro*, one with the *Massacre of Niobids* and the *Battle of the Centaurs* and the other with a *Portrait of a Man*, perhaps a poet since he holds in his hand *volumen* (Tarquinia, second century B.C.). A sarcophagus from Caere in limestone is decorated with polychrome reliefs of a funeral procession (Etruscan-Attic, late fifth to fourth century B.C.). An inscribed sarcophagus in *nenfro*, called the *Sarcophagus of the Magistrate*, represents the deceased on a biga symbolically making his final voyage (third century B.C.). In addition, two horses' heads in *nenfro* from the tomb at Vulci (fourth to third century B.C.) and a statuette of a woman in sandstone are exhibited. The woman, represented with bared breast, might be Lasa, a female demon from the Etruscan underworld (third to second century B.C.).

The Room of the Regolini-Galassi Tomb contains a group of important objects discovered at the Necropolis of Sorb, south of Cervetari. Excavated in 1836, the central tomb (called Regolini-Galassi after its founders) yielded funerary objects from the burial place of three individuals: a princess, a male personage, and a warrior. The tomb dates from the mid-seventh century B.C. and is indicative of the Orientalizing phase in Etrurian style. Among the objects is a magnificent gold fibula with representations of ducklings on the bow and embossed lions on the disc. The costume of the princess shows traces of gold foil, probably sewed on the fabric for decoration. Protocorinthian objects imported from Greece include an Egyptian-style cup in gilded silver and examples of local imitations of Protocorinthian forms. A small vase inlaid with silver is engraved with an alphabet in the graffito method. Other objects belonging to the princess include a biga, a throne, and a ceremonial cart intended for processions. The Room of the Regolini-Galassi Tomb is decorated with frescos by Federico Barocci and Taddeo Zuccari dating from 1503, the *Life of Moses*.

Numerous bronzes include an interesting tripod manufactured at Vulci from the late sixth century B.C.; a statuette of a *haruspex*, an Etruscan priest (identified by his tall headdress made of animal skin or felt and tied below the chin); and embossed studs with animal heads and mythological figures from a tomb in Tarquinia (late sixth century B.C.). Inscribed bronze sculptures of seated boys were probably more costly versions of traditional terracotta votive figures (from

Trasemene and Tarquinia, second to first century B.C.). An oval *cista*, or container for objects of feminine toilette, is embossed with a scene of Amazons, indicating the influence of Hellenistic Greek models.

The *Mars of Todi* is an important rare work of Italic art representing a young god leaning on a lance, offering a libation before battle. The piece, cast in separate parts, combines various fifth-century B.C. Greek influences and dates from the first half of the fourth century B.C.

A collection of cinerary urns made of limestone and alabaster are from Volterra, Chiusi, Perugia, and other sites. Particularly noteworthy is a vase from Volterra in veined alabaster with a cover representing a couple reclining at a banquet. The body of the vase depicts Oinomaos, king of Pisa in Olis, at the end of a chariot race, dying as a result of imposing a test on his daughter's suitors (second century B.C.). The collection of B. Gugliemi, housed in a separate room, consists of Greek painted ceramics, Etruscan objects, bronzes, gold objects, and *bucchero*, the Etruscan ceramic with a black, shiny finish produced from the seventh to fifth century B.C. The Jewelry Room houses a collection of ornaments, including earrings and rings in gold and gilded silver from Vulci (sixth century B.C.), amber objects from the end of the fifth century B.C., and a series of rings with settings in the form of a scarab in the Egyptian style of the sixth century B.C.

The Room of Terracottas includes urns from Villanova, a necropolis excavated in the mid-nineteenth century, near Bologna. These urns are generally single-handled, biconical shapes, engraved with geometrical designs (ninth to eighth century B.C.). A bust of a winged horse is an example of Etruscan sculpture-in-the-round of Attic influence (early fifth century B.C.). A series of votive offerings from the temples in the city of Caere are exhibited. A funerary monument with the dying Adonis is from Tuscania, and four stone slabs with floral decoration and human heads from Caere were originally attached to beams of the temple building.

The Antiquarium Romanum is a collection of minor works of art, including vases and objects of transparent polychrome glass. Decorative terracotta architectural elements from the first century B.C. are also exhibited. The reliefs *Labors of Hercules* are from Rome (second century A.D.), and an ivory doll, originally wearing a dress woven with gold, dates from the second-fourth century A.D., excavated in Rome near the Church of San Sebastiano.

The Room of the Greek Originals include a votive relief of Aesculapius seated on a throne with his daughter Hygieia and the dedicant, dating from about 410 B.C. A fragment of a horse's head from the western fronton of the Parthenon is an example of Phidian art of about 440–432 B.C. Other sculptures include a funerary stele depicting a young man with a boy servant of about 450 B.C., an exquisite example from the Early Classical period.

Many of the Greek vases in the vase collection were excavated in the Etruscan necropolis of Etruria, hence their inclusion in the Gregorian Etruscan Museum. In the Astarita Room, a collection of pottery donated in 1967 is housed, including

a large Corinthian crater depicting scenes of the adventures of Ulysses, an example of the epic representation (560 B.C.). In the Hemicycle are exhibited an Attic black-figure wine jug, painted by Anasis, an important work by the active vase painter dating from about 525 B.C.; an Attic black-figure amphora, signed by the painter Exekias, a highly important example of Attic painting representing Achilles and Ajax playing *macca* (c. 530 B.C.); and an Attic red-figure cup by the painter Brygos depicting Hermes after the theft of Apollo's herd (c. 480 B.C.).

The Room of the Biga houses a Roman chariot of the first century A.D. decorated with bas-reliefs. The object formerly stood in the Church of San Marco and served as a papal throne. The statue *Dionysis "Sardanapolis"*, inscribed along the cloak, is a Roman copy (first century A.D.) after an important Greek original from the circle of Praxiteles (fourth century B.C.). The *Discobulus Preparing to Hurl the Discus* is a Roman copy (first century A.D.) of a sculpture from the school of Polyclitus. The *Discobulus in the Act of Hurling the Discus* dates from the Hadrian period (second century A.D.—suggested by the support in the form of a tree trunk) and is after the famous bronze sculpture by Myron of about 460 B.C. This work was discovered in Hadrian's Villa near Tivoli.

The Gallery of the Candelabra, originally an open loggia, was enclosed in the eighteenth century by Simonetti. Ancient sculptures including several major examples are exhibited in the hall. Among the works is a figure of a Nike from the Roman Imperial period after a Greek model of the second century B.C., an old fisherman, and a figure of Atalanta. Several sarcophagi, including a Roman sarcophagus of a boy from A.D. 270–80 and a sarcophagus with bas-reliefs of scenes from the myth of Orestes (A.D. c. 160), are exhibited. The room takes its name from the several pairs of candelabra displayed that date from the second century A.D. Roman frescoes from Tor Manacia date from the second century A.D. as well.

The Stairway of the Assyrian Reliefs is hung with several reliefs and cuneiform inscriptions in the Assyrian and Sumerian languages (ninth to seventh century B.C.) and Arabic inscriptions (eleventh to twelfth century A.D.). The top sections of the stairway are frescoed with two large angels presenting the coat-of-arms to Julius II (from the sixteenth century).

The Pio-Clementine Museum is devoted mostly to ancient Greek and Roman sculptures; the works are displayed in a series of rooms entered through the Atrium of the Four Gates. The twelve rooms are reached by ascending the Simonetti Staircase into the Room of the Greek Cross. Exhibited there are two sphinxes in reddish grey granite from the Late Roman period (first-third century A.D.). A statue of Augustus (reigned 31 B.C. to 14 B.C.) was discovered at Otricoli. The important Early Christian sarcophagus of Costanzia, daughter of Emperor Constantine, is made of porphyry and dates from A.D. 350–60. The sides of the sarcophagus (which was formerly in the Church of Santa Costanza in Rome) are decorated in bas-relief with putti harvesting grapes, a Christian theme derived from traditional Dionysiac iconography. The sarcophagus of St.

Helen, mother of Emperor Constantine, is also of porphyry and dates from the beginning of the fourth century A.D.

The Round Room surmounted by a cupola was designed by Michelangelo Simonetti and based on the model of the Parthenon. Ancient mosaics from Otricoli form the pavement and depict figures of Greeks and centaurs. A porphyry basin from the Domus Aurea on the Esquiline Hill is exhibited, and the colossal portrait *Plotina* (d. A.D. 122), wife of Trajan, may have been executed for the occasion of her deification in A.D. 129. The statue *Juno Sospita*, representing the Italic god from Lanuvium, dates from the second century A.D. A statue of the emperor, *Claudius as Jupiter*, is from Lanuvium and dates from A.D. 50. The *Hera Barberini* is a major Roman statue of the goddess based on a Greek original from the late fifth century B.C., probably by Agorakritos, student of Phidias. The colossal bust *Antinous* was formerly in Hadrian's Villa and represents a young man greatly favored by Hadrian and who was deified after his death in A.D. 130.

The Chiaramonti Museum houses ancient works of art and is located in the Cortile della Pigna. The collection, with the exception of minor changes, exists today as it was originally arranged by Antonio Canova. The sarcophagus of C. Junius Guhodus and Metilia Acte is from Ostia and by its inscription can be placed in A.D. 161–70. Also exhibited are a bas-relief with a scene from the myth of Alcentis, a woman who gave her life for her husband, and a Roman version of the statue *Hephaestus* by Alcamenes, executed in 430 B.C. Several bas-relief fragments from the Esquiline Hill represent the Aglaurid sisters, dispensers of the nocturnal dew, as well as Horae figures. Bas-reliefs and an inscription identifying a funeral monument from the first century A.D. to be that of a miller and flour merchant are included in the collection. A funerary statue of Cornutus as Saturn is from the end of the third century A.D. Also from the Roman Imperial period is the group *Ganymede and the Eagle*. Two portraits of Emperor Tiberius are in the collection: one represents the emperor seated as Jupiter, and the other is a colossal bust. A colossal portrait head of Augustus is from the Veii. Several fragments of bas-reliefs representing Penelope, the wife of Ulysses (c. 450 B.C.), are probably from a Boetian funerary monument; another bas-relief represents the three Graces, a Roman copy of a fifth-century B.C. original. A fragment of the shield of Athena Parthenos is from a Neo-Attic marble copy of a work of Phidias (fifth century B.C.). A statue of Hercules with his cloth and lion skin is probably a copy after a work of the school of Lysippis (fourth century B.C.), and a statue of Ulysses is a Roman work of the first century A.D. that was originally part of a group depicting the adventures of the Cyclops.

The Braccio Nuovo is a wing dedicated to works of ancient art located between the Cortile della Biblioteca and the Cortile della Pigna. The wing was conceived in 1806 by Pius VI, and work commenced in 1817, after works of art confiscated by Napoleon were returned from Paris. The architectural design was carried out

by the Roman architect Raffaele Sterni and after his death completed by Pasquale Belli in 1822. The bas-reliefs above the niches are by Max Labourer, and the pavement, made of ancient mosaics from the second century A.D. and including scenes from the adventures of Ulysses, was found at Tor Marancia in the Via Ardeatina.

Among the works exhibited is the statue *Silenus with the Infant Dionysus*, a Roman copy of a Greek fourth-century B.C. original. The statue of Augustus of Prima Porta is a major work of Roman Imperial sculpture, found in 1863 in Livia's Villa on the Via Flaminia near Prima Porta. Augustus is represented in the gesture of *adlocutio* talking with his soldiers. A statue of Titus represents the emperor in civilian dress, the toga. Two peacocks of gilded bronze are probably from Hadrian's Mausoleum (Castel Sant'Angelo) and were in the Constantinian Basilica of St. Peter's during the Middle Ages. A statue of Demosthenes (d. 322 B.C.) is a Roman copy of a Greek bronze, probably a portrait of the Attic orator by Polyclitus. The *Wounded Amazon* is a copy of a work by Kresilas, a bronze of the fifth century B.C. The colossal statue representing the Nile is identified as the dispenser of benedictions by the surrounding sphinxes and crocodiles. The Roman work dating from the first century A.D. (perhaps derived from a Hellenistic original) was most likely excavated in A.D. 1513 near the Church of St. Maria-sopra-Minerva, a site of ancient temples. A statue of Giustiniani Athena is identified by the helmet, shield, and serpent and is a Roman elaboration of a Greek bronze original. The sculpture of Dorphyorus is a Roman copy of a major bronze work by Polyclitus from the fifth century B.C.

The Gregorian Profane Museum holds a rich collection of Greek and Roman antiquities formerly housed in the Lateran Palace. Most of the material was excavated from sites within the Papal States, including Ostia, and at the Baths of Caracalla. The works, exhibited in a dramatic exhibition space, are arranged in roughly chronological order.

Among the copies after Greek originals are a group of heads and torsos of adolescent boys. A statue of Marsyas from the Esquiline Hill is a copy after a bronze group of Athena and Marsyas by Myron. Another representation of Marsyas is a torso from Castelgandolfo. A basalt head known as *Idolino* is a copy after a Greek original executed in the style of Praxiteles (c. 440 B.C.). A group of portrait heads of famous Greeks includes one of Sophocles. This sculpture, found at Terracina, is believed to be a copy of an original work in the theater of Dionysis, documented in fourth-century B.C. literature. A portrait of the Greek lyric poet Anacreon is a marble copy of a portrait by Phidias from the fifth century B.C. A Hellenistic relief (first century B.C.) represents a woman and a comic poet, and a gallery of *hermae* (statues in the form of pillars) includes a bearded god, an Apollo figure, and Hercules. Also exhibited are Dionysiac figures, among them, a copy of the *Resting Satyr*, a copy of a sculpture attributed to Praxiteles and one frequently copied. A colossal statue of Poseidon is after a fourth-century B.C. bronze. A Neo-Attic relief representing Medea and the

daughters of Pelias is probably related to the dramatic trilogies performed in Athens during the Festival of Dionysis; such reliefs were used as votive offerings during the competitions (after a Greek model of the fifth century B.C.).

Various representations of robed male torsos, along with female statuettes, are exhibited. A statue of Artemis executed in the Severe style is displayed, and a torso of a sculpture of Athena of the Raspigliosi type is after a fifth-century B.C. work. The *Daughter of Niobe ("Chiaramonti")* may be part of a group representing the dying children of Niobe by either Skopas or Praxiteles now in the temple of Apollo Sosianus in Rome. A collection of Roman portrait heads of the first century and early second century A.D. are exhibited. A reconstruction of a round tomb from the outskirts of Vicovaro dates from the period of Tiberius or Claudius (20–40 A.D.). Sculptures dating from the first century A.D. found in the Roman theater at Caere are arranged in the Vicovaro tomb.

A floor mosaic of the "unswept-floor" style known as Asaroton is constructed from fragments found in a building on the Aventine. The representations of leftovers from a banquet are typical of the style; six tragic masks and other objects are placed in the borders. A group of reliefs with personifications of three Etruscan cities, Vetulonia, Vulci, and Tarquinia, are exhibited. A colossal statue of Claudius represents the emperor as the Capitoline Jove. Also exhibited are a colossal head of Augustus and a colossal seated statue of Tiberius from Caere. A metal trellis serves to exhibit various inscriptions from the theater at Caere honoring August, Germanicus Caesar, and other members of the Claudian family. Also from Caere are two statues with breastplates and a draped female figure with a portrait of Agrippina the Younger, wife of Claudius. A relief from the Altar of Vicomagistri depicts a sacrificial procession (from the Campus Martius). A portrait of Livia and a colossal head of Augustus from Veii (executed after the emperor's death) are also in the collection.

A group of funerary urns and altars from the first century are exhibited, many from the *columbarius* of the Volusii on the Via Appia. Of note is a cinerary vase in the form of a richly decorated altar with an inscription, a Medusa-head medallion in the center, and a decorative festoon. Among the several friezes exhibited are *Frieze B*, which represents the arrival of Emperor Vespasian and the welcoming by his son Domitian (c. 70). *Frieze A*, a work inspired by *Frieze B*, represents Domitian (now emperor) wearing a *paludamentum*, or traveling cloak. Fragments from the Sepulchre of the Haterij, excavated in 1848 in the Via Labicana, are gathered in the museum. In 1970 additional sculpture and epigraphic fragments were discovered at the site.

A relief depicting five buildings of ancient Rome includes the arched entrance to the temple of Isis and Serapis in the Campus Maximus, the Colosseum, a triumphal arch (probably the east entrance to the Circus Maximus), the Arch of Titus on the Sacred Way, and the Temple of the Thundering Jove. Another relief depicts a mausoleum and, next to this, building machinery including a man-powered crane. From the Sepulchre of the Haterij is a rose column, an example of decorative architectural elements. A group of sarcophagi of the Roman Im-

perial period features various decorative schemes, including bacchic scenes, allegorical representations of the seasons, and scenes from mythology.

Sculpture from the second and third centuries A.D. in the Profane Museum includes a portrait bust of the young Caracalla (211–17). A statue of Dogmatius, consul of Constantine (332–37), represents the figure in civilian dress and is inscribed with the various offices held and honors received. Reliefs from the Fountain of Amalthea depict a nymph offering a drink to a satyr with Pan playing his syrinx, from the second century. A group of religious sculptures pertaining to chthonic and mystery cults includes an *Omphalos Wrapped in Bands*. Two mosaics from the *exedrae* of the Baths of Caracalla with representations of athletes and referees are from the third century. Two decorative hermae depicting a faun carrying a young Dionysis may have decorated a courtyard or garden.

The Pio-Christian Museum contains Early Christian antiquities formerly housed in the Lateran Palace. The museum, founded by Pius IV in 1854, is now located in the new wing of the Vatican complex, inaugurated in 1974. The collection comprises two sections: sculpture, mosaics, and architectural fragments and inscriptions.

Various sarcophagi are exhibited, including fragments of a sarcophagus representing the Nativity and Epiphany, a popular subject in Early Christian art. Another sarcophagus represents the Crossing of the Red Sea (late fourth century). A plaster cast of the famous sarcophagus of Junius Bassus (housed in the Vatican Grottoes) is placed for comparison with contemporary examples. The Dogmatic sarcophagus features a pitched lid and was excavated in the Church of St. Paul's Outside-the-Walls in 1838. Scenes of the creation of man and woman and various stories from the New Testament are represented in bas-reliefs on the mid-fourth century work.

A double-tiered sarcophagus front includes portrait busts of the deceased couple and biblical scenes, dating from the early fourth century. A sarcophagus in the form of a bath represents a bearded shepherd carrying a ram on his shoulders, with figures of a philosopher, two listeners, a woman praying, and others arranged in icocephalic order (all heads on the same plane). A Good Shepherd sarcophagus is from St. Lawrence Outside-the-Walls; the central figure of the good shepherd is flanked with apostles and twelve sheep representing the Christian flock. The highly important statue *Good Shepherd*, a rare example of Early Christian sculpture-in-the-round, was formerly in the Mariotti Collection. The young, beardless figure of the shepherd is derived in style from classical representations of shepherd boys.

The Pio-Christian Museum also houses an outstanding collection of inscriptions. Included among them is the memorial stone of Abercius, bishop of Hieropolis in Phrygia.

The Inscription Gallery originated under Clement XI and was formed under Pius VII by Gaetano Marini. More than five thousand antique and Christian inscriptions were gathered during the Renaissance and post-Renaissance periods.

A series of rooms that constitute separate museums are of interest for the

variety of objects they house, as well as for their decoration. The Gallery of Tapestries contains ten tapestries woven at Brussels in the workshop of Pieter van Aelst. The tapestries that represent scenes from the life of Christ are after cartoons by the followers of Raphael. They are referred to as "New School" to differentiate them from the "Old School" tapestries woven at the same shop from cartoons by Raphael that are hung in the Pinacoteca. The Gallery of Maps, constructed and decorated between 1578 and 1580, is closed at the north end by the Tower of the Winds. This tower was used by Gregory XIII for his astrological observations, observations that resulted in today's Gregorian calendar. Maps designed by Ignozo Danti of Perugia, a mathematician, cosmographer, and architect, date from 1580–83. Forty panels represent regions of Italy, specific cities (such as Genoa and Venice), the territory of Avignon, and the islands of Corfu and Malta, and large general maps of ancient and modern Italy have pictorial representations of battle grounds and topography. The stuccoed vault is painted with eighty scenes from the history of the Church, executed by Cesare Nebbia and others under the direction of Girolamo Muziano.

The Rooms, Gallery and Chapel of St. Pius V contain various works of art, including a Roman sculpture of the second century, the *Sleeping Fisherboy*, probably after a Greek model of a cupid. Tapestries representing the Liberal Arts, made in Bruges after cartoons by C. Schut (seventeenth century), are exhibited. Also displayed are tapestries made by the Barbarini factory in 1634–35 after cartoons by Pietro da Cortona, as well as several tapestries of the fifteenth and early sixteenth centuries. The Chapel of St. Pius is decorated with frescoes by Giorgio Vasari and Federico Zuccari. The Room of the Sobieski houses a large canvas by the Polish artist J. Matejko (1838–93) representing the victory of John III Sobieski, king of the Turks, outside the walls of Vienna in 1683. The Room of the Immaculate Virgin is frescoed with works by Francesco Podesti (1800–1895) with scenes related to the Dogma of the Immaculate Conception of the Virgin, initiated by Pius XI in 1854. In the center of the room is the original wooden model of the Dome of St. Peter's dating from 1561. The Chapel of Urban XIII was decorated by Pietro da Cortona (1596–1669) in gilt stucco and frescoes.

Raphael's Stanze are rooms decorated by the master and his assistants, commissioned by Pope Julius II in 1508. The Stanza della Segnatura (Room of the Signature) was planned as a study for Julius II and was the first room painted by Raphael in 1508–11. The works exhibited, among the greatest by Raphael, include the following: *The Dispute over the Holy Sacrament*, the *Cardinal Virtues*, the *School of Athens*, and *Mount Parnassus*. On the ceiling above the *Dispute* is *Theology*; toward the left, *Justice*; opposite, *Philosophy*; and above the *Parnassus*, *Poetry*, showing an allegorical figure. The Room of the Heliodorus, a secret anteroom, was decorated between 1512 and 1514 in a political theme. The works *Leo Stopping the Invasion of Attila*, the *Miracle of Bolsena*, the *Expulsion of Heliodorus*, and the *Freeing of St. Peter* are shown. In the vault are frescoes of episodes from the Bible executed after drawings by Raphael.

The Hall of Constantine, a room intended for receptions, was completed in 1525. The decoration, commissioned by Leo X and Clement VII (the Medici popes) after Raphael's death, was executed by Giulio Romano and Francesco Perini. The scenes, emphasizing the triumph of the Church over paganism and the establishment of the Church in Rome, include the *Apparition of the Holy Cross to Constantine*, the *Battle of the Milvian Bridge*, the *Mythical Baptism of Constantine*, and the *Legend of Constantine's Donation of Rome*.

The Loggia of Raphael is decorated with frescoes after designs by Raphael executed by Giulio Romano, Francesco Penni, and Perin del Baga. The Loggia was constructed under the orders of Julius II around 1512, first by Bramante and then, after his death, by Raphael. Stucco decoration and grotesque figures on the walls and pilasters inspired by antique models are by Giovanni da Udine. In the vaults are painted scenes from the Old and New Testaments, a series referred to as the *Bible of Raphael*.

The Room of the Chiaroscuri, an anteroom to the apartment of Julius II, is decorated with figures of apostles and saints by pupils of Raphael, after cartoons by the master. The room was restored in 1582 under Gregory XIII and repainted by Taddeo and Federico Zuccari and Giovanni and Cherubino Alberti.

The Chapel of Nicholas V is located in the tower of Innocent III, one of the oldest parts of the Apostolic Palace. Giovanni da Fiesole (Fra Angelico) was commissioned to execute the fresco decorations, which represent scenes from the lives of Saints Stephen and Lawrence (upper and lower registers, respectively). These exquisite frescoes introduced the style of the Florentine Renaissance to Rome and were executed between 1448 and 1451.

The Borgia Apartment is notable for the fresco decoration by Pintoricchio, executed between 1494 and 1495. The rooms were abandoned after the death of Alexander VI until 1816, when Pius VII designated them as exhibition space for paintings returned from Paris after the fall of Napoleon. In effect, the apartments formed the first home of the Pinacoteca.

The Room of the Lives of the Saints is richly decorated with frescoes by Pintoricchio, and lunettes and spandrels in the cross vaults and bands are completely painted and decorated with elements in gilded bas-relief. Scenes from the myths of Isis and Osiris and of Io and Apistre Bull are represented as are symbolic references to the emblems of the Borgias. Lunette scenes include Susanna, St. Barbara, and St. Catherine. A tondo by Pintoricchio above the door is titled the *Madonna and Child Surrounded by Angels*. The Room of the Mysteries of the Faith is decorated with frescoed scenes from the life of Christ and the life of Mary. This vault is decorated with stucco and gilding and medallions with busts of the Prophets. The Room of the Pontiffs, used for receptions, may once have contained portraits of the popes, suggested by the inscriptions in the small vaults. The original wooden ceiling was reconstructed under Leo X with stucco and frescoes by Perin del Vaga and Giovanni da Udine. The Borgia Tower is noted for its landscape frescoes by Pintoricchio.

The Sistine Chapel, known particularly for its vault with exceptional paintings

by Michelangelo, was built between 1475 and 1481 for Sixtus VI della Rovere by Giovannino di Dolci after a design by Baccio Pontelli. Intended as a private chapel for the popes, the chapel is used today for the election of the pope and other holy ceremonies. The chamber is extremely important for its fifteenth-century fresco decoration. The marble balustrade and choir were executed by Mino da Fiesole and other fifteenth-century artists. The floor is inlaid in the Cosmatesque style.

The side walls feature frescoes by various Tuscan and Umbrian artists, including Perugino, Pintorrichio, Ghirlandaio, and Botticelli. *The Life of Moses* and the *Life of Christ* are painted in the upper registers of the side walls (Moses on the Gospel side and Christ on the Epistle side, according to iconographic tradition). The first painting in each series, the *Finding of Moses* and the *Birth of Christ*, respectively, both by Perugino, were destroyed for the *Last Judgment* fresco on the west wall. The *Journey of Moses into Egypt* is the work of Perugino and Pintoricchio, and the *Youth of Moses* is by Sandro Botticelli. Scenes by Cosimo Rosselli include the *Passage of the Red Sea*, *Moses on Mt. Sinai*, the *Sermon on the Mount*, and the *Last Supper*. Botticelli executed the *Punishment of the Sons of Corah*, the *Purification of the Leper*, and the *Temptations of Christ*. Luca Signorelli painted the *Testament and Death of Moses in View of the Promised Land*. Perugino executed the *Handing of the Keys to St. Peter* with the aid of Luca Signorelli, and the *Vocation of St. Peter and St. Andrew* is by Domenico Ghirlandaio. The two frescoes in the entrance wall, *Resurrection of Christ* by Ghirlandaio and the *Fight over the Body of Moses* by Signorelli, were both destroyed and in the sixteenth century repainted by Arrigo Palludano and Matteo da Lecce, respectively. Portraits of the twenty-four popes by Fra' Diamante, Ghirlandaio, Botticelli, and Rosselli are painted in the niches between the windows.

The ceiling fresco, executed between 1508 and 1515, is the masterpiece of Michelangelo Buonarroti's classic, or second, style. The painting represents scenes from the Book of Genesis: the *Creation of Light*, the *Creation of the Stars and Planets*, the *Separation of Land from Waters*, the *Creation of Man*, the *Creation of Woman*, the *Fall and Expulsion from the Garden of Eden*, the *Sacrifice of Noah*, the *Flood*, and the *Drunkenness of Noah*. Representations of prophets and sibyls personify the prophesies of the coming Messiah, and in each of the four corners of the ceiling are stories from the Old Testament alluding to the Redeemer.

The Last Judgment, painted on the west wall of the chapel, was executed by Michelangelo between 1535 and 1541 under Paul III Farnese. The work, in the master's late mannered style, represents the end of the world and its rebirth. The figure of St. Bartholomew in the center of the fresco holds his skin, which bears a caricatured self-portrait of Michelangelo.

The Rooms of the Apostolic Library feature various objects of art. The Room of the Addresses of Pius IX was created to preserve the addresses of the faithful, and vestments and fabrics exhibited include a linen and wool tunic of the third-fourth century and a linen and wool tunic in Oriental fashion of the fifth-sixth

century. Of note are rare examples of Sassanian fabrics (fourth century), important as models for later Byzantine silks. The Chapel of Pius V was constructed between 1566 and 1572 and decorated by Jacopo Zucchi after designs by Giorgio Vasari. Exhibited are objects from the Treasury of the Sancta Sanctorum, where, during the Middle Ages, the most venerated relics were kept. Included are an ivory from the fourth century with the story of the blind man, which functioned as a lid for a doctor's case. A silver casket with Christ enthroned between Saints Peter and Paul is a Roman work from the ninth century. The Room of the Addresses contains Roman and Paleo-Christian glass and decorative and cult objects in enamel, ivory, and precious metals. The *Rambona Diptych* made for Abbot Odelrico about 900 of the monastery of Rambona represents the *Madonna Enthroned* and the *Crucifixion* and is probably the product of a North Italian workshop. The cover of the *Codex Aureus of Lorch* is an excellent example of Carolingian book arts and represents Christ trampling a dragon and a lion. A series of enamels from the Constantine Basilica of St. Peter's are displayed as well as examples of encrusted glass, excavated from the Catacomb of St. Calixtus.

The Room of the Aldobrandini Wedding derives its name from the Roman fresco representing preparations for a marriage. The room itself was constructed in 1611 by Paul V and decorated by Guido Reni with *Stories of Samson*. Also exhibited is the important fresco cycle of landscapes from the first century B.C., *Scenes from the Odyssey*.

The Room of the Papri, intended to house the Papri of Ravenna from the sixth to ninth century, is decorated by Anton Raphael Mengs. Examples of gilt glass of the Paleo-Christian period with sacred and secular scenes are exhibited. Of particular interest is a full-length portrait of the ship builder Dedalo from the Catacomb of St. Saturnius in the Via Salaria, about 300, and the *Resurrection of Lazarus and the Wedding at Cana*, from the fourth century. The Gallery of Urban VIII was intended to house manuscripts of the Palatine Library, and the Sistine Room, created by Sixtus V, was for documents and registers from the papal archives. The Sistine Hall, originally intended as the reading room, is decorated with various frescoes executed under the direction of Cesare Nebbia. The Pauline Room features decorations by Giovanni Battista Ricci (c. 1610–11) under Paul V. The Alexandrine Room was constructed in 1690 under Alexander VIII and decorated about 1818 under Pius VII. Also exhibited in the Alexandrine Room is an embroidered linen altarcloth from the Sancta Sanctorum of the eleventh century. The Clementine Gallery is decorated with frescoes by Domenico de Angelis (c. 1818) and exhibits various studies by Gianlorenzo Bernini, including studies for *Charity*, the *Prophet Habakkuk*, and *Daniel in the Lion's Den*. Two porphyry columns with reliefs, the *Tetrarchs*, date from the third-fourth century.

The Pinacoteca (Picture Gallery) houses paintings from the eleventh to the nineteenth century, including several highly important examples of Italian Renaissance art. Early works include a signed panel, the *Madonna and Child*, by Vitale da Bologna (1309-before 1361) and the panel *St. Francis and Scenes from*

His Life by the school of Giunta Pisano (thirteenth century). A *Last Judgment* is by Giovanni and Niccolo, artists of the Roman school at the end of the eleventh or early twelfth century. The painting may be from the Chapel of St. Stephen in the Church of St. Paul Outside-the-Walls, Rome. One of the earliest representations of St. Francis is by Margaritone di Arezzo (1216–93) and is signed. The *Guardian Angel with the Infant John the Baptist* is attributed to Giovanni Baronzio, school of Rimini (fourteenth century), and may have been a predella panel. Allegretto Nuzi (c. 1320–73) executed the triptych *Madonna and Child with Saints Michael and Ursula*, signed and dated 1365. The *Madonna and Child with Saints* is by Giovanni del Biondo (active in Florence 1350–1400), and Giovanni Bonsi (Florence, fourteenth century) executed the *Madonna and Child with St. Honophrius, St. Nicholas, St. Bartholomew, and St. John the Evangelist*. This is the only securely signed and dated (1372) work by this artist.

Giotto's famous and thought-provoking *Stefaneschi Triptych* is in the Vatican collection. The work, executed about 1315 with the aid of assistants for Cardinal Jacopo Gaetano Stefaneschi, was for the high altar of the ancient Basilica of St. Peter's. Christ is represented enthroned with angels and Cardinal Stefaneschi. On the side panels are the *Beheading of St. Paul* and the *Crucifixion*. The back contains *St. Peter Enthroned*, and the side panels have *St. Mark, St. John the Evangelist, St. James*, and *St. Paul*. A predella panel is titled *Madonna Enthroned*.

A *Madonna and Child* by Jacopo del Casentino is one of the few works attributed to this artist who was noted by Vasari. Pietro Lorenzetti's *Christ Before Pilate* and Simone Martini's *Redeemer Giving His Blessing*, about 1320, are examples of the Sienese school of the fourteenth century. Bernardo Daddi's *Madonna of the Magnificat* and Giovanni di Paolo's *Nativity* are exhibited, and Lorenzo Monaco is represented by his *Stories of the Life of St. Benedict*. Gentile de Fabriano executed the panel for the Quartesi Chapel of the Church of San Nicolo in Florence.

A *Crucifixion*, probably part of a larger altarpiece, is attributed to the Florentine painter Masolino. Fra Angelico executed the *Virgin in Glory with St. Dominick, St. Catherine, and Angels*, about 1435, and *Stories of St. Nicholas of Bari*, a predella panel for the 1437 altarpiece for the Chapel of St. Nicholas in the Church of San Domenico at Perugia. A *Coronation of the Virgin* by Filippo Lippi was painted about 1460 for the Chapel of St. Bernard in the monastery of Monteoliveto at Arezzo. The panel the *Virgin Offering the Girdle to St. Thomas* by Benozzo Gozzoli, about 1450, was painted for the Church of San Fortunato at Montefalco. Melozzo da Forli's fresco *Sixtus IV and Platino* was painted in 1477 for one of the rooms of the Library of Sixtus IV and has now been transferred to canvas. The scene represents the nomination of Bartolomeo Platina as prefect of the Apostolic Library. A signed panel, the *Madonna and Child with Saints*, by Marco Palmezzano is dated 1537. The predella panel *Miracles of St. Vincent Ferreri* by Ercole da Roberti was painted for the altarpiece by Francesco del Cossa for the Grifoni Chapel in the Church of San Petronio in Bologna. The Venetian painter Carlo Crivelli is represented by two works: the *Madonna and*

Child (signed and dated 1482) and the *Pietà*, signed. Antonio Vivarini executed a polyptych, signed and dated 1469, for the Church of Camerino, *St. Anthony Abbot and Other Saints*, which was purchased for the Vatican by Pius IX.

Pintoricchio executed the *Coronation of the Virgin with Saints and Apostles*, about 1502, for the Monastery of the Fratta near Perugia. A *Madonna and Child with Saints*, commissioned in 1482 and completed 1495 for the Chapel of the Palazzo Communale in Perugia, is signed by Perugino. Niccolo Filotesio, called Cola dell'Amatine, painted the *Assumption* with the side panels *St. Lawrence and St. Benedict*, and *St. Mary Magdalene and St. Catherine*, signed and dated 1515.

Several highly important works by Raphael are in the Pinacoteca. The *Transfiguration*, a late work, represents Christ between Moses and Elijah with Saints Peter and John and other apostles and was commissioned in 1517 by Cardinal Giulio de' Medici. The work remained unfinished at the artist's death in 1520 and was completed by Giulio Romano and Francesco Penni. The *Coronation of the Virgin* was painted in 1505 for Maddalena Oddi, and the *Madonna da Foligno* was commissioned about 1512 by Sigismondo de' Conti, who is represented kneeling before St. Jerome. The panel was intended as an ex voto for the saving of Sigismondo's house from a bolt of lightning. The famous tapestries from the cartoons by Raphael (now in the British Museum [q.v.], London) are exhibited and represent ten scenes, the *Acts of the Apostles*. The tapestries were originally commissioned by Leo X for the walls of the presbytery of the Sistine Chapel.

The unfinished *St. Jerome* by Leonardo da Vinci, painted about 1480, was purchased by the Vatican. Giovanni Bellini's *Burial of Christ* was formerly the upper part of an altarpiece by Bellini executed about 1470–71 for the Church of San Francesco in Pesaro.

Titian's *Madonna dei Frari* is in the Vatican collection, painted in 1528 for the Church of San Niccolo dei Frari in Venice. *St. Helen* is by Veronese, and *St. George and the Dragon* is by Paris Bordone. The *Coronation of the Virgin* is a collaborative effort between Romano and Francesca Penni, painted about 1525 for the Convent Monteluce. Giorgio Vasari's *Stoning of St. Stephen* was formerly in the Chapel of Nicholas V in the Vatican, and two works by the Urbino painter Federico Barocci, *Rest on the Flight into Egypt* and the *Blessed Michelin*, are in the collection.

Works from the sixteenth century include the *Martyrdom of Saints Process and Martinian* by Valentin, and the *Communion of St. Jerome*, signed and dated 1619 by Domenichino. Caravaggio's *Deposition*, a highly important work by that master demonstrating both his realism and his ability with trompe-l'oeil, was painted for the Church of St. Maria in Vallicella in Rome, 1604, and it has recently been cleaned.

Guido Reni's *Crucifixion of St. Peter* is from the Church of Tre Fontane. Guercino's *St. Mary Magdalene* was painted about 1523, and the French artist Nicholas Poussin is represented by his *Martyrdom of St. Erasmus* about 1630. *St. Francis Xavier* is by Anthony van Dyck, painted during his 1622–23 stay in

Rome. Pietro da Cortona executed the *Virgin Appearing to St. Francis*, now in the Vatican, and the *Martyrdom of St. Lawrence* is by Jusepe Ribera, called Spagnoletto. A panel work, *Garland of Flowers with Madonna and Child*, is by the Antwerp artist Daniel Seghers. Also exhibited in the Pinacoteca are the *Portrait of George VI* of England by Thomas Lawrence (signed) and the *Portrait of Benedict XIV* by Giuseppe Maria Crespi. A collection of Byzantine icons is also exhibited.

The Collection of Modern Religious Art was established in 1973 and comprises paintings, sculptures, and other modern works of art, mostly gifts to the papal collections. Included are paintings by Sironi, Carena, Soffici, and Rosai. Decorations by Matisse for the Chapel at Vence are exhibited, as are a group of works by Rouault. Paintings by Chagall, Gauguin, Utrillo, Redon, Braque, Klee, Kandinsky, Moore, and Sutherland are displayed. Contemporary Italian painters are represented by Morandi, de Pisis, Carra, de'Chirico, Cagli, Casorati, Virgilio Guidi, Campigli, Levi, and Arturo Martini. Stained glass designed by Léger, Villon, and Meisterman are part of the collection, as are sculptures by Rodin, Barlach, Marini, Miró, Mestrovich, and Lipchitz. Watercolors by Ben Shahn and Feininger and canvases by Ensor, Bacon, and Hartung, as well as other artists, are also exhibited.

The collection is housed in rooms that formed part of the Borgia Apartment, as well as the room that served as the bedchamber of Nicholas V (indicated by a hook for a canopy in the fifteenth-century ceiling), and the thirteenth-century tower of Innocent, with fresco fragments from the time of Nicholas III.

The Historical Museum was established in 1973 and includes in the first section a collection of carriages formerly belonging to popes and cardinals. A collection of arms and armor of the papal forces (disbanded in 1970) is exhibited in the museum.

The Missionary-Ethnological Museum, opened in 1927 by Pius XI, was formerly housed in the Lateran Palace. The objects, which strongly reflect religious interests of the missionaries who collected them, are arranged by geographical location.

Oriental art includes objects from China and Japan. Two *takuchai* (guard lions) are from Peking and are executed in enamel. They represent "yang" and "ying," two essential aspects of Chinese philosophy. A figure of a philosopher (551–479 B.C.) wears the insignia of the Chou Dynasty. Japanese art includes models of Shinto temples and Buddhist masks (lions of the Nō theater). A perfume burner of the eighteenth century is decorated with Shinto scenes and mythological statues. From Korea are various objects from religious life, including household altars, vases, and so on. The religions of Tibet, including the original Bon Pö religion and Lamaism, are represented by various objects: a drum made from human skulls and various reliquaries. From Indochina are funerary and religious objects. Funerary stelae in carved wood from Central India are exhibited along with a votive ox, or *nandi*, from the eighteenth century. A triptych mask of Maha Kola, the demon of eighteen diseases, is exhibited.

Polynesian art includes wooden and stone statues of ancestors and gods of Polynesia. Also of interest are objects from the collection of two missionaries of the nineteenth century, Father Damiano de Veuster and Father Nicoleau, who worked among lepers in the South Seas. Sculptures from Melanesia (New Caledonia) represent spirits intended to protect the home. They are executed in talevis wood. Statues representing ancestor figures and ceremonial masks, including two great masks of the Tuban secret society of New Britain, are exhibited. The *Hut of the Spirit* from Central New Guinea is reconstructed from pieces. Aboriginal mythology is depicted in paintings on stone from Australia. From West Africa are statues in terracotta from the Ashanti tribe, as well as a collection of ancestor statues and masks.

From South and Central America are pre-Columbian objects, including a stone sculpture of Quetzalcoatl, the plumed serpent of the ancient Aztec religion. The sculpture is executed in stone and is of the classical Aztec style of the Mexican plateau. Objects of native North Americans are from ritual and daily life.

From Persia is a collection of majolica, formerly in the La Farina Collection in Palermo. Ancient Near Eastern art includes seals and stone fragments with Hittite inscriptions. Judaica from the Middle East includes a Torah scroll from 1400 and two *Meghilla Esters* (*Stories of Esther*), one in a silver case intended as a wedding gift. The collection of primitive art at the Vatican is exceptionally strong, if not extensively documented. Many rare native objects executed after the influence of Christianity are in the collection.

The Apostolic Library, one of the world's richest repositories of manuscripts from roll to codex, is open to visiting scholars with appointments. The Vatican maintains a photographic archive for reproductions of works in the collection. Also accessible are numerous museum shops with picture books, guides, slides, reproductions, and so on for the visitor.

Selected Bibliography

Museum publications: Vatican, *Guide to the Vatican, Monumenti, Musei e Gallerie Pontificie*, Rome, 1974; *Quinto Centenario della Biblioteca Apostolica Vaticana, 1475–1975*, Rome, 1975; numerous exhibition catalogues and guides, including *Direzione generale dei monumenti, musei e gallerie pontificie*, 1962; *Guida breva generale al musei e alle gallerie di pittura del Vaticano, del Laterno e della Biblioteca Vaticana*, Vatican City, 1948; *Die Skulpturen der Vaticanishchen Museen*, Berlin, n.d.; *Vatikanische Museum, Skulpturen*, Rome, 1910; *Guide to the Vatican Picture Gallery*, 1941.

Other publications: Calvesi, Maurizio, *Treasures of the Vatican* (Cleveland, 1962); de Campos, Deoclecio Redig, ed., *Musei Vaticani*, (Novara 1972); idem, *I palazzi vaticani* (Bologna 1967); Ehle, Franz, *Der vaticanische Palast in seiner Entwicklung bis zur Mitte des XV Jahrhunderts* (Vatican City 1935); Enni, Francia, *Pinacoteca Vaticana* (Milan 1960); Hermanin, Federico, *L'Appartemento Borgia nel Vaticano* (Rome 1934); *Rome, the Vatican Museums: A handbook for Student and Traveler*, 1924; Seymour, Charles, *Michelangelo, The Sistine Ceiling* (New York 1972); Wilde, Johannes, *The Decoration of the Sistine Chapel* (London 1948).

<div align="right">LORRAINE KARAFEL</div>

Venezuela

———— Caracas ————

MUSEUM OF COLONIAL ART OF CARACAS (officially MUSEO DE ARTE COLONIAL DE CARACAS), Quinta de Anauco, Avenida Panteón, San Bernardino, Caracas 1011.

The Museum of Colonial Art of Caracas was founded through the efforts of several Venezuelan art collectors of the early twentieth century who had discovered that during Venezuelan colonial times, the production of works of art was noteworthy and needed to be seriously preserved, studied, and made known to the general public. Therefore, in 1942 these collectors formed the Association of Friends of Colonial Art, which was to create on December 16 of that same year, under the leadership of Alfredo Machado Hernández, the Museum of Colonial Art of Caracas.

The Association of Friends of Colonial Art, a nonprofit organization, is the managing entity of the museum, as well as the owner of its collections. It is directed by a board, made up by the following members: the president, the vice-president, the secretary, the treasurer, the librarian, and five substitute directors, all of whom serve two-year terms, elected by the General Assembly of Members. The permanent staff is headed by an advisor and his assistant, who are in charge of conducting the work of restoration, conservation, organization, and cataloguing of the collection, as well as recommending new acquisitions. The remaining staff includes the administrator, the personnel manager, secretary, six guides, and the necessary maintenance and gardening crews. Working with the staff are several honorary committees that deal with architecture, landscaping, and cultural activities. Financial support for the institution is obtained from government allocations and other private sources. The profit from the sale of

admission tickets, postcards, and museum catalogues and other books, along with special grants, contributes to its maintenance.

The museum was originally located in an important eighteenth-century house in the colonial part of the city, lent by the government for this purpose. The restoration of that building was the first serious work ever made in that field in the country. It was one of the few examples of colonial architecture preserved in Caracas. Unfortunately, and despite the efforts of many protesters, the house was demolished eleven years later by the government of dictator General Marcos Perez Jimenez, to make way for the construction of an important avenue to be called Avenida Urdaneta. Due to this demolition, the museum was closed in 1953, and the whole collection was placed in storage for eight years. As a result of the generous gift made to Venezuela by the Eraso family of the historical Quinta de Anauco or Villa of Anauco, on June 25, 1958, the museum finally obtained an appropriate setting in which to show its collection. The mansion was donated with the expressly written clause that it should always remain the permanent headquarters for the museum, administered by the Venezuelan Association of Friends of Colonial Art.

The task of restoring the building was undertaken by the Ministry of Public Works, under the supervision of the late Carlos Manuel Möller, who was then the association's president. The museum opened to the public on October 12, 1961, and was declared an official Historical Monument on January 24, 1978.

The Quinta de Anauco is a country house built in 1797 for Captain Juan Javier Mijares de Solórzano, a descendant of old aristocratic families. The history of the Quinta is very rich, and all of its details from the time it was constructed are well known. After the War of Independence it was confiscated from the Mijares de Solórzano family to become government property. In 1827 it was purchased by General Francisco Rodriguez del Toro, Marquis del Toro, who gave it its present name (its name had been previously the House of Solórzano). After his death his heirs sold the house to Domingo Eraso, whose family kept it for ninety-seven years.

This country house is located in what is today the center of modern Caracas. The area was very fashionable at the end of the eighteenth century, and several similar houses were built around it; however, few remain today. The essential characteristics of eighteenth-century Venezuelan residential architecture can be found in this construction. Built on a small hill and surrounded by gardens, it has a main structure with a central patio, inside and outside corridors, and a two-story carriage house by the entrance. The main rooms have plastered ceilings, and the dining room and other rooms have closets built into the walls with doors. Some others have mural paintings, one of which is particularly interesting because it shows genre scenes. This was probably added in 1830. There is also a curious bathroom with a stone bathtub built into the floor, which had water running into it directly from a mountain stream. Behind the carriage house there is a replica of a fountain that existed in a colonial house of Caracas. The relief located over this fountain is also a replica of one with the coat of arms of the city, which

used to embellish a public fountain demolished in 1951. Twenty-four rooms have been furnished as period rooms of the seventeenth and eighteenth centuries. The Estrado room and the kitchen were faithfully reconstructed with authentic elements.

When the museum was first opened, all of the artworks and furnishings exhibited there had been lent by local collectors. This was when the Association of Friends of Colonial Art began assembling its initial collection. The major bequests forming this collection came from Alfredo Machado Hernández and from the government, which had purchased the collection of Lope Tejera. By 1953 the initial group of holdings had been collected.

Following the dormant period during which the museum was closed due to the lack of a home, many people were stimulated to make gifts to the association at the museum's reopening in the Quinta de Anauco. The Ministry of Public Works began by donating some pieces purchased from the Luis Suarez Borges Collection, and the association continued by purchasing from other great Venezuelan collections, such as those of Manuel Santaella, Carlos M. Möller, and Mauro Páez Pumar.

The collections began to be enriched and enlarged again, particularly between 1976 and 1980, when the association made important acquisitions for the history of colonial art in Venezuela. It was also in 1976 that a policy for accepting or purchasing objects was designed. This policy controls the quality and state of preservation of the objects to be bought or received, giving special attention to the local pieces. Foreign pieces are accepted only if they were imported or used in Venezuela during the colonial period.

The paintings of the collection offer an example of high quality that shows the development of Venezuelan colonial painting. For example the Caracas school of the late seventeenth century and early eighteenth century is represented by works of its most important masters: Francisco José de Lerma, with his *Our Lady of Mercy*, bequeathed by the widow of Carlos M. Möller; José Lorenzo Zurita, with the *Portrait of Bishop Valverdo*, his only known portrait; and a large anonymous portrait of historical significance portraying Don Juan Mijares de Solórzano, the grandfather of the original owner of the Quinta de Anauco. Caracas' pictorial work of the second half of the eighteenth century is very well represented by thirteen oil paintings by Juan Pedro López, one of the best artists of the period. His most important work is perhaps the *Altarpiece with Evangelists*. There are also two paintings of the *Virgin of the Rosary* and the *Portrait of the Founder of The Carmelite Convent of Caracas*, the only portrait known to be painted by this artist and given to the association in 1946. The most recent acquisition of another Juan Pedro López masterpiece was the *Ecce Homo*.

The Landaeta school, active in Caracas during the last years of the eighteenth century, is represented by four paintings, the most significant of which is the *Portrait of Priest Rodriguez Felipes*. A small painting, *St. Gertrude of Helfta*, is one of the few paintings known and signed by the master Francisco Contreras. It is dated 1785.

The popular schools of other regions of Venezuela have a poor showing. Nevertheless, there is an outstanding example of the famous school of El Tocuyo, *Los Azotes en la Columna*, and two extraordinary works by José Lorenzo de Alvarado, a well-known painter from Mérida of the late eighteenth century: *The Immaculate Conception* and *St. Lawrence*, both acquired recently. Mexican colonial painting is represented by few examples, all brought to Venezuela during colonial times.

Twenty-six pieces of sculpture are exhibited, four of which are Spanish. The *Infant Jesus* of the Sevillian school, attributed to Jerónimo Hernández (1560–80), was found in the state of Falcón, and *St. Joseph and the Child* of the eighteenth century had belonged to the Chapel of the Quinta de Anauco. There is only a limited representation of the sculpture of Caracas; yet it includes a very fine work by El Tocuyano, *Figures of the Nativity*, placed in a splendid carved and gilded niche by Francisco José Cardozo.

Undoubtedly, the most outstanding part of the collection exhibited in the museum is in the furniture department. This department has been divided into five groups: Baroque furniture, painted furniture, eighteenth-century furniture, marquetry furniture, and chests. The pieces come mostly from Caracas, with some examples from other parts of Venezuela, as well as a few from Mexico.

Baroque furniture made during the latter quarter of the seventeenth century and beginning of the eighteenth century is represented by several *frailero* armchairs, turned-leg tables, wardrobes of square design, and other typical examples, complemented by three small cabinets from Campeche, Mexico, inlaid with bone and ebony.

The group of painted furniture is the most interesting. A carved box with drawers, with a curious painted scene of nonreligious nature inside its cover, representing music and hunting, and a very fine table probably decorated by Juan Pedro López are the most important pieces. Also worth mentioning is a seventeenth-century Mexican lacquered chest that belonged to the hospital of La Guaira. Within this group are the pieces of the most important cabinetmaker and wood carver of colonial Venezuela, Domingo Gutierrez (1709–93). His work can be seen in several carved frames of the most pure Rococo style, two exquisite ceiling rosettes, also carved and gilded, and the carving of the previously mentioned altarpiece painted by López.

The largest number of pieces of furniture are from the eighteenth century, some forty-eight, of varied shapes and uses. In this group are found the two oldest examples known of a type of armchair made only in Venezuela, the *butaca*. This armchair was designed following the lines of a primitive Indian chair called *ture*, and its name is derived from an Indian word meaning seat. The *butaca* was usually upholstered and its seat and back slanted so as to make it the most comfortable chair made in those times. This unique design was not known in other parts of colonial America.

Generally, authorship of the furniture made in Caracas during colonial times is unknown. It is, therefore, outstanding that there are three eighteenth-century

pieces in the museum with known origin: a large chest of drawers made specially for the Sacristy of the Caracas Cathedral in 1755 by the Leon Quintana brothers, creators as well of the altarpiece under which these drawers stood and several other altarpieces in Caracas, and a corner table and a *butaca* attributed to Antonio José Limardo.

The introduction of the neoclassical style forced the local carvers and cabinetmakers to direct their techniques toward inlay and marquetry. By the end of the eighteenth century, a school of marquetry had been established in Caracas, having as its best representative Serafin Antonio Almeida. Because there are several important works known to be his in Caracas, the thirty pieces of the group exhibited in the museum can be attributed to him. All of these examples are made in cedar, veneered with a local dark fine-grained wood called *gateado* and inlaid with another very light-colored wood called *naranjillo*. Among these examples are a bed, a corner table, several *butacas* and dressers, a mirror frame, and a most unique and beautiful wardrobe.

A very small but extremely important department of the museum is the rug department. There are only four remaining examples from the eighteenth century of the famous rug industry that existed in Mérida between the seventeenth and nineteenth centuries. Of them, the most interesting is the prayer rug that once belonged to Doña Maria Ines de Uzcategui of Mérida. It is the only rug of this type preserved in Venezuela.

The glass department contains an interesting array of pieces, all imported during colonial times as goods purchased in exchange for the coffee and cocoa that Venezuela exported. There was no glass manufactured there. Among such pieces there is a complete collection of hall lamps in glass and cut crystal, one of them green Bohemia crystal; a less numerous group of hurricane shades, none of which is cut; and some drinking glasses, jars, and bottles, all from the eighteenth century.

The same historical background applies to the ceramic collection, even though a very primitive pottery industry did exist in Venezuela. This collection includes Chinese porcelain and Spanish, Dutch, Mexican, and local earthenware. English earthenware is represented by an uncommon group of Staffordshire jars commemorating certain battles of the Venezuelan War of Independence.

The only exhibit not presented in period style, but rather in modern museum design, is the silver exhibit. This department holds the best examples of Venezuelan craftsmanship, since the silversmithing tradition was the most highly developed one of the colonial period. The work of the three most renowned silversmiths of the eighteenth century is richly represented in the collection. They are Pedro Ignacio Ramos, Francisco de Landaeta, and Pedro Fermín Arias. The greater part of the objects exhibited is of religious nature; the scarcity of secular works is because the great majority of the silver used in homes was melted during the War of Independence to provide currency.

Complementing the general atmosphere of this colonial villa, there are various bronze and iron items of daily use that help bring to life the feeling of the period

represented there. They include bronze candlesticks, door knobs, snuffers, lanterns, pots, swords, and bells.

The museum has no department of conservation or restoration. All such work is given to outside professionals. There is also no department of photography; only some general postcards and slides are on sale with the museum catalogues. Special permits are issued to photographers.

The museum library, containing art and history books, is open to the public but is noncirculating. Concerts are offered by the Cultural Activities Committee and are free. The museum lends its facilities for concerts organized by other institutions.

The mansion can be visited only by guided tours. Special children's guided tours are available as well during vacation periods. A special exhibit entitled "Piece of the Month" is held every two months. It allows for special showing of extraordinary loans, bequests, or recent restorations of existing pieces.

Selected Bibliography

Publications by the Association of Friends of Colonial Art: Duarte, Carlos F., *Museo de Arte Colonial, Quinta de Anauco*, 1979 (Museum guide and catalogue, in Spanish, 356 pages, illustrated); idem, *Historia de la Quinta de Anauco*, 1979 (Separata, in Spanish, 24 pages illustrated); idem, *Brief Guides* to the Colonial Art Museum, 1978 (illustrated, in Spanish, English, French, German, and Italian); Möller, Carlos M., *Guía del Museo de Arte Colonial*, 1961 (translation in English, out of print).

Other publications: Catalogue of the Miniature exhibition (Caracas 1947), in Spanish (out of print); Catalogue of the Chest exhibition (Caracas 1963), in Spanish (out of print); Möller, Carlos M., *Páginas Coloniales* (Caracas 1962), in Spanish (articles on colonial architecture, furniture, ceramics, history, and so on, 281 pages illustrated).

CARLOS F. DUARTE

Yugoslavia

—— Belgrade ——

NATIONAL MUSEUM, BELGRADE (formerly MUZEJ KNEZA PAVLA [1935–1944], UMETNIČKI MUZEJ [1944–1952]; officially NARODNI MUZEJ, BEOGRAD; alternately STATE MUSEUM, BELGRADE), Trg Republike 1A, 11000 Belgrade.

The National Museum, Belgrade, traces its history from 1844, when Jovan Sterija Popović began a collection of documents, books, seals, and coins for the Ministry of Education (Popečiteljstvo). In 1881 the museum was separated from the library and put under the direction of an archaeologist. With Miloje M. Vasić, who became curator in 1906, the museum began a program of excavating systematically the nation's past, which greatly expanded its collections. The museum suffered under Austro-Hungarian occupation during World War I and was not reopened until 1923. In 1935 it was named the Museum of Prince Paul (Muzej Kneza Pavla) after the regent of Yugoslavia, a title it kept until 1944, when it was called the Museum of Art (Umetnički Muzej). In 1952 it again assumed its original name, the Narodni Muzej (National Museum), and moved to its present location on the Square of the Republic (Trg Republike).

The museum is an institution of the Republic of Serbia under the jurisdiction of the Ministry of Culture. The director of the museum supervises the curatorial departments: the Department of Prehistoric Antiquities, the Department of Greek and Roman Antiquities, the Department of Medieval Art, the Numismatic and Ethnographic Department, the Department of More Recent Yugoslav Art, the Department of Foreign Art, the Restoration Department, the Conservation and Preparation Department, the Library, and the Department of Education and Publication.

The museum occupies an impressive Baroque Revival building constructed

as a bank in 1903 and adapted for a museum in 1952. The interior entryway is flanked by a series of twelve monumental caryatids by Ivan Meštrović, the major sculptor of twentieth-century Yugoslavia.

The National Museum has a comprehensive collection of Serbian art from prehistory through World War II, some archaeological finds from other regions of Yugoslavia, and a small but representative selection of western European painting from the fourteenth through the twentieth century. Since World War II the creation and growth of a separate Museum of Contemporary Art in Belgrade, as well as regional and local archaeological museums, have slowed the expansion of the National Museum's collection. In fact, a few objects have been given to local museums in the regions where they were found.

The museum has a rich selection of neolithic art excavated from the soil of Yugoslavia. Most well known are the terracottas from Vinča and related sites, small, abstractly rendered anthropomorphic figures with incised ornament. The exhibition is archaeological and includes a selection of figures, some of the artifacts found with them (stone tools, vessels, a terracotta bucranium), maps; and even a section of the stratigraphy. Other noteworthy works of neolithic art are an especially fine figure of a mother goddess from Čaršija, an enthroned woman holding a dish from Bordjoš, and terracottas from Pločnik.

The collection also includes a selection of important Bronze Age objects, among them, the famous *Ritual Carriage* from Dupljaja and large bronze "votive rings," or bracelets. A treasure of gold jewelry found at Velika Vrbica near Kladovo is also on exhibit.

Bronze spiral ornaments from Žirovnica and embossed silver jewelry from Mramorac and Čurug are among the fine Iron Age "Hallstadt" finds. The objects from two Illyrian burial sites at Trebenište and Novi Pazar are incredibly rich and also interesting as assemblages. They illustrate the interactions between the Iron Age Balkan peoples and the Greeks. On display from a woman chieftain's grave tumulus at Novi Pazar is a wealth of gold—great belts, ornamental appliques, jewelry—and amber figurines. Finds from several graves at Trebenište near Ohrid in Macedonia include embossed gold face masks in the tradition of Mycenaean art, gold sandals, a silver horn-shaped rhyton, bronze helmets and vessels, and objects of Greek workmanship. Illyrian artifacts from other sites, intricate gold and silver jewelry and small bronzes, are also displayed.

A selection of later Iron Age art from the Celtic La Tène civilization that occupied the northern parts of present-day Yugoslavia in the fourth and third centuries B.C. includes small bronzes (e.g., a standing warrior and a horseman), pottery vessels, weapons, and jewelry. The museum also has some Dacian objects.

The Greek and Roman art in the National Museum comes almost exclusively from sites in Yugoslavia and is, therefore, interesting as evidence of Balkan history as well as in its own right. A series of Greek vases provides a representative sample ranging from the Mycenaean to the Hellenistic period. A fine black-figured *olpe* with a depiction of Pan and satyrs was found in the Illyrian

grave at Novi Pazar. There are several vases excavated at Trebenište and other sites in Macedonia. A group of vases from the Black Sea region comes from the private collection of King Milan Obrenović and General Mihailović. Among the numerous fine Greek bronzes is a unique Geometric figure of a smith at work. The extraordinary Archaic bronzes found at Trebenište include a bronze hydria with tripod and a remarkable bronze crater, one of the finest and best-preserved examples of Archaic Greek metalwork.

The museum owns several Greek sculptures such as a small marble copy of Phidias' *Athena Parthenos* and a Hellenistic head of a young woman in the style of Praxiteles. The bronze satyrs from Stobi are outstanding examples of Hellenistic sculpture, as is an archaizing Neo-Attic marble relief of Pan and the nymphs from the same site. Several fragmentary copies of Hellenistic originals from the Roman period—the *Head of a Satyr*, *Hermes*, and the fragmentary *Aphrodite*—are imports. Others, *Dionysus*, dated 119, and *Head of Serapis*, probably came from local Balkan workshops. There are a number of small bronzes in the Hellenistic style; several Aphrodites and one of Poseidon are especially notable. A selection of terracotta figurines of the Tanagra type is included. Large glass and bronze vessels are exhibited; one brown glass pitcher has applied silver decoration.

A group of Roman portrait sculpture provides a chronological survey: a fine bronze Trajanic head, a marble head from the period of Marcus Aurelius, a remarkable third-century *Portrait of a Philosopher* from Stobi, several Tetrarchic heads, and a bronze *Head of the Emperor Constantine* from his birthplace at Niš. A number of Roman bronzes, including a copy of Lyssipus' *Herakles Epitrapezos* with a likeness of Alexander Severus and an image of Fortuna, are notable.

Many Roman artifacts illustrate the military nature of Roman culture in the Balkans. Two fine bronze masks are from parade helmets and date from the Imperial period. A military scepter features silver relief decoration. The hoard of a Roman officer found at Tekija includes figures of gods in silver relief, silver vessels, and jewelry. Several Roman reliefs depict gladiators. Two especially interesting grave stelae show Achilles and the body of Hector and a scene of a tax collector. Some examples of Roman architectural sculpture come from the theater and palaces at Stobi.

Reminders of the cosmopolitan culture of the Roman Balkans are the bronze stamp with a menorah and the long synagogue inscription from Stobi, as well as the two Palmyrene heads found in Belgrade, ancient Singidunum. The popularity of mystery cults is attested to by marble reliefs of Mithras killing the bull, reliefs of the Thracian Rider, and lead plaques representing the Danubian Horseman.

A large sample of Roman crafts includes pottery (e.g., fine vessels and molds for sigillata ware), weights, iron keys and locks, medical instruments, jewelry (especially fibulae), and coins. An unusual example of silver open work depicts Leda and the swan. Several fine silver vessels include a cup with depictions of

Dionysus and Ariadne and commemorative plates issued by the fourth-century emperor Licinius.

The early Byzantine period is represented by a selection of finds mainly from Stobi in Macedonia and Caričin Grad, perhaps the birthplace of Emperor Justinian, in Serbia. Six large marble capitals from the nave arcades of the Episcopal Basilica at Stobi are finely carved with a wealth of Early Christian motifs. Two of the Ionic impost capitals from the galleries of the basilica, with marble screens, pieces of the ambo and other church furniture, fragments of figured wall frescoes, and carved stucco, are also exhibited.

Among the objects from Caričin Grad are fragments of a bronze imperial statue and the exquisitely carved hand of an ivory figure. Other early Byzantine objects include a fine bronze portrait head of an empress found at Balajnac near Niš, a statuette of the Good Shepherd from Belgrade, an extraordinary sardonyx cameo with a mounted emperor found at Kusadak, and gold medallions of Constantine the Great, Valentinian I, and other emperors. Many small objects— a weight in the shape of an empress's head, a censer, and lamps—round out the museum's large collection of bronzes.

The medieval exhibits of the National Museum begin with artifacts of the nomadic tribes that settled in the Balkans and brought the end of Roman culture. A rich variety of Slavic, Avar, Sarmatian, and Gothic objects is included. Careful displays illustrate subtle differences among the material cultures of these tribes. Especially noteworthy are the enameled Sarmatian fibulae, Gothic fibulae with inlaid stones, and the gold Avar jewelry. A selection of coarse Slavic pottery forms a striking comparison to the Greek and Roman ceramics from the Ancient Collection.

Several medieval Byzantine objects in the museum are imports brought into the Balkans with the renewed influence of Constantinople. They include gold jewelry, an enamel plaque representing an archangel, a small steatite plaque carved with an image of the Virgin in relief, silver spoons and vessels, a bronze censer with scenes from the life of Christ, and sgraffito ware.

The medieval Serbian state that flourished from the twelfth through the fourteenth century rivaled Byzantium. The museum has an extensive collection of medieval Serbian art, frescoes removed from the ruins of churches, icons, and decorative arts. The fresco fragments offer a sad reminder of the riches of lost paintings. Although the frescoes from Djurdjevi Stubovi near Novi Pazar (c. 1175) are very fragmentary, they are high-quality works, perhaps by Constantinopolitan artists. Other notable frescoes are from the Monastery of Gradac (c. 1275); their style is related to that of Sopoćani. Morava school frescoes from Sisojevac, dating from the late fourteenth century, and others from the church of St. Nicholas at Palež are also impressive. The museum has many examples of medieval stone carving with a large number of fragments from the Monastery Banjska and the Morava school Church of St. Stephan at Milentija near Brus.

The collection of icons includes some fine examples from the fourteenth through the seventeenth century. A fragmentary fourteenth-century icon of the

Nativity from Ohrid is a good example of the Palaeologue style. Several fifteenth-century icons are remarkable: a *Baptism of Christ*, a double-sided icon from Ohrid with the *Virgin and Child* on one side and the *Annunciation* on the other; the icon of the Serbian saints *Simeon and Sava*, from Hilandar, the Serbian monastery on Mt. Athos; and carved wooden iconostasis doors with a depiction of the Annunciation. The cross from the monastery of Blagoveštenje and an icon of the Deësis with Serbian saints by Avasalom Vujičić are outstanding among the seventeenth-century works. An interesting group of late icons is from the school of Boka Kotorska.

One of the museum's great treasures is the *Gospel of Miroslav*, the oldest extant Serbian manuscript. It was written for Miroslav, brother of Stefan Nemanja, between 1180 and 1190; the 296 miniatures and initials combine Byzantine and western Romanesque traditions.

There are numerous examples of medieval decorative arts, particularly liturgical arts. The extraordinary fifteenth-century embroidered vestments and crosses, the most elaborate of which is the wood and silver *Cross of the Metropolitan Nikanor* from the sixteenth century, are noteworthy. There are also many vessels of elaborately decorated silver, glass, and pottery. Many examples of gold and silver earrings, bracelets, and rings from the twelfth through seventeenth century are exhibited. The thirteenth-century gold agraffe of Prince Petar and the fourteenth-century gold ring of Queen Theodora are remarkable.

The National Museum houses the major collection of modern Serbian painting. The works are arranged historically so that one can trace their development from the origins in medieval icon painting through World War II. When the Serbs moved into the southern marches of the Austro-Hungarian Empire in 1690, their artists came under the influence of the European Baroque. The *Icon of St. Naum* by Hristifor Zefarović illustrates how the Baroque concepts of space and light began to liberate the Byzantine traditions. Icons from the church at Orlovat by Dimitrije Popović and the *Ascension* from the iconostasis of the Cathedral of Sremski Karlovci by Teodor Kračun illustrate the continuing influence of the Baroque style. Arsen Teodorović's paintings, such as *St. John the Baptist* and especially the fine portraits like *Portrait of Bishop Kirilo Živković*, show a mastery of Baroque grandeur. The works of Konstantin Daniel, particularly the *Portrait of the Artist's Wife* and his *Still Life*, exhibit great spontaneity and élan in the introduction of secular subject matter.

One of the most interesting of the early-nineteenth-century artists was Katarina Ivanović, the first woman painter in Serbian art. Trained in Vienna, she specialized in genre scenes like *A Basket with Grapes* and *The Italian Vintager* and portraits such as the striking *Self Portrait* and *Portrait of a Woman in Serbian Costume*. Djura Jakšić, poet and painter, was a key figure in Serbian Romanticism. A number of his dramatic paintings of Serbian history are exhibited, *The Killing of the Great Vožd Karadjordje*, for example. Stefan Todorović, a more accomplished painter, was similarly inspired by the drama and passion of Serbian

history, as seen in his early work *The Death of Hajduk Veljko*. Many of his portraits and landscapes like *The Monastery of Manasija* are also displayed.

The National Museum possesses most of the oeuvre of Djordje Krstić, one of the foremost Serbian realists. Several of his meticulously painted landscapes are on exhibit, as well as still lifes and some sentimental academic paintings such as *The Drowned Woman*. the work of Uroš Predić is also in the realist manner; he is best known for his history paintings like *Refugees from Herce-govina*. Paja Jovanović, another painter of national history, has an even greater reputation. Works such as *The Cockfight, Adornment of the Bride, Coronation of Dušan*, and *Migration of the Serbs* have become part of the Serbian national consciousness. His portraits, like one of Mihailo Pupin, a famous Serbian sci-entist, are also well represented.

The Serbian painters of the early twentieth century entered the mainstream of modern art. Many studied abroad, primarily in Munich or Paris; most returned to Yugoslavia, where artistic life began to flourish, particularly in Belgrade. Milan Milovanović, Marko Murat, and Beta and Rista Vukanović exploited the bright light and free brushwork of Impressionism in the early years of the century. The National Museum has many of their finest works. One of the most striking painters of this period is Nadežda Petrović, whose intense color anticipated Fauvism. The daring *Self Portrait* shows the full force of her style. Several of her landscapes (*Resnik, Quai de la Seine, Birches, Barges on the Sava*) are also in the museum's collection. The Balkan Wars and World War I cut short her career, as well as those of many other young artists.

During the twenties and thirties, Belgrade became a cultural capital with dozens of exhibitions and several periodicals dealing with art. Contacts with western European centers, especially Paris, were close. The National Museum possesses scores of fine paintings from this period. Many works by Jovan Bijelić, such as *The Little Dubravka* and *Still Life*, are exhibited. The museum also possesses a large number of canvases by Sava Šumanovic: *Woman in Nature, The Port of Nice, Bridge Over the Seine*, and many others. There are several paintings by Petar Dobrović, such as the impressive landscape *Horses at the Church of St. Mark*. The Expressionist use of color is seen in works such as *Corn Field* by Milan Konjović, *The Diggers* by Ignat Job, and *Female Nude* by Zora Petrović, another impressive woman painter. Milena Pavlović-Barilli's *Composition* be-longs to Surrealism. The paintings of Stojan Aralica, landscapes and still lifes, illustrate his virtuosity as a colorist. Both Marko Čelebonović's *Group* and Nedeljko Gvozdenović's *Girl in an Interior* and *Park* show great richness of color and pattern in an "intimist" manner. The Parisian scenes of Pedja Milo-savljecić emphasize the importance of France for twentieth-century Yugoslav artists. The museum has a *Self Portrait* by Moša Pijade, a painter and political revolutionary who subsequently became one of the leaders of Communist Yu-goslavia. Other paintings by these twentieth-century artists and more contem-porary Yugoslav art are exhibited in the Museum of Contemporary Art.

The National Museum has a less extensive collection of sculpture. There are several works by Petar Ubavkić, the first modern Serbian sculptor, such as his portrait busts *Vuk Karadžić* and *Karadjordje*. His *Woman with a Veil* is a tour de force of marble carving. Several early works of Ivan Meštrović, such as the monumental caryatids in the entryway of the museum, were intended for a memorial on the battlefield of Kosovo, where the Serbs lost to the Turks in 1389. Meštrović's ambitious plans were never realized, and the sculptures, which embodied Yugoslav nationalism and were the focus of the Serbian Pavilion at the International Exhibition in Rome in 1911, became part of the museum's collection. There are studies and bronzes of Serbian folklore heroes Marko Kraljević, Srdja Zlopogledja, and Miloš Obilić. A marble relief, *The Maiden of Kosovo*, and the over life-size figures *Widows*, *Small Widow*, and *Memories* are impressive testimony to Meštrović's skill at carving marble. Portraits of Meštrović's parents, a bronze of his father and a plaster study of his mother, are also in the collection.

The museum owns a small but representative collection of western European art. A fine *Nativity* and *Madonna Enthroned* by Paolo Veneziano are notable among early Italian paintings. Some late Byzantine-Cretan icons offer comparisons. Other early Italian paintings include an *Enthroned Virgin* by Spinello Aretino, *The Adoration* from the school of Ferrara, and a *Crucifixion with the Virgin and St. John* by a Tuscan master. There are a few early Northern paintings as well: a *Virgin* from the school of Cologne, a *Virgin of the Apocalypse with Donor and Saint* by an unknown master, and a *Temptation of St. Anthony* from the studio of Hieronymus Bosch.

The Italian Renaissance is represented by the tondo *Adoration* by Lorenzo di Credi. There are several Venetian works, including the full-length figures *St. Sebastian* and *St. Roch* by Vittore Carpaccio, a *Portrait of a Venetian Nobleman* attributed to Titian, and a *Virgin and Child with Donor* by Tintoretto. Northern Renaissance paintings include *The Portrait of a Man with a Rosary* by Joos van Cleve, a *Portrait of a Spanish Nobleman* by Anthonis Mor (Antonio Moro), *St. John Preaching* by an unknown Netherlandish master, and a large painting by the Romanist Jan Sanders van Hemessen, *The Tribute Money*.

The museum possesses a larger collection of Baroque paintings. Among the Italian examples are *Magdalen and Angels* attributed to Annibale Carracci, *Concert* after Caravaggio, *Entombment* by Daniele Crespi, *Bacchus and Ariadne* by Antonio Zanchi, and *St. Cecelia* by Bernardo Strozzi. Rubens is represented by the fine large canvas *Diana Presenting Pan with the Quarry*, in which Frans Snyders executed the animal still life, and a portrait study, *The Emperor Galba*. Several other Flemish Baroque portraits are on display: *Girl with a Bonnet* by Cornelis de Vos, *Woman with White Collar* by Justus Susterman, and a studio version, *Self Portrait*, by Anthony van Dyck. Two works by David Teniers, the *Temptation of St. Anthony* and the genre scene *In the Tavern*; a *Battle Scene* by Sebastian Vranx; and a fine flower piece by Jan "Velvet" Bruegel round out the Flemish Baroque collection.

The painting collection includes a variety of works by the seventeenth-century Dutch "little masters": *Still Life with Fruit* by Abraham van Beyeren, *Still Life* by Willem van Aelst, *Dutch Landscape* by Jan van Goyen, *Seascape* by Allart van Everdingen, and *Musicians* by Frans van Mieris. There are also several portraits, including *Man with a Black Cap* by Jan van Ravesteijn, *Lady with a Lamb* by Caspar Netscher, and the fine *Portrait of Children* by Jan Victors.

There are several eighteenth-century landscapes: the particularly nice *Landscape with St. John* by Alessandro Magnasco and views of Venice by Antonio Canaletto and Francesco Guardi. *The Park in Summer* by Hubert Robert is a good example of his work. The *Portrait of the Regent Philip of Orleans and Mme. Parabère* by Robert Levrac Tournières is a good example of Rococo portraiture.

The collection of nineteenth-century art contains a neoclassical work, *Coriolanus*, by Demares, an obscure pupil of David. There are two landscapes by Corot—*Italian Landscape* and *In the Park*—and *Claire de Lune* by Charles François Daubigny. By the Dutchman Johann Jongkind, there is the small landscape *Foundry in Grenoble*; the realist school is represented by the painting *The Haystacks* by Leon Lhermitte. Of Honoré Daumier there is *The Mother*. Portraits include those by the Austrian painters Ferdinand Waldmüller and Leopold Kupelwieser and the German Franz Krüger. Two fine small portraits by the Russian master Ilya Repin represent the painter Kuznetsov and the composer Glinka.

The museum is especially rich in late nineteenth- and early twentieth-century paintings. Many of these works come from the collection of Erich Šlomović, an enthusiastic follower of the Parisian art scene whose holdings were enriched by a generous gift from the art dealer Ambrose Vollard. Šlomović was murdered by the Nazis during World War II, and some years later his collection became part of the National Museum.

Almost all of the forty-five works by Renoir and twenty-eight by Degas in the museum belonged to Šlomović; only a fraction are exhibited. Most of the Renoirs are from his later years. Especially noteworthy are the oils *The Little Girl with the Straw Hat*, *Maison de la Poste at Cagnes*, *Bather*, *Lady in Small Purple Hat*, and *The Cup of Coffee*. The studies include *Scene of the Moulin de la Galette*, *The Smiling Man*, and several *Bathers*. Among the works of Degas are an early drawing, *Head of a Florentine*, as well as pastel and charcoal drawings, *Dancers in Blue Tutus*, *Woman Leaving Her Bath*, *Bust of Man in Soft Hat*, *Head of Drunken Man*, and many studies of dancers and women at their toilettes. *In the Drawing Room* is one of three Degas monotypes in the collection. *Barges on the Loing* by Alfred Sisley; two works by Camille Pissarro, *Place de la Comédie Française*—a gift of Mrs. Chester Beatty—and *Green Landscape*; *Mother and Child* by Mary Cassatt; and a *View of Rouen Cathedral* by Monet round out the exceptional Impressionist collection.

An early van Gogh, *The Peasant Woman*, and three works by Gauguin—*Still Life*, *Tahitian Woman*, and a watercolor, *Tahitian Woman with Dog*—represent the Post-Impressionists. There are several other late-nineteenth-century paintings:

Portrait of Mlle. Sère de Rivière by Toulouse-Lautrec; *Girl with a Cup* by Paul Signac; a similar subject, *Child at Table*; *Still Life*; and *Girl with Book* by Pierre Bonnard; the especially fine *Interior* by Édouard Vuillard; *Young Girl with Flowers* and *The Tired Centaur* by Odilon Redon; *View of the Sea* by Jan Toorop; and *House with Garden* by Max Liebermann.

A number of early-twentieth-century paintings complete the collection. Of the Fauve school there are Matisse's *Purple Beeches* and *At the Window*, Derain's *Sailboats*, and Vlaminck's *Snow*, *The Garden*, *Still Life with Fish*, and *Fields*. Cubism is represented by the early *Head of a Woman* by Picasso. *Portrait of a Woman* by André Lhote and *Two Sisters* by Marie Laurencin also reflect Cubist influences. There is a small early landscape by Kandinsky. Robert Delaunay is represented by *Runners*, an "Orphic" painting; Marc Chagall by a scene from a Russian village, *Man and Cow*; and Raoul Dufy by his *Self Portrait* and a landscape *The Bay of San-Juan-les-Pins*. The museum owns two fine paintings by Georges Rouault, *Clown* and *Père Ubu*. The collection also includes a *Still Life* by Suzanne Valadon and five paintings by her son Maurice Utrillo. An abstract *Composition* by Piet Mondrian is a typical example of his work.

The graphics department of the National Museum includes a large collection of prints and drawings by Yugoslav artists. There are also about two thousand foreign works, only a fraction of which are displayed. The holdings include prints by Dürer, Lucas van Leyden, Hendrich Goltzius, Marcantonio Raimondi, Rembrandt, and Hogarth. The collection is particularly strong in works of the nineteenth and twentieth centuries. Along with the drawings of Renoir and Degas mentioned above are drawings by Toulouse-Lautrec, van Gogh, Pissarro, Bonnard, Redon, Matisse, and Picasso and prints by Rouault and Chagall, among others.

The museum also possesses an extensive numismatic collection. It has an active program of publication in its periodical *Zbornik Narodnog Muzeja* and the many catalogs of its collections and the numerous exhibitions it organizes. There is an extensive research library. Photographs of many of the works of art are available.

Selected Bibliography

Museum publications: *National Museum, Beograd, Guidebook*, 1970; *Narodni Muzej, Beograd*, 1952; Garašanin, D., *Katalog metala, Narodni Muzej*, 1954; *Georges Rouault, 1871–1958, Izložba grafike*, 1958; Grbić, M., *Odabrana grčka i rimska plastika u Narodnom Muzeju u Beogradu*, 1958; *Iliri i Grci, njihovi kulturni odnosi u prošlosti naše zemlje na osnovu arheološkog materijala*, 1959; *Jean-Louis Forain, Pierre Bonnard, Izložba crteža*, 1961; *Katalog nalaza iz nekropole kod Trebeništa*, 1956; Kolarić, M., *Katarina Ivanović, Mina Vukomanović*, 1958; idem, *Klasicizam kod Srba*, 1965; idem, *Rano-gradjansko slikarstvo kod Srba*, 1957; idem, *Srpska grafika XVIII veka*, 1953; idem, *Srpska umetnost XVIII veka*, 1954; Mano-Zisi, D., *Antika u Narodnom Muzeju u Beogradu*, 1954; Milošević, D., *Art in Mediaeval Serbia from the 12th to the 17th Century*, 1980; idem, *Ikone bokokotorska ikonopisna škola u Narodnom Muzeju*, 1971; idem, *Miroslavljevo jevandjelje (L'evangéliaire de Miroslav)*, 1972; *Paul Signac i njegovi*

prijatelji, 1959; *Pleneristi*, 1960; *Zbornik Radova (Recueil des travaux)*, 1956–57 to the present.

Other publications: *Art on the Soil of Yugoslavia from Prehistoric Times to the Present* (Belgrade 1971); *L'Art en Yougoslavie de la préhistoire à nos jours, Grand Palais* (Paris 1971); Bihalji-Merin, O., ed., *Art Treasures of Yugoslavia* (Belgrade 1969); Mirković, L., *Miroslavljevo evandjelje* (Belgrade 1950); Rouart, D., *The Unknown Degas and Renoir in the National Museum of Belgrade* (New York 1964); Srejović, D., *Museums of Yugoslavia, Great Museums of the World* (Belgrade 1979).

RUTH E. KOLARIK

Zaire

———— Kinshasa ————

INSTITUTE OF THE NATIONAL MUSEUMS OF ZAIRE (officially L'IN-STITUT DES MUSÉES NATIONAUX DU ZAIRE; also IMNZ), Mont Ngalie-ma, Kinshasa.

The complex of museums known as the Institut des Musées Nationaux du Zaire (IMNZ) was formed by presidential decree in March 1970. The decree incorporated into a new national museum institute four existing museums and envisaged expansion to six.

The four original museums were established by the Belgian colonial govern-ment and the Friends of the Museum. They consisted of the Musée de la Vie Indigene, Kinshasa (formerly Leopoldville), the Musée de Leopold II in Lu-bumbashi (formerly Elizabethville), and two smaller museums in Kananga and Mbandaka (formerly Luluabourg and Coquilhatville). During the political trou-bles following independence in 1960, the collections of all of the museums deteriorated and began to be dispersed.

In 1970 President Mobutu decided to combine all of the museums into a single organization to centralize administration and preserve and augment the national art collection. The newly created IMNZ was put under the direction of M. Lucien Cahen, director of the Musée Royale de l'Afrique Centrale, Tervuren, Belgium. Frère Joseph Cornet was in charge of building up the collection at the central headquarters of the IMNZ in Kinshasa. He is now the director-general. By the end of 1971 university-trained Zairians were working in all sectors of the mu-seum's activities.

The IMNZ has been financed entirely by the government of Zaire, at first under direct control of the president's office but since 1975 under the control of

the Department of Culture and Arts. Its purpose is twofold: to exhibit the national art collection to the public and to function as a scientific research institute.

A director-general and associate director-general, appointed by the president, administer the IMNZ, which has a staff of more than fifty. It is divided into the research sections, the technical section, and the administrative section, each with a director. The research sections are traditional art, music, archaeology, and modern art, each with a section head. The technical section is concerned with restoration and documentation, maintenance of the collection, and photography. The administrative section deals with personnel, accounts, and transportation.

The reorganization of the national museums in 1970 envisaged three categories of museum: the headquarters, situated in the largest museum, was to be in Kinshasa; Lubumbashi, in Shaba Province, and Kisangani, in Haut Zaire, Zaire's two other university cities, were to have large museums with complete collections for exhibit and reserves; and there were to be three smaller museums, the two at Mbandaka, Equateur Province, and Kananga, Kasai, and another to be built at either Goma or Bukavu in Kivu. Thus a nationwide museum complex was planned, and plans for building were drawn up. Funds, however, were not forthcoming, and the IMNZ has had to operate and house its collection in temporary quarters in Kinshasa on Mont Ngaliema. These facilities do not include exhibition space, but in 1977 the Académie des Beaux Arts made a room available for a permanent exhibit and a second smaller room for temporary exhibits.

The museum building in Lubumbashi already existed in 1960. It houses the collection of the former Musée de Léopold II, as well as more pieces sent from Kinshasa. Currently, the exhibit open to the public there is larger than that in Kinshasa. The museum at Kisangani has never been built. The Kananga museum is small, staffed by only two people; the Mbandaka museum is currently closed, and no museum has yet been built in Kivu.

The IMNZ aimed to build, during an initial five-year period, a collection that represented all of Zaire. Since it has an ethnographic as well as an artistic orientation, its goal has been to collect not only pieces of aesthetic value but also ones that represent the whole range of fabricated objects, with functional value in society, for each of the different peoples of Zaire. The IMNZ also aimed to inventory traditional music systematically and to carry out archaeological excavations and protect existing sites.

The collection of traditional art was built up in two ways, beginning in 1970. The first was to send collecting missions to each of the different peoples of Zaire. Twelve or fifteen missions were carried out each year, each consisting of two scientific personnel, two vehicles, and two drivers who traveled through the villages of each region for two to three months. There were parallel missions for recording traditional music.

The collection was also built up by buying pieces that were brought to the museum for sale in large numbers twice a week. Documentation for works acquired by this means, however, was not nearly so complete or so reliable as that for pieces acquired in the field. After five years the collection numbered

forty thousand pieces. In many instances series of a particular object, rather than single examples, were obtained, to further research on particular topics. By 1975 only a few objects were coming onto the market, and the IMNZ was having financial difficulties. Acquisitions have continued but at a very slow rate. The collection now totals more than forty-five thousand pieces.

In its early years the IMNZ had little contact with the public: it had no space in which to exhibit nor did it have material for a sufficiently balanced exhibit, since collecting proceeded through one region of the country at a time. Thus, at first, work primarily consisted of collecting, restoring, and filing. The collection included the material acquired by the IMNZ and also what remained of the collections of the original museums. In 1977 the Belgian government made very important additions when it agreed to return to Zaire some of the works of traditional art from the Musée Royale de l'Afrique Centrale (q.v.) at Tervuren, the famous collection begun by Léopold II. The condition for return of the pieces was that they be exhibited to the public, and at this time the IMNZ found exhibition space. A careful selection was made by Tervuren to fill the gaps in the IMNZ's collection by giving back examples of art forms no longer obtainable from the people themselves.

The collection is now one of immense importance for scholars of traditional African art. It is relatively unknown because of its recent growth and its inaccessibility due to lack of a museum building in Kinshasa. As it becomes better known, the scale and quality of some of the holdings may revolutionize ideas on the art of certain peoples, for instance, the Kuba and the Kongo.

The Kuba holdings include some extraordinary treasures. One of them is a king figure (ndop), one of the limited series of commemorative statues of the Kuba kings in existence. It is one of the pieces returned by Tervuren. A unique Kuba holding in the collection is a royal costume. Such costumes are always buried with the king, but this example was obtained from an unsuccessful claimant to the throne who had a costume made prematurely and gave it to the museum when he failed to become king. Other Kuba masterpieces include an extraordinary number and variety of masks and, in many cases, the raffia costumes that go with them. Among the masks are many examples of the composite wood, leather, raffia cloth, bead, cowrie, and feather ornamented variety (*mwaash a mbooy*, *ngaadi mwaash*, and *bwoom*), used at initiations and royal dances, as well as a wide range of the wooden-helmet type. Other examples of Kuba art of superb quality and represented in large numbers are drums, carved boxes, raffia cloth, and beadwork. There is also a pair of the big bowls used for dyeing raffia. A rare holding is a considerable collection of the ornamented tablets (*bongotol*) made by women for the dead, to be buried with them or kept as mementos. The IMNZ was fortunately able to obtain many works of Kuba art during the dispersal of the royal treasure, including some objects previously almost unknown. One area of weakness in the Kuba collection is in carved goblets and cups, an art form in which the Tervuren collection is particularly strong. It is worth noting

here that the IMNZ's collection of cups from the neighboring Lele is numerous in contrast to the few held by Tervuren.

The IMNZ's holdings in Kongo art are another outstanding feature of its collection and greatly expand our knowledge of the scope of this art. Grave sculpture is especially noteworthy, in particular the series of about one hundred *mintadi*, the carved-stone grave figures often seated cross-legged. This is the finest museum collection of such works. Equally remarkable are the large number of pottery funerary stelae recently discovered. They are circular, hollow, up to two feet or more high, and have molded or incised decoration of great beauty and variety. This is an ancient Kongo art form previously completely unknown.

The collection of Yaka art is another area of strength for the IMNZ. It includes about three thousand small statues, which are not, however, well documented, and a huge number of masks, more recent than those at Tervuren.

Another area of unusual interest in the collection is its holdings in European earthenware from the trade with Europe found in Bas Zaire, including Toby jugs; Staffordshire figures; Jersey porcelain, including copper luster; ironstone ware; and dishes from Maestricht and Westerwalt.

The musicology section of the IMNZ has a large collection of tapes made from field recordings among the different peoples of Zaire. There are also still photographs and films of the ceremonies and dances. The archaeology section has applied modern techniques to existing excavations as a preliminary to excavation of new sites and completion of an archaeological survey of the entire country. The collection of modern art is small because of recent financial restrictions on purchasing. It consists mainly of sculpture and painting.

The IMNZ has published reports for 1970–71, 1972, and 1973 (*Rapports de l'Institut des Musées Nationaux*) that contain pertinent legislative texts, short reports on all field trips, and photographs.

Selected Bibliography

Museum publications: *Trésors de l'Art Traditional*, 1973; *Art from Zaire: 100 Masterworks from the National Collection*, 1975; *Pierres Sculptés du Bas Zaire*, 1978; *Perles, Parure, et Trésor de l'Africain*, 1979; *The Four Moments of the Sun: Kongo Funerary Art*, 1981.

Other publications: Nzembele Safiri and Zola Mpungu Mayala, "Faisons connaissance avec l'Institut des Musées Nationaux," *Cultures au Zaire et en Afrique*, Kinshasa, ONRD, no. 5 (1974), pp. 71–110; Cornet, J., *A Survey of Zairian Art: The Bronson Collection* (Raleigh, N.C. 1978); Neyt, F., *Traditional Arts and History of Zaire* (Brussels 1981); Van Guluwe, H., *Belgium's Contribution to the Zairian Cultural Heritage,"* *Museum*, vol. 31, pt. 1 (1979), pp. 32–37; Biebuyck, Daniel, *The Arts of Zaire*, vol. 1, *Southwestern Zaire* (Berkeley, Calif. 1985); idem, vol. 2, *Eastern Zaire* (Berkeley, Calif. 1986).

JANET MacGAFFEY

Glossary of Terms

Abhya Mudra. Symbolic hand gesture in Indian and Asian art signifying protection of the faithful and dispelling fear.

Acroterion. Ornamental block on the apex and at the lower angles of a pediment, bearing a statue or a carved finial.

Adlocutio. Latin speech, address.

Aedicula. Ornamental architectural frame, having columns or pilasters at the sides and an entablature or canopy at the top.

Aegis. Shield or breastplate of Zeus or Athena bearing, at its center, the head of the Gorgon (q.v.).

Akpata. Nigerian musical instrument, a type of harp.

Akwanshi (atal). Large Nigerian carved stone monuments, possibly memorials to dead chiefs. Middle Cross River, Nigeria.

Alaja. Nigerian priest.

Albarello. Majolica jar used in fifteenth and sixteenth-century Italy and Spain for storing dry drugs.

Amphora. Greek storage jar with a large egg-shaped body and two handles, extending from the lip to the shoulder.

Ancona. Large, elaborately framed altarpiece made in one piece composed of several compartments.

Animalier. Sculptor or painter of animal subjects.

Antefix. Ornament at the eaves of a classical building concealing the ends of the joint tiles of the roof.

Antependium. Decoration of the front of an altar, such as a covering of silk or a painted panel.

Apsara. Erotic heavenly nymph depicted in Indian art.

Aquamanile (pl. aquamanili). Medieval ewer or pitcher, often in grotesque animal form.

Architrave. Bema; lowest division of the entablature resting upon column tops; also loosely applied to the molded frame surrounding a door or window.

Arhat. Buddhist who has attained Nirvana.

Aribalos. Incan bottles of special form used for carrying beer.

Asologun. Nigerian musical instrument, a linguaphone.

Astracon. *See* Ostracon.

Astragal. Narrow half-round molding, often ornamented with bead and reel, beneath a capital.

Astrolabe. Instrument used to observe the positions of celestial bodies before the invention of the sextant.

Atlantes. Colossal carved male figures serving as pillars, also known as telamones; male equivalent of caryatids.

Autotochthounous. Native to the soil.

Avalokitesvara. Bodhisattva (q.v.) of mercy. Most popular of the Bodhisattva types represented in Mahayana Buddhist art.

Aworo. Nigerian chief priest.

Ayagapatta. Jain votive slab, as well as object of worship, decorated with symbols and diagrams symbolizing the cosmos.

Baldachino. Cloth canopy fixed or carried over an important person or a sacred object; ornamental structure resembling a canopy.

Berlina. Heavy traveling carriage.

Bibelot. Small household ornament or decorative object.

Biga. Two-wheeled chariot drawn by two horses harnessed abreast.

Bikarum. Skin-covered cap mask from Bokyi, Cross River State, Nigeria.

Blanc de chine. White Chinese porcelain associated primarily with the Ching Dynasty.

Bodegon. Spanish genre or still-life painting of a domestic subject.

Bodhisattva. Being who has attained the goal of Nirvana, but has postponed it in order to minister eternally to allay the suffering of all creatures; personification of the Buddha's virtues and power.

Bozzetto. Sculptor's preliminary sketch or model in clay or wax for a larger work, more fully worked out than a maquette (q.v.).

Brahma. Creator god of the Hindu sacred trinity including Shiva, "the destroyer," and Vishnu, "the preserver" (qq.v.).

Brocatelle. Stiff decorative fabric with patterns in high relief.

Bucchero ware. Greyish-black Etruscan pottery produced from the end of the seventh century B.C. until the beginning of the fifth century B.C.

Buccina. Conch-shell trumpet, often represented in the hands of a Triton.

Butaca. Venezuelan upholstered, slanted armchair.

Byobu. Japanese folding screens.

Cairac monster. Symbolic Guatemalan representation of natural forces of ruin.

Caldarium. Chamber with hot water baths in Roman baths buildings (thermae).

Canopic jar. Egyptian funerary vessel which held the entrails of an embalmed body.

Capricci. Imaginative landscapes or cityscapes, often architecturally accurate but fantastic in juxtaposition.

Cartonnage. Glued linen material of which Egyptian mummy cases are made.

Cartoon. Full-size drawing made for the purpose of transferring a design to a painting, tapestry, or other large work.

Cassone (pl. cassoni). Italian marriage chest.

Cauac. Symbolic representation of natural forces associated with rain usually taking the form of a grotesque head.

Cavinate. Shaped like a keel or prow of a ship.

Cella. The main body of a classical temple, excluding the portico and other external structures, containing an image of a deity; naos (q.v.).

Censer. Vessel in which incense is burned.

Chaitya. A Buddhist shrine.

Champlevé. Enameling technique in which enamel is fused into incised or hollowed areas of a metal base.

Chasuble. Sleeveless outer vestment worn by the celebrant at Mass.

Cheminée. Medieval fireplace.

Chia. Shang Dynasty Chinese bronze wine vessel; Chüeh (q.v.).

Chikan. Indian embroidery on calico or muslin, made chiefly in Lucknow.

Ch'ing tz'u. Green colored Chinese porcelain.

Chinoiserie. Chinese-inspired motifs and ornamentation especially popular in eighteenth-century Europe.

Chiton. Sleeveless gown or tunic worn next to the skin in ancient Greece.

Chthonic cult. Greek and Roman cult relating to deities and spirits of the underworld.

Chüeh. Chinese Shang Dynasty bronze vessel. Chia (q.v.) is a related type.

Chung. Chinese bells.

Ciborium. Vessel for Eucharistic wafers; canopy or baldachino (q.v.) placed over an altar or tomb.

Cippus. Stele (q.v.), burial stone, or monument.

Cist. Box or chest, especially for sacred utensils; also a stone chamber.

Cistern. Reservoir, tank, or vessel for the storage of water.

Claustra. Panels pierced with geometric designs used in nineteenth- and twentieth-century architecture.

Claustrum. Covered passages around an open space connecting church with chapter house, refectory, and other parts of a monastery; cloisters.

Clipeus. Large round shield or disk, ornamenting a temple or house.

CoBrA. Association of painters from Copenhagen, Brussels, and Amsterdam, post–World War II, founded in Paris.

Columbarium. Subterranean sepulchre with niches in walls for cinerary urns.

Commedia dell'arte. Sixteenth through eighteenth-century Italian comedy in which masked entertainers improvised on stock characters and themes.

Condottiere. Leader of a private band of mercenary soldiers in fourteenth- and fifteenth-century Europe.

Conpas. Small Incan stone figures representing llamas, alpacas.

Copper plate grants. Charters or land grants in several languages engraved upon copper.

Cosmati. Colored marble and decorative stone inlay work in geometric patterns.

Cuirass. Roman armor made of tooled leather, covering the body from neck to waist.

Daedalic. Greek sculptural style of the early Archaic period (late eighth and seventh century B.C.).

Daimio (also Daimyo). Hereditary feudal nobleman of Japan.

Découpage. Art of decorating an object with designs or illustrations cut from paper.

Dipa laksmi. Indian ceremonial temple lamp in the form of female lamp-bearers.

Dipa vriksa. Indian ceremonial temple lamp in the form of a tree which suspends other lamps.

Dossal. Ornamental cloth, usually embroidered, hung at the back of the altar or at the sides of the chancel.

Dotaku. Japanese bronze bell.

Dvarapalas. Indian door guardians.

Ebonist. Worker in ebony.

Egungun. Deity worshipped by the Yoruba people; male secret society or cult; ceremonial masks worn by members of secret society during masquerades and festivals, Cross River State, Nigeria.

Ekmukhalinga. Phallic emblem of Shiva; sometimes a head carved on all faces.

Ekpe. Ibibio for leopard, associated with political and judicial rituals in secret cult society of Efiks people; ceremonial mask worn during festivals, Cross River State, Nigeria.

Ekpo. Male secret society, with two masks—one beautiful and one fierce—of the Annang-Ibibio Division, Cross River State, Nigeria. (Unrelated to Ekpo masks of Ido Bendel State, Nigeria.)

Ekpu figures. Ancestral figures carved in special hard woods kept in special buildings or lineage houses of the Ekpe society of the Oron area, Cross River State, Nigeria.

Email champlevé. *See* Champlevé.

Emakimono. A Japanese horizontal picture scroll to be unrolled by hand.

Emedjo. Nigerian head-dress with human figure.

Epergne. Dish on an ornamental stand used as a table centerpiece.

Ephebe. Athenian youth between eighteen and twenty years old.

Exedra. Open, often detached rectilinear or curved alcove containing statues or seats in Greek or Roman architecture.

Ex voto. Prayer or votive offering.

Faience. Various kinds of glazed earthenware and porcelain.

Famille noire. Ching Dynasty Chinese porcelain with black background; from the mid-ninteenth century.

Famille rose. Ching Dynasty Chinese porcelain with predominantly rose colored decoration, from the Yung-cheng period, eighteenth century.

Famille verte. Ching Dynasty Chinese porcelain with predominantly green colored decoration adopted in the seventeenth century K'ang-hsi period.

Fang chien. Shang Dynasty Chinese square basin (China).

Fangle lei. Chinese bronze wine vessel.

Fang ting. Chinese square, footed, bronze cauldron.

Fang yu. Square Chinese bronze wine vessel.

Favrile. Tiffany hand-made iridescent glass ware.

Finial. Small ornamental terminal feature at top of a gable, piece of furniture, or lamp.

Fraktur. Illuminated, pictorial Pennsylvania Dutch writing.

Fresco secco. Wall painting on dry plaster ground.

Frigidarium. Chamber in Roman baths (thermae) equipped with a large cold-water bath.

Fuchi. Japanese decorated sword hilts.

Fusuma. A framed and papered sliding door in a Japanese house.

Gana. Dwarf attendants of Shiva (q.v.).

Geison. Projection of a cornice from a wall or colonnade.

Gigaku. A type of Japanese comic dance in which masks covering the whole head are worn.

Gigantomachia. Battle between giants and Olympians in Greek mythology.

Gloriette. Highly decorated chamber in a castle or other building.

Gorget. Piece of armor for the throat; crescent-shaped ornament worn on a chain around the neck as a badge of rank.

Gorgon. Any of three sister monsters, Stheno, Eurale, and Medusa, with snakes for hair, whose glance could turn onlookers into stone.

Greave. Piece of plate armor designed to protect the leg from knee to ankle.

Grisaille. Monochrome painting in grey or greyish color, designed to produce a three-dimensional effect.

Grivna. Russian neck ornament, also a Russian coin struck chiefly in the eighteenth century.

Guardaroba. Cloakroom, wardrobe.

Hacha. A flat stone, often elaborately carved, which resembles part of the costume worn by players of the ancient Mesoamerican ballgame.

Hagiography. Writing and critical study of the lives of the saints or venerated persons.

Halteres. Weights, similar to dumbbells, held in the hands to give impetus in leaping.

Haniwa. Cylindrical clay human or animal figures placed around a tumulus in pre-Buddhist Japan.

Havdalah (habdalah) ceremony. Religious ceremony observed by Jews at the conclusion of the Sabbath.

Havuspex. Etruscan priest.

Hekateion. Cult pillar of Hekate, Greek goddess of earth and Hades, associated with sorcery, hounds, and crossroads.

Herm (pl. hermae). Quadrangular stone pillar supporting a bust of Hermes, used by ancient Greeks and Romans to mark land boundaries, milestones, and as outdoor decoration.

Himation. Garment introduced in late Archaic Greece, consisting of a square of cloth, thrown over the shoulder and wrapped around the body.

Honden. Main hall of a Japanese temple.

Hoplite. Heavily armed ancient Greek foot soldier.

Horus. Egyptian sungod represented as a falcon or hawk.

Hu. Chinese wine-storage vessel with wide body, narrowed neck, and foot rim.

Huang. Chinese disc-shaped ritual jade object.

Hydria. Large Greek two- or three-handled jar for carrying water.

Hypaethron. Central space of a Greek temple or building open to the sky.

Iconostasis. Screen upon which paintings or icons were placed, which separated nave from sanctuary in Byzantine and Russian church architecture.

Ikebana. Japanese art of flower arrangement.

Ikem. Skin-covered ceremonial mask, Cross River State, Nigeria.

Imaret. Turkish hospice for pilgrims and travellers.

Inro. Small lacquered box for carrying medicines or other objects attached to a cord and worn by Japanese with no pockets.

Intaglio. Incised carving with the image or design sunk below the surface; gem, seal or piece of jewelry cut with an incised design.

Intarsia. Italian decoration in inlaid woodwork.

Isocephalic order. Composition having the heads of all figures at approximately the same level, especially in bas-reliefs.

Italiote. Pertaining to Greek colonies in southern Italy or Magna Graeca; Greek inhabitant of ancient Italy.

Ivan. A tall open portico or vaulted hall open to a courtyard.

Ixtle or **Istle.** Fibre from any of several American tropical plants, used in making bags, carpets, etc.

Jataka. Tales of the previous incarnation of Buddha. The "birthstory."

Kakemono. Japanese vertical hanging scroll containing paintings or text, intended to be viewed on a wall and rolled up when not in use.

Kami. Divine being or force in Japanese Shinto religion.

Karikpo. Society of Ogoni people that performs acrobatic masquerades to insure crop fertility and wears ceremonial animal masks, Rivers State, Nigeria.

Kashira. Pommel of a Japanese sword.

Katana. Long fighting sword of a Japanese Samurai.

Kernos. Mycenean ceramic piece, usually in the form of a ring with a number of attached cups or vases.

Keros. Carved and brightly painted Incan wooden vessels.

Kiddush. Jewish ceremony to proclaim the holiness of the Sabbath or a festival, consisting of a benediction before the evening meal.

Kinuta. Sung Dynasty Chinese club-shaped vase; the finest of celadon colors.

Kipu. Incan object made of knotted string used for counting.

Kirikane. Cut-gold decorating technique in the Fujiwara period of Japanese sculpture.

Knop. A small knob or similar rounded protuberance on the stem of a cup, a candlestick, etc.

Kogos. Japanese incense box.

Kore (pl. korai). Archaic period Greek statue of a clothed maiden.

K'ossu. Chinese embroidered silk tapestry technique often used to produce pictorial effects and copies of famous paintings of the past.

Kouros (pl. kouroi). Standing male nude statue of the Greek Archaic period.

Kozuka. Japanese detachable dagger blade.

Krater. Two-handled Greek wine-mixing vessel with wide neck and body and handles projecting from junction of neck and body.

Kuang. Chinese Shang Dynasty animal-shaped bronze ceremonial vessel.

Kuan yin. Chinese Avolokitesvara or Bodhisattva (qq.v.) of mercy.

Kudu. Horseshoe-shaped ornamental motif derived from the Buddhist Chaitya arch.

Kuei. Chinese bronze two-handled ceremonial vessel.

Kundika. Buddhist ewer for holy water.

Kwannon. Japanese equivalent of Chinese Kuan yin or Indian Avalokitesvara (qq.v.).

Kylix. High-stemmed Greek vessel with open, shallow bowl.

Lappet. Small flap or loosely-hanging part of a garment or headdress; an ornamental fabric produced by lappet weaving.

Lei. Chinese ritual vessel.

Lekane. Large, lidded, ovoid bowl on a short stem terminating in a foot, with two handles projecting vertically from the shoulder.

Lekythoi. An ellipsoidal, footed oil jar with narrow neck, flanged mouth, and curved handles extending from below the lip to the shoulder.

Loggia. Arcaded or roofed gallery colonnaded on one or both sides.

Loutrophorus. Greek water jar with elongated neck and flaring mouth which was used for carrying marriage-bath water and as a funerary monument set upon the tombs of unmarried persons.

Lu. Chinese bronze or porcelain incense burner.

Lunette. Semi-circular window or wall panel set into the inner base of a concave vault or dome.

Lung chuan. Sung Dynasty celadon ware named after the type-site located in Chekiang province.

Machicolation. Projecting wall or parapet allowing floor openings through which molten lead and missiles could be dropped on the enemy below.

Maenad. Ecstatic female companion of Dionysius in Greek mythology; counterpart of Roman Bacchante.

Maison de plaisance. Weekend house.

Maitreya. Buddha of the future.

Majolica. Highly decorated Italian earthenware covered with an opaque glaze of tin oxide.

Makama. Nigerian traditional title holder, magistrate.

Makara. Half-fish–half-crocodile creature depicted in Indian art.

Makimono. Horizontal handscroll containing text or painting, intended to be viewed as it is unrolled.

Mallams. Nigerian Muslim teachers or religious leaders.

Mandala. Magic diagram of the Buddhist hierarchy in the imagined shape of the cosmos.

Mandapa. Pillared hall for worshipers in an Indian temple; porch or hallway in front of an Indian shrine.

Mandorla. Almond-shaped body halo containing the representation of a sacred person.

Maniera (Mannerism). Italian sixteenth- and seventeenth-century style in the fine arts employing complex systems of perespective, elongated forms, and strained gestures.

Manillas. Nine or more types of copper or brass rods and curved segments of metal used as currency in southern Nigeria and distributed elsewhere as late as the 1940s, but first introduced by the Portuguese in the fifteenth century.

Maquette. Preliminary sketch for a sculpture in clay or wax. *See also* Bozzetto.

Martele. Hammerlike, shafted weapon having a head with a point on one end and a blunt face at the other.

Mastaba. Ancient Egyptian rectangular, flat-topped funerary mound with battered sides, covering a burial chamber below ground.

Megaron. Central hall of a Minoan or Mycenean house having a hearth at the center and four columns supporting the roof.

Menorah. Seven-branch candelabra for use in Jewish religious services.

Menuki. Pair of ornaments on the sides of the hilt of a Japanese sword or knife.

Metate. Stone with concave upper surface used as the lower millstone for grinding grain, especially maize.

Metope. Panel between two triglyphs in the frieze of a Doric order entablature.

Mihrab. Niche in the wall of a mosque indicating the qibla or direction of Mecca.

Millefleurs. Having a background sprinkled with representations of flowers, as in certain tapestries or pieces of glass work.

Minbar. Pulpit in a mosque.

Mithra (also Mithras). Persian god of light and truth, later of the sun, also worshipped in the Roman Empire during the early Christian centuries.

Mithuna. "Amorous Couples"; Indian sculptural motif representing male and female figures arm-in-arm.

Mohur. Gold coins introduced by various Mogul princes in sixteenth-century India, used later by the British as standard Indian coinage.

Monstrance. Vessel in which the consecrated Host is exposed for adoration.

Mudejar. Pertaining to Spanish Christian architecture of the eleventh through sixteenth centuries, produced under Moorish influence.

Mukanda. Chokwe rite of passage.

Naga, Nagini. Indian male- and female-serpent deity of lakes and rivers, supposed to bring safety and prosperity.

Nandi. The bull of Shiva (q.v.).

Naos. Inner chamber of a Greek temple, which contains the statue of the god; Roman cella (q.v.).

Naranjillo. Eight-colored Venezuelan wood.

Nenfro. Tufa stone used in Etruscan sculpture.

Netsuke. Small Japanese carved or decorated figure worn as a bob or button on a cord by which articles are suspended from a girdle.

Neue Sachlichkeit. Mid-nineteen-twenties movement in German art and literature representing a sharp reaction against experimental and impressionistic art.

Niello. Ornamental work in which a pattern engraved upon a metal ground is filled with niello, a lead-silver-copper-sulphur mixture, having a deep black color.

Nilotic. Of or pertaining to the Nile River or its inhabitants.

Ni-o. Benevolent kings who serve as Japanese temple gate guardian figures.

Nkisi n'konde. Congolese nail figure.

Ntoon. Chief from Nta group, Ejahm peoples, Middle Cross River, Nigeria.

Obassi-Njom. Ceremonial society, involved in detection of witchcraft, of the Ikom people; ceremonial masks of human and animal features, especially the crocodile, Middle Cross River, Nigeria.

Obi. A long, broad sash tied about the waist of a Japanese kimono.

Ocarina. Simple ovoid wind instrument with a projecting mouthpiece and finger holes.

Oinoche. Greek wine pitcher or jug with round or trefoil mouth and curved handle extending from lip to shoulder.

Okakagbe. Nigerian dance.

Oliphant. Medieval musical instrument made from the tusk of an elephant and used as a military bugle, hunting horn, or reliquary.

Oni. King, especially known among the Yoruba people, Ife, Nigeria.

Opus Tessellatum. Roman mosaic pavements with simple figure scenes or geometric designs made of closely fitted tiles (tessarae).

Orant. Female figure in ancient or early Christian art in a kneeling position with outstretched arms and palms up in a gesture of prayer.

Orejeras. Peruvian earrings.

Ormolu. Gilded metal, especially brass or bronze, or imitation gold leaf, used in decoration of furniture.

Orphrey. Ornamental band or border on an ecclesiastical garment; gold embroidery.

Ostracon. Fragments of limestone or potsherds used by the Egyptians in lieu of papyrus for letters, sketches, and ballots.

P'ai lou. Decorative or monumental Chinese gateway having a trabeated form with three compartments, the central one higher than the others.

Palatine. Princely; one of the seven hills upon which ancient Rome was built.

Paludamentum. Cloak worn by officials and the military in ancient Rome.

Pancratium (also Pankration). Ancient Greek athletic contest involving boxing and wrestling.

Papier colle. Cubist technique in which an arrangement of objects and materials was pasted upon a flat surface to achieve a formal design.

Parvati. Consort of the Indian god Shiva (q.v.), daughter of Himalaya, personification of the mountains, another name of the goddess Diva.

Patera. Shallow Roman drinking vessel; embossed ornament in the shape of a circle or ovoid.

Pectoral. Ornamental plate or cross worn on the breast.

Peribolos. A sacred precinct or sanctuary, surrounded by a wall, often containing a temple, statues, etc.

Pi. Chinese ritual jade disc with a hole in the center; symbol of heaven.

Pietre Dure. Type of Italian mosaic in which gemstones are used to imitate the effects of painting in decoration and furniture.

Pithos. Very large, wide-mouthed, ancient Greek vessel used for storing liquids or grain, or for burial of the dead.

Pluteus. Dwarf wall or parapet, as between columns, in Roman architecture.

Podestà. Chief magistrate in medieval Italian towns and republics.

Pokals. Large German glass standing cup.

Poros. Coarse limestone used for building by the ancient Greeks.

Porphyry. Fine-textured, hard, colored stone, mostly in purple and red, taking a high polish.

Predella. Base of a large altarpiece, frequently decorated with panel paintings or sculpture expanding the theme of the major panel(s).

Primo piano. First floor (Italy).

Pronk stilleven. Ostentatious still lifes.

Propylaeum. Imposing gateway in front of and separate from a Greek temple; entrance to the Acropolis in Athens.

Protome. Human or animal bust or half figure.

Putto (pl. putti). Representation of a cherubic, often winged, infant in pictorial or decorative art which developed from the Greek love god Eros.

Pyxis. Covered cylindrical box used in Classical times to hold jewels or toiletries; adopted by the early Church for relics and for the Host.

Quadriga. Classical two-wheeled chariot drawn by four horses harnessed abreast.

Quattrocento. Fifteenth century, as in a period of Italian art and literature.

Ragamala. A garland of musical modes; personified by princes and ladies. Poems describing the thirty-six musical modes.

Ramayana. Classical Sanscrit epic, often illustrated in Pahari painting.

Repoussé. Raised relief metal design formed by hammering the reverse side.

Retable. Shelf on which ornaments may be placed, or frame enclosing decorative panels above the back of an altar; carved altarpiece.

Revetment. Ornamental facing of marble, brick, or tiles on a masonry wall.

Rhyton. Drinking vessel of pottery or bronze, made in the shape of an animal head.

Rinceau. Ornamental foliate or floral motif.

Sagger. Box or case made of refractory baked clay in which fine ceramic wares are enclosed and protected while baking.

Santos. Small carved, brightly painted religious effigies.

Serdab. Hidden chamber inside Egyptian mastaba tomb (q.v.) containing a statue of the deceased.

Sgraffito. Ornamental technique in which a surface layer of paint, plaster, slip, etc., is incised to reveal a ground of contrasting color.

Shiva. God of destruction and regeneration, lord of the dance and one of the Hindu trinity including Brahma and Vishnu (qq.v.).

Shofar. Ram's horn blown as a wind instrument, used in Jewish religious services during the High Holidays.

Silenus. Greek god of the forest, oldest of the satyrs; foster-father and teacher of Dionysus, often depicted in a drunken state.

Sima. A curved molding, concave above, convex below; a raingutter.

Singerie. Picture or decoration in which monkeys are depicted in the role of humans.

Skied. Painting hung high on a wall, above the line of vision.

Socle. Base for a column, pedestal, or sculpture; plinth.

Spangehelm. Frankish chieftain's helmet.

Spherelaton. Bronze-on-wood cult statue.

Stamnos. Wide-mouthed ovoid storage jar tapering at the base and having two horizontal handles set on the shoulder.

Stele (pl. stelae). A standing slab of stone, carved with sculptures in relief and/or inscriptions, used as a gravestone or for other commemorative purposes.

Stellate. Star-shaped.

Stupa. Dome-shaped funeral mound in memory of Buddha or a Buddhist saint, commemorating some event or marking a sacred spot.

Sukkot (Sukkoth). Festival of Tabernacles celebrating the harvest and commemorating the period after the exodus from Egypt during which the Jews wandered in the wilderness and lived in huts.

Sumi-e. Japanese monochromatic ink painting.

Sura. Any of the 114 chapters of the Koran.

Surimono. Miniature Japanese color prints (ukiyo-e, q.v.) inscribed with a poem and designed, often by amateurs, to commemorate a special occasion.

Sutra. Text claimed to have been spoken by the Buddha himself.

Syrinx. Panpipes.

Tanka. Tibetan or Indian temple banners.

Tanto. Japanese dagger.

T'ao t'ieh. Chinese ogre mask; motif characteristic of the Shang dynasty.

Tazza. Shallow, saucerlike bowl or vase, usually having handles and a pedestal.

Temmoku. Brown-black or purple glazes used in Japanese tea bowls.

Tenebrism. Style of painting developed in the late sixteenth century, characterized by dramatic use of chiaroscuro.

Tenon. Projection formed on the end of a timber or the like for the insertion of a mortise of the same dimension forming a joint.

Tepidarium. Chamber in ancient Roman baths equipped with warm water baths.

Thiaso. Ancient Greek group or society worshipping and holding ceremonies in honor of a particular patron deity, usually Dionysus.

Thyrsus. Staff tipped with a pine cone, sometimes trimmed with ivy and vine branches, borne by Dionysus and the Maenads (q.v.).

Ting. Four-square Shang Dynasty Chinese bronze vessel with peg-like legs and loop handles on the sides.

Togatus. Clad in a toga, the loose outer garment worn by Roman citizens.

Tokonoma. Shallow alcove in Japanese architecture for the display of kakemono (q.v.).

Tondo. Painting or relief in circular format.

Torah. Handwritten scroll of the Pentateuch; first of the three Jewish divisions of the Old Testament, used in Jewish religious services.

Torana. Elaborately carved sacred gateway in Hindu and Buddhist architecture having two or three lintels between two posts.

Torc (torque). Collar or necklace worn by the ancient Britons, Gauls, and Germans in the form of a narrow, twisted band, usually of precious metals.

Trecento. The fourteenth century, as in a period in Italian art and literature.

Treen. Household utensils and dishes made of wood.

Tribhanga. Indian dance pose with one leg bent and the body slightly turned at the hips; favored motif in Indian art.

Triratna. Symbol of "the jewel"; the three components of Buddhism: Buddha, the teacher; Dharma, the doctrine; and Sahgha, the priesthood.

Trompe l'oeil. Visual deception, especially in painting, whereby spatial and tactile illusion is created through extremely fine detail.

Tsuba. Metal plate, usually elliptical, serving as the guard of a Japanese sword or knife.

Tsun. Chou Dynasty Chinese bronze vessel, often in the form of an animal or bird.

Tumi. Peruvian ceremonial knives.

Tz'u chou. Sung Dynasty Chinese decorated slip stoneware.

Ukiyo-e. Genre painting and printmaking style popular in Japan from the seventeenth through the nineteenth centuries.

Umiak. Eskimo boat made of a wooden frame covered with skins.

Veduta (pl. vedute). A painting or drawing of a place, usually a town, which may be imaginary or fantastic.

Verone. Balcony.

Vishnu. Hindu god, "the preserver"; one of the Hindu trinity including Brahma, "the creator," and Shiva, "the destroyer" (qq.v.).

Volumen. Egyptian roll of parchment.

Wakizashi. Short Japanese sword carried by a Samurai.

Yaksa (m.), Yaksi (f.). Dravidian nature spirits associated with fertility, depicted in Indian art as colossal male and female figures.

Yurt. Light, circular, portable tent of skins used by the Mongol and Turkic peoples of Central Asia.

Selected Bibliography

The following bibliography includes citations to books, serial publications, and other sources of information regarding art museums and museology. References to journal articles have been omitted, except for a few citations to those containing bibliographies. Entries have been classified according to the following thirty-four museological subject categories:

Access for the Handicapped
Accreditation
Architecture
Associations, Organizations
Attendance, Visitors
Automation
Bibliographies, Bibliographic Services,
 Indices
Cataloging, Registration
Climate Control, Lighting
Conservation, Restoration
Cooperation
Dictionaries, Encyclopedias
Directories
Education, Training
Ethics, Standards
Exhibitions, Displays
Finance, Accounting

General
History
Information Management, Documenta-
 tion, Statistics
Journals
Labels, Communication
Law, Legislation
Management, Administration
Museum Publications
Museum Stores
Personnel
Photography and Slides
Public Relations
Research
Security, Thefts, Insurance
Storage
Techniques, Methods
Trustees

In some instances, references to publications that cover more than one subject area appear in more than one category. References to publications regarding nonart museums and methodology have been included where subjects treated are of general museological interest.

The bibliography is intended to provide a selection of relevant materials available at

the date of compilation (October 1986), and to provide the reader with a means of enhancing and updating this listing. For this reason, references have been provided to a large number of hardcopy and automated bibliographic tools, journals, and professional associations.

Major online bibliographic services such as DIALOG, ORBIT, and BRS include an increasing number of databases which index and abstract publications in the arts. For example, *Artbibliographies Modern, Arts and Humanities Citation Index*, and *Dissertations Abstracts* are available for online as well as for manual searching. Low-cost versions of the major online services are available to personal computer users. Information brokers as well as university and public libraries now offer online search services. Toll-free telephone numbers are included in citations to online services, for users who may wish to request database catalogs.

Professional associations such as the American Association for State and Local History, American Association of Museums, and International Council of Museums provide a rich source of information. In addition to journals and books, they frequently publish bibliographies, reprints, and pamphlets, many of which are not available elsewhere. Most associations will provide a list of publications upon request. For this reason, addresses have been included in citations to professional organizations.

A selection of journals that publish articles on museums, museology, and related subjects have been included. Special issues of journals devoted to specific museum subjects are cited. References to relevant undated pamphlets and reprints are included, where sources are known.

Marlene A. Palmer,
with contributions by Linda Shearouse

ACCESS FOR THE HANDICAPPED

Art Galleries and Records Service. *Museums and the Handicapped*. Leicester, England: Leicestershire Museums, Art Galleries and Records Service, 1976.

Kenney, Alice P. *Access to the Past*. Nashville: American Association for State and Local History, 1980.

Royal Ontario Museum. *The Museum and the Visually Impaired: The Report of the Work Group on Facilities for the Visually Impaired*. Toronto: Royal Ontario Museum, 1980.

Smithsonian Institution. *Museums and Handicapped Students*. Washington, DC: Smithsonian Institution, 1977.

ACCREDITATION

Museum Accreditation: A Report to the Profession. Washington, DC: American Association of Museums, 1970.

Swinney, H. J., ed. *Professional Standards for Museum Accreditation*. Washington, DC: American Association of Museums, 1978.

ARCHITECTURE

Aloi, R. *Museums: Architecture, Technics*. New York: W. S. Heinman, 1962.

A Survey of Alternative Art Spaces. San Francisco: Second Floating Seminar, 1975.

Brawne, Michael. *The New Museum: Architecture and Display.* New York: Praeger, 1966.

Buildings for the Arts. New York: McGraw-Hill, 1978.

Coleman, Laurence Vail. *Museum Buildings.* Washington, DC: American Association of Museums, 1950.

Doumato, Lamia. *Museum Design, 1965–1979.* CPL Bibliography No. 29. Chicago: Council of Planning Librarians, 1980.

Harrison, Raymond O. *The Technical Requirements of Small Museums.* Technical Paper. Ottawa: Canadian Museums Association, 1969.

Jordan, Anne H. *Art Museums Designed for the Seventies.* Monticello, IL: Vance Bibliographies, 1982.

Museums and Adaptive Use: A Special Issue of Museum News. Washington, DC: American Association of Museums, n.d.

Museum Architecture. Special Edition of *Museum.* Paris: UNESCO, 1974.

Museums: Design and Planning. Special Issue of *Progressive Architecture.* Stamford, CT: Progressive Architecture, 1975.

New Places for the Arts. New York: Educational Facilities Laboratories, 1976.

Proposal for a National Museum of the Building Arts. Washington, DC: The Committee for a National Museum of the Building Arts, Inc., 1978.

ASSOCIATIONS, ORGANIZATIONS

American Association for State and Local History. 174 Second Ave., Nashville, TN 37204.

American Association of Museums. 1055 Thomas Jefferson St., NW, Washington, DC 20007.

American Association of Youth Museums. c/o Steven Ling, Lutz Children's Museum, 126 Cedar St., Manchester, CT 06040.

American Institute for Conservation of Historic and Artistic Works. 3545 Williamsburg Lane, NW, Washington, DC 20008.

Art Information Center. 280 Broadway, Suite 412, New York, NY 10007.

Art Libraries Society/North America. 3900 E. Timrod St., Tucson, AZ 85711.

Art Museum Association of America. 270 Sutter St., San Francisco, CA 94108.

Association of Architectural Librarians. 1735 New York Ave., NW, Washington, DC 20006.

Association of Art Museum Directors. 1130 Sherbrooke St., W., Suite 530, Montreal, H3G 1G1, Canada.

Canadian Conservation Institute. National Museums of Canada, Ottawa K1A 0M8, Canada.

College Art Association of America. 149 Madison Ave., New York, NY 10016.

Commonwealth Association of Museums. c/o Commonwealth Institute, Kensington High St., London W8 6NO, England.

Independent Curators Incorporated. 799 Broadway, Suite 642, New York, NY 10003.

Inter-American Center for Museographic Training. OAS, Pan American Union Building, 17th St. and Constitution Ave., NW, Washington, DC 20006.

Intermuseum Conservation Association. Allen Art Building, Oberlin, OH 44074.

International Association of Art Critics. 66 rue de la Concorde, B–1050 Bruxelles, Belgium.

International Association of Libraries and Museums of the Performing Arts. Alexander Schuvaloff, Curator of Theater Museum, Victoria and Albert Museum, South Kensington, London SW7 2RL, England.

International Centre for the Study of the Preservation and Restoration of Cultural Property. 13 Via di San Michele, 00153 Rome, Italy.

International Committee on the History of Art. Alfred A. Schmid, 59 boulevard de Perolles, CH–1700 Fribourg, Switzerland.

International Confederation of Architectural Museums. Royal Institute of British Architects, 21 Portman Square, London W1N 4AD, England.

International Council of Museums (ICOM). Maison de l'UNESCO, 1 rue Miollis, 75732 Paris Cedex 15, France.

International Exhibitions Foundation. 1700 Pennsylvania Ave., NW, Suite 580, Washington, DC 20006.

International Foundation for Art Research Inc. 46 E. 70th St., New York, NY 10021.

International Institute for Conservation of Historic and Artistic Works. 8 Buckingham St., London WC2N 6BA, England.

International Museum Photographers Association. P.O. Box 30051, Bethesda Station, Washington, DC 20014.

International Union for the Protection of Literary and Artistic Works. 34 chemin des Colombettes, Boite postale 18, CH–1211 Geneve 20, Switzerland.

Latin American Museological Association. Museo Nacional de Antropologia, Mexico DF, Mexico.

Museum Computer Network. ECC Building 26, State University of New York, Stony Brook, NY 11794.

Museum Education Roundtable. P.O. Box 8561, Rockville, MD 20856.

Museum Store Association. Elutherian Mills, 61 S. Pine St., Doylestown, PA 18901.

National Art Education Association. 1916 Association Drive, Reston, VA 22091.

National Conservation Advisory Council. c/o Office of Museum Programs, Smithsonian Institution, Washington, DC 20560.

Organization of Museums, Monuments, and Sites of Africa. P.O. Box 3343, Accra 21633, Ghana.

Professional Picture Framers Association. 4305 Sarellen Road, Richmond, VA 23231.

Saving and Preserving Arts and Cultural Environments. 1804 N. Van Ness, Los Angeles, CA 90028.

Scandinavian Union of Museums. Aalborg Historiske Museum, Postbox 1 805, DK–9100 Aalborg, Denmark.

South American Museums Association. IABE, Ciudad Universitaria, Madrid 3, Spain.

The Museums Association. 87 Charlotte St., London, W1, England.

United Nations Educational, Scientific, and Cultural Organization (UNESCO). Department of Culture, Monument and Museum Division, 1 rue Miollis, 75732 Paris Cedex 15, France.

United States Association of Museum Volunteers. 1307 New Hampshire Ave., NW, Washington, DC 20036.

Volunteer Committees of Art Museums of Canada and the United States. 6121 N. 22nd St., Phoenix, AZ 85016.

World Federation of Friends of Museums. Hotel d'Orsay, 9 quai Anatole France, 75005 Paris, France.

Scandinavian Union of Museums. Aalborg Historiske Museum, Postbox 1 805, DK–9100 Aalborg, Denmark.

South American Museums Association. IABE, Ciudad Universitaria, Madrid 3, Spain.

The Museums Association. 87 Charlotte St., London, W1, England.

United Nations Educational, Scientific, and Cultural Organization (UNESCO). Department of Culture, Monument and Museum Division, 1 rue Miollis, 75732 Paris Cedex 15, France.

United States Association of Museum Volunteers. 1307 New Hampshire Ave., NW, Washington, DC 20036.

Volunteer Committees of Art Museums of Canada and the United States. 6121 N. 22nd St., Phoenix, AZ 85016.

World Federation of Friends of Museums. Hotel d'Orsay, 9 quai Anatole France, 75005 Paris, France.

ATTENDANCE, VISITORS

Borhegyi, Stephan F. de and Irene A. Hanson. *Chronological Bibliography of Museum Visitor Surveys*. Milwaukee, WI: Milwaukee Public Museum, 1964.

Communicating with the Museum Visitor. Toronto: Royal Ontario Museum Communications Design Team, 1976.

Dimaggio, Paul. *Audience Studies of the Performing Arts and Museums*. Washington, DC: National Endowment for the Arts, 1978.

Elliott, Pamela. *Studies of Visitor Behavior in Museums and Exhibitions*. Washington, DC: Office of Museum Programs, Smithsonian Institution, 1975.

Ruder, William. *Museum Audiences—Bigger than Ever! But How Big Can We Really Build Them*. AAM Trust Committee Conference Transcripts. Washington, DC: American Association of Museums, n.d.

The Visitor and the Museum. Washington, DC: Program Planning Committee. Museum Educators of the American Association of Museums, 1977.

Tilden, Freeman. *Interpreting Our Heritage: Principles and Practices for Visitor Services in Parks, Museums, and Historic Places*. Rev. ed. Chapel Hill: University of North Carolina Press, 1967.

AUTOMATION

Calo, Mary Ann. *The Computer and the Art Museum*. Syracuse, NY: School of Library Science, Syracuse University, 1974.

Chenhall, Robert G. *Museum Cataloging in the Computer Age*. Nashville: American Association for State and Local History, 1975.

Computers and Their Potential Applications in Museums. Reprint of 1968 ed. Salem, NH: Ayer, n.d.

GRIPHOS Users Guide. Museum Computer Network. Stony Brook, NY: State University of New York at Stony Brook, n.d.

Porter, M. F. *A Unified Approach to Computerization of Museum Catalogues*. London: British Library Association, 1977.

Sarasan, Lenore and A. M. Neuner, comps. *Museum Collections and Computers*. Lawrence, KS: USA Association of Systematics Collections, 1983.

BIBLIOGRAPHIES, BIBLIOGRAPHIC SERVICES, INDICES

Abstracts of Papers Delivered in Art History Sessions. Abstracts of Slide Lectures Presented at CAA Annual Meetings. New York: College Art Association of America, 1968- .

Annuario Bibliografico di Storia dell' Arte. Modena, Italy: Societa Tipografica Modenese, 1954- .

Architectural Periodicals Index. London: RIBA Publications Ltd., 1973- .

Arntzen, Etta and Robert Rainwater. *Guide to the Literature of Art History.* Chicago: American Library Association, 1980.

Architecture Series: Bibliography. Monticello, IL: Vance Bibliographies, n.d.

Art and Archaeology Technical Abstracts. Marina del Rey, CA: Getty Conservation, 1955- .

Artbibliographies Current Titles. Oxford: Clio Press Ltd., 1972- .

Artbibliographies Modern. Oxford: Clio Press Ltd., 1969- .

Art Index. Bronx, NY: H. W. Wilson Co., 1929- .

Art/Kunst. Basel, Switzerland: Helbing and Lichtenhahn, 1972- .

Arts and Humanities Citation Index. Philadelphia: Institute for Scientific Information, 1976- .

Bibliographic Guide to Art and Architecture. [New York Public Library.] Boston: G. K. Hall, 1979- .

Bibliographie zur Kunstgeschichtlichen Literatur in ost- und sud-osteuropaischen Zeitschriften. Munich: Zentral Institut fur Kunstgeschicte in Munchen, 1974- .

Bibliographie zur Kunstgeschictlichen Literatur in Slawischen Zeitschriften. Munich: Zentral Institut fur Kunstgeschicte in Munchen, 1960–1972.

Books in Print. New York: Bowker, 1948- .

Borhegyi, Stephan Francis de. *Bibliography of Museums and Museum Work, 1900–1961.* Milwaukee, WI: Milwaukee Public Museum, 1961.

British Humanities Index. London: The Library Association, 1915- .

BRS [online bibliographic service]. 1200 Route 7, Latham, NY 12110, (800) 883–4707.

Catalog of the Avery Memorial Architectural Library. 2nd ed., enlarged. 19 vols. Suppl., 18 vols. Boston: G. K. Hall, 1968–80.

Catalog of the Harvard University Fine Arts Library, Harvard University, Fogg Art Museum. 15 vols. Suppl., 3 vols. Boston: G. K. Hall, 1971–75.

Catalog of the Library of the Museum of Modern Art. Boston: G. K. Hall, 1976. (Microfilm only.)

Chamberlain, Mary. *Guide to Art Reference Books.* Chicago: American Library Association, 1959.

Cheney, Frances N. and W. J. Williams. *Fundamental Reference Sources.* 2nd ed. Chicago: American Library Association, 1980.

Chapp, Jane. *Museum Publications.* 2 vols. New York: Scarecrow Press, 1962.

CMA Bibliography. Toronto: Canadian Museums Association Documentation Centre, 1984.

Current Contents: Art & Humanities. Philadelphia: Institute for Scientific Information, 1979- .

DIALOG Information Services, Inc. [online bibliographic service]. 3460 Hillview Ave., Palo Alto, CA 94304, (800) 982–5838.

Dictionary Catalog of the Library of the Freer Gallery of Art. 6 vols. Boston: G. K. Hall, 1967.

Dissertations Abstracts International. Section A: Humanities and Social Sciences. Ann Arbor, MI: University Microfilms International, 1938- .

Doumato, Lamia. *Museum Design, 1965–1979*. CPL Bibliography No. 29. Chicago: Council of Planning Librarians, 1980.

Ehresmann, Donald L. *Fine Arts: A Bibliographic Guide to Basic Reference Works, Histories, and Handbooks*. 2nd ed. Littleton, CO: Libraries Unlimited, 1979.

Emergency Preparedness for Museums, Historic Sites, and Archives: An Annotated Bibliography. Technical Leaflet. Nashville: American Association for State and Local History, n.d.

Freitag, Wolfgang M. *Art Books: A Basic Bibliography of Monographs on Artists*. New York: Garland, 1985..

The Frick Reference Library Original Index to Art Periodicals. 12 vols. Boston: G. K. Hall, 1983.

Goor, L. F. "Where to Find: Museum Management Bibliography." *Museum News*, 58 (1980), 67–77.

Index to Periodicals Compiled in the Ryerson Library. [Art Institute of Chicago.] 11 vols. First suppl. Boston: G. K. Hall, 1962–74.

International Museum Bibliography. Paris: International Museum Documentation Center, International Council of Museums, 1969- .

Jordan, Anne H. *Art Museums Designed for the Seventies*. Monticello, IL: Vance Bibliographies, 1982.

Karpel, Bernard, ed. *Arts in America: A Bibliography*. 4 vols. Washington, DC: Archives of American Art, Smithsonian Institution, 1979.

King, M. E. "Where to Find: Bibliography on University Museums." *Museum News*, 58 (1980), 55–57.

Library Catalog of the Conservation Center of the Institute of Fine Arts, New York University. Boston: G. K. Hall, 1980.

Library Catalog of the Metropolitan Museum of Art. 2nd ed. rev. & enl. 48 vols. 1st suppl. Boston: G. K. Hall, 1980–82.

Lucas, Edna Louise. *Art Books: A Basic Bibliography on the Fine Arts*. Greenwich, CT: New York Graphic Society, 1968.

Mobius, Helga. *Bibliographie zur Thuringischen Kunstgeschicte*. Berlin: Akademie-Verlag, 1974.

National Museums of Canada Publications Catalogue. Ottawa: National Museums Canada, 1976.

ORBIT [online bibliographic service]. Systems Development Corporation, 2500 Colorado Ave., Santa Monica, CA 90406, (800) 421–7229.

Rath, Frederick L., Jr. *Bibliography on Historical Organization Practices*. Series. Nashville: American Association for State and Local History, 1975–1980.

Rath, Frederick L., Jr., and Merrilyn Rogers O'Connell, eds. *Research: A Bibliography on Historical Organization Practices*. Nashville: American Association for State and Local History, 1975.

Reisner, Robert G. *Fakes and Forgeries in the Fine Arts: A Bibliography*. New York: Special Libraries Association, 1950.

Repertoire d'Art et d'Archeologie. Paris: Centre de Documentation Sciences Humaines, 1910- .

RILA. International Repertory of Literature of Art. Williamstown, MA: The J. Paul Getty Trust, c/o Sterling and Francine Art Institute, 1975- .

Roulstone, Michael. *The Bibliography of Museum and Art Gallery Publications and Audio-Visual Aids in Great Britain and Ireland, 1979–80.* Cambridge, MA: Meckler Books, 1980.

Selective Bibliography on Museums and Museum Practice. Ann Arbor, MI: Graduate Program in Museum Practice, University of Michigan, 1974.

Sheehy, Eugene P., ed. *Guide to Reference Books.* 9th ed. Chicago: American Library Association, 1976. Suppl. 1980; 2nd suppl., 1982.

Smith, Ralph C. *A Bibliography of Museums and Museum Work.* Washington, DC: American Association of Museums, 1928.

Subject Guide to Books in Print. New York: Bowker, 1957- .

Warburg Institute, London University. *Catalog of the Warburg Institute Library.* 12 vols. 1 suppl. 2nd ed. Boston: G. K. Hall, 1967.

Worldwide Art Catalogue Bulletin. Boston: Worldwide, 1963- .

CATALOGING, REGISTRATION

Cataloging Photographs: A Procedure for Small Museums. Technical Leaflet. Nashville: American Association for State and Local History, n.d.

Chenhall, Robert G. *Museum Cataloging in a Computer Age.* Nashville: American Association for State and Local History, 1975.

Chenhall, Robert G. *Nomenclature for Museum Cataloging.* Nashville: American Association for State and Local History, 1978.

Documenting Collections: Museum Registration and Records. Technical Leaflet. Nashville: American Association for State and Local History, n.d.

Dudley, Dorothy H. *Museum Registration Methods.* Rev. ed. Washington, DC: American Association of Museums, 1979.

Graham, John M. *Methods of Museum Registration.* Reprint. Washington, DC: American Association of Museums, n.d.

Hague, Donald V. and Catherine Hammond. *System for Cataloging Museum Periodicals.* Washington, DC: American Association of Museums, n.d.

Reibel, Daniel B. *Registration Methods for the Small Museum.* Nashville: American Association for State and Local History, 1978.

Schneider, Mary Jane. *Cataloging and Care of Collections for Small Museums.* Columbia, MO: University of Missouri Museum of Anthropology, 1971.

Starkey, Don J. *A Suggested Collections Record System for Museums.* Oklahoma City, OK: Oklahoma Museums Association, 1973.

CLIMATE CONTROL, LIGHTING

Amdur, Elias J. *Humidity Control: Isolated Area Plan.* Washington, DC: American Association of Museums, n.d.

Balder, J. J. *The Discoloration of Colored Objects Under the Influence of Daylight, Incandescent Lamplight, and Fluorescent Lamplight.* Leiden: The Netherlands Museum Association, 1956.

Buck, R. D. *Specification for Museum Air Conditioning.* Reprint. Washington, DC: American Association of Museums, n.d.

Carson, Frederick T. *Effect of Humidity on Physical Properties of Paper*. Washington, DC: U.S. Government Printing Office, 1944.

Control of the Museum Environment: A Basic Summary. London: International Institute for Conservation of Historic and Artistic Works, 1967.

Electrifying Exhibits: Low-Voltage Techniques. Technical Leaflet. Nashville: American Association for State and Local History, n.d.

Harrison, Laurence S. *Report on the Deteriorating Effects of Modern Light Sources*. New York: Metropolitan Museum of Art, 1953.

Lighting of Art Galleries and Museums. London: Illuminating Engineering Society, 1963.

Macleod, Kenneth J. *Relative Humidity*. Ottawa: Canadian Conservation Institute, National Museums of Canada, 1975.

Stolow, Nathan. *Fundamental Case Design for Humidity Sensitive Museum Collections*. Reprint. Washington, DC: American Association of Museums, n.d.

Thomson, Garry. *Conservation and Museum Lighting*. London: The Museums Association, 1970.

Thomson, Garry. *Museum Environment: Control for Preservation*. London: Butterworths, 1978.

Tse, Brian Hingpo. *A Study of Natural Light for Museums*. Cambridge, MA: The author, 1977.

CONSERVATION, RESTORATION

Applications of Science in the Examination of Works of Art; Proceedings of the Seminar: June 15–19, 1970. Boston: Museum of Fine Arts, 1973.

Asmus, J. F. et al. *Venetian Art Preservation Via Holography*. La Jolla, CA: Science Applications, Inc., 1972.

Birks, L. S. *Electron Probe Microanalysis*. New York: Wiley-Interscience, 1971.

Bradley, Morton C. *The Treatment of Pictures*. Cambridge, MA: Art Technology, 1950.

Butler, Marigene H. *Polarized Light Microscopy in the Conservation of Painting*. Chicago: Art Institute of Chicago, 1970.

The Care of Paintings. UNESCO Publications No. 778. Paris: UNESCO, 1951.

Clapp, Anne F. *Curatorial Care of Works of Art on Paper*. Oberlin, OH: Intermuseum Laboratory, 1978.

Conservation and Restoration for Small Museums. Perth, Australia: Western Australian Museum, 1981.

The Conservation of Cultural Property, with Special Reference to Tropical Conditions. Paris: UNESCO, 1968.

Conservation of Mural Paintings in Different Countries: Report on the General Situation. Rome: International Centre for the Study of the Preservation and the Restoration of Cultural Property, 1960.

Conservation of Paintings and the Graphic Arts. London: International Institute for Conservation of Historic and Artistic Works, 1972.

Contributions to the London Conference on Museum Climatology. London: International Institute for Conservation of Historic and Artistic Works, 1968.

Coremans, Paul. *Problems of Conservation in Museums*. London: Allen and Unwin, 1969.

Emile-Male, Gilberte. *The Restorer's Handbook of Easel Painting*. New York: Van Nostrand Reinhold Co., 1976.

Feller, Robert L. *Control of Deteriorating Effects of Light on Museum Objects: Heating Effects of Illumination by Incandescent Lamps*. Washington, DC: American Association of Museums, n.d.

Feller, Robert L., Nathan Stolow, and Elizabeth H. Jones. *On Picture Varnishes and Their Solvents*. Cleveland, OH: Case Western Reserve University Press, 1971.

Gulbeck, Per E. *The Care of Antiques and Historical Collections*. 2nd ed., rev. and expanded. Nashville: American Association for State and Local History, 1985.

Hanlan, J. E. *Effect of Electronic Photographic Lamps on the Materials of Works of Art*. Reprint. Washington, DC: American Association of Museums, n.d.

Harvard University, William Hayes Fogg Art Museum. *Technical Studies in the Field of the Fine Arts*. 10 vols. Cambridge, MA: Harvard University Press, 1932–42.

Held, Julius. *Alteration and Mutilation of Works of Art*. Raleigh, NC: Duke University Press, 1963.

Hours, Madeleine. *Conservation and Scientific Analysis of Painting*. New York: Van Nostrand Reinhold Co., 1976.

Infrared and Ultraviolet Photography. Rochester, NY: Eastman Kodak Co., 1972.

International Inventory of the Museum Laboratories and Restoration Workshops. Rome: International Centre for the Study of the Preservation and the Restoration of Cultural Property, 1960.

Keck, Caroline K. *A Handbook on the Care of Paintings for Historical Houses and Small Museums*. Nashville: American Association for State and Local History, 1967.

Keck, Caroline K. *How to Take Care of Your Paintings: The Art Owner's Guide to Preservation and Restoration*. Nashville: American Association for State and Local History, n.d.

Keck, Sheldon and Caroline K. Keck. *Conservation of Paintings*. Cooperstown, NY: New York State Historical Association, 1962.

MacLeish, A. Bruce. *The Care of Antiques and Historical Collections*. Nashville: American Association for State and Local History, 1972.

Museum Documentation Association. Conservation Working Party. *Proposals for the Documentation of Conservation in Museums*. MDA Occasional Paper 1 0140–7198. Duxford, England: Museum Documentation Association, 1977.

Museums and Preservation of the National Heritage within the Framework of Sweden's Cultural Policy. Stockholm: Riksantikvarieambetet och Statens Historika Museum, 1973.

Ostroff, Eugene. *Rescuing Nitrate Negatives*. Reprint. Washington, DC: American Association of Museums, n.d.

Perkinson, Roy L. *Conserving Works of Art on Paper*. Reprint. Washington, DC: American Association of Museums, n.d.

Plenderleith, Harold J. *The Conservation of Prints, Drawings, and Manuscripts*. Oxford, England: Oxford University Press, 1937.

Plenderleith, Harold J. and A.E.A. Warner. *The Conservation of Antiquities and Works of Art: Treatment, Repair, and Restoration*. 2nd ed. New York: Oxford University Press, 1971.

Pomerantz, Louis. *Is Your Contemporary Painting More Temporary Than You Think?* Chicago: International Book Co., 1962.

Presentation and Conservation of Modern Art. Special Issue of *Studio*. London: Studio International, 1975.

Rath, Frederick L., Jr., and Merrilyn Rogers O'Connell, eds. *Care and Conservation of*

Collections: A Bibliography on Historical Organization Practices. Nashville: American Association for State and Local History, 1975.

Recent Advances in Conservation. London: Butterworths, 1963.

Roche, Roger. *Conservation—Necessity and Functions*. Picture Conservation Report No. 3. Ottawa: Public Archives of Canada, 1971.

Ruhemann, Helmut. *The Cleaning of Paintings: Problems and Potentialities*. New York: Praeger, 1968.

Stolow, Nathan. *Procedures and conservation standards for museum collections in transit and on exhibition*. Paris: UNESCO, 1981.

Stout, George L. *The Care of Pictures*. 1948. Reprint. New York: Dover Publications, 1974.

Thomson, Garry, ed. *Recent Advances in Conservation, Contributions to the IIC Rome Conference, 1961*. London: Butterworths, 1963.

Toch, Maximillian. *Paint, Paintings, and Restoration*. New York: Van Nostrand, 1931.

Training in the Conservation of Paintings. London: Calouste Gulbenkian Foundation, 1972.

Turner, Gerald P.A. *Introduction to Paint Chemistry*. London: Chapman and Hall, 1967.

Wild, Angenitus Martinus De. *The Scientific Examination of Pictures: An Investigation of the Pigments Used by Dutch and Flemish Masters from the Brothers Van Eyck to the Middle of the 19th Century*. London: G. Bell & Sons, 1929.

COOPERATION

Huyghe, R. *Co-ordination of International Art Exhibitions*. Paris, International Council of Museums, 1950.

Museum and Cultural Exchange: Papers from the Eleventh General Conference of ICOM, Moscow, 23–29 May, 1977. Paris: International Council of Museums, 1979.

Museum Cooperation. Special Issue of *Museum News*. Washington, DC: American Association of Museums, 1980.

Museum Cooperation. Special Issue of *Museums Journal*. London: Museums Association, 1979.

DICTIONARIES, ENCYCLOPEDIAS

Aldine, Jules. *The Aldine Art Dictionary*. New York: Frederick Ungar, 1966.

Britannica Encyclopedia of American Art. Chicago: Encyclopedia Britannica Corporation, 1973.

Encyclopedia of World Art. 15 vols. New York: McGraw-Hill, 1956–1968.

Fleming, John and Hugh Honour. *Dictionary of the Decorative Arts*. New York: Harper and Row, 1977.

Gettens, Rutherford J. and George Stout. *Painting Materials: A Short Encyclopedia*. 1942. Reprint. New York: Dover Publications, 1966.

Haggar, Reginald G. *A Dictionary of Art Terms: Painting, Sculpture, Architecture, Engraving and Etching, Lithography and Other Art Processes, Heraldry*. New York: Hawthorn Books, 1962.

Lexikon der Kunst. Leipzig: Seemann, 1968–1971.

Mayer, Ralph. *A Dictionary of Art Terms and Techniques*. New York: Thomas Y. Crowell, 1969.

Meyers, Bernard S., ed. *McGraw-Hill Dictionary of Art*. 5 vols. New York: McGraw-Hill, 1969.

Murray, Peter and Linda Murray. *A Dictionary of Art and Artists*. Baltimore: Penguin Books, 1968.

Osborne, Harold, ed. *Oxford Companion to Art*. Oxford: Clarendon Press, 1970.

DIRECTORIES

Abse, Joan. *The Art Galleries of Britain and Ireland: A Guide to Their Collections*. Oldenhill, England: ABC Travel Guides, 1973–1974.

American Art Directory. New York: Jacques Cattell Press, 1985.

Beatty, Michael and James Nulte. *Guide to Art Museums: Midwest Edition*. South Bend, IN: And Books, 1984.

Buchanan, O. M. *Brief Directory of Museum Associations and Related Organizations*. St. Thomas, VI: Island Resources, 1976.

Christensen, Erwin Ottomar. *A Guide to Art Museums in the United States*. New York: Dodd, Mead, 1968.

Cooper, Barbara and Maureen Matheson, eds. *The World Museums Guide*. London: Threshold Books, 1973.

Duchien, Michel, ed. *Archives, Libraries, Museums and Information Centers with Index Archives*. Vols. 1–29. New York: K. G. Saur, 1984.

Duckles, Richard A., ed. *Directory of Museums, Art Galleries and Archives of British Columbia*. Victoria, BC: British Columbia Museums Association, 1985.

Faison, S. Lane, Jr. *The Art Museums of New England*. Boston: Godine, 1982.

Freudenheim, Tom. *American Museum Guides: Fine Arts*. Vol. 1. New York: Macmillan, 1983.

Germaine, Max. *Artists and Galleries of Australia and New Zealand*. Sydney: Lansdowne Editions, 1979.

Guide to Museum-Related Resource Organizations. Reprint. Washington, DC: American Association of Museums, n.d.

Hanauer, Gary. *Small Museums of the West*. San Francisco: California Living Books, 1983.

Handbook of Museums: West Germany, East Germany, Austria, Switzerland, Liechtenstein. 2nd ed. New York: K. G. Saur, 1981.

Hudson, Kenneth. *Directory of Museums and Living Displays*. 3rd ed. New York: Stockton Press, 1985.

Hudson, Kenneth and Ann Nicholls, eds. *Directory of World Museums*. 2nd ed. London: Macmillan, 1981.

International Directory of Arts/Internationales Kunst Adressbuch/Annuaire International des Beaux-Arts. 2 vols. Berlin: Deutsch Zentral Druckerie. 1952- .

Klotz, Heinrich. *New Museums in Germany*. New York: Rizzoli International, 1985.

London Art and Artists Guide. 2nd rev. ed. London: Art Guide Publications, 1981.

McCoy, Garnett. *Archives of American Art: a Directory of Resources*. New York: R. R. Bowker, 1972.

Mueller, Kimberly J. *California Museum Directory*. California Information Guides Series, Claremont, CA: California Institute Publications, 1980.

Museums in Africa: A Directory. Bonn: German Africa Society, 1970.

Museums of the World. Detroit: Gale Research Co., 1985.

The Official Museum Directory. Wilmette, IL: National Register, 1985.

Schweers, Hans F. *Gemalde in Deutschen Museen*. Munich: Saur, 1981.

Sherman, Lila. *Art Museums of America: A Guide to Collections in the United States and Canada*. New York: Morrow, 1981.

Sloan, Blanche Carlton. *Campus Art Museums and Galleries*. Carbondale, IL: Southern Illinois University Press, 1981.

Truesdell, Bill. *Directory of Unique Museums*. Phoenix, AZ: Oryx Press, 1985.

EDUCATION, TRAINING

A Curriculum for Museum Studies Training Programmes. Ottawa: Canadian Museums Association, 1979.

A Curriculum Guide for Universities and Museums. Washington, DC: American Association of Museums, 1973.

Australian UNESCO Seminar, University of Melbourne. *Training for the Museum Professional*. Canberra, Australia: Australian Government Publishing Service, 1975.

Booth, Jeanette H. et al. *Creative Museum Method and Educational Techniques*. Springfield, IL: C. C. Thomas, 1982.

Dong, Margaret. *Museum Studies International, 1984*. Washington, DC: Smithsonian Institution, 1985.

Hausman, Jerome J. *The Museum and the Art Teacher*. Washington, DC: George Washington University and the National Gallery of Art, n.d.

Inter-American Center for Museographic Training. OAS, Pan American Union Building, 17th St. and Constitution Ave., NW, Washington, DC 20006.

International Council of Museums, Training Unit. *La formation professionnelle du personnel de musee dans le monde: etat actuel du Probleme*. Jos, Nigeria: Centre bilingue de formation techniciens de musee en Afrique, 1972.

Low, Theodore L. *The Educational Philosophy and Practice of Art Museums in the United States*. Columbia University Teachers College. Contributions to Education No. 942. 1948. Reprint. New York: AMS Press.

Maxon, John. *Museum Techniques in Fundamental Education*. New York: Unipub, 1959.

Murphy, Judith and Ronald Gross. *The Arts and the Poor: New Challenge for Educators*. Washington, DC: Government Printing Office, 1968.

Museum Education Anthology. Rockville, MD: Museum Education Roundtable, n.d.

Museum Education for Retarded Adults: Reaching Out to a Neglected Audience. New York: Metropolitan Museum of Art, 1979.

Museums, Imagination, and Education. Paris: UNESCO, 1973.

Museums and Education. Washington, DC: Smithsonian Institution Press, 1968.

Museum Studies Programs in the United States and Abroad. Washington, DC: Smithsonian Institution Office of Museum Programs, 1979.

Newsom, Barbara, ed. *The Art Museum as Educator*. Berkeley, CA: University of California Press, 1978.

Oliver, Ruth N., ed. *Museum and the Environment: A Handbook for Education*. Washington, DC: American Association of Museums, n.d.

Olofsson, Ulla K., ed. *Museums and Children*. New York: Unipub, 1979.

Planning Museum Tours: For School Groups. Technical Leaflet. Nashville: American Association for State and Local History, n.d.

Russell, Charles. *Museums and Our Children*. New York: Central Book Company, 1956.

Schools and Museums. A Report on the School-Museum Cooperative Education Project. Albany, NY: University of the State of New York. State Education Department, Curriculum Development Center, 1968.

Stan, Susan. *Careers in an Art Museum.* Minneapolis: Lerner Pubs., 1983.

Thomas, Minor W., Jr. *Springfield Armory Museum, Springfield, Massachusetts: Proposals for Academic Museum Curricula.* Washington, DC: Preservation Press, 1974.

Training for Docents: How to Talk to Visitors. Technical Leaflet. Nashville: American Association for State and Local History, n.d.

Training in the Conservation of Paintings. London: Calouste Gulbenkian Foundation, 1972.

Volunteer Docent Programs: A Pragmatic Approach to Museum Interpretation. Technical Leaflet. Nashville: American Association for State and Local History, n.d.

Zetterberg, Hans L. *Museums and Adult Education.* New York: Kelley, 1969.

ETHICS, STANDARDS

Museum Ethics. Special Issue of *Museum Journal.* London: Museums Association, 1977.

Museum Ethics. Washington, DC: American Association of Museums, 1978.

Perrot, Paul N. *Ethics of the Museum.* Oklahoma City, OK: Oklahoma Museums Association, 1977.

Professional Practices in Art Museums: A Report of the Ethics and Standards Committee. Montreal: Association of Art Museum Directors, n.d.

Swinney, H. J., ed. *Professional Standards for Museum Accreditation.* Washington, DC: American Association of Museums, 1978.

EXHIBITIONS, DISPLAYS

Brawne, Michael. *The Museum Interior: Temporary and Permanent Display Techniques.* New York: Architectural Book Publishing Company, 1982.

Brawne, Michael. *The New Museum: Architecture and Display.* New York: Praeger, 1966.

Carmel, James H. *Exhibition Techniques—Travelling and Temporary.* New York: Reinhold, 1962.

Cofer, Janet. *Manikins for the Small Museum.* Columbia, MO: University of Missouri Museum of Anthropology, 1970.

Doumato, Lamia. *Museum Design, 1965–1979.* CPL Bibliography No. 29. Chicago: Council of Planning Librarians, 1980.

Exhibition Regulations. London: Arts Council of Great Britain, 1950.

Ezell, Mancil, ed. *Making Nonprojected Visuals and Displays.* Nashville: Broadman, 1975.

Fabricating Bubble-Top Cases for Portable Exhibits. Technical Leaflet. Nashville: American Association for State and Local History, n.d.

From Field-Case to Show-Case. Amsterdam: Gieben, 1980.

Gallery and Exhibit Design. Technical Leaflet. Nashville: American Association for State and Local History, n.d.

Hall, Pauline. *Display.* Toronto: Department of Public Records and Archives, 1969.

Harris, Karyn Jean. *Costume Display Techniques.* Nashville: American Association for State and Local History, 1977.

Huyghe, R. *Co-ordination of International Art Exhibitions*. Paris: International Council of Museums, 1950.

Mankind Discovering. Toronto: Royal Ontario Museum, Exhibits Communication Task Force, 1978–1979.

Manual of Exhibit Properties. Detroit: Detroit Historical Museum, 1956.

Neal, Arminta. *Exhibits for the Small Museum*. Nashville: American Association for State and Local History, 1976.

Planning Exhibits: From Concept to Opening. Technical Leaflet. Nashville: American Association for State and Local History, n.d.

Post, Nonnie. *On Permanent View*. New York: P. Glenn Publications, 1971.

Preparing Exhibits: Methods, Materials, and Bibliography. Technical Leaflet. Nashville: American Association for State and Local History, n.d.

Presentation and Conservation of Modern Art. Special Issue of *Studio*. London: Studio International, 1975.

Ross, David A. *Museum Exhibits*. Oklahoma City, OK: Oklahoma Museums Association, 1974.

Temporary and Traveling Exhibitions. Paris: UNESCO, 1963.

Wakefield, Hugh and Gabriel White. *Circulating Exhibitions*. Handbook for Museum Curators F1. London: The Museums Association, 1959.

Ward, Philip R. *In Support of Difficult Shapes*. Victoria, BC: British Columbia Provincial Museum, 1978.

Warren, Jefferson T. *Exhibit Methods*. New York: Sterling Publishing Company, 1972.

FINANCE, ACCOUNTING

Arey, June B. *The Purpose, Finance and Governance of Museums: Three Conferences on Present and Future Issues*. Wayzata, MN: Spring Hill Center, 1978.

Creative Approaches to Solving Museum Financial Problems. Conference Transcripts. Reprint. Washington, DC: American Association of Museums, n.d.

Daughtrey, William H. and Malvern J. Gross, Jr. *Museum Accounting Handbook*. Washington, DC: American Association of Museums, 1978.

Fox, Daniel M. *Engines of Culture: Philanthropy and Art Museums*. Madison, WI: State Historical Society of Wisconsin, 1963.

Hartman, Hedy A. *Funding Sources and Technical Assistance for Museums and Historical Agencies*. Nashville: American Association of State and Local History, 1979.

Hartman, Hedy A. *Fund Raising for Museums*. Bellevue, WA: Hartman Planning and Development Group, 1985.

Non-Profit Accounting: Current Developments. Technical Leaflet. Nashville: American Association for State and Local History, n.d.

Securing Grant Support: Effective Planning and Preparation. Technical Leaflet. Nashville: American Association for State and Local History, n.d.

GENERAL

Alexander, Edward P. *Museum Masters*. Nashville: American Association for State and Local History, 1983.

Alexander, Edward P. *Museums in Motion: An Introduction to the History and Functions of Museums*. Nashville: American Association for State and Local History, 1978.

Alexander, Edward P. *The Museum: A Living Book of History*. Detroit: Wayne State University Press, 1959.

Are Art Galleries Obsolete? Toronto: Peter Martin Associates, 1969.

Baxi, Smita J. *Modern Museum: Organisation and Practice in India*. New Delhi, India: Abhinav Publications, 1973.

Bazin, Germain. *The Museum Age*. New York: Universe Books, 1967.

Buchanan, O. M. *What Is a Museum: An Essay on a Definition Dilemma*. St. Thomas, VI: Island Resources, 1976.

Burcaw, G. Ellis. *Introduction to Museum Work*. Nashville: American Association for State and Local History, 1975.

Cart, Germaine. *Museums and Young People*. Paris: International Council of Museums, 1952.

Cauman, Samuel. *The Living Museum: Experiences of an Art Historian and Museum Director—Alexander Dorner*. New York: New York University Press, 1959.

Coleman, Laurence Vail. *The Museum in America*. 3 vols. Washington, DC: American Association of Museums, 1939.

College and University Museums. Special Issue of *Museum News*. Washington, DC: American Association of Museums, 1980.

Conflict in the Arts. Cambridge, MA: Arts Administration Research Institute, 1976.

Damm, Robert L. *What's Your Status: Governing Authority*. Reprint. Washington, DC: American Association of Museums, n.d.

Dana, John Cotton. *The New Museum*. Woodstock, VT: The Elm Tree Press, 1917.

Dickenson, Victoria, comp. *Guide to Federal Services for Museums*. Ottawa: National Museums of Canada Museum Assistance Programs, 1978.

Doherty, B., ed. *Museums in Crisis*. New York: Braziller, 1972.

Dwivedi, V. P., ed. *Museums and Museology: New Horizons: Essays in Honour of Dr. Grace Morley*. Delhi, India: Agam, 1980.

Flower, William H. *Essays on Museums*. 1898. Reprint. Salem, NH: Ayer, 1972.

Future Directions for Museums of American Art. Fort Worth, TX: Amon Carter Museum, 1980.

Gilman, Benjamin Ives. *Museum Ideals of Purpose and Methods*. Cambridge, MA: Harvard University Press, 1923.

Guthe, Carl Eugen. *So You Want a Good Museum? A Guide to the Management of Small Museums*. Washington, DC: American Association of Museums, 1973.

Harrison, Molly. *Changing Museums: Their Use and Misuse*. New York: Humanities Press, 1968.

Harvey, Emily D. and Bernard Friedberg, eds. *A Museum for the People*. Salem, NH: Ayer, 1971.

Hendon, William S. *Analyzing an Art Museum*. New York: Praeger, 1979.

Hudson, Kenneth. *Museums for the Nineteen-Hundred-Eighties: A Survey of World Trends*. New York: Holmes and Meier, 1978.

Kelly, Kenneth L. *Universal Color Language*. Reprint. Washington, DC: American Association of Museums, n.d.

Kuntz, Andreas. *Technikgeschichte und Museologie*. Frankfurt am Main, Germany: Lang, 1981.

Lee, Sherman E., ed. *On Understanding Art Museums*. New York: American Assembly, 1975.

Levin, Michael D. *Modern Museum: The Temple Showroom*. New York: Hippocrene Books, 1984.

Meyer, Karl E. *The Art Museum: Power, Money, and Ethics*. New York: Morrow, 1981.

Mills, John FitzMaurice. *Treasure Keepers*. Garden City, NY: Doubleday, 1973.

Museology and Museum Problems in Pakistan. Lahore, Pakistan: Lahore Museum, 1981.

Museum and Adaptive Use. Special Issue of *Museum News*. Washington, DC: American Association of Museums, n.d.

Museum and Archival Supplies Handbook. Toronto: Ontario Museum Association and Toronto Area Archivists Group, 1978.

Museum in Motion? The Hague, The Netherlands: Government Publishing Office, 1979.

Museums and Preservation of the National Heritage within the Framework of Sweden's Cultural Policy. Stockholm, Sweden: Riksantikvarieambetet och Statenshistorika Museum, 1973.

Museums for a New Century: a Report. Washington, DC: American Association of Museums, 1984.

Museums: Their New Audience. A Report to the Department of Housing and Urban Development by a Special Committee of the American Association of Museums. Washington, DC: American Association of Museums, 1972.

Naumer, Helmuth J. *Of Mutual Respect and Other Things: An Essay on Museum Trusteeship*. Washington, DC: American Association of Museums, 1977.

Neal, Arminta. *Help! For the Small Museum*. Boulder, CO: Pruett Press, 1969.

Problems and Trends in Museology. New Delhi, India: India Ministry of Education, 1966.

Reisner, Robert G. *Fakes and Forgeries in the Fine Arts: A Bibliography*. New York: Special Libraries Association, 1950.

Ripley, S. Dillon. *The Sacred Grove: Essays on Museums*. Washington, DC: Smithsonian Institution, 1979.

Russell, Charles. *Museums and Our Children*. New York: Central Book Company, 1956.

Savage, George. *Forgeries, Fakes, and Reproductions: A Handbook for the Art Dealer and Collector*. New York: Praeger, 1963.

Schuller, Sepp. *Forgers, Dealers, Experts: Adventures in the Twilight of Art Forgery*. London: A. Barker, 1960.

Searing, Helen. *New American Art Museums*. New York: Whitney Museum of American Art, 1982.

Smilor, Raymond W. *Museums in Transition*. Austin, TX: Management Strategies Group, 1983.

Standing Commission on Museums and Galleries. *Framework for a System for Museums: Report by a Working Party, 1978*. London: Her Majesty's Stationery Office, 1979.

Taylor, Francis Henry. *Babel's Tower, The Dilemma of the Modern Museum*. New York: Columbia University Press, 1945.

Thompson, John M. A., ed. *Manual of Curatorship: A Guide to Museum Practice*. London: Butterworths, 1984.

Wade, Robin. *The Changing Museum Scene*. Melbourne, Australia: Town and Country Planning Board, 1979.

Weil, Stephen E. *Beauty and the Beasts: On Museums, Art, the Law, and the Market*. Washington, DC: Smithsonian Institution, 1983.

Wittlin, Alma S. *Museums in Search of a Usable Future*. Cambridge, MA: MIT Press, 1978.

HISTORY

Alexander, Edward P. *Museums in Motion: An Introduction to the History and Functions of Museums*. Nashville: American Association for State and Local History, 1978.

Bell, Whitfield J., Jr., et al. *A Cabinet of Curiosities: Five Episodes in the Evolution of American Museums*. Charlottesville, VA: University of Virginia Press, 1967.

Coleman, Laurence Vail. *The Museum in America*. 3 vols. Washington, DC: American Association of Museums, 1939.

Constable, W. G. *Art History and Connoisseurship*. Cambridge, England: Cambridge University Press, 1938.

Guthe, Carl E. and Grace M. Guthe. *The Canadian Museum Movement*. Ottawa: Canadian Museums Association, 1957.

Hicks, Ellen C. *American Association of Museums After 72 Years*. Reprint. Washington, DC: American Association of Museums, n.d.

Hudson, Kenneth. *A Social History of Museums, What the Visitors Thought*. Atlantic Highlands, NJ: Humanities Press, 1975.

Impey, O. R. and A. G. MacGregor. *The Origin of Museums*. New York: Oxford University Press, 1985.

Katz, Herbert and Marjorie Katz. *Museums USA: A History and Guide*. Garden City, NY: Doubleday, 1965.

INFORMATION MANAGEMENT, DOCUMENTATION, STATISTICS

American Association of Museums. *A Statistical Survey of Museums in the United States and Canada*. America in Two Centuries Series. 1965. Reprint. Salem, NH: Ayer, 1976.

Collins, Marcia R. *Libraries for Small Museums*. Columbia, MO: University of Missouri Museum of Anthropology, 1977.

Deiss, William A. *Museum Archives: An Introduction*. Chicago: Society of American Archivists, 1984.

Documenting Collections: Museum Registration and Records. Technical Leaflet. Nashville: American Association for State and Local History, n.d.

Jones, Lois Swan and Sarah Scott Gibson. *Art Libraries and Information Services*. Orlando, FL: Academic Press, 1986.

Larsen, John C., ed. *Museum Librarianship*. Hamden, CT: Library Professional Publications, 1985.

Light, Richard D., Andrew Roberts, and Jennifer D. Stewart, eds. *Museum Documentation Systems: Developments and Applications*. London: Butterworths, 1985.

Museum Documentation Association. Conservation Working Party. *Proposals for the Documentation of Conservation in Museums*. MDA Occasional Paper 1 0140–7198. Duxford, England: Museum Documentation Association, 1977.

Museums, Art Galleries, and Related Institutions. Statistics Canada, Publications Sales, Ottawa, K1A 0, Canada.

Orna, Elizabeth and Charles Pettitt. *Information Handling in Museums*. Hamden, CT: Shoe String Press, 1981.

Pacey, Philip, ed. *A Reader in Art Librarianship*. Munich: K. G. Sauer, 1985.

Pacey, Philip, ed. *Art Library Manual. A Guide to Resources and Practice*. London: Bowker, 1977.

Practical Museum Documentation. Duxford, England: Museum Documentation Association, 1980.

Reibel, Daniel B. *Registration Methods for the Small Museum*. Nashville: American Association of State and Local History, 1978.

Roberts, D. A. and R. B. Light. *Museum Documentation Systems*. London: Butterworths, 1986.

Starkey, Don J. *A Suggested Collections Record System for Museums*. Oklahoma City, OK: Oklahoma Museums Association, 1973.

JOURNALS

Aviso. Washington, DC: American Association of Museums, 1968- .

Curator. Westport, CT: Meckler Publishing, 1958- .

Der Preparator. Bochum, West Germany: Verband Deutscher Praeparatoren e. V., n.d.

Gazette. Ottawa: Canadian Museums Association, 1967- .

ICC News. London: International Institute for Conservation of Historic and Artistic Works, n.d.

ICOM News/Nouvelles de l'ICOM. Paris: International Council of Museums, 1948- .

Information Fuer die Museen in der DDR. Berlin, East Germany: Institut fuer Museumsweses der Deutschen Demokratischen Republik, Informat-ionnnn-Dokumentation, 1969- .

International Journal of Museum Management and Curatorship. Bury St. Guilford, England, n.d.

London Federation of Museum and Art Galleries Newsletter. London: London Federation of Museums and Art Galleries, 1979- .

Midwest Museums Conference Quarterly. Chicago: Midwest Museums Conference, 1941- .

Muse. Ottawa: Canadian Museums Association, 1966- .

Musees. Montreal: La Societe des Musees Quebecois, 1978- .

Musees et Collections Publiques de France. Paris: Association Generale des Conservateurs de Musees et Collections Publiques de France, Editions Person, 1932- .

Museogramme. Ottawa: Canadian Museum Association, 1973- .

The Museologist. Buffalo, NY: Northeast Museums Conference, American Association of Museums, 1935- .

Museum. Braunschweig, West Germany: Georg Westerman Verlag GmbH., 1976- .

Museum. Paris: UNESCO, 1948- .

Museumjournal. Otterle, The Netherlands: Netherlands Ministry of Culture, Rijksmuseum Kroeller-Mueller, 1955- .

Museumkunde. Bonn, West Germany: Deutscher Museumsbund, 1980- .

Museum News. Washington, DC: American Association of Museums, 1924- .

Museum Quarterly. Toronto: Ontario Museum Association, 1971- .

Museum Store News. Doylestown, PA: Museum Store Association, 1954- .

Museum Studies/Hakbutsukan Kenkyu. Tokyo, Japan: Japanese Association of Museums—Nihon Hakubutsukan Kyokai, 1928- .

Museumnytt. Oslo, Norway: Norske Kunst- og Kulturhistoriske Museer, 1951- .

Museums Bulletin. London: Museums Association, 1961- .

Museums Journal. London: Museums Association, 1901- .

NEMS News. Durham, England: North of England Museums Service Ltd., n.d.

Neue Museumskunde; Theorie und Praxis der Museumsarbeit. Berlin, East Germany: Ministeri um fuer Kultur, n.d.

Progressive Architecture. Stamford, CT: Penton-IPC, Reinhold Publishing Division, 1920- .

SAMAB; a Journal of Museology. Southernwood, South Africa: South African Museums Association-Suider-Afrikaanse Museumvereiniging, 1936- .

Studies in Conservation. London: International Institute for Conservation of Historic and Artistic Works, 1952- .

Technology and Conservation of Art, Architecture, and Antiquities. Boston, MA: Technology Organization, Inc., 1976- .

Tecnica dell'Arte; Collana di Monografie di Studi Tecnicopittorici Metodi Conservativi e Perizie Techniche e Artistichi di Dipinti, Stampe, Documenti, Carte Valori. Rome: Studio Strini, 1955- .

Travelling Exhibition Information Service Newsletter. Largo, FL: The Humanities Exchange, n.d.

Western Museums Quarterly. Tucson, AZ: Western Regional Conference of American Association of Museums, 1962- .

Worldwide Art Catalogue Bulletin. Boston, MA: Worldwide Books, 1963- .

LABELS, COMMUNICATION

Communicating with the Museum Visitor: Guidelines for Planning. Toronto: Communications Design Team, Royal Ontario Museum, 1976.

Exhibit Labels: A Consideration of Content. Technical Leaflet. Nashvillle: American Association for State and Local History, n.d.

Legible Labels: Hand-Lettering. Technical Leaflet. Nashville: American Association for State and Local History, n.d.

Legible Labels: Three Dimensional Letters. Technical Leaflet. Nashville: American Association for State and Local History, n.d.

Making Exhibit Labels: A Mechanical Lettering System. Technical Leaflet. Nashville: American Association for State and Local History, n.d.

North, F. J. *Museum Labels*. Handbook for Museum Curators B3. London: The Museums Association, 1957.

Serrell, Beverly. *Making Exhibit Labels: A Step-by-Step Guide*. Nashville: American Association for State and Local History, 1983.

Setting Up a Silk-Screening Facility: Guidelines for the Small Museum. Technical Leaflet. Nashville: American Association for State and Local History, n.d.

LAW, LEGISLATION

Agreement on the Importation of Educational, Scientific, and Cultural Materials. Lake Success, NY: United Nations, 1950.

American Law Institute and American Bar Association. *ALI-ABA Course of Study: Legal Problems of Museum Administration*. Philadelphia, PA: Committee on Continuing Professional Education of the American Law Institute and the American Bar Association, 1981.

Hewitt, Arthur R. *Public Library Law, and the Law as to Museums and Art Galleries in England and Wales, Scotland and Northern Ireland*. London: Association of Assistant Librarians, 1975.

Knoll, Alfred P. *Museums*. San Francisco: Bay Area Lawyers for the Arts, 1976.

Legal and Business Problems of Artists, Art Galleries, and Museums. New York: Practicing Law Institute, 1973.

Malaro, Marie C. *A Legal Primer on Managing Museum Collections*. Washington, DC: Smithsonian Institution, 1985.

Molloy, Larry. *One Way to Comply with Section Five-Zero-Four*. Reprint. Washington, DC: American Association of Museums, n.d.

Museums. New York: Practicing Law Institute, 1973.

Phelan, Marilyn E. *Museums and the Law*. Nashville: American Association for State and Local History, 1982.

State Laws as They Pertain to Scientific Collecting Permits. Lubbock, TX: Texas Tech University, 1976.

Technical and Legal Aspects of the Preparation of International Regulations to Prevent the Illicit Export, Import, and Sale of Cultural Property. Paris: UNESCO, 1962.

U.S. Congress, House. *Museum Services Act*. Washington, DC: U.S. Government Printing Office, 1972.

U.S. Congress, House. *Museum Services Act*. Washington, DC: U.S. Government Printing Office, 1974.

U.S. Congress, Senate. *Arts, Humanities, and Museum Services Act of 1979*. Washington, DC: U.S. Government Printing Office, 1979.

U.S. Congress, Senate. *Museum Services*. Washington, DC: U.S. Government Printing Office, 1973.

U.S. Congress, Senate. Committee on Labor and Human Resources. *Museum Services Amendments of 1980: Report to Accompany S. 1429, 96th Congress, 2nd Session*. Washington, DC: U.S. Government Printing Office, Senate Report 96–558, 1980.

Weil, Stephen E. *Beauty and the Beasts: On Museums, Art, the Law, and the Market*. Washington, DC: Smithsonian Institution Press, 1983.

MANAGEMENT, ADMINISTRATION

Allen, Douglas A. and F. S. Wallis. *Administration: Handbook for Museum Curators*. London: The Museums Association, 1960.

Arey, June Batten. *The Purpose, Financing, and Governance of Museums: Three Conferences on Present and Future Issues*. Wayzata, MN: Spring Hill Center, 1978.

Converting Loans to Gifts: One Solution to "Permanent Loans." Technical Leaflet. Nashville: American Association for State and Local History, n.d.

Guthe, Carl Eugen. *So You Want a Good Museum? A Guide to the Management of Small Museums*. Washington, DC: American Association of Museums, 1973.

MacBeath, George and S. James Gooding, eds. *Basic Museum Management*. Ottawa: Canadian Museums Association, 1969.

Malaro, Marie C. *Collections Management Policies*. Reprint. Washington, DC: American Association of Museums, n.d.

Miller, Ronald L. *Personnel Policies for Museums: A Handbook for Management*. Washington, DC: American Association of Museums, n.d.

Museum Planning. Special Issue of *Museum News*. Washington, DC: American Association of Museums, 1980.

Perry, Kenneth, ed. *The Museums Forms Book*. Austin, TX: Texas Association of Museums, 1980.

The Organization of Museums: Practical Advice. Paris: UNESCO, 1960.
White, Anthony G. *Management of Visual Arts—Museums and Galleries: A Selected Bibliography*. Monticello, IL: Vance Bibliographies, 1979.
Zelermeyer, Rebecca. *Gallery Management*. Syracuse, NY: Syracuse University Press, 1976.

MUSEUM PUBLICATIONS

Clapp, Jane. *Museum Publications*. 2 vols. New York: Scarecrow, 1962.
Roulstone, Michael, ed. *The Bibliography of Museum and Art Gallery Publications and Audio-Visual Aids in Great Britain and Ireland*. Westport, CT: Meckler, 1980.
Wasserman, Paul, ed. *Catalog of Museum Publications and Media*. 2nd ed. Detroit: Gale, 1980.

MUSEUM STORES

Newcomb, Kathleen K. *The Handbook for the Museum Store: A Reference for Museum Store Managers and Personnel*. Virginia Beach, VA: Museum Publications, 1977.
The Museum Store: Organizing and Sales Techniques. Technical Leaflet. Nashville: American Association for State and Local History, n.d.

PERSONNEL

Career Opportunities in Art Museums, Zoos, and Other Interesting Places. Washington, DC: Government Printing Office, 1980.
Chapin, Isolde and Richard Mock. *New Faces in Public Places: Volunteers in the Humanities*. Washington, DC: National Center for Citizen Involvement, 1979.
Gallup, Donald Clifford. *A Curator's Responsibilities*. New Brunswick, NJ: New Jersey Graduate School of Library Service, 1976.
La formation professionnelle du personnel de musee dans le monde: Etat actuel du probleme. Professional Training of Museum Personnel in the World: Actual State of the Problem. Jos, Nigeria: International Council of Museums, Training Unit, 1972.
Miller, Ronald L. *Personnel Policies for Museums: A Handbook for Management*. Washington, DC: American Association of Museums, n.d.
Rudman, Jack. *Museum Attendant*. Career Examination Series C–1374. Syosset, NY: National Learning, n.d.
Rudman, Jack. *Museum Curator*. Career Examination Series C–1375. Syosset, NY: National Learning, n.d.
Rudman, Jack. *Museum Instructor*. Career Examination Series C–1705. Syosset, NY: National Learning, n.d.
Rudman, Jack. *Museum Intern*. Career Examination Series C–1376. Syosset, NY: National Learning, n.d.
Rudman, Jack. *Museum Laboratory Technician*. Career Examination Series C–1377. Syosset, NY: National Learning, n.d.
Rudman, Jack. *Museum Technician*. Career Examination Series C–522. Syosset, NY: National Learning, n.d.
Rudman, Jack. *Senior Museum Instructor*. Career Examination Series C–1016. Syosset, NY: National Learning, n.d.

Rudman, Jack. *Supervising Museum Instructor.* Career Examination Series C–1048. Syosset, NY: National Learning, n.d.

Shestack, Alan. *Director: Scholar and Businessman, Educator and Lobbyist.* Reprint. Washington, DC: American Association of Museums, n.d.

PHOTOGRAPHY AND SLIDES

Archival Preservation of Motion Pictures. Technical Leaflet. Nashville: American Association for State and Local History, n.d.

Cataloging Photographs: A Procedure for Small Museums. Technical Leaflet. Nashville: American Association for State and Local History, n.d.

Irvine, Betty Jo. *Slide Libraries. A Guide for Academic Institutions and Museums.* Littleton, CO: Libraries Unlimited Inc., 1974.

Mates, Robert E. *Photographing Art.* Philadelphia: Chilton Books, 1966.

Organizing Your 2 x 2 Slides: A Storage and Retrieval System. Technical Leaflet. Nashville: American Association for State and Local History, n.d.

Ostroff, Eugene. *Rescuing Nitrate Negatives.* Reprint. Washington, DC: American Association of Museums, n.d.

Petrini, Sharon. *A Handlist of Museum Sources for Slides and Photographs.* Santa Barbara, CA: Slide Library, Art Department, University of California, 1972.

Rempel, Seigfried. *The Care of Black-and-White Photographic Collections.* Ottawa: Canadian Conservation Institute, National Museums of Canada, 1980.

Weinstein, Robert A. and Larry Booth. *Collection, Use, and Care of Historical Photographs.* Nashville: American Association for State and Local History, 1977.

PUBLIC RELATIONS

Adams, G. Donald. *Museum Public Relations.* Nashville: American Association for State and Local History, 1983.

Effective Public Relations: Communicating Your Image. Technical Leaflet. Nashville: American Association for State and Local History, n.d.

Reaching Your Public Through Television. Technical Leaflet. Nashville: American Association for State and Local History, n.d.

Working Effectively with the Press. Technical Leaflet. Nashville: American Association for State and Local History, n.d.

RESEARCH

Jones, Lois Swan. *Art Research Methods and Resources: A Guide to Finding Art Information.* 2nd ed., rev. and enlarged. Dubuque, IA: Kendall Hunt, 1984.

Lewis, Ralph H. *Manual for Museums.* Washington, DC: National Park Service, U.S. Department of the Interior, 1976.

Museum and Research: Papers from the Eighth General Conference of the International Council of Museums, Munich, 7–29 - 8–9, 1968. Munich: Deutsches Museum, 1970.

Rath, Frederick L., Jr., and Merrilyn Rogers O'Connell, eds. *Research: A Bibliography on Historical Organization Practices.* Nashville: American Association for State and Local History, 1975.

SECURITY, THEFTS, INSURANCE

A Primer on Museum Security. New York: New York State Historical Association, 1966.

Emergency Preparedness for Museums, Historic Sites, and Archives: An Annotated Bibliography. Technical Leaflet. Nashville: American Association for State and Local History, n.d.

The Guarding of Cultural Property: Protection of the Cultural Heritage. New York: Unipub, 1977.

Esterow, Milton. *The Art Stealers*. New York: Macmillan, 1966.

Fennelly, Lawrence J. *Museum, Archive and Library Security*. New ed. Boston: Butterworths, 1983.

Insuring Against Loss. Technical Leaflet. Nashville: American Association for State and Local History, n.d.

Keck, Caroline K. *Safeguarding Your Collection in Travel*. Nashville: American Association for State and Local History, 1970.

Mason, Donald L. *The Fine Art of Art Security*. New York: Van Nostrand Reinhold, 1979.

Nauert, Patricia and Caroline M. Black. *Fine Arts Insurance: A Handbook for Art Museums*. Montreal: Association of Art Museum Directors, n.d.

Noblecourt, André. *Protection of Cultural Property in the Event of Armed Conflict*. Paris: UNESCO, 1958.

Protection of Museum Collections. Quincy, MA: National Fire Protection, 1974.

Security for Museums and Historic Houses: An Annotated Bibliography. Technical Leaflet. Nashville: American Association for State and Local History, n.d.

Tilotson, Robert G. *Museum Security: La Securite Dans les Musees*. Reprint. Washington, DC: American Association of Museums, n.d.

STORAGE

Dunn, Walter Scott. *Storing Your Collection*. Nashville: American Association for State and Local History, 1970.

Greene, Candace S. *Storage Techniques for the Conservation of Collections*. Oklahoma City, OK: Oklahoma Museums Association, 1977.

Johnson, Ernst Verner and Joanne C. Horgan. *Museum Collection Storage*. Technical Handbooks for Museums and Monuments No. 2. New York: Unipub, 1979.

Stansfield, G. *Physical Storage of Museum Reserve Collections*. London: Museums Association, 1971.

Storing Your Collections: Problems and Solutions. Technical Leaflet. Nashville: American Association for State and Local History, n.d.

TECHNIQUES, METHODS

Banks, Paul. *Matting and Framing Documents and Art Objects on Paper*. Chicago: The Newberry Library, 1968.

Caring for Collections. Washington, DC: American Association of Museums, 1984.

Clapp, Anne F. *Curatorial Care of Works of Art on Paper*. Oberlin, OH: Intermuseum Conservation Association, 1973.

Dolloff, Francis W. and Roy L. Parkinson. *How to Care for Works of Art on Paper*. Boston: Museum of Fine Arts, 1971.

Elder, William V., III. *Dismantling and Restoration of Historic Rooms*. Reprint. Washington, DC: American Association of Museums, n.d.

Fall, Frieda K. *General Rules for Handling Art Museum Objects*. Reprint. Washington, DC: American Association of Museums, n.d.

Fall, Frieda K. *New Industrial Packing Materials: Their Possible Uses for Museums*. Reprint. Washington, DC: American Association of Museums, n.d.

Harding, E. G. *The Mounting of Prints and Drawings*. London: Museums Association, 1972.

Harris, Karyn J. *Costume Display Techniques*. Nashville: American Association for State and Local History, 1977.

Keck, Caroline K. *A Handbook on the Care of Paintings for Historical Agencies and Small Museums*. Rev. ed. Nashville: American Association for State and Local History, 1967.

Keck, Caroline K. *Safeguarding Your Collection in Travel*. Nashville: American Association for State and Local History, 1970.

Landon, Edward. *Picture Framing: Modern Methods of Making and Finishing Picture Frames*. New York: American Artists Group, 1965.

Macbeth, James A. and Alfred C. Strohlein. *Use of Adhesives in Museums*. Reprint. Washington, DC: American Association of Museums, n.d.

The Manual of Curatorship. London: Butterworths, 1984.

Mayer, Ralph. *The Artist's Handbook of Materials and Techniques*. 4th ed., rev. New York: Viking, 1982.

Peterson, Harold L. *How to Tell if It's Fake: A Practical Handbook for the Detection of Fakes for the Antique Collector and Curator*. Nashville: American Association for State and Local History, n.d.

Pomerantz, Louis. *Know What You See: The Examination of Paintings by Photo-optical Techniques*. Washington, DC: American Institute of Conservation History, 1976.

Professional Practices in Art Museums. New York: Association of Art Museum Directors, 1971.

Rempel, Seigfried. *The Care of Black-and-White Photographic Collections*. Ottawa: Canadian Conservation Institute, National Museums of Canada, 1980.

Rowlison, Eric B. *Rules for Handling Works of Art*. Reprint. Washington, DC: American Association of Museums, n.d.

Schneider, Mary Jane. *Cataloging and Care of Collections for Small Museums*. Columbia, MO: Museum of Anthropology, University of Missouri, Columbia, 1971.

Setting up a Silk-Screen Facility: Guidelines for the Small Museum. Technical Leaflet. Nashville: American Association for State and Local History, n.d.

Werner, A. E. *Care of Glass in Museums*. Reprint. Washington, DC: American Association of Museums, n.d.

TRUSTEES

Museum Trusteeship. Special Edition of *Museum News*. Washington, DC: American Association of Museums, 1981.

Naumer, Helmuth J. *Of Mutual Respect and Other Things: An Essay on Museum Trusteeship*. Washington, DC: American Association of Museums, 1977.

The Role of the Trustee: Selection and Responsibility. Technical Leaflet. Nashville: American Association for State and Local History, n.d.

Ullberg, Alan D. *Museum Trusteeship*. Washington, DC: American Association of Museums, 1981.

Webber, E. Leland. *Museum Trustee and the Government*. Reprint. Washington, DC: American Association of Museums, n.d.

Index

A.B. (silver maker), 1311
Aachen, Hans von, 75, 374
Abadia, Juan de la, 911
Abatellis, Francesco, 602
Abbasi, Riza, 328
Abbate, Niccolo dell', 73, 544, 576, 1166
Abbott, Berenice, 1294
Abdulwa-hab, H.H., 989
Abe, Fujasiro, 709
Abe, Kojiro, 709
Aberli, Johann Ludwig, 942
Abildgaard, Nicolai Abraham, 215
Abreu, Rafael Gonzalez, 915
Abstract Expressionist collections: in Chicago,
 Illinois, 1124; in Cleveland, Ohio, 1151; in
 Cologne, Germany, 377; in Copenhagen,
 Denmark, 216; in London, England, 1043;
 in New York City, 1279, 1291, 1292, 1299,
 1304; in Paris, France, 298, 299; in Sydney,
 Australia, 49; in Washington, D.C., 1391–
 92, 1406
Academy Gallery, Florence, 547–50
Acconci, Vito, 301
Achenbach, Moore S., Mr. and Mrs., 1354
Achilles Painter, 44, 437, 999
Achtschellinck, L., 85
Acker, F. van, 86
Acropolis Museum (Athens), 420–24, 433,
 442
Adam, Robert, 1049, 1064, 1086, 1272, 1277,
 1325
Adami, Hugo, 300
Adams, Ansel, 1151–52, 1214, 1274, 1345,
 1358

Adams, Henry, 1103
Adam Thoroughgood House (Norfolk), 1312
Addresses of Pius IX, Room of the (Vatican
 City), 1478–79
Adeane, Robert, Sir, 996
Adelaide, Australia, 35–37
Adler, Blanche, 1082
Adler, Friedrich, 324, 454, 458
Administration of art museums, 15; *See also*
 specific museums
Ador, 1097
Aegean art, 1190–92
Aegina Museum (Athens), 399, 400, 401
Aegina sculptures, 395–96, 398–401
Aelst, Pieter Coecke van, 81, 331, 1476
Aelst, Willem van, 1497
Aertsen, Pieter, 75, 81, 91, 766, 790, 796
Aeschbacher, Hans, 976
Afghanistan, 26–31
African art collections: in Baltimore, Mary-
 land, 1087; in Berlin, Germany, 357–58; in
 Brooklyn, New York, 1233; in Chicago, Il-
 linois, 1126; in Cleveland, Ohio, 1162; in
 Detroit, Michigan, 1169; in Fort Worth,
 Texas, 1175; in Houston, Texas, 1187; in
 Kinshasa, Zaire, 1500–1503; in Lisbon,
 Portugal, 867–68; in Minneapolis, Minne-
 sota, 1216; in Montreal, Canada, 114; in
 Newark, New Jersey, 1224; in New York
 City, 1282; in Seattle, Washington, 1364–
 65; in St. Louis, Missouri, 1344–45; in Ter-
 vuren, Belgium, 100–106; in Toledo, Ohio,
 1374; in Toronto, Canada, 136; in Washing-
 ton, D.C., 1392. *See also* specific countries

Missouri, 1342; in Sydney, Australia, 48; in Toledo, Ohio, 1372; in Vienna, Austria, 59, 61; in Washington, D.C., 1402; in Worcester, Massachusetts, 1419; *See also* British collections

Engraving, ornamental, 1058

Engravings. *See* Prints and drawings

En'i, 700, 726

Enlightenment, 8, 21, 849–50, 918

Ennion of Sidon, 1310

Ensor, James, 52, 59, 81, 87, 89, 124, 376, 411, 417, 934, 1482

Enyo, 1215

Epigraphical collections. *See* Inscriptions, collections of

Epiktetos, 437, 611

Epstein, Jacob, 42, 124, 539, 1082, 1338

Erdiauwa I (Oba), 811

Erechtheum, 422

Eretria Painter, 437

Erhart, Gregor, 70, 283

Erhart, Michel, 357

Erh-li-kang period collections, 192–93, 197; *See also* Chinese art, collections of

Erlach, Benrhard Fischer von, 62

Ernst, Max, 42, 109, 297, 376, 377, 380, 386, 417, 925, 935, 976, 1085, 1151, 1185, 1290, 1299, 1301, 1393, 1408

Erotic artworks collections, 595

Errico, Antonio d' (called Tanzio da Varallo), 662

Ertborn, Florent van, 79

E.S., The Master, 387, 771, 1153

Escher, M.C., 125

Escorial, Diego Lopez del, 892

Escorial, El, 883

Esie National Museum, 803, 805

Eskimo art, 132, 1224, 1235; *See also* Alaskan art

Espinosa, Gustavo, 463

Espona, Santiago, 878

Esquivel, Antonio Maria, 905, 912, 918

Estes, Richard, 1300, 1305, 1373

Esteve, Maurice, 214, 298

Estrada, Jose Maria, 751

Eszterhazy, Miklos, Prince, 474, 478

Eszterhazy, Pal, Prince, 474

Eszterhazy Collection, 474, 477, 478

Etchings. *See* Prints and drawings

Ethnic art collections: in Jerusalem, Israel, 538; in Seattle, Washington, 1364–65

Ethnographical Museum (Berlin), 353, 357–60

Ethnographic collections: in Benin, Nigeria, 812; in Brussels, Belgium, 98–99; in Calcutta, India, 496; in Detroit, Michigan, 1169; in Dublin, Ireland, 528; in Guatemala City, 460–65; in Istanbul, Turkey, 993; in Jerusalem, Israel, 535–36; in Jos, Nigeria, 818; in Kabul, Afghanistan, 30; in Kaduna, Nigeria, 814–16; in Lagos, Nigeria, 820; in London, England, 1029–30; in Mexico City, 755–56, 759; in Newark, New Jersey, 1223–24; in Oron, Nigeria, 805–8; in Tervuren, Belgium, 101–4; in Toronto, Canada, 135–36

Ethnological Museum (East Berlin), 338

Etog, Sorel, 112

Etruscan collections: in Baltimore, Maryland, 1093; in Cincinnati, Ohio, 1131; in Cleveland, Ohio, 1139; in Copenhagen, Denmark, 222; in Detroit, Michigan, 1170; in Glasgow, Scotland, 1016–17; in Naples, Italy, 591; in New York City, 1258; in Osaka, Japan, 711; in Palermo, Sicily, 607–8, 612; in Paris, France, 276, 308; in Rome, Italy, 638–42; in Vatican City, 1468–71; in Warsaw, Poland, 847; *See also* Antiquities, collections of

Etty, William, 48

Euboulides, 435

Eugene of Savoy, Prince, 63, 68

Eugenie, Empress, 264

Eukleides, 435

Eumens II, 324

Eumorphopoulos, G., 425

Euphranor of Corinth, 404

Euphronios (Euphronius), 274, 437, 1258, 1432

European art. *See* specific countries

Evald, Maurice, 1097

Evans, Arthur, Sir, 446, 1074, 1075, 1076

Evans, Frederick H., 1152, 1274, 1327

Evans, Walker, 125, 1087, 1152, 1214, 1294

Evenepoel, H., 82, 88

Everdingen, Allart van, 1146, 1497

Evergood, Philip, 1304, 1310, 1390, 1392

Evreinova, E.A., 1444

Eworth, Hans, 123

Exekias, 44, 274, 325, 436, 640, 1115, 1258, 1371, 1471

Exitheos, 1258

Expressionist collections: in Basle, Switzerland, 934–35; in Bruges, Belgium, 86–87; in Brussels, Belgium, 89; in Cleveland,

Metalwork collections: in Amsterdam, 775; in Athens, Greece, 425; in Barcelona, Spain, 879–80; in Beijing, China, 146–47; in Bombay, India, 494; in Brooklyn, New York, 1243–44; drawings related to, 1058; in East Berlin, 323–24; in Florence, Italy, 559; in Hartford, Connecticut, 1181; in Istanbul, Turkey, 993; in Lagos, Nigeria, 820; in Lima, Peru, 832–33; in London, England, 1047, 1048; in Madras, India, 508; in New York City, 1257, 1261; in Paris, France, 253–54; in Tokyo, Japan, 733, 737; in Toledo, Ohio, 1371; in Vienna, Austria, 70; in Xian, China, 186–87; *See also* Bronze collections; Gold collections; Silver collections

Metaxas, Anastasio, 424

Met de Bles, Henri, 91, 791

"Metropolitan" museum, idea of, 1254

Metropolitan Museum of Art, The (New York), 14, 434, 1017, 1100, 1112, 1127, 1191, 1253–86; American art, 1275–79; arms and armor, 1283–84; Costume Institute, 1284; Egyptian art, 1255–57; European painting, 1262–70; European sculpture and decorative arts, 1270–72, 1275, 1276–77, 1279; Far Eastern art, 1279–81; Greek and Roman art, 1257–58; history and organization of, 1253–55; Islamic art, 1258–60; medieval art, 1260–62; modern art, 1279; musical instruments, 1283; photography, 1255, 1273–74; prints and drawings, 1272–73, 1275; Robert Lehman collection, 1274–75

Metsu, Gabriel, 92, 271, 309, 331, 388, 389, 392, 536, 785, 789, 1068, 1316, 1437

Metsys, Jan, 1315

Metsys, Quentin. *See* Massys, Quentin

Metzinger, Jean, 296

Metz school, 288

Meulen, Adam Frans van der, 577

Meunier, Constantin, 80, 89, 334, 347, 479, 944, 958, 1016, 1206, 1393

Meunier, John, 1012

Meuninckhove, J.B. van, 85

Meurice, Joan-Michel, 300

Mewar school of painting, 494, 518

Mexican art, collections of: in Cleveland, Ohio, 1161; in Los Angeles, California, 1204; in New York City, 1282; in Philadelphia, Pennsylvania, 1326; in Worcester, Massachusetts, 1421

Mexico, 749–63; Mexico City, 749–60; Tepotzotlan, 760–63

Meyer, Felix, 974

Meyer, Gedeon, 932

Meyers, Oliver, 810

Meyrick, Samuel, Sir, 1072

Meytens, Martin van, 65

Michael, Jakob, 533

Michallon, Achille Etna, 269

Michalowski, Kazimierz, 847

Michalowski, Pietr, 839, 840, 850

Michaux, Henri, 297, 1299

Michel, Claude, 1407

Michelangelo, Buonarroti, 5, 57, 280, 283, 335, 548, 549, 550, 556, 572, 576, 600, 638, 643, 770, 772, 904, 1004, 1027, 1033, 1051, 1076, 1102, 1154, 1272, 1359, 1435, 1478

Michelino, Domenico di, 549

Michelozzo di Bartolommeo, 557

Michetti, Niccolo, 627

Michigan, U.S., 1163–71

Middeleer, J., 86

Middle Babylonian era, 285

Middle Byzantine Period in Greece, 428

Middle class, patronage of arts by, 11

Middle Kingdom in Egypt, collections from: in Boston, Massachusetts, 1115; in Brooklyn, New York, 1229; in Cairo, Egypt, 235–36; in Cambridge, England, 997–98; in East Berlin, 320; in Kansas City, Missouri, 1191; in New York City, 1256; in Paris, France, 278

Middle Minoan I and II periods, 448

Middle Minoan II and III periods, 448–50

Middleton, John Henry, 996

Miel, Jan, 631, 658

Mierevelt, Michiel, 786, 903, 1437

Mieris, Frans van, 392, 789, 932, 1437, 1497

Mies van der Rohe, Ludwig, 365, 1183

Migliara, Giovanni, 583, 662

Mignard, Pierre, 1440

Mignon, Leon, 80

Mignot, Daniel, 1271

Mijares, Rafael, 749

Mijn (Myn), Herman (Heeroman), van der, 787

Mijtens (Mytens), Jan, 787

Miklos the Magnificent, Prince, 474

Milan, Italy, 579–89

Milano, Giovanni da, 549, 663

Miles, Elizabeth B., 1181

Millais, John Everett, Sir, 42, 121, 124, 1041, 1077, 1337

About the Contributors

Philip R. Adams is the director emeritus of the Cincinnati Art Museum, having served as director of that museum for twenty-nine years. He has written extensively on nineteenth- and twentieth-century art and has received numerous honorary degrees (Litt.D., D.F.A., and L.H.D.) for his contributions to art history and museum studies.

Barbara C. Anderson is with the J. Paul Getty Museum, after having taught at Southern Methodist University and the Universities of Texas and New Mexico. She received her Ph.D. from Yale University in 1979 and has specialized in sixteenth- to eighteenth-century art of Spain and Latin America.

Gretchen Anderson has been a Ph.D. candidate at the University of Chicago specializing in Austrian Baroque and Rococo art and architecture. She held a Kress Foundation Fellowship for two years for dissertation research in Vienna.

Martha Shipman Andrews has been, since 1976, the coordinator of the Inventory of American Paintings for the National Museum of American Art of the Smithsonian Institution. After receiving degrees from Wellesley and Simmons in art history and library science, she was with the Corcoran Gallery in Washington, D.C.

Emmanuel N. Arinze is head of educational services of the Lagos National Museum, National Commission for Museums and Monuments.

Julia F. Baldwin, documents librarian of the University Libraries at the University of Toledo, received degrees from Ohio State University and the University of Toledo. She currently serves on the American Library Association Government Documents Roundtable.

Elizabeth Courtney Banks is associate professor of classics at the University of Kansas. She received her Ph.D. in classics from the University of Cincinnati and has done much work in Aegean prehistory and Greek and Roman art.

Leah Tourkin Bar-Z'ev, an expert on Jewish ceremonial art and synagogue architecture, received an undergraduate degree from Case Western Reserve and has done graduate work at the Hebrew University of Jerusalem. Before moving to Israel, Bar-Z'ev worked for the Jewish Museum and the Yeshiva University Museum in New York.

Marjorie Harth Beebe, currently the director of Galleries of the Claremont Colleges in California, was formerly associate chairman and acting chairman of the Museum Practice Program and assistant to the director of the University of Michigan Museum of Art. She was the recipient of the National Museum Act Fellowship from the Smithsonian Institution for dissertation research in 1977–80, and her published work includes various museum catalogs and works on nineteenth-century French prints, eighteenth-century theater drawings, and Medardo Russo.

Daniel P. Biebuyck is the H. Rodney Sharp Professor of Anthropology and Humanities at the University of Delaware. Before this, he was at the University of Lovanium in Kinshasa, Zaire; professor and curator of African art collections at the University of California—Los Angeles; and visiting professor at Yale, New York University, London University, and the University of Liege. Since completing his graduate work in classics at Ghent State University and in anthropology at London University, he has had many works published on African art, oral literature, symbolism, and systems of thought.

Ilaria Bignamini is a recipient of the Wolfson Fellowship at the British Academy and is completing her Ph.D. thesis for the Courtauld Institute of London University. She has had works published on the history of industrial design (1750–1850), William Hogarth, Romantic art, and the history of art institutions of eighteenth- and nineteenth-century Britain and Italy.

Karen L. Blank is now with the Hilton M. Briggs Library of South Dakota University. Her master's degrees are in library science and business administration. She spent several years in Australia, working for the Parliamentary Library, which stimulated her interest in Australian and aboriginal art.

Caroline R. Boyle-Turner is currently working on an exhibition of prints from the Pont Aven School, which will tour the United States and travel to Japan in 1986–1987. She received her Ph.D. from Columbia University and has been adjunct professor in Paris for Southern Methodist University.

Claudia Brown is curator of Oriental art at the Phoenix Art Museum and is faculty associate at Arizona State University. Her graduate work at the University of Kansas was in the history of Asian art, and she has had works published on the paintings and decorative arts of the Yüan, Ming, and Ching dynasties.

Lorrie Bunker was the public relations director of the Avery Brundage Collection of the Asian Art Museum of San Francisco and has served on the planning committees of major exhibitions, such as "5,000 Years of Korean Art" and "Treasures from the Shanghai Museum."

Chira Chongkol is curator and director of the Division of National Museums of Thailand. She is also the secretary for the ICOM National Committee and has had published several museum guidebooks and articles on art of Southeast Asia. She has received degrees in education from universities in Bangkok and Sydney, Australia.

Tadeusz Chruścicki has been director of the National Museum in Cracow since 1974 and is also currently the vice-president of the Polish National Committee of ICOM. He did his graduate work at the Jagiellonian University in Cracow and has written extensively on museum history, museology, and art history.

Ellen P. Conant writes and lectures on Asian art history, especially Japanese painting from 1850 to 1950. She has taught at Mount Holyoke College, Wellesley College, the University of Georgia, and Yonsei University in Seoul, Korea. Her graduate work was undertaken at the Institute of Fine Arts, New York University, and at Bryn Mawr College. She has been a recipient of a Fulbright Scholarship at Kyoto University, as well as a Rockefeller Foundation research grant.

Michael P. Conforti is chief curator and also Bell Curator of Decorative Arts and Sculpture at the Minneapolis Institute of Arts. He received both his M.A. and Ph.D. in art history from Harvard University, and was a Fellow at the American Academy in Rome from 1975 to 1977. Conforti has written extensively on early-eighteenth-century Italian sculpture and early-nineteenth-century furniture.

James L. Connelly is associate professor of the Kress Foundation Department of Art History at the University of Kansas. He received undergraduate and doctoral degrees in European history and art history from the University of Kansas, completing his dissertation research at the Archives Nationales and the Louvre in Paris. Dr. Connelly is a recognized expert on French and English art and architecture of the seventeenth and eighteenth centuries. He was named a Benjamin Franklin Fellow of the Royal Society of Arts.

Robert E. Conrad has been an associate professor at the University of Illinois at Chicago and, most recently, a professor of history at the Free University of

Berlin. He has had works published on slavery in Brazil and on the abolition of Brazilian slavery. Dr. Conrad received his Ph.D. from Columbia University in Latin American history.

Ursula E. Conrad was granted her master's degree in medieval art history from the University of Chicago with departmental honors. She is now a doctoral candidate at that institution. She also received a graduate degree in art history from the University of Illinois at Chicago, bestowed with honors of the highest distinction. She has held several fellowships: University of Chicago Fellow, honorary Woodrow Wilson Fellow, and a Kress Foundation Fellowship for dissertation research in Germany.

Glen Cooke is curator of decorative arts at the Queensland Art Gallery in Brisbane, Australia. He received a master's degree in museum studies from George Washington University and has specialized in the computerization of museum records as well as in nineteenth-century English painting and decorative art.

Eustathia P. Costopoulos is completing a dissertation for her Ph.D. from the University of Chicago and her D.E.A. from the University of Paris. She received degrees in history and archaeology and art history from the National University of Athens and the Courtauld Institute of the University of London. Her speciality is nineteenth- and twentieth-century French art (notably prints and drawings) and art criticism.

Samuel P. Cowardin III is associate professor of art history at Clark University, Worcester, Massachusetts. He received his Ph.D. in art history from Harvard University, where he was a Fulbright Fellow. Dr. Cowardin has had work published on Indian art, and his fields of expertise also include the Italian Renaissance and color theory.

Thomas J. Denzler, a former lecturer at Brooklyn College, did his graduate work in art history at the Institute of Fine Arts of New York University. His period of particular interest is art of the nineteenth and twentieth centuries.

Felicity Devlin is education officer for the National Museum of Ireland and has written on the collections of the museum.

Carlos F. Duarte is the vice-president and adviser of the Colonial Museum of Caracas and the chief restorer at the Fine Arts Museum in Caracas. He is also a member of the Royal Academy of Fine Arts of Cordoba, Spain, and the adviser of the Colonial Art Museum of Mérida, Venezuela, and the Art Museum of the Simon Bolívar University in Caracas. Although Mr. Duarte has had works published in many areas, his specialty is the art and decorative arts of the Venezuelan colonial period.

Burton L. Dunbar III is professor of art history at the University of Missouri-Kansas City. He completed his doctorate in the history of art at the University of Iowa, specializing in Northern Renaissance art of the fifteenth and sixteenth centuries. Dr. Dunbar is the author of works on Flemish painting and drawing.

Nancy Hatch Dupree was with the Afghan Tourist organization from 1962 to 1978, and is now Program Associate of Islamic and Arabian Development Studies, Duke University. She was the recipient of a Ford Foundation grant and has completed a six-month research project in Pakistan. Her graduate work in Chinese and Japanese studies was undertaken at Columbia University, but she has also concentrated her interests in the fields of Kushan and Gandhāra art, as well as that of the transitional B.C.-A.D. period in India.

Ann E. Edwards is the assistant manager of the Public Relations Department of the Cleveland Museum of Art, which has led her to write in almost every area of art history. She was educated at Notre Dame College and Marquette University in Milwaukee and previously was with the Cleveland Museum of Natural History.

Patricia J. Fister is curator of Asian art at the Spencer Museum of Art and assistant professor of Asian art in the Kress Foundation Department of Art History, University of Kansas. She received a doctorate from the University of Kansas, where she specialized in Japanese Edo painting. She was a research fellow at the New Orleans Museum of Art and previously held a Fulbright Fellowship for research in Kyoto, Japan.

Agnes Ann Fitzgibbons is with Online Computer Systems, Inc., and received a graduate degree from Catholic University of America in Washington, D.C., in library and information science. She is a member of the Special Library Association and the American Society of Information Science and has had work published on automated manuscript preparation.

Geraldine E. Fowle is an associate professor at the University of Missouri-Kansas City. She received graduate degrees from the University of Michigan in economics and art history and has had works published on seventeenth-century French art, as well as on women artists.

Ellen K. Fox graduated Phi Beta Kappa from the University of Iowa and received her doctorate from the University of Minnesota, specializing in the Italian and Northern Renaissance. She has had work published on Milanese sixteenth-century Counter-Reformation art.

Ann Galonska most recently has been curatorial assistant at the Mark Twain Memorial and previously was a research assistant at the Wadsworth Athenaeum. She received a master's degree in art history from the University of Virginia.

Suzanne Garrigues is assistant professor of art history at Morgan State University. She received master's degrees from the University of the Americas and Johns Hopkins University and a Ph.D. from the University of Maryland. Although her specialization has been pre-Columbian and modern art of Mexico and Wilfredo Lam, she has also had work published on twentieth-century American painting.

Andrea Gasten is slide librarian for the University of Utrecht and adjunct instructor in the European Division of Troy State University. She received a *doctoraaldiploma* from the University of Utrecht in 1981 after also doing graduate work at the University of California, Santa Barbara. She has had works published on seventeenth-century Dutch genre and still-life painting, as well as mathematics in Dutch art of the Symbolist period.

Suzanne E. Gaynor is a research assistant at The Wallace Collection, London, and is the author of works on Venetian glass and Richard Wallace. She received a graduate degree from the Courtauld Institute, University of London, and holds a diploma in art gallery and museum studies from Manchester University.

Deborah A. Gribbon is assistant director for curatorial affairs at the J. Paul Getty Museum, Malibu, and was formerly curator of the Isabella Stewart Gardner Museum in Boston. Dr. Gibbon received graduate degrees in art history from Harvard University and has had work published on nineteenth-century French paintings and prints.

Marilyn Gridley is a lecturer at the University of Missouri-Kansas City. She received a doctorate from the University of Kansas in the field of Chinese and Japanese art. Dr. Gridley's published works include the subjects of modern Chinese painting and Buddhist sculpture and painting.

Eleanor Guralnick received her doctorate in art history (classical and ancient art, Near Eastern art, and archaeology) from the University of Chicago and has had many works published on topics such as the origins of Greek art, proportions of Greek sculpture, statistical methods for studying proportions of sculpture, and Assyrian sculpture. She recently has been president of the Archaeological Institute of America, Chicago Society.

Churlmo Hahn is the coordinator of the international programs at the National Museum of Korea in Seoul. He received both undergraduate and graduate degrees in English from Seoul National University. He is a member of ICOM.

William Hauptman, formerly a professor of art history at the University of Pennsylvania, is now doing independent research at the Musée cantonal des beaux-arts in Lausanne, Switzerland. In pursuing his interest in nineteenth-

century European painting and sculpture, Dr. Hauptman completed his Ph.D. at Pennsylvania State University.

Molly Siuping Ho, now living in Japan, was recently lecturer in art history in the Department of Fine Arts, Hong Kong University. She is a doctoral candidate at the University of Chicago and was the first recipient of an exchange fellowship to study in Beijing. Her specialty is in the Six Dynasties, T'ang through Yüan, Ming, and Ch'ing dynasties of China; early architecture and sculpture of India; Japanese painting; and Buddhist and Shinto sculpture.

Nils G. Hökby is the curator of the education department of the Nationalmuseum in Stockholm, Sweden. Dr. Hokby's expertise is in the field of Pop art, especially Swedish artists of the sixties.

Peter Hughes, assistant to the director of The Wallace Collection, London, completed graduate work in fifteenth-century art at the Courtauld Institute, University of London, after receiving a degree from Oxford. He has written extensively on silver, porcelain, French furniture, and the history of The Wallace Collection.

Alice R. M. Hyland teaches at the University of Alabama in Birmingham. Dr. Hyland received graduate degrees in Asian art from the University of Michigan. She has had works published on Suchou literati painting and Chinese ceramics and was a recipient of the American Oriental Society Fellowship for the study of Chinese painting.

Ann Stephens Jackson is a management and editorial consultant who has put her organizing skills to use in working as assistant editor on *Art Museums of the World*. A graduate in economics from Smith College, she was awarded the M.B.A. from Harvard University.

Virginia Jackson has been on the editorial board of *Art Museums of the World* for the past ten years. She has received degrees from the University of Minnesota and Pratt Institute Library School in Brooklyn with graduate studies in art history undertaken at the University of Missouri-Kansas City and the University of Kansas. She is also a certified archivist and has worked as field editor for the Smithsonian Institution Bicentennial Inventory of American Painting in the states of Kansas and Missouri.

David A. Jaffé is curator for European art before 1900 at the Australian National Gallery in Canberra and was formerly lecturer for Queensland University and a research associate at Melbourne University. He received a graduate degree in art history from the Courtauld Institute of the University of London. Mr. Jaffé

has written extensively on Renaissance art, specializing in Roman sixteenth-century painting.

Reinhild G.A.G. Janzen is research associate at the University of Kansas Museum of Anthropology. Dr. Janzen studied at the University of Gottingen and the University of Hamburg and received graduate degrees in the history of art from the University of Chicago and University of Kansas. She has had works published on Abrecht Altdorfer, African art, and the methodology of exhibit planning.

Flora S. Kaplan, director of the Museum Studies Program and assistant professor of anthropology at the Graduate School of Arts and Sciences, New York University, has returned from Nigeria, where she was Fulbright Senior scholar in 1983–84. Professor Kaplan graduated cum laude, Phi Beta Kappa, from Hunter College. She received graduate degrees from Columbia University and the Graduate Center of the City University of New York. She has had many works published in the fields of Benin art, Mexican folk art, theory of art style, and museum history, theory, and practice. Dr. Kaplan is on the United States governing committee of the American Museum Association/International Council of Museums.

Lorraine Karafel is an art historian and critic who has had many works published in all fields of art history. She received a master's degree from the Institute of Fine Arts, New York University, and has also studied at the École du Louvre and the University of Florence.

Virginia M. Kerr is on the staff of the Avery Architectural Library of Columbia University. She received a master's degree in library science from Drexel University and a master's degree in art history from the University of Chicago, where she is a Ph.D. candidate completing her dissertation on English Baroque architecture as it relates to libraries.

Duncan Kinkead is Andrew W. Mellon assistant professor of art history at Duke University. He was educated at Yale and holds a doctorate from the University of Michigan. He has had works published on Spanish Baroque painting and Italian Renaissance painting.

Christian M. Klemm is the curator of the collection at the Kunsthaus, Zurich. Dr. Klemm has written many catalogues for that institution.

Christopher A. Knight, winner of the Manufacturer's Hanover Trust/Art World Award for Distinguished Newspaper Art Criticism in 1982, is the art critic for the Los Angeles *Herald Examiner* and formerly curator of the La Jolla Museum of Contemporary Art.

Ruth E. Kolarik is an assistant professor in art history at the Colorado College. She received graduate degrees from the Universities of Kansas and Harvard and has been the recipient of numerous grants, including the Dumbarton Oaks Junior Fellowship. Dr. Kolarik is the author of works on Late Antique floor mosaics of the Balkans and the archaeology of Stobi.

Ellen Johnston Laing is the Maude I. Kerns professor of Oriental art at the University of Oregon. She received her doctorate from the University of Michigan and has written extensively on Chinese painting, particularly on the sixteenth-century painter Ch'iu Ying and Sung Dynasty painting. Professor Laing is also interested in twentieth-century Chinese art.

Jan Merlin Lancaster has been assistant curator for research at The Phillips Collection, Washington, D.C., and in that capacity has contributed to exhibition catalogues on Arthur Dove, Georges Braque, and Pierre Bonnard. She has also written a book on Raoul Dufy. Her graduate work in art history was undertaken at George Washington University.

Ellen G. Landau is assistant professor of art history at Case Western Reserve University, specializing in modern European art and American art since 1945. Dr. Landau did her graduate work at George Washington University and the University of Delaware. She has had works published on Hans Hofmann, Lee Krasner, and the Washington Color School.

Cynthia Lawrence is an assistant professor at Rutgers University and formerly was at SUNY at Stony Brook. She received her Ph.D. from the University of Chicago and has authored works on Flemish commemorative sculpture, selected works by Rubens and Rembrandt, and Netherlandish architectural painting.

William R. Levin is assistant professor in the art department of Centre College, Danville, Kentucky. Levin earned his Ph.D. from the University of Michigan, having concentrated in medieval and Renaissance art. He was a recipient of the Kress Foundation Fellowship and the ITT Fellowship to Italy and is the author of work on Italian iconography and the style of the Middle Ages and the Renaissance.

Felicia Lewandowski is assistant professor of art at Radford University in Virginia. She received a doctorate from the University of Kansas and has written on the artist Antonio Balestra. She is a member of the Art and Architectural Review Council of the Commonwealth of Virginia and the American Society for Eighteenth-Century Studies.

Barbara B. Lipton is the special projects consultant and guest curator for the Newark Museum. She has degrees in library science from Rutgers University

and in art history from the University of Michigan and has had works published on many subjects.

Yvonne A. Luke is a Ph.D. candidate at the Courtauld Institute of the University of London. She was awarded the Leverhulme scholarship for dissertation research on de Quincy in Paris.

Judith A. McCandless was most recently associate curator for twentieth-century art at the Museum of Fine Arts, Houston. She received degrees in art history from Skidmore College and Williams College and has written on American and European painting and sculpture of the twentieth century.

Lawrence J. McCrank is the dean of Auburn University at the Montgomery (Alabama) Library and Resource Center. He received graduate degrees in history from the Universities of Kansas and Virginia, and he received his M.L.S. from the University of Oregon. Dr. McCrank has had works published in many areas of history and librarianship and the books arts. He has had a Fulbright Fellowship and awards from the American Library Association.

Wendy H. McFarland was a curatorial assistant at the Ringling Museum of Art, Sarasota, Florida. She studied art history and design at the Ringling School of Art and Design and has assisted with all of the catalogues published by the museum in the last several years.

Janet MacGaffey teaches at Haverford College and Monmouth College. Her undergraduate work in anthropology was undertaken at Cambridge University, and she received graduate degrees from Bryn Mawr College. She has had work published on the Kongo potters of lower Zaire.

Letha E. McIntire is an assistant professor at Trinity University, San Antonio, Texas. She received her M.A. in Chinese art history, Chinese language, and calligraphy from the University of Hawaii and her Ph.D. from the University of Kansas. Dr. McIntire has written on landscape paintings by Ch'en Tao-fu and has specialized in the Yüan and Ming periods, emphasizing Wu School artists.

Diane Sachko Macleod is an assistant professor at the University of California at Davis. She was a Fulbright-Hays Scholar to the United Kingdom in 1978–79 for dissertation research, later receiving her Ph.D. from the University of California at Berkeley. Her field of specialization is nineteenth-century British painting, especially that of Dante Gabriel Rossetti.

Rekha Morris assisted with organizing and doing research for a major Kushan sculpture exhibition that travelled throughout the United States in late 1985–86.

She received her Ph.D. in Classical and Indian art from the University of Chicago and has had many articles published on early Indian sculpture, Rajasthani painting, Mughal painting, and recent Soviet excavations in Soviet Central Asia.

Francis D. Murnaghan, Jr., is United States circuit judge for the Fourth Circuit Court of Appeals and also is chairman of the board of The Walters Art Gallery, Baltimore. He has a keen interest in Irish painters from the seventeenth century to the present and has had works published primarily in the legal field.

Sean B. Murphy is professor of opthamology at McGill University. He has also had another career as chairman of the National Museums of Canada, former president of the Montreal Museum of Fine Arts, and former member of the Canada Council.

Diane M. Nemec-Ignashev, an assistant professor at Carleton College, Northfield, Minnesota, received her Ph.D. from the University of Chicago in Soviet and Russian literature and culture. She was awarded IREX and Fulbright fellowships for dissertation research in the USSR.

Robert Neuman is an assistant professor at Florida State University, including the university's Study Center in Florence, Italy. He received his Ph.D. from the University of Michigan and M.A. from the University of Kansas, specializing in seventeenth- and eighteenth-century European art and architecture.

Martina R. Norelli is an associate curator of graphic arts, National Museum of American Art, Smithsonian Institution. Her graduate work has been in museology at George Washington University, and she has had works published on American prints, American artist-naturalists, and Moscow and Leningrad.

Gregory Olson has been with the Art Museum Association in San Francisco, having completed his Ph.D. at the University of Chicago. He also has studied at the Zentralinstitut für Kunstgeschichte, Munich, and the Courtauld Institute, London, as a Kress Foundation Research Fellow. He has had works published on seventeenth- and eighteenth-century drawings.

Gabrielle G. Palmer was the former project director for the Guadalupe Historic Foundation in charge of restoration of an eighteenth-century Mexican colonial church in Sante Fe, New Mexico, and its conversion to a museum and cultural center. Her Ph.D. was awarded by the University of New Mexico, and she has written on colonial religious sculpture in Ecuador and other subjects pertaining to Spanish colonial art.

Marlene A. Palmer is a member of the editorial board of *Art Museums of the World*. President of FEMTO Associates, she was formerly librarian of the Slide

and Photographic Archive of the National Museum of American Art and curator of Naval Battle Prints at the United States Naval Academy Museum. She received an M.A. in art history and an M.L.S. in library and information services from the University of Maryland and has had works published on William Blake and Whistler.

Samuel Paz is the director of educational services at the National Museum of Fine Arts in Buenos Aires, Argentina.

Elinor L. Pearlstein is assistant curator of Oriental art at the Cleveland Museum of Art, where she has made many contributions to catalogues of exhibitions of Oriental art organized by that museum. Her graduate work in Asian art was undertaken at the University of Michigan, and her particular specialty is early Chinese art and archaeology.

Marla F. Prather was formerly curator of painting and sculpture at the Spencer Museum of Art, University of Kansas, and is now a doctoral candidate at Columbia University. She has written on nineteenth-century sculpture and lithography, and her specialty is nineteenth-century French painting.

Carmen Quintana is in the graduate program in art history at the University of Chicago, where her field is in Spanish Renaissance and Baroque art.

Donald Rabiner is an assistant professor at Arizona State University, where his field is Italian Baroque art. Dr. Rabiner received his Ph.D. from the University of Kansas and has had works published not only in his area but also on the subject of chinoiserie.

Ronald D. Rarick is presently a Kress Foundation Department of Art History Fellow doing dissertation research in Paris and Besançon, France. He will receive his Ph.D. from the University of Kansas, which also awarded him a fellowship, and where he has been a graduate teaching assistant. Mr. Rarick is a member of Phi Beta Kappa.

Tara K. Reddi is an expert in the department of nineteenth- and twentieth-century prints of Sotheby's, New York. She received an art history degree from Barnard College, Columbia University.

Georgine Szalay Reed is assistant designer for exhibitions at the National Museum of American Art. She has also been on the staff of Dumbarton Oaks and the Virginia Museum of Fine Arts and has lectured on the Italian Renaissance for the Smithsonian Associates Program. Her graduate work in the Italian Renaissance through Mannerism was undertaken at the University of Maryland.

Catharine H. Roehrig has been assistant director of the Berkeley Theban Mapping project. She received her M.A. from Bryn Mawr and Ph.D. from the University of California at Berkeley in the field of Egyptian archaeology. She has written on the royal tombs of the Egyptian New Kingdom and on procedures for mapping tombs.

Ernest August Rohdenburg III is a fine arts consultant who was formerly consultant to the Library of Congress and curator at the Maryland Historical Society. He received a master's degree in art history from the University of Maryland, where he specialized in nineteenth-century American painting, about which he has written.

Novelene Ross is curator of education at the Wichita Art Museum. She received a doctorate from Washington University in St. Louis and has had work published on Édouard Manet.

Andrzej Rottermund is the former deputy director of the National Museum in Warsaw and is now with the Institute of Art of the Polish Academy of Science. He was awarded a doctorate from Warsaw University and has written on Polish neoclassicism, the royal castle in Warsaw, and the history of museums.

Renata Rutledge has acted as an art consultant for international cultural exchange and has done research for the Institute of Museum Services. She studied at the New School for Social Research in New York and has written articles and essays on museum security and contemporary sculpture.

Ronnie J. Scherer teaches at Fordham University and Montclair State College and is a doctoral candidate at Columbia University. She received both the Whiting and Wittkower fellowships while completing work toward her M.Phil. at Columbia University. Her specialty is in Greek and Roman art and archaeology.

Marilee Schmit is a program specialist for the Latin America Institute of the University of New Mexico. Her graduate work at the university was in anthropology and Latin American ethnology, and she was awarded a Tinker Foundation Fellowship for Research in Latin America in 1981 to study embroidery techniques of northern Ecuador.

Raymond V. Schoder is emeritus professor of classical studies at Loyola University, Chicago. Father Schoder's doctorate was earned at St. Louis University in classical literature and archaeology, and he has had numerous books and articles published on ancient Greek art and Mediterranean archaeology.

Gyde Vanier Shepherd is assistant director in charge of public programs and curator of European art at the National Gallery of Canada. He was educated at

McGill University and Oxford University and undertook his graduate work in fine arts at Harvard University. He has written many articles on the collections of the National Gallery. Shepherd is a governor of the Montreal Museum of Fine Arts and a member of the board of the Elizabeth Greenshields Foundation in Montreal.

Randi E. Sherman is photographs editor for World Book, Inc., and a freelance writer and editor specializing in subjects about art. Her graduate work in art history, specializing in Spanish and medieval art, was undertaken at the University of Chicago. She also has written on American art, including contemporary art in Chicago.

Robert B. Simon is the director of the Fine Arts Group of Crosson Dannis, Inc., and has been a consulting curator for several public and private art collections. Dr. Simon was a former Andrew Mellon and Chester Dale Fellow in the Department of European Paintings at the Metropolitan Museum. He received his doctorate from Columbia University and has written on Agnolo Bronzino and Nicholas Poussin.

Carol Hynning Smith has worked on special projects for both the Minneapolis Institute of Arts and the University Gallery at the University of Minnesota. She received a master's degree from the University of Maryland, with a specialty in nineteenth-century European art, and she has had work published on drawings and watercolors of the nineteenth and twentieth centuries.

Judith Berg Sobré is an associate professor of art history at the University of Texas at San Antonio. She received her doctorate from Harvard University and has written on Spanish painting of the fourteenth and fifteenth centuries. She recently spent a year in Spain on a Fulbright Fellowship doing research at a number of institutions.

Thomas W. Sokolowski is the director of New York University's Grey Art Gallery after serving as chief curator of the Chrysler Museum in Norfolk, Virginia. His graduate work was undertaken at the Institute of Fine Arts, New York University, and he has written on Roman eighteenth-century art, as well as curating a number of exhibitions at the Chrysler.

Adriana Soldi was formerly conservation assistant in the Textile Department of the National Museum of Anthropology and Archaeology in Lima, Peru. She pursued graduate studies in anthropology at the University of Illinois and has specialized in pre-Columbian art and textile iconography. Ms. Soldi was a recipient of a Fulbright grant for work in these fields.

Marie Spiro is an associate professor at the University of Maryland at College Park. Her doctorate was awarded by the Institute of Fine Arts, New York

University. Dr. Spiro has had many works published on Roman, Early Christian, and Byzantine mosaics. She is on the managing committee of the American School of Classical Studies at Athens.

Frauke Steenbock is head of the Museum Library of the State Museums in West Berlin and was formerly assistant in the Department of Prints and Drawings at the same institution. She received her doctorate in early medieval decorative arts and book illustration from Bonn University and is the author of works on these subjects.

Kate Steinway is curator of prints and photographs at the Connecticut Historical Society. Her graduate work in art history was undertaken at the University of Chicago, and she has specialized in a wide range of subjects, including Renaissance, Greek and Roman, and American art, as well as prints and photographs.

Andrea Stone is assistant professor of art history at the University of Wisconsin, Milwaukee. She received her Ph.D. in pre-Columbian art from the University of Texas and is a former Fulbright-Hays Fellow. She has had works published on Classical Maya cave painting and Classical Maya epigraphy, dynastic history, and iconographic interpretation.

Edward J. Sullivan is assistant professor of fine arts at New York University. He received his Ph.D. from the same institution. He has specialized in and written on Spanish painting from the seventeenth through the nineteenth century.

Marsha Tajima formerly worked in the Indian section of the Department of Asian Art at the Los Angeles County Museum of Art. She received her doctorate, specializing in South Asian art history, from the University of Chicago and was a junior fellow of the American Institute of Indian Studies in New Delhi to further her dissertation research.

René Taylor is director emeritus of the Ponce Art Museum. His Ph.D. was awarded by the University of London. He has specialized in the art of the sixteenth through eighteenth century, chiefly Spanish and Latin American.

Gerard C. C. Tsang is the planning officer for museums in the Cultural Services Department, Hong Kong, and was formerly assistant curator at both the Hong Kong Museum of History and the Hong Kong Museum of Art. His graduate degree is from the University of Manchester, England, in art gallery and museum studies. He has had works published in the field of Chinese decorative arts.

Nnennaya Samuel Ukwu is a curator of the Enugu National Museum of the National Commission for Museums and Monuments in Nigeria. She has studied at New York University's Graduate School of Arts and Science in the field of

museum studies and political science and has presented papers on late-nineteenth- and twentieth-century Ibo and Ibibio head and face masks, masquerades, and religious shrines.

Pilar Viladas is senior editor of *Progressive Architecture* magazine. She received a degree in art history from Harvard University, and her major interest is in contemporary art and architecture and interior design.

Stephen Vollmer was formerly curator of the San Antonio Museum Association, with a specialty in Latin American colonial art. A graduate of the University of the Americas in Mexico City, he has done extensive research in Central and South America. He is now the director of Ex Voto Gallery in San Antonio, which specializes in folk art of the Americas and the Caribbean basin.

Bret Waller, associate director for education and public affairs at the J. Paul Getty Museum, was formerly director of the Memorial Art Gallery of the University of Rochester. He received a graduate degree in fine arts and art history from the University of Kansas. He has specialized in nineteenth- and twentieth-century art and printmaking, has had many exhibition catalogs published, and has written on museum matters.

Stephen H. Whitney writes frequently on the arts and has been a lecturer in art history for the Coe College, Washington, D.C., Study Program and at the University of Grenoble (France), University of Maryland, and Trinity College, Washington, D.C. He received a master's degree in art history from the University of Maryland, College Park. His published work includes twentieth-century European and eighteenth-century French painting.

Mary Louise Wood is programming officer for Academic Travel Abroad and formerly was senior staff lecturer at The Walters Art Gallery, where she also wrote on the collections. She received her Ph.D. from Johns Hopkins University, specializing in Italian Romanesque sculpture.

David A. Young is head of museum advisory services at the Royal Ontario Museum and was the former head of programs and public relations at the same institution. Mr. Young was educated at the University of Toronto and has written on the collections of the ROM.

Patrick Youngblood, who is with an art gallery in London, received his M.A. from the Courtauld Institute of the University of London. He also studied at Vanderbilt University. Mr. Youngblood has specialized in the art of nineteenth-century England.

Eric M. Zafran, a member of the editorial board of *Art Museums of the World*, is the James A. Murnaghan Curator of Renaissance and Baroque Art at the Walters Art Gallery, Baltimore. He was previously curator of European art at the High Museum in Atlanta, Georgia. Dr. Zafran received his Ph.D. from the Institute of Fine Arts, New York University, and has written many catalogs for exhibitions he has curated in fields ranging from eighteenth- and nineteenth-century French painting and seventeenth-century Dutch painting to nineteenth-century photography, as well as catalogs for other collections and exhibitions.

Ruth Ziegler is a vice-president of Sotheby's, New York, and print expert in nineteenth-century and modern prints. She also is an expert in Latin American and contemporary prints. Ms. Ziegler studied in Munich and at Cambridge University, as well as at the Institute of Fine Arts, New York University. She has written articles in her fields of specialization.